Praise for
Photographer's Market

"In short, this is the guidebook photographers must see if they want to be seen."
—Today's Photographer

"A sharp photographer could make a pretty comfortable living just pursuing the clients found in here." **—Studio Photography Magazine**

"The *Photographer's Market* is the perfect resource book for the serious amateur photographer who's always dreamed of crossing over into the real world of professional photography." **—Communication Arts**

"Perhaps the best and most used source for pro and amateur alike. Very highly recommended."
—Amelia

"Offers endless outlets for photographers' photos, along with advice from leading experts on how to start and sustain a successful photography career."
—The Rangefinder

1999
PHOTO GRAPHER'S MARKET

2,000 PLACES TO SELL YOUR PHOTOGRAPHS

EDITED BY
MEGAN LANE

WRITER'S DIGEST BOOKS
CINCINNATI, OHIO

Managing Editor, Annuals Department: Cindy Laufenberg
Supervising Editor: Barbara Kuroff
Production Editor: Tricia Waddell

Writer's Digest Books website: http://www.writersdigest.com

International Standard Serial Number 0147-247X
International Standard Book Number 0-89879-851-5

Attention Booksellers: This is an annual directory of F&W Publications. Return deadline for this edition is December 31, 1999.

Contents

© Fran Putney

Page 41

Whether you're a full-time pro or just beginning your freelance career you can benefit from these tips about how to sell yourself and your work.

In the increasingly competitive editorial market, editors are looking for more from photographers. A successful writer and photographer, Fran Putney explores how photographers can use writing to increase their sales.

The Markets

The publications listed here offer hundreds of opportunities for you to see your photos in print. These markets include large circulation magazines as well as specialized publications. All are looking for high-quality work in a wide range of styles and subject matter.

Insider Report:
magazine, explains why planning is crucial to great home and garden photography.

© Alex Saunderson

Page 105

© Cheryl A. Ertelt

Page 291

Resources

© Tom Wasinger

Page 513

© Chris Amaral

Page 522

From the Editor

1998 presented great challenges to the photographic community, particularly to freelance photographers. Clip disks of stock photography began eating away at stock sales and assignments for freelancers. Publishers struggled with how or how not to compensate shooters for the use of their work in electronic media. Photographers had to fight to keep their images from being manipulated by computers. Imaging technologies were born, improved upon and declared obsolete at a dizzying pace.

It was enough to make even the most seasoned photographers hang up their cameras. But they didn't. You didn't. Instead, you bought the *1999 Photographer's Market*. As I was struggling to put together this edition, I too felt daunted by all the changes in the industry. I did my best to keep up with advancing software and the latest lawsuits, and to help those of you who came to me with complaints about unprofessional markets. But eventually, I had to stop and ask myself why we go to so much trouble for photography.

The answer came to me one night, bent over my bathtub, agitating a small red tray by the dim glow of a safe light. The reason why I will never give up on photography exists in a single instant—the instant a piece of white paper begins to change and an image appears as if by magic. What we do as photographers is so much more important than most people realize. Life is a series of moments that are here and then gone. A camera traps those moments, forever, so we have time to enjoy and reflect on them.

And just as no two photographers are alike, no two photographs are alike either. The instant you press the button on your camera, the instant the shutter opens, the instant the image is burned onto the film can never be recaptured. It's gone, it's gone, it's gone. So whether you shoot close-ups of flowers for nature magazines or cars for advertisements or create art to hang in galleries, your work is invaluable.

Remember this the next time you become frustrated with your equipment or your marketing efforts. But remember it especially the next time a buyer offers you a deal that is less than ideal. It's OK to walk away from a sale. If you don't want to sell all rights to your one-of-a-kind image, then don't. If you don't want to settle for a low fee, then don't. No matter how many clip disks are produced or how good digital imaging becomes, nothing will ever replace the eye of a photographer or the magic we bring to the world.

If you need a little inspiration to get you through tough decisions, take a look at the interviews with photographers **Walter Wick** (page 238) and **Corson Hirschfeld** (page 463). Both have found creative ways to do the work they love and developed the kind of enthusiasm that naturally leads to success. If you need more practical advice about how to increase your sales, **Maria Piscopo** demonstrates how to take your marketing efforts to the next level on page 34. Freelance writer/photographer **Fran Putney** also offers practical tips on making more money with each sale by learning to write the words that go with your images on page 40.

So, good luck in 1999 and let me know how you're doing—on good days and bad. I always respond to e-mails (photomarket@fwpubs.com). If you let me know how we can make *Photographer's Market* a better resource for you, I promise I'll do my best to make it so.

Megan Lane
www.writersdigest.com

How to Use This Book to Sell Your Photos

I've been using Market books since I was about thirteen, flipping through the pages of *Writer's Market*, dreaming of the day I would first be published. I've never quite been able to give up that habit of random browsing, searching for a gem. But as I've matured and my marketing efforts for both my writing and my photography have become more serious, I've had to learn to really use the Market books. Every reader will have a unique way of sifting through the mountain of information to find just the right market, but here are some guidelines to keep in mind while you're flipping through this book.

First, know what kind of buyer you want to reach. This can be determined by the subjects you photograph, your location, or, perhaps, your style of living. The key is to concentrate on what you like to do and market your efforts accordingly. To simplify such searches we've included an extensive subject index in the back of this book. Beginning on page 589, you'll find 38 categories from Animals to Vintage Images that cover the Publications, Gifts & Paper Products, Book Publishers, Stock Photo Agencies and Galleries sections of the book.

The second key to finding the best markets for your work is to remain open minded. If you shoot wild animals in their natural habitat, sure, a magazine might love those photos. But don't forget about book publishers and greeting card manufacturers, too. Wouldn't that yawning tiger be perfect on the cover of a children's book or make a great illustration for a humorous birthday card?

Last, but not least, carefully read the listing of any market you're considering. We contact each photo buyer every year to find out exactly what they are looking for. We also ask how they like to see work submitted and what they pay for the photos they buy. And don't forget to read the editorial comments and tips included with some listings. This information can give you particular insight into the personality and viability of a company.

Of course the best way to make sure you've found a good fit for your work is to study the images a market actually buys. This is a simple task if the market is a magazine and you can find it on a newsstand or at the library. You'll have to be more creative for other kinds of markets. You can find sample images from book publishers, ad agencies and record labels on the Internet. You can also write for sample copies of trade magazines, brochures from galleries and catalogs from greeting card and poster publishers. You should always look for some kind of sample image before sending your work. There is no better way to ensure a good fit.

Not all of the marketing advice in this book comes from the within the listings, however. You will also find helpful information in the introductions to each section. In the first 45 pages we've included articles to help improve your business knowledge, including segments on pricing, copyright, proper ways to submit and store images, portfolios and taxes. This year we'll take a look at advanced strategies for marketing and increasing editorial sales, as well. You'll also find real world marketing successes scattered throughout the book in the captions with the photos we've included. Each image was first purchased by a market listed in this book, and we've contacted both the buyer and the photographer to find out what made the deal work.

Before plunging into the markets, take a look at the following page. Each listing follows the same format so studying these diagrams will help you know where to look for important information.

NEW
LISTING

NUMBER OF
PHOTOGRAPHERS
NEEDED

WHERE TO
CONTACT THEM

WHAT THEY BUY

WHO TO CONTACT

EXAMPLE OF
PAST CLIENT

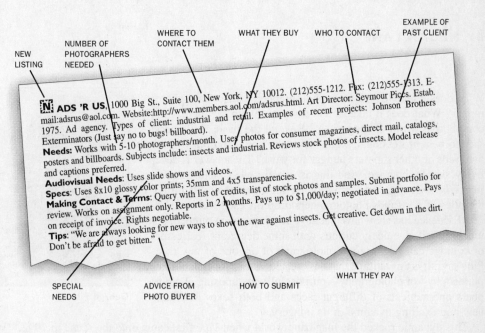

ADS 'R US, 1000 Big St., Suite 100, New York, NY 10012. (212)555-1212. Fax: (212)555-1313. E-mail:adsrus@aol.com. Website:http://www.members.aol.com/adsrus.html. Art Director: Seymour Pics. Estab. 1975. Ad agency. Types of client: industrial and retail. Examples of recent projects: Johnson Brothers Exterminators (Just say no to bugs! billboard).
Needs: Works with 5-10 photographers/month. Uses photos for consumer magazines, direct mail, catalogs, posters and billboards. Subjects include: insects and industrial. Reviews stock photos of insects. Model release and captions preferred.
Audiovisual Needs: Uses slide shows and videos.
Specs: Uses 8x10 glossy color prints; 35mm and 4x5 transparencies.
Making Contact & Terms: Query with list of credits, list of stock photos and samples. Submit portfolio for review. Works on assignment only. Reports in 2 months. Pays up to $1,000/day; negotiated in advance. Pays on receipt of invoice. Rights negotiable.
Tips: "We are always looking for new ways to show the war against insects. Get creative. Get down in the dirt. Don't be afraid to get bitten."

SPECIAL
NEEDS

ADVICE FROM
PHOTO BUYER

HOW TO SUBMIT

WHAT THEY PAY

EXTRA COMMENTS
FROM *PHOTOGRAPHER'S
MARKET* EDITOR

WHERE TO FIND THEM
ON THE INTERNET

HOW LONG THEY'VE
BEEN IN BUSINESS

MISSION
STATEMENT

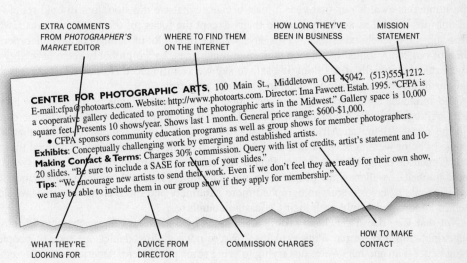

CENTER FOR PHOTOGRAPHIC ARTS, 100 Main St., Middletown OH 45042. (513)555-1212. E-mail:cfpa@photoarts.com. Website: http://www.photoarts.com. Director: Ima Fawcett. Estab. 1995. "CFPA is a cooperative gallery dedicated to promoting the photographic arts in the Midwest." Gallery space is 10,000 square feet. Presents 10 shows/year. Shows last 1 month. General price range: $600-$1,000.
• CFPA sponsors community education programs as well as group shows for member photographers.
Exhibits: Conceptually challenging work by emerging and established artists.
Making Contact & Terms: Charges 30% commission. Query with list of credits, artist's statement and 10-20 slides. "Be sure to include a SASE for return of your slides."
Tips: "We encourage new artists to send their work. Even if we don't feel they are ready for their own show, we may be able to include them in our group show if they apply for membership."

WHAT THEY'RE
LOOKING FOR

ADVICE FROM
DIRECTOR

COMMISSION CHARGES

HOW TO MAKE
CONTACT

Vibe Magazine—A Picture of America for the 21st Century

BY MEGAN LANE

George Pitts

What does it take to be a great photographer, a successful photographer? What does it take to win assignments in the increasingly competitive world of magazines? Beyond the basic skills necessary to be a professional, what will make you stand out from the hundreds of other shooters hungry for work? The answer is deceptively simple: courage. And that is exactly what picture editors, like *Vibe*'s George Pitts, are looking for when they sift through the piles of portfolios photographers drop off each week.

"Evidence has shown us that anyone who is open minded, genuinely gifted, genuinely curious with some degree of fearlessness or courage can take a good photograph of anyone of any race," Pitts says. It is this attitude that has created *Vibe*'s "open laboratory philosophy" of photography—purposefully juxtaposing photographers and subjects of different races and both sexes to create a new and exciting dynamic in its imagery.

This dynamic rocked the magazine world when *Vibe* first came onto the scene in 1992. "We won numerous awards our first year in part because what we did stood out in bold relief—we did our jobs as well as anybody else did theirs except the focus [of the magazine] was a whole other subject, a whole other race," Pitts says. "Since then a lot of publishers have incorporated some of our innovations to enhance their own magazines, so we probably seem less edgy and urgent than we initially did. I think it's safe to say we've influenced *Harper's Bazaar* and *Spin*, and our influence extends to England to *The Face* magazine."

This influence comes not only from the "look" of *Vibe* photography or from the raw hipness of its writing, but from the inclusion of people of color both in front of and behind the camera and the page. "Being an African-American," Pitts says, "I was acutely conscious that when people of color were in magazines they didn't tend to be the central subjects. I noticed that men and women of color, be they Asian, Puerto Rican, African-American or otherwise, were not photographed as well as white people were and that bothered me. I thought on some subtle level that if people of color were photographed more sublimely and more creatively, they would be seen in a more equal light with their Caucasian counterparts."

Not that *Vibe* doesn't include writing and photos by and about Caucasians who fit into the magazine's hip hop format. Pitts explains, "We're not trying to depict one race of people as being better than another. We're just trying to bring some parity here. America is this incredibly, theoretically idealistic melting pot of all these different races, ethnic groups and cultures; yet in the real world white people have been photographed and written about to death, to the detriment of other cultures."

Vibe's challenge of maintaining diversity in its photographs and photographers is met by Pitts's willingness to work with a large pool of shooters. "Most magazines use a roster of five to ten people who they never vary from," he says. "We, on the other hand, easily have at least 50 to 100 photographers we work with or have some intention of working with. Because black

"This photograph exists as a piece of narrative about Kool Keith, who exists in the world of cheap motels and procured sexual favors," says photographer Brian Cross about his portrait of the rapper. *Vibe* Picture Editor George Pitts became familiar with Cross's work through the purchase of a stock photo. Cross won this assignment because of his friendship with Keith and Pitts's confidence in his work. Pitts believed the trust between photographer and subject would lead to an unusual, powerful image. The image was so successful that Cross has earned several other assignments from it, including a cover shot for *Raygun*.

people, women, Asian and Latin photographers have been denied the opportunity to photograph white people at other magazines, we take great pride in hiring people of every race and both genders."

And while less progressive magazines might hire an African-American photographer to shoot an African-American subject, *Vibe* takes a different approach. "Sometimes a black person is the best person to shoot a subject. But they might be the best person to shoot a white or Asian subject. It really depends on the photographer's capability and receptivity to the subject."

This careful selection process is clear in the provocative work Pitts impels his photographers to deliver. For a photo shoot with the controversial rapper Kool Keith, Pitts wanted to find a photographer who could allow the real Keith to shine through. "Keith, it's safe to say, is what black people would call a freak. In his case he's got a passion and an obsession with sex. We found a photographer who not only knew Keith, but was someone he trusted, and we had some confidence that Keith would participate in whatever kind of shoot we could propose." The image ended up showing Keith bound and masked in a shower flanked by two powerful women dressed in provocative attire. "I like the gender switch that's visible," Pitts says, "the role playing. Normally women are perceived in a more submissive light whereas Keith is obviously game and even very open about being seen as the submissive in relationship to some strong, sexually charged women."

A memorable *Vibe* image of the Notorious B.I.G. called for a photographer with specific technical skills. Biggie is backlit against a classic horror movie sky and an ominous, dark bird is perched on the edge of the cigar hanging from his mouth. "Biggie had the physical presence—he just had a certain kind of profile that bore a strong resemblance to Alfred Hitchcock's, and we were able to exploit that, I think, in a very interesting way. The photographer is normally known as a fashion photographer, very experienced in doing rear projection. Because he was very conscious of the history of film and he's very resourceful, he was seen as the ideal choice. And of course that picture is an obvious tribute to *The Birds*."

But sometimes it takes more than one photographer to tackle a tough assignment. "Hip hop subjects are some of the most volatile, unpredictable and sometimes unprofessional subjects you'll ever find in the media," Pitts says. But that doesn't stop him from also calling them "tremendous fun." For a shot of one such subject, Pitts chose a photo team—a man and a woman known collectively as Guzman. "That's a growing phenomenon in photography—groups, pairs, trios, collectives of people working together. Guzman took on the considerable task of photographing the volatile, unpredictable, wild and wacky Wu-Tang Clan. They did individual portraits as well as group portraits." The image that stands out is a portrait of the Wu-Tang's Method Man lighting a match and exhaling a puff of thick white smoke. There is a palpable feeling of challenge in the air around him. "Our subjects tend to be thoroughly themselves in front of the camera," Pitts says. "They are a fearless bunch and therefore we need an equally courageous and open-minded photographer to capitalize on such moments."

Vibe doesn't only cover rappers, however, and flipping through pages often uncovers a hard-hitting news piece with powerful documentary photos. One of the best such stories last year was about a Latino gang. "This was a very well-done story by a young black female photographer," Pitts says. "She documented the lifestyle, the day-to-day activities of a large and very powerful Latino gang called the Latin Kings. It was a very easy story to select because virtually every picture was interesting, filled with visual and sociological information."

That is another reason *Vibe* stands out from typical "music" magazines—there is no one "look" a *Vibe* photograph must achieve. "We tend to be more eclectic in our approach than some magazines that aspire to a visual seamlessness," Pitts explains. "We like different kinds of stories to rub up against each other. Whether it's hard-core photojournalism or a really bracing and possibly difficult photo essay, we want that to rub shoulders with a slick cover shoot done in a kind of Richard Avedon way against a white seamless background."

This challenging juxtaposition of the real and the ideal is also evident in *Vibe*'s fashion

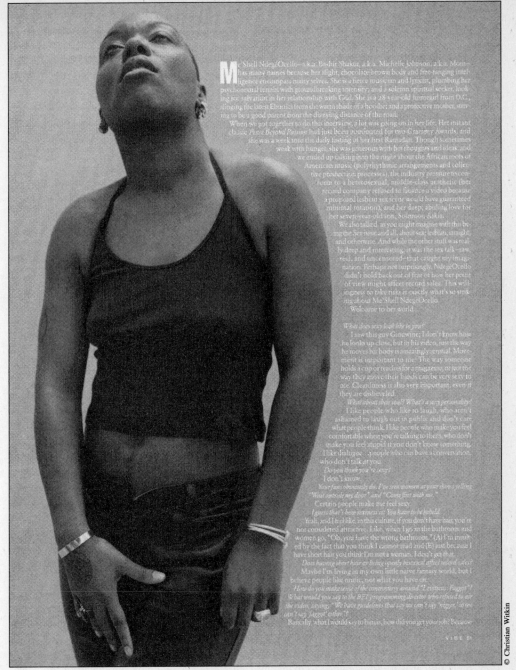

"This is an extremely unconventional picture—very simple. I would say 95% of American magazines would go out of their way not to publish such a picture," says George Pitts of Christian Witkin's striking portrait of singer Me'Shell NdegéOcello. "That picture pretty much continues the tradition of us trying to reinvent and broaden the range of magazine portraiture." The highly sought after Witkin was first "discovered" by *Vibe*. "Christian happens to be the nephew of the great art photographer Joel Peter Witkin, so obviously, a certain kind of edginess runs in the bloodline."

photography. Instead of slick studio shots with supermodels—unattainable perfections—*Vibe* fashion is shot mostly on location around New York City, making the work look much more like documentary photography. "We like to confuse genres and make them irrelevant," Pitts says. And readers have responded favorably. "It enables them to identify with the subjects more immediately. They feel more of a commonness with either the narrative line or the subjects. We use people who are not models. We use real people."

But the "reality" of *Vibe*'s photography also shows up in unexpected places, like a story about singer Me'Shell NdegéOcello. "I would say 95% of American magazines would go out of their way not to publish such a picture. Many people would find the picture unflattering and uncommercial." But the un-retouched image shot from below, by the increasingly famous Christian Witkin, is one of the most powerful portraits *Vibe* has ever published.

Another portrait with a similar feel was done by a new photographer for *Vibe*'s monthly emerging talent story. "That's the area where we can hire the newest and freshest talent. It's where we test photographers to see if they have the ability to do larger, more complex work. If they're able to deliver that one memorable picture, then they're on their way to doing more complicated feature stories or fashion stories for the magazine."

To get their feet in this door, photographers have to catch Pitts's attention, first with a strong portfolio, then with their own vibe in a personal meeting. "Sometimes the photographer's talent lies not strictly in the professionalism of their photography but in the seductiveness of their personality," Pitts says. "And when I say seductive I mean that someone with a kind of generous and curious intelligence and personality will no doubt bring those same qualities to a photo shoot. That's why it is crucial, if the editor sees any value in a portfolio, to follow up and meet the photographer."

Pitts takes these meetings seriously and arranges as many as his schedule will allow. He is always willing to take a chance with an emerging talent or to find a way to help photographers make the most of their skills, even if that means helping them make contacts at magazines other than *Vibe*. There is nothing typical about this picture editor or his magazine and neither can be neatly classified or labeled.

"Depending on your own knowledge of culture and photography and current events you could see *Vibe* as an art magazine, a music and culture magazine, a political magazine or combination of all those things," Pitts says. "I guess I see it as a music and culture magazine that endeavors to do everything as originally as possible. Because of this historical moment we have virtually an inexhaustible series of topics. In part because of the racism and the state of affairs in terms of American culture, black, Latin and Asian people have gone undocumented for most of this century. So there is so much work to do in illustrating their passions, their lifestyles, their loves, their concerns. And I think if anyone understands history correctly, one sees that we're just beginning to document these minority cultures, therefore it's easier to do fresh, original and significant work because in previous decades no one endeavored to do it."

What this means for photographers in the 21st century is they will be able to embrace the multiculturalism that makes America unique as a country. They will be able to do more interesting and powerful work, and there will be plenty of places to publish the real face of America. Stock agencies are already calling for work that more accurately reflects a world whose people come in many shades. The need and desire for such images are evident throughout the industry from greeting cards to ad agencies to magazines. Some magazines just run ahead of the pack.

Getting Down to Business

Photography is an art that requires a host of skills, some which can be learned and some which are innate. To make money from your photography, the one skill you can't do without is a knowledge of business. Thankfully, this skill can be learned. What you'll find on the following pages are the basics of running a photography business. We'll cover:

- Creating a Plan for Your Business, pg. 9
- Using Essential Business Forms, pg. 14
- Finding Buyers for Your Work, pg. 17
- Submitting Your Work, pg. 20
- Showcasing Your Talent, pg. 20
- Charging for Your Work, pg. 23
- Figuring Small Business Taxes, pg. 26
- Organizing Your Images, pg. 27
- Protecting Your Copyright, pg. 30
- Dealing With International Clients, pg. 32

CREATING A PLAN FOR YOUR BUSINESS

Creating a business plan in the proper format is essential if you want to apply for a loan. But even if you have all the money you need to start your studio, a plan will take the guesswork out of the start-up process and help you prepare for the future. Remember, this document is not set in stone. Your business plan will change as your business changes. The following outline and marketing worksheet were created by the Small Business Administration. They can be found on their website at http://www.sba.gov along with a details about how to complete each part.

Elements of a business plan

1. Cover sheet
2. Statement of purpose
3. Table of contents
 - I. The Business
 - A. Description of business
 - B. Marketing plan
 - C. Competition
 - D. Operating procedures
 - E. Personnel
 - F. Business insurance
 - II. Financial Data
 - A. Loan applications
 - B. Capital equipment and supply list
 - C. Balance sheet
 - D. Break-even analysis
 - E. Pro-forma income projections (profit & loss statements)
 - Three-year summary
 - Detail by month, first year
 - Detail by quarters, second and third years
 - Assumptions upon which projections were based
 - F. Pro-forma cash flow

III. Supporting Documents
- Tax returns of principals for last three years
- Personal financial statement (all banks have these forms)
- In the case of a franchised business, a copy of franchise contract and all supporting documents provided by the franchisor
- Copy of proposed lease or purchase agreement for building space
- Copy of licenses and other legal documents
- Copy of résumés of all principals
- Copies of letters of intent from suppliers, etc.

The financial portion of your business plan is very important and must be very specific. You'll need this information to set your prices, to get loans to cover equipment and start-up costs and to plan for the future. Contact your local Small Business Administration office for free instructional pamphlets about how to create profit and loss statements and cashflow projections. In the meantime you should try to determine exactly how much money you spend in your daily life and how much you will spend in your business life by creating a budget.

In order to get a realistic picture of your spending habits before you create a budget for your business, you should keep a notebook of all your expenses, one column for personal expenses and one for photography. Write down every cent you spend for at least a month, even the nickel you gave your daughter—it adds up. Then multiply your monthly expenses by 12 to get your annual expenses and estimate other periodic expenditures like office supplies, car repairs and self-promotions. Just make sure to build in emergency money for unforeseen events like dropping your camera off a bridge.

Creating a marketing plan

The marketing plan is one of the most immediately useful parts of your business plan and you'll need it even if you never apply for a bank loan. This SBA worksheet will walk you through the steps of developing a working marketing plan to ensure that your business will be a success.

I. Market Analysis
 A. Target Market - Who are the customers?
 1. We will be selling primarily to (check all that apply):
 a. Private sector
 b. Wholesalers
 c. Retailers
 d. Government
 e. Other
 2. We will be targeting customers by:
 a. Product line/services. We will target specific lines:
 b. Geographic area? Which areas?
 c. Sales? We will target sales of:
 d. Industry? Our target industry is:
 e. Other?
 3. How much will our selected market spend on our type of product or service this coming year? $ _____

B. Competition
 1. Who are our competitors?
 Name _____
 Address _____

 Years in Business _____
 Market Share _____
 Price/Strategy _____
 Product/Service _____
 Features _____

 Name _____
 Address _____

 Years in Business _____
 Market Share _____
 Price/Strategy _____
 Product/Service _____
 Features _____

 2. How competitive is the market?
 High _____
 Medium _____
 Low _____

 3. List below your strengths and weaknesses compared to your competition. Consider such areas as location, size of resources, reputation, services, personnel, etc.):

Strengths | Weaknesses
1. _____ | 1. _____
2. _____ | 2. _____
3. _____ | 3. _____
4. _____ | 4. _____

C. Environment
 1. The following are some important economic factors that will affect our product or service (such as trade area growth, industry health, economic trends, taxes, rising energy prices, etc.):

 2. The following are some important legal factors that will affect our market:

 3. The following are some important government factors:

4. The following are other environmental factors that will affect our market, but over which we have no control:

II. Product or Service Analysis
A. Description
1. Describe here what the product/service is and what it does:

B. Comparison
1. What advantages does our product/service have over those of the competition (consider such things as unique features, patents, expertise, special training, etc.)?

2. What disadvantages does it have?

C. Some Considerations
1. Where will you get your materials and supplies?

2. List other considerations:

III. Marketing Strategies—Market Mix
A. Image
1. First, what kind of image do we want to have (such as cheap but good, or exclusiveness, or customer-oriented, or highest quality, or convenience, or speed, or . . .)?

B. Features
1. List the features we will emphasize:
 a. _____
 b. _____
 c. _____

C. Pricing
1. We will be using the following pricing strategy:
 a. Markup on cost _____ What % markup? _____
 b. Suggested price _____
 c. Competitive _____
 d. Below competition _____

 e. Premium price _____

 f. Other _____

 2. Are our prices in line with our image?

 ☐ YES ☐ NO

 3. Do our prices cover costs and leave a margin of profit?

 ☐ YES ☐ NO

D. Customer Services

 1. List the customer services we provide:

 a. _____

 b. _____

 c. _____

 2. These are our sales/credit terms:

 a. _____

 b. _____

 c. _____

 3. The competition offers the following services:

 a. _____

 b. _____

 c. _____

E. Advertising/Promotion

 1. These are the things we wish to say about the business:

 2. We will use the following advertising/promotion sources:

 a. Television

 b. Radio

 c. Direct mail

 d. Personal contacts

 e. Trade associations

 f. Newspapers

 g. Magazines

 h. Yellow Pages

 i. Billboards

 j. Other _____

 3. The following are the reasons why we consider the media we have chosen to be the most effective:

WHERE TO LEARN MORE ABOUT STARTING A BUSINESS

• Take a course at a local college. Many community colleges offer short-term evening and weekend courses on topics like creating a business plan or finding financial assistance to start a small business.

• Contact the Small Business Administration at (800)827-5722 or check out their website at http://www.sba.gov. "The U.S. Small Business Administration was created by Congress in 1953 to help America's entrepreneurs form successful small enterprises. Today, SBA's program offices in every state offer financing, training and advocacy for small firms."

• Contact the Small Business Development Center at (202)205-6766. The SBDC offers free or low-cost advice, seminars and workshops for small business owners.

• Read a book. Try *The Business of Commercial Photography* by Ira Wexler (Amphoto Books) or *The Business of Studio Photography* by Edward R. Lilley (Allworth Press). The business section of your local library will also have many general books about starting a small business.

USING ESSENTIAL BUSINESS FORMS

Using carefully crafted business forms will not only make you look more professional in the eyes of your clients; it will make bills easier to collect while protecting your copyright. Forms from delivery memos to invoices can be created on a home computer with minimal design skills and printed in duplicate at most quick-print centers. When producing detailed contracts, remember that proper wording is imperative. You want to protect your copyright and, at the same time, be fair to clients. Therefore, it's a good idea to have a lawyer examine your forms before using them.

The following forms are useful when selling stock photography, as well as when shooting on assignment:

Delivery Memo

This document should be mailed to potential clients along with a cover letter when any submission is made. A delivery memo provides an accurate count of the images that are enclosed and it provides rules for usage. The front of the form should include a description of the images or assignment, the kind of media in which the images can be used, the price for such usage and the terms and conditions of paying for that usage. Ask clients to sign and return a copy of this form if they agree to the terms you've spelled out.

Terms & Conditions

This form often appears on the back of the delivery memo, but be aware that conditions on the front of a form have more legal weight than those on the back. Your terms and conditions should outline in detail all aspects of usage for an assignment or stock image. Include copyright information, client liability and a sales agreement. Also be sure to include conditions covering the alteration of your images, transfer of rights and digital storage. The more specific your terms and conditions are to the individual client, the more legally binding they will be. If you own a computer and can create forms yourself, seriously consider altering your standard contract to suit each assignment or other photography sale.

Invoice

This is the form you want to send more than any of the others, because mailing it means you have made a sale. The invoice should provide clients with your mailing address, an explanation of usage and the amount due. Be sure to include a reasonable due date for payment, usually 30 days. You should also include your business tax identification number or social security number.

Model/Property Releases

Get into the habit of obtaining releases from anyone you photograph. They increase the sales potential for images and can protect you from liability. A model release is a short form, signed by the person(s) in a photo, that allows you to sell the image for commercial purposes. The property release does the same thing for photos of personal property. When photographing children, remember that a parent or guardian must sign before the release is legally binding. In exchange for signed releases some photographers give their subjects copies of the photos, others pay the models. You may choose the system that works best for you but keep in mind that a legally binding contract must involve consideration, the exchange of something of value. Once you obtain a release, keep it in a permanent file.

You do not need a release if the image is being sold editorially. However, some magazine editors are beginning to require such forms in order to protect themselves, especially when an image is used as a photo illustration instead of as a straight documentary shot. You **always** need a release for advertising purposes or for purposes of trade and promotion. In works of art, you only need a release if the subject is recognizable. When traveling in a foreign country it is a good idea to carry releases written in that country's language. To translate releases into a foreign language, check with an embassy or a college language professor.

PROPERTY RELEASE

In consideration of $ _____ and/or _____
_____, receipt of which is acknowledged, I being the legal owner of or having the right to permit the taking and use of photographs of certain property designated as _____, do hereby give _____, his/her assigns, licensees, and legal representatives the irrevocable right to use this image in all forms and media and in all manners, including composite or distorted representations, for advertising, trade, or any other lawful purposes, and I waive any rights to inspect or approve the finished product, including written copy that may be created in connection therewith.

Short description of photographs: _____

Additional information: _____

I am of full age. I have read this release and fully understand its contents.

Please print:
Name _____
Address _____
City _____ State _____ Zip Code ____
Country _____

Sample property release

MODEL RELEASE

In consideration of $_____ and/or _____, receipt of which is acknowledged, I, _____, do hereby give _____, his/her assigns, licensees, and legal representatives the irrevocable right to use my image in all forms and media and in all manners, including composite or distorted representations, for advertising, trade, or any other lawful purposes, and I waive any rights to inspect or approve the finished product, including written copy that may be created in connection therewith. The following name may be used in reference to these photographs:

My real name, or _____

Short description of photographs: _____

Additional information: _____

I am of full age. I have read this release and fully understand its contents.

Please print:
Name _____
Address _____
City _____ State _____ Zip Code _____
Country _____

Signature _____
Witness _____ Date _____

CONSENT

(If model is under the age of 18) I am the parent or guardian of the minor named above and have the legal authority to execute the above release. I approve the foregoing and waive any rights in the premises.

Please print:
Name _____
Address _____
City _____ State _____ Zip Code _____
Country _____

Signature _____
Witness _____ Date _____

Sample model release

WHERE TO LEARN MORE ABOUT BUSINESS FORMS

• *The Photographer's Market Guide to Photo Submission and Portfolio Formats* by Michael Willins (Writer's Digest Books).
• *Business and Legal Forms for Photographers* by Tad Crawford (Allworth Press).
• *Legal Guide for the Visual Artist* by Tad Crawford (Allworth Press).
• *ASMP Professional Business Practices in Photography* (Allworth Press).
• The American Society of Media Photographers also offers traveling business seminars that cover issues from forms to pricing to collecting unpaid bills. Write them at 14 Washington Rd., Suite 502, Princeton Junction NJ 08550, for a schedule of upcoming business seminars.
• The Volunteer Lawyers for the Arts, 1 E. 53rd St., 6th Floor, New York NY 10022, (212)319-2910.The VLA is a nonprofit organization, based in New York City, dedicated to providing all artists, including photographers, with sound legal advice.

FINDING BUYERS FOR YOUR WORK

Most of the research needed to find clients can be done at your public library. The Business Reference section and librarians will be most helpful when you know what you are looking for. From manufacturers to direct marketing agencies to book publishers, there is a directory for every market. But before you spend hours at the library copier with a pocketful of change, check with the librarian or the directory publishers for a copy of the book on disk or online. Then, you can download the information into your personal computer and use it for making sales calls or mailing labels.

Another note: watch for directories that have some kind of qualifier for a firm to be listed. When you are looking for new clients, you want to work with the highest level of information possible. Some directories will list a book publisher simply because it exists, while others will list only book publishers that answer an annual survey of what kinds of photography assignments are available.

Advertising Agencies

• *Standard Directory of Advertising Agencies*, National Register, (908)464-6800.
• *ADWEEK Agency Directory*, Adweek Publications, (212)536-5336.

When looking for advertising photography assignments, there are two ways to research prospective clients. One is to look for advertising agencies based on the type of clients they represent—if you do food photography, look for an agency with food clients. Even subject categories as broad as "people" or "product photography" can be broken down into specific client types. For leads on people photography look at ad agencies that have "service" sector clients such as healthcare, financial or insurance companies. For product photography, look at agencies with "manufacturing" clients such as computer or electronics companies. True, you do see people in computer advertising, but when doing primary research you are taking your best guess at the most likely leads for the work you want to do.

The second way to win advertising clients is to sell your personal style to the agency. This kind of client is not specific to any industry or subject category. To make an educated guess, however, take a close look at agencies with consumer advertising clients. Find the agencies that use work that is compatible, but not necessarily similar, to yours.

Corporate Clients

- *Standard Directory of Advertisers*, National Register, (908)464-6800.
- Chamber of Commerce Directory of any city or county chamber.
- *ADWEEK Client (Brand) Directory*, Adweek Publications, (212)536-5336.
- *Services Directory*, Database Publishing, (714)778-6400.
- *Manufacturers Register*, Database Publishing, (714)778-6400.
- *Encyclopedia of Associations* (by industry), Gale Research, (800) 347-4253.

Above are just a few of the dozens of directories that list the names of companies you can develop into photography leads. Watch for qualified information, such as a Chamber of Commerce or an industry association directory—companies have to be a member to be listed. The value of this level of information is that it ''weeds'' out the less aggressive companies and leaves you with firms that are actively promoting their products and services. What can you guess from this qualifier? These companies are probably doing more promotion and need more photography.

Direct Marketing Agencies

- *Directory of Major Mailers*, Target Marketing, (215)238-5300.
- *Gale's Directory of Databases*, Gale Research, (800)877-4253.

A relatively new client for photography services, direct marketing agencies are firms that are responsible for the design and production of promotions—primarily direct mail. Since so many companies have found direct mail more cost effective than some forms of print or electronic advertising, millions of dollars in marketing budgets have been taken away from ad agencies and given over to direct marketing agencies. This is particularly good for catalog and other consumer photography projects.

Editorial/Magazines/Public Relations

- *Standard Rate & Data Service*, (847)375-5000.
- *Bacon's Directory*, (312)922-2400.
- *O'Dwyer's Directory of Publications*, (212)679-2471.
- *The Green Book*, AG Editions, (212)929-0959.
- *Writer's Market*, Writer's Digest Books, (800)289-0963.

Though the rates are often fixed at a ''page rate,'' many photographers seek editorial assignments for self-promotion reasons such as:
1. the credibility of having published work
2. the contacts they can make with corporate clients
3. lots of creative freedom to pursue their personal style
4. the exposure to thousands—even millions—of people who read the magazine

Be sure when you pursue editorial clients you have thoroughly read and reviewed copies of the publication so you are familiar with their style—what they call ''focus''—and the direction of their photography needs. Some publications are cutting edge, some are conservative. You should know who you are selling to.

Graphic Designers/Design Firms

- *The Design Directory*, Wefler & Associates, (847)475-1866.
- *The Workbook* (Directory Section), Scott & Daughters, (213)856-0008.

Design firms are wonderful clients for photographers. Like ad agencies, they work with the "better" projects a company feels can't always be done internally. Like editorial clients, they work very collaboratively with their photographers and often use the photographer's perspective rather than a tightly drawn comprehensive outline of the photography. Their photography projects often have extensive shots lists, such as an annual report or a corporate capabilities brochure. Sometimes their photo needs are regular and seasonal, such as catalogs or trade show photos.

Paper Products/Book Publishers/Music & Movie Producers

- *The Photographer's Market*, Writer's Digest Books, (800)289-0963.
- *LA 411* (entertainment industry), (213)460-6304.

Paper products is a very subject-specific market and great for stock photography sales. It includes publishers of calendars, greeting cards, posters and other novelty products. In this market category, photography projects or assignments are often done on a small advance plus royalty payment. Be sure to have your personal attorney or a reliable agent look over any contract before you agree to the use of your work. Book publishers and music and movie producers need photography for cover art. These markets can be lucrative while allowing you to shoot more creative work.

SECONDARY MARKET RESEARCH

Once you have set up a primary database, here are some additional resources for developing new leads for your photography business:

Daily Newspaper

Every day in the business section you will find news released by companies that includes: new products, expanded services, changes in personnel. Any of these are opportunities for you to get in the door with your photography services.

Trade Magazines

Check in the periodicals section of your library. You'll find magazines for every possible industry and trade. These publications, much like newspapers, include news releases that are specific to the area of photography you're interested in. You may even want to subscribe so you can use the magazines for approaching potential clients on a more regular basis.

Trade Show Exhibitor's Guides

Every industry has some kind of annual trade show. The value of this research is that the exhibitors are pre-qualified for buying photography. Many companies choose not to participate in their own industry trade show. You can make a good guess the ones in attendance need more photography for brochures and displays than their competitors who have stayed home.

Awards Annuals

Finally, when you have a very strong visual style, you'll find the clients who'll value your work tend to win the creative awards in their industry. If a client used a strong photography style once, they are more likely to do it again. Research these clients by reviewing advertising and design industry award annuals published by magazines such as *Communication Arts* and *HOW* magazine.

—by Maria Piscopo

SUBMITTING YOUR WORK

Editors, art directors and other photo buyers are busy people. Many only spend ten percent of their work time actually choosing photographs for publication. The rest of their time is spent making and returning phone calls, arranging shoots, coordinating production and a host of other unglamorous tasks that make publication possible. They want to discover new talent and you may even have the exact image they are looking for, but if you don't follow a market's submission instructions to the letter, you have little chance of acceptance.

To learn the dos and don'ts of photography submissions, read each market's listing carefully and make sure to send only what they ask for. Don't send prints if they only want slides. Don't send color if the only want black and white. Send for guidelines whenever they are available to get the most complete and up-to-date submission advice. When in doubt follow these ten rules when sending your work to a potential buyer:

1. Don't forget your SASE—Always include a self-addressed stamped envelope whether you want your submission back or not. Make sure your SASE is big enough, has enough packaging and has enough postage to ensure the safe return of your work.

2. Don't over-package—Never make a submission difficult to open and file. Don't tape down all the loose corners. Don't send anything too large to fit in a standard 8½×11 file.

3. Don't send originals—Try not to send things you must have back. **Never** ever send originals unsolicited.

4. Do label everything—Put a label directly on the slide mount or print you are submitting. Include your name, address and phone number, as well as the name or number of the image. Your slides and prints will almost certainly get separated from your letter.

5. Do your research—Always research the places to which you want to sell your work. Request sample issues of magazines, visit galleries, examine ads, look at websites, etc. Make sure your work is appropriate before you send it out. A blind mailing is a waste of postage and a waste of time for both you and the art buyer.

6. Follow directions—Always request submission guidelines. Include a SASE for reply. Follow ALL the directions exactly, even if you think they're silly.

7. Send to a person, not a title—Try to send submissions to a specific person in an organization. When you address a cover letter to Dear Sir or Madame it shows you know nothing about the company you want to buy your work.

8. Include a business letter—Always include a cover letter, no more than one page, that lets the potential buyer know you are familiar with their company, what your photography background is (briefly) and where you've sold work before (if it pertains to what you're trying to do now).

9. Don't forget to follow through—Follow up major submissions with postcard samples several times a year.

10. Have something to leave behind—If you're lucky enough to score a portfolio review, always have a sample of your work to leave with the art director. Make it small enough to fit in a file but big enough not to get lost. Always include your contact information directly on the leave-behind.

SHOWCASING YOUR TALENT

There are basically three ways to acquaint photo buyers with your work: through the mail, over the Internet or in person. No one way is better or more effective than another. They each serve an individual function and should be used in concert to increase your visibility and, with a little luck, your sales.

Self-promotions

When you are just starting to get your name out there and want to begin generating assignments and stock sales, it's time to design a self-promotion campaign. This is your chance to do your best, most creative work and package it in an unforgettable way to get the attention of busy photo buyers. Self-promotions traditionally are samples printed on card stock and sent through the mail to potential clients. If the image you choose is strong and you carefully target your mailing, a traditional self-promotion can work.

But don't be afraid to go out on a limb here. You want to show just how amazing and creative you are and you want the photo buyer to hang onto your sample for as long as possible. Why not make it impossible to throw away? Instead of a simple postcard, maybe you could send a small, usable notepad with one of your images at the top or a calendar the photo buyer can hang up and use all year. If you target your mailing carefully, this kind of special promotion needn't be expensive.

If you're worried that a single image can't do justice to your unique style, you have two options. One way to get multiple images in front of photo buyers without sending an overwhelming package is to design a campaign of promotions that builds from a single image to a small group of related photos. Make the images tell a story and indicate that there are more to follow. If you are computer savvy, the other way to showcase a sampling of your work is to point photo buyers to an online portfolio of your best work. Send a single sample that includes your Internet address and ask buyers to take a look.

Portfolio presentations

Once you've actually made contact with potential buyers and piqued their interest they'll want to see a larger selection of your work, your portfolio. Once again, there's more than one way to get this sampling of images in front of buyers. Portfolios can be digital—stored on a disk, CD-ROM or posted on the Internet; they can take the form of a large box or binder and require a special visit and presentation by you; or they can come in a small binder and be sent through the mail. Whichever way or ways you choose to showcase your best work, you should always have more than one portfolio and each should be customized for potential clients.

Keep in mind that your portfolios should contain your best work, dupes only. Never put originals in anything that will be out of your hands for more than a few minutes. Also don't include more than 20 images. If you try to show too many pieces you'll overwhelm the buyer and any image that is less than your best will detract from the impact of your strongest work. Finally, be sure to show only work a buyer is likely to use. It won't do any good to show a shoe manufacturer your shots of farm animals or a clothing company your food pictures.

WHERE TO FIND IDEAS FOR GREAT SELF-PROMOTIONS

- *HOW* magazine's self-promotion annual, October issue.
- *Best Small Budget Self-Promotions* by Carol Buchanan (North Light Books).
- *The Best Seasonal Promotions* by Poppy Evans (North Light Books).
- *Fresh Ideas in Promotion* (1&2) by Lynn Haller (North Light Books).
- Yahoo, www.yahoo.com, follow these links for online portfolios and promotions: Arts and Humanities: Visual Arts: Photography: Photographers.

SAMPLE SELF-PROMOTIONS

Photographer David Winston came up with the idea of a self-promotional bookmark in an effort to stand out from the typical 8½ × 11 promotions floating around art directors' desks. "I wanted a different design that might also have an extra function so it would be harder to discard." Winston managed to include 5 clear images on a single strip of paper. "The design has worked very well for me."

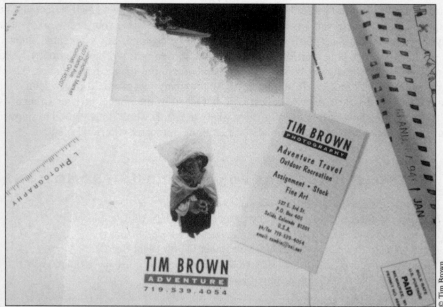

Simple and elegant can sometimes be more effective than big and flashy. Photographer Tim Brown found this to be true of his most recent promotional effort, a simple postcard-size mailer featuring two of his best images. "I designed my card, with the help of a local graphic artist, to be high impact, simple and have a touch of humor. I mailed 500 to specific ad agencies, design firms, photo buyers, etc. I received requests for portfolios, some assignment work, sales from stock and got my name out there as well."

CHARGING FOR YOUR WORK

No matter how many books you read about what photos are worth and how much you should charge, no one can set your fees for you, and if you let someone try you'll be setting yourself up for financial ruin. Figuring out what to charge for your work is a complex task that will require a lot of time and effort. But the more time you spend finding out how much you need to charge, the more successful you'll be at targeting your work to the right markets and getting the money you need to keep your business, and your life, going.

Keep in mind that what you charge for an image may be completely different from what a photographer down the street charges. There is nothing wrong with this if you've calculated your prices carefully. Perhaps the photographer works in a basement on old equipment and you have a brand new, state-of-the-art studio. You'd better be charging more. Why the disparity? For one thing, you've got a much higher overhead, the continuing costs of running your business. You're also probably delivering a higher quality product and are more able to meet client requests quickly. So how do you determine just how much you need to charge in order make ends meet?

Setting your break-even rate

All photographers, before negotiating assignments, should consider their break-even rate, the amount of money they need to make in order to keep their studio open. To arrive at the actual price you'll quote to a client you should add onto your base rate things like usage, your experience, how quickly you can deliver the image, and what kind of prices the market will bear.

BASE RATE WORKSHEET

(Take a look at your business plan to fill in the blanks here. If you're not sure of some of the numbers, estimate by looking at prices in catalogs or at office supply stores. Remember, expenses like film and processing will be charged to your clients.)

Business Expenses:

Rent (office, studio, darkroom) _____

Gas and electric _____

Insurance (equipment) _____

Telephone, fax, internet _____

Office supplies _____

Postage _____

Stationery _____

Self-promotions/portfolios _____

Camera and lighting equipment _____

Office equipment/computers _____

Staff salaries _____

Taxes _____

Professional organization dues _____

Personal expenses _____

(Your personal expenses include everything that makes up your standard of living: food, clothing, medical, car and home insurance, gas, repairs and other car expenses, entertainment, retirement savings and investments, etc.)

Before you divide your annual expenses by the 365 days in the year, remember you won't be shooting billable assignments every day. A better way to calculate your base fee is by billable weeks. Assume that at least one day a week is going to be spent conducting office business and marketing your work. This amounts to approximately ten weeks. Add in days for vacation and sick time, perhaps three weeks, and add another week for workshops and seminars. This totals 14 weeks of nonbillable time and 38 billable weeks throughout the year.

Now estimate the number of assignments/sales you expect to complete each week and multiply that number by 38. This will give you a total for your yearly assignments/sales. Finally, divide the total overhead and administrative expenses by the total number of assignments. This will give you an average price per assignment, your break-even or base rate.

As an example, let's say your expenses come to $65,000 per year (this includes $35,000 of personal expenses). If you complete 2 assignments each week for 38 weeks your average price per assignment must be about $855. This is what you should charge to break even on each job. But, don't forget, you want to make money.

Establishing usage fees

Too often, photographers shortchange themselves in negotiations because they do not understand how the images in question will be used. Instead, they allow clients to set prices and prefer to accept lower fees rather than lose sales. Unfortunately, those photographers who shortchange themselves are actually bringing down prices throughout the industry. Clients realize if they shop around they can find photographers willing to shoot assignments at very low rates.

There are ways to combat low prices, however. First, educate yourself about a client's line of work. This type of professionalism helps during negotiations, because it shows buyers that you are serious about your work. The added knowledge also gives you an advantage when negotiating fees, because photographers are not expected to understand a client's profession.

For example, if most of your clients are in the advertising field, acquire advertising rate cards for magazines so you know what a client pays for ad space. You can also find print ad rates in the *Standard Rate and Data Service* directory at the library. Knowing what a client is willing to pay for ad space and considering the importance of your image to the ad will give you a better idea what the image is really worth to the client.

For editorial assignments, fees may be more difficult to negotiate because most magazines have set page-rates. They may make exceptions, however, if you have experience or if the assignment is particularly difficult or time-consuming. If a magazine's page-rate is still too low to meet your break-even price, consider asking for extra tearsheets and copies of the issue your work appears in. These pieces can be used in your portfolio and as mailers, and the savings they represent in printing costs may make up for the discrepancy between the page-rate and your break-even price.

There are still more ways to negotiate sales. Some clients, such as gift and paper product manufacturers, prefer to pay royalties each time a product is sold. Special markets, such as galleries and stock agencies, typically charge photographers a commission from 20 to 50 percent for displaying or representing their images. In these markets, payment on sales comes from the purchase of prints by gallery patrons, or from fees on the "rental" of photos by clients of stock agencies. Pricing formulas should be developed by looking at your costs and the current price levels in those markets, as well as on the basis of submission fees, commissions and other administrative costs charged to you.

Bidding for jobs

As you build your business you will likely encounter another aspect of pricing and negotiating that can be very difficult. Like it or not, clients often ask photographers to supply bids for jobs. In some cases, the bidding process is merely procedural and the assignment will go to the photographer who can best complete the assignment. In other instances, the photographer who submits the lowest bid will earn the job. When asked to submit a bid, it is imperative to find out which bidding process is being used. Putting together an accurate estimate takes time, and you do not want to waste your efforts if your bid is being sought merely to meet some budget quota.

If you decide to bid on a job it's important to consider your costs carefully. You do not want to bid too much on projects and repeatedly get turned down, but you also don't want to bid too low and forfeit income. When a potential client calls to ask for a bid there are seven dos and don'ts to consider:

1. Always keep a list of questions by the telephone so you can refer to it when bids are requested. The answers to the questions should give you a solid understanding of the project and help you reach a price estimate.
2. Never quote a price during the initial conversation, even if the caller pushes for a "ballpark figure." An on-the-spot estimate can only hurt you in the negotiating process.
3. Immediately find out what the client intends to do with the photos and ask who will own copyrights to the images after they are produced. It is important to note that many clients believe if they hire you for a job they'll own all the rights to the images you create. If they insist on buying all rights, make sure the price they pay is worth the complete loss of the images.
4. If it is an annual project, ask who completed the job last time, then contact that photographer to see what he or she charged.
5. Find out who you are bidding against and contact those people to make sure you received the same information about the job. While agreeing to charge the same price is illegal, sharing information about reaching a price is not.
6. Talk to photographers not bidding on the project and ask them what they would charge.
7. Finally, consider all aspects of the shoot, including preparation time, fees for assistants and stylists, rental equipment and other materials costs. Don't leave anything out.

WHERE TO FIND MORE INFORMATION ABOUT PRICING

• *Pricing Photography: The Complete Guide to Assignment & Stock Prices* by Michal Heron and David MacTavish (Allworth Press).
• *The Photographer's Market Guide to Photo Submission and Portfolio Formats* by Michael Willins (Writer's Digest Books).
• *ASMP Professional Business Practices in Photography* (Allworth Press).
• *fotoQuote*, a software package produced by the CRADOC Corporation, is a customizable, annually updated database of stock photo prices for markets from ad agencies to calendar companies. The software also includes negotiating advice and scripted telephone conversations. Call (800)679-0202 for ordering information.

FIGURING SMALL BUSINESS TAXES

Whether you make occasional sales from your work or you derive your entire income from your photography skills, it is a good idea to consult with a tax professional. If you are just starting out, an accountant can give you solid advice about organizing your financial records. If you are an established professional, an accountant can double check your system and maybe find a few extra deductions. When consulting with a tax professional, it is best to see someone familiar with the needs and concerns of small business people, particularly photographers. You can also conduct your own tax research by contacting the Internal Revenue Service.

The IRS has numerous free booklets that provide specific information, such as allowable deductions and tax rate structures. These include:

- Tax Guide for Small Businesses, #334
- Travel, Entertainment and Gift Expenses, #463
- Tax Withholding and Estimated Tax, #505
- Business Expenses, #535
- Accounting Periods and Methods, #538
- Business Use of Your Home, #587
- Guide to Free Tax Services, #910

To order any of these booklets, phone the IRS at (800)829-3676. IRS forms and publications, as well as answers to questions and links to help, are available on the internet at http://www.irs.us-treas.gov/basic/cover.html.

Self-employment tax

As a freelancer it's important to be aware of tax rates on self-employment income. All income you receive without taxes being taken out by an employer qualifies as self-employment income. Normally, when you are employed by someone else, the employer shares responsibility for the taxes due. However, when you are self-employed you must pay the entire amount yourself.

Freelancers frequently overlook self-employment taxes and fail to set aside a sufficient amount of money. They also tend to forget state and local taxes. If the volume of your photo sales reaches a point where it becomes a substantial percentage of your income, then you are required to pay estimated tax on a quarterly basis. This requires you to project the amount of money you expect to generate in a three-month period. However burdensome this may be in the short run, it works to your advantage in that you plan for and stay current with the various taxes you are required to pay.

Deductions

Many deductions can be claimed by self-employed photographers. It's in your best interest to be aware of them. Examples of 100 percent deductible claims include production costs of résumés, business cards and brochures; photographer's rep commissions; membership dues; costs of purchasing portfolio materials; education/business-related magazines and books; insurance; and legal and professional services.

Additional deductions can be taken if your office or studio is home-based. The catch here is that your work area must be used only on a professional basis; your office can't double as a family room after hours. The IRS also wants to see evidence that you use the work space on a regular basis via established business hours and proof that you've actively marketed your work. If you can satisfy these criteria, then a percentage of mortgage interests, real estate taxes, rent, maintencance costs, utilities and homeowner's insurance, plus office furniture and equipment, can be claimed on your tax form at year's end.

If you are working out of your home, keep separate records and bank accounts for personal and business finances, as well as a separate business phone. Since the IRS can audit tax records as far back as seven years, it's vital to keep all paperwork related to your business. This includes invoices, vouchers, expenditures and sales receipts, canceled checks, deposit slips, register tapes and business ledger entries for this period. The burden of proof will be on you if the IRS

questions any deductions claimed. To maintain professional status in the eyes of the IRS, you will need to show a profit for three years out of a five-year period.

Sales tax

Sales taxes are deceptively complicated and need special consideration. For instance, if you work in more than one state, use models or work with reps in one or more states, or work in one state and store equipment in another, you may be required to pay sales tax in each of the states that apply. In particular, if you work with an out-of-state stock photo agency that has clients over a wide geographic area, you should explore your tax liability with a tax professional.

As with all taxes, sales taxes must be reported and paid on a timely basis to avoid audits and/or penalties. In regard to sales tax, you should:

- Always register your business at the tax offices with jurisdiction in your city and state.
- Always charge and collect sales tax on the full amount of the invoice, unless an exemption applies.
- If an exemption applies because of resale, you must provide a copy of the customer's resale certificate.
- If an exemption applies because of other conditions, such as selling one-time reproduction rights or working for a tax-exempt, nonprofit organization, you must also provide documentation.

ORGANIZING YOUR IMAGES

If a client called you right now and asked to use one of your photos, what are the chances you'd be able to lay your hands on that photo quickly? As a photographer you must be able to do just that if you plan to make money. If you can't, you'll miss out on sales, not only from the immediate projects that come up, but from future sales to clients who know you can meet their deadlines.

The key to locating images is proper organization. Not only do you need a place to store your work; you also must have a filing system in place that allows you to easily retrieve images. Your filing system should simplify the process of quickly locating images and submitting them.

To create a filing system for your images you will need:
- labels,
- plastic protectors (archival quality) for transparencies, negatives and prints,
- three-ring binders or a filing cabinet,
- an established coding system for all of your work,
- a computer with database or labeling software (optional).

Although computers are not essential for labeling images, they certainly simplify the process. Database software not only helps when labeling images; it can assist you in tracking submissions, conducting mass mailings or completing client correspondence. Plus, if you've ever labeled slides by hand you know that the process can be tedious.

Coding and labeling your photos

Developing a coding system is not difficult. At first it may seem overwhelming, especially if you currently house thousands of photos in shoe boxes and have no established coding system. However, once you have the system in place the process becomes routine and relatively simple to maintain.

Start by creating a list of the subjects you shoot. As an example, let's suppose you photograph wildlife and nature. Make a list of everything you've photographed—birds, flowers, mountains, etc. Next, break this list down even farther into subcategories. For birds, you may end up with subcategories like waterfowl, raptors or perching birds. Flowers might be separated by seasons in which they flourish, or regions in which they are found. After you've created your list of subjects, assign three-letter codes to each one. And obviously, don't duplicate codes.

Once you establish a coding system for each subject, the next step is to use those codes in conjunction with numbers to identify each image. For example, perhaps you recently photographed a nesting site for a Bald Eagle. Your code might look something like this: 98WBR1-AKO. Translated from left to right this means you took the image in 1998; it's a wildlife photograph of a bird (raptor); and it's the first photo of a raptor catalogued in 1998. The "AK" shows the photo was taken in Alaska and the "O" on the end means it is an original slide rather than a duplicate. Replace the "O" with a "D" if the image is a duplicate. When you photograph a subject that needs a model release, add "MR" onto the end for further clarification.

Now, you may ask why all this information is necessary. The year shows you how recent the photo is. Clients often prefer images that are current. And it's good to update subjects after a few years. The three-letter subject code is necessary for obvious reasons. When a client needs a specific subject, the three-letter codes make it easy to find the appropriate shot. The number following the three-letter code helps you distinguish one shot from another. The next two letters are state codes that can be extremely useful when submitting work to regional publications. Clients also frequently request shots by region. And the "O" code is important to keep you from submitting original work on speculation to a client.

Along with the file number, each photo should contain your copyright notice which states the year the image was created and gives your name (e.g., © 1999 John Q. Photographer). Also include a brief explanation of the image contents. Remember with captioning software it's easy to write extensive descriptions onto labels. When shooting slides, however, too much information can clutter presentation and may actually be distracting to the viewer. Three or four words should suffice for 35mm. If you want to provide lengthier captions when submitting material, do so on a separate sheet of paper. Be certain to list slide numbers beside each caption.

If you shoot with medium or large format cameras, you can either purchase mounts for your images or place the transparencies into plastic sleeves. Labels can be attached to protective sleeves or mounts when work is mailed to potential clients. When submitting prints, place a label on the back of each photo and make sure it contains your copyright notice, image number and a brief description of each image. You should also include your address and telephone number.

One word of caution: never submit negatives to potential clients. You risk damaging the negatives, or worse, having them lost. Most buyers can use a print to generate a suitable image. You also can send contact sheets for their review.

Storing your photos

Now that you've properly labeled your work, the next step is to file images so they can easily be located. First, store them in a cool, dry location. Moisture can produce mold on your film and slide mounts. If your work isn't correctly stored, transparencies can be eaten by moths. To prevent damage, place 35mm slides in archival-quality plastic slide protectors. Each page holds up to 20 slides and can be placed inside a binder for easy storage. The binder system also works for larger transparencies and negatives. Prints also should be kept in plastic pages.

Other storage areas do exist. File cabinets can work well for archiving, but they aren't as portable as binders. I've even heard of one photographer who stores images inside an old refrigerator. His main reason for using a refrigerator is to protect his work in the event of a fire: The insulation content of refrigerators makes them almost as useful as vaults when it comes to photo archiving.

This raises the issue of image protection. Because disasters such as fires or floods can strike at any time, it's wise to store duplicates of your best images in a different location. Safe deposit boxes work well as secondary storage facilities. The last thing you want is for all your work to be destroyed. Such disasters can ruin your business because most insurance companies will only replace the cost of the film, not the potential value of the images.

Another means of storage is digital archiving. If you are serious about your work, you probably have thousands of images in your files. Digital archiving is a great way to protect your work because CDs, DAT tapes or hard drives can store thousands of images in small spaces.

Having images in a digital format can also help you meet client demands. As technology develops, more and more clients are using digital versions of images for things like composition layouts, inhouse newsletters or websites. If you can provide digital images to clients, you might see your sales increase as a result.

One important point to consider if you supply images digitally is that digital images are easy to alter and, therefore, easy to steal. The growth in digital technology makes it important to protect yourself against misuse and theft of your work. To do this, add a clause in your contracts that discusses image alterations and computer storage of your work. If a client plans to make radical changes to your images, stipulate that those alterations must meet with your approval.

Also, don't let clients keep digital files of your images. Specify that any digital files of your work should be deleted once your images are published. People change jobs and the next person using a client's computer may find your work and unknowingly think it's fair game for other projects.

Tracking your images

Finally, you need a system of tracking submissions so that you know who has your images and when they were mailed to clients. You want to know who received them, and when the material is due back.

Talk to any professional photographer and you will learn that photo editors, creative directors and art directors habitually hold images for long periods of time. Sometimes this means buyers are deciding which images to use; sometimes buyers are just too busy to return photos. As a photographer, this can be extremely problematic. You don't want to offend potential clients by ordering the return of your images, but you have a business to run.

If you have a computer with database software, you can easily track images by logging in their file codes, jotting down who should have received the mateial, when it was sent, and when it is due back to you. Sort the file by the dates when the images are due back. If you don't receive your work by the given dates, get on the phone and make some follow-up calls.

When photo editors hold images with no intention of using them, they essentially keep you from submitting those photos to other editors who might buy them. This is one reason that having a sound filing system is so important. By tracking your submissions you can follow up with letters or phone calls to retrieve images from uninterested buyers.

PROTECTING YOUR COPYRIGHT

What makes copyright so important to a photographer? First of all, there's the moral issue. Simply put, stealing someone's work is wrong. By registering your photos with the Copyright Office in Washington DC, you are safeguarding against theft. You're making sure that if someone illegally uses one of your images they can be held accountable. By failing to register your work, it is often more costly to pursue a lawsuit than it is to ignore the fact that the image was stolen.

Which brings us to issue number two—money. You should consider theft of your images to be a loss of income. After all, the person stealing one of your photos used it for a project, their project or someone else's. That's a lost sale for which you will never be paid.

The importance of registration

There is one major misconception about copyright—many photographers don't realize that once you create a photo it becomes yours. You own the copyright, regardless of whether you register it. Note: You cannot copyright an idea. Simply thinking about something that would make a great photograph does not make that scene yours. You have to actually have something on film.

The fact that an image is automatically copyrighted does not mean that it shouldn't be registered. Quite the contrary. You cannot even file a copyright infringement suit until you've registered your work. Also, without timely registration of your images, you can only recover actual damages—money lost as a result of sales by the infringer plus any profits the infringer earned. For example, recovering $2,000 for an ad sale can be minimal when weighed against the expense of hiring a copyright attorney. Often this deters photographers from filing lawsuits if they haven't registered their work. They know that the attorney's fees will be more than the actual damages recovered, and, therefore, infringers go unpunished.

Registration allows you to recover certain damages to which you otherwise would not be legally entitled. For instance, attorney fees and court costs can be recovered. So too can statutory damages—awards based on how deliberate and harmful the infringement was. Statutory damages can run as high as $100,000. These are the fees that make registration so important.

In order to recover these fees there are rules regarding registration that you must follow. The rules have to do with the timeliness of your registration in relation to the infringement:

- **Unpublished images** must be registered before the infringement takes place.
- **Published images** must be registered within three months of the first date of publication or before the infringement began.

The process of registering your work is simple. Contact the Register of Copyrights, Library of Congress, Washington DC 20559, (202)707-9100, and ask for Form VA (works of visual art). Registration costs $20, but you can register photographs in large quantities for that fee. For bulk registration, your images must be organized under one title, for example, "The works of John Photographer, 1990-1995."

The copyright notice

Another way to protect your copyright is to mark each image with a copyright notice. This informs everyone reviewing your work that you own the copyright. It may seem basic, but in court this can be very important. In a lawsuit, one avenue of defense for an infringer is "innocent infringement"—basically the "I-didn't-know" argument. By placing your copyright notice on your images, you negate this defense for an infringer.

The copyright notice basically consists of three elements: the symbol, the year of first publication and the copyright holder's name. Here's an example of a copyright notice for an image published in 1999—© 1999 John Q. Photographer. Instead of the symbol ©, you can use the word "Copyright" or simply "Copr." However, most foreign countries prefer © as a common designation.

Also consider adding the notation "All rights reserved" after your copyright notice. This

phrase is not necessary in the U.S. since all rights are automatically reserved, but it is recommended in other parts of the world.

Know your rights

The digital era is making copyright protection more difficult. Often images are manipulated so much that it becomes nearly impossible to recognize the original version. As this technology grows, more and more clients will want digital versions of your photos. Don't be alarmed, just be careful. Your clients don't want to steal your work. They often need digital versions to conduct color separations or place artwork for printers.

So, when you negotiate the usage of your work, consider adding a phrase to your contract that limits the rights of buyers who want digital versions of your photos. You might want them to guarantee that images will be removed from computer files once the work appears in print. You might say it's OK to do limited digital manipulation, and then specify what can be done. The important thing is to discuss what the client intends to do with the image and spell it out in writing.

It's essential not only to know your rights under the Copyright Law, but also to make sure that every photo buyer you deal with understands them. The following list of typical image rights should help you in your dealings with clients:

- **One-time rights.** These photos are "leased" on a one-time basis; one fee is paid for one use.
- **First rights.** This is generally the same as purchase of one-time rights, though the photo buyer is paying a bit more for the privilege of being the first to use the image. He may use it only once unless other rights are negotiated.
- **Serial rights.** The photographer has sold the right to use the photo in a periodical. It shouldn't be confused with using the photo in "installments." Most magazines will want to be sure the photo won't be running in a competing publication.
- **Exclusive rights.** Exclusive rights guarantee the buyer's exclusive right to use the photo in his particular market or for a particular product. A greeting card company, for example, may purchase these rights to an image with the stipulation that it not be sold to a competing company for a certain time period. The photographer, however, may retain rights to sell the image to other markets. Conditions should always be in writing to avoid any misunderstandings.
- **Electronic rights.** These rights allow a buyer to place your work on electronic media, such as CD-ROMs or online services. Often these rights are requested with print rights.
- **Promotion rights.** Such rights allow a publisher to use a photo for promotion of a publication in which the photo appeared. The photographer should be paid for promotional use in addition to the rights first sold to reproduce the image. Another form of this—agency promotion rights—is common among stock photo agencies. Likewise, the terms of this need to be negotiated separately.
- **Work for hire.** Under the Copyright Act of 1976, section 101, a "work for hire" is defined as: "(1) a work prepared by an employee within the scope of his or her employment; or (2) a work . . . specially ordered or commissioned for use as a contribution to a collective, as part of a motion picture or audiovisual work or as a supplementary work . . . if the parties expressly agree in a written instrument signed by them that the work shall be considered a work made for hire."
- **All rights.** This involves selling or assigning all rights to a photo for a specified period of time. This differs from work for hire, which always means the photographer permanently surrenders all rights to a photo and any claims to royalties or other future compensation. Terms for all rights—including time period of usage and compensation—should only be negotiated and confirmed in a written agreement with the client.

It is understandable for a client not to want a photo to appear in a competitor's ad. Skillful negotiation usually can result in an agreement between the photographer and the client that says the image(s) will not be sold to a competitor, but could be sold to other industries, possibly offering regional exclusivity for a stated time period.

DEALING WITH INTERNATIONAL CLIENTS

An international client is anyone outside your native country with whom you do business. If you live in London, a client in New York would be considered international and the reverse is also true. Reaching out to the international marketplace can greatly increase your sales potential, but you'll have to be creative and professional when approaching markets in unfamiliar territory. Most of your dealings with these clients will not be in person. Instead, you will contact them by mail, telephone, e-mail or fax. Before you type a quick letter to that stock agency in Hong Kong or call the editor of a British magazine, here as some important things to keep in mind.

International mail

1. Always type your correspondence and double check the spelling. Your handwriting may not be understandable to someone in another country.
2. Use a simple letterhead that clearly displays your address, phone number, e-mail address, website, etc.
3. Make it clear why you are writing and exactly how you want the recipient to respond.
4. If you'd like the recipient of your letter to write back to you, include a SAE with an international reply coupon. IRCs are available at post offices around the world and will allow your SAE to be returned easily. International post offices will not deliver a letter from outside the U.S. if it is stamped with U.S. postage. The reverse is also true.
5. The United States Postal Service offers pre-barcoded, postage-paid cards and envelopes for large mailings to foreign countries from the U.S. You'll only be billed for the postage on the cards and envelopes that are returned to you.

Global e-mail

1. Even though e-mail by its nature is a global form of communication, you should be especially sensitive when using it to communicate with international clients.
2. Don't be too informal. Even though e-mail is quick and easy, you should still treat your clients with respect by addressing them by their surnames and using polite English, not slang.
3. Don't expect an immediate response. You may send a quick message at 9 a.m. EST, a reasonable business time, but in British Columbia, Canada it's only 6 a.m. Your client won't be working for another three hours.

International phone and fax

1. The biggest concern when using phone lines is having all the right numbers. To get an international line in the U.S., dial 011; in Europe, dial 00.
2. You'll also need the correct country and city codes for the place you wish to call. The country code for the U.S. is 1 and the area code will always be the first three digits of a phone number written between parentheses, (513)555-1212. Most international businesses will include the country and city codes at the beginning of their phone number, **44 151** 5551212.

3. Country codes likely to appear in this book include: Australia, 61; Canada, 1; Hong Kong, 852; Ireland, 353; South Africa, 27; United Kingdom, 44. If can't locate the city and country codes call 1 02880 for international operator assistance. You can also find a large list of country and city codes, as well as U.S. area codes, on the Internet at http://www.the-acr.com/codes/cntrycd.htm.

5. When calling someone a great distance from you be sure you're aware of the time difference. You may want to keep this in mind when sending faxes as well. A small business person with a home-based office may not appreciate a ringing phone and squealing fax at three in the morning.

6. When you call an international client, keep in mind that they may have trouble understanding you even if you both speak English. Don't raise your voice; simply speak more slowly and clearly. If you're sending a fax, use proper English and write simple, short sentences to make sure you're understood.

In all your dealings with international clients you should be aware of cultural differences and business etiquette. It is better to err on the side of politeness rather than risk offending someone. Do a little research before you begin an international campaign. Try the library or the Internet. Several companies offer booklets detailing business etiquette in major countries. Try http://www.worldbiz.com, for example. Pay special attention to religious holidays and seasons. You wouldn't enjoy a call on Christmas morning and your clients won't want to be disturbed on special days either.

A note about currency and measurements: Because this book is produced in the U.S., all measurements are in inches unless stated otherwise. One inch is equal to 2.54 centimeters. Currency is reported in U.S. dollars unless otherwise stated. You can find a good currency converter on the Internet at http://www.xe.net/cgi-bin/ucc/convert.

Focus On: Using Professional Marketing Tactics to Improve Your Photography Business

BY MARIA PISCOPO

You learned in photography school all about producing photographic images and digital technology. But with few exceptions, schools don't address the business aspects of "selling yourself." The thousands of photographers who begin and run their businesses by referral and word-of-mouth are being forced to reevaluate their strategy.

Though business classes can be taken at any college, there are many issues particular to the photography industry that make an article like this necessary in today's marketplace. Whether you plan to pursue employment with freelance assignments on the side or fulltime self-employment, or you have been in business for 20 years, you will find tips and techniques here that you can use today.

Maria Piscopo

You will also find that money by itself is not the key to self-promotion. For photographers to add professional marketing techniques to their creative process they must "plan the work, then work the plan." This article will teach you how to plan your interactions with potential clients to turn each meeting into an assignment or a fact-finding mission.

GETTING APPOINTMENTS WITHOUT REJECTION

No matter how great you are as a photographer, at some point you will have to talk to people to get appointments, close a sale, follow up—all are verbal contacts with your clients you might not feel comfortable making. After all, if you were good at talking to people, you would have been a salesman, not a photographer. But knowing how to talk to clients is one of the most important business tools next to your camera.

The best preparation for any kind of phone call or talking to clients is called "scripting." This is simply a process of writing down the expected interaction between you and your client. It requires you to prepare carefully, just as you would before going out on any photo shoot. Preparing scripts for your phone calls and meetings in order to get portfolio appointments and do follow-ups is the most useful marketing tool you can develop.

You should always use a script when talking to clients because you want to make the best

MARIA PISCOPO *began her career as a marketing representative for artists and photographers in 1978. She is the author of* The Photographer's Guide to Marketing and Self-Promotion *published by Writer's Digest Books and* Marketing & Promoting Your Work *published by North Light Books. She is a member of SPAR and sits on the advisory boards of PhotoPlus and the University of California at Long Beach Arts & Humanities department.*

use of your time, get more information about what clients want and have the best chance to get jobs. Start by writing down the anticipated conversation as you would like it to go. Be sure to plan for all variables. In other words, no matter what a client's response, you have anticipated your reply. Not only will this technique help you get more out of every call, but you will approach the entire chore of "selling" with more motivation and inspiration. You may even like it.

Steps for script writing

Step 1. Open with a brief and specific introduction of your services. First you get people's attention, then you tell them what you want. For example, "Hello, I am a food photographer and my name is _____. I am interested in the XYZ Restaurants account and would like to show my food portfolio to you this week. When would be a good time to come by?" The key word here is "when" and gives you more options in terms of having a conversation than if you had asked, "May I come and show my portfolio?" The easy answer to that question is "No" and doesn't give the client time to seriously consider your request (and their needs).

Step 2. Find out what the client does or needs first, then decide what you will talk about. Talk portrait photography to portrait clients, corporate photography to corporate clients. What you do as a photographer depends on who you are talking to. Clients can only care about what they need.

Step 3. Come up with something interesting. After all, you are most likely trying to replace another photographer with whom the buyer is secure. Why should the buyer switch? For example, "Have you seen our new background samples?" or "Our photography helped our last client double the sales of his product" or "We offer consultations for clients making the switch to digital imaging; when would you like to schedule yours?"

Step 4. Always use sentences that begin with "How, who, what, when, where and why" to encourage information gathering, reduce the time you spend and reduce the rejection that comes with a "No." For example, when showing your portfolio, ask these open-ended questions to get information, confirm the information and verify agreements you have reached:

"How often do you use a different photographer?"
"What other photography needs do you have?"
"When will you be looking at bids on that job?"
"Who else in the office buys this kind of photography?"

Step 5. Anticipate objections and questions about your services and know exactly what information you want to get. Never hang up the phone without achieving some specific objective. Get an appointment or a piece of information—anything. Successfully accomplishing any objective keeps you motivated to do this day after day. For example, when you want more information from the client, ask:

"When would be a good time to check back on that job?"
"How do you feel about a follow-up call in three weeks?"
"What will you look for in the bids on that job?"
"Who will have final approval on the choice of photographer?"

PORTFOLIO PRESENTATION GUIDELINES

Traditionally, photographers have approached clients for appointments to show their portfolios. In today's new marketplace, this has been getting more and more difficult. Clients are too busy, pressed for time and stressed with the changes in the company they are dealing with. Certainly an appointment to show your work and begin a relationship still works, but what if

you can't get in? What if you have so many prospective clients that seeing every one of them will take forever to generate assignments?

You now have two choices for approaching prospective clients: *relationship selling*, where you are seeking an appointment, and *needs selling*, where you are looking for more information before you try to get the appointment to show your work. Here's how they work.

Relationship selling to get an appointment

Step 1. Ask for contact by name.

Step 2. Receptionist asks, "What is this regarding?" Your response should revolve around your specific marketing message, that is, what kind of photography you are selling. The more specific the message, the easier it is for your prospective client to determine whether she needs or wants to see you and your portfolio at this time. So your responses could be: "Regarding an appointment to discuss food photography needs" or "Regarding the food photo promo she received (if you sent one)" or "Referred by Joe regarding my food photography portfolio."

Step 3. Simple. You will either get an appointment or not. No matter what response you hear back, Mary Client has only two responses to give you. Comments such as "in a meeting" or "can't come to the phone" mean the same thing as "We're not looking at food photo portfolios at this time."

Step 4. When you do not get an appointment, don't get off the phone without a piece of information you can recycle back into another contact with Mary Client. Pick any of the responses below or make up your own, just don't quit at this point without knowing what happens next. Possible responses:

"Who else can tell me about food photography needs?"
"When should I call back for an appointment?"
"How can I best reach Mary?"
"Who else in the company uses food photography?"
"What kind of needs for food photography are there?"
"How often does your company work with a food photographer?"

Information selling to determine needs

This approach starts out the same way as appointment selling.

Step 1. Ask for contact by name.

Step 2. Receptionist asks, "What is this regarding?" Now, your response is directed towards seeking out more information so you can determine if you want to ask for an appointment. This sifting of clients is useful when you have a lot of leads or simply want to save everyone's time and just make appointments with the clients who are ready to work with you. This approach results in fewer portfolio appointments, but each appointment is to discuss a need for photography. Here are some responses:

"We're updating our files. What need at this time does Mary have for food photography?"
"We just need information. When will Mary be reviewing food photography portfolios?"

Step 3. If the response is positive, go for the appointment. If Mary doesn't need food photography at this time, simply ask when you should check back. If this is a client you really want to work with, suggest that you'll send your mini-portfolio for Mary to keep until the two of you can get together.

EFFECTIVE, JOB-GETTING PORTFOLIO PRESENTATIONS

Finally, you have the appointment and want to make the most of your time with your prospective client. There is no way to "can" a presentation of your portfolio, since each one will be

customized to the client's needs and responses to your work. You should, however, be sure to cover the following points in order to make the most of your time together.

Step 1. Have an introduction that helps the client focus on who you are, what you do and why you are there.

Step 2. Present your images from the client's perspective of the value to her, not the image itself. She can see what it is. What you should talk about is how you got there.

Step 3. Be prepared for hard, tough questions. If the client isn't asking you about price, experience or other clients (to name a few), she is not interested in putting you on the short list at this time.

Step 4. Leave behind something to help the client remember what you can do for her.

Step 5. Call to follow-up. This is the most important step and the entire reason you are meeting with this client. Always be left in charge of the follow-up; it is not the client's job. Choose any of the questions below to conclude the meeting:

"When should we get together?"
"When should I call you?"
"How about a call next month?"
"How do you want to keep in touch?"
"When should I send more information?"
"What would you like to see more of?"

Step 6. As you are packing to leave, ask for a referral: "Who else do you know who may need food photography?" Then, be sure to send a nice thank-you note (your own personal photo card, of course) whether you get the job or not. The referral should be rewarded.

CREATING PROMO PIECES

Direct mail promotions with a strong marketing message and plan are one of the best marketing tools to bring in new clients. For example, if you have decided to go after corporate communications photography assignments, your promo and mailings will focus on just that message. Don't worry about being too specific when mailing promos to new clients. Once they become clients, they will always give you other projects, but first you need to get them in the door.

Direct mail does not mean mailing promotional material and then making a call to see if the client received the piece. That is a technique used with the above "sales scripts." The concept of direct mail marketing promotion means you have designed a campaign of promo pieces with a specific response in mind. (For two examples of successful promo pieces, see page 22.) Here are some guidelines for creating a successful direct mail promo campaign:
• Use your highest level of technical and creative ability. There is often a "gap" between the work you show in your direct mail and the work that comes from such a mailing. The job the client wants you to do might not be as glamorous or exciting as the work you are showing. Don't worry. It could just be that they don't have a high level of work at this time, yet want to begin a relationship with you by starting with a simple job.
• Distinguish between your current clients and your prospective clients when planning your direct mail. If all your current buyers are wedding and portrait clients and your new marketing message is for corporate communications clients, the mailings won't make a lot of sense. Your marketing messages should be designed to bring in new clients, not scare them away. If your current clients are so different from the clients you want to work for, then design a promo for each of them.
• Look for crossover images that can be used in more than one mailing. For example, a very nicely done portrait of a business executive could be used in either a "corporate communications" or a "consumer portraits" mail campaign.

• Add credibility as often as possible to your direct mail promo pieces. This could be in the form of client testimonials, results from past projects or—best yet—membership in a professional photography association.

• Plan spaced repetition of your mailings. There really isn't any hard and fast rule about timing except that mailings should be geared to the client's quantity of jobs. If they are too close together, you are wasting money. If they're too far apart, you won't build recognition.

• Once you have designed your direct mail campaign, you must schedule production, printing and mailing. You could have the greatest concept and design, but if the pieces do not get mailed on schedule, you won't be successful.

• Plan ahead for possible reuse of the printed pieces you are mailing. Because the presentation of a direct mail promo changes the perception of it, you can use a promo more than once if you redesign it. For example, a stack of past mailers can be cut and bound to make "new" promo pieces.

• Decide, before you design your direct mail piece, what response you are looking for. Set a specific goal. Do you want the recipient to call? To be impressed? To anticipate the next mailing? To refer you to their friends? If you are not very clear on your expectations for this mailer, your potential clients will never be able to figure it out. Also, be sure you have all response avenues open by including your phone and fax numbers and e-mail, website and mailing addresses.

Although your clients will never know how much time you spend "scripting" for your interactions with them, they will appreciate how prepared you are. In the business world, neatness counts—in your telephone and interviewing style, in your portfolio presentations and in your mailings. The more you look and sound like a professional, the more eager potential clients will be to take you on.

GETTING HELP WITH YOUR BUSINESS

Traditionally, the photographer has worn all the hats in the business. But, just because you are a sole-proprietor does not mean you have to work alone. Today's photography business owner may need to employ a full or part-time person to help with the daily chores of marketing and management. This person is not a rep. You could have an independent representative and still need a marketing coordinator. Where a rep has his or her own business and other people to promote, you have the undivided attention of an employee.

Before you say, "I can't afford to hire someone," keep an open mind. Maybe you can't afford not to get help. In the past, you could be just a photographer and survive nicely on whatever work came through the door. That is no longer true. Now, you need to be a business owner and learn to delegate the work you don't have time to do yourself.

There are many tasks you could give someone else to allow you the time and creative energy to work on self-assignments or other "business owner" responsibilities. As you go through your day, write down the tasks that did not require your personal attention. Do this for several weeks. Then, categorize the tasks into specific jobs in the areas of marketing, office management and photography production.

Here is a sample list of tasks you can delegate:

Marketing Management
1. Organize client/prospect database
2. Research new leads/update database
3. Organize materials for portfolios
4. Prepare materials for cost proposals
5. Manage direct mail/mailing house

6. Inventory promo pieces/publicity/tearsheets
7. Keep master calendar of ad design and production
8. Respond to requests from ads/mailings
9. Send/return traveling and drop-off portfolios
10. Write/mail press releases

Office Management
1. Billing, bookkeeping and filing
2. Updating vendor files and samples
3. Taking inventory and ordering office supplies
4. Stock photography filing and research
5. Answering phones

Photography Production
1. Order and inventory film and supplies
2. Research props and background supplies
3. Test equipment on maintenance basis
4. Test cases of film
5. Shoot Polaroids of "test" models for jobs
6. Organize and maintain location packing lists
7. Prepare, pack and unpack location shoots
8. Pick up and shop for props, backgrounds
9. Transport film to and from processing labs
10. Perform janitorial/maintenance chores

Finding the right employee is critical to the success of working with a marketing coordinator. Remember, whoever you choose will often be the first person encountered by current and potential clients and will probably be logging cash disbursements and receipts. This is an important and responsible position. You may experience hesitation and doubt, but overcoming your concerns and concentrating on the search for the right individual will pay off in the long run.

—*Maria Piscopo*

Focus On: Combining Text and Photos to Increase Sales

BY FRAN M. PUTNEY

Every business person seeks ways to increase sales. As a freelance photographer, you may feel you are already approaching all the suitable markets for your work. But what if you could expand your business by offering another product? The simplest way to make more money from existing editorial contacts is to also sell the article or text that will accompany your photographs. Think about it—someone is going to get paid to write that story. Why not you? Brush up on your writing skills, and you can be the someone who earns those extra fees.

Fran Putney

I am both the author of and photographer for most of my articles. I started out as a writer and had to acquire photography as my second skill. I took some photography classes as part of the journalism curriculum in college, and was encouraged to learn to take my own pictures during a summer internship at a county newspaper. Since then, I've attended several photography workshops and seminars to strengthen my skills. If I had to evaluate myself as a photographer, I'd say I have a good eye, but I'm not as strong a technician as I'd like to be. But I'm always out there practicing and working at both my crafts, because I know that by being able to offer both an article and pictures to an editor, I am able to maximize my business opportunities.

MAKE AN EDITOR'S JOB EASY

For the last two years, I have been both a staff writer and photographer for a local company that publishes three community newspapers in my city. Rather than having to line up a separate photographer, my editor finds it convenient to have me do the shooting at the same time I do the interview for an article. Last week, for example, I was assigned to do a story about a metalsmith who was donating a sculpture to a local park. My editor asked me to take the pictures, too, and since I was already interviewing the artist, it was easy to schedule. Because I already knew the story—heck, I wrote it—I knew what kind of pictures would best illustrate the article. Local newspapers are a great place to try your hand at writing because of the volume of stories and pictures they need in a short amount of time. Those editors will appreciate your ability to deliver the words and images they need without tying up staff photographers.

But magazine editors will be just as happy to receive complete editorial packages, an article plus the images that go with it. I recently sold an article about Barnsley Gardens, a historic site in Adairsville, Georgia, to the *North Georgia Journal*. I am certain part of the reason the editor

FRAN PUTNEY *is a freelance writer and photographer from Atlanta, Georgia. She's published articles on parenting topics, travel and business in local, regional and national newspapers and magazines. Her credits include* North Georgia Journal, Girls' Life, San Diego Family Magazine, Cats Magazine, Pharmaceutical Executive, Metro Parent (*Detroit*), Atlanta Parent, Atlanta 30306, *and many others.*

Writer/photographer Fran Putney studied journalism in college and even took a few photography courses, but that second skill is proving more and more valuable as her freelance career advances. This shot of eight-year-old Caitlin Eley brushing her dog Ragalin was published in *San Diego Family Magazine*, accompanying Putney's story about kids and their pets. Putney believes her main talent still lies in writing. "But I'm always out there practicing and working at both my crafts because I know that by being able to offer both an article and pictures to an editor, I am able to maximize my business opportunities."

bit was because I offered to supply both the manuscript and photography. My fee for this work was based on a per word and per image basis. Since I was providing both, my take for this work was much better than if I had supplied just the article or tried to sell him pictures of a place for which he might never have assigned a story.

Once you've become comfortable writing for newspapers and local magazines you can branch out into regional and national publications. The most effective way to do this is to choose a specialty and build writing credits in that area. I cover a lot of parenting topics and sell articles to numerous parenting publications around the country. Whenever possible, I supply my own photographs to accompany those manuscripts. I've sold packages about kids and pets, reading groups, and parents who have home-based businesses. Last summer one of my photographs was published in *Mothering* magazine, and later in the year, when I sent the editor a manuscript (without photographs), her familiarity with my work was certainly a factor in her giving it such careful consideration. But I'm certainly not the first person to increase her sales this way.

TAKE WRITING FOR GRANT-ED

Photographer Ruth Leitman began writing in order to obtain grants for her film work. Already an established photographer for publications such as *Rolling Stone*, *Newsweek*, *Spin* and *Ms.*, Leitman needed to write extensive grants to get money for the films she wanted to do. Leitman went to art school, and her emphasis had always been on the visual aspects of creativity. "Writing doesn't come as easily as photography," she says. "I wrote a Rockefeller Grant. It took a lot of perseverance and learning how to be persuasive. My husband helped me edit a little bit, but really it had to come from me." Leitman ended up getting the grant. "It was like winning the lottery."

Now, in addition to writing grants, Leitman sees writing as a way to maintain artistic control of the projects she works on. She has begun writing storyboards and video scripts for some of her clients who are independent record companies. She also writes narrative scripts for films.

Because writing doesn't come as naturally to her as photography, Leitman often struggles with staring at a blank page. "I know how it needs to look and feel, and I'm going to have to devise a way to write it," she says about carrying through a film idea. "The way I write is a lot more quirky and dialectic because I'm a lot more of a street artist and write more emotionally. It's a lot more about how I feel than how I think. But every once in a while," she says with modest satisfaction, "I'll get a great line."

TURN HOBBIES INTO STORIES

Jack Gurner says he always dreamed about writing articles for magazines but, with a photography career in full swing and training in writing that didn't get beyond freshman English in college, he hadn't really considered it a possibility. His photography career included a job as a combat documentation photographer for the Air Force and work on the daily newspaper, *The Memphis Press Scimitar*, plus running his own studio. Then he started buying *Writer's Digest*, a magazine that helps writers of all types improve their creative and business skills. "The articles about contacting editors, preparing articles, etc. made me feel I could write and get published," Gurner says.

In the late 1970s he wrote an article about a scale modeling project and submitted it to the hobbyist magazine *Scale Modeler*. The article was accepted and published a few months later. "One of the editors told me the article was fairly well written, but the

Jack Gurner

photos were great. That's what started me thinking a photographer has an edge over many writers. After all, editors can rewrite an article, but they can't fix poor photographs. Even with today's advanced digital photography software, little can be done to make a bad photograph usable for magazine reproduction."

Photographer Jack Gurner never believed he could be a writer until he started buying *Writer's Digest*, a magazine that helps writers of all types improve their creative and business skills. "The articles about contacting editors, preparing articles, etc. made me feel that I could write and get published." His first successes were with hobbyist magazines whose editors were willing to assist the fledgling writer. This photo illustration was published in a consumer video magazine article about videotaping family pets.

© Jack Gurner

That first success made Gurner confident that he could compete in the magazine marketplace. His early efforts were directed at hobby-related publications "whose editorial standards were fairly loose." He found a more challenging project when Bob Hayden, editor of *Fine Scale Modeler*, asked him to write an article. "I had to rewrite some portions of my article and check some references before the piece was accepted. I even had to reshoot a couple of the photographs. I was much more pleased with the end results, so the extra work was worth it."

Gurner and his wife, Jessie, began to collaborate on some projects. Together they produced an article and pictures about John Luther "Casey" Jones and other interesting local railroad history in their town of Water Valley, Mississippi, for *Mississippi* magazine. The resulting 9-page article and photos appeared in the November/December 1989 issue and netted them $900, their biggest sale up until that time.

All these successes led to yet another coup. Gurner sent an article about producing a local history video, which had been rejected by another publication, to *Camcorder*. They liked the article and photos so much, they not only ran the piece but asked him to do others, and he now works as a contributing editor for the magazine.

Gurner firmly believes his ability to produce quality photography and write good articles is a formula for success. "In many cases, the amount of pay for an article is double what it would be without photos. I think any editor would be very happy to receive a complete package. Having to have photos taken or even having to look for stock images takes time and money."

FIND A WRITING PARTNER

Beginning writers are often advised to write what they know. Montana-based husband and wife team Larry and Rebecca Javorsky do just that, focusing their writing and photography on outdoor themes. Larry is a fish and wild-life research technician. "My jobs in the outdoors made me want to capture the beauty I saw on film," he says. He began carrying a camera with him to work and about eight years ago began selling his photographs to magazines. His wife Rebecca, who he says is a great writer, joined him in the last few years. Together, they have produced and sold projects to publications such as *Creation Illustrated* and *Ranger Rick*.

"We aim towards magazines with outdoor themes," Larry says. "We also are trying to get into the calendar market. The combination of outdoor scenes and people has given us some success in the religious publishing market, as well." Rebecca homeschools their two sons, ages five and seven, which frees them up to travel. "Our eventual goal is to write about our experiences in the outdoors as a family," Larry says.

The Javorsky Family

With Rebecca as the primary writer on their team, Larry keeps his photography skills honed by reading books and magazines relevant to his work. *Outdoor Photographer* is his favorite magazine. He also teaches photography in the local high school adult education program and in his own weekend workshops. "I've learned that the best way to learn something is to teach it," he says. The Javorskys find their markets through resources such as *Photographer's Market*, which Larry says is the best resource to use for the generalist approach he and Rebecca take. He also subscribes to the *Guilfoyle Report*, a newsletter for outdoor photographers and finds "a fair bit of business through word of mouth." Though Larry says he gets very little feedback from editors, he and his wife have found that when they include an article with their pictures, the response seems to be much better.

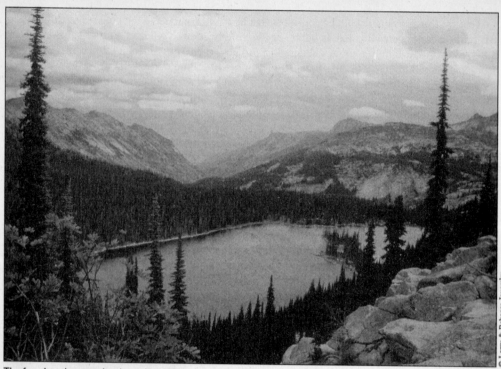

© Larry & Rebecca Javorsky

The fact that photographer Larry Javorsky isn't a writer didn't stop him from producing editorial packages with an outdoor theme. He simply teamed up with his wife Rebecca. This talented duo have found their work published in magazines including *Creation Illustrated* and *Ranger Rick*. "This photo was taken from the Idaho border, looking down into Montana at Fish Lake. I'm smack in the middle of the Selway-Bitterroot Wilderness. What I like most about it is the perspective; looking down on the lake and the valley below, rather than looking across the lake, which is more typical."

A PICTURE PLUS 1,000 WORDS

If you cringe when you think about writing, be assured that you can overcome your fear if you're motivated. And I don't know about you, but the thought of increasing my freelancing sales motivates me. Here are some tips for getting started.

1. Brush up on your writing skills by taking an evening class or workshop.

2. Learn the business of writing by reviewing magazines like *Writer's Digest* or *The Writer*, which can be found on the newsstands or *Editor & Writer*, Blue Dolphin Communications, (603)924-4407. For market information, try books like the annual *Photographer's Market*. *Writer's Market*, available from Writer's Digest Books, is also an excellent resource for editorial markets.

3. Read publications to which you'd like to submit articles. Pay close attention to their style, format and editorial content.

4. Editors don't always have much time to comment on submissions, but if they do, learn from their criticisms and compliments.

5. Submit, submit, submit. Rejection is a fact of life in the freelancing business. Don't be thin-skinned. When an article or proposal comes back rejected, review it to see if there are any improvements you can make before sending it out to the next appropriate market.

6. Write, write, write. Like any other skill, the more you do it, the better you'll get.

The Markets

The majority of markets listed in this book are those which are actively seeking new freelance contributors. Some important, well-known companies which have declined complete listings are included within their appropriate section with a brief statement of their policies. In addition, firms which for various reasons have not renewed their listings from the 1998 edition are listed, with an explanation for their absence, in the General Index at the back of this book.

- Market listings are published free of charge to photography buyers and are not advertisements. While every measure is taken to ensure that the listing information is as accurate as possible, we cannot guarantee or endorse any listing.
- *Photographer's Market* reserves the right to exclude any listing which does not meet its requirements.
- Although buyers are given the opportunity to update their listing information prior to publication, the photography marketplace changes constantly throughout the year and between editions. Therefore, it is possible that some market information will be out of date by the time you make use of it.

COMPLAINT PROCEDURE

If you feel you have not been treated fairly by a listing in *Photographer's Market*, we advise you to take the following steps:

- First try to contact the listing. Sometimes one phone call or a letter can quickly clear up the matter.
- Document all your correspondence with the listing. When you write to us with a complaint, provide the details of your submission, the date of your first contact with the listing and the nature of your subsequent correspondence.
- We will enter your letter into our files and attempt to contact the listing.
- The number and severity of complaints will be considered in our decision whether to delete the listing from the next edition.

KEY TO SYMBOLS AND ABBREVIATIONS

N	New Markets
	Canadian Markets
	Markets located outside the United States and Canada
	Audiovisual Markets
•	Introduces special comments by the editor of *Photographer's Market*
SASE	Self-addressed stamped envelope
IRC	International Reply Coupon, for use on reply mail in markets outside of your own country
Ms, Mss	Manuscript(s)
©	Copyright

(For definitions and abbreviations relating specifically to the photographic industry, see the Glossary in the back of the book.)

Publications

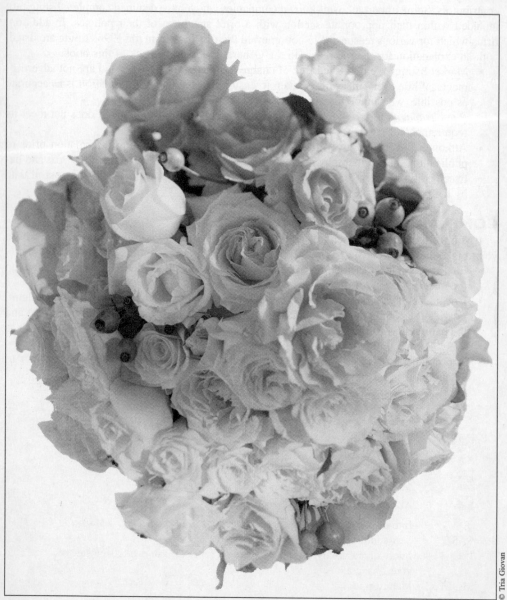

CONSUMER PUBLICATIONS

Research is the key to selling any kind of photography and if you want your work to appear in a consumer publication you're in luck. Magazines are the easiest market to research because they're available on newsstands and at the library and at your doctor's office and . . . you get the picture. So do your homework. Before you send your query or cover letter and samples, before you drop off your portfolio on the prescribed day, look at a copy of the magazine. The library is an especially helpful place when searching for sample copies because they're free and there will be at least a year's worth of back issues right on the shelf.

Once you've read a few issues and feel confident your work is appropriate for a particular magazine, it's time to hit the keyboard or the typewriter. Most first submissions take the form of a query or cover letter and samples. So what kind of letter do you send? That depends on what kind of work you're selling. If you simply want to let an editor know you are available for assignments or have a list of stock images appropriate for the publication, send a cover letter, a short business letter that introduces you and your work and tells the editor why your photos are right for the magazine. If you have an idea for a photo essay or plan to provide the text and photos for an article, you should send a query letter, a 1 to 1½ page letter explaining your story or essay idea and why you're qualified to shoot it. (You'll find a sample query letter on the next page.)

Both kinds of letters can include a brief list of publication credits and any other relevant information about yourself. Both also should be accompanied by a sample of your work—a tearsheet, a slide or a printed piece, but never an original negative. Be sure your sample photo is of something the magazine might publish. It will be difficult for the editor of a mountain biking magazine to appreciate your skills if you send a sample of your fashion work.

If your letter piques the interest of an editor, he or she may want to see more. If you live near the editorial office you can schedule an appointment to show your portfolio in person. Or you can inquire about the drop-off policy—many magazines have a day or two each week when artists can leave their books for art directors. If you're in Wichita and the magazine is in New York, you'll have to send your portfolio through the mail. Consider using FedEx or UPS; both have tracking services that can locate your book if it gets waylaid on its journey.

To make your search for markets easier, there is a subject index in the back of this book. The index is divided into 38 topics from Animals to Vintage images, and markets are listed according to the types of photographs they want to see. Consumer Publications is the largest section in this book so take a look at the index on page 589 before you tackle it.

◀ Freelance photographer Tria Giovan discovered *Southern Accents* magazine by looking at periodicles on a newsstand. This market has benefited Giovan by giving her "exposure from photo credits in a national magazine." But more than that, she has developed a relationship with Art Director Ann Carothers, who often commissions the photographer for work. This shot of a magnificent rose bouquet from the Hathaway gardens near Dallas, Texas, communicates Giovan's desire to "capture the simplicity and beauty of a garden." (Ann Carothers explains why planning is crucial to great home and garden photography on page 49.)

SAMPLE QUERY LETTER FOR MAGAZINES

February 27, 1997

Michael Willins
7016 Ragland Road
Cincinnati, OH 45244-3110
(513) 561-6044

Jenny Carmichael ◄ ──────────────────────────── Current contact.
Then & Now Magazine
732 Main Street
San Francisco, CA 94113

Dear Ms. Carmichael: ◄ ──────────────────────── Salutation.

In recent weeks I've reviewed past editions of *Then & Now Magazine* and devel-
oped a story idea that is perfect for its pages. ◄ ─────────── Cite knowledge of
 magazine.

Ever since they were created, the Little Rascals TV characters have been enjoyed
by millions of people, young and old. I know that 65% of *Then & Now*'s readers
range in age from 60 to 75, and I'm certain they would love to see what the show's
cast members are doing today. My idea is to photograph the core members and ── State assignment
provide short bios that explain what happened in each character's career since concept.
leaving the show.

Enclosed are photos from past assignments I've completed that should give you a
sample of my photographic skills. Please return them in the enclosed SASE when ── Provide samples of
you are through reviewing them. I've also enclosed a list of previous clients and past work.
photographic awards I've earned.

May I discuss this idea with you in the coming weeks?

I look forward to your reply.

Best regards,

Michael Willins
Writer/Photographer

Excerpted from The Photographer's Market Guide to Photo Submission & Portfolio Formats © 1997 by Michael Willins.
Used with permission of Writer's Digest Books, a division of F&W Publications, Inc.

It takes careful planning to shoot great pictures of homes and gardens

The goal of *Southern Accents* magazine is simple: "We want to leave readers feeling they have visited a home or garden, that they have really seen it from all aspects and have enjoyed seeing it. We want beautiful photography that readers will 'ooh' and 'ah' over as they turn the pages," says Art Director Ann Carothers. But achieving the graceful elegance abundant in every issue is no easy task. Careful planning of each issue and selection of freelancers is required to achieve this goal and to ensure plenty of "oohs" and "ahs."

Originally launched in 1977 by Atlanta-based W.R.C. Smith, and later acquired by Birmingham's Southern Progress Corporation, *Southern Accents* explores a previously ignored market. Up until that point, no one had tapped into the rich world of architecture, interior design and landscape of the South, a part of the country where the low cost of living gives people more disposable income. Twenty years later, the magazine's success proves this subject has an enormous appeal.

Since the content of *Southern Accents* has an extensive scope, planning and creativity are essential. Articles range from gardening design, where "the layout of the garden is played up," to travel in Europe, like a recent feature on Portugal. Making sure each issue contains "an artist, antique stories, a gardening essay, garden design, visual arts, travel and more" demands innovation and imagination. In the September/October 1998 issue, for example, Carothers says that instead of showing how the Aiken-Rhett estate in Charleston, South Carolina, was preserved, the story took an unusual approach and focused on the preservation of the slave quarters.

Carothers, who has been with *Southern Accents* for over five years, says a strong regional focus is the key difference between it and other shelter magazines, like *Architectural Digest*, that concentrate on home and garden design. "We run stories about southerners and houses where people actually live. *Architectural Digest* runs houses from all over. What sets us apart from the other shelter books is that we are regional, only covering the homes and gardens in the South and southerners' homes in Europe, Mexico, etc. We always have a southern connection."

The magazine remains distinct from its sister publication, *Southern Living*, because of the "upscale homes and gardens" featured in each issue. Even though the two magazines are owned by the same corporation and appeal to the same southern audience, they each have distinctive personalities. For example, articles on entertaining center around themes like the Fabergé Ball or Carol Issak Barden's 50th birthday party. "We show families getting together to get across different entertaining ideas for a party, and include antiques and table settings." Stories about entertaining in *Southern Living*, on the other hand, emphasize things like food, sharing recipes with readers.

Another important difference for photographers to note: *Southern Accents* only uses freelancers, whereas *Southern Living* has a full-time staff of photographers. "We usually

INSIDER REPORT, *continued*

use 15-20 photographers per issue. We select photographers based on their look for particular subject matter. This way we can achieve a good mix of photography in each issue," Carothers says.

Here, planning becomes crucial because maintaining this mix means not only choosing a freelancer carefully, but also selecting the right photographer for a particular job. Each of the magazine's various departments—Homes, Architecture, Gardens, Travel, Entertaining and Products—has separate needs and requires specific skills from freelancers. "Homes photography has to have the right angles and lighting. Architecture has to play up or emphasize the architecture and materials used. Photographers for Entertaining have to be good with people and parties. Travel photographers have to capture the essence and mood of the location's places and people." Carothers says. Products is the only department that differs; "shots for our Accents column are often sent in by the manufacturers, but we do shoot some here in our studios." Carothers must take all this into consideration when she looks at photographers' samples and when she makes assignments.

An important skill Carothers looks for in freelancers' portfolios is "their lighting." This aspect of a shoot requires planning on the part of photographers. "Even in tough situations, like if there is no natural light or available light, they should still light the home so that it looks beautiful but not artificially lit." Another necessary skill is "how fast they

© Michael Mundy

"Silence" was the message Michael Mundy wanted to convey in this shot of Kries and Sandy Beall's living room in Point Clear, Alabama. Mundy captured this affect by allowing the white furniture to play against the intricate textures of the collection of antique hat molds on the bookshelves and the model sailboat on the mantle. Perfect for *Southern Accents* magazine, this image illustrates how antiques can enrich a comfortable living area. According to Art Director Ann Carothers, a goal of the magazine is to show "how to use antiques in decorating and how to put them in a modern interior as people actually use them today."

INSIDER REPORT, *Carothers*

shoot, how many shots they can get out of a home or garden shoot in two days" (the standard amount of time to shoot a home or garden).

Each issue of the magazine is organized far in advance. "We have to shoot gardens in their season, usually shot and held for the next year. Same with homes; most are shot a year in advance." This ensures landscapes always look their best, regardless of season. When planning an issue, "our Design Editor decides what homes and gardens run based on the interior and/or landscape design." Then, "depending on the subject matter, the editor, stylist, photographer and myself work together to plan a story shoot. Photographers with a stylist often come up with the look of the story, and sometimes bring us story ideas and homes and gardens that would work for our magazine."

When a subject is finally chosen, some instruction is necessary for freelancers who have never worked for *Southern Accents*. "We have used many of our freelance photographers for some time, and they know the style of the magazine. You develop a relationship with certain photographers. You know what they are going to get out of a shoot. But when we use someone new, we tell them what format we prefer and the style and look we are after in that particular shoot. We also send a recent issue to let them know what the magazine is about." Before the assignment is made, the editor "scouts" a home or garden, then plans a shooting script to give to the photographer. The shooting script lets a freelancer know "what shots we need, what we need to emphasize in the shoot."

Choosing the site of the shoot often depends on the subject matter. An excursion to someone's house is naturally required for articles on architecture, landscapes and design, but often Southern Progress's in-house studio is "used for objects like antiques, china, and transferware." The studio is ideal because it provides backdrops and natural light. In one issue, "Chinese furniture was shot in a warehouse because the furniture was already there, and we could use the painted background inside the warehouse."

If the idea of photographing antiques, gardens and homes appeals to you, "send in portfolios with transparencies and/or printed material either published or unpublished." And for up-and-coming freelancers who are planning for their future and want to know how to break into a market like *Southern Accents*, Carothers offers this advice: "Be aphotographer's assistant to someone who is already established in the business. Learn their techniques and secrets of the trade, and pick up clients from there."

—*Donya Dickerson*

N AAA MICHIGAN LIVING, 1 Auto Club Dr., Dearborn MI 48126. (248)816-9265. Fax: (248)816-2251. E-mail: regarbo@aol.com. Executive Editor: Ron Garbinski. Circ. 1 million. Estab. 1918. Monthly magazine. Emphasizes auto use, as well as travel in Michigan, US, Canada and foreign countries. Free sample copy and photo guidelines.

Needs: Scenic and travel. "We buy photos without accompanying ms only for stories listed on our editorial calendar. Seeks queries about travel in Michigan, US and Canada. We maintain a file of stock photos and subjects photographers have available." Captions required.

Making Contact & Terms: Query with list of stock photo subjects. Uses 35mm, 2¼×2¼ or 4×5 transparencies. For covers in particular, uses 35mm, 4×5 or 8×10 color transparencies. SASE. Reports in 6 weeks. Pays up to $450/color photo depending on quality and size; $450/cover; $55-500/ms. Pays on publication for photos and for mss. Buys one-time rights. Simultaneous submissions and previously published work not accepted.

ABOARD MAGAZINE, 100 Almeria Ave., Suite 220, Coral Gables FL 33134. (305)441-9738. Fax: (305)441-9739. Contact: Vanessa Otero. Circ. 180,000. Estab. 1976. Inflight magazine for 11 separate Latin American national airlines. Bilingual bimonthly. Emphasizes travel through Central and South America. Readers are mainly Latin American businessmen, and American tourists and businessmen. Sample copy free with SASE. Photo guidelines free with SASE.
Needs: Uses 50 photos/issue; 30 supplied by freelance photographers. Needs photos of travel, scenic, fashion, sports and art. Special needs include good quality pictures of Latin American countries, particularly Chile, Guatemala, Ecuador, Bolivia, Rep. Dominicana, El Salvador, Peru, Nicaragua, Honduras, Paraguay, Uruguay. Model/property release preferred. Captions preferred.
Making Contact & Terms: Query with samples. Provide business card, brochure, flier or tearsheets to be kept on file for possible future assignments. Accepts digital images for Mac on Syquest. SASE. Reports in 2 months. Payment varies; $150 for photo/text package; pays $100 for photo only. Pays on publication. Credit line given. Buys one-time rights. Previously published work OK.
Tips: If photos are accompanied by an article, chances of them being accepted are much better. "Send sample of your work with proper credits, list of photo topics/places you have available and fees."

[N] ACC ATHLETE, 3101 Poplarwood Court, Suite 113, Raleigh NC 27604. (919)954-7500. Fax: (919)954-8600. Director of Photography: Bob Donnan. Circ. 100,000. Estab. 1997. Monthly sports magazines for fans of college sports. Sample copy for $5.
Needs: Buys 40 photos from freelancers/issue. Needs photos of sports action and personalities. Photo captions required.
Making Contact & Terms: Provide résumé, business card, self-promotion piece or tearsheets to be kept on file for possible future assignments. Art director will contact photographer for portfolio review if interested. Keeps samples on file. Reports back only if interested, send non-returnable samples. Pays $50-200 for b&w inside; $75-500 for color inside. **Pays on acceptance.** Credit line given. Buys one-time or electronic rights. Previously published work OK.
Tips: "We work with a broad range of photographers who have passion and insight into their sports. We look for dynamic sports action and strong personal pictures of coaches and athletes."

ACCENT ON LIVING, P.O. Box 700, Bloomington IL 61702. (309)378-2961. Fax: (309)378-4420. E-mail: acntlvg@aol.com. Website: http://www.blvd.com/accent. Editor: Betty Garee. Circ. 20,000. Estab. 1955. Quarterly magazine. Emphasizes successful disabled young adults (18 and up) who are getting the most out of life in every way and *how* they are accomplishing this. Readers are physically disabled individuals of all ages, socioeconomic levels and professions. Sample copy $3.50 with 5×7 SAE and 5 first-class stamps. Free photo/writers guidelines; enclose SASE.
Needs: Uses 40-50 photos/issue; 95% supplied by freelancers. Needs photos for Accent on People department, "a human interest photo column on disabled individuals who are gainfully employed or doing unusual things." Also uses occasional photo features on disabled persons in specific occupations: art, health, etc. Manuscript required. Photos depict handicapped persons coping with the problems and situations particular to them: how-to, new aids and assistive devices, news, documentary, human interest, photo essay/photo feature, humorous and travel. "All must be tied in with physical disability. We want essentially action shots of disabled individuals doing something interesting/unique or with a new device they have developed—not photos of disabled people shown with a good citizen 'helping' them." Model release preferred. Captions preferred.
Making Contact & Terms: Query first with ideas, get an OK, and send contact sheet for consideration. Uses glossy prints and color photos, transparencies preferred. Accepts images in digital format for Mac on zip or floppy disk (300dpi). Provide letter of inquiry and samples to be kept on file for possible future assignments. Cover is usually tied in with the main feature inside. SASE. Reports in 3 weeks. Pays $50-up/color cover; pays $15-up/color inside; pays $10-up/b&w inside. Pays on publication. Credit line given if requested. Previously published work OK.
Tips: "Concentrate on improving photographic skills. Join a local camera club, go to photo seminars, etc.

**FOR EXPLANATIONS OF THESE SYMBOLS,
SEE THE INSIDE FRONT AND BACK COVERS OF THIS BOOK.**

We find that most articles are helped a great deal with *good* photographs—in fact, good photographs will often mean buying a story and passing up another one with very poor or no photographs at all." Looking for *good* quality photos depicting what article is about. "We almost always work on speculation."

N **ACROSS THE BOARD MAGAZINE**, published by The Conference Board, 845 Third Ave., New York NY 10022-6679. (212)339-0454. Contact: Picture Editor. Circ. 30,000. Estab. 1976. General interest business magazine with 10 monthly issues (January/February and July/August are double issues). Readers are senior executives in large corporations.
Needs: Use 10-15 photos/issue some supplied by freelancers. Wide range of needs, including location portraits, industrial, workplace, social topics, environmental topics, government and corporate projects, foreign business (especially east and west Europe and Asia).
Making Contact and Terms: Query *by mail only* with list of stock photo subjects and clients, and brochure or tearsheets to be kept on file. Accepts digital images. Cannot return material. "No phone queries please. We pay $125-400 inside, up to $500 for cover or $400/day for assignments. We buy one-time rights, or six-month exclusive rights if we assign the project."
Tips: "Our style is journalistic and we are assigning photographers who are able to deliver high-quality photographs with an inimitable style. We are interested in running full photo features with business topics from the U.S. or worldwide. If you are working on a project, please send non-returnable samples."

N **⊕** **ACTIVE LIFE**, Aspen Publishing, Christ Church Cosway St., London Nw1 5NJ United Kingdom. Phone: (0171)262 2622. Fax: (0171)706 4811. Website: http://www.aspen~intermet.net/. Contact: Helene Hodge. Circ. 300,000. Estab. 1990. Bimonthly consumer magazine.
Needs: Reviews photos with accompanying ms only. Model release required. Photo caption preferred.
Making Contact & Terms: Send query letter with samples. Uses 35mm transparencies. Keeps samples on file; include SASE for return of material. Pays on publication. Credit line given. Rights negotiable. Simultaneous submissions and/or previously published work OK.

ADIRONDACK LIFE, Rt. 9N, P.O. Box 410, Jay NY 12941. (518)946-2191. Art Director: Ann Hough. Circ. 50,000. Estab. 1970. Bimonthly. Emphasizes the people and landscape of the Adirondack region. Sample copy $4 with 9×12 SAE and 5 first-class stamps. Photo guidelines free with SASE.
Needs: "We use about 40 photos/issue, most supplied by freelance photographers. All photos must be taken in the Adirondacks and all shots must be identified as to location and photographer."
Making Contact & Terms: Send one sleeve (20 slides) of samples. Send b&w prints (preferably 8×10) or color transparencies in any format. SASE. Pays $300/cover; $50-200/color or b&w photo; $150/day plus expenses. Pays 30 days after publication. Credit line given. Buys first North American serial rights. Simultaneous submissions OK.
Tips: "Send quality work pertaining specifically to the Adirondacks. In addition to technical proficiency, we look for originality and imagination. We emphasize vistas and scenics. We are using more pictures of people and action."

ADVENTURE CYCLIST, Box 8308, Missoula MT 59807. (406)721-1776. Editor: Dan D'Ambrosio. Circ. 30,000. Estab. 1974. Publication of Adventure Cycling Association. Magazine published 9 times/year. Emphasizes bicycle touring. Readers are mostly male professionals. Sample copy and photographer's guidelines free with 9×12 SAE and 4 first-class stamps.
Needs: Covers. Model release preferred. Captions required.
Making Contact & Terms: Submit portfolio for review. SASE. Reports in 3 weeks. Payment negotiable. Pays on publication. Credit line given. Buys one-time rights. Simultaneous submissions and previously published work OK.

THE ADVOCATE, 6922 Hollywood Blvd., 10th Floor, Los Angeles CA 90028. (213)871-1225. Fax: (213)467-6805. Picture Editor: Michael Matson. Circ. 74,000. Estab. 1967. Biweekly magazine. Emphasizes gay and lesbian issues. Readers are gays and lesbians, ages 21-70. Photo guidelines free with SASE.
Needs: Uses 55 photos/issue; 50% supplied by freelancers. Model release required for minors.
Making Contact & Terms: Send promo cards. Send 35mm, 2¼×2¼, 4×5 transparencies. Keeps samples on file. SASE. Reports in 3 weeks. Payment negotiable. Pays net 30 days from delivery of assignment. Credit line given. Buys one-time rights.
Tips: "Be flexible. Have ideas to contribute. Don't bombard editors with follow-up calls. Our deadlines are tight. We'll call you if we need you."

AGE WAVE @ GET UP AND GO!, (formerly *Mature Lifestyles News Magazine*), 4575 Via Royale, Suite 102, Ft. Myers FL 33919. (941)931-9191. Fax: (941)931-9195. Graphic Design Manager: Glenn

Fraller. Circ. 254,000. Circ. 1986. Monthly tabloid. Emphasis on 50-65 age group. Readers are male and female, 50-75, employed boomers, early retirees, retirees, semi-retired executives. Free sample copy.
Needs: Uses 2 photos/issue; 2 supplied by freelancers. Needs photos of personalities, how-to. Special photo needs include cover shots.
Making Contact & Terms: Submit portfolio for review. Query with stock photo list. Provide résumé, business card, brochure, flier or tearsheets to be kept on file for possible assignments. Send 2¼×2¼, 4×5 transparencies. Keeps samples on file. SASE. Reports in 1 month. Pays $250/color cover. Pays on publication. Credit line given. Buys one-time rights. Previously published work OK.

AIM MAGAZINE, P.O. Box 1174, Maywood IL 60153. (312)874-6184. Editor: Myron Apilado. Circ. 7,000. Estab. 1974. Quarterly magazine. Magazine dedicated to promoting racial harmony and peace. Readers are high school and college students, as well as those interested in social change. Sample copy for $4 with 9×12 SAE and 6 first-class stamps.
Needs: Uses 10 photos/issue. Needs "ghetto pictures, pictures of people deserving recognition, etc." Needs photos of "integrated schools with high achievement." Model release required.
Making Contact & Terms: Send unsolicited photos by mail for consideration. Send b&w prints. SASE. Reports in 1 month. Pays $25/color cover; $10/b&w cover. **Pays on acceptance.** Credit line given. Buys one-time rights. Simultaneous submissions OK.
Tips: Looks for "positive contributions."

AIR LINE PILOT, 535 Herndon Pkwy., Box 1169, Herndon VA 22070. (703)481-4460. Fax: (703)689-4370. E-mail: 73714.41@compuserve.com. Website: http://www.alpa.org. Editor-in-Chief: Gary DiNunno. Circ. 72,000. Estab. 1933. Publication of Air Line Pilots Association. 10 issues/year. Emphasizes news and feature stories for commercial airline pilots. Photo guidelines for SASE. Guidelines available on website.
Needs: Uses 12-15 photos/issue; 25% comes from freelance stock. Needs dramatic 35mm transparencies, prints or high resolution IBM compatible images on disk or CD of commercial aircraft, pilots and co-pilots performing work-related activities in or near their aircraft. "Pilots must be ALPA members in good standing. Our editorial staff can verify status." Special needs include dramatic images technically and aesthetically suitable for full-page magazine covers. Especially needs vertical composition scenes. Model release required. Captions required; include aircraft type, airline, location of photo/scene, description of action, date, identification of people and which airline they work for.
Making Contact & Terms: Query with samples. Send unsolicited photos by mail for consideration. "Currently use two outside vendors for assignment photography. Most freelance work is on speculative basis only." Accepts images in digital format for Windows. Send via compact disc, SyQuest, zip disk or Online. SASE. Pays $25-100/b&w photo; $50-350/color photo. **Pays on acceptance.** Buys all rights. Simultaneous submissions and previously published work OK.
Tips: In photographer's samples, wants to see "strong composition, poster-like quality and high technical quality. Photos compete with text for space so they need to be very interesting to be published. Be sure to provide brief but accurate caption information and send in only professional quality work. For our publication, cover shots do not need to tie in with current articles. This means that the greatest opportunity for publication exists on our cover. Check website for criteria and requirements. Send samples of slides to be returned upon review. Make appointment to show portfolio."

ALABAMA LIVING, P.O. Box 244014, Montgomery AL 36124. (334)215-2732. Fax: (334)215-2733. Editor: Darryl Gates. Circ. 315,000. Estab. 1948. Publication of the Alabama Rural Electric Association. Monthly magazine. Emphasizes rural life and rural electrification. Readers are older males and females living in rural areas and small towns. Sample copy free with 9×12 SASE and 4 first-class stamps.
Needs: Uses 6-12 photos/issue; 1-3 supplied by freelancers. Needs photos of nature/wildlife, travel— southern region, some scenic and Alabama specific. Special photos needs include vertical scenic cover shots. Captions preferred; include place and date.
Making Contact & Terms: Query with stock photo list or transparencies ("dupes are fine") in negative sleeves. Keeps samples on file. SASE. Reports in 1 month. Pays $40-50/color cover; $60-75/photo/text package. Pays on publication. Credit line given. Buys one-time rights; negotiable. Simultaneous submissions OK. Previously published work OK "if previously published out-of-state."

ALASKA, 4220 B St., Suite 210, Anchorage AK 99503. (907)561-4772. Fax: (907)561-5669. Editor: Bruce Woods. Photo Editor: Donna Rae Thompson. Circ. 250,000. Estab. 1935. Monthly magazine. Readers are people interested in Alaska. Sample copy $4. Free photo guidelines.
Needs: Buys 500 photos annually, supplied mainly by freelancers. Captions required.
Making Contact & Terms: Interested in receiving work from established and newer, lesser-known

photographers. Send carefully edited, captioned submission of 35mm, 2¼×2¼ or 4×5 transparencies. SASE. Reports in 4 weeks. Pays $50/b&w photo; $75-500/color photo; $300/day; $2,000 maximum/ complete job; $300/full page; $500/cover. Buys one-time rights; negotiable.

Tips: "Each issue of *Alaska* features an 6- to 8-page photo feature. We're looking for themes and photos to show the best of Alaska. We want sharp, artistically composed pictures. Cover photo always relates to stories inside the issue."

ALIVE NOW MAGAZINE, 1908 Grand Ave., P.O. Box 189, Nashville TN 37202. (615)340-7218. E-mail: alivenow@upperroom.org. Website: http://www.upperroom.org/alivenow/. Associate Editor: Eli Fisher. Circ. 70,000. Estab. 1971. Bimonthly magazine published by The Upper Room. "*Alive Now* uses poetry, short prose, photography and contemporary design to present material for personal devotion and reflection. It reflects on a chosen Christian concern in each issue. The readership is composed of primarily college-educated adults." Sample copy free with 6×9 SAE and 4 first-class stamps. Themes list free with SASE; photo guidelines available.

Needs: Uses about 20 b&w prints/issue; 90% supplied by freelancers. Needs b&w photos of "family, friends, people in positive and negative situations, scenery, celebrations, disappointments, ethnic minority subjects in everyday situations—Native Americans, Hispanics, Asian-Americans and African-Americans." Model release preferred.

Making Contact & Terms: Query with samples. Send 8×10 glossy b&w prints by mail for consideration. Send return postage with photographs. Submit portfolio for review. SASE. Reports in 6 months; "longer to consider photos for more than one issue." Pays $40/b&w inside; no color photos. Pays on publication. Credit line given. Buys one-time rights. Simultaneous and previously published submissions OK.

Tips: Looking for high reproduction, quality photographs. Prefers to see "a variety of photos of people in life situations, presenting positive and negative slants, happy/sad, celebrations/disappointments, etc. Use of racially inclusive photos is preferred. Send photos to keep on file (photocopies are accepted, but please send several photographs to show quality)."

N ALL-STATER SPORTS, 1500 W. Third Ave., Suite 222, Columbus OH 43212-2817. (614)487-1280. Fax: (614)487-1283. E-mail: contact@all-statersports.com. Website: http://www.all-statersports.com. Associate Editor: Stephanie Strong. Circ. 55,000. Estab. 1996. Bimonthly magazine. "Our mission is to inform, inspire, and recognize today's high school athlete." Sample copy for $5.50. Art guidelines free.

Needs: Buys 2 photos from freelancers/issue. Needs photos of outstanding high school athletes in action. Reviews photos with or without ms. Special photo needs include state championship (high school) photos. Model release preferred; property release preferred. News photos do not need model releases. Photo captions required; include who, what, when, where.

Making Contact & Terms: Send query letter with samples. Art director will contact photographer for portfolio review if interested. Keeps samples on file. Reports in 1-2 months on queries; 1-2 months on samples. Pays $25-150 for color cover; $10-30 for b&w inside; $10-50 for color inside. Pays on publication. Credit line given. Buys one-time, electronic rights; negotiable. Previously published work OK.

Tips: "We are a new magazine with a small staff, and we are always looking for good stories with excellent pictures. Let us know of possibilities in your area of the country. Please only send sample work that is sports oriented."

ALLURE, Conde Nast Publications, Inc., 360 Madison Ave., New York, NY 10017. (212)880-8800. Fax: (212)880-8287. *Allure* covers beauty and total image. It looks at the complex role beauty plays in culture and analyzes the trends in cosmetics, skincare, fashion, haircare, fitness and health. This magazine did not respond to our request for information. Query before submitting.

ALOHA, THE MAGAZINE OF HAWAII AND THE PACIFIC, P.O. Box 3260, Honolulu HI 96801. (808)593-1191. Fax: (808)593-1327. Associate Editor: Joyce Akamine. Circ. 70,000. Estab. 1978. Bimonthly. Emphasizes culture, arts, history of Hawaii and its people. Readers are "affluent, college-educated people from all over the world who have an interest in Hawaii." Sample copy $2.95 with 9×11 SAE and 9 first-class stamps. Photo guidelines free with SASE.

Needs: Uses about 50 photos/issue; 90% supplied by freelance photographers. Needs "scenics, travel, people, florals, strictly about Hawaii. We buy primarily from stock. Assignments are rarely given and when they are, they are usually given to one of our regular local contributors. Subject matter must be Hawaiian in some way." Model release required if the shot is to be used for a cover. Captions required.

Making Contact & Terms: Submit portfolio for review. Query with stock photo list. Send unsolicited photos by mail for consideration. Provide résumé, business card, brochure, flier or tearsheets. SASE. Reports in 3 weeks. Pays $25/b&w photo; $75/color transparency; $125/photo running across a two-page

spread; $250/cover shot. Pays on publication. Credit line given. Buys one-time rights.

Tips: Prefers to see "a unique way of looking at things, and of course, well-composed images. Generally, we are looking for outstanding scenic photos that are not standard sunset shots printed in every Hawaii publication. We need to see that the photographer can use lighting techniques skillfully, and we want to see pictures that are sharp and crisp." Competition is fierce, and it helps if a photographer can first bring in his portfolio to show to our art director. Then the art director can give him ideas regarding our needs."

AMELIA MAGAZINE, 329 "E" St., Bakersfield CA 93304. (805)323-4064. Editor: Frederick A. Raborg, Jr. Circ. 1,750. Quarterly magazine. Emphasizes literary: fiction, non-fiction, poetry, reviews, fine illustrations and photography, etc. "We span all age groups, three genders and all occupations. We are also international in scope. Average reader has college education." Sample copy $9.95 and SASE. Photo guidelines free with SASE.

• Because this is a literary magazine it very seldom uses a lot of photographs. However, the cover shots are outstanding, fine art images.

Needs: Uses 4-6 photos/issue depending on availability; all supplied by freelance photographers. "We look for photos in all areas including male and female nudes and try to match them to appropriate editorial content. We sometimes use photos alone; color photos on cover. We use the best we receive; the photos usually convince us." Model release required. Captions preferred.

Making Contact & Terms: Send unsolicited photos by mail for consideration. Send b&w or color, 5×7 and up, glossy or matte prints; 35mm or 2¼×2¼ transparencies. SASE. Reports in 2 weeks. Pays $100/color cover; $50/b&w cover; $5-25/b&w inside. **Pays on acceptance.** Credit line given. Buys one-time rights or first North American serial rights. "We prefer first North American rights, but one-time is fine." Simultaneous submissions OK.

Tips: In portfolio or samples, looks for "a strong cross-section. We assume that photos submitted are available at time of submission. Do your homework. Examine a copy of the magazine, certainly. Study the 'masters of contemporary' photography, i.e., Adams, Avedon, etc. Experiment. Remember we are looking for photos to be married to editorial copy usually. We allow photographers 40% discount on subscriptions to follow what we do. Requests for discounts must be on letterhead with or without samples."

AMERICA WEST AIRLINES MAGAZINE, 4636 E. Elwood St., Suite 5, Phoenix AZ 85040. (602)997-7200. America West Airlines magazine. Circ. 125,000. Monthly. Emphasizes general interest—including: travel, interviews, business trends, food, etc. Readers are primarily business people and business travelers; substantial vacation travel audience. Photo guidelines free with SASE. Sample copy $3.

Needs: Uses about 20 photos/issue supplied by freelance photographers. "Each issue varies immensely; we primarily look for stock photography of places, people, subjects such as animals, plants, scenics—we assign some location and portrait shots. We publish a series of photo essays with brief, but interesting accompanying text." Model release required. Captions required.

Making Contact & Terms: Provide résumé, business card, brochure, tearsheets or color samples to be kept on file for possible future assignments. Include SASE with portfolio submission, but query first. Pays $100-225/color inside, depends on size of photo and importance of story. Pays on publication. Credit line given. Buys one-time rights. Previously published work OK.

Tips: "We judge portfolios on technical quality, consistency, ability to deliver with a certain uniqueness in style or design, versatility and creativity. Photographers we work with most often are those who are both technically and creatively adept, and who can take the initiative conceptually by providing new approaches or ideas."

N: AMERICAN ANGLER, The Magazine of Fly Fishing and Fly Tying, Abenaki Publishers, Inc., 160 Benmont Ave., Bennington VT 05201. (802)447-1518. Fax: (802)447-2471. Editor: Gary Soucie. Circ. 57,000. Estab. 1978. Bimonthly consumer magazine. "Fly fishing only. More how-to than where-to, but we need shots from all over. More domestic than foreign. More trout, salmon, and steelhead than bass or saltwater." Sample copy for $6 and 9×12 SAE with $2.62 first-class postage or Priority Mail Flate Rate Envelope with $3. Photo guidelines with SAE with 55¢ first-class postage.

Needs: Buys 3-10 photos from freelancers/issue; 18-60 photos/year; most of our photos come from writers of articles. "The spirit, essence and exhilaration of Fly Fishing. Always need good fish-behavioral stuff—spawning, rising, riseforms, etc." Photo captions required.

Making Contact & Terms: Send query letter with samples, brochure, stock photo list, tearsheets. Provide résumé, business card, self-promotion piece or tearsheets to be kept on file for possible future assignments. Portfolio review by prior arrangement. Prefers slides, but also uses 4×5 to 8×10 matte to glossy color and b&w prints; must be very sharp and good contrast. Accepts images in digital format, PhotoShop, TIF, minimum 30 dpi; Mac 3½ disk, Zip disk, CO, SyQuest. Query deadline: 6-10 months prior to cover date. Submission deadline: 5 months before cover date. Reports in 4-6 weeks on queries; 3-4 weeks on samples.

Pays $450/color cover; $450/b&w cover; $50-250/b&w inside; $50-250/color inside. Pays on publication. Credit line given. Buys one-time rights, first rights for covers. Simultaneous submission and previously published work OK—"but only for inside 'editorial' use—not for covers, prominent feature openers, etc."
Tips: "We are sick of the same old shots: grip and grin, angler casting, angler with bent rod, fish being released. Sure, we need them, but there's a lot more to fly fishing. Don't send us photos that look exactly like the ones you see in most fishing magazines. Think like a storyteller. Let me know where the photos were taken, at what time of year, and anything else that's pertinent to a fly fisher."

AMERICAN BAR ASSOCIATION JOURNAL, 750 N. Lake Shore Drive, Chicago IL 60611. (312)988-6002. Photo Editor: Beverly Lane. Publication of the American Bar Association. Monthly magazine. Emphasizes law and the legal profession. Readers are lawyers of all ages. Circ. 400,000. Estab. 1915. Photo guidelines available.
Needs: Uses 50-100 photos per month; 90% supplied by freelance photographers. Needs vary; mainly shots of lawyers and clients by assignment only.
Making Contact & Terms: Send non-returnable printed samples with résumé and two business cards with rates written on back. "If samples are good, portfolio will be requested. *ABA Journal* keeps film. However, if another publication requests photos, we will release and send the photos. Then, that publication pays the photographer." Payment negotiable. Cannot return unsolicited material. Credit line given.
Tips: "NO PHONE CALLS. The *ABA Journal* does not hire beginners."

AMERICAN CRAFT, 72 Spring St., New York NY 10012. (212)274-0630. Fax: (212)274-0650. Editor/Publisher: Lois Moran. Managing Editor: Pat Dandignac. Circ. 45,000. Estab. 1941. Bimonthly magazine of the American Craft Council. Emphasizes contemporary creative work in clay, fiber, metal, glass, wood, etc. and discusses the technology, materials and ideas of the artists who do the work. Free sample copy with 9×12 SAE and 5 first-class stamps.
Needs: Visual art. Shots of crafts: clay, metal, fiber, etc. Captions required.
Making Contact & Terms: Arrange a personal interview to show portfolio. Uses 8×10 glossy b&w prints; 4×5 transparencies and 35mm film; 4×5 color transparencies for cover, vertical format preferred. SASE. Reports in 1 month. Pays according to size of reproduction; $40 minimum/b&w and color photos; $175-500/cover photos. Pays on publication. Buys one-time rights. Previously published work OK.

AMERICAN FITNESS, Dept. PM, 15250 Ventura Blvd., Suite 200, Sherman Oaks CA 91403. (818)905-0040. Editor: Peg Jordan. Circ. 35,000. Estab. 1983. Publication of the Aerobics and Fitness Association of America. Publishes 6 issues/year. Emphasizes exercise, fitness, health, sports nutrition, aerobic sports. Readers are fitness enthusiasts and professionals, 75% college educated, 66% female, majority between 20-45. Sample copy $2.50.
Needs: Uses about 20-40 photos/issue; most supplied by freelancers. Assigns 90% of work. Needs action photography of runners, aerobic classes, swimmers, bicyclists, speedwalkers, in-liners, volleyball players, etc. Special needs include food choices, youth and senior fitness, people enjoying recreation, dos and don'ts. Model release required.
Making Contact & Terms: Query with samples or with list of stock photo subjects. Send b&w prints; 35mm, 2¼×2¼ transparencies; b&w contact sheets by mail for consideration. SASE. Reports in 2 weeks. Pays $10-35/b&w or color photo; $50-100 for text/photo package. Pays 4-6 weeks after publication. Credit line given. Buys first North American serial rights. Simultaneous submissions and previously published work OK.
Tips: Fitness-oriented outdoor sports are the current trend (i.e. mountain bicycling, hiking, rock climbing). Over-40 sports leagues, youth fitness, family fitness and senior fitness are also hot trends. Wants high-quality, professional photos of people participating in high-energy activities—anything that conveys the essence of a fabulous fitness lifestyle. Also accepts highly stylized studio shots to run as lead artwork for feature stories. "Since we don't have a big art budget, freelancers usually submit spin-off projects from their larger photo assignments."

AMERICAN FORESTS MAGAZINE, Dept. PM, 910 17th St., Suite 600, Washington DC 20006. (202)955-4500, ext 203. Fax: (202)887-1075. E-mail: mrobbins@amfor.org. Website: http://www.amfor.org. Editor: Michelle Robbins. Circ. 25,000. Estab. 1895. Publication of American Forests. Quarterly. Emphasizes use, enjoyment and management of forests and other natural resources. Readers are "people from all walks of life, from rural to urban settings, whose main common denominator is an abiding love for trees, forests or forestry." Sample copy and free photo guidelines with magazine-sized envelope and 7 first-class stamps.
Needs: Uses about 40 photos/issue, 80% supplied by freelance photographers (most supplied by article

authors). Needs woods scenics, wildlife, woods use/management and urban forestry shots. Model release preferred. Captions required; include who, what, where, when and why.

Making Contact & Terms: Query with résumé of credits. Accepts images in digital format for Mac (TIFF or EPS; use Photoshop). Send via compact disc, SyQuest, zip (300 dpi) or call for information. "We regularly review portfolios from photographers to look for potential images for upcoming magazines or to find new photographers to work with." SASE. Reports in 2 months. $300/color cover photo; $50-75/b&w inside; $75-150/color inside; $250-800 for text/photo package. **Pays on acceptance.** Credit line given. Buys one-time rights.

Tips: Seeing trend away from "static woods scenics, toward more people and action shots." In samples wants to see "overall sharpness, unusual conformation, shots that accurately portray the highlights and 'outsideness' of outdoor scenes."

THE AMERICAN GARDENER, A Publication of the American Horticultural Society, 7931 E. Boulevard Dr., Alexandria VA 22308. (703)768-5700. Fax: (703)768-7533. E-mail: editor@ahs.org. Website: http://www.ahs.org. Managing Editor: Mary Yee. Circ. 26,000. Estab. 1923. Bi-monthly magazine. Sample copy $3. Photo guidelines free with SAE and first-class postage.

Needs: Uses 35-50 photos/issue. Needs photos of plants, gardens, landscapes. Reviews photos with or without ms. Photo captions required; include complete botanical names of plants including genus, species and botanical variety or cultivar.

Making Contact & Terms: Send query letter with samples, stock photo list. Art director will contact photographer for portfolio review if interested. Uses color negatives only, 35mm, 4×5 transparencies. Does not keep samples on file. Will return unsolicited material with SASE. Pays $100 maximum for color cover; $50-65 for color inside. Pays on publication. Credit line given. Buys one-time rights.

Tips: "Lists of plant species for which photographs are needed are sent out to a selected list of photographers approximately 10 weeks before publication. We currently have about 20 photographers on that list. Most of them have photo libraries representing thousands of species. Before adding photographers to our list, we need to determine both the quality and quantity of their collections. Therefore, we ask all photographers to submit both some samples of their slides (these will be returned immediately if sent with a self-addressed, stamped envelope) and a list indicating the types and number of plants in their collection. After reviewing both, we may decide to add the photographer to our photo call for a trial period of six issues (one year)."

AMERICAN HUNTER, 11250 Waples Mill Rd., Fairfax VA 22030-9400. (703)267-1300. Editor: John Zent. Circ. 1.4 million. Publication of the National Rifle Association. Monthly magazine. Sample copy and photo guidelines free with 9×12 SAE. Free writer's guidelines with SASE.

Needs: Uses wildlife shots and hunting action scenes. Photos purchased with or without accompanying ms. Seeks general hunting stories on North American game. Captions preferred.

Making Contact & Terms: Send material by mail for consideration. Uses 8×10 glossy b&w prints and 35mm color transparencies. (Uses 35mm transparencies for cover). Vertical format required for cover. SASE. Reports in 1 month. Pays $25/b&w print; $75-275/transparency; $300/color cover; $200-500 for text/photo package. Pays on publication for photos. Credit line given. Buys one-time rights.

AMERICAN MOTORCYCLIST, Dept. PM, 33 Collegeview Rd., Westerville OH 43081-6114. (614)891-2425. Vice President of Communication: Greg Harrison. Managing Editor: Bill Wood. Circ. 183,000. Publication of the American Motorcyclist Association. Monthly magazine. For "enthusiastic motorcyclists, investing considerable time in road riding or competition sides of the sport. We are interested in people involved in, and events dealing with, all aspects of motorcycling." Sample copy and photo guidelines for $1.50.

Needs: Buys 10-20 photos/issue. Subjects include: travel, technical, sports, humorous, photo essay/feature and celebrity/personality. Captions preferred.

Making Contact & Terms: Query with samples to be kept on file for possible future assignments. Reports in 3 weeks. SASE. Send 5×7 or 8×10 semigloss prints; transparencies. Pays $30-100/photo; $50-100/slide; $250 minimum/cover. Also buys photos in photo/text packages according to same rate; pays $7/column inch minimum for story. Pays on publication. Buys first North American serial rights.

Tips: Uses transparencies for covers. "The cover shot is tied in with the main story or theme of that issue and generally needs to be with accompanying manuscript. Show us experience in motorcycling photography and suggest your ability to meet our editorial needs and complement our philosophy."

AMERICAN SKATING WORLD, 1816 Brownsville Rd., Pittsburgh PA 15210-3908. (800)245-6280. Fax: (412)885-7617. Managing Editor: H. Kermit Jackson. Circ. 15,000. Estab. 1981. Monthly tabloid. Emphasizes ice skating—figure skating primarily, speed skating secondary. Readers are figure skating

participants and fans of all ages. Sample copy $3.25 with 8 × 12 SAE and 3 first-class stamps. Photo guidelines free with SASE.

Needs: Uses 20-25 photos/issue; 4 supplied by freelancers. Needs performance and candid shots of skaters and "industry heavyweights." Reviews photos with or without manuscript. Model/property release preferred for children and recreational skaters. Captions required; include name, locale, date and move being executed (if relevant).

Making Contact & Terms: Query with résumé of credits. Keeps samples on file. SASE. Report on unsolicited submissions could take 3 months. Pays $25/color cover; $5/b&w inside. Pays 30 days after publication. Buys one-time rights color; all rights b&w; negotiable. Simultaneous submissions and/or previously published work OK.

Tips: "Pay attention to what's new, the newly emerging competitors, the newly developed events. In general, be flexible!" Photographers should capture proper lighting in performances and freeze the action instead of snapping a pose.

N AMERICAN SOCIETY FOR THE PREVENTION OF CRUELTY TO ANIMALS (ASPCA), 424 E. 92nd St., New York NY 10128. (212)876-7700, ext. 4449. Fax: (212)410-0087. Website: http://www.aspca.org. Contact: Photo Editor. Estab. 1866. Photos used in quarterly and bi-monthly color magazines, pamphlets, booklets. Publishes *ASPCA Animal Watch Magazine* and *ASPCA Animaland Magazine* (for kids 7-12).

Needs: Photos of animals (domestic and wildlife): farm, domestic, lab, stray and homeless animals, endangered, trapped, injured, fur animals, marine and wildlife, rain forest animals. Model/property release preferred.

Making Contact & Terms: Please send a detailed, alphabetized stock list that can be kept on file for future reference. SASE. Reports when needed. Pays $75/b&w photo (inside use); $75/color photo (inside use); $300/cover. Prefers color. Credit line given. Buys one-time rights; negotiable.

Tips: "We prefer exciting pictures: strong colors, interesting angles, unusual light."

AMERICAN SURVIVAL GUIDE, % Visionary, L.P., 265 S. Anita Dr., Suite 120, Orange CA 92868-3310. (714)939-9991 ext. 204 or 203. Fax: (714)939-9909. Editor: Jim Benson. Circ. 60,000. Estab. 1980. Monthly magazine. Emphasizes firearms, military gear, emergency preparedness, survival food storage and self-defense products. Average reader is male, mid-40s, all occupations and with conservative views. Sample copy $6. Photo guidelines free with SASE.

Needs: Uses more than 100 photos/issue; 35-45% supplied by freelance photographers. Photos purchased with accompanying manuscript only. Occasionally buys photos only (e.g., earthquake disaster photos, etc.). Model release required. Captions required.

Making Contact & Terms: Send written query detailing article and photos. Note: Will not accept text without photos or other illustrations. Pays $80/color photo and b&w page rate. Pays on publication. Credit line given. Buys all rights; negotiable.

Tips: Wants to see "professional looking photographs—in focus, correct exposure, good lighting, interesting subject and people in action. Dramatic poses of people helping each other after a disaster, riots or worn torn area. Wilderness survival too. Look at sample copies to get an idea of what we feature. We only accept photos with an accompanying manuscript (floppy disk with WordPerfect or Microsoft Word files). The better the photos, the better chance you have of being published."

N AMERICA'S CUTTER, Go Go Communications, Inc., 201 W. Moore, Suite 200, Terrell TX 75160. (972)563-7001. Fax: (972)563-7004. E-mail: acutterl@airmail.net. Website: http://www.americascutter.com. Publisher/Editor: Carroll Brown Arnold. Circ. 5,500. Estab. 1995. Monthly equestrian consumer magazine. *America's Cutter* gives global coverage to the entire cutting horse industry. Sample copy for $2.95.

Needs: Buys 2-5 photos from freelancers/issue. Needs photos of cutting horse enthusiasts, owners, trainers, riders and lots of action shots. Reviews photos with or without ms. Model release preferred; property release preferred. Photo captions preferred.

Making Contact & Terms: Send query letter with samples, brochure, stock photo list, tearsheets. Uses 35mm, 2¼ × 2¼, 4 × 5, 8 × 10 transparencies. Keeps samples on file. Reports in 2-3 weeks on queries; 2-

MARKET CONDITIONS are constantly changing! If you're still using this book and it's 2000 or later, buy the newest edition of *Photographer's Market* at your favorite bookstore or order directly from Writer's Digest Books.

3 weeks on samples. Pays $5-50 for color cover; $5-25 for b&w and color inside. Pays on publication. Credit line given. Buys one-time rights, electronic rights.

Tips: "You must know our industry."

ANCHOR NEWS, 75 Maritime Dr., Manitowoc WI 54220. (920)684-0218. Fax: (920)684-0219. Editor: Jay Martin. Circ. 1,900. Publication of the Wisconsin Maritime Museum. Quarterly magazine. Emphasizes Great Lakes maritime history. Readers include learned and lay readers interested in Great Lakes history. Sample copy free with 9×12 SAE and $1 postage. Guidelines free with SASE.

Needs: Uses 8-10 photos/issue; infrequently supplied by freelance photographers. Needs historic/nostalgic, personal experience and general interest articles on Great Lakes maritime topics. How-to and technical pieces and model ships and shipbuilding are OK. Special needs include historic photography or photos that show current historic trends of the Great Lakes. Photos of waterfront development, bulk carriers, sailors, recreational boating, etc. Model release required. Captions required.

Making Contact & Terms: Query with samples. Send 4×5 or 8×10 glossy b&w prints by mail for consideration. SASE. Reports in 1 month. Pays in copies only on publication. Credit line given. Buys first North American serial rights. Simultaneous submissions and previously published work OK.

Tips: "Besides historic photographs, I see a growing interest in underwater archaeology, especially on the Great Lakes, and underwater exploration—also on the Great Lakes. Sharp, clear photographs are a must. Our publication deals with a wide variety of subjects; however, we take a historical slant with our publication. Therefore photos should be related to a historical topic in some respect. Also current trends in Great Lakes shipping. A query is most helpful. This will let the photographer know exactly what we are looking for and will help save a lot of time and wasted effort."

N ⊕ ANIMAL ACTION/ANIMAL LIFE, RSPCA Photolibrary, RSPCA, Causeway, Horsham, W. Sussex RH12 1HG England. Phone: (1403)223150. Fax: (1403)241048. E-mail: photolibrary@rspca.org.uk. Website: http://www.rspca.org.uk. Photolibrary Manager: Andrew Forsyth. Circ. 70,000. Estab. 1830. Monthly animal welfare campaign magazine. Sample copy free. Art guidelines free.

Needs: Buys 300 photos/year. Needs photos of domestic and wild animals. Reviews photos with or without ms. Special photo needs include African mammals, polar and underwater wildlife. Model release preferred for people with domestic animals. Photo caption required; include Latin names (where appropriate).

Making Contact & Terms: Send query letter with samples. Art director will contact photographer for portfolio review if interested. Portfolio should include transparencies. Uses 35mm, 2¼×2¼, 4×5, 8×10 transparencies. Accepts images in digital format. Keeps samples on file; include SASE for return of material. Reports in 1 month on queries. Pays extra for electronic usage of photos. Pays after quarterly sales report. Credit line given. Buys one-time rights; negotiable. Simultaneous submissions and/or previously published work OK.

Tips: "Our information pack gives details. We have our own agency to sell and buy photography, so photographers must be willing to allow us to represent their work. Caption clearly and edit more strictly. Quality threshold is ever increasing."

ANIMALS, 350 S. Huntington Ave., Boston MA 02130. (617)522-7400. Fax: (617)522-4885. Photo Editor: Detrich Gehring. Publication of the Massachusetts Society for the Prevention of Cruelty to Animals and the American Humane Education Society. Circ. 100,000. Estab. 1868. Bimonthly. Emphasizes animals, both wild and domestic. Readers are people interested in animals, conservation, animal welfare issues, pet care and wildlife. Sample copy $2.95 with 9×12 SASE. Photo guidelines free with SASE.

Needs: Uses about 45 photos/issue; approximately 95% supplied by freelance photographers. "All of our pictures portray animals, usually in their natural settings, however some in specific situations such as pets being treated by veterinarians or wildlife in captive breeding programs." Needs vary according to editorial coverage. Special needs include clear, crisp shots of animals, wild and domestic, both close-up and distance shots with spectacular backgrounds, or in the case of domestic animals, a comfortable home or backyard. Model release required in some cases. Captions preferred; include species, location.

Making Contact & Terms: Query with résumé of credits and list of stock photo subjects. Provide résumé, business card, brochure, flier or tearsheets to be kept on file for possible future assignments. SASE. Reports in 6 weeks. Fees are usually negotiable; pays $50-150/b&w photo; $75-300/color photo; payment depends on size and placement. Pays on publication. Credit line given. Buys one-time rights.

Tips: Photos should be sent to Detrich Gehring, photo editor. Gehring does first screening. "Offer original ideas combined with extremely high-quality technical ability. Suggest article ideas to accompany your photos, but only propose yourself as author if you are qualified. We have a never-ending need for sharp, high-quality portraits of mixed-breed dogs and cats for both inside and cover use. Keep in mind we seldom use domestic cats outdoors; we often need indoor cat shots."

APPALACHIAN TRAILWAY NEWS, Box 807, Harpers Ferry WV 25425. (304)535-6331. Fax: (304)535-2667. Editor: Judith Jenner. Circ. 26,000. Estab. 1939. Publication of the Appalachian Trail Conference. Bimonthly. Emphasizes the Appalachian Trail. Readers are conservationists, hikers. Sample copy $3 (includes postage and guidelines). Guidelines free with SASE.
Needs: Uses about 20-30 b&w and color photos/issue; 4-5 supplied by freelance photographers (plus 13 color slides each year for calendar). Needs scenes from the Appalachian Trail, specifically of people using or maintaining the trail. Special needs include candids—people/wildlife/trail scenes. Photo information required.
Making Contact & Terms: Query with ideas. Send 5×7 or larger glossy b&w prints; b&w contact sheet; or 35mm transparencies or prints by mail for consideration. Duplicate slides preferred over originals (for query). SASE. Reports in 3 weeks. **Pays on acceptance.** Pays $150/cover; $200 minimum/color slide calendar photo; $10-50/inside. Credit line given. Rights negotiable. Simultaneous submissions and/or previously published work OK.

APPALOOSA JOURNAL, P.O. Box 8403, Moscow ID 83843. (208)882-5578. Fax: (208)882-8150. Editor: Robin Hirzel. Circ. 30,000. Estab. 1946. Association publication of Appaloosa Horse Club. Monthly magazine. Emphasizes Appaloosa horses. Readers are Appaloosa owners, breeders and trainers, child through adult. Sample copy $5. Photo guidelines free with SASE.
Needs: Uses 30 photos/issue; 10% supplied by freelance photographers. Needs photos (color and b&w) to accompany features and articles. Special photo needs include photographs of Appaloosas (high quality horses) in winter scenes. Model release required. Captions required.
Making Contact & Terms: Send unsolicited 8 × 10 b&w and color prints or 35mm and 2¼ × 2¼ transparencies by mail for consideration. Reports in 3 weeks. Pays $100-300/color cover; $25-50/color inside; $25-50/b&w inside. **Pays on acceptance.** Credit line given. Buys first North American serial rights. Previously published work OK.
Tips: In photographer's samples, wants to see "high-quality color photos of world class, characteristic Appaloosa horses with people in appropriate outdoor environment. We often need a freelancer to illustrate a manuscript we have purchased. We need specific photos and usually very quickly."

⒩ ⒮ ARUBA NIGHTS, (The Island's premiere lifestyle & travel magazine), 1831 René Levesque Blvd. W., Montreal, Quebec H3H 1R4 Canada. (514)931-1987. Fax: (514)931-6273. E-mail: nights@odyssee.net. Office Co-ordinator: Zelly Zuskin. Circ. 225,000. Estab. 1988. Yearly tourist guide of where to eat, sleep, dance etc. in Aruba.
Needs: Buys 30 photos from freelancers/year. Needs travel photos of Aruba—beaches, water, sun, etc. Reviews photos with or without ms. Model release required; property release required for private homes. Photo caption required; include exact location.
Making Contact & Terms: Send query letter with tearsheets. Art director will contact photographer for portfolio review if interested. Uses 4×5 matte color and b&w prints; 35mm, 2¼×2¼, 4×5, 8×10 transparencies. Keeps samples on file. Reports back only if interested, send non-returnable samples. Pays $250-400 for color cover; $50 maximum for color inside. **Pays on acceptance**. Credit line given. Buys one-time rights. Simultaneous submissions and previously published work OK.

ASPIRE, CCM Communications, 107 Kenner Ave., Nashville TN 37205. (615)386-3011. (615)386-3380. Design & Production Director: Brian Smith. Circ. 50,000. Estab. 1991. Bimonthly magazine. Emphasizes Christian lifestyle and health. Readers are female Christians, ages 30-45.
Needs: Uses 20 photos/issue; 5-8 supplied by freelancers. Needs photos of editorial concepts. Model release required. Property release preferred. Captions preferred.
Making Contact & Terms: Send résumé, business card, brochure, flier or tearsheets to be kept on file for possible assignments. Keeps samples on file. Pays $50-100/hour; $500-800/day; $50-500/job; $250-750/color cover; $50-300/b&w cover; $200-500/color inside; $50-200/b&w inside. **Pays on acceptance**. Credit line given. Buys first North American serial rights; negotiable. Simultaneous submissions and/or previously published work OK.

ASTRONOMY, 21027 Crossroads Circle, Waukesha WI 53187. (414)796-8776. Fax: (414)796-1142. Photo Editor: David J. Eicher. Circ. 175,000. Estab. 1973. Monthly magazine. Emphasizes astronomy, science and hobby. Median reader: 40 years old, 85% male, income approximately $68,000/yr. Sample copy $3. Photo guidelines free with SASE.
Needs: Uses approximately 100 photos/issue; 70% supplied by freelancers. Needs photos of astronomical images. Model/property release preferred. Captions required.
Making Contact & Terms: Send unsolicited photos by mail for consideration. Send 8×10 glossy color and b&w photos; 35mm, 2¼×2¼, 4×5, 8×10 transparencies. Keeps samples on file. SASE. Reports in

2 weeks. Pays $150/cover; $25 for routine uses. Pays on publication. Credit line given.

N: AT-HOME MOTHER, 406 E. Buchanan, Fairfield IA 52556. (515)472-3202. Fax: (515)469-3068. E-mail: ahmrc@lisco.com. Editor-in-Chief: Jeanette Lisefski. Circ. 20,000. Estab. 1997. Quarterly consumer magazine for the support and education of at-home mothers and those who would like to be. Sample copy for $4.
Needs: Buys up to 5 photos from freelancers/issue; up to 20 photos/year. Needs photos of mothers with children—mostly at home (inside) or mothers working in home office with children. Special photo needs include cover shots and interiors to go with editorial spreads. Model release required; property release required.
Making Contact & Terms: To show portfolio, photographer should follow-up with call and/or letter after initial query. Uses 4×5, 8×10 transparencies. Prefer images in digital format. Quarterly deadlines: February 1, May 1, August 1, November 1. Keeps samples on file. Reports in 1 month on queries; 1 month on samples. Pays $100-400 for color cover; $10-50 for b&w inside; $10-100 for color inside. Pays on publication. Credit line given. Buys one-time rights. Simultaneous submissions and previously published work OK.
Tips: "We like colorful work showing happy interaction between mother and child(ren). We need pictures of mother working in a home office with child, also in the picture, playing or interacting with mother. We do not like trendy, 'spikey' or chaotic photos."

ATLANTA HOMES & LIFESTYLES, 1100 Johnson Ferry Rd. NE, Suite 595, Atlanta GA 30342. (404)252-6670. Fax: (404)252-6673. Editor: Barbara Tapp. Circ. 38,000. Estab. 1983. Magazine published 10 times/year. Covers residential design (home and garden); food, wine and entertaining; people, travel and lifestyle subjects. Sample copy $2.95.
Needs: Needs photos of homes (interior/exterior), people, travel, decorating ideas, products, gardens. Model/property release required. Captions preferred.
Making Contact & Terms: Submit portfolio for review. Send unsolicited photos by mail for consideration. Provide résumé, business card, brochure, flier or tearsheets to be kept on file for possible assignments. Send 35mm, 2¼×2¼ transparencies. SASE. Reports in 2 months. Pays $50-650/job. Pays on publication. Credit line given. Buys one-time rights. Simultaneous submissions and/or previously published work OK.

ATLANTA PARENT, 4330 Georgetown Square II, Suite 506, Atlanta GA 30338. (770)454-7599. Fax: (770)454-7699. Assistant to Publisher: Peggy Middendorf. Circ. 75,000. Estab. 1983. Monthly magazine. Emphasizes parents, families, children, babies. Readers are parents with children ages 0-16. Sample copy $3.
Needs: Uses 4-8 photos/issue; all supplied by freelancers. Needs photos of babies, children in various activities, parents with kids. Model/property release required. Captions preferred.
Making Contact & Terms: Query with stock photos or photocopies of photos. Send unsolicited photos by mail for consideration. Send 3×5 or 4×6 b&w prints. Keeps samples on file. SASE. Reports in 3 months. Pays $20-75/color photo; $20/b&w photo. Pays on publication. Credit line given. Buys one-time rights; negotiable. Simultaneous and/or previously published work OK.

AUDUBON MAGAZINE, 700 Broadway, New York NY 10003. (212)979-3000. Fax: (212)353-0398. Photo Editor: Jill Hilycord. Bimonthly magazine. Circ. 475,000. Emphasizes wildlife. Sample copy $4. First-class $5.
Needs: Photo essays of nature subjects, especially wildlife, showing animal behavior, unusual portraits with good lighting and artistic composition. Nature photos should be artistic and dramatic, not the calendar or postcard scenic. Uses color covers only; horizontal wraparound format requires subject off-center. Also uses journalistic and human interest photos.
Making Contact & Terms: Important: Query first before sending material; include tearsheets or list previously published credits. SASE. "We are not responsible for unsolicited material."

AUTO SOUND & SECURITY, 774 S. Placentia Ave., Placentia CA 92870. (714)572-6887. Fax: (714)572-4265. Editor: Clark Emery. Estab. 1990. Monthly magazine. Emphasizes automotive aftermarket electronics. Readers are largely male students, ages 16-26. Sample copy free with SASE.
Needs: Uses 100 photos/issue; less than half supplied by freelancers. Needs photos of custom installations of aftermarket autosound systems and sub-systems. Model/property release required for vehicle owners and models (full features only).
Making Contact & Terms: Provide résumé, business card, brochure, flier or tearsheets to be kept on file for possible assignments. Deadlines: three months prior to cover date. Keeps samples on file. SASE.

Reports in 2 weeks. Pays $300-500/job; $100 and up/color page rate. Pays on publication. Credit line given. Rights negotiable.

AUTOMOTIVE SERVICE ASSOCIATION (ASA), 1901 Airport Freeway, Bedford TX 76021. (817)283-6205. Fax: (817)685-0225. E-mail: asainfo@asashop.org. Website: http://www.asashop.org. Vice President of Communication:. Circ. 15,000. Estab. 1952. Publication of Automotive Service Association. Monthly magazine. Emphasizes automotive articles pertinent to members, legislative concerns, computer technology related to auto repair. Readers are male and female, ages 25-60, automotive repair owners, aftermarket. Free sample copy; additional copies $3.
Needs: Uses 20 photos/issue; 50% supplied by freelancers. Needs cover photos, technology photos and photos pertaining to specific articles. Special cover photo needs include late model 1960s automobiles. Model/property release required. Captions required.
Making Contact & Terms: Submit portfolio for review. Send unsolicited photos by mail for consideration. Send 4×5 medium format transparencies. Accepts images in digital format for Mac. Send via SyQuest. Deadline: 30-40 days prior to publication. Keeps samples on file. SASE. Reports in 3 weeks. Payment negotiable. Pays on publication. Buys all rights; negotiable. Previously published work OK.

AWARE COMMUNICATIONS INC., 305 SW 140th Terrace, Newberry FL 32669. (352)332-9600. Fax: (352)332-9696. Vice President-Creative: Scott Stephens. Publishes quarterly and annual magazines and poster. Emphasizes education—medical, pre-natal, sports safety and job safety. Readers are high school males and females, medical personnel, women, home owners.
● This company produces numerous consumer publications: *Student Aware*, *Technology Education*, *Sports Safety*, *Medaware*, *Perfect Prom* and *Insect Protect!*.
Needs: Uses 20-30 photos/issue; 10% supplied by freelancers. Needs photos of medical subjects, teenage sports and fitness, pregnancy and lifestyle (of pregnant mothers). Model/property release required.
Making Contact & Terms: Submit portfolio for review. Send unsolicited photos by mail for consideration. Send 35mm, 2¼×2¼, 4×5, 8×10 transparencies. Accepts images in digital format for Windows. Send via compact disc, floppy disk or SyQuest. Keeps samples on file. SASE. Reports only when interested. Pays $400/color cover; $100/color inside; $200-1,000/complete job. Pays on publication. Credit line given. Buys one time rights; negotiable. Simultaneous submissions and/or previously published work OK. Offers internships for photographers year round. Contact Creative Vice President: Scott Stephens.
Tips: Looks for quality of composition and color sharpness. "Photograph people in all lifestyle situations."

▓N▓ BABYFACE, The Score Group, 4931 S.W. 75th Ave., Miami FL 33155. (305)662-5959. Fax: (305)662-5952. E-mail: gablel@scoregroup.com. Contact: Lisa Gable. Monthly men's magazine featuring models between ages 18-21. Sample copy for $7. Art guidelines available.
Needs: Model release required as well as copies of 2 forms of I.D. from the model, one of them being a photo I.D.
Making Contact & Terms: Portfolio should include color transparencies. Uses 35mm transparencies; kodachrome film or larger format transparencies. Include SASE for return of material. Reports in 1 month maximum on queries. Pays $1,250-1,800 for color sets of 100-200 transparencies for inside. "Please do not send individual photos except for test shots." Pays on publication. Buys first rights in North America with a reprint option, electronic rights and non-exclusive worldwide publishing rights.

BACK HOME IN KENTUCKY, P.O. Box 681629, Franklin TN 37068-1629. (615)794-4338. Fax: (615)790-6188. Editor: Nanci Gregg. Circ. 13,000. Estab. 1977. Bimonthly magazine. Emphasizes subjects in the state of Kentucky. Readers are interested in the heritage and future of Kentucky. Sample copy $3.50 with 9×12 SAE and 5 first-class stamps.
● This publication performs its own photo scans and has stored some images on Photo CD. They have done minor photo manipulation of photos for advertisers.
Needs: Uses 25 photos/issue; all supplied by freelance photographers, less than 10% on assignment. Needs photos of scenic, specific places, events, people. Reviews photos solo or with accompanying ms. Also seeking vertical cover (color) photos. Special needs include winter, fall, spring and summer in Kentucky; Christmas; the Kentucky Derby sights and sounds; horses—send us good shots of horses at work and play. Model release required. Captions required.
Making Contact & Terms: Send any size color prints or 35mm transparencies by mail for consideration. Accepts images in digital format for Mac (TIFF or EPS). Send via compact disc, floppy disk, SyQuest 88 or Zip disk (133 line screen or better). Reports in 2 weeks. Pays $20-50/color photo; $50 minimum/cover; $15-100/text/photo package. Pays on publication. Credit line given. Usually buys one-time rights; also all rights; negotiable. Simultaneous submissions and previously published work OK.
Tips: "We look for someone who can capture the flavor of Kentucky—history, events, people, homes,

© Holli Alewine

"We are always looking for outstanding images by amateur photographers who capture the scenic beauty of the state in all seasons," says Nanci Gregg of *Back Home in Kentucky* magazine. Photographer and horse breeder Holli Alewine submitted this image and Gregg chose it for the magazine's "Parting Shots" department, a final image that closes each issue. "It simply was a good expression of the solitary peace to be found in a Kentucky field in a winter snowstorm," Gregg says. The image was later published in a horse magazine devoted to the Tennessee Walking Horse, the breed of Alewine's animals.

etc. Have a great story to go with the photo—by self or another."

BACKPACKER MAGAZINE, 135 N. Sixth St., Emmaus PA 18098. (610)967-8371. E-mail: dbstauffer@aol.com. Website: http://www.bpbasecamp.com. Photo Editor: Deborah Burnett Stauffer. Magazine published 9 times annually. Readers are male and female, ages 35-45. Photo guidelines free with SASE.
Needs: Uses 40 photos/issue; almost all supplied by freelancers. Needs transparencies of wildlife, scenics, people backpacking, camping. Reviews photos with or without ms. Model/property release required.
Making Contact & Terms: Query with résumé of credits, photo list and example of work to be kept on file. Accepts images in digital format for Mac. Send via online, SyQuest or zip disk. SASE. Payment varies. Pays on publication. Credit line given. Rights negotiable. Sometimes considers simultaneous submissions and previously published work.

BALLOON LIFE, 2336 47th Ave. SW, Seattle WA 98116-2331. (206)935-3649. Fax: (206)935-3326. E-mail: tom@balloonlife.com. Website: http://www.balloonlife.com. Editor: Tom Hamilton. Circ. 4,000. Estab. 1986. Monthly magazine. Emphasizes sport ballooning. Readers are sport balloon enthusiasts. Sample copy free with 9×12 SAE and 6 first-class stamps. Photo guidelines free with #10 SASE.
 ● 95% of artwork is scanned digitally inhouse by this publication, then color corrected and cropped for placement.
Needs: Uses about 15-20 photos/issue; 90% supplied by freelance photographers on assignment. Needs how-to photos for technical articles, scenic for events. Model/property release preferred. Captions preferred.
Making Contact & Terms: Send b&w or color prints; 35mm transparencies by mail for consideration. "We are now scanning our own color and doing color separations in house. As such we prefer 35mm transparencies above all other photos." Accepts images in digital format for Mac (TIFF). Send via compact disc, online, floppy disk, SyQuest 44 or Zip disk (300 dpi). SASE. Reports in 1 month. Pays $50/color cover; $15-50/b&w or color inside. Pays on publication. Credit line given. Buys one-time and first North American serial rights. Simultaneous submissions and previously published work OK.
Tips: "Photographs, generally, should be accompanied by a story. Cover the basics first. Good exposure, sharp focus, color saturation, etc. Then get creative with framing and content. Often we look for one single photograph that tells readers all they need to know about a specific flight or event. We're evolving our coverage of balloon events into more than just 'pretty balloons in the sky.' I'm looking for photographers who can go the next step and capture the people, moments in time, unusual happenings, etc. that make an event unique. Query first with interest in sport, access to people and events, experience shooting balloons or other outdoor special events."

BALTIMORE, 1000 Lancaster St., Suite 400, Baltimore MD 21202. (410)752-4200. Fax: (410)625-0280. Associate Art Director: Philip Iglehart. Art Director: Tabatha Wilson. Director of Photography: David Colwell. Circ. 65,000. Estab. 1907. Monthly magazine for Baltimore region. Readers are educated Baltimore denizens, ages 35-60. Sample copy $2.95 with 9×12 SASE.
Needs: Uses 200 photos/issue; 30-50 supplied by freelancers. Needs photos of lifestyle, profile, news, food, etc. Special photo needs include photo essays about Baltimore. Model release required. Captions required; include name, age, neighborhood, reason/circumstances of photo.
Making Contact & Terms: Provide résumé, business card, brochure, flier or tearsheets to be kept on file for possible assignments. SASE. Call for photo essays. Reports in 1 month. Pays $100-350/day. Pays 30 days past invoice. Credit line given. Buys first North American serial rights; negotiable.

BASSIN', Dept. PM, 2448 E. 81st St., 5300 CityPlex Tower, Tulsa OK 74137-4207. (918)491-6100. Executive Editor: Mark Chesnut. Circ. 275,000 subscribers, 100,000 newsstand sales. Published 8 times/year. Emphasizes bass fishing. Readers are predominantly male, adult; nationwide circulation with heavier concentrations in South and Midwest. Sample copy $2.95. Photo guidelines free.
Needs: Uses about 50-75 photos/issue; "almost all of them" are supplied by freelance photographers. "We need both b&w and Kodachrome action shots of bass fishing; close-ups of fish with lures, tackle, etc., and scenics featuring lakes, streams and fishing activity." Captions required.
Making Contact & Terms: Query with samples. SASE. Reports in 6 weeks. Pays $400-500/color cover; $25/b&w inside; $75-200/color inside. Pays on publication. Credit line given. Buys first North American serial rights.
Tips: "Don't send lists—I can't pick a photo from a grocery list. In the past, we used only photos sent in with stories from freelance writers. However, we would like freelance photographers to participate."

BC OUTDOORS, 780 Beatty St., Suite 300, Vancouver, British Columbia V6B 2M1 Canada. (604)606-4644. Fax: (604)687-1925. Acting Editor: Roegan Lloydd. Circ. 42,000. Estab. 1945. Emphasizes fishing, both fresh water and salt; hunting; RV camping; wildlife and management issues. Published 8 times/year (January/February, March, April, May, June, July/August, September/October, November/December). Free sample copy with $2 postage (Canadian).
Needs: Uses about 30-35 photos/issue; 99% supplied by freelance photographers. "Fishing (in our territory) is a big need—people in the act of catching or releasing fish. Hunting, canoeing and camping. Family oriented. By far most photos accompany mss. We are always on lookout for good covers—fishing, wildlife, recreational activities, people in the outdoors—vertical and square format, primarily of British Columbia and Yukon. Photos with mss must, of course, illustrate the story. There should, as far as possible, be something happening. Photos generally dominate lead spread of each story. They are used in everything from double-page bleeds to thumbnails. Column needs basically supplied inhouse." Model/property release preferred. Captions or at least full identification required.
Making Contact & Terms: Send by mail for consideration actual 5×7 or 8×10 b&w prints; 35mm, 2¼×2¼, 4×5 or 8×10 color transparencies; color contact sheet. If color negative, send jumbo prints, then negatives only on request. Query with list of stock photo subjects. SASE or IRC. Reports in 1-2 weeks normally. Pays $20-75/b&w photo; $25-200/color photo; and $250/cover. Pays on publication. Credit line given. Buys one-time rights inside; with covers "we retain the right for subsequent promotional use." Simultaneous submissions not acceptable if competitor; previously published work OK.
Tips: "We see a trend toward more environmental/conservation issues."

BEAUTY HANDBOOK, 75 Holly Hill Lane, 3rd Floor, Greenwich CT 06830. Fax: (203)869-3971. Creative Director: Blair Howell. Circ. 1.1 million. Quarterly magazine. Emphasizes beauty, health, fitness, hair, cosmetics, nails. Readers are female, ages 25-45, interested in improving appearance. Sample copy free with 9×12 SAE and 4 first-class stamps.
● Also publishes *Black Beauty Handbook* and *Health Handbook*.
Needs: Uses 30-40 photos/issue; all supplied by freelancers. Needs photos of studio and natural-setting shots of attractive young women applying makeup, styling hair, etc.—similar in content to *Glamour* and *Mademoiselle*. Model/property release preferred. Offers internships for photographers. Contact Creative Director: Blair Howell.
Making Contact & Terms: Send unsolicited photos by mail for consideration. Query with stock photo list. Send color prints; 35mm, 2¼×2¼, 4×5. Keeps samples on file. SASE. Reports in 2 weeks. Photographers must be willing to work for tearsheets; moderate pay for completed assignments from publisher. Rights negotiable. Simultaneous submissions and previously published work OK.

THE BIBLE ADVOCATE, P.O. Box 33677, Denver CO 80233. (303)452-7973. Fax: (303)452-0657. E-mail: cofgsd@denver.net. Website: http://www.denver.net/~baonline. Editor: Calvin Burrell. Circ. 13,500. Estab. 1863. Publication of the Church of God (Seventh Day). Monthly magazine; 10 issues/year. Advocates the Bible and represents the Church of God. Sample copy free with 9×12 SAE and 4 first-class stamps.
● *The Bible Advocate* is using more and more CD-ROM art and fewer slides from photographers.
Needs: Needs scenics and some religious shots (Jerusalem, etc.). Captions preferred, include name, place.
Making Contact & Terms: Submit portfolio for review. SASE. Reports as needed. No payment offered.

THE INTERNATIONAL MARKETS INDEX, located in the back of this book, lists markets located outside the U.S. by country.

Rights negotiable. Simultaneous submissions and previously published work OK.

Tips: To break in, "be patient—right now we use material on an as-needed basis. We will look at all work, but please realize we don't pay for photos or cover art. Send samples and we'll review them. We are working several months in advance now. If we like a photographer's work, we schedule it for a particular issue so we don't hold it indefinitely."

[N] **BIG TEN ATHLETE**, 3101 Poplarwood Court, Suite 113, Raleigh NC 27604. (919)954-7500. Fax: (919)954-8600. Director of Photography: Bob Donnan. Circ. 100,000. Estab. 1997. Monthly sports magazines for fans of college sports. Sample copy for $5.

Needs: Buys 40 photos from freelancers/issue. Needs photos of sports action and personalities. Photo captions required.

Making Contact & Terms: Provide résumé, business card, self-promotion piece or tearsheets to be kept on file for possible future assignments. Art director will contact photographer for portfolio review if interested. Keeps samples on file. Reports back only if interested, send non-returnable samples. Pays $50-200 for b&w inside; $75-500 for color inside. **Pays on acceptance.** Credit line given. Buys one-time or electronic rights. Previously published work OK.

Tips: "We work with a broad range of photographers who have passion and insight into their sports. We look for dynamic sports action and strong personal pictures of coaches and athletes."

BIRD TIMES, (formerly Caged Bird Hobbyist), 7-L Dundas Circle, Greensboro NC 27407-1645. (336)292-4047. Fax: (336)292-4272. Executive Editor: Rita Davis. Managing Editor: Karen McCullough. Bimonthly magazine. Emphasizes primarily pet birds, plus some feature coverage of birds in nature. Sample copy $5 and 9×12 SASE. Photo guidelines free with SASE.

Needs: Needs photos of pet birds. Special needs arise with story schedule. Write for photo needs list. Common pet birds are always in demand (cockatiels, parakeets, etc.) Captions required; include common and scientific name of bird; additional description as needed. "Accuracy in labeling is essential."

Making Contact & Terms: Send unsolicited photos by mail for consideration but include SASE for return. "Please send duplicates." Transparencies or slides preferred. Glossy photographs acceptable. "We cannot assume liability for originals." Send 4×6, 8×10 glossy color prints; 35mm, 2¼×2¼ transparencies. Deadlines: 3 months prior to issue of publication. Keeps samples on file. SASE. Reports in 2 months. Pays $150-250/color cover; $25-50/color inside. Pays on publication. Buys all rights; negotiable.

Tips: "We are looking for pet birds primarily, but we frequently look for photos of some of the more exotic breeds, and we look for good composition (indoor or outdoor). Photos must be professional and of publication quality—in focus and with proper contrast. We work regularly with a few excellent freelancers, but are always on the lookout for new contributors. Pictures we think we might be able to use will be scanned into our CD-ROM file and the originals returned to the photographer."

BIRD WATCHER'S DIGEST, Dept. PM, Box 110, Marietta OH 45750. (740)373-5285. Editor/Photography and Art: Bill Thompson III. Circ. 99,000. Bimonthly. Emphasizes birds and bird watchers. Readers are bird watchers/birders (backyard and field, veterans and novices). Digest size. Sample copy $3.50.

Needs: Uses 25-35 photos/issue; all supplied by freelance photographers. Needs photos of North American species.

Making Contact & Terms: Query with list of stock photo subjects and samples. SASE. Reports in 2 months. Pays $50-up/color inside. Pays on publication. Credit line given. Buys one-time rights. Previously published work in other bird publications should not be submitted.

[N] [🌐] BIRD WATCHING MAGAZINE, Bretton Court, Bretton, Peterborough PE3 802 England. Phone: (01733)264666. Fax: (01733) 465939. E-mail: dave.cromack@ecm.emap.com. Circ. 21,000. Estab. 1986. Monthly hobby magazine for bird watchers. Sample copy free for SAE with first-class postage/IRC.

Needs: Needs photos of birds (mainly British). Reviews photos with or without ms. Photo caption preferred.

Making Contact & Terms: Provide résumé, business card, self-promotion piece or tearsheets to be kept on file for possible future assignments. Uses 35mm, 2¼×2¼ transparencies. Keeps samples on file. Returns unsolicited material if SASE enclosed. Reports in 1 month on queries; 1 month on samples. Pays £70 minimum for color cover; £20 minimum for color inside. Pays on publication. Buys one-time rights. Simultaneous submissions OK.

Tips: "All photos are held on file here in the office once they have been selected. They are returned when used or a request for there return is made. Make sure all slides are well labelled: bird, name, date, place taken, photographers name and address."

BIRDS & BLOOMS, 5400 S. 60th St., Greendale WI 53129. (414)423-0100. Fax: (414)423-8463. Photo Coordinator: Trudi Bellin. Estab. 1994. Bimonthly magazine. Celebrates "the beauty in your own backyard." Readers are male and female 30-50 (majority) who prefer to spend their spare time in their "outdoor living room." Heavy interest in "amateur" gardening, backyard bird-watching and bird feeding. Sample copy $2 with 9×12 SASE and 6 first-class stamps.

Needs: Uses 170 photos/issue; 20% supplied by freelancers. Needs photos of backyard flowers and birds. Special photo needs include vertical materials for cover use, must include humans or "human elements" (i.e., fence, birdhouse, birdbath). Also needs images for two-page spreads focusing on backyard birds or gardening. Model release required for private homes. Photo captions required; include season, location, common and/or scientific names.

Making Contact & Terms: Query with résumé of credits. Query with stock photo list. Send unsolicited photos by mail for consideration. Send color prints; 35mm, 2¼×2¼, 4×5, 8×10 transparencies. Keep samples on file (tearsheets; no dupes). SASE. Reports in 1-3 months for first review. Pays $300/color cover; $75-300/color inside; $150/color page rate; $100-200/photo/text package. Pays on publication. Credit line given. Buys one-time rights. Simultaneous submissions and previously pubilshed work OK.

Tips: "Technical quality is extremely important; focus must be sharp, no soft focus; colors must be vivid so they 'pop off the page.' Study our magazine thoroughly—we have a continuing need for sharp, colorful images, and those who can supply what we need can expect to be regular contributors."

[N] ⊕ BIZARRE, John Brown Publishing, The New Boathouse, 136-142 Bramley Rd., London W10 6SR England. Phone: 171 565 3000. Fax: 171 565 3056. E-mail: miket@johnbrown.co.uk. Website: http://www.bizarremag.com. Picture Editor: Mike Trow. Circ. 70,000. Estab. 1997. Monthly magazine. Sample copy free with SAE and first-class postage or IRC. Art guidelines free with SAE with first-class postage or IRC.

Needs: Needs photos of the bizarre or unusual of any subject. Reviews photos with or without ms. Model release preferred; property release preferred. Photo caption required.

Making Contact & Terms: Send query letter with samples, brochure, stock photo list, tearsheets. Keeps samples on file. Reports in 1 month on queries; 1 month on samples. All fees negotiable with individual photographers. Pays extra for electronic usage of photos. Pays on publication. Credit line given. Simultaneous submissions and/or previously published work OK.

Tips: "Read our magazine. It's unique. When submitting work think about whether your photos really are bizarre and submit some information about the pictures. The image is everything. As long as it is amazing or tells an amazing story the style/format doesn't matter."

BLACK CHILD MAGAZINE, Heritage Publishing Group, P.O. Box 12048, Atlanta GA 30355. (404)350-7877. Fax: (404)350-0819. Associate Publisher: Gabe Grosz. Circ. 25,500. Estab. 1995. Quarterly magazine. Emphasizes children of African-American heritage, with or without family, from birth to early teens. Also, transracial adoptees. Sample copies $2 with 9×12 SAE and 4 first-class stamps. Photo guidelines free with SASE.

• *Black Child* is published by Heritage Publishing Group, publisher of *Interrace* magazine also listed in this section.

Needs: Uses 15-20 photos/issue; 12-15 supplied by freelancers. Needs photos of children and their families. Must be of African-American heritage. Special photo needs include children playing, serious shots, schooling, athletes, arts, entertainment.

Making Contact & Terms: Send unsolicited photos by mail for consideration. Accepts images in digital format for Mac. Send via floppy disk (133 line per inch or 2400 dpi). Send 3×5, 4×6, 8×10 color or b&w prints. Keeps samples on file. SASE. Reports in 1 month or less. Pays $20/photo for less than ½ page; $28 for ½ page; $35 for full page; $50/cover. Also pays by the hour, $15-25; or by the roll. Call for details. Pays on publication. Credit line given. Buys one-time rights. Simultaneous submissions and/or previously published work OK.

Tips: "We're looking for kids in all types of settings and situations! Family settings are also needed (single parent, two-parent, grandparent, step-parent, foster or adopted parent)."

BLIND SPOT PHOTOGRAPHY MAGAZINE, 49 W. 23rd St., New York NY 10010. (212)633-1317. Fax: (212)691-5465. E-mail: photo@blindspot.com. Contact: Editors. Circ. 28,000. Estab. 1993. Semi-annual magazine. Emphasizes fine arts and contemporary photography. Readers are creative designers, curators, collectors, photographers, ad firms, publishers, students and media. Sample copy $14. Photo guidelines free with SASE.

• Although this publication does not pay, the image quality inside is superb. It is worth submitting here just to get the tearsheet from an attractive publication.

Needs: Uses 90 photos/issue; all supplied by freelancers. Needs unpublished photos from galleries and

museums. Captions required; include titles, dates of artwork.

Making Contact & Terms: Send unsolicited photos by mail for consideration. Submit portfolio for review. Send SASE with return postage. Send up to 16×20 color and b&w prints; 35mm, 2¼×2¼, 4×5, 8×10 transparencies. Limit submission to 25 pieces or fewer. Deadlines: For May issue—late March; for November issue—late September. Does not keep samples on file. SASE. Reports in 3 weeks. No payment available. Acquires one-time and electronic rights. Simultaneous submissions OK.

THE BLOOMSBURY REVIEW, Dept. PM, 1762 Emerson St., Denver CO 80218. (303)863-0406. Editor: Tom Auer. Art Director: Chuck McCoy. Circ. 50,000. Published 6 times a year. Emphasizes book reviews, articles and stories of interest to book readers. Sample copy $3.50.

Needs: Uses 2-3 photos/issue; all supplied by freelance photographers. Needs photos of people who are featured in articles. Photos purchased with or without accompanying ms. Model release preferred. Captions preferred.

Making Contact & Terms: Provide brochure, tearsheets and sample print to be kept on file for possible future assignments. SASE. Reports in 1 month. Payment negotiable. Payment by the job varies. Pays on publication. Credit line and one-line bio given. Buys one-time rights.

Tips: "Send good photocopies of work to Art Director."

BLUE RIDGE COUNTRY, P.O. Box 21535, Roanoke VA 24018. (540)989-6138. Editor: Kurt Rheinheimer. Circ. 75,000. Estab. 1988. Bimonthly magazine. Emphasizes outdoor scenics of Blue Ridge Mountain region. Photo guidelines free with SASE.

Needs: Uses up to 10-15 photos/issue; all supplied by freelance photographers. Needs photos of travel, scenics and wildlife. Seeking more scenics with people in them. Model release preferred. Captions required.

Making Contact & Terms: Query with list of stock photo subjects and samples. Uses 35mm, 2¼×2¼, 4×5 transparencies. SASE. Reports in 2 months. Pays $100/color cover; $25-100/color inside. Pays on publication. Credit line given. Buys one-time rights.

THE B'NAI B'RITH INTERNATIONAL JEWISH MONTHLY, 1640 Rhode Island Ave. NW, Washington DC 20036. (202)857-6645. Fax: (202)296-1092. E-mail: ijm@bnaibrith.org. Website: http://bnaibrith.org/ijm. Editor: Eric Rozenman. Readership: 200,000. Estab. 1886. Bimonthly magazine. Specializes in social, political, historical, religious, cultural and service articles relating chiefly to the Jewish Community of the US and abroad.

Needs: Buys 200 photos/year, stock and on assignment. Occasionally publishes photo essays.

Making Contact & Terms: Present samples and text (if available). SASE. Reports in 6 weeks. Pays up to $500/color cover; $300/color full-page; $100/b&w page. Pays on publicaiton. Buys first serial rights.

Tips: "Be familiar with our format and offer suggestions or experience relevant to our needs." Looks for "technical expertise, ability to tell a story within the frame."

BODY, MIND, SPIRIT MAGAZINE, P.O. Box 701, Providence RI 02901. (401)351-4320. Fax: (401)272-5767. Publisher: Jim Valliere. Associate Publisher: Jane Kuhn. Circ. 150,000. Estab. 1982. Bimonthly. Focuses on spirituality, meditation, alternative healing, and the body/mind connection. Targeted to all who are interested in personal transformation and growth. Sample copy free with 9×12 SAE.

Needs: Uses 10-15 photos/issue. Photographs for different areas of magazine which include; natural foods, holistic beauty and skin care, alternative healing, herbs, meditation, spirituality, and the media section which includes; reviews of books, audio tapes, videos and music. "Photos should show creativity, depth of feeling, positive energy, imagination and a light heart." Model release required. Captions required.

Making Contact & Terms: Query with samples/portfolio. Provide résumé, business card, brochure, price requirements if available, flier or tearsheets to be kept on file for possible future assignments. SASE. Reports in 3 months. Pays up to $150/b&w and up to $400/color. Pays on publication. Credit line given. Buys one-time rights. Previously published work OK.

[N] [⊡] BONAIRE NIGHTS, (The island's premiere lifestyle and travel magazine), 1831 René Levesque Blvd. W., Montreal, Quebec H3H 1R4 Canada. (514)931-1987. Fax: (514)931-6273. E-mail: nights@odyssee.net. Office Coordinator: Zelly Zuskin. Circ. 60,000. Estab. 1994. Yearly tourist guide to where to eat, sleep, dance etc. in Bonaire.

Needs: Buys 30 photos from freelancers/year. Needs travel photos of Bonaire with beaches, water, sun, etc. Reviews photos with or without ms. Model release required; property release required for private homes. Photo caption required, include exact location.

Making Contact & Terms: Send query letter with tearsheets. Art director will contact photographer for portfolio review if interested. Uses 4×5 matte color and b&w prints; 35mm, 2¼×2¼, 4×5, 8×10 transparencies. Keeps samples on file. Reports back only if interested, send non-returnable samples. Pays

$250-400 for color cover; $50 for color inside. **Pays on acceptance.** Credit line given. Buys one-time rights. Simultaneous submissions and/or previously published work OK.

BOWHUNTER, 6405 Flank Dr., Harrisburg PA 17112. (717)657-9555. Editor: Dwight Schuh. Editorial Director: Richard Cochran. Art Director: Mark Olszewski. Circ. 200,000. Estab. 1971. Published 9 times/year. Emphasizes bow and arrow hunting. Sample copy $2. Writer's guidelines free with SASE.
Needs: Buys 50-75 photos/year. Scenic (showing bowhunting) and wildlife (big and small game of North America). No cute animal shots or poses. "We want informative, entertaining bowhunting adventure, how-to and where-to-go articles." Photos purchased with or without accompanying ms.
Making Contact & Terms: Query with samples. SASE. Reports on queries in 2 weeks; on material in 6 weeks. Uses 5×7 or 8×10 glossy b&w and color prints, both vertical and horizontal format; 35mm and $2\frac{1}{4} \times 2\frac{1}{4}$ transparencies, vertical format; vertical format preferred for cover. Pays $50-125/b&w inside; $75-250/color inside; $300/cover, occasionally "more if photo warrants it." **Pays on acceptance.** Credit line given. Buys one-time publication rights.
Tips: "Know bowhunting and/or wildlife and study several copies of our magazine before submitting any material. We're looking for better quality and we're using more color on inside pages. Most purchased photos are of big game animals. Hunting scenes are second. In b&w we look for sharp, realistic light, good contrast. Color must be sharp; early or late light is best. We avoid anything that looks staged; we want natural settings, quality animals. Send only your best, and if at all possible let us hold those we indicate interest in. Very little is taken on assignment; most comes from our files or is part of the manuscript package. If your work is in our files it will probably be used."

BOWLING MAGAZINE, 5301 S. 76th St., Greendale WI 53129. (414)423-3232. Fax: (414)421-7977. Editor: Bill Vint. Circ. 150,000. Estab. 1934. Publication of the American Bowling Congress. Bimonthly magazine. Emphasizes ten-pin bowling. Readers are males, ages 30-55, in a cross section of occupations. Sample copy free with 9×12 SAE and 5 first-class stamps. Photo guidelines free with SASE.
Needs: Uses 30-40 photos/issue; 5-10 supplied by freelancers. Needs photos of outstanding bowlers or human interest features. Model release preferred. Captions required.
Making Contact & Terms: Provide résumé, business card, brochure, flier or tearsheets to be kept on file for possible assignments. Deadline discussed on case basis. SASE. Reports in 1-2 weeks. Pays $25-50/hour; $100-150/day; $50-150/job; $50-150/color cover; $25-50/color inside; $20-30/b&w inside; $150-300/photo/text package. **Pays on acceptance.** Credit line given. Buys all rights.

BOYS' LIFE, Boy Scouts of America Magazine Division, 1325 W. Walnut Hill Lane, Irving TX 75038. (972)580-2358. Fax: (972)580-2079. Contact: Photo Editor. Circ. 1.6 million. Estab. 1910. Monthly magazine. General interest youth publication. Readers are primarily boys, ages 8-18. Photo guidelines free with SASE.
• Boy Scouts of America Magazine Division also publishes *Scouting* and *Exploring* magazines.
Needs: Uses 50-80 photos/issue; 99% supplied by freelancers. Needs photos of all categories. Captions required.
Making Contact & Terms: Interested in all photographers, but do not send work. Query with list of credits. Pays $400 base editorial day rate against placement fees. Pays on acceptance. Buys one-time rights.
Tips: "Learn and read our publications before submitting anything."

N **BRACKET RACING USA**, McMillen Argus, 299 Market St., Saddlebrook NJ 07663. (201)712-9300. Fax: (201)712-9899. Website: http://www.cskpub.com. Drag racing magazine published 8 times/year.
Needs: Buys 70% of photos from freelancers. Needs photos of cars, people racing. Photo captions required.
Making Contact & Terms: Send query letter with samples. Uses color and b&w prints; 35mm transparencies. Does not keep samples on file. Pays $75 minimum for b&w cover; $75 minimum for color cover; $400 minimum for b&w inside; $600 for color inside. Pays on publication. Credit line given. Buys all rights.
Tips: "Read our magazine. Give me full captions."

BRAZZIL, P.O. Box 42536, Los Angeles CA 90050. (213)255-8062. Fax: (213)257-3487. E-mail: brazzil @brazzil.com. Website: http://www.brazzil.com. Editor: Rodney Mello. Circ. 12,000. Estab. 1989. Monthly magazine. Emphasizes Brazilian culture. Readers are male and female, ages 18-80, interested in Brazil. Photo guidelines free; "no SASE needed."
Needs: Uses 20 photos/issue; 12 supplied by freelancers. Needs photos of Brazilian scenes, people shots. Special photo needs include close up faces for cover. Model/property release preferred. Captions preferred; include subject identification.

Making Contact & Terms: Contact by phone. Send 8 × 10 glossy b&w prints. Accepts images in digital format for Windows (TIFF). Send via online, floppy disk, zip disk. Deadlines: the 10th of each month. Keeps samples on file. SASE. Reports in 1-2 weeks. Payment negotiable. Pays on publication. Credit line given. Buys one-time rights. Simultaneous submissions and/or previously published work OK.

■■ **BRIARPATCH**, 2138 McIntyre St., Regina, Saskatchewan S4P 2R7 Canada. (306)525-2949. Fax: (306)565-3430. Managing Editor: George Manz. Circ. 2,000. Estab. 1973. Magazine published 10 times per year. Emphasizes Canadian and international politics, labor, environment, women, peace. Readers are left-wing political activists. Sample copy $3.
Needs: Uses 15-30 photos/issue; 15-30 supplied by freelancers. Needs photos of Canadian and international politics, labor, environment, women, peace and personalities. Model/property release preferred. Captions preferred; include name of person(s) in photo, etc.
Making Contact & Terms: Query with stock photo list. Send unsolicited photos by mail for consideration. Do not send slides! Provide résumé, business card, brochure, flier or tearsheets to be kept on file for possible assignments. Send (minimum 3 × 5) color and b&w prints. Keeps samples on file. SASE. Reports in 1 month. "We cannot pay photographers for their work since we do not pay any of our contributors (writers, photo, illustrators). We rely on volunteer submissions. When we publish photos, etc., we send photographer 5 free copies of magazine." Credit line given. Buys one-time rights. Simultaneous submissions and previously published work OK.
Tips: "We keep photos on file and send free magazines when they are published."

Ñ: BRIDE AGAIN MAGAZINE, 1240 N. Jefferson, Suite G, Anaheim CA 92807. (714)632-7000. Fax: (714)632-5405. Website: http://www.brideagain.com. Circ. 125,000. Estab. 1998. Quarterly magazine designed specifically for brides getting married for a second (or more) time. The magazine covers issues such as etiquette, remarriage, blending families, unique honeymoon locations and beauty for the older, more mature bride.
Needs: Buys 10-20 photos from freelancers/issue; 40-80 photos/year. Reviews photos with or without ms. Model release required; property release required. Photo caption preferred.
Making Contact & Terms: Send query letter with brochure, stock photo list. Art director will contact photographer for portfolio review of b&w, color prints if interested. Keeps samples on file. Returns unsolicited material if SASE enclosed. Reports in 3 weeks on queries. Pays on publication. Credit line given. Simultaneous submissions and/or previously published work OK.
Tips: "Photos need to relate to a second-time bride: older, mature models, realistic, warm, friendly, welcoming and emotional. We want a photo that makes you connect, such as brides with children and images of families relating."

BRIDE'S, (formerly *Bride's & Your New Home*), 140 E. 45th St., New York NY 10017. (212)880-8530. Fax: (212)880-8331. Design Director: Phyllis Richmond Cox. Produced by Conde Nast Publications. Bimonthly magazine. Emphasizes bridal fashions, home furnishings, travel. Readers are mostly female, newly engaged; ages 21-35.
Needs: Needs photos of home furnishings, tabletop, lifestyle, fashion, travel. Model release required.
Making Contact & Terms: Submit portfolio for review. Provide résumé, business card, brochure, flier or tearsheets to be kept on file for possible assignments. Keeps samples on file. SASE. Reports in 3 weeks. Payment negotiable. Pays after job is complete. Credit line given. Buys one-time rights, all rights; negotiable.

BRITISH CAR, Dept. PM, P.O. Box 1683, Los Altos CA 94023-1683. (415)949-9680. Fax: (415)949-9685. Editor: Gary G. Anderson. Circ. 30,000. Estab. 1985. Bimonthly magazine. Publication for owners and enthusiasts of British motor cars. Readers are US citizens, male, 40 years old and owners of multiple cars. Sample copy $5. Photo guidelines free for SASE.
Needs: Uses 100 photos/issue; 50-75% (75% are b&w) supplied by freelancers. "Photos with accompanying manuscripts required. However, sharp uncluttered photos of different British marques may be submitted for file photos to be drawn on as needed." Photo captions required that include description of vehicles, owner's name and phone number, interesting facts, etc.
Making Contact & Terms: Send unsolicited photos by mail for consideration. Send 5 × 7 and larger b&w or color prints. Does not keep samples on file unless there is a good chance of publication. SASE. "Publisher takes all reasonable precautions with materials, however cannot be held liable for damaged or lost photos." Reports in 6-8 weeks. Pays $25-100/color inside; $10-35/b&w inside. Payment negotiable, however standard rates will be paid unless otherwise agreed in writing prior to publication." Pays on publication. Buys world rights; negotiable.
Tips: "Find a journalist to work in cooperation with."

BUGLE MAGAZINE, P.O. Box 8249, Missoula MT 59807-8249. (406)523-4573. Fax: (406)523-4550. Photo Coordinator: Mia McGreevey. Circ. 200,000. Estab. 1984. Publication of the Rocky Mountain Elk Foundation. Bi-monthly magazine. Nonprofit organization that specializes in elk, elk habitat and hunting. Readers are 98% hunters, both male and female; 54% are 35-54; 48% have income over $50,000. Sample copy $5. Photo guidelines free with SASE.
Needs: Uses 50 photos/issue; all supplied by freelancers. "*Bugle* editor sends out bi-monthly letter requesting specific images for upcoming issue." Model/property release required. Captions preferred; include name of photographer, location of photo, information on what is taking place.
Making Contact & Terms: Send unsolicited photos by mail for consideration. Send no more than 20 35mm, 2¼×2¼, 4×5 transparencies. Does not keep samples on file. SASE. Reports in 1-2 weeks. Pays $250/cover; $150/spread; $100/full-page; $50/half page. Pays on publication. Credit line given. Rights negotiable. Previously published work OK.
Tips: "We look for high quality, unusual, dramatic and stimulating images of elk and other wildlife. Photos of elk habitat and elk in unique habitat catch our attention, as well as those depicting specific elk behavior. We are also interested in habitat project photos involving trick tanks, elk capture and release, etc. And images showing the effects of human development on elk habitat. Outdoor recreation photos are also welcome. Besides *Bugle* we also use images for billboards, brochures and displays. We work with both amateur and professional photographers, with the bulk of our editorial material donated."

BUSINESS IN BROWARD, 1301 S. Andrews Ave., Ft. Lauderdale FL 33316. (954)763-3338. Publisher: Sherry Friedlander. Circ. 30,000. Estab. 1986. Magazine published 8 times/year. Emphasizes business. Readers are male and female executives, ages 30-65. Sample copy $4.
Needs: Uses 30-40 photos/issue; 75% supplied by freelancers. Needs photos of local sports, local people, ports, activities and festivals. Model/property release required. Photo captions required.
Making Contact & Terms: Contact through rep. Submit portfolio for review. Reports in 2 weeks. Pays $150/color cover; $75/color inside. Pays on publication. Buys one-time rights; negotiable. Previously published work OK.
Tips: "Know the area we service."

N BUSINESS 98, Success Strategies For Small Business, Group IV Communications, 125 Auburn Court, Suite 100, Thousand Oaks CA 91362. (805)496-6156. Fax: (805)496-5469. E-mail: gosmallbiz@aol.com. Website: http://www.yoursource.com. Photo Editor: Pam Froman. Circ. 430,000. Estab. 1994. Bi-monthly magazine. "We provide practical, how-to tips for small business owners." Sample copy for $4 and 9×12 SASE. Art guidelines free with #10 SASE.
Needs: Buys 20 photos from freelancers/issue; 120 photos/year. Needs photos of people in normal, everyday business situations . . . "but no boring shots of someone behind a desk or talking on the phone." Reviews photos with or without ms. Model release required for shots of small business owners, everyday people.
Making Contact & Terms: Send query letter with samples, tearsheets. Provide résumé, business card, self-promotion piece or tearsheets to be kept on file for possible future assignments. Art director will contact photographer for portfolio review of color tearsheets, slides, transparencies if interested. Uses 35mm 2¼×2¼, 4×5, 8×10 transparencies. Keeps samples on file. Reports back only if interested, send non-returnable samples. Pays $600-750 for color cover plus expenses; $400-500 for color inside plus expenses. Pays $100-150 for electronic usage of photos. **Pays on acceptance.** Credit line given. Buys first rights and non-exclusive reprint rights.
Tips: "We want to capture the excitement of running a small business. We do not want typical head shots. People posed on seamless backrounds are not our style. Deliver innovation and solve the shot with craft and creativity. Don't even think of sending film of a person on the phone, at a computer, or shaking hands. When submitting samples of your work give me natural shots of people that fit our simplistic, colorful style. Photos of fruit baskets won't let me determine if you do great work."

N CALIFORNIA JOURNAL, Statenet, 2101 K St., Sacramento CA 95816-4920. (916)444-2840. Fax: (916)444-2339. Website: http://www.statenet.com. Art Director: Dagmar Thompson. Circ. 15,000. Estab.

THE SUBJECT INDEX, located at the back of this book, lists publications, book publishers, galleries, gift and paper product companies and stock agencies according to the subject areas they seek.

1970. Monthly magazine covering independent analysis of government and politics in California—bipartisan news reporting. Sample copy free.

Needs: Buys 4-20 photos from freelancers/issue; 300 photos/year. Needs photos of politics, people, environmental issues, human needs, educational issues. Special photo needs include political year in California—campaign candids, political profiles. Photo caption preferred; include photographer credit.

Making Contact & Terms: Send query letter with samples, brochure. Provide résumé, business card, self-promotion piece or tearsheets to be kept on file for possible future assignments. If interested, art director will contact photographer for portfolio review of b&w, color slides, transparencies, Macintosh disks. Uses 17×11 maximum color and b&w prints; 35mm, 2¼×2¼, 4×5 transparencies. Keeps samples on file. Reports back only if interested, send non-returnable samples. Pays $300-600 for color cover; $100-400 for b&w inside. Pays on publication. Credit line given. Buys all rights; negotiable. Simultaneous submissions and/or previously published work OK.

Tips: "Interested only in California photography."

CALLIOPE, World History for Young People, Cobblestone Publishing, Inc., 30 Grove St., Peterborough NH 03458. (603)924-7209. Fax: (603)924-7380. Managing Editor: Denise L. Babcock. Circ. 10,500. Estab. 1990. Magazine published 9 times/year, September-May. Emphasis on non-United States history. Readers are children, ages 8-14. Sample copies $4.50 with 9×12 or larger SAE and 5 first-class stamps. Photo guidelines free with SASE.

Needs: Uses 40-45 photos/issue; 15% supplied by freelancers. Needs contemporary shots of historical locations, buildings, artifacts, historical reenactments and costumes. Reviews photos with or without accompanying ms. Model/property release preferred. Captions preferred.

Making Contact & Terms: Query with stock photo list. Send unsolicited photos by mail for consideration. Provide résumé, business card, brochure, flier or tearsheets to be kept on file for possible future assignments. Send b&w or color prints; 35mm transparencies. Samples kept on file. SASE. Reports in 1 month. Pays $15-100/inside; cover (color) photo negotiated. Pays on publication. Credit line given. Buys one-time rights; negotiable. Simultaneous submissions and/or previously published work OK.

Tips: "Given our young audience, we like to have pictures which include people, both young and old. Pictures must be dynamic to make history appealing. Submissions must relate to themes in each issue."

CALYPSO LOG, Box 112, 61 E. Eighth St., New York NY 10003. (212)673-9097. Fax: (212)673-9183. E-mail: cousteauny@aol.com. American Section Editor: Lisa Rao. Circ. 200,000. Publication of The Cousteau Society. Bimonthly. Emphasizes expedition activities of The Cousteau Society; educational/science articles; environmental activities. Readers are members of The Cousteau Society. Sample copy $2 with 9×12 SAE and $1 postage. Photo guidelines free with SASE.

Needs: Uses 10-14 photos/issue; 1-2 supplied by freelancers; 2-3 photos/issue from freelance stock.

Making Contact & Terms: Query with samples and list of stock photo subjects. Uses color prints; 35mm and 2¼×2¼ transparencies (duplicates only). SASE. Reports in 5 weeks. Pays $75-200/color photo. Pays on publication. Buys one-time rights and "translation rights for our French publication." Previously published work OK.

Tips: Looks for sharp, clear, good composition and color; unusual animals or views of environmental features. Prefers transparencies over prints. "We look for ecological stories, food chain, prey-predator interaction and impact of people on environment. Please request a copy of our publication to familiarize yourself with our style, content and tone and then send samples that best represent underwater and environmental photography."

CAMPUS LIFE, 465 Gundersen Dr., Carol Stream IL 60188. Art Director: Doug Johnson. Circ. 100,000. Estab. 1943. Bimonthly magazine. "*Campus Life* is a magazine for high school and college-age youth. We emphasize balanced living—emotionally, spiritually, physically and mentally." Sample copy $2. Photo guidelines free with SASE.

Needs: Buys 15 photos/issue; 10 supplied by freelancers, most are assigned. Head shots (of teenagers in a variety of moods); humorous, sport and candid shots of teenagers/college students in a variety of settings. "We look for diverse racial teenagers in lifestyle situations, and in many moods and expressions, at work, play, home and school. No travel, how-to, still life, travel scenics, news or product shots. Shoot for a target audience of 17-year-olds." Photos purchased with or without accompanying ms. Special needs include "Afro-American males/females in positive shots." Model/property release preferred for controversial stories. Captions preferred.

Making Contact & Terms: Submit portfolio for review. Query with résumé of credits. Provide brochure, tearsheets, résumé, business card or flier to be kept on file for possible assignments. Uses 6×9 glossy b&w prints and 35mm or larger transparencies. Keeps samples on file. SASE. Reports in 2 months. Pays $100-150/b&w photo; $100-300/color photo. Pays on publication. Credit line given. Buys one-time rights;

negotiable. Simultaneous submissions and previously published work OK if marked as such.

Tips: "Look at a few issues to get a feel for what we choose. Ask for copies of past issues of *Campus Life*. Show work that fits our editorial approach. We choose photos that express the contemporary teen experience. We look for unusual lighting and color. Our guiding philosophy: that readers will 'see themselves' in the pages of our magazine." Looks for "ability to catch teenagers in real-life situations that are well-composed but not posed. Technical quality, communication of an overall mood, emotion or action."

CANADIAN RODEO NEWS, 2116 27th Ave. NE, #223, Calgary, Alberta T2E 7A6 Canada. (403)250-7292. Fax: (403)250-6926. E-mail: rodeonews@iul-ccs.com. Website: http://www.rodeocanada.c om. Editor: Vicki Mowat. Circ. 4,285. Estab. 1964. Monthly tabloid. Emphasizes professional rodeo in Canada. Readers are male and female rodeo contestants and fans—all ages. Sample copy and photo guidelines free with 9×12 SASE.

Needs: Uses 20-25 photos/issue; 3 supplied by freelancers. Needs photos of professional rodeo action or profiles. Captions preferred; include identity of contestant/subject.

Making Contact & Terms: Send unsolicited photos by mail for consideration. Phone to confirm if usable. Send any color/b&w print. Keeps samples on file. SASE. Reports in 1 month. Pays $25/color cover; $15/color inside; $15/b&w inside; $45-75/photo/text package. Pays on publication. Credit line given. Rights negotiable. Simultaneous submissions and/or previously published work OK.

Tips: "Photos must be from or pertain to professional rodeo in Canada. Phone to confirm if subject/ material is suitable before submitting. *CRN* is very specific in subject."

CANADIAN YACHTING, 395 Matheson Blvd. E., Mississauga, Ontario L4Z 2H2 Canada. (905)890-1846. Fax: (905)890-5769. Editor: Heather Ormerod. Circ. 15,800. Estab. 1976. Bimonthly magazine. Emphasizes sailing (no powerboats). Readers are mostly male, highly educated, high income, well read. Sample copy free with 9×12 SASE.

Needs: Uses 28 photos/issue; all supplied by freelancers. Needs photos of all sailing/sailing related (keelboats, dinghies, racing, cruising, etc.). Model/property release preferred. Captions preferred.

Making Contact & Terms: Submit portfolio for review. Query with stock photo list. Send unsolicited photos by mail for consideration. Send transparencies. SASE. Reports in 1 month. Pays $150-350/color cover; $30-70/color inside; $30-70/b&w inside. Pays 60 days after publication. Buys one-time rights. Simultaneous submissions and previously published work OK.

CANNABIS CANADA, Marijuana and Hemp Around the World, Hemp BC, 21 Water St., Suite 504, Vancouver, British Columbia V6B 1A1 Canada. (604)669-9069. Fax: (604)669-9038. E-mail: mbutts@hempbc.com. Website: http://www.Hempbc.com. Art Director: Michael Butts. Circ. 32,000. Estab. 1995. Bimonthly magazine that advocates the beneficial uses of cannabis and works toward an end to prohibition and censorship everywhere. "We cover all aspects of cannabis culture." Sample copy for $5.95 and $1 shipping.

Needs: Buys 25 photos/issue. Needs photos of marijuana, hemp, buds, major event coverage. Reviews photos with or without ms. Model release preferred for any photos of naked people or people breaking the law. Photo caption preferred; include photographer, subject(s).

Making Contact & Terms: Send query letter with samples. Provide résumé, business card, self-promotion piece or tearsheets to be kept on file for possible future assignments. Art director will contact photographer for portfolio review of color prints, tearsheets if interested. Uses 8×14 maximum color and b&w prints; 35mm transparencies. Accepts images in digital format for Mac. Keeps samples on file. Cannot return material. Reports back only if interested, send non-returnable samples. Pays $50-150 for color inside. Pays on publication. Credit line given. Buys one-time rights, first rights, poster/postcard use, calendar use, occasionally web use. Previously published work OK.

Tips: "Pickup our magazine or check our website. Must make deadline. Allow the Art Director to choose the shot."

CANOE & KAYAK, Dept. PM, P.O. Box 3146, Kirkland WA 98083. (425)827-6363. Fax: (425)827-1893. Art Director: Catherine Black. Circ. 63,000. Estab. 1973. Bimonthly magazine. Emphasizes a variety of paddle sports, as well as how-to material and articles about equipment. For upscale canoe and kayak enthusiasts at all levels of ability. Also publishes special projects/posters. Free sample copy with 9×12 SASE.

Needs: Uses 30 photos/issue: 90% supplied by freelancers. Canoeing, kayaking, ocean touring, canoe sailing, fishing when compatible to the main activity, canoe camping but not rafting. No photos showing disregard for the environment, be it river or land; no photos showing gasoline-powered, multi hp engines; no photos showing unskilled persons taking extraordinary risks to life, etc. Accompanying mss for "editorial

coverage striving for balanced representation of all interests in today's paddling activity. Those interests include paddling adventures (both close to home and far away), camping, fishing, flatwater, whitewater, ocean kayaking, poling, sailing, outdoor photography, how-to projects, instruction and historical perspective. Regular columns feature paddling techniques, conservation topics, safety, interviews, equipment reviews, book/movie reviews, new products and letters from readers." Photos only occasionally purchased without accompanying ms. Model release preferred "when potential for litigation." Property release required. Captions are preferred, unless impractical.

Making Contact & Terms Interested in reviewing work from newer, lesser-known photographers. Query or send material. "Let me know those areas in which you have particularly strong expertise and/or photofile material. Send best samples only and make sure they relate to the magazine's emphasis and/or focus. (If you don't know what that is, pick up a recent issue first, before sending me unusable material.) We will review dupes for consideration only. Originals required for publication. Also, if you have something in the works or extraordinary photo subject matter of interest to our audience, let me know! It would be helpful to me if those with substantial reserves would supply indexes by subject matter." Uses 5×7 and 8×10 glossy b&w prints; 35mm, $2\frac{1}{4} \times 2\frac{1}{4}$ and 4×5 transparencies; color transparencies for cover; vertical format preferred. SASE. Reports in 1 month. Pays $300/cover color photo; $150/half to full page color photos; $100/full page or larger b&w photos; $75/quarter to half page color photos; $50/quarter or less color photos; $75/half to full page b&w photos; $50/quarter to half page b&w photos; $25/less than quarter b&w photos. Pays on publication. Credit line given. Buys one-time rights, first serial rights and exclusive rights. Simultaneous submissions and previously published work OK, in noncompeting publications.

Tips: "We have a highly specialized subject and readers don't want just any photo of the activity. We're particularly interested in photos showing paddlers' *faces*; the faces of people having a good time. We're after anything that highlights the paddling activity as a lifestyle and the urge to be outdoors." All photos should be "as natural as possible with authentic subjects. We receive a lot of submissions from photographers to whom canoeing and kayaking are quite novel activities. These photos are often clichéd and uninteresting. So consider the quality of your work carefully before submission if you are not familiar with the sport. We are always in search of fresh ways of looking at our sport. All paddlers must be wearing PFDs."

CAPE COD LIFE INCLUDING MARTHA'S VINEYARD AND NANTUCKET, P.O. Box 1385, Pocasset MA 02559-1385. Phone/fax: (508)564-4466. E-mail: capelife@capecodlife.com. Website: http://www.capecodlife.com. Publisher: Brian F. Shortsleeve. Circ. 35,000. Estab. 1979. Bimonthly magazine. Emphasizes Cape Cod lifestyle. "Readers are 55% female, 45% male, upper income, second home, vacation homeowners." Sample copy for $3.75. Photo guidelines free with SASE.

Needs: Uses 30 photos/issue; all supplied by freelancers. Needs "photos of Cape and Island scenes, people, places; general interest of this area." Reviews photos with or without a ms. Model release required. Property release preferred. Photo captions required; include location.

Making Contact & Terms: Submit portfolio for review. Send unsolicited photos by mail for consideration. Send 35mm, $2\frac{1}{4} \times 2\frac{1}{4}$, 4×5 transparencies. Keeps samples on file. SASE. Accepts images in digital format for Mac (TIFF). Send via zip or floppy disk or online (300dpi). Pays $225/color cover; $25-225/b&w/color inside, depending on size. Pays 30 days after publication. Credit line given. Buys one-time rights; reprint rights for *Cape Cod Life* reprints; negotiable. Simultaneous submissions and previously published work OK.

Tips: "Write for photo guidelines. Mail photo to the attention of our Managing Editor, Nancy E. Berry. Photographers who do not have images directly related to Cape Cod, Martha's Vineyard, Nantucket and the Elizabeth Islands should not submit." Looks for "clear, somewhat graphic slides. Show us scenes we've seen hundreds of times with a different twist and elements of surprise."

THE CAPE ROCK, Southeast Missouri State University, Cape Girardeau MO 63701. (314)651-2156. Editor-in-Chief: Harvey Hecht. Circ. 1,000. Estab. 1964. Emphasizes poetry and poets for libraries and interested persons. Semiannual. Free photo guidelines.

Needs: Uses about 13 photos/issue; all supplied by freelance photographers. "We like to feature a single photographer each issue. Submit 25-30 thematically organized b&w glossies (at least 5×7), or send 5 pictures with plan for complete issue. We favor a series that conveys a sense of place. Seasons are a consideration too: we have spring and fall issues. Photos must have a sense of place: e.g., an issue featuring Chicago might show buildings or other landmarks, people of the city (no nudes), travel or scenic. No how-to or products. Sample issues and guidelines provide all information a photographer needs to decide whether to submit to us." Model release not required "but photographer is liable." Captions not required "but photographer should indicate where series was shot."

Making Contact & Terms: Send actual b&w photos by mail for consideration. Query with list of stock photo subjects. Submit portfolio by mail for review. SASE. Reporting time varies. Pays $100 and 10 copies

on publication. Credit line given. Buys "all rights, but will release rights to photographer on request." Returns unused photos.

Tips: "We don't make assignments, but we look for a unified package put together by the photographer. We may request additional or alternative photos when accepting a package."

CAREER FOCUS, 1300 Broadway, Suite 660, Kansas City MO 64111-2412. (816)960-1988. Fax: (816)960-1989. Circ. 250,000. Estab. 1988. Bimonthly magazine. Emphasizes career development. Readers are male and female African-American and Hispanic professionals, ages 21-45. Sample copy free with 9 × 12 SAE and 4 first-class stamps. Photo guidelines free with SASE.

Needs: Uses approximately 40 photos/issue. Needs technology photos and shots of personalities; career people in computer, science, teaching, finance, engineering, law, law enforcement, government, hi-tech, leisure. Model release preferred. Captions required; include name, date, place, why.

Making Contact & Terms: Query with résumé of credits and list of stock photo subjects. Keeps samples on file. SASE. Reports in 1 month. Pays $10-50/color photo; $5-25/b&w photo. Pays on publication. Credit line given. Buys one-time rights. Simultaneous submissions and previously published work OK.

Tips: "Freelancer must be familiar with our magazine to be able to submit appropriate manuscripts and photos."

CAREERS & COLLEGES MAGAZINE, 989 Avenue of Americas, New York NY 10018. (212)563-4688. Fax: (212)967-2531. E-mail: staff@careersandcolleges.com. Website: http://www.careersandcolleges.com. Art Director: Leah Bossio. Circ. 100,000. Estab. 1980. Quarterly magazine. Emphasizes college and career choices for teens. Readers are high school juniors and seniors, male and female, ages 16-19. Sample copy $2.50 with 9 × 12 SAE and 5 first-class stamps.

Needs: Uses 4 photos/issue; 80% supplied by freelancers. Needs photos of teen situations, study or career related, some profiles. Model release preferred. Property release required. Captions preferred.

Making Contact & Terms: Send tearsheets and promo cards. Submit portfolio for review; please call for appointment—drop off Monday-Wednesday in morning; can be picked up later in the afternoon. Keeps samples on file. SASE. Reports in 3 weeks. Pays $800-1,000/color cover photo; $350-450/color inside; $600-800/color page rate. **Pays on acceptance.** Credit line given. Buys one-time rights; negotiable.

Tips: "Must work well with teen subjects, hip, fresh style, not too corny. Promo cards or packets work the best, business cards are not needed unless they contain your photography."

CARIBBEAN TRAVEL AND LIFE MAGAZINE, 330 W. Canton Ave., Winter Park FL 32789. (407)628-4802. Fax: (407)628-7061. Assistant Photo Editor: Robert Moll. Circ. 129,000. Estab. 1985. Published 8 times/year. Emphasizes travel, culture and recreation in islands of Caribbean, Bahamas and Bermuda. Readers are male and female frequent Caribbean travelers, age 32-52. Sample copy $4.95. Photo guidelines free with SASE.

Needs: Uses about 100 photos/issue; 90% supplied by freelance photographers: 10% assignment and 90% freelance stock. "We combine scenics with people shots. Where applicable, we show interiors, food shots, resorts, water sports, cultural events, shopping and wildlife/underwater shots. We want images that show intimacy between people and place." Captions preferred. "Provide thorough caption information. Don't submit stock that is mediocre."

Making Contact & Terms: Query with list of stock photo subjects. Uses 4-color photography. SASE. Reports in 3 weeks. Pays $750/color cover; $350/spread; $250/full page; $150/¾ page; $125/½ page; $75/¼ page. Pays after publication. Buys one-time rights. Does not pay research or holding fees.

Tips: Seeing trend toward "fewer but larger photos with more impact and drama. We are looking for particularly strong images of color and style, beautiful island scenics and people shots—images that are powerful enough to make the reader want to travel to the region; photos that show people doing things in the destinations we cover; originality in approach, composition, subject matter. Good composition, lighting and creative flair. Images that are evocative of a place, creating story mood. Good use of people. Submit stock photography for specific story needs, if good enough can lead to possible assignments. Let us know exactly what coverage you have on a stock list so we can contact you when certain photo needs arise."

CAROLINA QUARTERLY, Greenlaw Hall, CB#3520, University of North Carolina, Chapel Hill NC 27599-3520. (919)962-0244. Fax: (919)962-3520. Editor: John Black. Circ. 1,500. Estab. 1948. Emphasizes "current poetry, short fiction." Readers are "literary, artistic—primarily, though not exclusively, writers and serious readers." Sample copy $5.

Needs: Sometimes uses 1-8 photos/issue; all supplied by freelance photographers from stock. Often photos are chosen to accompany the text of the magazine.

Making Contact & Terms: Send b&w prints by mail for consideration. Accepts images in digital format. SASE. Reports in 3 months, depending on deadline. Pays $50/job. Credit line given. Buys one-time rights.

Tips: "Look at a recent issue of the magazine to get a clear idea of its contents and design."

CAT FANCY, Fancy Publications, Inc., P.O. Box 6050, Mission Viejo CA 92690. (714)855-8822. Editor-in-Chief: Jane Calloway. Circ. 303,000. Estab. 1965. Readers are "men and women of all ages interested in all phases of cat ownership." Monthly. Sample copy $5.50. Photo guidelines and needs free with SASE.
Needs: Uses 20-30 photos/issue; all supplied by freelancers. "For purebred photos, we prefer shots that show the various physical and mental attributes of the breed. Include both environmental and portrait-type photographs. We also need good-quality, interesting color photos of mixed-breed cats for use with feature articles and departments." Model release required.
Making Contact & Terms: Send 35mm or 2¼ × 2¼ color transparencies. No duplicates. SASE. Reports in 8-10 weeks. Pays $35-100/b&w photo; $50-250/color photo; and $50-450 for text/photo package. Credit line given. Buys first North American serial rights.
Tips: "Nothing but sharp, high contrast shots, please. Send SASE for list of specific photo needs. We prefer color photos and action shots to portrait shots. We look for photos of all kinds and numbers of cats doing predictable feline activities—eating, drinking, grooming, being groomed, playing, scratching, taking care of kittens, fighting, being judged at cat shows and accompanied by people of all ages."

CATHOLIC LIBRARY WORLD, 9009 Carter, Allen Park MI 48101. (313)388-7429. Fax: (413)592-4871. E-mail: allencg@aol.com. Editor: Allen Gruenke. Circ. 1,100. Estab. 1929. Publication of the Catholic Library Association. Quarterly magazine. Emphasizes libraries and librarians (community, school, academic librarians, research librarians, archivists). Readers are librarians who belong to the Catholic Library Association; generally employed in Catholic institutions or academic settings. Sample copy $10.
Needs: Uses 2 photos/issue. Needs photos of authors of children's books and librarians who have done something to contribute to the community at large. Special photo needs include photos of annual conferences. Model release preferred for photos of authors. Captions preferred.
Making Contact & Terms: Send 5 × 7 b&w prints. Accepts images in digital format for Windows. Send via compact disc, Zip disk (1200 dpi). Deadlines: January 15, April 15, July 15, September 15. SASE. Reports in 1-2 weeks. Pays with copies and photo credit. Acquires one-time rights. Previously published work OK.

CATHOLIC NEAR EAST MAGAZINE, 1011 First Ave., New York NY 10022-4195. Fax: (212)838-1344. Executive Editor: Michael LaCività. Circ. 100,000. Estab. 1974. Bimonthly magazine. A publication of Catholic Near East Welfare Association, a papal agency for humanitarian and pastoral support. *Catholic Near East* informs Americans about the traditions, faiths, cultures and religious communities of Middle East, Northeast Africa, India and Eastern Europe. Sample copy and guidelines available with SASE.
Needs: 60% supplied by freelancers. Prefers to work with writer/photographer team. Evocative photos of people—not posed—involved in activities; work, play, worship. Also interested in scenic shots and photographs of art objects and the creation of crafts, etc. Liturgical shots also welcomed. Extensive captions required if text is not available.
Making Contact & Terms: Query first. "Please do not send an inventory, rather, send a letter explaining your ideas." SASE. Reports in 3 weeks; acknowledges receipt of material immediately. Credit line given. "Credits appear on page 3 with masthead and table of contents." Pays $50-150/b&w photo; $75-300/color photo; $20 maximum/hour; $100 maximum/assignment. Pays on publication. Buys first North American serial rights. Simultaneous submissions and previously published work OK, "but neither is preferred. If previously published please tell us when and where."
Tips: "Stories should weave current lifestyles with issues and needs. Avoid political subjects, stick with ordinary people. Photo essays are welcomed. Write requesting sample issue and guidelines, then send query. We rarely use stock photos but have used articles and photos submitted by single photojournalist or writier/photographer team."

⊞ CATS & KITTENS, 7-L Dundas Circle, Greensboro NC 27407. (336)292-4047. Fax: (336)292-4272. Executive Editor: Rita Davis. Managing Editor: Karen McCullough. Bimonthly magazine about cats. "Articles include breed profiles, stories on special cats, cats in art and popular culture." Sample copy for $5 and 9 × 12 SASE. Photo guidelines free with SASE.
Needs: Photos of various cat breeds, posed and unposed, interacting with other cats and with people. Caption required; include breed name, additional description as needed.
Making Contact & Terms: Send unsolicited photos by mail for consideration, "but please include SASE if you want them returned. Please send duplicates. We cannot assume liability for unsolicited originals." Transparencies or slides preferred. Glossy prints acceptable. Reports in 2 months. Pays $150-250/color cover; $25-50/color inside. Pays on publication. Buys all rights, negotiable.
Tips: "We seek good composition (indoor or outdoor). Photos must be professional and of publication

quality—good focus and contrast. We work regularly with a few excellent freelancers, but are always seeking new contributors. Pictures we think we might be able to use will be scanned into our CD-ROM file and the originals returned to the photographer."

CEA ADVISOR, Dept. PM, Connecticut Education Association, 21 Oak St., Hartford CT 06106. (860)525-5641. Fax: (860)725-6356. Managing Editor: Michael Lydick. Circ. 30,000. Monthly tabloid. Emphasizes education. Readers are public school teachers. Sample copy free with 6 first-class stamps.
Needs: Uses about 20 photos/issue; 1 or 2 supplied by freelancers. Needs "classroom scenes, students, school buildings." Model release preferred. Captions preferred.
Making Contact & Terms: Send b&w contact sheet by mail for consideration. Provide résumé, business card, brochure, flier or tearsheets to be kept on file for possible future assignments. Cannot return material. Reports in 1 month. Pays $50/b&w cover; $25/b&w inside. Pays on publication. Credit line given. Buys all rights. Simultaneous submissions and/or previously published work OK.

CHARISMA MAGAZINE, 600 Rinehart Rd., Lake Mary FL 32746. (407)333-0600. Design Manager: Mark Poulalion. Circ. 200,000. Monthly magazine. Emphasizes Christians. General readership. Sample copy $2.50.
Needs: Uses approximately 20 photos/issue; ⅓ supplied by freelance photographers. Needs editorial photos—appropriate for each article. Model release required. Captions preferred.
Making Contact & Terms: Send unsolicited photos by mail for consideration. Provide brochure, flier or tearsheets to be kept on file for possible assignments. Send color 35mm, 2¼×2¼, 4×5 or 8×10 transparencies. Cannot return material. Reports ASAP. Pays $300/color cover; $150/b&w inside; $50-150/hour or $400-600/day. Pays on publication. Credit line given. Buys all rights; negotiable. Simultaneous submissions and previously published work OK.
Tips: In portfolio or samples, looking for "good color and composition with great technical ability. To break in, specialize; sell the sizzle rather than the steak!"

CHARLOTTE MAGAZINE, 127 W. Worthington Ave., Suite 208, Charlotte NC 28203. (704)335-7181. Fax: (704)335-3739. Art Director: Carrie Porter. Circ. 30,000. Estab. 1995. Monthly magazine. Emphasizes Charlotte, North Carolina. Readers are upper-middle class, ages 30 and up. Sample copy $3.95 with 9×12 SASE and 2 first-class stamps.
Needs: Uses 15-20 photos/issue; 6-10 supplied by freelancers. Subject needs depend on editorial content. Model/property release preferred for young children. Captions preferred; include names.
Making Contact & Terms: Submit portfolio for review. Provide résumé, business card, brochure, flier or tearsheets to be kept on file for possible assignments. Send 35mm transparencies. Keeps samples on file. SASE. Reports in 1-2 weeks. Payment negotiable. Pays on publication. Credit line given. Buys one-time rights.
Tips: "Look at the publication; get a feel for the style and see if it coincides with your photography style."

THE CHESAPEAKE BAY MAGAZINE, 1819 Bay Ridge Ave., Annapolis MD 21403. (410)263-2662, (DC)261-1323. Fax: (410)267-6924. Art Director: Karen Ashley. Circ. 37,000. Estab. 1972. Monthly. Emphasizes boating—Chesapeake Bay only. Readers are "people who use Bay for recreation." Sample copy available.
● *Chesapeake Bay* is CD-ROM equipped and has does corrections and manipulates photos inhouse.
Needs: Uses "approximately" 45 photos/issue; 60% supplied by freelancers; 40% by freelance assignment. Needs photos that are Chesapeake Bay related (must); vertical powerboat shots are badly needed (color). Special needs include "vertical 4-color slides showing boats and people on Bay."
Making Contact & Terms: Interested in reviewing work from newer, lesser-known photographers. Query with samples or list of stock photo subjects. Send 35mm, 2¼×2¼, 4×5 or 8×10 transparencies by mail for consideration. SASE. Reports in 3 weeks. Pays $300/color cover; $25-75/b&w inside; $35-250/color inside; $150-1,000/photo/text package. Pays on publication. Credit line given. Buys one-time rights. Simultaneous submissions OK.
Tips: "We prefer Kodachrome over Ektachrome. Looking for: boating, bay and water-oriented subject matter. Qualities and abilities include: fresh ideas, clarity, exciting angles and true color. We're using larger photos—more double-page spreads. Photos should be able to hold up to that degree of enlargement. When photographing boats on the Bay—keep the 'safety' issue in mind. (People hanging off the boat, drinking, women 'perched' on the bow are a no-no!)"

CHESS LIFE, 3054 NYS Route 9W, New Windsor NY 12553. (914)562-8350. Fax: (914)561-CHES (2437)/(914)236-4852. E-mail: chesslife_uscf@juno.com. Website: http://www.uschess.org. Editor-in-Chief: Glenn Petersen. Art Director: Jami Anson. Circ. 70,000. Estab. 1939. Publication of the U.S. Chess

Federation. Monthly. *Chess Life* covers news of all major national and international tournaments; historical articles, personality profiles, columns of instruction, occasional fiction, humor for the devoted fan of chess. Sample copy and photo guidelines free.

Needs: Uses about 10 photos/issue; 7-8 supplied by freelancers. Needs "news photos from events around the country; shots for personality profiles." Special needs include "Spot Light" section. Model release preferred. Captions preferred.

Making Contact & Terms: Query with samples. Provide business card and tearsheets to be kept on file for possible future assignments. Prefers 35mm transparencies for cover shots. Also accepts digital images on broadcast tape, VHS and Beta. SASE. Reports in "2-4 weeks, depending on when the deadline crunch occurs." Pays $150-300/b&w or color cover; $25/b&w inside; $35/color inside; $15-30/hour; $150-250/day. Pays on publication. Credit line given. Buys one-time rights; "we occasionally purchase all rights for stock mug shots." Simultaneous submissions and previously published work OK.

Tips: Using "more color, and more illustrative photography. The photographer's name, address and date of the shoot should appear on the back of all photos. Also, name of person(s) in photograph, and event should be identified." Looks for "clear images, good composition and contrast—with a fresh approach to interest the viewer. Increasing emphasis on strong portraits of chess personalities, especially Americans. Tournament photographs of winning players and key games are in high demand."

CHILDHOOD EDUCATION, The Olney Professional Bldg., 17904 Georgia Ave., Suite 215, Olney MD 20832. (301)570-2111. Director of Publications/Editor: Anne Bauer. Assistant Editor: Bruce Herzig. Circ. 15,000. Estab. 1924. Publication for the Association for Childhood Education International. Bimonthly journal. Emphasizes the education of children from infancy through early adolescence. Readers include teachers, administrators, day-care workers, parents, psychologists, student teachers, etc. Sample copy free with 9×12 SAE and $1.44 postage. Photo guidelines free with SASE.

Needs: Uses 5-10 photos/issue; 2-3 supplied by freelance photographers. Subject matter includes children infancy-14 years in groups or alone, in or out of the classroom, at play, in study groups; boys and girls of all races and in all cities and countries. Wants close-ups of children, unposed. Reviews photos with or without accompanying ms. Special needs include photos of minority children; photos of children from different ethnic groups together in one shot; boys and girls together. Model release required.

Making Contact & Terms: Send unsolicited photos by mail for consideration. Uses 8×10 glossy b&w and color prints and color transparencies. SASE. Reports in 1 month. Pays $75-100/color cover; $25-50/b&w inside. Pays on publication. Credit line given. Buys one-time rights. Simultaneous submissions and previously published work are discouraged but negotiable.

Tips: "Send pictures of unposed children, please."

CHILDREN'S DIGEST, P.O. Box 567, Indianapolis IN 46206. (317)636-8881 ext. 220. Fax: (317)684-8094. Photo Editor: Penny Rasdall. Circ. 106,000. Estab. 1950. Magazine published 8 times/year. Emphasizes health and fitness. Readers are preteens—kids 10-13. Sample copy $1.25. Photo guidelines free with SASE.

Needs: "We have featured photos of health and fitness, wildlife, children in other countries, adults in different jobs, how-to projects." *Reviews photos with accompanying ms only.* "We would like to include more photo features on nature, wildlife or anything with an environmental slant." Model release preferred.

Making Contact & Terms: Send complete manuscript and photos on speculation; 35mm transparencies. SASE. Reports in 10 weeks. Pays $70-275/color cover; $70-155/color inside; $35-70/b&w inside. Pays on publication. Buys one-time rights.

CHILDREN'S MINISTRY MAGAZINE, % Group Publishing, Inc., 1515 Cascade Ave., Loveland CO 80538. (970)669-3836. Art Director: Rose Anne Buerge. Circ. 50,000. Estab. 1991. Bimonthly magazine. Provides ideas and support to adult workers (professional and volunteer) with children in Christian churches. Sample copy $2 with 9×12 SAE. Photo guidelines free with SASE.

● This publication is interested in receiving work on Photo CD.

Needs: Uses 20-25 photos/issue; 1-3 supplied by freelancers. Needs photos of children (infancy—6th grade) involved in family, school, church, recreational activities; with or without adults; generally upbeat and happy. Reviews photos with or without a manuscript. Especially needs good portrait-type shots of

● **SPECIAL COMMENTS** within listings by the editor of *Photographer's Market* are set off by a bullet.

individual children, suitable for cover use; colorful, expressive. Model release required. Captions not needed.

Making Contact & Terms: Send unsolicited photos by mail for consideration. Send 35mm, 2¼×2¼, 8×10 transparencies. Samples filed. SASE. Reports in 1 month. Pays minimum $100/color inside; $50/ b&w inside. **Pays on acceptance.** Credit line given. Buys one-time rights. Simultaneous submissions and previously published work OK.

Tips: "We seek to portray people in a variety of ethnic, cultural and economic backgrounds in our publications. We look for photographers with the ability to portray emotion in photos. Real life shots are preferable to posed ones."

THE CHRISTIAN CENTURY, 407 S. Dearborn St., Suite 1405, Chicago IL 60605. (312)427-5380. Fax: (312)427-1302. Production Coordinator: Matthew Giunti. Circ. 32,000. Estab. 1884. Weekly journal. Emphasis on religion. Readers are clergy, scholars, laypeople, male and female, ages 40-85. Sample copy $3. Photo guidelines free with SASE.

Needs: Buys 50 photos/year; all supplied by freelancers; 75% comes from stock. People of various races and nationalities; celebrity/personality (primarily political and religious figures in the news); documentary (conflict and controversy, also constructive projects and cooperative endeavors); scenic (occasional use of seasonal scenes and scenes from foreign countries); spot news; and human interest (children, human rights issues, people "in trouble," and people interacting). Reviews photos with or without accompanying ms. For accompanying mss seeks articles dealing with ecclesiastical concerns, social problems, political issues and international affairs. Model/property release preferred. Captions preferred; include name of subject and date.

Making Contact & Terms: Interested in reviewing work from newer, lesser-known photographers. "Send crisp black-and-white images. We will consider a stack of photos in one submission. Send cover letter with prints. Don't send negatives or color prints." Also accepts digital files on floppy disk in Photoshop or TIFF format (EPS also if it's not too large). Uses 8×10 b&w prints. Does not keep samples on file. SASE. Reports in 1 month. Pays $50-150/photo (b&w or color). Pays on publication. Credit line given. Buys one-time rights; negotiable. Simultaneous submissions and previously published work OK.

Tips: Looks for diversity in gender, race, age and religious settings. Photos should reproduce well on newsprint.

CHRISTIAN HOME & SCHOOL, 3350 E. Paris Ave. SE, Grand Rapids MI 49512-3054. (616)957-1070, ext. 239. Senior Editor: Roger Schmurr. Circ. 57,000. Estab. 1922. Publication of Christian Schools International. Published 6 times a year. Emphasizes Christian family issues. Readers are parents who support Christian education. Sample copy free with 9×12 SAE with 4 first-class stamps. Photo guidelines free with SASE or along with sample copy.

Needs: Uses 10-15 photos/issue; 7-10 supplied by freelancers. Needs photos of children, family activities, school scenes. Model release preferred.

Making Contact & Terms: Query with samples. Query with list of stock photo subjects. Uses color slides and transparencies. SASE. Reports in 3 weeks. Pays $125/inside editorial; $250/cover; $50-100/ inside spot usage; all color. Pays on publication. Credit line given. Buys one-time rights. Simultaneous submissions and previously published work OK.

Tips: Assignment work is becoming rare. Freelance stock most often used.

CHRISTIANITY AND THE ARTS, P.O. Box 118088, Chicago IL 60611. (312)642-8606. Fax: (312)266-7719. E-mail: chrnarts@aol.com. Publisher: Marci Whitney-Schenck. Circ. 4,000. Estab. 1994. Nonprofit quarterly magazine. Emphasizes "Christian expression—visual arts, dance, music, literature, film. We reach Protestant, Catholic and Orthodox readers throughout the United States and Canada." Readers are "upscale and well-educated, with an interest in several disciplines, such as music and the visual arts." Sample copy $6.

Needs: "Parting Shot" page is devoted to "arty photos."

Making Contact & Terms: "We occasionally pay a freelance photographer $100/photo. Usually, there is no pay, but the photographer gets exposure."

THE CHRONICLE OF THE HORSE, P.O. Box 46, Middleburg VA 20118. (540)687-6341. Fax: (540)687-3937. Editor: John Strassburger. Circ. 23,000. Estab. 1937. Weekly magazine. Emphasizes English horse sports. Readers range from young to old. "Average reader is a college-educated female, middle-aged, well-off financially." Sample copy for $2. Photo guidelines free with SASE.

Needs: Uses 10-25 photos/issue; 90% supplied by freelance photographers. Needs photos from competitive events (horse shows, dressage, steeplechase, etc.) to go with news story or to accompany personality profile. "A few stand alone. Must be cute, beautiful or newsworthy. Reproduced in b&w." Prefers purchas-

ing photos with accompanying ms. Captions required with every subject identified.

Making Contact & Terms: Query with idea. Send b&w and color prints (reproduced b&w). SASE. Reports in 3 weeks. Pays $15-100/photo/text package. Pays on publication. Credit line given. Buys one-time rights. Prefers first North American rights. Simultaneous submissions and previously published work OK.

Tips: "We do not want to see portfolio or samples. Contact us first, preferably by letter. Know horse sports."

[N] CICADA, 329 E St., Bakersfield CA 93304-2031. (805)323-4064. E-mail: amelia@lightspeed.net. Editor: Frederick A. Raborg, Jr. Circ. 600. Estab. 1984. Quarterly literary magazine that publishes Japanese and other Asian and Indian poetry forms and fiction related to the Orient, plus articles and book reviews related to the forms. Sample copy for $4.95. Art guidelines free with SAE and 1 first-class stamp.

Needs: Buys 1-2 photos from freelancers/issue; 4-6 photos/year. Needs photos of anything with an oriental flavor, particularly if somehow arousing a haiku moment. All types and subjects are considered. Considers b&w only at this time. Reviews photos with or without ms. Model release required in cases of visible faces. Photo captions required only for identification of subject matter.

Making Contact & Terms: Send query letter with samples. Uses 5×7, 8×10 glossy or matte b&w prints only. Keeps samples on file. Reports in 2-4 weeks on queries; 1-2 months on samples. Pays $25 for b&w cover; $10-20 for b&w inside. **Pays on acceptance.** Buys one-time rights. Simultaneous submissions and/or previously published work OK if in non-competitive markets.

Tips: "We allow photographers a 40% discount on subscriptions to allow them to follow what we do reasonably. (Regular subscription—$14; price to photographers $8.40.) Remember to include SASE with sufficient postage and of sufficient size."

CIRCLE K MAGAZINE, 3636 Woodview Trace, Indianapolis IN 46268. (317)875-8755. Executive Editor: Nicholas K. Drake. Circ. 15,000. Published 5 times/year. For community service-oriented college leaders "interested in the concept of voluntary service, societal problems, leadership abilities and college life. They are politically and socially aware and have a wide range of interests."

Needs: Assigns 0-5 photos/issue. Needs general interest photos, "though we rarely use a nonorganization shot without text. Also, the annual convention requires a large number of photos from that area." Prefers ms with photos. Seeks general interest features aimed at the better-than-average college student. "Not specific places, people topics." Captions required, "or include enough information for us to write a caption."

Making Contact & Terms: Works with freelance photographers on assignment only basis. Provide calling card, letter of inquiry, résumé and samples to be kept on file for possible future assignments. Send query with résumé of credits. Uses 8×10 glossy b&w prints or color transparencies. Uses b&w and color covers; vertical format required for cover. SASE. Reports in 3 weeks. Pays $225-350 maximum for text/photo package, or on a per-photo basis—$25 minimum/b&w print and $100 minimum/cover. **Pays on acceptance.** Credit line given. Previously published work OK if necessary to text.

CIVITAN MAGAZINE, P.O. Box 130744, Birmingham AL 35213-0744. (205)591-8910. Fax: (205)592-6307. E-mail: civitan@civitan.org. Website: http://www.civitan.org/civitan. Editor: Dorothy Wellborn. Circ. 36,000. Estab. 1920. Publication of Civitan International. Bimonthly magazine. Emphasizes work with mental retardation/developmental disabilities. Readers are men and women, college age to retirement and usually managers or owners of businesses. Sample copy free with 9×12 SAE and 2 first-class stamps. Photo guidelines not available.

Needs: Uses 8-10 photos/issue; 50% supplied by freelancers. Always looking for good cover shots (travel, scenic and how-to). Model release preferred. Captions preferred.

Making Contact & Terms: Send unsolicited 2¼×2¼ or 4×5 transparencies or b&w prints by mail for consideration. Provide résumé, business card, brochure, flier or tearsheets to be kept on file for possible assignments. Reports in 1 month. Pays $50/color cover; $10 b&w inside. **Pays on acceptance.** Buys one-time rights. Simultaneous submissions and previously published work OK.

[N] [globe] CLASSIC CD MAGAZINE, Future Publishing, 30 Monmouth St., Bath, Avon BA1 2BW Great Britain. 01225 442244. Fax: 01225 732396. Art Editor: David Eachus. Circ. 36,000. Estab. 1990. Monthly consumer magazine. "Classic CD is the complete guide to classical music with articles and reviews of the top releases exclusively illustrated by extracts on our cover disc." Sample copy available.

Needs: Needs photos of composers, musicians, etc. Reviews photos with or without a ms. Photo captions preferred.

Making Contact & Terms: Send query letter with tearsheets. Provide résumé, business card, self-promotion piece or tearsheets to be kept on file for possible future assignments. To show portfolio, photographer

should follow-up with call and/or letter after initial query. Art director will contact photographer for portfolio review if interested. Portfolio should include b&w and color prints, slides, thumbnails, tearsheets, transparencies. Keeps samples on file. Reports back only if interested, send non-returnable samples. Pays 30 days after publication. Credit line given. Buys one-time rights. Simultaneous submissions and/or previously published work OK.

Tips: "Read our magazine. Do not submit too much."

THE CLASSIC MOTORCYCLE, EMAP National Publications, 20/22 Station Rd., Kettering, Northants NN15 7HH United Kingdom. Phone: (01536)386775. Fax: (01536)386782. E-mail: classic_bike @dial.pipex.com. Circ. 30,000. Monthly consumer magazine covering classic motorcycles 1900-1970 including European machines as well as those manufactured in the UK.
Needs: Needs photos of classic motorcycles. Reviews photos with or without ms. Photo captions preferred.
Making Contact & Terms: Provide résumé, business card, self-promotion piece or tearsheets to be kept on file for possible future assignments. To show portfolio, photographer should follow-up with call. Portfolio should include transparencies. Uses 35mm, 2¼×2¼ transparencies; Fuji Provia film. Keeps samples on file. Reports in 2 weeks. Pays £150/day for a photo shoot plus film and expenses. Pays on publication. Credit line given. Buys first rights.
Tips: "Action photography is difficult—we are always impressed with good action photography."

CLASSICS, Security Publications Ltd., Berwick House, 8/10 Knoll Rise, Orpington, Kent BR6 0PS United Kingdom. Phone: (01689)887200. Fax: (01689)838844. E-mail: classics@splgroup.demon.co. uk. Editor: Andrew Noakes. Estab. 1997. Published monthly on the first Wednesday of every month. "The essential, practical magazine for classic car owners, filled with authoritative technical advice on maintenance and restoration, plus stories of reader's own cars and a unique guide to 2,000 specialists in every issue." Sample copy free for 9×12 SAE. Art guidelines free.
Needs: Buys 70 photos from freelancers/issue; 1,000 photos/year. Needs photos of classic cars—1970s and earlier, mostly English/European. Reviews photos with or without ms. Special photo needs include restoration picture sequences and "we are looking for overseas correspondants." Photo captions required; include make/model of vehicle, names of people and any technical details.
Making Contact & Terms: Send query letter with samples, stock photo list, tearsheets. Art director will contact photographer for portfolio review if interested. "Freelance submissions can be in any format if quality is good." Keeps samples on file. Pays $10-50 for b&w and color inside. Pays 30 days after publication. Buys one-time rights and all rights on some occasions; negotiable. Simultaneous submissions and/or previously published work OK.
Tips: "Read the magazine to see what we use—then supply us with more of the same. Weed out the unsharp, the badly exposed and the poorly cropped. They are always unusable."

CLEVELAND MAGAZINE, City Magazines Inc., 1422 Euclid Ave., #730, Cleveland OH 44115. (216)771-2833. Fax: (216)781-6318. E-mail: information@clevelandmagazine.com. Website: http://www.c levelandmagazine.com. Design Director: Gary Slvzewski. Circ. 50,000. Estab. 1972. Monthly consumer magazine. General interest to upscale audience.
Needs: Buys 50 photos from freelancers/issue; 600 photos/year. Needs photos of people, architecture, interiors. Reviews photos with or without ms. Special photo needs include environmental portraits. Model release required for portraits; property release required for individual homes. Photo caption required; include names, date, location, event, phone.
Making Contact & Terms: Provide business card, self-promotion piece or tearsheets to be kept on file for possible future assignments. To show portfolio, photographer should follow-up with call. Portfolio should include only your best, favorite work. Uses color and b&w prints; 35mm, 2¼×2¼, 4×5, 8×10 transparencies. Accepts images in digital format. Keeps samples on file. Reports back only if interested, send non-returnable samples. Pays $350-600 for color cover; $100-400 for b&w and color inside. **Pays on acceptance.** Credit line given. Buys one-time publication, electronic and promotional rights. Simultaneous submissions and/or previously published work OK.
Tips: "Ninety percent of our work is people. Arrange the work you want to show me ahead of time and be professional, instead of telling me you just threw this together."

COAST MAGAZINE, P.O. Box 1209, Gulfport MS 39502. (228)594-0004. Fax: (228)594-0074. Creative Director: Belinda Mallery. Circ. 25,000. Estab. 1993. Bimonthly magazine. Emphasizes lifestyle. Readers are mostly female (59%), ages 34-46, affluent ($35,000 plus income). Sample copy free with 10×13 SAE and $2.90 first-class postage.
Needs: Uses 30-40 photos/issue; 5-10% supplied by freelancers. Needs focus on local people from the Mississippi coast. Model/property release required. Captions required; include pertinent information.

Making Contact & Terms: Arrange personal interview to show portfolio. Query with stock photo list. Send 35mm transparencies. Does not keep samples on file. SASE. Reports in 1 month. Pays $50-500/job. Pays on publication. Credit line given.

COBBLESTONE: AMERICAN HISTORY FOR KIDS, Cobblestone Publishing Company, 30 Grove St., Suite 6, Peterborough NH 03458. (603)924-7209. Fax: (603)924-7380. Editor: Meg Chorlian. Circ. 36,000. Estab. 1980. Publishes 9 issues/year, September-May. Emphasizes American history; each issue covers a specific theme. Readers are children 8-14, parents, teachers. Sample copy for $4.95 and 9×12 SAE with 5 first-class stamps. Photo guidelines free with SASE.
Needs: Uses about 40 photos/issue; 5-10 supplied by freelance photographers. "We need photographs related to our specific themes (each issue is theme-related) and urge photographers to request our themes list." Model release required. Captions preferred.
Making Contact & Terms: Query with samples or list of stock photo subjects. Send 8×10 glossy prints or 35mm, 2¼×2¼ transparencies. SASE. Accepts images in digital format for Mac or Windows. Send via SyQuest or Zip disk. "Photos must pertain to themes, and reporting dates depend on how far ahead of the issue the photographer submits photos. We work on issues 6 months ahead of publication." Cover photo (color) negotiated; $15-100/inside b&w and color use. Pays on publication. Credit line given. Buys one-time rights. Simultaneous submissions and previously published work OK.
Tips: "Most photos are of historical subjects, but contemporary color images of, for example, a Civil War battlefield, are great to balance with historical images. However, the amount varies with each monthly theme. Please review our theme list and submit related images."

COLLAGES & BRICOLAGES, P.O. Box 360, Shipperville PA 16254. E-mail: c&b@penn.com. Editor: Marie-José Fortis. Art Editor: Michael Kressley. Estab. 1986. Annual magazine. Emphasizes literary works, avant-garde, poetry, fiction, plays and nonfiction. Readers are writers and the general public in the US and abroad. Sample copy $10.
Needs: Uses 5-10 photos/issue; all supplied by freelancers. Needs photos that make a social statement, surrealist photos and photo collages. Reviews photos (August-March) with or without a ms. Photo captions preferred; include title of photo and short biography of artist/photographer.
Making Contact & Terms: Send unsolicited photos by mail for consideration. "Photos should be no larger than 8½×11 with at least a 1″ border." Send matte b&w prints. SASE. Reports in 3 months. Pays in copies. Simultaneous submissions and/or previously published work grudgingly considered.
Tips: "*C&B* is primarily meant for writers. It will include photos if: a) they accompany or illustrate a story, a poem, an essay or a focus *C&B* might have at the moment; b) they constitute the cover of a particular issue; or c) they make a statement (political, social, spiritual)."

N ⊕ COLLECT IT!, P.O. Box 3658, Bracknell, Berkshire RG12 1GE United Kingdom. (1344)868 280. Fax: (1344) 861 777. E-mail: collectit@dial.pipex.com. Director/Editor: Gwyn Jones. Circ. 30,000. Estab. 1997. A glossy monthly magazine for collectors covering affordable antiques and collectibles.
Needs: Photos of collectibles and collectors. Reviews photos with or without ms. Special photo needs include US and Canadian market.
Making Contact & Terms: Send query letter with samples. Does not keep samples on file; include SASE for return of material. Reports in 2 months on queries. Pays on publication. Credit line sometimes given. Buys one-time rights or all rights; negotiable.

COLLECTOR CAR & TRUCK MARKET GUIDE, (formerly Collector Car & Truck Market Guide), 41 N. Main St., N. Grafton MA 01536-1559. (508)839-6707. Fax: (508)839-6266. Production Director: Kelly Hulitzky. Circ. 20,000. Estab. 1994. Bimonthly magazine. Emphasizes old cars and trucks. Readers are primarily males, ages 30-60. Sample copy free with SASE and 6 first-class stamps.
Needs: Uses 3 photos/issue; all supplied by freelancers. Needs photos of old cars and trucks. Model/property release required. Captions required; include year, make and model. Provide résumé, business card, brochure, flier or tearsheets to be kept on file for possible assignments. Does not keep samples on file. SASE. Reports in 1 month. Pays $150-200/color cover; $100-125/b&w inside. Pays net 30 days. Buys one-time rights. Previously published work OK.

COLONIAL HOMES MAGAZINE, Dept. PM, 1790 Broadway, New York NY 10019. (212)830-2950. Editor: Annette Stramesi. Bimonthly. Circ. 600,000. Focuses on traditional American architecture, interior design, antiques and crafts. Sample copy available.
Needs: All photos supplied by freelance photographers. Needs photos of "American architecture and interiors of 18th century or 18th century style." Special needs include "American food and drink; private and museum homes; historic towns in America." All art must be identified.

Making Contact & Terms: Submit portfolio to Art Director Michael Liberatore for review. Send 4×5 or 2¼×2¼ transparencies by mail for consideration. Provide résumé, business card, brochure, flier or tearsheets to be kept on file for possible future assignments. SASE. Accepts images in digital format for Mac. Send via SyQuest or Zip disk. Reports in 1 month. Pays $700-900/day. Pays on publication. Credit line given. Buys all rights. Previously published work OK.

COMPANY: A MAGAZINE OF THE AMERICAN JESUITS, Dept. PM, 3441 N. Ashland Ave., Chicago IL 60657. (773)281-1534. Fax: (773)281-2667. E-mail: editor@companysj.com. Website: http://www.companysj.com. Editor: Martin McHugh. Circ. 128,000. Estab. 1983. Published by the Jesuits (Society of Jesus). Quarterly magazine. Emphasizes people; "a human interest magazine about people helping people." Sample copy free with 9×12 SAE and 4 first-class stamps. Photo guidelines free with SASE.
Needs: All photos supplied by freelancers. Needs photo-stories of Jesuit and allied ministries and projects, only photos related to Jesuit works. Photos purchased with or without accompanying ms. Captions required.
Making Contact & Terms: Query with samples. Provide résumé, business card, brochure, flier or tearsheets to be kept on file for possible future assignments. SASE. Accepts images in digital format for Mac or Windows. Send at 220-300 dpi via compact, floppy or Zip disk, SyQuest or online. Reports in 1 month. Pays $300/color cover; $100-400/job. Pays on publication. Credit line given. Buys one-time rights; negotiable.
Tips: "Avoid large-group, 'smile-at-camera' photos. We are interested in people photographs that tell a story in a sensitive way—the eye-catching look that something is happening."

COMPLETE WOMAN, 875 N. Michigan Ave., Suite 3434, Chicago IL 60611-1901. (312)266-8680. Art Director: Juli McMeekin. Estab. 1980. Bimonthly magazine. General interest magazine for women. Readers are "females, 21-40, from all walks of life."
Needs: Uses 50-60 photos/issue; 300 photos/year. Needs "high-contrast shots of attractive women, how-to beauty shots, women with men, etc." Model release required.
Making Contact & Terms: Query with list of stock photo subjects and samples. Provide résumé, business card, brochure, flier or tearsheets to be kept on file for possible assignments. Send b&w, color prints and transparencies. SASE. Reports in 1 month. Pays $75-150/b&w or color inside. Pays on publication. Credit line given. Buys one-time rights. Simultaneous and previously published work OK.
Tips: "We use photography that is beautiful and flattering, with good contrast and professional lighting. Models should be attractive, 18-28, and sexy. We're always looking for nice couple shots."

CONDE NAST TRAVELER, Condé Nast Publications, Inc., 360 Madison Ave., New York NY 10017. (212)880-8800. Fax: (212)880-2190. *Conde Nast Traveler* provides the experienced traveler with an array of diverse travel experiences encompassing art, architecture, fashion, culture, cuisine and shopping. This magazine has very specific needs and contacts a stock agency when seeking photos.

THE CONNECTION PUBLICATION OF NJ, INC., P.O. Box 2122, Teaneck NJ 07666. (201)692-1512. Fax: (201)861-0492. Contact: Editor. Weekly tabloid. Readers are male and female executives, ages 18-62. Circ. 41,000. Estab. 1982. Sample copy $1.50 with 9×12 SAE.
Needs: Uses 12 photos/issue; 4 supplied by freelancers. Needs photos of personalities. Reviews photos with accompanying ms only. Photo captions required.
Making Contact & Terms: Send unsolicited photos by mail for consideration. Send b&w prints. Keeps samples on file. SASE. Reports in 2 weeks. Payment negotiable. Pays on publication. Credit line given. Buys one-time rights; negotiable. Previously published work OK.
Tips: "Work with us on price."

COSMOPOLITAN, Hearst Corporation Magazine Division, 224 W. 57th St., 8th Floor, New York NY 10019. (212)649-2000. *Cosmopolitan* targets young women for whom beauty, fashion, fitness, career, relationships and personal growth are top priorities. It includes articles and columns on nutrition and food, travel, personal finance, home/lifestyle and celebrities. This magazine did not respond to our request for information. Query before submitting.

▣ ▧ THE COTTAGE MAGAZINE, Harrison House Publishing, 4623 William Head Rd., Victoria, British Columbia V9C 3Y7 Canada. (250)478-9209. Fax: (250)478-1184. E-mail: edit@cottageplan.com.

CONTACT THE EDITOR, of *Photographer's Market* by e-mail at photomarket@fwpubs.com with your questions and comments.

Website: http://www.cottageplan.com. Editor: Peter Chettleburgh. Circ. 12,000. Estab. 1992. Bimonthly consumer magazine produced for the owners and would-be owners of rural and recreational property in western Canada. Sample copy free with SAE and Canadian postage or IRC.

Needs: Buys 1 cover photo from freelancers/issue. Needs photos of rural and recreational themes relating to country life in western Canada. Reviews photos with or without ms. Model release preferred.

Making Contact & Terms: Call editor with idea. Uses color prints; 35mm, 2¼×2¼, 4×5 transparencies. Keeps samples on file. Reports in 1 month on queries. Pays $300 for color cover. Pays on publication. Credit line given. Buys one-time rights. Simultaneous submissions OK.

Tips: "Must submit a photo taken in western Canada."

COUNTRY, 5925 Country Lane, Greendale WI 53129. (414)423-0100. Fax: (414)423-8463. Photo Coordinator: Trudi Bellin. Estab. 1987. Bimonthly magazine. "For those who live in or long for the country." Readers are rural-oriented, male and female. "*Country* is supported entirely by subscriptions and accepts no outside advertising." Sample copy $2. Photo guidelines free with SASE.

Needs: Uses 150 photos/issue; 20% supplied by freelancers. Needs photos of scenics—country only. Model/property release required. Captions preferred; include season, location.

Making Contact & Terms: Query with list of stock photo subjects. Send unsolicited photos by mail for consideration. Send 35mm, 2¼×2¼, 4×5 and 8×10 transparencies. Tearsheets kept on file but not dupes. SASE. Reports within 3 months. Pays $300/color cover; $75-150/color inside; $150/color page (full-page bleed). Pays on publication. Credit line given. Buys one-time rights. Previously published work OK.

Tips: "Technical quality is extremely important: focus must be sharp, no soft focus; colors must be vivid so they 'pop off the page.' Study our magazine thoroughly—we have a continuing need for sharp, colorful images, and those who can supply what we need can expect to be regular contributors."

COUNTRY WOMAN, Dept. PM, P.O. Box 643, Milwaukee WI 53201. Managing Editor: Kathy Pohl. Emphasizes rural life and a special quality of living to which country women can relate; at work or play, in sharing problems, etc. Sample copy $2. Free photo guidelines with SASE.

Needs: Uses 75-100 photos/issue, most supplied by readers, rather than freelance photographers. "We're always interested in seeing good shots of farm, ranch and country women (in particular) and rural families (in general) at work and at play." Uses photos of farm animals, children with farm animals, farm and country scenes (both with and without people) and nature. Want on a regular basis scenic (rural), seasonal, photos of rural women and their family. "We're always happy to consider cover ideas. Covers are often seasonal in nature and *always* feature a country woman. Additional information on cover needs available." Photos purchased with or without accompanying ms. Good quality photo/text packages featuring interesting country women are much more likely to be accepted than photos only. Captions are required. Work 6 months in advance. "No poor-quality color prints, posed photos, etc."

Making Contact & Terms: Send material by mail for consideration. Uses transparencies. Provide brochure, calling card, letter of inquiry, price list, résumé and samples to be kept on file for possible future assignments. SASE. Reports in 3 months. Pays $100-150 for text/photo package depending on quality of photos and number used; pays $300 for front cover; $200 for back cover; partial page inside $50-125, depending on size. Many photos are used at ¼ page size or less, and payment for those is at the low end of the scale. No b&w photos used. **Pays on acceptance.** Buys one-time rights. Previously published work OK.

Tips: Prefers to see "rural scenics, in various seasons; emphasis on farm women, ranch women, country women and their families; slides appropriately simple for use with poems or as accents to inspirational, reflective essays, etc."

℔ THE COVENANT COMPANION, 5101 N. Francisco Ave., Chicago IL 60625. (773)784-3000. E-mail: covcom@compuserve.com. Editor: Donald L. Meyer. Managing Editor: Jane K. Swanson-Nystrom. Art Director: David Westerfield. Circ. 20,000. Monthly denominational magazine of The Evangelical Covenant Church. Emphasizes "gathering, enlightening and stimulating the people of our church and keeping them in touch with their mission and that of the wider Christian church in the world."

Needs: Mood shots of home life, church life, church buildings, nature, commerce and industry and people. Also uses fine art, scenes, city life, etc.

Making Contact & Terms: "We need to keep a rotating file of photos for consideration." Send 5×7 and 8×10 glossy prints; color slides for cover only. Also accepts digital images in TIFF files. Send via Compact or floppy disk. SASE. Pays $25/b&w photo; $50-75/color cover. Pays within 2 months of publication. Credit line given. Buys one-time rights. Simultaneous submissions OK.

Tips: "Give us photos that illustrate life situations and moods. We use b&w photos which reflect a mood or an aspect of society—wealthy/poor, strong/weak, happiness/sadness, conflict/peace. These photos or

illustrations can be of nature, people, buildings, designs and so on. Give us a file from which we can draw."

CRC PRODUCT SERVICES, 2850 Kalamazoo Ave SE, Grand Rapids MI 49560. (616)246-0780. Fax: (616)246-0834. E-mail: heetderd@crcna.org. Art Acquisition: Dean Heetderks. Publishes numerous magazines with various formats. Emphasizes living the Christian life. Readers are Christians ages 35-85. Photo guidelines free with SASE.
Needs: Uses 6-8 photos/issue; all supplied by freelancers. Needs photos of people, holidays and concept. Reviews photos purchased with or without a ms. Special photo needs include real people doing real activities: couples, families. Model/property release required. Captions preferred.
Making Contact & Terms: Provide résumé, business card, brochure, flier or tearsheets to be kept on file for possible assignments. Send any color or b&w prints; 35mm, 2¼×2¼, 4×5, 8×10 transparencies; digital format. Keeps samples on file. Cannot return material. Reports in 1-2 weeks. Pays $300-600/color cover; $200-400/b&w cover; $200-300/color inside; $200-300/b&w inside. **Pays on acceptance**. Buys one-time and electronic rights. Simultaneous submissions and/or previously published work OK.

THE CREAM CITY REVIEW, University of Wisconsin-Milwaukee, English Dept., Box 413, Milwaukee WI 53201. (414)229-4708. Art Director: Laurie Buman. Circ. 2,000. Estab. 1975. Biennial journal. Emphasizes literature. Sample copy $5. Photo guidelines free with SASE.
Needs: Uses 6-20 photos/issue; most supplied by freelancers. Needs photos of fine art and other works of art. Captions preferred.
Making Contact & Terms: Interested in reviewing work from newer, lesser-known photographers. Send unsolicited photos by mail for consideration. Send all sizes b&w and color prints; 35mm, 2¼×2¼, 4×5, 8×10 transparencies. SASE. Reports in 2 months. Pays complimentary copies and/or subscription. Credit line given. Buys one-time rights. Simultaneous submissions and/or previously published work OK.
Tips: "We currently receive very few unsolicited submissions, and would like to see more. Though our primary focus is literary, we are dedicated to producing a visually exciting journal. The artistic merit of submitted work is important. We have been known to change our look based on exciting work submitted. Take a look at *Cream City Review* and see how we like to look. If you have things that fit, send them."

N CRUISE TRAVEL, 990 Grove St., Evanston IL 60201. (708)491-6440. Managing Editor: Charles Doherty. Circ. 200,000. Estab. 1979. Bimonthly magazine. Emphasizes cruise ships, ports, vacation destinations, travel tips, ship history. Readers are "those who have taken a cruise, plan to take a cruise, or dream of taking a cruise." Sample copy $5 postpaid. Photo guidelines free with SASE.
Needs: Uses about 50 photos/issue; 75% supplied by freelance photographers. Needs ship shots, interior/exterior, scenic shots of ports, shopping shots, native sights, etc. Photos rarely purchased without accompanying ms. Model release preferred. Captions required.
Making Contact & Terms: Query with samples. "We are not seeking overseas contacts." Uses color prints; 35mm (preferred), 2¼×2¼, 4×5, 8×10 transparencies. SASE. Reports in 2 weeks. Pays variable rate for color cover; $25-150/color inside; $200-500/text/photo package for original work. **Pays on acceptance** or publication; depends on package. Credit line usually given, depends on arrangement with photographer. Buys one-time rights. Simultaneous submissions and previously published work OK.
Tips: "We look for bright, colorful travel slides with good captions. Nearly every purchase is a photo/text package, but good photos are key. We prefer 35mm originals for publication, all color."

CRUISING WORLD MAGAZINE, 5 John Clark Rd., Newport RI 02840. (401)847-1588. Fax: (401)848-5048. Art Director: William Roche. Circ. 130,000. Estab. 1974. Emphasizes sailboat maintenance, sailing instruction and personal experience. For people interested in cruising under sail. Sample copy free for 9×12 SAE.
Needs: Buys 25 photos/year. Needs "shots of cruising sailboats and their crews anywhere in the world. Shots of ideal cruising scenes. No identifiable racing shots, please." Also wants exotic images of cruising sailboats, people enjoying sailing, tropical images, different perspectives of sailing, good composition, bright colors. For covers, photos "must be of a cruising sailboat with strong human interest, and can be located anywhere in the world." Prefers vertical format. Allow space at top of photo for insertion of logo. Model release preferred. Property release required. Captions required; include location, body of water, make and model of boat.
Making Contact & Terms: Interested in receiving work from newer, lesser-known photographers "as long as their subjects are marine related." Send 35mm color transparencies. "We rarely accept miscellaneous b&w shots and would rather they not be submitted unless accompanied by a manuscript." For cover, "submit original 35mm slides. *No* duplicates. Most of our editorial is supplied by author. We look for good color balance, very sharp focus, the ability to capture sailing, good composition and action. Always looking

for *cover shots."* Reports in 2 months. Pays $50-300/color inside; $500/color cover. Pays on publication. Credit line given. Buys all rights, but may reassign to photographer after publication; first North American serial rights; or one-time rights.

CUPIDO, % Red Alder Books, P.O. Box 2992, Santa Cruz CA 95063. (408)426-7082. Fax: (408)425-8825. E-mail: eronat@aol.com. Photo Representative: David Steinberg. Circ. 60,000. Estab. 1984. Monthly magazine. Emphasizes quality erotica. Sample copy $10 (check payable to Red Alder Books).
Needs: Uses 50 photos/issue. Needs quality erotic and sexual photography, visually interesting, imaginative, showing human emotion, tenderness, warmth, humor OK, sensuality emphasized. Reviews photos only (no manuscripts, please).
Making Contact & Terms: Contact through rep or arrange personal interview to show portfolio or submit portfolio for review. Query with stock photo list or send unsolicited photos by mail for consideration. Send 8 × 10 or 11 × 14 b&w, color prints; 35mm, 2¼ × 2¼, 4 × 5, 8 × 10 transparencies. Keeps samples on file. SASE. Reports in 1 month. Pays $500-800/color cover; $60-90/color or b&w inside. Pays on publication. Credit line given. Buys one-time rights. Simultaneous submissions and/or previously published work OK.
Tips: "Not interested in standard, porn-style photos. Imagination, freshness, emotion emphasized. Glamor OK, but not preferred."

🆖 🔧 CURAÇAO NIGHTS, (The Island's premiere lifestyle and travel magazine), 1831 René Levesque Blvd. W., Montreal, Quebec H3H 1R4 Canada. (514)931-1987. Fax: (514)931-6273. E-mail: nights@odyssee.net. Office Coordinator: Zelly Zuskin. Circ. 155,000. Estab. 1991. Yearly tourist guide of where to eat, sleep, dance etc. in Curaçao.
Needs: Buys 30 photos/year. Needs travel photos of Curaçao—beaches, water, sun etc. Reviews photos with or without ms. Model release required; property release required for private homes. Photo caption required; include exact location.
Making Contact & Terms: Send query letter with tearsheets. Art director will contact photographer for portfolio review if interested. Uses 4 × 5 matte color, b&w prints; 35mm, 2¼ × 2¼, 4 × 5, 8 × 10 transparencies. Keeps samples on file. Reports back only if interested; send non-returnable samples. Pays $250-400 for color; $50 maximum for color. **Pays on acceptance.** Credit line given. Buys one-time rights. Simultaneous submissions and/or previously published work OK.

🆖 CURIO, P.O. Box 522, Bronxville NY 10708-0522. (914)961-8649. E-mail: qenm20b@prodigy.com. Publisher: M. Teresa Lawrence. Circ. 50,000. Estab. 1996. Quarterly consumer magazine. *"Curio* is a quarterly publication that features lively coverage and analysis of arts, politics, health, entertainment and lifestyle issues. The magazine, as a whole, is best described as a salon; a place where people come to exchange ideas." Sample copy for $6. Art guidelines for SASE. "Specific guidelines apply for specific sections in the magazine. Artists are strongly suggested to query with SASE first."
Needs: Buys 50-200 photos/year. Specifically interested in photo-essays. Reviews photos with or without a ms. Model release is required. Photo captions required.
Making Contact & Terms: Provide résumé, business card, self-promotion piece or tearsheets to be kept on file for possible future assignments or "send complete 6-page photo layout for review and/or acceptance (color copies of layouts are fine for initial review)." Art director will contact photographer for portfolio review if interested. Portfolio should include b&w and/or color prints, tearsheets, transparencies. Accepts images in digital format for Mac on Quark. Send via Zip disk, floppy disk or JAZZ. "Six-page photo essay may be submitted via Zip disk (133 line screen 300 maximum density for scanning)." Keeps samples on file. Reports in 2 months on queries. Reports back only if interested, send non-returnable samples. Pays $140 max for individual photos; $250-500 per photo shoot; $300 flat fee for 6-page photo essay; $50 extra is paid for electronic usage. Pays on publication. Buys first rights, electronic rights. Simultaneous submissions and previously published work OK. Provides summer and winter photography internships.
Tips: "I want to see variety, passion and edgy attitude in the work."

CYCLE WORLD MAGAZINE, Dept. PM, 1499 Monrovia Ave., Newport Beach CA 92663. (714)720-5300. Editor-in-Chief: David Edwards. VP/Editorial Director: Paul Dean. Monthly magazine. Circ. 310,000. For active motorcyclists who are "young, affluent, educated and very perceptive."
Needs: "Outstanding" photos relating to motorcycling. Buys 10 photos/issue. Prefers to buy photos with mss. For Slipstream column see instructions in a recent issue.
Making Contact & Terms: Buys all rights. Send photos for consideration. Pays on publication. Reports in 6 weeks. SASE. Send 8 × 10 glossy prints. "Cover shots are generally done by the staff or on assignment." Uses 35mm color transparencies. Pays $50-200/b&w, color photos.
Tips: Prefers to buy photos with mss. "Read the magazine. Send us something good. Expect instant harsh

rejection. If you don't know our magazine, don't bother us."

DAKOTA OUTDOORS, P.O. Box 669, Pierre SD 57501. (605)224-7301. Fax: (605)224-9210. E-mail: dakdoor@aol.com. Website: http://www.capjournal.com/dakoutdoors. Managing Editor: Rachel Engbrecht. Circ. 7,000. Estab. 1978. Monthly magazine. Emphasizes hunting and fishing in the Dakotas. Readers are sportsmen interested in hunting and fishing, ages 35-45. Sample copy free for 9×12 SAE and 3 first-class stamps. Photo guidelines free with SASE.
- All photos for *Dakota Outdoors* are scanned and reproduced digitally. They now store photos on CD and do computer manipulation.
Needs: Uses 15-20 photos/issue; 8-10 supplied by freelancers. Needs photos of hunting and fishing. Reviews photos with or without ms. Special photo needs include: scenic shots of sportsmen. Model/property release required. Captions preferred.
Making Contact & Terms: Send 3×5 b&w prints; 35mm b&w transparencies by mail for consideration. Accepts images in digital format for Mac. Send via Zip disk. Keeps samples on file. SASE. Reports in 3 weeks. Pays $50-150/b&w cover; $5-50/b&w inside; payment negotiable. Pays on publication. Credit line given. Usually buys one-time rights; negotiable.
Tips: "We want good quality outdoor shots, good lighting, identifiable faces, etc.—photos shot in the Dakotas. Use some imagination and make your photo help tell a story. Photos with accompanying story are accepted."

DANCING USA, 10600 University Ave. NW, Minneapolis MN 55448-6166. (612)757-4414. Fax: (612)757-6605. Editor: Patti P. Johnson. Circ. 20,000. Estab. 1982. Bimonthly magazine. Emphasizes romance of ballroom, Latin and swing dance and big bands, techniques, personal relationships, dance music reviews. Readers are male and female, all backgrounds, with ballroom dancing and band interest, age over 45. Sample copy free with 9×12 SAE and 4 first-class stamps.
Needs: Uses 25 photos/issue; 1-3 supplied by freelancers. Prefer action dancing/band photos. Non-dance competitive clothing, showing romance and/or fun of dancing. Model/property release preferred. Captions preferred; include who, what, when, where, how if applicable.
Making Contact & Terms: Send unsolicited photos by mail for consideration. Send 4×5 matte color or b&w prints. Keeps samples on file. SASE. Reports in 1 month. Pays $50-100/color cover; $20/color inside; $10/b&w inside; $10-50/photo/text package. Pays on publication. Credit line given. Buys one-time rights. Simultaneous submissions and previously published work OK.

DAS FENSTER, 1060 Gaines School Rd., B-3, Athens GA 30605. (706)548-4382. Fax: (706)548-8856. Owner/Business Manager: Alex Mazeika. Circ. 18,000. Estab. 1904. Monthly magazine. Emphasizes general topics written in the German language. Readers are German, ages 35 years plus. Sample copy free with SASE.
Needs: Uses 25 photos/issue; 20-25 supplied by freelancers. Needs photos of German scenics, wildlife and travel. Captions preferred.
Making Contact & Terms: Send unsolicited photos by mail for consideration. Send 4×5 glossy b&w prints. Accepts images in digital format for Mac (TIFF). Send via floppy disk or zip disk (266 dpi). Keeps samples on file. SASE. Reports in 3 weeks. Pays $40/b&w page rate. Pays on publication. Credit line given. Buys one-time rights; negotiable. Previously published work OK.

N DECORATIVE ARTIST'S WORKBOOK, F&W Publications, 1507 Dana Ave., Cincinnati OH 45207. (513)531-2690. Fax: (513)531-2902. E-mail: dawedit@aol.com. Editor: Anne Hevener. Circ. 86,000. Estab. 1987. Bimonthly magazine. "How-to magazine for decorative painters. Includes step-by-step projects for a variety of skill levels." Sample copy for $3. "This magazines uses mostly local photographers who can shoot on location in Cincinnati."
Needs: Buys 3-6 photos/year. Specific location shots of home interios.
Making Contact & Terms: Provide résumé, business card, self-promotion piece or tearsheets to be kept on file for possible future assignments. Art director will contact photographer for portfolio review if interested. Uses $2\frac{1}{4} \times 2\frac{1}{4}$, 4×5 transparencies. Does not keep samples on file; include SASE for return of material. Pays $250-350/color inside. **Pays on acceptance.** Credit line given. Buys first rights.

DEER AND DEER HUNTING, 700 E. State St., Iola WI 54990. (715)445-2214. Editor: Pat Durkin. Distribution 200,000. Estab. 1977. 8 issues/year. Emphasizes white-tailed deer and deer hunting. Readers are "a cross-section of American deer hunters—bow, gun, camera." Sample copy and photo guidelines free with 9×12 SAE with 7 first-class stamps.
Needs: Uses about 25 photos/issue; 20 supplied by freelance photographers. Needs photos of deer in natural settings. Model release and captions preferred.

Making Contact & Terms: Query with résumé of credits and samples. "If we judge your photos as being usable, we like to hold them in our file. It is best to send us duplicates because we may hold the photo for a lengthy period." SASE. Reports in 2 weeks. Pays $500/color cover; $50/b&w inside; $75-250/color inside. Pays within 10 days of publication. Credit line given. Buys one-time rights. Simultaneous submissions and previously published work OK.

Tips: Prefers to see "adequate selection of b&w 8×10 glossy prints and 35mm color transparencies, action shots of whitetail deer only as opposed to portraits. We also need photos of deer hunters in action. We are currently using almost all color—very little b&w. Submit a limited number of quality photos rather than a multitude of marginal photos. Have your name on all entries. Cover shots must have room for masthead."

N ☒ **DETECTIVE FILES GROUP**, Globe Publishing, 1350 Sherbrooke St. W., Montreal, Quebec H3G 2T4 Canada. (514)849-7733. Fax: (514)849-7730. Editor-in-Chief: Dominick Merle. Circ. 150,000. Bimonthly consumer magazines of factual detective articles for a general audience. Sample copy free for SAE with IRCs. Art guidelines available.

Needs: Buys 50-80 cover shots. Needs photos of models in crime scenes. Reviews photos with or without ms. Model release required.

Making Contact & Terms: Send query letter with samples. Uses 2¼×2¼ transparencies. Reports in 2 weeks on queries; 6 weeks on samples. Pays $200 minimum for color cover. **Pays on acceptance.** Credit line not given. Buys all rights.

N **DIRT RAG**, AKA Productions, 181 Saxonburg Rd., Pittsburgh PA 15238. (412)767-9910. Fax: (412)767-9920. E-mail: dirtrag@dirtragmag.com. Website: http://www.dirtragmag.com. Circ. 32,000. Estab. 1989. Published every 6 weeks from February-November. "Mountain bike lifestyle magazine. Focus is the sport of mountain biking, but we do also cover music, beer, movies and books." Sample copies and art guidelines are available with SAE and first-class postage.

Needs: Buys 2 photos from freelancers/issue; 14 photos/year. Needs photos of mountain biking. Reviews photos with or without ms. Special photo needs include 4-color cover shots. Model release required. Photo caption preferred.

Making Contact & Terms: "Send in what you have and we'll take a look." Deadlines: "Send photos anytime, we'll use them as we get them." Keeps samples on file; include SASE for return of material. Reports back only if interested. Pays $350 minimum for color cover; $25-100 for b&w or color inside. Pays on publication. Credit line given. Buys one-time rights. Simultaneous submissions and/or previously published work OK.

Tips: "Check out our magazine. It's different. We try and have a certain style. A little off center. Leave space for the logo in upper left corner on cover shots. We stay away from rad, extreme stuff."

THE DIVER, Dept. PM, P.O. Box 28, Saint Petersburg FL 33731-0028. (813)866-9856. Publisher/Editor: Bob Taylor. 6 issues/year. Emphasizes springboard and platform diving. Readers are divers, coaches, officials and fans. Circ. 1,500. Sample copy $2 with 9×12 SAE and 4 first-class stamps.

Needs: Uses about 10 photos/issue; 30% supplied by freelance photographers. Needs action shots, portraits of divers, team shots and anything associated with the sport of diving. Special needs include photo spreads on outstanding divers and tournament coverage. Captions required.

Making Contact & Terms: Send 4×5 or 8×10 prints by mail for consideration; "simply query about prospective projects." SASE. Reports in 1 month. Pays $35/cover photo; $5-15/inside photo; $75 for text/photo package. Pays on publication. Credit line given. Buys one-time rights. Simultaneous submissions and previously published work OK.

Tips: "Study the field; stay busy."

DIVERSION MAGAZINE, 1790 Broadway, 6th Floor, New York NY 10019. (212)969-7542. Fax: (212)969-7557. Photo Editor: Ericka Camastro. Circ. 176,000. Monthly magazine. Emphasizes travel. Readers are doctors/physicians. Sample copy free with SASE.

Needs: Uses varying number of photos/issue; all supplied by freelancers. Needs a variety of subjects, "mostly worldwide travel. Hotels, restaurants and people." Model/property release preferred. Captions preferred; include precise locations.

Making Contact & Terms: Query with list of stock photo subjects. Keeps samples on file. SASE. Reports in 3 weeks. Pays $350/color cover; $135/quarter color page inside; $225/color full page rate; $200-250/day. Pays on publication. Credit line given. Buys one-time rights. Simultaneous submissions and/or previously published work OK.

Tips: "Send updated stock list and photo samples regularly."

DOG & KENNEL, 7-L Dundas Circle, Greensboro NC 27407. (336)292-4047. Fax: (336)292-4272. Executive Editor: Rita Davis. Managing Editor: Karen McCullough. Bimonthly magazine about dogs. "Articles include breed profiles, stories about special dogs, dogs in art and popular culture, etc." Sample copy for $5 and 9×12 SASE. Photo guidelines free with SASE.
Needs: Photos of dogs, posed, candid and interacting with other dogs and people. Captions required, include the breed name and additional descriptions as needed.
Making Contact & Terms: Send unsolicited photos by mail for consideration, "but please include SASE if you want them returned. Please send duplicates. We cannot assume liability for unsolicited originals." Transparencies or slides preferred. Glossy prints acceptable. Reports in 2 months. Pays $150-250/color cover; $25-50/color inside. Pays on publication. Buys all rights, negotiable.
Tips: "We seek good composition (indoor or outdoor). Photos must be professional and of publication quality—good focus and contrast. We work regularly with a few excellent freelancers, but are always seeking new contributors. Pictures we think we might be able to use will be scanned into our CD-ROM file and the originals returned to the photographer."

THE DOLPHIN LOG, Box 112, 61 E. Eighth St., New York NY 10003. (212)673-9097. Fax: (212)673-9183. E-mail: cousteauny@aol.com. Editor: Lisa Rao. Circ. 80,000. Estab. 1981. Publication of The Cousteau Society, Inc., a nonprofit organization. Bimonthly magazine. Emphasizes "ocean and water-related subject matter for children ages 8 to 12." Sample copy $2.50 with 9×12 SAE and 3 first-class stamps. Photo guidelines free with SASE.
Needs: Uses about 20 photos/issue; 2-6 supplied by freelancers; 10% stock. Needs "selections of images of individual creatures or subjects, such as architects and builders of the sea, how sea animals eat, the smallest and largest things in the sea, the different forms of tails in sea animals, resemblances of sea creatures to other things. Also excellent potential for cover shots or images which elicit curiosity, humor or interest." No aquarium shots. Model release required if person is recognizable. Captions preferred, include when, where and, if possible, scientifically accurate identification of animal.
Making Contact & Terms: Query with samples or list of stock photos. Send 35mm, 4×5 transparencies or b&w contact sheets by mail for consideration. Send duplicates only. SASE. Reports in 1 month. Pays $50-200/color photo. Pays on publication. Credit line given. Buys one-time rights and worldwide translation rights. Simultaneous and previously published submissions OK.
Tips: Prefers to see "rich color, sharp focus and interesting action of water-related subjects" in samples. "No assignments are made. A large amount is staff-shot. However, we use a fair amount of freelance photography, usually pulled from our files, approximately 45-50%. Stock photos purchased only when an author's sources are insufficient or we have need for a shot not in file. These are most often hard-to-find creatures of the sea." To break in, "send a good submission of dupes in keeping with our magazine's tone/content; be flexible in allowing us to hold slides for consideration."

DOUBLETAKE MAGAZINE, 1317 W. Pettigrew St., Durham NC 27705. (919)660-3669. Fax: (919)660-3668. E-mail: dtmag@aol.com. Website: http://www.duke.edu/doubletake/. Assistant Editor: Caroline Nasrallah. Circ. 45,000. Estab. 1995. Quarterly magazine covering all writing (fiction, nonfiction and poetry) and photography, mostly documentary. General interest, 18 and over. Sample copy for $12. Photo guidelines free with SASE.
Needs: Uses photos on approximately half of the pages (50+ pages/issue); 95% supplied by freelancers. Needs completed photo essays. "We also accept works in progress. We are interested in work that is in the broad photo-journalistic/humanistic tradition." Model release preferred for children. Captions preferred.
Making Contact & Terms: Send unsolicited photos by mail for consideration. Send SASE for guidelines. "We prefer copy slides, no more than 40." Send 35mm transparencies. "We have an ongoing review process. We do not keep samples from every photographer." SASE. Reports in 8-9 weeks usually (varies). Pays $250/full published page; $125/half page; etc. Minimum is $75. Pays on publication. Credit line given. Buys first North American serial rights. Simultaneous submissions OK.

**FOR EXPLANATIONS OF THESE SYMBOLS,
SEE THE INSIDE FRONT AND BACK COVERS OF THIS BOOK.**

DOWN BEAT MAGAZINE, Dept. PM, Jazz Blues & Beyond, 102 N. Haven Rd., Elmhurst IL 60126. (630)941-2030. Editorial Director: Frank Alkyer. Monthly. Emphasizes jazz musicians. Circ. 90,000. Estab. 1934. Sample copy available for SASE.
Needs: Uses about 30 photos/issue; 95% supplied by freelancers. Needs photos of live music performers/posed musicians/equipment, "primarily jazz and blues." Captions preferred.
Making Contact & Terms: Query with list of stock photo subjects; send 8×10 b&w prints; 35mm, $2\frac{1}{4} \times 2\frac{1}{4}$, 4×5, 8×10 transparencies; b&w or color contact sheets by mail. Unsolicited samples for consideration will not be returned unless accompanied by SASE. Provide résumé, business card, brochure, flier or tearsheets to be kept on file for possible future assignments. "Send us two samples of your best work and a list of artists photographed." Reports only when needed. Pays $35/b&w photo; $75/color photo; $175/complete job. Credit line given. Buys one-time rights. Simultaneous submissions and previously published work OK.
Tips: "We prefer live shots and interesting candids to studio work."

N ⊕ DRIVING MAGAZINE, Safety House, Beddington Farm Rd., Croydon CR0 4XZ United Kingdom. Phone: (44)181 665 5151. Fax: (44)181 665 5565. E-mail: driving@atlas.co.uk. Estab. 1979. Monthly magazine.
Needs: Buys 6 photos from freelancers/issue. Needs photos with "road safety themes—serious accidents but . . . numerous pix of traffic signs etc." Reviews photos with or without ms. Property release preferred. Photo caption preferred.
Making Contact & Terms: Provide résumé, business card, self-promotion piece or tearsheets to be kept on file for possible future assignments. Uses color prints. Keeps samples on file; cannot return material. Pays £10 minimum for color inside. Pays on publication. Buys one-time rights. Simultaneous submissions OK.
Tips: "Put your name and address on back of all submitted material."

DUCKS UNLIMITED, One Waterfowl Way, Memphis TN 38120. (901)758-3825. Managing Editor: Diane Jolie. Circ. 580,000. Estab. 1937. Association publication of Ducks Unlimited, a nonprofit organization. Bimonthly magazine. Emphasizes waterfowl conservation. Readers are professional males, ages 40-50. Sample copy $3. Guidelines free with SASE.
Needs: Uses approximately 140 photos/issue; 60% supplied by freelance photographers. Needs images of wild ducks and geese, waterfowling and scenic wetlands. Special photo needs include dynamic shots of waterfowl interacting in natural habitat.
Making Contact & Terms: Send only top quality portfolio of not more than 40 35mm or larger transparencies for consideration. SASE. Reports in 1 month. Pays $100 for images less than half page; $125/half page; $150/full page; $225/2-page spread; $400/cover. **Pays on acceptance.** Credit line given. Buys one-time rights plus permission to reprint in our Mexican and Canadian publications. Previously published work OK, if noted.

E MAGAZINE, 28 Knight St., Norwalk CT 06851. (203)854-5559. Fax: (203)866-0602. E-mail: emagazine@prodigy.net. Photo Editor: Tracey Rembert. Circ. 50,000. Estab. 1990. Nonprofit consumer magazine. Emphasizes environmental issues. Readers are environmental activists; people concerned about the environment. Sample copy for 9×12 SAE and $5. Photo guidelines free with SASE.
Needs: Uses 42 photos/issue; 55% supplied by freelancers. Needs photos of threatened landscapes, environmental leaders, people and the environment, pollution, transportation, energy, wildlife and activism. Photo captions required: location, identities of people in photograph, date, action in photograph.
Making Contact & Terms: Query with résumé of credits and list of stock photo subjects. Keeps printed samples on file. Reports in 6 weeks. Pays free—$150/color photo; negotiable. Pays several weeks after publication. Credit line given. Buys one-time rights. Simultaneous submissions and previously published work OK.
Tips: Wants to see "straightforward, journalistic images. Abstract or art photography or landscape photography is not used." In addition, "please do not send manuscripts with photographs. These can be addressed as queries to the managing editor."

EARTH MAGAZINE, 21027 Crossroads Circle, Waukesha WI 53186-4055. (414)796-8776. Fax: (414)798-6468. E-mail: dpinkalla@earthmag.com. Website: http://www.earthmag.com. Editorial Assistant: Diane Pinkalla. Circ. 90,000. Estab. 1992. Bimonthly magazine. Emphasizes earth science for general audience. Sample copy $6.95 ($3.95 plus $3 shipping and handling). Photo guidelines free with SASE for amateurs.
Needs: Uses 70 photos/issue; 25% supplied by freelancers. Needs photos of earth science: landforms, air

and water phenomena, minerals, fossils, researchers at work, geologic processes. Model/property release preferred. Captions required; include location, feature and date.

Making Contact & Terms: Send stock list and samples for file. Accepts images in digital format for Mac. Send by e-mail or via Zip disk. Pays $25-200/color or b&w inside. Pays on publication. Credit line given. Buys one-time rights. Previously published work OK.

Tips: Wants to see excellent technical quality in photos of real earth science, not just pretty pictures.

EASTERN CHALLENGE, P.O. Box 14866, Reading PA 19612-4866. (610)375-0300. Fax: (610)375-6862. E-mail: ec@imi.org. Co-Editors: Nancy Maurer and Byron Barnshaw. Circ. 22,000. Estab. 1967. Publication of the International Missions, Inc. Quarterly magazine. Emphasizes "church-planting ministry in a number of countries." Sample copy free with SASE.

Needs: Uses 2 + photos/issue. Needs photos of scenics and personalties. Reviews photos with or without accompanying ms. Model/property release preferred. Captions preferred.

Making Contact & Terms: Send unsolicited photos by mail for consideration. Provide résumé, business card, brochure, flier or tearsheets to be kept on file for possible assignments. Accepts images in digital format for Windows (TIFF, GIF, JPEG). Send via compact disc, floppy disk, SyQuest, Zip disk. Keeps samples on file. SASE. Reports in 1 month. Pays "minimal or nominal amount; organization is nonprofit." Pays on publication. Credit line given. Buys all rights; negotiable. Simultaneous submissions and/or previously published work OK.

Tips: Looks for "color and contrast; relevance to program of organization."

EDUCATIONAL LEADERSHIP MAGAZINE, 1250 N. Pitt St., Alexandria VA 22314. (703)549-9110, ext. 430. Fax: (703)299-8637. E-mail: judiconnelly@ascd@ccmail.ascd.org. Designer: Judi Connelly. Circ. 190,000. Publication of the Association for Supervision and Curriculum Development. Magazine; 8 issues/year. Emphasizes schools and children, especially grade school and high school levels, classroom activities. Readers are teachers and educators worldwide.

Needs: Uses 30-40 photos/issue; all supplied by freelancers. Model release required. Property release preferred. Captions preferred.

Making Contact & Terms: Provide résumé, business card, brochure, flier or tearsheets to be kept on file for possible future assignments. Send all size glossy b&w prints; 35mm, 2¼ × 2¼, 4 × 5 transparencies. Accepts images in digital format for Photoshop. Send via compact disc, floppy disk, SyQuest. Keeps samples on file. Cannot return material. Reports in 3 weeks. Pays $50/b&w photo; $100/color photo; $400/day minimum. Pays on publication. Buys one-time rights. Simultaneous submissions and previously published work OK.

N: THE ELKS MAGAZINE, 425 W. Diversey Pkwy., Chicago IL 60614-6196. (773)528-4500. E-mail: elksmag@elks.org. Website: http://www.elksmag.com. Associate Editor: Peter Milne. Circ. 1.2 million. Estab. 1922. Monthly magazine whose mission is to provide news of Elks to all 1.2 million members. "In addition, we have general interest articles. Themes: Americana; history; wholesome, family info; sports; industries; adventure. We do not cover religion, politics, controversial issues." Sample copy free.

Needs: Buys 1 photo from freelancers/issue; 12 photos/year. Needs photos of nature—for covers only. Reviews photos with or without ms. Photo caption required; include facts only: Location of photo.

Making Contact & Terms: Send query letter with samples, brochure. Uses 35mm, 2¼ × 2¼, 4 × 5, 8 × 10 transparencies. Does not keep samples on file. Reports in 6-8 weeks on queries. Pays $450-500 for color cover. **Pays on acceptance.** Credit line given. Buys one-time rights. Simultaneous submissions OK.

Tips: "Just send your slides of nature (landscape or rural scenes, woodland animals). We will review them as soon as possible and return those we don't purchase. Artistry and technical excellence are as important as subject matter."

ENERGY TIMES, 548 Broad Hollow Rd., Melville NY 11747. (516)777-7773. Fax: (516)755-1064. Art Director: Ed Canavan. Circ. 600,000. Estab. 1992. Published 10 times/year. Emphasizes health food industry. Readers are 72% female, 28% male, average age 42.3, interested in supplements and alternative health care, exercise 3.2 times per week. Sample copy $1.25.

Needs: Uses 25 photos/issue; 5 supplied by freelancers. Needs photos of herbs, natural lifestyle, food. Model/property release required. Captions preferred.

Making Contact & Terms: Provide résume, business card, brochure, flier or tearsheets to be kept on file for possible assignments. Deadlines ongoing. Keeps samples on file. SASE. Reports in 2 weeks. Pays $275/color cover; $85/color inside; "inside rates negotiable based on size." Pays on publication. Rights negotiable. Previously published work OK.

Tips: "Photos must clearly illustrate the editorial context. Photos showing personal energy are highly regarded. Sharp, high-contrast photos are the best to work with. Bright but non-tacky colors will add

vibrance to a publication. When shooting people, the emotion captured in the subject's expression is often as important as the composition."

[N] **ENTREPRENEUR**, Dept. PM, 2392 Morse Ave., Irvine CA 92614. (714)261-2325. Fax: (714)755-4211. E-mail: rricardo@entrepreneurmag.com. Website: http://www.entrepreneurmag.com. Photo Editor: Rachelle Ricardo. Publisher: Lee Jones. Editor: Rieva Lesonsky. Design Director: Richard R. Olson. Circ. 435,000. Estab. 1977. Monthly. Emphasizes business. Readers are existing and aspiring small business owners.

Needs: Uses about 30 photos/issue; many supplied by freelance photographers; 60% on assignment; 40% from stock. Needs "people at work: home office, business situations. I want to see colorful shots in all formats and styles." Model/property release preferred. Captions required; include names of subjects.

Making Contact & Terms: Arrange a personal interview to show portfolio. Query with sample or list of stock photo subjects. Provide résumé, business card, brochure, flier or tearsheets to be kept on file for possible future assignments; "follow-up for response." Accepts images in digital format for Mac. Send via compact, Zip or floppy disk, SyQuest or online (300 dpi). Pays $75-200/b&w photo; $250-350/color photo; $125-225/color stock. Pays "depending on photo shoot, per hour or per day. We pay $350-400 plus all expenses for assignments." Pays on publication. Credit line given. Buys one-time rights; negotiable.

Tips: "I am looking for photographers who use the environment creatively; I do not like blank walls for backgrounds. Lighting is also important. I prefer medium format for most shoots. I think photographers are going back to the basics—a good clean shot, different angles and bright colors. I am extremely tired of a lot of motion-blurred effect with gelled lighting. I prefer examples of your work—promo cards and tearsheets along with business cards and résumés. Portfolios are always welcome."

[N] **[globe]** **EOS MAGAZINE**, Robert Scott Associates, The Old Barn, Ball Lane, Tackley, Kidlington, Oxfordshire 0X5 3AG United Kingdom. Phone: (+44)(0)1869 331741. Fax: (+44)(0)1869 331641. E-mail: robert.scott@eos-magazine.com. Website: http://www.eos-magazine.com. Publisher: Robert Scott. Circ. 18,400. Estab. 1993. Quarterly consumer magazine for all users of Canon EOS cameras. Art guidelines free.

Needs: Buys 100 photos from freelancers/issue; 400 photos/year. Needs photos showing use of or techniques possible with EOS cameras and accessories. Reviews photos with or without ms. Model release preferred. Photo caption required; include technical details of photo equipment and techniques used.

Making Contact & Terms: Send query letter with samples. Uses 8×10 glossy color and b&w prints; 35mm transparencies. Accepts images in digital format. Keeps samples on file; include SASE for return of material. Reports in 1 week on queries; 2 weeks on samples. Pays $75 for color cover; $15-45 for b&w or color inside. Pays extra for electronic usage of photos. Pays on publication. Credit line given. Buys one-time rights. Simultaneous submissions and/or previously published work OK.

Tips: "Request our 'Notes for Contributors' leaflet."

[N] **[globe]** **EVA MAGAZINE**, IPC, Kings Reach Tower, Stamford St., London ST10 8PA England. Phone: 011 44 171 261 6062. Fax: 011 44 171 261 6442. Picture Editor: Vanessa Colls. Circ. 200,000. Woman's weekly magazine for 18-25 year olds. Sample copies free.

Needs: Needs photos of lifestyles, relationships and celebrities. Reviews photos with or without ms. Special photo needs include more relationship photos. Model release preferred. Photo caption required.

Making Contact & Terms: Provide résumé, business card, self-promotion piece or tearsheets to be kept on file for possible future assignments. Picture editor will contact photographer for portfolio review if interested. Portfolio should include b&w and/or color, prints, tearsheets or transparencies. Uses 35mm transparencies. Accepts images in digital format. Deadlines are very tight. Does not keep samples on file; include SASE for return of material. Reports back only if interested. Pays $300-600 for color cover; $100-250 for color inside. Pays on publication. Credit line given. Buys one-time rights, all rights; negotiable. Previously published work OK.

Tips: "We want classy, well lit, creative, sensitive pictures. Always see magazine first. Photographers should always caption and don't over or undershoot. Pictures must be to deadlines."

FACES: The Magazine About People, Cobblestone Publishing Inc., 7 School St., Peterborough NH 03458. (603)924-7209. Fax: (603)924-7380. Editor: Elizabeth Crooker. Circ. 13,500. Estab. 1984. 9 issues/year, September-May. Emphasizes cultural anthropology for young people ages 8-14. Sample copy $4.50 with 8×11 SASE and 5 first-class stamps. Photo guidelines free with SASE.

Needs: Uses about 30-35 photos/issue; about 75% supplied by freelancers. "Photos (color) for text must relate to themes; cover photos (color) should also relate to themes." Send SASE for themes. Photos purchased with or without accompanying ms. Model release preferred. Captions preferred.

Making Contact & Terms: Query with stock photo list and/or samples. SASE. Reports in 1 month.

Pays $25-100/inside use; cover (color) photos negotiated. Pays on publication. Credit line given. Buys one-time rights. Simultaneous submissions and previously published work OK.
Tips: "Photographers should request our theme list. Most of the photographs we use are of people from other cultures. We look for an ability to capture people in action—at work or play. We primarily need photos showing people, young and old, taking part in ceremonies, rituals, customs and with artifacts and architecture particular to a given culture. Appropriate scenics and animal pictures are also needed. All submissions must relate to a specific future theme."

FAMILY CIRCLE, Gruner & Jahr USA Publishing, 375 Lexington Ave., New York NY 10017. (212)499-2000. *Family Circle* is written for contemporary women, providing information on issues ranging from financial planning to food, from health to beauty and fashion to planning the perfect family outing. This magazine did not respond to our request for information. Query before submitting.

FAMILY MOTOR COACHING, Dept. PM, 8291 Clough Pike, Cincinnati OH 45244. (513)474-3622. Editor: Pamela Wisby Kay. Circ. 104,000. Estab. 1963. Publication of Family Motor Coach Association. Monthly. Emphasizes motor homes. Readers are members of national association of motor home owners. Sample copy $2.50. Writer's/photographer's guidelines free with SASE.
Needs: Uses about 45-50 photos/issue; 40-45 supplied by freelance photographers. Each issue includes varied subject matter—primarily needs travel and scenic shots and how-to material. Photos purchased with accompanying ms only. Model release preferred. Captions required.
Making Contact & Terms: Query with résumé of credits. SASE. Reports in 2 months. Pays $100-500/text/photo package. **Pays on acceptance.** Credit line given if requested. Prefers first North American rights, but will consider one-time rights on photos *only.*

FAMILY PUBLISHING GROUP, INC., 141 Halstead Ave., Mamaroneck NY 10543. (914)381-7474. Fax: (914)381-7672. E-mail: editor@familygroup.com. Senior Editor: Betsy F. Woolf. Circ. 155,000. Estab. 1986. Monthly magazine. Emphasizes parenting. Readers are women, ages 25-50. Sample copy $3.50 with 8½×11 SASE.
● This publisher produces *New York Family, Westchester Family, Connecticut Family, Baby Guide* and *Can't Live Without It.*
Needs: Uses 10 photos/issue; 3-5 supplied by freelancers. Needs photos of children, families, depends on subject. Model release required. Photographers need to identify subjects on occasion, but rarely need captions.
Making Contact & Terms: Query with stock photo list. Provide résumé, business card, brochure, flier or tearsheets to be kept on file for possible assignments. Send 5×7 matte or glossy color and b&w prints; digital format (Mac disc). Deadlines: 6 weeks prior to date of publication. Reporting time varies. Pays $40-60/color inside; $25-40/b&w inside. Pays on publication. Credit line given. Buys one-time rights with exclusivity for 2 years within readership area; negotiable.

FARM & COUNTRY, 1 Yonge St., Suite 1504, Toronto, Ontario M5E 1E5 Canada. (416)364-5324. Fax: (416)364-5857. E-mail: agpub@inforamp.net. Website: http://www.agpub.on.ca. Editor: Richard Charteris. Circ. 45,000. Estab. 1935. Magazine published 24 times/year. Emphasizes agriculture. Readers are farmers, ages 20-70. Sample copy free with SASE. Photo guidelines available.
Needs: Uses 50 photos/issue; 5 supplied by freelancers. Needs photos of farm livestock, farmers farming, farm activities. *No rural scenes.* Special photo needs include food processing, shoppers, rural development, trade, politics. Captions preferred; include subject name, location, description of activity, date.
Making Contact & Terms: Submit portfolio for review. Query with résumé of credits. Query with stock photo list. Send unsolicited photos by mail for consideration. Provide résumé, business card, brochure, flier or tearsheets to be kept on file for possible assignments. Send 2¼×2¼ transparencies. Also accepts images in digital format for Mac. Send via online, floppy disk, SyQuest (266 dpi). Published second and fourth Mondays—2 weeks earlier. Keeps samples on file. SASE. Reports in 1 month. Pays $30-50/b&w photo; $50-100/color photo; $20-40/hour; $150-350/job. Pays on publication. Buys all rights; negotiable. Previously published work OK. Offers internships for photographers. Contact Editor: Richard Charteris.
Tips: Looking for "action, color, imaginative angles, vertical. Be able to offer wide range of color—on disk, if possible."

FARM & RANCH LIVING, 5400 S. 60th St., Greendale WI 53129. (414)423-0100. Fax: (414)423-8463. Associate Editor: Trudi Bellin. Estab. 1978. Bimonthly magazine. "Concentrates on farming and ranching as a way of life." Readers are full-time farmers and ranchers. Sample copy $2. Photo guidelines free with SASE.
Needs: Uses about 130 photos/issue; about 20% from freelance stock; 45% assigned. Needs agricultural

and scenic photos. "We assume you have secured releases. If in question, don't send the photos." Captions should include season, location.

Making Contact & Terms: Query with samples or list of stock photo subjects. Send 35mm, 2¼×2¼, 4×5, 8×10 transparencies by mail for consideration. SASE. "We only want to see one season at a time; we work one season in advance." Reports within 3 months. Pays $300/color cover; $75-150/color inside; $150/color page (full-page bleed); $50-100/b&w photo. Pays on publication. Buys one-time rights. Previously published work OK.

Tips: "Technical quality extremely important. Colors must be vivid so they pop off the page. Study our magazines thoroughly. We have a continuing need for sharp, colorful images. Those who supply what we need can expect to be regular contributors."

FELLOWSHIP, Box 271, Nyack NY 10960. (914)358-4601. Fax: (914)358-4924. Editor. Richard Deats. Circ. 8,500. Estab. 1935. Publication of the Fellowship of Reconciliation. Publishes 32-page b&w magazine 6 times/year. Emphasizes peace-making, social justice, nonviolent social change. Readers are people interested in peace, justice, nonviolence and spirituality. Sample copy free with SASE.

Needs: Uses 8-10 photos/issue; 90% supplied by freelancers. Needs stock photos of people, monuments, civil disobedience, demonstrations—Middle East, Latin America, Caribbean, prisons, anti-nuclear, children, farm crisis, gay/lesbian, the former Soviet Union. Also natural beauty and scenic; b&w only. Captions required.

Making Contact & Terms: Provide résumé, business card, brochure, flier or tearsheets to be kept on file for possible future assignments. "Call on specs." SASE. Reports in 3 weeks. Pays $27/b&w cover; $15/b&w inside. Pays on publication. Credit line given. Buys one-time rights. Simultaneous submissions and/or previously published work OK.

Tips: "You must want to make a contribution to peace movements. Money is simply token (our authors contribute without tokens)."

N: THE FIELD, Room 2115, Kings Reach Tower, Stratford St., London SEI QLS United Kingdom. (0171)261-6237. Fax: (0171)261-5358. Art Editor: Rebecca Halstrey. Circ. 31,000. Estab. 1853. Monthly consumer magazine. "Oldest country magazine in England; full color/gloss." Sample copy free. Art guidelines free.

Needs: Needs animals, travel, personalities and events. Reviews photos with or without a ms. Model release required; property release preferred. Photo captions required; include full name of either animal, person or location and date.

Making Contact & Terms: Send query letter with samples. Provide résumé, business card, self-promotion piece or tearsheets to be kept on file for possible future assignments. To show portfolio, photographer should follow-up with call. Art director will contact photographer for portfolio review if interested. Keeps samples on file. Reports back only if interested, send non-returnable samples. Pays on publication. Credit line given. Buys first rights. Simultaneous submissions OK.

Tips: "Read our magazine. Any submission needs to be appropriate."

FINE GARDENING, 63 S. Main St., P.O. Box 5506, Newtown CT 06470. (203)426-8171. Fax: (203)426-3434. Editor: LeeAnne White. Circ. 200,000. Estab. 1988. Bimonthly magazine. Emphasizes gardening. Readers are male and female gardeners, all ages (30-60 mostly). Sample copy $5. Photo guidelines free with SASE.

Needs: Uses 80 photos/issue; 20-30 supplied by freelancers on assignment basis. A few stock photos purchased.

Making Contact & Terms: Contact before sending portfolio for review. If you have an extensive holding of horticultural stock photos, send stock list. Photographers paid day rate upon completion of assignment. Pays $75-500 upon publication for stock photos. Credit line given. Buys one-time rights for stock photos.

FINESCALE MODELER, 21027 Crossroads Circle, P.O. Box 1612, Waukesha WI 53187-1612. (414)796-8776. Fax: (414)796-1383. E-mail: rhayden@finescale.com. Website: http://www.finescale.com. Editor: Bob Hayden. Photo Editor: Paul Boyer. Circ. 80,000. Published 10 times/year. Emphasizes "how-to-do-it information for hobbyists who build nonoperating scale models." Readers are "adult and juvenile hobbyists who build nonoperating model aircraft, ships, tanks and military vehicles, cars and figures." Sample copy $3.95. Photo guidelines free with SASE.

Needs: Uses more than 50 photos/issue; "anticipates using" 10 supplied by freelance photographers. Needs "in-progress how-to photos illustrating a specific modeling technique; photos of full-size aircraft, cars, trucks, tanks and ships." Model release required. Captions required.

Making Contact & Terms: Provide résumé, business card, brochure, flier or tearsheets to be kept on file for possible future assignments. "Phone calls are OK." Reports in 2 months. Pays $25 minimum/color

cover; $8 minimum inside; $40/page; $50-500 for text/photo package. Pays for photos on publication, **for text/photo package on acceptance**. Credit line given. Buys all rights. "Will sometimes accept previously published work if copyright is clear."
Tips: Looking for "sharp contrast prints or slides of aircraft, ships, cars, trucks, tanks, figures, and science-fiction subjects. In addition to photographic talent, must have comprehensive knowledge of objects photographed and provide complete caption material. Freelance photographers should provide a catalog stating subject, date, place, format, conditions of sale and desired credit line before attempting to sell us photos. We're most likely to purchase color photos of outstanding models of all types for our regular feature, 'Showcase.' "

FIRST HAND LTD., P.O. Box 1314, Teaneck NJ 07666. (201)836-9177. Fax: (201)836-5055. E-mail: firsthand3@aol.com. Editor: Bob Harris. Circ. 60,000. Estab. 1980. Monthly digest. Emphasizes gay erotica and stories and letters from readers. Readers are male, gay, wide range of ages. Sample copy $5. Photo guidelines free with SASE.
Needs: Uses 1 photo/issue; all supplied by freelancers. Needs erotic male photographs for covers. "No full-frontal nudity. We especially need photos with an athletic theme." Model release required. "We need proof of age with all model releases, preferably a copy of a driver's license." Captions preferred; include model's name.
Making Contact & Terms: Send unsolicited photos by mail for consideration. Send 35mm transparencies. Does not keep samples on file. Reports in 1 month. Pays $150/color cover. Pays on publication. Credit line given. Buys all rights; negotiable. Previously published work OK.

FLORIDA WILDLIFE, 620 S. Meridian St., Tallahassee FL 32399-1600. (904)488-5563. Fax: (904)488-6988. E-mail: subletd@mail.state.fl.us. Website: http//www.state.fl.us/gfc/. Editor: Dick Sublette. Circ. 29,000. Estab. 1947. Publication of the Florida Game & Fresh Water Fish Commission. Bimonthly magazine. Emphasizes wildlife, hunting, fishing, conservation. Readers are wildlife lovers, hunters and fishermen. Sample copy $3.50. Photo guidelines free with SASE.
Needs: Uses about 20-40 photos/issue; 75% supplied by freelance photojournalists. Needs Florida fishing and hunting, all flora and fauna of Florida; how-to; covers and inside illustration. Do not feature products in photographs. No alcohol or tobacco. Special needs include hunting and fishing activities in Florida scenes; showing ethical and enjoyable use of outdoor resources. "Must be able to ID species and/or provide accurate natural history information with materials." Model release preferred. Captions required; include location and species.
Making Contact & Terms: Query with samples. Send 35mm color transparencies by mail for consideration. "Do not send negatives." SASE. Will consider digital images. Keeps materials on file, or will review and return if requested. Pays $50-75/color back cover; $100/color front cover; $30-75/color inside. Pays on publication. Credit line given. Buys one-time rights; possible use of published photos in low resolution on magazine website. Simultaneous submissions OK "but we prefer originals over duplicates." Previously published work OK but must be mentioned when submitted.
Tips: "Study back issues to determine what we buy from freelancers (no saltwater species as a rule, etc.) Use flat slide mounting pages or individual sleeves. Show us your best. Annual photography contest often introduces us to good freelancers. Rules printed in March-April issue. Contest form must accompany entry; available on Internet or by writing/calling; winners receive honorarium and winning entries are printed in September-October and November-December issues."

FLOWER AND GARDEN MAGAZINE, 4645 Belleview, Kansas City MO 64112. (816)531-5730. Fax: (816)531-3873. Staff Editor: Roberta Schneider. Executive Editor: Angela Hughes. Estab. 1957. "We publish 6 times a year and require several months of lead time." Emphasizes home gardening. Readers are male and female homeowners with a median age of 47. Sample copy $4.50. Photo guidelines free with SASE.
Needs: Uses 25-50 photos/issue; 75% supplied by freelancers. "We purchase a variety of subjects relating to home lawn and garden activities. Specific horticultural subjects must be accurately identified."
Making Contact & Terms: To make initial contact, "Do not send great numbers of photographs, but rather a good selection of 1 or 2 specific subjects. We do not want photographers to call. We return photos by certified mail—other means of return must be specified and paid for by the individual submitting them. It is not our policy to pay holding fees for photographs." Pays $100/¼ page; $150/½ page; $200/full page; $300-500/color cover. Prefers color. Pays on publication. Buys one-time and non-exclusive reprint rights. Model/property release preferred. Captions preferred; please provide exact name of plant (botanical), variety name and common name.
Tips: Wants to see "clear shots with crisp focus. Also, appealing subject matter—good lighting, technical accuracy, depictions of plants in a home garden setting rather than individual close-ups. Let us know what

you've got, we'll contact you when we need it. We see more and more freelance photographers trying to have their work published. In other words, supply is greater than demand. Therefore, a photographer who has too many conditions and provisions will probably not work for us.''

FLY FISHERMAN, Cowles Enthusiast Media, 6405 Flank Dr., Harrisburg PA 17112. (717)657-9555. Editor and Publisher: John Randolph. Managing Editor: Philip Hanyok. Circ. 150,000. Published 6 times/ year. Emphasizes all types of fly fishing for readers who are "100% male, 83% college educated, 98% married. Average household income is $81,800 and 49% are managers or professionals; 68% keep their copies for future reference and spend 35 days a year fishing.'' Sample copy $3.95 with 9 × 12 SAE and 4 first-class stamps. Photo/writer guidelines for SASE.
Needs: Uses about 45 photos/issue, 80% of which are supplied by freelance photographers. Needs shots of "fly fishing and all related areas—scenics, fish, insects, how-to." Captions required.
Making Contact & Terms: Send 35mm, 2¼ × 2¼, 4 × 5 or 8 × 10 color transparencies by mail for consideration. SASE. Reports in 6 weeks. Payment negotiable. Pays on publication. Credit line given. Buys one-time rights.

FLY ROD & REEL: THE MAGAZINE OF AMERICAN FLY-FISHING, Dept. PM, P.O. Box 370, Camden ME 04843. (207)594-9544. Fax: (207)594-5144. Editor: Jim Butler. Magazine published bimonthly. Emphasizes fly-fishing. Readers are primarily fly fishermen ages 30-60. Circ. 62,500. Estab. 1979. Free sample copy with SASE. Photo guidelines free with SASE.
Needs: Uses 25-30 photos/issue; 15-20 supplied by freelancers. Needs "photos of fish, scenics (preferrably with anglers in shot), equipment." Photo captions preferred that include location, name of model (if applicable).
Making Contact & Terms: Query with list of stock photo subjects. Send unsolicited photos by mail for consideration. Provide résumé, business card, brochure, flier or tearsheets to be kept on file for possible assignments. Send glossy b&w, color prints; 35mm, 2¼ × 2¼, 4 × 5 transparencies. Keeps samples on file. SASE. Reports in 1 month. Pays $600/color cover photo; $75/color inside photo; $75/b&w inside; $150/ color page rate; $150/b&w page rate. Pays on publication. Credit line given. Buys one-time rights.
Tips: "Photos should avoid appearance of being too 'staged.' We look for bright color (especially on covers), and unusual, visually appealing settings. Trout and salmon are preferred for covers. Also looking for saltwater fly-fishing subjects.''

N 🌐 **FLY-FISHING & FLY-TYING**, Rolling River Publications Ltd., 3 Aberfeldy Rd., Kenmore, Perthshire PH15 2HF United Kingdom. Website: http://www.pixnet.co.uk/flyfishing-and-flytying. Administrator: Hazel Pirie. Estab. 1990. Bimonthly magazine about fly fishing on rivers and lakes.
Needs: Buys 10 photos from freelancers/issue; 80 photos/year. Needs photos of fly-fishers in picturesque settings. Reviews photos with or without ms. Photo caption required; include location, time of year.
Making Contact & Terms: Send query letter with samples and SAE. Portfolio should include color, slides. Uses color prints; 35mm transparencies; caption each slide on mount. Keeps samples on file; include SASE for return of material. Pays on publication. Buys first rights.

FOR SENIORS ONLY, 339 N. Main St., New City NY 10956. (914)638-0333. Fax: (914)634-9423. Art Director: David Miller. Circ. 350,000. Estab. 1970. Biannual publication. Emphasizes career and college guidance—with features on travel, computers, etc. Readers are male and female, ages 16-19. Sample copy free with 6½ × 9½ SAE and 8 first-class stamps.
Needs: Uses various number of photos/issue; 50% supplied by freelancers. Needs photos of travel, college-oriented shots and youths. Reviews photos with or without ms. Model/property release required.
Making Contact & Terms: Send unsolicited photos by mail for consideration. Send 5½ × 8½ color prints; 35mm, 8 × 10 transparencies. SASE. Reports when needed. Payment negotiable. Pays on publication. Credit line given. Buys one-time rights; negotiable. Simultaneous submissions and/or previously published work OK.

FOTOTEQUE, (Fine Art Photo Journal of the International Society of Fine Art Photographers), P.O. Box 735, Miami FL 33144. E-mail: fototeque@aol.com. Photo Editor/Researcher: Alex Gonzalez. Estab. 1991.

THE INTERNATIONAL MARKETS INDEX, located in the back of this book, lists markets located outside the U.S. by country.

Publisher. Photos used in magazine *Fototeque*, and documentary biannual book. SASE for submission guideline samples ($10 for magazine $15 book).
Needs: Buys 30 photos/month. Subjects include fine art, b&w photos. Captions preferred; include technical data (i.e., camera, lens, aperture, film). Also needs photo essays, portfolios, gallery reviews and fine art. Has annual competition.
Making Contact & Terms: Submit portfolio for review by querying first in writing. Include a SASE for reply. "We do not return materials unless adequate return shipping and postage needs are included." Do not send unsolicited photos. Uses b&w prints no larger than 8×10. All prints and slides must be marked "duplicate" press prints or sides. Keeps samples on file. SASE. Reports in 1 month. Pays $15-100/b&w photo. Pays 3 months after publication. Buys one-time rights.
Tips: Wants to see still life, portrait work, documentaries and photo essays. We need critiques, reviews (of new work and shows) and artist bios and portfolio from USA and foreign countries (must be translated). Has a special Portfolio/Gallery section in each issue."

🌐 **FRANCE MAGAZINE**, Dormer House, The Square, Stow-on-the-Wold, Gloucestershire GL54 1BN England. Phone: (011 44)1451 833200. Fax: (011 44)1451 833234. E-mail: francemag@btinternet.com. Department Editor: Jon Stackpool. Circ. 61,000. Estab. 1990. Quarterly magazine. Emphasizes France. Readers are male and female, ages over 45; people who holiday in France. Sample copy $9.
Needs: Uses 250 photos/issue; 200 supplied by freelancers. Needs photos of France and French subjects: people, places, customs, curiosities, produce, towns, cities, countryside. Captions required; include location and as much information as is practical.
Making Contact & Terms: Interested in receiving work on spec: themed sets very welcome. Send unsolicited photos by mail for consideration. Accepts images via E-mail. Send 35mm, 2¼×2¼ transparencies. Keep samples on file. SASE. Reports in 1 month. Pays £100/color cover; £50/color full page; £25/¼ page and under. Pays quarterly following publication. Credit line given. Buys one-time rights. Previously published work OK.

N **FRANCE TODAY**, France Press, 1051 Divisadero St., San Francisco CA 94115. (415)921-5100. Fax: (415)921-0213. E-mail: fpress@hooked.net. Website: http://www.francepress.com. Assistant Editor: Cara Ballard. Circ. 30,000. Estab. 1982. Bimonthly magazine geared towards an English speaking audience interested in French culture and travel. Sample copy for SAE with 4 first-class stamps.
Needs: Needs original and unique photos of France and French related themes. Reviews photos with or without ms. Model release preferred. Photo caption preferred.
Making Contact & Terms: Send query letter with samples. To show portfolio, photographer should follow-up with call. Portfolio can include photos in any format. Uses color and b&w prints; 35mm, 2¼×2¼, 4×5, 8×10 transparencies. Keeps samples on file; include SASE for return of material. Reports in 2 months on queries. Pays $200-300 for color cover; $25-100 for b&w and color inside. Pays on publication. Buys all rights; negotiable. Simultaneous submissions and/or previously published work OK.

N **FUR-FISH-GAME**, A.R. Harding Publishing, 2878 E. Main St., Columbus OH 43212. Editor: Mitch Cox. Monthly outdoor magazine emphasizing hunting, trapping, fishing and camping.
Needs: Buys 4 photos from freelancers/issue; 50 photos/year. Needs photos of fresh water fish, wildlife and wilderness and rural scenes. Reviews photos with or without ms. Photo caption required; include subject.
Making Contact & Terms: Send query letter "and nothing more." Uses color, b&w prints; 35mm transparencies. Does not keep samples on file; include SASE for return of material. Reports in 2-4 weeks on queries. Pays $25 minimum for b&w and color inside. Pays on publication. Credit line given. Buys one-time rights. Simultaneous submissions and/or previously published work OK.

N 🌐 **FURNITURE & CABINETMAKING**, GMC Publications Ltd., 86 High St., Lewes, E. Sussex BN7 1XN United Kingdom. (01273)477374. Fax: ((01273)487692. E-mail: paulricha@aol.com. Editor: Paul Richardson. Circ. 30,000. Estab. 1996. Monthly consumer magazine. "Aimed at experienced amateurs rising to professional makers with up to 20 people in their workshops." Sample copies/art guidelines free.
Needs: Needs photos of fine furniture and makers. Reviews photos with or without a ms. Photo captions required.
Making Contact & Terms: Send query letter with samples, brochure. Provide résumé, business card, self-promotion piece or tearsheets to be kept on file for possible future assignments. To show portfolio, photographer should follow-up with call. Uses 2¼×2¼ transparencies. Unsolicited material returned by SASE. Pays on publication. Credit line given. Previously published work OK.
Tips: "We look for ability to take pieces of furniture on medium or large format film and 35mm trannies of details in controlled, even lighting."

N FUTURIFIC MAGAZINE, The Foundation for Optimism, 150 Haven Ave. Terrace 3, New York NY 10032. Editor-in-Chief: Mr. Balint Szent-Miklosy. Monthly. Circ. 10,000. Emphasizes future-related subjects. Readers range from leaders from all walks of life. Sample copy with $10—for postage and handling.

Needs: Would use up to 10 photos/issue; if supplied by freelance photographers. Needs photos showing a positive, upbeat look at what the future will look like. Photos purchased with or without accompanying ms. Captions preferred.

Making Contact & Terms: Send by mail for consideration b&w prints or contact sheets. Reports in 1 month. Payment negotiable. Pays on publication. Buys one-time rights. Simultaneous submissions and/or previously published work OK.

Tips: "Photographs should illustrate what directions society and the world are heading. Optimistic only."

N ⊕ GALAXY PUBLICATIONS LTD., P.O. Box 312, Witham, Essex CM8 3SZ United Kingdom. Phone: (01376) 510555. Fax: (01376) 570680. E-mail: drider@fiesta.org. Website: http://www.fiesta.org. Picture Editor: Andy Morgan. 4 monthly magazines: *Fiesta, Knave, Ravers, Teazer.* Sample copy free. Art guidelines free.

Needs: Buys 10 photos from freelancers/issue; 2,000 photos/year. Needs photos of nude female models. Reviews photos with or without ms. Model release required; property release required. Photo caption required; include photographers name and address and reference number.

Making Contact & Terms: Photographers can send samples or full sets of 100 transparencies or more. Art director will contact photographer for portfolio review if interested. Portfolio should include slides. Uses 35mm, 2¼×2¼ transparencies. Does not keep samples on file; include SASE for return of material. Reports in 2 weeks on queries. Pays £600 maximum for color inside. Pays on publication. Credit line not given. Buys first UK rights. Previously published work OK.

Tips: "Read our magazine, look at what is being accepted. Sets have to be technically good, colourful, interesting, have a good selection of poses. Those photographers that supply sets with cover poses will have an advantage over others. Supply contact name and address, reference number, model release. Supply slides mounted in glass-less mounts and sleeved. Editors are looking for young girl sets—trendy-trashy or plush sets."

N GAME & FISH PUBLICATIONS, 2250 Newmarket Pkwy., Suite 110, Marietta GA 30067. (404)953-9222. Fax: (404)933-9510. Photo Editor: Michael Skinner. Editorial Director: Ken Dunwoody. Combined circ. 525,000. Estab. 1975. Publishes 31 different monthly outdoors magazines: *Alabama Game & Fish, Arkansas Sportsman, California Game & Fish, Florida Game & Fish, Georgia Sportsman, Great Plains Game & Fish, Illinois Game & Fish, Indiana Game & Fish, Iowa Game & Fish, Kentucky Game & Fish, Louisiana Game & Fish, Michigan Sportsman, Mid-Atlantic Game & Fish, Minnesota Sportsman, Mississippi Game & Fish, Missouri Game & Fish, New England Game & Fish, New York Game & Fish, North Carolina Game & Fish, Ohio Game & Fish, Oklahoma Game & Fish, Pennsylvania Game & Fish, Rocky Mountain Game & Fish, South Carolina Game & Fish, Tennessee Sportsman, Texas Sportsman, Virginia Game & Fish, Washington-Oregon Game & Fish, West Virginia Game & Fish, Wisconsin Sportsman,* and *North American Whitetail.* All magazines (except *Whitetail*) are for experienced fishermen and hunters and provide information about where, when and how to enjoy the best hunting and fishing in their particular state or region, as well as articles about game and fish management, conservation and environmental issues. Sample copy $2.50 with 10×12 SAE. Photo guidelines free with SASE.

Needs: 50% of photos supplied by freelance photographers; 5% assigned. Needs photos of live game animals/birds in natural environment and hunting scenes; also underwater game fish photos and fishing scenes. Model release preferred. Captions required; include species identification and location. Number slides/prints. In captions, identify species and location.

Making Contact & Terms: Query with samples. Send 8×10 glossy b&w prints or 35mm transparencies (preferably Fujichrome, Ekta, Kodachrome) with SASE for consideration. Reports in 1 month. Pays $250/ color cover; $75/color inside; $25/b&w inside. Pays 75 days prior to publication. Tearsheet provided. Credit line given. Buys one-time rights. Simultaneous submissions not accepted.

Tips: "Study the photos that we are publishing before sending submission. We'll return photos we don't expect to use and hold remainder in-house so they're available for monthly photo selections. Please do not send dupes. Photos will be returned upon publication or at photographer's request."

N GAMES MAGAZINE, Kappa Publishing Group, Inc., 7002 W. Butler Pike, Ambler PA 19002. (215)643-6385. Fax: (215)628-3571. E-mail: gamespub@itw.com. Art Director: Carl Doney. Circ. 182,000. Estab. 1977. Bimonthly consumer magazine. Unique collection of puzzles, brain teasers, Eyeball Benders,

games of logic and mystery etc. Also reporting on events of interest to puzzle and game people. Art guidelines free for SAE with first-class postage.
Needs: Buys 30-200 photos/year. Reviews photos with or without ms but only with an idea for a puzzle. Model release preferred; property release preferred. Photo caption required; include everything that relates to the puzzle.
Making Contact & Terms: Send query letter with samples. "We are interested only in photos with puzzle or quiz ideas." Art director will contact photographer for portfolio review if interested. Portfolio should include photos with puzzle ideas. Uses 35mm, $2\frac{1}{4} \times 2\frac{1}{4}$, 4×5 transparencies. Accepts images in digital format. "We work on the Macintosh platform." Keeps samples on file. Reports back only if interested, send non-returnable samples. Pays $1,000-2,000 for color cover; $50-1,500 for b&w inside; $50-2,000 for color inside. Pays extra for electronic usage of photos. Supplemental use pays from 10% to 50% of initial fee, depending on use. Pays on publication. Credit line given. Buys one-time rights, sometimes more. Simultaneous submissions and/or previously published work OK.
Tips: "Read the magazine. We have a very narrow niche market. Submit photos only with idea for use as a puzzle or eyeball bender etc."

[N] GENERAL LEARNING COMMUNICATIONS, 900 Skokie Blvd., Northbrook IL 60062. (847)205-3093. Fax: (847)564-8197. E-mail: gwilson@glcomm.com. Supervisor/Photography: Gina Wilson. Estab. 1969. Publishes four monthly school magazines running September through May. *Current Health I* is for children aged 9-13. *Current Health II, Writing!, Career World* are for high school teens.
Needs: Color photos of children aged 11-13 for *Current Health*, all other publications for teens aged 14-18, geared to our topic themes for inside use and cover; 35mm or larger transparencies only. Model release preferred. Captions preferred.
Making Contact & Terms: "Send business card and tearsheets and fax or e-mail any info about yourself. Photographers can contact me monthly to find out what my current needs are." Accepts images in digital format for Mac. Send via CD, Zip disk or online at 300 dpi. Pays $100/inside; $400/cover. Pays on publication. Credit line given. Buys one-time rights. Payment negotiable for electronic usage. Simultaneous submissions and previously published work OK.
Tips: "We are looking for contemporary photos of children and teens, including minoritites. Do not send outdated or posed photos. Please adhere to age requirements. If the kids are not the right age they will not be used."

GENT, 14411 Commerce Way, Suite 420, Miami Lakes FL 33016. (305)557-0071. Fax: (305)557-6005. E-mail: gent@dugent.com. Website: http://www.dugent.com. Editor: Nye Willden. Circ. 150,000. Monthly magazine. Showcases "slim and stacked" D-cup nude models. Sample copy $6 (postpaid). Photo guidelines free with SASE.
Needs: Buys in sets, not by individual photos. "We publish manuscripts on sex, travel, adventure, cars, racing, sports, gambling, grooming, fashion and other topics that traditionally interest males. Nude models must be extremely large breasted (minimum 38" bust line). Sequence of photos should start with woman clothed, then stripped to brassiere and then on to completely nude. Bikini sequences also recommended. Cover shots must have nipples covered. Full-figured models also considered if they are reasonably attractive and measure up to our 'D-Cup' image." Model release and photocopy or photograph of picture ID required.
Making Contact & Terms: Send material by mail for consideration. Send transparencies. Prefer Kodachrome or large format; vertical format required for cover. SASE. Accepts images in digital format via SyQuest or Zip disk. Reports in 4-6 weeks. Pays $1,200-2,500/set (first rights); $600 (second rights); $300/cover; $250-500 for text and photo package. Pays $75/image for electronic rights. Pays on publication. Credit line given. Buys one-time rights or second serial (reprint) rights. Previously published work OK.

[N] GERMAN LIFE MAGAZINE, Zeitgeist Publishing, Inc., 226 N. Adams St., Rockville MD 20850. (301)294-9081. Fax: (301)294-7821. E-mail: editor@germanlife.com. Website: http://www.germanlife.c om. Editor: Heidi L. Whitesell. Circ. 40,000. Estab. 1994. Bimonthly magazine focusing on history, culture, and travel relating to German-speaking Europe. Also devoted to covering the German influence on the shaping of North America. Sample copy free for $4.95 and 9×12 SAE with $1.47 postage. Art guidelines free for $9\frac{1}{2} \times 4\frac{1}{4}$ SAE with 1 first-class stamp.
Needs: Buys up to 8 photos from freelancers/issue; up to 50 photos/year. Needs photos of history, culture, and travel relating to German-speaking Europe—also relating to German-American topics regarding North America. Reviews photos with or without ms. Special photo needs include summer festivals, Oktoberfests, wine festivals, Christmas, winter activities. Model release required; property release required. Photo caption required. Include correct name of place/location; correct names and/or titles of person(s); correct date of event shown.
Making Contact & Terms: Send query letter with samples (no more than 25), stock photo list. Provide

résumé, business card, self-promotion piece or tearsheets to be kept on file for possible future assignments. Uses 5×7 minimum glossy color and b&w prints; 35mm, 2¼×2¼, 4×5, 8×10 transparencies. Deadlines: minimum of 4 month lead time, suggest 6. Reports in 1 month on queries. Pays $250 minimum for color cover; $40-60 for b&w inside; $50-75 for color inside. Pays on publication. Credit line given. Buys one-time rights. Simultaneous submissions and/or previously published work OK.

Tips: "Read our magazine. We especially look for off-the-beaten track insights/shots regarding Germany, Switzerland and Austria. Include complete caption information."

N: GIRLFRIENDS MAGAZINE, HAF Enterprises, 3415 Cesar Chavez, Suite 101, San Francisco CA 94110. (415)648-9464. Fax: (415)648-4705. E-mail: staff@gfriends.com. Website: http://www.gfriends.com. Executive Editor: Diane Anderson. Circ. 75,000. Estab. 1994. Monthly, glossy, national magazine focused on culture, politics, and entertainment from a lesbian perspective. Sample copy for $4.95 and 9×12 SAE with $1.50 first-class postage. Art guidelines free.

Needs: Needs photos of travel, celebrities, stock photos of lesbians/the community. Reviews photos with or without ms. Model release required; property release preferred. Photo caption preferred; include name of models, contact information.

Making Contact & Terms: Send query letter with samples. Provide résumé, business card, self-promotion piece or tearsheets to be kept on file for possible future assignments. Art director will contact photographer for portfolio review if interested. Portfolio should include color. Uses 8×10 glossy color prints; 35mm, 2¼×2¼ transparencies. Accepts images in digital format by prior arrangement. Keeps samples on file; include SASE for return of material. Reports in 6-8 weeks on queries; 6-8 weeks on samples. Payment for cover arranged individually. Pays $30-200 for color inside. Pays on publication. Credit line given. Buys one-time rights. Simultaneous submissions OK.

Tips: "Read our magazine to see what type of photos we use. We're looking to increase our stock photography library of women. We like colorful, catchy photos, beautifully composed, with models who are diverse in age, size and ethnicity."

GLAMOUR, Conde Nast Publication, Inc., 350 Madison Ave., New York NY 10017-3704. (212)880-8800. *Glamour* provides the contemporary American women information on trends, recommends how she can adapt them to her needs, and motivates her to take action. Over half of its editorial content focuses on fashion, beauty and health, and coverage of personal relationships, career, travel, food and entertainment. This magazine did not respond to our request for information. Query before submitting.

N: GO BOATING MAGAZINE, Duncan McIntosh Co., 17782 Cowan, Suite C, Irvine CA 92614. (949)660-6150. Fax: (949)660-6172. Website: http://www.goboatingmag.com. Managing Editor: Erin McNiff. Circ. 100,000. Estab. 1997. Bimonthly consumer magazine geared to active families that own power boats from 14-25 feet in length. Contains articles on cruising and fishing destinations, new boats and marine electronics, safety, navigation, seamanship, maintenance how-tos, consumer guides to boating services, marine news and product buyer guides. Sample copy for $5. Art guidelines free with SASE.

Needs: Buys 25 photos from freelancers/issue. Needs photos of cruising destinations, boating events, seamanship, boat repair procedures and various marine products. Photos should also contain scenes of families interacting. Reviews photos with or without ms. Model release required. Photo caption preferred; include place, date, identify people and any special circumstances.

Making Contact & Terms: Send query letter with stock photo list and provide résumé, business card, self-promotion piece or tearsheets to be kept on file for possible future assignments. Art director will contact photographer for portfolio review if interested. Uses color transparencies; 35mm, 2¼×2¼. Accepts images in digital format for Mac. Send via CD, SyQuest or Zip disk. Deadlines: 15th of the month preceeding publication. Reports in 1-2 months on queries. Pays $250 maximum for color cover; $35 maximum for b&w inside; $50-200 for color inside. Pays $400-600 by the day. Pays on publication. Credit line given. Buys first North American, second rights and reprint rights for one year via print and electronic media. Simultaneous submissions and/or previously published work OK.

Tips: "When submitting work, label each slide with your name, address, daytime phone number and Social Security Number on a photo delivery memo. Submit photos with SASE. All photos will be returned within 60 days."

GOLF ILLUSTRATED, P.O. Box 5300, Jenks OK 74037-5300 or 5300 Cityplex Tower, 2448 E. 81st St., Tulsa OK 74137-4207. (918)491-6100. Fax: (918)491-9424. Executive Editor: Mark Chesnut. Circ. 270,000. Estab. 1914. Magazine published 8 times/year. Emphasizes golf. Readers are mostly male, ages 40-60. Sample copy $2.95. Photo guidlines free with SASE.

Needs: Uses 40-60 photos/issue; 90% supplied by freelancers. Needs photos of various golf courses, golf

travel, other golf-related shots. Model/property release preferred. Captions required; include who, what, when and where.

Making Contact & Terms: Query with résumé of credits. Provide résumé, business card, brochure, flier or tearsheets to be kept on file for possible assignments. Send 35mm, 2¼×2¼ transparencies. Keeps samples on file. SASE. Reports in 3 weeks. Pays $400-600/color cover; $100-300/color inside. Pays on publication. Credit line given. Buys one-time rights. Previously published work OK.

GOLF TIPS, 12121 Wilshire Blvd., #1200, Los Angeles CA 90025. (310)820-1500. Fax: (310)820-2793. Art Director: Warren Keating. Circ. 300,000. Estab. 1986. Magazine published 9 times/year. Readers are hardcore golf enthusiasts. Sample copy free with SASE.

Needs: Uses 60 photos/issue; 40 supplied by freelancers. Needs photos of golf instruction (usually pre-arranged, on-course); equipment-studio. Reviews photos purchased with accompanying ms only. Model/property release preferred. Captions required.

Making Contact & Terms: Query with résumé of credits. Submit portfolio for review. Send prints; 35mm, 2¼×2¼, 4×5, 8×10 transparencies; digital format. Accepts images in digital format for Mac. Send via SyQuest, Zip disk (300 dpi). Cannot return material. Reports in 1 month. Pays $400-800/day; $100-150 inside; $500-800/color cover; $100-400/color inside. Pays on publication. Buys one-time rights; negotiable.

GOOD HOUSEKEEPING, Hearst Corporation Magazine Division, 959 Eighth Ave., New York NY 10019-3795. (212)649-2000. Art Director: Scott Yardley. *Good Housekeeping* articles focus on food, fitness, beauty and childcare, drawing upon the resources of the Good Housekeeping Institute. Editorial includes human interest stories, and articles that focus on social issues, money management, health news and travel. Photos purchased mainly on assignment. This magazine did not respond to our request for information. Query before submitting.

■ **GOSPEL HERALD**, 4904 King St., Beamsville, Ontario L0R 1B6 Canada. (905)563-7503. Fax: (905)563-7503. E-mail: EPerry9953@aol.com. Co-editor: Wayne Turner. Managing Editor: Eugene Perry. Circ. 1,370. Estab. 1936. Consumer publication. Monthly magazine. Emphasizes Christianity. Readers are primarily members of the Churches of Christ. Sample copy free with SASE.

Needs: Uses 2-3 photos/issue; percentage supplied by freelancers varies. Needs scenics, shots, especially those relating to readership—moral, religious and nature themes.

Making Contact & Terms: Send unsolicited photos by mail for consideration. Send b&w, any size and any format. Payment not given, but photographer receives credit line.

Tips: "We have never paid for photos. Because of the purpose of our magazine, both photos and stories are accepted on a volunteer basis."

GRAND RAPIDS MAGAZINE, 549 Ottawa Ave. NW, Grand Rapids MI 49503-1444. (616)459-4545. Fax: (616)459-4800. Publisher: John H. Zwarensteyn. Editor: Carole R. Valade. Estab. 1964. Monthly magazine. Emphasizes community-related material of metro Grand Rapids area and Western Michigan; local action and local people.

Needs: Animal, nature, scenic, travel, sport, fashion/beauty, photo essay/photo feature, fine art, documentary, human interest, celebrity/personality, humorous, wildlife, vibrant people shots and special effects/experimental. Wants on a regular basis Western Michigan photo essays and travel-photo essays of any area in Michigan. Model release required. Captions required.

Making Contact & Terms: Freelance photos assigned and accepted. Provide business card to be kept on file for possible future assignments; "only people on file are those we have met and personally reviewed." Arrange a personal interview to show portfolio. Query with résumé of credits. Send material by mail for consideration. Submit portfolio for review. Send 8×10 or 5×7 glossy b&w prints; contact sheet OK; 35mm, 120mm or 4×5 transparencies or 8×10 glossy color prints; Uses 2¼×2¼ and 4×5 color transparencies for cover, vertical format required. SASE. Reports in 3 weeks. Pays $25-50/b&w photo; $35-75/color photo; $100-200/cover. Buys one-time rights, exclusive product rights, all rights; negotiable.

Tips: "Most photography is by our local freelance photographers, so freelancers should sell us on the unique nature of what they have to offer."

GRAND RAPIDS PARENT MAGAZINE, 549 Ottawa NW, Grand Rapids MI 49503. (616)459-4545. Fax: (616)459-4800. Editor: Carole R. Valade. Circ. 24,000. Estab. 1989. Monthly magazine. Sample copy $2. Photo guidelines free with SASE.

Needs: Uses 20-50 photos/issue; all supplied by freelancers. *Only using in state photographers—west Michigan region.* Needs photos of families, children, education, infants, play, etc. Model/property release required. Captions preferred; include who, what, where, when.

Making Contact & Terms: Query with résumé of credits. Query with stock photo list. Sometimes keeps samples on file. SASE. Reports in 1 month, if interested. Pays $200/color cover; $35/color inside; $35/b&w inside; $50 minimum/color page rate. Pays on publication. Credit line given. Buys one-time rights, all rights; negotiable. Simultaneous submissions and/or previously published work OK.

Tips: "We are not interested in 'clip art' variety photos. We want the honesty of photojournalism, photos that speak to the heart, that tell a story, that add to the story told."

GRIT MAGAZINE, 1503 SW 42nd St., Topeka KS 66609. (800)678-5779. Fax: (913)274-4305. Fax: (785)274-4305. E-mail: Grit@kspress.com. Website: http://www.grit.com. Contact: Editor. Circ. 400,000. Estab. 1882. Biweekly magazine. Emphasizes "family-oriented material which is helpful, inspiring or uplifting. Readership is national." Sample copy $4.

Needs: Buys "hundreds" of photos/year; 90% from freelancers. Needs on a regular basis "photos of all subjects, provided they have up-beat themes that are so good they surprise us. Need *short*, unusual stories—heartwarming, nostalgic, inspirational, off-beat, humorous—or human interest with b&w or color photos. Be certain pictures are well composed, properly exposed and pin sharp. No cheesecake. No pictures that cannot be shown to any member of the family. No pictures that are out of focus or over-or under-exposed. No ribbon-cutting, check-passing or hand-shaking pictures. We use 35mm and up." Photos purchased with accompanying ms. Model release required. Captions required. "Single b&w photo or color slide, that stands alone must be accompanied by 50-100 words of meaningful caption information."

Making Contact & Terms: Study magazine. Send material by mail for consideration. Prefers color slides/professional quality. Accepts images in digital format for Mac. Send via SyQuest or Zip disk. Reports in 6 months. Rates negotiable. Generally $25 and up for b&w; $50 and up for color. Uses much more color than b&w. Rights negotiable. SASE. Pays on publication.

Tips: "We need major-holiday subjects: Easter, Fourth of July, Christmas or New Year. Remember that *Grit* publishes on newsprint and therefore requires sharp, bright, contrasting colors for best reproduction. Avoid sending shots of people whose faces are in shadows; no soft focus. Need photos of small town, rural life; outdoor scenes with people; gardens; back roads and country life shots."

⟨N⟩ GUIDE, Review & Herald Publishing Association, 55 W. Oak Ridge Rd., Hagerstown MD 21740-7390. (301)791-7000, ext. 2433. Fax: (301)790-9734. E-mail: guide@rhpa.org. Website: http://www.rhpa.org/Guide. Editor: Tim Lale. Circ. 33,000. Estab. 1953. Weekly 32-page Christian story magazine given out in churches to 10- to 14-year-olds. Each issue contains 3-4 true or based-on-truth stories by, about, or of interest to fifth to eighth graders, and 1-3 Bible-based puzzles. Most stories are adventure, humor, nature, or personal growth situations; all must have a clear spiritual point. Published by Seventh-day Adventists, but stories are accepted from Christian writers of other denominations.

Making Contact & Terms: Send query letter with samples, brochure, stock photo list tearsheets. Art director will contact photographer for portfolio review if interested. Portfolio should include b&w and/or color, prints, tearsheets or slides. Keeps samples on file. Reports back only if interested, send non-returnable samples. Pays $200 maximum for b&w cover; $200 maximum for b&w inside. **Pays on acceptance**. Credit line given. Buys one-time rights.

Tips: "We need fast workers with quick turnaround."

GUIDEPOSTS, Dept. PM, 16 E. 34th St., 21st Floor, New York NY 10016. (212)251-8124. Fax: (212)684-0679. Photo Editor: Candice Smilow. Circ. 4 million. Estab. 1945. Monthly magazine. Emphasizes tested methods for developing courage, strength and positive attitudes through faith in God. Free sample copy and photo guidelines with 6×9 SAE and 3 first-class stamps.

● This company uses digital manipulation and retouching when necessary.

Needs: Uses 85% assignment, 15% stock (variable). "Photos mostly used are of an editorial reportage nature or stock photos, i.e., scenic landscape, agriculture, people, animals, sports. We work four months in advance. It's helpful to send stock pertaining to upcoming seasons/holidays. No lovers, suggestive situations or violence." Model release preferred.

Making Contact & Terms: Send photos or arrange a personal interview. Send 35mm transparencies; vertical format required for cover, usually shot on assignment. SASE. Reports in 1 month. Pays by job or on a per-photo basis; pays $150-400/color inside; $800 and up/color cover; $400-600/day; negotiable. **Pays on acceptance.** Credit line given. Buys one-time rights. Simultaneous submissions OK.

Tips: "I'm looking for photographs that show people in their environment. I like warm, saturated color for portraits and scenics. We're trying to appear more contemporary. We want to stimulate a younger audience and yet maintain a homey feel. For stock—scenics; graphic images with intense color. *Guideposts* is an 'inspirational' magazine. NO violence, nudity, sex. No more than 60 images at a time. Write first and ask for a photo guidelines/sample issue; this will give you a better idea of what we're looking for. I will review transparencies on a light box. I am interested in the experience as well as the photograph. I

am also interested in the photographer's sensibilities—Do you love the city? Mountain climbing? Farm life? We also publish *Angels on Earth*."

GUNGAMES MAGAZINE, P.O. Box 516, Moreno Valley CA 92556. (909)485-7986. Fax: (909)485-6628. E-mail: ggamesed@aol.com. Editor: Roni Toldanes. Circ. 125,000. Estab. 1995. Bimonthly magazine. Emphasizes shooting sports—"the fun side of guns." Readers are male and female gun owners, ages 18-90. Sample copy $3.50 plus S&H or SASE.
Needs: Uses many photos/issue; most supplied by freelancers. Needs photos of personalities, shooting sports and modern guns and equipment. "No self-defense topics; avoid hunting photos. Just shooting tournaments." Captions required.
Making Contact & Terms: Send unsolicited photos by mail for consideration. Send color prints; 35mm transparencies. Does not keep samples on file. Cannot return material. Reports in 1 month. Payment negotiable. Pays on publication. Credit line given. Buys one-time rights; negotiable.

HADASSAH MAGAZINE, 50 W. 58th St., New York NY 10019. (212)688-0558. Fax: (212)446-9521. Editorial Assistant: Leah Finkelshteyn. Circ. 300,000. Publication of the Hadassah Women's Zionist Organization of America. Monthly magazine. Emphasizes Jewish life, Israel. Readers are 85% females who travel and are interested in Jewish affairs, average age 59. Photo guidelines free with SASE.
Needs: Uses 10 photos/issue; most supplied by freelancers. Needs photos of travel and Israel. Captions preferred, include where, when, who and credit line.
Making Contact & Terms: Submit portfolio for review. Send unsolicited photos by mail for consideration. Keeps samples on file. SASE. Reports in 1 month. Pays $400/color cover; $100-125/¼ page color inside; $75-100/¼ page b&w inside. Pays on publication. Credit line given. Buys one-time rights.
Tips: "We're looking for kids of all ethnic/racial make up. Cute, upbeat kids are a plus. We also need photos of families and travel photos, especially of places of Jewish interest."

HEALTH & BEAUTY MAGAZINE, 10 Woodford, Brewery Rd., Blackrock, Dublin, Ireland. Phone: (01)2954095. Mobile: 087-531566. Fax: (01)01-2954095. Advertising Manager: David Briggs. Circ. 11,000. Estab. 1985. Bimonthly magazine. Emphasizes all body matters. Readers are male and female, ages 17-50 (all keen on body matters). Sample copy free with A4 SASE.
Needs: Uses approximately 100 photos/issue; 50% supplied by freelancers. Needs photos related to health, hair, fashion, beauty, food, drinks. Reviews photos with or without ms. Model/property release preferred. Captions preferred; include photo description.
Making Contact & Terms: Send unsolicited photos by mail for consideration. Provide résumé, business card, brochure, flier or tearsheets to be kept on file for possible assignments. Send any size glossy color and b&w prints; 35mm, 2¼×2¼, 4×5, 8×10 transparencies; prints preferred. Keeps samples on file. SASE. Reports in 1 month. Payment negotiable. Credit line given. Buys all rights; negotiable. Simultaneous submissions and/or previously published work OK.
Tips: Looks for "male and female models of good body shape, shot in interesting locations with interesting body and facial features. Continue on a regular basis to submit good material for review."

HIGHLIGHTS FOR CHILDREN, Dept. PM, 803 Church St., Honesdale PA 18431. (717)253-1080. Photo Editor: Sharon Umnik Circ. nearly 3 million. Monthly magazine. For children, ages 2-12. Free sample copy.
● *Highlights* is currently expanding photographic needs.
Needs: Buys 100 or more photos annually. "We will consider outstanding photo essays on subjects of high interest to children." Photos purchased with accompanying ms. Wants no single photos without captions or accompanying ms.
Making Contact & Terms: Send photo essays for consideration. Prefers transparencies. SASE. Reports in 7 weeks. Pays $30 minimum/b&w photo; $55 minimum/color photo. Pays $100 minimum for ms. Buys all rights.
Tips: "Tell a story which is exciting to children. We also need mystery photos, puzzles that use photography/collage, special effects, anything unusual that will visually and mentally challenge children."

HIGHWAYS, The Official Publication of The Good Sam Club, Affinity Group Inc., 2575 Vista Del Mar Dr., Ventura CA 93001-3920. (805)667-4100. Fax: (805)667-4454. E-mail: goodsam@tl.com. Website: http://www.tl.com. Editor: Ron Epstein. Circ. 920,000. Estab. 1966. Consumer magazine published 11 times/year. "We go exclusively to recreation vehicle owners so our stories and photos include traveling in an RV or the RV industry including motorhomes, trailers, pop-ups, tents, etc." Sample copies free for 8½×11 SAE. Art guidelines free.
Needs: Buys 2 photos from freelancers/issue; 25 photos/year. Needs photos of recreational vehicles in

various travel destinations. Reviews photos with accompanying ms only. Model release preferred; property release preferred. Photo captions required. "The obvious is fine."

Making Contact & Terms: Send query letter with samples, stock photo list. Art director will contact photographer for portfolio review if interested. Portfolio should include color tearsheets. Uses 35mm, 2¼×2¼ transparencies. Unsolicited material returned by SASE. Reports in 6 weeks on queries; 1 months on samples. Pays $400-500/color cover; $75-150/b&w inside; $100-350/color inside. Pays on publication. Credit line given. Buys one-time rights. Simultaneous submissions, previously published work OK.

Tips: "We mostly buy packages—manuscript and photos—from freelancers, so we rely on freelance photographers primarily for cover photos. (All covers are vertical.) If you shoot RVs with colorful scenery, there's a good chance we can do business sometime. Our travel features touch on all parts of the United States and Canada. Photographers who shoot RVs are scarce, so this is good chance to get into the market. Know who reads the magazine. We go to RV owners, not car enthusiasts. If you've never shot a picture of an RV, then don't send us anything."

[N] HISTORIC TRAVELER, The Guide to Great Historic Destinations, Cowles Enthusiast Media, 6405 Flank Dr., Harrisburg PA 17112. (717)540-6703. Fax: (717)657-9552. E-mail: jeffk@cowles.com. Website: http://www.cowles.com. Design Director: Jeff King. Circ. 100,000. Estab. 1995. Bimonthly travel magazine emphasizing historic destinations, primarily in North America. Includes 1 international destination/issue. Sample copy for $5. Art guidelines available for SASE.

Needs: Buys 70 photos from freelancers/issue; 420 photos/year. Needs photos of travel, archive, architecture. *Historic Traveler* is 75% recent coverage and 25% archive shots. Reviews photos with or without ms. Special photo needs: dynamic cover images. Model release preferred; property release preferred. Photo caption required.

Making Contact & Terms: Send query letter with stock photo list. Art director will contact photographer for portfolio review if interested. Portfolio should include color tearsheets or slides. Uses 35mm, 2¼×2¼, 4×5, 8×10 transparencies. Accepts images in digital format: Mac TIFF's. Include SASE for return of material. "Prefer not to receive unsolicited samples (slides)." Reports in 1 month on queries; 1 month on samples. Pays $600-900 for b&w or color cover; $125-275 for b&w or color inside. Pays $25 for web use on http://www.thehistorynet.com. Pays on publication. Credit line given. Buys one-time rights. Simultaneous submissions and/or previously published work OK.

Tips: "We like to mix solid shots with detail shots—artifacts of history. Edit your submission to only the best and most appropriate shots."

HOCKEY ILLUSTRATED, 233 Park Ave. S., New York NY 10003. (212)780-3500. Fax: (212)780-3555. Editor: Stephen Ciacciarelli. Circ. 50,000. Published 4 times/year, in season. Emphasizes hockey superstars. Readers are hockey fans. Sample copy $3.50 with 9×12 SASE.

Needs: Uses about 60 photos/issue; all supplied by freelance photographers. Needs color slides of top hockey players in action. Captions preferred.

Making Contact & Terms: Query with action color slides. SASE. Pays $150/color cover; $75/color inside. **Pays on acceptance.** Credit line given. Buys one-time rights.

HOME EDUCATION MAGAZINE, P.O. Box 1587, Palmer AK 99645. (907)746-1336. E-mail: hem-editor@home-ed-magazine.com. Website: http://www.home-ed-magazine.com. Managing Editor: Helen Hegener. Circ. 8,900. Estab. 1983. Bimonthly magazine. Emphasizes homeschooling. Readership includes parents, educators, researchers, media, etc.—anyone interested in home schooling. Sample copy for $4.50. Photo guidelines free with SASE.

Needs: Number of photos used/issue varies based on availability; 50% supplied by freelance photographers. Needs photos of parent/child or children. Special photo needs include homeschool personalities and leaders. Model/property releases preferred. Captions preferred.

Making Contact & Terms: Send unsolicited b&w prints by mail for consideration. Prefers b&w prints in normal print size (3×5). "Enlargements not necessary for inside only—we need enlargements for cover submissions." Accepts images in digital format for Mac. Send via compact disc, online, flopy disk, Sy-Quest, Zip disk (266 dpi). Uses 35mm transparencies. SASE. Reports in 1 month. Pays $50/color cover; $10/b&w inside; $50-150/photo/text package. **Pays on acceptance.** Credit line given. Buys first North American serial rights; negotiable.

Tips: In photographer's samples, wants to see "sharp clear photos of children doing things alone, in groups or with parents. Know what we're about! We get too many submissions that are simply irrelevant to our publication."

HORIZONS MAGAZINE, P.O. Box 2639, Bismarck ND 58502. (701)222-0929. Fax: (701)222-1611. E-mail: lhalvors@btigate.com. Website: http://www.ndhorizons.com. Editor: Lyle Halvorson. Estab. 1971.

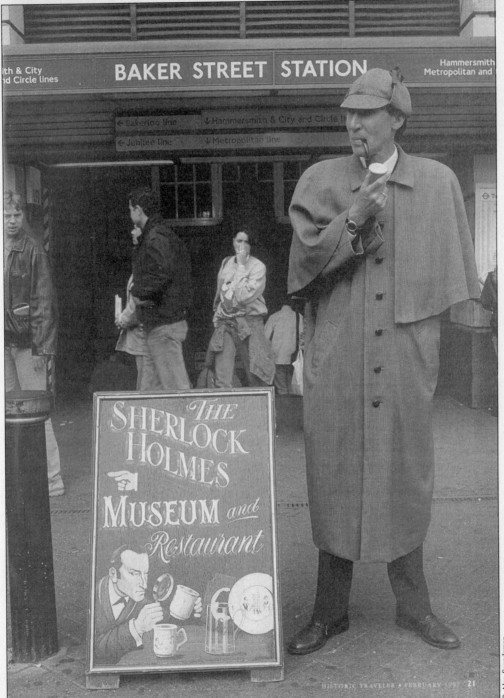

Historic Traveler's design director, Jeff King, discovered photographer Alex Saunderson in his magazine's sister publication, *British Heritage*. He commissioned Saunderson to do a 15-image photo essay on the London of Sherlock Holmes. "This is the perfect 'free-standing' image of London's enthusiasm for its most famous detective," King says. "It is also a great travel magazine photo because it shows both location and an interesting personality. Alex had a great sense for photo-illustrating the editorial content."

Quality regional magazine. Photos used in magazines, audiovisual and calendars.

Needs: Buys 50 photos/year; offers 25 assignments/year. Scenics of North Dakota events, places and people. Model/property release preferred. Captions preferred.

Making Contact & Terms: Query with samples. Query with stock photo list. Accepts images in digital format. Works on assignment only. Uses 8×10 glossy b&w prints; 35mm, $2\frac{1}{4} \times 2\frac{1}{4}$, 4×5 transparencies. Does not keep samples on file. SASE. Reports in 2 weeks. Pays $150-250/day; $200-300/job. Pays on usage. Credit line given. Buys one-time rights; negotiable.

Tips: "Know North Dakota events, places. Have strong quality of composition and light."

THE HORSE, 1736 Alexandria Dr., Lexington KY 40504. (606)278-2361. Fax: (606)276-4450. E-mail: thall@thehorse.com or kherbert@thehorse.com. Website: http://www.thehorse.com. Editorial Assistant: Tom Hall. Circ. 24,900. Estab. March 1995 (name changed from *Modern Horse Breeding* to *The Horse*). Monthly magazine. Emphasizes equine health. Readers are equine veterinarians and top-level horse owners, trainers and barn managers. Sample copy free with SASE. Photo guidelines free with SASE.

Needs: Uses 30 photos/issue; 10-20 supplied by freelancers. Needs generic horse shots, horse health such as farrier and veterinarian shots. "We use all breeds and all disciplines." Model/property relese preferred. Captions preferred.

Making Contact & Terms: Send unsolicited photos by mail for consideration. Send color and b&w prints; 35mm, $2\frac{1}{4} \times 2\frac{1}{4}$, 4×5, 8×10 transparencies. Accepts images in digital format for Mac (JPEG or TIFF). Send via compact disc, online, floppy disk, SyQuest, Zip disk, Jazz (300 dpi 6×4). Keeps samples on file. Reports in 1-2 weeks. Pays $150/color cover; $150/b&w cover; $25-75/color inside; $25-75/b&w inside. Pays on publication. Buys one-time rights. Previously published work OK.

HORTICULTURE MAGAZINE, 98 N. Washington St., Boston MA 02114. (617)742-5600. Fax: (617)367-6364. Photo Editor: Tina Schwinder. Circ. 350,000. Estab. 1904. Monthly magazine. Emphasizes gardening. Readers are all ages. Sample copy $2.50 with 9×12 SAE with $2 postage. Photo guidelines free with SASE.

Needs: Uses 25-30 photos/issue; 100% supplied by freelance photographers. Needs photos of gardening, individual plants. Model release preferred. Captions required.

Making Contact & Terms: Arrange a personal interview to show portfolio. Query with samples. Send 35mm color transparencies by mail for consideration. Submit portfolio for review. Provide résumé, business card, brochure, flier or tearsheets to be kept on file for possible future assignments. SASE. Reports in 1 month. Pays $500/color cover; $50-250/color page. Pays on publication. Credit line given. Buys one-time rights. Simultaneous submissions OK.

Tips: Wants to see gardening images, i.e., plants and gardens.

HOST COMMUNICATIONS, INC., 904 N. Broadway, Lexington KY 40505. (606)226-4510. Fax: (606)226-4575. Production Manager: Joe Miller. Estab. 1971. Weekly magazine. Emphasizes collegiate athletics. Includes football, basketball and Texas football sections and NCAA Basketball Championship Guide. Readers are predominantly male, ages 18-49. Sample copy free with 9×12 SAE and $2.90 postage.

Needs: Uses 30 photos/issue; 25 supplied by freelancers. Needs action photography. Model release preferred; photo captions preferred.

Making Contact & Terms: Submit portfolio for review. Send unsolicited photos by mail for consideration. Provide résumé, business card, brochure, flier or tearsheets to be kept on file for possible future assignments. Send color prints; 35mm transparencies. Deadlines vary depending on publication. SASE. Pays $50-100/color cover; $50-100/color inside; $25-100/color page. Pays on publication. Credit line given. Buys one-time rights.

Tips: Looks for crispness, clarity of photography, action captured in photography.

HSUS NEWS, 700 Professional Dr., Gaithersburg MD 20879-3418. Art Director: T. Tilton. Circ. 500,000. Estab. 1954. Publication of The Humane Society of the US Association. Quarterly magazine. Emphasizes animals. Sample copy free with 10×14 SASE.

Needs: Uses 60 photos/issue. Needs photos of animal/wildlife shots. Model release required.

Making Contact & Terms: Query with list of stock photo subjects. Send unsolicited transparencies by mail for consideration. Provide résumé, business card, brochure, flier or tearsheets to be kept on file for possible assignments. Reports in 3 weeks. Pays $500/color cover; $225/color inside; $150/b&w inside. **Pays on acceptance.** Credit line given. Buys one-time rights. Previously published work OK.

Tips: To break in, "don't pester us. Be professional with your submissions."

IDAHO WILDLIFE, P.O. Box 25, Boise ID 83707. (208)334-3748. Fax: (208)334-2148. E-mail: dronayn e@idfg.state.id.us. Website: http://www.state.id.us/fishgame/fishgame.html. Editor: Diane Ronayne. Circ.

150,000 +. Estab. 1978. Quarterly magazine. Emphasizes wildlife, hunting, fishing. Readers are aged 25-70, 80% male, purchase Idaho hunting or fishing licenses; ¼ nonresident, ¾ resident. Sample copy $1. Photo guidelines free with SASE.

Needs: Uses 20-40 photos/issue; 30-60% supplied by freelancers. Needs shots of "wildlife, hunting, fishing in Idaho; habitat management." Photos of wildlife/people should be "real," not too "pretty" or obviously set up. Model release preferred. Captions required; include species and location.

Making Contact & Terms: Query with list of stock photo subjects. SASE. Accepts images in digital format for Windows (TIFF or EPS). Send via Online, floppy disk, SyQuest, Zip disk or Bernoulli (300 dpi). Reports in 1 month. Pays $80/color cover; $40/color or b&w inside. Pays on publication. Credit line given. Buys one-time rights. Simultaneous submissions and previously published work OK. Offers internship year-round. Contact Diane Ronayne. "Need help with archiving, too. No pay but would get clips and experience photographing wildlife and wildlife and fish management."

Tips: "E-mail or write first for want list and contest rules. 99% of photos published are taken in Idaho. Seldom use scenics. Love action hunting or fishing images but must look 'real' (i.e., natural light). Only send your *best* work. We don't pay as much as the 'Big Three' commercial hunting/fishing magazines but our production quality is as high or higher and we value photography and design as much as text. We began placing information, including the *Idaho Wildlife* table of contents on the Internet in early 1996. Annual photo contest pays cash awards. Entry deadline Sept 1, 1998. No entry fee but photos must be taken in Idaho."

IDEALS MAGAZINE, Ideals Publications Incorporated, P.O. Box 305300, Nashville TN 37230-5300. (615)333-0478. Editor: Lisa Ragan. Circ. 200,000. Estab. 1944. Magazine published 6 times/year. Emphasizes an idealized, nostalgic look at America through poetry and short prose, using "seasonal themes—bright flowers and scenics for Thanksgiving, Christmas, Easter, Mother's Day, Friendship and Country—all thematically related material. Issues are seasonal in appearance." Readers are "mostly women who live in rural areas, aged 50 and up." Sample copy $4. Photo guidelines free with SASE.

Needs: Uses 20-25 photos/issue; all supplied by freelancers. Needs photos of "bright, colorful flowers, scenics, still life, children, pets, home interiors; subject-related shots depending on issue. We regularly send out a letter listing the photo needs for our upcoming issue." Model/property release required. No research fees.

Making Contact & Terms: Submit tearsheets to be kept on file. No color copies. Will send photo needs list if interested. Do not submit unsolicited photos or transparencies. Work only with 2¼ × 2¼, 4 × 5, 8 × 10 transparencies; no 35mm. Keeps samples on file. Payment negotiable. Pays on publication. Credit line given. Buys one-time rights. Simultaneous and previously published work OK.

Tips: "We want to see *sharp* shots. No mood shots, please. No filters. Would suggest the photographer purchase several recent issues of *Ideals* magazine and study photos for our requirements."

N̄ IMMERSED MAGAZINE, The International Technical Diving Magazine, FDR Station, P.O. Box 7934, New York NY 10150. Phone/fax: (201)792-1331. E-mail: immersed@njscuba.com. Website: http://www.immersed.com. Editor/Publisher: Robert J. Sterner. Circ. 20,000. Estab. 1996. Quarterly consumer magazine that covers the cutting edge of scuba diving with articles that emphasize training, safety, science and history. Art guidelines free.

Needs: Buys 3 photos from freelancers/issue; 12 photos/year. Needs underwater photos taken under extreme conditions: gear, shipwrecks, animals and plantlife. Reviews photos with or without ms. "Manuscript gives photos an edge in use. Special photo needs include medical treatments involving divers and moderate to deep ocean depths." Model release preferred for photos with identifiable faces. Property release preferred. Photo caption required.

Making Contact & Terms: Send query letter with stock photo list. Provide résumé, business card, self-promotion piece or tearsheets to be kept on file for possible future assignments. Art director will contact photographer for portfolio review if interested. Uses 35mm transparencies. Accepts images in digital format. Keeps samples on file. Reports back only if interested, send non-returnable samples. Payment negotiated individually. Pays on publication. Credit line given. Buys all rights; negotiable. Simultaneous submissions OK.

Tips: "We're read by scuba divers who aggressively pursue their sport wherever there is water, warm or cold. The more challenging the conditions, the better. Query first before submitting work. We're theme oriented, so the stories and art needed to illustrate them tend to fall into subjects like medical treatments, gear design or archaeology."

"IN THE FAST LANE", ICC National Headquarters, 2001 Pittston Ave., Scranton PA 18505. (717)585-4082. Editor: D.M. Crispino. Circ. 2,000. Publication of the International Camaro Club. Bimonthly, 20-

page newsletter. Emphasizes Camaro car shows, events, cars, stories, etc. Readers are auto enthusiasts/Camaro exclusively. Sample copy $2.

Needs: Uses 20-24 photos/issue; 90% assigned. Needs Camaro-oriented photos only. "At this time we are looking for photographs and stories on the Camaro pace cars 1967, 1969, 1982 and the Camaro Z28s, 1967-1981." Reviews photos with accompanying ms only. Model release required. Captions required.

Making Contact & Terms: Send 3½×5 and larger b&w or color prints by mail for consideration. SASE. Reports in 2 weeks. Pays $5-25 for text/photo package. Pays on publication. Credit line given. Buys one-time rights. Previously published work OK.

Tips: "We need quality photos that put you at the track, in the race or in the midst of the show. Magazine is bimonthly; timeliness is even more important than with monthly. We are looking for all Yenko Camaro stories especially the 1981 Yenko Turbo Z."

N INDEPENDENT BUSINESS, America's Small Business Magazine, Group IV Communications, 125 Auburn Court, Suite 100, Thousand Oaks CA 91362. (805)496-6156. Fax: (805)496-5469. E-mail: gosmallbiz@aol.com. Website: http://www.yoursource.com. Circ. 600,000. Estab. 1989. *IB* is a bimonthly national business magazine for and about small business in America. "Our readership consists of well-established small business owners who've been in business an average of 19 years. We appeal to these people by providing images of down-to-earth people who are proud of their business and their independence." Sample copy for $4 and 9×12 SASE. Art guidelines free with #10 SASE.

Needs: Buys 6 photos from freelancers/issue; 50 photos/year. Needs photos of people in natural business situations. Reviews photos with or without ms. Model release required for all subjects.

Making Contact & Terms: Provide résumé, business card, self-promotion piece or tearsheets to be kept on file for possible future assignments. Art director will contact photographer for portfolio review if intereted. Portfolio should include color prints, tearsheets, slides, transparencies or thumbnails. Uses 35mm, 2¼×2¼, 4×5, 8×10 transparencies. Keeps samples on file. Reports back only if interested, send non-returnable samples. Pays $650-750 and expenses for color cover; $400-500 and expenses for color inside. Pays extra for electronic usage of photos; $100-150/use. **Pays on acceptance.** Credit line given. Buys first rights, non-exclusive reprint rights.

Tips: "No visionary shots gazing over the sea or a city skyline. The article will deliver the inspiration. We want you to deliver innovation and solve the shot with craft and creativity. Don't even think of sending film of an owner talking on the phone, working at a computer or shaking hands."

INDIANAPOLIS BUSINESS JOURNAL, 431 N. Pennsylvania St., Indianapolis IN 46204. (317)634-6200. Fax: (317)263-5060. E-mail: ibjedit@aol.com. Picture Editor: Robin Jerstad. Circ. 17,000. Estab. 1980. Weekly newspaper/monthly magazine. Emphasizes Indianapolis business. Readers are male, 28 and up, middle management to CEO's.

Needs: Uses 15-20 photos/issue; 3-4 supplied by freelancers. Needs portraits of business people. Model release preferred. Captions required; include who, what, when and where.

Making Contact & Terms: Query with résumé and credits. Query with stock photo list. Accepts images in digital format for Mac (EPS/TIFF). Send via compact disc, online, floppy disk or SyQuest (170 dpi). Cannot return material. Reports in 3 weeks. Pays $50-75/color inside; $25-50/b&w inside. Pays on publication. Credit line given. Buys one-time rights. Simultaneous submissions and/or previously published work OK. Offers internships for photographers during the summer. Contact Picture Editor: Robin Jerstad.

Tips: "We generally use local freelancers (when we need them). Rarely do we have needs outside the Indianapolis area."

INDIANAPOLIS WOMAN, 6081 E. 82nd St., Suite 401, Indianapolis IN 46250. (317)580-0939. Fax: (317)581-1329. Creative Director: Amy Mansfield. Circ. 50,000. Estab. 1994. Monthly magazine. Readers are females, ages 20-55. Sample copy free with 9×12 SASE. Photo guidelines free with SASE.

Needs: Uses 48 photos/issue. Needs photos of beauty, fashion, dining out. Model relese required. Property release required. Captions preferred; include subject, date, photographer.

Making Contact & Terms: Provide résumé, business card, brochure, flier or tearsheets to be kept on file for possible assignments. Keeps samples on file. SASE. Reports on an as needed basis. Payment negotiable. Credit line given. Rights negotiable. Previously published work OK.

THE SUBJECT INDEX, located at the back of this book, lists publications, book publishers, galleries, gift and paper product companies and stock agencies according to the subject areas they seek.

INLINE: THE SKATER'S MAGAZINE, 2025 Pearl St., Boulder CO 80302. (303)440-5111. Fax: (303)440-3313. Photo Editor: Annelies Cunis. Circ. 40,000. Estab. 1991. Bimonthly tabloid. Emphasizes inline skating (street, speed, vertical, fitness, hockey, basics). Readers are male and female skaters of all ages. Sample copy free with 11 × 14 SASE.
Needs: Uses 20-50 photos/issue; 75% supplied by freelancers. Needs photos of skating action, products, scenics, personalities, how-to. Captions preferred; include location and model.
Making Contact & Terms: Provide résumé, business card, brochure, flier or tearsheets to be kept on file for possible assignments. Keeps samples on file. SASE. Reports in 3 weeks. Pays $50-500/job; 200-300/color cover; $50-125/color inside; $25-100/b&w inside; $100/color page rate; $75/b&w page rate. Pays on publication. Credit line given. Buys one-time rights; negotiable. Simultaneous submissions and previously published work OK.
Tips: "Freelancers should get in touch to arrange any kind of submission before sending it. However, I am always interested in seeing new work from new photographers."

N: INSIGHT MAGAZINE, Review & Herald Publishing Assoc., 55 W. Oak Ridge Dr., Hagerstown MD 21740-7390. (301)791-7000, ext. 2433. Fax: (301)790-9734. E-mail: insight@rhpa.org. Designer: Doug Bendall. Circ. 20,000. Estab. 1970. *INSIGHT* is a weekly Seventh-day Adventist teen magazine. "We print teens' true stories about God's involvement in their lives. All stories, if illustrated by a photo, must uphold moral and church organization standards while capturing a hip, teen style." Sample copy free.
Needs: "Query with photo samples so we can evaluate style." Model release required; property release required. Photo caption preferred; include who, what, where, when, what.
Making Contact & Terms: Send query letter with samples. Provide résumé, business card, self-promotion piece or tearsheets to be kept on file for possible future assignments. Reports back only if interested, send non-returnable samples. Pays $150-300 for b&w cover; $200-400 for color cover; $150-300 for b&w inside; $200-400 for color inside. **Pays on acceptance.** Credit line given. Buys first rights. Simultaneous submissions and/or previously published work OK.

INTERNATIONAL RESEARCH & EDUCATION (IRE), 21098 IRE Control Center, Eagan MN 55121-0098. (612)888-9635. Fax: (612)888-9124. IP Director: George Franklin, Jr. IRE conducts in-depth research probes, surveys, and studies to improve the decision support process. Company conducts market research, taste testing, brand image/usage studies, premium testing, and design and development of product/service marketing campaigns. Photos used in brochures, newsletters, posters, audiovisual presentations, annual reports, catalogs, press releases, and as support material for specific project/survey/reports.
Needs: Buys 75-110 photos/year; offers 50-60 assignments/year. "Subjects and topics cover a vast spectrum of possibilities and needs." Model release required.
Audiovisual Needs: Uses freelance filmmakers to produce promotional pieces for 16mm or videotape.
Making Contact & Terms: Provide résumé, business card, brochure, flier or tearsheets to be kept on file for possible future assignments. "Materials sent are put on optic disk for options to pursue by project managers responsible for a program or job." Works on assignment only. Uses prints (15% b&w, 85% color), transparencies and negatives. Cannot return material. Reports when a job is available. Payment negotiable; pays on a bid, per job basis. Credit line given. Buys all rights.
Tips: "We look for creativity, innovation and ability to relate to the given job and carry out the mission accordingly."

INTERRACE MAGAZINE, Heritage Publishing Group, P.O. Box 12048, Atlanta GA 30355. (404)350-7877. Fax: (404)350-0819. Associate Publisher: Gabe Grosz. Circ. 25,000. Estab. 1989. Quarterly magazine. Emphasizes interracial couples and families, mixed-race people and biracial/multicultural children. Readers are male and female, ages 18-70, of all racial backgrounds. Sample copies $2 with 9 × 12 SAE and 4 first-class stamps. Photo guidelines free with SASE.
Needs: Uses 20-30 photos/issue; 15-20 supplied by freelancers. Needs photos of people/couples/personalities; must be interracial couple or interracially involved; biracial/multiracial people and children.
Making Contact & Terms: Send unsolicited photos by mail for consideration. Accepts images in digital format for Mac. Send via floppy disk (133 line per inch or 2400 dpi). Send 3 × 5, 4 × 6, 8 × 10 color or b&w prints. Keeps samples on file. SASE. Reports in 1 month or less. Pays $35/color cover; $35/b&w cover; $20/full page; $15/half page; $10/less than half page. Also pays by the hour, $15-25; and by the roll. Call for details. Pays on publication. Credit line given. Buys one-time rights. Simultaneous submissions and/or previously published work OK.
Tips: "We're looking for unusual, candid, upbeat, artistic, unique photos. We're looking for not only black and white couples/people. All racial make ups are needed."

THE IOWAN MAGAZINE, 108 Third St., Suite 350, Des Moines IA 50309. (515)282-8220. Fax: (515)282-0125. Editor: Jay P. Wagner. Circ. 25,000. Estab. 1952. Quarterly magazine. Emphasizes "Iowa—its people, places, events, nature and history." Readers are over 30, college-educated, middle to upper income. Sample copy $4.50 with 9×12 SAE and 8 first-class stamps. Photo guidelines free with SASE.
Needs: Uses about 80 photos/issue; 50% by freelance photographers on assignment and 50% freelance stock. Needs "Iowa scenics—all seasons." Model/property releases preferred. Captions required.
Making Contact & Terms: Send color 35mm, 2¼×2¼ or 4×5 transparencies by mail for consideration. SASE. Reports in 1 month. Pays $25-50/b&w photo; $50-200/color photo; $200-500/day. Pays on publication. Credit line given. Buys one-time rights; negotiable.

N: ISLANDS AND AQUA MAGAZINES, Island Publishing, 3886 State St., Santa Barbara CA 931055. (805)682-7177. Fax: (805)569-0349. E-mail: cwheeler@islandsmag.com. Website: http://www.islandsmag.com and http://www:aquamag.com. Photo Researcher: Charles Wheeler. Circ. 250,000 (*Islands*), 125,000 (*Aqua*). Bimonthly magazines. "*Islands* is a travel magazine and *AQUA* is a water sports/scuba magazine."
Needs: Buys 25 photos from freelancers/issue; 300 photos/year. Needs photos of travel, water sports. Reviews photos with or without ms. Model release preferred; property release preferred for models. Photo captions required required; include name, phone, address, subject information.
Making Contact & Terms: Send query letter with tearsheets. Provide résumé, business card, self-promotion piece or tearsheets to be kept on file for possible future assignments. To show portfolio, photographer should follow-up with call. Portfolio should include b&w and/or color prints, slides, tearsheets, transparencies. Uses color 35mm, 2¼×2¼, 4×5, 8×10 transparencies. Keeps samples on file. Unsolicited material returned by SASE. Accepts images in digital format for Mac (TIFF). Send via CD or online. Pays $250-600/color cover; $75-350/color inside. Pays 30 days after publication. Credit line given. Buys one-time rights. Simultaneous submissions OK.

N: ITALIAN AMERICA, 219 E St., NE, Washington DC 20002. (202)547-8115. Fax: (202)546-8168. E-mail: markeditor@aol.com. Website: http://www.osia.org. Circ. 70,000. Estab. 1996. Quarterly. "*Italian America* is the official publication of the Order Sons of Italy in America, the nation's oldest and largest organization of American men and women of Italian heritage. *Italian America* strives to provide timely information about OSIA, while reporting on individuals, institutions, issues and events of current or historical significance in the Italian-American community." Sample copy free. Art guidelines free.
Needs: Buys 5-10 photos from freelancers/issue; 25 photos/year. Needs photos of travel, history, personalities. Reviews photos with or without ms. Special photo needs include travel in Italy. Model release preferred. Photo caption required.
Making Contact & Terms: Send query letter with tearsheets. Provide résumé, business card, self-promotion piece or tearsheets to be kept on file for possible future assignments. Art director will contact photographer for portfolio review if interested. Portfolio should include color tearsheets. Uses 35mm, 4×5, 8×10 transparencies. Keeps samples on file. Reports back only if interested, send non-returnable samples. Pays $250-500 for color cover; $50-250 for color inside. Pays on publication. Credit line given. Buys one-time rights. Simultaneous submissions OK.

ITE JOURNAL, 525 School St. SW, #410, Washington DC 20024. (202)554-8050. Fax: (202)863-5486. Director of Communication and Marketing: Shannon Gore Peters. Production Editor: Linda L. Sigmon. Circ. 14,000. Estab. 1930. Publication of Institute of Transportation Engineers. Monthly journal. Emphasizes surface transportation, including streets, highways and transit. Readers are transportation engineers and professionals.
Needs: One photo used for cover illustration per issue. Needs "strikingly scenic shots of streets, highways, traffic, transit systems." Model release required. Captions preferred, include location, name or number of road or highway and details.
Making Contact & Terms: Query with list of stock photo subjects. Send 35mm or 2¼×2¼ transparencies by mail for consideration. Provide résumé, business card, brochure, flier or tearsheets to be kept on file for possible assignments. "Send originals; no dupes please." Pays $250/color cover; $50/b&w inside. Pays on publication. Credit line given. Buys multiple-use rights. Simultaneous submissions and/or previously published work OK.

N: JEWISH ACTION, The Magazine of the Orthodox Union, 333 Seventh Ave., New York NY 10001-5004. (212)613-8146. Fax: (212)613-8333. Editor: Ms. Friedland. Circ. 20,000. Estab. 1986. Quarterly magazine with adult Orthodox Jewish readership. Sample copy for $5 and 8½×11 SAE.
Needs: Buys 6 photos/year. Needs photos of Jewish lifestyle, Israel and occasional photo essays of Jewish

life. Reviews photos with or without ms. Model release preferred; property release preferred. Photo caption required; include description of activity where taken, when.

Making Contact & Terms: Send query letter with samples, brochure or stock photo list. Uses color and/or b&w prints. Keeps samples on file. Reports in 2 months on queries; 2 months on samples. Pays $250 maximum for b&w cover; $400 maximum for color colver; $100 maximum for b&w inside; $150 maximum for color inside. Pays within 6 weeks of publication. Credit line given. Buys one-time rights. Simultaneous submissions OK.

Tips: "Be aware that models must be clothed in keeping with Orthodox laws of modesty. Make sure to include identifying details. Don't send work depicting religion in general. We are specifically Othodox Jewish.

N **JOURNAL OF ASIAN MARTIAL ARTS**, Via Media Publishing Co., 821 W. 24th St., Erie PA 16502-2523. (814)455-9517. Fax: (814)838-7811. E-mail: viamedia@ncinter.net. Website: http://www.ncinter.net/~viamedia. Editor-in-Chief: Michael DeMarco. Circ. 10,000. Estab. 1992. "An indexed, notch bound quarterly magazine exemplifying the highest standards in writing and graphics available on the subject. Comprehensive, mature, and eye-catching. Covers all historical and cultural aspects of Asian martial arts." Sample copy for $10. Art guidelines for SAE with 1 first-class stamp.

Needs: Buys 120 photos from freelancers/issue; 580 photos/year. Needs photos of action shots; technical sequences of martial arts; photos that capture the philosophy and aesthetics of Asian martial traditions. Model release preferred for photos taken of subjects not in public demonstration; property release preferred. Photo caption preferred. Include short description, photographer's name, year taken.

Making Contact & Terms: Send query letter with samples, stock photo list. Provide résumé, business card, self-promotion piece or tearsheets to be kept on file for possible future assignments. Art director will

© Donna Maloney

"I first made contact with Michael DeMarco, editor-in-chief of *The Journal of Asian Martial Arts*, through Professor Burt Konzak, chief instructor of the Toronto Academy of Karate and Judo," says photographer Donna Maloney. Konzak, along with another professor and a pediatrician, had written an article on the impact of karate on children. DeMarco was publishing the article. When Professor Konzak approached Maloney about doing the photography for his article she jumped at the chance to do the action shots. DeMarco was very pleased with the resulting images. "In addition to being clear, sharp photographs, Maloney's use of color, action and camera angle catches the inner feelings of her subjects, exuding the complex attitudes of a serious martial artist." Maloney went on to stage an exhibition of her martial arts work entitled "Images of the Orient."

contact photographer for portfolio review if interested. Uses color and b&w prints; 35mm, 2¼×2¼, 4×5, 8×10 transparencies. Accepts images in digital format. Keeps samples on file; include SASE for return of material. Reports in 2 months on queries; 2 months on samples. Pays $100-500 for color cover; $10-100 for b&w inside. Credit line given. Buys first rights and reprint rights. Previously published work OK.
Tips: "Read the journal. We are unlike any other martial arts magazine and would like photography to compliment the text portion, which is sophisticated with the flavor of traditional Asian aesthetics. When submitting work, be well organized and include a SASE."

N. THE JOURNAL OF ITALIAN FOOD, WINE & TRAVEL, 241 W. 109th St., #4A, New York NY 10025. (212)864-0775. E-mail: coxdenise@aol.com. Circ. 50,000. Estab. 1991. Bimonthly guide to the best of Italian food, wine and travel for the discriminating reader. Sample copies available.
Needs: Buys 10 photos from freelancers/issue; 60 photos/year. Needs photos of food, wine and travel of Italy only. Reviews photos with or without ms. Model release required. Photo captions preferred.
Making Contact & Terms: Send query letter with samples, brochure, stock photo list, tearsheets. Provide résumé, business card, self-promotion piece or tearsheets to be kept on file for possible future assignments. Uses 35mm, 2¼×2¼, 4×5, 8×10 transparencies. Keeps samples on file. Reports in 3 months on queries or samples. Pays $750 maximum/color cover; $100 maximum/b&w inside; $500 maximum/color inside. Pays on publication. Credit line given. Buys all rights. Simultaneous submissions and previously published work OK.
Tips: "Our magazine is a very specific one—Italy, Italian food, wine, travel. Keeping that in mind would be of ample help. Always include captions or details to inform us as to what region, city, county, people we are looking at in your submission. We appreciate nice landscapes and city shots."

N. JOURNAL OF PHYSICAL EDUCATION, RECREATION & DANCE, American Alliance for Health, Physical Education, Recreation & Dance, Reston VA 22091. (703)476-3400. Fax: (703)476-9527. Website: http://www.aahperd.org. Editor: Michael T. Shoemaker. Circ. 30,000. Estab. 1896. Monthly magazine. Emphasizes "teaching and learning in public school physical education: youth sports, youth fitness; dance on elementary, secondary or college levels (not performances, classes only); recreation for youth, children, families; girls and women's athletics; and *physical* education and fitness." Sample copy free with 9×12 SAE and 7 first-class stamps. Photo guidelines free with SASE.
Needs: Freelancers supply cover photos only; 80% from assignment. Model release required. Captions preferred.
Making Contact & Terms: Query with list of stock photo subjects. Buys 5×7 or 8×10 color prints; 35mm transparencies. Buys b&w photos by contract. SASE. Accepts images in digital format for Windows (TIFF, EPS). Send via Zip or floppy disk. Reports in 2 weeks. Pays $30/b&w photo; $250/color photo. Credit line given. Buys one-time rights. Previously published work OK.
Tips: "Innovative transparencies relating to physical education, recreation and sport are considered for publication on the cover—vertical format." Looks for "action shots, cooperative games, no competitive sports and classroom scenes. Send samples of *relevant* photos."

JUDICATURE, 180 N. Michigan, Suite 600, Chicago IL 60601-7401. (312)558-6900, ext. 119. Fax: (312)558-9175. E-mail: drichert@ajs.org. Website: http://www.ajs.org. Editor: David Richert. Circ. 11,000. Estab. 1917. Publication of the American Judicature Society. Bimonthly. Emphasizes courts, administration of justice. Readers are judges, lawyers, professors, citizens interested in improving the administration of justice. Sample copy free with 9×12 SAE and 6 first-class stamps.
Needs: Uses 2-3 photos/issue; 1-2 supplied by freelancers. Needs photos relating to courts, the law. "Actual or posed courtroom shots are always needed." Model/property releases preferred. Captions preferred.
Making Contact & Terms: Send 5×7 glossy b&w prints by mail for consideration. Provide résumé, business card, brochure, flier or tearsheets to be kept on file for possible future assignments. SASE. Accepts images in digital format for Mac. Send via floppy disk, SyQuest or over the Internet. Reports in 2 weeks. Pays $250/b&w cover; $350/color cover; $125-300/color inside; $125-250/b&w inside. Pays on publication. Credit line given. Buys one-time rights. Simultaneous submissions and previously published work OK.

JUNIOR SCHOLASTIC, 555 Broadway, New York NY 10012. (212)343-6295. Editor: Lee Baier. Senior Photo Researcher: Diana Gongora Circ. 575,000. Biweekly educational school magazine. Emphasizes middle school social studies (grades 6-8): world and national news, US and world history, geography, how people live around the world. Sample copy $1.75 with 9×12 SAE.
Needs: Uses 20 photos/issue. Needs photos of young people ages 11-14; non-travel photos of life in other

countries; US news events. Reviews photos with accompanying ms only. Model release required. Captions required.

Making Contact & Terms: Arrange a personal interview to show portfolio. "Please do not send samples—only stock list or photocopies of photos." Reports in 1 month. Pays $200/color cover; $75/b&w inside; $150/color inside. **Pays on acceptance.** Credit line given. Buys one-time rights. Simultaneous submissions OK.

Tips: Prefers to see young teenagers; in US and foreign countries, especially "personal interviews with teenagers worldwide with photos."

KANSAS, 700 SW Harrison, Suite 1300, Topeka KS 66603. (913)296-3479. Editor: Andrea Glenn. Circ. 50,000. Estab. 1945. Quarterly magazine. Emphasizes Kansas travel, scenery, arts, recreation and people. Photos are purchased with or without accompanying ms or on assignment. Free sample copy and photo guidelines.

Needs: Buys 60-80 photos/year; 75% from freelance assignment, 25% from freelance stock. Animal, human interest, nature, photo essay/photo feature, scenic, sport, travel and wildlife, all from Kansas. No b&w, nudes, still life or fashion photos. Model/property release preferred. Captions (with subject and specific location of photograph identified) required.

Making Contact & Terms: Send material by mail for consideration. Transparencies must be identified by location and photographer's name on the mount. Uses 35mm, 2¼×2¼ or 4×5 transparencies. Photos are returned after use. Pays $50 minimum/color inside; $150 minimum/color cover. **Pays on acceptance.** Credit line given. Buys one-time rights. Previously published work OK.

Tips: Kansas-oriented material only. Prefers Kansas photographers. "Follow guidelines, submission dates specifically. Shoot a lot of seasonal scenics."

N KANSAS CITY MAGAZINE, ABARTA Metro Publishing, 7101 College Blvd., Suite 600, Overland Park KS 66210. (913)338-0900. Fax: (913)338-1148. Website: http://www.kcmag.com. Director of Design: Kevin Swanson. Circ. 30,000. Estab. 1994. Bimonthly consumer magazine. Sample copy for $3.50 and 9×12 SAE.

Needs: Buys 25 photos from freelancers/issue; 125 photos/year. Needs photos of lifestyles and personalities. Reviews photos with or without ms. Model release and property release preferred. Photo caption preferred.

Making Contact & Terms: Art director will contact photographer for portfolio review if interested. Portfolio should include b&w and/or color, prints, slides or transparencies. Uses 35mm, 2¼×2¼, 4×5 transparencies. Accepts images in digital format. Keeps samples on file; include SASE for return of material. Reports back only if interested. Pays $200-500 for b&w cover; $300-700 for color cover; $100-350 for b&w or color inside. **Pays on acceptance.** Credit line given. Buys one-time rights, electronic rights; negotiable. Simultaneous submissions OK.

Tips: "I like conceptual work, simple yet dramatic."

KASHRUS MAGAZINE—The Guide for the Kosher Consumer, P.O. Box 204, Parkville Station, Brooklyn NY 11204. (718)336-8544. Editor: Rabbi Yosef Wikler. Circ. 10,000. Bimonthly. Emphasizes kosher food and food technology. Readers are kosher food consumers, vegetarians and producers. Sample copy $2.

Needs: Uses 3-5 photos/issue; all supplied by freelance photographers. Needs photos of travel, food, food technology, seasonal nature photos and Jewish holidays. Model release preferred. Captions preferred.

Making Contact & Terms: Send unsolicited photos by mail for consideration. Provide résumé, business card, brochure, flier or tearsheets to be kept on file for possible future assignments. Uses 2¼×2¼, 3½×3½ or 7½×7½ matte b&w prints. SASE. Reports in 1 week. Pays $40-75/b&w cover; $25-50/b&w inside; $75-200/job; $50-200/text/photo package. Pays part on acceptance; part on publication. Buys one-time rights, first North American serial rights, all rights; negotiable. Simultaneous submissions and previously published work OK.

N ⊕ KERRANG!, Mappin House, 4 Winsley St., London W1N 7AR England. E-mail: kerrang@ecm.e map.com. Art Editor: Sarah Collins. Circ. 45,000. Weekly rock music magazine.

Needs: "We normally use our own photographers on a regular basis but would consider new applications." Needs photos of live, location, studio shots. Reviews photos with or without ms.

Making Contact & Terms: Send query letter with samples. Art director will contact photographer for portfolio review if interested. Portfolio should include b&w and/or color, prints or transparencies. Uses 8×10 color and b&w prints; 35mm, 2¼×2¼, 4×5 transparencies. Accepts images in digital format. Keeps samples on file; include SASE for return of material. Reports in 1 month on queries; 1 month on

samples. "Will discuss payment on commission." Pays on publication. Credit line given. Buys one-time rights, first rights. Previously published work OK.

KEYNOTER, 3636 Woodview Trace, Indianapolis IN 46268. (317)875-8755. Fax: (317)879-0204. Art Director: Jim Patterson. Circ. 190,000. Publication of the Key Club International. Monthly magazine through school year (7 issues). Emphasizes teenagers, above average students and members of Key Club International. Readers are teenagers, ages 14-18, male and female, high GPA, college-bound, leaders. Sample copy free with 9×12 SAE and 3 first-class stamps. Photo guidelines free with SASE.
Needs: Uses varying number of photos/issue; varying percentage supplied by freelancers. Needs vary with subject of the feature article. Reviews photos purchased with accompanying ms only. Model release required. Captions preferred.
Making Contact & Terms: Query with résumé of credits. Accepts images in digital format for Windows. Send via compact disc, floppy disk or SyQuest. Pays $700/color cover; $500/b&w cover; $400/color inside; $100/b&w inside. **Pays on acceptance.** Credit line given. Buys first North American serial rights and first international serial rights.

KITE LINES, P.O. Box 466, Randallstown MD 21133-0466. (410)922-1212. Fax: (410)922-4262. E-mail: kitelines@compuserve.com. Publisher-Editor: Valerie Govig. Circ. 13,000. Estab. 1977. Quarterly. Emphasizes kites and kite flying exclusively. Readers are international adult kiters. Sample copy $5. Photo guidelines free with SASE.
Needs: Uses about 45-65 photos/issue; "up to about 50% are unassigned or over-the-transom—but nearly all are from *kiter*-photographers." Needs photos of "unusual kites in action (no dimestore plastic kites), preferably with people in the scene (not easy with kites). Needs to relate closely to *information* (article or long caption)." Special needs include major kite festivals; important kites and kiters. Captions required. "Identify kites, kitemakers and kitefliers as well as location and date."
Making Contact & Terms: Query with samples or send 2-3 b&w 8×10 uncropped prints or 35mm or larger transparencies (dupes OK) by mail for consideration. Provide relevant background information, i.e., knowledge of kites or kite happenings. SASE. Reports in "2 weeks to 2 months (varies with work load, but any obviously unsuitable stuff is returned quickly—in 2 weeks." Pays $0-30/inside; $0-50/cover; special jobs on assignment negotiable; generally on basis of film expenses paid only. "We provide extra copies to contributors. Our limitations arise from our small size. However, *Kite Lines* is a quality showcase for good work." Pays within 30 days after publication. Buys one-time rights; usually buys first world serial rights. Previously published work considered.
Tips: In portfolio or samples wants to see "ability to select important, *noncommercial* kites. Just take a great kite picture, and be patient with our tiny staff. Considers good selection of subject matter; good composition—angles, light, background and sharpness. But we don't want to look at 'portfolios'—just *kite* pictures, please."

KIWANIS MAGAZINE, 3636 Woodview Trace, Indianapolis IN 46268. (317)875-8755. Fax: (317)879-0204. Website: http://kiwanismail@kiwanis.org. Managing Editor: Chuck Jonak. Art Director: Jim Patterson. Circ. 285,000. Estab. 1915. Published 10 times/year. Emphasizes organizational news, plus major features of interest to business and professional men and women involved in community service. Free sample copy and writer's guidelines with SAE and 5 first-class stamps.
Needs: Uses photos with or without ms.
Making Contact & Terms: Send résumé of stock photos. Provide brochure, business card and flier to be kept on file for future assignments. Accepts images in digital format for Mac, Windows. Send via compact disc, floppy disk, SyQuest. Assigns 95% of work. Uses 5×7 or 8×10 glossy b&w prints; accepts 35mm but prefers 2¼×2¼ and 4×5 transparencies. Pays $50-400/b&w photo; $75-1,000/color photo; $400-1,000/text/photo package. Buys one-time rights.
Tips: "We can offer the photographer a lot of freedom to work *and* worldwide exposure. And perhaps an award or two if the work is good. We are now using more conceptual photos. We also use studio set-up shots for most assignments. When we assign work, we want to know if a photographer can follow a concept into finished photo without on-site direction." In portfolio or samples, wants to see "studio work with flash and natural light."

CONTACT THE EDITOR, of *Photographer's Market* by e-mail at photomarket@fwpubs.com with your questions and comments.

LACMA PHYSICIAN, P.O. Box 513465, Los Angeles CA 90051-1465. (213)630-1123. Fax: (213)630-1152. E-mail: lpmag@lacmanet.org. Website: www.lacmanet.org. Managing Editor: Barbara L. Feiner. Circ. 11,000. Estab. 1875. Monthly. Emphasizes Los Angeles County Medical Association news and medical issues. Readers are physicians and members of LACMA.
Needs: Uses about 1-12 photos/issue; from both freelance and staff assignments. Needs photographers who can conceptualize and work with editor to illustrate cover stories and other articles. Model release required.
Making Contact & Terms: Send promo piece. Pay varies based on photo use. Pays on publication with submission of invoice. Credit line given. Buys one-time rights or first North American serial rights "depending on what is agreed upon; we buy nonexclusive rights to use work on our website."
Tips: "We want photographers who can get an extraordinary photo that captures the subject matter."

LACROSSE MAGAZINE, 113 W. University Pkwy., Baltimore MD 21210. (410)235-6882. Fax: (410)366-6735. E-mail: mbouchard@lacrosse.org. Editor: Marc Bouchard. Circ. 15,000. Estab. 1978. Publication of The Lacrosse Foundation. Monthly magazine during lacrosse season (March, April, May, June); bimonth off-season (July/August, September/October, November/December, January/February). Emphasizes sport of lacrosse. Readers are male and female lacrosse enthusiasts of all ages. Sample copy free with general information pack.
Needs: Uses 30-40 photos/issue; 50-75% supplied by freelancers. Needs lacrosse action shots. Captions required; include rosters with numbers for identification.
Making Contact & Terms: Send unsolicited photos by mail for consdieration. Provide résumé, business card, brochure, flier or tearsheets to be kept on file for possible assignments. Send 4×6 glossy color and b&w prints. Keeps samples on file. SASE. Reports in 3 weeks. Pays $100/color cover; $50/color inside; $50/b&w inside. Pays on publication. Credit line given. Buys one-time rights. Simultaneous submissions and/or previously published work OK.

LAKE SUPERIOR MAGAZINE, Lake Superior Port Cities, Inc., P.O. Box 16417, Duluth MN 55816-0417. (218)722-5002. Fax: (218)722-4096. Editor: Paul L. Hayden. Circ. 20,000. Estab. 1979. Bimonthly magazine. "Beautiful picture magazine about Lake Superior." Readers are ages 35-55, male and female, highly educated, upper-middle and upper-management level through working. Sample copy $3.95 with 9×12 SAE and 5 first-class stamps. Photo guidelines free with SASE.
• This publication now uses a desktop system for color scanning and storage of high resolution files.
Needs: Uses 30 photos/issue; 70% supplied by freelance photographers. Needs photos of scenic, travel, wildlife, personalities, underwater, all photos Lake Superior-related. Photo captions preferred.
Making Contact & Terms: Send unsolicited photos by mail for consideration. Provide résumé, business card, brochure, flier or tearsheets to be kept on file for possible assignments. Uses b&w prints; 35mm, 2¼×2¼, 4×5 transparencies. SASE. Reports in 3 weeks. Pays $125/color cover; $40/color inside; $20/b&w inside. Pays on publication. Credit line given. Buys first North American serial rights; reserves second rights for future use. Simultaneous submissions OK.
Tips: "Be aware of the focus of our publication—Lake Superior. Photo features concern only that. Features with text can be related. We are known for our fine color photography and reproduction. It has to be 'tops.' We try to use images large, therefore detail quality and resolution must be good. We look for unique outlook on subject, not just snapshots. Must communicate emotionally."

LAKELAND BOATING MAGAZINE, 500 Davis St., Suite 100, Evanston IL 60201. (847)869-5400. Editor: Randall W. Hess. Circ. 45,000. Estab. 1945. Monthly magazine. Emphasizes powerboating in the Great Lakes. Readers are affluent professionals, predominantly men over 35. Sample copy $6 with 9×12 SAE and 10 first-class stamps.
Needs: Needs shots of particular Great Lakes ports and waterfront communities. Model release preferred. Captions preferred.
Making Contact & Terms: Query with list of stock photo subjects. Provide résumé, business card, brochure, flier or tearsheets to be kept on file for possible assignments. SASE. Pays $20-100/b&w photo; $25-100/color photo. **Pays on acceptance.** Credit line given. Buys one-time rights.

LANDSCAPE ARCHITECTURE, 636 Eye Street NW, Washington DC 20001. (202)898-2444. Design Director: Jeff Roth. Circ. 35,000. Estab. 1910. Publication of the American Society of Landscape Architects. Monthly magazine. Emphasizes "landscape architecture, urban design, parks and recreation, architecture, sculpture" for professional planners and designers. Sample copy $7. Photo guidelines free with SASE.
Needs: Uses about 75-100 photos/issue; 80% supplied by freelance photographers. Needs photos of land-

scape- and architecture-related subjects as described above. Special needs include aerial photography and environmental portraits. Model release required. Credit, caption information required.

Making Contact & Terms: Query with samples or list of stock photo subjects. Provide brochure, flier or tearsheets to be kept on file for possible future assignments. SASE. Reporting time varies. Pays $400/day. Pays on publication. Credit line given. Buys one-time rights. Previously published work OK.

Tips: "We take an editorial approach to photographing our subjects."

LAW PRACTICE MANAGEMENT, Box 11418, Columbia SC 29211-1418. (803)754-3563. Managing Editor/Art Director: Delmar L. Roberts. Circ. 22,005 (BPA). Estab. 1975. Published 8 times/year. Publication of the Law Practice Management Section, American Bar Association. For practicing attorneys and legal administrators. Sample copy $10 (make check payable to American Bar Association).

Needs: Uses 1-2 photos/issue; all supplied by freelance photographers. Occasionally needs photos of some stock subjects such as group at a conference table, someone being interviewed, scenes showing staffed office-reception areas; *imaginative* photos illustrating such topics as time management, employee relations, trends in office technology, alternative billing, lawyer compensation. Computer graphics of interest. Abstract shots or special effects illustrating almost anything concerning management of a law practice. "We'll exceed our usual rates for exceptional photos of this latter type." No snapshots or Polaroid photos. Model release required. Captions required.

Making Contact & Terms: Uses 5×7 glossy b&w prints; 35mm, 2¼×2¼, 4×5 transparencies. Send unsolicited photos by mail for consideration. They are accompanied by an article pertaining to the lapida "if requested." SASE. Reports in 3 months. Pays $350-450/color cover (vertical format); $50-100/b&w inside photo; $200-300/job. Pays on publication. Credit line given. Usually buys all rights, and rarely reassigns to photographer after publication.

N: LEG SEX, The SCORE Group, 4931 S.W. 75th Ave., Miami FL 33155. (305)662-5959. Fax: (305)662-5952. E-mail: gablel@scoregroup.com. Contact: Lisa Gable. Monthly men's magazine featuring photo sets of models with a strong emphasis on the legs and feet. Sample copy for $7. Art guidelines available.

Needs: Model release required; as well as copies of two forms of I.D. from the model, one of them being a photo I.D.

Making Contact & Terms: Portfolio should include color transparencies. Uses color prints; 35mm transparencies; Kodachrome film or larger format transparencies. Include SASE for return of material. Reports in 1 month maximum on queries. Pays $1,250-1,800 for color sets of 100-200 transparencies. "Please do not send individual photos except for test shots." Pays on publication. Buys first rights in North America with a reprint option, electronic rights and non-exclusive worldwide publishing rights.

LIBIDO: THE JOURNAL OF SEX AND SENSIBILITY, 5318 N. Paulina St., Chicago IL 60640. (773)275-0842. Fax: (773)275-0752. E-mail: rune@mcs.com. Website: http://www.sensualsource.com. Photo Editor: Marianna Beck. Circ. 10,000. Estab. 1988. Quarterly journal. Emphasizes erotic photography. Subscribers are 60% male, 40% female, generally over 30, college educated professionals. Sample copy $8. Photo guidelines free with SASE.

Needs: Uses 30-35 photos/issue; 30 supplied by freelancers. Needs erotic photos (need not be nude, but usually it helps); nude figure-studies and couples. Reviews photos with or without ms. Model release required. "Besides dated releases, all photos taken after July 5, 1995 must comply with federal record keeping requirements."

Making Contact & Terms: Send unsolicited photos by mail for consideration. Send 4×5, 8×10 matte or glossy b&w prints and slides. Accepts images in digital format for Mac (JPEG) for electronic issue; TIFFS for print. Send via online, floppy disk. Keeps samples on file. Reports in 1 month. Pays $75/b&w cover; $20-50/b&w inside. Pays on publication. Credit line given. Buys one-time and electronic rights. Previously published work OK.

Tips: "Fit your work to the style and tone of the publication. We're print driven, photos must support stories and poems."

LIFE, Dept. PM, Time-Life Bldg., Rockefeller Center, New York NY 10020. (212)522-1212. Photo Editor: Marie Schumann. Circ. 1.4 million. Monthly magazine. Emphasizes current events, cultural trends, human behavior, nature and the arts, mainly through photojournalism. Readers are of all ages, backgrounds and interests.

Needs: Uses about 100 photos/issue. Prefers to see topical and unusual photos. Must be up-to-the minute and newsworthy. Send photos that could not be duplicated by anyone or anywhere else. Especially needs humorous photos for last page article "Just One More."

Making Contact & Terms: Send material by mail for consideration to the Picture Desk. Do not send

negatives or original transparencies—send prints, dupe sides or laser copies. SASE. Uses 35mm, 2¼×2¼, 4×5 and 8×10 slides. Pays $500/page; $1,000/cover. Credit line given. Buys one-time rights.
Tips: "Familiarize yourself with the topical nature and format of the magazine before submitting photos and/or proposals."

Ⓝ ⊕ LINCOLNSHIRE LIFE, County Life Ltd., P.O. Box 81, Lincoln LN1 1HD United Kingdom. Phone: (01522) 527127. Fax: (01522) 5860035. Editor: Jez Ashberry. Circ. 10,000. Estab. 1961. Monthly consumer county magazine featuring the culture and history of Lincolnshire. Sample copy for £1.50. Art guidelines free.
Needs: Buys 10 photos from freelancers/issue; 120 photos/year. Needs photos of Lincolnshire scenes, animals, people. Photo caption required.
Making Contact & Terms: Send query letter with samples. Art director will contact photographer for portfolio review if interested. Portfolio should include slides or transparencies. Keeps samples on file. Reports in 1 month on queries; 1 month on samples. Payment negotiable. Pays on publication. Credit line given. Buys first rights. Previously published work OK.
Tips: "Read our magazine. Submit portrait, not landscape shots."

THE LION, 300 22nd St., Oak Brook IL 60523-8842. (630)571-5466. Fax: (630)571-8890. Editor: Robert Kleinfelder. Circ. 600,000. Estab. 1918. For members of the Lions Club and their families. Monthly magazine. Emphasizes Lions Club service projects. Free sample copy and guidelines available.
Needs: Uses 50-60 photos/issue. Needs photos of Lions Club service or fundraising projects. "All photos must be as candid as possible, showing an activity in progress. Please, no award presentations, meetings, speeches, etc. Generally photos purchased with ms (300-1,500 words) and used as a photo story. We seldom purchase photos separately." Model release preferred for young or disabled children. Captions required.
Making Contact & Terms: Works with freelancers on assignment only. Provide résumé to be kept on

© Marian Bond

"I have been writing articles for *The Lion* for about 25 years and have had my photos published along with each story," says Marian Bond. Although Bond and *Lion* Editor Robert Kleinfelder have never met face-to-face, they have a strong professional relationship. "He knows me well enough to know he can depend on my work. We discussed the idea for the story by telephone and he said I should go ahead with the project." The project was an article and photos about Team Penning, a fundraising project of the Anza, California, Lions Club. The sport requires three riders to "cut" three cows out of a herd and maneuver them into a pen in as little time as possible. Bond earned $500 for this story and the action shots that illustrate it.

file for possible future assignments. Query first with résumé of credits or story idea. Send 5×7, 8×10 glossy b&w and color prints; 35mm transparencies. SASE. Reports in 2 weeks. Pays $10-25/photo; $100-600/text/photo package. **Pays on acceptance.** Buys all rights; negotiable.

THE LIVING CHURCH, 816 E. Juneau Ave., P.O. Box 92936, Milwaukee WI 53202. (414)276-5420. Fax: (414)276-7483. Managing Editor: John Schuessler. Circ. 9,000. Estab. 1878. Weekly magazine. Emphasizes news of interest to members of the Episcopal Church. Readers are clergy and lay members of the Episcopal Church, predominantly ages 35-70. Sample copies available.
Needs: Uses 8-10 photos/issue. Needs photos to illustrate news articles. Always in need of stock photos—churches, scenic, people in various settings. Captions preferred.
Making Contact & Terms: Send unsolicited photos by mail for consideration. Send 5×7 or larger glossy b&w prints. Also accepts color/b&w TIFF files, resolution 72 and 300 dpi. SASE. Reports in 1 month. Pays $25-50/b&w cover; $10-25/b&w inside. Pays on publication. Credit line given.

LOG HOME LIVING, 4200 T Lafayette Center Dr., Chantilly VA 20151. (703)222-9411. Fax: (703)222-3209. Website: http://www.loghomeliving.com. Executive Editor: Janice Brewster. Circ. 120,000. Estab. 1989. Ten times/year magazine. Emphasizes buying and living in log homes. Sample copy $3.50/issue. Photo guidelines free with SASE.
Needs: Uses over 100 photos/issue; 10 supplied by freelancers. Needs photos of homes—living room, dining room, kitchen, bedroom, bathroom, exterior, portrait of owners, design/decor—tile sunrooms, furniture, fireplaces, lighting, porch and deck, doors. Model release preferred. Caption required.
Making Contact & Terms: Send unsolicited photos by mail for consideration. Keeps samples on file. SASE. Reports back only if interested. Pays $200-600/color cover; $50-100/color inside; $100/color page rate; $500-1,000/photo/text package. **Pays on acceptance.** Credit line given. Buys first North American serial rights; negotiable. Previously published work OK.

N: LONGBOWS & RECURVES, Traditional Bowhunting at its best, 1828 Proper St., Corinth MS 38834-5199. (601)287-5003. Fax: (601)287-1214. E-mail: longbows@longbows-recurves.com. Website: http://www.longbows-recurves.com. Art Director: Shari Hawley. Circ. 12,000. Estab. 1996. Quarterly consumer magazine. "Devoted to the traditional bowhunting market and traditional target shooting. *Longbows & Recurves* has a mix of first person hunting stories, how-to, fiction and history." Sample copy free. Art guidelines free.
Needs: Needs photos of wild game, traditional bow hunting, 3-D shooting competitions. Reviews photos with or without ms. Model release preferred; property release preferred. Photo captions preferred; include names, location, equipment, date and time, exact wording of photo credit.
Making Contact & Terms: Send query letter with stock photo list. Provide résumé, business card, self-promotion piece or tearsheets to be kept on file for possible future assignments. Art director will contact photographer for portfolio review if interested. Portfolio should include b&w and/or color prints, slides, thumbnails, transparencies. Uses 5×7 minimum, glossy color and b&w prints; 35mm, 2¼×2¼, 4×5, 8×10 transparencies. Keeps samples on file. Accepts images in digital format for Mac (TIFF). Send via SyQuest, Zip disk or Syjet (230 MB MO). Pays on publication. Credit line given. Buys one-time rights. Simultaneous submissions and/or previous previously published work OK.
Tips: "Read our magazine. When submitting work—research and do homework on the magazine, the subject and the audience."

N: LOTTERY & CASINO NEWS (formerly Lottery Player's Magazine), 321 New Albany Rd., Moorestown NJ 08057. (609)778-8900. Fax: (609)273-6350. E-mail: regalpub@lottery-casino-news.com. Editor-in-chief: Samuel W. Valenza, Jr.. Circ. 200,000. Estab. 1981. Bi-monthly tabloid. Covers gaming industry news: lottery, casinos, riverboat casinos, Indian casinos, with an emphasis on winners in all aspects of gaming; Casino show reviews. Will accept photos with or without ms. Captions required.
Needs: Uses 15-20 photos/issue; 1-2 supplied by freelancers. Needs photos of people buying lottery tickets, lottery winners, lottery and gaming activities. Reviews photos with or without ms. Captions required.
Making Contact & Terms: Provide résumé, business card, brochure, flier or tearsheets to be kept on file for possible assignments. "Call with ideas." Keeps samples on file. SASE. Accepts images in digital format for Windows. Send via floppy or Zip disk or online. Reports in 3 weeks. Pays $20-60/color cover; $20/b&w inside; rates vary. Pays 2 months after publication. Buys one-time rights, first North American serial rights, all rights; negotiable. Simultaneous submissions and/or previously published work OK.
Tips: "Photos should be clear, timely and interesting, with a lot of contrast."

N: LOUIE, 234 Berkeley St., Boston MA 02116. (617)262-6100. Fax: (617)262-4549. Website: http://www.louis-boston.com. Contact: Maria Fei. Circ. 75,000. Twice a year consumer magazine. "Cutting edge

catalog concept (no prices!)/magazine geared towards affluent, well educated, professionals who appreciate the finer things." Sample copy free.
Needs: Reviews photos with accompanying ms only depending on issue. Photo caption preferred.
Making Contact & Terms: Send query letter with samples, brochure, stock photo list, tearsheets. Provide résumé, business card, self-promotion piece or tearsheets to be kept on file for possible future assignments. Portfolio should include b&w and/or color, prints or tearsheets. Uses 4×5 prints. Reports back only if interested, send non-returnable samples. Payment varies. Credit line sometimes given depending upon circumstances. Buys negotiated rights.

LUTHERAN FORUM, P.O. Box 327, Delhi NY 13753. (607)746-7511. Editor: Ronald Bagnall. Circ. 3,500. Quarterly. Emphasizes "Lutheran concerns, both within the church and in relation to the wider society, for the leadership of Lutheran churches in North America."
Needs: Uses cover photo occasionally. "While subject matter varies, we are generally looking for photos that include people, and that have a symbolic dimension. We use *few* purely 'scenic' photos. Photos of religious activities, such as worship, are often useful, but should not be 'cliches'—types of photos that are seen again and again." Captions "may be helpful."
Making Contact & Terms: Query with list of stock photo subjects. SASE. Reports in 2 months. Pays $15-25/b&w photo. Pays on publication. Credit line given. Buys one-time rights. Simultaneous submissions or previously published work OK.

MACLEAN'S MAGAZINE, 777 Bay St., Toronto, Ontario M5W 1A7 Canada. (416)596-5379. Fax: (416)596-7730. E-mail: pbregg@macleans.com. Photo Editor: Peter Bregg. Circ. 500,000. Estab. 1905. Weekly magazine. Emphasizes news/editorial. Readers are a general audience. Sample copy $3 with 9×12 SASE.
Needs: Uses 50 photos/issue. Needs a variety of photos similar to *Time* and *Newsweek*. Captions required; include who, what, where, when, why.
Making Contact & Terms: Send business card. Uses color prints; transparencies; 266 dpi, 6×8 average digital formats. Deadline each Friday. Cannot return material. Don't send originals. Reports in 3 weeks. Pays $350/day; $600/color cover; $200/color inside; $50 extra for electronic usage. Pays on publication. Credit line given. Buys one-time and electronic rights. Simultaneous submissions and previously published work OK.

THE MAGAZINE ANTIQUES, 575 Broadway, New York NY 10012. (212)941-2800. Fax: (212)941-2819. Editor: Allison E. Ledes. Circ. 63,969. Estab. 1922. Monthly magazine. Emphasizes art, antiques, architecture. Readers are male and female collectors, curators, academics, interior designers, ages 40-70. Sample copy $10.50.
Needs: Uses 60-120 photos/issue; 40% supplied by freelancers. Needs photos of interiors, architectural exteriors, objects. Reviews photos with or without ms.
Making Contact & Terms: Submit portfolio for review; phone ahead to arrange dropoff. Send 8×10 glossy prints; 4×5 transparencies. Does not keep samples on file. SASE. Reports in 2 weeks. Payment negotiable. Pays on publication. Credit line given. Buys one-time rights; negotiable. Previously published work OK.

MANAGEMENT ACCOUNTING, 10 Paragon Dr., Montvale NJ 07645. (201)573-9000. Fax: (201)573-0639. Editor: Kathy Williams. Circ. 95,000. Estab. 1919. Publication of Institute of Management Accountants. Monthly. Emphasizes management accounting and financial management. Readers are financial executives.
Needs: Uses about 25 photos/issue; 40% from stock houses. Needs stock photos of business, high-tech, production and factory. Model release required for identifiable people. Captions required.
Making Contact & Terms: Query with samples. Provide résumé, business card, brochure, flier or tearsheets to be kept on file for possible future assignments. Uses prints and transparencies. SASE. Reports in 2 weeks. Pays $100-200/b&w photo; $150-250/color photo. **Pays on acceptance.** Credit line given. Buys one-time rights. Simultaneous submissions and previously published work OK.
Tips: Prefers to see "ingenuity, creativity, dramatics (business photos are often dry), clarity, close-ups, simple but striking. Aim for a different slant."

THE MANITOBA TEACHER, 191 Harcourt St., Winnipeg, Manitoba R3J 3H2 Canada. (204)888-7961. Fax: (204)831-0877. Communications Officer: Raman Job. Managing Editor: Judy Edmond. Circ. 17,000. Publication of The Manitoba Teachers' Society. Published nine times per year. Emphasizes education in Manitoba—emphasis on teachers' interest. Readers are teachers and others in education. Sample copy free with 10×14 SAE and Canadian stamps.

Needs: Uses approximately 4 photos/issue; 80% supplied by freelancers. Needs action shots of students and teachers in education-related settings. Model release required.

Making Contact & Terms: Send 8×10 glossy b&w prints by mail for consideration. Submit portfolio for review. Provide résumé, business card, brochure, flier or tearsheets to be kept on file for possible assignments. SASE. Reports in 1 month. Pays $40/photo for single use.

Tips: "Always submit action shots directly related to major subject matter of publication and interests of readership of that publication."

MARLIN MAGAZINE, P.O. Box 2456, Winter Park FL 32790. (407)628-4802. Fax: (407)628-7061. E-mail: marlin@worldzine.com. Editor: David Ritchie. Circ. 40,000 (paid). Estab. 1981. Bimonthly magazine. Emphasizes offshore big game fishing for billfish, tuna and other large pelagics. Readers are 94% male, 75% married, average age 43, very affluent businessmen. Free sample copy with 8×10 SASE. Photo guidelines free with SASE.

Needs: Uses 40-50 photos/issue; 98% supplied by freelancers. Needs photos of fish/action shots, scenics and how-to. Special photo needs include big game fishing action and scenics (marinas, landmarks etc.). Model release preferred. Captions preferred.

Making Contact & Terms: Send unsolicited photos by mail for consideration. Send 35mm transparencies. Also accepts high resolution images on CD (Mac). SASE. Reports in 1 month. Pays $750/color cover; $50-300/color inside; $35-150/b&w inside; $150-200/color page rate. Pays on publication. Buys first North American rights. Simultaneous submissions OK, with notification.

Tips: "Send in sample material with SASE. No phone call necessary."

MARTIAL ARTS TRAINING, P.O. Box 918, Santa Clarita CA 91380-9018. (805)257-4066. Fax: (805)257-3028. E-mail: rainbow@rsabbs.com. Editor: Douglas Jeffrey. Circ. 40,000. Bimonthly. Emphasizes martial arts training. Readers are martial artists of all skill levels. Sample copy free. Photo guidelines free with SASE.

Needs: Uses about 100 photos/issue; 90 supplied by freelance photographers. Needs "photos that pertain to fitness/conditioning drills for martial artists. Photos purchased with accompanying ms only. Model release required. Captions required.

Making Contact & Terms: Send 5×7 or 8×10 b&w prints; 35mm transparencies; b&w contact sheet or negatives by mail for consideration. Accepts images in digital format for Mac. SASE. Reports in 1 month. Pays $50-150 for photo/text package. Pays on publication. Credit line given. Buys all rights.

Tips: Photos "must be razor-sharp, b&w or color. Technique shots should be against neutral background. Concentrate on training-related articles and photos."

⦿ MATURE OUTLOOK, Meredith Corp., 1716 Locust St., Des Moines IA 50309-3023. (515)284-2647. Fax: (515)284-2064. E-mail: bshearer@mdp.com. Circ. 700,000. Bimonthly magazine. General interest (food, travel, health, recreation) for mature audience (55+).

Needs: Buys 50 photos from freelancers/issue; 300 photos/year. Needs photos of hobbies, locations and recreation with seniors. Reviews photos with or without a ms. Model release required; property release preferred. Photo captions required; include who, and what. Art director will contact photographer for portfolio review if interested. Portfolio should include b&w and/or color prints, slides, tearsheets, transparencies. Uses 35mm transparencies. Keeps samples on file. Reports back only if interested, send non-returnable samples. Pays extra for electronic usage of photos. Pays on publication. Credit line given. Buys one-time rights. Simultaneous submissions OK.

Tips: "I like 'natural' looking people doing 'natural' looking things. Include business card with home location."

⦿ ⊕ MAYFAIR MAGAZINE, Paul Raymond Publications, 2 Archer St., London W1V 8JJ England. Phone: (0171)292 8028. Fax: (0171)734 5030. E-mail: mayfair@pr-org.co.uk. Editor: Steve Shields. Circ. Huge!. Estab. 1966. Monthly consumer magazine. Adult glamor.

Needs: Buys many photos from freelancers. "Extreme sports, humor, thrills and spills!" Reviews photos with or without a ms. "We're always looking for mad, bad, dangerous and/or crazy images! Any female featured must be over 18 years."

Making Contact & Terms: Send query letter with samples. Does not keep samples on file; include

 SPECIAL COMMENTS within listings by the editor of *Photographer's Market* are set off by a bullet.

SASE for return of material. Reports back only if interested, send non-returnable samples. Pays week before publication. Simultaneous submissions and/or previously published work OK.
Tips: "Send in your work by all means, but don't be 'pushy' or keep calling—we'll let you know. Think carefully before going to all the trouble—you wouldn't believe how many inappropriate images we receive. Maddening!!!"

MEDIPHORS, P.O. Box 327, Bloomsburg PA 17815. E-mail: mediphor@ptd.net. Website: http://www.mediphors.org. Editor: Eugene D. Radice, MD. Circ. 900. Estab. 1993. Semiannual magazine. Emphasizes literary/art in medicine and health. Readers are male and female adults in the medical fields and literature. Sample copy $6. Photo guidelines free with SASE.
Needs: Uses 5-7 photos/issue; all supplied by freelancers. Needs artistic photos related to medicine and health. Also photos to accompany poetry, essay, and short stories. Special photo needs include single photos, cover photos, and photos accompanying literary work. Releases usually not needed—artistic work. Photographers encouraged to submit titles for their artwork.
Making Contact & Terms: Send unsolicited photos by mail for consideration. Send minimum 3×4 any finish b&w prints. Keeps samples on file. SASE. Reports in 1 month. Pays on publication 2 copies of magazines. Credit line given. Buys first North American serial rights.
Tips: Looking for "b&w artistic photos related to medicine & health. Our goal is to give new artists an opportunity to publish their work. Prefer photos where people CANNOT be specifically identified. Examples: Drawings on the wall of a Mexican Clinic, an abandoned nursing home, an old doctor's house, architecture of an old hospital."

MEN ONLY, Paul Raymond Publications, 2 Archer St., London W1V 8JJ United Kingdom. Phone: (+44)171-292 8000. Fax: (+44)171-734 5030. E-mail: menonly@pr-org.co.uk. Editor: Mike Collier. Circ. 250,000. Estab. 1936. Monthly top-class men's sex magazine (straight) with men's interest features: sports, entertainment etc.
Needs: High quality glamour sets suitable for UK market i.e. no hardcore. Special photo needs include new, fresh, athletic, happy girls (over 18 only) also sports/image-led features. Model release required; property release required. No sets considered without model release and I.D.
Making Contact & Terms: Photographer should call the editor to show portfolio. Portfolio should include color slides or transparencies. Uses color prints. Include SASE for return of material. Pays on publication. Credit line given. Buys first rights; negotiable.
Tips: "Look at the magazine to get an idea of what we want and the high standards required. Imaginative sets and locations, 'themed' sets with a narrative flow and a wide range of poses always set good photographers apart. Include all necessary paperwork. Look at latest edition to see if work is suitable before submitting. The trend now is toward a fresh, natural look (this does not mean models should look like they just got out of bed!)"

MENNONITE PUBLISHING HOUSE, 616 Walnut Ave., Scottdale PA 15683. (724)887-8500. Fax: (724)887-3111. Photo Secretary: Debbie Cameron. Publishes *Story Friends* (ages 4-9), *On The Line* (ages 10-14), *Christian Living*, *The Mennonite*, *Purpose* (adults).
Needs: Buys 10-20 photos/year. Needs photos of children engaged in all kinds of legitimate childhood activities (at school, at play, with parents, in church and Sunday School, at work, with hobbies, relating to peers and significant elders, interacting with the world); photos of youth in all aspects of their lives (school, work, recreation, sports, family, dating, peers); adults in a variety of settings (family life, church, work, and recreation); abstract and scenic photos. Model release preferred.
Making Contact & Terms: Send 8½×11 b&w photos by mail for consideration. Provide résumé, business card, brochure, flier or tearsheets to be kept on file for possible assignments. SASE. Reports in 1 month. Pays $30-70/b&w photo. Credit line given. Buys one-time rights. Simultaneous submissions and/or previously published work OK.

MICHIGAN NATURAL RESOURCES MAGAZINE, 30600 Telegraph Rd., Suite 1255, Bingham Farms MI 48025-4531. (248)642-9580. Fax: (248)642-5290. Editor: Richard Morscheck. Creative Director: Michael Wagester. Circ. 55,000. Estab. 1931. Bimonthly. Emphasizes natural resources in the Great Lakes region. Readers are "appreciators of the out-of-doors; 15% readership is out of state." Sample copy $4. Photo guidelines free with SASE.
Needs: Uses about 40 photos/issue; 25% from assignment and 75% from freelance stock. Needs photos of Michigan wildlife, Michigan flora, how-to, travel in Michigan, outdoor recreation. Captions preferred.
Making Contact & Terms: Query with samples or list of stock photo subjects. Send original 35mm color transparencies by mail for consideration. SAE. Reports in 1 month. Pays $50-250/color page; $500/job; $800 maximum for photo/text package. Pays on publication. Credit line given. Buys one-time rights.

Tips: Prefers "Kodachrome 64 or 25 or Fuji 50 or 100, 35mm, *razor-sharp in focus!* Send about 20 slides with a list of stock photo topics. Be sure slides are sharp, labeled clearly with subject and photographer's name and address. Send them in plastic slide filing sheets. Looks for unusual outdoor photos. Flora, fauna of Michigan and Great Lakes region. Strongly recommend that photographer look at past issues of the magazine to become familiar with the quality of the photography and the overall content. We'd like our photographers to approach the subject from an editorial point of view. Every article has a beginning, middle and end. We're looking for the photographer who can submit a complete package that does the same thing."

MICHIGAN OUT-OF-DOORS, P.O. Box 30235, Lansing MI 48909. (517)371-1041. Fax: (517)371-1505. Editor: Dennis C. Knickerbocker. Circ. 120,000. Estab. 1947. Monthly magazine. For people interested in "outdoor recreation, especially hunting and fishing; conservation; environmental affairs." Sample copy $2.50; free editorial guidelines.
Needs: Use 6-12 freelance photos/issue. Animal, nature, scenic, sport (hunting, fishing and other forms of noncompetitive recreation), and wildlife. Materials must have a Michigan slant. Captions preferred.
Making Contact & Terms: Send any size glossy b&w prints; 35mm or 2¼×2¼ color transparencies. SASE. Reports in 1 month. Pays $20 minimum/b&w photo; $175/cover photo; $40/inside color. Credit line given. Buys first North American serial rights. Previously published work OK "if so indicated."
Tips: Submit seasonal material 6 months in advance. Wants to see "new approaches to subject matter."

THE MIDWEST MOTORIST, Dept. PM, Auto Club of Missouri, 12901 N. Forty Dr., St. Louis MO 63141. (314)523-7350. Fax: (314)523-6982. Managing Editor: Deborah Klein. Circ. 428,000. Bimonthly. Emphasizes travel and driving safety. Readers are "members of the Auto Club of Missouri, ranging in age from 25-65 and older." Free sample copy and photo guidelines with SASE; use large manila envelope.
Needs: Uses 8-10 photos/issue, most supplied by freelancers. "We use four-color photos inside to accompany specific articles. Our magazine covers topics of general interest, historical (of Midwest regional interest), humor (motoring slant), interview, profile, travel, car care and driving tips. Our covers are full color photos mainly corresponding to an article inside. Except for cover shots, we use freelance photos only to accompany specific articles." Captions required. Model release preferred.
Making Contact & Terms: Query with résumé of credits and list of stock photo subjects. Does not keep samples on file. SASE. Reports in 4 weeks. Pays $175-350/cover; $75-200/color photo; $75-350 photo/text package. **Pays on acceptance.** Credit line given. Buys first rights. Simultaneous submissions and previously published work OK.
Tips: "Send an 8½×11 SASE for sample copies and study the type of covers and inside work we use. Photo needs driven by an editoral calendar/schedule. Write to request a copy and include SASE."

MODE MAGAZINE, 22 E. 49th St., 6th Floor, New York NY 10017. (212)843-4038. (212)843-4096. E-mail: modemag@aol.com. Art Director: Karmen Lizzul. Published 10 times/year. Circ. 550,000. Emphasizes beauty and fashion for women sizes 12 and up. Readers are females of all occupations, ages 18-55.
Needs: Uses 75-100 photos/issue; 25 supplied by freelancers. Needs photos of fashion spreads, still lifes, personalities. Model/property release required. Captions preferred; include where photo was taken if on location, name of clothing/accessories and stores where they can be purchased.
Making Contact & Terms: Contact through rep. Provide resume, business card, brochure, flier or tearsheets to be kept on file for possible assignments. Send 35mm, 2¼×2¼, 4×5, 8×10 transparencies. "No negatives." Keeps samples on file. SASE. Reports in 1-2 weeks. Payment negotiable. **Pays on acceptance.** Credit line given. Buys one-time rights.
Tips: "Be innovative, creative and have a fresh outlook—uniqueness stands out."

MODERN MATURITY, 601 E. St., NW, Washington DC 20049. (202)434-2277. Photo Editor: M.J. Wadolny. Circ. 20 million. Bimonthly. Readers are age 50 and older. Sample copy free with 9×12 SASE. Guidelines free with SASE.
Needs: Uses about 50 photos/issue; 45 supplied by freelancers; 75% from assignment and 25% from stock.
Making Contact & Terms: Arrange a personal interview to show portfolio. SASE. Pays $50-200/b&w photo; $150-1,000/color photo; $350/day. **Pays on acceptance.** Credit line given. Buys one-time and first North American serial rights.
Tips: Portfolio review: Prefers to see clean, crisp images on a variety of subjects of interest. "Present yourself and your work in a professional manner. Be familiar with *Modern Maturity*. Wants to see creativity and ingenuity in images."

N ⊕ THE MONTHLY/THE LIFESTYLE, New Freedom Publications, Bow House Business Centre/ 153-159, Bowrd, London E32 ST England. Phone: (181)983 3011. Fax: (181)983 6322. Circ. 22,000. Estab. 1900. Monthly/bimonthly. "A naturist magazine promoting naked living, health, art, humor, opinion, news, personal experiences. Distances itself from both 'naturist' label and glamour images." Art guidelines free.
Needs: Buys 40 photos from freelancers/issue. Needs photos of naked people looking natural and happy; no children. Reviews photos with or without a ms. Model release required.
Making Contact & Terms: Send query letter with samples. Art director will contact photographer for portfolio review if interested. Portfolio should include prints or slides. Keeps samples on file; include SAE for return of material. Pays £100 for color cover; £10 for b&w inside; £15 minimum for color inside. Pays on publication. Buys one-time rights. Simultaneous submissions and previously published work OK.
Tips: "We are after very natural looking pics, no posing etc. Pictures of men are of particular interest, and groups also. The pictures should have life, energy or movement. The models don't need to be conventionally attractive. We are always on the lookout for new work. When submitting work, provide copies of model releases."

MOPAR MUSCLE MAGAZINE, 3816 Industry Blvd., Lakeland FL 33811. (941)644-0449. Fax: (941)648-1187. Website: http://www.d-p-g.com. Editor Greg Rager. Circ. 100,000. Estab. 1988. Monthly magazine. Emphasizes Chrysler products—Dodge, Plymouth, Chrysler (old and new). Readers are Chrysler product enthusiasts of all ages. Guidelines free with SASE.
Needs: Uses approximately 120 photos/issue; 50% supplied by freelancers. Needs photos of automotive personalities, automobile features, technical how-tos. Reviews photos with or without ms. Model release required. Property release required of automobile owners. Captions required; include all facts relating to the automotive subject.
Making Contact & Terms: Send unsolicited photos by mail for consideration. Send 35mm, 2¼×2¼, 4×5 color transparencies. Keeps samples on file. Reports in 3 weeks. Pays $50 minimum. Pays on publication. Credit line given. Buys all rights; negotiable.

MOTHER EARTH NEWS, Sussex Publishers, 49 E. 21st St., 11th Floor, New York NY 10010. (212)260-3214. Fax: (212)260-7445. Photo Editor: Jamey O'Quinn. Estab. 1992. Bimonthly magazine. Readers are male and female, highly educated, active professionals. Photo guidelines free with SASE.
 • Sussex also publishes *Psychology Today* listed in this section.
Needs: Uses 19-25 photos/issue; all supplied by freelancers. Needs photos of environmental issues and farmlands, animals, countryside living, crafts/tools, portraits of people on their land and in gardens, etc. Model/property release preferred.
Making Contact & Terms: Submit portfolio for review. Send promo card with photo. Also accepts Mac files. Call before you drop off portfolio. Keeps samples on file. Cannot return material. Reports back only if interested. For assignments, pays $1,000/cover plus expenses; $300-500/inside photo plus expenses; for stock, pays $100/¼ page; $300/full page.

MOUNTAIN LIVING, Wiesner Publishing, 7009 S. Potomac St., Englewood CO 80112. (303)397-7600. Fax: (303)397-7619. E-mail: rgriggs@winc.usa.com. Editor: Robyn Griggs. Circ. 35,000. Estab. 1994. Bimonthly magazine. Emphasizes shelter, lifestyle. Sample copy $3.95.
Needs: Uses 50-75 photos/issue; all supplied by freelancers. Needs photos of home interiors, sporting events, nature, travel, scenics. Reviews photos purchased with accompanying ms only. Model/property release required. Captions preferred.
Making Contact & Terms: Submit portfolio for review. Query with stock photo list. Provide resume, business card, brochure, flier or tearsheets to be kept on file for possible assignments. Send 35mm, 2¼×2¼ transparencies. Keeps samples on file. SASE. Reports in 6 weeks. Pays $500-600/day; $500-600/job. **Pays on acceptance**. Credit line given. Buys one-time and first North American serial rights; negotiable. Previously published work OK.

◤◢ MOVING PUBLICATIONS LIMITED, 44 Upjohn Rd., #100, Don Mills, Ontario M3B 2W1 Canada. Administrative Assistant: Penny Glover. Circ. 225,000. Estab. 1973. Annual magazines. Emphasizes moving to a geographic area. Readers are male and female, ages 35-55.
Needs: Uses 20 photos/issue. Needs photos of housing shots, attractions, leisure. Special photo needs include cover shots. Model/property release required. Captions should include location.
 • This publisher produces guides to locations such as Alberta, Vancouver & British Columbia; Winnipeg and Manitoba; Montreal; Toronto and area; Saskatchewan; Ottawa/Hull; Southwestern Ontario area.
Making Contact & Terms: Only free photographs accepted. Do not send unsolicited material. Phone/

fax to determine requirements.

Tips: "For front covers, we look for general scenic shots."

MULTINATIONAL MONITOR, P.O. Box 19405, Washington DC 20036. (202)387-8030. Fax: (202)234-5176. E-mail: monitor@essential.org. Website: http://www.essential.org/monitor. Editor: Robert Weissman. Circ. 6,000. Estab. 1978. Monthly magazine. "We are a political-economic magazine covering operations of multinational corporations." Emphasizes multinational corporate activity. Readers are in business, academia and many are activists. Sample copy free with 9×12 SAE.

Needs: Uses 12 photos/issue; number of photos supplied by freelancers varies. "We need photos of industry, people, cities, technology, agriculture and many other business-related subjects." Captions required, include location, your name and description of subject matter.

Making Contact & Terms: Query with list of stock photo subjects. SASE. Reports in 3 weeks. Pays $0-35/color and b&w photos and transparencies. Pays on publication. Credit line given. Buys one-time rights.

◼◼ MUSCLEMAG INTERNATIONAL, 6465 Airport Rd., Mississauga, Ontario L4V 1E4 Canada. (905)678-7311. Fax: (905)678-9236. Editor: Johnny Fitness. Circ. 300,000. Estab. 1974. Monthly magazine. Emphasizes male and female physical development and fitness. Sample copy $6.

Needs: Buys 3,000 photos/year; 50% assigned; 50% stock. Needs celebrity/personality, fashion/beauty, glamour, swimsuit, how-to, human interest, humorous, special effects/experimental and spot news. "We require action exercise photos of bodybuilders and fitness enthusiasts training with sweat and strain." Wants on a regular basis "different" pics of top names, bodybuilders or film stars famous for their physique (i.e., Schwarzenegger, The Hulk, etc.). No photos of mediocre bodybuilders. "They have to be among the top 100 in the world or top film stars exercising." Photos purchased with accompanying ms. Captions preferred.

Making Contact & Terms: Send material by mail for consideration; send $3 for return postage. Uses 8×10 glossy b&w prints. Query with contact sheet. Send 35mm, 2¼×2¼ or 4×5 transparencies; vertical format preferred for cover. Reports in 1 month. Pays $85-100/hour; $500-700/day and $1,000-3,000/complete package. Pays $20-50/b&w photo; $25-500/color photo; $500/cover photo; $85-300/accompanying ms. **Pays on acceptance.** Credit line given. Buys all rights.

Tips: "We would like to see photographers take up the challenge of making exercise photos look like exercise motion." In samples wants to see "sharp, color balanced, attractive subjects, no grain, artistic eye. Someone who can glamorize bodybuilding on film." To break in, "get serious: read, ask questions, learn, experiment and try, try again. Keep trying for improvement—don't kid yourself that you are a good photographer when you don't even understand half the attachments on your camera. Immerse yourself in photography. Study the best; study how they use light, props, backgrounds, best angles to photograph. Current biggest demand is for swimsuit-type photos of fitness men and women (splashing in waves, playing/posing in sand, etc.) Shots must be sexually attractive."

MUZZLE BLASTS, P.O. Box 67, Friendship IN 47021. (812)667-5131. Fax: (812)667-5137. Art Director: Terri Trowbridge. Circ. 25,000. Estab. 1939. Publication of the National Muzzle Loading Rifle Association. Monthly magazine emphasizing muzzleloading. Sample copy free. Photo guidelines free with SASE.

Needs: Interested in North American wildlife, muzzleloading hunting, primitive camping. Model/property release required. Captions preferred.

Making Contact & Terms: Query with stock photo list. Deadlines: 15th of the month—4 months before cover date. Keeps samples on file. SASE. Reports in 1-2 weeks. Pays $300/color cover; $25/b&w inside. Pays on publication. Credit line given. Buys one-time rights. Simultaneous submissions OK.

ℕ NA'AMAT WOMAN, 200 Madison Ave., New York NY 10016-4001. (212)725-8010. Fax: (212)447-5187. Editor: Judith A. Sokoloff. Circ. 20,000. Estab. 1926. Published 5 times/year. Organization magazine focusing on issues of concern to contemporary Jewish families. Sample copy free for SAE with $1.01 first-class postage.

Needs: Buys 5-10 photos from freelancers/issue; 50 photos/year. Needs photos of Jewish themes, Israel, women and children. Reviews photos with or without a ms. Photo captions preferred.

Making Contact & Terms: Provide résumé, business card, self-promotion piece or tearsheets to be kept on file for possible future assignments. Art director will contact photographer for portfolio review if interested. Uses color, b&w prints. Keeps samples on file; include SASE for return of material. Reports in 6 weeks on queries; 6 weeks on samples. Pays $150 maximum for b&w cover; $35-50 for b&w inside. Pays on publication. Credit line given. Buys one-time rights, first rights.

N: NAKED MAGAZINE, Serengeti Publishing Corp., 7985 Santa Monica Blvd., Suite 109-232, W. Hollywood CA 90046. (800)796-2533. President: Robert Steele. Circ. 20,000. Estab. 1994. Monthly gay male special interest magazine. Sample copy free. Art guidelines free.
Needs: Buys 6 photos from freelancers/issue. Needs photos of naked events. Reviews photos with accompanying ms. Model release required; property release required. Photo captions required.
Making Contact & Terms: Send query letter with samples. Art director will contact photographer for portfolio review if interested. Uses 2¼×2¼ transparencies. Keeps samples on file. Reports in 1 month on queries. Reports back only if interested, send non-returnable samples. Payment varies. Pays on publication. Credit line given. Buys all rights; negotiable. Simultaneous submissions and/or previously published work OK.

N: NATIONAL GARDENING, Dept. PM, 180 Flynn Ave., Burlington VT 05401. (802)863-1308. Fax: (802)863-5962. E-mail: nga@garden.org. Website: http://www.garden.org. Editor: Michael MacCaskey. Managing Editor: Eileen Murray. Circ. 195,000. Estab. 1979. Publication of the National Gardening Associa tion. Bimonthly. Covers fruits, vegetables, herbs and ornamentals. Readers are home and community gardeners. Sample copy $3.50. Photo guidelines free with SASE.
Needs: Uses about 50-60 photos/issue; 80% supplied by freelancers. "Most of our photographers are also gardeners or have an avid interest in gardening or gardening research." Ongoing needs include: "people gardening; special techniques; how-to; specific varieties (please label); garden pests and diseases; soils; unusual (or impressive) gardens in different parts of the country. We sometimes need someone to photogr aph a garden or gardener in various parts of the country for a specific story."
Making Contact & Terms: "We send out a photo needs list for each issue." Query with samples or list of stock photo subjects. SASE. Accepts images in digital format for Mac. Send via Zip disk or online. Reports in 2 months. Pays $450/color cover; and $75-200/color inside. Also negotiates day rate against number of photos used. Pays on publication. Credit line given. Buys first North American serial rights and electronic rights for NGA website use.
Tips: "We need top-quality work. Most photos used are color. We look for general qualities like sharp focus, good color balance, good sense of lighting and composition. Also interesting viewpoint, one that makes the photos more than just a record (getting down to ground level in the garden, for instance, instead of shooting everything from a standing position). Look at the magazine carefully and at the photos used. When we publish a story on growing broccoli, we love to have photos of people planting or harvesting broccoli, in addition to lush close ups. We like to show process, step-by-step, and, of course, inspire people."

NATIONAL GEOGRAPHIC, National Geographic Society, 1145 17th St. NW, Washington DC 200346. (202)775-6700. Fax: (202)828-5658. *Naitonal Geographic* is a source of information about the world and its people dealing with the changing universe and man's involvement in it. It reveals the people and places of the world as well as the major technological advances that impact on our lives. This magazine did not respond to our request for information. Query before submitting.

THE NATIONAL NOTARY, 9350 DeSoto Ave., Box 2402, Chatsworth CA 91313-2402. (818)739-4000. Editor: Ann K. Bailey. Circ. 154,000. Bimonthly. Emphasizes "Notaries Public and notarization— goal is to impart knowledge, understanding and unity among notaries nationwide and internationally." Readers are employed primarily in the following areas: law, government, finance and real estate. Sample copy $5.
Needs: Uses about 20-25 photos/issue; 10 supplied by non-staff photographers. "Photo subject depends on accompanying story/theme; some product shots used." Unsolicited photos purchased with accompany ing ms only. Model release required.
Making Contact & Terms: Query with samples. Provide business card, tearsheets, résumé or samples to be kept on file for possible future assignments. Prefers to see prints as samples. Cannot return material. Reports in 6 weeks. Pays $25-300 depending on job. Pays on publication. Credit line given "with editor's approval of quality." Buys all rights. Previously published work OK.
Tips: "Since photography is often the art of a story, the photographer must understand the story to be able to produce the most useful photographs."

THE NATIONAL RURAL LETTER CARRIER, 1630 Duke St., 4th Floor, Alexandria VA 22314-3465. (703)684-5545. Managing Editor: Kathleen O'Connor. Circ. 96,000. Biweekly magazine. Emphasi zes Federal legislation and issues affecting rural letter carriers and the activities of the membership for rural carriers and their spouses and postal management.
● This magazine uses a limited number of photos in each issue, usually only a cover photograph.
Needs: Unusual mailboxes. Photos purchased with accompanying ms. Captions required.

MASTER GARDENERS • GROWING LEEKS • FREE SEEDS

National
Gardening
For the food and flower gardening enthusiast

holiday
gift
plants

herbs indoors
welcoming winter birds
new zone maps

DECEMBER 1997 $2.95 US/$3.50 CAN

0 74820 08598 1

© Diane Lackie

The magazine of The National Gardening Association

After reading the listing for *National Gardening* magazine in *Photographer's Market*, Canadian photographer Diane Lackie wrote to request photo guidelines. She then submitted eight images, including this Amaryllis shot, which were held in the magazine's stock file. In July, Photo Editor Shila Patel was planning the magazine's December issue and contacted Lackie about her Amaryllis. She earned $450 for the cover shot. "It takes perseverance and patience to self-market and rejections can't be taken personally," Lackie says. "I've found my images being more and more accepted and I'm learning to tailor submissions to each magazine's needs. I had three covers this past fall."

Making Contact & Terms: Send material by mail for consideration. Uses 8×10 b&w or color glossy prints, vertical format necessary for cover. Pays $75/photo. Pays on publication. Credit line given. Previou sly published work OK.

Tips: "Please submit sharp and clear photos."

NATIVE PEOPLES MAGAZINE, 5333 N. Seventh St., Suite C-224, Phoenix AZ 85014. (602)252-2236. Fax: (602)265-3113. E-mail: native_peoples@amcolor.com. Website: http://www.nativepeoples.com. Editor: Gary Avey. Circ. 94,000. Estab. 1987. Quarterly magazine. Dedicated to the sensitive protrayal of the arts and lifeways of the native peoples of the Americas. Readers are primarily upper-demographic members of affiliated museums (i.e. National Museum of the American Indian/Smithsonian). Sample copy free with SASE. Photo guidelines free with SASE.

Needs: Uses 50-60 photos/edition; 100% supplied by freelancers. Needs Native American lifeways photos. Model/property release preferred. Captions preferred; include names, location and circumstances.

Making Contact & Terms: Submit portfolio for review. Send unsolicited photos by mail for consideration. Send transparencies, all formats. Also accepts digital files on disk with proof copy. SASE. Reports in 1 month. Pays $250/color cover; $250/b&w cover; $45-150 color inside; $45-150/b&w inside. Pays on publication. Buys one-time rights.

Tips: "We prefer to send magazine and guidelines rather than pour over general portfolio."

NATURAL HISTORY MAGAZINE, Central Park W. at 79th St., New York NY 10024. (212)769-5500. Editor: Bruce Stutz. Picture Editor: Kay Zakariasen. Circ. 520,000. Monthly magazine. For primarily well-educated people with interests in the sciences. Free photo guidelines.

Needs: Buys 400-450 photos/year. Animal behavior, photo essay, documentary, plant and landscape. "We are interested in photoessays that give an in-depth look at plants, animals, or people and that are visually superior. We are also looking for photos for our photographic feature, 'The Natural Moment.' This feature focuses on images that are both visually arresting and behaviorally interesting." Photos used must relate to the social or natural sciences with an ecological framework. Accurate, detailed captions required.

Making Contact & Terms: Query with résumé of credits. "We prefer that you come in and show us your portfolio, if and when you are in New York. Please don't send us any photographs without a query first, describing the work you would like to send. No submission should exceed 30 original transparencies or negatives. However, please let us know if you have additional images that we might consider. Potential liability for submissions that exceed 30 originals shall be no more than $100 per slide." Uses 8×10 glossy, matte and semigloss b&w prints; and 35mm, 2¼×2¼, 4×5, 6×7 and 8×10 color transparencies. Covers are always related to an article in the issue. SASE. Reports in 2 weeks. Pays (for color and b&w) $400-600/cover; $350-500/spread; $300-400/oversize; $250-350/full-page; $200-300/¾ page; $150-225/½ page; $125-175/¼ page; $100-125/1/16 page or less. Pays $50 for usage on contents page. Pays on publication. Credit line given. Buys one-time rights. Previously published work OK but must be indicated on delivery memo.

Tips: "Study the magazine—we are more interested in ideas than individual photos. We do not have the time to review portfolios without a specific theme in the social or natural sciences."

NATURAL LIVING TODAY, 175 Varick St., New York NY 10014. (212)924-1762. Fax: (212)691-7828. Editor-in-Chief: Alexis Tannenbaum. Circ. 150,000. Estab. 1996. Bimonthly magazine. Emphasizes natural living for women, (ex: natural beauty, alternative healing, vegetarianism, organic and macrobiotic eating). Readers are women aged 18-40, from various occupations (students, executives).

Needs: Uses 60-70 photos/issue; 70% supplied by freelancers. Needs photos of celebrities, cosmetics, models and food. Model release required.

Making Contact & Terms: Query with résumé of credits. Only wants to work with photographers on assignment. However, stock of celebrities is needed. "Send nothing unsolicited." Payment negotiable. Pays on publication. Credit line given. Rights negotiable.

NATURAL WAY, 1 Bridge St., Suite 125, Irvington NY 10533. (914)591-2011. Fax: (914)591-2017. E-mail: natway@aol.com. Art Director: Amie Crabtree. Circ. 125,000. Estab. 1994. Bimonthly consumer magazine emphasizing alternative health. Readers are 70% female over 35. Sample copy $3.50.

MARKET CONDITIONS are constantly changing! If you're still using this book and it's 2000 or later, buy the newest edition of *Photographer's Market* at your favorite bookstore or order directly from Writer's Digest Books.

Needs: Uses 40-45 photos/issue; 95% supplied by freelancers. Needs photos of food, beauty, health. Model release preferred for people. Captions preferred.

Making Contact & Terms: Submit portfolio for review. Send unsolicited photos by mail for consideration. Provide résumé, business card, brochure, flier or tearsheets to be kept on file for possible assignments. Keeps samples on file. SASE. Reports in 1 month. Pays $75-335/color inside; $75-200/b&w inside. Pays on publication. Credit line given. Buys one-time rights. Previously published work.

NATURE CONSERVANCY MAGAZINE, 1815 N. Lynn St., Arlington VA 22209. (703)841-8742. Fax: (703)841-9692. E-mail: cgelb@tnc.org. Website: http://www.tnc.org. Photo Editor: Connie Gelb. Circ. 900,000. Estab. 1951. Publication of The Nature Conservancy. Bimonthly. Emphasizes "nature, rare and endangered flora and fauna, ecosystems in North and South America, the Caribbean, Indonesia, Micronesia and South Pacific and compatible development." Readers are the membership of The Nature Conservancy. Sample copy free with 9 × 12 SAE and 5 first-class stamps. Write for guidelines. Articles reflect work of the Nature Conservancy and its partner organizations.

Needs: Uses about 20-25 photos/issue; 70% from freelance stock. The Nature Conservancy welcomes permission to make duplicates of slides submitted to the *Magazine* for use in slide shows and online use. Captions required; include location and names (common and Latin) of flora and fauna. Proper credit should appear on slides.

Making Contact & Terms: Interested in reviewing non-returnable samples and photo-driven story ideas from newer, lesser-known photographers. Many photographers contribute the use of their slides. Accepts images in digital format for Windows. Send via website (at least 72 dpi). Uses color transparencies. Pays $400/color cover; $300/color back cover; $150-250/color inside; $75-150/b&w photo; negotiable day rate. Will occasionally pay extra for photos of rare/endangered species. Pay from $35-200 for unlimited Web use for 1 year. Pays on publication. Credit line given. Buys one-time rights; starting to consider all rights for public relations and online purposes; negotiable.

Tips: Seeing more large-format photography and more interesting uses of motion and mixing available light with flash and b&w. "Photographers must familiarize themselves with our organization. We only run articles reflecting our work (in the U.S.) or that of our partner organizations in Latin America and Asia/Pacific. Membership in the Nature Conservancy is only $25/year and the state newsletter will keep photographers up to date on what the Conservancy is doing in your state. Many of the preserves are open to the public. We look for rare and endangered species, wetlands and flyways, indigenous/traditional people of Latin America, South Pacific and the Caribbean."

NATURE PHOTOGRAPHER, P.O. Box 2019, Quincy MA 02269. (617)847-0095. Fax: (617)847-0952. E-mail: mjsquincy@pipeline.com. Photo Editor: Helen Longest-Slaughter. Circ. 25,000. Estab. 1990. Bimonthly, 4-color, high-quality magazine. Emphasizes "conservation-oriented, low-impact nature photography" with strong how-to focus. Readers are male and female nature photographers of all ages. Sample copies free with 10 × 13 SAE with 6 first-class stamps.

Needs: Uses 25-35 photos/issue; 90% supplied by freelancers. Needs nature shots of "all types—abstracts, animal/wildlife shots, flowers, plants, scenics, environmental images, etc." Shots must be in natural settings; no set-ups, zoo or captive animal shots accepted. Reviews photos with or without ms twice a year, May (for fall/winter issues) and November (for spring/summer). Captions required; include description of subject, location, type of equipment, how photographed. "This information published with photos."

Making Contact & Terms: Prefers to see 35mm, 2¼ × 2¼ and 4 × 5 transparencies. Does not keep samples on file. SASE. Reports within 4 months, according to deadline. Pays $100/color cover; $25-40/color inside; $20/b&w inside; $75-150/photo/text package. Pays on publication. Credit line given. Buys one-time rights. Simultaneous submissions and previously published work OK.

Tips: Recommends working with "the best lens you can afford and slow speed slide film." Suggests editing with a 4 × or 8 × lupe (magnifier) on a light board to check for sharpness, color saturation, etc. Color prints are not normally used for publication in magazine.

NATURIST LIFE INTERNATIONAL, P.O. Box 300-F, Troy VT 05868-0300. (802)744-6565. E-mail: nli@together.net. Website: http://www.homepages.together.net/~nli/home.htm. Editor-in-chief: Jim C. Cunningham. Circ. 2,000. Estab. 1987. Quarterly magazine. Emphasizes nudism. Readers are male and female nudists, age 30-80. Sample copy $5. Photo guidelines free with SASE.

● *Naturist Life* holds yearly Vermont Naturist Photo Safaris organized to shoot nudes in nature.

Needs: Uses approximately 45 photos/issue; 80% supplied by freelancers. Needs photos depicting family-oriented, nudist/naturist work and recreational activity. Reviews photos with or without ms. Model release required. Property release preferred for recognizable nude subjects. Captions preferred.

Making Contact & Terms: Query with résumé of credits. Send unsolicited photos by mail for consideration. Provide résumé, business card, brochure, flier or tearsheets to be kept on file for possible assignments.

Send 8×10 glossy color and b&w prints; 35mm, 2¼×2¼, 4×5, 8×10 (preferred) transparencies. Does not keep samples on file. SASE. Reports in 2 weeks. Pays $50 color cover; $25/color inside; $25/b&w inside. Only pays $10 if not transparency or 8×10 glossy. Pays on publication. Credit line given. "Prefer to own all rights but sometimes agree to one-time publication rights." Offers internships for photographers during July. Contact Editor: Jim C. Cunningham.

Tips: "The ideal *NLI* photo shows ordinary-looking people of all ages doing everyday activities, in the joy of nudism."

NAUGHTY NEIGHBORS, 4931 SW 75th Ave., Miami FL 33155. (305)662-5959. Fax: (305)662-5952. E-mail: gablel@scoregroup.com Assistant Editor: Lisa Gable. Circ. 250,000. Estab. 1995. Published 13 times/year. Emphasizes "nude glamor with a voyeuristic focus—amateurs and the swinging scene." Readers are male, 18 and over. Sample copy $7. Photo guidelines free with SASE.

Needs: Uses approximately 200 photos/issue; all supplied by freelancers. Needs photos of nude females; "amateurs, not professional models." Model release required, as well as two forms of I.D. from model (one must be a picture I.D.).

Making Contact & Terms: Send unsolicited photos by mail for consideration. Send 4×6 or 8×10 glossy color prints; 35mm transparancies or larger format. Kodachrome film. Keeps samples on file. SASE. Reports in 4 weeks. Pays $150-900 for color sets of around 40 transparancies or high quality prints. "Please do not send individual photos, except for test shots." Pays on publication. Buys firstrights in North America with reprint option, electronic rights and non-exclusive worldwide publishing rights. Simultaneous submissions OK.

Tips: "Study samples of the magazine for insights into what we are looking for. We recommend using on-camera flash or one umbrella to enhance 'amateur' feeling of the photography."

N NEVADA FARM BUREAU AGRICULTURE AND LIVESTOCK JOURNAL, 1300 Marietta Way, Sparks NV 89431. (702)358-3276. Contact: Ed Foster. Circ. 7,200. Monthly tabloid. Emphasizes Nevada agriculture. Readers are primarily Nevada Farm Bureau members and their families; men, women and youth of various ages. Members are farmers and ranchers. Sample copy free with 10×13 SAE with 3 first-class stamps.

Needs: Uses 5 photos/issue; 30% occasionally supplied by freelancers. Needs photos of Nevada agriculture people, scenes and events. Model release preferred. Captions required.

Making Contact & Terms: Send 3×5 and larger b&w prints, any format and finish by mail for consideration. SASE. Reports in 1 week. Pays $10/b&w cover; $5/b&w inside. **Pays on acceptance.** Credit line given. Buys one-time rights.

Tips: "In portfolio or samples, wants to see: newsworthiness, 50%; good composition, 20%; interesting action, 20%; photo contrast, resolution, 10%. Try for new angles on stock shots: awards, speakers, etc., We like 'Great Basin' agricultural scenery such as cows on the rangelands and high desert cropping. We pay little, but we offer credits for your résumé."

NEW CHOICES LIVING EVEN BETTER AFTER 50, (formerly *New Choices for Retirement Living*), 28 W. 23rd St., New York NY 10010. (212)366-8817. Fax: (212)366-8899. Photo Editor: Regina Flanagan. Circ. 600,000. 10 issues a year (double issues—July/Aug., Dec./Jan.). Emphasizes people over 50, retired or planning to retire. Readers are 50 plus years old, male and female, interested in retirement living.

Needs: Uses 30-40 photos/issue; 50% supplied by freelancers; 50% supplied by stock. Needs photos related to health and fitness, money and finances, family values, travel and entertainment. Reviews photos with or without ms. "No unsolicited photos please!" Model release required; property release preferred. Captions required.

Making Contact & Terms: Provide résumé, business card, brochure, flier or tearsheets to be kept on file for possible assignments. Reports in 1 month. Pays $200/¼ color page rate. **Pays on acceptance** and assignment within 30 days. Credit line given. Buys one-time rights; negotiable.

Tips: "*New Choices* targets a very select market—seniors, people aged fifty and over. Our assignments are very specific concepts and the key to a successful assignment is communication. I rarely send a photographer more than 300 miles for an assignment because our budget just doesn't allow for it, so I end up calling photgraphers in the location of my subjects, which vary with each article. Communication is very important between the photo editor and the photographer."

NEW MOON PUBLISHING, P.O. Box 3620, Duluth MN 55803-3620. (218)728-5507. Fax: (218)728-0314. E-mail: newmoon@computerpro.com. Girls Editorial Board: %Bridget Grosser or Barbara Stretchberry. Circ. 22,000. Estab. 1993. Bimonthly magazine. Emphasizes girls, ages 8-14; *New Moon* is edited by girls for girls. Readers are girls, ages 8-14. Sample copy $6.50.

Needs: Uses 15-25 photos/issue; 5 supplied by freelancers. Needs photos for specific stories. Model/

property release required. Captions required; include names, location, ages of kids.
Making Contact & Terms: Submit portfolio for review. Accepts images in digital format for Mac. Call for details. Send 4×6 glossy color b&w prints; 35mm transparencies. Keeps samples on file. SASE. Reports in 6 months. Pays $25-50/b&w inside. Pays on publication. Credit line given. Buys all rights. Simultaneous submissions and previously published work OK.
Tips: "Read and get to know style of magazine first!"

N: NEW THOUGHT JOURNAL, The Beat of a Thousand Drummers, 2520 Evelyn Dr., Dayton OH 45409. Phone/fax: (937)293-9717. E-mail: ntjmag@aol.com. Editor: Jeffrey M. Ohl. Circ. 5,000. Estab. 1994. Quarterly literary magazine. "*New Thought Journal*, reflects the creative and spiritual intent of authors, artists, musicians, poets and philosophers as they intuitively mirror a silent consensus that is building in our world." Sample copy for $6. Art guidelines free for #10 SAE with 1 first-class stamp.
Needs: Reviews photos with or without ms. Photo captions required; include description and contributor's identification.
Making Contact & Terms: Send query letter with samples. Uses 8½×11 glossy color, b&w prints. Reports back only if interested, send non-returnable samples. Credit line given. Buys one-time rights. Simultaneous submissions and/or previously published work OK.

NEW YORK SPORTSCENE, 990 Motor Pkwy., Central Islip NY 11722. (516)435-8890. Fax: (516)435-8925. Editor-in-Chief: Jerry Beech. Managing Editor: John Lane. Circ. 42,000. Estab. 1995. Monthly magazine. Emphasizes professional and major college sports in New York. Readers are 95% male; median age: 30; 85% are college educated. Sample copy $3.
Needs: Uses 30 photos/issue; all supplied by freelancers. Needs photos of sports action, fans/crowd reaction.
Making Contact & Terms: Send unsolicited photos by mail for consideration. Send color prints; 35mm transparencies. Keeps samples on file. SASE. Reports in 3 weeks. Payment negotiable. Pays 30 days after publication.
Tips: "Slides should capture an important moment or event and tell a story. There are numerous sports photographers out there—your work must stand out to be noticed."

NEW YORK STATE CONSERVATIONIST MAGAZINE, Editorial Office, NYSDEC, 50 Wolf Rd., Albany NY 12233-4502. (518)457-5547. Contact: Photo Editor. Circ. 100,000. Estab. 1946. Bimonthly nonprofit, New York State government publication. Emphasizes natural history, environmental, and outdoor interests pertinent to New York State. Sample copy $3.50. Photo guidelines free with SASE.
Needs: Uses 40 photos/issue; 80% supplied by freelance photographers. Needs wildlife shots, people in the environment, outdoor recreation, forest and land management, fisheries and fisheries management, environmental subjects. Model release preferred. Captions required.
Making Contact & Terms: Interested in reviewing work from newer, lesser-known photographers. Query with samples. Send 35mm, 2¼×2¼, 4×5 or 8×10 transparencies by mail for consideration. Submit portfolio for review. Provide résumé, business card, brochure, flier or tearsheets to be kept on file for possible future assignments. Reports in 3 weeks. Pays $15/b&w or color photo. Pays on publication. Buys one-time rights. Simultaneous submissions and previously published work OK.
Tips: Looks for "artistic interpretation of nature and the environment, unusual ways of picturing environmental subjects (even pollution, oil spills, trash, air pollution, etc.); wildlife and fishing subjects at all seasons. Try for unique composition, lighting. Technical excellence a must."

NEWS PHOTOGRAPHER, Dept. PM, 1446 Conneaut Ave., Bowling Green OH 43402. (419)352-8175. Fax: (419)354-5435. E-mail: jgordon@bgnet.bgsu.edu. Website: http://jgordon@bgnet.bgsu.edu. Editor: James R. Gordon. Circ. 11,000. Estab. 1946. Publication of National Press Photographers Association, Inc. Monthly magazine. Emphasizes photojournalism and news photography. Readers are newspaper, magazine, television freelancers and photojournalists. Sample copy free with 9×12 SAE and 9 first-class stamps.
 ● *News Photographer* is 100% digital—to printer.
Needs: Uses 50 photos/issue. Needs photos of photojournalists at work; photos which illustrate problems of photojournalists. Special photo needs include photojournalists at work, assaulted, arrested; groups of news photographers at work; problems and accomplishments of news photographers. Captions required.
Making Contact & Terms: Send glossy b&w/color prints; 35mm, 2¼×2¼ transparencies or negs by mail for consideration. Also accepts JPEG'd to Mac or DOS floppy or 44 or 88MB SyQuest cartridge. "We prefer the photos (color and/or b&w) JPEG'ed to a Mac floppy disk, Zip Disk, or a 44MB. SyQuest cartridge (indicate whether Unsharp Mask has been applied in Photoshop). We'd prefer file size for each image less than 10MB. before compression. (We do not have "Iron Mike" software.) Prints (silver image or thermal) are always acceptable. Photos may also be sent by way of the Internet." Provide résumé,

business card, brochure, flier or tearsheets to be kept on file for possible assignments; make contact by telephone. Reports in 3 weeks. Pays $75/color page rate; $50/b&w page rate; $50-150/photo/text package. **Pays on acceptance.** Credit line given. Buys one-time rights. Simultaneous submissions previously published work OK.

NEWSWEEK, Newsweeks, Inc., 251 W. 57th St., New York NY 10019-6999. (212)445-4000. Circ. 3,180,000. *Newsweek* reports the week's developments on the newsfront of the world and the nation through news, commentary and analysis. News is divided into National Affairs, International, Business, Lifestyle, Society and the Arts. Relevant visuals, including photos, accompany most of the articles. This magazine did not respond to our request for information. Query before submitting.

NFPA JOURNAL, 1 Batterymarch Park, Quincy MA 02169-9101. (617)984-7566. Art Director: Wendy C. Simpson. Circ. 65,000. Publication of National Fire Protection Association. Bimonthly magazine. Emphasizes fire protection issues. Readers are fire professionals, engineers, architects, building code officials, ages 20-65. Sample copy free with 9×12 SAE.
Needs: Uses 25-30 photos/issue; 25% supplied by freelance photographers. Needs photos of fires and fire-related incidents. Especially wants to use more photos for Fire Fighter Injury and Fire Fighter Fatality. Model release preferred. Captions preferred.
Making Contact & Terms: Query with list of stock photo subjects, send unsolicited photos by mail for consideration. Provide résumé, business card, brochure, flier or tearsheets to be kept on file for possible assignments. Send color prints and 35mm transparencies in 3-ring slide sleeve with date. SASE. Reports in 3 weeks or "as soon as I can." Payment negotiated. Pays on publication. Credit line given. Buys rights depending "on article and sensitivity of subject. We are not responsible for damage to photos."
Tips: "Send cover letter, 35mm color slides preferably with manuscripts and photo captions."

NORTH AMERICAN WHITETAIL MAGAZINE, P.O. Box 741, Marietta GA 30061. (770)953-9222. Fax: (770)933-9510. Photo Editor: Gordon Whittington. Circ. 170,000. Estab. 1982. Published 8 times/year (July-February) by Game & Fish Publications, Inc. Emphasizes trophy whitetail deer hunting. Sample copy $3. Photo guidelines free with SASE.
Needs: Uses 20 photos/issue; 40% supplied by freelancers. Needs photos of large, live whitetail deer, hunter posing with or approaching downed trophy deer, or hunter posing with mounted head. Also use photos of deer habitat and sign. Model release preferred. Captions preferred; include where scene was photographed and when.
Making Contact & Terms: Query with résumé of credits and list of stock photo subjects. Send unsolicited 8×10 b&w prints; 35mm transparencies (Kodachrome preferred). Will return unsolicited material in 1 month if accompanied by SASE. Pays $250/color cover; $75/inside color; $25/b&w photo. Tearsheets provided. Pays 75 days prior to publication. Credit line given. Buys one-time rights. Simultaneous submissions not accepted.
Tips: "In samples we look for extremely sharp, well-composed photos of whitetailed deer in natural settings. We also use photos depicting deer hunting scenes. Please study the photos we are using before making submission. We'll return photos we don't expect to use and hold the remainder. Please do not send dupes. Use an 8× loupe to ensure sharpness of images and put name and identifying number on all slides and prints. Photos returned at time of publication or at photographer's request."

NORTHERN OHIO LIVE, Dept. PM, 11320 Juniper Rd., Cleveland OH 44106. (216)721-1800. Art Director: Stacy Vickroy. Circ. 35,000. Estab. 1980. Monthly magazine. Emphasizes arts, entertainment and lifestyle. Readers are upper income, ages 25-60, professionals. Sample copy $2 with 9×12 SAE.
Needs: Uses 30 photos/issue; 20-100% supplied by freelance photographers. Needs photos of people in different locations, fashion and locale. Model release preferred. Captions preferred (names only are usually OK).
Making Contact & Terms: Arrange a personal interview to show portfolio. Provide résumé, business card, brochure, flier or tearsheet to be kept on file for possible assignments. SASE. Reports in 3 weeks. Pays $250/color cover; $250/b&w cover; $100/color inside; $50/b&w inside; $30-50/hour; $250-500/day (approximate rates—rates vary per assignment). Pays on publication. Credit line given. Buys one-time rights. Previously published work OK.
Tips: In photographer's portfolio wants to see "good portraits, people on location, photojournalism strengths, quick turn-around and willingness to work on *low* budget. Mail sample of work. Portfolio review should be short—only *best quality* work!"

NUGGET, 14411 Commerce Way, Suite 420, Miami Lakes FL 33016. (305)557-0071. Editor-in-Chief: Christopher James. Circ. 100,000. Magazine published 12 times a year. Emphasizes sex and fetishism for

men and women of all ages. Sample copy $5 postpaid; photo guidelines free with SASE.

Needs: Uses 100 photos/issue. Interested only in nude sets—single woman, female/female or male/female. All photo sequences should have a fetish theme (sadomasochism, leather, bondage, transvestism, transsexuals, lingerie, golden showers, infantilism, wrestling—female/female or male/female—women fighting women or women fighting men, amputee models, etc.). Also seeks accompanying mss on sex, fetishism and sex-oriented products. Model release required.

Making Contact & Terms: Submit material for consideration. Buys in sets, not by individual photos. No Polaroids or amateur photography. Send 8×10 glossy b&w prints, contact sheet OK; transparencies, prefers Kodachrome or large format; vertical format required for cover. SASE. Reports in 2 weeks. Pays $250 minimum/b&w set; $400-1,200/color set; $200/cover; $250-350/ms. Pays on publication. Credit line given. Buys one-time rights or second serial (reprint) rights. Previously published work OK.

ODYSSEY, Science That's Out of This World, Cobblestone Publishing, Inc., 30 Grove St., Peterborough NH 03458. (603)924-7209. Fax: (603)924-7380. E-mail: edody@aol.com. Senior Editor: Elizabeth Lindstrom. Circ. 29,000. Estab. 1979. Monthly magazine, September-May. Emphasis on astronomy and space exploration. Readers are children, ages 8-14. Sample copy $4.50 with 9×12 or larger SAE and 5 first-class stamps. Photo guidelines free with SASE.

Needs: Uses 30-35 photos/issue. Needs photos covering many areas of service. Reviews photos with or without ms. Model/property release required. Captions preferred.

Making Contact & Terms: Query with stock photo list. Send unsolicited photos by mail for consideration. Accepts images in digital format for Mac. Provide résumé, business card, brochure, flier or tearsheets to be kept on file for possible future assignments. Send color prints or transparencies. Samples kept on file. SASE. Reports in 1 month. Payment negotiable for color cover and other photos; $25-100/inside color use. Pays on publication. Credit line given. Buys one-time and all rights; negotiable. Offers internships for photographers. Would consider internships for photographers. Contact Managing Editor: Denise Babcock.

Tips: "We like photos that include kids in reader-age range and plenty of action. Each issue is devoted to a single theme. Photos should relate to those themes."

OFF DUTY MAGAZINE, 3505 Cadillac Ave., Suite 0-105, Costa Mesa CA 92626. Fax: (714)549-4222. E-mail: odutyedit@aol.com. Managing Editor: Tom Graves. Circ. 507,000. Estab. 1970. Published 6 times/year. Emphasizes the military community. Readers are military members and their spouses, ages 20-45. Sample copy free with 9×12 SASE and 6 first-class stamps.

Needs: Uses 25 photos/issue; 5 supplied by freelancers. "We're looking solely for freelancers to handle occasional assignments around the U.S." Model/property release preferred. Captions required.

Making Contact & Terms: Provide résumé, business card, brochure, flier or tearsheets to be kept on file for possible assignments. Also accepts digital files in TIFF, EPS, or JPEG 300 dpi or higher preferably on Mac-formatted disk; 44MB SyQuest OK. Keeps samples on file. Pays $300/color cover; up to $75-200/color inside. **Pays on acceptance.** Credit line given. Buys one-time rights.

Tips: "I don't want to receive unsolicited photos for consideration, just résumés and brochure/samples for filing. Send good samples and you have a good shot at an assignment if something comes up in your area."

OFFICE PRO, (formerly *The Secretary*), 2800 Shirlington Rd., Suite 706, Arlington VA 22206. (703)998-2534. E-mail: officepromag@strattonpub.com. Managing Editor: Angela Hickman Brody. Circ. 40,000. Estab. 1942. Association publication of Professional Secretaries International. Published 9 times a year. Emphasizes administrative support profession—proficiency, continuing education, new products/methods and equipment related to office administration/communications. Readers include career secretaries, administrative assistants, and office managers, 98% women, in myriad offices, with wide ranging responsibilities.

Needs: Uses 1-2 feature photos and several "Product News" photos/issue; freelance photos 100% from stock. Needs office professionals in appropriate and contemporary office settings using varied office equipment or performing varied office tasks. Must be in good taste and portray professionalism. Especially interested in photos featuring members of minority groups. Reviews photos with or without accompanying ms. Model release preferred.

Making Contact & Terms: Query with samples. Send unsolicited photos by mail for consideration. Uses 3½×4½, 8×10 glossy prints; 35mm, 2¼×2¼, 4×5 and 8×10 transparencies. SASE. Reports in 1 month. Pays $150 maximum/b&w photo; $500 maximum/color photo. Pays on publication. Credit line given. Buys first North American serial rights. Simultaneous submissions and previously published work OK.

OFFSHORE, 220-9 Reservoir St., Needham MA 02194. (781)449-6204, ext. 26. Fax: (781)449-9702. Editor: Betsy Frawley Hagerty. E-mail: offeditor@aol.com. Monthly magazine. Emphasizes boating in the

Northeast region, from Maine to New Jersey. Sample copy free with 9×12 SASE.

Needs: Uses 25-30 photos/issue; 25-30 supplied by freelancers. Needs photos of recreational boats and boating activities. Boats covered are mostly 20-40 feet, mostly power, but some sail, too. Especially looking for inside back page photos of a whimsical, humorous, or poignant nature, or that say "Goodbye" (all nautically themed)—New Jersey to Maine. Captions required; include location.

Making Contact & Terms: Please call before sending photos. Cover photos should be vertical format and have strong graphics and/or color. Accepts images in digital format for Mac. Send via online, floppy disk, SyQuest. Pays $300/color cover; $50-200 for color inside. Pays on publication. Credit line given. Buys one-time rights. Simlultaneous submissions and/or previously published work OK.

OHIO MAGAZINE, 62 E. Broad St., Columbus OH 43215. (614)461-5083. Website: http://www.ohioma gazine.com. Art Director: Brooke Wenstrup. Estab. 1979. Magazine published 10 times/year. Emphasizes features throughout Ohio for an educated, urban and urbane readership. Sample copy $4 postpaid.

Needs: Travel, photo essay/photo feature, b&w scenics, personality, sports and spot news. Photojournalism and concept-oriented studio photography. Model/property releases preferred. Captions required.

Making Contact & Terms: Send material by mail for consideration. Query with samples. Arrange a personal interview to show portfolio. Send tear sheets, slides and 8×10 b&w glossy prints; contact sheet requested. Also uses 35mm, $2\frac{1}{4} \times 2\frac{1}{4}$ or 4×5 transparencies; square format preferred for covers. Accepts images in digital format for Mac via Zip disk. SASE. Reports in 1 month. Pays $100-1,000/job; $30-250/color photo; $350/assignment. Pays within 90 days after acceptance. Credit line given. Buys one-time rights; negotiable. Provides summer internships.

Tips: "Please look at magazine before submitting to get an idea of what type of photographs we use. Send sheets of slides and/or prints with return postage and they will be reviewed. Dupes for our files are always appreciated—and reviewed on a regular basis. We are leaning more toward well-done documentary photography and less toward studio photography. Trends in our use of editorial photography include scenics, single photos that can support an essay, photo essays on cities/towns, more use of 180° shots. In reviewing a photographer's portfolio or samples we look for humor, insight, multi-level photos, quirkiness, thoughtful-ness; stock photos of Ohio; ability to work with subjects (i.e., an obvious indication that the photographer was able to make subject relax and forget the camera—even difficult subjects); ability to work with givens, bad natural light, etc.; creativity on the spot—as we can't always tell what a situation will be on location."

OKLAHOMA TODAY, P.O. Box 53384, Oklahoma City OK 73152. (405)521-2496. Fax: (405)522-4588. Editor-in-Chief: Louisa McCune. Circ. 45,000. Estab. 1956. Bimonthly magazine. "We cover all aspects of Oklahoma, from history to people profiles, but we emphasize travel." Readers are "Oklahomans, whether they live in-state or are exiles; studies show them to be above average in education and income." Sample copy $4.95. Photo guidelines free with SASE.

Needs: Uses about 50 photos/issue; 90-95% supplied by freelancers. Needs photos of "Oklahoma subjects only; the greatest number are used to illustrate a specific story on a person, place or thing in the state. We are also interested in stock scenics of the state." Other areas of focus are adventure—sport/travel, reenactment, historical and cultural activities. Model release required. Captions required.

Making Contact & Terms: Query with samples. Send 8×10 glossy b&w prints; 35mm, $2\frac{1}{4} \times 2\frac{1}{4}$, 4×5, 8×10 transparencies or b&w contact sheets by mail for consideration. No color prints. Also accepts digital files (Mac compatible). SASE. Reports in 2 months. Pays $50-200/b&w photo; $50-200/color photo; $125-1,000/job. Pays on publication. Buys one-time rights with a six-month from publication exclusive, plus right to reproduce photo in promotions for magazine, without additional payment with credit line. Simultaneous submissions and/or previously published work OK (on occasion).

Tips: To break in, "read the magazine. Subjects are normally activities or scenics (mostly the latter). I would like good composition and very good lighting. I look for photographs that evoke a sense of place, look extraordinary and say something only a good photographer could say about the image. Look at what Ansel Adams and Eliot Porter did and what Muench and others are producing and send me that kind of quality. We want the best photographs available and we give them the space and play such quality warrants."

ONBOARD MEDIA, 960 Alton Rd., Miami Beach FL 33139. (305)673-0400. Fax: (305)674-9396. E-mail: onboard@netpoint.net. Photo Director: Jessica Thomas. Circ. 792,184. Estab. 1992. Annual maga-zine. Emphasizes travel in the Caribbean, Far East, Mexican Riviera, Bahamas, Alaska. The publication reaches cruise vacationers or 3-1-night Caribbean, Bahamas, Mexican Riviera, Alaska and Far East itinerar-ies. Sample copy free with 11×14 SASE. Photo guidelines free with SASE.

Needs: All photos supplied by freelancers. Needs photos of scenics, nature, prominent landmarks based in Caribbean, Mexican Riviera, Bahamas and Alaska. Model/property release preferred. Captions required; include where the photo was taken and explain the subject matter.

Making Contact & Terms: Query with stock photo list. Provide résumé, business card, brochure, flier

or tearsheets to be kept on file for possible assignments. Send 35mm, 2¼×2¾, 4×5, 8×10 transparencies. Keeps samples on file. SASE. Reports in 3 weeks. Rates negotiable per project. Pays on publication. Previously published work OK.

OPEN WHEEL MAGAZINE, 65 Parker St. #2, Newbury Port MA 01950. (978)463-3787. Fax: (978)463-3250. Editor: Rob Sneddon. Circ. 60,000. Estab. 1980. Monthly. Emphasizes sprint car, super-modified, Indy and midget racing. Readers are fans, owners and drivers of race cars and those with business in racing. Photo guidelines free for SASE.

Needs: Uses 100-125 photos/issue supplied by freelance photographers; almost all come from freelance stock. Needs documentary, portraits, dramatic racing pictures, product photography, special effects, crash. Photos purchased with or without accompanying ms. Model release required for photos not shot in pit, garage or on track. Captions required.

Making Contact & Terms: Send by mail for consideration 8×10 glossy b&w or color prints and any size slides. SASE. Reports in 6 weeks. Pays $20/b&w inside; $35-250/color inside. Pays on publication. Buys all rights.

Tips: "Send the photos. We get dozens of inquiries but not enough pictures. We file everything that comes in and pull 80% of the pictures used each issue from those files. If it's on file, the photographer has a good shot."

THE OTHER SIDE, 300 W. Apsley St., Philadelphia PA 19144. (215)849-2178. Art Director: Cathleen Benberg. Circ. 17,000. Estab. 1965. Bimonthly magazine. Emphasizes social justice issues from a Christian perspective. Sample copy $4.

• This publication is an Associated Church Press and Evangelical Press Association award winner.

Needs: Buys 6 photos/issue; 95-100% from stock, 0-5% on assignment. Documentary, human interest and photo essay/photo feature. Model/property release preferred. Captions preferred.

Making Contact & Terms: Send samples of work to be photocopied for our files and/or photos. Send 8×10 glossy b&w prints; or color transparencies. Materials will be returned on request. SASE. Pays $20-30/b&w photo; $50-75/cover. Credit line given. Buys one-time rights. Simultaneous submissions and previously published work OK.

Tips: In reviewing photographs/samples, looks for "sensitivity to subject, creativity, and good quality darkroom work."

 OUR FAMILY, P.O. Box 249, Battleford, Saskatchewan, S0M 0E0 Canada. Fax: (306)937-7644. E-mail: gregomimary@sk.sympatico.com. Editor: Nestor Gregoire. Circ. 8,000. Estab. 1949. Monthly magazine. Emphasizes Christian faith as a part of daily living for Roman Catholic families. Sample copy $2.50 with 9×12 SAE and $1.10 Canadian postage. Free photo and writer's guidelines with SAE and 52¢ Canadian postage.

Needs: Buys 5 photos/issue; cover by assignment, contents all freelance. Head shot (to convey mood); human interest ("people engaged in the various experiences of living"); humorous ("anything that strikes a responsive chord in the viewer"); photo essay/photo feature (human/religious themes); and special effects/experimental (dramatic—to help convey a specific mood). "We are always in need of the following: family (aspects of family life); couples (husband and wife interacting and interrelating or involved in various activities); teenagers (in all aspects of their lives and especially in a school situation); babies and children; any age person involved in service to others; individuals in various moods (depicting the whole gamut of human emotions); religious symbolism; and humor. We especially want people photos, but we do not want the posed photos that make people appear 'plastic,' snobbish or elite. In all photos, the simple, common touch is preferred. We are especially in search of humorous photos (human and animal subjects). Stick to the naturally comic, whether it's subtle or obvious." Photos are purchased with or without accompanying ms. Model release required if editorial topic might embarrass subject. Captions required when photos accompany ms.

Making Contact & Terms: Send material by mail for consideration or query with samples after consult-

ing photo spec sheet. Provide letter of inquiry, samples and tearsheets to be kept on file for possible future assignments. Send 8×10 glossy b&w prints; transparencies or 8×10 glossy color prints are used on inside pages, but are converted to b&w. SAE and IRC. (Personal check or money order OK instead or IRC.) Reports in 1 month. Pays $35/b&w photo; 7-10¢/word for original mss; 5¢/word for nonoriginal mss. **Pays on acceptance.** Credit line given. Buys one-time rights and simultaneous rights. Simultaneous submissions or previously published work OK.

Tips: "Send us a sample (20-50 photos) of your work after reviewing our Photo Spec Sheet. Looks for "photos that center around family life—but in the broad sense — i.e., our elderly parents, teenagers, young adults, family activities. Our covers (full color) are a specific assignment. We do not use freelance submissions for our cover."

OUT MAGAZINE, 110 Greene St., Suite 600, New York NY 10012. (212)334-9119. Fax: (212)334-9227. E-mail: outmag@aol.com. Art Director: George Karabotsos. Photo Editor: Axel Kessler. Circ. 150,000. Estab. 1992. Monthly magazine. Emphasizes gay and lesbian lifestyle. Readers are gay men and lesbians of all ages and their friends.

Needs: Uses over 100 photos/issue; more than half supplied by freelancers. Needs portraits, photojournalism and fashion photos. Reviews photos with or without ms. Model release required. Captions required.

Making Contact & Terms: Submit portfolio every Wednesday for review. Also accepts digital images on Zip disk and images via the Internet. Accepts "visual dispatch" and party photos from around the country; return postage required. Unsolicited material is not returned. Payment negotiated directly with photographer. Pays on publication. Credit line given. Buys all rights; negotiable. Simultaneous submissions and/or previously published work OK.

Tips: "Don't ask to see layout. Don't call every five minutes. Turn over large portion of film."

OUTBURN, Subversive and Post Alternative Music, P.O. Box 66119, Los Angeles CA 90066-0119. (310)915-7668. E-mail: outburn@cogent.net. Website: http://www.centermix.com/outburn. Art Director: Rodney. Circ. 3,500. Estab. 1996. Three times/year consumer magazine. "*Outburn* covers music in the industrial, gothic, ethereal, noise, electronic, ambient and experimental genres as well as cutting edge art and design. We promote giving artists a voice." Sample copy for $5.50.

Needs: Needs photos of bands and dark or disturbing artistic photos. Reviews photos with or without ms.

Making Contact & Terms: Send query letter with samples. Provide résumé, business card, self-promotion piece or tearsheets to be kept on file for possible future assignemtns. Art director will contact photographer for portfolio review if interested. Portfolio should include b&w and/or color, prints. Uses any size color b&w prints. Accepts images in digital format at 300 DPI, for Mac. Keeps samples on file; include SASE for return of material. Reports back only if interested, send non-returnable samples. Instead of payment "we print your bio, contact information and self-portrait." Credit line given.

Tips: "We look for work that is confrontational, unusual and personal."

OUTDOOR AMERICA, 707 Conservation Lane, Gaithersburg MD 20878-2983. (301)548-0150. Fax: (301)548-0146. E-mail: zachh@iwla.org. Website: http://www.iwla.org. Editor: Zachary Hoskins. Circ. 45,000. Estab. 1922. Published quarterly. Emphasizes natural resource conservation and activities for outdoor enthusiasts, including hunters, anglers, hikers and campers. Readers are members of the Izaak Walton League of America and all members of Congress. Sample copy $2.50 with 9×12 envelope. Guidelines free with SASE.

Needs: Needs vertical wildlife or shots of anglers or hunters for cover. Buys pictures to accompany articles on conservation and outdoor recreation for inside. Model release preferred. Captions required; include date taken, model info, location and species.

Making Contact & Terms: Query with résumé of photo credits. Send stock photo list. Tearsheets and non-returnable samples only. Uses 35mm and 2¼×2¼ slides. Not responsible for return of unsolicited material. SASE. Pays $350/color cover; $50-100/inside. **Pays on acceptance.** Credit line given. Buys one-time rights. Simultaneous and/or previously published work OK.

Tips: "*Outdoor America* seeks vertical photos of wildlife (particular game species); outdoor recreation subjects (fishing, hunting, camping or boating) and occasional scenics (especially of the Chesapeake Bay and Upper Mississippi river). We also like the unusual shot—new perspectives on familiar objects or subjects. We do not assign work. Approximately one half of the magazine's photos are from freelance sources. Our cover has moved from using a square photo format to full bleed."

OUTDOOR CANADA, 703 Evans Ave., Suite 202, Toronto, Ontario M9C 5E9 Canada. (416)695-0311. Fax: (416)695-0381. E-mail: ocanada@istar.ca. Editor: James Little. Circ. 95,000. Estab. 1972. Magazine published 8 times a year. Free writers' and photographers' guidelines "with SASE or SAE and IRC only."

Needs: Buys 200-300 photos annually. Needs photos of wildlife, people fishing, hiking, camping, hunting, ice-fishing, action shots. Captions required including identification of fish, bird or animal.
Making Contact & Terms: Send a selection of color photocopies, or transparencies with return postage for consideration. No phone calls, please. For cover allow undetailed space along left side of photo for cover lines. **SAE and IRC for American contributors, SASE for Canadians *must* be sent for return of materials.** Reports in 3 weeks. Pays $400/cover photo; $75-250/inside color photo depending on size used. Pays on publication. Buys one-time rights.

OUTDOOR LIFE MAGAZINE, Dept. PM, 2 Park Ave., New York NY 10016. (212)779-5093. Art Director: Jim Keleher. Circ. 1.35 million. Monthly. Emphasizes hunting, fishing, shooting, camping and boating. Readers are "outdoorsmen of all ages." Sample copy "not for individual requests." Photo guidelines with SASE.
Needs: Uses about 50-60 photos/issue; 75% supplied by freelance photographers. Needs photos of "all species of wildlife and fish, especially in action and in natural habitat; how-to and where-to." Captions preferred.
Making Contact & Terms: Send 5×7 or 8×10 b&w glossy prints; 35mm or 2¼×2¼ transparencies; b&w contact sheet by mail for consideration. Prefers Kodachrome 35mm slides. Prefers dupes. SASE. Reports in 1 month. Pays $35-275/b&w inside, $50-700/color inside depending on size of photos; $800-1,000/cover. Rates are negotiable. Pays on publication. Credit line given. Buys one-time rights.
Tips: "Have name and address clearly printed on each photo to insure return, send in 8×10 plastic sleeves. Multi subjects encouraged."

OVER THE BACK FENCE, 5311 Meadow Lane Ct., Suite 3, Elyria OH 44035. (440)934-1812. Fax: (440)934-1816. E-mail: backfencpub@centuryinter.net. Contact: Creative Editor. Estab. 1994. Quarterly magazine. "This is a regional magazine serving Northern and Southern Ohio. We are looking for photos of interesting people, events, and history of our area." Sample copy $4. Photo guidelines free with SASE.
Needs: Uses 50-70 photos/issue; 80% supplied by freelance assignment; 20% by freelance stock. Needs photos of scenics, attractions, food (specific to each issue), historical locations in our region (call for specific counties). Model release required for identifiable people. Captions preferred; include locations, description, names, date of photo (year); and if previously published, where and when.
Making Contact & Terms: Provide résumé, business card, brochure, flier or tearsheets to be kept on file for possible assignments. Query with stock photo list and résumé of credits. Accepts images in digital format for Windows (TIFF, EPS) Send via compact disc, floppy disk, Zip and Jaz disk. Deadlines: 6 months minimum before each issue. SASE. Reports in 3 months. Pays $100/color cover; $100/b&w cover; $25-100/color inside; $25-100/b&w inside. "We pay mileage fees to photographers on assignments. Request our photographer's rates and guidelines for specifics." Pays on publication. Credit line given except in the case of ads, where it may or may not appear. Buys one-time rights. Simultaneous submissions and previously published work OK, "but must identify photos used in other publications."
Tips: "We are looking for sharp, colorful images and prefer using color transparencies over color prints when possible. Nostalgic and historical photos are usually in black & white."

OXYGEN, (formerly *Push!* magazine), Muscle Mag International Corp. (USA), 6465 Airport Rd., Mississauga, Ontario L4V 1E4 Canada. Phone/fax: (905)678-7311. Editor-in-Chief: Robert Kennedy. Circ. 250,000. Estab. 1997. Bimonthly magazine. Emphasizes exercise and nutrition for women. Readers are women, ages 16-35. Sample copy $5.
Needs: Uses 300 photos/issue; 80% supplied by freelancers. Needs photos of women in weight training and exercising aerobically. Model release preferred. Captions preferred; include names of subjects.
Making Contact & Terms: Send unsolicited photos by mail for consideration. Send 35mm, 2¼×2¼ transparencies. Deadlines: 1st of each month. Does not keep samples on file. SASE. Reports in 3 weeks. Pays $100-200/hour; $400-600/day; $400-1,000/job; $500-600/color cover; $35-50/color or b&w inside. **Pays on acceptance.** Credit line given. Buys all rights.

PADDLER MAGAZINE, P.O. Box 5450, Steamboat Springs CO 80477. (970)879-1450. Fax: (970)870-1404. E-mail: editor@aca-paddler.org. Website: http://www.aca-paddler.org/paddler. Editor: Eugene Buchanan. Circ. 85,000. Estab. 1990. Bimonthly magazine. Emphasizes kayaking, rafting, canoeing and sea kayaking. Sample copy $3.50. Photo guidelines free with SASE.
Needs: Uses 30-50 photos/issue; 90% supplied by freelancers. Needs photos of scenics and action. Model/property release preferred. Captions preferred; include location.
Making Contact & Terms: Query with stock photo list. Send unsolicited photos by mail for consideration. Send 35mm transparencies. Accepts images in digital format on compact disc, Zip disk or floppy. Keeps samples on file. SASE. Reports in 2 months. Pays $25-200/color photo; $200/color cover; $50/inset

color cover; $75/color full page inside. Pays on publication. Credit line given. Buys first North American serial rights; negotiable.

Tips: "Send dupes and let us keep them on file."

PENNSYLVANIA, P.O. Box 576, Camp Hill PA 17011. (717)697-4660. Editor: Matthew K. Holliday. Circ. 30,000. Bimonthly. Emphasizes history, travel and contemporary issues and topics. Readers are 40-70 years old, professional and retired; average income is $59,000. Sample copy $2.95. Photo guidelines free with SASE.

● If you want to work with this publication make sure you review several past issues and obtain photo guidelines.

Needs: Uses about 40 photos/issue; most supplied by freelance photographers. Needs include travel and scenic. All photos must be in Pennsylvania. Reviews photos with or without accompanying ms. Captions required.

Making Contact & Terms: Query with samples. Send 5×7 and up color prints; 35mm and 2¼×2¼ transparencies (duplicates only, no originals) by mail for consideration. SASE. Reports in 2 weeks. Pays $100/color cover; $15-25/color inside; $50-400/text/photo package. Credit line given. Buys first rights. Simultaneous submissions and previously published work OK.

PENNSYLVANIA ANGLER & BOATER, P.O. Box 67000, Harrisburg PA 17106-7000. (717)657-4518. Fax: (717)657-4549. E-mail: amichaels@fish.state.pa.us. Website: http://www.fish.state.pa.us. Editor: Art Michaels. Bimonthly. "*Pennsylvania Angler & Boater* is the Keystone State's official fishing and boating magazine, published by the Pennsylvania Fish and Boat Commission." Readers are "anglers and boaters in Pennsylvania." Sample copy and photo guidelines free with 9×12 SAE and 9 oz. postage.

Needs: Uses about 50 photos/issue; 80% supplied by freelancers. Needs "action fishing and boating shots." Model release preferred. Captions required.

Making Contact & Terms: Query with résumé of credits. Send 35mm or larger transparencies by mail for consideration. SASE. Reports in 2 weeks. Pays up to $400/color cover; $25 up/color inside; $50-300 for text/photo package. **Pays on acceptance.** Credit line given. Buys variable rights.

PENNSYLVANIA GAME NEWS, 2001 Elmerton Ave., Harrisburg PA 17110-9797. (717)787-3745. Editor: Bob Mitchell. Circ. 150,000. Monthly magazine. Published by the Pennsylvania Game Commission. For people interested in hunting, wildlife management and conservation in Pennsylvania. Free sample copy with 9×12 SASE. Free editorial guidelines.

Needs: Considers photos of "any outdoor subject (Pennsylvania locale), except fishing and boating." Photos purchased with accompanying ms.

Making Contact & Terms: Submit seasonal material 6 months in advance. Send 8×10 glossy b&w prints. SASE. Reports in 2 months. Pays $5-20/photo. **Pays on acceptance.** Buys all rights, but may reassign after publication.

PENNSYLVANIAN MAGAZINE, Dept. PM, 2941 N. Front St., Harrisburg PA 17110. (717)236-9526. Fax: (717)236-8164. Editor: T. Michael Mullen. Circ. 7,000. Estab. 1962. Monthly magazine of Pennsylvania State Association of Boroughs (and other local governments). Emphasizes local government in Pennsylvania. Readers are officials in municipalities in Pennsylvania. Sample copy free with 9×12 SAE and 5 first-class stamps.

Needs: Number of photos/issue varies with inside copy. Needs "color photos of scenics (Pennsylvania), local government activities, Pennsylvania landmarks, ecology—for cover photos only; authors of articles supply their own photos." Special photo needs include photos of street and road maintenance work; wetlands scenic. Model release preferred. Captions preferred that include identification of place and/or subject.

Making Contact & Terms: Query with résumé of credits. Query with list of stock photo subjects. Send unsolicited photos by mail for consideration. Provide résumé, business card, brochure, flier or tearsheets to be kept on file for possible assignments. Send color prints and 35mm transparencies. Does not keep samples on file. SASE. Reports in 1 month. Pays $25-30/color cover. Pays on publication. Buys one-time rights.

Tips: "We're looking for a variety of scenic shots of Pennsylvania which can be used for front covers of the magazine, especially special issues such as engineering, winter road maintenance or park and recreation. Photographs submitted for cover consideration should be vertical shots; horizontal shots receive minimal consideration."

PENTECOSTAL EVANGEL, 1445 Boonville, Springfield MO 65802. (417)862-2781. Fax: (417)862-0416. E-mail: pevangel@ao.org. Website: http://www.ag.org/evangel. Editor: Hal Donaldson. Managing

Editor: Ken Horn. Circ. 250,000. Official voice of the Assemblies of God, a conservative Pentecostal denomination. Weekly magazine. Emphasizes denomination's activities and inspirational articles for membership. Free sample copy and photographer's/writer's guidelines.

• *Pentecostal Evangel* uses a number of images taken from the Internet and CD-ROMs.

Needs: Uses 25 photos/issue; 5 supplied by freelance photographers. Human interest (very few children and animals). Also needs seasonal and religious shots. "We are interested in photos that can be used to illustrate articles or concepts developed in articles. We are not interested in merely pretty pictures (flowers and sunsets) or in technically unusual effects or photos. We use a lot of people and mood shots." Model release preferred. Captions preferred.

Making Contact & Terms: Send material by mail for consideration. Uses 8 × 10 b&w and color prints; 35mm or larger transparencies; color 2¼ × 2¼ to 4 × 5 transparencies for cover; vertical format preferred. Also accepts digital images for Mac in TIFF files (300 dpi). SASE. Reports in 6-8 weeks. Pays $30-50/ b&w photo; $50-200/color photo; $100-500/job. **Pays on acceptance.** Credit line given. Buys one-time rights; simultaneous rights; or second serial (reprint) rights. Simultaneous submissions and previously published work OK if indicated.

Tips: "Send seasonal material six months to a year in advance—especially color."

PERSIMMON HILL, 1700 NE 63rd, Oklahoma City OK 73111. (405)478-6404. Fax: (405)478-4714. Editor: M. J. Van Deventer. Circ. 15,000. Estab. 1970. Publication of the National Cowboy Hall of Fame museum. Quarterly magazine. Emphasizes the West, both historical and contemporary views. Has diverse international audience with an interest in preservation of the West. Sample copy $9 with 9 × 12 SAE and 10 first-class stamps. Writers and photography guidelines free with SASE.

• This magazine has received Outstanding Publication honors from the Oklahoma Museums Association, the International Association of Business Communicators and Ad Club.

Needs: Uses 70 photos/issue; 95% supplied by freelancers; 90% of photos in each issue come from assigned work. "Photos must pertain to specific articles unless it is a photo essay on the West." Model release required for children's photos. Photo captions required including location, names of people, action. Proper credit is required if photos are of an historical nature.

Making Contact & Terms: Submit portfolio for review. SASE. Reports in 6 weeks. Pays $350/color cover; $50/color inside; $25-100/b&w inside; $200/photo/text package; $40-60/hour; $250-500/day; $300-750/job. Credit line given. Buys first North American serial rights.

Tips: "Make certain your photographs are high quality and have a story to tell. We are using more contemporary portraits of things that are currently happening in the West and using fewer historical photographs. Work must be high quality, original, innovative. Photographers can best present their work in a portfolio format and should keep in mind that we like to feature photo essays on the West in each issue. Study the magazine to understand its purpose. Show only the work that would be beneficial to us or pertain to the traditional Western subjects we cover."

N ⊕ **PET REPTILE**, Freestyle Publications Ltd., Alexander House, Ling Rd., Tower Park, Poole, Dorset BH12 4N2 United Kingdom. Phone: (01202)735090. Fax: (01202)733 969. E-mail: gjames@freepu bs.co.uk. Website: http://www.freepubs.co.uk. Editor: Gethin James. Estab. 1997. Monthly magazine aimed at anyone with an interest in keeping reptiles, amphibians or invertebrates. Sample copy free.

Needs: Buys 50 photos from freelancers/issue; 600 photos/year. Needs photos of all reptiles, amphibians, invertebrates. Reviews photos with or without ms. Special photo needs include good quality cover shots. Photo captions required.

Making Contact & Terms: Send query lettter with samples. Art director will contact photographer for portfolio review if interested. Portfolio should include b&w and/or color, prints, tearsheets, slides, transparencies or thumbnails. Uses any format. Call for details on deadlines. Include SASE for return of material. Pays £50-75 for color cover; £10-50 for b&w inside; £10-50 for color inside. Pays on publication. Rights negotiated. Previously published work OK.

Tips: "Variety is important. Unusual angles are preferrable." Photographers should always "enclose captions."

PETERSEN'S PHOTOGRAPHIC, 6420 Wilshire Blvd., Los Angeles CA 90048-5515. (213)782-2200. Fax: (213)782-2465. Editor: Ron Leach. Circ. 200,000. Estab. 1972. Monthly magazine. Emphasizes photography. Sample copies available on newsstands. Photo guidelines free with SASE.

Needs: No assignments. All queries, outlines and mss must be accompanied by a selection of images that would illustrate the article.

Making Contact & Terms: Submit portfolio for review. Send unsolicited photos by mail for consideration. Send unmounted glossy color or b&w prints no larger than 8 × 10; 35mm, 2¼ × 2¼, 4 × 5, 8 × 10 transparencies preferred. All queries and mss must be accompanied by sample photos for the article.

Deadlines: 6 months in advance for seasonal photos. SASE. Reports in 2 months. Payment negotiable. Pays per published page (text and photos). Pays on publication. Credit line given. Buys one-time rights. Previously published work OK.
Tips: "We need images that are visually exciting and technically flawless. The articles mostly cover the theme 'We Show You How.' Send great photographs with an explanation of how to create them."

PETS QUARTERLY MAGAZINE, 2495 Main St., P.O. Box 15, Buffalo NY 14214. (416)955-1550. Fax: (416)955-1391. Publisher: Jim Eaton. Circ. 62,000. Estab. 1991. Quarterly consumer magazine. Emphasizes pets, dogs, cats, fish, exotic animals. Readers are mostly female (over 90%). Sample copy $2.
Needs: Uses 25 photos/issues; all supplied by freelancers. Needs humorous shots of pets; close-up portraits; pets and people. Captions required.
Making Contact & Terms: Query with stock photo list. Send 3×5 glossy color prints. Keeps samples on file. SASE. Reports in 1 month. Pays $50/b&w cover; $25/color inside. Pays on publication. Buys one-time rights. Previously published work OK.
Tips: "We still prefer to see material in 'hard copy' format."

PHI DELTA KAPPA, Eighth & Union Sts., P.O. Box 789, Bloomington IN 47402. Website: http://www.pdkintl.org/kappan.htm. Design Director: Carol Bucheri. Estab. 1915. Produces *Phi Delta Kappan* magazine and supporting materials. Photos used in magazine, fliers and subscription cards.
Needs: Buys 5 photos/year. Education-related subjects: innovative school programs, education leaders at state and federal levels, social conditions as they affect education. Reviews stock photos. Model release required. Photo captions required; include who, what, when, where.
Making Contact & Terms: Query with list of education-related stock photo subjects before sending samples. Provide photocopies, brochure or flier to be kept on file for possible future assignments. Uses 8×10 b&w prints. SASE. Reports in 3 weeks. Pays $20-100/b&w photo; $30-400/color photo; $30-500/job. Credit line and tearsheets given. Buys one-time rights.
Tips: "Don't send photos that you wouldn't want to hang in a gallery. Just because you do a photo for publications does not mean you should lower your standards. Spots should be touched up (not with a ball point pen), the print should be good and carefully done, subject matter should be in focus. Send me photocopies of your b&w prints that we can look at. We don't convert slides and rarely use color."

[N] [●] PHOTO LIFE, Apex Publications, Toronto Dominion Center, Suite 2550, P.O. Box 77, Toronto, Ontario M5K 1E7 Canada. (800)905-7468. Fax: (800)664-2739. Editor: Jacques Thibault. Circ. 73,500. Magazine published 6 times/year. Readers are advanced amateur and professional photographers. Sample copy or photo guidelines free with SASE.
Needs: Uses 70 photos/issue; 100% supplied by freelance photographers. Needs landscape/wildlife shots, travel, scenics, b&w images and so on. Priority is given to Canadian photographers.
Making Contact & Terms: Query with résumé of credits. SASE. Accepts images in digital format for Mac. Send via SyQuest, CD or Zip disk (300 dpi). Reports in 1 month. Pays $75-100/color photo; $400 maximum/complete job; $700 maximum/photo/text package. **Pays on acceptance**. Buys first North American serial rights and one-time rights.
Tips: "Looking for good writers to cover any subject of interest to the advanced photographer. Fine art photos should be striking, innovative. General stock, outdoor and travel should be presented with a strong technical theme."

[N] [●] PHOTO TECHNIQUE, IPC Magazines, Kings Reach Tower, Stamford St., London United Kingdom SE1 9LS. Phone: 0171-261 5323. Fax: 0171-261 5404. Editor: Liz Walker. Circ. 39,000. Estab. 1993. Monthly consumer magazine for amateur and professional photographers with emphasis on improving techniques. Sample copy available.
Needs: Needs photos of everything—especially outdoor, portraits and action. Reviews photos with or without ms. Special photo needs include high impact shots with interesting technique/anecdote behind them. Photo captions preferred; include type of camera, lens, film, exposure, filters, tripod used.
Making Contact & Terms: Send query letter with samples. Portfolios may be dropped off every Wednesday. Uses 8×10 maximum color/b&w prints. Keeps samples on file 6 months maximum. Pays £150

THE INTERNATIONAL MARKETS INDEX, located in the back of this book, lists markets located outside the U.S. by country.

sterling minimum for cover; £20 sterling minimum for inside. Pays on publication. Credit line given. Buys one-time rights, first rights.

Tips: "Read our magazine. Phone with ideas or email. Send SAE. Don't sent previously published work which has been in UK photo magazines. Please don't send 1970-80s glamour."

N PHOTO TECHNIQUES, Preston Publications, 6600 W. Touhy Ave., Niles IL 60714. (847)647-2900. Fax: (847)647-1155. Editor: Michael C. Johnston. Circ. 37,000. Estab. 1979. Bimonthly traditional photography magazine for advanced workers—most own their own darkrooms. Sample copy for $5 or free with 9×12 SASE. Art guidelines for SAE.

Needs: Publishes expert technical articles about photography. Especially needs "On Assignment" and lighting articles. Reviews photos with or without ms. Photo captions required; include technical data.

Making Contact & Terms: Send article or portfolio for review. Portfolio should include b&w and/or color, prints, slides or transparencies. Uses any and all formats—prefer 8×10 prints. Keeps samples on file; include SASE for return of material. Pays $300 and up for color cover; $100-225 per page. Pays on publication. Credit line given. Buys one-time rights. "Prefer that work not have been previously published in any competing photography magazine; small, scholarly, or local publication OK."

Tips: "We need people to be familiar with our magazine before submitting/querying; however, we receive surprisingly few portfolios and are interested in seeing more. We are most interested in non-big-name photographers. Include return postage/packaging. Also, we much prefer complete finished submissions; when people ask 'would you be interested . . . ?' Often the answer is simply. 'We don't know! Let us see it.' We are very interested in having freelance writers submit work they've written about local or lesser-known working photographers, along with pictures. Often the photographers will not take the time to create a viable magazine piece. Even with minimal written material, having a writer manage the submission can be very helpful."

N ⊕ PHOTON, Icon Publications Ltd., Maxwell Place, Kelso Scotland TD5 7BB. Phone: (+44)1573 226032. Fax: (+44)153 226000. E-mail: david@maxwellplace.demon.co.uk. Circ. 6,500. Estab. 1989. Monthly consumer magazine for professional and enthusiast photographers.

Needs: Complete articles or portfolios. Must be exceptional. Reviews photos with or without ms. Photo captions required; include technical data.

Making Contact & Terms: Send query letter with samples or tearsheets. Art director will contact photographer review if interested. Uses color b&w prints; 35mm, 2¼×2¼ transparencies. Accepts images in digital format. Keeps samples on file; include SASE for return of material. Reports in 6 weeks on queries; 6 weeks on samples. Pays $150-200 for color cover; $20-75 for b&w inside; $30-100 for color inside. Pays on publication. Credit line given. Buys one-time rights. Previously published work OK.

Tips: "Our readers look for new information of value to working creative photographers."

PHOTORESOURCE MAGAZINE, P.O. Box 705, Tucumcari NM 88401-0705. Phone/fax: (505)487-2729. E-mail: info@photoresource.com. Editor: William Johnson. Circ. 15,000. Estab. 1994. Biweekly magazine. Readers are male and female, ages 18-55. Photo/writers guidelines free with #10 SASE.

Needs: Uses 2-6 photos/issue; all supplied by freelancers. Model/property release required. Photo captions required.

Making Contact & Terms: Query with résumé of credits. Accepts images in digital format for Windows (JPEG only). Can send 3 photos via E-mail to artdept@photoresource.com for consideration. Does not keep samples on file. Reports in 1 month. Payment negotiable. Pays on publication. Credit line given. Buys one-time rights. Simultaneous submissions OK.

PLANNING, American Planning Association, 122 S. Michigan Ave, Chicago IL 60603. (312)431-9100. (312)431-9985. E-mail: rsessions@planning.org. Editor: Sylvia Lewis. Photo Editor: Richard Sessions. Circ. 30,000. Estab. 1972. Monthly magazine. "We focus on urban and regional planning, reaching most of the nation's professional planners and others interested in the topic." Free sample copy and photo guidelines with 10×13 SAE and 4 first-class stamps. Writer's guidelines included on photo guidelines sheet.

Needs: Buys 50 photos/year, 95% from freelance stock. Photos purchased with accompanying ms and on assignment. Photo essay/photo feature (architecture, neighborhoods, historic preservation, agriculture); scenic (mountains, wilderness, rivers, oceans, lakes); housing; and transportation (cars, railroads, trolleys, highways). "No cheesecake; no sentimental shots of dogs, children, etc. High artistic quality is very important. We publish high-quality nonfiction stories on city planning and land use. Ours is an association magazine but not a house organ, and we use the standard journalistic techniques: interviews, anecdotes, quotes. Topics include energy, the environment, housing, transportation, land use, agriculture, neighborhoods and urban affairs." Captions required.

Making Contact & Terms: Query with samples. Uses 8×10 glossy and semigloss b&w prints; contact sheet OK; 4-color prints; 35mm or 4×5 transparencies. SASE. Accepts images in digital format for Mac (JPEG or EPS). Send via Zip disk. Reports in 1 month. Pays $50-100/b&w photo; $50-200/color photo; up to $350/cover; $200-600/ms. Pays $25-75 for electronic use of images. Pays on publication. Credit line given. Previously published work OK.
Tips: "Just let us know you exist. Eventually, we may be able to use your services. Send tearsheets or photocopies of your work, or a little self-promo piece. Subject lists are only minimally useful. How the work looks is of paramount importance."
or second serial (reprint) rights. Simultaneous submissions and previously published work OK if indicated.
Tips: "Send seasonal material six months to a year in advance—especially color."

PLAYBOY, 680 North Lake Shore Dr., Chicago IL 60611. (312)751-8000. Fax: (312)587-9046. Photography Director: Gary Cole. Circ. 3.15 million, US Edition; 5 million worldwide. Estab. 1954. Monthly magazine. Readers are 75% male and 25% female, ages 18-70; come from all economic, ethnic and regional backgrounds.
 • This is a premiere market that demands photographic excellence. *Playboy* does not use freelance photographers per se, but if you send images they like they may use your work and/or pay a finder's fee.
Needs: Uses 50 photos/issue. Needs photos of glamour, fashion, merchandise, travel, food and personalities. Model release required. Models must be at least 18 years old.
Making Contact & Terms: Contact through rep. Submit portfolio for review. Query with résumé of credits. Send unsolicited photos by mail for consideration. Provide résumé, business card, brochure, flier or tearsheets to be kept on file for possible assignments. Send color 35mm, $2\frac{1}{4} \times 2\frac{1}{4}$, 4×5, 8×10 transparencies. Reports in 1-2 weeks. Pays $300 and up/job. **Pays on acceptance.** Buys all rights.
Tips: Lighting and attention to detail is most important when photographing women, especially the ability to use strobes indoors. Refer to magazine for style and quality guidelines.

N PLAYBOY'S NEWSSTAND SPECIALS, 680 N. Lakeshore Dr., Chicago IL 60611. (312)751-8000. Fax: (312)751-2818. E-mail: newstand@playboy.com. Circ. 300,000. Estab. 1984. Monthly magazine for male sophisticate. Art guidelines available.
Needs: Needs photos of beautiful women. Model/property release required. Photo captions required.
Making Contact & Terms: Send query letter with samples. Uses 35mm, $2\frac{1}{4} \times 2\frac{1}{4}$ tranparencies; Kodachrome film. Does not keep samples on file. Credit line given. Buys one-time rights or all rights.

N POETS & WRITERS MAGAZINE, 72 Spring St., New York NY 10012. (212)226-3586. Fax: (212)226-3963. E-mail: jim@pw.org. Website: http://www.pw.org. Circ. 60,000. Estab. 1987. Bimonthly literary trade magazine. "Designed for poets, fiction writers and creative nonfiction writers. We supply our readers with information about the publishing industry, conferences and workshop opportunities, grants and awards available to writers, as well as interviews with contemporary authors."
Needs: Buys 2 photos from freelancers/issue. Needs photos of contemporary writers: poets, fiction writers, writers of creative nonfiction. Photo captions required.
Making Contact & Terms: Provide résumé, business card, self-promotion piece or tearsheets to be kept on file for possible future assignments. Art director will contact photographer for portfolio review if interested. Uses b&w prints. Pays $500 maximum for b&w cover; $150 maximum for b&w inside. Pays on publication. Credit line given.
Tips: "We seek black and white photographs to accompany articles and profiles. We'd be pleased to have photographers' lists of author photos."

POLO PLAYERS EDITION MAGAZINE, (formerly *Polo Magazine*), 3500 Fairlane Farms Rd., #9, Wellington FL 33414. (561)793-9524. Fax: (561)793-9576. Editor: Gwen Rizzo. Circ. 7,000. Estab. 1975. Monthly magazine. Emphasizes the sport of polo and its lifestyle. Readers are primarily male; average age is 40. 90% of readers are professional/managerial levels, including CEO's and presidents. Sample copy free with 10×13 SASE. Photo guidelines free with SASE.
Needs: Uses 50 photos/issue; 70% supplied by freelance photographers; 20% of this by assignment. Needs photos of polo action, portraits, travel, party/social and scenics. Most polo action is assigned, but freelance needs range from dynamic action photos to spectator fashion to social events. Photographers may write and obtain an editorial calendar for the year, listing planned features/photo needs. Captions preferred, where necessary include subjects and names.
Making Contact & Terms: Query with list of stock photo subjects. Provide résumé, business card, brochure, flier or tearsheets to be kept on file for possible assignments. SASE. Reports in 2 weeks. Pays $25-150/b&w photo, $30-300/color photo, $150/half day, $300/full day, $200-500/complete package. Pays

on publication. Credit line given. Buys one-time or all rights; negotiable. Simultaneous submissions and previously published work OK "in some instances."

Tips: Wants to see tight focus on subject matter and ability to capture drama of polo. "In assigning action photography, we look for close-ups that show the dramatic interaction of two or more players rather than a single player. On the sidelines, we encourage photographers to capture emotions of game, pony picket lines, etc." Sees trend toward "more use of quality b&w images." To break in, "send samples of work, preferably polo action photography."

⟦N⟧ PONTOON & DECK BOAT, Harris Publishing, 520 Park Ave., Idaho Falls ID 83402. (208)524-7000. Fax: (208)522-5241. E-mail: steve@houseboating.net. Website: http://www.houseboating.net. Editor: Steve Smede. Circ. 82,000. Estab. 1995. Bimonthly consumer magazine geared towards the pontoon and deck boating lifestyle. "Our audience is composed of people who utilize these boats for varied family activities and fishing. Sample copies available. Call for guidelines.

Needs: Buys 2-6 photos/issue from freelancers; 14-20 photos/year. Needs photos of family activities, travel, vessel layouts and components. Reviews photos with or without ms. Special photo needs include: family activities and remodeling, scenics with pontoon or deck boat. Property release and captions preferred.

Making Contact & Terms: Send query letter with samples. To show portfolio, photographer should follow-up with call. Portfolio should include color slides and transparencies. Keeps samples on file. Reports in 1-2 months on queries. Pays on publication. Credit line sometimes given depending on nature of use. Buys one-time rights. Simultaneous submissions OK.

Tips: "We're saturated with 'brochure' photography. Show us something daring you won't find in a brochure or advertisement. This is a family publication and should illustrate how families utilize pontoon and deck boats."

⟦N⟧ POP CULTURE, Turquoise Productions, 3932 Wilshire Blvd., #212, Los Angeles CA 90010. (213)383-1091. Fax: (213)383-1093. E-mail: popcultmag@aol.com. Website: http://www.pop-culture.com. Creative/Editorial Director: Sean Perkin. Circ. 100,000. Estab. 1993. *Pop Culture* is a bimonthly general interest international publication that chronicles the events and ideas that shape culture. Each issue explores the numerous aspects of life, people and events worldwide that define the times in which we live.

Needs: Buys 50-100 photos from freelancers/issue; 350-600 photos/year. Needs photos of popular culture. Reviews photos with or without ms. Model release required; property release preferred. Photo captions preferred.

Making Contact & Terms: Send query letter with samples, tearsheets. Provide résumé, business card, self-promotion piece or tearsheets to be kept on file for possible future assignments. Art director will contact photographer for portfolio review if interested. Portfolio should include work representative of photographers talent. Uses 8×10 color/b&w prints; 35mm, 2¼×2¼, 4×5, 8×10 transparencies. Accepts images in digital format. Reports back only if interested, send non-returnable samples. Pays $25-500 for b&w inside; $25-500 for color inside. Pays on publication. Credit line given. Previously published work OK.

Tips: "Photographer's should be aware of the trend in multi-platform publishing—print, video, internet, promotional."

POPULAR ELECTRONICS, 500 Bi-County Blvd., Farmingdale NY 11735. (516)293-3000. Fax: (516)293-3115. Editor: Ed Whitman. Circ. 58,207. Estab. 1989. Monthly magazine. Emphasizes hobby electronics. Readers are hobbyists in electronics, amateur radio, CB, audio, TV, etc.—"Mostly male, ages 13-59." Sample copy free with 9×12 SAE and 90¢ postage.

Needs: Uses about 20 photos/issue; 20% supplied by freelance photographers. Photos purchased with accompanying ms only. Special needs include regional photo stories on electronics. Model/property release required. Captions preferred.

Making Contact & Terms: Send complete ms and photo package with SASE. Reports in 2 weeks. Pays $200-350 for text/photo package. **Pays on acceptance.** Credit line given. Buys all rights; negotiable. Simultaneous submissions and previously published work OK.

POPULAR PHOTOGRAPHY, 1633 Broadway, New York NY 10019. (212)767-6578. Fax: (212)767-5629. Send to: Your Best Shot/Hard Knocks. Circ. 450,000. Estab. 1937. Monthly magazine. Readers are male and female photographers, amateurs to professionals of all ages. Photo guidelines free with SASE.

Needs: Uses many photos/issue; many supplied by freelancers, mostly professionals. Uses amateur and professional photos for monthly contest feature, Your Best Shot, and Hard Knocks. Needs scenics, nature, portraits.

Making Contact & Terms: Send unsolicited photos by mail for consideration. Send prints size 8×12

and under, color and b&w; any size transparencies. Does not keep samples on file. SASE. Reports in 3 months. Pays prize money for contest: $300 (first), $200 (second), $100 (third) and honorable mention. **Pays on acceptance.** Credit line given. Buys one-time rights.

POPULATION BULLETIN, 1875 Connecticut Ave., Suite 520, Washington D.C. 20009. (202)483-1100. Fax: (202)328-3937. E-mail: shershey@prb.org. Website: http://www.prb.org/prb/. Production Manager: Sharon Hershey. Circ. 15,000. Estab. 1929. Publication of the nonprofit Population Reference Bureau. Quarterly journal. Publishes other population-related publications, including a monthly newsletter. Emphasizes demography. Readers are educators (both high school and college) of sociology, demography and public policy.

Needs: Uses 6-8 photos/issue; 70% supplied by freelancers. Needs vary widely with topic of each edition—international and US people, families, young, old, all ethnic backgrounds. Everyday scenes, close-up pictures of people in developing countries. Model/property release required. Captions preferred.

Making Contact & Terms: Query with list of stock photo subjects. Send unsolicited photos by mail for consideration. Send b&w prints or photocopies. Pays $50-100/b&w photo. **Pays on acceptance.** Buys one-time rights. Simultaneous submissions and previously published work OK.

Tips: "Looks for subjects relevant to the topics of our publications. Generally looking for pictures of people. Primarily black and white."

PRAIRIE DOG, P.O. Box 470757, Aurora CO 80047. E-mail: jrhart@bigfoot.com. Editor-in-Chief: John R. Hart. Circ. 600. Estab. 1995. Biannual magazine. Emphasizes literature. Readers are lovers of fiction, poetry, art and photography, ages 20-75. Sample copy $5.95 with 9×12 SAE and 4 first-class stamps. Photo guidelines free with SASE.

Needs: Uses 4-10 photos/issue; all supplied by freelancers. Needs photos of scenics, still life, wildlife and travel. Model/property release required for nudes. Captions preferred; include subject and place.

Making Contact & Terms: Send unsolicited photos by mail for consideration. Send 5×7 glossy color or b&w prints. Keeps samples on file. SASE. Reports in 3-6 months. Pays with 1 copy of magazine. Buys one-time rights; negotiable. Simultaneous submissions OK.

PRESBYTERIAN RECORD, 50 Wynford Dr., North York, Ontario M3C 1J7 Canada. (416)441-1111. Fax: (416)441-2825. Editor: Rev. John Congram. Circ. 55,000. Estab. 1875. Monthly magazine. Emphasizes subjects related to The Presbyterian Church in Canada, ecumenical themes and theological perspectives for church-oriented family audience. Photos purchased with or without accompanying ms. Free sample copy and photo guidelines with 9×12 SAE and $1 Canadian postage minimum or International Postal Coupons.

Needs: Religious themes related to features published. No formal poses, food, nude studies, alcoholic beverages, church buildings, empty churches or sports. Captions preferred.

Making Contact & Terms: Send photos. Uses prints only for reproduction; 8×10, 4×5 glossy b&w or color prints and 35mm and 2¼×2¼ color transparencies. Usually uses 35mm color transparency for cover or ideally, 8×10 transparency. Vertical format used on cover. SAE, IRCs for return of work. Reports in 1 month. Pays $15-35/b&w print; $60 minimum/cover; $30-60 for text/photo package. Pays on publication. Credit line given. Buys one-time rights; negotiable. Simultaneous submissions and/or previously published work OK.

Tips: "Unusual photographs related to subject needs are welcome."

PRIDE MAGAZINE, 3023 N. Clark, #910, Chicago IL 60657. (773)472-4552. Fax: (773)472-0576. E-mail: pridemag@aol.com. Contact: David Cohen. Circ. 10,000. Estab. 1995. Quarterly magazine. Sample copy free.

Needs: Buys 6-10 photos from freelancers/issue; 40 photos/year. Needs photos of fashion stories. Reviews photos with or without ms. Model/property release required. Photo captions required; include description of clothes, designer name—model's name etc.

Making Contact & Terms: Send query letter with samples, tearsheets. Provide résumé, business card, self-promotion piece or tearsheets to be kept on file for possible future assignments. To show portfolio, photographer should follow-up with call and/or letter after initial query. Art director will contact photographer for portfolio review if interested. Portfolio should include b&w and/or color, prints or tearsheets. Uses 8×10 matte color/b&w prints. Deadlines: February 15, April 15, July 15, October 15 of each year. Keeps samples on file. Reports back only if interested, send non-returnable samples. Pays $100-300 for cover; $25-300 for inside. Pays on publication. Credit line sometimes given depending upon "reputation, size and establishment of creditor." Buys first rights, or all rights. "Usually whatever we print—we keep all rights."

Tips: "We need fast workers with quick turnaround. Friendly, trusty and responsible—photographer needs

to be organized and time efficient. Needs to have good ideas, too. We like to publish alternative lifestyles. Like to see action fashion photography."

PRIMAVERA, Box 37-7547, Chicago IL 60637. (773)324-5920. Contact: Board of Editors. Annual magazine. "We publish original fiction, poetry, drawings, paintings and photographs that deal with women's experiences." Sample copy $5. Photo guidelines free with SASE.
Needs: Uses 2-12 photos/issue; all supplied by freelancers.
Making Contact & Terms: Send unsolicited photos or photocopies by mail for consideration. Send b&w prints. SASE. Reports in 1 month. Pays on publication 2 copies of volume in which art appears. Credit line given. Buys one-time rights.

PRIME TIME SPORTS & FITNESS, Dept. PM, P.O. Box 6097, Evanston IL 60204. (847)864-8113. Fax: (847)864-1206. E-mail: rallyden@prodigy.net. Editor: Dennis Dorner. Magazine publishes 8 times/ year. Emphasizes sports, recreation and fitness; baseball/softball, weight lifting and bodybuilding, etc. Readers are professional males (50%) and females (50%), 19-45. Photo guidelines on request.
Needs: Uses about 70 photos/issue; 60 supplied by freelancers. Needs photos concerning women's fitness and fashion, swimwear and aerobic routines. Special photo needs include women's workout and swimwear photos. Upcoming short-term needs: summer swimwear, women's aerobic wear, portraits of women in sports. "Don't send any photos that would be termed photobank access." Model/property release required. Captions preferred; include names, the situation and locations.
Making Contact & Terms: Send unsolicited photos by mail for consideration. Submit portfolio for review. "Contact us by fax, phone or mail and we will set appointment." Accepts images in digital format for Windows via compact disc. SASE. Reports in 2 months. Pays $200/color and b&w cover; $20/color and b&w inside; $20/color page rate; $50/b&w page rate; $30-60/hour. Time of payment negotiable. Credit line given. Buys all rights; negotiable. Simultaneous submissions and previously published work OK. Offers internships for photographers during the summer. Contact Editor: Dennis Denver.
Tips: Wants to see "tight shots of personalities, people, sports in action, but only tight close-ups." There are a "plethora of amateur photographers who have trouble providing quality action or fashion shots and yet call themselves professionals. Photographers can best present themselves by letting me see their work in our related fields (both published and unpublished) by sending us samples. Do not drop by or phone, it will not help."

N PRIME TIMES, Members Magazine of NARCUP, Inc., 634 W. Main St., Suite 207, Madison WI 53703-2662. (608)257-4640. Fax: (608)257-4670. E-mail: grotepub@mailbag.com. Art Director: Susan Walsh. Circ. 80,000. Estab. 1979. Bimonthly publication sent to members of National Association for Retired Credit Union People (NARCUP, Inc.) containing financial and consumer related information. Magazine contains information related or directed to the over 50 age group. Sample copy for $3.75 and 9×12 SAE with 4 first-class stamps.
Needs: Buys 10-15 photos from freelancers/issue; 50-60 photos/year. Needs photos of national and international travel. Reviews photos with or without ms. Model release required for senior citizens in activities. Photo captions preferred.
Making Contact & Terms: Send query letter with samples, stock photo list. Provide résumé, business card, self-promotion piece of tearsheets to be kept on file for possible future assignments. Art director will contact photographer for portfolio review if interested. Portfolio should include slides or transparencies. Uses 35mm, 2¼×2¼, 4×5 transparencies. Accepts images in digital format. Mac platform—Photoshop 3.0, TIFF's. Include SASE for return of material. Reports in 1-2 months on queries. Reports back only if interested, send non-returnable samples. Pays on publication. Credit line given. Buys one-time rights. Previously published work OK.
Tips: "We need great color and 'in focus' images! Send business card for my rolodex file."

PRINCIPAL MAGAZINE, 1615 Duke St., Alexandria VA 22314-3483. (703)684-3345. Website: http:// www.haesp.org. Editor: Lee Greene. Circ. 30,000. Estab. 1921. Publication of the National Association of Elementary School Principals. Bimonthly (5 issues per year). Emphasizes public education—kindergarten to 8th grade. Readers are mostly principals of elementary and middle schools. Sample copy free with SASE.
Needs: Uses 10-15 b&w and color photos/issue; mostly supplied by freelancers. Needs photos of school scenes (classrooms, playgrounds, etc.), teaching situations, school principals at work, computer use and technology and science activities. The magazine sometimes has theme issues, such as back to school, technology and early childhood education. *No posed groups.* Close-ups preferred. Reviews photos and returns any that don't meet its needs in SASE; holds those that will be considered for future publication indefinitely. Model release preferred.

© David Zaitz

This turtle's-eye-view shot of two residents of a suburban turtle shelter, which houses 800 of the slow-moving creatures, was first published in *Westways Magazine*, a publication of the Automobile Club of Southern California. Photographer David Zaitz made the second sale to *Prime Times* after the editors saw the published image. "The photo was taken to emphasize the size of the animals as well as depict the inherent quirkiness of the establishment," Zaitz says. The image has since won the photographer stock sales, as well.

Making Contact & Terms: Query with samples and list of stock photo subjects. Send b&w prints, b&w contact sheet, or color slides by mail for consideration. SASE. "We hold submitted photos indefinitely for possible stock use, so send dupes or photocopies." Reports in 1-2 months. Pays $50/b&w photo. Pays on publication. Credit line given. Buys one-time rights; negotiable.

THE PROGRESSIVE, 409 E. Main St., Madison WI 53703. Art Director: Patrick JB Flynn. Circ. 35,000. Estab. 1909. Monthly political magazine. "Grassroots publication from a left perspective, interested in foreign and domestic issues of peace and social justice." Free sample copy and photo guidelines upon request.
Needs: Uses 12 or more b&w photos/issue; generally supplied by freelance photographers. Looking for images documenting the human condition and the social/political structures of contemporary society. Special photo needs include "Third World countries, labor activities, environmental issues and political movements." Captions (name, place, date) and credit information required.
Making Contact & Terms: Query with photocopies and stock photo list to be kept on file for possible future assignments. Art director will contact photographer for portfolio review if interested. SASE. Reports once every month. Pays $300/color and b&w cover photo; $40-150/b&w inside photo. Pays on publication. Credit line given. Buys one-time rights. Simultaneous submissions and previously published work OK.
Tips: "Interested in photo essays and in images that make a visual statement."

PSYCHOLOGY TODAY, Sussex Publishers, 49 E. 21st St., 11th Floor, New York NY 10010. (212)260-3214, ext. 117. Fax: (212)260-7445. Photo Editor: Jamey O'Quinn. Estab. 1992. Bimonthly magazine. Readers are male and female, highly educated, active professionals. Photo guidelines free with SASE.
● Sussex also publishes *Mother Earth News* listed in this section.
Needs: Uses 19-25 photos/issue; supplied by freelancers and stock agencies. Needs photos of humor, photo montage, symbolic, environmental, portraits, conceptual. Model/property release preferred.

Making Contact & Terms: Submit portfolio for review. Send promo card and stock list. Also accepts Mac files but prefers photographic images. Keeps samples on file. Cannot return material. Reports back only if interested. For assignments, pays $1,000/cover plus expenses; $300-500/inside photo plus expenses; for stock, pays $100/¼ page; $300/full page.

Q SAN FRANCISCO MAGAZINE, 584 Castro St., Suite 521, San Francisco CA 94114. (415)764-0324. Fax: (415)626-5744. E-mail: qsf1@aol.com. Website: http://www.qsanfrancisco.com. Editor: Robert Adams. Circ. 47,000. Estab. 1995. Bimonthly magazine. Emphasizes city, entertainment, travel. Readers are 75% gay male, 20% lesbian, 5% straight males and females. Sample copy free with 9×12 SAE and $1.93 postage.
Needs: Uses 20 photos/issue; 10 supplied by freelancers. Needs photos of travel, personalities. Model release required. Property release preferred. Captions required; include name, place, date.
Making Contact & Terms: Provide resume, business card, brochure, flier or tearsheets to be kept on file for possible assignments. Arrange personal interview to show portfolio. Cannot return material. Reports in 6-8 weeks. Accepts images in digital format for Mac. Send via Zip disk or floppy disk at size 100%, resolution 300 dpi. Pays $50-200/job; $100-200/color or b&w cover; $50-150/color inside; $50-100/b&w inside; $50-150/color or b&w page. Pays on publication. Credit line given. Rights negotiable.
Tips: Accepts photography interns year round.

RACQUETBALL MAGAZINE, 1685 W. Uintah, Colorado Springs CO 80904-2921. (719)635-5396. Fax: (719)635-0685. E-mail: rbzine@webaccess.net. Website: http://www.racqmag.com. Production Manager: Kevin Vicroy. Circ. 45,000. Estab. 1990. Publication of the United States Racquetball Association. Bimonthly magazine. Emphasizes racquetball. Sample copy $4. Photo guidelines available.
Needs: Uses 20-40 photos/issue; 20-40% supplied by freelancers. Needs photos of action racquetball. Model/property release preferred. Captions required.
Making Contact & Terms: Provide résumé, business card, brochure, flier or tearsheets to be kept on file for possible assignments. Deadlines: 1 month prior to each publication date. Keeps samples on file. SASE. Reports in 1 month. Pays $200/color cover; $25-75/color inside; $3-5/b&w inside. Pays on publication. Credit line given. Buys all rights; negotiable. Previously published work OK.

N: RADIANCE, The Magazine for Large Women, P.O. Box 30246, Oakland CA 94604. Phone/fax: (510)482-0680. Publisher/Editor: Alice Ansfield. Circ. 15,000. Estab. 1984. Quarterly magazine. "We're a positive/self-esteem magazine for women all sizes of large. We have diverse readership, 90% women, ages 25-70 from all ethnic groups, lifestyles and interests. We focus on body acceptance. We encourage and support women in living proud, full, active lives, new, with self-love and self-respect." Sample copy $3.50. Writer's guidelines free with SASE. Photo guidelines not available.
Needs: Uses 20 photos/issue; all supplied by freelance photographers. Needs portraits, cover shots, fashion photos. Model release preferred. Captions preferred.
Making Contact & Terms: Send unsolicited photos by mail for consideration. Provide résumé, business card, brochure, flier or tearsheets to be kept on file for possible assignments. SASE. Reports in 4 months. Pays $50-200/color cover; $15-25/b&w inside; $8-20/hour; $400/day. Pays on publication. Credit line given. Buys one-time rights. Simultaneous submissions OK.
Tips: In photographer's portfolio or samples wants to see "clear, crisp photos, creativity, setting, etc." Recommends freelancers "get to know the magazine. Work with the publisher (or photo editor) and get to know her requirements. Try to help the magazine with its goals."

RAG MAG, Box 12, Goodhue MN 55027. (612)923-4590. Editor: Beverly Voldseth. Circ. 300. Estab. 1982. Magazine. Emphasizes poetry and fiction, but is open to good writing in any genre. Sample copy $6 with 6¼×9¼ SAE and 4 first-class stamps.
 • Non-theme submissions beginning January 1999.
Needs: Uses 3-4 photos/issue; all supplied by freelancers. Needs photos that work well in a literary

● **SPECIAL COMMENTS** within listings by the editor of *Photographer's Market* are set off by a bullet.

magazine; faces, bodies, stones, trees, water, etc. Reviews photos without a manuscript. Uses photos on covers.

Making Contact & Terms: Send up to 8 unsolicited photocopies of photos by mail for consideration; include name on back of copies with brief bio. Always supply your name and address and add an image title or number on each photo for easy reference. Do not send originals. 6×9 vertical shots are best. Does not keep samples on file. SASE. Reports in 2 weeks-2 months. Pays in copies. Pays on publication. Buys one-time rights. Simultaneous submissions and previously published work OK.

Tips: "I do not want anything abusive, sadistic or violent."

[N] RAILNEWS MAGAZINE, P.O. Box 379, Waukesha WI 53187. (414)542-4900. Fax: (414)542-7595. E-mail: pentrex@execpc.com. Editor: Brent Haight. Circ. 28,000. Estab. 1968. Monthly magazine. Emphasizes modern railroading. Readers are mostly male, well-educated, ages 25-60. Photo guidelines free with SASE.

Needs: Uses 15-20 photos/issue; all supplied by freelancers. Needs photos of all aspects of railroading—freight, passengers, commuters. Reviews photos with or without ms. Model/property release preferred for any recognizable person in the photo. Captions required; include name of train, direction of travel, date, location.

Making Contact & Terms: Send unsolicited photos by mail for consideration. Send 5×7 glossy b&w prints; 35mm, 2¼×2¼ transparencies. Does not keep samples on file. SASE. Reports in 1-6 months. Pays $100/color cover; $50/b&w cove; $15-75/color inside photo; $15-75/b&w inside. Pays on publication. Credit line given. Buys one-time rights.

Tips: "Railnews covers all aspects of railroading today—hobby, operational, industry, breaking news. We feel this magazine is a good way for unknown photographers to see their work in print and get their name before the public."

[N] RANGER RICK AND YOUR BIG BACKYARD, 8925 Leesburg Pike, Vienna VA 22184-0001. (703)790-4525. Fax: (703)442-7332. E-mail: carr@nwf.org. Website: http://www.nwf.org. Photo Editor: Page Carr. Monthly educational magazines published by the National Wildlife Federation. *Ranger Rick* for children age 7 and up. Circ. 610,000. Estab. 1967. *Your Big Backyard* for children age 3-6. Circ. 450,000.

Needs: Both magazines publish only the highest possible quality photographs. Needs photos of wild animals of every kind and other subjects related to natural sciences and the environment, with an emphasis on their appeal to children. Subjects are varied and can include anything that is visually exciting, humorous, unusual, or of scientific interest to kids. Also publishes photo stories about real kids involved with conservation, their environment, the outdoors, science, and wildlife, ethnic diversity preferred. *Ranger Rick* uses 90% stock, assigns 10%. *Your Big Backyard* needs the same kind of material, but in a simpler more direct style to appeal to very young children (e.g. portraits of baby animals); uses 100% stock.

Making Contact & Terms: Send SASE for guidelines, non-returnable printed samples or website addresses are also welcome. *Ranger Rick* space rates: $300 (quarter page) to $1,000 (cover); *Your Big Backyard*: $200-600. Pays 3 months before publication.

Tips: "Production standards are extremely high for both magazines, and photography is by leading professionals. Fresh, creative approaches and unusual subjects are always welcome, but technical quality must be exceptional. Production lead time is long and originals may be held for months. Accurate scientific identification of wildlife is appreciated."

READING TODAY, International Reading Association, 800 Barksdale Rd., P.O. Box 8139, Newark DE 19714-8139. (302)731-1600, ext. 250. Fax: (302)731-1057. E-mail: 74673.3641@compuserve.com. Editor: John Micklos, Jr. Circ. 90,000. Estab. 1983. Publication of the International Reading Association. Bimonthly newspaper. Emphasizes reading education. Readers are educators who belong to the International Reading Association. Sample copy available. Photo guidelines free with SASE.

Needs: Uses 20 photos/issue; 3 supplied by freelancers. Needs classroom shots and photos of people of all ages reading in various settings. Reviews photos with or without ms. Model/property release preferred. Captions preferred; include names (if appropriate) and context of photo.

Making Contact & Terms: Query with résumé of credits. Query with stock photo list. Send unsolicited photos by mail for consideration. Send 3½×5 or larger color and b&w (preferred) prints. Deadline: 8 weeks prior to publication date for any given issue. SASE. Reports in 1 month. Pays $45/b&w inside; $75/color inside. **Pays on acceptance.** Credit line given. Buys one-time rights. Simultaneous submissions and previously published work OK.

REAL PEOPLE, 450 Fashion Ave., Suite 1701, New York NY 10123-1799. (212)244-2351. Fax: (212)244-2367. Editor: Alex Polner. Circ. 100,000. Estab. 1988. Bimonthly magazine. Emphasizes celebrities. Readers are women 35 and up. Sample copy $4 with 6×9 SAE.
Needs: Uses 30-40 photo/issue; 10% supplied by freelancers. Needs celebrity photos. Reviews photos with accompanying ms. Model release preferred where applicable. Photo captions preferred.
Making Contact & Terms: Query with résumé of credits and/or list of stock photo subjects. Provide résumé, business card, brochure, flier or tearsheets to be kept on file for possible assignments. Send samples or tearsheets, perhaps even an idea for a photo essay as it relates to entertainment field. Accepts images in digital format for Mac (EPS, TIFF, JPG). Send via compact disc, floppy disk, SyQuest, Zip disk (high). SASE. Reports only when interested. Pays $100-200/day. Pays on publication. Credit line given. Buys one-time rights.

REFORM JUDAISM, 838 Fifth Ave., New York NY 10021. (212)650-4240. Managing Editor: Joy Weinberg. Circ. 300,000. Estab. 1972. Publication of the Union of American Hebrew Congregations. Quarterly magazine. Emphasizes Reform Judaism. Readers are members of Reform congregations in North America. Sample copy $3.50.
Needs: Uses 35 photos/issue; 10% supplied by freelancers. Needs photos relating to Jewish life or Jewish issues, Israel, politics. Captions required.
Making Contact & Terms: Provide résumé, business card, brochure, flier or tearsheets to be kept on file for possible assignments. Reports in 1 month. Pays on publication. Credit line given. Buys one-time rights; first North American serial rights. Simultaneous submissions and/or previously published work OK.
Tips: Wants to see "excellent photography: artistic, creative, evocative pictures that involve the reader."

RELAY MAGAZINE, P.O. Box 10114, Tallahassee FL 32302-2114. (850)224-3314. Editor: Stephanie Wolanski. Circ. 1,800. Estab. 1957. Association publication of Florida Municipal Electric. Monthly magazine. Emphasizes municipally owned electric utilities. Readers are city officials, legislators, public power officials and employees. Sample copy free with 9×12 SAE and 3 first-class stamps.
 ● *Relay* is purchasing more photos on CD.
Needs: Uses various amounts of photos/issue; various number supplied by freelancers. Needs b&w photos of electric utilities in Florida (hurricane/storm damage to lines, utility workers, etc.). Special photo needs include hurricane/storm photos. Model/property release preferred. Captions required.
Making Contact & Terms: Query with letter, description of photo or photocopy. Uses 3×5, 4×6, 5×7 or 8×10 b&w prints. Also accepts digital images. Keeps samples on file. SASE. Reports in 3 months. Payment negotiable. Rates negotiable. **Pays on acceptance.** Credit line given. Buys one-time rights, repeated use (stock); negotiable. Simultaneous submissions and/or previously published work OK.
Tips: "Must relate to our industry. Clarity and contrast important. Query first if possible. Always looking for good black & white hurricane, lightning-storm and Florida power plant shots."

RELIX MAGAZINE, P.O. Box 94, Brooklyn NY 11229. (718)258-0009. Editor: Phyllis Antoniello. Circ. 60,000. Estab. 1974. Bimonthly. Emphasizes rock and roll music and classic rock. Readers are music fans, ages 13-50. Sample copy $5.
Needs: Uses about 50 photos/issue; "about 30%" supplied by freelance photographers; 20% on assignment; 80% from stock. Needs photos of "music artists—in concert and candid, backstage, etc." Special needs: "photos of rock groups, especially the Grateful Dead, San Francisco-oriented groups, sixties related bands and the newer "jam bands" and "roots rock" bands. Captions preferred.
Making Contact & Terms: Send 5×7 or larger b&w and color prints by mail for consideration. SASE. Reports in 2 months. "We try to report immediately; occasionally we cannot be sure of use." Pays $25-75/ b&w photo; $25-300/color. Pays on publication. Credit line given. Buys all rights; negotiable. Simultaneous submissions and previously published work OK.
Tips: "Black and white photos should be printed on grade 4 or higher for best contrast."

REMINISCE, 5400 S. 60th St., Greendale WI 53129. (414)423-0100. Fax: (414)423-8463. Photo Coordinator: Trudi Bellin. Estab. 1990. Bimonthly magazine. "For people who love reliving the good times." Readers are male and female, interested in nostalgia, ages 55 and over. "*Reminisce* is supported entirely by subscriptions and accepts no outside advertising." Sample copy $2. Photo guidelines free with SASE.
Needs: Uses 130 photos/issue; 20% supplied by freelancers. Needs photos with people interest—"we need high-quality color shots with nostalgic appeal, as well as good quality b&w vintage photography." Model/property release required. Captions preferred; season, location.
Making Contact & Terms: Query with list of stock photo subjects. Send unsolicited photos by mail for consideration. Send 35mm, 2¼×2¼, 4×5, 8×10 transparencies. Submit seasonally. Tearsheets filed but not dupes. SASE. Reports within 3 months. Pays $300/color cover; $75-150/color inside; $150/color page

(full page bleed); $50-100/b&w photo. Pays on publication. Credit line given. Buys one-time rights. Previously published work OK.

Tips: "We are continually in need of authentic color taken in the '40s, '50s and '60s and b&w stock photos. Technical quality is extremely important; focus must be sharp, no soft focus; colors must be vivid so they 'pop off the page.' Study our magazine thoroughly—we have a continuing need for vintage color and b&w images, and those who can supply what we need can expect to be regular contributors."

REPTILE & AMPHIBIAN MAGAZINE, 1168 Rt. 61 Hwy. South, Pottsville PA 17901. (717)622-6050. Fax: (717)622-5858. E-mail: eramus@csrlink.net. Website: http://petstation.com/repamp.html. Editor: Erica Ramus. Circ. 14,000. Estab. 1989. Bimonthly magazine. Specializes in reptiles and amphibians only. Readers are college-educated, interested in nature and animals, familiar with basics of herpetology, many are breeders and conservation oriented. Sample copy $5. Photo guidelines with SASE.

Needs: Uses 50 photos/issue; 80% supplied by freelance photographers. Needs photos of related subjects. Photos purchased with or without ms. Model/property releases preferred. Captions required; clearly identify species with common and/or scientific name on slide mount.

Making Contact & Terms: Send cover letter describing qualifications with representative samples. Must identify species pictured. Provide résumé, business card, brochure, flier or tearsheets to be kept on file for possible assignments. Send b&w and glossy prints; 35mm transparencies. Originals returned in 3 months. SASE. Reports in 1 month. Pays $25-50/color cover; $25/color inside; and $10/b&w inside. Pays on acceptance if needed immediately, or publication if the photo is to be filed for future use. Credit line given. Buys one-time rights. Previously published work OK.

Tips: In photographer's samples, looks for quality—eyes in-focus; action shots—animals eating, interacting, in motion. "Avoid field-guide type photos. Try to get shots with action and/or which have 'personality.'" All animals should be clearly identified with common and/or scientific name. "Request a 'want list', which describes our needs for the next few issues."

REQUEST MAGAZINE, 10408 Yellow Circle Dr., Minneapolis MN 55343. (612)931-8379. Fax: (612)931-8490. Art Director: David Yamada. Associate Art Director: David Simpson. Circ. 600,000. Estab. 1989. Monthly magazine. Emphasizes music, all types: rock, metal, rap, country, blues, world, reggae, techno/rave, blues, jazz, etc. Readers are male 54%, female 46%, median age 23.6. Free sample copy.

Needs: Uses 20-100 photos/issue; 50% supplied by freelancers. Needs music photos: color or b&w, live, studio or location. Frequent requests for archival photos. Special photo needs include more exclusive photos of well-known musicians, different styles, "arty" photos, unusual locations or processing techniques." Model release issues dealt with as they arise, no predetermined policy at this point. I.D.'s of band members, etc. required."

Making Contact & Terms: Submit portfolio for review. Query with stock photo list. Keeps samples on file. Cannot return material. Reports in 1-2 weeks or as photos are needed. Payment negotiable. Pays on publication. Buys one-time rights. Previously published work OK.

RIFLE & SHOTGUN SPORT SHOOTING, 5300 CityPlex Tower, 2448 E. 81st St., Tulsa OK 74137-4207. (918)491-6100. Fax: (918)491-9424. Executive Editor: Mark Chesnut. Circ. 100,000. Estab. 1994. Bimonthly magazine. Emphasizes shooting sports, including hunting. Readers are primarily male over 35. Sample copy $2.50. Photo guidelines free with SASE.

Needs: Uses 40-50 photos/issue; all supplied by freelancers. Needs photos of various action shots of shooting sports. Special photo needs include wildlife shots for cover; skeet, trap, sporting clays, rifle shooting and hunting shots for inside use. Model/property release preferred. Captions preferred.

Making Contact & Terms: Send unsolicited photos by mail for consideration. Send 35mm, 2¼×2¼ transparencies. Keeps samples on file. SASE. Reports in 3 weeks. Pays $400-600/color cover; $75-200/ color inside; $300-450/photo/text package. **Pays on acceptance**. Credit line given. Buys first North American serial rights.

THE ROANOKER, P.O. Box 21535, Roanoke VA 24018. (540)989-6138. Fax: (540)989-7603. Editor: Kurt Rheinheimer. Circ. 14,000. Estab. 1974. Bimonthly. Emphasizes Roanoke and western Virginia. Readers are upper income, educated people interested in their community. Sample copy $3.

Needs: Uses about 40 photos/issue; most are supplied on assignment by freelance photographers. Needs "travel and scenic photos in western Virginia; color photo essays on life in western Virginia." Model/ property releases preferred. Captions required.

Making Contact & Terms: Send any size glossy b&w or color prints and transparencies (preferred) by mail for consideration. SASE. Reports in 1 month. Pays $15-25/b&w photo; $20-35/color photo; $100/ day. Pays on publication. Credit line given. Rights purchased vary; negotiable. Simultaneous submissions and previously published work OK.

ROCK & ICE, P.O. Box 3595, Boulder CO 80307. (303)499-8410. E-mail: mail@rockandice.com. Website: http://www.rockandice.com. Photo Editor: Galen Nathanson. Circ. 50,000. Estab. 1984. Bimonthly magazine. Emphasizes rock and ice climbing and mountaineering. Readers are predominantly professional, ages 10-90. Sample copy for $6.50. Photo guidelines free with SASE.
- Photos in this publication usually are outstanding action shots. Make sure your work meets the magazine's standards. Do not limit yourself to climbing shots from the U.S.

Needs: Uses 90 photos/issue; all supplied by freelance photographers; 20% on assignment, 80% from stock. Needs photos of climbing action, personalities and scenics. Buys photos with or without ms. Captions required.

Making Contact & Terms: Query with list of stock photo subjects. Send unsolicited photos by mail for consideration. Send b&w prints; 35mm, 2¼ × 2¼ and 4 × 5 transparencies. Accepts images in digital format for Mac. Send via compact disc, online, floppy disk, SyQuest (175L). SASE. Pays $500/cover; $200/color and b&w page; $25/Website image. Pays on publication. Credit line given. Buys one-time rights and first North American serial rights. Previously published work OK.

Tips: "Samples must show some aspect of technical rock climbing, ice climbing, mountain climbing or indoor climbing, scenics of places to climb or images of people who climb or who are indigenous to the climbing area. Climbing is one of North America's fastest growing sports."

ROCKFORD REVIEW, P.O. Box 858, Rockford IL 61105. Editor: David Ross. Association publication of Rockford Writers' Guild. Triquarterly magazine. Circ. 750. Estab. 1982. Emphasizes poetry and prose of all types. Readers are of all stages and ages who share an interest in quality writing and art. Sample copy $5.
- This publication is literary in nature and publishes very few photographs. However, the photos on the cover tend to be experimental (e.g. solarized images, photograms, etc.).

Needs: Uses 1-5 photos/issue; all supplied by freelancers. Needs photos of scenics and personalities. Model/property release preferred. Captions preferred; include when and where of the photos and biography.

Making Contact & Terms: Send unsolicited photos by mail for consideration. Send 8 × 10 or 5 × 7 glossy b&w prints. Does not keep samples on file. SASE. Reports in 6 weeks. Pays in one copy of magazine, but work is eligible for *Review*'s $25 Editor's Choice prize. Pays on publication. Credit line given. Buys first North American serial rights. Simultaneous submissions OK.

Tips: "Experimental work with a literary magazine in mind will be carefully considered. Avoid the 'news' approach." Sees more opportunities for artsy photos.

ROLLER HOCKEY, 12327 Santa Monica Blvd., Suite 202, Los Angeles CA 90025. (310)442-6660. Fax: (310)442-6663. E-mail: rhm@artnet.net. Website: http://www.rhockey.com. Associate Editor: Amber Vasques. Circ. 35,000. Estab. 1992. Magazine published 9 times/year. Emphasizes roller hockey, specifically inline hockey. Readers are male and female, ages 12-45. Sample copy $2.95. Photo guidelines free with SASE.

Needs: Uses 50 photos/issue; 35 supplied by freelancers. Needs photos of roller hockey. Special photo needs include play from local and professional roller hockey leagues. Model/property release preferred for professionals in staged settings. Captions preferred; include who, what, where, when, why, how.

Making Contact & Terms: Send unsolicited photos by mail for consideration. Query with stock photo list. Submit portfolio for consideration. Reports within 1 week. Send 3 × 5, 5 × 7 glossy color b&w prints; 35mm transparencies. Accepts images in digital format for Mac (TIFF). Send via compact disc, floppy disk, SyQuest, Zip disk (300 dpi). Deadlines: 3 months prior to any season. SASE. Reports in 1 month. Pays $150-200/color cover; $30/color inside; $20/b&w inside. Pays on publication. Credit line given. Buys all rights; negotiable. Previously published work OK.

ROLLING STONE, Dept. PM, 1290 Avenue of the Americas, New York NY 10104. (212)484-1616. Photo Editor: Racheal Knepfer. Emphasizes all forms of entertainment (music, movies, politics, news events).

Making Contact & Terms: "All our photographers are freelance." Provide brochure, calling card, flier, samples and tearsheet to be kept on file for future assignments. Needs famous personalities and rock groups in b&w and color. No editorial repertoire. SASE. Reports immediately. Pays $150-350/day.

Tips: "Drop off portfolio at mail room any Wednesday between 10 am and 3 pm. Pick up Thursday between 11 am and 3 pm. Leave a card with sample of work to keep on file so we'll have it to remember."

THE ROTARIAN, 1560 Sherman Ave., Evanston IL 60201. (847)866-3000. Fax: (847)866-9732. E-mail: 75457.3577@compuserve.com. Website: http://www.rotary.org. Editor-in-Chief: Willmon L. White. Editor: Charles W. Pratt. Circ. 514,565. Estab. 1911. Monthly organization magazine for Rotarian business and professional men and women and their families. "Dedicated to business and professional ethics,

community life and international understanding and goodwill." Free sample copy and photo guidelines with SASE.

Needs: Buys 5 photos from freelancers per issue; 60 photos per year. "Our greatest needs are for the identifying face or landscape, one that says unmistakably, 'This is Japan, or Minnesota, or Brazil, or France or Sierra Leone,' or any of the other states, countries and geographic regions this magazine reaches and we need lively shots of people." Property release and captions preferred.

Making Contact & Terms: Query with résumé of credits, stock photo list, or send photos for consideration. Art director will contact photographer for portfolio review if interested. Portfolio should include color slides, tearsheets and transparencies. Uses b&w and color; 35mm, 2¼ × 2¼, 4 × 5. Deadlines: at least two months ahead of issue. Keeps samples on file. SASE. Reports in 3 weeks. **Pays on acceptance.** Payment negotiable. Buys one-time rights; occasionally all rights; negotiable. Credit line given. Simultaneous submissions and previously published work OK.

Tips: "We prefer vertical shots in most cases. The key words for the freelance photographer to keep in mind are *internationality* and *variety*. Study the magazine. Read the kinds of articles we publish. Think how your photographs could illustrate such articles in a dramatic, story-telling way. Key submissions to general interest, art-of-living material."

Ⓝ ⊕ THE ROUTER, GMC Publications Ltd., 86 High St., Lewes, E. Sussex BN7 1XN United Kingdom. Phone: (01273)477374. Fax: (012373)487692. E-mail: Routermag@aol.com. Editor: Alan Goodsell. Circ. 30,000. Estab. 1997. Bimonthly consumer magazine. Sample copy free. Art guidelines free.

Needs: "Objects made principally with a router." Reviews photos with or without a ms. Photo captions required.

Making Contact & Terms: Send query letter with samples, brochure. Provide résumé, business card, self-promotion piece or tearsheets to be kept on file for possible future assignments. To show portfolio, photographer should follow-up with call. Portfolio should include transparencies. Uses 35mm, 2¼ × 2¼ transparencies. "Payment is negotiable with editor." Pays on publication. Credit line given. Previously published work OK.

Tips: "We look for the ability to take inanimate objects in controlled lighting situations and quality on time."

RUGBY MAGAZINE, 2350 Broadway, New York NY 10024. (212)787-1160. Fax: (212)595-0934. E-mail: rugbymag@aol.com. Publisher: Ed Hagerty. Circ. 10,000. Estab. 1975. Monthly tabloid. Emphasizes rugby matches. Readers are male and female, wealthy, well-educated, ages 23-60. Sample copy $4 with $1.25 postage.

Needs: Uses 20 photos/issue most supplied by freelancers. Needs rugby action shots. Reviews photos purchased with accompanying ms only.

Making Contact & Terms: Send unsolicited photos by mail for consideration. Provide résumé, business card, brochure, flier or tearsheets to be kept on file for possible assignments. Uses 3 × 5 color and b&w prints; 2¼ × 2¼ × 2¼ transparencies. Keeps samples on file. SASE. Reports in 1-2 weeks. "We only pay when we assign a photographer. Rates are very low, but our magazine is a good place to get some exposure. Pays on publication. Credit line given. Buys one-time rights. Simultaneous submissions and previously published work OK.

RUNNER'S WORLD, 135 N. Sixth St., Emmaus PA 18098. (610)967-8917. Fax: (610)967-7725. E-mail: rwreap@aol.com. Executive Editor: Amby Burfoot. Photo Editor: Liz Reap. Circ. 435,000. Monthly magazine. Emphasizes running. Readers are median aged: 37, 65% male, median income $40,000, college-educated. Photo guidelines free with SASE.

Needs: Uses 100 photos/issue; 25% freelance, 75% assigned; features are generally assigned. Needs photos of action, features, photojournalism. Model release and captions preferred.

Making Contact & Terms: Query with samples. Accepts images in digital format for Mac. Contact photo editor before sending portfolio or submissions. Pays as follows: color—$350/full page, $250/half page, $210/quarter page, $600/full page spread. Cover shots are assigned. Pays on publication. Credit line given. Buys one-time rights. Simultaneous submissions and previously published work OK.

Tips: "Become familiar with the publication and send photos in on spec. Also send samples that can be

THE SUBJECT INDEX, located at the back of this book, lists publications, book publishers, galleries, gift and paper product companies and stock agencies according to the subject areas they seek.

kept in our source file. Show full range of expertise; lighting abilities—quality of light—whether strobe sensitivity for people—portraits, sports, etc.. Both action and studio work if applicable, should be shown." Current trend is non-traditional treatment of sports coverage and portraits. Call prior to submitting work. Be familiar with running, as well as the magazine."

RURAL HERITAGE, 281 Dean Ridge Lane, Gainesboro TN 38562-5039. (931)268-0655. E-mail: editor-@ruralheritage.com. Website: http://www.ruralheritage.com. Editor: Gail Damerow. Circ. 4,000. Estab. 1976. Bimonthly magazine in support of modern day farming and logging with draft animals. Sample copy $6 ($6.50 outside the U.S.).
Needs: "Most of the photos we purchase illustrate stories or poems. Exceptions are front cover, where we use draft animals in harness."
Making Contact & Terms: "For covers we prefer color horizontal shots, 5×7 glossy (color or 35mm slide). Interior is b&w. Accepts images in digital format for Mac (TIFF, EPS). Send via compact disc, floppy disk, SyQuest (1200 line art, 300 half tones). "Do not submit photo files via e-mail please." Please include SASE for the return of your material, and put your name and address on the back of each piece. Pays $10/photo to illustrate a story or poem; $15/photo for captioned humor; $75/front cover. Also provides 2 copies of issue in which work appears. Pays on publication.
Tips: "Animals usually look better from the side than from the front. We like to see all the animal's body parts, including hooves, ears and tail. For animals in harness, we want to see the entire implement or vehicle. We prefer action shots (plowing, harvesting hay, etc.). Look for good contrast that will print well in black and white (for interior shots); watch out for shadows across animals and people. Please include the name of any human handlers involved, the farm, the town (or county), state, and the animal's names (if any) and breeds."

RUSSIAN LIFE MAGAZINE, 89 Main St., #2, Montpelier VT 05602. (802)223-4955. (802)223-6105. E-mail: ruslife@rispubs.com. Executive Editor: Mikhail Ivanov. Estab. 1990. Monthly magazine.
Needs: Uses 25-35 photos/issue. Offers 10-15 freelance assignments annually. Needs photojournalism related to Russian culture, art and history. Model/property release preferred.
Making Contact & Terms: Works with local freelancers only. Query with samples. Send 35mm, 2¼×2¼, 4×5, 8×10 transparencies; 35mm film; Kodak CD digital format. SASE "or material not returned." Reports in 1 month. Pays $25-200 (color photo with accompanying story), depending on placement in magazine. Pays on publication. Credit line given. Buys one-time and electronic rights.

SAILING, Dept. PM, 125 E. Main St., Box 248, Port Washington WI 53074. (414)284-3494. Editor: Micca L. Hutchins. Circ. 50,000. Monthly magazine. Emphasizes sailing. Our theme is "the beauty of sail." Readers are sailors with great sailing experiences—racing and cruising. Sample copy free with 11×15 SAE and 9 first-class stamps. Photo guidelines free with SASE.
Needs: "We are a photo journal-type publication so about 50% of issue is photos." Needs photos of exciting sailing action, onboard deck shots; sailor-type boat portraits seldom used. Special needs include high-quality color—mainly good *sailing*. Captions required. "We must have area sailed, etc., identification."
Making Contact & Terms: Query with samples. Send 35mm transparencies by mail for consideration. "Request guidelines first—a big help." SASE. Reports in 1 month. Payment varies from $150 and up. Pays 30 days after publication. Credit line given. Buys one-time rights. Simultaneous submissions and previously published work OK "if not with other sailing publications who compete with us."
Tips: "We are looking for good, clean, sharp photos of sailing action—exciting shots are for us. Please request a sample copy to become familiar with format. Knowledge of the sport of sailing a requisite for good photos for us."

SAILING WORLD, 5 John Clarke Rd., Newport RI 02840. (401)847-1588. Fax: (401)848-5048. Assistant Art Director: Mike Boardman. Circ. 62,000. Estab. 1962. Monthly magazine. Emphasizes sailboat racing and performance cruising for sailors, upper income. Readers are males 35-45, females 25-35 who are interested in sailing. Sample copy $5. Photo guidelines free with SASE.
Needs: "We will send an updated photo letter listing our needs on request." Freelance photography in a given issue: 20% assignment and 80% freelance stock. Covers most sailing races.
Making Contact & Terms: Uses 35mm and 2¼×2¼ transparencies for covers. Vertical and square (slightly horizontal) formats. Reports in 1 month. Pays $500 for cover; regular color $50-300 (varies with use). Pays on publication. Credit line given. Buys first N.A. serial rights.
Tips: "We look for photos that are unusual in composition, lighting and/or color that feature performance sailing at its most exciting. We would like to emphasize speed, skill, fun and action. Photos must be of high quality. We prefer Fuji Velvia or Kodachrome 64 film. We have a format that allows us to feature

work of exceptional quality. A knowledge of sailing and experience with on-the-water photography is really a requirement. Please call with specific questions or interests. We cover current events and generally only use photos taken in the past 30-60 days."

⚙ ☄ ST. MAARTEN NIGHTS, (The Island's premiere lifestyle and travel magazine), 1831 René Leresque Blvd. W., Montreal, Quebec H3H IR4 Canada. (514)931-1987. Fax: (514)931-6273. E-mail: nights@odyssee.net. Office Coordinator: Zelly Zuskin. Circ. 225,000. Estab. 1983. Yearly tourist magazine guide of where to eat, sleep, dance etc. in St. Maarten.
Needs: Buys 30 photos/year. Needs travel photos of St. Maarten, such as beaches, water, sun etc. Reviews photos with or without ms. Model release required. Property release required for private homes. Photo captions required; include exact location.
Making Contact & Terms: Send query letter with tearsheets. Art director will contact photographer for portfolio review if interested. Uses 4×5 matte color and b&w prints; 35mm, 2¼×2¼, 4×5, 8×10 transparencies. Keeps samples on file. Reports back only if interested, send non-returnable samples. Pays $250-400 for color cover; $50 maximum for color inside. **Pays on acceptance.** Credit line given. Buys one-time rights. Simultaneous submissions and/or previously published work OK.

SALT WATER SPORTSMAN, 77 Franklin St., Boston MA 02110. (617)338-2300. Fax: (617)338-2309. Editor: Barry Gibson. Circ. 150,000. Estab. 1939. Monthly magazine. Emphasizes all phases of salt water sport fishing for the avid beginner-to-professional salt water angler. "Number-one monthly marine sport fishing magazine in the US." Sample copy free with 9×12 SAE and 7 first-class stamps. Free photo and writer's guidelines.
Needs: Buys photos (including covers) without ms; 20-30 photos/issue with ms. Needs salt water fishing photos. "Think scenery, mood, fishing action, storytelling close-ups of anglers in action. Make it come alive—and don't bother us with the obviously posed 'dead fish and stupid fisherman' back at the dock. Wants, on a regular basis, cover shots (verticals depicting salt water fishing action)." For accompanying ms needs fact/feature articles dealing with marine sportfishing in the US, Canada, Caribbean, Central and South America. Emphasis on how-to.
Making Contact & Terms: Send material by mail for consideration or query with samples. Provide résumé and tearsheets to be kept on file for possible future assignments. Holds slides for 1 year and will pay as used. Also accepts digital images on an 88mg SyQuest disk with proof of image. Uses 35mm or 2¼×2¼ transparencies; cover transparency vertical format required. SASE. Reports in 1 month. Pay included in total purchase price with ms, or pays $50-400/color photo; $1,000 minimum/cover; $250-up/text-photo package. **Pays on acceptance.**
Tips: "Prefers to see a selection of fishing action and mood; must be sport fishing oriented. Read the magazine! Example: no horizontal cover slides with suggestions it can be cropped, etc. Don't send Ektach-rome. We're using more 'outside' photography—that is, photos not submitted with ms package. Take lots of verticals and experiment with lighting. Most shots we get are too dark."

SANDLAPPER MAGAZINE, P.O. Box 1108, Lexington SC 29071. (803)359-9941. Fax: (803)359-0629. Managing Editor: Dan Harmon. Estab. 1989. Quarterly magazine. Emphasizes South Carolina topics.
Needs: Uses about 5 photographers/issue. Needs photos of South Carolina subjects. Model release preferred. Captions required; include places and people.
Making Contact & Terms: Query with samples. Send 8×10 color and b&w prints; 35mm, 2¼×2¼, 4×5, 8×10 transparencies. Keeps samples on file. SASE. Reports in 1 month. Pays $25-100/color inside; $25-75/b&w inside. Pays on publication. Credit line given. Buys first rights plus right to reprint.
Tips: Looking for any South Carolina topic—scenics, people, action, mood, etc.

⚙ SAY AMEN MAGAZINE, Word Communications, P.O. Box 360658, Lithonia GA 30036-0658. Website: http://www.sayamen.com. Editor-in-Chief: Vikki Conwell. Circ. 50,000. Estab. 1995. Quarterly national Christian magazine targeted to the African-American market. Sample copy free. Art guidelines free.
Needs: Needs various action photos of people in prayer, working in a ministry, performing daily tasks, etc. Reviews photos with or without ms. Model release preferred for any shots with identifiable faces of subjects. Property release preferred. Photo caption preferred; include subject and location.
Making Contact & Terms: Send query letter with samples, stock photo list. Provide résumé, business card, self-promotion piece or tearsheets to be kept on file for possible future assignments. Keeps samples on file; include SASE for return of material. Reports in 3 weeks on queries; 3 weeks on samples. Reports back only if interested, send non-returnable samples. Pays $150-200 for b&w cover; $400-500 for color cover; $50-70 for b&w inside; $55-75 for color inside. Pays on publication. Credit line not given. Previously published work OK.

Tips: "*Say Amen* is a national magazine which dialogues through informative content. We are not a gospel music magazine. We welcome and invite photographers to look at our magazine and see where their talents may best be utilized. Please be thorough in your fee requirement and your turnaround time."

SCHOLASTIC MAGAZINES, 555 Broadway, New York NY 10012. (212)343-6100. Fax: (212)343-6185. Senior Picture Editor: Moya McAllister. Estab. 1920. Publication of magazine varies from weekly to monthly. "We publish 22 titles per year on topics from current events, science, math, fine art, literature and social studies. Interested in featuring high-quality well-composed images of students of all ages and all ethnic backgrounds." Sample copy free with 9×12 SAE with 3 first-class stamps.
Needs: Uses 15 photos/issue. Needs photos of various subjects depending upon educational topics planned for academic year. Model release preferred. Captions required. Images must be interesting, bright and lively!
Making Contact & Terms: Query with résumé, business card, brochure, flier or tearsheets to be kept on file for possible assignments. Accepts digital images for Mac (compact disc, online, SyQuest). Material cannot be returned. Pays $400/color cover; $100/b&w inside (¼ page); $125/color inside (¼ page). Pays 25% additional for electronic usage. Pays on publication. Buys one-time rights. Previously published work OK.

SCHOOL MATES, 3054 NYS Rt. 9W, New Windsor NY 12553. (914)562-8350, ext. 152. Fax: (914)561-2437. E-mail: schoolmate-uscf@juno.com. Website: http://www.uschess.org. Publication Director: Jay Hastings. Publication of the US Chess Federation. Bimonthly magazine. Emphasizes chess. Readers are male/female, ages 7-15. Sample copy free with 9×12 SAE and 2 first-class stamps.
Needs: Buys 5-30 photos/issue; most supplied by freelancers. Needs photos of children playing chess. Photo captions preferred.
Making Contact & Terms: Send unsolicited photos by mail for consideration. Provide résumé, business card, brochure, flier or tearsheets to be kept on file for possible future assignments. Send color or b&w prints. Accepts images in digital format for Windows. Send via compact disc, Zip disk or floppy disk at 600 dpi. Keeps samples on file. Send xerox samples of kids and chess. SASE. Reports in 1 month. Pays $15 minimum for b&w or color inside photo. Pays $100-150/color cover. Pays on publication. Credit line given. Rights negotiable.

SCIENCE AND CHILDREN, 1840 Wilson Blvd., Arlington VA 22201-3000. (703)243-7100. Associate Editor: Katherine Roberts. Circ. 24,000. Publication of the National Science Teachers Association. Monthly (September to May) journal. Emphasizes teaching science to elementary school children. Readers are male and female elementary science teachers and other education professionals.
Needs: Uses 10 photos/issue; 1-2 supplied by freelancers. Needs photos of "a variety of science-related topics, though seasonals, nature scenes and animals are often published. Also children." Special photo needs include children doing science in all settings, especially classroom and science fairs. Model/property release required. Captions required.
Making Contact & Terms: Arrange personal interview to show portfolio. Send stock lists and photocopies of b&w or color prints. Unsolicited material will not be returned. Pays $200/color cover; $75/color inside; $50 b&w inside. Pays on publication. Credit line given.
Tips: "We look for candid shots that are sharp in focus and show the excitement of science discovery. We also want photographs that reflect the fact that science is accessible to people of every race, gender, economic background and ability."

SCIENCE SCOPE, 1840 Wilson Blvd., Arlington VA 22201. (703)243-7100. Fax: (703)243-7177. E-mail: sciencescope@nsta.org. Website: http://www.nsta.org/pubs/scope. Assistant Editor: Vicki Moll. Publication of the National Science Teachers Association. Journal published 8 times/year during the school year. Emphasizes activity-oriented ideas—ideas that teachers can take directly from articles. Readers are mostly middle school science teachers. Single copy $6.25. Photo guidelines free with SASE.
Needs: Uses cover shots, about half supplied by freelancers. Needs photos of mostly classroom shots with students participating in an activity. "In some cases, say for interdisciplinary studies articles, we'll need a specialized photo." Need for photo captions "depends on the type of photo."
Making Contact & Terms: Arrange personal interview to show portfolio. Query with stock photo list. Provide résumé, business card, brochure, flier or tearsheets to be kept on file for possible assignments. Keeps samples on file. SASE. Accepts images in digital format for Windows. Send via SyQuest, Zip disk or online. Pays $200 for cover photos and $50 for small b&w photos. Pays on publication. Sometimes pays kill fee. Credit line given. Buys one-time rights; negotiable. Considers previously published work; "prefer not to, although in some cases there are exceptions."
Tips: "We look for clear, crisp photos of middle level students working in the classroom. Shots should

be candid with students genuinely interested in their activity. (The activity is chosen to accompany manuscript.) Please send photocopies of sample shots along with listing of preferred subjects and/or listing of stock photo topics."

SCIENTIFIC AMERICAN, 415 Madison Ave., New York NY 10017. (212)754-1462. Fax: (212)755-1976. E-mail: bgerety@sciam.com. Photography Editor: Bridget Gerety. Circ. 600,000. Estab. 1854. Emphasizes science technology and people involved in science. Readers are mostly male, 15-55.
Needs: Uses 100 photos/issue; all supplied by freelancers. Needs photos of science and technology, personalities, photojournalism and how-to shots; especially "amazing science photos." Model release required. Property release preferred. Captions required.
Making Contact & Terms: Arrange personal interview to show portfolio. "Do not send unsolicited photos." Provide résumé, business card, brochure, flier or tearsheets to be kept on file for possible assignments. Keeps samples on file. Cannot return material. Reports in 1 month. Pays $350/day; $1,000/color cover. Pays on publication. Credit line given. Buys one-time and electronic rights; negotiable.
Tips: Wants to see strong natural and artificial lighting, location portraits and location shooting. "Send business cards and promotional pieces frequently when dealing with magazine editors. Find a niche."

SCORE, Canada's Golf Magazine, 287 MacPherson Ave., Toronto, Ontario M4V 1A4 Canada. (416)928-2909. Fax: (416)928-1357. Editor: Bob Weeks. Circ. 160,000. Estab. 1980. Magazine published 6 times/year. Emphasizes golf. "The foundation of the magazine is Canadian golf and golfers." Readers are affluent, well-educated, 80% male, 20% female. Sample copy $2 (Canadian). Photo guidelines free with SAE with IRC.
Needs: Uses between 30 and 40 photos/issue; approximately 95% supplied by freelance photographers. Needs "professional-quality, golf-oriented color and b&w material on prominent Canadian male and female pro golfers on the US PGA and LPGA tours, as well as the European and other international circuits, scenics, travel, close-ups and full-figure." Model releases (if necessary) required. Captions required.
Making Contact & Terms: Query with samples and with list of stock photo subjects. Send 8×10 or 5×7 glossy b&w prints and 35mm or 2¼×2¼ transparencies by mail for consideration. Provide résumé, business card, brochure, flier or tearsheets to be kept on file for possible future assignments. SASE with IRC. Reports in 3 weeks. Pays $75-100/color cover; $30/b&w inside; $50/color inside; $40-65/hour; $320-520/day; and $80-2,000/job. **Pays on acceptance.** Credit line given. Buys all rights. Simultaneous submissions OK.
Tips: "When approaching *Score* with visual material, it is best to illustrate photographic versatility with a variety of lenses, exposures, subjects and light conditions. Golf is not a high-speed sport, but invariably presents a spectrum of location puzzles: rapidly changing light conditions, weather, positioning, etc. Capabilities should be demonstrated in query photos. Scenic material follows the same rule. Specific golf hole shots are certainly encouraged for travel features, but wide-angle shots are just as important, to 'place' the golf hole or course, especially if it is located close to notable landmarks or particularly stunning scenery. Approaching *Score* is best done with a clear, concise presentation. A picture is absolutely worth a thousand words, and knowing your market and your particular strengths will prevent a mutual waste of time and effort. Sample copies of the magazine are available and any photographer seeking to work with *Score* is encouraged to investigate it prior to querying."

SCORE, 4931 SW 75th Ave., Miami FL 33155. (305)662-5959. Fax: (305)662-5952. E-mail: score@score group.com. Editor: John Fox. Circ. 150,000. Estab. 1992. Monthly magazine. Emphasizes large-busted models. Readers are males between 18-50 years of age.
Needs: Uses 150 photos/issue; 100% supplied by freelancers. Model release required for photo identification (such as a driver's license) is also required and/or copy of model's birth certificate.
Making Contact & Terms: Query with stock photo list. Send unsolicited photos by mail for consideration. Photo submissions should consist of a minimum of 100 transparencies of one model. Send 35mm transparencies. SASE. Reports in 3 weeks. Pays $150/color page rate; photo sets of individual models—$1,250-1,800. Pays on publication. Credit line given (if requested). Buys one-time rights; negotiable.
Tips: "Study samples of our publication. We place a premium on—and pay a premium for—new discoveries and exclusives."

SCOUTING MAGAZINE, Boy Scouts of America Magazine Division, 1325 W. Walnut Hill Lane, Irving TX 75038. (972)580-2358. Fax: (972)580-2079. Contact: Photo Editor. Circ. 1 million. Published 6 times a year. Magazine for adults within the Scouting movement.
• Boy Scouts of America Magazine Division also publishes *Boys' Life* and *Exploring* magazines.
Needs: Assigns 90% of photos; uses 10% from stock. Needs photos dealing with success and/or personal interest of leaders in Scouting. Captions required.

Making Contact & Terms: Query with ideas. SASE. Pays $400 base editorial day rate against placement fees. **Pays on acceptance.** Buys one-time rights.
Tips: Study the magazine carefully.

SCRAP, 1325 G St. NW, Suite 1000, Washington DC 20005. (202)737-1770. Fax: (202)626-0900. E-mail: KentKiser@compuserve.com. Website: http://www.scrap.org. Editor: Kent Kiser. Circ. 7,000. Estab. 1988. Publication of the Institute of Scrap Recycling Industries. Bimonthly magazine. Covers scrap recycling for owners and managers of recycling operations worldwide. Sample copy $7.50.
Needs: Uses approximately 100 photos/issue; 15% supplied by freelancers. Needs operation shots of companies being profiled and studio concept shots. Model release required. Captions required.
Making Contact & Terms: Arrange personal interview to show portfolio. Query with list of stock photo subjects. Accepts images in digital format for Windows. Send via online, floppy disk or SyQuest (270 dpi). Provide résumé, business card, brochure, flier or tearsheets to be kept on file for possible assignment. Reports in 1 month. Pays $600-1,000/day. Pays on publication. Credit line given. Rights negotiable. Previously published work OK.
Tips: Photographers must possess "ability to photograph people in corporate atmosphere, as well as industrial operations; ability to work well with executives, as well as laborers. We are always looking for good color photographers to accompany our staff writers on visits to companies being profiled. We try to keep travel costs to a minimum by hiring photographers located in the general vicinity of the profiled company. Other photography (primarily studio work) is usually assigned through freelance art director."

[N] [⊕] SCUBAWORLD, Freestyle Publications, Alexander House, Ling Rd., Tower Park, Poole BH12 QNZ England. Phone: 01202-735090. Fax: 01202-733969. E-mail: rchumbley@freepubs.co.uk. Circ. 22,000. Estab. 1995. Monthly magazine about diving. Art guidelines free.
Needs: Buys 15 photos/year. Needs photos for eye catching front covers i.e. marine life, diving and adventure. Reviews photos with or without a manuscript. Photo captions preferred.
Making Contact & Terms: Send query letter with samples. Portfolio should include slides. Will return unsolicited material with SASE. Pays on publication. Buys first rights.
Tips: "Primarily aim for front covers."

SEA KAYAKER, P.O. Box 17170, Seattle WA 98107. (206)789-1326. Fax: (206)781-1141. E-mail: mail@seakayakermag.com. Website: http://www.seakayakermag.com. Editor: Christopher Cunningham. Circ. 25,000. Estab. 1984. Bimonthly magazine. Emphasizes sea kayaking—kayak cruising on coastal and inland waterways. Sample copy $5.75. Photo guidelines free with SASE.
Needs: Uses 50 photos/issue; 85% supplied by freelancers. Needs photos of sea kayaking locations, coastal camping and paddling techniques. Reviews photos with or without ms. Always looking for cover images (some to be translated into paintings, etc.). Model/property release preferred. Captions preferred.
Making Contact & Terms: Submit portfolio for review. Send unsolicited photos by mail for consideration. Send 5×7 color and b&w prints; 35mm transparencies. Keeps samples on file. SASE. Reports in 1 month. Pays $250/color cover; $25-100/color inside; $15-75/b&w inside. Pays on publication. Credit line given. Buys one-time rights, first North American serial rights.
Tips: Subjects "must relate to sea kayaking and cruising locations. Send dupe slides."

[N] SEC ATHLETE, 3101 Poplarwood Court, Suite 113, Raleigh NC 27604. (919)954-7500. Fax: (919)954-8600. Director of Photography: Bob Donnan. Circ. 100,000. Estab. 1997. Monthly sports magazines for fans of college sports. Sample copy for $5.
Needs: Buys 40 photos from freelancers/issue. Needs photos of sports action and personalities. Photo captions required.
Making Contact & Terms: Provide résumé, business card, self-promotion piece or tearsheets to be kept on file for possible future assignments. Art director will contact photographer for portfolio review if interested. Keeps samples on file. Reports back only if interested, send non-returnable samples. Pays $50-200 for b&w inside; $75-500 for color inside. **Pays on acceptance.** Credit line given. Buys one-time or electronic rights. Previously published work OK.
Tips: "We work with a broad range of photographers who have passion and insight into their sports. We look for dynamic sports action and strong personal pictures of coaches and athletes."

SECURE RETIREMENT, 10 G St NE, Washington DC 20002. (202)216-0420. Fax: (202)216-0451. E-mail: secure_retirement@ncpssm.org. Editor: Denise Fremeau. Circ. 2 million. Estab. 1992. Publication of the National Committee to Preserve Social Security and Medicare. Magazine published 6 times yearly. Emphasizes aging and senior citizen issues. Readers are male and female retirees/non-retirees, ages 50-80. Sample copy free with 9×12 SASE.
 • *Secure Retirement* now buys all its photos from freelancers.

Needs: Uses 20-25 photos/issue; all supplied by freelancers. Needs photos of generic, healthy lifestyle seniors, intergenerational families. Model release required. Captions preferred.
Making Contact & Terms: Arrange personal interview to show portfolio. Provide résumé, business card, brochure, flier or tearsheets to be kept on file for possible assignments. "Do not send unsolicited 35mm or 4×5 slides; color or b&w prints OK. SASE. Pays $100-500/day; $100-500/color and b&w inside. Pays on publication. Credit line given. Simultaneous submissions and/or previously published work OK.
Tips: "We are interested in hiring freelancers to cover events for us across the nation (approximately 3-7 events/month)."

N: SEEK, Standard Publishing, 8121 Hamilton Ave., Cincinnati OH 45231-2396. (513)931-4050, ext. 365. Fax: (513)931-0950. Editor: Eileen Wilmoth. Circ. 45,000. Estab. 1970. Weekly consumer magazine. "Colorful, illustrated weekly take-home or pass-along paper designed to appeal to modern adults/older teens. Its use ranges from the classroom of the Sunday morning Bible class to group discussion and light inspirational reading for individuals and the family."
Needs: Buys 1-2 photos from freelancers/issue; 50-75 photos/year. Reviews photos with or without a ms. Model release required; property release required for private homes.
Making Contact & Terms: Send query letter with samples. Uses color and b&w prints. Does not keep samples on file. Reports back only if interested, send non-returnable samples. Pays $60/b&w cover; $50/b&w inside. **Pays on acceptance**. Credit line given. Buys one-time rights. Simultaneous submissions and previously published work OK.

N: ⊕ SELECT MAGAZINE, Emap Metro, Emap Place, Mappin House, 4 Winsley St., 1st Floor, W1N 7AR England. Fax: (0181)312 8250. Circ. 110,000. Estab. 1992. Monthly magazine emphasizing music and lifestyle.
Needs: Needs photos of themes and personalities. Special photo needs include gossip. Photo captions required.
Making Contact & Terms: Send query letter with samples, brochure. Portfolios may be dropped off every Thursday. Portfolio should include color prints, tearsheets. Uses color prints. Reports back only if interested, send non-returnable samples. Will return material with SASE. Pays £125/half day; £250/full day. Pays on publication. Simultaneous submissions OK.
Tips: "Read the magazine, know my name and understand our style of photography. Always shoot in color and understand the gutter has got to go somewhere."

SENTIMENTAL SOJOURN, 11702 Webercrest, Houston TX 77048. (713)733-0338. Editor: Charlie Mainze. Circ. 1,000. Estab. 1993. Annual magazine. Sample copy $12.50.
Needs: Uses photos on almost every page. Needs sensual images evocative of the sentimental, usually including at least one human being, suitable for matching with sentimental poetry. "Delicate, refined, romantic, nostalgic, emotional idealism—can be erotic, but must be suitable for a general readership." Model/property release required for any model.
Making Contact & Terms: Send unsolicited photos by mail for consideration. Provide résumé, business card, brochure, flier or tearsheets to be kept on file for possible assignments. Send color and b&w prints; 35mm, 2¼×2¼, 4×5 transparencies. Keeps samples on file. SASE, but generally keep for a few years. Reports when need for work arises, could be 2 years. Pays $50-200/color cover; $50-200/b&w cover; $10-100/color inside; $10-100/b&w inside; also pays a percentage of page if less than full page. Credit line given. Buys one-time rights, first North American serial rights. Previously published work OK.
Tips: "Symbols of the dead and dying had better be incomparably delicate. Send a celebration of emotions."

SEVENTEEN MAGAZINE, 850 Third Ave., 9th Floor, New York NY 10022. (212)407-9700. *Seventeen* is a young women's first fashion and beauty magazine. Tailored to young women in their teens and early 20s, *Seventeen* covers fashion, beauty, health, fitness, food, cars, college, careers, talent, entertainment, fiction, plus crucial personal and global issues. Photos usually by assignment only. This magazine did not repond to our request for information. Query before submitting.

SHOWBOATS INTERNATIONAL, 1600 SE 17th St., Suite 200, Ft. Lauderdale FL 33316. (954)525-8626. Fax: (954)525-7954. E-mail: showboats@aol.com. Executive Editor: Marilyn Mower. Circ. 60,000.

CONTACT THE EDITOR, of *Photographer's Market* by e-mail at photomarket@fwpubs.com with your questions and comments.

Estab. 1981. Bimonthly magazine. Emphasizes exclusively large yachts (100 feet or over). Readers are mostly male, 40 plus years of age, incomes above $1 million, international. Sample copy $5.
 • This publication has received 20 Florida Magazine Association Awards plus two Ozzies since 1989.
Needs: Uses 90-150 photos/issue; 80-90% supplied by freelancers. Needs photos of very large yachts and exotic destinations. "Almost all shots are commissioned by us." Model/property releases required. Color photography only. Captions preferred.
Making Contact & Terms: Arrange personal interview to show portfolio. Submit portfolio for review. Query with résumé of credits. Provide résumé, business card, brochure, flier or tearsheets to be kept on file for possible assignments. Accepts images in digital format for Mac. Send via compact disc, SyQuest, Zip disk (high resolution). Does not keep samples on file. SASE. Reports in 3 weeks. Pays $500/color cover; $100-375/color page rate; $550-850/day. Pays on publication. Credit line given. Buys first serial rights, all rights; negotiable. Previously published work OK, however, exclusivity is important.
Tips: Looking for excellent control of lighting; extreme depth of focus; well-saturated transparencies. Prefer to work with photographers who can supply both exteriors and beautiful, architectural quality interiors. "Don't send pictures that need any excuses. The larger the format, the better. Send samples. Exotic location shots should include yachts."

SIGNPOST FOR NORTHWEST TRAILS MAGAZINE, Dept. PM, 1305 Fourth Ave., #512, Seattle WA 98101. (206)625-1367. E-mail: dnelson024@aol.com. Editor: Dan Nelson. Circ. 3,800. Estab. 1966. Publication of the Washington Trails Association. Monthly. Emphasizes "backpacking, hiking, cross-country skiing, all nonmotorized trail use, outdoor equipment and minimum-impact camping techniques." Readers are "people active in outdoor activities, primarily backpacking; residents of the Pacific Northwest, mostly Washington; age group: 9-90, family-oriented, interested in wilderness preservation, trail maintenance." Photo guidelines free with SASE.
Needs: Uses about 20-25 photos/issue; 50% supplied by freelancers. Needs "wilderness/scenic; people involved in hiking, backpacking, canoeing, skiing, wildlife, outdoor equipment photos, all with Pacific Northwest emphasis." Captions required.
Making Contact & Terms: Send 5×7 or 8×10 glossy b&w prints by mail for consideration. SASE. Reports in 1 month. No payment for inside photos. Pays $25/b&w cover photo. Pays on publication. Credit line given. Buys one-time rights. Simultaneous submissions and previously published work OK.
Tips: "We are a b&w publication and prefer using b&w originals for the best reproduction. Photos must have a Pacific Northwest slant. Photos that meet our cover specifications are always of interest to us. Familiarity with our magazine would greatly aid the photographer in submitting material to us. Contributing to *Signpost* won't help pay your bills, but sharing your photos with other backpackers and skiers has its own rewards."

N SINGLES LIFESTYLE & ENTERTAINMENT MAGAZINE, 7611 S. Orange Blossom Trail, #190, Orlando FL 32809. Publisher: Michael Orlando. Circ. 25,000. Estab. 1997. Bimonthly tabloid magazine for Central Florida and Orlando area single, divorced and widowed persons, 21-65 years old. Heavy emphasis on area entertainment, club and social scene, with many articles and features on computers, personal finance, single life, dating, etc. Sample copy free. Art guidelines free.
Needs: Buys 5-10 photos from freelancers/issue; 125-250 photos/year. Needs photos of couples in a dating theme, celebrities, etc. "Please requst our guidelines for more details." Reviews photos with or without ms. Special photo needs include seasonal photo theme needs for our cover. "All photos need model release except candid celebrity photo where celebrity is at a public access event. We do not accept photos from papperazzi."
Making Contact & Terms: Send query letter with samples, stock photo list. Provide résumé, business card, self-promotion piece or tearsheets to be kept on file for possible future assignments. To show portfolio, photographer should follow-up with letter after initial query. Uses 5×7, 8×10 color and b&w prints. Deadlines: 30 days prior to publishing. Keeps samples on file. Reports in a month. Pays $75-100 for color cover; $25-50 for b&w inside; $50-75 for color inside. Pays on publication. Credit line given. Buys one-time rights. Previously pubished work OK.
Tips: "Please request sample issue with guidelines to really see our needs. We use photos for article enhancement as well as photos to be placed in advertisements. For consideration, send one to two recent samples of work—pubished or unpublished. Photos only returned with SASE. All samples must have return name, address etc. on back of print. Send prints only, no slides, etc."

N SINISTER WISDOM, P.O. Box 3252, Berkeley CA 94703. Contact: Editor. Circ. 3,000. Estab. 1976. Published 3 times/year. Emphasizes lesbian/feminist themes. Readers are lesbians/women, ages 20-90. Sample copy $6.50. Photo guidelines free with SASE.

Needs: Uses 3-6 photos/issue. Needs photos relevant to specific theme, by lesbians only. Reviews photos with or without a ms. Model/property release required. Captions preferred.
Making Contact & Terms: Send unsolicited photos by mail for consideration. Provide résumé, business card, brochure, flier or tearsheets to be kept on file for possible assignments. Send all sizes or finishes. Reports in 2-9 months. Accepts images in digital format for Mac. Send via Zip disk or floppy disk. Pays in copies on publication. Credit line given. Buys one-time rights; negotiable.
Tips: "Read at least one issue of *Sinister Wisdom*."

SKATING, 20 First St., Colorado Springs CO 80906-3697. (719)635-5200. Fax: (719)635-9548. E-mail: skatemag@aol.com. Editor: Jay Miller. Circ. 45,000. Estab. 1923. Publication of The United States Figure Skating Association. Magazine published 10 times/year. Emphasizes competitive figure skating. Readers are primarily active skaters coaches and officials and girls who spend up to 15 hours a week skating. Sample copy $3.
Needs: Uses 25 photos/issue; 90% supplied by freelancers. Needs sports action shots of national and world-class figure skaters; also casual, off-ice shots of skating personalities. Model/property release required. Captions preferred; include who, what, when where. Send unsolicited photos by mail for consideration. Send 3½×5, 4×6, 5×7 glossy color prints; 35mm transparencies. Accepts images in digital format for Mac. Deadlines: 15th of every month. Keeps samples on file. Cannot return material. Reports in 2 weeks. Pays $50/color cover photo; $35/color inside photo; $15/b&w inside photo. Pays on publication. Credit line given. Buys one-time rights; negotiable.
Tips: "We look for a mix of full-body action shots of skaters in dramatic skating poses and tight, close-up or detail shots that reveal the intensity of being a competitor. Shooting in ice arenas can be tricky. Flash units are prohibited during skating competitions, therefore, photographers need fast, zoom lenses that will provide the proper exposure, as well as stop the action."

SKI CANADA, 117 Indian Rd., Toronto, Ontario M6R 2V5 Canada. (416)538-2293. Fax: (416)538-2475. E-mail: mac@skicanadamag.com. Editor: Iain MacMillan. Monthly magazine published 6 times/year, September through February. Readership is 65% male, ages 25-44, with high income. Circ. 55,000. Sample copy free with SASE.
Needs: Uses 40 photos/issue; 100% supplied by freelance photographers. Needs photos of skiing—travel (within Canada and abroad), competition, equipment, instruction, news and trends. Model release not required; photo captions preferred.
Making Contact & Terms: Send unsolicited photos by mail for consideration. Provide résumé, business card, brochure, flier or tearsheets to be kept on file for possible assignments. Send color and 35mm transparencies. SASE. Reports in 1 month. Pays $100/photo/page; cover $350; rates are for b&w or color. Pays within 30 days of publication. Credit line given. Simultaneous submissions OK.
Tips: "Please request in writing (or by fax), an editorial lineup, available in late fall for the following year's publishing schedule. Areas covered: travel, equipment, instruction, competition, fashion and general skiing stories and news."

SKIPPING STONES: A Multicultural Children's Magazine, P.O. Box 3939, Eugene OR 97403. (541)342-4956. E-mail: skipping@efn.org. Website: http://www.nonviolence.org/skipping. Managing Editor: Arun N. Toké. Circ. 3,000. Estab. 1988. Nonprofit, noncommercial magazine published 5 times/year. Emphasizes multicultural and ecological issues. Readers are youth ages 8-16, their parents and teachers, schools and libraries. Sample copy $6 (including postage). Photo guidelines free with SASE.
Needs: Uses 25-40 photos/issue; most supplied by freelancers. Needs photos of animals, wildlife, children 8-16, cultural celebrations, international, travel, school/home life in other countries or cultures. Model release preferred. Captions preferred; include site, year, names of people in photo.
Making Contact & Terms: Send unsolicited photos by mail for consideration. Send 4×6, 5×7 glossy color or b&w prints. Keeps samples on file. SASE. Reports in 2 months. Pays contributor's copy; "we're a labor of love." For photo essays; "we provide 5 copies to contributors. Additional copies at a 25% discount. Sometimes, a small honorarium for photography. Credit line given. Buys one-time and first North American serial rights; negotiable. Simultaneous submission OK. Offers internships during the summer and fall. Contact Executive Editor: Arun Toké.
Tips: "We publish b&w inside; color on cover. Should you send color photos, choose the ones with good contrast which can translate well into b&w photos. We are seeking meaningful, humanistic and realistic photographs."

SKYDIVING, 1725 N. Lexington Ave., DeLand FL 32724. (904)736-4793. Fax: (904)736-9786. Editor: Sue Clifton. Circ. 14,200. Estab. 1979. Monthly magazine. Readers are "sport parachutists worldwide, dealers and equipment manufacturers." Sample copy $3. Photo guidelines for SASE.

Needs: Uses 50 photos/issue; 5 supplied by freelancers. Selects photos from wire service, photographers who are skydivers and freelancers. Interested in anything related to skydiving—news or any dramatic illustration of an aspect of parachuting. Model release preferred. Captions preferred; include who, what, why, when, how.
Making Contact & Terms: Send actual 5×7 or larger b&w or color photos or 35mm or 2¼×2¼ transparencies by mail for consideration. Keeps samples on file. SASE. Reports in 1 month. Pays $50-100/color cover; $25-50/color inside; $15-50/b&w inside. Pays on publication. Credit line given. Buys one-time rights.

SMITHSONIAN, Arts & Industrial Building, 900 Jefferson Dr., Washington DC 20560. (212)490-2510. Fax: (212)986-4259. *Smithsonian* magazine chronicles the arts, the environment, sciences and popular culture of the times for today's well-rounded individuals with diverse, general interests, providing its readers with information and knowledge in an entertaining way. This magazine did not respond to our request for information. Query before submitting.

SNOW COUNTRY MAGAZINE, 5520 Park Ave., Trumbull CT 06611. (203)373-7296 Fax: (203)373-7111. E-mail: smcneill@snowcountry.com. Photo Editor: Sharon McNeill. Circ. 465,000. Estab. 1988. Magazine published 8 times/year. Emphasizes skiing, mountain sports and living. Readers are 70% male, 39 years old, professional/managerial with average household income of $90,000.
Needs: Uses 90 photos/issue; 95% supplied by freelancers. Needs photos of downhill skiing, cross-country skiing, telemark skiing, snowboarding, mountain biking, in-line skating, hiking, scenic drives, ski area resorts, ice/rock climbing, people profiles, Heli skiing, snowcat skiing, rafting, camping. Special photo needs include good ski area resort shots showing family interaction, scenic drives going into white-capped mountains. Also b&w and color photos to be used as a photo essay feature in each issue. The photos should have a theme and relate to the mountains. Model/property release preferred. Captions preferred.
Making Contact & Terms: Provide brochure, flier or tearsheets to be kept on file for possible assignments. Also accepts digital images on CD. Keeps samples on file. SASE. Reports in 1 month. Pays $250/½ day; $400/day; $800/color cover; $100-400/color space rate. Pays on publication. Buys first North American serial rights; negotiable. Simultaneous submissions and/or previously published work OK.
Tips: "Looking for unique shots that put our readers in snow country, a place in the mountains. We want sophisticated photography that illustrates a sense of place, great adventure and mountain life and culture."

SOARING, Box E, Hobbs NM 88241-7504. (505)392-1177. Fax: (505)392-8154. E-mail: 74521.116@compuserve.com. Website: http://www.ssa.org. Art Director: Jon McKinley. Circ. 16,010. Estab. 1937. Monthly magazine. Emphasizes the sport of soaring in sailplanes and motorgliders. Readership consists of white collar and professional males and females, ages 14 and up. Sample copy and photo guidelines free with SASE.
Needs: Uses 25 or more photos/issue; 95% supplied by freelancers. "We hold freelance work for a period of usually six months, then it is returned. If we have to keep work longer, we notify the photographer. The photographer is always updated on the status of his or her material." Needs sharply focused transparencies, any format. Especially needs aerial photography. "We need a good supply of sailplane transparencies for our yearly calendar." Model release preferred. Captions required.
Making Contact & Terms: Send unsolicited photos by mail for consideration. Uses b&w prints, any size and format. Also uses transparencies, any format. SASE. Accepts images in digital format for Mac. Send hi res images only via compact or Zip disk. Reports in 2 weeks. Pays $50/color cover. Pays $50-100 for calendar photos. Pays on publication. Credit line given. Buys one-time rights. Simultaneous submissions OK.
Tips: "Exciting air-to-air photos, creative angles and techniques are encouraged. We pay only for the front cover of our magazine and photos used in our calendars. We are a perfect market for photographers who have sailplane photos of excellent quality. Send work dealing with sailplanes only and label all material. A simple note, picture and address will get things rolling."

SOARING SPIRIT, P.O. Box 38, Malibu CA 90265. Editor: Dick Sutphen. Art Director: Jason D. McKean. Circ. 120,000. Estab. 1976. Quarterly magazine. Emphasizes metaphysical, psychic development, reincarnation, self-help with tapes. Everyone receiving the magazine has attended a Sutphen Seminar or purchased Valley of the Sun Publishing books or tapes from a line of over 300 titles: video and audio tapes, subliminal/hypnosis/meditation/New Age music/seminars on tape, etc. Sample copy free with 9×12 SAE and 5 first-class stamps.
Needs: "We purchase about 20 photos per year for the magazine and also for cassette album covers, videos and CDs. We are especially interested in surrealistic photography which would be used as covers,

to illustrate stories and for New Age music cassettes. Even seminar ads often use photos that we purchase from freelancers." Model release required.

Making Contact & Terms: Send b&w and color prints; 35mm transparencies by mail for consideration. SASE. Reports in 2 weeks. Pays $100/color photo; $50/b&w photo. Pays on publication. Credit line given if desired. Buys one-time rights; negotiable. Simultaneous submissions and previously published work OK.

SOCIETY, Rutgers University, New Brunswick NJ 08903. (732)445-2280. Fax: (732)445-3138. E-mail: ihorowit@gardalf. Website: http://www.transactionpub.com. Editor: Irving Louis Horowitz. Circ. 31,000. Estab. 1962. Bimonthly magazine. Readers are interested in the understanding and use of the social sciences and new ideas and research findings from sociology, psychology, political science, anthropology and economics. Free sample copy and photo guidelines.

Needs: Buys 75-100 photos/annually. Human interest, photo essay and documentary. Needs photo essays—"no random photo submissions." Essays (brief) should stress human interaction; photos should be of people interacting (not a single person) or of natural surroundings. Include an accompanying explanation of photographer's "aesthetic vision."

Making Contact & Terms: Send 8 × 10 b&w glossy prints for consideration. SASE. Reports in 3 months. Pays $200-250/photo essay. Pays on publication. Buys all rights to one-time usage.

SPARE TIME MAGAZINE, 5810 W. Oklahoma Ave., Milwaukee WI 53219. (414)543-8110. Fax: (414)543-9767. Editor: Peter Abbott. Circ. 301,500. Estab. 1955. Published 11 times yearly (monthly except July). Emphasizes income-making opportunities. Readers are income opportunity seekers with small capitalization. People who want to learn new techniques to earn extra income. Sample copy $2.50.

• *Spare Time Magazine* has increased its publication from 9 to 11 issues.

Needs: Uses one photo/issue. Needs photos that display money-making opportunities. Model/property release required.

Making Contact & Terms: Send unsolicited photos by mail for consideration. Send color or b&w prints; 2¼ × 2¼ transparencies. Keeps samples on file. Contacts photographer if photo accepted. Pays $15-50/color or b&w photo. Pays on publication. Buys one-time rights, all rights; negotiable. Simultaneous submissions and previously published work OK.

N SPFX: SPECIAL EFFECTS MAGAZINE, 70 W. Columbia Ave., Palisades Park NJ 87650-1004. (201)945-1112. Fax: (201)945-2662. E-mail: spfxted@aol.com. Editor: Ted A. Bohus. Circ. 6,000-10,000. Estab. 1978. Biannual film magazine emphasizing science fiction, fantasy and horror films past, present and future. Includes feature articles, interviews and rare photos. Sample copy for $5. Art guidelines free.

Needs: Needs film stills and film personalities. Reviews photos with or without ms. Special photo needs include rare film photos. Model/property release preferred. Photo captions preferred.

Making Contact & Terms: Send query letter with samples. Provide résumé, business card, self-promotion piece or tearsheets to be kept on file for possible future assignments. To show portfolio, photographer should follow-up with letter after initial query. Art director will contact photographer for portfolio review if interested. Portfolio should include b&w and/or color, prints, tearsheets, slides, transparencies or thumbnails. Uses any size prints. Accepts images in digital format for Macintosh on Zip disk. Keeps samples on file. Reports back only if interested, send non-returnable samples. Payment varies. Pays on publication. Credit line given. Previously published work OK.

SPORT MAGAZINE, 110 Fifth Ave., 4th Floor, New York NY 10011. (213)782-2830. Contact: Photo Editor. Monthly magazine. Emphasizes sports, both professional and collegiate. Readers are ages 9-99, male and female. Circ. 1 million.

Needs: Uses 80 photos/issue; 20% supplied by freelance photographers. Needs photos of sports action (i.e., strobed basketball, hockey, football, baseball). "Always need good editorial (non-action) photographers for portrait work, especially photographers who can work on location."

Making Contact & Terms: Query with résumé of credits or stock photo subjects. "No unsolicited work accepted." Reports in 1 month. Pays $700/color cover or $400/day. Pays on publication. Credit line given. Buys one-time rights.

Tips: In portfolio or samples looking for "tight, sharp, action—hockey and basketball must be strobed, color transparencies preferred, well-lighted portraits or feature style and candid shots of athletes. No prints. Assignments are being given to those who continue to excel and are creative."

SPOTLIGHT MAGAZINE, 126 Library Lane, Mamaroneck NY 10543. (914)381-4740, ext. 20. Fax: (914)381-4641. Publisher: Susan Meadow. Circ. 75,000. Monthly magazine. Readers are largely upscale, about 60% female. Sample copy $2.50.

Needs: Uses 30-35 photos/issue; 10-15 supplied by freelancers. Model release required. Captions required.

Making Contact & Terms: Accepts images for Mac (TIFF). Send via compact disc, floppy disk, SyQuest, Zip disk (high resolution). Query with résumé of credits. Also accepts digital files on SyQuest disk in TIFF format. Keeps samples on file. SASE. Reports in 1 month. Pays $40-125/photo. Pays on publication. Credit line given. Buys all rights "but flexible on reuse." Contact Art Director: Kathee Casey Pennucci.

N: SPSM&H, Shakespeare, Petrarch, Sidney, Milton & Hopkins, Amelia, 329 E St., Bakersfield CA 93304-2031. (805)323-4064. E-mail: amelia@lightspeed.net. Editor: Frederick A. Raborg, Jr. Circ. 600. Estab. 1985. Quarterly literary magazine. "Publishes sonnets, sonnet sequences and crowns, fiction of a Gothic/romantic nature, articles about the sonnet and book reviews of sonnet volumes." Sample copy $4.95. Art guidelines for SAE with 1 first-class stamp.
Needs: Buys 1-2 photos/issue; 4-6 photos/year. "Anything slightly out of the ordinary with romantic concept. Some Gothic. Black & white only, preferably photos which can be used as wrap-around cover." Reviews photos with or without a manuscript. "Surprise us!" Model release required for any portrait or body shots when face is recognizable. Photo captions required for content identification.
Making Contact & Terms: Send query letter with samples. Uses 5×7 or 8×10 glossy or matte b&w prints. Keeps samples on file. Reports in 2 weeks on queries; 2-8 weeks on close samples. Pays $25/b&w cover; $10-20/b&w inside. **Pays on acceptance.** Credit line given. Buys one-time rights. Simultaneous submissions and previously published work in non-competitive markets OK.
Tips: "We allow photographers a 40% discount on subscriptions to follow what we do. Request for discount must be on letterhead with or without samples. Enclose SASE of appropriate size."

STAR, 660 White Plains Rd., Tarrytown NY 10591. (914)332-5000. Editor: Phillip Bunton. Photo Director: Alistair Duncan. Circ. 2.8 million. Weekly. Emphasizes news, human interest and celebrity stories. Sample copy and photo guidelines free with SASE.
Needs: Uses 100-125 photos/issue; 75% supplied by freelancers. Reviews photos with or without accompanying ms. Model release preferred. Captions required.
Making Contact & Terms: Query with samples and with list of stock photo subjects. Send 8×10 b&w prints; 35mm, $2\frac{1}{4} \times 2\frac{1}{4}$ transparencies by mail for consideration. SASE. Reports in 2 weeks. Payment negotiable. Pays on publication. Credit line sometimes given. Simultaneous submissions and previously published work OK.

THE STATE: Down Home in North Carolina, P.O. Box 4552, Greensboro NC 27408-7017. (910)286-0600 or (800)948-1409. Fax: (910)286-0100. E-mail: mannmedia2@aol.com. Editor: Mary Ellis. Circ. 32,000. Estab. 1933. Monthly magazine. Regional publication, privately owned, emphasizing travel, history, nostalgia, folklore, humor, all subjects regional to North Carolina for residents of, and others interested in, North Carolina. Sample copy $3. "Send for our photography guidelines."
Needs: Freelance photography used; 5% assignment and 5% stock. Photos on travel, history and human interest in North Carolina. Captions required.
Making Contact & Terms: Send material by mail for consideration. Uses 5×7 and 8×10 glossy b&w prints; also glossy color prints and slides. Uses b&w and color cover photos, vertical preferred. SASE. Accepts images in digital format for Mac (TIFF). Send via CD, SyQuest, Zip, Jaz or floppy disk (300-500 dpi). Pays $25/b&w photo; $50-250/cover; $125-500/complete job. Credit line given. Pays on publication.
Tips: Looks for "North Carolina material; solid cutline information."

N: STEAM CLASSIC, Ebony Media Ltd., Trevithick House, Moorswater, Liskeard, Cornwall Pl14 4LH United Kingdom. Phone: 1579-340100. Fax: 1579-340200. Website: http://www.ebony.co.uk/steam%20classic/default.htm. Editor: John Huxley. Circ. 12,000. Estab. 1990. Bimonthly special interest magazine on railways with a concentration on steam locomotives.
Needs: Needs railway oriented photos. Reviews photos with or without ms. Photo captions required.
Making Contact & Terms: Send query letter with samples. Uses 35mm, $2\frac{1}{4} \times 2\frac{1}{4}$ transparencies. Deadlines: first day of February, May, July, September, November. Keeps samples on file; include SASE for return of material. Reports back only if interested, send non-returnable samples. Pays £50 minimum for color cover; £15 minimum for b&w inside; £20 minimum for color inside. Electronic usage rates determined by arrangement with editor. Pays on publication. Credit line given. Buys one-time rights. Simultaneous submissions OK.

STOCK CAR RACING MAGAZINE, 65 Parker St., #2, Newburyport MA 01950. (978)463-3787. Fax: (978)463-3250. Editor: Dick Berggren. Circ. 400,000. Estab. 1966. Monthly magazine. Emphasizes all forms of stock car competition. Read by fans, owners and drivers of race cars and those with racing businesses. Photo guidelines free with SASE.
Needs: Buys 50-70 photos/issue. Documentary, head shot, photo essay/photo feature, product shot, person-

ality, crash pictures, special effects/experimental, technical and sport. No photos unrelated to stock car racing. Photos purchased with or without accompany ms and on assignment. Model release required unless subject is a racer who has signed a release at the track. Captions required.

Making Contact & Terms: Send material by mail for consideration. Uses 8×10 glossy b&w prints; 35mm or $2\frac{1}{4} \times 2\frac{1}{4}$ transparencies. Kodachrome 64 or Fuji 100 preferred. Pays \$20/b&w inside; \$35-250/color inside; \$250/cover. Pays on publication. Credit line given. Buys one-time rights.

Tips: "Send the pictures. We will buy anything that relates to racing if it's interesting, if we have the first shot at it, and it's well printed and exposed. Eighty percent of our rejections are for technical reasons—poorly focused, badly printed, too much dust, picture cracked, etc. We get far fewer cover submissions than we would like. We look for full-bleed cover verticals where we can drop type into the picture and position our logo."

STRAIGHT, 8121 Hamilton Ave., Cincinnati OH 45231. (513)931-4050. Fax: (513)931-0950. Editor: Heather E. Wallace. Circ. 35,000. Estab. 1950. Weekly. Readers are ages 13-19, mostly Christian; a conservative audience. Sample copy free with SASE and 2 first-class stamps. Photo guidelines free with SASE.

Needs: Uses about 4 photos/issue; all supplied by freelance photographers. Needs color photos of teenagers involved in various activities such as sports, study, church, part-time jobs, school activities, classroom situations. Outside nature shots, groups of teens having good times together are also needed. "Try to avoid the sullen, apathetic look—vital, fresh, thoughtful, outgoing teens are what we need. Any photographer who submits a set of quality color transparencies for our consideration, whose subjects are teens in various activities and poses, has a good chance of selling to us. This is a difficult age group to photograph without looking stilted or unnatural. We want to purport a clean, healthy, happy look. No smoking, drinking or immodest clothing. We especially need masculine-looking guys and minority subjects." Model release required.

Making Contact & Terms: Send color transparencies by mail for consideration. Enclose sufficient packing and postage for return of photos. Reports in 6 weeks. Pays \$75-125/color photo. **Pays on acceptance.** Credit line given. Buys one-time rights. Simultaneous submissions and previously published work OK.

Tips: "Our publication is almost square in shape. Therefore, 5×7 or 8×10 prints that are cropped closely will not fit our proportions. Any photo should have enough 'margin' around the subject that it may be cropped square. This is a simple point, but absolutely necessary. Look for active, contemporary teenagers with light backgrounds for photos. For our publication, keep up with what teens are interested in. Subjects should include teens in school, church, sports and other activities. Although our rates may be lower than the average, we try to purchase several photos from the same photographer to help absorb mailing costs. Review our publication and get a feel for our subjects."

THE STRAIN, 1307 Diablo Dr., Crosby TX 77532-3004. (713)738-4887. For articles contact: Alicia Adler; for columns, Charlie Mainze. Circ. 1,000. Estab. 1987. Monthly magazine. Emphasizes interactive arts and 'The Arts'. Readers are mostly artists and performers. Sample copy \$5 with 9×12 SAE and 7 first-class stamps. Photo guidelines free with SASE.

Needs: Uses 5-100 photos/issue; 95% supplied by freelance photographers. Needs photos of scenics, personalities, portraits. Model release required. Captions preferred.

Making Contact & Terms: Send any format b&w and color prints or transparencies by mail for consideration. SASE. The longer it is held, the more likely it will be published. Reports in 1 year. Pays \$50/color cover; \$100/b&w cover; \$5 minimum/color inside; \$5 minimum/b&w inside; \$5/b&w page rate; \$50-500/photo/text package. Pays on publication. Credit line given. Buys one-time rights or first North American serial rights. Simultaneous submissions and previously published work OK.

SUB-TERRAIN MAGAZINE, 175 E. Broadway, #204-A, Vancouver, British Columbia V5T 1W2 Canada. (604)876-8710. Fax: (604)879-2667 (for queries only). E-mail: subter@pinc.com. Managing Editor: Brian Kaufman. Estab. 1988. Quarterly b&w literary magazine.

**FOR EXPLANATIONS OF THESE SYMBOLS,
SEE THE INSIDE FRONT AND BACK COVERS OF THIS BOOK.**

© Gordon Baer/Cincinnati

"Gordon Baer sent us unsolicited work in 1997. This is generally the source of most of our acceptances," says Julie Burke, art director for *The Sun*. "Recovery, spirituality and renewal were strong themes in the issue, and we felt Baer's photograph evoked each of these ideas in a joyful, quiet way." The photo, published on the magazine's September cover, is only one image from an essay Baer created at The University of Missouri Photojournalism Workshop. "I wanted to convey an honest portrayal of this person's life related to her family, friends, community and herself," he says. *The Sun* published more images from the series in its December issue.

Needs: Uses "many" unsolicited photos. Needs "artistic" photos. Captions preferred.
Making Contact & Terms: Submit portfolio for review. Send unsolicited photos by mail for consideration. Send color or b&w prints. Keeps samples on file "sometimes." Reports in 2-4 months. Pays $50-300/photo (solicited material only). Also pays in contributor's copies. Pays on publication. Credit line given. Buys one-time rights. Simultaneous submissions OK.

THE SUN, A Magazine of Ideas, 107 N. Roberson, Chapel Hill NC 27516. (919)942-5282. Fax: (919)932-3101. Contact Production Manager: Julie Burke. Circ. 35,000. Estab. 1974. Literary magazine featuring personal essays, interviews, poems, short stories and photo essays. Sample copy $5.00. Photo guidelines free with SASE.
 • *The Sun* has doubled its payment.
Needs: Uses about 10-20 photos/issue; all supplied by freelance photographers. Reviews photos with or without ms. Model release preferred.
Making Contact & Terms: Send cover letter and b&w prints by mail for consideration. Uses 4×5, 6×9, 8×10 b&w prints. "Don't send slides!" Does not keep samples on file; include SASE for return of material. Reports in 4-6 weeks. Pays $50-200/b&w cover and inside photos. Pays on publication. Credit line given. Buys one-time rights; negotiable. Previously published work OK.
Tips: Looks for "artful and sensitive photographs that are not overly sentimental. We use many photos of people. All the photographs we publish come to us as unsolicited submissions. Read the magazine and get to know the styles we like. When submitting work, send return postage and secure return packaging."

TAMPA REVIEW, The University of Tampa, 19F, Tampa FL 33606-1490. (813)253-6266. Editor: Richard B. Mathews. Circ. 750. Estab. 1988. Semiannual literary magazine. Emphasizes literature and art.

Readers are intelligent, college level. Sample copy $5. Photo guidelines free with SASE.
- *Tampa Review* currently reproduces all images via in-house scans, stores images on SyQuest removable hard disks and color-corrects or retouches with Photoshop.

Needs: Uses 6 photos/issue; 100% supplied by freelancers. Needs photos of artistic, museum-quality images. Photographer must hold rights, or release. "We have our own release form if needed." Photo captions required.

Making Contact & Terms: Provide résumé, business card, brochure, flier or tearsheets to be kept on file for possible assignments. Send b&w, color prints "suitable for vertical 6×8 or 6×9 reproduction." SASE. Reports by end of April. Pays $10/image. Pays on publication. Credit line given. Buys first North American serial rights.

Tips: "We are looking for artistic photography, not for illustration, but to generally enhance our magazine. We will consider paintings, prints, drawings, photographs, or other media suitable for printed reproduction. Submissions should be made in February and March for publication the following year."

N TECHNIQUES, (formerly *Vocational Education Journal*), 1410 King St., Alexandria VA 22314. (703)683-3111. Fax: (703)683-7424. E-mail: avahq@avaonline.org. Website: http://www.avaonline.org. Circ. 42,000. Estab. 1926. Monthly magazine for American Vocational Association. Emphasizes education for work and on-the-job training. Readers are teachers and administrators in high schools and colleges. Sample copy free with 10×13 SASE.
- This publication has begun to use computer manipulated images.

Needs: Uses 8-10 photos/issue, 1-2 supplied by freelancers. Needs "students in classroom and job training settings; teachers; students in work situations." Model release preferred for children. Captions preferred; include location, explanation of situation.

Making Contact & Terms: Query with list of stock photo subjects. Send unsolicited photos by mail for consideration. Provide résumé, business card, brochure, flier or tearsheets to be kept on file for possible assignments. Send 5×7 color prints and 35mm transparencies. Keeps samples on file. SASE. Reports as needed. Pays $400 up/color cover; $50 up/color inside; $30 up/b&w inside; $500-1,000/job. Pays on publication. Credit line given. Buys one-time rights; sometimes buys all rights; negotiable. Simultaneous submissions and previously published work OK.

TENNIS WEEK, 341 Madison Ave., New York NY 10017. (212)808-4750. Fax: (212)983-6302. E-Mail: tennisweek@tennisweek.com. Website: http://www.tennisweek.com. Publisher: Eugene L. Scott. Managing Editors: Heather Holland and Kim Kodl. Circ. 80,000. Biweekly. Readers are "tennis fanatics." Sample copy $4 current issue, $5 back issue.

Needs: Uses about 16 photos/issue. Needs photos of "off-court color, beach scenes with pros, social scenes with players, etc." Emphasizes originality. Subject identification required.

Making Contact & Terms: Send actual 8×10 or 5×7 b&w photos by mail for consideration. SASE. Accepts images in digital format for Mac in EPS-CYMK. Send via compact disc, SyQuest, online, Zip disk, or floppy disk at 270 LPI 133. Reports in 2 weeks. Send portfolio via mail or CD-Rom. Pays $50/b&w photo; $150/color cover. Pays on publication. Credit line given. Rights purchased on a work-for-hire basis.

TEXAS GARDENER, P.O. Box 9005, Waco TX 76714. (817)772-1270. Fax: (817)772-9696. Editor/Publisher: Chris S. Corby. Managing Editor: Vivian Whatley. Circ. 35,000. Bimonthly. Emphasizes gardening. Readers are "65% male, home gardeners, 98% Texas residents." Sample copy $2.95.

Needs: Uses 20-30 photos/issue; 90% supplied by freelance photographers. Needs "color photos of gardening activities in Texas." Special needs include "cover photos shot in vertical format. Must be taken in Texas." Model release preferred. Captions required.

Making Contact & Terms: Query with samples. SASE. Reports in 3 weeks. Pays $100-200/color cover; $5-15/b&w inside; $25-100/color inside. Pays on publication. Credit line given. Buys one-time rights.

Tips: "Provide complete information on photos. For example, if you submit a photo of watermelons growing in a garden, we need to know what variety they are and when and where the picture was taken. Also, ask for a copy of our editorial calendar. Then use it in selecting images to send us on speculation."

TEXAS HIGHWAYS, P.O. Box 141009, Austin TX 78714. (512)483-3675. Editor: Jack Lowry. Photo Editor: Michael A. Murphy. Circ. 350,000. Monthly. "*Texas Highways* interprets scenic, recreational, historical, cultural and ethnic treasures of the state and preserves the best of Texas heritage. Its purpose is to educate and entertain, to encourage recreational travel to and within the state, and to tell the Texas story to readers around the world." Readers are 45 and over (majority); $24,000 to $60,000/year salary bracket with a college education. Sample copy and photo guidelines free.

Needs: Uses about 60-70 photos/issue; 50% supplied by freelance photographers. Needs "travel and

scenic photos in Texas only." Special needs include "fall, winter, spring and summer scenic shots and wildflower shots (Texas only)." Captions required; include location, names, addresses and other useful information.

Making Contact & Terms: Query with samples. Provide business card and tearsheets to be kept on file for possible future assignments. "We take only color originals, 35mm or larger transparencies. No negatives." SASE. Reports in 1 month. Pays $120/half-page color inside; $170/full-page color photo; $400/front cover. Pays on publication. Credit line given. Buys one-time rights. Simultaneous submissions OK.

Tips: "Know our magazine and format. We accept only high-quality, professional level work—no snapshots. Interested in a photographer's ability to edit their own material and the breadth of a photographer's work. Look at 3-4 months of the magazine. Query not just for photos but with ideas for new/unusual topics."

TEXAS REALTOR MAGAZINE, P.O. Box 2246, Austin TX 78768. (512)370-2286. Fax: (512)370-2390. Art Director: Lauren Levi. Circ. 43,000. Estab. 1972. Publication of the Texas Association of Realtors. Monthly magazine. Emphasizes real estate sales and related industries. Readers are male and female realtors, ages 20-70. Sample copy free with SASE.

Needs: Uses 10 photos/issue; all supplied by freelancers. Needs photos of architectural details, business, office management, telesales, real estate sales, commercial real estate, nature. Especially wants to see architectural detail and landscape for covers. Property release required.

Making Contact & Terms: Pays $75-300/color photo; $1,500/job. Buys one-time rights; negotiable.

THIN AIR MAGAZINE, P.O. Box 23549, Flagstaff AZ 86002. (520)523-6743. Fax: (520)523-7074. Website: http://www.nau.edu./~english/thinair/TAFRAMES.html. Circ. 500. Estab. 1995. Biannual magazine. Emphasizes arts and literature—poetry, fiction and essays. Readers are collegiate, academic, writerly adult males and females interested in arts and literature. Sample copy $4.00.

Needs: Uses 2-4 photos/issue; all supplied by freelancers. Needs scenic/wildlife shots and b&w photos that portray a statement or tell a story. Looking for b&w cover shots. Model/property release preferred for nudes. Captions preferred; include name of photographer, date of photo.

Making Contact & Terms: Send unsolicited photos by mail for consideration. Send 8×10 b&w prints. Photos accepted August-May only. Keeps samples on file. SASE. Reports in 3 months. Pays with 2 contributor's copies. Credit line given. Buys one-time rights. Simultaneous submissions and previously published work OK.

TIDE MAGAZINE, 4801 Woodway, Suite 220 W, Houston TX 77056. (713)626-4222. Fax: (713)961-3801. Editor: Doug Pike. Circ. 58,000. Estab. 1979. Publication of the Coastal Conservation Association. Bimonthly magazine. Emphasizes coastal fishing, conservation issues *exclusively* along the Gulf and Atlantic Coasts. Readers are mostly male, ages 25-50, coastal anglers and professionals.

Needs: Uses 16-20 photos/issue; 12-16 supplied by freelancers. Needs photos of *only* Gulf and Atlantic coastal activity, recreational fishing and coastal scenics, tight shots of fish (saltwater only). Model/property release preferred. Captions not required, but include names, dates, places and specific equipment or other key information.

Making Contact & Terms: Query with stock photo list. SASE. Reports in 1 month. Pays $150/color cover; $50/color inside; $25/b&w inside; $300/photo/text package. Pays on publication. Credit line given. Buys one-time rights; negotiable. Simultaneous submissions and/or previously published work OK.

Tips: Wants to see "fresh twists on old themes—unique lighting, subjects of interest to my readers. Take time to discover new angles for fishing shots. Avoid the usual poses, i.e. 'grip-and-grin.' We see too much of that already."

⚇ TIGER BEAT, TV Movie Screen, Sterling/Macfadden, 233 Park Ave. S, New York NY 10003. (212)780-3500. Fax: (212)780-3555. E-mail: tigerbmail@aol.com. Website: http://www.nextlevel/tigerbeat .com. Editor: Louise Barile. Circ. 250,000. Estab. 1965. *Tiger Beat* is a monthly entertainment magazine for teenage girls interested in young celebrities in movies, music and on TV.

Needs: Buys 30 photos from freelancers/issue; 300 photos/year. Needs photos of young celebrities. Reviews photos with or without ms. Model/property release preferred. Photo captions preferred.

Making Contact & Terms: Send query letter with samples. Art director will contact photographer for portfolio review if interested. Deadlines: Seasonal material should be sent 3 months in advance. Does not keep samples on file. Reports in 1 month. Pays $50 minimum for b&w cover; $50 minimum for color cover; $35-75 for b&w inside; $50-300 for color inside. Pays on publication. Credit line not given. Simultaneous submissions and/or previously published work OK.

Tips: "We are looking for clear, crisp photos of celebrities looking as attractive as possible. Please look at a current issue for the personalities we cover."

Teen magazine *Tiger Beat* is always looking for images of the latest Hollywood heart-throb. But it takes experience to get the right shot. "I have traveled extensively to interview actors about their latest film or projects for a variety of magazines both foreign and domestic," says celebrity photographer Jean Cummings. "This photograph of Leonardo DiCaprio was taken during an interview on the roof of the Beverly Hilton Hotel. The photo conveys his boyish good looks and the charisma he brings to the screen."

TiGER beat
Leo DiCaprio

© Jean Cummings

TIKKUN, 26 Fell St., San Francisco CA 94102. (415)575-1200. Fax: (415)281-0832. E-mail: magazine@tikkun.org. Website: http://www.tikkun.org. Production Manager: David Van Ness. Circ. 20,000. Estab. 1986. Bimonthly journal. Publication is a political, social and cultural Jewish critique. Readers are 75% Jewish, white, middle-class, literary people ages 30-60.
Needs: Uses 15 photos/issue; 30% supplied by freelancers. Needs political, social commentary; Middle Eastern; US photos. Reviews photos with or without ms.
Making Contact & Terms: Send unsolicited photos by mail for consideration. Uses b&w "or good photo copy" prints. Keeps samples on file. SASE. Accepts images in digital format for Mac (Photoshop EPS). Send via Zip disk. Reporting time varies. "Turnaround is 4 months, unless artist specifies other." Pays $50/b&w inside. Pays on publication. Credit line given. Buys all rights; negotiable. Simultaneous submissions and/or previously published work OK.
Tips: "Send samples. Look at our magazine and suggest how your photos can enhance our articles and subject material."

N TIMBER HOMES ILLUSTRATED, Goodman Media Group, 1700 Broadway, 34th Floor, New York NY 10019. (212)541-7100. Fax: (212)245-1241. Photo Editor: Bruce Perez. Estab. 1996. Quarterly consumer magazine. Sample copy available. Contact photo department (212)541-7100, ext. 256.
Needs: House Tours, Showcase homes (timber-frame, post-and-beam). Reviews photos with or without a ms. Photo captions preferred; include room descriptions.
Making Contact & Terms: Contact through rep. Send query letter with samples, brochure, stock photo list, tearsheets. Provide résumé, business card, self-promotion piece or tearsheets to be kept on file for possible future assignments. To show portfolio, photographer should follow-up with letter after initial query. Portfolio should include color tearsheets or transparencies. Uses color prints; 2¼×2¼, 4×5 transparencies. We work 4 months ahead. Pays on publication. Credit line given. Buys one-time rights, first rights or all rights; negotiable. Simultaneous submissions and/or previously published work OK.
Tips: "Please look at magazine to see the types of photos we feature. Our house tours are dramatic and focus on the beauty of the woodwork of a home."

TIME, Time Inc., Time/Life Building, 1271 Avenue of the Americas, New York NY 10020. (212)522-1212. *TIME* is edited to report and analyze a complete and compelling picture of the world, including national and world affairs, news of business, science, society and the arts, and the people who make the

news. This magazine did not respond to our request for information. Query before submitting.

TODAY'S MODEL, P.O. Box 205-454, Brooklyn NY 11220. (718)651-8523. Fax: (718)651-8863. Publisher: Sumit Arya. Circ. 100,000. Estab. 1993. Monthly magazine. Emphasizes modeling and performing arts. Readers are male and female ages 13-28, parents of kids 1-12. Sample copy $3 with 9×12 SAE and 10 first-class stamps.
Needs: Uses various number photos/issue. Needs photos of fashion—studio/on location/runway; celebrity models, performers, beauty and hair—how-to; photojournalism—modeling, performing arts. Reviews photos with or without ms. Needs models of all ages. Model/property release required. Captions preferred; include name and experience (résumé if possible).
Making Contact & Terms: Provide résumé, sample photos, promo cards, business card, brochure, flier or tearsheets to be kept on file for possible future assignments. Keeps samples on file. Reports only when interested. Payment negotiable. Pays on publication. Buys all rights; negotiable. Considers simultaneous submissions and/or previously published work.

TODAY'S PHOTOGRAPHER INTERNATIONAL, P.O. Box 18205, Washington DC 20036. (910)945-9867. Photography Editor: Vonda H. Blackburn. Circ. 131,000. Estab. 1986. Bimonthly magazine. Emphasizes making money with photography. Readers are 90% male photographers. For sample copy, send 9×12 SAE. Photo guidelines free with SASE.
Needs: Uses 40 photos/issue; all supplied by freelance photographers. Model release required. Photo captions preferred.
Making Contact & Terms: Send 35mm, 2¼×2¼, 4×5, 8×10 b&w and color prints or transparencies by mail for consideration. SASE. Reports at end of the quarter. Payment negotiable. Credit line given. Buys one-time rights, per contract. Simultaneous submissions and previously published work OK.
Tips: Wants to see "consistently fine-quality photographs and good captions or other associated information. Present a portfolio which is easy to evaluate—keep it simple and informative. Be aware of deadlines. Submit early."

TOTAL TV, CABLE GUIDE and SEE, 570 Lexington Ave., 17th Floor, New York NY 10022. (212)750-6116. Fax: (212)750-6235. Website: http.//www.totaltv.com. Photo Editor: Cherie Cincilla. Weekly magazines. Emphasizes movie and TV personalities, sports figures, musicians, nature.
Needs: Uses 30 photos/issue; all supplied by freelancers. Needs photos of personalities or TV and movie coverage. Reviews photos with or without ms. Model/property release preferred. Captions preferred.
Making Contact & Terms: Accepts digital files on Zip disks. SASE. Reports in 1-2 weeks. Pays $75 minimum/photo (b&w or color); $500-2,000/job. **Pays on acceptance.** Credit line given. Simultaneous submissions and/or previously published work OK.
Tips: "Photographers may drop off portfolios any day—3 day return policy."

TOUCH, P.O. Box 7259, Grand Rapids MI 49510. (616)241-5616. Fax: (616)241-5558. E-mail: gemsgccs@iserv.net. Managing Editor: Carol Smith. Circ. 15,500. Estab. 1970. Publication of Gems/Calvinettes. Monthly. Emphasizes "girls 7-14 in action. The magazine is a Christian girls' publication geared to the needs and activities of girls in the above age group." Readers are "Christian girls ages 7-14; multiracial." Sample copy and photo guidelines for $1 with 9×12 SASE. "Also available is a theme update listing all the themes of the magazine for one year."
Needs: Uses about 5-6 photos/issue. Needs "photos suitable for illustrating stories and articles: photos of girls aged 7-14 from multicultural backgrounds involved in sports, Christian service and other activities young girls would be participating in." Model/property release preferred.
Making Contact & Terms: Send 5×7 glossy color prints by mail for consideration. SASE. Accepts images in digital format for Mac (TIFF). Send via compact or Zip disk, SyQuest or online. Reports in 2 months. Pays $20-40/photo; $50/cover. Pays on publication. Credit line given. Buys one-time rights. Simultaneous submissions OK.
Tips: "Make the photos simple. We prefer to get a spec sheet or CDs rather than photos and we'd really like to hold photos sent to us on speculation until publication. We select those we might use and send others back. Freelancers should write for our annual theme update and try to get photos to fit the theme of each issue." Recommends that photographers "be concerned about current trends in fashions and hair styles and that all girls don't belong to 'families.'" To break in, "a freelancer can present a selection of his/her photography of girls, we'll review it and contact him/her on its usability."

TRACK & FIELD NEWS, 2570 El Camino Real, Suite 606, Mountain View CA 94040. (650)948-8417. Fax: (650)948-9445. E-mail: edit@trackandfieldnews.com. Website: http://www.trackandfieldnews.com. Associate Editor (Features/Photography): Jon Hendershott. Circ. 35,000. Estab. 1948. Monthly magazine.

SUPER BOWL: THE PACK IS BACK! BUT CAN THEY BUCK THE BRONCOS?

TOTAL

TV

FOR THE
WEEK OF
JAN. 24–30
$1.25

ROCK
'N' JOCKS

TV's biggest space cases
touch down on Super Sunday
with a one-hour special

HOT NEWS! Please Deliver by January 22

MediaOne
This is Broadband. This is the way.

Ian White first met *Total TV* Photo Editor Cherie Cincilla at college orientation, although their professional relationship wouldn't bloom for another five years. Now he shoots most of the magazine's Los Angeles assignments. "I have shot close to 30 covers for them. Most of my celebrity book is what it is thanks to *Total TV*. This was shot for an issue which coincided with a "3rd Rock" Superbowl special. I only shot for 5 minutes and 45 seconds after waiting for over 9 hours so I went for a simple football read." Those five minutes earned White $2,000 plus expenses.

Emphasizes national and world-class track and field competition and participants at those levels for athletes, coaches, administrators and fans. Sample copy free with 9×12 SAE. Free photo guidelines.

Needs: Buys 10-15 photos/issue; 75% of freelance photos on assignment, 25% from stock. Wants on a regular basis, photos of national-class athletes, men and women, preferably in action. "We are always looking for quality pictures of track and field action, as well as offbeat and different feature photos. We always prefer to hear from a photographer before he/she covers a specific meet. We also welcome shots from road and cross-country races for both men and women. Any photos may eventually be used to illustrate news stories in *T&FN*, feature stories in *T&FN* or may be used in our other publications (books, technical journals, etc.). Any such editorial use will be paid for, regardless of whether material is used directly in *T&FN*. About all we don't want to see are pictures taken with someone's Instamatic or Polaroid. No shots of someone's child or grandparent running. Professional work only." Captions required; include subject name, meet date/name.

Making Contact & Terms: Query with samples or send material by mail for consideration. Prefers 8×10 glossy b&w prints; 35mm transparencies, although color prints are acceptable. Accepts images in digital format for Mac (limited use). Send via compact disc, online, floppy disk, Zip disk. SASE. Reports in 7-10 days. Pays $25/b&w inside; $60/color inside ($100/interior color, full page); $175/color cover. Payment is made bimonthly. Credit line given. Buys one-time rights.

Tips: "No photographer is going to get rich via *T&FN*. We can offer a credit line, nominal payment and, in some cases, credentials to major track and field meets to enable on-the-field shooting. Also, we can offer the chance for competent photographers to shoot major competitions and competitors up close, as well as being the most highly regarded publication in the track world as a forum to display a photographer's talents."

N: TRAILER BOATS MAGAZINE, Poole Publications Inc., 20700 Belshaw Ave., Carson CA 90746. (310)537-6322. Fax: (310)537-8735. E-mail: tbmeditors@aol.com. Editor: Jim Hendricks. Circ. 90,000. Estab. 1971. Monthly magazine. "We are the only magazine devoted exclusively to legally trailerable boats and related activities" for owners and prospective owners. Sample copy $1.25. Free writer's guidelines.

Needs: Uses 15 photos/issue with ms. 95-100% of freelance photography comes from assignment; 0-5% from stock. Scenic (with ms), how-to, humorous, travel (with ms). For accompanying ms, need articles related to trailer boat activities. Photos purchased with or without accompanying ms. "Photos must relate to trailer boat activities. No long list of stock photos or subject matter not related to editorial content." Captions preferred; include location of travel pictures.

Making Contact & Terms: Query or send photos or contact sheet by mail for consideration. Uses transparencies. Accepts images in digital format for Mac (EPS, TIFF, PIC). Send at 300 dpi. SASE. Reports in 1 month. Pays per text/photo package or on a per-photo basis. Pays $25-200/color photo; $150-400/cover; additional for mss. **Pays on acceptance.** Credit line given. Buys one-time and all rights; negotiable.

Tips: "Shoot with imagination and a variety of angles. Don't be afraid to 'set-up' a photo that looks natural. Think in terms of complete feature stories; photos and mss. It is rare any more that we publish freelance photos without accompanying manuscripts."

N: TRAILER LIFE, Dept. PM, 2575 Vista Del Mar, Ventura CA 93001. Publisher: Bill Estes. Editorial Director: Barbara Leonard. Circ. 300,000. Monthly magazine. Emphasizes the why, how and how-to of owning, using and maintaining a recreational vehicle for personal vacation or full-time travel. Send for editorial guidelines.

Needs: Human interest, how-to, travel and personal experience. The editors are particularly interested in photos for the cover; an RV must be included.

Making Contact & Terms: Send material by mail for consideration or query with samples. Uses 8×10 b&w glossy prints; 35mm and 2¼×2¼ transparencies. SASE. Reports in 3 weeks. Pays $50-150/b&w photo; $75-300/color photo; $500 for cover. **Pays on acceptance.** Credit line given. Buys first North American rights.

TRANSPORT TOPICS, 2200 Mill Rd., Alexandria VA 22314. (703)838-1735. Fax: (703)548-3662. Website: http://www.ttnews.com. Chief Photographer: Michael James. Circ. 31,000. Estab. 1935. Publica-

MARKET CONDITIONS are constantly changing! If you're still using this book and it's 2000 or later, buy the newest edition of *Photographer's Market* at your favorite bookstore or order directly from Writer's Digest Books.

tion of the American Trucking Associations. Weekly tabloid. Emphasizes the trucking industry. Readers are male executives 35-65.

Needs: Uses approximately 12 photos/issue; amount supplied by freelancers "depends on need." Needs photos of truck transportation in all modes. Model/property release preferred. Captions preferred.

Making Contact & Terms: Send unsolicited 35mm or 2¼×2¼ transparencies by mail for consideration. Provide résumé, business card, brochure, flier or tearsheets to be kept on file for possible assignments. Does not keep samples on file. SASE. Reports in 1 month. Payment negotiable. Pays standard "market rate" for color cover photo. **Pays on acceptance.** Credit line given. Buys one-time rights; negotiable. Simultaneous submissions and previously published work OK.

Tips: "Trucks/trucking must be dominant element in the photograph—not an incidental part of an environmental scene."

TRAVEL & LEISURE, 1120 Avenue of the Americas, New York NY 10036. (212)382-5600. Editor: Nancy Novogrod. Design Director: Pamela Berry. Circ. 1.2 million. Monthly magazine. Emphasizes travel destinations, resorts, dining and entertainment.

Needs: Nature, still life, scenic, sport and travel. Does not accept unsolicited photos. Model release required. Captions required.

Making Contact & Terms: Uses 8×10 semigloss b&w prints; 35mm, 2¼×2¼, 4×5 and 8×10 transparencies, vertical format required for cover. Pays $200-500/b&w inside; $200-500/color inside; $1,000/cover or negotiated. Sometimes pays $450-1,200/day; $1,200 minimum/complete package. Pays on publication. Credit line given. Buys first world serial rights, plus promotional use. Previously published work OK.

Tips: Seeing trend toward "more editorial/journalistic images that are interpretive representations of a destination."

⊕ **TRAVELLER**, 45-49 Brompton Road, London SW3 1DE Great Britain. Phone: (0171)581-4130. Fax: (0171)581-1357. Managing Editor: Miranda Haines. Circ. 35,000. Quarterly. Readers are predominantly male, professional, age 35 and older. Sample copy £2.50.

Needs: Uses 30 photos/issue; all supplied by freelancers. Needs photos of travel, wildlife. Reviews photos with or without ms. Captions preferred.

Making Contact & Terms: Send 35mm transparencies. Does not keep samples on file. SASE. Reports in 1 month. Pays £50/color cover; £25/color inside. Pays on publication. Buys one-time rights.

Tips: Looks for "original, quirky shots with impact, which tell a story."

[N] ⊕ **TRIUMPH WORLD**, CH Publications, P.O. Box 75, Tadworth, Surrey KT20 7XF England. Phone: 01895 623612. Fax: 01895 623613. Editor: Tony Beadle. Estab. 1995. Top quality bimonthy magazine for enthusiasts and owners of Triumph cars.

Needs: Buys 60 photos from freelancers/issue. Needs photos of Triumph cars. Reviews photos with or without ms. Photo captions preferred.

Making Contact & Terms: Send query letter with samples, tearsheets. Uses color and b&w prints; 35mm, 2¼×2¼, 4×5 transparencies. Pays 6 weeks after publication. Credit line given. Buys first rights.

Tips: "Be creative—we do not want cars parked on grass or public car parks with white lines coming out from underneath. Make use of great 'American' locations available. Provide full information about where and when subject was photographed."

TROUT: The Voice of America's Trout and Salmon Anglers, 1500 Wilson Blvd., Suite 310, Arlington VA 22209-2404. (703)522-0200. Fax: (703)284-9400. E-mail: trout@tu.org. Website: http://www.tu.org. Editor: Christine Arena. Circ. 98,000. Estab. 1959. Quarterly magazine. Emphasizes conservation and restoration of America's trout and salmon species and the streams and rivers they inhabit. Readers are conservation-minded anglers, primarily male, with an average age of 46. Sample copy free with 9×12 SAE and 4 first-class stamps. Photo guidelines free with SASE.

Needs: Uses 25-50 photos/issue; 100% supplied by freelancers. Needs photos of trout and salmon, trout and salmon angling, conservation issues, and river/watershed scenics, as well as authentic examples of environmental degradation (ex. forest logging, eroded streams, livestock grazing, acid rain/air pollution, hydroelectric dams, hard-rock mining and mining pollution, etc.). Special photo needs include endangered species of trout and salmon especially native desert trout species. Pacific and Atlantic salmon. Model/property release required. Captions preferred; include species of fish; if angling shot: location (river/stream, state, name of park or wilderness area). U.S.A. only.

Making Contact & Terms: Query with résumé of credits. Deadlines: Spring, 1/1; Summer, 4/1; Fall, 7/1; Winter, 10/1. Does not keep samples on file. Send non-returnable samples. SASE. Reports in 2 months. Pays $500/color cover; $75-350/color inside; $75-350/b&w inside. Pays on publication. Credit line given. Buys first North American serial rights; negotiable. Simultaneous submissions OK.

Tips: "If the fish in the photo could not be returned to the water alive with a reasonable expectation it would survive, we will not run the photo. The exception is when the photo is explicitly intended to represent 'what not to do.' Our emphasis is on fly fishing; however, we need photos of spin casting on occasion."

N: TURKEY & TURKEY HUNTING, Krause Publications, 700 E. State St., Iola WI 54990-0001. (715)445-2214. Fax: (715)445-4087. E-mail: lovettb@krause.com. Circ. 50,000. Estab. 1983. Magazine published 6 times a year. Provides features and news about wild turkeys and turkey hunting. Sample copies free. Art guidelines free.
Needs: Buys 150 photos/year. Needs action photos of wild turkeys and hunter interaction scenes. Reviews photos with or without ms.
Making Contact & Terms: Send query letter with samples. Uses 35mm transparencies. Include SASE for return of material. Reports in 3 months on queries. Pays $300 minimum for color cover; $75 minimum for b&w inside; $260 minimum for color inside. Pays on publication. Credit line given. Buys one-time rights.

TURKEY CALL, P.O. Box 530, Edgefield SC 29824. Parcel services: 770 Augusta Rd. (803)637-3106. Fax: (803)637-0034. Publisher: National Wild Turkey Federation, Inc. (nonprofit). Editor: Jay Langston. Circ. 132,000. Estab. 1973. Bimonthly magazine. For members of the National Wild Turkey Federation—people interested in conserving the American wild turkey. Sample copy $3 with 9 × 12 SASE. Contributor guidelines free with SASE.
Needs: Buys at least 50 photos/year. Needs photos of "wild turkeys, wild turkey hunting, wild turkey management techniques (planting food, trapping for relocation, releasing), wild turkey habitat." Captions required.
Making Contact & Terms: Send copyrighted photos to editor for consideration. Send 8 × 10 glossy b&w prints; color transparencies, any format; prefers originals, 35mm accepted. SASE. Reports in 6 weeks. Pays $35 minimum/b&w photo; maximum $200/inside color; $400/cover. **Pays on acceptance.** Credit line given. Buys one-time rights.
Tips: Wants no "poorly posed or restaged shots, mounted turkeys representing live birds, domestic turkeys representing wild birds or typical hunter-with-dead-bird shots. Photos of dead turkeys in a tasteful hunt setting are considered. Keep the acceptance agreement/liability language to a minimum. It scares off editors and art directors." Sees a trend developing regarding serious amateurs who are successfully competing with pros. "Newer equipment is partly the reason. In good light and steady hands, full auto is producing good results. I still encourage tripods, however, at every opportunity."

U.S.A. SOFTBALL MAGAZINE, (formerly *Amateur Softball Association*), 2801 NE 50th St., Oklahoma City OK 73111. (405)425-3463. Director of Communications: Ronald A. Babb. Promotion of amateur softball. Photos used in newsletters, newspapers, association magazine.
Needs: Buys 10-12 photos/year; offers 5-6 assignments annually. Subjects include action sports shots. Model release required. Captions required.
Making Contact & Terms: Contact ASA national office first before doing any work. Uses prints or transparencies. SASE. Reports in 2 weeks. Pays $50 for previously published photo. Assignment fees negotiable. Credit line given. Buys all rights.

⬆ UP HERE, P.O. Box 1350, Yellowknife, Northwest Territories X1A 2N9 Canada. (867)920-4343. Fax: (867)873-2844. E-mail: uphere@outcrop.com. Editor: Cooper Langford. Circ. 35,000. Estab. 1984. Bimonthly magazine. Emphasizes Canada's north. Readers are white collar men and women ages 30 to 60. Sample copy $3 and 9 × 12 SAE. Photo guidelines free with SASE.
Needs: Uses 20-30 photos/issue; 90% supplied by freelance photographers. Purchases photos with and without accompanying ms. Captions required.
Making Contact & Terms: Provide résumé, business card, brochure, flier or tearsheets to be kept on file for possible assignments. Occasionally accepts images in digital format for Mac. Send via compact disc, online, SyQuest 88, Zip disk (contact magazine for specs). Strongly prefers transparencies or prints. SASE. Reports in 2 months. Pays $35-100/b&w photo; $50-150/color photo; $150-500/cover. Pays on publication. Credit line given. Buys one-time rights.
Tips: "We are a *people* magazine. We need stories that are uniquely Northern (people, places, etc.). Few scenics as such. We approach local freelancers for given subjects, but are building a library. We can't always make use of photos alone, but a photographer could profit by sending sheets of dupes for our stock files." Wants to see "sharp, clear photos, good color and composition. We always need verticals to consider for the cover, but they usually tie in with an article inside."

V.F.W. MAGAZINE, 406 W. 34th St., Kansas City MO 64111. (816)756-3390. Fax: (816)968-1169. Editor: Richard Kolb. Art Director: Robert Widener. Circ. 2.2 million. Monthly magazine, except July. For members of the Veterans of Foreign Wars (V.F.W.)—men and women who served overseas, and their families. Sample copy free with SAE and 2 first-class stamps.

Needs: Photos illustrating features on current defense and foreign policy events, veterans issues and, accounts of "military actions of consequence." Photos purchased with or without accompanying ms. Present model release on acceptance of photo. Captions required.

Making Contact & Terms: Uses mostly color prints and transparencies but will consider b&w. SASE. Reports in 1 month. Pays $25-50/b&w photo; $35-250/color photo. **Pays on acceptance.** Buys one-time and all rights; negotiable.

Tips: "Go through an issue or two at the local library (if not a member) to get the flavor of the magazine." When reviewing samples "we look for familiarity with the military and ability to capture its action and people. We encourage military photographers to send us their best work while they're still in the service. Though they can't be paid for official military photos, at least they're getting published by-lines, which is important when they get out and start looking for jobs."

VANITY FAIR, Condé Nast Building, 350 Madison Ave., New York NY 10017. (212)880-8800. Photography Director: Susan White. Monthly magazine.

Needs: 50% of photos supplied by freelancers. Needs portraits. Model/property release required for everyone. Captions required for photographer, styles, hair, makeup, etc.

Making Contact & Terms: Contact through rep. Submit portfolio for review. Provide résumé, business card, brochure, flier or tearsheets to be kept on file for possible assignments. Reports in 1-2 weeks. Payment negotiable. Pays on publication.

Tips: "We solicit material after a portfolio drop. So, really we don't want unsolicited material."

VERMONT LIFE, 6 Baldwin St., Montpelier VT 05602. (802)828-3241. Editor: Tom Slayton. Circ. 80,000. Estab. 1946. Quarterly magazine. Emphasizes life in Vermont: its people, traditions, way of life, farming, industry and the physical beauty of the landscape for "Vermonters, ex-Vermonters and would-be Vermonters." Sample copy $5 with 9×12 SAE. Free photo guidelines.

Needs: Buys 30 photos/issue; 90-95% supplied by freelance photographers, 5-10% from stock. Wants on a regular basis scenic views of Vermont, seasonal (winter, spring, summer, autumn), submitted 6 months prior to the actual season; animal; documentary; human interest; humorous; nature; photo essay/photo feature; still life; travel; and wildlife. "We are using fewer, larger photos and are especially interested in good shots of wildlife, birds." No photos in poor taste, nature close-ups, cliches or photos of places other than Vermont. Model/property releases preferred. Captions required.

Making Contact & Terms: Query first. Send 35mm or $2\frac{1}{4} \times 2\frac{1}{4}$ color transparencies. SASE. Reports in 3 weeks. Pays $75-200/b&w photo; $75-200/color photo; $250/day; $400-800 job. Pays on publication. Credit line given. Buys one-time rights; negotiable. Simultaneous submissions OK.

Tips: "We look for clarity of focus; use of low-grain, true film (Kodachrome or Fujichrome are best); unusual composition or subject."

VERMONT MAGAZINE, 20½ Main St., Middlebury VT 05753. (802)388-8480. Fax: (802)388-8485. E-mail: vtmag@sover.net. Photo Editor: Cronin Sleeper. Circ. 50,000. Estab. 1989. Bimonthly magazine. Emphasizes all facets of Vermont and nature, politics, business, sports, restaurants, real estate, people, crafts, art, architecture, etc. Readers are people interested in Vermont, including residents, tourists and summer home owners. Sample copy $3 with 9×12 SAE and 5 first-class stamps. Photo guidelines free with SASE.

Needs: Uses 30-40 photos/issue; 75% supplied by freelance photographers. Needs animal/wildlife shots, travel, Vermont scenics, how-to, portraits, products and architecture. Special photo needs include Vermont activities such as skiing, ice skating, biking, hiking, etc. Model release preferred. Captions required.

Making Contact & Terms: Query with résumé of credits and samples of work. Send 8×10 b&w prints or 35mm or larger transparencies by mail for consideration. Submit portfolio for review. Provide tearsheets to be kept on file for possible assignments. SASE. Reports in 2 months. Pays $450/color cover; $200/color page rate; $75-200/color or b&w inside; $300/day. Pays on publication. Credit line given. Buys one-time rights and first North American serial rights; negotiable. Previously published work OK, depending on "how it was previously published."

Tips: In portfolio or samples, wants to see tearsheets of published work, and at least 40 35mm transparencies. Explain your areas of expertise. Looking for creative solutions to illustrate regional activities, profiles and lifestyles. "We would like to see more illustrative photography/fine art photography where it applies to the articles and departments we produce."

N: VIBE, 215 Lexington Ave., New York NY 10016. (212)448-7300. Fax: (212)448-7400. Circ. 600,000. Estab. 1993. Monthly magazine. Sample copy free. Art guidelines free.

Needs: Buys 5-10 photos from freelancers/issue; 100 photos/year. Needs photos of hip hop artists (candid or formal) and multicultural paparazzi images. Reviews photos with or without a ms. Special photo needs include excellent documentary work on socio-political, multicultural, and unusual original themes. Model release preferred. Photo captions required; include location, dates, names of subjects, motivation of photographer for exploring subject.

Making Contact & Terms: Send query letter with samples, tearsheets. Provide résumé, business card, self-promotion piece or tearsheets to be kept on file for possible future assignments. Portfolio may be dropped off every Wednesday. Portfolio should include b&w and/or color, prints or tearsheets. "Disc fine but not ideal." Uses color and b&w prints; 35mm, 2¼×2¼, 4×5, 8×10 transparencies. Accepts images in digital format. Keeps samples on file; cannot return material. **Pays on acceptance.** Credit line given. Buys one-time rights, electronic rights; negotiable. Simultaneous submissions OK.

Tips: "Read our magazine. We're always looking for well-crafted, authentic, stylish, compassionate photography in all genres but especially portraiture, fashion, documentary, digital, still life, and any hybrid combination of these directions. Submit commercial and successful personal work. Examine a year's worth of *Vibe* before submitting. Don't judge us by one issue!! Aspire beyond trends to a level of excellence!"

VIDEOMAKER MAGAZINE, P.O. Box 4591, Chico CA 95927. (916)891-8410. Fax: (916)891-8443. E-mail: editor@videomaker.com. Website: http://www.videomaker.com. Editor: Stephen Muratore. Art Director: Sam Piper. Circ. 150,000. Estab. 1986. Monthly magazine. Emphasizes video production from hobbyist to low-end professional level. Readers are mostly male, ages 25-40. Sample copy free with 9×12 SAE.

Needs: Uses 50-60 photos/issue; 10-15% supplied by freelancers. Subjects include tools and techniques of consumer video production, videomakers in action. Reviews photos with or without ms. Model/property release required. Captions required.

Making Contact & Terms: Send unsolicited photos by mail for consideration; any size or format, color or b&w. SASE. Reports in 1 month. Payment negotiable. Pays on publication. Credit line given. Rights negotiable. Simultaneous submissions and previously published work OK.

N: VIPER MAGAZINE, The Quarterly Magazine for Dodge Viper Enthusiasts, J.R. Thompson Company, 31690 W. 12 Mile Rd., Farmington Hills MI 48334. (248)553-4566. Fax: (248)553-2138. E-mail: jrt@jrthompson.com. Editor-in-Chief: Daniel Charles Ross. Circ. 15,000. Estab. 1992. Quarterly magazine published by and for the enthusiasts of the Dodge Viper sports car. Sample copy for $6. Art guidelines free.

Needs: Buys 3-10 photos from freelancers/issue; 12-40 photos/year. Needs photos of "All Viper, only Viper—unless the shot includes another car suffering indignity at the Viper's hands." Reviews photos with or without a ms. "Can always use fresh pro outlooks on racing or pro/amateur series." Model release required; property release preferred for anything not shot in the public domain or in a "news" context. Photo captions required; include names and what's happening.

Making Contact & Terms: Send query letter with samples, brochure, stock photo list or tearsheets. Provide résumé, business card, self-promotion piece or tearsheets to be kept on file for possible future assignments. Uses any size color prints; 35mm, 2¼×2¼, 4×5, 8×10 transparencies. Keeps samples on file; include SASE for return of material. Reports in 3-4 weeks on queries; 2-3 weeks on samples. Payment varies. **Pays on acceptance.** Credit line given. Buys all rights; negotiable. Simultaneous submissions and/or previously published work OK.

Tips: "Know what we want—we don't have time to train anyone. That said, unpublished pro-grade work will probably find a good home here. Send first-class work—not outtakes, have patience; and don't waste our time—or yours. Would like to see less 'buff-book—standard' art and more of a 'fashion' edge."

VIRGINIA WILDLIFE, P.O. Box 11104, Richmond VA 23230. (804)367-1000. Editor: Lee Walker. Art Director: Emily Pels. Circ. 55,000. Monthly magazine. Emphasizes Virginia wildlife, as well as outdoor features in general, fishing, hunting and conservation for sportsmen and conservationists. Free sample copy and photo/writer's guidelines.

Needs: Buys 350 photos/year; about 95% purchased from freelancers. Photos purchased with accompanying ms. Good action shots relating to animals (wildlife indigenous to Virginia), action hunting and fishing shots, photo essay/photo feature, scenic, human interest outdoors, nature, outdoor recreation (especially boating) and wildlife. Photos must relate to Virginia. Accompanying mss: features on wildlife; Virginia travel; first-person outdoors stories. Pays 15¢/printed word. Model release preferred for children. Property release preferred for private property. Captions required; identify species and locations.

Making Contact & Terms: Send 35mm and 2¼×2¼ or larger transparencies. Vertical format required

for cover. SASE. Reports (letter of acknowledgment) within 30 days; acceptance or rejection within 45 days of acknowledgement. Pays $30-50/color photo; $125/cover; $75/back cover. Pays on publication. Credit line given. Buys one-time rights.
Tips: "We don't have time to talk with every photographer who submits work to us, since we do have a system for processing submissions by mail. Our art director will not see anyone without an appointment. In portfolio or samples, wants to see a good eye for color and composition and both vertical and horizontal formats. We are seeing higher quality photography from many of our photographers. It is a very competitive field. Show only your best work. Name and address must be on each slide. Plant and wildlife species should also be identified on slide mount. We look for outdoor shots (must relate to Virginia); close-ups of wildlife."

VISIONS, 3100 Broadway, Suite 660, Kansas City MO 64111. (816)960-1988. Fax: (816)221-1112. Editor: Neoshia Michelle Paige. Circ. 100,000. Semi-annual magazine. Emphasizes Native Americans in high school, college, vocational-technical, careers. Readers are Native American students 16-22. Sample copy free with 9×12 SAE and 5 first-class stamps.
Needs: Uses 30 photos/issue. Needs photos of students in-class, at work, on campus, in vocational/technical training in health, engineering, technology, computers, law, science, general interest. Model/property release required. Captions required; include name, age, location, what's going on in photo.
Making Contact & Terms: Query with ideas and SASE. Reports in 1 month. Pays $10-50/color photo; pays $5-25/b&w inside. Pays on publication. Buys first North American serial rights. Simultaneous submissions and previously published work OK.

VISTA, 999 Ponce de Leon Blvd., Suite 600, Coral Gables FL 33134. (305)442-2462. Fax: (305)443-7650. Editor: Peter Ekstein. Circ. 1.2 million. Estab. 1985. Monthly newspaper insert. Emphasizes Hispanic life in the US. Readers are Hispanic-Americans of all ages. Sample copy available.
Needs: Uses 10-50 photos/issue; all supplied by freelancers. Needs photos mostly of personalities with story only. No "stand-alone" photos. Reviews photos with accompanying ms only. Special photo needs include events in the Hispanic American communities. Model/property release preferred. Captions required.
Making Contact & Terms: Provide résumé, business card, brochure, flier or tearsheets to be kept on file for possible assignments. Accepts images in digital format for Mac (TIFF, EPS). Send via compact disc, online, floppy disk, SyQuest, zip disk (300 dpi). Keeps samples on file. SASE. Reports in 3 weeks. Pays $300/color cover; $150/color inside; $75/b&w inside; day assignments are negotiated. Pays 25% extra for Web usage. Pays on publication. Credit line given. Buys one-time rights. Previously published work OK.
Tips: "Build a file of personalities and events. Hispanics are America's fastest-growing minority."

VOGUE, Conde Nast Publications, Inc., 350 Madison Ave., New York NY 10017-3799. (212)880-8800. *Vogue* reflects the changing roles and concerns of women, covering not only evolutions in fashion, beauty, and style, but the important issues and ideas of the arts, health care, politics, and world affairs. Articles about European and American fashion designers suggest concepts, create new trends—and encourage ideas that keep life exciting and modern. This magazine did not respond to our request for information. Query before submitting.

VOICE OF SOUTH MARION, P.O. Box 700, Belleview FL 34421. (904)245-3161. E-mail: vosn@aol.com. Editor: Jim Waldron. Circ. 1,800. Estab. 1969. Weekly tabloid. Readers are male and female, ages 12-65, working in agriculture and various small town jobs. Sample copy $1.
Needs: Uses 15-20 photos/issue; 2 supplied by freelance photographers. Features pictures that can stand alone with a cutline. Captions required.
Making Contact & Terms: Send b&w or color prints by mail for consideration. SASE. Reports in 2 weeks. Pays $10/b&w cover; $5/b&w inside. Pays on publication. Credit line given. Buys one-time rights.

N VOLUPTUOUS, 13360 S.W. 128 St., Miami FL 33186. (305)238-5040. Fax: (305)238-6716. E-mail: gablel@scoregroup.com. Associate Editor: Lisa Gable. Circ. 110,000. Estab. 1994. Published 13 times/year. *Voluptuous* specializes in nude pictorials of Rubenesque models. Readers are males, 18-50 years of age. Sample copy $7. Photo guidelines free with SASE.
Needs: Uses 250 photos/issue; all supplied by freelancers. Model release required; also requires photo identification and/or birth certificate for models.
Making Contact & Terms: Query with stock photo list. Send unsolicited photos by mail for consideration. Send 35mm transparencies or larger format. Kodachrome film. SASE. Reports in 1 month. Pays $1,250-1,800 for color sets of 100-200 transparencies. "Please do not send individual photos except for test shots." Pays on publication. Credit line given (if requested). Buys first North American rights with

reprint option, electronic rights and non-exclusive worldwide publishing rights; negotiable. Previously published work OK, but pays at a lesser, second rights page rate.

Tips: "Study sample copies of our magazine before submitting. Pre-edit your material before submitting. We're impressed by quality of photos and variety of poses—not just quantity."

THE WAR CRY, The Salvation Army, 615 Slaters Lane, Alexandria VA 22313. (703)684-5500. Fax: (703)684-5539. E-mail: warcry@usn.salvationarmy.org. Website: http://www.publications.salvationarmyus a.org. Editor-in-Chief: Lt. Colonel Marlene Chase. Circ. 300,000. Publication of The Salvation Army. Biweekly. Emphasizes the inspirational. Readers are general public and membership. Sample copy free with SASE.

Needs: Uses about 6 photos/issue. Needs "inspirational, scenic, general photos and photos of people that match our themes (write for theme list)."

Making Contact & Terms: Send color prints or color slides by mail for consideration. Accepts images in digital format for Mac. Send via compact disc, SyQuest, floppy disk, Jaz disk and preferably high resolution. SASE. Reports in 2 weeks. Pays up to $200/color photo; payment varies for text/photo package. **Pays on acceptance.** Credit line given "if requested." Buys one-time rights. Simultaneous submissions and previously published work OK.

Tips: "Write for themes; send a brochure and/or samples. Get a copy of our publication first. We use clear shots, and are trying to merge out of 'posed' stock photography."

WASHINGTONIAN, 1828 L St. NW, Suite 200, Washington DC 20036. (202)296-3600. Fax: (202)785-1822. Photo Editor: Jay Sumner. Monthly city/regional magazine emphasizing Washington metro area. Readers are 40-50, 54% female, 46% male and middle to upper middle professionals. Circ. 160,000. Estab. 1965.

Needs: Uses 75-150 photos/issue; 100% supplied by freelance photographers. Needs photos for illustration, portraits, reportage; tabletop of products, food; restaurants; nightlife; house and garden; fashion; and local and regional travel. Model release preferred; captions required.

Making Contact & Terms: Submit portfolio for review. Provide résumé, business card, brochure, flier or tearsheets to be kept on file for possible assignments. Pays $125-250/b&w photo; $150-300/color photo; $175-$350/day. Credit line given. Buys one-time rights ("on exclusive shoots we share resale").

Tips: "Read the magazine you want to work for. Show work that relates to its needs. Offer photo-story ideas. Send samples occasionally of new work."

THE WATER SKIER, 799 Overlook Dr., Winter Haven FL 33884. (941)324-4341. Fax: (941)325-8259. E-mail: 76774.1141@compuserve. com. Website: usawaterski.org. Editor: Greg Nipon. Circ. 30,000. Estab. 1950. Publication of the American Water Ski Association. Magazine published 7 times a year. Emphasizes water skiing. Readers are male and female professionals ages 20-45. Sample copy $2.50. Photo guidelines available.

Needs: Uses 25-35 photos/issue. 1-5 supplied by freelancers. Needs photos of sports action. Model/property release required. Captions required.

Making Contact & Terms: Call first. Accepts images in digital format for Mac (TIFF). Send via compact disc, floppy disk or SyQuest. SASE. Reports in 1 month. Pays $25-50/b&w photo; $50-150/color photo. Pays on publication. Credit line given. Buys all rights.

WATERCRAFT WORLD, 601 Carlson Pkwy, #600, Minnetonka MN 55305. (612)476-2200. Fax: (612)476-8065. E-mail: editor@watercraftworld.com. Website: http://www.ehlertpowersports.com. Associate Editor: Matt Gruhn. Circ. 40,000. Estab. 1987. Published 9 times/year. Emphasizes personal watercraft (jet skis). Readers are 95% male, average age 35, boaters, outdoor enthusiasts. Sample copy $3.

● This publication is doing more storing of images on CD and computer manipulation of photos.

Needs: Uses 30-50 photos/issue; 25% supplied by freelancers. Needs photos of jet ski travel, action, technology, race coverage. Model/property release required. Captions preferred.

Making Contact & Terms: Query with résumé of credits. Provide résumé, business card, brochure, flier or tearsheets to be kept on file for possible future assignments. "Call with ideas." Also accepts digital images for Mac via SyQuest, Photo CD, Zip disk and floppy disk at 266 dpi minimum. SASE. Reports in

THE SUBJECT INDEX, located at the back of this book, lists publications, book publishers, galleries, gift and paper product companies and stock agencies according to the subject areas they seek.

1 month. Pays $20-200/b&w photo; $25/color photo; $250/color cover. Pays on publication. Credit line given. Rights negotiable.

WATERWAY GUIDE, 6151 Powers Ferry Rd. NW, Atlanta GA 30339. (770)618-0313. Fax: (770)618-0349. Editor: Judith Powers. Circ. 50,000. Estab. 1947. Cruising guides with 3 annual regional editions. Emphasizes recreational boating. Readers are men and women ages 25-65, management or professional, with average income $95,000 a year. Sample copy $31.95 and $3 shipping. Photo guidelines free with SASE.
Needs: Uses 10-15 photos/issue; all supplied by freelance photographers. Needs photos of boats, Intracoastal Waterway, bridges, landmarks, famous sights and scenic waterfronts. Expects to use more coastal shots from Maine to the Bahamas; also, Hudson River, Lake Champlain and Gulf of Mexico. Model release required. Captions required.
Making Contact & Terms: Send unsolicited photos by mail for consideration. Send color prints or 35mm transparencies. SASE. Reports in 4 months. Pays $600/color cover; $50/color inside. Pays on publication. Credit line given. Must sign contract for copyright purposes.

WESTERN HORSEMAN, P.O. Box 7980, Colorado Springs CO 80933. (719)633-5524. Editor: Pat Close. Monthly magazine. Circ. 230,000. Estab. 1936. Readers are active participants in western horse activities, including pleasure riders, ranchers, breeders and riding club members. Model/property release preferred. Captions required; include name of subject, date, location.
Needs: Articles and photos must have a strong horse angle, slanted towards the western rider—rodeos, shows, ranching, stable plans, training. "We do not buy single photographs/slides; they must be accompanied by an article. The exception: We buy 35mm color slides for our annual cowboy calendar. Slides must depict ranch cowboys/cowgirls at work."
Making Contact & Terms: Submit material by mail for consideration. Pays $25/b&w photo; $50-75/ color photo; $400-600 maximum for articles. For the calendar, pays $125-225/slide. "We buy mss and photos as a package." Payment for 1,500 words with b&w photos ranges from $100-600. Buys one-time rights; negotiable.
Tips: "For color, we prefer 35mm slides. For b&w, either 5×7 or 8×10 glossies. We can sometimes use color prints if they are of excellent quality. In all prints, photos and slides, subjects must be dressed appropriately. Baseball caps, T-shirts, tank tops, shorts, tennis shoes, bare feet, etc., are unacceptable."

WESTERN OUTDOORS, 3197-E Airport Loop, Costa Mesa CA 92626. (714)546-4370. E-mail: woutd oors@aol.com. Editor: Jack Brown. Circ. 100,000. Estab. 1961. Magazine published 9 times/year. Emphasizes fishing and boating for Far West states. Sample copy $2; OWAA members, $1. Editorial and photo guidelines free with SASE.
Needs: Uses 80-85 photos/issue; 70% supplied by freelancers; 80% comes from assignments, 25% from stock. Cover photos of fishing in California, Oregon, Washington, Baja. "We are moving toward 100% four-color books, meaning we are buying only color photography. A special subject need will be photos of boat-related fishing, particularly small and trailerable boats and trout fishing cover photos." Most photos purchased with accompanying ms. Model/property release preferred for women and men in brief attire. Captions required.
Making Contact & Terms: Query or send photos for consideration. Send 35mm transparencies. SASE. Reports in 3 weeks. Pays $50-150/color; $250/cover; $400-600 for text/photo package. **Pays on acceptance**. Buys one-time rights for photos only; first North American serial rights for articles; electronic rights are negotiable.
Tips: "Submissions should be of interest to Western fishermen, and should include a 1,120-1,500 word ms; a Trip Facts Box (where to stay, costs, special information); photos; captions; and a map of the area. Emphasis is on fishing and hunting how-to, somewhere-to-go. Submit seasonal material 6 months in advance. Make your photos tell the story and don't depend on captions to explain what is pictured. Avoid 'photographic cliches' such as 'dead fish with man.' Get action shots, live fish. In fishing, we seek individual action or underwater shots. For cover photos, use vertical format composed with action entering picture from right; leave enough left-hand margin for cover blurbs, space at top of frame for magazine logo. Add human element to scenics to lend scale. Get to know the magazine and its editors. Ask for the year's editorial schedule (available through advertising department) and offer cover photos to match the theme of an issue. In samples, looks for color saturation, pleasing use of color components; originality, creativity; attractiveness of human subjects, as well as fish; above all—sharp, sharp, sharp focus! Send duplicated transparencies as samples, but be prepared to provide originals." Sees trend toward electronic imagery, computer enhancement and electronic transmission of images.

WHERE CHICAGO MAGAZINE, 1165 N. Clark St., Chicago IL 60610. (312)642-1896. Fax: (312)642-5467. Editor: Margaret Doyle. Circ. 100,000. Estab. 1985. Monthly magazine. Emphasizes shopping, dining, nightlife and entertainment available in Chicago and its suburbs. Readers are male and female traveling executives and tourists, ages 25-55. Sample copy $4.

Needs: Uses 1 photo/issue; 90% supplied by freelancers. Needs scenic, seasonal shots of Chicago; "must include architecture or landmarks that identify a photo as being shot in Chicago." Reviews photos with or without ms. "We look for seasonal shots on a monthly basis." Model/property release required. Captions required.

Making Contact & Terms: Send unsolicited photos by mail for consideration. Provide résumé, business card, brochure, flier or tearsheets to be kept on file for possible assignments. Send 35mm, 2¼×2¼, 4×5, 8×10 transparencies. SASE. Reports in 1 month. Pays $300/color cover. **Pays on acceptance.** Credit line given. Buys one-time rights; negotiable. Simultaneous submissions and previously published work OK.

Tips: "We only consider photos of downtown Chicago, without people in them. Shots should be colorful and current, in a vertical format. Keep our deadlines in mind. We look for covers two months in advance of issue publication."

WHERE MAGAZINE, 475 Park Ave. S., Suite 2100, New York NY 10016. (212)725-8100. Fax: (212)725-3412. Editor-in-Chief: Lois Anzelowitz-Tanner. Circ. 119,000. Estab. 1936. Monthly. Emphasizes points of interest, shopping, restaurants, theater, museums, etc. in New York City (specifically Manhattan). Readers are visitors to New York staying in the city's leading hotels. Sample copy available in hotels.

Needs: Buys cover photos only. Covers showing New York scenes; color photos only. Vertical compositions preferred. Model release preferred. Captions preferred.

Making Contact & Terms: Arrange a personal interview to show portfolio. Does not return unsolicited material. Pays $300-500/color photo. Pays on publication. Credit line given. Rights purchased vary. Simultaneous submissions and previously published work OK.

:N: WIESNER INC., 7009 S. Potomac, Englewood CO 80112. (303)397-7600 Fax: (303)397-7619. E-mail: rgriggs@winc.usa.com. Website: http://www.mtnliving.com. Art Director: Loneta Showell. Consumer magazines. Publishes the following magazines: *Atlanta Homes & Lifestyles*; *Colorado Homes & Lifestyles Magazine*; *Seattle Homes and Lifestyles*; *St. Louis Homes & Lifestyles*; *Mountain Living*; *Colorado Business*; and *Mountain Pilot*.

Needs: Needs photos of homes, architecture, art, sports and travel.

Making Contact & Terms: Send query letter with samples. Provide résumé, business card, self-promotion piece or tearsheets to be kept on file for possible future assignments. Does not keep samples on file. Reports in 6 weeks on queries. Reports back only if interested, send non-returnable samples. **Pays on acceptance.** Simultaneous submissions and/or previously published work OK.

WINDSURFING, 330 W. Canton Ave., Winter Park FL 32789. (407)628-4802. Fax: (407)628-7061. Editor: Tom James. Managing Editor: Jason Upright. Circ. 75,000. Monthly magazine published 8 times/year. Emphasizes board-sailing. Readers are all ages and all income groups. Sample copy free with SASE. Photo guidelines free with SASE.

Needs: Uses 80 photos/issue; 60% supplied by freelance photographers. Needs photos of boardsailing, flat water, recreational travel destinations to sail. Model/property release preferred. Captions required; include who, what, where, when, why.

Making Contact & Terms: Query with samples. Send unsolicited photos by mail for consideration. Provide résumé, business card, brochure, flier or tearsheets to be kept on file for possible future assignments. Send 35mm, 2¼×2¼ and 4×5 transparencies by mail for consideration. Kodachrome and slow Fuji preferred. SASE. Reports in 3 weeks. Pays $450/color cover; $40-150/color inside; $25-100/b&w inside. Pays on publication. Credit line given. Buys one-time rights unless otherwise agreed on. Previously published work OK.

Tips: Prefers to see razor sharp, colorful images. The best guideline is the magazine itself. "Get used to shooting on, in or under water. Most of our needs are found there."

WINE & SPIRITS, 2 West 32nd, Suite 601, New York NY 10001. (212)695-4660, ext. 12. Fax: (212)695-2920. E-mail: winespir@aol.com. Art Director: Peter A. Johnstone. Circ. 70,000. Estab. 1985. Bimonthly magazine. Emphasizes wine. Readers are male, ages 39-60, married, parents, children, $70,000 plus income, wine consumers. Sample copy $2.95; September and November special issues $6.50.

Needs: Uses 0-30 photos/issue; all supplied by freelancers. Needs photos of food, wine, travel, people. Captions preferred; include date, location.

Making Contact & Terms: Submit portfolio for review. Provide résumé, business card, brochure, flier or tearsheets to be kept on file for possible assignments. Accepts images in digital format for Mac. Send

via SyQuest, Zip disk (266 dpi). Reports in 1-2 weeks, if interested. Pays $200-1,000/job. Pays on publication. Credit line given. Buys one-time rights. Simultaneous submissions OK.

N WISCONSIN SNOWMOBILE NEWS, P.O. Box 182, Rio WI 53960-0182. (920)992-6370. E-mail: wisnow@peoples.net. Editor: Cathy Hanson. Circ. 34,000. Estab. 1969. Publication of the Association of Wisconsin Snowmobile Clubs. Magazine published 7 times/year. Emphasizes snowmobiling. Sample copy free with 9 × 12 SAE and 4 first-class stamps.
Needs: Uses 20-24 photos/issue; 85% supplied by freelancers. Needs photos of snowmobile action, posed snowmobiles, travel, new products. Model/property release preferred. Captions preferred; include where, what, when.
Making Contact & Terms: Submit portfolio for review. Send unsolicited photos by mail for consideration. Provide résumé, business card, brochure, flier or tearsheets to be kept on file for possible assignments. Send 8 × 10 glossy color and b&w prints; 35mm, 2¼ × 2¼, 4 × 5, 8 × 10 transparencies. Keeps samples on file. SASE. Reports in 1-2 weeks. Pays $10-50/color photo. Pays on publication. Credit line given. Buys one-time rights, all rights; negotiable. Simultaneous submissions and/or previously published work OK.

WISCONSIN TRAILS, Dept. PM, P.O. Box 5650, Madison WI 53705. (608)231-2444. Photo Editor: Nancy Mead. Circ. 35,000. Bimonthly magazine. For people interested in history, travel, recreation, personalities, the arts, nature and Wisconsin in general. Sample copy $4. Photo guidelines free with SASE.
Needs: Buys 300 photos/year. Seasonal scenics and photos relating to Wisconsin. Annual Calendar: uses horizontal and vertical formats; scenic photographs. Wants no color or b&w snapshots, color negatives, cheesecake, shots of posed people, b&w negatives ("proofs or prints, please") or "photos of things clearly not found in Wisconsin. We greatly appreciate caption info."
Making Contact & Terms: Query with résumé of credits. Arrange a personal interview to show portfolio. Submit portfolio or submit contact sheet or photos for consideration. Provide calling card and flier to be kept on file for possible future assignments. Send contact sheet or 5 × 7 or 8 × 10 glossy b&w prints. Send transparencies; "we use all sizes." Send 35mm, 2¼ × 2¼ or 4 × 5 transparencies for cover; "should be strong seasonal scenics or people in action." Uses vertical format; top of photo should lend itself to insertion of logo. Locations preferred and needed. SASE. Reports in 3 weeks. Pays $125-200/calendar and cover photos; $50-100/b&w photo. Pays on publication. Buys first serial rights or second serial (reprint) rights. Simultaneous submissions OK "only if we are informed in advance." Previously published work OK.
Tips: "Because we cover only Wisconsin and because most photos illustrate articles (and are done by freelancers on assignment), it's difficult to break into *Wisconsin Trails* unless you live or travel in Wisconsin." Also, "be sure you specify how you want materials returned. Include postage for any special handling (insurance, certified, registered, etc.) you request."

N WOMAN ENGINEER, Equal Opportunity Publications, Inc., 1160 E. Jericho Turnpike, Suite 200, Huntington NY 11743. (516)421-9478. Fax: (516)421-0359. Editor: Anne Kelly. Circ. 16,000. Estab. 1979. Published three times a year. Emphasizes career guidance for women engineers at the college and professional levels. Readers are college-age and professional women in engineering. Sample copy free with 9 × 12 SAE and 6 first-class stamps.
Needs: Uses at least one photo per issue (cover); planning to use freelance work for covers and possibly editorial; most of the photos are submitted by freelance writers with their articles. Model release preferred. Captions required.
Making Contact & Terms: Query with list of stock photo subjects or call to discuss our needs. SASE. Reports in 6 weeks. Pays $25/color cover photo; $15/b&w photo; $15/color photo. Pays on publication. Credit line given. Buys one-time rights. Simultaneous submissions OK.
Tips: "We are looking for strong, sharply focused photos or slides of women engineers. The photo should show a woman engineer at work, but the background should be uncluttered. The photo subject should be dressed and groomed in a professional manner. Cover photo should represent a professional woman engineer at work, convey a positive and professional image. Read our magazine, and find actual women engineers to photograph. We're not against using cover models, but we prefer cover subjects to be women engineers working in the field."

N WOMAN'S DAY SPECIAL INTEREST PUBLICATIONS, Hachette Filipacchi Magazines, 1633 Broadway, New York NY 10019. (212)767-6794. Fax: (212)767-5612. Associate Art Director: Peter Hedrington. Circ. 100,000. Estab. 1970. "*Woman's Day Special Interest Publications* are high-end one subject consumer magazines. 41 issues are produced annually with subjects ranging from food, health, home decorating and remodeling, crafts and Christmas Ideas."
Needs: Buys 50 photos from freelancers/issue; 2,000 photos/year. Needs photos of food, crafts, interiors,

kids, gardening, remodeling projects, health, Christmas and holidays. Reviews photos with or without a ms. Model/property release preferred. Photo captions preferred.

Making Contact & Terms: Send query letter with samples, tearsheets. Provide résumé, business card, self-promotion piece or tearsheets to be kept on file for possible future assignments. Art director will contact photographer for portfolio review if interested. Portfolio should include tearsheets or transparencies. Uses 35mm, 2¼×2¼, 4×5 transparencies. Keeps samples on file; cannot return material. Reports back only if interested, send non-returnable samples. Payment negotiable. **Pays on acceptance.** Credit line given. Buys one-time rights. Simultaneous submissions and/or previously published work OK.

Tips: "All materials should be tasteful and upscale. Always include card to keep on file and sample that can also be kept. Trends include the use of natural light and simple but sophisticated proping."

WOMEN'S SPORTS AND FITNESS MAGAZINE, 2025 Pearl St., Boulder CO 80302. (303)440-5111. Fax: (303)440-3313. Editorial Manager: Laurie Russo. Art Director: Theron Moore. Circ. 210,000. Estab. 1974. Published 8 times/year. Readers want to celebrate an active lifestyle through the spirit of sports. Recreational interests include participation in two or more sports, particularly cycling, running and swimming. Sample copy and photo guidelines free with SASE.

Needs: 80% of photos supplied by freelance photographers. Needs photos of indoor and outdoor fitness, product shots (creative approaches as well as straight forward), outdoor action and location. Model release preferred. Captions preferred.

Making Contact & Terms: Write before submitting material to receive photo schedule. The photographer must first send printed samples, then call to set up an appointment. Provide business card, brochure, flier or tearsheets to be kept on file for possible future assignments. "I prefer to see promo cards and tearsheets first to keep on file. Then follow up with a call for specific instructions." Accepts images in digital format for Mac (QuarkXPress, Photoshop). Send via compact disc, online, floppy disk, SyQuest, Zip disk. SASE. Reports in 1 month. Pays $125-400/b&w or color photo; $200-400/day; $200-3,000 (fees and expenses)/job. Pays on publication. Credit line given. Buys one-time rights.

Tips: Looks for "razor sharp images and nice light. Check magazine before submitting query. We look especially for photos of women who are genuinely athletic in active situations that actually represent a particular sport or activity. We want to see less set-up, smiling-at-the-camera shots and more spontaneous, real-action shots. We are always interested in seeing new work and new styles of photography."

WOMENWISE, CFHC, Dept. PM, 38 S Main St., Concord NH 03301. (603)225-2739. Fax: (603)228-6255. Editor: Luita Spangler. Circ. 3,000. Estab. 1978. Publication of the Concord Feminist Health Center. Quarterly tabloid. Emphasizes women's health from a feminist perspective. Readers are women, all ages and occupations. Sample copy $2.95.

Needs: All photos supplied by freelancers; 80% assignment; 20% or less stock. Needs photos of primarily women, women's events and demonstrations, etc. Model release required. Captions preferred.

Making Contact & Terms: Arrange a personal interview to show portfolio. Send b&w prints. Pays $15/b&w cover photo; sub per b&w inside photo. Pays on publication. Credit line given. Buys first North American serial rights.

Tips: "We don't publish a lot of 'fine-arts' photography now. We want photos that reflect our commitment to empowerment of all women. We prefer work by women. Do not send originals to us, even with SASE. We are small (staff of three) and lack the time to return original work."

WOODENBOAT MAGAZINE, P.O. Box 78, Brooklin ME 04616. (207)359-4651. Fax: (207)359-8920. Editor: Matthew P. Murphy. Circ. 105,000. Estab. 1974. Bimonthly magazine. Emphasizes wooden boats. Sample copy $4.95. Photo guidelines free with SASE.

Needs: Uses 100-125 photos/issue; 95% supplied by freelancers. Needs photos of wooden boats: in use, under construction, maintenance, how-to. Captions required; include identifying information, name and address of photographer on each image.

Making Contact & Terms: Query with stock photo list. Keeps samples on file. SASE. Reports in 1 month. Pays $350/day; $350/color cover; $25-125/color inside; $15-75/b&w page rate. Pays on publication. Credit line given. Buys first North American serial rights. Simultaneous submissions and/or previously published work OK with notification.

WOODMEN, 1700 Farnam St., Omaha NE 68102. (402)342-1890. Fax: (402)271-7269. E-mail: service-@woodmen.com. Website: http://www.woodmen.com. Editor: Scott J. Darling. Assistant Editor: Billie Jo Foust. Circ. 507,000. Estab. 1890. Official publication for Woodmen of the World/Omaha Woodmen Life Insurance Society. Bimonthly magazine. Emphasizes American family life. Free sample copy and photographer guidelines.

Needs: Buys 15-20 photos/year. Needs photos of the following themes: historic, family, insurance, animal,

fine art, photo essay/photo feature, scenic, human interest, humorous; nature, still life, travel, health and wildlife. Model release required. Captions preferred.

Making Contact & Terms: Send material by mail for consideration. Uses 8×10 glossy b&w prints on occasion; 35mm, 2¼×2¼ and 4×5 transparencies; 4×5 transparencies for cover, vertical format preferred. SASE. Accepts images in digital format for Mac. Send high res scan via Zip or compact disk. Reports in 1 month. Pays $50/b&w inside; $75 minimum/color inside; $300/cover. **Pays on acceptance.** Credit line given on request. Buys one-time rights. Previously published work OK.

Tips: "Submit good, sharp pictures that will reproduce well."

[N] [globe] WOODTURNING. 166 High St., Lewes E. Sussex BN7 1XU United Kingdom. Phone: (01273)477374. Fax: (01273)487692. Editor: Terry Porter. Circ. 30,000. Estab. 1990. Published 12 times per year. Emphasizes woodturning. Readers are mostly male, age 30 and older. Sample copy £3.25 (English currency), $6.50, £1, $2 (US) first-class stamps.

Needs: Reviews photos with accompanying ms only. "Photos nearly all sent by writers with articles." Some gallery photos of work, rest how-to with projects. Captions required.

Making Contact & Terms: Provide résumé, business card, brochure, flier or tearsheets to be kept on file for possible future assignments. Keeps samples on file sometimes. SASE. Reports in 2 weeks. Pays £50/color page rate; £50/page. Pays on publication. Credit line given if requested. Buys one-time rights. Considers simultaneous submission and/or previously published work (photos).

Tips: "We normally only consider articles on woodturning or woodturners with photos. Occasionally we use unusual photos with captions of woodturnings."

WRESTLING WORLD, Sterling/MacFadden, 233 Park Ave. S., New York NY 10003. (212)780-3500. Fax: (212)780-3555. Editor: Stephen Ciacciarelli. Circ. 50,000. Bimonthly magazine. Emphasizes professional wrestling superstars. Readers are wrestling fans. Sample copy $3.50 with 9×12 SAE and 3 first-class stamps.

Needs: Uses about 60 photos/issue; all supplied by freelance photographers. Needs photos of wrestling superstars, action and posed, color slides and b&w prints.

Making Contact & Terms: Query with representative samples, preferably action. SASE. Reports ASAP. Pays $150/color cover; $75/color inside; $50-125/text/photo package. **Pays on acceptance.** Credit line given on color photos. Buys one-time rights.

[N] YOGA JOURNAL, 2054 University Ave., Suite 600, Berkeley CA 94704. (510)841-9200. Fax: (510)644-3101. E-mail: jonathan@yogajournal.com. Website: http://www.yogajournal.com. Art Director: Jonathan Wieder. Circ. 108,000. Estab. 1975. Bimonthly magazine. Emphasizes yoga, holistic health, bodywork and massage, meditation, and Eastern spirituality. Readers are female, college educated, median income, $74,000, and median age, 47. Sample copy $5.

Needs: Uses 20-30 photos/issue; 1-5 supplied by freelancers. Needs photos of travel, editorial by assignment. Special photo needs include botanicals, foreign landscapes. Model release preferred. Captions preferred; include name of person, location.

Making Contact & Terms: "Do not send unsolicited original art." Provide samples or tearsheets for files. Uses 35mm, 2¼×2¼, 4×5, 8×10 transparencies. Keeps samples on file. Accepts images in digital format for Mac (EPS or TIFF). Send via compact disc, Zip disk or online at 300 dpi. Reports in 1 month only if requested. Pays $50-100/b&w photo; pays $100-200/color photo. **Pays on acceptance.** Buys one-time rights.

Tips: Seeking electronic files.

YOUR HEALTH, 5401 NW Broken Sound Blvd., Boca Raton FL 33487. (800)749-7733, (561)997-7733. Fax: (561)997-9210. E-mail: yhealth@aol.com. Website: http://www.yourhealthmag.com. Editor: Susan Gregg. Photo Editor: Judy Browne. Circ. 40,000. Estab. 1963. Monthly magazine. Emphasizes healthy lifestyles: aerobics, sports, eating, celebrity fitness plans, plus medical advances and the latest technology. Readers are consumer audience; males and females 20-70. Sample copy free with 9×12 SASE. Call for photo guidelines.

Needs: Uses 40-45 photos/issue; all supplied by freelance photographers. Needs photos depicting lifestyles, nutrition and diet, sports (runners, tennis, hiking, swimming, etc.), food, celebrities, arthritis, back

CONTACT THE EDITOR, of *Photographer's Market* by e-mail at photomarket@fwpubs.com with your questions and comments.

pain, headache, etc. Also any photos illustrating exciting technological or scientific breakthroughs. Model release required.

Making Contact & Terms: Provide résumé, business card, brochure, flier or tearsheets to be kept on file for possible future assignments, and call to query interest on a specific subject. Accepts images in digital format for Mac. SASE. Reports in 2 weeks. Pay depends on photo size and color. Pays $50-100/ b&w photo; $75-200/color photo; $75-150/photo/text package. Pays on publication. Buys one-time rights. Simultaneous submissions and previously published work OK.

Tips: "Pictures and subjects should be interesting; bright and consumer-health oriented. We are using both magazine-type mood photos, and hard medical pictures. We are looking for different, interesting, unusual ways of illustrating the typical fitness, health nutrition story; e.g. an interesting concept for fatigue, insomnia, vitamins. Send prints or dupes to keep on file. Our first inclination is to use what's on hand."

YOUR MONEY MAGAZINE, 8001 Lincoln Ave., 6th Floor, Skokie IL 60077-3657. Art Director: Beth Ceisel. Circ. 500,000. Estab. 1979. Bimonthly magazine. Emphasizes personal finance.

Needs: Uses 18-25 photos/issue, 130-150 photos/year; all supplied by freelance assignment. Considers all styles depending on needs. "Always looking for quality location photography, especially environmental portraiture. We need photographers with the ability to work with people in their environment, especially people who are not used to being photographed." Model/property release required.

Making Contact & Terms: Portfolio drop off is the 2nd Tuesday of every month. Provide a business card, flier or tearsheets to be kept on file. Accepts images in digital format for Mac. Send via compact disc, online, floppy disk, Zip disk. Transparencies, slides, proofs or prints returned after publication. Samples not filed are returned with SASE. Reports only when interested. Pays up to $1,000/color cover; $450/b&w page; $200-500/b&w photo; $500/color page. **Pays on acceptance.** Credit line given.

Tips: "Show your best work. Include tearsheets in portfolio."

YOUTH RUNNER MAGAZINE, P.O. Box 1156, Lake Oswego OR 97035. (503)236-2524. Fax: (503)620-3800. E:mail: dank@youthrunner.com. Website: http://www.youthrunner.com. Editor: Dan Kesterson. Circ. 100,000. Estab. 1996. Quarterly magazine and website. Emphasizes track and cross country and road racing for young athletes, 8-18. Sample copy free with 9×12 SASE and 5 first-class stamps. Photo guidelines free with SASE.

Needs: Uses 30-50 photos/issue. Needs action shots from track and cross country meets and indoor meets. Model release preferred. Property release required. Captions preferred.

Making Contact & Terms: Send unsolicited photos by mail for consideration. Provide résumé, business card, brochure, flier or tearsheets to be kept on file for possible assignments. Call. Send transparencies. Accepts images in digital format. Keeps samples on file. SASE. Reports in 1 month. Payment $25 minimum. Credit line given. Buys all and electronic rights. Simultaneous submissions OK.

YOUTH UPDATE, St. Anthony Messenger Press, 1615 Republic St., Cincinnati OH 45210. (513)241-5615. Fax: (513)241-0399. Art Director/Youth Update: June Pfaff Daley. Circ. 27,000. Estab. 1982. Company publication. Monthly 4-page, 3-color newsletter. Emphasizes topics for teenagers (13-19) that deal with issues and practices of the Catholic faith but also show teens' spiritual dimension in every aspect of life. Readers are male and female teenagers in junior high and high school. Sample copy free with SASE.

Needs: Uses 2 photos/issue; 2 supplied by freelancers. Needs photos of teenagers in a variety of situations. Model/property release preferred. Captions preferred.

Making Contact & Terms: Query with stock photo list. Send unsolicited photos by mail for consideration. Provide résumé, business card, brochure, flier or tearsheets to be kept on file for possible future assignments. Uses b&w prints. Keeps samples on file. SASE. Reports in 1 month. Pays $75-90/hour; $200-300/job; $50/b&w cover; $50/b&w inside. Pays on publication. Buys one-time rights. Simultaneous submissions and/or previously published work OK.

NEWSPAPERS & NEWSLETTERS

When working with newspapers always remind yourself that time is of the essence. Newspapers have various deadlines for each section that is produced. An interesting feature or news photo has a better chance of getting in the next edition if the subject is timely and has a local appeal. Most of the markets in this section are interested in regional coverage. Find publications near you and contact editors to get an understanding of their deadline schedules.

Also, ask editors if they prefer certain types of film or if they want color slides or black and white prints. Many smaller newspapers do not have the capability to run color images, so black and white prints are preferred. However, color slides can be converted to black and white. Editors

who have the option of running color or black and white photos often prefer color film because of its versatility.

Although most newspapers rely on staff photographers, some hire freelancers as stringers for certain stories. Act professionally and build an editor's confidence in you by supplying innovative images. For example, don't get caught in the trap of shooting "grip-and-grin" photos when a corporation executive is handing over a check to a nonprofit organization. Turn the scene into an interesting portrait. Capture some spontaneous interaction between the recipient and the donor. By planning ahead you can be creative.

When you receive assignments think about the image before you snap your first photo. If you are scheduled to meet someone at a specific location, arrive early and scout around. Find a proper setting or locate some props to use in the shoot. Do whatever you can to show the editor that you are willing to make that extra effort.

Always try to retain resale rights to shots of major news events. High news value means high resale value, and strong news photos can be resold repeatedly. If you have an image with a national appeal, search for those larger markets, possibly through the wire services. You also may find buyers among national news magazines, such as *Time* or *Newsweek*.

While most newspapers offer low payment for images, they are willing to negotiate if the image will have a major impact. Front page artwork often sells newspapers, so don't underestimate the worth of your images.

N ☑ **ALBERTA SWEETGRASS**, Aboriginal Multi Media Society of Alberta, 15001 112 Ave., Edmonton, Alberta T5M 2V6 Canada. (403)455-2945. Fax: (403)455-7639. E-mail: edsweet@ammsa.com. Website: http://www.ammsa.com. Editor: Rob McKinley. Circ. 8,000. Estab. 1983. Monthly newspaper with emphasis on Aboriginal issues in Alberta i.e. native arts, crafts, sports, community events, powwows and news issues. Sample copy free. Art guidelines free.
Needs: Needs any human interest photos depicting Aboriginal lifestyles or events. Special photo needs include cultural photos of Aboriginal special events, powwows, round dances, or Aboriginal dignitaries for picture library file. Photo captions required; include name, age, place, date and Aboriginal background (what first nation or reserve they are from).
Making Contact & Terms: Provide résumé, business card, self-promotion piece or tearsheets to be kept on file for possible future assignments. Photographers should also telephone us. Uses color prints and 35mm transparencies. "Deadlines can be discussed over telephone." SASE. Reports in 1 month on queries. Pays $50/color cover maximum; $15/b&w inside maximum; $15/color inside maximum. Pays on publication. Credit line given. Buys all rights. Previously published work OK.
Tips: "We want photos that focus on events that are taking place away from a main event i.e. people getting ready for a powwow as well as the powwow itself. Cute kids are always good. When submitting your work, get it in on time, with time to spare. Include all information for the cutline and make sure names are correct."

AMERICAN MUSEUM OF NATURAL HISTORY LIBRARY, PHOTOGRAPHIC COLLECTION, Library Services Department, Central Park West, 79th St., New York NY 10024. (212)769-5419. Fax: (212) 769-5009. E-mail: speccol@amnh.org. Senior Special Collections Librarian: Barbara Mathè. Estab. 1869. Provides services for advertisers, authors, film and TV producers, general public, government agencies, picture researchers, publishers, scholars, students and teachers.
Needs: Model release required. Captions required.
Making Contact & Terms: "We accept only donations with full rights (nonexclusive) to use; we offer visibility through credits." Credit line given. Buys all rights.
Tips: "We do not review portfolios. Unless the photographer is willing to give up rights and provide images for donation with full rights (credit lines are given), the museum is not willing to accept work."

☒ AMERICAN SPORTS NETWORK, Box 6100, Rosemead CA 91770. (626)292-2222. Website: http://www.fitnessamerica.com or http://www.musclemania.com. President: Louis Zwick. Associate Producer: Ron Harris. Circ. 842,144. Publishes 4 newspapers covering "general collegiate, amateur and professional sports, i.e., football, baseball, basketball, wrestling, boxing, powerlifting and bodybuilding, fitness, health contests, etc."
Needs: Uses about 10-85 photos/issue in various publications; 90% supplied by freelancers. Needs "sport action, hard-hitting contact, emotion-filled photos. Publishes special bodybuilder annual calendar, collegiate

and professional football pre- and post-season editions." Model release and captions preferred.
Making Contact & Terms: Send 8×10 glossy b&w prints, 4×5 transparencies, video demo reel or film work by mail for consideration. Provide résumé, business card, brochure, flier or tearsheets to be kept on file for possible future assignments. SASE. Reports in 1 week. Pays $1,400/color cover; $400/inside b&w; negotiates rates by the job and hour. Pays on publication. Buys first North American serial rights. Simultaneous submissions and previously published work OK.

ANCHORAGE DAILY NEWS, Dept. PM, 1001 Northway Dr., Anchorage AK 99508. (907)257-4347. Editor: Pat Dougherty. Photo Editor: Richard Murphy. Daily newspaper. Emphasizes all Alaskan subjects. Readers are Alaskans. Circ. 71,000 weekdays, 94,000 Sundays. Estab. 1946. Sample copy free with 11×14 SAE and 8 first-class stamps.
Needs: Uses 10-50 photos/issue; 0-5% supplied by freelance photographers; most from assignment. Needs photos of all subjects, primarily Alaskan subjects. In particular, looking for freelance images for travel section; wants photos of all areas, especially Hawaii. Model release preferred. Captions required.
Making Contact & Terms: Contact photo editor with specific ideas. SASE. Reports in 1-3 weeks. Interested only in color submissions. Pays $35 minimum/color photo: photo/text package negotiable. Pays on publication. Credit line given. Buys one-time rights. Simultaneous submissions OK.
Tips: "We, like most daily newspapers, are primarily interested in timely topics, but at times will use dated material." In portfolio or samples, wants to see "eye-catching images, good use of light and active photographs."

ARIZONA BUSINESS GAZETTE, Box 194, Phoenix AZ 85001. (602)444-7300. Fax: (602)444-7363. General Manager: Stephanie Pressly. Circ. 8,000. Estab. 1880. Weekly newspaper.
Needs: 25% of photos come from assignments. Interested in business subjects, portraits and an ability to illustrate business series and concepts. Model release preferred. Captions required; include name, title and photo description.
Making Contact & Terms: Provide résumé, business card, brochure, flier or tearsheets to be kept on file for possible assignments. Cannot return unsolicited material. Reports when possible. Pays $95/color photo; $85/assignment; $125/day. Pays on publication. Buys one-time rights. Does not consider simultaneous submissions or previously published work.
Tips: Wants to see an "ability to shoot environmental portraits, creatively illustrate stories on business trends and an ability to shoot indoor, outdoor and studio work." Photographers should live in Arizona with some newspaper experience.

BAY & DELTA YACHTSMAN, Dept. PM, 155 Glendale Ave. #11, Sparks NV 89431-5751. (702)353-5100. Fax: (703)353-5111. E-mail: customer.service@yachtsforsale.com. Website: http://www.yachtsforsale.com. Publisher: Don Abbott. Circ. 25,000. Estab. 1965. Monthly slick tabloid. Emphasizes recreational boating for boat owners of northern California. Sample copy $3. Writer's guidelines free with SASE.
Needs: Buys 5-10 photos/issue. Wants sport photos; power and sail (boating and recreation in northern California); spot news (about boating); travel (of interest to boaters). Seeks mss about power boats and sailboats, boating personalities, locales, piers, harbors, and how-tos in northern California. Photos purchased with or without accompanying ms. Model release required. Captions preferred.
Making Contact & Terms: "We would love to give a newcomer a chance at a cover." Send material by mail for consideration. Uses any size b&w or color glossy prints. Uses color slides for cover. Vertical (preferred) or horizontal format. SASE. Reports in 1 month. Pays $5 minimum/b&w photo; $150 minimum/cover photo; $1.50 minimum/inch for ms. Pays on publication. Credit line given. Buys one-time rights. Simultaneous submissions or previously published work OK but must be exclusive in Bay Area (nonduplicated).
Tips: Prefers to see action b&w, color slides, water scenes. "We do not use photos as stand-alones; they must illustrate a story. The exception is cover photos, which must have a Bay Area application—power, sail or combination; vertical format with uncluttered upper area especially welcome."

BETHUNE THEATREDANSE, 8033 Sunset Blvd., Suite 221, Los Angeles CA 90046. (213)874-0481. Fax: (213)851-2078. Administrative Director: Marcy Hanigan. Estab. 1979. Dance company. Photos used in posters, newspapers, magazines.
Needs: Number of photos bought annually varies; offers 2-4 freelance assignments annually. Photographers used to take shots of dance productions, dance outreach classes (disabled children's program) and performances, and graphics and scenic. Examples of uses: promotional pieces for the dance production "Cradle of Fire" and for a circus fundraiser performance (all shots in 35mm format). Reviews stock photos if they show an ability to capture a moment. Captions preferred; include company or name of subject, date, and equipment shown in photo.

Audiovisual Needs: Uses slides and videotape. "We are a multimedia company and use videos and slides within our productions. We also use video for archival purposes." Subject matter varies.

Making Contact & Terms: Provide résumé, business card, self-promotion piece or tearsheets to be kept on file for possible future assignments. Uses 8×10 color or b&w prints; 35mm transparencies and videotape. Keeps samples on file. Cannot return material. Reports only when in need of work. Payment for each job is negotiated differently. Credit line sometimes given depending on usage. "We are not always in control of newspapers or magazines that may use photos for articles." Buys all rights; negotiable.

Tips: "We need to see an ability to see and understand the aesthetics of dance—its lines and depth of field. We also look for innovative approaches and personal signature to each individual's work. Our productions work very much on a collaborative basis and a videographer's talents and uniqueness are very important to each production. It is our preference to establish ongoing relationships with photographers and videographers."

[N] BIG APPLE PARENT, Family Communications, Inc. 36 E. 12th St., 4th Floor, New York NY 10003. (212)533-2277. Fax: (212)475-6186. E-mail: parentspaper@mindspring.com. Managing Editor: Helen Freedman. Circ. 62,000. Estab. 1985. Monthly newspaper. Sample copy free.

Needs: Buys 1-2 photos from freelancers/issue; 15 photos/year. Needs photos of kids and family themes. Reviews photos with or without a ms. Model release required.

Making Contact & Terms: "We need photocopies of available photos to keep on file." Uses color, b&w prints; 35mm transparencies. Keeps samples on file; include SASE for return of material. Reports in 1 week on samples. Pays $30/b&w inside maximum. Pays at the end of month following publication. Buys one-time New York City rights. Simultaneous submissions and previously published work OK.

Tips: "All kid and family themes are possible for us—from infant through teen. We are always looking for photos to illustrate our articles. Candid shots are best. We don't use portraiture. Our approach is journalistic. Send us photocopies of your photos that we can keep on file. Make sure your name, address and phone number is on every copy as we catalog according to theme. If your photo fits a particular story, we'll call you."

CALIFORNIA REDWOOD ASSOCIATION, 405 Enfrente Dr., Suite 200, Novato CA 94949. (415)382-0662. Fax: (415)382-8531. E-mail: allsebrook@world.net.att.net. Website: http://www.cal-lredwood.org. Publicity Manager: Pamela Allsebrook. Estab. 1916. "We publish a variety of literature, a small black and white periodical, run color advertisements and constantly use photos for magazine and newspaper publicity. We use new, well-designed redwood applications—residential, commercial, exteriors, interiors and especially good remodels and outdoor decks, fences, shelters."

Needs: Gives 40 assignments/year. Prefers photographers with architectural specialization. Model release required.

Making Contact & Terms: Send query material by mail for consideration for assignment or send finished speculation shots for possible purchase. Uses b&w prints. For color, uses 2¼×2¼ and 4×5 transparencies; contact sheet OK. Reports in 1 month. Payment based on previous use and other factors. Credit line given whenever possible. Usually buys all but national advertising rights. Simultaneous submissions and previously published work OK if other uses are made very clear.

Tips: "We like to see any new redwood projects showing outstanding design and use of redwood. We don't have a staff photographer and work only with freelancers. We generally look for justified lines, true color quality, projects with style and architectural design, and tasteful props. Find and take 'scout' shots or finished pictures of good redwood projects and send them to us."

CAPPER'S, 1503 SW 42nd St., Topeka KS 66609-1265. (800)678-5779, ext. 4346. Fax: (800)274-4305. Editor: Ann Crayhan. Circ. 370,000. Estab. 1879. Biweekly tabloid. Emphasizes human-interest subjects. Readers are "mostly Midwesterners in small towns and on rural routes." Sample copy $1.50.

Needs: Uses about 20-25 photos/issue, 1-3 supplied by freelance photographers. "We make no photo assignments. We select freelance photos with specific issues in mind." Needs "35mm color slides or larger transparencies of human-interest activities, nature (scenic), etc., in bright primary colors. We often use photos tied to the season, a holiday or an upcoming event of general interest." Captions preferred.

Making Contact & Terms: "Send for guidelines and a sample copy (SAE, 85¢ postage). Study the types of photos in the publication, then send a sheet of 10-20 samples with caption material for our consideration. Although we do most of our business by mail, a phone number is helpful in case we need more caption information. Phone calls to try to sell us on your photos don't really help." Accepts digital images through AP Leaf Desk. Reporting time varies. Pays $10-15/b&w photo; $30-40/color photo; only cover photos receive maximum payment. Pays on publication. Credit line given. Buys one-time rights.

Tips: "Generally, we're looking for photos of everyday people doing everyday activities. If the photographer can present this in a pleasing manner, these are the photos we're most likely to use. Season shots are

appropriate for *Capper's*, but they should be natural, not posed. We steer clear of dark, mood shots; they don't reproduce well on newsprint. Most of our readers are small town or rural Midwesterners, so we're looking for photos with which they can identify. Although our format is tabloid, we don't use celebrity shots and won't devote an area much larger than 5×6 to one photo."

CATHOLIC HEALTH WORLD, 4455 Woodson Rd., St. Louis MO 63134. (314)427-2500. Fax: (314)427-0029. Editor: Sandy Gilfillan. Circ. 11,500. Estab. 1985. Publication of Catholic Health Association. Semimonthly newspaper emphasizing health care—primary subjects dealing with our member facilities. Readers are hospital and long-term care facility administrators, public relations staff people. Sample copy free with 9×12 SASE.
Needs: Uses 4-15 photos/issue; 1-2 supplied by freelancers. Any photos that would help illustrate health concerns (i.e., pregnant teens, elderly). Model release required.
Making Contact & Terms: Send unsolicited photos by mail for consideration. Uses 5×7 or 8×10 b&w and color glossy prints. SASE. Reports in 2 weeks. Pays $40-60/photo. Pays on publication. Credit line given. Buys one-time rights. Simultaneous submissions OK.

COMPIX PHOTO AGENCY, 3621 NE Miami Court, Miami FL 33137. (305)576-0102. Fax: (305)576-0064. President: Alan J. Oxley. Estab. 1986. News/feature syndicate. Has 1 million photos. Clients include: mostly magazines and newspapers.
Needs: Wants news photos and news/feature picture stories, human interest, celebrities and stunts.
Specs: Uses 35mm, 2¼×2¼, 4×5, 8×10 transparencies.
Payment & Terms: Pays 50% commission. Photo captions required; include basic journalistic info.
Making Contact: "Send us some tearsheets. Don't write asking for guidelines."
Tips: "This is an agency for the true picture journalist, not the ordinary photographer. We are an international news service which supplies material to major magazines and newspapers in 30 countries, and we shoot hard news, feature stories, celebrities, royalty, stunts, animals and things bizarre. We offer guidance, ideas and assignments but work *only* with experienced, aggressive photojournalists who have good technical skills and can generate at least some of their own material."

DAILY BUSINESS REVIEW, 1 SE Third Ave., Suite 900, Miami FL 33131. (305)347-6622. Art Director: John Rindo. Staff Photographers: Aixa Montero-Green, Melanie Bell. Circ. 11,000. Estab. 1926. Daily newspaper. Emphasizes law, business and real estate. Readers are 25-55 years old, average net worth of $750,000, male and female. Sample copy for $3 with 9×11 SASE.
Needs: Uses 8 photos/issue; 10% supplied by freelance photographers. Needs mostly portraits, however we use live news events, sports and building mugs. Photo captions "an absolute must."
Making Contact & Terms: Arrange a personal interview to show portfolio. Submit portfolio for review. Send 35mm, 8×10 b&w and color prints. Accepts all types of finishes. Cannot return unsolicited material. If used, reports immediately. Pays $75-150 for most photos; pays more if part of photo/text package. Credit line given. Buys all rights; negotiable. Previously published work OK.
Tips: In photographer's portfolio, looks for "a good grasp of lighting and composition; the ability to take an ordinary situation and make an extraordinary photograph. We work on daily deadlines, so promptness is a must and extensive cutline information is needed."

FISHING AND HUNTING NEWS, Dept. PM, 511 Eastlake Ave. E., Box 19000, Seattle WA 98109. (206)624-3845. Managing Editor: Patrick McGann. Published 22 times/year, not in December or July. Emphasizes how-to material, fishing and hunting locations and new products for hunters and fishermen. Circ. 133,000. Free sample copy and photo guidelines.
Needs: Buys 300 or more photos/year. Wildlife—fish/game with successful fishermen and hunters. Captions required.
Making Contact & Terms: Send samples of work for consideration. Uses slide size transparencies and snapshot size b&w. SASE. Reports in 2 weeks. Pays $5-15 minimum/b&w print, $50-100 minimum/cover and $10-20 editorial color photos. Credit line given. **Pays on acceptance.** Buys all rights, but may reassign to photographer after publication. Submit model release with photo.
Tips: Looking for fresh, timely approaches to fishing and hunting subjects. Query for details of special issues and topics. "We need newsy photos with a fresh approach. Looking for near-deadline photos from Oregon, California, Utah, Idaho, Wyoming, Montana, Colorado, Texas, Alaska and Washington (sportsmen with fish or game)."

THE FRONT STRIKER BULLETIN, P.O. Box 18481, Asheville NC 28814. (704)254-4487. Fax: (704)254-1066. E-mail: bill@matchcovers.com. Owner: Bill Retskin. Circ. 700. Estab. 1986. Publication of The American Matchcover Collecting Club. Quarterly newsletter. Emphasizes matchcover collecting.

Readers are male, blue collar workers, average age 55 years. Sample copy $4.00
Needs: Uses 2-3 photos/issue; none supplied by freelancers. Needs table top photos of older match covers or related subjects. Reviews photos with accompanying ms only.
Making Contact & Terms: Send unsolicited photos by mail for consideration. Send 5×7 matte b&w prints. Keeps samples on file. SASE. Reports in 1 month. Payment negotiable. Pays on publication. Credit line given. Buys one-time rights; negotiable.

GLOBE, Dept. PM, 5401 NW Broken Sound Blvd., Boca Raton FL 33487. (561)989-1029. Photo Editor: Ron Haines. Circ. 2 million. Weekly tabloid. "For everyone in the family. *Globe* readers are the same people you meet on the street, and in supermarket lines—average, hard-working Americans."
Needs: Celebrity photos only!!!
Making Contact & Terms: Send transparencies or prints for consideration. Color preferred. SASE. Reports in 1 week. Pays $75/b&w photo (negotiable); $125/color photo (negotiable); day and package rates negotiable. Buys first serial rights. Pays on publication unless otherwise arranged.
Tips: "Do **NOT** write for photo guidelines. Study the publication instead."

GRAND RAPIDS BUSINESS JOURNAL, 549 Ottawa NW, Grand Rapids MI 49503. (616)459-4545. Fax: (616)459-4800. Editor: Carole Valade. Circ. 6,000. Estab. 1983. Weekly tabloid. Emphasizes West Michigan business community. Sample copy $1.
Needs: Uses 10 photos/issue; 100% supplied by freelancers. Needs photos of local community, manufacturing, world trade, stock market, etc. Model/property release required. Captions required.
Making Contact & Terms: Query with résumé of credits. Query with stock photo list. Deadlines: two weeks prior to publication. SASE. Reports in 1 month. Pays $25-35/b&w cover; $35/color inside; $25/b&w inside. Pays on publication. Credit line given. Buys one-time rights, first North American serial rights; negotiable. Simultaneous submissions and previously published work OK.

GULF COAST GOLFER, 9182 Old Katy Rd., Suite 212, Houston TX 77055. (713)464-0308. Editor: Bob Gray. Circ. 35,000. Monthly tabloid. Emphasizes golf below the 31st parallel area of Texas. Readers are age 40 and older, $72,406 average income, upscale lifestyle and play golf 2-5 times weekly. Sample copy free with SASE and 9 first-class stamps.
Needs: "Photos are bought only in conjunction with purchase of articles." Model release preferred. Captions preferred.
Making Contact & Terms: "Use the telephone." SASE. Reports in 2 weeks. Payment negotiable. Pays on publication. Credit line given. Buys one-time rights or all rights, if specified.

N INSIDE TEXAS RUNNING, Dept. PM, 9514 Bristlebrook, Houston TX 77083. (281)498-3208. Fax: (281)879-9980. E-mail: insidetxrunning@prodigy.net. Website: http://www.runningnetwork.com/texasrunning. Publisher/Editor: Joanne Schmidt. Circ. 10,000. Estab. 1977. Tabloid published 10 times/year. Readers are Texas runners and joggers of all abilities. Sample copy for 9 first-class stamps.
Needs: Uses about 16 photos/issue; 10 supplied by freelancers; 80% percent of freelance photography in issue comes from assignment from freelance stock. Needs photos of "races, especially outside of Houston area; scenic places to run; how-to (accompanying articles by coaches); also triathlon and road races." Special needs include "top race coverage; running camps (summer); variety of Texas running terrain." Captions preferred.
Making Contact & Terms: Send glossy b&w or color prints by mail for consideration. SASE. Reports in 1 month. Pays $10-25/b&w or color inside; $10-50/color cover. Pays on publication. Credit line given. Buys one-time rights; negotiable. Simultaneous submissions outside Texas and previously published work OK.
Tips: Prefers to see "human interest, contrast and good composition" in photos. Must use color prints for covers. "Look for the unusual. Race photos tend to look the same." Wants "clear photos with people near front; too often photographers are too far away when they shoot and subjects are a dot on the landscape." Wants to see road races in Texas outside of Houston area.

INTERNATIONAL PUBLISHING MANAGEMENT ASSOCIATION, 1205 W. College St., Liberty MO 64068-3733. (816)781-1111. Fax: (816)781-2790. E-mail: ipmainfo@ipma.org. Website: http://www.ipma.org. Membership association for corporate publishing professionals. Photos used in brochures and newsletters.

Needs: Buys 5-10 photos/year. Subject needs: equipment photos, issues (i.e., soy ink, outsourcing), people. Reviews stock photos. Captions preferred (location).

Making Contact & Terms: Query with stock photo list. Provide résumé, business card, brochure, flier or tearsheets to be kept on file for possible future assignments. Uses 5×7 b&w prints. Keeps samples on file. SASE. Reports in 3 weeks. Payment negotiable. Pays on usage. Credit line given. Buys one-time rights.

JEWISH EXPONENT, Dept. PM, 226 S. 16th St., Philadelphia PA 19102. (215)893-5740. Executive Editor: Bertram Korn, Jr. Weekly newspaper. Emphasizes news of impact to the Jewish community. Circ. 70,000.

Needs: On a regular basis, wants news and feature photos of a cultural, heritage, historic, news and human interest nature involving Jews and Jewish issues. Query as to photographic needs for upcoming year. No art photos. Photos purchased with or without accompanying mss. Captions required. Uses 8×10 glossy prints; 35mm or 4×5 transparencies. Model release required "where the event covered is not in the public domain."

Making Contact & Terms: Query with résumé of credits or arrange a personal interview. "Telephone or mail inquiries first are essential. Do not send original material on speculation." Provide résumé, business card, letter of inquiry, samples, brochure, flier and tearsheets to be kept on file. SASE. Reports in 1 week. Free sample copy. Pays $65/assignment; $10/b&w print; $25/color print; fees negotiable. Credit line given. Pays on publication. Rights purchased vary; negotiable.

Tips: "Photographers should keep in mind the special requirements of high-speed newspaper presses. High contrast photographs probably provide better reproduction under newsprint and ink conditions."

THE LAWYERS WEEKLY, 75 Clegg Rd., Markham, Ontario L6G 1A1 Canada. (905)479-2665. Fax: (905)479-3758. E-mail: tlw@butterworths.ca. Website: http://www.butterworths.ca/tlw.htm. Production Assistant: Tamara Lora. Circ. 7,000. Estab. 1983. Weekly newspaper. Emphasizes law. Readers are male and female lawyers and judges, ages 25-75. Sample copy $8. Photo guidelines free with SASE.

Needs: Uses 12-20 photos/issue; 5 supplied by freelancers. Needs head shot photos of lawyers and judges mentioned in story.

Making Contact & Terms: Provide résumé, business card, brochure, flier or tearsheets to be kept on file for possible assignments. Deadlines: 1-2 day turnaround time. Accepts images in digital format (JPEG, TIFF). Does not keep samples on file. SASE. Reports only when interested. **Pays on acceptance.** Credit line not given.

Tips: "We need photographers across Canada to shoot lawyers and judges on an as-needed basis. Send a résumé and we will keep your name on file. Mostly black & white work."

THE LOG NEWSPAPERS, 2924 Emerson, Suite 200, San Diego CA 92106. (619)226-6140. Fax: (619)226-0573. E-mail: logedit@aol.com. Website: http://www.thelog.com. Editor: Joel Zlotnik. Circ. 80,000. Estab. 1971. Biweekly newspaper. Emphasizes recreational boating. Sample copy free with 8½×11 envelope.

Needs: Uses 20-25 photos/issue; 75% supplied by freelancers. Needs photos of marine-related, historic sailing vessels, sailing/boating in general. Model/property release preferred for up-close people, private yachts. Captions required; include location, name and type of boat, owner's name, race description if applicable.

Making Contact & Terms: Provide résumé, business card, brochure, flier or tearsheets to be kept on file for possible assignments. Send 4×6 or 8×10 glossy color or b&w prints; 35mm transparencies; digital format on TIFF or EPS files. Keeps samples on file. SASE. Reports in 1 month. Pays $75/color cover; $25/b&w inside. Pays on publication. Credit line given. Buys all rights; negotiable. Simultaneous submissions and/or previously published work OK.

**FOR EXPLANATIONS OF THESE SYMBOLS,
SEE THE INSIDE FRONT AND BACK COVERS OF THIS BOOK.**

LONG ISLAND PARENTING NEWS, P.O. Box 214, Island Park NY 11558. (516)889-5510. Fax: (516)889-5513. E-mail: LIParent@family.com. Website: http://www.LIPN.com. Director: Andrew Elias. Circulation: 57,000. Estab. 1989. Monthly newspaper. Emphasizes parenting issues and children's media. Readers are mostly women, ages 25-45, with kids, ages 0-12. Sample copy for $3 with 9×12 SAE and 5 first-class stamps. Model release required.
Needs: Uses 1-3 photos/issue; 1-2 supplied by freelancers. Needs photos of kids, families, parents. Model release required.
Making Contact & Terms: Send unsolicited photos by mail for consideration. Send 5×7 or 8×10 color or b&w prints. Keeps samples on file. SASE. Accepts images in digital format for Mac (TIFF). Send via Zip or floppy disk. Reports in 6 weeks. Pays $50/color cover; $25-100/color inside; $25-100/b&w inside. Pays on publication. Credit line given. Buys one-time rights.

[N] METRO, 550 S. First St., San Jose CA 95113. (408)298-8000. Chief Photographer: Christopher Gardner. Circ. 91,000. Alternative newspaper, weekly tabloid format. Emphasis on news, arts and entertainment. Readers are adults ages 25-44, in Silicon Valley. Sample copy $3.
Needs: Uses 15 photos/issue; 10% supplied by freelance photographers. Model release required for model shots. Captions preferred.
Making Contact & Terms: Query with résumé of credits, list of stock photos subjects. Provide résumé, business card, brochure, flier or tearsheets to be kept on file for possible assignments. Also accepts digital images on Zip cartridge, small floppy, CD—all on Mac format. Does not return unsolicited material. Pays $75-100/color cover; $50-75/b&w cover; $50/b&w inside. Pays on publication. Credit line given. Buys one-time rights and online web rights. Simultaneous submissions and/or previously published work OK "if outside of San Francisco Bay area."

MILL CREEK VIEW, 16212 Bothell-Everett Hwy., Suite F-313, Mill Creek WA 98012-1219. (425)787-9529. Fax: (425)743-9882. Publisher: F.J. Fillbrook. Newspaper.
Needs: Photos for news articles and features. Captions required.
Making Contact & Terms: Submit portfolio for review. Send unsolicited photos by mail for consideration. Provide résumé, business card, brochure, flier or tearsheets to be kept on file for possible assignment. Send 4×6 matte b&w prints. Keeps samples on file. SASE. Reports in 1 month. Pays $10-25/b&w photo. Pays on publication. Credit line given.

MISSISSIPPI PUBLISHERS, INC., 201 S. Congress St., Jackson MS 39205. (601)961-7073. Photo Editors: Chris Todd and Jennifer L. Davis. Circ. 115,000. Daily newspaper. Emphasizes photojournalism: news, sports, features, fashion, food and portraits. Readers are in very broad age range of 18-70 years; male and female. Sample copy for 11×14 SAE and 54¢.
Needs: Uses 10-15 photos/issue; 1-5 supplied by freelance photographers. Needs news, sports, features, portraits, fashion and food photos. Special photo needs include food and fashion. Model release and captions required.
Making Contact & Terms: Provide résumé, business card, brochure, flier or tearsheets to be kept on file for possible assignments. Uses 8×10 matte b&w and color prints; 35mm, $2\frac{1}{4} \times 2\frac{1}{4}$, 4×5, 8×10 transparencies. SASE. Reports 1 week. Pays $50-100/color cover; $25-50/b&w cover; $25/b&w inside; $20-50/hour; $150-400/day. Pays on publication. Credit line given. Buys one-time or all rights; negotiable.

MODEL NEWS, 244 Madison Ave., Suite 393, New York NY 10016-2817. (212)969-8715. Publisher: John King. Circ. 288,000. Estab. 1975. Monthly newspaper. Emphasizes celebrities and talented models, beauty and fashion. Readers are male and female, ages 15-80. Sample copy $2.00 with 8×10 SAE and 1 first-class stamp. Photo guidelines $2.00.
Needs: Uses 1-2 photos/issue; 1-2 supplied by freelancers. Review photos with accompanying ms only. Special photo needs include new celebrities, famous faces, VIP's, old and young. Model release preferred. Captions preferred.
Making Contact & Terms: Contact through rep. Arrange personal interview to show portfolio. Submit portfolio for review. Send unsolicited photos by mail for consideration. Provide résumé, business card, brochure, flier or tearsheets to be kept on file for possible future assignments. Send 8×10 b&w prints. Keeps samples on file. SASE. Reports in 3 weeks. Pays $60/b&w photo; $70/color photo. Pays on publication. Credit line given. Buys all rights. Considers simultaneous submissions.

[N] MOM GUESS WHAT NEWSPAPER, 1725 L St., Sacramento CA 95814. (916)441-6397. Fax: (916)441-6422. E-mail: info@mgwnews.com. Website: http://www.mgwnews.com. Editor: Linda Birner. Circ. 21,000. Estab. 1978. Weekly tabloid. Gay/lesbian newspaper that emphasizes political, entertainment, etc. Readers are gay and straight people. Sample copy $1. Photo guidelines free with SASE.

Needs: Uses about 8-10 photos/issue; all supplied by freelancers, 80% from assignment and 20% from stock. Model release required. Captions required. Accepts images in digital format for Mac and Windows in Photoshop 4. Send via Zip disk (85 line).

Making Contact & Terms: Arrange a personal interview to show portfolio. Send 8×10 glossy color or b&w prints by mail for consideration. SASE. Pays $5-100/photo; $50-75/hour; $100-250/day; $5-200 per photo/text package. Pays on publication. Credit line given. Buys one-time rights; negotiable. Previously published work OK.

Tips: Prefers to see gay/lesbian related stories, human rights, civil rights and some artsy photos in portfolio; *no* nudes or sexually explicit photos. "When approaching us, give us a phone call first and tell us what you have or if you have a story idea." Uses photographers as interns (contact editor).

NATIONAL MASTERS NEWS, P.O. Box 50098, Eugene OR 97405. (503)343-7716. Fax: (503)345-2436. E-mail: natmanews@aol.com. Website: http://members.aol.com/natmanews/index.html. Editor: Al Sheahen. Circ. 8,000. Estab. 1977. Monthly tabloid. Official world and US publication for Masters (age 35 and over) track and field, long distance running and race walking. Sample copy free with 9×12 SASE.

Needs: Uses 25 photos/issue; 20% assigned and 80% from freelance stock. Needs photos of Masters athletes (men and women over age 35) competing in track and field events, long distance running races or racewalking competitions. Captions preferred.

Making Contact & Terms: Send any size matte or glossy b&w print by mail for consideration, "may write for sample issue." SASE. Reports in 1 month. Pays $7.50 minimum for b&w or color photos. Pays on publication. Credit line given. Buys one-time rights. Simultaneous submissions and previously published work OK.

NATIONAL NEWS BUREAU, P.O. Box 43039, Philadelphia PA 19129. (215)849-9016. Editor: Andy Edelman. Circ. 300 publications. Weekly syndication packet. Emphasizes entertainment. Readers are leisure/entertainment-oriented, 17-55 years old.

Needs: "Always looking for new female models for our syndicated fashion/beauty columns." Uses about 20 photos/issue; 15 supplied by freelance photographers. Captions required.

Making Contact & Terms: Arrange a personal interview to show portfolio. Query with samples. Submit portfolio for review. Send 8×10 b&w prints, b&w contact sheet by mail for consideration. SASE. Reports in 1 week. Pays $50-1,000/job. Pays on publication. Credit line given. Buys all rights.

N ⊕ NEW CHRISTIAN HERALD, Christian Media Ltd., 96 Dominion Rd., Worthing, West Sussex BN14 8JP England. Phone: (01903)821082. Fax: (01903)821081. E-mail: editorial@newchristianherald.org. Website: http://www.newchristianherald.org. Editor: Russ Bravo. Circ. 18,000. Estab. 1874. Weekly newspaper. For sample copy send SAE with first-class postage or IRC.

Needs: Needs photos of church services, mood shots. Reviews photos with or without ms. Model release required; property release required. Photo caption required; include description of subject, name and address of photographer.

Making Contact & Terms: Send query letter with samples. Art director will contact photographer for portfolio review if interested. Portfolio should include prints. Uses color, b&w prints; 2¼×2¼ transparencies. Keeps samples on file; include SASE for return of material. Reports back only if interested, send non-returnable samples. Pays on publication. Credit line given. Buys first rights; negotiable.

Tips: "Read the paper. Put name and address with each individual photo sent and include all details of subject."

NEW HAVEN ADVOCATE, 1 Long Wharf Dr., New Haven CT 06511. (203)789-0010. Publisher: Gail Thompson. Photographer: Kathleen Cei. Circ. 55,000. Estab. 1975. Weekly tabloid. Member of Alternative Association of News Weeklys. Readers are male and female, educated, ages 20-50.

Needs: Uses 7-10 photos/issue; 0-1 supplied by freelancers. Reviews photos with or without ms. Model release required. Captions required.

Making Contact & Terms: Provide résumé, business card, brochure, flier or tearsheets to be kept on file for possible assignments. Does not keep samples on file. SASE. Reports in 1 month. Payment negotiable. Pays on publication. Credit line given. Buys one-time rights. Simultaneous submissions and/or previously published work OK.

NEW YORK TIMES MAGAZINE, 229 W. 43 St., New York NY 10036. (212)556-7434. Photo Editor: Kathy Ryan. Weekly. Circ. 1.8 million.

Needs: The number of freelance photos varies. Model release and photo captions required.

Making Contact & Terms: Drop off portfolio for review. "Please Fed Ex mailed-in portfolios." SASE. Reports in 1 week. Pays $250/b&w page rate; $300/color page rate; $225/half page; $350/job (day rates);

$650/color cover. **Pays on acceptance.** Credit line given. Buys one-time rights.

NORTH TEXAS GOLFER, 9182 Old Katy Rd., Suite 212, Houston TX 77055. (713)464-0308. Editor: Bob Gray. Monthly tabloid. Emphasizes golf in the northern areas of Texas. Readers are age 40 and older, $72,406 income, upscale lifestyle and play golf 2-5 times weekly. Circ. 31,000. Sample copy $2.50 with SAE.
Needs: "Photos are bought only in conjunction with purchase of articles." Model release and captions preferred.
Making Contact & Terms: "Use the telephone." SASE. Reports in 2 weeks. Payment negotiable. Pays on publication. Credit line given. Buys one-time rights or all rights, if specified.

PACKER REPORT, 1317 Lombardi Access Rd., Green Bay WI 54304. (920)497-6500, ext. 6. Editor: Todd Korth. Circ. 48,000. Estab. 1972. Weekly tabloid. Emphasizes Green Bay Packer football. Readers are 94% male, all occupations, ages. Sample copy free with SASE and 3 first-class stamps.
Needs: Uses 10-16 photos/issue; all supplied by freelancers. Needs photos of Green Bay Packer football.
Making Contact & Terms: Query with résumé of credits. Provide résumé, business card, brochure, flier or tearsheets to be kept on file for possible assignments. Does not keep samples on file. SASE. Reports in 1 month. Pays $50/color cover; $10-50/color inside; $10-20/b&w page rate. Pays on publication. Credit line given. Buys one-time rights; negotiable. Simultaneous submissions and previously published work OK.

[N] PLAY THE ODDS, Raley Management Inc., 11614 Ashwood, Little Rock AR 72211. Phone/fax: (501)224-9452. E-mail: playtheodds@worldnet.att.net. Website: http://home.att.net/~playtheodds/index.html. Editor/Publisher: Tom Raley. Estab. 1997. Monthly newsletter that covers all areas of the gaming industry including casino news, new games, entertainment, etc. Sample copy for $2. Art guidelines free.
Needs: Buys 2 photos from freelancers/issue; 24 photos/year. Needs photos of casinos, entertainers and casino properties. Reviews photos with or without ms. Special photo needs include photos of "casinos located outside of major gaming areas and cover girls in sexy showgirl outfits." Model release required. Photo captions preferred.
Making Contact & Terms: Send query letter with samples. Art director will contact photographer for portfolio review if interested. Portfolio should include b&w and/or color, prints. Uses 35mm, 4×5 transparencies. Keeps samples on file; include SASE for return of material. Reports in 1 month. Pays $200-500/b&w cover; $50-150/b&w inside. Pays on acceptance. Credit line given. Buys one-time rights. Simultaneous submissions and previously published work OK.
Tips: "Check out a copy of our newsletter to see if we are a market you are interested in. Write a cover letter and introduce yourself, don't just send in photos with a SASE."

PRORODEO SPORTS NEWS, 101 Pro Rodeo Dr., Colorado Springs CO 80919. (719)593-8840. Fax: (719)548-4889. Editor: Paul Asay. Circ. 40,000. Publication of Professional Rodeo Cowboys Association. Biweekly newspaper, weekly during summer (12 weeks). Emphasizes professional rodeo. Sample copy free with 8×10 SAE and 4 first-class stamps. Photo guidelines free with SASE.
• *Prorodeo* scans about 95% of their photos, so *high quality* prints are very helpful.
Needs: Uses about 25-50 photos/issue; all supplied by freelancers. Needs action rodeo photos. Also uses behind-the-scenes photos, cowboys preparing to ride, talking behind the chutes—something other than action. Model/property release preferred. Captions required, including contestant name, rodeo and name of animal.
Making Contact & Terms: Send 5×7, 8×10 glossy b&w and color prints by mail for consideration. Also accepts images in digital format, contact for information. SASE. Pays $85/color cover; $35/color inside; $15/b&w inside. Other payment negotiable. Pays on publication. Credit line given. Buys one-time rights.
Tips: In portfolio or samples, wants to see "the ability to capture a cowboy's character outside the competition arena, as well as inside. In reviewing samples we look for clean, sharp reproduction—no grain. Photographer should respond quickly to photo requests. I see more PRCA sponsor-related photos being printed."

ROLL CALL NEWSPAPER, 900 Second St. NE, Suite 107, Washington DC 20002. (202)289-4900. Fax: (202)289-5337. E-mail: maureenkeating@rollcall.com. Website: http://www.rollcall.com. Photo Editor: Maureen Keating. Circ. 20,000. Estab. 1955. Semiweekly newspaper. Emphasizes US Congress and politics. Readers are politicians, lobbyists and congressional staff. Sample copy free with 9×12 SAE with 4 first-class stamps.
Needs: Uses 15-25 photos/issue; up to 5 supplied by freelancers. Needs photos of anything involving

current congressional issues, good or unusual shots of congressmen. Captions required.

Making Contact & Terms: Query with samples or list of stock photo subjects. Send unsolicited photos by mail for consideration. Uses 8×10 glossy b&w prints; 35mm transparencies. Does not return unsolicited material. Reports in 1 month. Pays $50-125/b&w photo; $75-250/color photo (if cover); $50-75/hour; $200-300/day. Pays on publication. Credit line given. Buys one-time rights. Simultaneous submissions OK.

Tips: "We're always looking for unique candids of congressmen or political events. In reviewing photographer's samples, we like to see good use of composition and light for newsprint."

N. SHOW BIZ NEWS, 244 Madison Ave., #393 New York NY 10016-2817. (212)969-8715. Publisher: John King. Circ. 310,000. Estab. 1975. Monthly newspaper. Emphasizes model and talent agencies coast to coast. Readers are male and female, ages 15-80. Sample copy $2.00 with 8×10 SAE and 1 first-class stamp. Photo guidelines $2.00.

Needs: Uses 1-2 photos/issue; 1-2 supplied by freelancers. Reviews photos with accompanying ms only. Needs photos of new celebrities, famous faces, VIP's, old and young. Model release preferred. Captions preferred.

Making Contact & Terms: Contact through rep. Arrange personal interview to show portfolio. Submit portfolio for review. Send unsolicited photos by mail for consideration. Send 8×10 b&w prints. Keeps samples on file. SASE. Reports in 3 weeks. Pays $60-70/b&w cover photo; $30/b&w inside photo. Pays on publication. Gives credit line. Buys all rights. Considers simultaneous submissions.

SINGER MEDIA CORP., INC., Seaview Business Park, 1030 Calle Cordillera, Unit #106, San Clemente CA 92673. E-mail: singer@deltanet.com. Chairman: Kurt Singer. Worldwide media licensing. Estab. 1940. Newspaper syndicate (magazine, journal, books, newspaper, newsletter, tabloid). Emphasis on foreign syndication.

• Singer Media is starting to store images on optical disks.

Needs: Needs photos of celebrities, movies, TV, rock/pop music pictures, top models, posters. Uses 35mm, $2\frac{1}{4} \times 2\frac{1}{4}$, 4×5. Will use dupes or photocopies, cannot guarantee returns. Usually requires releases on interview photos. Photo captions required and accompanying text desired.

Making Contact & Terms: Interested in receiving work from newer, lesser-known photographers, depending on subject. Query with list of stock photo subjects or tearsheets of previously published work. Color preferred. Accepts images in digital format for Windows (JPEG or GIF). Reports in 6 weeks. Pays $25-1,000/b&w photo; $50-1,000/color photo. Pays 50/50% of all syndication sales. Pays after collection. Credit line given. Negotiates one-time, foreign rights. Previously published work preferred.

Tips: "Worldwide, mass market, text essential. Trend is toward international interest. Survey the market for ideas."

SLO-PITCH NEWS, VARSITY PUBLICATIONS, 13540 Lake City Way NE, Suite 3, Seattle WA 98125. (206)367-2420. Fax: (206)367-2636. Editor: Dick Stephens. Circ. 15,800. Estab. 1985. Publication of United States Slo-Pitch Softball Association (USSSA). Tabloid published 8 times/year. Emphasizes slo-pitch softball. Readers are men and women, ages 13-70. Sample copy for 10×14 SASE and $2. Photo guidelines free with SASE.

Needs: Uses 10-30 photos/issue; 90% supplied by freelancers. Needs stills and action softball shots. Special photo needs include products, tournaments, general, etc. Model/property release preferred for athletes. Captions required.

Making Contact & Terms: Send unsolicited photos by mail for consideration. Provide résumé, business card, brochure, flier or tearsheets to be kept on file for possible assignments. Send color and b&w prints. Deadlines: 1st of every month. Keeps samples on file. Cannot return material. Reports in 1 month. Pays $10-30/b&w cover; $10-30/color inside; $10-25/b&w inside; $10-25/color page rate; $10-25/b&w page rate. Pays on publication. Credit line given. Rights negotiable. Simultaneous submissions and previously published work OK.

Tips: Looking for good sports action and current stock of subjects. "Keep sending us recent work and call periodically to check in."

SOUTHERN MOTORACING, P.O. Box 500, Winston-Salem NC 27102. (910)723-5227. Fax: (910)722-3757. Associate: Greer Smith. Editor/Publisher: Hank Schoolfield. Circ. 15,000. Biweekly tabloid. Emphasizes autoracing. Readers are fans of auto racing.

Needs: Uses about 10-15 photos/issue; some supplied by freelance photographers. Needs "news photos on the subject of Southeastern auto racing." Captions required.

Making Contact & Terms: Query with samples; send 5×7 or larger matte or glossy b&w prints; b&w negatives by mail for consideration. SASE. Reports in 1 month. Pays $25-50/b&w cover; $5-50/b&w

inside; $50-100/page. Pays on publication. Credit line given. Buys first North American serial rights. Simultaneous submissions OK.

Tips: "We're looking primarily for *news* pictures, and staff produces many of them—with about 25% coming from freelancers through long-standing relationships. However, we're receptive to good photos from new sources, and we do use some of those. Good quality professional pictures only, please!"

SUN, 5401 NW Broken Sound Blvd., Boca Raton FL 33487. (561)989-1070. Fax: (561)998-0798. Photo Editor: Bella Center. Weekly tabloid. Readers are housewives, college students, middle Americans. Sample copy free with extra large SAE and $1.70 postage.
Needs: Uses about 60 photos/issue; 50% supplied by freelance photographers. Wants varied subjects: prophesies and predictions, amazing sightings (i.e., Jesus, Elvis, angels), stunts, unusual pets, health remedies, offbeat medical, human interest, inventions, spectacular sports action; human interest and offbeat pix and stories; and celebrity photos. "Also—we are always in need of interesting, offbeat, humorous stand-alone pix." Model release preferred. Captions preferred.
Making Contact & Terms: Query with stock photo list. Send 8×10 b&w prints, 35mm transparencies, b&w contact sheet or b&w negatives by mail for consideration. Accepts digital images via Mac to Mac W Z modem, ISDN, Leaf Desk, SyQuest, floppy disk. Send through mail with SASE. Reports in 2 weeks. Pays $150-250/day; $150-250/job; $75/b&w cover; $125-200/color cover; $50-125/b&w inside; $125-200/color inside. Pays on publication. Buys one-time rights. Simultaneous submissions and previously published work OK.
Tips: "We are specifically looking for the unusual, offbeat, freakish true stories and photos. *Nothing* is too far out for consideration. We would suggest you send for a sample copy and take it from there."

SUNSHINE: THE MAGAZINE OF SOUTH FLORIDA, 200 E. Las Olas Blvd., Ft. Lauderdale FL 33301-2293. (305)356-4685. Art Director: Greg Carannante. "*Sunshine* is a Sunday newspaper magazine emphasizing articles of interest to readers in the Broward and Palm Beach counties region of South Florida." Readers are "the 800,000 readers of the Sunday edition of the *Sun-Sentinel*." Sample copy and guidelines free with SASE.
Needs: Uses about 12-20 photos/issue; 30% supplied by freelancers. Needs "all kinds of photos relevant to a South Florida readership." Photos purchased with accompanying ms. Model release sometimes required. Captions preferred.
Making Contact & Terms: Query with samples. Provide résumé, business card, brochure, flier or tearsheets to be kept on file for possible future assignments. SASE. Reports in 1 month. "All rates negotiable; the following are as a guide only." Pays $200/color cover photo; $75-150/color inside photo; $500-1,000 for text/photo package. Pays within 2 months of acceptance. Credit line given. Buys one-time rights. Simultaneous and previously published submissions OK.

TORONTO SUN PUBLISHING, 333 King St., Toronto, Ontario M5A 3X5 Canada. (416)947-2399. Fax: (416)947-3580. Director of Photography: Hugh Wesley. Circ. 300,000. Estab. 1971. Daily newspaper. Emphasizes sports, news and entertainment. Readers are 60% male, 40% female, ages 25-60. Sample copy free with SASE.
Needs: Uses 30-50 photos/issue; 20% supplied by freelancers. Needs photos of Toronto personalities making news out of town. Reviews photos with or without ms. Captions preferred.
Making Contact & Terms: Phone. Send any size color prints; 35mm transparencies; press link digital format. Deadline: 11 p.m. daily. Does not keep samples on file. Reports in 1-2 weeks. Pays $150/job. Pays on publication. Credit line given. Buys one-time and other negotiated rights. Simultaneous submissions and previously published work OK.
Tips: "The squeaky wheel gets the grease when it delivers the goods. Don't try to oversell a questionable photo. Return calls promptly."

TRIBUNE-REVIEW, 622 Cabin Hill Dr., Greensburg PA 15601. (412)836-5454 or (800)433-3045. Fax: (412)838-5171. E-mail: tgombar@tribweb.com. Website: http://www.tribune-review.com. Director of Photography: Tod Gombar. Circ. 200,000. Estab. 1889. Daily newspaper. Emphasizes news, features, sports, travel, consumer information and food. Sample copy 50¢.
Needs: Uses 25-35 photos/issue; 10% supplied by freelancers. Model release required; property release

THE INTERNATIONAL MARKETS INDEX, located in the back of this book, lists markets located outside the U.S. by country.

preferred. Captions required.

Making Contact & Terms: Arrange personal interview to show portfolio. Provide résumé, business card, brochure, flier or tearsheets to be kept on file for possible future assignments. "All work submitted should be digitized in Mac format on floppy disks, magneto optical disks or Zip disks, using JPEG Photoshop at 200 dpi." Deadlines: daily. Keeps samples on file. Reports in 1-2 weeks. Pays on publication. Buys one-time and other negotiated rights. Simultaneous submissions OK. Offers internships for photographers June-August. Contact Director of Photography: Tod Gombar.

Tips: "Illustration photos are important to us; people-oriented subject material is a must."

VELONEWS, 1830 N. 55th St., Boulder CO 80301-2700. (303)440-0601. Fax: (303)444-6788. Photo Editor: Nate Cox. Paid circ. 55,000. The journal of competitive cycling. Covers road racing, mountain biking and recreational riding. Sample copy free with 9 × 12 SAE and 4 first-class stamps.

Needs: Bicycle racing and nationally important races. Looking for action shots that show the emotion of cycling, not just finish-line photos with the winner's arms in the air. No bicycle touring. Photos purchased with or without accompanying ms. Uses news, features, profiles. Captions and identification of subjects required.

Making Contact & Terms: Send samples of work or tearsheets with assignment proposal. Query first on ms. Send negatives and transparencies. SASE. Reports in 3 weeks. Pays $16.50-50/b&w inside; $33-100/color inside; $150/color cover; $15-100/ms. Credit line given. Pays on publication. Buys one-time rights.

Tips: "We're a newspaper; photos must be timely. Use fill flash to compensate for harsh summer light."

WATERTOWN PUBLIC OPINION, Box 10, Watertown SD 57201. (605)886-6903. Fax: (605)886-4280. Editor: Gordon Garnos. Circ. 17,500. Estab. 1887. Daily newspaper. Emphasizes general news of this area, state, national and international news. Sample copy 50¢.

Needs: Uses up to 8 photos/issue. Reviews photos with or without ms. Model release required. Captions required.

Making Contact & Terms: Send unsolicited photos by mail for consideration. Send b&w or color prints. Does not keep samples on file. SASE. Accepts images in digital format for Mac. Send via compact disc. Reports in 1-2 weeks. Pays $5-25/b&w or color cover; $5-25/b&w or color inside; $5-25/color page rate. Pays on publication. Credit line given. Buys one-time rights; negotiable. Simultaneous submissions OK.

WESTART, Box 6868, Auburn CA 95604. (530)885-0969. Editor-in-Chief: Martha Garcia. Circ. 4,000. Emphasizes art for practicing artists, artists/craftsmen, students of art and art patrons, collectors and teachers. Free sample copy and photo guidelines.

Needs: Uses 20 photos/issue, 10 supplied by freelancers. "We will publish photos if they are in a current exhibition, where the public may view the exhibition. The photos must be black & white. We treat them as an art medium. Therefore, we purchase freelance articles accompanied by photos." Wants mss on exhibitions and artists in the Western states. Captions required.

Making Contact & Terms: Send 5 × 7 or 8 × 10 b&w prints by mail for consideration. SASE. Reports in 2 weeks. Payment is included with total purchase price of ms. Pays $25 on publication. Buys one-time rights. Simultaneous and previously published submissions OK.

TRADE PUBLICATIONS

Most trade publications are directed toward the business community in an effort to keep readers abreast of the ever-changing trends and events in their specific professions. For photographers, shooting for these professions can be financially rewarding and can serve as a stepping stone toward acquiring future jobs.

As often happens with this category, the number of trade publications produced increases or decreases as professions develop or deteriorate. In recent years, for example, magazines involving computers have flourished as the technology continues to grow.

Trade publication readers are usually very knowledgeable about their businesses or professions. The editors and photo editors, too, are often experts in their particular fields. So, with both the readers and the publications' staffs, you are dealing with a much more discriminating audience. To be taken seriously, your photos must not be merely technically good pictures, but also should communicate a solid understanding of the subject and reveal greater insights.

In particular, photographers who can communicate their knowledge in both verbal and visual form will often find their work more in demand. If you have such expertise, you may wish to

query about submitting a photo/text package that highlights a unique aspect of working in that particular profession or that deals with a current issue of interest to that field.

Many photos purchased by these publications come from stock—both from freelance inventories and from stock photo agencies. Generally, these publications are more conservative with their freelance budgets and use stock as an economical alternative. For this reason, listings in this section will often advise sending a stock list as an initial method of contact. Some of the more established publications with larger circulations and advertising bases will sometimes offer assignments as they become familiar with a particular photographer's work. For the most part, though, stock remains the primary means of breaking in and doing business with this market.

AAP NEWS, 141 Northwest Pt. Blvd., Elk Grove Village IL 60007. (847)981-6755. Fax: (847)228-5097. E-mail: Kidsdocs@aap.org. Art Director/Production Coordinator: Michael Hayes. Estab. 1985. Publication of American Academy of Pediatrics. Monthly tabloid newspaper.
Needs: Uses 60 photos/year. 12 freelance assignments offered/year. Needs photos of children, pediatricians, health care providers—news magazine style. Model/property release required as needed. Captions required; include names, dates, location and explanation of situations.
Making Contact & Terms: Provide résumé, business card, tearsheets to be kept on file (for 1 year) for possible assignments. Also accepts digital files on SyQuest or Zip. Cannot return material. Pays $75/hour; $75-125/one-time use of photo. Pays on publication. Buys one-time or all rights; negotiable. Simultaneous submissions and previously published work OK.
Tips: "We want great photos of 'real' children in 'real-life' situations, and the more diverse the better."

ABA BANKING JOURNAL, 345 Hudson St., New York NY 10014. (212)620-7256. Fax: (212)633-1165. E-mail: ababj@aol.com. Website: http://www.banking.com. Art Director: Wendy Williams. Circ. 30,000. Estab. 1909. Monthly magazine. Emphasizes "how to manage a bank better. Bankers read it to find out how to keep up with changes in regulations, lending practices, investments, technology, marketing and what other bankers are doing to increase community standing."
Needs: Buys 12-24 photos/year; freelance photography is 50% assigned, 50% from stock. Personality, and occasionally photos of unusual bank displays or equipment. "We need candid photos of various bankers who are subjects of articles." Photos purchased with accompanying ms or on assignment.
Making Contact & Terms: Query with samples. For color: uses 35mm transparencies and 2¼×2¼ transparencies. For cover: uses color transparencies. Accepts images in digital format for Mac. Send via online, SyQuest. Call and set up appointment for portfolio review. SASE. Reports in 1 month. Pays $200-500/photo. **Pays on acceptance.** Credit line given. Buys one-time rights.
Tips: "Most of our subjects are not comfortable being photographed."

ACCOUNTING TODAY, 11 Penn Plaza, New York NY 10001. (212)631-1596. Fax: (212)564-9896. Contact: Managing Editor. Circ. 35,000. Estab. 1987. Biweekly tabloid. Emphasizes finance. Readers are CPAs in public practice.
Needs: Uses 2-3 photos/issue; all supplied by freelancers. "We assign news subjects, as needed." Captions required.
Making Contact & Terms: Provide résumé, business card, brochure, flier or tearsheets to be kept on file for possible assignments. Keeps samples on file. Cannot return material. Pays $250/shoot. **Pays on acceptance.** Credit line given. Buys all rights; negotiable.

AG PILOT INTERNATIONAL MAGAZINE, P.O. Box 1607, Mt. Vernon WA 98273. (360)336-9737. Fax: (360)336-2506. Publisher: Tom J. Wood. Circ. 7,400. Estab. 1978. Monthly magazine. Emphasizes agricultural aviation and aerial fire suppression (airborne fire fighting). Readers are male cropdusters, ages 20-70. Sample copy $3.
Needs: Uses 20-30 photos/issue; 20% supplied by freelancers. Needs photos of ag aircraft suitable for cover shots. Model/property release preferred. Captions preferred; include who, what, where, when, why.
Making Contact & Terms: Send unsolicited photos by mail for consideration. Send 3×5 any finish color or b&w prints. Keeps samples on file. SASE. Usually reports in 1 month, but may be 2-3 months. Pays $30-150/color cover; $10-30/color inside; $5-20/b&w inside; $50-250/photo/text package. Pays on publication. Credit line given. Buys all rights; negotiable. "Must have final image via e-mail or disk."
Tips: "Subject must be cropdusting and aerial fire suppression (airborne fire fighting). Learn about the aerial application business before submitting material."

N AIR CARGO WORLD, Journal of Commerce, 1230 National Press Bldg., Washington DC 20045. (202)661-3387. Fax: (202)783-2550. E-mail: paulpage@nationalpress.com. Editor: Paul Page. Circ. 23,000. Estab. 1942. Monthly trade magazine aimed at businesses in the air cargo industry or customers of air cargo companies. Sample copy for SAE with first-class postage.
Needs: Buys 1 photo/issue; 10 photos/year. Needs photos of air cargo operations. Reviews photos with or without ms.
Making Contact & Terms: Send query letter with samples. Keeps samples on file. Reports back only if interested, send non-returnable samples. Pays $500/color cover minimum. Pays on publication. Credit line not given. Buys one-time rights. Simultaneous submissions OK.
Tips: "Looking for graphically interesting, dynamic approach to a topic that generally produces hackneyed results."

AMERICAN AGRICULTURIST, 2389 N. Triphammer Rd., Ithaca NY 14850. (607)257-8670. Fax: (607)257-8238. E-mail: ejacobs@farmprogress.com. Editor: Eleanor Jacobs. Circ. 24,000. Estab. 1842. Monthly. Emphasizes agriculture in New York. Photo guidelines free with SASE.
Needs: Occasionally photos supplied by freelance photographers; 90% on assignment, 25% from stock. Needs photos of farm equipment, general farm scenes, animals. Geographic location: only New York. Reviews photos with or without accompanying ms. Model release required. Captions preferred.
Making Contact & Terms: Query with samples and list of stock photo subjects. Send 35mm transparencies by mail for consideration. Accepts images in digital format for Windows (TIFF). SASE. Reports in 3 months. Pays $200/color cover and $75-150/inside color photo. **Pays on acceptance.** Credit line given. Buys one-time rights.
Tips: "We need shots of modern farm equipment with the newer safety features. Also looking for shots of women actively involved in farming and shots of farm activity. We also use scenics. We send out our editorial calendar with our photo needs yearly."

AMERICAN BANKER, Dept. PM, 1 State St. Plaza, New York NY 10004. (212)803-8313. Fax: (212)843-9600. Photo Editor: Tamara Lynas. Art Director: Debbie Romaner. Circ. 20,000. Estab. 1835. Daily tabloid. Emphasizes banking industry. Readers are male and female, senior executives in finance, ages 35-59.
• This publication scans its photos on computer.
Needs: "We are a daily newspaper and we assign a lot of pictures throughout the country. We mostly assign environmental portraits with an editorial, magazine style to them."
Making Contact & Terms: Send unsolicited b&w or color prints by mail for consideration. Provide résumé, business card, brochure, flier or tearsheets to be kept on file for possible assignments. Keeps samples on file. SASE. Pays creative fee of $300. Credit line given.
Tips: "We look for photos that offer a creative insight to corporate portraiture and technically proficient photographers who can work well with stuffy businessmen in a limited amount of time—30 minutes or less is the norm. Photographers should send promo cards that indicate their style and ability to work with executives. Portfolio should include 5-10 samples either slides or prints, with well-presented tearsheets of published work. Portfolio reviews by appointment only. Samples are kept on file for future reference."

AMERICAN BEE JOURNAL, Dept. PM, 51 S. Second St., Hamilton IL 62341. (217)847-3324. Fax: (217)847-3660. Editor: Joe M. Graham. Circ. 13,000. Estab. 1861. Monthly trade magazine. Emphasizes beekeeping for hobby and professional beekeepers. Sample copy free with SASE.
Needs: Uses about 25 photos/issue; 1-2 supplied by freelance photographers. Needs photos of beekeeping and related topics, beehive products, honey and cooking with honey. Special needs include color photos of seasonal beekeeping scenes. Model release preferred. Captions preferred.
Making Contact & Terms: Query with samples. Send 5×7 or 8½×11 b&w and color prints by mail for consideration. SASE. Reports in 2 weeks. Pays $75/color cover; $10/b&w inside. Pays on publication. Credit line given. Buys all rights.

AMERICAN BREWER MAGAZINE, Box 510, Hayward CA 94543-0510. (510)538-9500. President: Bill Owens. Circ. 15,000. Estab. 1986. Quarterly magazine. Emphasizes micro-brewing and brewpubs. Readers are males ages 25-35. Sample copy $5.
Needs: Uses 5 photos/issue; 5 supplied by freelancers. Reviews photos with accompanying ms only. Captions required.
Making Contact & Terms: Contact by phone. Reports in 2 weeks. Payment negotiable per job. **Pays on acceptance.** Credit line given. Buys one-time rights; negotiable. Simultaneous submissions OK.

AMERICAN CHAMBER OF COMMERCE EXECUTIVES, 4232 King St., Alexandria VA 22302. (703)998-0072. Fax: (703)931-5624. Vice President of Marketing: Marlies Mulckhuyse. Circ. 5,000. Monthly trade newsletter. Emphasizes chambers of commerce. Readers are chamber professionals (male and female) interested in developing chambers and securing their professional place. Free sample copy.
Needs: Uses 1-15 photos/issue; 0-10 supplied by freelancers. Special photo needs include coverage of our annual conference in October 1998 in Newport Beach, California. Model release required. Captions preferred.
Making Contact & Terms: Query with stock photo list. Provide résumé, business card, brochure, flier or tearsheets to be kept on file for possible future assignments. Send 4×6 matte b&w prints. Keeps samples on file. SASE. Reports in 1-2 weeks. Pays $10-50/hour. **Pays on acceptance** Buys all rights.

AMERICAN FARRIERS JOURNAL, P.O. Box 624, Brookfield WI 53008-0624. (414)782-4480. Fax: (414)782-1252. Editor: Frank Lessiter. Circ. 8,500 (paid). Estab. 1974. Magazine published 7 times/year. Emphasizes horseshoeing and horse health for professional horseshoers. Sample copy free with SASE.
Needs: Looking for horseshoeing photos, documentary, how-to (of new procedures in shoeing), photo/ essay feature, product shot and spot news. Photos purchased with or without accompanying ms. Captions required.
Making Contact & Terms: Query with printed samples. Uses 4-color transparencies for covers. Vertical format. Artistic shots. SASE. Pays $25-50/b&w photo; $30-100/color photo; up to $150/cover photo. Pays on publication. Credit line given.

AMERICAN FIRE JOURNAL, Dept. PM, 9072 Artesia Blvd., Suite 7, Bellflower CA 90706. (562)866-1664. Fax: (562)867-6434. Editor: Carol Carlsen Brooks. Circ. 6,000. Estab. 1952. Monthly magazine. Emphasizes fire protection and prevention. Sample copy $3.50 with 10×12 SAE and 6 first-class stamps. Free photo and writer's guidelines.
Needs: Buys 5 or more photos/issue; 90% supplied by freelancers. Documentary (emergency incidents, showing fire personnel at work); how-to (new techniques for fire service); and spot news (fire personnel at work). Captions required. Seeks short ms describing emergency incident and how it was handled by the agencies involved.
Making Contact & Terms: Query with samples. Provide résumé, business card or letter of inquiry. SASE. Reports in 1 month. Uses b&w semigloss prints; for cover uses 35mm color transparencies; covers must be verticals. Pays $10-25/b&w inside, negotiable; $25-100/color inside; $100/cover; $1.50-2/inch for ms.
Tips: "Don't be shy! Submit your work. I'm always looking for contributing photographers (especially if they are from outside the Los Angeles area). I'm looking for good shots of fire scene activity with captions. The action should have a clean composition with little smoke and prominent fire and show good firefighting techniques, i.e., firefighters in full turnouts, etc. It helps if photographers know something about firefighting so as to capture important aspects of fire scene. We like photos that illustrate the drama of firefighting— large flames, equipment and apparatus, fellow firefighters, people in motion. Write suggested captions. Give us as many shots as possible to choose from. Most of our photographers are firefighters or 'fire buffs.' "

ANIMAL SHELTERING, Humane Society of the US, 2100 L St. NW, Washington DC 20037. (202)452-1100. Fax: (301)258-3081. E-mail: asm@ix.netcom.com. Editor: Scott Kirkwood. Circ. 5,000. Estab. 1978. Bimonthly magazine. Emphasizes animal protection. Readers are animal control and shelter workers, men and women, all ages. Sample copy free.
Needs: Uses 25 photos/issue; 75% supplied by freelance photographers. Needs photos of domestic animals interacting with people/humane workers; animals in shelters; animals during the seasons; animal care and obedience; humane society work and functions; other companion animal shots. "We do not pay for manuscripts." Model release required for cover photos only. Captions preferred.
Making Contact & Terms: Provide résumé, business card, brochure, flier or tearsheets to be kept on file for possible assignments. SASE. Reports in 4 weeks. Pays $45/b&w cover; $35/b&w inside. "We accept color, but magazine prints in b&w." **Pays on acceptance.** Credit line given. Buys one-time rights.
Tips: "We almost always need good photos of people working with animals in an animal shelter, in the field, or in the home. We do not use photos of individual dogs, cats and other companion animals as much as we use photos of people working to protect, rescue or care for dogs, cats and other companion animals."

ATHLETIC MANAGEMENT, 438 W. State St., Ithaca NY 14850. (607)272-0265. Fax: (607)272-2105. Editor-in-Chief: Eleanor Frankel. Circ. 30,000. Estab. 1989. Bimonthly magazine. Emphasizes the management of athletics. Readers are managers of high school and college athletic programs.
Needs: Uses 6-10 photos/issue; 50% supplied by freelancers. Needs photos of athletic events and athletic

equipment/facility shots. Model release preferred.

Making Contact & Terms: Submit portfolio for review. Keeps samples on file. SASE. Reports in 1-2 weeks. Pays $350-500/color cover; $100-150/b&w cover or color inside; $50-100/b&w inside photo. Pays on publication. Credit line given. Buys first North American serial rights; negotiable. Previously published work OK.

ATLANTIC PUBLICATION GROUP INC., 2430 Mall Dr., Suite 160, Charleston SC 29406. (803)747-0025. Fax: (803)744-0816. E-mail: apg1@earthlink.net. Website: http://atlanticpublicationgrp.com. Editorial Services Manager: Shannon Clark. Circ. 6,500. Estab. 1985. Publications for Chambers of Commerce and Visitor Products from Hawaii to the East Coast. Quarterly magazines. Emphasizes business. Readers are male and female business people who are members of chambers of commerce, ages 30-60.

Needs: Uses 10 photos/issue; all supplied by freelancers. Needs photos of business scenes, manufacturing, real estate, lifestyle. Model/property release required. Captions preferred.

Making Contact & Terms: Provide résumé, business card, brochure, flier or tearsheets to be kept on file for possible assignment. Query with stock photo list. Unsolicited material will not be returned. Deadlines: quarterly. Keeps samples on file. SASE. Accepts images in digital format for Mac. Send via SyQuest or Zip disk. Reports in 1 month. Pays $100-400/color cover; $100-250/b&w cover; $50-100/color inside; $50/b&w inside. **Pays on acceptance.** Credit line given. Buys one-time rights; negotiable. Simultaneous submissions and previously published work OK.

AUTOMATED BUILDER, 1445 Donlon St. #16, Ventura CA 93003. (805)642-9735. Fax: (805)642-8820. E-mail: abmag@autbldrmag.com. Website: http://www.autbldrmag.com. Editor and Publisher: Don Carlson. Circ. 26,000. Estab. 1964. Monthly. Emphasizes home and apartment construction. Readers are "factory and site builders and dealers of all types of homes, apartments and commercial buildings." Sample copy free with SASE.

Needs: Uses about 40 photos/issue; 10-20% supplied by freelance photographers. Needs in-plant and job site construction photos and photos of completed homes and apartments. Photos purchased with accompanying ms only. Captions required.

Making Contact & Terms: "Call to discuss story and photo ideas." Send 3×5 color prints; 35mm or 2¼×2¼ transparencies by mail for consideration. Will consider dramatic, preferably vertical cover photos. Send color proof or slide. SASE. Reports in 2 weeks. Pays $300/text/photo package; $150/cover. Credit line given "if desired." Buys first time reproduction rights.

Tips: "Study sample copy. Query editor by phone on story ideas related to industrialized housing industry."

N AVIONICS MAGAZINE, 1201 Seven Locks Rd., Potomac MD 20854. (301)340-7788, ext. 2840. Fax: (301)340-0542. Editor: David Robb. Circ. 24,000. Estab. 1978. Monthly magazine. Emphasizes aviation electronics. Readers are avionics engineers, technicians, executives. Sample copy free with 9×12 SASE.

Needs: Uses 15-20 photos/issue; 10% supplied by freelancers. Reviews photos with or without ms. Captions required.

Making Contact & Terms: Send unsolicited photos by mail for consideration. Provide résumé, business card, brochure, flier or tearsheets to be kept on file for possible assignments. Send 8½×11 glossy color prints; 35mm, 2¼×2¼, 4×5, 8×10 transparencies. Keeps samples on file. SASE. Reports in 1-2 months. Pays $200-500/color cover. **Pays on acceptance.** Credit line given. Rights negotiable. Simultaneous submissions OK.

BARTENDER MAGAZINE, P.O. Box 158, Liberty Corner NJ 07938. (908)766-6006. Fax: (908)766-6607. Art Director: Erica DeWitte. Circ. 150,000. Estab. 1979. Quarterly magazine. *Bartender Magazine* serves full-service drinking establishments (full-service means able to serve liquor, beer and wine). "We serve single locations including individual restaurants, hotels, motels, bars, taverns, lounges and all other full-service on-premises licensees." Sample copy $2.50.

Needs: Number of photos/issue varies. Number supplied by freelancers varies. Needs photos of liquor-related topics, drinks, bars/bartenders. Reviews photos with or without ms. Model/property release required. Captions preferred.

Making Contact & Terms: Provide résumé, business card, brochure, flier or tearsheets to be kept on file for possible assignments. SASE. Payment negotiable. Pays on publication. Credit line given. Buys all rights; negotiable. Previously published work OK.

N BEEF TODAY, Farm Journal Publishing, Inc., Centre Square W., 1500 Market St., 28th Floor, Philadelphia PA 19102-2181. (215)557-8959. Art Director: Alfred Casciato. Circ. 220,000. Monthly magazine.

Emphasizes American agriculture. Readers are active farmers, ranchers or agribusiness people. Sample copy and photo guidelines free with SASE.

● This company also publishes *Farm Journal*, *Top Producer*, *Hogs Today* and *Dairy Today*.

Needs: Uses 20-30 photos/issue; 75% supplied by freelance photographers. "We use studio-type portraiture (environmental portraits), technical, details, scenics." Model release preferred. Captions required.

Making Contact & Terms: Arrange a personal interview to show portfolio. Query with résumé of credits along with business card, brochure, flier or tearsheets to be kept on file for possible assignments. SASE. Reports in 2 weeks. Payment negotiable. "We pay a cover bonus." **Pays on acceptance.** Credit line given. Buys one-time rights. Simultaneous submissions OK.

Tips: In portfolio or samples, likes to "see about 20 slides showing photographer's use of lighting and photographer's ability to work with people. Know your intended market. Familiarize yourself with the magazine and keep abreast of how photos are used in the general magazine field."

BEVERAGE & FOOD DYNAMICS, Dept. PM, 1180 Avenue of the Americas, 11th Floor, New York NY 10036. (212)827-4700. Fax: (212)827-4720. Editor: Richard Brandes. Art Director: Paul Viola. Circ. 67,000. Magazine published nine times/year. Emphasizes distilled spirits, wine and beer and all varieties of non-alcoholic beverages (soft drinks, bottled water, juices, etc.), as well as gourmet and specialty foods. Readers are national—retailers (liquor stores, supermarkets, etc.), wholesalers, distillers, vintners, brewers, ad agencies and media.

Needs: Uses 30-50 photos/issue; 5 supplied by freelance photographers and photo house (stock). Needs photos of retailers, product shots, concept shots and profiles. Special needs include good retail environments; interesting store settings; special effect photos. Model release required. Captions required.

Making Contact & Terms: Query with samples and list of stock photo subjects. Send non-returnable samples, slides, tearsheets, etc. with a business card. "An idea of your fee schedule helps, as well as knowing if you travel on a steady basis to certain locations." SASE. Reports in 2 weeks. Pays $550-750/color cover; $450-950/job. Pays on publication. Credit line given. Buys one-time rights or all rights on commissioned photos. Simultaneous submissions OK.

Tips: "We're looking for good location photographers who can style their own photo shoots or have staff stylists. It also helps if they are resourceful with props. A good photographer with basic photographs is always needed. We don't manipulate other artists work, whether its an illustration or a photograph. If a special effect is needed, we hire a photographer who manipulates photographs."

BUILDINGS: The Facilities Construction and Management Magazine, 427 Sixth Ave. SE, P.O. Box 1888, Cedar Rapids IA 52406. (319)364-6167. Fax: (319)364-4278. Editor: Linda Monroe. Circ. 56,600. Estab. 1906. Monthly magazine. Emphasizes commercial real estate. Readers are building owners and facilities managers. Sample copy $6.

Needs: Uses 50 photos/issue; 10% supplied by freelancers. Needs photos of concept, building interiors and exteriors, company personnel and products. Model/property release preferred. Captions preferred.

Making Contact & Terms: Provide résumé, business card, brochure, flier or tearsheets to be kept on file for possible assignments. Send 3×5, 8×10, b&w or color prints; 35mm, 2¼×2¼, 4×5 transparencies upon request only. SASE. Reports as needed. Pays $350/color cover; $200/color inside. Pays on publication. Credit line given. Rights negotiable. Simultaneous submissions OK.

BUSINESS CREDIT MAGAZINE, National Association of Credit Management, 8815 Centre Park Dr., Suite 200, Columbia MD 21045. (410)740-5560. Fax: (410)740-5574. E-mail: katherinej@nacm.org. Website: http://www.nacm.org. Vice President, Communications: Katherine Jeschke. Circ. 40,000. Estab. 1896. Publication of the National Association of Credit Management. Monthly magazine. Emphasizes business credit, finance, banking and customer financial services. Readers are male and female executives, 25-65—VPs, CEOs, CFOs, middle management—and entry-level employees. Free sample copy.

Needs: Uses 1-5 photos/issue. Needs photos of technology, industry, commerce, banking and business (general, international, concepts). Special photo needs include: international; computer technology (Internet, global village); humorous; business-related; and technology-related.

Making Contact & Terms: "We're particularly interested in having annual convention covered, May '98 New Orleans. We're willing to use students with teacher recommendations. Query with résumé of credits. Provide résumé, business card, brochure, flier or tearsheets to be kept on file for possible future assignments. Send 4×6 glossy color and b&w prints; 35mm, 2¼×2¼ transparencies. Accepts images in digital format for Mac. Send via floppy disk, Zip disk (low res for approval—high res for use). Deadlines: 2 months prior to publication; always 1st of month. SASE. Reports in 1 month. Pays $50-100/hour; $250-500/color cover; $250-375/b&w cover; $100-375/color inside; $100-275/b&w inside; $100-200/color page rate; $100-150/b&w page rate. **Pays on acceptance.** Credit line given. Buys one-time and all rights;

negotiable. Previously published work OK. Offers internships for photographers year-round. Contact Vice President, Communications: Katherine Jeschke.

Tips: "Be familiar with publication and offer suggestions. Be available when called and be flexible with nonprofit groups such as NACM."

BUSINESS NH MAGAZINE, 404 Chestnut St., #201, Manchester NH 03101. (603)626-6354. Fax: (603)626-6359. Art Director: Nikki Bonenfant. Circ. 13,000. Estab. 1984. Monthly magazine. Emphasizes business. Readers are male and female—top management, average age 45. Sample copy free with 9×12 SAE and 5 first-class stamps.

Needs: Uses 3-6 photos/issue. Needs photos of people, high-tech, software and locations. Model/property release preferred. Captions required; include names, locations, contact phone number.

Making Contact & Terms: Arrange personal interview to show portfolio. Provide résumé, business card, brochure, flier or tearsheets to be kept on file for possible assignments. Accepts images in digital format for Mac (TIFF). Send via compact disc, floppy disk, Zip disk (300 PPI, ISOLPI). Keeps samples on file. SASE. Reports in 3 weeks. Pays $300-500/color cover; $50-100/color inside; $50-75/b&w inside. Pays on publication. Credit line given. Buys one-time rights. Offers internships for photographers. Contact Art Director: Nikki Bonenfant.

Tips: Looks for "people in environment shots, interesting lighting, lots of creative interpretations, a definite personal style. If you're just starting out and want excellent statewide exposure to the leading executives in New Hampshire, you should talk to us."

[N] CAMP MANAGEMENT, 94 Station St., Hingham MA 02043. (781)749-3360. Fax: (781)740-0888. E-mail: campmngt@camp1.com. Website: http://www.camp1.com. Editor: Judy Beeh. Circ. 8,000. Estab. 1994. Bimonthly trade journal covering children's summer camps. "As a magazine for camp professionals, *Camp Management* is designed to be a valuable resource, offering practical tips and solutions, news from the field and profiles of successful programs. We aim to be a forum for the camp community." Sample copies available. Art guidelines free for $4\frac{1}{8} \times 9\frac{1}{2}$, SAE with 1 first class stamp.

Needs: Buys 1 photo from freelancer/issue; 6 photos/year. Needs photos of children in outdoor and summer camp settings. Reviews photos with or without ms. Model release required for minors. Property release required for private camp property. Captions preferred; include subject, location, date, description of action, byline.

Making Contact & Terms: Send query letter with samples, brochure, stock photo list, tearsheets. Provide résumé, business card, self-promotion piece to be kept on file for possible future assignments. Art director will contact photographer for portfolio review if interested. Portfolio should include color and b&w prints, tearsheets, slides, transparencies. Uses color and b&w prints and 35mm, $2\frac{1}{4} \times 2\frac{1}{4}$, 4×5, 8×10 transparencies. Accepts images in digital format on CD or ZIP disk. Keeps samples on file. Reports in 2 months. SASE. Pays on publication. Credit line given. Buys one-time and first rights. Simultaneous submissions and previously published work OK.

Tips: "We look for fresh candid images that accurately depict camp life. Think: kids, summer, camp, nature and fun. We are also open to artwork that plays with humor or leans toward the thought-provoking. Clearly label all submissions and enclose proper SASE with query."

[N] CED MAGAZINE, 600 S. Cherry St., Suite 400, Denver CO 80222. (303)393-7449. Fax: (303)393-6654. Editor: Roger Brown. Art Director: Don Ruth. Circ. 22,500. Estab. 1975. Monthly magazine. Emphasizes cable TV or video networking. Readers are typically male, ages 30-50, who are technical and engineering oriented.

Needs: Uses 2-3 photos/issue. Needs photos of technology. Model/property release preferred.

Making Contact & Terms: Provide résumé, business card, brochure, flier or tearsheets to be kept on file for possible assignments. Keeps samples on file. SASE. Reports in 3 weeks. Pays $400-1,700/job; $600-1,000/color cover; $200-400/color inside. **Pays on acceptance**. Credit line given. Buys one-time rights; negotiable. Previously published work OK.

THE CHRONICLE OF PHILANTHROPY, 1255 23rd St. NW, 7th Floor, Washington DC 20037. (202)466-1205. Fax: (202)466-2078. E-mail: sue.lalumia@chronicle.com. Art Director: Sue LaLumia. Circ. 39,000. Estab. 1988. Biweekly tabloid. Readers come from all aspects of the nonprofit world such

● **SPECIAL COMMENTS** within listings by the editor of *Photographer's Market* are set off by a bullet.

as charities, foundations and relief agencies such as the Red Cross. Sample copy free.
Needs: Uses 20 photos/issue; 50-75% supplied by freelance photographers. Needs photos of people (profiles) making the news in philanthropy and environmental shots related to person(s)/organization. Most shots arranged with freelancers are specific. Model release required. Captions required.
Making Contact & Terms: Arrange a personal interview to show portfolio. Send unsolicited photos by mail for consideration. Send 35mm, 2¼×2¼ transparencies and prints by mail for consideration. Provide résumé, business card, brochure, flier or tearsheets to be kept on file for possible assignments. Will send negatives back via certified mail. Reports in 1-2 days. Pays (color and b&w) $275 plus expenses/half day; $450 plus expenses/full day; $75/b&w reprint; $150/color reprint. Pays on publication. Buys one-time rights. Previously published work OK.

Ⓝ CLAVIER, Dept. PM, 200 Northfield Rd., Northfield IL 60093. (847)446-5000. Editor: Judy Nelson. Circ. 20,000. Estab. 1962. Magazine published 10 times/year. Readers are piano and organ teachers. Sample copy $2.
Needs: Human interest photos of keyboard instrument students and teachers. Special needs include synthesizer photos and children performing.
Making Contact & Terms: Send material by mail for consideration. Uses glossy b&w prints. For cover: Kodachrome, glossy color prints or 35mm transparencies. Vertical format preferred. SASE. Reports in 1 month. Pays $225/color cover; $10-25/b&w inside. Pays on publication. Credit line given. Buys all rights.
Tips: "We look for sharply focused photographs that show action and for clear color that is bright and true. We need photographs of children and teachers involved in learning music at the piano. We prefer shots that show them deeply involved in their work rather than posed shots. Very little is taken on specific assignment except for the cover. Authors usually include article photographs with their manuscripts. We purchase only one or two items from stock each year."

CLEANING & MAINTENANCE MANAGEMENT MAGAZINE, 13 Century Hill Dr., Latham NY 12110. (518)783-1281. Fax: (518)783-1386. E-mail: dominic@facility~maintenance.com. Website: http://facility~maintenance. Senior Editor: Tom Williams. Managing Editor: Dominic Tom. Circ. 40,000. Estab. 1963. Monthly. Emphasizes management of cleaning/custodial/housekeeping operations for commercial buildings, schools, hospitals, shopping malls, airports, etc. Readers are middle- to upper-level managers of in-house cleaning/custodial departments, and managers/owners of contract cleaning companies. Sample copy free (limited) with SASE.
Needs: Uses 10-15 photos/issue. Needs photos of cleaning personnel working on carpets, hard floors, tile, windows, restrooms, large buildings, etc. Model release preferred. Captions required.
Making Contact & Terms: Provide résumé, business card, brochure, flier or tearsheets to be kept on file for possible assignments. "Query with specific ideas for photos related to our field." SASE. Reports in 1-2 weeks. Pays $25/b&w inside. Credit line given. Rights negotiable. Simultaneous submissions and previously published work OK.
Tips: "Query first and shoot what the publication needs."

CLIMATE BUSINESS MAGAZINE, P.O. Box 13067, Pensacola FL 32591. (904)433-1166. Fax: (904)435-9174. E-mail: burchellpub@gulf.net. Website: http://www.burchellpublishing.com. Publisher: Elizabeth A. Burchell. Circ. 15,000. Estab. 1990. Bimonthly magazine. Emphasizes business. Readers are executives, ages 35-54, with average annual income of $80,000. Sample copy $4.75.
Needs: Uses 50 photos/issue; 20 supplied by freelancers. Needs photos of Florida topics: technology, government, ecology, global trade, finance, travel and life shots. Model/property release required. Captions preferred.
Making Contact & Terms: Send unsolicited photos by mail for consideration. Provide résumé, business card, brochure, flier or tearsheets to be kept on file for possible assignments. Send 5×7 b&w or color prints; 35mm, 2¼×2¼ transparencies. Keeps samples on file. SASE. Accepts images in digital format for Mac (TIFF and EPS). Send at 300 dpi via compact, floppy or Zip disk, SyQuest or online. Reports in 3 weeks. Pays $75/color cover; $25/color inside; $25/b&w inside; $75/color page. Pays on publication. Buys one-time rights.
Tips: "Don't overprice yourself and keep submitting work."

COMMERCIAL CARRIER JOURNAL, 201 King of Prussia Rd., Radnor PA 19089. (610)964-4513. Fax: (610)964-4512. Executive Editor: Paul Richards. Managing Editor: Paul Richards. Circ. 85,600. Estab. 1911. Monthly magazine. Emphasizes truck and bus fleet maintenance operations and management.
Needs: Spot news (of truck accidents, Teamster activities and highway scenes involving trucks). Photos purchased with or without accompanying ms, or on assignment. Model release required. *Detailed* captions required.

Making Contact & Terms: Query first; send material by mail for consideration. For color photos, uses prints and 35mm transparencies. For covers, uses color transparencies. Uses vertical cover only. Needs accompanying features on truck fleets and news features involving trucking companies. SASE. Reports in 3 months. Payment varies. Pays on a per-job or per-photo basis. **Pays on acceptance.** Credit line given. Buys all rights.

CONSTRUCTION BULLETIN, 9443 Science Center Dr., New Hope MN 55428. (612)537-7730. Fax: (612)537-1363. Editor: G.R. Rekela. Circ. 5,000. Estab. 1893. Weekly magazine. Emphasizes construction in Minnesota, North Dakota and South Dakota *only*. Readers are male and female executives, ages 23-65. Sample copy $3.50.
Needs: Uses 25 photos/issue; 1 supplied by freelancers. Needs photos of construction equipment in use on Minnesota, North Dakota, South Dakota job sites. Reviews photos purchased with accompanying ms only. Captions required; include who, what, where, when.
Making Contact & Terms: Send unsolicited photos by mail for consideration. Send 8×10 matte color prints. Keeps samples on file. SASE. Reports in 1 month. Payment negotiable. Pays on publication. Credit line given. Buys one-time rights. Previously published work OK.
Tips: "Be observant, keep camera at hand when approaching construction sites in Minnesota, North Dakota and South Dakota."

⚑ CONSTRUCTION COMMENT, 920 Yonge St., 6th Floor, Toronto, Ontario M4W 3C7 Canada. (416)961-1028. Fax: (416)924-4408. Executive Editor: Lori Knowles. Circ. 5,000. Estab. 1970. Semiannual magazine. Emphasizes construction and architecture. Readers are builders, contractors, architects and designers in the Ottawa area. Sample copy and photo guidelines available.
Needs: Uses 25 photos/issue; 50% supplied by freelance photographers. Needs "straightforward, descriptive photos of buildings and projects under construction, and interesting people shots of workers at Ottawa construction sites." Model release preferred. Captions preferred.
Making Contact & Terms: Arrange a personal interview to show portfolio. Query with résumé of credits or list of stock photo subjects. Provide résumé, business card, brochure, flier or tearsheets to be kept on file for possible assignments. SASE (IRCs). Reports in 1 month. Pays $125/color cover; $75/b&w cover; $25/color or b&w inside. Pays on publication. Credit line given. Buys all rights to reprint in our other publications; rights negotiable. Simultaneous submissions and previously published work OK.
Tips: Looks for "representative photos of Ottawa building projects and interesting construction-site people shots."

CONSTRUCTION EQUIPMENT GUIDE, 470 Maryland Dr., Ft. Washington PA 19034. (215)885-2900 or (800)523-2200. Fax: (215)885-2910. E-mail: cegglen@aol.com. Editor: Beth Baker. Circ. 80,000. Estab. 1957. Biweekly trade newspaper. Emphasizes construction equipment industry, including projects ongoing throughout the country. Readers are male and female of all ages. Many are construction executives, contractors, dealers and manufacturers. Free sample copy. Photo guidelines free with SASE.
Needs: Uses 75 photo/issue; 20 supplied by freelancers. Needs photos of construction job sites and special event coverage illustrating new equipment applications and interesting projects. Call to inquire about special photo needs for coming year. Model/property release preferred. Captions required for subject identification.
Making Contact & Terms: Send unsolicited photos by mail for consideration. Provide résumé, business card, brochure, flier or tearsheets to be kept on file for possible future assignments. Send any size matte or glossy b&w prints. Keeps samples on file. SASE. Reports in 3 weeks. Payment negotiable. Pays on publication. Credit line given. Buys all rights; negotiable. Simultaneous submissions OK.

CONTEMPORARY DIALYSIS & NEPHROLOGY, 18 E. 41st St., 20th Floor, New York NY 10017. (Also has California office that was in the process of moving at press time.) Associate Publisher: Susan Sommer. Circ. 16,300. Estab. 1980. Monthly magazine. Emphasizes renal care (kidney disease). Readers are medical professionals involved in kidney care. Sample copy $4.
Needs: Uses various number of photos/issue. Model release required. Captions required.
Making Contact & Terms: Contact through rep. Send unsolicited photos by mail for consideration. Send 35mm transparencies. Keeps samples on file. SASE. Reports in 2 weeks. Payment negotiable. Credit line given.

Ⓝ CORRECTIONS TECHNOLOGY & MANAGEMENT, Hendon Publishing, Inc., 1000 Skokie Blvd., Suite 500, Wilmette IL 60091. (847)256-8555. Fax: (847)256-8574. E-mail: timburke@flash.net. Editor-in-Chief: Tim Burke. Circ. 18,000. Estab. 1997. Monthly trade journal. "CTM brings a fresh, lively, independent view of what's hot in the corrections market to busy correctional facility managers and officers.

CTM delivers useful information in an eye-catching format." For sample copy, send 9×12 SAE with $1.71 first-class postage.

Needs: Buys 25 photos from freelancers/issue. Needs photos of correctional professionals doing their job. Reviews photos with or without ms. Special photo needs include technology in corrections industry and facility design. Model release required for inmates; property release required. Photo caption required; include description of actions, correct spelling of locations, facilities, names of people in photos.

Making Contact & Terms: Provide résumé, business card, self-promotion piece or tearsheets to be kept on file for possible future assignments. Call editor. Art director will contact photographer for portfolio review if interested. Uses color prints. Keeps samples on file; include SASE for return of material. Reports in 2 weeks. Pays $300 for cover; $25 for inside. Pays on publication. Credit line given.

Tips: "Read CTM to get a feel. Then go get the shot nobody else can get! That's the one we want. Think of our reader, a professional in the field of corrections, who has seen a lot of things. The photos must be able to grab that reader's attention. Make your work the best it can be. Don't send it to us unless it's thrilling."

THE CRAFTS REPORT, 300 Water St., Wilmington DE 19801. (302)656-2209. Fax: (302)656-4894. Art Director: Mike Ricci. Circ. 20,000. Estab. 1975. Monthly. Emphasizes business issues of concern to professional craftspeople. Readers are professional working craftspeople, retailers and promoters. Sample copy $5.

Needs: Uses 15-25 photos/issue; 0-10 supplied by freelancers. Needs photos of professionally-made crafts, craftspeople at work, studio spaces, craft schools—also photos tied to issue's theme. Model/property release required; shots of artists and their work. Captions required; include artist, location.

Making Contact & Terms: Query with résumé of credits. Provide résumé, business card, brochure, flier or tearsheets to be kept on file for possible assignments. Keeps samples on file. SASE. Pays $250-400/ color cover; $25-50/inside; assignments negotiated. Pays on publication. Credit line given. Buys one-time and first North American serial rights; negotiable. Simultaneous submissions and previously published work OK.

Tips: "Shots of craft items must be professional-quality images. For all images be creative—experiment. Color, black & white and alternative processes considered."

CRANBERRIES, Dept. PM, P.O. Box 190, Rochester MA 02770. (508)763-8080. Fax: (508)763-4141. E-mail: cranzine@ultranet.com. Publisher/Editor: Carolyn Gilmore. Circ. 1,200. Monthly, but December/ January is a combined issue. Emphasizes cranberry growing, processing, marketing and research. Readers are "primarily cranberry growers but includes anybody associated with the field." Sample copy free.

Needs: Uses about 10 photos/issue; half supplied by freelancers. Needs "portraits of growers, harvesting, manufacturing—anything associated with cranberries." Captions required.

Making Contact & Terms: Send 4×5 or 8×10 b&w or color glossy prints by mail for consideration; "simply query about prospective jobs." Accepts images in digital format for Windows (TIFF). Send via compact disc, floppy disk. SASE. Pays $25-60/b&w cover; $15-30/b&w inside; $35-100 for text/photo package. Pays on publication. Credit line given. Buys one-time rights. Simultaneous submissions and previously published work OK.

Tips: "Learn about the field."

N DAIRY TODAY, Farm Journal Publishing, Inc., Centre Square West, 1500 Market St., Philadelphia PA 19102-2181. (215)557-8959. Fax: (215)568-3989. Website: http://www.farmjournal.com. Art Director: Alfred Casciato. Circ. 111,000. Monthly magazine. Emphasizes American agriculture. Readers are active farmers, ranchers or agribusiness people. Sample copy and photo guidelines free with SASE.

● This company also publishes *Farm Journal, Beef Today, Hogs Today* and *Top Producer.*

Needs: Uses 10-20 photos/issue; 50% supplied by freelancers. "We use studio-type portraiture (environmental portraits), technical, details, scenics." Model release preferred. Captions required.

Making Contact & Terms: Arrange a personal interview to show portfolio. Query with résumé of credits along with business card, brochure, flier or tearsheets to be kept on file for possible assignments. Accepts digital images. "Portfolios may be submitted via CD-ROM or floppy disk." SASE. Reports in 2 weeks. Pays $75-400/color photo; $200-400/day. Pays extra for electronic usage of images. "We pay a cover bonus." **Pays on acceptance.** Credit line given. Buys one-time rights. Simultaneous submissions OK.

Tips: In portfolio or samples, likes to "see about 40 slides showing photographer's use of lighting and ability to work with people. Know your intended market. Familiarize yourself with the magazine and keep abreast of how photos are used in the general magazine field."

DANCE TEACHER NOW, 3101 Poplarwood Court, Suite 310, Raleigh NC 27604-1010. (919)872-7888. Fax: (919)872-6888. E-mail: dancenow@aol.com. Website: http://www.dance-teacher.com. Editor:

Neil Offen. Circ. 8,000. Estab. 1979. Magazine published 10 times per year. Emphasizes dance, business, health and education. Readers are dance instructors and other related professionals, ages 15-90. Sample copy free with 9×12 SASE. Guidelines free with SASE.

Needs: Uses 20 photos/issue; all supplied by freelancers. Needs photos of action shots (teaching, etc.). Reviews photos with accompanying ms only. Model/property release preferred. Model releases required for minors and celebrities. Captions preferred; include date and location.

Making Contact & Terms: Provide résumé, business card, brochure, flier or tearsheets to be kept on file for possible assignments. Keeps samples on file. SASE. Accepts digital images for Windows on SyQuest, Zip disk, floppy or online; call art director for requirements. Pays $50 minimum/color cover; $20-150/color inside; $20-125/b&w inside. Pays on publication. Credit line given. Buys one-time rights plus publicity rights; negotiable.

DECA DIMENSIONS, 1908 Association Dr., Reston VA 20191. (703)860-5000. Fax: (703)860-4013. E-mail: carol_lund@DECA.org. Website: http://www.DECA.org. Managing Editor: Carol Lurd. Circ. 160,000. Estab. 1947. Quarterly association magazine. Membership magazine for ages 16-20 enrolled in marketing education and interested in marketing, management, entrepreneurship, leadership and personal development. Sample copy free.

Needs: Needs photos of young people at work, in school, or doing community service. Reviews photos with or without ms. Special photo needs include young people in work situations. Model release preferred. Photo caption preferred stating type of activity.

Making Contact & Terms: Send query letter with stock photo list, tearsheets. Provide résumé, business card, self-promotion piece or tearsheets to be kept on file for possible future assignments. Art director will contact photographer for portfolio review if interested. Portfolio should include b&w and/or color, prints, tearsheets or thumbnails. Uses 3×5 glossy color prints; 35mm transparencies. Keeps samples on file; include SASE for return of material. Reports back only if interested. Pays $150/color cover maximum; $35/b&w inside maximum; $60/color inside maximum. **Pays on acceptance**. Credit line given. Buys one-time rights. Simultaneous submissions and/or previously published work OK.

Tips: "I like color and action with an ethnic mix and gender mix."

DELTA DESIGN GROUP, INC., 409 Washington Ave., Box 1676, Greenville MS 38702. (601)335-6148. Fax: (601)378-2826. President: Noel Workman. Publishes magazines dealing with cotton, soybeans, health care, casino, travel and Southern agriculture.

Needs: Photos used for text illustration, promotional materials and slide presentations. Buys 25 photos/year; offers 10 assignments/year. Southern agriculture (cotton, rice, soybeans, sorghum, forages, beef and dairy, and catfish); California and Arizona irrigated cotton production; all aspects of life and labor on the lower Mississippi River; Southern historical (old photos or new photos of old subjects); recreation (boating, water skiing, fishing, canoeing, camping), casino gambling. Model release required. Captions preferred.

Making Contact & Terms: Query with samples or list of stock photo subjects or mail material for consideration. SASE. Reports in 1 week. Pays $50 minimum/job. Credit line given, except for photos used in ads or slide shows. Rights negotiable. Simultaneous submissions and previously published work OK.

Tips: "Wide selections of a given subject often deliver a shot that we will buy, rather than just one landscape, one portrait, one product shot, etc."

DENTAL ECONOMICS, Box 3408, Tulsa OK 74101. (918)835-3161. Editor: Dr. Joseph Blaes. Circ. 110,000. Monthly magazine. Emphasizes dental practice administration—how to handle staff, patients and bookkeeping and how to handle personal finances for dentists. Free sample copy. Photo and writer's guidelines free with SASE.

Needs: "Our articles relate to the business side of a practice: scheduling, collections, consultation, malpractice, peer review, closed panels, capitation, associates, group practice, office design, etc." Also uses profiles of dentists.

Making Contact & Terms: Send material by mail for consideration. Uses 8×10 b&w glossy prints; 35mm or 2¼×2¼ transparencies. "No outsiders for cover." SASE. Reports in 5-6 weeks. Credit line given. Buys all rights but may reassign to photographer after publication.

Tips: "Write and think from the viewpoint of the dentist—not as a consumer or patient. If you know of a dentist with an unusual or very visual hobby, tell us about it. We'll help you write the article to accompany your photos. Query please."

ELECTRIC PERSPECTIVES, 701 Pennsylvania Ave. NW, Washington DC 20004. (202)508-5714. Fax: (202)508-5759. E-mail: ericbcm@eei.org. Associate Editor: Eric Blume. Circ. 20,000. Estab. 1976. Publication of Edison Electric Institute. Bimonthly magazine. Emphasizes issues and subjects related to investor-owned electric utilities. Sample copy available on request.

Needs: Uses 20-25 photos/issue; 60% supplied by freelancers. Needs photos relating to the business and operational life of electric utilities—from customer service to engineering, from executive to blue collar. Model release required. Captions preferred.

Making Contact & Terms: Interested in receiving work from all photographers, including newer, lesser-known photographers. Query with stock photo list. Send unsolicited photos by mail for consideration. Provide résumé, business card, brochure, flier or tearsheets to be kept on file for possible assignments. Send 8×10 glossy color prints; 35mm, 2¼×2¼, 4×5 transparencies. Keeps samples on file. SASE. Reports in 1 month. Pays $200-400/color cover; $100-300/color inside; $200-350/color page rate; $750-1,500/photo/text package. Pays on publication. Buys one-time rights; negotiable (for reprints).

Tips: "We're interested in annual-report quality transparencies in particular. Quality and creativity is often more important than subject."

ELECTRICAL APPARATUS, Barks Publications, Inc., 400 N. Michigan Ave., Chicago IL 60611-4198. (312)321-9440. Associate Publisher: Elsie Dickson. Circ. 17,000. Monthly magazine. Emphasizes industrial electrical machinery maintenance and repair for the electrical aftermarket. Readers are "persons engaged in the application, maintenance and servicing of industrial and commercial electrical and electronic equipment." Sample copy $4.

Needs: "Assigned materials only. We welcome innovative industrial photography, but most of our material is staff-prepared." Photos purchased with accompanying ms or on assignment. Model release required "when requested." Captions preferred.

Making Contact & Terms: Query with résumé of credits. Contact sheet or contact sheet with negatives OK. SASE. Reports in 3 weeks. Pays $25-100/b&w or color. Pays on publication. Credit line given. Buys all rights, but exceptions are occasionally made.

EMPIRE STATE REPORT, 33 Century Hill Dr., Latham NY 12110. Fax: (518)783-0005. Editor: Victor Schaffner. Circ. 15,000. Estab. 1976. Monthly magazine. Emphasizes New York state politics and public policy. Readers are state policy makers and those who wish to influence them. Sample copy with 8½×11 SAE and 6 first-class stamps.

Needs: Uses 10-20 photos/issue; 5-10 supplied by freelancers. Needs photos of New York state personalities (political, government, business); issues; New York state places, cities, towns. Model/property release preferred. Captions preferred; include subject matter of photo.

Making Contact & Terms: Send unsolicited photos by mail for consideration. Provide résumé, business card, brochure, flier or tearsheets to be kept on file for possible assignments. Keeps samples on file. SASE. Reports in 3 weeks. Pays $125-250/color cover; $50-75/b&w inside. Pays on publication. Credit line given. Buys one-time rights. Simultaneous submissions and previously published work OK.

Tips: "Subject matter is the most important consideration at ESR. The subject must have a New York connection. But, on some occasions, a state issue can be illustrated with a more general photograph."

ERGONOMICS IN DESIGN, P.O. Box 1369, Santa Monica CA 90406-1369. (310)394-1811. Fax: (310)394-2410. E-mail: 72133.1474@compuserve.com. Website: http://hfes.org. Managing Editor: Lois Smith. Circ. 6,000. Estab. 1993. Publication of Human Factors and Ergonomics Society. Quarterly magazine. Emphasizes how ergonomics research is applied to tools, equipment and systems people use. Readers are BA/MA/PhDs in psychology, engineering and related fields. Sample copy $9.

Needs: Needs photos of technology areas such as medicine, transportation, consumer products. Model/property release preferred. Captions preferred.

Making Contact & Terms: Query with stock photo list. Keeps samples on file. SASE. Reports in 2 weeks. Accepts digital images; inquire before submitting. Pays on publication. Credit line given. Buys one-time rights. Simultaneous submissions and previously published work OK.

Tips: Wants to see high-quality color work for strong (sometimes subtle) cover that can also be modified in b&w for lead feature opener inside book.

EUROPE, 2300 M St. NW, 3rd Floor, Washington DC 20037. (202)862-9557. Editor-in-Chief: Robert J. Guttman. Managing Editor: Peter Gwin. Photo Editor: Anne Alvarez. Circ. 25,000. Magazine published 10 times a year. Covers the Europe Union with "in-depth news articles on topics such as economics, trade, US-EU relations, industry, development and East-West relations." Readers are "business people, professionals, academics, government officials." Free sample copy.

Needs: Uses about 20-30 photos/issue, most of which are supplied by stock houses and freelance photographers. Needs photos of "current news coverage and sectors, such as economics, trade, small business, people, transport, politics, industry, agriculture, fishing, some culture, some travel. No traditional costumes. Each issue we have an overview article on one of the 15 countries in the European Union. For this we need a broad spectrum of photos, particularly color, in all sectors. If a photographer queries and lets us

know what he has on hand, we might ask him to submit a selection for a particular story. For example, if he has slides or b&ws on a certain European country, if we run a story on that country, we might ask him to submit slides on particular topics, such as industry, transport or small business." Model release preferred. Captions preferred; identification necessary.

Making Contact & Terms: Query with list of stock photo subjects. Initially, a list of countries/topics covered will be sufficient. SASE. Reports in 1 month. Pays $75-150/b&w inside; $100 minimum/color inside; $400/cover; per job negotiable. Pays on publication. Credit line given. Buys one-time rights. Simultaneous submissions and previously published work OK.

Tips: "For certain articles, especially the Member States' Reports, we are now using more freelance material than previously. We need good photo and color quality, but not touristy or stereotypical. We want to show modern Europe growing and changing. Feature business or industry if possible."

FARM CHEMICALS, Dept. PM, 37733 Euclid Ave., Willoughby OH 44094. (216)942-2000. Fax: (216)942-0662. Editorial Director: Charlotte Sine. Group Editor: Jim Sulecki. Circ. 32,000. Estab. 1894. Monthly magazine. Emphasizes application and marketing of fertilizers and protective chemicals for crops for those in the farm chemical industry. Free sample copy and photo guidelines with 9×12 SAE.

Needs: Buys 6-7 photos/year; 5-30% supplied by freelancers. Photos of agricultural chemical and fertilizer application scenes (of commercial—not farmer—applicators). Model release preferred. Captions required.

Making Contact & Terms: Query first with résumé of credits. Uses 8×10 glossy b&w and color prints or transparencies. SASE. Reports in 3 weeks. Pays $25-50/b&w photo; $50-125/color photo. **Pays on acceptance.** Buys one-time rights. Simultaneous submissions and previously published work OK.

[N] FARM JOURNAL, INC., Centre Square West, 1500 Market St., Philadelphia PA 19102-2181. (215)557-8959. Fax: (215)568-3989. Editor: Sonja Hillgren. Art Director: Alfred Casciato. Circ. 800,000. Estab. 1877. Monthly magazine. Emphasizes the business of agriculture: "Good farmers want to know what their peers are doing and how to make money marketing their products." Free sample copy upon request.

● This company also publishes *Top Producer, Hogs Today, Beef Today* and *Dairy Today. Farm Journal* has received the Best Use of Photos/Design from the American Agricultural Editors' Association (AAEA).

Needs: Freelancers supply 60% of the photos. Photos having to do with the basics of raising, harvesting and marketing of all the farm commodities. People-oriented shots are encouraged. Also uses human interest and interview photos. All photos must relate to agriculture. Photos purchased with or without accompanying ms. Model release required. Captions required.

Making Contact & Terms: Arrange a personal interview or send photos by mail. Provide calling card and samples to be kept on file for possible future assignments. Uses glossy or semigloss color or b&w prints; 35mm or 2¼×2¼ transparencies, all sizes for covers. SASE. Reports in 1 month. Pays by assignment or photo. Pays $200-400/job. Cover bonus. **Pays on acceptance.** Credit line given. Buys one-time rights; negotiable. Simultaneous submissions OK.

Tips: "Be original, take time to see with the camera. Be selective. Look at use of light—available or strobed—and use of color. I look for an easy rapport between photographer and subject. Take as many different angles of subject as possible. Use fill where needed."

[N] ⊕ FARMERS WEEKLY, Reed Business Information Ltd., Quadrant House, The Quadrant, Sutton, Surrey SM2 5AS England. Phone: (0181)652 4914. Fax: (0181)652 4005. E-mail: barry.dixon@rbi.co.uk. Website: http://www.fwi.co.uk. Picture Library Manager: Barry Dixon. Circ. 100,000. Estab. 1934. Weekly trade journal aimed at UK agricultural industry.

Needs: Reviews photos with or without ms. Photo captions required; include full agricultural technical information.

Making Contact & Terms: Photographers should contact us by phone to show portfolio. Portfolio should include slides, tearsheets. Uses 35mm, 2¼×2¼ transparencies. Deadlines: Tuesday evenings. Does not keep samples on file; include SASE for return of material. Payment varies. Pays on publication. Will negotiate with a photographer unwilling to sell all rights.

Tips: "Read our magazine. Ring first before subitting work."

THE SUBJECT INDEX, located at the back of this book, lists publications, book publishers, galleries, gift and paper product companies and stock agencies according to the subject areas they seek.

FIRE CHIEF, 35 E. Wacker, Suite 700, Chicago IL 60601. (312)726-7277. Fax: (312)726-0241. E-mail: firechfmag@ichiefs.org. Editor: Scott Baltic. Circ. 48,000. Estab. 1956. Monthly magazine. Emphasizes fire department management and operations. Readers are overwhelmingly fire officers and predominantly chiefs of departments. Free sample copy. Photo guidelines free with SASE.

Needs: Uses 1 photo/issue; all supplied by freelancers. Needs photos of a fire chief in action at an emergency scene. "Contact us for a copy of our current editorial calendar." Model/property release preferred. Captions required; include names, dates, brief description of incident.

Making Contact & Terms: Send unsolicited photos by mail for consideration. Send any glossy color prints; 35mm, 2¼ × 2¼ transparencies. Keeps samples on file. SASE. Reports in 1 month. Pays $300/color cover; $25-50/color inside. Pays on publication. Buys first serial rights; negotiable.

Tips: "We want a photo that captures a chief officer in command at a fire or other incident, that speaks to the emotions (the burden of command, stress, concern for others). Most of our cover photographers take dozens of fire photos every month. These are the guys who keep radio scanners on in the background most of the day. Timing is everything."

FIRE ENGINEERING, Park 80 West Plaza 2, 7th Floor, Saddle Brook NJ 07663. (201)845-0800. Fax: (201)845-6275. E-mail: dianet@pennwell.com. Editor: Bill Manning. Estab. 1877. Training magazine for firefighters. Photo guidelines free with SASE.

Needs: Uses 400 photos/year. Needs action photos of firefighters working. Captions required; include date, what is happening, location and fire department contact.

Making Contact & Terms: Send unsolicited photos by mail for consideration. Send prints; 35mm transparencies. SASE. "We accept scans of photos as long as it is a high-resolution version." Reports in up to 3 months. Pays $35-150/color inside; $300/color cover. Pays on publication. Credit line given. Rights negotiable.

Tips: "Firefighters must be doing something. Our focus is on training and learning lessons from photos."

N ⊠ FLORAL MANAGEMENT MAGAZINE, 1601 Duke St., Alexandria VA 22314. (703)836-8700. Fax: (800)208-0078. Editor and Publisher: Kate Penn. Estab. 1894. National trade association magazine representing growers, wholesalers and retailers of flowers and plants. Photos used in magazine and promotional materials.

Needs: Offers 15-20 assignments/year. Needs photos of floral business owners and employees on location. Reviews stock photos. Model release required. Captions preferred.

Audiovisual Needs: Uses slides (with graphics) for convention slide shows.

Making Contact & Terms: Query with samples. Provide résumé, business card, brochure, flier or tearsheets to be kept on file for possible future assignments. Uses b&w prints, or transparencies. SASE. Reports in 1 week. Pays $400-600/cover shot; $75-150/hour; $125-250/job; $75-500/color inside. Credit line given. Buys one-time rights.

Tips: "We shoot a lot of tightly composed, dramatic shots of people so we look for these skills. We also welcome input from the photographer on the concept of the shot. Our readers, as business owners, like to see photos of other business owners. Therefore, people photography, on location, is particularly popular."

FOOD & SERVICE, P.O. Box 1429, Austin TX 78767-1429. (512)472-3666. Art Director: Gina Wilson. Circ. 6,500. Estab. 1940. Publication of the Texas Restaurant Association. Published 8 times a year. Emphasizes restaurant owners and managers in Texas—industry issues, legislative concerns, management techniques. Readers are restaurant owners/operators in Texas. Sample copy free with 10 × 13 SAE and 6 first-class stamps. Photo guidelines free with SASE.

Needs: Uses 1-3 photos/issue; 1-3 supplied by freelancers. Needs editorial photos illustrating business concerns (i.e. health care issues, theft in the workplace, economic outlooks, employee motivation, etc.) Reviews photos purchased with or without a manuscript (but prefers with). Model release required for paid models. Property release preferred for paid models.

Making Contact & Terms: Provide résumé, business card, brochure, flier or tearsheets to be kept on file for possible assignments. Accepts digital images in Photoshop 300 DPI RGB files on magnetic optical 230 drive for Macintosh. Deadlines: 2-3 week turnaround from assignment date. Keeps samples on file. SASE. Reports in 2 months. Pays $75-450/job; $200-450/color cover; $200-300/b&w cover; $200-300/color inside; $100-250/b&w inside. **Pays on acceptance.** Credit line given. Buys one-time rights. Previously published work OK.

Tips: "Please don't send food shots—even though our magazine is called *Food & Service*. We publish articles about the food service industry that interest association members—restaurant owners and operators (i.e. legislative issues like health care; motivating employees; smokers' vs. non-smokers' rights; proper food handling; plus, occasional member profiles. Avoid clichés and over-used trends. Don't be weird for weird's sake. Photos in our magazines must communicate (and complement the editorial matter)."

FOOD DISTRIBUTION MAGAZINE, 1580 NW Boca Raton Blvd., #6, Boca Raton FL 33432. (561)447-0810. Fax: (561)368-9125. Editor: Dale Rim. Circ. 35,000. Estab. 1959. Monthly magazine. Emphasizes gourmet and specialty foods. Readers are male and female food-industry executives, ages 30-60. Sample copy $5.
Needs: Uses 10 photos/issue; 3 supplied by freelancers. Needs photos of food: prepared food shots, products on store shelves. Reviews photos with accompanying ms only. Model release required for models only. Captions preferred; include photographer's name, subject.
Making Contact & Terms: Send unsolicited photos by mail for consideration. Send any size color prints or slides and 4×5 transparencies. SASE. Reports in 1-2 weeks. Pays $100 minimum/color cover; $50 minimum/color inside. Pays on publication. Credit line given. Buys all rights. Simultaneous submissions OK.

FOOD PRODUCT DESIGN MAGAZINE, 3400 Dundee Rd., Suite 100, Northbook IL 60062. (847)559-0385. Fax: (847)559-0389. Art Director: Barbara Weeks. Circ. 26,000. Estab. 1991. Monthly. Emphasizes food development. Readers are research and development people in food industry.
Needs: Needs food shots (4-color). Special photo needs include food shots—pastas, cheese, reduced fat, meat products, sauces, etc.; as well as group shots of people, lab shots, focus group shots.
Making Contact & Terms: Query with stock photo list. Reports in 1-2 weeks. Pays on publication. Credit line given. Buys all rights for use in magazine. Simultaneous submissions and/or previously published work OK.
Tips: Prefers to work with local photographers.

FORD NEW HOLLAND NEWS, P.O. Box 1895, New Holland PA 17557. Editor: Gary Martin. Circ. 300,000. Estab. 1960. Published 8 times a year. Emphasizes agriculture. Readers are farm families. Sample copy and photo guidelines free with 9×12 SASE.
Needs: Buys 30 photos/year. 75% freelance photography/issue from assignment and 25% freelance stock. Needs photos of scenic agriculture relating to the seasons, harvesting, farm animals, farm management and farm people. Model release required. Captions required.
Making Contact & Terms: "Show us your work." SASE. Reports in 6 weeks. "We need photos of farm crops and animals. Collections viewed and returned quickly." Pays $50-500/color photo, depends on use and quality of photo. **Pays on acceptance.** Buys first North American serial rights. Previously published work OK.
Tips: Photographers "must see beauty in agriculture and provide meaningful caption material. It also helps to team up with a good agricultural writer and query us."

N: FOREST LANDOWNER, P.O. Box 95385, Atlanta GA 30347. (404)325-2954. Fax: (404)325-2955. E-mail: snewton100@aol.com. Managing Editor: Steve Newton. Circ. 10,000. Estab. 1950. Publication of Forest Landowners Association. Bimonthly magazine. Emphasizes forest management and forest policy issues for private forest landowners. Readers are forest landowners and forest industry consultants; 94% male between the ages of 46 and 55. Sample copy $3 (magazine), $25 (manual).
Needs: Uses 15-25 photos/issue; 3-4 supplied by freelancers. Needs photos of unique or interesting southern forests. Model/property release preferred. Captions preferred.
Making Contact & Terms: Send unsolicited photos by mail for consideration. Query with stock photo list. Send Zip disk color prints, negatives or transparencies. Accepts images in digital format for Windows (TIF). Send via compact disc, floppy disk or SyQuest. Keeps samples on file. SASE. Reports in 3 weeks. Pays $200-300/hour; $100-300/cover; $30-50/inside color. Pays on publication. Credit line given. Buys one-time and all rights; negotiable. Simultaneous submissions and previously published work OK.
Tips: "We are a small shop with limited resources. Consequently we use more computer images to save time."

GENERAL AVIATION NEWS & FLYER, Dept. PM, P.O. Box 39099, Tacoma WA 98439-0099. (206)471-9888. Fax: (206)471-9911. Managing Editor: Kirk Gormley. Circ. 35,000. Estab. 1949. Biweekly tabloid. Emphasizes aviation. Readers are pilots and airplane owners and aviation professionals. Sample copy $3.50. Photo guidelines free with SASE.
Needs: Uses 30-40 photos/issue; 10-50% supplied by freelancers. Reviews photos with or without ms, but "strongly prefer with ms." Especially wants to see "travel and destinations, special events."
Making Contact & Terms: Query with résumé of credits. Captions preferred. Send unsolicited prints (up to 8×10, b&w or color) or transparencies (35mm or 2¼×2¼) by mail for consideration. Does not keep samples on file. SASE. Reports in 1 month. Pays $35-50/color cover; $35/color inside; $10/b&w inside. Pays on publication. Credit line given. Buys one-time rights.
Tips: Wants to see "sharp photos of planes with good color, airshows not generally used."

GEOTECHNICAL FABRICS REPORT, 1801 County Rd. B.W., Minneapolis MN 55113. (612)222-2508 or (800)225-4324. Fax: (612)225-6966. Editor: Dianne Cormany. Circ. 18,000. Estab. 1983. Published 9 times/year. Emphasizes geosynthetics in civil engineering applications. Readers are civil engineers, professors and consulting engineers. Sample copies available.

Needs: Uses 10-15 photos/issue; various number supplied by freelancers. Needs photos of finished applications using geosynthetics, photos of the application process. Reviews photos with or without ms. Model release required. Captions required; include project, type of geosynthetics used and location.

Making Contact & Terms: Send unsolicited photos by mail for consideration. Send any size color and b&w prints. Keeps samples on file. SASE. Reports in 1 month. Payment negotiable. Credit line given. Buys all rights; negotiable. Simultaneous submissions OK.

Tips: "Contact manufacturers in the geosynthetics industry and offer your services. We will provide a list, if needed."

THE GROWING EDGE, 341 SW Second St., P.O. Box 1027, Corvallis OR 97333. (541)757-2511. Fax: (541)757-0028. E-mail: aknutson@peak.org. Website: http://www.growingedge.com. Editor: Amy Knutson. Circ. 20,000. Estab. 1989. Published bimonthly. Emphasizes "new and innovative techniques in gardening indoors, outdoors and in the greenhouse—hydroponics, artificial lighting, greenhouse operations/control, water conservation, new and unusual plant varieties." Readers are serious amateurs to small commercial growers.

Needs: Uses about 40 photos per issue; most supplied with articles by freelancers. Occasional assignment work (5%); 80% from freelance stock. Model release required. Captions required; include plant types, equipment used.

Making Contact & Terms: Send query with samples. Prefers 35mm slides. Accepts b&w or color prints; transparencies (any size); b&w or color negatives with contact sheets. Accepts images in digital format for Mac. SASE. Reports in 6 weeks or will notify and keep material on file for future use. Pays $175/cover; $25-50/b&w inside; $25-175/color inside; $300-800/text/photo package. Pays on publication. Credit line given. Buys first world and one-time anthology rights; negotiable.

Tips: "Most photographs are used to illustrate processes and equipment described in text. Some photographs of specimen plants purchased. Many photos are of indoor plants under artificial lighting. The ability to deal with tricky lighting situations is important." Expects more assignment work in the future, especially for covers. Need cover photos.

⚑ HARD HAT NEWS, Lee Publications, Inc., 6113 State Hwy. 5, Palatine Bridge NY 13428-0121. (518)673-3237. Fax: (518)673-2381. E-mail: hardhat@telenet.net. Editor: Mary Hilton. Circ. 24,000. Estab. 1980. Biweekly trade journal covering heavy construction, equipment, road and bridge work. Sample copy free.

Needs: Buys 10 photos from freelancers/issue; 260 photos/year. Needs photos of heavy equipment in use; heavy construction projects in progress—roads, bridges, excavation, demolition. Photo caption required; include names of people in photo, location of jobsite, contact name if I need to get more information.

Making Contact & Terms: Send query letter with tearsheets. Provide résumé, business card, self-promotion piece or tearsheets to be kept on file for possible future assignments. "Just send in photo—I need to see it to decide." Uses 5×7 and 8×10 color b&w color, prints; 35mm transparencies. Does not keep samples on file; include SASE for return of material. Reports in 2 weeks. Pays $5/color cover minimum; $5/b&w inside minimum; $5/color inside minimum. Pays on publication. Credit line given. "We are not copyrighted—we don't buy rights." Simultaneous submissions and/or previously published work OK.

Tips: "Best shots for cover are vertical and shot at a fairly long distance—will send sample cover on request. For inside shots, we only use photos of current jobsites or projects—get a contact name, show action, dirt and equipment! Put a caption securely attached to the back of every photo."

▓ HEATING, PLUMBING & AIR CONDITIONING (HPAC), 1370 Don Mills Rd., Suite 300, Don Mills, Ontario M3B 3N7 Canada. (416)759-2500. Fax: (416)759-6979. Publisher: Bruce Meacock. Circ. 17,000. Estab. 1927. Bimonthly magazine plus annual buyers guide. Emphasizes heating, plumbing, air conditioning, refrigeration. Readers are predominantly male, mechanical contractors ages 30-60. Sample copy $4.

Needs: Uses 10-15 photos/issue; 2-4 supplied by freelancers. Needs photos of mechanical contractors at work, product shots. Model/property release preferred. Captions preferred.

Making Contact & Terms: Send unsolicited photos by mail for consideration. Send 4×6, glossy/semi-matte color b&w prints; 35mm transparencies. Also accepts digital images. Cannot return material. Reports in 1 month. Payment negotiable. Pays on publication. Credit line given. Buys one-time rights; negotiable. Simultaneous submissions and/or previously published work OK.

HEREFORD WORLD, P.O. Box 014059, Kansas City MO 64101. (816)842-3757. Editor: Ed Bible. Circ. 10,000. Estab. 1947. Monthly magazine. Emphasizes Hereford cattle for registered breeders, commercial cattle breeders and agribusinessmen in related fields.
Making Contact & Terms: Query. Uses b&w prints and color transparencies and prints. Reports in 2 weeks. Pays $5/b&w print; $100/color transparency or print. Pays on publication.
Tips: Wants to see "Hereford cattle in quantities, in seasonal and/or scenic settings."

HISPANIC BUSINESS, 360 S. Hope Ave., Suite 300C, Santa Barbara CA 93105. (805)682-5843. Circ. 200,000. Estab. 1979. Monthly publication. Emphasizes Hispanics in business (entrepreneurs and executives), the Hispanic market. Sample copy $5.
Needs: Uses 25 photos/issue; 20% supplied by freelancers. Needs photos of personalities and action shots. No mug shots. Captions required; include name, title.
Making Contact & Terms: Query with résumé of credits. Keeps samples on file. Reports in 2 weeks. Pays $450/color cover; $150/color inside. Pays on publication. Credit line given. Rights negotiable.
Tips: Wants to see "unusual angles, bright colors, hand activity. Photo tied to profession."

N: HOGS TODAY, Farm Journal Publishing, Inc., Centre Square W., 1500 Market St., 28th Floor, Philadelphia PA 19102-2181. (215)557-8959. Art Director: Alfred Casciato. Circ. 125,000. Monthly magazine. Sample copy and photo guidelines free with SASE.
● This company also publishes *Farm Journal*, *Beef Today*, *Dairy Today* and *Top Producer*.
Needs: Uses 20-30 photos/issue; 75% supplied by freelancers. "We use studio-type portraiture (environmental portraits), technical, details, scenics." Model release preferred. Captions required.
Making Contact & Terms: Arrange a personal interview to show portfolio. Query with résumé of credits along with business card, brochure, flier or tearsheets to be kept on file for possible assignments. SASE. Reports in 2 weeks. Payment negotiable. "We pay a cover bonus." **Pays on acceptance.** Credit line given. Buys one-time rights. Simultaneous submissions OK.
Tips: In portfolio or samples, likes to "see about 20 slides showing photographer's use of lighting and ability to work with people. Know your intended market. Familiarize yourself with the magazine and keep abreast of how photos are used in the general magazine field."

HOME FURNISHINGS EXECUTIVE, 305 W. High St., Suite 400, High Point NC 27260. (910)883-1650. Fax: (910)883-1195. E-mail: hfexec@aol.com. Editor: Trisha McBride. Monthly magazine. "We are an issue-oriented business journal that tries to provide a forum for constructive dialogue between retailers and manufacturers in the home furnishings industry. Our readers include industry retailers, manufacturers and suppliers." Sample copy and photo guidelines free with SASE.
Needs: Uses 15-20 photos/issue; 50% supplied by freelancers. Needs personality photos, shots of store interiors.
Making Contact & Terms: Query with résumé of credits. Provide résumé, business card, brochure, flier or tearsheets to be kept on file for possible assignments. Accepts images in digital format for Mac. Send via compact disc, floppy disk, SyQuest. Reports only when interested. Pays $250-1,500/color; $100-1,500/b&w. **Pays on acceptance.** Credit line given. Buys first North American serial rights.
Tips: Looks for "ability to capture personality in business subjects for profiles; ability to handle diverse interiors."

HOME LIGHTING & ACCESSORIES, 1011 Clifton Ave., Clifton NJ 07013. (973)779-1600. Fax: (973)779-3242. Editor-in-Chief: Linda Longo. Circ. 12,000. Estab. 1923. Monthly magazine. Emphasizes outdoor and interior lighting. Readers are small business owners, specifically lighting showrooms and furniture stores. Sample copy $6.
Needs: Uses 50 photos/issue; 10 supplied by freelancers. Needs photos of lighting applications that are unusual—either landscape for residential or some commercial and retail stores. Reviews photos with accompanying ms only. Model/property release preferred. Captions required (location and relevant names of people or store).
Making Contact & Terms: Query with résumé of credits. Send unsolicited photos by mail for consideration. Provide résumé, business card, brochure, flier or tearsheets to be kept on file for possible future assignments. Send 5×7, 8×10 color prints; 4×5 transparencies. Keeps samples on file. SASE. Reports in 1 month. Pays $90/color cover; $5-10/color inside. Pays on publication. Credit line given. Buys one-time rights. Simultaneous submissions and/or previously published work OK.

IB (INDEPENDENT BUSINESS): AMERICA'S SMALL BUSINESS MAGAZINE, Group IV Communications, 125 Auburn Court, Suite 100, Thousand Oaks CA 91362. (805)496-6156. Fax: (805)496-5469. E-mail: gosmallbiz@aol.com. Website: http://www.yoursource.com. Editor: Daniel Kehrer. Editorial

Director: Don Phillipson. Photo Editor: Pamela Froman. Circ. 600,000. Estab. 1990. Bimonthly magazine. Emphasizes small business. All readers are small business owners throughout the US. Sample copy $4. Photo guidelines free with SASE.

Needs: Uses 25-35 photos/issue; all supplied by freelancers. Needs photos of "people who are small business owners. All pictures are by assignment; no spec photos." Special photo needs include dynamic, unusual photos of offbeat businesses and their owners. Model/property release required. Captions required; include correct spelling on name, title, business name, location.

Making Contact & Terms: Query with résumé of credits and samples. Provide résumé, business card, brochure, flier or tearsheets to be kept on file for possible assignments. Unsolicited original art will not be returned. Pays $350/color inside plus expenses. Pays $400-500 per complete job plus expenses. Pays $100-150 per electronic use of images. **Pays on acceptance.** Credit line given. Buys first and nonexclusive reprint rights.

Tips: "We want colorful, striking photos of small business owners that go well above-and-beyond the usual business magazine. Capture the essence of the business owner's native habitat."

IEEE SPECTRUM, 345 E. 47th St., New York NY 10017. (212)705-7568. Fax: (212)705-7453. Website: http://www.spectrum.IEEE.org. Art Director: Mark Montgomery. Circ. 300,000. Publication of Institute of Electrical and Electronics Engineers, Inc. (IEEE). Monthly magazine. Emphasizes electrical and electronics field and high technology. Readers are male/female; educated; age range: 24-60.

Need: Uses 3-6 photos/issue; 3 provided by freelancers. Special photo needs include portrait photography and high technology photography. Model/property release required. Captions preferred.

Making Contact & Terms: Arrange personal interview to show portfolio. Provide résume, business card, brochure, flier or tearsheets to be kept on file for possible assignments. Pays $1,500-2,000/color cover; $200-400/color inside. **Pays on acceptance.** Credit line given. Buys one-time rights. Previously published work OK.

Tips: Wants photographers who are consistent, have an ability to shoot color and b&w, display a unique vision and are receptive to their subjects.

IGA GROCERGRAM, 1301 Carolina St., Greensboro NC 27401. (910)378-6065. Fax: (910)275-2864. Managing Editor: Wes Isley. Publication of the Independent Grocers Alliance. Circ. 18,000. Estab. 1926. Monthly magazine, plus special issues. Emphasizes food industry. Readers are IGA retailers, mainly male. Sample copy $2 plus postage.

Needs: Uses 25-35 photos/issue; all supplied by freelancers. Needs in-store shots, food (appetite appeal). Prefers shots of IGA stores. Model/property release preferred. Captions preferred.

Making Contact & Terms: Send unsolicited 35mm transparencies by mail for consideration. Provide résumé, business card, brochure, flier or tearsheets to be kept on file for possible assignments. Keeps samples on file. Reports in 3 weeks. Pay negotiable. **Pays on acceptance.** Credit line given. Buys one-time rights. Simultaneous submissions and previously published work OK.

INDOOR COMFORT NEWS, 454 W. Broadway, Glendale CA 91204. (818)551-1555. Fax: (818)551-1115. Managing Editor: Chris Callard. Circ. 20,000. Estab. 1955. Publication of Institute of Heating and Air Conditioning Industries. Monthly magazine. Emphasizes news, features, updates, special sections on CFC's, Indoor Air Quality, Legal. Readers are predominantly male—25-65, HVAC/R/SM contractors, wholesalers, manufacturers and distributors. Sample copy free with 10×13 SAE and 10 first-class stamps.

Needs: Interested in photos with stories of topical projects, retrofits, or renovations that are of interest to the heating, venting, and air conditioning industry. Property release required. Captions required; include what it is, where and what is unique about it.

Making Contact & Terms: Send unsolicited photos by mail for consideration. Provide résumé, business card, brochure, flier or tearsheets to be kept on file for possible assignments. Send 3×5 glossy color and b&w prints. Deadlines: first of the month, 2 months prior to publication. Keeps samples on file. SASE. Reports in 1-2 weeks. Payment negotiable. Credit line given.

Tips: Looks for West Coast material—projects and activities with quality photos of interest to the HVAC industry. "Familiarize yourself with the magazine and industry before submitting photos."

MARKET CONDITIONS are constantly changing! If you're still using this book and it's 2000 or later, buy the newest edition of *Photographer's Market* at your favorite bookstore or order directly from Writer's Digest Books.

INSIDE AUTOMOTIVES, 21700 Northwestern Hwy., Suite 565, Southfield MI 48075. (248)557-2430. Fax: (248)557-2431. E-mail: autoinfo@atlanta.com. Managing Editor: Scott Worden. Circ. 11,200. Estab. 1994. Bimonthly magazine. Emphasizes automotive interiors. Readers are engineers, designers, management OEMS and material and components suppliers. Sample copy $4. Photo guidelines free with SASE.
Needs: Uses 20 photos/issue; 10% supplied by freelancers. Needs photos of technology related to articles. Model/property release preferred for technical information. Captions required; include who and what is in photos.
Making Contact & Terms: Provide résumé, business card, brochure, flier or tearsheets to be kept on file for possible future assignments. Contact editor by letter or fax. Send 3×5, 5×7 color and b&w photos; 35mm transparencies. Keeps samples on file. SASE. Payment negotiable. Pays on publication. Credit line given. Buys one-time rights. Simultaneous submissions OK.

JEMS COMMUNICATIONS, 1947 Camino Vida Roble, Suite 200, Carlsbad CA 92008. (760)431-9797. Fax: (760)431-9567. E-mail: jems.editor@mosby.com. Managing Editor: Lisa Dionne. Circ. 45,000. Estab. 1980. Monthly magazine. Emphasizes emergency medical services by out-of-hospital providers. Readers are EMTS and paramedics. Sample copy available. Photo guidelines free with SASE.
Needs: Uses 35-40 photos/month; 15-20 supplied by freelancers. Needs photos of paramedics and EMTs on actual calls following proper procedures with focus on caregivers, not patients. Model/property release required for EMS providers, patients and family members. Captions preferred; include city, state, incident and response organizations identified.
Making Contact & Terms: Query with letter requesting rates and guidelines. Send 8×10 glossy color and b&w prints; 35mm $2\frac{1}{4} \times 2\frac{1}{4}$, 4×5, 8×10 transparencies. Accepts photos in digital format for Mac (Photoshop). Keeps samples on file. Cannot return material. Reports in 3 weeks. Pays $200+/color cover; $25-300/color inside; $25-100/b&w inside; pays extra for electronic usage of photos. Credit line given. Buys one-time rights.
Tips: "Study samples before submitting. We want the photos to focus on caregivers, not patients. We want providers following protocols in a variety of settings."

JOURNAL OF PROPERTY MANAGEMENT, 430 N. Michigan Ave., 7th Floor, Chicago IL 60611. (312)329-6059. Fax: (312)661-0217. Website: http://www.irem.org. Associate Editor: Jennifer Towne. Executive Editor: Mariwyn Evans. Estab. 1934. Bimonthly magazine. Emphasizes real estate management. Readers are mid- and upper-level managers of investment real estate. Sample copy free with SASE.
Needs: Uses 6 photos/issue; 50% supplied by freelancers. Needs photos of buildings (apartments, condos, offices, shopping centers, industrial), building operations and office interaction. Model/property release preferred.
Making Contact & Terms: Accepts images in digital format for Windows (EPS, TIFF). Send via compact disc, floppy disk, SyQuest, Zip disk. Pays $200/color photo.

JOURNAL OF PSYCHOACTIVE DRUGS, Dept. PM, 612 Clayton St., San Francisco CA 94117. (415)565-1904. Fax: (415)864-6162. Editor: Richard B. Seymour. Circ. 1,400. Estab. 1967. Quarterly. Emphasizes "psychoactive substances (both legal and illegal)." Readers are "professionals (primarily health) in the drug abuse treatment field."
Needs: Uses 1 photo/issue; supplied by freelancers. Needs "full-color abstract, surreal, avant garde or computer graphics."
Making Contact & Terms: Query with samples. Send 4×6 color prints or 35mm slides by mail for consideration. SASE. Reports in 2 weeks. Pays $50/color cover. Pays on publication. Credit line given. Buys one-time rights. Simultaneous submissions and previously published work OK.

■ KEYSTONE PRESS AGENCY, INC., 202 E. 42nd St., New York NY 10017. (212)924-8123. E-mail: balperf@worldnet.att.net. Managing Editor: Brian F. Alpert. Types of clients: book publishers, magazines and major newspapers.
Needs: Uses photos for slide sets. Subjects include: photojournalism. Reviews stock photos/footage. Captions required.
Specs: Uses 8×10 glossy b&w and color prints; 35mm and $2\frac{1}{4} \times 2\frac{1}{4}$ transparencies.
Making Contact & Terms: Cannot return material. Reports upon sale. Payment is 50% of sale per photo. Credit line given.

Ⓝ LAW & ORDER MAGAZINE, Hendon Publishing, 1000 Skokie Blvd., Suite 500, Wilmette IL 60091. (847)256-8555. Fax: (847)256-8574. Editorial Director: Bruce Cameron. Circ. 35,000. Estab. 1953. Monthly magazine published for police department administrative personnel. The articles are designed

with management of the department in mind and are how-to in nature. Sample copy free. Art guidelines free.

Needs: Buys 10 photos from freelancers/issue; 120 photos/year. Needs photos of police, crime, technology, weapons, vehicles. Reviews photos with or without ms. Special photo needs include police using technology—laptop computers etc. Model release required for any police department personnel. Property release required. Photo caption required; include name and department of subject, identify products used.

Making Contact & Terms: Send query letter with stock photo list. Art director will contact photographer for portfolio review if interested. Portfolio should include color, prints, slides, transparencies. Uses color prints; 35mm, 4×5 transparencies. Keeps samples on file; include SASE for return of material. Reports in 3 weeks on queries; 2 weeks on samples. Pays $200-350/color cover; $25/color inside. Pays on publication. Credit line given. Buys all rights; negotiable. Simultaneous submissions OK.

Tips: "Read the magazine. Get a feel for what we cover. We like work that is dramatic and creative. Police are moving quickly into the high tech arena. We are interested in photos of that. Police officers during training activities are also desirable."

LLAMAS MAGAZINE, P.O.Box 250, Jackson CA 95642. (209)223-0469. Fax: (209)223-0466. E-mail: claypress@aol.com. Circ. 5,500. Estab. 1979. Publication of The International Camelid Journal. Magazine published 5 times a year. Emphasizes llamas, alpacas, vicunas, guanacos and camels. Readers are llama and alpaca owners and ranchers. Sample copy $5.75. Photo and editorial guidelines free with SASE.

Needs: Uses 30-50 photos/issue; all supplied by freelancers. Wants to see "any kind of photo with llamas, alpacas, camels in it. Always need good verticals for the cover. Always need good action shots." Model release required. Captions required.

Making Contact & Terms: Send unsolicited b&w or color 35mm prints or 35mm transparencies by mail for consideration. Provide résumé, business card, brochure, flier or tearsheets to be kept on file for possible assignments. SASE. Reports in 2 weeks. Pays $5-25/b&w; $25-300/color. Pays on publication. Credit line given. Buys one-time rights. Simultaneous submissions and previously published work OK.

Tips: "You must have a good understanding of llamas and alpacas to submit photos to us. It's a very specialized market. Our rates are modest, but our publication is a very slick 4-color magazine and it's a terrific vehicle for getting your work into circulation. We are willing to give photographers a lot of free tearsheets for their portfolios to help publicize their work."

N: MANAGERS REPORT, 1700 Southern Blvd., West Palm Beach FL 33411. (561)687-4700. Fax: (561)687-9654. E-mail: mgrreport@aol.com. Executive Editor: Lisa Pinder. Circ. 20,000. Estab. 1986. Monthly trade magazine for condominium managers and board members. Sample copy and art guidelines available.

Needs: Buys 1 photo from freelancers/issue; 12 photos/year. Needs photos of managers, board members and communities. Model release preferred. Property release preferred. Captions required.

Making Contact & Terms: Send query letter with stock photo list. Keeps samples on file; include SASE for return of material. Reports back only if interested, send non-returnable samples. Pays $50/color cover; $50/b&w; $50/color inside. Pays on acceptance. Buys all rights; negotiable.

MARKETERS FORUM, 383 E. Main St., Centerport NY 11721. (516)754-5000. Fax: (516)754-0630. Publisher: Martin Stevens. Circ. 70,000. Estab. 1981. Monthly magazine. Readers are entrepreneurs and retail store owners. Sample copy $5.

Needs: Uses 3-6 photos/issue; all supplied by freelancers. "We publish trade magazines for retail variety goods stores and flea market vendors. Items include: jewelry, cosmetics, novelties, toys, etc. (five-and-dime-type goods). We are interested in creative and abstract impressions—not straight-on product shots. Humor a plus." Model/property release required.

Making Contact & Terms: Send unsolicited photos by mail for consideration. Send color prints; 35mm, 4×5 transparencies. Does not keep samples on file. SASE. Reports in 2 weeks. Pays $100/color cover; $50/color inside. **Pays on acceptance.** Buys one-time rights. Simultaneous submissions and/or previously published work OK.

MARKETING & TECHNOLOGY GROUP, 1415 N. Dayton, Chicago IL 60622. (312)266-3311. Fax: (312)266-3363. Art Director: Scott Dreyer. Circ. 18,000. Estab. 1993. Publishes 3 magazines: *Carnetec*, *Meat Marketing & Technology*, and *Poultry Marketing & Technology*. Emphasizes meat and poultry processing. Readers are predominantly male, ages 35-65, generally conservative. Sample copy $4.

Needs: Uses 15-30 photos/issue; 1-3 supplied by freelancers. Needs photos of food, processing plant tours, product shots, illustrative/conceptual. Model/property release preferred. Captions preferred.

Making Contact & Terms: Provide résumé, business card, brochure, flier or tearsheets to be kept on file for possible assignments. Submit portfolio for review. Keeps samples on file. Reports in 1 month.

Payment negotiable. Pays on publication. Credit line given. Buys all rights; negotiable. Simultaneous submissions and previously published work OK.

Tips: "Work quickly and meet deadlines. Follow directions when given; and when none are given, be creative while using your best judgment."

MINORITY BUSINESS ENTREPRENEUR, 3528 Torrance Blvd., Suite 101, Torrance CA 90503. (310)540-9398. Fax: (310)792-8265. E-mail: mbewbe@ix.netcom.com. Website: http://www.mbemag.c om. Executive Editor: Jeanie Barnett. Circ. 40,000. Estab. 1984. Bimonthly magazine. Emphasizes minority- and women-owned businesses. Readers are business owners of all ages and industries. Sample copy $3 with 9½×12½ SAE and 5 first-class stamps. "We have editorial guidelines and calendar of upcoming issues available."

Needs: Uses 30 feature photos/issue; 2% supplied by freelancers. Needs "good shots for cover profiles and minority features of our entrepreneurs." Model/property release required. Captions preferred; include name, title and company of subject, and proper photo credit.

Making Contact & Terms: Query with résumé of credits. Provide résumé, business card, brochure, flier or tearsheets to be kept on file for possible assignments. Send 5×7, 8×10 matte prints. "Never submit unsolicited photos. Photographers interested in showing their portfolios must make an appointment with the executive editor." Accepts images in digital format for Windows (Postscript, EPS). Send via floppy disk, SyQuest. SASE. Reports in 5 weeks. Payment negotiable. Pays on publication. Credit line given. Buys first North American serial rights; negotiable.

Tips: "We're starting to run color photos in our business owner profiles. We want pictures that capture them in the work environment. Especially interested in minority and women photographers working for us. Our cover is an oil painting composed from photos. It's important to have high quality b&ws which show the character lines of the face for translation into oils. Read our publication and have a good understanding of minority business issues. Never submit photos that have nothing to do with the magazine."

MODERN BAKING, Dept. PM, 2700 River Rd., Suite 418, Des Plaines IL 60018. (847)299-4430. Fax: (847)296-1968. Editor: Ed Lee. Circ. 27,000. Estab. 1987. Monthly. Emphasizes on-premise banking, in supermarkets, food service establishments and retail bakeries. Readers are owners, managers and operators. Sample copy for 9×12 SAE with 10 first-class stamps.

Needs: Uses 30 photos/issue; 1-2 supplied by freelancers. Needs photos of on-location photography in above-described facilities. Model/property release preferred. Captions required; include company name, location, contact name and telephone number.

Making Contact & Terms: Provide résumé, business card, brochure, flier or tearsheets to be kept on file for possible future assignments. SASE. Reports in 2 weeks. Pays $50 minimum; negotiable. **Pays on acceptance.** Credit line given. Buys all rights; negotiable.

Tips: Prefers to see "photos that would indicate person's ability to handle on-location, industrial photography."

MORTGAGE ORIGINATOR MAGAZINE, 1360 Sunset Cliffs Blvd., San Diego CA 92107. (619)223-9989. Fax: (619)223-9943. E-mail: mtgemom@aol.com Publisher: Chris Salazar. Circ. 10,000. Estab. 1991. Monthly magazine. Emphasizes mortgage banking. Readers are sales staff. Sample copy $6.95.

Needs: Uses 8 photos/issue. Needs photos of business.

Making Contact & Terms: Query with stock photo list. Send unsolicited photos by mail for consideration. Send color prints; 35mm transparencies. Keeps samples on file. Payment negotiable. Pays on publication. Credit line given. Buys exclusive industry rights. Simultaneous submissions and previously published work OK.

MOUNTAIN PILOT, 7009 S. Potomac St., Englewood CO 80112-4029. (303)397-7600. Fax: (303)397-7619.E-mail: ehuber@winc.usa.com. Website: http://www.mountainpilot.com. Editor: Ed Huber. Bimonthly national magazine on mountain aviation. Circ. 15,000. Estab. 1985. Published by Wisner Publishing Inc. Emphasizes mountain aviation—flying, safety, education, experiences, survival, weather, location destinations. Readers are mid-life male, affluent, mobile. Sample copy free with SASE.

Needs: Uses assignment photos. Model release and photo captions required.

Making Contact & Terms: Provide résumé, business card, brochure, flier or tearsheets to be kept on file for possible assignments: contact by phone. Accepts digital format for Mac (TIFF or EPS). Send via floppy disk, SyQuest, Zip disk (300 live screen 150 for output). SASE. Reports in 1 month. Pays negotiable text package. Pays 30 days after publication. Credit line given. Buys all rights; negotiable. Simultaneous submissions and previously published work OK.

Tips: Looks for "unusual destination pictures, mountain aviation oriented." Trend is "imaginative." Make

shot pertinent to an active pilot readership. Query first. Don't send originals—color copies acceptable. Copy machine reprints OK for evaluation.

MUSHING MAGAZINE, P.O. Box 149, Ester AK 99725. (907)479-0454. Fax: (907)479-3137. E-mail: editor@mushing.com. Website: http://www.mushing.com. Publisher: Todd Hoener. Circ. 7,000. Estab. 1987. Bimonthly magazine. Readers are dog drivers, mushing enthusiasts, dog lovers, outdoor specialists, innovators and sled dog history lovers. Sample copy $5 in US. Photo guidelines free with SASE.
Needs: Uses 20 photos/issue; most supplied by freelancers. Needs action photos: all-season and wilderness; also still and close-up photos: specific focus (sledding, carting, dog care, equipment, etc). Special photo needs include skijoring, feeding, caring for dogs, summer carting or packing, 1-3 dog-sledding and kids mushing. Model release preferred. Captions preferred.
Making Contact & Terms: Send unsolicited photos by mail for consideration. Reports in 6 months. Pays $150 maximum/color cover; $35 maximum/color inside; $15-35/b&w inside. Pays $10 extra for one year of electronic user rights on the web. Pays on publication. Credit line given. Buys first serial rights and second reprint rights.
Tips: Wants to see work that shows "the total mushing adventure/lifestyle from environment to dog house." To break in, one's work must show "simplicity, balance and harmony. Strive for unique, provocative shots that lure readers and publishers. Send a selection of 20 (more or less) slides for us to review for a particular issue or for several months for a few issues."

NAILPRO, 7628 Densmore Ave., Van Nuys CA 91406-2042. (818)782-7328. Fax: (818)782-7450. Executive Editor: Linda Lewis. Circ. 50,000. Estab. 1989. Published by Creative Age Publications. Monthly magazine. Emphasizes topics for professional manicurists and nail salon owners. Readers are females of all ages. Sample copy $2 with 9 × 12 SASE.
Needs: Uses 10-12 photos/issue; all supplied by freelancers. Needs photos of beautiful nails illustrating all kinds of nail extensions and enhancements; photographs showing process of creating and decorating nails, both natural and artificial. Model release required. Captions required; identify people and process if applicable.
Making Contact & Terms: Send color prints; 35mm, 2¼ × 2¼, 4 × 5. Keeps samples on file. SASE.

Photographer Stacey Burns first made contact with Creative Age, publishers of *Nailpro*, through a personal reference. Now she shoots for them regularly. "I am 'on call' to provide illustrative images to accompany articles in Creative Age's magazines," she says. "This article was about Flo-Jo's new career after the Olympics, and her plans to open her own salon. In addition to her gold medals in track & field, Flo-Jo is well known for her awesomely long nails." Burns says each shot she does for Creative Age publications makes them more likely to work with her in the future. "For this type of location shot, it's important to be mobile. I do a lot more in-studio product shots, so it was refreshing to pack up and go on location."

© Stacey Burns

Reports in 1 month. Pays $500/color cover; $50-200/color inside; $50/b&w inside. **Pays on acceptance**. Credit line given. Buys one-time rights. Previously published work OK.

Tips: "Talk to the person in charge of choosing art about photo needs for the next issue and try to satisfy that immediate need; that often leads to assignments."

NATION'S BUSINESS, U.S. Chamber of Commerce, 1615 H St. NW, Washington DC 20062. (202)463-5447. Photo Editor: Laurence L. Levin. Assistant Photo Editor: Frances Borchardt. Circ. 865,000. Monthly. Emphasizes business, how to run your business better, especially small business. Readers are managers, upper management and business owners. Sample copy free with 9 × 12 SASE.

Needs: Uses about 40-50 photos/issue; 60% supplied by freelancers. Needs portrait-personality photos, business-related pictures relating to the story. Model release preferred. Captions required.

Making Contact & Terms: Arrange a personal interview to show portfolio. Submit portfolio for review. SASE. Reports in 3 weeks. Pays $200/b&w or color inside; $175-300/day. Pays on publication. Credit line given. Buys one-time rights.

Tips: In reviewing a portfolio, "we look for the photographer's ability to light, taking a static situation and turning it into a spontaneous, eye-catching and informative picture."

NAVAL HISTORY, (formerly Proceedings/Naval History), US Naval Institute, 118 Maryland Ave., Annapolis MD 21402. (410)268-6110. Fax: (410)269-7940. Website: http://www.USNI.org. Contact: Photo Editor. Circ. 50,000. Estab. 1873. Bimonthly association publication. Emphasizes Navy, Marine Corps, Coast Guard. Readers are age 18 and older, male and female, naval officers, enlisted, retirees, civilians. Sample copy free with 9 × 12 SASE. Photo guidelines free with SASE.

Needs: Uses 50 photos/issue; 40% supplied by freelancers. Needs photos of foreign and US Naval, Coast Guard and Marine Corps vessels, personnel and aircraft. Captions required.

Making Contact & Terms: Send unsolicited photos by mail for consideration: 8 × 10 glossy or matte, b&w or color prints; transparencies. Accepts images in digital format for Mac in JPEG files via compact disc, Zip disk, floppy disk or online at 300 dpi. SASE. Reports in 1 month. Pays $200/color or b&w cover; $25/color inside; $25/b&w page rate; $250-500/photo/text package. Pays on publication. Credit line given. Buys one-time rights. Simultaneous submissions and previously published work OK.

NEW METHODS, P.O. Box 22605, San Francisco CA 94122-0605. (415)379-9065. Art Director: Ronald S. Lippert, AHT. Circ. 5,600. Estab. 1981. Monthly. Emphasizes veterinary personnel, animals. Readers are veterinary professionals and interested consumers. Sample copy $3.20 (20% discount on 12 or more). Photo guidelines free with SASE.

Needs: Uses 12 photos/issue; 2 supplied by freelance photographers. Assigns 95% of photos. Needs animal, wildlife and technical photos. Most work is b&w. Model/property releases preferred. Captions preferred.

Making Contact & Terms: Arrange a personal interview to show portfolio. Query with résumé of credits, samples or list of stock photo subjects. Provide résumé, business card, brochure, flier or tearsheets. SASE. Reports in 2 months. Payment is rare, negotiable; will barter. Credit line given. Simultaneous submissions and previously published work OK.

Tips: Ask for photo needs before submitting work. Prefers to see "technical photos (human working with animal(s) or animal photos (*not cute*)" in a portfolio or samples. On occasion, needs photographer for shooting new products and local area conventions.

[N] THE NEW YORK OPERA NEWSLETTER, The Classical Singer's Magazine, P.O. Box 278, Maplewood NJ 07040. (973)378-9549. Fax: (973)378-2372. E-mail: tnyon@aol.com. Editor: C.J. Williamson. Circ. 4,000. Estab. 1988. Monthly trade journal for classical singers, about classical singers and by classical singers. Sample copy free.

Needs: "We've been using headshots, but would like to move to many more types of photographs of classical singers, their life and their work." Needs photos of singers as people not icons, young singers at a lesson, singers coming to a performance, audience—looking for photos with personality, emotion, pathos. Reviews photos with or without ms. Call for calendar and ideas. Photo caption preferred include; where, when, who.

Making Contact & Terms: Send query letter with samples. Portfolio may be dropped off any time. Send e-mail. Portfolio should include b&w prints. Uses b&w prints. Keeps samples on file; will return material with SASE. Reports in 1 month on queries. Pays $50/b&w cover maximum; $10-35/b&w inside. Pays on publication. Credit line given. Buys one-time rights. Photo may be used in a reprint of an article on paper or website. Simultaneous submissions and/or previously published work OK.

Tips: "We would like to use photos to go with a story—but also photos which reveal the exultation and devastation of a singer's life and career, their ordinary life portrayed with sensitivity. Singers of all levels

from college to retired, performing and touching people from nursing homes to the Metropolitan Opera. Could be competition winners/losers, nerves before a performance, exhaustion after. Our publication is expanding rapidly. We want to make insightful photographs a big part of that expansion."

911 MAGAZINE, P.O. Box 11788, Santa Ana CA 92711. (714)544-7776. E-mail: editor@9-1-1magazine. com. Editor: Randall Larson. Circ. 13,000. Estab. 1988. Bimonthly magazine. Emphasizes public safety communications—police, fire, paramedic, dispatch, etc. Readers are ages 20-65. Sample copy free with 9×12 SAE and 7 first-class stamps. Photo guidelines free with SASE.

Needs: Uses up to 25 photos/issue; 75% supplied by freelance photographers; 20% comes from assignment, 5% from stock. "From the Field" department photos are needed of incidents involving public safety communications showing proper techniques and attire. Model release preferred. Captions preferred; if possible include incident location by city and state, agencies involved, duration, dollar cost, fatalities and injuries.

Making Contact & Terms: Query with list of stock photo subjects. Send unsolicited photos by mail for consideration. Provide résumé, business card, brochure, flier or tearsheets to be kept on file for possible assignments. Uses 35mm, 2¼×2¼, 4×5, 8×10 glossy contacts, b&w or color prints; 35mm, 2¼×2¼, 4×5, 8×10 transparencies. Accepts images in digital format for Mac or Windows. SASE. Reports in 3 weeks. Pays $100-300/color cover; $50-75/color inside; $20-50/b&w inside. Pays on publication. Credit line given. Buys one-time rights.

Tips: "We need photos for unillustrated cover stories and features appearing in each issue. Topics include rescue, traffic, communications, training, stress, media relations, crime prevention, etc. Calendar available. Assignments possible."

NORTHEAST EXPORT, 404 Chestnut St., #201, Manchester NH 03101. (603)626-6354. Fax: (603)626-6359. Art Director: Nikki Bonenfant. Circ. 12,000. Estab. 1997. Semimonthly magazine. Emphasizes international trade by northeast companies. Readers are male and female—top management, average age 45. Sample copy free with 9×12 SAE and 5 first-class stamps.

Needs: Uses 3-6 photos/issue. Needs photos of exporting, shipping and receiving, cargo, international

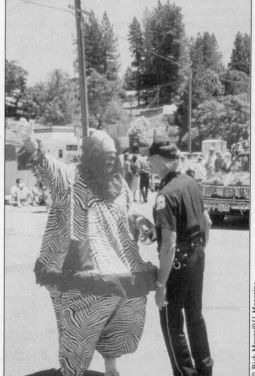

Beginning writers are often advised to write what they know. The same advice applies to photographers. "My wife and several of my friends kept telling me I should submit some photos to *911* magazine, which we get at work," says Rick Mouze. "To make a long story short, I sent in the slide of the cop & clown, and lo and behold, there it was in the magazine." Mouze's humorous shot earned him $50 and helped him establish a working relationship with the magazine. He also got a boost in his confidence as a photographer. "Just keep submitting your photos and one day you'll be published," he advises. "It also doesn't hurt to have the moral support of your loved ones encouraging you."

© Rick Mouze/911 Magazine

trade zones, high-tech and manufacturing. Model/property release preferred. Captions required; include names, locations, contact phone number.

Making Contract & Terms: Arrange personal interview to show portfolio. Provide résumé, business card, brochure, flier or tearsheets to be kep on file for possible assignments. Accepts images in digitial format for Mac (TIFF). Send via compact disc, floppy disk, zip disk (300 dpi, 150 lpi). Keeps samples on file. SASE. Reports in 3 weeks. Pays $300-500/color cover; $50-100/color inside; $50-75/b&w inside. Pays on publication. Credit line given. Buys one-time rights. Offers internships for photographers. Contact Art Director: Nikki Bonenfant.

Tips: Looks for "people in environment shots, interesting lighting, lots of creative interpretations, a definite personal style. We are a publishing company that has a reputation for quality, award-winning publications."

O&A MARKETING NEWS, 532 El Dorado St., Suite 200, Pasadena CA 91101. (626)683-9993. Fax: (626)683-0969. Editor: Kathy Laderman. Circ. 9,000. Estab. 1966. Bimonthly tabloid. Emphasizes petroleum marketing in the 13 Western states. Readers are active in the petroleum industry and encompass all ages, interests and genders. Sample copy free with 10×13 SAE and $2.50 postage.

Needs: Uses 150-200 photos/issue; 10 supplied by freelancers. Needs photos of interesting—and innovative—activities at gasoline stations, car washes, quick lubes and convenience stores in the 13 Western states. Model/property release preferred. Captions required (what is pictured, where it is, why it's unusual).

Making Contact & Terms: Send unsolicited photos by mail for consideration. Send 5×7 (preferred, but others OK) matte or glossy b&w prints. SASE. Reports in 3 weeks. Pays $5/b&w inside; other forms of payment vary, depending on length of text submitted. Buys one-time rights. Simultaneous submissions and/or previously published work OK.

Tips: "We're looking for sharp, newspaper-style black & white photos that show our Western readers something new, something different, something they wouldn't necessarily see at a gas station or convenience store near their home."

OCULAR SURGERY NEWS, Dept. PM, 6900 Grove Rd., Thorofare NJ 08086. (609)848-1000. Fax: (609)853-5991. E-mail: cweddo@slackinc.com. Associate Editor: Conni Waddington. Circ. 18,000. Biweekly newspaper. Emphasizes ophthalmology, medical and eye care. Readers are ophthalmologists in the US. Sample copy free with 9×12 SAE and 10 first-class stamps.

Needs: Uses 30 photos/issue; less than 10% supplied by freelancers. Needs photos for business section on a monthly basis. Topics like managed care, money management, computers and technology, patient satisfaction, etc.

Making Contact & Terms: Query with list of stock photo subjects. Provide résumé, business card, brochure, flier or tearsheets to be kept on file for possible assignments. SASE. Reports in 2 weeks. Pays $300/color cover; $150/color inside; $150-250/day. Pays on publication. Credit line given. Buys one-time rights.

OHIO TAVERN NEWS, 329 S. Front St., Columbus OH 43215. (614)224-4835. Fax: (614)224-8649. Editor: Chris Bailey. Circ. 8,200. Estab. 1939. Tabloid newspaper. Emphasizes beverage alcohol/hospitality industries in Ohio. Readers are liquor permit holders: restaurants, bars, distillers, vintners, wholesalers. Sample copy free for 9×12 SASE.

Needs: Uses 1-4 photos/issue. Needs photos of people, places, products covering the beverage alcohol/hospitality industries in Ohio. Captions required; include who, what, where, when and why.

Making Contact & Terms: Send unsolicited photos by mail for consideration. Send up to 8×10 glossy b&w prints. Deadlines: first and third Friday of each month. Keeps samples on file. SASE. Reports in 1 month. Pays $15/photo. Pays on publication. Credit line given. Buys one-time rights; negotiable. Simultaneous submissions OK.

PACIFIC BUILDER & ENGINEER, Vernon Publications Inc., 12437 NE 173rd Place, Woodinville WA 98072. (425)488-3211. Fax: (425)488-0946. Editor: Carl Molesworth. Circ. 14,500. Estab. 1902. Biweekly

magazine. Emphasizes non-residential construction in the Northwest and Alaska. Readers are construction contractors. Sample copy $7.
Needs: Uses 8 photos/issue; 4 supplied by freelancers. Needs photos of ongoing construction projects to accompany assigned feature articles. Reviews photos purchased with accompanying ms only. Photo captions preferred; include name of project, general contractor, important subcontractors, model/make of construction equipment, what is unusual/innovative about project.
Making Contact & Terms: Query with résumé of credits. Accepts images in digital format for PC (Quark, Photoshop, FreeHand). Send via floppy disk, SyQuest, Zip disk (133 line screen ERP 2438 dots/inch). Does not keep samples on file. SASE. Reports in 1 month. Pays $25-125/color cover; $15-50/b&w inside. Pays on publication. Buys first North American serial rights.
Tips: "All freelance photos must be coordinated with assigned feature stories."

PACIFIC FISHING, 1515 NW 51st, Seattle WA 98107. (206)789-5333. Fax: (206)784-5545. Editor: Brad Warren. Art Director: Barbara Bosh. Circ. 9,100. Estab. 1979. Monthly magazine. Emphasizes commercial fishing on West Coast—California to Alaska. Readers are 80% owners of fishing operations, primarily male, ages 25-55; 20% processors, marketers and suppliers. Sample copy free with 11×14 SAE and 8 first-class stamps. Photo guidelines free with SASE.
Needs: Uses 15 photos/issue; 10 supplied by freelancers. Needs photos of *all* aspects of commercial fisheries on West Coast of US and Canada. Special needs include "high-quality, active photos and slides of fishing boats and fishermen working their gear, dockside shots and the processing of seafood." Model/property release preferred. Captions required; include names and locations.
Making Contact & Terms: Query with résumé of credits and sample photos. Query with list of stock photo subjects. Keeps samples on file. SASE. Reports in 2-6 weeks. Pays $200/color cover; $50-100/color inside; $25-50/b&w inside. Pays on publication. Credit line given. Buys one-time rights, first North American serial rights. Previously published work OK "if not previously published in a competing trade journal."
Tips: Wants to see "clear, close-up and active photos, especially on board fishing vessels."

PAPER AGE, 51 Mill St., Suite 5, Hanover MA 02339-1650. (781)829-4581. Fax: (781)829-4503. Editor: John F. O'Brien Jr.. Circ. 35,000. Estab. 1884. Monthly tabloid. Emphasizes paper industry—news, pulp and paper mills, technical reports on paper making and equipment. Readers are employees in the paper industry. Sample copy free.
Needs: Uses 25-30 photos/issue; very few supplied by freelancers. Needs photos of paper mills—inside/outside; aerial; forests (environmentally appealing shots); paper recycling facilities. Property release preferred (inside shots of paper mill equipment). Photo captions required; include date, location, description of shot.
Making Contact & Terms: Send unsolicited photos by mail for consideration. Send any size glossy prints. Keeps samples on file. SASE. Reports in 1-2 weeks. Payment negotiable. Pays on publication. Credit line given. Buys all rights; negotiable.

THE PARKING PROFESSIONAL, 701 Kenmore, Suite 200, Fredericksburg VA 22401. (540)371-7535. Fax: (540)371-8022. Editor: Kim Jackson. Circ. 3,000. Estab. 1984. Publication of the International Parking Institute. Monthly magazine. Emphasizes parking: public, private, institutional, etc. Readers are male and female public parking managers, ages 30-60. Free sample copy.
Needs: Uses 12 photos/issue; 4-5 supplied by freelancers. Model release required. Captions preferred, include location, purpose, type of operation.
Making Contact & Terms: Contact through rep. Arrange personal interview to show portfolio for review. Query with résumé of credits. Provide résumé, business card, brochure, flier or tearsheets to be kept on file for possible assignments. Send 5×7, 8×10 color or b&w prints; 35mm, $2\frac{1}{4} \times 2\frac{1}{4}$, 4×5, 8×10 transparencies. Keeps samples on file. SASE. Reports in 1-2 weeks. Pays $100-300/color cover; $25-100/color inside; $25-100/b&w inside; $100-500/photo/text package. Pays on publication. Credit line given. Buys one-time, all rights; negotiable. Previously published work OK.

PEDIATRIC ANNALS, 6900 Grove Rd., Thorofare NJ 08086. (609)848-1000. E-mail: ped@slackinc.com. Website: http://www.slackinc.com/ped.htm. Editor: Kimberly A. Callar. Circ. 36,000. Monthly journal. Readers are practicing pediatricians. Sample copy free with SASE.
Needs: Uses 1 cover photo/issue. Needs photos of "children in medical settings, some with adults." Written release required. Captions preferred.
Making Contact & Terms: Query with samples. Provide résumé, business card, brochure, flier or tearsheets to be kept on file for possible future assignments. Pays $300-600/color cover. Pays on publication. Credit line given. Buys one-time North American rights including any and all subsidiary forms of publica-

tion, such as electronic media and promotional pieces. Simultaneous submissions and previously published work OK.

N PEI, Photo Electronic Imaging, 229 Peachtree St., NW, Suite 2200, International Tower, Atlanta GA 30303. Fax: (404)614-6406. E-mail: info@peimag.com. Website: http://www.peimag.com. Circ. 45,000. Monthly magazine covering digital imaging techniques and processes. Audience includes professional imaging specialists, desktop publishers, graphic artists and related fields. Readership seeks in-depth articles on current technology, step-by-step tutorials and artist profiles. Sample copies available for $4.
Needs: Buys technical manuscripts with accompanying photos, 15-20/issue. Model release preferred. Caption preferred. Include how the images were created, platform, software, file size, etc.
Making Contact & Terms: Send query letter with samples, brochure, tearsheets. To show portfolio, photographer should follow up with call. Uses glossy color and b&w prints and 35 mm, $2\frac{1}{4} \times 2\frac{1}{4}$, 4×5, 8×10 transparencies. Accepts images in digital format. Send Photoshop or TIFF files via CD, floppy disk, JAZ or ZIP cartridges. Keeps samples on file. Reports back only if interested, send non-returnable samples. Pays on publication. Credit line given. Buys first rights. Previously published work OK.
Tips: "We are looking for digital artists with dynamic imagery to feature in the magazine."

N ⊕ PEOPLE MANAGEMENT, Personnel Publications Ltd., 17 Britton St., London EC1M 5NQ England. Phone: 0171 880 6200. Fax: 0171 336 7635. E-mail: mark@ppltd.co.uk. Website: http://www.peoplemanagement.co.uk. Circ. 80,000. Trade journal for professionals in personnel, training and development.
Needs: Reviews photos with or without ms. Model release preferred. Photo captions preferred.
Making Contact & Terms: Send query letter with samples. To show portfolio, photographer should follow-up with call. Portfolio should include b&w prints, slides, transparencies. Keeps samples on file; include SASE for return of material. Reports back only if interested, send non-returnable samples. Pays £300-600/cover; £175-300/inside. Pays on publication. Rights negotiable.

PET BUSINESS, 7-L Dundas Circle, Greensboro NC 27407. (910)292-4047. Fax: (910)292-4272. Executive Editor: Rita Davis. Circ. 19,000. Estab. 1974. Monthly news magazine for pet industry professionals. Sample copy $3. Guidelines free with SASE.
Needs: Photos of well-groomed pet animals (preferably purebred) of any age in a variety of situations. Identify subjects. Animals: dogs, cats, fish, birds, reptiles, amphibians, small animals (hamsters, rabbits, gerbils, mice, etc.) Also, can sometimes use shots of petshop interiors—but must be careful not to be product-specific. Good scenes would include personnel interacting with customers or caring for shop animals. Model/property release preferred. Captions preferred; include essential details regarding animal species.
Making Contact & Terms: Submit photos for consideration. Reports within 3 months with SASE. Pays $20/color print or transparency for inside use; $100 for cover use. Pays on publication. Credit line given. Buys all rights; negotiable.
Tips: Wants uncluttered background. Portrait-style always welcome. Close-ups best. News/action shots if timely. "Make sure your prints have good composition, and are technically correct, in focus and with proper contrast. Avoid dark pets on dark backgrounds! Send only 'pet' animal, not zoo or wildlife, photos."

N PET PRODUCT NEWS MAGAZINE, P.O. Box 6050, Mission Viejo CA 92690. (714)855-8822. Fax: (714)855-3045. Managing Editor: Mary K. McHale. Monthly tabloid. Emphasizes pets and business subjects. Readers are pet store owners and managers. Sample copy $5.50. Photo guidelines free with SASE.
Needs: Uses 25-50 photos/issue; 75-100% supplied by freelancers. Needs photos of people interacting with pets, retailers interacting with customers and pets, pets doing "pet" things, pet stores and vets examining pets. Reviews photos with or without ms. Model/property release preferred. Captions preferred; include type of animal, name of pet store, name of well-known subjects, any procedures being performed on an animal that are not self-explanatory.
Making Contact & Terms: Send unsolicited photos by mail for consideration. Send any size glossy color and b&w prints; 35mm transparencies or slides. SASE. Reports in 2 months. "Photo prices vary, typically ranging from $35-70/photo." Pays on publication. Credit line given; must appear on each slide or photo. Buys one-time rights. Previously published work OK.
Tips: Looks for "appropriate subjects, clarity and framing, sensitivity to the subject. No avant garde or special effects. We need clear, straight-forward photography. Definitely no 'staged' photos, keep it natural. Read the magazine before submission. We are a trade publication and need business-like, but not boring, photos that will add to our subjects."

N PETROGRAM, 209 Office Plaza, Tallahassee FL 32301. (904)877-5178. Fax: (904)877-5864. Editor: Priscilla Dawson. Circ. 700. Estab. mid-1970s. Monthly association publication. Emphasizes the petroleum

industry and convenience stores. Readers are predominantly male, increasingly female, ages 30-60. Sample copy free with 9×12 SAE and 4 first-class stamps.

Needs: Uses 3-15 photos/issue; 1 supplied by freelancer. Needs photos of petroleum equipment, convenience store settings, traffic situations and environmental protection (Florida specific). Needs portrait-oriented cover photos, not landscape-oriented photos. Reviews photos with or without a ms. Model/property release preferred. Captions preferred; include location and date.

Making Contact & Terms: Submit portfolio for review. Query with stock photo list. Send unsolicited photos by mail for consideration. Provide résumé, business card, brochure, flier or tearsheets to be kept on file for possible assignments. Send 5×7, 8×10 glossy b&w or color prints. Keeps samples on file. SASE. Reports in 3 weeks. Pays $100/color cover; $75/b&w cover; $50/color inside; $25/b&w inside. Pays on publication. Credit line given. Rights negotiable.

Tips: "We are new at considering freelance. We've done our own up to now except very occasionally when we've hired a local photographer. We are a good place for 'non-established' photographers to get a start."

PHOTO TECHNIQUES, Dept. PM, Preston Publications, 6600 W. Touhy, P.O. Box 48312, Niles IL 60714. (847)647-2900. Fax: (847)647-1155. Publisher: Tinsley S. Preston, III. Editor: Mike Johnston. Circ. 40,000. Estab. 1979. Bimonthly magazine. Covers darkroom techniques, creative camera use, photochemistry and photographic experimentation/innovation, plus general user-oriented photography articles aimed at advanced amateurs and professionals. Sample copy $4.50. Photography and writer's guidelines free with SASE.

Needs: "The best way to publish photographs in *Photo Techniques* is to write an article on photo or darkroom techniques and illustrate the article. The exceptions are: cover photographs—we are looking for striking poster-like images that will make good newsstand covers; and the Portfolio feature—photographs of an artistic nature. Most of freelance photography comes from what is currently in a photographer's stock." Model/property release preferred. Captions required if photo is used.

Making Contact & Terms: "We do not want to receive more than 10 or 20 in any one submission. We ask for submissions on speculative basis only. Except for portfolios, we publish few single photos that are not accompanied by some type of text." Send dupe slides first. All print submissions should be 8×10. Pays $300/covers; $100/page and up for text/photo package; negotiable. Pays on publication only. Credit line given. Buys one-time rights.

Tips: "We are looking for exceptional photographs with strong, graphically startling images. No run-of-the-mill postcard shots please. We are the most technical general-interest photographic publication on the market today. Authors are encouraged to substantiate their conclusions with experimental data. Submit samples, article ideas, etc. It's easier to get photos published with an article."

PLASTICS NEWS, 1725 Merriman Rd., Akron OH 44313. (330)836-9180. Fax: (330)836-2322. Managing Editor: Don Loepp. Circ. 60,000. Estab. 1989. Weekly tabloid. Emphasizes plastics industry business news. Readers are male and female executives of companies that manufacture a broad range of plastics products; suppliers and customers of the plastics processing industry. Sample copy $1.95.

Needs: Uses 10-20 photos/issue; 1-3 supplied by freelancers. Needs photos of technology related to use and manufacturing of plastic products. Model/property release preferred. Captions required.

Making Contact & Terms: Send unsolicited photos by mail for consideration. Provide résumé, business card, brochure, flier or tearsheets to be kept on file for possible assignments. Query with stock photo list. Keeps samples on file. SASE. Reports in 2 weeks. Pays $125-175/color cover; $125-175/color inside; $100-150/b&w inside. Pays on publication. Credit line given. Buys one-time and all rights. Simultaneous submissions and previously published work OK.

N: POLICE AND SECURITY NEWS, DAYS Communications, Inc., 15 W. Thatcher Rd., Quakertown PA 18951-2503. (215)538-1240. Fax: (215)538-1208. E-mail: p&sn@netcarrier.com. Associate Publisher: Al Menear. Circ. 21,982. Estab. 1984. Bimonthly trade journal. "*Police and Security News* is edited for middle and upper management and top administration. Editorial content is a combination of articles and columns ranging from the latest in technology, innovative managerial concepts, training and industry news in the areas of both public law enforcement and private security. Sample copy free with $9\frac{1}{2} \times 10$ SAE and $2.17 first-class postage.

Needs: Buys 2 photos from freelancers/issue; 12 photos/year. Needs photos of law enforcement and security related. Reviews photos with or without a ms. Captions preferred.

Making Contact & Terms: Provide résumé, business card, self-promotion piece or tearsheets to be kept on file for possible future assignments. Art director will contact photographer for portfolio review if interested. Portfolio should include b&w, color, prints or tearsheets. Uses color and b&w prints. Keeps samples on file; include SASE for return of material. Reports back only if interested, send non-returnable

samples. Pays $60/b&w inside. Pays on publication. Credit line not given. Buys one-time rights; negotiable. Simultaneous submissions and previously published work OK.

POLICE MAGAZINE, 21061 South Western Ave., Torrance CA 90501. (310)533-2400. Fax: (310)533-2504. Executive Editor: Dennis Hall. Estab. 1976. Monthly. Emphasizes law enforcement. Readers are various members of the law enforcement community, especially police officers. Sample copy $2 with 9×12 SAE and 6 first-class stamps. Photo guidelines free with SASE.
Needs: Uses in-house photos and freelance submissions. Needs law enforcement related photos. Special needs include photos relating to daily police work, crime prevention, international law enforcement, police technology and humor. Model release required. Property release preferred. Captions preferred.
Making Contact & Terms: Arrange a personal interview to show portfolio. Send b&w prints, 35mm transparencies, b&w contact sheet or color negatives by mail for consideration; prefers color photos. Also accepts digital images. SASE. Payscale available in photographer's guidelines. Payment negotiable. Pays on publication. Buys all rights. Simultaneous submissions OK.
Tips: "Send for our editorial calendar and submit photos based on our projected needs. If we like your work, we'll consider you for future assignments. A photographer we use can grasp the conceptual and the action shots."

POLICE TIMES/CHIEF OF POLICE, 3801 Biscayne Blvd., Miami FL 33137. (305)573-0070. Fax: (305)573-9819. Executive Editor: Jim Gordon. Circ. 50,000. Quarterly (*Police Times*) and bimonthly (*Chief of Police*). Readers are law enforcement officers at all levels. Sample copy $2.50. Photo guidelines free with SASE.
Needs: Buys 60-90 photos/year. Photos of police officers in action, civilian volunteers working with the police and group shots of police department personnel. Wants no photos that promote other associations. Police-oriented cartoons also accepted on spec. Model release preferred. Captions preferred.
Making Contact & Terms: Send photos for consideration. Send glossy b&w and color prints. SASE. Reports in 3 weeks. Pays $5-10 minimum/inside; $25-50 minimum/cover. **Pays on acceptance.** Credit line given if requested; editor's option. Buys all rights, but may reassign to photographer after publication; includes internet publication rights. Simultaneous submissions and previously published work OK.
Tips: "We are open to new and unknowns in small communities where police are not given publicity."

N ⊕ POST MAGAZINE, Insurance Weekly, TBP Group Ltd., 39 Earlham St., London WC2H 9LD England. Phone: 0171-306 7000. Fax: 0171-306 71701. E-mail: postmag@benn.co.uk. Editor-in-Chief: D. Worsfold. Circ. 9,500. Estab. 1840. Weekly trade journal that covers insurance, including reports from around the world. Interested in the companies, the people and the events (i.e. major claims). Well known for legal coverage. Sample copy free.
Needs: Buys 10 photos from freelancers/issue; 500 photos/year. Needs photos of places, especially business centers and immediate pictures of major claims. Reviews photos with or without ms. Model release preferred.
Making Contact & Terms: Send query letter with brochure, stock photo list. Art director will contact photographer for portfolio review if interested. Portfolio should include color transparencies. Uses 35mm transparencies. Accepts images in digital format. Keeps samples on file; include SASE for return of material. Reports in 2 weeks. Pays £50-150/color cover; £30-80/color inside. Pays on publication. Credit line given. Buys one-time, all and electronic rights; negotiable. Previously published work OK.

POWERLINE MAGAZINE, 1650 S. Dixie Hwy., 5th Floor, Boca Raton FL 33432. (561)750-5575. Fax: (561)750-5316. E-mail: mail@egsa.org. Website: http://www.egsa.org. Editor: James McMullen. Photos used in trade magazine of Electrical Generating Systems Association and PR releases, brochures, newsletters, newspapers and annual reports.
Needs: Buys 40-60 photos/year; gives 2 or 3 assignments/year. "Need cover photos, events, award presentations, groups at social and educational functions." Model release required. Property release preferred. Captions preferred; include identification of individuals only.
Making Contact & Terms: Provide résumé, business card, brochure, flier or tearsheets to be kept on file for possible future assignments. Solicits photos by assignment only. Uses 5×7 glossy b&w and color

prints; b&w and color contact sheets; b&w and color negatives. SASE. Reports as soon as selection of photographs is made. Payment negotiable. Buys all rights; negotiable.

Tips: "Basically a freelance photographer working with us should use a photojournalistic approach, and have the ability to capture personality and a sense of action in fairly static situations. With those photographers who are equipped, we often arrange for them to shoot couples, etc., at certain functions on spec, in lieu of a per-day or per-job fee."

THE PREACHER'S MAGAZINE, E. 10814 Broadway, Spokane WA 99206. (509)226-3464. Fax: (509)926-8740. Editor: Randal E. Denny. Circ. 18,000. Estab. 1925. Quarterly professional journal for ministers. Emphasizes the pastoral ministry. Readers are pastors of large to small churches in 5 denominations; most pastors are male. No sample copy available. No photo guidelines.

Needs: Uses 1 photo/issue; all supplied by freelancers. Large variety needed for cover, depends on theme of issue. Model release preferred.

Making Contact & Terms: Send 35mm b&w/color prints by mail for consideration. Reports ASAP. Pays $25/b&w inside; $75/color cover. **Pays on acceptance.** Credit line given. Buys one-time rights. Simultaneous submissions and previously published work OK.

Tips: In photographer's samples wants to see "a variety of subjects for the front cover of our magazine. We rarely use photos within the magazine itself."

PRODUCE MERCHANDISING, a Vance Publishing Corp. magazine, Three Pine Ridge Plaza, 10901 W. 84th Terrace, Lenexa KS 66214. (913)438-8700. Fax: (913)438-0691. E-mail: producemerchandising@compuserv.com. Website: http://www.producemerchandising.com/. Managing Editor: Janice L. McCall. Circ. 12,000. Estab. 1988. Monthly magazine. Emphasizes the fresh produce industry. Readers are male and female executives who oversee produce operations in US and Canadian supermarkets. Sample copy available.

Needs: Uses 30 photos/issue; 2-5 supplied by freelancers. Needs in-store shots, either environmental portraits for cover photos or display pictures. Captions preferred; include subject's name, job title and company title—all verified and correctly spelled.

Making Contact & Terms: Provide résumé, business card, brochure, flier or tearsheets to be kept on file for possible future assignments. Keeps samples on file. Reporting time "depends on when we will be in a specific photographer's area and have a need." Pays $500-600/color cover transparencies; $25-50/color photo; $50-100/color roll inside. **Pays on acceptance.** Credit line given. Buys all rights.

Tips: "We seek photographers who serve as our on-site 'art director,' to ensure art sketches come to life. Supermarket lighting (fluorescent) offers a technical challenge we can't avoid. The 'greening' effect must be diffused/eliminated."

PROFESSIONAL PHOTOGRAPHER/STORYTELLERS, 229 Peachtree St. NW, Suite 2200, International Tower, Atlanta GA 30303. (404)522-8600. Fax: (404)614-6406. E-mail: ppaeditor@aol.com. Editorial Director: Kimberly Brady. Art Director: Debbie Todd. Circ. 28,000. Estab. 1907. Monthly. Emphasizes professional photography in the fields of portrait, wedding, commercial/advertising, stock, sports, outdoor, corporate and industrial. Readers include professional photographers and photographic services and educators. Approximately half the circulation is Professional Photographers of America members. Sample copy $5 postpaid. Photo guidelines free with SASE.

● PPA members submit material unpaid to promote their photo businesses and obtain recognition. Images sent to *Professional Photographer* should be technically perfect and photographers should include information about how the photo was produced.

Needs: Uses 25-30 photos/issue; all supplied by freelancers. "We only accept material as illustration that relates directly to photographic articles showing professional studio, location, commercial and portrait techniques. A majority are supplied by Professional Photographers of America members." Reviews photos with accompanying ms only. "We always need commercial/advertising and industrial success stories. How to sell your photography to major accounts, unusual professional photo assignments. Also, photographer and studio application stories about the profitable use of electronic still imaging for customers and clients." Model release preferred. Captions required.

Making Contact & Terms: Query with résumé of credits. "We want a story query, or complete ms if writer feels subject fits our magazine. Photos will be part of ms package." Accepts images in digital format for Mac. Send via compact disc, online, floppy disk, SyQuest, Zip disk, jaz. Uses 8×10 glossy unmounted b&w or color prints; 35mm, 2¼ × 2¼, 4 × 5 and 8 × 10 transparencies. SASE. Reports in 2 months. Credit line given.

PROGRESSIVE RENTALS, 9015 Mountain Ridge Dr., Suite 220, Austin TX 78759. (512)794-0095. Fax: (512)794-0097. E-mail: nferguson@apro-rto.com. Art Director: Neil Ferguson. Circ. 5,000. Estab.

1983. Member of Association of Progressive Rental Organizations. Bimonthly magazine. Emphasizes the rental-purchase industry. Readers are owners and managers of rental-purchase stores in North America, Canada, Great Britain and Australia. Sample copy free with 9 × 12 SAE and $1.50 postage. Photo guidelines free with SASE.

Needs: Uses 1-2 photos/issue; all supplied by freelancers. Needs "strongly conceptual, cutting edge photos that relate to editorial articles on business/management issues." Model/property release preferred.

Making Contact & Terms: Provide brochure, flier or tearsheets to be kept on file for possible assignments. Send glossy color and b&w prints; 2¼×2¼, 4×5 transparencies; digital format (high resolution, proper size, flattened image, saved in proper format, etc.). Keeps samples on file. SASE. Reports in 1 month "if we're interested." Pays $200-450/job; $350-450/color cover; $200-450/color inside; $200-350/b&w inside. Pays on publication. Credit line given. Buys one-time and electronic rights. Simultaneous submissions and previously published work OK.

Tips: "Always ask for a copy of the publication you are interested in working with. Understand the industry and the specific editorial needs of the publication, i.e., don't send beautiful still life photography to a trade association publication."

PUBLIC WORKS MAGAZINE, 200 S. Broad St., Ridgewood NJ 07450. (201)445-5800. Fax: (201)445-5170. E-mail: jkircher@compuserve.com. Contact: James Kircher. Circ. 67,000. Monthly magazine. Emphasizes the planning, design, construction, inspection, operation and maintenance of public works facilities (bridges, water systems, landfills, etc.) Readers are civil engineers, consulting engineers and private contractors doing municipal work. Sample copy free upon request.

Needs: Uses dozens of photos/issue. "Most photos are supplied by authors or with company press releases." Captions required.

Making Contact & Terms: Provide résumé, business card, brochure, flier or tearsheets to be kept on file for possible assignments. SASE. Reports in 2 weeks. Payment negotiated with editor. Credit line given "if requested." Buys one-time rights.

Tips: "Nearly all of the photos used are submitted by the authors of articles (who are generally very knowledgeable in their field). They may occasionally use freelancers. Cover personality photos are done by staff and freelance photographers." To break in, "learn how to take good clear photos of public works projects that show good detail without clutter. Prepare a brochure and pass around to small and mid-size cities, towns and civil type consulting firms; larger (organizations) will probably have staff photographers."

PURCHASING MAGAZINE, 275 Washington St., Newton MA 02158. (617)964-3030. Fax: (617)558-4705. Art Director: Michael Roach. Circ. 90,000. Estab. 1993. Bimonthly. Readers are management and purchasing professionals.

Needs: Uses 0-10 photos/issue, most on assignment. Needs corporate photos and people shots. Model/property release preferred. Captions required.

Making Contact & Terms: Arrange a personal interview to show portfolio. Provide résumé, business card, brochure, flier or tearsheets to be kept on file for possible future assignments. Cannot return material. Pays $300-500/b&w; $300-500/color; $50-100/hour; $400-800/day; $200-500/photo/text package. **Pays on acceptance.** Credit line given. Buys all rights for all media including electronic media. Simultaneous submissions and previously published work OK.

Tips: In photographer's portfolio looks for informal business portrait, corporate atmosphere.

N: QSR, The Magazine of Quick Service Restaurant Success, 4905 Pine Cone Dr., Suite 2, Durham NC 27707. (919)489-1916. Fax: (919)489-4767. E-mail: darwin@jayi.com. Website: http://www.jayi.com. Art Directors: Darwin Tomlinson and Tory Bartelt. Estab. 1997. Bimonthly trade magazine directed toward the business aspects of quick-service restaurants (fast food). "Our readership is primarily management level and above, usually franchisers and franchisees. Our goal is to cover the quick-service restaurant industry objectively, offering our readers the latest news and information pertinent to their business." Sample copies and art guidelines available for free.

Needs: Buys 1-5 photos from freelancers/issue; 15-20 photos/year. Needs corporate identity portraits, images associated with fast food, general images for feature illustration. Reviews photos with or without ms. Special photo needs include portraits of corporate level executives, which are both visually appealing and hold a level of restraint applicable to a business related magazine. Model and property release preferred.

Making Contact & Terms: Send query letter with samples, brochure, stock photo list, tearsheets. Art director will contact photographer for portfolio review if interested. Portfolio should include slides and digital sample files. Uses 8 × 10 color prints and 2¼×2¼, 4×5, 8×10 transparencies. Keeps samples on file. Reports back only if interested, send non-returnable samples. Pays on publication. Buys all rights, negotiable. Simultaneous submissions and previously published work OK.

Tips: "Willingness to work with subject and magazine deadlines essential. Willingness to follow artistic

guidelines necessary, but should be able to rely on one's own eye should need arise. Our covers always feature quick-service restaurant executives with some sort of name recognition (i.e. a location shot with signage in the background, use of product props which display company logo)."

QUICK FROZEN FOODS INTERNATIONAL, 2125 Center Ave., Suite 305, Fort Lee NJ 07024-5898. (201)592-7007. Fax: (201)592-7171. Editor: John M. Saulnier. Circ. 13,000. Quarterly magazine. Emphasizes retailing, marketing, processing, packaging and distribution of frozen foods around the world. Readers are international executives involved in the frozen food industry: manufacturers, distributors, retailers, brokers, importers/exporters, warehousemen, etc. Review copy $12.
Needs: Buys 20-30 photos/year. Plant exterior shots, step-by-step in-plant processing shots, photos of retail store frozen food cases, head shots of industry executives, product shots, etc. Captions required.
Making Contact & Terms: Query first with résumé of credits. Uses 5×7 glossy b&w and color prints. SASE. Reports in 1 month. Payment negotiable. Pays on publication. Buys all rights, but may reassign to photographer after publication.
Tips: A file of photographers' names is maintained; if an assignment comes up in an area close to a particular photographer, he may be contacted. "When submitting your name, inform us if you are capable of writing a story, if needed."

THE RANGEFINDER, 1312 Lincoln Blvd., Santa Monica CA 90401. (310)451-8506. Fax: (310)395-9058. Editor: Bill Hurter. Circ. 50,000. Estab. 1952. Monthly magazine. Emphasizes topics, developments and products of interest to the professional photographer. Readers are professionals in all phases of photography. Sample copy free with 11×14 SAE and 2 first-class stamps. Photo guidelines free with SASE.
Needs: Uses 30-40 photos/issue; 70% supplied by freelancers. Needs all kinds of photos; almost always run in conjunction with articles. "We prefer photos accompanying 'how-to' or special interest stories from the photographer." No pictorials. Special needs include seasonal cover shots (vertical format only). Model release required. Property release preferred. Captions preferred.
Making Contact & Terms: Query with résumé of credits. Keeps samples on file. SASE. Reports in 1 month. Pays $100 minimum/printed editorial page with illustrations. Covers submitted gratis. Pays on publication. Credit line given. Buys first North American serial rights; negotiable. Previously published work occasionally OK; give details.

RECOMMEND WORLDWIDE, 5979 NW 151st St., Suite 120, Miami Lake FL 33014. (305)828-0123. Art Director: Janet Rosemellia. Photo Editor: Greg Oates. Circ. 62,000. Estab. 1985. Monthly. Emphasizes travel. Readers are travel agents, meeting planners, hoteliers, ad agencies. Sample copy free with 8½×11 SAE and 10 first-class stamps.
Needs: Uses about 40 photos/issue; 50% supplied by freelance photographers. "Our publication divides the world up into seven regions. Every month we use travel destination-oriented photos of animals, cities, resorts and cruise lines. Features all types of travel photography from all over the world." Model/property release required. Captions preferred; identification required on every slide.
Making Contact & Terms: "We prefer a résumé, stock list and sample card or tearsheets with photo review later." SASE. Pays $150/color cover; up to 20 square inches: $25; 21-35 square inches $35; 36-80 square inches $50; over 80 square inches $75; supplement cover: $75; front cover less than 80 square inches $50. Pays 30 days upon publication. Credit line given. Buys one-time rights. Simultaneous submissions and previously published work OK.
Tips: Prefers to see "35mm, quality transparencies, travel-oriented. Photos must have high color saturation and evoke a sense of local impact."

REFEREE, P.O. Box 161, Franksville WI 53126. (414)632-8855. Fax: (414)632-5460. E-mail: refmag@ex ecpc.com. Photo Editor: Jeff Stern. Circ. 35,000. Estab. 1976. Monthly magazine. Readers are mostly male, ages 30-50. Sample copy free with 9×12 SAE and 5 first-class stamps. Photo guidelines free with SASE.
Needs: Uses up to 50 photos/issue; 75% supplied by freelancers. Needs action officiating shots—all sports. Photo needs are ongoing. Captions required.
Making Contact & Terms: Send unsolicited photos by mail for consideration. Any format is accepted. Accepts images in digital format for Mac (TIFF). Send via SyQuest, optical 128m (266). Reports in 2 weeks. Pays $100/color cover; $75/b&w cover; $35/color inside; $20/b&w inside. Pays on publication. Credit line given. Rights purchased negotiable. Simultaneous submissions and previously published work OK.
Tips: Prefers photos which bring out the uniqueness of being a sports official. Need photos primarily of officials at or above the high-school level in baseball, football, basketball, soccer and softball in action. Other sports acceptable, but used less frequently. "When at sporting events, take a few shots with the officials in mind, even though you may be on assignment for another reason. Don't be afraid to give it a

© Byron Lemmon

Photographer Byron Lemmon learned about *Rangefinder* magazine through its listings in *Photographer's Market* and *Writer's Market*. After receiving a positive response to a detailed query letter, Lemmon submitted several images and a manuscript to the magazine. "This is an example of a three-tone posterization to illustrate an article on black & white photography. It was selected to illustrate the inherent abstractness of the medium." Since its publication, the image has been republished three times in trade and consumer magazines and used in the photographer's self-promotion efforts.

try. We're receptive, always looking for new freelance contributors. We are constantly looking for pictures of officials/umpires. Our needs in this area have increased."

REGISTERED REPRESENTATIVE, 18818 Teller Ave., Suite 280, Irvine CA 92612. (714)851-2220. Art Director: Chuck LaBresh. Circ. 90,000. Estab. 1976. Monthly magazine. Emphasizes stock brokerage industry. Magazine is "requested and read by 90% of the nation's stock brokers."
Needs: Uses about 8 photos/issue; 5 supplied by freelancers. Needs environmental portraits of financial and brokerage personalities, and conceptual shots of financial ideas, all by assignment only. Model/property release is photographer's responsibility. Captions required.
Making Contact & Terms: Provide brochure, flier or tearsheets to be kept on file for possible future assignments. Cannot return material. Accepts images in digital format for Mac (TIFF or EPS). Send via compact or Jazz disk at 300 dpi. Pays $250-600/b&w or color cover; $100-250/b&w or color inside. Pays 30 days after publication. Credit line given. Buys one-time rights. Publisher requires signed rights agreement. Simultaneous submissions and previously published work OK.
Tips: "I usually give photographers free reign in styling, lighting, camera lenses, whatever. I want something that is unusual but not strange. I assume the photographer is the guy on the scene: the one who can best make visual decisions."

RESOURCE RECYCLING, P.O. Box 10540, Portland OR 97296-0540. (503)227-1319. Fax: (503)227-6135. Editor: Jerry Powell. Circ. 16,000. Estab. 1982. Monthly. Emphasizes "the recycling of post-consumer waste materials (paper, metals, glass, plastics etc.) and composting." Readers are "recycling company managers, local government officials, waste haulers and environmental group executives." Sample copy free with 11 first-class stamps plus 9×12 SAE.
Needs: Uses about 5-15 photos/issue; 1 supplied by freelancers. Needs "photos of recycling facilities, curbside recycling collection, secondary materials (bundles of newspapers, soft drink containers), etc." Model release preferred. Captions required.
Making Contact & Terms: Send glossy color prints and contact sheet. Accepts images in digital format for Mac. Send via floppy disk, SyQuest 44mb, Zip disk (high res). SASE. Reports in 1 month. Payment "varies by experience and photo quality." Pays on publication. Credit line given. Buys first North American serial rights. Simultaneous submissions OK.
Tips: "Because *Resource Recycling* is a trade journal for the recycling and composting industry, we are looking only for photos that relate to recycling and composting issues."

RESTAURANT HOSPITALITY, 1100 Superior Ave., Cleveland OH 44114. (216)931-9254. Fax: (216)696-0836. E-mail: rheditors@aol.com. Editor-in-Chief: Michael DeLuca. Art Director: Christopher Roberto. Circ. 123,000. Estab. 1919. Monthly. Emphasizes "hands-on restaurant management ideas and strategies." Readers are "restaurant owners, chefs, food service chain executives."
- *Restaurant Hospitality* won the Ozzie Award for best design (circulation over 50,000) in 1993 and 1994 and the *Folio* Editorial Excellence Award for best written/edited magazine in food service, 1994, 1995 and 1996.
Needs: Uses about 30 photos/issue; 50% supplied by freelancers. Needs "people with food, restaurant and food service interiors and occasional food photos." Special needs include "subject-related photos; query first." Model release preferred. Captions preferred.
Making Contact & Terms: Send résumé of credits or samples, or list of stock photo subjects. Provide résumé, business card, brochure, flier or tearsheets to be kept on file for possible future assignments. Accepts images in digital format for Mac. Send via online or floppy disk. Pays $350/half day; $150-450/job includes normal expenses. **Pays on acceptance.** Credit line given. Buys one-time rights plus reprint rights in all media. Previously published work OK "if exclusive to foodservice press."
Tips: "Let us know you exist. We can't assign a story if we don't know you. Send résumé, business card, samples, etc. along with introductory letter to Art Director Christopher Roberto."

RISTORANTE MAGAZINE, P.O. Box 73, Liberty Corner NJ 07938. (908)766-6006. Fax: (908)766-6607. Art Director: Erica Lynn DeWitte. Circ. 50,000. Estab. 1994. Quarterly magazine for the Italian connoisseur and Italian restaurants with liquor licenses.
Needs: Number of photos/issue varies. Number supplied by freelancers varies. "Think Italian!" Reviews photos with or without ms. Model/property release required. Captions preferred.
Making Contact & Terms: Provide résumé, business card, brochure, flier or tearsheets to be kept on file for possible assignments. SASE. Payment negotiable. Pays on publication. Credit line given. Buys all rights; negotiable. Previously published work OK.

N: THE SCHOOL ADMINISTRATOR, 1801 N. Moore St., Arlington VA 22209. (703)875-0753. Fax: (703)528-2146. Website: http://www.aesa.org. Managing Editor: Liz Griffin. Circ. 16,500. Publication of American Association of School Administrators. Monthly magazine. Emphasizes K-12 education. Readers are school administrators including superintendents and principals, ages 50-60, largely male though this is changing. Sample copy $7.

Needs: Uses 23 photos/issue. Needs classroom photos, photos of school principals and superintendents and school board members interacting with parents and students. Model/property release preferred for physically handicapped students. Captions required; include name of school, city, state, grade level of students and general description of classroom activity.

Making Contact & Terms: Send unsolicited photos by mail for consideration (photocopy of b&w prints). Provide résumé, business card, brochure, flier or tearsheets to be kept on file for possible assignments. Photocopy of prints should include contact information including fax number. "Send a SASE for our editorial calendar. In cover letter include mention of other clients. Familiarize yourself with topical nature and format of magazine before submitting prints." Send 5×7, 8×10 matte or glossy color b&w prints; 35mm, 2¼×2¼, 4×5, 8×10 transparencies. Work assigned is 3-4 months prior to publication date. Keeps samples on file. SASE. Reports in 3 weeks. Pays $200-300/color cover. $10-75/color and b&w inside. Credit line given. Buys one-time rights. Simultaneous submissions and previously published work OK.

Tips: "Prefer photos with interesting, animated faces and hand gestures. Always looking for unusual human connection where the photographer's presence has not made subjects stilted."

SEAFOOD LEADER, 5305 Shilshole Ave. NW, #200, Seattle WA 98107. (206)789-6506. Fax: (206)789-9193. Photo Editor: Scott Wellsandt. Circ. 16,000. Estab. 1981. Published bimonthly. Emphasizes seafood industry, commercial fishing. Readers are processors, buyers and sellers of seafood. Sample copy $5 with 9×12 SASE.

Needs: Uses about 40 photos/issue; 50% supplied by freelance photographers, most from stock. Needs photos of international seafood harvesting and farming, supermarkets, restaurants, shrimp, Alaska, many more. Captions preferred; include name, place, time.

Making Contact & Terms: Query with list of stock photo subjects. Send photos on subjects we request. SASE. "We only want it on our topics." Reports in 1 month. Pays $100/color cover; $50/color inside; $25/b&w inside. Pays on publication. Credit line given. Buys one-time rights. Previously published work OK.

Tips: "Send in slides relating to our needs—request editorial calendar." Looks for "aesthetic shots of seafood and commercial fishing, shots of people interacting with seafood in which expressions are captured (i.e. not posed shots); artistic shots of seafood emphasizing color and shape. We want clear, creative, original photography of commercial fishing, fish species, not sports fishing."

SECURITY DEALER, Dept. PM, 445 Broad Hollow Rd., Suite 21, Melville NY 11747. (516)845-2700. Fax: (516)845-7109. Associate Publisher/Editor: Susan Brady. Circ. 28,000. Estab. 1967. Monthly magazine. Emphasizes security subjects. Readers are business owners who install alarm, security, CCTV, home automation and access control systems. Sample copy free with SASE.

Needs: Uses 2-5 photos/issue; none at present supplied by freelance photographers. Needs photos of security-application-equipment. Model release preferred. Captions required.

Making Contact & Terms: Send b&w and color prints by mail for consideration. SASE. Reports "immediately." Pays $25-50/b&w; $400/color cover; $50-100/inside color. Pays 30 days after publication. Credit line given. Buys one-time rights in security trade industry. Simultaneous submissions and/or previously published work OK.

Tips: "Do not send originals, dupes only, and only after discussion with editor."

SIGNCRAFT MAGAZINE, P.O. Box 60031, Fort Myers FL 33906. (813)939-4644. Editor: Tom McIltrot. Circ. 20,000. Estab. 1980. Bimonthly magazine. Readers are sign makers and sign shop personnel. Sample copy $5. Photo guidelines free with SASE.

Needs: Uses over 100 photos/issue; few at present supplied by freelancers. Uses photos of well-designed, effective signs. Captions preferred.

THE INTERNATIONAL MARKETS INDEX, located in the back of this book, lists markets located outside the U.S. by country.

Making Contact & Terms: Query with samples. Send b&w or color prints; 35mm, 2¼ × 2¼ transparencies; b&w, color contact sheet by mail for consideration. SASE. Reports in 1 month. Payment negotiable. Pays on publication. Credit line given. Buys first North American serial rights. Previously published work possibly OK.
Tips: "If you have some background or past experience with sign making, you may be able to provide photos for us."

SOCIAL POLICY, 25 W. 43rd St., Room 620, New York NY 10036. (212)642-2929. Fax: (212)642-1956. Managing Editor: Audrey Gartner. Circ. 3,500. Estab. 1970. Quarterly. Emphasizes "social policy issues—how government and societal actions affect people's lives." Readers are academics, policymakers, lay readers. Sample copy $2.50.
Needs: Uses about 9 photos/issue; all supplied by freelance photographers. Needs photos of social consciousness and sensitivity. Model release preferred.
Making Contact & Terms: Arrange a personal interview to show portfolio. Query with samples. Provide résumé, business card, brochure, flier or tearsheets to be kept on file for possible future assignments. Reports in 2 weeks. Pays $100/b&w cover; $40/b&w inside. Pays on publication. Credit line given. Buys one-time rights. Simultaneous submissions and previously published work OK.
Tips: "Be familiar with social issues. We're always looking for relevant photos."

⒩ SONGWRITER'S MONTHLY, "The Stories Behind Today's Songs", 332 Eastwood Ave., Feasterville PA 19053-4514. (215)953-0952 or (800)574-2986. Fax: (215)953-0952. E-mail: alfoster@aol.com. Website: http://www.geocities.com/TimesSquare/1917/index.htm. Editor: Allen Foster. Circ. 2,500. Estab. 1992. Monthly trade publication for songwriters and individuals interested or involved in music or the music business. Call to request sample copies. For art guidelines send SAE with 1 first-class stamp.
Needs: Buys 1 photo from freelancers/issue; 12 photos/year. Need great live shots of known or unknown musicians performing and photos of music events or conferences. Model release preferred; property release preferred. Photo caption preferred; include who, where, when and if applicable, what song is being performed.
Making Contact & Terms: Send query letter with tearsheets. "Contact us with your interests." Uses b&w prints. Does not keep samples on file; include SASE for return of material. Reports in 2-3 weeks. Pays $15-20/b&w cover; $10-15/b&w inside. **Pays on acceptance.** Credit line given if requested. Buys one-time rights. Simultaneous submissions and/or previously published work OK.
Tips: "We want images with good contrast that capture the artist's emotion."

SOUTHERN LUMBERMAN, 128 Holiday Court, Suite 116, P.O. Box 681629, Franklin TN 37068-1629. (615)791-1961. Fax: (615)790-6188. Managing Editor: Nanci Gregg. Circ. 13,500. Estab. 1881. Monthly. Emphasizes forest products industry—sawmills, pallet operations, logging trades. Readers are predominantly owners/operators of midsized sawmill operations nationwide. Sample copy $3.50 with 9 × 12 SAE and 5 first-class stamps. Photo guidelines free with SASE.
● This publication digitally stores and manipulates images for advertising purposes.
Needs: Uses about 3-4 photos/issue; 25% supplied by freelancers. "We need color prints or slides of 'general interest' in the lumber industry. We need photographers from across the country to do an inexpensive color shoot in conjunction with a phone interview. We need 'human interest' shots from a sawmill scene—just basic 'folks' shots—a worker sharing lunch with the company dog, sawdust flying as a new piece of equipment is started; face masks as a mill tries to meet OSHA standards, etc." Looking for photo/text packages. Model release required. Captions required.
Making Contact & Terms: Query with samples. Send 5×7 or 8×10 glossy color prints; 35mm, 4×5 transparencies for consideration. SASE. Reports in 6 weeks. Pays minimum $20-35/color; $100-150/photo/text package. Pays on publication. Credit line given. Buys first North American serial rights.
Tips: Prefers color close-ups in sawmill, pallet, logging scenes. "Try to provide what the editor wants—call and make sure you know what that is, if you're not sure. Don't send things that the editor hasn't asked for. We're all looking for someone who has the imagination/creativity to provide what we need. I'm not interested in 'works of art'—I want and need color feature photos capturing essence of employees working at sawmills nationwide. I've never had someone submit anything close to what I state we need—try that. *Read* the description, shoot the pictures, send a contact sheet or a couple 4×6s."

SPEEDWAY SCENE, P.O. Box 300, North Easton MA 02356. (508)238-7016. Editor: Val LeSieur. Circ. 70,000. Estab. 1970. Weekly tabloid. Emphasizes auto racing. Sample copy free with 8½×11 SAE and 4 first-class stamps.
Needs: Uses 200 photos/issue; all supplied by freelancers. Needs photos of oval track auto racing. Reviews photos with or without ms. Captions required.

How The NASD Was Corrupted

The recent SEC investigation of the NASD shows that the self-regulatory system was corrupted by the influence of powerful market making firms. Top NASD officials knew about problems and chose to look the other way. NASD staff went along. Even the SEC had plenty of clues that something was amiss. How was it that the nation's chief SRO went astray?

BY DAN JAMIESON
WITH RR STAFF

© Anne Ford Doyle

A satisfied client passed photographer Anne Ford Doyle's name on to the picture editor at *Registered Representative* and the magazine contacted her with this assignment. "They asked for a news/grainy feel. I used infrared black & white film and shot several different angles." Doyle also visited the site to determine the best time of day for the shoot and shot on two different days to capture variations in the clouds around the building.

Making Contact & Terms: Send unsolicited photos by mail for consideration. Send b&w, color prints. Reports in 1-2 weeks. Payment negotiable. Credit line given. Buys all rights. Simultaneous submissions and/or previously published work OK.

STEP-BY-STEP GRAPHICS, 6000 N. Forest Park Dr., Peoria IL 61614-3592. (309)688-2300. Fax: (309)688-8515. Managing Editor: Holly Angus. Circ. 45,000. Estab. 1985. Bimonthly. How-to magazine for traditional and electronic graphics. Readers are graphic designers, illustrators, art directors, studio owners, photographers. Sample copy $7.50.
Needs: Uses 130 photos/issue; all supplied by freelancers. Needs how-to ("usually tight") shots taken in artists' workplaces. Assignment only. Model release required. Captions required.
Making Contact & Terms: Query with samples. Provide résumé, business card, brochure, flier or tearsheets to be kept on file for possible future assignments. SASE. Reports in 1 month. Pays by the job on a case-by-case basis. **Pays on acceptance.** Credit line given. Buys one-time rights or first North American serial rights.
Tips: In photographer's samples looks for "color and lighting accuracy particularly for interiors." Most shots are tight and most show the subject's hands. Recommend letter of inquiry plus samples.

SUCCESSFUL MEETINGS, 355 Park Ave. S., New York NY 10010. (212)592-6401. Fax: (212)592-6409. Art Director: Don Salkaln. Circ. 75,000. Estab. 1955. Monthly. Emphasizes business group travel for all sorts of meetings. Readers are business and association executives who plan meetings, exhibits, conventions and incentive travel. Sample copy $10.
Needs: Special needs include *good*, high-quality corporate portraits, conceptual, out-of-state shoots (occasionally).
Making Contact & Terms: Arrange a personal interview to show portfolio. Query with résumé of credits and list of stock photo subjects. SASE. Reports in 2 weeks. Pays $500-750/color cover; $50-150/b&w inside; $75-200/color inside; $150-250/b&w page; $200-300/color page; $200-600/text/photo package; $50-100/hour; $175-350/½ day. **Pays on acceptance.** Credit line given. Buys one-time rights. Simultaneous submissions and previously published work OK "only if you let us know."

N TEACHING TOLERANCE MAGAZINE, 400 Washington Ave., Montgomery AL 36104. Design Director: Rodney Diaz. Circ. 300,000. Estab. 1992. National education magazine published by Southern Poverty Law Center. Quarterly. Emphasizes teaching racial/cultural tolerance. Readers are male/female teachers and educators, adult.
Needs: Uses approximately 36 photos/issue; all supplied by freelancers on assignment.
Making Contact & Terms: Story photographers only. Send tearsheets of previously published story photography. "No stock photos. No items returned. Absolutely no phone calls." Keeps samples on file. Pays $600-1,000/day; $600-1,000/job; $100-300/color inside. Rates depend on usage/negotiation. **Pays on acceptance.** Credit line given. Buys one-time rights, all rights; negotiable. Simultaneous submissions and/or previously published work OK.

N THOROUGHBRED TIMES, P.O. Box 8237, Lexington KY 40533. (606)260-9800. Editor: Mark Simon. Circ. 24,000. Estab. 1985. Weekly tabloid magazine. Emphasizes thoroughbred breeding and racing. Readers are wide demographic range of industry professionals. No photo guidelines.
Needs: Uses 18-20 photos/issue; 40-60% supplied by freelancers. "Looks for photos only from desired trade (thoroughbred breeding and racing)." Needs photos of specific subject features (personality, farm or business). Model release preferred. Captions preferred.
Making Contact & Terms: Provide résumé, business card, brochure, flier or tearsheets to be kept on file for possible assignments. SASE. Reports in 1 month. Pays $25/b&w cover or inside; $50/color; $150/day. Pays on publication. Credit line given. Buys one-time rights. Previously published work OK.

N TOP PRODUCER, Farm Journal Publishing, Inc., Centre Square West, 1500 Market St., Philadelphia PA 19102-2181. (215)557-8959. Fax: (215)568-3989. Website: http://www.farmjournal.com. Art Director: Alfred Casciato. Circ. 250,000. Monthly. Emphasizes American agriculture. Readers are active farmers, ranchers or agribusiness people. Sample copy and photo guidelines free with SASE.
Needs: Uses 20-30 photos/issue; 50% supplied by freelance photographers. "We use studio-type portraiture (environmental portraits), technical, details and scenics." Model release preferred. Captions required.
Making Contact & Terms: Arrange a personal interview to show portfolio. Query with résumé of credits along with business card, brochure, flier or tearsheets to be kept on file for possible assignments. Also accepts digital images. "Portfolios may be submitted via CD-ROM or floppy disk." SASE. Reports in 2 weeks. Pays $75-400/color photo; $200-400/day. Pays extra for electronic usage of images. "We pay a

cover bonus." **Pays on acceptance.** Credit line given. Buys one-time rights. Simultaneous submissions and previously published work OK.
Tips: In portfolio or samples, likes to "see about 40 slides showing photographer's use of lighting and photographer's ability to work with people. Know your intended market. Familiarize yourself with the magazine and keep abreast of how photos are used in the general magazine field."

TOPS NEWS, % TOPS Club, Inc., Box 07360, Milwaukee WI 53207. Editor: Kathleen Davis. Estab. 1948. TOPS is a nonprofit, self-help, weight-control organization. Photos used in membership magazine.
Needs: "Subject matter to be illustrated varies greatly." Reviews stock photos.
Making Contact & Terms: Query with stock photo list. Provide résumé, business card, brochure, flier or tearsheets to be kept on file for possible future assignments. Uses any size transparency or print. SASE. Reports in 1 month. Pays $75-135/color photo. Buys one-time rights.
Tips: "Send a brief, well-composed letter along with a few selected samples with a SASE."

TRUCK ACCESSORY NEWS, 6255 Barfield Rd., Suite 200, Atlanta GA 30328. (404)252-8831. Fax: (404) 252-4436. Editor: Alfreda Vaughn. Circ. 8,500. Estab. 1994. Monthly magazine. Emphasizes retail truck accessories. Readers are male and female executives. Sample copy available.
Needs: Uses 75 photos/issue; 5-10 supplied by freelancers. Needs photos of trucks and truck accessory retailers. Model/property release required. Captions required.
Making Contact & Terms: Provide résumé, business card, brochure, flier or tearsheets to be kept on file for possible assignments. Send 5×7, 8×10 color prints; 2¼×2¼, 4×5, 8×10 transparencies. Keeps samples on file. SASE. Reports in 3 weeks. Pays $350-450/half day. Pays on publication. Credit line given. Buys all rights; negotiable.

UNDERGROUND CONSTRUCTION, (formerly *Pipeline and Utilities Construction*), P.O. Box 219368, Houston TX 77218-9368. (281)558-6930. Fax: (281)558-7029. E-mail: rcarpen@undergroundinfo.com. Website: http://www.undergroundinfo.com. Editor: Robert Carpenter. Circ. 35,000. Estab. 1945. Monthly. Emphasizes construction and rehabilitation of oil and gas, water and sewer underground pipelines and cable. Readers are key contractor personnel and construction company managers and owners. Sample copy $3.
Needs: "Uses photos of underground construction and rehabilitation."
Making Contact & Terms: Send unsolicited photos by mail for consideration. Accepts color prints and transparencies. SASE. Reports in 1 month. Pays $20-250/color photo. Buys one-time rights.
Tips: "Freelancers are competing with staff as well as complimentary photos supplied by equipment manufacturers. Subject matter must be unique, striking and 'off the beaten track' (i.e., somewhere we wouldn't travel ourselves to get photos)."

U.S. NAVAL INSTITUTE PROCEEDINGS, U.S. Naval Institute, 118 Maryland Ave., Annapolis MD 21402. (410)268-6110. Website: http://www.USNI.org. Contact: Photo Editor. Circ. 100,000. Monthly magazine. Emphasizes matters of current interest in naval, maritime and military affairs—including strategy, tactics, personnel, shipbuilding and equipment. Readers are officers in the Navy, Marine Corps and Coast Guard; also for enlisted personnel of the sea services, members of other military services in this country and abroad and civilians with an interest in naval and maritime affairs. Free sample copy.
Needs: Buys 15 photos/issue. Needs photos of Navy, Coast Guard and merchant ships of all nations; military aircraft; personnel of the Navy, Marine Corps and Coast Guard; and maritime environment and situations. No poor quality photos. Captions required.
Making Contact & Terms: Query first with résumé of credits. Uses 8×10 glossy, color and b&w prints or transparencies. SASE. Accepts images in digital format for Mac in JPEG files via compact disc, Zip disk, floppy disk or online at 300 dpi. Reports in 1 month on pictorial feature queries; 6-8 weeks on other materials. Uses 8×10 glossy prints or slides, color and b&w. Pays $10 for official military photos submitted with articles; $250-500 for naval/maritime pictorial features; $200/color cover; $50 for article openers; $25/inside editorial. Pays on publication. Buys one-time rights.
Tips: "These features consist of copy, photos and photo captions. The package should be complete, and there should be a query first. In the case of the $25 shots, we like to maintain files on hand so they can be used with articles as the occasion requires. Annual photo contest—write for details."

UTILITY AND TELEPHONE FLEETS, P.O. Box 183, Cary IL 60013. (847)639-2200. Fax: (847)639-9542. Publisher: Alan Richter. Circ. 18,000. Estab. 1987. Magazine published 8 times a year. Emphasizes equipment and vehicle management and maintenance. Readers are fleet managers, maintenance supervisors, generally 35 and older in age and primarily male. Sample copy free with SASE. No photo guidelines.
Needs: Uses 30 photos/issue; 3-4% usually supplied by a freelance writer with an article. Needs photos of

vehicles and construction equipment. Special photo needs include alternate fuel vehicles and eye-grabbing colorful shots of utility vehicles in action as well as utility construction equipment. Model release preferred. Captions required; include person's name, company and action taking place.
Making Contact & Terms: Provide résumé, business card, brochure, flier or tearsheets to be kept on file for possible assignments. SASE. Reports in 2 weeks. Pays $50/color cover; $10/b&w inside; $50-200/ photo/text package ($50/published page). Pays on publication. Credit line given. Buys one-time rights; negotiable.
Tips: "Be willing to work cheap and be able to write; the only photos we have paid for so far were part of an article/photo package. Looking for shots focused on our market with workers interacting with vehicles, equipment and machinery at the job site."

WATER WELL JOURNAL, 601 Dempsey Rd., Westerville OH 43081. (614)882-8179. Fax: (614)898-7786. E-mail: gswans@ngwa.org. Website: http://www.ngwa.org. Senior Editor: Gloria J. Swanson. Circ. 32,000. Estab. 1947. Monthly. Emphasizes construction of water wells, development of ground water resources and ground water cleanup. Readers are water well drilling contractors, manufacturers, suppliers and ground water scientists. Sample copy $21 (US); $36 (foreign).
Needs: Uses 1-3 freelance photos/issue plus cover photos. Needs photos of installations and how-to illustrations. Model release preferred. Captions required.
Making Contact & Terms: Contact with résumé of credits; inquire about rates. "We'll contact." Pays $10-50/hour; $200/color cover; $50/b&w inside; "flat rate for assignment." Pays on publication. Credit line given "if requested." Buys all rights.

WINES & VINES, 1800 Lincoln Ave., San Rafael CA 94901. (415)453-9700. Fax: (415)453-2517. E-mail: geninfo@winesandvines.com. Contact: Dottie Kubota-Cordery. Circ. 5,000. Estab. 1919. Monthly magazine. Emphasizes winemaking in the US for everyone concerned with the wine industry, including winemakers, wine merchants, suppliers, consumers, etc.
Needs: Wants color cover subjects on a regular basis.
Making Contact & Terms: Query or send material by mail for consideration. Will call if interested in reviewing photographer's portfolio. Provide business card to be kept on file for possible future assignments. Accepts images in digital format for Mac or Windows (Adobe, Aldus, Quark). Send via compact disc, SyQuest, Zip disk (150-200). SASE. Reports in 3 months. Pays $50/b&w print; $100-300/color cover. Pays on publication. Credit line given. Buys one-time rights. Previously published work OK.

N WIRELESS REVIEW, (formerly *Electrical Wholesaling*), 9800 Metcalf, Overland Park KS 66212-2215. (913)967-7258. Fax: (913)967-1905. E-mail: cheri_jones@intertec.com. Art Director: Cheri Jones. Bimonthly magazine. Emphasizes cellular industry. Readers are male and female executives. Sample copy free with 9×12 SAE and 10 first-class stamps.
Needs: Uses 15 photos/issue; 3 supplied by freelancers, usually the cover photo. Needs color photos of executive portraits, photo/illustration. Special photos include executive portraits, company profile photos, photo/illustration.
Making Contact & Terms: Provide business card, brochure or tearsheets to be kept on file for possible assignments. Keeps samples on file. SASE. Pays $300-1,000/job; $700/color cover and one inside; $300/ color inside. Credit line given. Buys one-time rights. Simultaneous submissions OK.
Tips: "Must be professional on the phone. If you are going to be taking a photo of a CEO, I need to make sure you are professional. I need someone who can take a blah environment and make it spectacular through the use of color and composition."

N WORLD FENCE NEWS, Dept. PM, 6101 W. Courtyard Dr., Bldg. 3, Suite 115, Austin TX 78730. (800)231-0275. Fax: (512)349-2567. Managing Editor: Rick Henderson. Circ. 13,000. Estab. 1983. Monthly tabloid. Emphasizes fencing contractors and installers. Readers are mostly male fence company owners and employees, ages 30-60. Sample copy free with 10×12 SASE.
Needs: Uses 35 photos/issue; 20 supplied by freelancers. Needs photos of scenics, silhouettes, sunsets which include all types of fencing. Also, installation shots of fences of all types. "Cover images are a major area of need." Model/property release preferred mostly for people shots. Captions required; include location, date.
Making Contact & Terms: "If you have suitable subjects, call and describe." SASE. Reports in 3 weeks. Pays $100/color cover; $25/b&w inside. **Pays on acceptance.** Credit line given. Buys one-time rights. Previously published work OK.

N ⊕ WORLD FISHING, For a Global View of the Fishing Industry, Nexus Media Ltd., Nexus House, Azalea Dr., Swanley, Kent BR8 8HY United Kingdom. Phone: 44(1322)660070. Fax:

44(1322)666408. E-mail: Mark.Say@nexusmedia.co.uk. Circ. 6,700. Monthly glossy trade journal with commercial fisheries focus.

Needs: Photos of fishing vessels, especially at sea; processing at sea scenes; ports. Reviews photos with or without ms. Photo captions required.

Making Contact & Terms: Pays on publication. Buys one-time rights. Previously published work OK.

Tips: "Keep focus on fishing industry. We will take stock photos. We are unable to commission photos."

WRITER'S DIGEST/WRITER'S YEARBOOK, 1507 Dana Ave., Cincinnati OH 45207. (513)531-2222. Fax: (513)531-1843. Managing Editor: Peter Blocksom. Circ. 250,000. Estab. 1920. Monthly magazine. Emphasizes writing and publishing. Readers are "writers and photojournalists of all description: professionals, beginners, students, moonlighters, bestselling authors, editors, etc." Sample copy $3.50 ($3.70 in Ohio). Guidelines free with SASE.

Needs: Buys 15 photos/year. Uses about 10% freelance material each issue. Purchases about 75% of photos from stock or on assignment; 25% of those with accompanying ms. Primarily celebrity/personality ("to accompany profiles"); some how-to, human interest and product shots. All must be writer-related. Submit model release with photo. Captions required.

Making Contact & Terms: Query with résumé of credits, list of photographed writers, or contact sheet. Provide brochure and samples (print samples, not glossy photos) to be kept on file for possible future assignments. "We never run photos without text." Also accepts digital files—JPEG and TIFF acceptable; EPS preferred. Uses 8×10 glossy prints; send contact sheet. "Do *not* send negatives." Pays $75-200. "Freelance work is rarely used on the cover." **Pays on acceptance.** Credit line given. Buys first North American serial rights, one-time use only. Simultaneous submissions OK if editors are advised. Previously published work OK.

Tips: "We most often use photos with profiles of writers; in fact, we won't buy the profile unless we can get usable photos. The story, however, is always our primary consideration, and we won't buy the pictures unless they can be specifically related to an article we have in the works. We sometimes use humorous shots in our Writing Life column. Shots should not *look* posed, even though they may be. Photos with a sense of place, as well as persona, preferred. Have a mixture of tight and middle-distance shots of the subject. Study a few back issues. Avoid the stereotyped writer-at-typewriter shots; go for an array of settings. Move the subject around, and give us a choice. We're also interested in articles on how a writer earned extra money with photos, or how a photographer works with writers on projects, etc."

YALE ROBBINS, INC., 31 E. 28th St., 12th Floor, New York NY 10016. (212)683-5700. Fax: (212)545-0764. Managing Editor: Peg Rivard. Circ. 10,500. Estab. 1983. Annual magazine and photo directory. Emphasizes commercial real estate (office buildings). Readers are real estate professionals—brokers, developers, potential tenants, etc. Sample copy free to interested photographers.

Needs: Uses 150-1,000 photos/issue. Needs photos of buildings. Property release required.

Making Contact & Terms: Provide résumé, business card, brochure, flier or tearsheets to be kept on file for possible future assignments. Send 35mm transparencies. Keeps samples on file. SASE. Reports in 1 month. Pays $15-20/color slide; payment for color covers varies. Pays on publication. Credit line given. Buys all rights; negotiable. Simultaneous submissions and previously published work OK.

Book Publishers

PHOTO ILLUSTRATIONS

There are diverse needs for photography in the book publishing industry. Publishers need photos for the obvious covers, jackets, text illustration and promotional materials, but now may also need them for use on CD-ROMs and even websites. Generally, though, publishers either buy individual or groups of photos for text illustration, or they publish entire books of photography.

Those in need of text illustration use photos for cover art and interiors of textbooks, travel books and nonfiction books. For illustration, photographs may be purchased from a stock agency or from a photographer's stock or the publisher may make assignments. Publishers usually pay for photography used in book illustration or on covers on a per-image or per-project basis. Some pay photographers on hourly or day rates, if on an assignment basis. No matter how payment is made, however, the competitive publishing market requires freelancers to remain flexible.

To approach book publishers for illustration jobs, send a cover letter and photographs or slides and a stock photo list with prices, if available. If you have published work, tearsheets are very helpful in showing publishers how your work translates to the printed page.

PHOTO BOOKS

Publishers who produce photography books usually publish themed books featuring the work of one or several photographers. It is not always necessary to be well-known to publish your photographs as a book. What you do need, however, is a unique perspective, a saleable idea and quality work.

For entire books, publishers may pay in one lump sum or with an advance plus royalties (a percentage of the book sales). When approaching a publisher for your own book of photographs, query first with a brief letter describing the project and samples. (You'll find a sample book proposal on the next page.) If the publisher is interested in seeing the complete proposal, photographers can send additional information in one of two ways depending on the complexity of the project.

Prints placed in sequence in a protective box, along with an outline, will do for easy-to-describe, straight-forward book projects. For more complex projects, you may want to create a book dummy. A dummy is basically a book model with photographs and print arranged as they will appear in finished book form. Book dummies show exactly how a book will look including the sequence, size, format and layout of photographs and accompanying text. The quality of the dummy is important, but keep in mind the expense can be prohibitive.

To find the right publisher for your work first check the Subject Index to help narrow your search, then read the appropriate listings carefully. Send for catalogs and guidelines for those publishers that interest you. Also, become familiar with your local bookstore. By examining the books already published, you can find those publishers who produce your type of work. Check for both large and small publishers. While smaller firms may not have as much money to spend, they are often more willing to take risks, especially on the work of new photographers.

◀ Two atoms of hydrogen and one atom of oxygen were all it took to inspire photographer Walter Wick to create his award-winning children's book *A Drop of Water*. The book, which won the Boston Globe-Horn Book Award for nonfiction, married Wick's love of photography with his passion for science. This shot of an egg being dropped into a glass of water was created to illustrate the principles of surface tension. Wick shows how doing the work you love will make you a better photographer on page 238.

SAMPLE QUERY LETTER FOR BOOK PROPOSAL

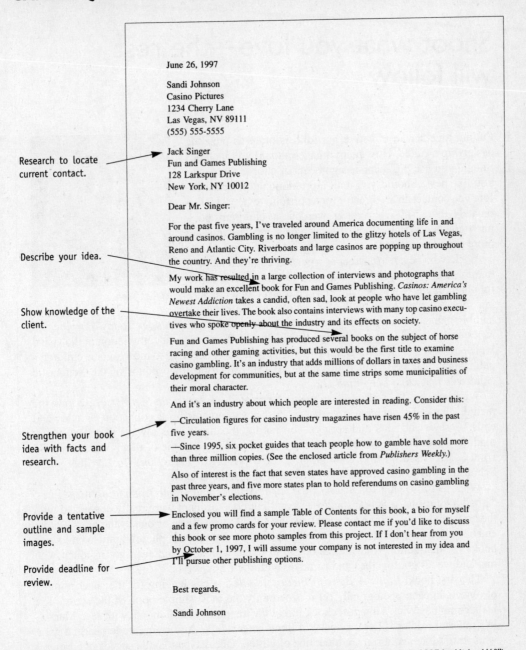

June 26, 1997

Sandi Johnson
Casino Pictures
1234 Cherry Lane
Las Vegas, NV 89111
(555) 555-5555

Research to locate current contact.

Jack Singer
Fun and Games Publishing
128 Larkspur Drive
New York, NY 10012

Dear Mr. Singer:

Describe your idea.

For the past five years, I've traveled around America documenting life in and around casinos. Gambling is no longer limited to the glitzy hotels of Las Vegas, Reno and Atlantic City. Riverboats and large casinos are popping up throughout the country. And they're thriving.

My work has resulted in a large collection of interviews and photographs that would make an excellent book for Fun and Games Publishing. *Casinos: America's Newest Addiction* takes a candid, often sad, look at people who have let gambling overtake their lives. The book also contains interviews with many top casino executives who spoke openly about the industry and its effects on society.

Show knowledge of the client.

Fun and Games Publishing has produced several books on the subject of horse racing and other gaming activities, but this would be the first title to examine casino gambling. It's an industry that adds millions of dollars in taxes and business development for communities, but at the same time strips some municipalities of their moral character.

And it's an industry about which people are interested in reading. Consider this:

Strengthen your book idea with facts and research.

—Circulation figures for casino industry magazines have risen 45% in the past five years.
—Since 1995, six pocket guides that teach people how to gamble have sold more than three million copies. (See the enclosed article from *Publishers Weekly*.)

Also of interest is the fact that seven states have approved casino gambling in the past three years, and five more states plan to hold referendums on casino gambling in November's elections.

Provide a tentative outline and sample images.

Enclosed you will find a sample Table of Contents for this book, a bio for myself and a few promo cards for your review. Please contact me if you'd like to discuss this book or see more photo samples from this project. If I don't hear from you by October 1, 1997, I will assume your company is not interested in my idea and I'll pursue other publishing options.

Provide deadline for review.

Best regards,

Sandi Johnson

Excerpted from The Photographer's Market Guide to Photo Submission & Portfolio Formats © *1997 by Michael Willins. Used with permission of Writer's Digest Books, a division of F&W Publications, Inc.*

INSIDER REPORT

Shoot what you love—the rest will follow

Putting together an effective portfolio is often as puzzling as solving a riddle. How many images should you include? Should you use big name assignments or choose the pieces you like best? Should you mail a promotional postcard before you contact an art director for a portfolio review? Unfortunately, there isn't one right answer, but, as children's book photographer Walter Wick discovered, some answers are more right than others.

Walter Wick

Wick, who began his career as a general commercial photographer in New York, never dreamed his inventive, colorful photographs would become the centerpiece of a top-selling series of children's books for Scholastic. He certainly had big name clients, shooting covers for magazines like *Psychology Today, Fortune* and *Newsweek*. He even thought he'd probably do a book one day—a compilation of the visual logic puzzles he created for *Games Magazine*. "It never occurred to me to pursue children's publishing," he says. But it did occur to Jean Marzollo, then editor of the Scholastic children's magazine *Let's Find Out*.

Wick sent her the reprint of an image he created for *American Showcase*. He took the picture almost by accident one day when he was organizing a collection of odds and ends—screws and nuts and springs—on his lightboard. "I was always very lazy about mailing those reprints out but apparently I managed to get some of them out anyway. So I got a call based on that photograph to do a poster for *Let's Find Out*. At that point, Scholastic was just another one of my many magazine clients."

Wick had also shot for Scholastic's *Super Science* and *Home Computing* magazines. "I had a lot of ins at Scholastic," he says, "but none of them were really connected with the book division. The poster somehow floated into the offices of one of the book editors and became a favorite. It was sort of an inspiration to think about photography in children's books for that editor. And the editor got in touch with Jean and Jean got in touch with me, and we all got together and came up with the I Spy series."

The first book, *I Spy: A Book of Picture Riddles*, is challenging for the sheer number of objects in each photograph. Yet it is certainly the most simple book of the series. The book combines Wick's images, chock full of the trappings of childhood, with Jean Marzollo's musical riddles. "I spy a snake, a three-letter word,/ And flying underneath, a great white bird;/ Nine gold stars, a blue tube of glitter,/ One clay cat, and a six-legged critter."

Published in 1992, *I Spy* was so successful that Wick started to think about children's books as an outlet for his passions—combining photography with puzzles and games. Seven books later the series will soon include an anthology of the best and hardest photographs with new riddles by Marzollo, a mini-book for younger children, board books and a CD-ROM. Wick's relationship with Scholastic has also allowed him to create a science

INSIDER REPORT, *Wick*

© Walter Wick

"I spy a lamb, a small silver jack, a bright yellow pencil, a blue thumbtack . . . ," wrote Jean Marzollo below this photograph by Walter Wick. This puzzling picture and others like it make up the first book of Wick and Marzollo's acclaimed series, I Spy. All the books challenge children to find objects hidden in unusual ways. The book was born by a happy accident when a poster Wick created for a Scholastic magazine ended up in the book division. An editor there liked Wick's playful use of random objects. "And the editor got in touch with Jean and Jean got in touch with me and we all got together and came up with the I Spy series."

INSIDER REPORT, *continued*

picture book called *A Drop of Water*, and a book of optical illusions that will be published next year. "I'm fully ensconced in the book world right now. I turn down all the commercial assignments that come my way and I'm happier doing this work, at least for now."

But Wick says he's always been happy with his photography career. "I always enjoyed doing assignments because most of them were right up my alley." Of course there were more difficult shots. "I never really turned down work," he says, "but about 10% were like root canals because my heart wasn't in it." Even if Wick got stuck with boring assignments to pay the bills, he could always create interesting work for himself.

"Whenever I did a self-promotional piece I would do sort of an epic thing—it was really heavily conceived and planned—with model-making and all kinds of production put into it. I would only do 1 or 2 a year, whereas some photographers would take a week and shoot 10 or 12 new shots, maybe even a whole new portfolio. I always gravitated toward the complex and high-concept types of images." Even so, Wick had to learn how to win assignments through trial and error.

"My first portfolio was what I thought people would like and I got no work whatsoever; then I did seven or eight shots of what I wanted to do and I started getting work." Wick says that, especially in New York, photographers are chosen for their specialties, and if they are doing work they don't love it will show. "It shows in the personal interviews you have with people. It shows in your enthusiasm and it shows, perhaps, even in your work. There are a few people who can choose a particular area like packaging and do it primarily as a business, but that's not me. I was never able to do that."

Now, Wick can choose the subjects he wants to shoot. "But I couldn't have done that when I started out. I didn't have the power to do that. But because I chose to cultivate my passions into my work, to fold it in together, when I'm hired for a job I'm hired for more than my ability as a photographer. I'm hired for my expertise as a photographer and my expertise in the subject matter. That is a very, very powerful reason to be hired." For example, Wick explains, if an underwater photographer doesn't become an expert in fish and underwater plant life, he'll never be as good of a photographer as he could be.

"The other things I bring to photography are sometimes intangible," he says. "I wouldn't pin them down as an expertise necessarily, but I have an affinity for puzzles and games. I have a sense of how to make hidden objects interesting and have variety to them rather than just looking for one Waldo or something. I devise different ways to hide objects and I have kids looking for not only objects, but shadows and reflections of objects. So I involve a lot of optical games. I also put in a lot of things that hold your interest beyond the act of finding things."

Wick has certainly found his niche in photography and in children's book publishing, but he wouldn't advise anyone to necessarily follow the same path. He believes people should allow their careers to be directed by their passions and desires. "I think my natural ability comes from the past—a sense of play that I had as a child and that I never lost. I've always had a sense of discovery and invention."

—*Megan Lane*

AAIMS PUBLISHERS, 11000 Wilshire Blvd., P.O. Box 241777, Los Angeles CA 90024-9577. (213)968-1195. Fax: (213)931-7217. E-mail: aaims1@aol.com. Personnel Manager: Samuel P. Elliott. Estab. 1969. Publishes adult trade, "how-to," description and travel, sports, adventure, fiction and poetry. Photos used for text illustration, promotional materials and book covers. Examples of recently published titles: *Family Reunions: How To Plan Yours*; *A Message From Elvis*; and *U.S. Marines Force Recon: A Black Hero's Story.*
Needs: Offers 4 or 5 freelance assignments annually. Shots of sports figures and events. Reviews stock photos. Model/property release required.
Making Contact & Terms: Arrange personal interview to show portfolio. Query with samples. Uses 3×5 glossy b&w/prints. SASE. Reports in 3 weeks. Pays $10-50/b&w photo; $50/hour. Credit line may be given. Buys all rights; negotiable. Offers internships for photographers. Contact Assistant Director: Olatunde Master.

ABBEVILLE PRESS, 22 Cortlandt St., 32nd Floor, New York NY 10007. (212)577-5555. Fax: (212)577-5580. Director of Photography: Naomi Ben-Shahar. Publishes art books, travel books, cookbooks, children's books, calendars, stylebooks. Photos used for text illustration, promotional materials, book covers, dust jackets. Examples of recently published titles: *Goddesses in Art* (illustrations), *100 Classic Cocktails* (illustrations), *Hugs to Kisses* (illustrations).
Needs: Buys 500-5,000 photos annually; offers 5-10 freelance assignments annually. Wants focused material that is well-lit. Prefers large format. Reviews stock photos of wildflowers (North American). Model/property release required for people or artwork. Captions required.
Making Contact & Terms: Provide résumé, business card, brochure, flier or tearsheets to be kept on file for possible future assignments. Uses up to 11×14 matte or glossy b&w prints; "2¼×2¼, 4×5 and 8×10 transparencies preferred, but we will take 35mm." Keeps samples on file. SASE. Reports in 1 month. Pays per picture rated range from $75-150. **Pays on receipt of invoice.** Credit line given. Rights purchased depends upon project and whether there was a work-for-hire arrangement; negotiable.
Tips: "We review portfolios. We love to receive good ideas for books. You can submit materials on the following subjects: art, travel, nature, food, animals."

ADAMS-BLAKE PUBLISHING, 8041 Sierra St., Fair Oaks CA 95628. Phone/fax: (916)962-9296. Editorial Assistant: Monica Blane. Estab. 1992. Publishes business, career and reference material. Photos used for text illustration, promotional materials and book covers. Examples of published titles: *Computer Money* (promo); *Core 911* (cover/promo); and *Complete Guide to TV Movies* (promo).
Needs: Buys 10-15 photos annually; offers 5 freelance assignments annually. Wants photos of people in office situations. Model/property release required. Captions required; include where and when.
Making Contact & Terms: Query with résumé of credits. Provide résumé, business card, brochure, flier or tearsheets to be kept on file for possible future assignments. Uses 5×7 and 8×10 glossy b&w prints; 35mm transparencies. Keeps samples on file. SASE. Reports in 1 month. Pays $50-100/color photo; $50-100/b&w photo. **Pays on acceptance.** Credit line given. Buys one-time and book rights; negotiable. Simultaneous submissions and previously published work OK.
Tips: "We publish business books and look for subjects using office equipment in meetings and at the desk/work site. Don't send a whole portfolio. We only want your name, number and a few samples. Having an e-mail address and fax number will help you make a sale. Don't phone or fax us. We also look for b&w book covers. They are cheaper to produce and, if done right, can be more effective than color."

AERIAL PHOTOGRAPHY SERVICES, 2511 S. Tryon St., Charlotte NC 28203. (704)333-5143. Fax: (704)333-5148. Photography/Lab Manager: Joe Joseph. Estab. 1960. Publishes pictorial books, calendars, postcards, etc. Photos used for text illustration, book covers. Examples of recently published titles: *Blue Ridge Parkway Calendar, Great Smoky Mountain Calendar, North Carolina Calendar*, all depicting the seasons of the year. Photo guidelines free with SASE.
Needs: Buys 100 photos annually. Landscapes, scenics, mostly seasons (fall, winter, spring). Reviews stock photos. Model/property release preferred. Captions required; include location.
Making Contact & Terms: Send unsolicited photos by mail for consideration. Works with local freelancers on assignment only. Uses 5×7, 8×10 matte color prints; 35mm, 2¼×2¼, 4×5 transparencies; c-41

MARKET CONDITIONS are constantly changing! If you're still using this book and it's 2000 or later, buy the newest edition of *Photographer's Market* at your favorite bookstore or order directly from Writer's Digest Books.

© Galyn C. Hammond

Photographer Galyn Hammond has twice sold her stock image of a Turkish cat with two different colored eyes. Both times to Abbeville Press. "I had read about these unusual cats before traveling to Turkey and, upon spotting one near a market in Istanbul, I photographed it," Hammond says. Her good fortune led to publication in both *Tiny Folio: Cats Up Close* and *Cats Up Close*. Hammond learned that Abbeville was looking for cat images through a listing in PhotoSource International's *Photo-Letter*. "As a photographer who travels to foreign countries, I keep my eyes open for the unusual, the local dress, local customs, etc. I don't stay in deluxe hotels. I want the feel of the country and its people."

120mm film mostly. SASE. Reports in 3 weeks. Payment negotiable. **Pays on acceptance.** Credit line given. Buys all rights; negotiable. Simultaneous submissions OK.
Tips: Looking for "fresh looks, creative, dynamic, crisp images. We use a lot of nature photography, scenics of the Carolinas area including Tennessee and the mountains. We like to have a nice variety of the four seasons. We also look for good quality chromes good enough for big reproduction. Only submit images that are very sharp and well exposed. We get a lot of useless photos and that takes a lot of our time, so please be considerate on that particular aspect. Seeing large format photography the most (120mm-4×5). If you would like to submit images in a CD, that is acceptable too. The industry is looking for fast action/response and computers are promising a lot."

AGRITECH PUBLISHING GROUP, 95 Court St., Unit A, Exeter NH 03833-2621. (603)773-9823. President: Robert Griset. Vice President of Sales: Andie Taylor. Estab. 1988. Publishes adult trade, juvenile, textbooks. Subject matter includes horses, pets, farm animals/management, gardening, Western art/Americana and agribusiness. 60% of books related to horses. Photos used for text illustration, promotional materials, book covers and dust jackets.
Needs: Number of purchases and assignments varies. Reviews stock photos. Model/property release required. Captions preferred.
Making Contact & Terms: Submit portfolio for review. Query with samples. Provide résumé, business card, brochure, flier, duplicates or tearsheets to be kept on file for possible future assignments. Keeps samples on file. SASE. Subject matter varies. Payment negotiable. Pays on publication. Credit line sometimes given depending upon subject and/or photo. Buys book rights and all rights.
Tips: "Limit queries to what we look for and need."

ALLYN AND BACON PUBLISHERS, 160 Gould St., Needham MA 02194. Fax: (617)455-1294. Photography Director: Susan Duane. Textbook publisher (college). Photos used in textbook covers and interiors.

Needs: Offers 4 assignments plus 80 stock projects/year. Multi-ethnic photos in education, health and fitness, people with disabilities, business, social sciences and good abstracts. Reviews stock photos. Model/property release required.

Making Contact & Terms: Provide self-promotion piece or tearsheets to be kept on file for possible future assignments. "Do not call or send stock lists." Uses b&w prints, any format; all transparencies. Keeps samples on file. Cannot return samples. Reports back in "24 hours to 4 months." Pays $50-225/photo; negotiable/day or complete job. Pays on usage. Credit line given. Buys one-time rights; negotiable. Offers internships for photographers January-June. Contact Photography Director: Susan Duane.

Tips: "Send tearsheets and promotion pieces. Need bright, strong, clean abstracts and unstaged, nicely lit people photos."

ALPINE PUBLICATIONS, INC., 225 S. Madison Ave., Loveland CO 80537. (970)667-9317. Publisher: B.J. McKinney. Estab. 1975. Publishes how-to, training and breed books for dogs, horses, pets. Photos used for text illustration and book covers.

Needs: Wants photos of dogs and horses (singly and in combination), working and training photos, how-to series on assignment. Reviews stock photos. Model release required for people and animals. Captions preferred; include breed and registered name.

Making Contact & Terms: Query with samples. Query with stock photo list. Works on assignment only. Uses 5×7, 8×10 glossy color and b&w prints; 35mm, 2¼×2¼, 4×5 transparencies. Keeps samples on file. SASE. Reports in 1 month. Pays $25-300/color photo; $15-50/b&w photo. Pays on publication. Credit line given. Buys book rights; negotiable. Simultaneous submissions and previously published work OK.

Tips: "We look for clear, very sharp-focused work and prefer purebred, excellent-quality specimens. Natural behavior-type shots are very desirable. Be flexible in rates—we're small and growing. We actively seek lesser-known talents, believing your work will sell our product, not your name. Be patient."

AMERICAN & WORLD GEOGRAPHIC PUBLISHING, P.O. Box 5630, Helena MT 59604. (406)443-2842. Fax: (406)443-5480. Photo Librarian: Jamie Mitchell. Estab. 1973. Publishes material relating to geography, weather, photography—scenics and adults and children at work and play. Photos used for text illustration, promotional materials, book covers and dust jackets (inside: alone and with supporting text). Examples of published titles: *Wisconsin from the Sky* (aerial coffee table book); *The Quad-Cities and the People* (text, illustration); and *Oklahoma: The Land and Its People* (text, illustration). Photo guidelines free with SASE.

Needs: Buys 1,000 photos annually; offers 1-10 freelance assignments annually. Looking for photos that are clear with strong focus and color—scenics, wildlife, people, landscapes. Captions required; include name and address on mount. Package slides in individual protectors, then in sleeves.

Making Contact & Terms: Query with samples. Query with stock photo list. Uses 35mm, 2¼×2¼, 4×5 and 8×10 transparencies. SASE. Reporting time depends on project. Pays $75-350/color photo. Pays on publication. Buys one-time rights. Simultaneous submissions and/or previously published work OK.

Tips: "We seek bright, heavily saturated colors. Focus must be razor sharp. Include strong seasonal looks, scenic panoramas, intimate close-ups. Of special note to *wildlife* photographers, specify shots taken in the wild or in a captive situation (zoo or game farm). We identify shots taken in the wild."

AMERICAN ARBITRATION ASSOCIATION, 140 W. 51st St., New York NY 10020-1203. (212)484-4000. Editorial Director: Jack A. Smith. Publishes law-related materials on all facets of resolving disputes in the labor, commercial, construction and insurance areas. Photos used for text illustration. Examples of published titles: *Dispute Resolution Journal* (cover and text); *Dispute Resolution Times* (text); and *AAA Annual Report* (text).

Needs: Buys 10 photos annually; assigns 5 freelance projects annually. General business and industry-specific photos. Reviews stock photos. Model release and photo captions preferred.

Making Contact & Terms: Provide résumé, business card, brochure, flier or tearsheets to be kept on file for possible future assignments. Uses 8×10 glossy b&w prints; 35mm transparencies. SASE. Reports "as time permits." Pays $250-400/color photo, $75-100/b&w photo, $75-100/hour. Credit lines given "depending on usage." Buys one-time rights. Also buys all rights "if we hire the photographer for a shoot." Simultaneous submissions and previously published work OK.

AMERICAN BAR ASSOCIATION PRESS, 750 N. Lake Shore Dr., Chicago IL 60611. (312)988-6054. Fax: (312)988-6035. Photo Service Coordinator: Russell Glidden. "The ABA Press publishes 10 magazines, each addressing various aspects of the law. Readers are members of the sections of the American Bar Association." Photos used for text illustration, promotional materials, book covers. Examples of published titles: *Business Law Today*, portrait shot of subject of story; *Criminal Justice*, photo for story on crack. Photo guidelines free with SASE.

Needs: Buys 3-5 photos/issue. Rarely gives freelance assignments. "We are looking for serious photos that illustrate various aspects of the law, including courtroom scenes and still life law concepts. Photos of various social issues are also needed, e.g., crime, AIDS, homelessness, families, etc. Photos should be technically correct. Photos should show emotion and creativity. Try not to send any gavels or Scales of Justice. We have plenty of those." Reviews stock photos. Model/property release preferred; "required for sensitive subjects." Photo captions preferred.

Making Contact & Terms: Query with stock photo list. Send unsolicited photos by mail for consideration. Provide résumé, business card, brochure, flier or tearsheets with SASE to be kept on file for possible future assignments. Uses 5×7, 8×10 b&w prints; 35mm, 2¼×2¼, 4×5, 8×10 transparencies. Keeps samples on file. Reports in 4-6 weeks. Pays $150-450/b&w; $500-700/color. Assignment fees will be negotiated. When photos are given final approval, photographers will be notified to send an invoice. Credit line given. Buys one-time rights; negotiable. "We reserve the right to republish if publication is used on the Internet." Simultaneous submissions and/or previously published works OK.

Tips: "Be patient, present only what is relevant."

AMERICAN BIBLE SOCIETY, 1865 Broadway, New York NY 10023. Fax: (212)408-1305. Assistant Director/Product Development: Christina Murphy. Estab. 1816. Publishes Bibles, New Testaments, illustrated Scripture booklets, leaflets and wide range of products on religious and spiritual topics. Photos used for covers, text illustration, promotional materials, calendar and tray cards. Examples of published titles: *Hospital Scripture Tray Cards*, Series of 7 (covers); *God Is Our Shelter and Strength*, booklet on natural disasters; and *Run Toward the Goal*, booklet for youth.

Needs: Buys approx. 10-25 photos annually; offers at least 10 freelance assignments annually. Needs scenic photos, people (multicultural), religious activities, international locations (particularly Israel, Jerusalem, Bethlehem, etc.). Reviews stock photos. Model release required. Property release preferred. Releases needed for portraits and churches. Captions preferred; include location and names of identifiable persons.

Making Contact & Terms: Query with samples. Provide résumé, business card, brochure, flier or tearsheets to be kept on file for possible future assignments. Uses any size glossy color and b&w prints; 35mm, 2¼×2¼, 4×5, 8×10 transparencies. Keeps samples on file. SASE. Reports within 1 month. Pays $100-500/color photo; $50-200/b&w photo. **Pays on receipt of invoice.** Credit line sometimes given depending on nature of publication. Buys one-time and all rights; negotiable. Simultaneous and/or previously published work OK.

Tips: Looks for "special sensitivity to religious and spiritual subjects and locations; contemporary, multicultural people shots are especially desired."

AMERICAN COLLEGE OF PHYSICIAN EXECUTIVES, 4890 W. Kennedy Blvd., Suite 200, Tampa FL 33609-2575. (813)287-2000. Fax: (813)287-8993. E-mail: ssasenick@acp.org. Editor: Susan Sasenick. Estab. 1979. Publishes adult trade for physician executives. Photos used for text illustration. Example of recently published title: *Physician Executivie Journal*.

Needs: Buys 10 photos annually. Looking for photos of abstracts and still lifes. Reviews stock photos.

Making Contact & Terms: Query with samples. Query with stock photo list. Provide résumé, business card, brochure, flier or tearsheets to be kept on file for possible future assignments. Accepts all formats, including prints, transparencies, film and videotape and digital. Keeps samples on file. SASE. Reports in 1 month. Payment negotiable. Pays on publication, receipt of invoice. Credit line given. Buys one-time rights and electronic rights; negotiable. Simultaneous submissions and previously published work OK.

AMERICAN MANAGEMENT ASSOCIATION, 1601 Broadway, New York NY 10019. (212)903-8058. Fax: (212)903-8452. E-mail: snewton@amanet.org. Art & Production Director: Seval Newton. Estab. 1923. Publishes trade books and magazines on management. Photos used for text illustration, book covers, magazine articles and covers. Examples of recently published titles: *Management Review*, July '95 issue (cover, inside journalistic photos) and February '96 issue (cover photo, ergonomics article).

Needs: Buys 10 photos annually; offers 3-5 freelance assignments annually. Needs business and office photos. Reviews stock photos of management, business, office and professions. Model/property release required for people and locations. Captions required; include name, title of person, location and date.

Making Contact & Terms: Provide résumé, business card, brochure, flier or tearsheets to be kept on file for possible future assignments. Works with freelancers on assignment only. Uses 35mm slides, 8×10 color prints; 2¼×2¼, 4×5 transparencies. Negatives and Kodak digital format OK. Keeps samples on file. SASE. Reports only if interested. Pays $350-500/day; 25% more for electronic usage. Pays on publication. Credit line given. Buys all rights; negotiable. Simultaneous submissions OK.

Tips: "We appreciate photographers who know and use Photoshop for enhancement and color correction. Delivery on a Kodak CD with color correction is a big plus."

AMERICAN PLANNING ASSOCIATION, 122 S. Michigan, Suite 1600, Chicago IL 60603. (312)431-9100. Fax: (312)431-9985. Art Director: Richard Sessions. Publishes planning and related subjects. Photos used for text illustration, promotional materials, book covers, dust jackets. Photo guidelines and sample for $1 postage.
Needs: Buys 100 photos annually; offers 8-10 freelance assignments annually. Needs planning related photos. Captions required; include what's in the photo and credit information.
Making Contact & Terms: Provide résumé, business card, brochure, flier or tearsheets to be kept on file for possible future assignments. "Do not send original work—slides, prints, whatever—with the expectation of it being returned." Uses 8×10 glossy color or b&w prints. Keeps samples on file. SASE. Reports in 1-2 weeks. Pays $80-100 for existing stock photos. **Pays on receipt of invoice.** Credit line given. Buys one-time and electronic rights (CD-ROM and online). Simultaneous submissions and previously published work OK.

AMERICAN SCHOOL HEALTH ASSOCIATION, P.O. Box 708, Kent OH 44240. (330)678-1601. Fax: (330)678-4526. Managing Editor: Thomas M. Reed. Estab. 1927. Publishes professional journals. Photos used for book covers.
Needs: Looking for photos of school-age children. Model/property release required. Captions preferred; include photographer's full name and address.
Making Contact & Terms: Query with samples. Uses 35mm transparencies. Does not keep samples on file. SASE. Reports as soon as possible. Payment negotiable. Pays on publication. Credit line given. Buys one-time rights. Simultaneous submissions and previously published work OK.

AMHERST MEDIA INC., P.O. Box 586, Amherst NY 14226. (716)874-4450. Fax: (716)874-4508. Publisher: Craig Alesse. Estab. 1979. Publishes how-to photography. Photos used for text illustration and book covers. Examples of published titles: *The Freelance Photographer's Handbook*; *Wedding Photographer's Handbook* (illustration); and *Lighting for Imaging* (illustration).
Needs: Buys 25 photos annually; offers 6 freelance assignments annually. Model release required. Property release preferred. Captions preferred.
Making Contact & Terms: Query with résumé of credits. Uses 5×7 prints; 35mm transparencies. Does not keep samples on file. SASE. Reports in 1 month. Pays $30-100/color photo; $30-100/b&w photo. Pays on publication. Credit line sometimes given depending on photographer. Rights negotiable. Simultaneous submissions OK.

AMPHOTO BOOKS, 1515 Broadway, New York NY 10036. (212)764-7300. Senior Editor: Robin Simmen. Publishes instructional and how-to books on photography. Photos usually provided by the author of the book.
Needs: Submit model release with photos. Photo captions explaining photo technique required.
Making Contact & Terms: Query with résumé of credits and book idea, or submit material by mail for consideration. SASE. Reports in 1 month. Payment negotiable. Pays on royalty basis. Buys one-time rights. Simultaneous submissions and previously published work OK.
Tips: "Submit focused, tight book ideas in form of a detailed outline, a sample chapter, and sample photos. Be able to tell a story in photos and be aware of the market."

N ◾ **ANVIL PRESS**, 204-A 175 E. Broadway, Vancouver, British Columbia V5T 1W2 Canada. (604)876-8710. Fax: (604)879-2667. E-mail: subter@pinc.com. Managing Editor: Brian Kaufman. Estab. 1988. Publishes trade paperback originals and reprints. Subjects include contemporary literature. Photos used for book covers. Examples of recently published titles: *Salvage King, Ya!* (book cover); *Sub-Rosa* (book cover).
Needs: Buys 20 freelance photos annually.
Marketing Contact & Terms: Send query letter with samples. To show portfolio, photographer should follow-up with call. Keeps samples on file. Reports in 2 months on queries; 2 months on samples. Send nonreturnable samples. Pays by the project for cover. Pays $10-30 for inside photos. Considers simultaneous subimssions.

N **APPALACHIAN MOUNTAIN CLUB BOOKS**, 5 Joy St., Boston MA 02108. (617)523-0636. Fax: (617)523-0722. Website: http://www.outdoors.org. Production Manager: Elisabeth L. Brady. Estab. 1876. Publishes hardcover originals, trade paperback originals and reprints. Subjects include nature, outdoor, recreation, paddlesports, hiking/backpacking, skiing. Photos used for text illustrations, book covers. Examples of recently published titles: *River Rescue, 3rd ed.* (cover); *Exploring the Hidden Charles* (cover); *Appalachia* (cover).
Needs: Buys 10-15 freelance photos annually. Looking for photos of paddlesports, skiing and outdoor

recreation. Model release required; property release required. Photo caption preferred; include where photo was taken, description of subject, author's name and phone number.

Marketing Contact & Terms: Send query letter with brochure, stock photo list or tearsheets. Art director will contact photographer for portfolio review if interested. Portfolio should include b&w or color, prints, tearsheets. Works with local freelancers on assignment only. Uses 3×5 glossy color and b&w prints; 35mm, 2¼×2¼ transparencies. Keeps samples on file; include SASE for return of material. Reports back only if interested, send non-returnable samples. Pays by the project, $200-450 for color cover; $50 for b&w inside. **Pays on acceptance.** Credit line given. Buys first North American serial rights. Considers previously published work.

ARDSLEY HOUSE PUBLISHERS INC., 320 Central Park West, New York NY 10025. (212)496-7040. Fax: (212)496-7146. Publishing Assistant: Karen Bianco. Estab. 1981. Publishes college textbooks—music, film, history, philosophy, mathematics. Photos used for text illustration and book covers. Examples of published titles: *Ethics in Thought and Action* (text illustration); *Music Melting Round* (text illustration, book cover); and *Greek & Latin Roots of English* (text illustration).

Needs: Buys various number of photos annually; offers various freelance assignments annually. Needs photos that deal with music, film and history. Reviews stock photos. Model/property release preferred.

Making Contact & Terms: Query with samples. Query with stock photo list. Provide résumé, business card, brochure, flier or tearsheets to be kept on file for possible future assignments. Uses color and b&w prints. Keeps samples on file. SASE. Reports in 1 month. Pays $25-50/color photo; $25-50/b&w photo. **Pays on acceptance.** Credit line given. Buys book rights; negotiable.

 ARNOLD PUBLISHING LTD., 11016-127 St., Edmonton, Alberta T5M 0T2 Canada. (403)454-7477. Fax: (403)454-7463. E-mail: info@arnold.ca. Contact: Production Coordinator. Publishes social studies textbooks and related materials. Photos used for text illustration and CD-ROM. Examples of recently published titles: *Japan* (textbook); and *Marooned-Resource Explorer* (educational CD-ROM).

Needs: Buys hundreds of photos annually; offers 2-3 freelance assignments annually. Looking for photos of history of Canada, world geography, geography of Canada. Reviews stock photos. Model/property release required. Captions preferred; include description of photo and setting.

Making Contact & Terms: Query with stock photo list. Provide résumé, business card, brochure, flier or tearsheets to be kept on file for possible future assignments.

ART DIRECTION BOOK CO., INC., 456 Glenbrook Rd., Stamford CT 06906. (203)353-1441 or (203)353-1355. Fax: (203)353-1371. Contact: Art Director. Estab. 1939. Publishes only books of advertising art, design, photography. Photos used for dust jackets.

Needs: Buys 10 photos annually. Needs photos for advertising.

Making Contact & Terms: Submit portfolio for review. Works on assignment only. SASE. Reports in 1 month. Pays $200 minimum/b&w photo; $500 minimum/color photo. Credit line given. Buys one-time and all rights.

ASSOCIATION OF BREWERS, INC., 736 Pearl St., Boulder CO 80302. (303)447-0816. Fax: (303)447-2825. E-mail: vicki@aob.org. or stephanie@aob.org. Website: http://www.beertown.org. Graphic Production Director: Tyra Segars. Art Directors: Vicki Hopewell and Stephanie Johnson. Estab. 1978. Publishes beer how-to, cooking with beer, adult trade, hobby, brewing and beer-related books. Photos used for text illustration, promotional materials, books, magazines. Examples of published magazines: *Zymurgy* (front cover and inside) and *The New Brewer* (front cover and inside). Examples of published book titles: *Great American Beer Cook Book* (front/back covers and inside); *Scotch Ale* (cover front/back).

Needs: Buys 15-50 photos annually; offers 20 freelance assignments annually. Needs still lifes, people, beer and events. Reviews stock photos. Model/property release preferred.

Making Contact & Terms: Submit portfolio for review. Query with samples. Provide résumé, business card, brochure, flier or tearsheets to be kept on file for possible future assignments. Uses color and b&w

prints, 35mm transparencies. Keeps samples on file. SASE. Reports in 1-2 weeks. Payment negotiable; all jobs done on a quote basis. Pays 30 days after receipt of invoice. Credit line given. Preferably buys one-time usage rights, but negotiable. Simultaneous submissions and previously published works OK.

Tips: "Send samples for us to keep in our files which depict whatever your specialty is plus some samples of beer-related objects, equipment, events, people, etc."

AUGSBURG FORTRESS, PUBLISHERS, P.O. Box 1209, Minneapolis MN 55440. (612)330-3300. Fax: (612)330-3455. Contact: Photo Secretary. Publishes Protestant/Lutheran books (mostly adult trade), religious education materials, audiovisual resources and periodicals. Photos used for text illustration, book covers, periodical covers and church bulletins. Guidelines free with SASE.

Needs: Buys 1,000 color photos and 250 b&w photos annually. No assignments. People of all ages, variety of races, activities, moods and unposed. "Always looking for church scenarios—baptism, communion, choirs, acolytes, ministers, Sunday school, etc." In color, wants to see nature, seasonal, church year and mood. Model release required.

Making Contact & Terms: Send material by mail for consideration. "We are interested in stock photos." Provide tearsheets or low res. digital files to be kept on file for possible future assignments. Uses 8×10 glossy or semiglossy b&w prints, 35mm, $2\frac{1}{4} \times 2\frac{1}{4}$ color transparencies or digital images on disk for Mac in EPS or TIFF files. Send via CD or Zip disk at 300 dpi. SASE. Reports in 6-8 weeks. "Write for guidelines, then submit on a regular basis." Pays $55-165/b&w photo; $93-328/color photo. Credit line nearly always given. Buys one-time rights. Simultaneous submissions and previously published work OK.

AUTONOMEDIA, P.O. Box 568, Brooklyn NY 11211. Phone/fax: (718)963-2603. E-mail: autonobook@ aol.com. Website: http://www.autonomedia.org. Editor: Jim Fleming. Estab. 1974. Publishes books on radical culture and politics. Photos used for text illustration and book covers. Examples of recently published titles: *TAZ* (cover illustration); *Cracking the Movement* (cover illustration); and *Zapatistas* (cover and photo essay).

Needs: The number of photos bought annually varies, as does the number of assignments offered. Model/property release preferred. Captions preferred.

Making Contact & Terms: Query with samples. Send unsolicited photos by mail for consideration. Works on assignment only. Does not keep samples on file. SASE. Reports in 1 month. Payment negotiable. Pays on publication. Buys one-time and electronic rights.

BEHRMAN HOUSE INC., 235 Watchung Ave., West Orange NJ 07052. (201)669-0447. Fax: (201)669-9769. Attn: Editorial Dept. Estab. 1921. Publishes Judaica textbooks. Photos used for text illustration, promotional materials and book covers.

Needs: Interested in stock photos of Jewish content, particularly holidays, with children. Model/property release required.

Making Contact & Terms: Query with résumé of credits. Query with samples. Provide résumé, business card, brochure, flier or tearsheets to be kept on file for possible future assignments. Interested in stock photos. SASE. Reports in 3 weeks. Pays $50-500/color photo; $20-250/b&w photo. Credit line given. Buys one-time rights; negotiable.

Tips: Company trend is increasing use of photography.

N BENTLEY AUTOMOTIVE PUBLISHERS, 1734 Massachusetts Ave., Cambridge MA 02138. (617)547-4170. Fax: (617)876-9235. E-mail: mbentley@rb.com. President: Michael Bentley. Estab. 1950. Publishes professional, technical, consumer how-to books. Photos used for text illustration, promotional materials, book covers, dust jackets. Examples of published titles: *Race Car Aerodynamics* (cover); *Chevy by the Numbers* (cover and interior photos); and *Going Faster: The Skip Barber Racing School Textbook of Race Driving* (cover).

Needs: Buys 70-100 photos annually; offers 5-10 freelance assignments annually. Looking for motorsport, automotive technical and engineering photos. Reviews stock photos. Model/property release required. Captions required; include date and subject matter.

Making Contact & Terms: Query with samples. Send unsolicited photos by mail for consideration. Provide résumé, business card, brochure, flier or tearsheets to be kept on file for possible future assignments. Uses 8×10 transparencies. Accepts images in digital format. Keeps samples on file; cannot return material. Works on assignment only. SASE. Reports in 4-6 weeks. Payment negotiable. Credit line given. Buys electronic and one-time rights. Simultaneous submissions and previously published work OK.

BLACKBIRCH PRESS, INC., 260 Amity Rd., Woodbridge CT 06525. (203)387-7525. Fax: (203)389-1596. Contact: Sonja Glassman. Estab. 1979. Publishes juvenile nonfiction. Photos used for text illustration,

promotional materials, book covers and dust jackets. Example of published titles: *Nature Close-Up: Earthworms.*

Needs: Buys 300 photos annually. Interested in set up shots of kids, studio product/catalog photos and location shots. Reviews stock photos of nature, animals and geography. Model release required. Property release preferred. Captions required.

Making Contact & Terms: Query with résumé of credits. Query with samples. Query with stock photo list. Works on assignment only. Uses 35mm, 2¼×2¼, 4×5 transparencies. Keeps samples on file. Cannot return material. Reports in 1 month. Pays $50-100/hour; $500-800/day; $100-200/color photo; $60-80/b&w photo. Pays on acceptance or publication. Credit line given. Buys one-time, book, all rights; negotiable. Simultaneous submissions and previously published work OK.

Tips: "We're looking for photos of people, various cultures and nature."

BLUE BIRD PUBLISHING, 2266 S. Dobson, Mesa AZ 85202. Publisher: Cheryl Gorder. Estab. 1985. Publishes adult trade books on home education, spirituality, healing and business. Photos used for text illustration. Examples of recently published titles: *Road School* and *Divorced Dad's Handbook*. In both, photos used for text illustration.

Needs: Buys 40 photos annually; offers 3 freelance assignments annually. Types of photos "depends on subject matter of forthcoming books." Reviews stock photos. Model release required; photo captions preferred.

Making Contact & Terms: Query with list of stock photo subjects. Provide résumé, business card, brochure, flier or tearsheets to be kept on file for possible future assignments. Pays $25-150/color photo, $25-150/b&w photo; also pays flat fee for bulk purchase of stock photos. Buys book rights. Simultaneous submissions and previously published work OK.

Tips: "We will continue to grow rapidly in the coming years and will have a growing need for stock photos and freelance work. Send a list of stock photos for our file. If a freelance assignment comes up in your area, we will call."

BLUE DOLPHIN PUBLISHING, INC., P.O. Box 8, Nevada City CA 95959. (916)265-6925. Fax: (916)265-0787. President: Paul M. Clemens. Estab. 1985. Publishes comparative spiritual traditions, self-help, lay psychology, humor, cookbooks, children's books, natural living and healing. Photos used for text illustration, promotional materials, book covers and dust jackets. Examples of recently published titles: *Mary's Message of Hope*; *Summer with the Leprechauns: A True Story*; *You're Not Old Until You're 90*; *Women Who Take Care*; and *UFO's: A Great New Dawn for Humankind*. Photos used throughout text or on covers.

Needs: Buys 1-25 photos annually; offers 1-3 freelance assignments annually. Looking for New Age, spiritual/psychological or regional. Model release preferred; property release required. Captions preferred.

Making Contact & Terms: Query with a few samples. Provide résumé, business card, brochure, flier or tearsheets to be kept on file for possible future assignments. Works on assignment only. Uses 3×5, 5×7 color and/or b&w prints; 35mm, 2¼×2¼, 4×5, 8×10 transparencies. "We can scan images into our system and output directly to color separations." Keeps samples on file. SASE. Reports in 1 month. Pays $20-200/b&w photo; $20-300/color photo; $20/hour, or by arrangement per project. **Pays on receipt of invoice.** Credit line given. Buys one-time and book rights; prefers all rights; negotiable. Simultaneous submissions and previously published work OK.

Tips: Looks for "clarity, composition. Do 'different' things in life. Shoot the unique perspective. We're getting more electronic—looking for the unusual perspective."

BONUS BOOKS, INC., 160 E. Illinois St., Chicago IL 60611. (312)467-0580. Fax: (312)467-9271. E-mail: bb@bonus-books.com. Website: http://www.bonus-books.com. Managing Editor: Andrea Lacko. Estab.1980. Publishes adult trade: sports, consumer, self-help, how-to and biography. Photos used for text illustration and book covers. Examples of recently published titles: *Agassi and Ecstasy*, *MJ Unauthorized*, *Shock Marketing.*

Needs: Buys 1 freelance photo annually; gives 1 assignment annually. Model release required. Property release preferred with identification of location and objects or people. Captions required.

Making Contact & Terms: Query with résumé of credits, query with samples. Provide résumé, business card, brochure, flier or tearsheets to be kept on file for possible future assignments. Uses 8×10 matte b&w prints and 35mm transparencies. Accepts images in digital format for Windows. Send via JPEG files on SyQyest, Zip disk or floppy at 600 dpi. Solicits photos by assignment only. Does not return unsolicited material. Reports in 1 month. Pays in contributor's copies and $150 maximum for color transparency. Credit line given if requested. Buys one-time rights.

Tips: "Don't call. Send written query. In reviewing a portfolio, we look for composition, detail, high

quality prints, well-lit studio work. We are not interested in nature photography or greeting-card type photography."

BOSTON MILLS PRESS, 132 Main St., Erin, Ontario N0B 1T0 Canada. (519)833-2407. Fax: (519)833-2195. Publisher: John Denison. Estab. 1974. Publishes coffee table books, local guide books. Photos used for text illustration, book covers and dust jackets. Examples of recently published titles: *Union Pacific: Salt Lake Route*; *Gift of Wings*; and *Superior: Journey on an Inland Sea*.
Needs: "We're looking for book length ideas *not* stock. We pay a royalty on books sold plus advance."
Making Contact & Terms: Interested in receiving work from established and newer, lesser-known photographers. Query with résumé of credits. Uses 35mm transparencies. Does not keep samples on file. SASE and IRC. Reports in 3 weeks. Payment negotiated with contract. Credit line given. Simultaneous submissions OK.

BRISTOL FASHION PUBLICATIONS, P.O. Box 20, Enola PA 17025-0020. Fax: (717)564-1711. Publisher: John P. Kaufman. Estab. 1993. Publishes marine, how-to and boat repair books. Photos used for front and back covers and text illustration. Photo guidelines free with SASE.
Needs: Buys 10-50 photos annually. Looking for b&w photos of hands using tools for boat repair (before and after cosmetic repairs). Reviews stock photos. Model/property release preferred for identifiable people and boats. "If the job being photographed needs an explanation, we cannot use the photo. When we review photos it should be obvious what job is being done."
Making Contact & Terms: Query with samples. Provide résumé, business card, brochure, flier or tearsheets to be kept on file for possible future assignments. No calls. Uses 3½×5 to 5×7 glossy color (cover) and b&w (inside) prints; 35mm, 2¼×2¼, 4×5 transparencies; color and b&w scanned images in TIFF, JPEG and BMP. Prefers JPEG. Submit via floppy disk, Zip disk or CD, (300 dpi or better). May keep samples on file or will return with SASE. Reports in 1 month. Pays $25-100/color photo; $15-30/b&w photo; will assign specific shots and pay stock amounts for photos used. If photos are supplied on disk in JPEG and usable, will pay $5 additional. Disks returned with SASE. Pays on publication. Credit line given. Buys book rights. Simultaneous submissions and/or previously published work OK.
Tips: "We are more apt to use a scanned image supplied by the photographer. We want to see the photos (prints, slides) first. We make copies of the photos we may use and note the photographers name and phone number on the copy. If we want an image for a book, we will call and ask for a disk to be sent within seven days. We scan all photos for our books. Obviously, photographers who can save us this step have a good chance of selling us their photos. Mail at least 20 new submissions each month if possible. Our editors use more photos because the disk or photo is in their hands. Good contrast and sharp images are recommended, but neither help if we do not have the image to use. We would use more interior photos to replace line drawings but we cannot acquire them easily."

THE BUREAU FOR AT-RISK YOUTH, 135 Dupont St., P.O. Box 760, Plainview NY 11803-0760. (516)349-5520. Editor-in-Chief: Sally Germain. Estab. 1990. Publishes educational materials for teachers, mental health professionals, social service agencies on children's issues such as building self-esteem, substance abuse prevention, parenting information, etc. Photos used for text illustration, promotional materials, book covers, dust jackets. Began publishing books that use photos in 1994.
Needs: Occasionally uses photos for posters of children and adults in family and motivational situations. Model release required.
Making Contact & Terms: Send unsolicited photos by mail for consideration. Provide résumé, business card, brochure, flier or tearsheets to be kept on file for possible future assignments. "Please call if you have questions." Uses 2¼×2¼ transparencies. Keeps samples on file. SASE. Reports in 3-6 months. Payment negotiable; "Fees have not yet been established." Will pay on a per project basis. Pays on publication or receipt of invoice. Credit line sometimes given, depending upon project. Rights purchased depend on project; negotiable. Simultaneous submissions and/or previously published work OK.

CAPSTONE PRESS, 818 N. Willow St., Mankato MN 56001. (507)388-6650. Fax: (507)625-4662. E-mail: m.norstad@mail.capstone~press.com. Contact: Photo Researcher. Estab. 1991. Publishes juvenile nonfiction and educational books; subjects include animals, ethnic groups, vehicles, sports and scenics.

THE SUBJECT INDEX, located at the back of this book, lists publications, book publishers, galleries, gift and paper product companies and stock agencies according to the subject areas they seek.

Photos used for text illustration, promotional materials and book covers. Examples of recently published titles: *The Golden Retriever*; *Monster Trucks*; and *Rock Climbing* (covers and interior illustrations). Photo "wish lists" for projects are available on request.

Needs: Buys 1,000-2,000 photos annually. "Our subject matter varies (usually 100 or more different subjects/year); no artsy stuff." Model/property release preferred. Captions are preferred; "basic description; if people of color, state ethnic group; if scenic, state location."

Making Contact & Terms: Query with stock photo list. Provide résumé, business card, brochure, flier or tearsheets to be kept on file for possible future assignments. Uses various sizes color prints and b&w prints (if historical); 35mm, 2¼×2¼, 4×5 transparencies; digital format. Keeps samples on file. Reports in 6 months. Pays $50/interior photo; $150/cover photo. **Pays on receipt of invoice.** Credit line given. Buys one-time rights; North American rights negotiable. Simultaneous submissions and previously published work OK.

Tips: "Be flexible. Book publishing usually takes at least six months. Capstone does not pay holding fees. Be prompt. The first photos in are considered for covers first."

CELO VALLEY BOOKS, 346 Seven Mile Ridge Rd., Burnsville NC 28714. Production Manager: D. Donovan. Estab. 1987. Publishes all types of books. Photos used for text illustration, book covers and dust jackets. Examples of published titles: *Foulkeways: A History* (text illustraton and color insert); *Tomorrow's Mission* (historical photos); *River Bends and Meanders* (cover and text photos).

Making Contact & Terms: Provide résumé, business card, brochure, flier or tearsheets to be kept on file for possible future assignments. Keeps samples on file. Uses various sizes b&w prints. Reports only as needed. Payment negotiable. Credit line given. Buys one-time rights and book rights. Simultaneous submissions OK.

Tips: "Send listing of what you have. We will contact you if we have a need."

CENTERSTREAM PUBLICATION, P.O. Box 17878, Anaheim CA 92807. Phone/fax: (714)779-9390. Owner: Ron Middlebrook. Estab. 1982. Publishes music history (guitar—drum), music instruction all instruments, adult trade, juvenile, textbooks. Photos used for text illustration, book covers. Examples of published titles: *Dobro Techniques*, *History of Leedy Drums*, *History of National Guitars*.

Needs: Reviews stock photos of music. Model release preferred. Captions preferred.

Making Contact & Terms: Query with samples. Query with stock photo list. Send unsolicited photos by mail for consideration. Provide résumé, business card, brochure, flier or tearsheets to be kept on file for possible future assignments. Works on assignment only. Uses color b&w prints; 35mm, 2¼×2¼, 4×5 transparencies. Keeps samples on file. Reports in 1 month. Payment negotiable. **Pays on receipt of invoice.** Credit line given. Buys all rights. Simultaneous submissions and/or previously published work OK.

N CHARIOT VICTOR/VICTOR, Cook Communications Ministry, 1040 Lee Vance View, Colorado Springs CO 80918. (719)536-3271. Art Director: Bill Gray. Estab. 1800s. Publishes hardcover originals and reprints; trade paperback originals and reprints; mass market paperback originals. Subjects include fiction (Christian) and adult issues (life, spirituality, Christian living). Photos used for text illustration, promotional materials, book covers, dust jackets. Examples of recently published titles: *Billy Graham, Personal Life of A Public Man*; *The Christian Dads Answer Book*; *Seasons of the Spirit*. Photo guidelines sheet free with SASE.

Needs: Buys 6-10 freelance photos annually. "Looking for miscellaneous photos mostly, such as people, nature and special effects." Interested in reviewing stock photos of people, families, miscellaneous. Model release required.

Marketing Contact & Terms: Send query letter with samples, brochure. Art director will contact photographer for portfolio review if interested. Portfolio should include color slides, transparencies. Works with freelancers on assignment only. Uses color prints; 2¼×2¼, 4×5 transparencies. Accepts images in digital format. "We will work with a previous scanned image, high res only, on Zip/SyQuest." Keeps samples on file. Cannot return material. Reports back only if interested, send non-returnable samples. Pays by the project, $250-800 for color cover. Pays by the project, $50-250 for color inside. **Pays on acceptance.** Credit line given. Buys first North American serial rights and rights to use photos for as long as book is in print. Simultaneous submissions OK.

Tips: "Mostly I will only work with photographers to do photo shoots. All others are used for stock photography. Look at the Christian fiction adult section in Christian bookstores. Look for the Victor imprint to get ideas of our work. When submitting work, send a return envelope at your expense. Do not send anything to me without my approval if you want it back. We do not go for fleshy, romantic animals or just nature shots."

CLEANING CONSULTANT SERVICES, P.O. Box 1273, Seattle WA 98111. (206)682-9748. Fax: (206)622-6876. E-mail: wgriffin@seanet.com. Website: http://www.cleaningconsultants.com. Publisher: William R. Griffin. "We publish books on cleaning, maintenance and self-employment. Examples are related to janitorial, housekeeping, maid services, window washing, carpet cleaning, etc. We also publish a monthly magazine for self-employed cleaners. For a sample issue of *Cleaning Business* send $3 SASE." Photos are used for text illustration, promotional materials, book covers and all uses related to production and marketing of books. Photo guidelines free with SASE.
Needs: Buys 20-50 freelance photos annually; offers 5-15 freelance assignments annually. Photos of people doing cleaning work. "We are always looking for unique cleaning-related photos." Reviews stock photos. Model release preferred. Captions preferred.
Making Contact & Terms: Query with résumé of credits, samples, list of stock photo subjects or send unsolicited photos by mail for consideration. Provide résumé, business card, brochure, flier or tearsheets to be kept on file for possible future assignments. Uses 5×7 and 8×10 glossy b&w and color prints. SASE. Reports in 3 weeks. Pays $5-50/b&w photo; $5/color photo; $10-30/hour; $40-250/job; negotiable depending on specific project. Credit lines generally given. Buys all rights; depends on need and project; rights negotiable. Simultaneous submissions and previously published work OK.
Tips: "We are especially interested in color photos of people doing cleaning work in other countries, for use on the covers of our monthly magazine, *Cleaning Business*. Be willing to work at reasonable rates. Selling two or three photos does not qualify you to earn top-of-the-line rates. We expect to use more photos, but they must be specific to our market, which is quite select. Don't send stock sample sheets. Send photos that fit our specific needs. Call if you need more information or would like specific guidance."

CLEIS PRESS, Box 14684, San Francisco CA 94114. (415)575-4700. Fax: (415)575-4705. E-mail: sfcleis @aol.com. Art Director: Frédérique Delacoste. Estab. 1979. Publishes fiction, nonfiction, trade and lesbian/gay erotica. Photos used for book covers. Examples of recently published titles: *Best Lesbian Erotica 1997*, *Best Gay Erotica 1997*, *Food For Life* and *Dark Angels* (all fiction collections).
Needs: Buys 20 photos annually. Reviews stock photos.
Making Contact & Terms: Provide résumé, business card, brochure, flier or tearsheets to be kept on file for possible future assignments. Works with local freelancers on assignment only. Uses color and b&w prints; 35mm transparencies. Keeps samples on file. SASE. Reports in 3 weeks. Pays $150/photo for all uses in conjunction with book. **Pays on acceptance**. Credit line given. Buys book rights; negotiable.

N COFFEE HOUSE PRESS, 27 N. Fourth St., Suite 400, Minneapolis MN 55401. (612)338-0125. Fax: (612)338-4004. Art Director: Kelly Kofron. Publishes hardcover originals, trade paperback reprints and originals, letterpress. Subjects include literary fiction and poetry. Photos used for text illustration, book covers, dust jackets. *Our Sometime Sister* (cover art); *Glass Houses* (cover art); *Paul Metcalf, Collected Works, Vol. 2* (text illustration). Photo guidelines sheet free with SASE.
Needs: Buys 5-15 freelance photos annually. Interested in reviewing stock photos, unique, artistic and historical images. Model release preferred; property release preferred for copyright use, author photo. Photo captions required; include name and date (optional title).
Making Contact & Terms: Provide business card, self-promotion piece or tearsheets to be kept on file for possible future assignment. Art director will contact photographer for portfolio review if interested. Portfolio should include b&w and color prints. Uses matte, color and b&w prints; 35mm, 4×5, 8×10 transparencies. Accepts images in digital format Mac platform on CD-ROM. Keeps samples on file. SASE. Reports back only if interested, send non-returnable samples. Pays $400 maximum for b&w cover or inside; $400 maximum for color cover or inside. Pays on publication. Credit line given. Buys one-time rights. Simultaneous submissions and previously published work OK.
Tips: "We are nonprofit and can't afford to pay much, but we have great national exposure and offer a lot of creativity. Personally we prefer postcards with artist information on back because it's easy to file for reference."

COMMUTERS LIBRARY, P.O. Box 3168, Falls Church VA 22043. (703)847-6355. Fax: (703)827-8937. E-mail: commlib@aol.com. Editor: Joseph Langenfeld. Estab. 1992. Publishes audiobooks (literature). Photos used for promotional materials, book covers and dust jackets. Examples of recently published titles: *Classic Poe* (cover) and *The Eyes* (cover).
Needs: Buys 5 photos annually; offers 2 freelance assignments annually. Reviews stock photos of authors' portraits and book-related scenes. Model/property release preferred.
Making Contact & Terms: Query with stock photo list. Uses 8×10 prints. SASE. Reports in 3 weeks. Payment negotiable. Pays on publication. Credit line given. Buys book rights. Previously published work OK.

© Jonathan Williams

Writer Jonathan Williams has been photographing poet Paul Metcalf for 45 years. He has also published six books by Metcalf through his small press, The Jargon Society. When Coffee House Press published Metcalf's collected works, the poet offered a portrait of himself by Williams for the cover. Williams says the image conveys "a country writer getting away from his non-electric typewriter for a few minutes to smoke his pipe." Although Williams is primarily a writer and publisher he is no stranger to the world of photography. "I studied with photographer Aaron Siskind at Black Mountain College in 1951 and I have written many essays over the years on contemporary photographers as a contributing editor of *Aperture* magazine."

COMPASS AMERICAN GUIDES, 5332 College Ave., Suite 201, Oakland CA 94618. (510)547-7233. Fax: (510)547-2145. Creative Director: Christopher C. Burt. Estab. 1990. Publishes travel guide series for every state in the U.S. and 15 major cities, also Canadian provinces and cities. Photos used for text illustration and book covers. Examples of recently published titles: *Compass American Guide to Coastal California*, *Compass American Guide to North Carolina*, and *Compass American Guide to Underwater Wonders of the National Parks*.
Needs: Buys 1,000-1,500 photos annually; offers 8-10 freelance assignments annually. Reviews stock photos (depends on project). Model release required, especially with prominent people. Property release preferred. Captions required.
Making Contact & Terms: Interested in receiving work from newer, lesser-known photographers as well as seasoned professionals. Provide résumé, business card, brochure, flier or tearsheets to be kept on file for possible future assignments. "Do not phone; fax OK." Works on assignment only. Uses 35mm, 2¼×2¼, 4×5, 8×10 transparencies. Keeps samples on file. Cannot return unsolicited material. Reports in "one week to five years." Pays $5,000/job. **Pays ⅓ advance, ⅓ acceptance, ⅓ publication.** Buys one-time and book rights. Photographer owns copyright to images. Simultaneous submissions and previously published work OK.
Tips: "Our company works only with photographers native to, or currently residing in, the state or city in which we are publishing the guide. We like creative approaches that capture the spirit of the place being covered. We need a mix of landscapes, portraits, things and places."

N CONARI PRESS, 2550 Ninth St., Suite 101, Berkeley CA 94710. (510)649-7185 or (510)461-0538. Fax: (510)649-7190. Art Director: Ame Beanland. Estab. 1987. Publishes hardcover originals and reprints; trade paperback originals and reprints. Subjects include women's studies, psychology, parenting, inspiration, home and relationships (all nonfiction titles). Photos used for text illustrations, book covers, dust jackets. Examples of recently published titles *Feeding the Body, Nourishing the Soul* (cover image for trade paper); *The Pleasure Zone* (book jacket); *Women of the Beat Generation* (book jacket).
Needs: Buys 5-10 freelance photos annually. Looking for artful photos, subject matter varies. Interested in reviewing stock photos of most anything except high tech, corporate, or industrial images. Model release required. Photo caption preferred; include photography copyright.
Marketing Contact & Terms: Provide résumé, business card, self-promotion piece or tearsheets to be kept on file for possible future assignments. Art director will contact photographer for portfolio review if interested. Portfolio should include b&w or color, prints, tearsheets, slides, transparencies or thumbnails. Uses color, b&w prints; 4×5, 8×10 transparencies. Keeps samples on file; include SASE for return of material. Pays by the project, $400-1,000 for color cover. Payment varies for color inside. Pays on publication. Credit line given on copyright page. Simultaneous submissions and previously published work OK.
Tips: "Review our book list to make sure the work is appropriate."

CONSERVATORY OF AMERICAN LETTERS, P.O. Box 298, Thomaston ME 04861. (207)354-0998. Fax: (207)354-8953. E-mail: cal@ime.net. President: Robert Olmsted. Estab. 1986. Publishes "all types of books except porn and evangelical." Photos used for promotional materials, book covers and dust jackets. Examples of recently published titles: *Dan River Stories* and *Dan River Anthology* (cover); *After the Light* (covers).
Needs: Buys 2-3 photos annually. Model release required if people are identifiable. Photo captions preferred.
Making Contact & Terms: Uses 3×5 to 8×10 b&w glossy prints, also 5×7 or 6×9 color prints, vertical format. SASE. Reports in 1 week. Pays $5-50/b&w photo; $20-200/color photo; per job payment negotiable. Credit line given. Buys one-time and all rights; negotiable.
Tips: "We are a small market. We need *few* photos, but can never find them when we do need them."

THE CONSULTANT PRESS LTD., 163 Amsterdam Ave., #201, New York NY 10023. (212)838-8640. Fax: (212)873-7065. Estab. 1980. Publishes how-to, art and photography business. Photos used for book covers. Examples of recently published titles: *Art of Displaying Art* (cover); *Publishing Your Art as Cards, Posters and Calendars* (cover/art); and *Art of Creating Collectors* (text).
Needs: Buys 20 photos annually (usually from author of text). Model release required.
Making Contact & Terms: Query with samples. Provide résumé, business card, brochure, flier or tear-

CONTACT THE EDITOR, of *Photographer's Market* by e-mail at photomarket@fwpubs.com with your questions and comments.

sheets to be kept on file for possible future assignments. Uses 35mm, 2¼×2¼ transparencies; digital format. Does not keep samples on file. SASE. Reports in 1-2 weeks. Payment factored into royalty payment for book. Pays on publication. Credit line given. Buys book rights.

CORNERSTONE PRODUCTIONS INC., 1754 Austin Dr., Decatur GA 30032. (770)621-2514. President/CEO: Ricardo A. Scott J.D. Estab. 1985. Publishes adult trade, juvenile and textbooks. Photos used for text illustration, promotional materials and book covers. Examples of published titles: *A Reggae Education* (illustrative); and *Allied Health Risk-Management* (illustrative).
Needs: Buys 10-20 photos annually; offers 50% freelance assignments annually. Photos should show life in all its human and varied forms—reality! Reviews stock photos of life, nature, medicine, science, the arts. Model/property release required. Captions required.
Making Contact & Terms: Submit portfolio for review. Send unsolicited photos by mail for consideration. Uses 5×7, 10×12 glossy color and b&w prints; 4×5, 8×10 transparencies; VHS videotape. Keeps samples on file. SASE. Reports in 1 month. Payment negotiable. Pays on publication. Credit line sometimes given depending upon the particular projects and arrangements, done on an individual basis. Buys all rights; negotiable. Simultaneous submissions and previously published work OK.
Tips: "The human aspect and utility value is of prime importance. Ask 'How can this benefit the lives of others?' Let your work be a reflection of yourself. Let it be of some positive value and purpose towards making this world a better place."

CRABTREE PUBLISHING COMPANY, 350 Fifth Ave., Suite 3308, New York NY 10118. (905)262-5814. Fax: (905)262-5890. Photo Researcher: Hammelore Sotzek. Estab. 1978. Publishes juvenile nonfiction, library and trade—natural science, history, geography (including cultural geography), 18th and 19th-century America. Photos used for text illustration, book covers. Examples of recently published titles: *Vietnam: the Land* (text illustration, cover); *Spanish Missions* (text illustration); and *How a Plant Grows* (text illustration, cover).
• When reviewing a portfolio, this publisher looks for bright, intense color and clarity.
Needs: Buys 400-600 photos annually. Wants photos of children, cultural events around the world, animals (exotic and domestic). Model/property release required for children, photos of artwork, etc. Captions preferred; include place, name of subject, date photographed, animal behavior.
Making Contact & Terms: Unsolicited photos will be considered but not returned without SASE. Provide résumé, business card, brochure, flier or tearsheets to be kept on file for possible future assignments. Uses color prints; 35mm, 2¼×2¼, 4×5, 8×10 transparencies. Keeps samples on file. SASE. Reports in 1-2 weeks. Pays $40-75/color photo. Pays on publication. Credit line given. Buys non-exclusive rights. Simultaneous submissions and/or previously published works OK.
Tips: "Since books are for younger readers, lively photos of children and animals are always excellent." Portfolio should be "diverse and encompass several subjects, rather than just one or two; depth of coverage of subject should be intense, so that any publishing company could, conceivably, use all or many of a photographer's photos in a book on a particular subject."

CREATIVE WITH WORDS PUBLICATIONS, P.O. Box 223226, Carmel CA 93922. (408)655-8627. Editor: Brigitta Geltrich. Estab. 1975. Publishes poetry and prose anthologies according to set themes. Uses b&w photos for text illustration and book covers. Examples of recently published titles: humor; sports and hobbies; and sky, space, heaven. Ask for photo guidelines with SASE.
Needs: Looking for theme-related b&w photos. Model/property release preferred.
Making Contact & Terms: Query with samples. Request theme list, then query with photos. Uses any size b&w photos. "We will reduce to fit the page." Does not keep samples on file. SASE. Reports in 2-3 weeks after deadline if submitted for a specific theme. Payment negotiable. Pays on publication. Credit line given. Buys one-time rights.

CROSS CULTURAL PUBLICATIONS, INC., P.O. Box 506, Notre Dame IN 46556. (219)272-0889. Fax: (219)273-5973. E-mail: crosscult@aol.com. General Editor: Cy Pullapilly. Estab. 1980. Publishes nonfiction, multicultural books. Photos used for book covers and dust jackets. Examples of recently published titles: *Paper Airplanes in the Himalayas*, *An Agenda for Sustainability*, and *The Cloud and the Lights* (all covers).
Needs: Buys very few photos annually; offers very few freelance assignments annually. Model release preferred. Captions preferred.
Making Contact & Terms: Provide résumé, business card, brochure, flier or tearsheets to be kept on file for possible future assignments. Works on assignment only. Does not keep samples on file. Cannot return material. Reports in 3 weeks. Payment negotiable; varies depending on individual agreements. **Pays on acceptance.** Credit line given. Simultaneous submissions and previously published work OK.

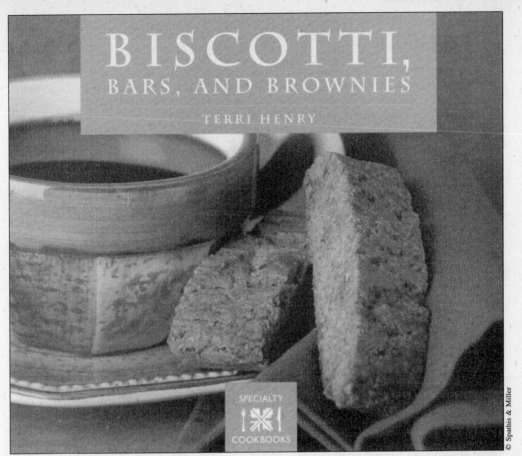

© Spathis & Miller

Dimitri Spathis and Michele Miller call their successful relationship "a photographic collaboration." It is clear from their work that the two are meant to be together. This biscotti shot, published by The Crossing Press as the cover image for a book dedicated to the Italian dessert, was also used in an Italian cookbook by the same publishing house. "This image is 'worth its weight in gold,' " say Spathis and Miller. The shot won the pair a Gold Award in the stock category in the Photo District News 12th Annual Awards for Photo Design. The photographers won the attention of The Crossing Press by sending a direct mail card of their work.

CROSSING PRESS, P.O. Box 1048, Freedom CA 95019. (408)722-0711. Fax: (408)722-2749. E-mail: crossing@aol.com. Website: http://www.crossingpress.com. Publisher: Elaine Gill. Art Director: Karen Narita. Estab. 1971. Publishes adult trade, cooking, health, and New Age books. Photos used for text illustration, book covers. Examples of recently published titles: *Recurring Dreams*, *Quick Breads*, and *Wholesome Cookies* (all covers).

Needs: Buys 70-100 photos annually; offers 3-6 freelance assignments annually. Looking for photos of nature images, dream images, food, people, how-to steps for health books. Reviews stock photos of food, people, avant-garde material (potential book covers). Model/property release required.

Making Contact & Terms: Query with samples. Provide brochure, flier or tearsheets to be kept on file for possible future assignments. Uses color and b&w. Accepts images in digital format for Mac. Send via CD, SyQuest, Zip disk or floppy disk. SASE. Payment negotiable. Pays on publication. Credit line given. Buys one-time and book rights; negotiable. Simultaneous submissions and previously published works OK.

Tips: Looking for "photos of evocative images, prepared food, nature shots, conceptual/imaginary images."

DIAL BOOKS FOR YOUNG READERS, 375 Hudson St., New York NY 10014. (212)366-2803. Fax: (212)366-2020. Senior Editor: Toby Sherry. Publishes children's trade books. Photos used for text illustra-

tion, book covers. Examples of published titles: *How Many* (photos used to teach children how to count); and *Jack Creek Cowboy.*

Making Contact & Terms: Photos are only purchased with accompanying book ideas. Works on assignment only. Does not keep samples on file. Payment negotiable. Credit line given.

DOCKERY HOUSE PUBLISHING INC., 1720 Regal Row, Suite 228, Dallas TX 75235. (214)630-4300. Fax: (214)638-4049. Art Director: Janet Todd. Photos used for text illustration, promotional material, book covers, magazines. Example of recently published title: *Celebration of America* (scenery of travel spots).

Needs: Looking for food, scenery, people. Needs vary. Reviews stock photos. Model release preferred.

Making Contact & Terms: Query with samples. Provide résumé, business card, brochure, flier or tearsheets to be kept on file for possible future assignments. Works on assignment only. Uses all sizes and finishes of color, b&w prints; 35mm, 2¼×2¼, 4×5 transparencies. Keeps samples on file. Cannot return material. Payment negotiable. Payment varies. Pays net 30 days. Credit line sometimes given depending upon type of book. Buys all rights; negotiable.

DOWN THE SHORE PUBLISHING CORP., P.O. Box 3100, Harvey Cedars NJ 08008. (609)978-1233. Fax: (609)597-0422. Publisher: Raymond G. Fisk. Estab. 1984. Publishes regional calendars; regional books (specific to the mid-Atlantic shore and New Jersey). Photos used for text illustration, scenic calendars (New Jersey and mid-Atlantic only). Example of recently published titles: *Great Storms of the Jersey Shore* (text illustration). Photo guidelines free with SASE.

Needs: Buys 30-50 photos annually. Scenic coastal shots, photos of beaches and New Jersey lighthouses (New Jersey and mid-Atlantic region). Reviews stock photos. Model release required. Property release preferred. Captions preferred; *specific location* identification essential.

Making Contact & Terms: Query with stock photo list. Provide résumé, business card, brochure, flier or tearsheets to be kept on file for possible future requests. "We have a very limited use of prints." 35mm, 2¼×2¼, 4×5 transparencies, preferred. Does not keep samples on file. SASE. Reports in 4-6 weeks. Pays $10-150/b&w photo; $20-200/color photo. Pays 90 days from publication. Credit line given. Buys one-time or book rights; negotiable. Previously published work OK.

Tips: "We are looking for an honest depiction of familiar scenes from an unfamiliar and imaginative perspective. Images must be specific to our very regional needs. Limit your submissions to your best work. Edit your work very carefully."

N DUMMIES TRADE PRESS/IDG BOOKS, 645 N. Michigan Ave., Suite 800, Chicago IL 60611. (312)482-8937. Fax: (312)482-8975. E-mail: mfkelly@idgbooks.com. Website: http://www.idgbooks.com. Editorial Coordinator: Maureen Kelly. Estab. 1992. Publishes trade paperback originals. Subjects include: gardening, home decorating and remodeling, sports and fitness, health and medical, travel. Photos used for text illustration, promotional materials, book covers. Examples of recently published titles: *Annuals for Dummies, Grilling for Dummies, Decks & Patios for Dummies.* Photo guidelines sheet available.

Needs: Buys 700 freelance photos/year. Looking for action sports photos, sports star portraits, travel photos. Interested in reviewing stock photos of gardening, sports, home decorating. Model release required; property release preferred.

Making Contact & Terms: Provide resume, business card, self-promotion piece or tearsheets to be kept on file for possible future assignments. Works with freelancers on assignment only. Keeps samples on file. Reports back only if interested, send non-returnable samples. Pays by the project, $70-125 for color inside. Pays on publication. Credit line given on copyright page. Buys one-time world rights. Simultaneous submissions OK.

Tips: "Please query by mail, not by phone."

EASTERN PRESS, INC., P.O. Box 881, Bloomington IN 47402. Publisher: Don Lee. Estab. 1981. Publishes university-related Asian subjects: language, linguistics, literature, history, archaeology. Teaching English as Second Language (TESL); Teaching Korean as Second Language (TKSL); Teaching Japanese as Second Language (TJSL); Chinese, Arabic. Photos used for text illustration. Examples of recently published titles: *An Annotated Bibliography on South Asia* and *An Annotated Prehistoric Bibliography on South Asia.*

Needs: Depends upon situation. Looking for higher academic. Captions for photos related to East Asia/Asian higher academic.

Making Contact & Terms: Provide résumé, business card, brochure, flier or tearsheets to be kept on file for possible future assignments. Uses 6×9 book b&w prints. Keeps samples on file. Reports in 1 month (sometimes 1-2 weeks). Payment negotiable. **Pays on acceptance.** Credit line sometimes given. Rights negotiable.

Tips: Looking for "East Asian/Arabic textbook-related photos. However, it depends on type of book to be published. Send us résumé and about two samples. We keep them on file. Photos on, for example, drama, literature or archaeology (Asian) will be good, also TESL."

N ⬛ ECW PRESS, 2120 Queen St. E., Toronto, Ontario M4E 1E2 Canada. (416)694-3348. Fax: (416)698-9906. E-mail: ecw@sympatico.ca. Website: http://www.ecw.ca/press. Publisher: Jack David. Estab. 1974. Publishes hardcover original, trade paperback original. Subjects include biography, sports, travel, fiction, poetry. Photos used for text illustrations, book covers, dust jackets. Examples of recently published titles: *Melissa Etheridge* (text illustration); *Gillian Anderson* (text illustration); *Godzilla* (text illustration).
Needs: Buys hundreds of freelance photos annually. Looking for color, b&w, fan/backstage, paparazzi, action, original, rarely used. Interested in reviewing stock photos. Property release required for entertainment or star shots. Photo captions required; include identification of all people.
Making Contact & Terms: Send query letter. Provide e-mail. To show portfolio, photographer should follow-up with letter after initial query. Does not keep samples on file; include SASE for return of material. Reports in 3 weeks. Pays by the project, $250-600/color cover; $50-125/color inside. Pays on publication. Credit line given. Buys one-time book rights (all markets).
Tips: "We have many projects on the go. Query for projects needing illustrations."

EMC/PARADIGM PUBLISHING, 375 Montreal Way, St. Paul MN 55102. (612)215-7681. Fax: (612)290-2828. E-mail: jsilver@emcp.com. Art Director: Joan Silver. Estab. 1989. Publishes textbooks on business, office and computer information systems. Photos used for text illustration, promotional materials and book covers. Examples of recently published titles: *Psychology: Realizing Human Potential* (250 photos); *Business Communication* (120 photos); and *Business Math* (70 photos).
Needs: Buys 500 photos annually; offers 10 freelance assignments annually. Needs photos of people in high-tech business settings. Model/property release preferred. Captions preferred; technical equipment may need to be tagged.
Making Contact & Terms: Provide résumé, business card, brochure, flier or tearsheets to be kept on file for possible future assignments. Uses 35mm transparencies. Keeps samples on file. SASE. Reports in 1 month. Pays $25-300/color photo; $25-300/b&w photo. **Pays on receipt of invoice.** Credit line given. Buys one-time, book and all rights; negotiable. Simultaneous submissions and previously published work OK. Offers internships for photographers during August. Contact Art Director: Joan Silver.

ENTRY PUBLISHING, INC., 27 W. 96th St., New York NY 10025. (212)662-9703. Fax: (212)622-0549. President: Lynne Glasner. Estab. 1981. Publishes education/textbooks, secondary market. Photos used for text illustrations.
Needs: Number of freelance photos bought and freelance assignments given vary. Often looks for shots of young teens in school settings. Reviews stock photos. Model release required. Captions preferred.
Making Contact & Terms: Query with list of stock photo subjects. Provide résumé, business card, brochure, flier or tearsheets to be kept on file for possible future assignments. Uses b&w prints. Accepts images in digital format for Windows. SASE. Reports in 3 weeks. Payment depends on job requirements. Credit line given if requested. Buys one-time rights; negotiable. Simultaneous submissions and previously published work OK.
Tips: "Have wide range of subject areas for review and use. Stock photos are most accessible and can be available quickly during the production of a book."

FERGUSON PUBLISHING COMPANY, 200 W. Madison, Suite 300, Chicago IL 60606. (312)346-7440. Fax: (312)346-5081. Picture Editor: Irene L. Ferguson. Publishes the New Standard Encyclopedia and other reference books. Photos used for text illustration. To see style/themes used, look at encyclopedias in library, especially New Standard Encyclopedia.
Needs: Buys 50 photos annually (stock photos only). Major cities and countries, points of interest, agricultural and industrial scenes, plants and animals. Model release preferred. Captions required.
Making Contact & Terms: Query with stock photo list. Do not send unsolicited photos. Uses 8×10 glossy b&w prints; contact sheet OK; uses transparencies. SASE. Reports in 1 month. Pays $75-125/b&w photo; $135-300/color photo. Credit line given. Buys one-time rights. Simultaneous submissions and previously published work OK.

⬛ FIFTH HOUSE PUBLISHERS, #9, 6125-11th St. SE, Calgary, Alberta T2H 2L6 Canada. (403)571-5230. Fax: (403)571-5235. E-mail: 5thhouse@cadvision.com. Managing Editor: Charlene Dobmeier. Estab. 1982. Publishes calendars, history, biography, Western Canadiana. Photos used for text illustration, book covers, dust jackets and calendars. Examples of recently published titles: *The Canadian Weather Trivia*

Calendar, The Canadian Skywatchers Calendar and *Once Upon a Tomb: Stories from Canadian Grave-yards.*
Needs: Buys 15-20 photos annually. Looking for photos of Canadian weather and astronomy. Model/property release preferred. Captions required; include location and identification.
Making Contact & Terms: Query with samples. Query with stock photo list. Keeps samples on file. SASE. Reports in 3 weeks. Pays $300 (Canadian)/calendar image. Pays on publication. Credit line given. Buys one-time rights.

FINE EDGE PRODUCTIONS, Box 303, Route 2, Bishop CA 93514. (760)387-2412. Fax: (760)387-2286. E-mail: fineedgepr@aol.com. Website: http://www.fineedge.com. Contact: Don Douglass. Estab. 1986. Publishes outdoor guide and how-to books; custom topographic maps—mostly mountain biking and sailing. Publishes 6 new titles/year. Photos used for text illustration, promotional materials, book covers. Examples of recently published titles: *Mountain Biking the Eastern Sierra's Best 100 Trails*; *Exploring the North Coast of British Columbia*; *Exploring the San Juan & Gulf Islands*. "Call to discuss" photo guidelines.
Needs: Buys 200 photos annually; offers 1-2 freelance assignments annually. Looking for area-specific mountain biking (trail usage), northwest cruising photos. Model release required. Captions preferred with place and activity.
Making Contact & Terms: Query with samples. Uses 3×5, 4×6 glossy b&w prints; color for covers. SASE. Reports in 1-2 months. Pays $150-500/color photo; $10-50/b&w photo. Pays on publication. Credit line given. Rights purchased vary. Simultaneous submissions and/or previously published works OK.
Tips: Looking for "photos which show activity in realistic (not artsy) fashion—want to show sizzle in sport. Increasing—now going from disc directly to film at printer."

FIVE CORNERS PUBLICATIONS, P.O. Box 66, Bridgewater VT 05034. (802)672-3868. Fax: (802)672-3296. E-mail: editor@fivecorners.com. Website: http://www.fivecorners.com. Editor: Donald Kroitzsh. Estab. 1990. Publishes adult trade (such as coffee table photo books), a travel newsletter and how-to books about travel. Photos used for text illustration. Examples of published titles: *American Photographers at the Turn of the Century: People & Our World*; *American Photographers at the Turn of the Century: Nature & Landscape; and The Curiosity Book* (text illustration using 35mm b&w prints).
Needs: Buys 20 photos annually. Interested in complementary photos to articles, showing technical matter and travel scenes. Model release preferred. Captions required.
Making Contact & Terms: Query with résumé of credits. Works with freelancers only. Uses color and b&w prints; 35mm, $2\frac{1}{4} \times 2\frac{1}{4}$, 4×5, 8×10 transparencies. Accepts images in digital format for Windows (TIFF, GIF, JPG). Send via compact disc, Online, floppy disk, SyQuest or Zip disk. SASE. Reports in 1-2 weeks. Pays $25/color photo; $25/b&w photo. Pays on publication. Credit line given. Buys one-time rights. Simultaneous submissions and/or previously published work OK.

N. MICHAEL FRIEDMAN PUBLISHING GROUP, INC., 15 W. 26th St., New York NY 10010. (212)685-6610. Fax: (212)685-0102. E-mail: photo@metrobooks.com. Website: http://www.metrobooks.com. Photography Director: Christopher Bain. Estab. 1977. Publishes adult trade: interior design; travel; gardening; transportation; sports; food and entertaining; stage and screen; history; and culture. Photos used for text illustration, promotional materials, book covers and dust jackets.
Needs: Buys 12,000 freelance photos annually; offers 10-15 freelance assignments annually. Reviews stock photos. Captions preferred.
Making Contact & Terms: Query with specific list of stock photo subjects. Uses 35mm, 120 and 4×5 transparencies. Accepts images in digital format for Mac and Windows. Send via CD or Zip disk. Pays $75-100/color stock photo; $350-600/day. Payment upon publication of book for stock photos; within 30-45 days for assignment. Credit line always given. Buys rights for all editions. Simultaneous submissions and previously published work OK. For terms, see website: http://www.metrobooks.com/terms.html.

GLENCOE PUBLISHING/MCGRAW HILL, 21600 Oxnard St., Suite 500, Woodland Hills CA 91367. Attention: Photo Editor. Publishes elementary and high school textbooks, religion, careers, business, office automation, social studies and fine arts. Photos used for text illustration and book covers. Examples of published titles: *Art Talk*, *Career Skills* and *Marketing Essentials*.

THE INTERNATIONAL MARKETS INDEX, located in the back of this book, lists markets located outside the U.S. by country.

Needs: Buys 500 photos annually. Occasionally offers assignments. Children and teens at leisure, in school, in Catholic church; interacting with others: parents, siblings, friends, teachers; Catholic church rituals; young people (teens, early 20s) working, especially in jobs that go against sex-role stereotypes. Model release preferred.

Making Contact & Terms: Send stock photo list. List kept on file for future assignments. Uses 8×10 glossy b&w prints and 35mm slides. Pays $50/b&w photo, $100/color photo (¼ page). Buys one-time rights, but prefers to buy all rights on assignment photography with some out takes available to photographer. Simultaneous submissions and previously published work OK.

Tips: "A good ethnic mix of models is important. We look for a contemporary, unposed look."

GOLDEN WEST PUBLISHERS, 4113 N. Longview, Phoenix AZ 85014. (602)265-4392. Fax: (602)279-6901. Contact: Hal Mitchell. Estab. 1972. Publishes trade paperback originals. Subjects primarily include regional cookbooks and general interest. Photos used for book covers. Examples of recently published titles: *Low Fat Mexican Recipes (cover); Vegi-Mex Mexican Recipes* (cover); *Winning Recipes* (cover).

Needs: Buys 10-20 freelance photos annually. Looking for photos of food and geographic interest. Interested in reviewing stock photos of fresh and prepared foods. Photo caption preferred.

Marketing Contact & Terms: Send query letter with samples, brochure, stock photo list. Art director will contact photographer for portfolio review if interested. Portfolio should include color, prints, tearsheets, slides, transparencies. Uses color prints; 35mm, $2\frac{1}{4} \times 2\frac{1}{4}$, 4×5, 8×10 transparencies. Keeps samples on file; include SASE for return of material. Reports back only if interested, send non-returnable samples. Pays by the project, $200-375 for color cover. **Pays on acceptance**. Credit line given. Buys one-time rights, all rights; negotiable. Simultaneous submissions and/or previously published work OK.

Tips: "We produce affordable cookbooks and we need to purchase affordable photos. Send samples that pertain to our needs."

GRAPHIC ARTS CENTER PUBLISHING COMPANY, P.O. Box 10306, Portland OR 97296-0306. (503)226-2402. Fax: (503)223-1410. Photo Editor: Diana Eilers. Publishes adult trade photo essay books and state, regional recreational calendars. Examples of published titles: *Oklahoma Crossroads*; *Oregon Wine Country*; and *Bison: Monarch of the Plains*.

Needs: Offers 5-10 freelance assignments annually. Needs photos of landscape, nature, people, historic architecture and destiny attractions.

Making Contact & Terms: Uses 35mm, $2\frac{1}{4} \times 2\frac{1}{4}$ and 4×5 transparencies (35mm as Kodachrome 25 or 64). Accepts images in digital format for Mac. Send via compact disc, JAZZ, SyQuest or Zip disk. Pays by royalty—amount varies based on project; advances against royalty are given. Pays $2,200-4,000/calendar fees. Credit line given. Buys book rights.

Tips: "Photographers must be previously published and have a minimum of five years fulltime professional experience to be considered. Call first to present your book or calendar proposal before you send in a submission. Topics proposed must have strong market potential."

GRAPHIC ARTS PUB INC., 3100 Bronson Hill Rd., Livonia NY 14487. Phone/fax: (716)346-2276. Estab. 1979. Publishes textbooks, adult trade—how-to quality and reproduction of color for printers and publishers. Photos used for text illustration, promotional materials, book covers. Examples of published titles: *Color Separation on the Desktop* (cover and illustrations); *Quality & Productivity in the Graphic Arts*.

Needs: Varies; offers 1-2 freelance assignments annually. Looking for technical photos. Model release preferred.

Making Contact & Terms: Works on assignment only. Uses color prints; 35mm transparencies.

GREAT QUOTATIONS PUBLISHING CO., 1967 Quincy Court, Glendale Heights IL 60139. (630)582-2800. Fax: (630)582-2813. Senior Marketing Manager: Patrick Caton. Estab. 1985. Publishes gift books.

Needs: Buys 10-20 photos annually; offers 10 freelance assignments annually. Looking for inspirational or humorous. Reviews stock photos of inspirational, humor, family. Model/property release preferred.

Making Contact & Terms: Provide résumé, business card, brochure, flier or tearsheets to be kept on file for possible future assignments. Works on assignment only. Uses color and b&w prints; 35mm, $2\frac{1}{4} \times 2\frac{1}{4}$, 4×5 transparencies. Keeps samples on file. SASE. "We prefer to maintain a file of photographers and contact them when appropriate assignments are available." Payment negotiable. Pays on publication. "We will work with artist on rights to reach terms all agree on." Simultaneous submissions and previously published work OK.

Tips: "We intend to introduce 30 new books per year. Depending on the subject and book format, we may

use photographers or incorporate a photo image in a book cover design. Unfortunately, we decide on new product quickly and need to go to our artist files to coordinate artwork with subject matter. Therefore, more material and variety of subjects on hand is most helpful to us."

GROLIER, INC., 6 Park Lawn Dr., Bethel CT 06801. (203)797-3500. Fax: (203)797-3344. Director of Photo Research: Lisa Grize. Estab. 1829. Publishes encyclopedias and yearbooks. Examples of published titles: *The New Book of Knowledge*; *Academic American Encyclopedia*; and *Encyclopedia Americana*, and corresponding annuals. All photo use is text illustration unless otherwise negotiated.
Needs: Buys 3,000 stock photos/year. Interested in unposed photos of the subject in its natural habitat that are current and clear. Model/property release preferred for any photos used in medical articles, education articles, etc. Captions mandatory; include dates, specific locations and natural history subjects should carry Latin identifications.
Making Contact & Terms: Query with list of stock photo subjects. Uses 8×10 glossy b&w/color prints; 35mm, 4×5, 8×10 (reproduction quality dupes preferred) transparencies. Cannot return unsolicited material. Pays $65-100/b&w photo; $150-200/color photo. Very infrequent freelance photography is negotiated by the job. Credit line given "either under photo or on illustration credit page." Buys one-time and foreign language rights; negotiable.
Tips: "Send subject lists and small selection of samples. Printed samples *only* please. In reviewing samples we consider the quality of the photographs, range of subjects and editorial approach. Keep in touch but don't overdo it."

GRYPHON HOUSE, P.O. Box 207, Beltsville MD 20704. (301)595-9500. Fax: (301)595-0051. E-mail: rosanna@ghbooks.com. Editor-in-Chief: Kathy Charner. Estab. 1970. Publishes educational resource materials for teachers and parents of young children. Examples of recently published titles: *Crisis Manual for Teachers* (text illustration); and *Toddlers Together* (book cover).
Needs: Looking for b&w and color photos of young children, (birth-6 years.) Reviews stock photos. Model release required.
Making Contact & Terms: Query with samples. Query with stock photo list. Uses 5×7 glossy color (cover only) and b&w prints. Accepts photographs in digital format for Mac. Send via compact discs, SyQuest or Zip disk. Keeps samples on file. Reports in 1 month. Payment negotiable. **Pays on receipt of invoice.** Credit line given. Buys book rights. Simultaneous submissions OK.

■■ **GUERNICA EDITIONS, INC.**, P.O. Box 117, Station P, Toronto, Ontario M5S 2S6 Canada. (416)657-8885. Editor: Antonio D'Alfonso. Estab. 1978. Publishes adult trade (literary). Photos used for book covers. Examples of recently published titles: *How to Sing to a Dago* (cover); *My Father, Marconi* (cover).
Needs: Buys various number of photos annually; "often" assigns work. Needs life events, including characters; houses. Photo captions required. "We use authors' photo everywhere."
Making Contact & Terms: Query with samples. Uses color and/or b&w prints. Sometimes keeps samples on file. Cannot return material. Reports in 1-2 weeks. Pays $100-150 for cover. Pays on publication. Credit line given. Buys book rights. "Photo rights go to photographers. All we need is the right to reproduce the work."

HANCOCK HOUSE PUBLISHERS, 1431 Harrison Ave., Blaine WA 98231-0959. (800)938-1114. Fax: (800)983-2262. President: David Hancock. Estab. 1968. Publishes trade books. Photos used for text illustration, promotions, book covers. Examples of recently published titles: *Antarctic Splendor*, by Frank S. Todd, (over 250 color images); *Pheasants of the World* (350 color photos). Photos used for text illustration.
Needs: Birds/nature. Model release and photo captions preferred. Reviews stock photos.
Making Contact & Terms: SASE. Reports in 1 month. Payment negotiable. Credit line given. Buys non-exclusive rights. Simultaneous submissions and previously published work OK.

HARMONY HOUSE PUBLISHERS, P.O. Box 90, Prospect KY 40059 or 1008 Kent Rd., Goshen KY 40026. (502)228-4446. Fax: (502)228-2010. Owner: William Strode. Estab. 1984. Publishes photographic books on specific subjects. Photos used for text illustration, promotion materials, book covers and dust jackets. Examples of published titles: *Christmas Collections* (35mm/4×5 photos); *Appalachian Trail* (35mm); *The Saddlebred-American Horse of Distinction* (35mm).
Needs: Number of freelance photos purchased varies. Assigns 30 shoots each year. Captions required.
Making Contact & Terms: Query with résumé of credits along with business card, brochure, flier or tearsheets to be kept on file for possible future assignments. Query with samples or stock photo list. Submit portfolio for review. Works on assignment mostly. Uses 35mm, 2¼×2¼, 4×5 or 8×10 transparencies.

Payment negotiable. Credit line given. Buys one-time rights and book rights. Simultaneous submissions and previously published work OK.

Tips: To break in, "send in book ideas to William Strode, with a good tray of slides to show work."

HERALD PRESS, 616 Walnut Ave., Scottdale PA 15683. (724)887-8500. Fax: (724)887-3111. E-mail: jim@mph.org. Website: http://www.mph.org. Contact: James Butti. Estab. 1908. Photos used for book covers and dust jackets. Examples of published titles: *Lord, Teach Us to Pray*; *Starting Over*; and *Amish Cooking* (all cover shots).

Needs: Buys 5 photos annually; offers 10 freelance assignments annually. Subject matter varies. Reviews stock photos of people and other subjects. Model/property release required. Captions preferred (identification information).

Making Contact & Terms: Query with samples. Provide résumé, business card, brochure, flier or tearsheets to be kept on file for possible future assignments. Works on assignment only or select from file of samples. Uses varied sizes of glossy color and/or b&w prints; 35mm transparencies. Keeps samples on file. SASE. Reports in 1 month. Payment negotiable. Accepts images in digital format for Windows in TIFF and EPS.WMT files. Send via Zip disk, floppy disk or online. **Pays on acceptance.** Credit line given. Buys book rights; negotiable. Simultaneous submissions and previously published work OK.

Tips: "We put your résumé and samples on file. It is best to send 5×7 or 8×10 samples for us to circulate through departments."

N HIPPOCRENE BOOKS INC., 171 Madison Ave., New York NY 10016. (212)685-4371. Fax: (212)779-9338. E-mail: hippocre@ix.netcom.com. Website: http://www.netcom.com/~hippocre. Managing Editor: Carol Chitnis. Estab. 1970. Publishes hardcover originals and reprints, trade paperback originals and reprints, foreign language dictionaries. Subjects include foreign language dictionaries and study guides, international ethnic cookbooks, travel, bilingual international love poetry, Polish interest, Russian interest, Judaica. Photos used for book covers, dust jackets. Examples of recently published titles: 1998 Spring Catalog (on cover); 1997 Fall Catalog (cover-inside, front and back).

Needs: Buys 3 freelance photos annually. Looking for ethnic food, travel destinations/sites. Interested in reviewing stock photos of ethnic/international food. Photo captions preferred.

Making Contact & Terms: Send query letter with samples, brochure, stock photo list, tearsheets. Reports back only if interested, send non-returnable samples. Pays by the project, $50-200 for color cover. Credit line given. Buys all rights. Considers simultaneous submissions and previously published work.

Tips: "We only use color photographs on covers. We want colorful, eye-catching work."

HOLLOW EARTH PUBLISHING, P.O. Box 1355, Boston MA 02205-1355. Phone/fax: (603)433-8735. E-mail: hep2@aol.com. President/Publisher: Helian Yvette Grimes. Publishes adult trade, mythology, computers (Macintosh), science fiction and fantasy. Photos used for text illustration, promotional materials, book covers, dust jackets and magazines. Examples of published titles: *Complete Guide to B&B's and Country Inns (USA)*, *Complete Guide to B&B's and Country Inns (worldwide)*, and *Software Guide for the Macintosh Power Book*. E-mail us for photo guidelines.

Needs: Buys 150-300 photos annually. Needs photos of bed & breakfasts, country inns, Macintosh Powerbook and computer peripherals. Reviews stock photos. Model/property release required. Captions required; include what it is, where and when.

Making Contact & Terms: E-mail queries only. No unsolicited photographs. Works with local freelancers on assignment only. Uses 5×7, 8½×11 glossy or matte color and b&w prints; 35mm, 2¼×2¼, 4×5 transparencies. Also accepts images on disk in EPS, TIFF, or Adobe Photoshop formats. Keeps samples on file. SASE. Reports in 1 month. Pays $50-600/color photo; $50-600/b&w photo. **Pays on acceptance.** Credit line given. Buys all rights "but photographer can use photographs for other projects after contacting us." Rights negotiable. No simultaneous submissions.

Tips: Wants to see portfolios with strong content, impact, graphic design. "Be unique and quick in fulfilling assignments, and pleasant to work with."

HOME PLANNERS, A Division of Hanley-Wood, Inc., 3275 W. Ina Road, Suite 110, Tucson, AZ 85741. (520)297-8200. Fax: (520)297-6219. Art Director: Cindy J. Coatsworth Lewis. Estab. 1946. Publishes material on home building and planning and landscape design. Photos used for text illustration, promotional materials and book covers. Examples of recently published titles: *Home Planners Gold*; *Country Houses*; and *Easy-Care Landscape Plans*. In all 3, photos used for cover and text illustrations.

Needs: Buys 25 freelance photos annually; offers 10 freelance assignments annually. Homes/houses—"but for the most part, it must be a specified house built with one of our plans." Property release required.

Making Contact & Terms: Provide résumé, business card, brochure, flier or tearsheets to be kept on file for possible assignments. Works on assignment only. Uses 4×5 transparencies. SASE. Reports in 1

month. Pays $25-100/color photo; $500-750/day; maximum $500/4-color cover shots. Credit line given. Buys all rights. Simultaneous submissions and previously published work OK.
Tips: Looks for "ability to shoot architectural settings and convey a mood. Looking for well-thought, professional project proposals."

HOMESTEAD PUBLISHING, Box 193, Moose WY 83012. Editor: Carl Schreier. Publishes 20-30 titles per year in adult trade, natural history, guidebooks, fiction, Western American, art and fiction. Photos used for text illustration, promotional, book covers and dust jackets. Examples of published titles: *Yellowstone: Selected Photographs*; *Field Guide to Yellowstone's Geysers; Hot Springs and Fumaroles*; *Field Guide to Wildflowers of the Rocky Mountains*; *Rocky Mountain Wildlife*; and *Grand Teton Explorers Guide*.
Needs: Buys 600-700 photos annually; offers 6-8 freelance assignments annually. Natural history. Reviews stock photos. Model release preferred. Photo captions required; accuracy and the highest quality very important.
Making Contact & Terms: Query with samples. Provide résumé, brochure, flier or tearsheets to be kept on file for possible future assignments. Uses 8×10 glossy b&w prints; 35mm, $2\frac{1}{4} \times 2\frac{1}{4}$, 4×5 and 6×7 transparencies. SASE. Reports in 4-6 weeks. Pays $70-300/color photo, $50-300/b&w photo. Credit line given. Buys one-time and all rights; negotiable. Simultaneous submissions and previously published work OK.
Tips: In freelancer's samples, wants to see "top quality—must contain the basics of composition, clarity, sharpness, in focus, low grain etc. Looking for well-thought out, professional project proposals."

HOWELL PRESS, INC., 1147 River Road, Suite 2, Charlottesville VA 22901. (804)977-4006. Fax: (804)971-7204. President: Ross A. Howell, Jr. Estab. 1986. Publishes illustrated books. Examples of recently published titles: *Mustang: North American P-51*; *Corvette GTP*; and *Stuck on Cactus: A Beginning Grower's Guide* (photos used for illustration, jackets and promotions for all books).
Needs: Aviation, military history, gardening, maritime history, motorsports, cookbooks only. Model/property release preferred. Captions required; clearly identify subjects.
Making Contact & Terms: Photographer's guidelines available; send query. Uses b&w and color prints. Keeps samples on file. SASE. Reports in 1 month. Payment negotiable. Buys one-time rights. Simultaneous submissions and previously published work OK.
Tips: When submitting work, please "provide a brief outline of project, including cost predictions and target market for project. Be specific in terms of numbers and marketing suggestions."

I.G. PUBLICATIONS LTD., 1311 Howe St., Suite 601, Vancouver, British Columbia V6Z 2P3 Canada. (604)691-1749. Fax: (604)691-1748. Property Coordinator: Jane Lightle. Estab. 1977. Publishes tourist magazines/books of local interest to include areas/cities of Vancouver, Victoria, Banff/Lake Louise, Calgary. Photos used for text illustration, book covers. Examples of published titles: *International Guide* and *Visitor's Choice*, text illustration and covers. Photo guidelines free with SASE.
Needs: Buys 50-100 photos annually. Looking for photos of mountains, lakes, views, lifestyle, buildings, festivals, people, sports and recreation, specific to each area as mentioned above. Reviews stock photos. Model release required. Property release is preferred. Captions required "detailed but brief."
Making Contact & Terms: Query with samples. Works with local freelancers only from Brisith Columbia and Alberta. Uses 4×5 to 8×10 color prints; 35mm transparencies. Keeps digital images on file. SASE. Reports in 3 weeks. Pays $65/color photo. Pays 30-60 days. Credit line given. Previously published works OK.
Tips: "Please submit photos that are relative to our needs only. Photos should be specific, clear, artistic, colorful."

INNER TRADITIONS INTERNATIONAL, 1 Park St., Rochester VT 05767. (802)767-3174. Fax: (802)767-3726. E-mail: gotoit.com. Art Director: Peri Champine. Estab. 1975. Publishes adult trade: New Age, health, self-help, esoteric philosophy. Photos used for text illustration and book covers. Examples of recently published titles: *Great Book of Hemp* (cover, interior); *Birth Without Violence* (cover); and *Aroma Therapy: Scent and Psyche* (cover).
Needs: Buys 10-50 photos annually; offers 10-50 freelance assignments annually. Reviews stock photos. Model/property release required. Captions preferred.

● **SPECIAL COMMENTS** within listings by the editor of *Photographer's Market* are set off by a bullet.

Making Contact & Terms: Provide résumé, business card, brochure, flier or tearsheets to be kept on file for possible future assignments. Works with freelancers on assignment only. Uses 35mm, 4×5 transparencies. Keeps samples on file. SASE. Reports in 1 month. Pays on publication. Credit line given. Buys book rights; negotiable. Simultaneous submissions OK.

N **JOSSEYBASS PUBLISHERS**, 350 Sansome St., 5th Floor, San Francisco CA 94104. (415)433-1740. Fax: (415)433-4611. Website: http://www.jbp.com. Art Director: Paula Goldstein. Estab. 1968. Publishes hardcover originals; trade paperback originals and trade paperback reprints; CD-ROMs; Training Packages. Subjects include business, people in everyday settings, kids in educational settings and some nature scenes. Photos used for book covers, dust jackets. Examples of recently published titles: *Leading Without Power (full cover image, nature scene); Daughters of Thunder* (image of face on cover); *All Kids are Our Kids* (image of children).
Needs: Buys 40 freelance photos annually. Looking for photos of people of varied races in normal settings, not posed; nature scenes; and education related shots of kids. Interested in reviewing stock photos. Model release required for kids/people shots; property release preferred. Photo caption preferred.
Marketing Contact & Terms: Send query letter with samples. Provide résumé, business card, self-promotion piece or tearsheets to be kept on file for possible future assignments. Art director will contact photographer for portfolio review if interested. Portfolio should include slides, transparencies. Uses color, b&w prints; 35mm transparencies. Accepts images in digital format. Keeps samples on file. Reports back only if interested, send non-returnable samples. Payment varies by project. Pays extra for electronic usage of photos. Pays on publication. Credit line given. Buys one-time worldwide rights but prefers all rights.

JUDICATURE, 180 N. Michigan Ave., Suite 600, Chicago IL 60601. (312)558-6900 ext 119. Fax: (312)558-9175. E-mail: ajspubs@interaccess.com. Editor: David Richert. Estab. 1917. Publishes legal journal, court and legal books. Photos are used for text illustration and cover of bimonthly journal.
Needs: Buys 10-12 photos annually; rarely offers freelance assignments. Looking for photos relating to courts, the law. Reviews stock photos. Model/property release preferred. Captions preferred.
Making Contact & Terms: Query with samples. Works on assignment only. Uses 5×7 color and b&w prints; 35mm transparencies. Keeps samples on file. SASE. Reports in 1-2 weeks. Pays $150-200/color photo; $150-200/b&w photo; cover use $200-300. **Pays on receipt of invoice.** Credit line given. Buys one-time rights. Simultaneous and/or previously published work OK.

B. KLEIN PUBLICATIONS., P.O. Box 6578, Delray Beach FL 33482. (561)496-3316. Fax: (561)496-5546. President: Bernard Klein. Estab. 1953. Publishes adult trade, reference and who's who. Photos used for text illustration, promotional materials, book covers, dust jackets. Examples of published titles: *1933 Chicago World's Fair, 1939 NY World's Fair* and *Presidential Ancestors.*
Needs: Reviews stock photos.
Making Contact & Terms: Query with résumé of credits. Query with samples. Send unsolicited photos by mail for consideration. Works on assignment only. Cannot return material. Reports in 1-2 weeks. Payment negotiable.
Tips: "We have several books in the works that will need extensive photo work in the areas of history and celebrities."

KREGEL PUBLICATIONS, 733 Wealthy SE, P.O. Box 2607, Grand Rapids MI 49501-2607. (616)451-4775. Fax: (616)451-9330. E-mail: kregelpub@aol.com. Director of Graphic & Print Production: Nick Richardson. Publishes books for Christian and Bible colleges, reference works and commentaries, sermon helps and adult trade books. Photos used for book covers and printed jackets. Examples of recently published titles: *Biblical Manhood & Womanhood,* (cover, digital-photo disc); *Honey from the Rock,* (scenic, full bleed, 35mm); and *Master's Plan of Prayer,* (scenic, full bleed, 4×5).
● Kregel received the Gold Medallion ECPA award for *Spanish Romanos Commentary.*
Needs: Buys 12-40 photos annually. Scenic and/or biblical. Holy Land, scenery and inhabitants sometimes used; religious symbols, stained glass and church activities of non-Catholic origin may be submitted. Reviews stock photos. Model release preferred.
Making Contact & Terms: Query with phone call to approve photo submission before sending. Uses 35mm, 2¼×2¼ and 4×5 transparencies. Accepts images in digital format for Mac (TIFF or EPS). Send via compact disc, 44m6 SyQuest, Zip disk or 230, 128 MO. Keeps duplicates on file. SASE. Reports in 3 months. Pays $200-400/color photo. Credit line given. Buys book rights and one-time rights with allowances for reproductions. Prefers purchase of photos for unlimited use. Previously published work OK.
Tips: "Prior submission approval a must! High quality scenics of 'inspirational calendar' type preferred."

LAYLA PRODUCTION INC., 340 E. 74, New York NY 10021. (212)879-6984. Fax: (212)879-6399. Manager: Lori Stein. Estab. 1980. Publishes adult trade, how-to gardening and cooking books. Photos used for text illustration and book covers. Example of recently published title: *American Garden Guides*, 12 volumes (commission or stock, over 4,000 editorial photos).

Needs: Buys over 150 photos annually; offers 6 freelance assignments annually. Gardening and cooking. Buys all rights.

Making Contact & Terms: Provide résumé, business card, brochure, flier or tearsheets to be kept on file for possible future assignments. Specifications for submissions are very flexible. SASE. Reports in 1 month; prefers no unsolicited material. Pays $25-200/color photo; $10-100/b&w photo; $30-75/hour; $250-400/day. Other methods of pay depends on job, budget and quality needed. Simultaneous submissions and previously published work OK.

Tips: "We're usually looking for a very specific subject. We *do* keep all résumés/brochures received on file—but our needs are small, and we don't often use unsolicited material. We will be working on gardening books through 1999."

LERNER PUBLICATIONS COMPANY, 241 First Ave. N., Minneapolis MN 55401. (612)332-3344 or (800)328-4929. Fax: (612)332-7615. Senior Photo Researcher: Beth Osthoff. Estab. 1959. Publishes educational books for young people covering a wide range of subjects, including animals, biography, history, geography and sports. Photos used for text illustration, promotional materials, book covers, dust jackets. Examples of recently published titles: *Gloria Steinem* (text and cover); *Northern Ireland* (text and cover); and *Picabo Street* (text and cover).

Needs: Buys over 1,000 photos annually; rarely offers assignments. Model/property release preferred when photos are of social issues (i.e., the homeless). Captions required; include who, where, what and when.

Making Contact & Terms: Query with stock photo list. Provide résumé, brochure, flier or tearsheets to be kept on file. "No calls, please." Uses any size glossy color and b&w prints; 35mm, 2¼×2¼, 4×5 transparencies. Cannot return material. Reports only when interested. Pays $50-125/color photo; $35-75/b&w photo; negotiable. **Pays on receipt of invoice.** Credit line given. Buys one-time rights. Previously published works OK.

Tips: Prefers crisp, clear images that can be used editorially. "Send in as detailed a stock list as you can, and be willing to negotiate use fees. We are using freelance photographers more and more."

LIFETIME BOOKS, 2131 Hollywood Blvd., Hollywood FL 33020. (954)925-5242. Fax: (954)925-5244. Senior Editor: Callie Rucker. Estab. 1943. Publishes nonfiction business, health, cookbooks, self-help, how-to and psychology. Photos are used for text illustration, book covers and dust jackets.

Needs: Reviews stock photos. Model release required. Captions preferred.

Making Contact & Terms: Query with samples. Query with stock photo list. Uses color prints. Keeps samples on file. SASE. Payment negotiable. **Pays on acceptance.** Credit line given. Buys nonexclusive, multiple-use rights; negotiable. Simultaneous submissions and/or previously published work OK.

LITURGY TRAINING PUBLICATIONS, 1800 N. Hermitage, Chicago IL 60622. (773)486-8970. Fax: (773)486-7094. Prepress Director: Diana Kodner. Estab. 1964. Publishes materials that assist parishes, institutions and households in the preparation, celebration and expression of liturgy in Christian life. Photos used for text illustration, book covers. Examples of published titles: *Infant Baptism, a Parish Celebration* (text illustration); *The Postures of the Assembly During the Eucharistic Prayer* (cover); and *Teaching Christian Children about Judaism* (text illustration).

Needs: Buys 30 photos annually; offers 5 freelance assignments annually. Needs photos of processions, assemblies with candles in church, African-American worship, sacramental/ritual moments. Reviews stock photos. Model/property release preferred. Captions preferred.

Making Contact & Terms: Arrange personal interview to show portfolio. Submit portfolio for review. Query with résumé of credits. Query with samples. Query with stock photo list. Send unsolicited photos by mail for consideration. Provide résumé, business card, brochure, flier or tearsheets to be kept on file for possible future assignments. Uses 5×7 glossy b&w prints; 35mm transparencies. Keeps samples on file. SASE. Reports in 1-2 weeks. Pays $50-225/color photo; $25-200/b&w photo. Pays on publication. Credit line given. Buys one-time rights; negotiable. Simultaneous submissions; previously published work.

Tips: "Please realize that we are looking for very specific things—people of mixed age, race, socio-economic background; shots in focus; post-Vatican II liturgical style; candid photos; photos that are not dated. We are not looking for generic religious photography. We're trying to use more photos, and will if we can get good ones at reasonable rates."

LLEWELLYN PUBLICATIONS, P.O. Box 64383, St. Paul MN 55164. Art Director: Lynne Menturweck. Publishes consumer books (mostly adult trade paperback) with astrology, wiccan, occult, self-help, health and New Age subjects, geared toward an educated audience. Uses photos for book covers. Examples of recently published titles: *Complete Book of Incense, Oils & Brews*; *Sarava!, Mother Nature's Herbal* and *Advanced Candle Magic* (all covers).
Needs: Buys 10-20 freelance photos annually. Science/fantasy, sacred sites, gods and goddesses (statues, etc.), nature, high-tech and special effects. Reviews stock photos. Model release preferred.
Making Contact & Terms: Query with samples. Prefers 35mm or 4×5 transparencies. Provide slides, brochure, flier or tearsheets to be kept on file for possible future assignments. SASE. Reports in 5 weeks. Pays $125-600/color cover photo. Pays on publication. Credit line given. Buys all rights.
Tips: "Send materials that can be kept on file."

LONELY PLANET PUBLICATIONS, 155 Filbert, Suite 251, Oakland CA 94607-2538. (510)893-8555. E-mail: info@lonelyplanet.com. Photo Editor: Hugh D'Andrade. Estab. 1971. Publishes trade paperback originals and reprints. Subjects include travel. Photos used for text illustrations, promotional materials, book covers. Examples of recently published titles: *Chicago Travel Guide* (book cover, text illustration); *Mexico Travel Guide* (book cover, text illustration); *Mexico City Travel Guide* (book cover, text illustration). Photo guidelines sheet free with SASE.
Needs: Buys 300-500 freelance photos annually. Looking for "off the beaten track" travel imagery; no monuments. Interested in reviewing stock photos. Model release preferred for photos of individuals for book covers. Photo captions preferred.
Marketing Contact & Terms: Send query letter with samples, stock photo list, tearsheets. Provide résumé, business card, self-promotion piece or tearsheets to be kept on file for possible future assignments. Art director will contact photographer for portfolio review if interested. Portfolio should include slides. Uses 35mm, 2¼×2¼, 4×5 transparencies. Does not keep samples on file; include SASE for return of material. Reports in 3-4 weeks on queries; 3-4 weeks on samples. Reports back only if interested, send non-returnable samples. Pays by the project, $500-1,500 for color cover; $300-500 for color inside. Pays on publication. Credit line given. Buys one-time rights. Simultaneous submissions and/or previously published work OK.
Tips: "When choosing freelancers I like to see a good selection of printed samples first. We're looking for travel images that convey the spirit of a place through off-beat views, details and people photos. Not so interested in staged photos or clichéd, classic shots (i.e. Eiffel Tower, etc.). When submitting work, send samples/stock list first, include captions with slide submissions and send only excellent work—small submissions are OK."

LOOMPANICS UNLIMITED, P.O. Box 1197, Port Townsend WA 98368. (360)385-5087. Fax: (360)385-7785. E-mail: loompseditor@olympus.net Editorial Assistant: Vanessa McGrady. Estab. 1975. Publishes how-to and nonfiction for adult trade. Photos used for book covers. Examples of published titles: *Free Space!* (color photos on cover and interior); *Secrets of a Superhacker* (photo collage on cover); and *Stoned Free* (interior photos used as line-drawing guide).
Needs: Buys 2-3 photos annually; offers 1-2 freelance assignments annually. "We're always interested in photography documenting crime and criminals." Reviews stock photos. Model/property release preferred. Captions preferred.
Making Contact & Terms: Query with samples. Query with stock photo list. Provide tearsheets to be kept on file for possible future assignments. Uses b&w prints. Samples kept on file. SASE. Reports in 1 month. Pays $10-250 for cover photo; $5-20 interior photo. Credit lines given. Buys all rights. Simultaneous submissions and previously published work OK.
Tips: "We look for clear, high contrast b&w shots that *clearly* illustrate a caption or product. Find out as much as you can about what we are publishing and tailor your pitch accordingly."

LUCENT BOOKS, P.O. Box 289011, San Diego CA 92128. (619)485-7424. Fax: (619)485-9549. Production Coordinator: Tracey Engel. Estab. 1987. Publishes juvenile nonfiction—social issues, biographies and histories. Photos used for text illustration and book covers. Examples of recently published titles: *Teen Drug Abuse, Juvenile Crime* and *Child Abuse*.
Needs: Buys hundreds of photos annually, including many historical and biographical images, as well as controversial topics such as euthanasia. Reviews stock photos. Model/property release required; photo captions required.
Making Contact & Terms: Submit portfolio for review. Query with résumé of credits. Query with samples. Uses 5×7, 8½×11 b&w prints. Provide résumé, business card, brochure, flier or tearsheets to be kept on file for possible future assignments. Keeps samples on file. SASE. Reports in 1 month. Pays

$25-75/b&w photo. Credit lines given on request. Simultaneous submissions and previously published work OK.

LYNX IMAGES INC., 104 Scollard St., Toronto, Ontario M5R 1G2 Canada. (416)925-8422. Fax: (416)925-8352. E-mail: lynximag@interlog.com. Website: http://www.lynximages.com. Contact: Russell Floren. Estab. 1988. Publishes travel, history. Photos used for text illustration, promotional materials, book covers and dust jackets. Examples of recently published titles: *Alone In The Night* (cover, promotional materials); *Ghosts of the Boy* (cover, promotional materials); and *North Channel* (cover and promotional materials).

Needs: Buys 10-20 photos annually; offers 10 freelance assignments annually. Looking for photos of mood, style to fit book. Reviews stock photos of the Great Lakes and other travel images. Model release preferred for people. Property release required for ships. Captions required, include date, location and site.

Making Contact & Terms: Query with samples. Works with local freelancers only. Uses 16mm film and Betacame SP videotape. Uses images in digital format for Mac in Photoshop. Send via Zip disk, floppy disk or JAZ disk. Keeps samples on file. Reports in 1 month. Pays a negotiated flat fee for work. **Pays on receipt of invoice.** Credit line sometimes given depending upon work. Buys all rights. Simultaneous submissions OK.

THE LYONS PRESS, 31 W. 21st St., New York NY 10010. (212)620-9580. Fax: (212)462-4411. Art Director: Cathy Hunt. Publishes hardcover originals, trade paperback originals and reprints. Subjects include nature, outdoors, cooking, gardening, fishing, sports and animals. Photos used for book covers, dust jackets. Examples of recently published titles: *The Good Cigar* (front cover); *The Mushroom Feast* (front cover); *The Essential Cyclist* (front cover).

Needs: Buys 40 freelance photos annually. Looking for photos of sports, nature, cooking, still lifes. Interested in reviewing stock photos. Model release preferred; property release required. Photo caption required; include credit information.

Marketing Contact & Terms: Provide résumé, business card, self-promotion piece or tearsheets to be kept on file for possible future assignment. Art director will contact photographer for portfolio review if interested. Portfolio should include b&w and/or color, prints, tearsheets. Uses color, b&w prints. Accepts images in digital format, only in the case of receiving final art. Keeps samples on file. Reports back only if interested, send non-returnable samples. Pays by the project, $350-400 for color cover. Payment for inside depends on project. Pays on publication. Credit line given. Buys first North American serial rights. Previously published work OK.

Tips: "To work for us, a good attitude and flexibility are crucial. Always enclose a price range when submitting work."

MAGE PUBLISHERS, 1032 29th St. NW, Washington DC 20008. (202)342-1642. Fax: (202)342-9269. E-mail: mage1@access.digex.net. Website: http://www.mage.com. Editor: Tony Ross. Estab. 1987. Publishes hardcover original and reprint, trade paperback original and reprint. Subjects include books on Persian art, cooking culture, history. Photos used for text illustrations, book covers, dust jackets.

Needs: Buys 5 freelance photos annually. Only looking for photos taken in Iran. Photo captions preferred; include location, date.

Making Contact & Terms: Send query letter. Art director will contact photographer for portfolio review if interested. Portfolio should include b&w and color prints, slides, transparencies. Reports in 2 months. **Pays half on acceptance and half at publication.** Credit line given. Buys all rights. Simultaneous submissions OK.

Tips: "We are only interested in photos taken in Iran. Query first."

MILKWEED EDITIONS, 430 First Ave., Suite 400, Minneapolis MN 55401-1743. (612)332-3192. E-mail: Beth_Olson@milkweed.org. Website: http://www.milkweed.org. Managing Editor: B. Olson. Estab. 1979. Publishes fiction (adult and children), nonfiction and poetry. Photos used for book covers and dust

jackets and a few interior illustrations. Examples of recently published titles: *Boundary Waters*; *A Keeper of Sheep*; *Homestead* (color photos for cover illustrations); and *Children Bob Moses Led* (b&w photo).

Needs: Interested in high-quality photos, able to stand on own; "should not be journalistic." Model release required.

Making Contact & Terms: Query with samples. Provide résumé, business card, brochure, book list, flier or tearsheets to be kept on file. Uses b&w glossy prints and color transparencies. SASE. Accepts images in digital format for Mac on SyQuest, Zip disk or floppy disk. Reports in 3 months. "We buy piece work. We are a nonprofit publisher of poetry, fiction, children's fiction, and adult nonfiction. Photographers who are willing to work with us in keeping down our costs and in reviewing a manuscript to determine the best possible cover image are welcome to send a letter and book list." Credit line given. Buys cloth and paperback edition rights. Simultaneous submissions and previously published work OK.

Tips: "Look at our books for examples. Then send in a good color copy to keep on file."

MOON PUBLICATIONS, INC., P.O. Box 3040, Chico CA 95927-3040. (530)345-5473. Fax: (530)345-6751. E-mail: dhurst@moon.com. Photo Buyer: Dave Hurst. Estab. 1973. Publishes travel material. Photos used for text illustration, promotional materials and book covers. Examples of recently published titles: *Indonesia Handbook*, 6th Edition; *Nepal Handbook,* (2nd Edition) and *Tasmania Handbook* (1st Edition). All photos used for cover and text illustration. Photo guidelines free with SASE.

Needs: Buys 25-30 photos annually. Looking for people and activities typical of area being covered, landscape or nature. Reviews stock photos. Photo captions preferred; include location, description of subject matter.

Making Contact & Terms: Query with stock photo list. Provide résumé, business card, brochure, flier or tearsheets to be kept on file for possible future assignments. Uses 35mm, $2\frac{1}{4} \times 2\frac{1}{4}$, 4×5, 8×10 transparencies. Accepts images in digital format for Mac in TIFF and EPS files. Send via CD, Zip disk or floppy disk at 300 dpi or higher. Keeps samples on file. SASE. Pays $400/cover photo. Pays on publication. Credit line given. Buys book rights; negotiable. Previously published work OK.

Tips: Wants to see "sharp focus, visually interesting (even unusual) compositions portraying typical activities, styles of dress and/or personalities of indigenous people of area covered in handbook. Unusual land or seascapes. Don't send snapshots of your family vacation. Try to look at your own work objectively and imagine whether the photograph you are submitting really deserves consideration for the cover of a book that will be seen worldwide. We continue to refine our selection of photographs that are visually fascinating, unusual."

[N] MOTORBOOKS INTERNATIONAL, 729 Prospect Ave., Osceola WI 54020. (715)294-3345. Fax: (715)294-4448. Estab. 1965. Publishes trade and specialist and how-to, automotive, aviation and military. Photos used for text illustration, book covers and dust jackets. Examples of recently published titles: *The American Drive-In*, *Fire Trucks in Action* and *How to Restore Your Harley-Davidson* (photos used for text illustration and covers).

Needs: Anything to do with transportation including tractors, cycles or airplanes. Model release preferred.

Making Contact & Terms: Works on assignment typically as part of a book project. "Present a résumé and cover letter first, and we'll follow up with a request to see samples." Unsolicited submissions of original work are discouraged. SASE. Reports in 1 month. Payment negotiable. Credit line given. Rights negotiable. Simultaneous submissions and previously published work OK.

[image] MOUNTAIN AUTOMATION CORPORATION, P.O. Box 6020, Woodland Park CO 80866. (719)687-6647. Fax: (719)687-2448. E-mail: mtnauto@compuserve.com. President: Claude Wiatrowski. Estab. 1976. Publishes souvenir books. Photos used for text illustration, promotional materials and book covers. Examples of published titles: *Colorado's Black Canyon* (throughout); *Pike's Peak By Rail* (extra illustrations in video) and *Georgetown Loop RR* (extra illustrations in video).

Needs: Complete projects for illustrated souvenir books and videos, not individual photos. Model release required. Property release preferred. Captions required.

Making Contact & Terms: Query with book project. Uses 35mm, $2\frac{1}{4} \times 2\frac{1}{4}$, 4×5 transparencies. "Although we will deal with larger formats if necessary, we prefer 35mm for transfer to Kodak Photo CD." Accepts images in digital format for Windows (TIFF and PCD preferred). Send via compact disc or floppy disk. Keeps samples on file. SASE. Reports in 1 month. Pays royalty on complete book projects. Credit lines given. Buys all rights. Simultaneous submissions OK.

Tips: "Provide a contact with a tourist attraction, chamber of commerce or other entity willing to purchase souvenir books. We *only* are interested in complete illustrated book or video projects for the souvenir market with very targeted markets."

JOHN MUIR PUBLICATIONS, P.O. Box 613, Santa Fe NM 87504. Graphics Editor: Tom Gaukel. Estab. 1969. Publishes adult travel books. Photos used for text illustration and book covers. Examples of recently published titles: *Travel Smart* series, *City Smart Guidebook* series, *Adventures in Nature* series and *Rick Steves' European Travel Guides*.
Needs: Travel photos (sights, hotels, restaurants, scenics) of US and Canadian cities and regions. Also, general travel coverage of Central American and European countries. Model release preferred.
Making Contact & Terms: Query with samples, stock photo list, résumé and/or letter of interest. Accepts images in digital format for Mac for preview only. Submit via Zip disk or diskette. No disks or samples will be returned. Payment negotiable. Rights negotiable. Terms vary from project to project.

MUSEUM OF NORTHERN ARIZONA, 3101 N. Fort Valley Rd., Flagstaff AZ 86001. (520)774-5213. Fax: (520)779-1527. Editor: Carol Haralson. Estab. 1928. Publishes biology, geology, archaeology, anthropology and history. Photos used for Plateau Journal Magazine, published twice a year. Examples of recently published title: *Canyon Journal* article illustration (slides, 4×5 b&w prints). Forty b&w and color photos used for text in each.
Needs: Buys approximately 80 photos annually. Biology, geology, history, archaeology and anthropology—subjects on the Colorado Plateau. Reviews stock photos. Photo captions preferred, include location, description and context.
Making Contact & Terms: Uses 8×10 glossy b&w prints; also 35mm, 2¼×2¼, 4×5 and 8×10 transparencies. Prefers 2¼×2¼ transparencies or larger. Possibly accepts images in digital format for Mac. Submit via Zip disk. SASE. Reports in 1 month. Pays $55-250/color photo; $55-250/b&w photo. Credit line given. Buys one-time and all rights; negotiable. Simultaneous submissions and previously published work OK. Offers internships for photographers. Contact Photo Archivist: Tony Marinella.
Tips: Wants to see top-quality, natural history work. To break in, send only pre-edited photos.

MUSIC SALES CORP., 257 Park Ave. S., New York NY 10010. (212)254-2100. Contact: Daniel Earley. Publishes instructional music books, song collections and books on music. Recent titles include: *Bob Dylan: Time Out of Mind*; *Paul Simon: Songs from the Capeman*; and *AC/DC Bonfire*. Photos used for cover and/or interiors.
Needs: Buys 200 photos annually. Present model release on acceptance of photo. Captions required.
Making Contact & Terms: Query first with résumé of credits. Provide business card, brochure, flier or tearsheet to be kept on file for possible future assignments. Uses 8×10 glossy prints; 35mm, 2×2 or 5×7 transparencies. SASE. Reports in 2 months. Pays $50-75/b&w photo, $250-750/color photo. Simultaneous submissions and previously published work OK.
Tips: In samples, wants to see "the ability to capture the artist in motion with a sharp eye for framing the shot well. Portraits must reveal what makes the artist unique. We need rock, jazz, classical—on stage and impromptu shots. Please send us an inventory list of available stock photos of musicians. We rarely send photographers on assignment and buy mostly from material on hand." Send "business card and tearsheets or prints stamped 'proof' across them. Due to the nature of record releases and concert events, we never know exactly when we may need a photo. We keep photos on permanent file for possible future use."

N: NASW PRESS, National Association of Social Workers, 750 First St., NE, Suite 700, Washington DC 20002-4241. (202)408-8600. Fax: (202)336-8312. Website: http://www.naswpress.org. Senior Editor: Chris Davis. Estab. 1955. Publishes textbooks, CD-ROMs, journals. Subjects include social work, health, education. Photos used for journal covers. Examples of recently published titles: *Social Work*, *Health & Social Work*, *Social Work in Education*.
Needs: Buys 10 freelance photos annually. Wants photos about social work, healthcare, education, poverty and multicultural issues. Model release required. Photo caption preferred.
Marketing Contact & Terms: Send query letter with samples. To show portfolio, photographer should follow-up with call. Art director will contact photographer for portfolio review if interested. Uses color prints. Keeps samples on file. Reports back only if interested, send non-returnable samples. Pays by the project, $250 maximum for color cover. Pays on publication. Credit line given. Buys one-time, all, electronic rights; negotiable. Considers simultaneous submissions and previously published work.

NEGATIVE CAPABILITY, 62 Ridgelawn Dr. E., Mobile AL 36608. (334)343-6163. Fax: (334)344-8478. Editor: S. Walker. Estab. 1981. Publishes books of poetry, fiction, essays and articles. Photos used for text illustration, book covers and dust jackets. Examples of recently published titles: *Negative Capability* (journal) and *Little Dragons* (book).
Needs: Buys over 10 photos annually. Captions required.
Making Contact & Terms Query with samples. Send unsolicited photos by mail for consideration. Provide résumé, business card, brochure, flier or tearsheets to be kept on file for possible future assignments.

Uses 5×7 b&w prints. Keeps samples on file. SASE. Reports in 1 month. Pays in copies or by arrangement for covers. Credit line given. Buys one-time rights.

NEW LEAF PRESS, INC., Box 726, Green Forest AR 72638. (501)438-5288. Art Director: Janell Robertson. Publishes adult trade, fiction of religious nature, gifts, devotions and general trade. Photos used for book covers and dust jackets. Example of published title: *Moments for Friends*.
Needs: Buys 10 freelance photos annually. Landscapes, dramatic outdoor scenes, "anything that could have an inspirational theme." Reviews stock photos. Model release required. Captions preferred.
Making Contact & Terms: Query with copies of samples and list of stock photo subjects. Does not assign work. Uses 35mm slides and transparencies. SASE. Reports in 4-6 weeks. Pays $100-175/color photo and $50-100/b&w photo. Credit line given. Buys one-time and book rights. Simultaneous submissions and previously published work OK. "Not responsible for submitted slides and photos from queries. Please send copies, no originals unless requested."
Tips: In order to contribute to the company, send color copies of "quality, crisp photos." Trend in book publishing is toward much greater use of photography.

NORTHLAND PUBLISHING, P.O. Box 1389, Flagstaff AZ 86002. (520)774-5251. Fax: (520)774-0592. E-mail: rudy@northlandpub.com. Art Director: Jennifer Schaber. Estab. 1966. Southwest themes—native American cowboy, hispanic culture—all in trade, juvenile, cookbooks, fiction. Photos used for text illustration, promotional materials, book covers and dust jackets. Examples of recently published titles: *Pronghorn* (cover/interior); *Mountains and Mesas* (cover/interior); *Healthy Southwest Cooking* (interior); and *Writing Down the River* (interior).
Needs: Buys 10-50 photos annually; offers 6-8 freelance assignments annually. Looking for photos with creative interesting angles—"try not to use computer-aided material." Reviews stock photos of natural history. Model/property release required. Captions preferred.
Making Contact & Terms: Query with samples. Works on assignment only. Uses 2¼×2¼, 4×5 transparencies. Keeps samples on file. SASE. Reports in 1-2 weeks. Payment negotiable. **Pays on receipt of invoice.** Credit line given. Buys one-time and all rights. Previously published work OK.
Tips: "We do not prefer to work with digital imagery, but will use digital information after an image is produced. Often we look for specific images, but we frequently have published a new book with an idea from a photographer."

[N] W.W. NORTON AND COMPANY, 500 Fifth Ave., New York NY 10110. (212)354-5500. Fax: (212)869-0856. Website: http://www.wwnorton.com. Trade and College Department Photo Editors: Ruth Mandel and Neil Hoos. Estab. 1923. Photos used for text illustration, book covers and dust jackets. Examples of recently published titles: *Shaping a Nation*; and *We the People*.
Needs: Variable. Photo captions preferred.
Making Contact & Terms: Send stock photo list. Do not enclose SASE. Reports as needed. Accepts images in digital format for Mac. Send via CD, SyQuest, Online, Zip disk or floppy disk at 300 dpi for reproduction and archival work. Payment negotiable. Credit line given. Buys one-time rights; negotiable. Simultaneous submissions and previously published work OK.
Tips: "Competitive pricing and minimal charges for electronic rights are a must."

[N] NTC/CONTEMPORARY PUBLISHING GROUP, Tribune Co., 4255 W. Touhy Ave, Lincolnwood IL 60646-1975. (847)679-5500. Fax: (847)679-6388. Art Director: Kim Bartko. Estab. 1961. Publishes hardcover originals, trade paperback originals and reprints; textbooks. Subjects include business, language instruction, parenting, cooking, travel, crafts, quilting, exercise, self-help, sports and entertainment. Photos used for text illustration, book covers, dust jackets. Examples of recently published titles: *Feng Shui in the Garden* (cover); *And Then Fuzzy Told Seve* (cover); *Ultimate Snowboarding* (cover and interior).
Needs: Buys 40 freelance photos annually. Looking for photos of families, sports and travel. Interested in reviewing stock photos of families (multicultural), sports and travel. Model release preferred for people on the cover; property release required. Photo caption preferred, include copyright owner and location.
Marketing Contact & Terms: Send query letter with brochure, stock photo list, tearsheets. "Do not send original photos." Provide résumé, business card and tearsheets to be kept on file for possible future assignments. Art director will contact photographer for portfolio review if interested. Portfolio should include prints, tearsheets, slides, transparencies. Uses 35mm, 2¼×2¼, 4×5 transparencies. Accepts images in digital format via e-mail or disk. Reports in 2 weeks on queries. Reports back only if interested, send non-returnable samples. Payment negotiable by project. **Pays on acceptance.** Credit line given. Buys all rights; negotiable. Previously published work OK.
Tips: "Study the categories we specialize in. We prefer color and recent shots. Send brief stock list (not

more than 1 page)."

THE OLIVER PRESS, Charlotte Square, 5707 W. 36th St., Minneapolis MN 55416-2510. (612)926-8981. Fax: (612)926-8965. Editor: Teresa Faden. Estab. 1991. Publishes history books and collective biographies for the school and library market. Photos used for text illustration, promotional materials and book covers. Examples of published titles: *Women of the U.S. Congress* (9 freelance photos in the book, 1 on the back cover); *Women Who Reformed Politics* (7 freelance photos in the book); and *Amazing Archaeologists and Their Finds* (8 freelance photos in the book, 3 on the front cover).
Needs: Photographs of people in the public eye: politicians, business people, activists, etc. Reviews stock photos. Captions required; include the name of the person photographed, the year, and the place/event at which the picture was taken.
Making Contact & Terms: Query with stock photo list. Uses 8 × 10 glossy b&w prints. Keeps samples on file. SASE. Reports in 1 month. Pays $35-50/b&w photo. Pays on publication. Credit line given. Buys book rights, including the right to use photos in publicity materials; negotiable. Simultaneous submissions and previously published work OK.
Tips: "We are primarily interested in photographs of public officials, or people in other fields (science, business, law, etc.) who have received national attention. We are not interested in photographs of entertainers. Do not send unsolicited photos. Instead, send us a list of the major subjects you have photographed in the past."

C. OLSON & CO., P.O. Box 100-PM, Santa Cruz CA 95063-0100. (408)458-9004. E-mail: bttrsweett@aol.com. Editor: C. L. Olson. Estab. 1977. Examples of published titles: *World Health; Carbon Dioxide & the Weather* (cover).
Needs: Uses 2 photos/year—b&w or color; all supplied by freelance photographers. Photos of fruit and nut trees (in blossom or with fruit) in public access locations like parks, schools, churches, streets, businesses. "You should be able to see the fruits up close with civilization in the background." Also needs photos of people under stress from loud noise, photos relating to male circumcision, photos showing people (children and/or adults) wounded in war. Model/property release required for posed people and private property. Captions preferred.
Making Contact & Terms: Query with samples. SASE, plus #10 window envelope. Accepts images in digital format for Mac. Send via CD, Zip disk, floppy disk or Online. Reports in 2 weeks. Payment negotiable. **Pays on acceptance** or publication. Credit line given on request. Buys all rights. Simultaneous submissions and previously published work OK.
Tips: Open to both amateur and professional photographers. "To ensure that we buy your work, be open to payment based on a royalty for each copy of a book we sell."

N OUR SUNDAY VISITOR, INC., 200 Noll Plaza, Huntington IN 46750. (219)356-8400. Fax: (219)356-8472. E-mail: rbeemer@osv.com. Managing Editor: Richard G. Beemer. Estab. 1912. Publishes religious (Catholic) periodicals, books and religious educational materials. Photos used for text illustration, promotional materials, book covers and dust jackets. Examples of recently published titles: *St. Leonard's Way of the Cross* (b&w on cover); *Catholic Traditions in the Garden* (color on cover); and *The Inner Life of Thérèse Lisieux* (color on cover).
Needs: Buys 15-20 photos annually; offers 25-30 freelance assignments annually. Interested in family settings, "anything related to Catholic Church." Reviews stock photos. Model/property release required. Captions preferred.
Making Contact & Terms: Query with samples. Works with freelancers on assignment only. Uses 8 × 10 glossy, color and/or b&w prints; 35mm transparencies. Keeps samples on file. SASE. Reports in 1 month. Payment negotiable. Pays on acceptance, receipt of invoice. Credit line given. Buys one-time rights.

OUTDOOR EMPIRE PUBLISHING, INC., Box C-19000, Seattle WA 98109. (206)624-3845. Fax: (206)695-8512. Art Director: Patrick McGann. Publishes how-to, outdoor recreation and large-sized paperbacks. Photos used for text illustration, promotional materials, book covers and newspapers.
Needs: Buys 6 photos annually; offers 2 freelance assignments annually. Wildlife, hunting, fishing, boating, outdoor recreation. Model release preferred. Captions preferred.

MARKET CONDITIONS are constantly changing! If you're still using this book and it's 2000 or later, buy the newest edition of *Photographer's Market* at your favorite bookstore or order directly from Writer's Digest Books.

Making Contact & Terms: Query with samples or send unsolicited photos by mail for consideration. Provide résumé, business card, brochure, flier or tearsheets to be kept on file for possible future assignments. Works on assignment only. Uses 8 × 10 glossy b&w and color prints; 35mm, 2¼ × 2¼ and 4 × 5 transparencies. SASE. Reports in 3 weeks. Payment "depends on situation/publication." Credit line given. Buys all rights. Simultaneous submissions OK.

Tips: Prefers to see slides or contact sheets as samples. "Be persistent; submit good quality work. Since we publish how-to books, clear informative photos that tell a story are very important."

RICHARD C. OWEN PUBLISHERS, INC., P.O. Box 585, Katonah NY 10536. (914)232-3903. Fax: (914)232-3977. Editor (Children's Books): Janice Boland. Editor (Professional Books): Amy Haggblom. Publishes picture/storybook fiction and nonfiction for 5- to 7-year-olds; author autobiographies for 7- to 10-year-olds; professional books for educators. Photos used for text illustration, promotional materials and book covers of professional books. Examples of recently published titles: *Meet the Author*; *Books for Young Learners* (children's).

Needs: Number of photos bought annually varies; offers 3-10 freelance assignments annually. Needs unposed people shots and nature photos that suggest storyline. "For children's books, must be child-appealing with rich, bright colors and scenes, no distortions or special effects. For professional books, similar, but often of classroom scenes, including teachers. Nothing posed, should look natural and realistic." Reviews stock photos of children involved with books and classroom activities, age ranging from kindergarten to sixth grade, "not posed or set up, not portrait type photos. Realistic!" Model release required for children and adults. Children (under the age of 21) must have signature of legal guardian. Property release preferred. Captions required. Include "any information we would need for acknowledgements, including if special permission was needed to use a location."

Making Contact & Terms: Submit portfolio by mail for review. Provide résumé, business card, brochure, flier, or tearsheets to be kept on file for possible future assignments. Include a cover letter with name, address, and daytime phone number, and indicate *Photographer's Market* as a source for correspondence. Works with freelancers on assignment only. "For samples, we like to see any size color prints (or color copies). For materials that are to be used, we need 35mm mounted transparencies. We usually use full-color photos." Keeps samples on file "if appropriate to our needs." Reports in 1 month. Pays $50 for b&w photo; $50-150/color photo; $500-2,000/job; $400/day (2-day maximum). "Each job has its own payment rate and arrangements." **Pays on acceptance.** Credit line given sometimes, depending on the project. "Photographers' credits appear in children's books, and in professional books, but not in promotional materials for books or our company." For children's books, publisher retains ownership, possession and world rights, and applies to first and all subsequent editions of a particular title, and to all promotional materials. Simultaneous submissions OK. "After a project (children's books) photos can be used by photographer for portfolio."

Tips: Wants to see "real people in natural, real life situations. No distortion or special effects. Bright, clear images with jewel tones and rich colors. Keep in mind what would appeal to children. Be familiar with what the publishing company has already done. Listen to the needs of the company."

[N] PEANUT BUTTER PUBLISHING, Pier 55, Suite 301, 1101 Alaskan Way, Seattle WA 98101. (206)748-0345. Publisher: Elliott Wolf. Estab. 1971. Publishes cookbooks (primarily gourmet); restaurant guides; novels, children's books, assorted adult trade books. Photos used for promotional materials and book covers.

Needs: Buys 24-36 photos/year; offers up to 5 freelance assignments/year. "We are primarily interested in shots displaying a variety of foods in an appealing table or buffet setting. Good depth of field and harmonious color are important. We are also interested in cityscapes that capture one or another of a city's more pleasant aspects. No models." Reviews stock photos.

Making Contact & Terms: Arrange a personal interview to show portfolio. Query with samples or send unsolicited photos by mail for consideration. Uses 2¼ × 2¼ or 4 × 5 slides. SASE. Reports in 2 weeks. Pays $50-300/color photo. Credit line given. Buys one-time, exclusive product and all rights. Simultaneous submissions and previously published work OK.

PELICAN PUBLISHING CO., P.O. Box 3110, Gretna LA 70054. (504)368-1175. Fax: (504)368-1195. Production Manager: Tracey Clements. Publishes adult trade, juvenile, textbooks, how-to, cooking, fiction, travel, science and art books. Photos used for book covers. Examples of published titles: *Maverick Hawaii* (cover), *Maverick Berlin* and *Coffee Book*.

Needs: Buys 8 photos annually; offers 3 freelance assignments annually. Wants to see travel (international) shots of locations and people and cooking photos of food. Reviews stock photos of travel subjects. Model/property release required. Captions required.

Making Contact & Terms: Query with stock photo list. Provide résumé, business card, brochure, flier

or tearsheets to be kept on file for possible future assignments. Uses 8×10 glossy color prints; 35mm, 4×5 transparencies. Keeps samples on file. SASE. Reports as needed. Pays $100-500/color photo; negotiable with option for books as payment. **Pays on acceptance.** Credit line given. Buys one-time rights and book rights; negotiable.

Tips: "Be flexible on price. Keep publisher up on new materials."

PHOTOGRAPHER'S MARKET, 1507 Dana Ave., Cincinnati OH 45207. (513)531-2690, ext. 226. Fax: (513)531-7107. E-mail: photomarket@fwpubs.com. Photo guidelines free with SASE.

Needs: Publishes 35-40 photos per year. Uses general subject matter. Photos must be work sold to listings in *Photographer's Market*. Photos are used to illustrate to readers the various types of images being sold to photo buyers listed in the book. "We receive a lot of photos for our Publications section. Your chances of getting published are better if you can supply images for sections other than Publications." Look through this book for examples.

Making Contact & Terms: Submit photos for inside text usage in fall and winter to ensure sufficient time to review them by deadline (end of February). Be sure to include SASE for return of material. All photos are judged according to subject uniqueness in a given edition, as well as technical quality and composition within the market section in the book. Photos are held and reviewed at close of deadline. Uses color and b&w (b&w preferred) prints, any size and format; 5×7 or 8×10 preferred. Also uses tearsheets and transparencies, all sizes, color and b&w. Pays $50 plus complimentary copy of book. Pays when book goes to printer (June). Book forwarded in September upon arrival from printer. Credit line given. Buys second reprint and promotional rights. Simultaneous submissions OK. Work must be previously published.

Tips: "Send photos with brief cover letter describing the background of the sale. If sending more than one photo, make sure that photos are clearly identified. Slides should be enclosed in plastic slide sleeves, and prints should be reinforced with cardboard. Cannot return material if SASE is not included. Tearsheets will be considered disposable unless SASE is provided and return is requested. Because photos are printed in black and white on newsprint stock, some photos, especially color shots, may not reproduce well. Photos should have strong contrast and not too much fine detail that will fill in when photo is reduced to fit our small page format."

THE PHOTOGRAPHIC ARTS CENTER, 163 Amsterdam Ave., #201, New York NY 10023. (212)838-8640. Fax: (212)873-7065. Publisher: Robert S. Persky. Estab. 1980. Publishes books on photography and art, emphasizing the business aspects of being a photographer, artist and/or dealer. Photos used for book covers. Examples of recently published titles: *Publishing Your Art as Cards, Posters & Calendars* (cover illustration); *The Photographer's Complete Guide to Getting & Having an Exhibition*; and *Creating Successful Advertising* (text illustration).

Needs: Business of photography and art. Model release required.

Making Contact & Terms: Query with samples and text. Uses 5×7 glossy b&w or color prints; 35mm transparencies. SASE. Reports in 3 weeks. Pays $25-100/b&w and color photos. Credit line given. Buys one time rights.

Tips: Sees trend in book publishing toward "books advising photographers how to maximize use of their images by finding business niches such as gallery sales, stock and cards and posters." In freelancer's submissions, looks for "manuscript or detailed outline of manuscript with submission."

PLAYERS PRESS INC., P.O. Box 1132, Studio City CA 91614. Vice President: David Cole. Estab. 1965. Publishes entertainment books including theater, film and television. Photos used for text illustration, promotional materials, book covers and dust jackets. Examples of recently published titles: *Period Costume for Stage and Screen: Medieval-1500*; *Men's Garments 1830-1900*; and *Clown Tales*.

Needs: Buys 50-1,000 photos annually. Needs photos of entertainers, actors, directors, theaters, productions, actors in period costumes, scenic designs and clowns. Reviews stock photos. Model release required for actors, directors, productions/personalities. Photo captions preferred for names of principals and project/production.

Making Contact & Terms: Query with list of stock photo subjects. Send unsolicited photos by mail for consideration. Uses 8×10 glossy or matte b&w prints; 5×7 glossy color prints; 35mm, $2\frac{1}{4} \times 2\frac{1}{4}$ transparencies. Accepts images in digital format for Mac via CD or floppy disk. SASE. Reports in 3 weeks. Pays $100 maximum/color photo; $100 maximum/b&w photo. Credit line sometimes given, depending on book. Buys all rights; negotiable in "rare cases." Simultaneous submissions and previously published work OK.

Tips: Wants to see "photos relevant to the entertainment industry. Do not telephone; submit only what we ask for."

POLESTAR BOOK PUBLISHERS, P.O. Box 5238, Station B, Victoria, British Columbia V8R 6N4 Canada. (250)361-9718. Fax: (250)361-9738. E-mail: polestar@direct.ca. Publisher: Michelle Benjamin. Estab. 1981. Publishes sports, fiction, poetry, junior/YA fiction. Photos are used for book covers and dust jackets. Examples of recently published titles: *Cadillac Kind* (covers); *Long Shot* (text, illustration); and *Celebrating Excellence* (text and cover).
Needs: Buys 50 photos annually. Reviews stock photos of sports and general. Model/property release preferred.
Making Contact & Terms: Provide résumé, business card, brochure, flier or tearsheets to be kept on file for possible future assignments. Uses color and b&w prints; 35mm, 2¼ × 2¼ transparencies; digital format. Keeps samples on file. SAE and IRC. Pays $20-300/color photo; $20-100/b&w photo. Pays on publication. Credit line given. Buys book rights; negotiable. Simultaneous submissions and/or previously published work OK.

PRAKKEN PUBLICATIONS, INC., 3970 Varsity Dr., P.O. Box 8623, Ann Arbor MI 48107. (734)975-2800. Fax: (734)975-2787. Production & Design Manager: Sharon K. Miller. Estab. 1934. Publishes *The Education Digest* (magazine), *Tech Directions* (magazine for technology and vocational/technical educators), text and reference books for technology and vocational/technical education and general education reference. Photos used for text illustration, promotional materials, book covers, magazine covers and text. Examples of titles: *Managing the Occupational Education Laboratory* (text and marketing); and *Tech Directions* (covers and magazine). No photo guidelines available.
Needs: Education "in action" and especially technology and vocational-technical education. Photo captions necessary; scene location, activity.
Making Contact & Terms: Query with samples. Send unsolicited photos by mail for consideration. Uses any size image and all media. Keeps sample on file. SASE. Payment negotiable. Methods of payment to be arranged. Credit line given. Rights negotiable.
Tips: Wants to see "high-quality action shots in tech/voc-ed classrooms" when reviewing portfolios. Send inquiry with relevant samples to be kept on file. "We buy very few freelance photographs but would be dlighted to see something relevant."

PROSTAR PUBLICATIONS LTD., 13468 Beach Ave., Marina del Rey CA 90292. (310)577-1975. Fax: (310)577-9272. Editor: Peter L. Griffes. Estab. 1989. Publishes how-to, nonfiction. Photos used for book covers. Examples of published titles: *Pacific Boating Almanac* (aerial shots of marinas); and *Pacific Northwest Edition*. Photo guidelines free with SASE.
Needs: Buys less than 100 photos annually; offers very few freelance assignments annually. Reviews stock photos of nautical (sport). Model/property release required. Captions required.
Making Contact & Terms: Query with stock photo list. Uses color and b&w prints. Does not keep samples on file. SASE. Reports in 1 month. Pays $10-50/color or b&w photo. Pays on publication. Credit line given. Buys book rights; negotiable. Simultaneous submissions and previously published work OK.

THE QUARASAN GROUP, INC., 214 W. Huron, Chicago IL 60610-3616. (312)787-0750. Fax: (312)787-7154. E-mail: quarasan@aol.com. Photography Coordinator: Amy Cismoski. A complete book publishing service and design firm. Offers design of interiors and covers to complete editorial and production stages, art and photo procurement. Photos used in brochures, books and other print products.
Needs: Buys 1,000-5,000 photos/year; offers 75-100 assignments/year. "Most products we produce are educational in nature. The subject matter can vary. For textbook work, male-female/ethnic/handicapped/minorities balances must be maintained in the photos we select to ensure an accurate representation." Reviews stock photos and CD-ROMs. Model release required. Captions required.
Making Contact & Terms: Query with stock photo list or nonreturnable samples (photocopies OK). Provide résumé, business card, brochure, flier or tearsheets to be kept on file for possible future assignments. Prefers 8 × 10 b&w glossy prints; 35mm, 2¼ × 2¼, 4 × 5, or 8 × 10 transparencies, or b&w contact sheets. Cannot return material. "We contact once work/project requires photos." Payment based on final use size. Pays on a per photo basis or day rate. Credit line given, but may not always appear on page. Usually buys all rights or sometimes North American rights.
Tips: "Learn the industry. Analyze the products on the market to understand *why* those photos were chosen. Clients still prefer work-for-hire, but this is changing. We are always looking for experienced photo researchers and top-notch photographers local to the Chicago area."

REIDMORE BOOKS INC., 18228 102 St., Edmonton, Alberta T56 1S7 Canada. (403)424-4420. Fax: (403)441-9919. E-mail: reidmore@compusmart.ab.ca. Website: http://www.reidmore.com. Editor-in-Chief: Leah-Ann Lymer. Estab. 1979. Publishes social studies textbooks for K-12. Photos used for text illustration and book covers. Examples of recently published titles: *The Northern Circumpolar World*;

Japan: Its People and Culture, 2nd edition; and *Beginnings: From the First Nations to the Great Migration.* Photo guidelines available.

Needs: Buys 500 photos annually; offers 1-3 freelance assignments annually. Looking for Canadian photos of animals, geography, lifestyle/people, landmarks, attractions, sports/leisure and famous Canadians. "Photo depends on the project, however, images should contain unposed action." Reviews stock photos. Model release required; property release preferred. Captions required; "include scene description and photographer's control number."

Making Contact & Terms: Query with résumé of credits. Query with samples. Query with stock photo list. Provide résumé, business card, brochure, flier or tearsheets to be kept on file for possible future assignments. Art director will contact photographer for portfolio review if interested. Portfolio should include color prints and slides. Uses color prints and 35mm transparencies. Accepts images in digital format for Mac (Photoshop, Illustrator, QuarkXPress) on CD-ROM. "Photographers can e-mail compacted scans or we can download their scans off their website (300 dpi). Keeps samples of tearsheets, etc. on file. Cannot return material. Reports in 1 month. Pays $75-150/color cover; $50-75/b&w inside; $75/100 for color inside. Payment for electronic usage is negotiable. Pays on publication. Credit line given. Buys one-time rights and book rights; negotiable. Simultaneous submissions and previously published work OK.

Tips: "I look for unposed images which show lots of action. Please be patient when you submit images for a project. The editorial process can take a long time and it is in your favor if your images are at hand when last minute changes are made."

REIMAN PUBLICATIONS, L.P., 5400 S. 60th St., Greendale WI 53129. (414)423-0100. Fax: (414)423-8463. Photo Coordinator: Trudi Bellin. Estab. 1965. Publishes adult trade—cooking, people-interest, country themes. Examples of recently published titles: *This Old Barn* (covers, text illustration); *A Day in the Life of the Amish* (covers, text illustration); and *Tough Times, Strong Women* (covers, text illustration).

Needs: Buys "hundreds" of photos/annually. Looking for vintage color photos; nostalgic b&w photos, and colorful, sharp-focus agricultural, scenic and backyard beauty photos. Reviews stock photos of nostalgia, agriculture, rural, scenics, birds, flowers and flower gardens. Model/property release required for children and private homes. Photo captions preferred; include season, location, era (when appropriate).

Making Contact & Terms: Query with résumé of credits. Query with stock photo list. Send unsolicited photos by mail for consideration. Uses color and b&w prints; 35mm, 2¼×2¼, 4×5, 8×10 transparencies. Keeps samples on file ("tearsheets; no duplicates"). SASE. Reports in 3 months for first review. Pays $75-300/color photo; $25-100/b&w photo. Pays on publication. Credit line given. Buys one-time rights. Simultaneous submissions and previously published work OK.

Tips: "Our nostalgic books need authentic color taken in the '40s, '50s, and '60s and b&w stock photos. All projects require technical quality: focus must be sharp, no soft focus; colors must be vivid so they 'pop off the page.'"

SILVER MOON PRESS, 160 Fifth Ave., Suite 622, New York NY 10010. (212)242-6499. Fax: (212)242-6799. Editor: David Katz. Estab. 1991. Publishes juvenile fiction and general nonfiction. Photos used for text illustration, book covers, dust jackets. Examples of published titles: *Police Lab* (interiors); *Drums at Saratoga* (interiors); *A World of Holidays* (interiors).

Needs: Buys 5-10 photos annually; offers 1 freelance assignment annually. Looking for general-children, subject-specific photos. Reviews general stock photos. Captions preferred.

Making Contact & Terms: No samples. Provide résumé, business card, brochure, flier or tearsheets to be kept on file for possible future assignments. Uses vary greatly. Keeps samples on file. SASE. Reports in 1 month. Pays $25-100/b&w photo. Pays on publication. Credit line given. Buys all rights; negotiable. Simultaneous submissions and/or previously published works OK.

N: SKYLIGHT TRAINING AND PUBLISHING INC., Simon & Schuster, 2626 S. Clearbrook Dr., Arlington Heights IL 60005. (847)290-6600. Fax: (847)290-6609. E-mail: info@irisskylight.com. Website: http://www.irisskylight.com. Production Supervisor: Bob Crump. Estab. 1976. Publishes trade paperback originals, textbooks.

Making Contact & Terms: Buys one-time rights.

Tips: "Follow directions and when submitting work show all the blocks of a shot."

THE SPEECH BIN INC., 1965 25th Ave., Vero Beach FL 32960. (561)770-0007. Fax: (561)770-0006. Senior Editor: Jan J. Binney. Estab. 1984. Publishes textbooks and instructional materials for occupational and physical therapists, speech-language pathologists, audiologists and special educators. Photos used for book covers, instructional materials and catalogs. Example of published title: *Talking Time* (cover); also catalogs.

Needs: Scenics are currently most needed photos. Also needs children; children with adults; school scenes;

elderly adults; handicapped persons of all ages. Model release required.

Making Contact & Terms: Provide résumé, business card, brochure, flier or tearsheets to be kept on file for possible future assignments. Works on assignment plus purchases stock photos from time to time. Uses 8 × 10 glossy b&w prints. Full-color scenics for catalog. SASE. Reports in 3 weeks. Payment negotiable. Credit line given. Buys all rights; negotiable. Previously published work OK.

Tips: "When presenting your work, select brightly colored eye-catching photos."

SPINSTERS INK, 3201 Columbus Ave. S., Minneapolis MN 55407-2030. (612)827-6177. Fax: (612)827-4417. E-mail: liz@spinsters-ink.com. Website: http://www.spinsters-ink.com. Production Manager: Liz Tufte. Estab. 1978. Publishes feminist books by women. Photos used for book covers. Example of recently published titles: *Give Me Your Good Ear* (cover); and *The Activist's Daughter* (cover). Photo guidelines free on request.

Needs: Buys 1 photo annually; offers 6 freelance assignments annually. Wants positive images of women in all their diversity. "We work with photos of women by women." Model release required. Captions preferred.

Making Contact & Terms: Query with samples. Works with freelancers on assignment only. Uses 5 × 7, 8 × 10 color or b&w prints; 4 × 5 transparencies; Macintosh disk; 100mb Zip disk; photo CD. Keeps samples on file. SASE. Reports in 3 weeks. Pays $150-250/job. **Pays on acceptance.** Credit line given. Buys book rights; negotiable. Simultaneous submissions OK.

Tips: "Spinsters Ink books are produced electronically, so we prefer to receive a print as well as a digital image when we accept a job. Please ask for guidelines before sending art."

STAR PUBLISHING COMPANY, 940 Emmett Ave., Belmont CA 94002. (415)591-3505. Fax: (415)591-3898. E-mail: hoffman@starpublishing.com. Website: http://www.starpublishing.com. Managing Editor: Stuart Hoffman. Estab. 1978. Publishes textbooks, regional history, professional reference books. Photos used for text illustration, promotional materials and book covers. Examples of recently published titles: *Applied Food Microbiology* and *Medical Mycology*.

Needs: Biological illustrations, photomicrographs, business, industry and commerce. Reviews stock photos. Model release required. Captions required.

Making Contact & Terms: Query with samples and list of stock photo subjects. Provide résumé, business card, brochure, flier or tearsheets to be kept on file for possible future assignments. Uses 5 × 7 minimum b&w and color prints; 35mm transparencies. SASE. Reports within 90 days when a response is appropriate. Payment negotiable "depending on publication, placement and exclusivity." Credit line given. Buys one-time rights; negotiable. Previously published submissions OK.

Tips: Wants to see photos that are technically (according to book's subject) correct, showing photographic excellence.

STRANG COMMUNICATIONS COMPANY, 600 Rinehart Rd., Lake Mary FL 32746. (407)333-0600. Fax: (407)333-7100. E-mail: markp@strang.mhs.compuserve.com. Design Assistant: Sally J. Perez. Estab. 1975. Publishes religious magazines and books for Sunday School and general readership. Photos used for text illustration, promotional materials, book covers and dust jackets. Examples of recently published titles: *Charisma Magazine*; *New Man Magazine*; *Ministries Today Magazine*; and *Vida Cristiana* (all editorial, cover). Photo guidelines free with SASE.

Needs: Buys 50-75 photos annually; offers 50-75 freelance assignments annually. People, environmental portraits, situations. Reviews stock photos. Model/property release preferred for all subjects. Captions preferred; include who, what, when, where.

Making Contact & Terms: Arrange personal interview to show portfolio or call and arrange to send portfolio. Query with samples. Provide résumé, business card, brochure, flier or tearsheets to be kept on file for possible future assignments. Works with freelancers on assignment only. Uses 8 × 10 prints; 35mm, 2¼ × 2¼, 4 × 5 transparencies. Accepts photographs in digital format for Mac (PhotoShop). Send via compact disc, Online, floppy disk, SyQuest or Zip disk. Keeps samples on file. SASE. Pays $5-75/b&w photo; $50-550/color photo; negotiable with each photographer. Pays on publication and receipt of invoice. Credit line given. Buys one-time, first-time, book, electronic and all rights; negotiable. Simultaneous submissions and previously published work OK. Offers internships for photographers. Contact Design Manager: Mark Poulalion.

THE INTERNATIONAL MARKETS INDEX, located in the back of this book, lists markets located outside the U.S. by country.

Tips: "Be flexible. Listen to the needs of the client and cultivate a long-term relationship."

THISTLEDOWN PRESS LTD., 633 Main St., Saskatoon, Saskatchewan S7H 0J8 Canada. (306)244-1722. Fax: (306)244-1762. Director of Production: A.M. Forrie. Publishes adult/young adult fiction and poetry. Photos used for text illustration, promotional materials, book covers.
Needs: Looking for realistic color or b&w photos.
Making Contact & Terms: Query with samples. Include SAE and IRCs. "Project oriented—rates negotiable."

THORSON & ASSOCIATES, P.O. Box 94135, Washington MI 48094. (810)781-0907. New Product Development: Timothy D. Thorson. Estab. 1988. Technical publisher and book producer creating trade and specialized projects for a variety of clients.
 • This publisher is very interested in photographers with multimedia experience such as CD-ROM, Macromedia Director, etc.
Needs: Offers 2-3 freelance assignments annually. Needs aviation/military, automotive and architectural subjects. Reviews stock photos of aviation/military, automotive, architecture and the arts. Captions preferred; include subject, location, rights offered.
Making Contact & Terms: Query with stock photo list. Provide résumé, business card, brochure, flier or tearsheets to be kept on file for possible future assignments. Works on assignment only. Keeps samples on file. SASE. Reports in 1 month. Payment negotiable. Pays on usage. Credit line sometimes given depending upon customer. Rights vary based on project; negotiable.
Tips: "We need reliable, self-motivated photographers to provide photos for assigned books in a wide range of fields. Thorson & Associates is also open to original book proposals suggested by a photographer's work or experience; special access to museums or collections, collections of old aircraft, military equipment, classic automobiles, or significant historical buildings. I anticipate a considerable increase in our needs over the next 12-24 months."

TITAN MAGAZINES/BOOKS, 42-44 Dolben St., London SE1 0UP England. (0171)620-0200. Fax: (0171)620-0032. E-mail: 101 447.2455. Art Director: Chris Teather. Estab. 1976. Publishes trade paperback original and reprint. Subjects include Star Trek, Babylon 5, Star Wars, general science fiction related film and TV, X-Files, horror films, Simpsons. Photos used for book covers, dust jackets. Examples of recently published titles: *Star Trek Magazine* (front cover).
Needs: Star Trek and Babylon 5 character shots, cast members in uniform to be used on our magazine covers.
Making Contact & Terms: Send query letter with samples. To show portfolio, photographer should follow-up with call. Uses 35mm, 2¼×2¼, 4×5 transparencies. Keeps samples on file. SASE. Payment negotiable. Pays on publication. Buys one-time rights. Previously published work OK.

TRAKKER MAPS INC., 12027 SW 117th Ct., Miami FL 33186. (305)255-4485. Fax: (305)232-5257. Production Manager: Oscar Darias. Estab. 1980. Publishes street atlases and folding maps. Photos used for covers of folding maps and atlas books. Examples of recently published titles: *Florida Folding Map* (cover illustration).
Needs: Buys 3 photos annually. Looking for photos that illustrate the lifestyle/atmosphere of a city or region (beach, swamp, skyline, etc.). Reviews stock photos of Florida cities.
Making Contact & Terms: Provide résumé, business card, brochure, flier or tearsheets to be kept on file for possible future assignments. Uses color prints; 35mm, 2¼×2¼ transparencies. Keeps samples on file. SASE. Reports in 1 month. Pays $50-200/color photo. **Pays on receipt of invoice.** Credit line sometimes given depending upon request of photographer. Buys all rights. Simultaneous submissions and previously published work OK.
Tips: "We want to see "clarity at 4×4½″ (always vertical) and 6×8″ (always horizontal); colors that complement our red-and-yellow cover style; subjects that give a sense of place for Florida's beautiful cities; scenes that draw customers to them and make them want to visit those cities and, naturally, buy one of our maps or atlases to help them navigate. Have patience. We buy few freelance photos but we do buy them. Let your photos do your talking for you; don't hassle us. *Listen* to what we ask for. More and more, we want eye-grabbing shots that *say* the name of the city. For example, a photo of a polo match on the cover of the West Palm Beach folding map says 'West Palm Beach'' better than a photo of palm trees or flamingos."

TRUTH CONSCIOUSNESS/DESERT ASHRAM, 3403 W. Sweetwater Dr., Tucson AZ 85745-9301. (520)743-8821. Editor: Sita Stuhlmiller. Estab. 1974. Publishes books and a periodical, *Light of Consciousness, A Journal of Spiritual Awakening.*

Needs: Buys/assigns about 45 photos annually. Looking for people in prayer or meditation, "universal spiritual, all traditions that in some way illustrate or evoke upliftment, reverence, devotion or other spiritual qualities." Art is used that relates to or supports a particular article.

Making Contact & Terms: Send b&w and color slides, cards, prints. Include self-addressed, stamped mailer for return of work. Payment negotiable; prefers gratis. Model release preferred. Captions preferred. Accepts images in digital format for Mac in Photoshop. Send via CD, SyQuest, Zip disk or floppy disk at 300 dpi, 150 linescreen. Credit line given; also, artist's name/address/phone (if wished) printed in separate section in magazine.

Tips: "Keep our guideliens in mind. (Your work) needs an inspiring element."

N: TUTTLE PUBLISHING, Imprint of Periplus Editions, 153 Milk St., 5th Floor, Boston MA 02109. Fax: (617)951-4045. Estab. 1953 in Japan; 1991 in US. Publishes hardcover originals and reprints; trade paperback originals and reprints. Subjects include cooking, martial arts, alternative health, Eastern religion and philosophy, spirituality. Photos used for text illustrations, promotional materials, book covers, dust jackets. Examples of recently published titles: *Food of Jamaica* (text illustration); *Food of Santa Fe* (text illustration); *An Accidental Office Lady* (cover).

Needs: Buys 50 freelance photos annually. Model release preferred; property release preferred. Photo caption required, include location, description and some additional information-color.

Marketing Contact & Terms: Provide résumé, business card, self-promotion piece or tearsheets to be kept on file for possible future assignments. "No calls please." Art director will contact photographer for portfolio review if interested. Portfolio should include color tearsheets. Uses 35mm, 2¼×2¼, 4×5, 8×10 transparencies. Keeps samples on file. Reports back only if interested, send non-returnable samples. Payment varies. Buys one-time rights, all rights. Simultaneous submissions and previously published work OK.

Tips: "For our regional cookbooks we look for exciting photos that reveal insider familiarity with the place. We are always looking for new interpretations of 'East meets West.' "

2M COMMUNICATIONS LTD., 121 W. 27 St., New York NY 10001. (212)741-1509. Fax: (212)691-4460. President: Madeleine Morel. Estab. 1982. Publishes adult trade biographies. Photos used for text illustration. Examples of previously published titles: *Diane Keaton, Magic and the Bird* and *The Princess and the Duchess;* all for text illustration.

Needs: Buys approximately 200 photos annually. Candids and publicity. Reviews stock photos. Model release required. Captions preferred.

Making Contact & Terms: Query with stock photo list. Uses b&w prints; 35mm transparencies. Reports in 1 month. Payment negotiable. Credit line given. Buys one-time, book and world English language rights. Simultaneous submissions OK.

ULYSSES PRESS, P.O. Box 3440, Berkeley CA 94703. (510)601-8301. Fax: (510)601-8307. Publisher: Leslie Henriques. Estab. 1983. Publishes trade paperbacks, including travel guidebooks and health books. Photos used for book covers. Examples of previously published titles: *Hidden Hawaii* (cover photos on front and back); *New Key to Costa Rica* (color signature) and *Hidden Southwest* (cover photos).

Needs: Buys hundreds of photos annually. Wants scenic photographs of destinations covered in guidebooks and covers for health books. Some use of portraits for back cover. Model release required. Property release preferred.

Making Contact & Terms: Query with stock photo list. Provide résumé, business card, brochure, flier or tearsheets to be kept on file for possible future assignments. Uses 35mm, 2¼×2¼ transparencies. Accepts images in digital format for Windows. Send via compact disc or Zip disk. Does not keep samples on file. Cannot return material. Reports as needed. Payment depends on placement and size of photo: $150-350 non-agency color photo. Pays on publication. Credit line given. Buys one-time rights. Simultaneous submissions and previously published work OK.

U.S. NAVAL INSTITUTE PRESS, 118 Maryland Ave., Annapolis MD 21402. (410)268-6110. Fax: (410)269-7940. Contact: Photo Editor. Estab. 1873. Publishes naval and maritime subjects, novels. Photos used for text illustration, promotional materials, book covers and dust jackets. Examples of published titles: *The Hunt for Red October* (book cover); *The U.S.N.I. Guide to Combat Fleet* (70% photos); and *A Year at the U.S. Naval Academy* (tabletop picture book). Photo guidelines free with SASE.

Needs: Buys 240 photos annually; offers 12 freelance assignments annually. "We need dynamic cover-type images that are graphic and illustrative." Reviews stock photos. Model release preferred. Captions required.

Making Contact & Terms: Query with résumé of credits. Uses 8×10 glossy color and b&w prints; 35mm, 2¼×2¼, 4×5, 8×10 transparencies. Keeps samples on file. SASE. Reports in 1 month. Pays

$25-200/color and b&w photos. Pays on publication or receipt of invoice. Credit line given. Buys one-time rights; negotiable. Simultaneous submissions and previously published work OK.
Tips: "Be familiar with publications *Proceedings* and *Naval History* published by U.S. Naval Institute."

UNIVELT, INC., P.O. Box 28130, San Diego CA 92198. (760)746-4005. Fax: (760)746-3139. Website: http://www.univelt.staigerland.com. Manager: Robert H. Jacobs. Estab. 1970. Publishes technical books on astronautics. Photos used for text illustration, book covers and dust jackets. Examples of recently published titles: *History of Rocketry and Astronautics* and *Strategies for Mars: A Guide to Human Exploration*.
Needs: Uses astronautics; most interested in photographer's concept of space, and photos depicting space flight and related areas. Reviews stock photos; space related only. Captions required.
Making Contact & Terms: Generally does not use freelance photos. Call before submitting. Uses 6×9 or $4\frac{1}{2} \times 6$ b&w photos. Reports in 1 month. Pays $25-100/b&w photo. Credit line given, if desired. Buys one-time rights. Simultaneous submissions and previously published work OK.
Tips: "Photos should be suitable for front cover or frontispiece of space books."

VERNON PUBLICATIONS INC., 3000 Northup Way, Suite 200, Bellevue WA 98004. Fax: (206)822-9372. Editorial Director: Michele A. Dill. Estab. 1960. Publishes travel guides, a travel magazine for RVers, relocation guides, homeowner guides. Photos used for text illustration, promotional materials and book covers. Examples of published titles: *The Milepost*; *RV West* (magazine); and *Info Guide* (annual guide). Photo guidelines free with SASE, specify which publication you want guidelines for.
● This publisher likes to see high-resolution, digital images.
Needs: Buys 200-300 photos annually. Model release required. Property release preferred. Captions required; include place, time, subject, and any background information.
Making Contact & Terms: Query with samples. "Tearsheets or duplicates are fine for queries. Don't send originals." Provide résumé, business card, brochure, flier or tearsheets to be kept on file for possible future assignments. Include SASE for return. Uses b&w prints; 35mm, $2\frac{1}{4} \times 2\frac{1}{4}$ transparencies. SASE. Reporting time varies. Payment negotiable. Pays on publication. Credit line given. Buys one-time, book and all rights; negotiable. Simultaneous submissions and previously published work OK; however, it depends on where the images were previously published.

VICTORY PRODUCTIONS, 581 Pleasant St., Paxton MA 01612. (508)755-0051. Fax: (508)755-0025. E-mail: Victory@VictoryPrd.com. Website: http://wwwVictoryPrd.com. Contact: S. Littlewood. Publishes children's books. Examples of recently published titles: a children's reference book (36mm, $4\frac{1}{4}$ and 4×5); and a 6-volume encyclopedia (36mm).
Needs: Children and animals. Model/property release required.
Making Contact & Terms: Provide résumé, business card, brochure, flier or tearsheets to be kept on file for possible future assignments. Works on assignment only. Accepts images in digital format for Mac. Send via compact disc, Online, floppy disk, SyQuest or Zip disk. Keeps samples on file. Reports in 1-2 weeks. Payment negotiable; varies by project. Credit line usually given, depending upon project. Rights negotiable.

N VINTAGE BOOKS, Random House, 23-1 201 E. 50th St., New York NY 10022. (212)572-4973. Fax: (212)940-7676. E-mail: lhanifin@randomhouse.com. Publishes trade paperback reprint; fiction. Photos used for book covers. Examples of recently published titles: *Selected Stories*, by Alice Munro (cover); *The Fight*, by Norman Mailer (cover); *Bad Boy*, by Thompson (cover).
Needs: Buys 100 freelance photos annually. Model/property release required. Photo captions preferred.
Making Contact & Terms: Send query letter with samples, stock photo list. Portfolios may be dropped off every Wednesday. To show portfolio, photographer should follow-up with call. Art director will contact photographer for portfolio review if interested. Keeps samples on file. Reports back only if interested, send non-returnable samples. Pays by the project, per use negotiation. Pays on publication. Credit line given. Buys one-time rights, first North American serial rights.
Tips: "Show what you love. Include samples with name, address and phone number."

VOYAGEUR PRESS, 123 N. Second St., Stillwater MN 55082. Fax: (612)430-2211. E-mail: tberger@voyageurpress.com. Acquisitions Editor: Todd R. Berger. Estab. 1972. Publishes adult trade books, hardcover originals and hardcover reprints. Subjects include travel, wildlife, Americana, collectibles, dogs, cats, farms, hunting, fishing and cooking. Photos used for text illustration, book covers, dust jackets, calendars. Examples of recently published titles: *Love of Labs* (interior/cover); *This Old Tractor* (interior/cover); and *Classic Freshwater Fish Cooking* (interior/cover). Photo guidelines free with SASE.
Needs: Buys 700 photos annually. Primarily wildlife, specific dog breeds and large game animals. Artistic

angle is crucial—books often emphasize high-quality photos. Model release required. Captions preferred; include location, species, interesting nuggets, depending on situation.

Making Contact & Terms: Query with résumé of credits, samples, brochure, detailed stock list or tearsheets. Provide résumé, business card, brochure, flier or tearsheets to be kept on file for possible future assignments. Uses 35mm, 2¼×2¼, 4×5, some 8×10 transparencies. Accepts images in digital format on CD-ROM. Keeps samples on file. Cannot return materials. Reports back only if interested; send nonreturnable samples. Payment negotiable. Pays on publication. Credit line given. Buys all rights; negotiable. Considers simultaneous submissions.

Tips: "We are often looking for specific material (crocodile in the Florida Keys; farm scenics in the Southwest; wolf research in Yellowstone) so subject matter is important. But outstanding color and angles, interesting patterns and perspectives, are strongly preferred whenever possible. If you have the capability and stock to put together an entire book, your chances with us are much better. Though we use some freelance material, we publish many more single-photographer works. Include detailed captioning info on the mounts."

N J. WESTON WALCH, PUBLISHER, 321 Valley St., P.O. Box 658, Portland ME 04104-0658. (207)772-2846. Fax: (207)772-3105. Contact: Art Acquisitions. Estab. 1927. Publishes supplementary educational materials for grades 6-12 and adult education. All subject areas. Photos used for text illustration, promotional materials and book covers. Examples of recently published titles: *Focus on U.S. History* series (interior maps, photos, line art); *Hands-on Culture* series (cover photos, text illustrations); *World Records* posters (photography).

Needs: Buys 30-40 or more photos/year; varies widely. Offers up to 5 freelance assignments annually. Black and white and color photos of middle school and high school students, ethnically diverse, in-school, library or real-life situations, historical photos, current events photos, special needs students and chemistry, ecology and biology. Reviews stock photos. Model release required. Captions preferred.

Making Contact & Terms: Query with samples. Query with stock photo list. Provide résumé, business card, brochure, flier or tearsheets to be kept on file for possible future assignments. Uses 8×10 glossy b&w prints; also 35mm, 2¼×2¼, 4×5 and 8×10 transparencies. SASE. Pays $35-100/b&w; $100-500/ color photo. Credit line sometimes given depending on photographer's request. Buys one-time rights.

Tips: One trend with this company is a "growing use of b&w and color photos for book covers." Especially wants to see "subjects/styles suitable for use in secondary schools."

WAVELAND PRESS, INC., P.O. Box 400, Prospect Heights IL 60070. (847)634-0081. Fax: (847)634-9501. Photo Editor: Jan Weissman. Estab. 1975. Publishes college textbooks. Photos used for text illustration and book covers. Examples of published titles: *Our Global Environment*, Fourth Edition (inside text); *Africa & Africans*, Fourth Edition (chapter openers and cover); and *Principles of Agribusiness Management*, Second Edition (chapter openers).

Needs: Number of photos purchased varies depending on type of project and subject matter. Subject matter should relate to college disciplines: criminal justice, anthropology, speech/communication, sociology, archaeology, etc. Model/property release required. Captions preferred.

Making Contact & Terms: Query with stock photo list. Provide résumé, business card, brochure, flier or tearsheets to be kept on file for possible future assignments. Uses 5×7, 8×10 glossy b&w prints. Keeps samples on file. SASE. Reports in 2-4 weeks. Pays $25-200/color photo; $25-100/b&w photo. Pays on publication. Credit line given. Buys one-time and book rights. Simultaneous submissions and previously published work OK.

WEIGL EDUCATIONAL PUBLISHERS LIMITED, 1902 11th St. SE, Calgary, Alberta T2G 3G2 Canada. Fax: (403)233-7769. E-mail: weigl@mail.telusplanet.net. Website: http://www.weigl.com. Attention: Editorial Department. Estab. 1979. Publishes textbooks, library and multimedia resources: social studies, biography, life skills, environment/science studies, multicultural, language arts and geography. Photos used for text illustration and book covers. Example of published titles: *Women in Profile Series* (cover and inside); *Early Canada Revised* (cover and inside); *The Untamed World Series* (cover and inside).

Needs: Buys 200-300 photos annually. Social issues and events, politics, education, technology, people gatherings, multicultural, environment, science, agriculture, life skills, landscape, wildlife, biography and people doing daily activities. Reviews stock photos. Model/property release required. Captions required.

Making Contact & Terms: Query with samples. Query with stock photo list. Provide tearsheets to be kept on file for possible future assignments. Tearsheets or samples that don't have to be returned are best. Keeps samples on file. Uses 5×7, 3×5, 4×6, 8×10 color/b&w prints; 35mm, 2¼×2¼ transparencies. SASE. "We generally get in touch when we actually need photos." Payment is negotiable. Credit line given (photo credits as appendix). Buys one-time, book and all rights; negotiable. Simultaneous submissions and previously published work OK.

Tips: Needs "clear, well-framed shots that don't look posed. Action, expression, multicultural representation are important, but above all, education value is sought. People must know what they are looking at. Please keep notes on what is taking place, where and when. As an educational publisher, our books use specific examples as well as general illustrations."

SAMUEL WEISER INC., P.O. Box 612, York Beach ME 03910-0612. Fax: (207)363-5799. E-mail: weiserbooks@worldnet.att.net. Vice President: B. Lundsted. Estab. 1956. Publishes books on esoterica, Oriental philosophy, alternative health and mystery traditions. Photos used for book covers. Examples of published titles: *Modern Mysticism*, by Micheal Gellert (Nicolas Hays imprint); *Foundations of Personality*, by Hamaker-Zondag. Photo guidelines free with SASE.
Needs: Buys 2-6 photos annually. Needs photos of flowers, abstracts (such as sky, paths, roads, sunsets) and inspirational themes. Reviews stock photos.
Making Contact & Terms: Query with samples. Query with stock photo list. Send unsolicited photos by mail for consideration. Provide résumé, business card, brochure, flier or tearsheets to be kept on file for possible future assignments. "We'll take color snapshots to keep on file, or color copies." Accepts images in digital format for Mac. Send via compact disc, floppy disc, SyQuest or Zip disk. Keeps samples on file. Uses color prints. SASE. Reports in 1 month. Pays $100/b&w and $150-200/color. Credit line given. Buys one-time rights. "We pay once for life of book because we do small runs." Simultaneous submissions and previously published work OK.
Tips: "We don't pay much and we don't ask a lot. We have to keep material on file or we won't use it. Color photocopies, cheap Kodak prints, something that shows us an image that we assume is pristine on a slide and we can call you or fax you for it. We do credit line on back cover, and on copyright page of book, in order to help artist/photographer get publicity. We like to keep inexpensive proofs because we may see a nice photo and not have anything to use it on now. We search our files for covers, usually on tight deadline. We don't want to see goblins and Halloween costumes."

WISCONSIN TRAILS BOOKS, P.O. Box 5650, Madison WI 53705. (608)231-2444. Photo Editor: Nancy Mead. Estab. 1960. Publishes adult nonfiction, guide books and photo essays. Photos used for text illustration and book covers. Examples of titles: *Ah Wisconsin* (all photographs) and *Best Wisconsin Bike Trips* (cover and ⅓ inside-photos). Photo guidelines free on request with SASE.
Needs: Buys many photos and gives large number of freelance assignments annually. Wisconsin nature and historic scenes and activities. Captions preferred, include location information.
Making Contact & Terms: Query with samples or stock photo list. Send unsolicited photos by mail for consideration. Provide résumé to be kept on file for possible assignments. Uses 5×7 or 8×10 b&w prints and any size transparencies. SASE. Reports in 1 month. Pays $25-100/b&w photo; $50-200/color photo. Credit line given. Buys one-time rights. Simultaneous submissions and previously published work OK.
Tips: "See our products and know the types of photos we use."

WORD PUBLISHING, P.O. Box 141000, Nashville TN 37214. Executive Art Director: Tom Williams. Estab. 1951. Publishes Christian books. Photos used for book covers, publicity, brochures, posters and product advertising. Examples of recently published titles: *The Great House of God*, by Max Lucado; *Angels*, by Billy Graham; and *The MacArthur Study Bible*. Photos used for covers. "We do not provide want lists or photographer's guidelines."
Needs: Needs photos of people, studio shots and special effects. Model release required; property release preferred.
Making Contact & Terms: Provide brochure, flier or tearsheets to be kept on file for possible future assignments. "Please don't call." SASE. Reports in 1 month. Assignment photo prices determined by the job. Pays $350-1,000 for stock. Credit line given. Rights negotiable.
Tips: In portfolio or samples, looking for strikingly lighted shots, good composition, clarity of subject. Something unique and unpredictable. "We use the same kinds of photos as the secular market. I don't need crosses, church windows, steeples, or wheat waving in the sunset. Don't send just a letter. Give me something to look at, not to read about." Opportunity is quite limited: "We have hundreds of photographers on file, and we use about 5% of them."

WUERZ PUBLISHING LTD., 895 McMillan Ave., Winnipeg, Manitoba R3M 0T2 Canada. (204)956-0308. Fax: (204)956-5053. Director: Steve Wuerz. Estab. 1989. Publishes university-level science

CONTACT THE EDITOR, of *Photographer's Market* by e-mail at photomarket@fwpubs.com with your questions and comments.

textbooks, especially in environmental sciences (chemistry, physics and biology). Photos used for text illustration, book covers to accompany textbooks in diskettes or CD-ROM materials. Examples of published titles: *Mathematical Biology*; *Energy Physics & the Environment*; and *Environmental Chemistry* (all cover and text illustration). Photo guidelines free with SASE.

Needs: Buys more than 100 photos annually; offers 4 assignments with research combined. Reviews stock photos. Model/property release "as appropriate." Captions required; include location, scale, genus/species.

Making Contact & Terms: Query with résumé of credits. Query with samples. Query with stock photo list. Provide résumé, business card, brochure, flier or tearsheets to be kept on file for possible future assignments. Works on assignment only. SAE and IRCs. Reports usually in 1 month. Payment negotiable. Credit line given. Buys book rights. Simultaneous submissions and previously published work OK.

Tips: "In all cases, the scientific principle or the instrument being displayed must be clearly shown in the photo. In the past we have used photos of smog in Los Angeles and Denver, tree frogs from Amazonia, wind turbines from California, a plasma reactor at Harwell United Kingdom, fireworks over London, and about 50 different viruses. Summarize your capabilities. Summarize your collection of 'stock' photos, preferably with quantities. Outline your 'knowledge level,' or how your collection is organized, so that searches will yield answers in reasonable time."

ZOLAND BOOKS, 384 Huron Ave., Cambridge MA 02138. Design Director: Lori K. Pease. Publishes adult trade, some juvenile, mostly fiction, some photography, poetry. Photos used for book covers and dust jackets. Examples of recently published titles: *Blanket Knowledge* and *Human Rights* (both covers). Photo guidelines and catalog free with 5×8 SASE.

Needs: Buys 3-5 photos annually; offers 3-5 freelance assignments annually. Subject matter varies greatly with each book.

Making Contact & Terms: Query with samples. Provide résumé, business card, brochure, flier or tearsheets to be kept on file for possible future assignments. Mostly works with freelancers. Use 4×5 glossy, b&w prints; 2¼×2¼, 4×5 transparencies. Accepts images in digital format for Mac. Send via SyQuest. Keeps samples on file. SASE. Reports in 1-2 months. Payment negotiable. **Pays on acceptance**. Credit line given. Rights vary with project; negotiable. Simultaneous submissions and previously published work OK.

Tips: "Please keep in mind we are a literary book publisher distributed to the book trade."

Gift & Paper Products

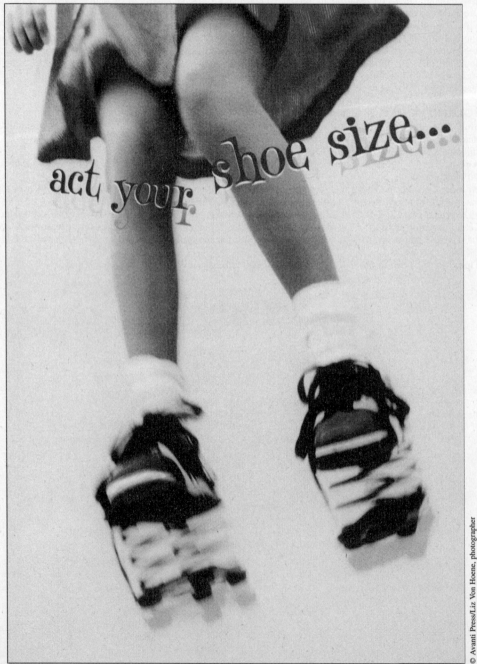

act your shoe size...

GREETING CARDS AND BEYOND

The greeting card industry takes in close to $7 billion a year—80 percent through giants American Greetings, Gibson Greetings and Hallmark Cards. Naturally, the "big three" are difficult companies to break into, but there is plenty of room for photo sales to smaller companies.

There are more than 1,800 greeting card companies in the United States, many of which produce low-priced cards that fill a niche in the market, focusing on anything from the cute to the risqué to seasonal topics. A number of listings in this section produce items like calendars, mugs and posters, as well as greeting cards.

Before approaching greeting card, poster or calendar companies, it's important to research the industry to see what's being bought and sold. Start by checking out card, gift and specialty stores that carry greeting cards and posters. Pay attention to the selections of calendars, especially the large seasonal displays during December. Studying what you see on store shelves will give you an idea of what types of photos are marketable.

There is also a greeting card industry publication available. The Greeting Card Association debuted *Greetings Today* in July, 1997. This publication for marketers, publishers, designers and retailers of greeting cards offers industry news, and information on trends, new products and trade shows.

APPROACHING THE MARKET

After your initial research, query companies you are interested in working with and send a stock photo list. You can help narrow your search by consulting our newly expanded Subject Index, now including Paper Products. Check the index for companies interested in the topics you shoot.

Since these companies receive large volumes of submissions, they often appreciate knowing what is available rather than actually receiving samples. This kind of query can lead to future sales even if your stock inventory doesn't meet their immediate needs. Buyers know they can request additional submissions as their needs change. Some listings in this section advise sending quality samples along with your query while others specifically request only a list. As you plan your queries, follow their instructions. It will help you establish a better rapport with companies from the start.

Some larger companies have staff photographers for routine assignments, but also look for freelance images. Usually, this is in the form of stock, and images are especially desirable if they are of unusual subject matter or remote scenic areas for which assignments—even to staff shooters—would be too costly. Freelancers are usually offered assignments once they have established track records and demonstrated a flair for certain techniques, subject matter or locations. Smaller companies are more receptive to working with freelancers, though they are less likely to assign work because of smaller budgets for photography.

The pay in this market can be quite lucrative if you provide the right image at the right time for a client in need of it, or if you develop a working relationship with one or a few of the better

◄ This card from the Avanti Press *4U* line showcases the sophisticated, romantic approach of these greeting cards. Using the creatively cropped image of a little girl jumping in the air by photographer Liz Von Hoene, this nostalgic birthday card reads "Act your shoe size . . . not your age." *4U* cards use interpretive images, integrated text and generous writing space to create a gift product that has been embraced by both upscale consumers and a broad spectrum of retailers. The cards feature photography that is artistic, graphic and emotionally expressive focusing on characters with universal appeal. (Avanti's role in the growing photo gift market is explored on page 285.)

paying markets. You should be aware, though, that one reason for higher rates of payment in this market is that these companies may want to buy all rights to images. But with changes in the copyright law, many companies are more willing to negotiate sales which specify all rights for limited time periods or exclusive product rights rather than complete surrender of copyright.

PLANNING YOUR COLOR PALATE

If you choose to pursue the decorative print and poster market you may have to pay more attention to the specific colors in your photographs. The home and office decor industry carefully chooses colors based on what they think is popular and will appeal to consumers. Every year the color designers of the Color Marketing Group gather to forecast the "hot" colors of the future. Color designers are "specialists who enhance the design and salability of a product through their knowledge and appropriate application of color." Whether your work is full color or hand-tinted black & white, you can increse the salability of your work by becoming aware of color trends. These colors also can help you select frames that will be appealing to consumers.

1998 CMG Colors

Apache—A centered rich red, not too yellow, not too blue.

Cortez—A rich brown-based apricot, with a strong European influence.

Desert Sun—A rich golden yellow with a flavor of curry.

Mantis—An acidic, lime-yellow, from the retro influence of the 50s.

Palo Verde—A yellow-based, ethereal sage green.

Expearment—A clean, versatile mid-tone green.

Zuni—A liquid turquise, reminiscent of swimming pools.

Phoenician—A rich, Mediterranean blue.

Too Blue—A saturated, red-bsed blue, clear and vibrant.

Purplexed—A rich, red purple, ethnic and exotic.

Frontier—A soft, red-based brown.

Hi-Ho Silver—Grey with a silver touch, evocative of brushed chrome, both in flat and metallic finishes.

Black Tie—A sueded, elegant black.

Fool's Gold—The essence of blond-gold, burnished with green, reminiscent of the aged qualities of old world coins, both in flat and metallic finishes.

Ghost Town—A soft, powdered white.

Camelback—A classic, yellow-influenced beige.

INSIDER REPORT

Photography finds a niche in the giftware industry

Walk into any book or card store and you will see that the gift products market is booming. The growing popularity of beautifully designed journal books, note cards, stationery products, coffee mugs, address and date books, wrapping paper, gift bags and boxes has expanded the gift market far beyond greeting cards. While fine art and illustration images have been traditionally featured on these products, photography is increasingly being used to grab the attention of a visually sophisticated public.

When you only have a few seconds to catch the eye of a potential customer, image counts, says Marion Gotbetter, Creative Manager at Avanti Press, a leader in the photography greeting card market and a new entry in the expanded gift product arena. "Images need to be bright and bold. They need to stand out, be an easy read, evoke an immediate response and attract the consumer's attention so they want to pick up that product over any other."

Since 1980, Avanti Press has been creating a unique brand of photographic greeting cards and notecard folios with both broad-based and upscale consumer appeal. They distribute two lines, the Avanti line featuring innovative, fun, humorous images and the 4U line of sophisticated romantic cards featuring fine art interpretive images. They have also expanded into related products by placing some of their best-selling images on mugs, gift bags, wrapping paper and tissue wrap.

Despite competition from mass market companies like Hallmark, Avanti has distinguished itself by featuring visually expressive photography, "rich looking" high-quality printing, unique graphic design elements and distinguishing product details. For example, Avanti will reproduce photographic elements from the front of a card on the the inside and back of the card, making it more graphically appealing. As a result, Avanti has earned industry-wide recognition for printing excellence and product innovation, collecting over 50 graphic art and product quality awards in the past decade.

When Avanti decided to branch out into gift products, it capitalized on its strengths to create product "vignettes," coordinated gift products that offer consumers a total package—a card, gift bag and wrapping paper that are visually related. Also referred to as "boutiquing," this marketing strategy was popularized by the success of Ann Geddes's whimsical photographs of babies being used on gift books, calendars, gift boxes and cards. Boutiquing is especially popular with retailers because it allows them to create thematic, eye-catching displays that instantly attract customers.

The photographic subjects most successful with this approach are images with universal sentimental appeal such as cute animals, kids and babies, and florals. When Avanti's creative team is choosing photographers, they look for freelancers who have a unique style, an appropriate specialty and an understanding of Avanti's product lines. The Avanti line features images that are narrative, easy to understand, fun and funny. The products feature color images of children under four years old and pet animals. The 4U products offer

INSIDER REPORT, *Gotbetter*

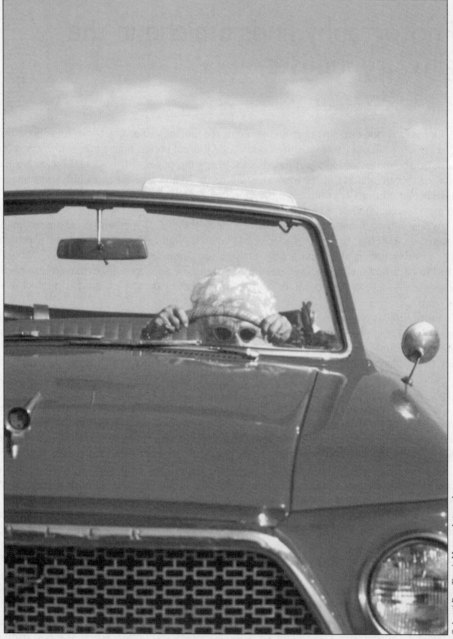

This popular birthday card from the Avanti line shows why this unique brand of innovative, fun greeting cards have proven to have broad-based consumer appeal. The humorous photo by Dennis Mosner opens up to read, "It's not the years, it's the mileage. Happy Birthday!" Avanti images are narrative, easy to understand, visually expressive, whimsical and funny. Even the back of the card features creative graphic detailing by repeating a small cut-out image of the "driving grandma" under the Avanti logo.

INSIDER REPORT, *continued*

images that are sophisticated, graphic, artistic and evoke emotion. These tend to be florals and narrative still lifes and include black and white, hand-tinted and color photography. Images in both lines tend not to focus on individual personalities, but rather on characters that have universal appeal.

Avanti obtains photographic material through existing imagery and assignment work. The creative team researches photographers' work and stock photography agencies, but they are also approached by freelancers submitting portfolios. Avanti publishes submission guidelines to assist freelance photographers breaking into the market. The art directors then work closely with photographers to execute concepts and create the unique images Avanti is known for.

While Avanti mostly licenses existing images, that is rapidly changing, says Art Buyer Angela Lewis Reid. "Avanti is starting to work more and more with freelance photographers on an assignment basis to obtain just the right image." Reid and the art directors regularly review portfolios in search of specific styles that will complement their concepts. It is then up to Reid to work with assignment photographers to map out the photography production expenses in addition to going over the fee and licensing agreements. "We try to develop a long-lasting business relationship with each of the photographers," explains Reid. "Just as important as the chemistry between photographer and art director, is the chemistry between the art buyer and the photographer." In the end, it is this successful chemistry that ultimately attracts consumers to Avanti's imaginative cards and gifts.

—*Tricia Waddell*

ACME GRAPHICS, INC., Box 1348, Cedar Rapids IA 52406. (319)364-0233. Fax: (319)363-6437. President: Stan Richardson. Estab. 1913. Specializes in printed merchandise for funeral directors.
Needs: Religious, nature. Reviews stock photos.
Making Contact & Terms: Query with samples. Send unsolicited photos by mail for consideration. Uses 35mm transparencies; color contact sheets; color negatives. SASE. Reports in 2 weeks. Pays $50/b&w photo; $50/color photo. Also, pays according to price set by photographer. **Pays on acceptance.** Buys all rights.

ADVANCED GRAPHICS, P.O. Box 8517, 2101 Martin Way, Pittsburg CA 94565. (925)432-2262. Fax: (925)432-9259. Photo Editor: Steve Henderson. Estab. 1985. Specializes in life-size standups and cardboard displays.
Needs: Buys 20 images annually; number supplied by freelancers varies. Interested in celebrities (movie and TV stars, entertainers). Reviews stock photos.
Making Contact & Terms: Query with stock photo list. Uses 4×5, 8×10 transparencies. Keeps samples on file. SASE. Reports in 1 month. NPI; negotiable. **Pays on acceptance.** Credit line given. Buys exclusive product rights; negotiable. Simultaneous submissions and/or previously published work OK.
Tips: "We specialize in publishing life-size standups which are cardboard displays of celebrities. Any pictures we use must show the entire person, head to toe. We must also obtain a license for each image that we use from the celebrity pictured or from that celebrity's estate. The image should be vertical and not too wide."

ALFRESCO PUBLICATIONS, P.O. Box 14191, Tulsa OK 74159. President: Jim Bonner. Estab. 1989. Specializes in posters, framing prints and print sets. Photo guidelines $1 with SASE.
Needs: Buys 300-400 images annually; all supplied by freelancers. Interested in glamour, semi-nude, nude. Model release required.

Making Contact & Terms: Send for guidelines. Uses color prints. Does not keep samples on file. SASE. Reports in 1 week. **Pays on acceptance.** Credit line sometimes given depending upon usage. Buys all rights; negotiable. Simultaneous submissions and/or previously published work OK.

Tips: "We like working with beginners using amateur models, so we don't have to teach them how to avoid the professional posed look. If you are looking for your first sale, we want to see your work."

 ART IN MOTION, 2000 Hartley Ave., Coquitlam, British Columbia V3K 6W5 Canada. (604)525-3900. Fax: (604)525-6166. Submissions Director: Lynn Harrison. Specializes in greeting cards, postcards, posters, framing prints and wall decor.

Needs: "We are publishers of fine art reproductions, so we have not been involved in the use of photographs until now."

Making Contact & Terms: Submit portfolio for review. Does not keep samples on file. SASE. Reports in 1-2 weeks. Payment negotiable. Pays on usage. Credit line given. Buys all rights; negotiable. Simultaneous submissions OK.

ART RESOURCE INTERNATIONAL LTD./BON ART, Fields Lane, Brewster NY 10509. (914)277-8888. Fax: (914)277-8602. E-mail: bonartinc.@aol.com. Vice President: Robin Bonnist. Estab. 1980. Specializes in posters and fine art prints.

Needs: Buys 50 images/year. Interested in all types but does not wish to see regional. Model release required. Captions preferred.

Making Contact & Terms: Send unsolicited photos by mail for consideration. Works on assignment only. Uses 35mm, 4×5 and 8×10 transparencies. SASE. Reports in 1 month. Pays $50-250/photo. Pays on publication. Credit line given if required. Buys all rights; exclusive reproduction rights. Simultaneous submissions and previously published work OK.

Tips: Looks for "new and exciting material; subject matter with universal appeal."

ASHTON-DRAKE GALLERIES, 9200 N. Maryland Ave., Niles IL 60714. (847)581-8107. Fax: (847)966-3026. Senior Manager Artist Relations and Recruitment: Andrea Ship. Estab. 1985. Specializes in collectible dolls and ornaments.

Needs: Interested in children, babies and fashion. Model release required.

Making Contact & Terms: Submit portfolio for review. Works with freelancers on assignment only. Uses color prints; 8×10 transparencies. Keeps samples on file. Reports in 1 month or more. Pays flat fee for job. **Pays on acceptance.** Buys all rights.

THE AVALON HILL GAME CO., 4517 Harford Rd., Baltimore MD 21214. (410)254-9200. Fax: (410)254-0991. E-mail: jyd@ix.netcom.com. Website: http://www.avalonhill.com. President: Jack Dott. Estab. 1949. Specializes in games.

Needs: Buys 100 images annually; 95% supplied by freelancers. Offers 15 assignments annually. Specializes in military subjects. Submit seasonal material 3 months in advance. Reviews stock photos of military subjects. Model/property release required for models, etc. Captions preferred.

Making Contact & Terms: Query with stock photo list. Works on assignment only. Uses 5×8, $8\frac{1}{2} \times 11$ color and b&w prints; 35mm, 4×5 transparencies. Keeps samples on file. SASE. Reports in 3 weeks. Pays $50-500/job. Pays on usage. Credit line given. Buys exclusive product rights. Simultaneous submissions and/or previously published work OK.

AVANTI PRESS INC., 134 Spring St., Suite 602, New York NY 10012. (212)941-9000. Fax: (212)941-8008. Attention: Art Submissions. Estab. 1980. Specializes in photographic greeting cards, note cards and related products. Photo guidelines free with SASE.

Needs: Buys approximately 250 images annually; all supplied by freelancers. Offers assignments annually. Interested in humorous, narrative, colorful, simple, to the point; also babies, children, animals (in humorous situations), florals (exceptional). Has specific deadlines for seasonal material. Does NOT want travel,

FOR EXPLANATIONS OF THESE SYMBOLS,
SEE THE INSIDE FRONT AND BACK COVERS OF THIS BOOK.

sunsets, landscapes, nudes, high-tech. Reviews stock photos. Model/property release required. Now have an alternative, multi-occasion line—4U. Personal, artistic, expressive, friendly, intimate, mysterious are words which describe the types of images needed for this line.
Making Contact & Terms: Arrange personal interview to show portfolio. Query with stock photo list. Please do not submit original material. Will work with all mediums and formats. Reports quarterly. Payment negotiable. Pays on license. Credit line given. Buys 5-year worldwide, exclusive card rights.
Tips: "Know our card lines. Stretch the boundaries of creativity."

BEAUTYWAY, Box 340, Flagstaff AZ 86002. (520)526-1812. President: Kenneth Schneider. Estab. 1979. Specializes in postcards, note cards and posters.
Needs: Buys 100-200 freelance photos/year (fee pay and Joint Venture). "Joint Venture is a program within Beautyway in which the photographer invests in his own images and production costs and works more closely in overall development. Through Joint Venture, photographers may initiate new lines or subjects with Beautyway." Interested in (1) nationwide landscapes emphasizing subjects of traveler interest and generic scenes of sea, lake and river; (2) animals, birds and sealife, with particular interest in young animals, eyes and interaction; (3) air, water and winter sports; (4) the most important attractions and vistas of major cities, emphasizing sunset, storm, cloud and night settings. Model release required.
Making Contact & Terms: Query with samples, stock list and statement of interests or objectives. All transparency formats OK. Ship in protective sleeves with photographer's name, title and location of image on frame. SASE. First report averages 2 weeks, others vary. Pays $45 for up to 2,400 postcards; $70 for up to 4,800 postcards; $120 for up to 9,600 postcards; $8 per 1,200 postcards thereafter. Previously published work OK if not potentially competitive.
Tips: Looks for "very sharp photos with bright colors and good contrast. Subject matter should be easily identified at first glance. We seek straightforward, basic scenic or subject shots. Obvious camera manipulation such as juxtaposing shots or unnatural filter use is almost always rejected. When submitting transparencies, the person's name, address and name and location of subject should be upon each transparency sleeve."

BEPUZZLED, 22 E. Newberry Rd., Bloomfield CT 06002. (800)874-6556. Fax: (860)769-5799. Creative Service Manager: Sue Tyska. Estab. 1986. Specializes in mystery, puzzles and games.
Needs: Buys 10-20 images annually; 10% supplied by freelancers. Offers 50-70 assignments annually. Interested in humorous and seasonal. Submit seasonal material 3 months in advance. Reviews stock photos. Model/property release required.
Making Contact & Terms: Arrange personal interview to show portfolio. Provide résumé, business card, self-promotion piece or tearsheets to be kept on file for possible future assignments. Works with local freelancers only. Uses 2¼×2¼, 4×5, 8×10. Keeps samples on file. SASE. Cannot return material. Call to follow up. Pays $1,000-1,500/job. Pays on usage. Credit line sometimes given. Buys all rights, exclusive product rights and world-wide rights. Simultaneous submissions OK.
Tips: "We use very little digital photography. We prefer local photographers (but have used stock or other photos). We have two cycles a year for development of new products—timing is everything."

BILLIARD LIBRARY COMPANY, (formerly Billboard Library Company), 1570 Seabright Ave., Long Beach CA 90813. (562)437-5413. Fax: (562)436-8817. Production Manager: Darian Baskin. Estab. 1973. Specializes in posters and wall decor relating to billiards.
Needs: Buys 3-7 images annually; all supplied by freelancers. "We specialize in leisure sports, specifically billiards, but also bowling and darts." Model/property release preferred.
Making Contact & Terms: Query with samples. Uses any size color and b&w prints; 35mm, 2¼×2¼, 4×5, 8×10 transparencies. Keeps samples on file. SASE. Reports in 1 month. Pays royalty on images based on prints sold. Pays on usage. Credit line given. Simultaneous submissions and/or previously published work OK.

BLUE SKY PUBLISHING, P.O. Box 19974, Boulder CO 80308-2974. (303)530-4654. Fax: (303)530-4627. Website: http://www.blueskypublishing.com. Art Director: Theresa Brown. Estab. 1989. Specializes in greeting cards, calendars, stationary, address books, journals and note pads.
Needs: Buys 12-24 images annually; all supplied by freelancers. Interested in Rocky Mountain winter landscapes, dramatic winter scenes featuring wildlife in mountain settings, winter scenes from the Southwest, unique and creative Christmas still life images, and scenes that express the warmth and romance of the holidays. Submit seasonal material 1 year in advance. Reviews stock photos. Model/property release preferred.
Making Contact & Terms: Submit 24-48 of your best images for review. Query with samples. Provide résumé, business card, self-promotion piece or tearsheets to be kept on file for possible future assignments.

Uses 35mm, 4×5 (preferred) transparencies. Keeps samples on file. SASE. "We try to respond within one month—sometimes runs two months." Pays $150-250/color photo; 3-5% royalties. **Pays on acceptance.** Credit line given. Buys exclusive product rights for 5 years; negotiable. Simultaneous submissions and/or previously published work OK.

Tips: "We choose photographs with expressive use of color and composition, and strong emotional impact."

BRISTOL GIFT CO. INC., P.O. Box 425, Washingtonville NY 10992. (914)496-2821. Fax: (914)496-2859. E-mail: bristol@ny.frontiercomm.net. President: Matthew Ropiecki. Estab. 1988. Specializes in framing prints and wall decor.

Needs: Interested in religious, nature, still life. Submit seasonal material 6 months in advance. Reviews stock photos. Model/property release preferred.

Making Contact & Terms: Query with samples. Uses 4×5, 8×10 color prints; 4×5 transparencies. Accepts images in digital format for Windows. Send via compact disc or floppy disk. Keeps samples on file. SASE. Reports in 1 month. Payment negotiable; depends on agreement. Buys exclusive product rights. Previously published work OK.

CARDMAKERS, High Bridge Rd., P.O. Box 236, Lyme NH 03768. (603)795-4422. Fax: (603)795-4222. Owner: Peter D. Diebold. Estab. 1978. Specializes in greeting cards.

● This company expects photo cards to be a growing portion of their business.

Needs: Buys stock and assigns work. Needs nautical scenes which make appropriate Christmas and everyday card illustrations. Model/property release preferred.

Making Contact & Terms: Provide self-promotion piece to be kept on file for possible future assignments. Uses color prints; 35mm, 4×5, 8×10 transparencies. Keeps samples on file. SASE. Reports in 3 weeks. Pays $100+/b&w and color photos. **Pays on acceptance.** Credit line negotiable. Buys exclusive

© Carl R. Sams II

"As seen by example from this card, many dramatic images are captured in the early morning. By staying in bed and sleeping in, many salable shots are missed and never seen," says photographer Carl Sams. For his efforts, this early bird won the publication of his striking Oak tree as a greeting card. "We were seeking a 'mighty' Oak tree in an autumnal setting," says CardMakers President Peter Diebold. Diebold learned of the image from a faxed list of photographers who had stock shots of Oak trees. Sams and his business partner, Bruce Montagne, submitted several images, but the dramatic sunrise shot stood out from the others.

© Cheryl A. Ertelt

"I wrote to Cedco for guidelines, then sent some sample slides," says part-time photographer Cheryl Ertelt. "I was invited to submit slides for their 1998 calendar line. This was one of three images they bought for their calendars. A fourth image was bought for a World Wildlife Fund book they were doing." Ertelt shot the pair of dogs originally as a portrait for a friend and earned $200 from its sale. "I work full-time as a physical therapist and have been increasing my photography in the last four years. I've gotten the majority of the contacts from *Photographer's Market*."

product rights and all rights; negotiable. Simultaneous submissions and previously published work OK.
Tips: "We are seeking photos primarily for our nautical Christmas and everyday card line but would also be interested in any which might have potential for business to business Christmas greeting cards. Emphasis is on humorous situations. A combination of humor and nautical scenes is best. Please do not load us up with tons of stuff. We have recently acquired/published designs using photos and are active in the market presently. The best time to approach us is during the first nine months of the year (when we can spend more time reviewing submissions)."

CEDCO PUBLISHING CO., 100 Pelican Way., San Rafael CA 94901. (415)451-3000. Fax: (415)457-1226. E-mail: sales@cedco.com. Website: http://www.cedco.com. Contact: Photo Dept. Estab. 1980. Specializes in calendars and picture books. Photo guidelines free with SASE.
Needs: Buys 1,500 images/year; 1,000 supplied by freelancers. Wild animals, pigs, America, Ireland, inspirational, islands, whales, Israel, Buddhas, men in swimsuits on the beach, Australian wildlife, dolphins, surfing, general stock and studio stock. Especially needs 4×5 photos of the East Coast and South, flowers, footprints in sand, crystals and minerals. New ideas welcome. Model/property release required. Captions required.
Making Contact & Terms: Query with non-returnable samples and a list of stock photo subjects. "Do not send any returnable material unless requested." Uses 35mm, 2¼×2¼, 4×5, 8×10 transparencies. Keeps samples on file. Reports as needed. Pays $200/b&w photo; $200/color photo; payment negotiable. Pays the December prior to the year the calendar is dated (i.e., if calendar is 2000, photographers are paid in December 1999). Credit line given. Buys one-time rights. Simultaneous submissions and previously published work OK.
Tips: No phone calls.

CENTRIC CORPORATION, 6712 Melrose Ave., Los Angeles CA 90038. (213)936-2100. Fax: (213)936-2101. E-mail: centric@juno.com. President: Sammy Okdot. Estab. 1986. Specializes in gift products: T-shirts, clocks, watches, pens, mugs and frames.

Needs: Interested in humor, nature and thought-provoking images. Submit seasonal material 5 months in advance. Reviews stock photos.

Making Contact & Terms: Submit portfolio for review. Query with résumé of credits. Provide résumé, business card, self-promotion piece or tearsheets to be kept on file for possible future assignments. Works with local freelancers only. Uses 8½×11 color and b&w prints; 35mm transparencies. Keeps samples on file. SASE. Reports in 1-2 weeks. Pays by the job; negotiable. **Pays on acceptance.** Rights negotiable.

CLASS PUBLICATIONS, INC., 71 Bartholomew Ave., Hartford CT 06106. (203)951-9200. Contact: Scott Moynihan. Specializes in posters.

Needs: Buys 50 images/year. Creative photography, especially humorous, cars, semi-nudes, guys, girls, etc. Interested in stock photos. Model release preferred. Captions preferred.

Making Contact & Terms: Query with samples. Submit portfolio for review. Uses b&w and color prints, contact sheets, negatives; 35mm, 2¼×2¼, 4×5 and 8×10 transparencies. SASE. Reports in 2 weeks. Payment negotiable. Pays per photo or royalties on sales. Pays on acceptance or publication. Credit line sometimes given. Buys one-time and exclusive poster rights. Simultaneous submissions and previously published work OK.

Tips: Looks for "creativity that would be widely recognized and easily understood."

COMSTOCK CARDS, 600 S. Rock Blvd., Suite 15, Reno NV 89502. (702)856-9400. Fax: (702)856-9406. E-mail: comstock@intercomm.com. Website: http://www.comstockcards.com. Contact: Cindy Thomas or Patti Wolf. Estab. 1986. Specializes in greeting cards, invitations, notepads, games and gift wrap. Photo guidelines free with SASE.

Needs: Buys/assigns 30-40 photos/year; all supplied by freelancers. Want wild, outrageous and shocking adult humor; seductive hot men or women images. "No male frontal nudity. We like suggestive images, not 'in your face' images." Definitely does not want to see traditional, sweet, cute, animals or scenics. "If it's appropriate to show your mother, we don't want it!" Submit seasonal material 10 months in advance. Model/property release required. Photo captions preferred with cutline.

Making Contact & Terms: Query with samples and tearsheets. Uses 5×7 color prints, 35mm, 2¼×2¼ color transparencies or digital images. SASE. Reports in 1-2 months. Pays $50-150/color photo. Pays on publication. Credit line given if requested. Buys all rights; negotiable.

Tips: "Submit with SASE if you want material returned."

CONCORD LITHO GROUP, 92 Old Turnpike Rd., Concord NH 03301. (603)225-3328. Fax: (603)225-6120. Vice President/Creative Services: Lester Zaiontz. Estab. 1958. Specializes in bookmarks, greeting cards, calendars, postcards, posters, framing prints, stationery, gift wrap and wall decor. Photo guidelines free with SASE.

Needs: Buys 150 images annually; 60% are supplied by freelancers. Does not offer assignments. Interested in nature, seasonal, domestic animals, dogs and cats, religious, inspirational, florals and scenics. Submit seasonal material minimum 6-8 months in advance. Does not want nudes, comedy or humorous—nothing wild or contemporary. Model/property release required for historical/nostalgia, homes and gardens, dogs and cats. Captions preferred; include accurate information pertaining to image (location, dates, species, etc.).

Making Contact & Terms: Submit portfolio for review. Query with samples and stock photo list. Uses 8×10 satin color prints; 35mm, 2¼×2¼, 4×5, 8×10 transparencies; anything on Macintosh platform. Keeps samples on file. SASE. Reporting time may be as long as 6 months. Pays $150 minimum for one-time usage. Pays on usage. Credit line sometimes given depending upon client and/or product. Buys one-time rights. Simultaneous submissions and/or previously published work OK.

N: CREATIVE ARTS BOOK COMPANY, 833 Bancroft Way, Berkeley CA 94710. (570)848-4777. Fax: (570)848-4844. Website: http://www.creativeartsbooks.com. Editor: G. Samsa. Estab. 1968. Specializes in calendars, books.

Needs: Buys 150 images annually; 100% are supplied by freelancers. Interested in everything but religious. Submit seasonal material 9-12 months in advance. Reviews stock photos. Model/property release preferred. Photo caption preferred.

Making Contact & Terms: Send query letter with samples, brochure, stock photo list, tearsheets. Provide

THE INTERNATIONAL MARKETS INDEX, located in the back of this book, lists markets located outside the U.S. by country.

résumé, business card, self-promotion piece or tearsheets to be kept on file for possible future assignments. To show portfolio, photographer should follow-up with letter after initial query. Portfolio should include b&w and/or color, prints, tearsheets, slides or thumbnails. Uses any size color or b&w prints; 35mm, 4×5 transparencies. Accepts images in digital format. Does not keep samples on file. SASE. Reports in 2 months on queries; 1 month on samples. Payment varies by project. Pays on publication. Credit line given. Buys one-time rights; negotiable.

N: CRISLOID, 55 Porter St., Providence RI 02905. (401)461-7200. Fax: (401)785-3750. President: Michael Caruso. Estab. 1939. Specializes in decorations, games, gifts, wooden ware.
Needs: Interested in sports, nature and seasonal. Model/property release required.
Making Contact & Terms: Send query letter with samples and stock photo list. Portfolios may be dropped off every Monday. Portfolio should include b&w and/or color, prints. Keeps samples on file; include SASE for return of material. Payment negotiable. **Pays on acceptance.** Credit line sometimes given depending upon amount. Buys all rights.

CUSTOM & LIMITED EDITIONS, 41 Sutter St. #1634, San Francisco CA 94104. Phone/fax: (415)337-0177. E-mail: rfwoody@aol.com. Publisher: Ron Fouts. Estab. 1987. Specializes in prints and custom books.
Needs: Buys hundreds of images annually; 60% supplied by freelancers. "We look for a focused pattern of development in a portfolio. We are interested in the photographer's statement." Interested in reviewing stock photos only in the context of a series or statement. Model release required. Captions preferred; include title and date of photograph.
Making Contact & Terms: Query with résumé, business card, self-promotion piece or tearsheets to be kept on file for possible future assignments. Uses 8×10 glossy preferred color and b&w prints; 35mm, 2¼×2¼ transparencies. Accepts images in digital format for Mac. Send via compact disc or SyQuest. Samples sometimes kept on file depending on the nature of the work. SASE. Reports in 3 weeks. "All of our work is custom and payments are negotiated in each case." Negotiated terms. Credit is given somewhere in the publication. Rights negotiable. Simultaneous submissions and/or previously published work OK.
Tips: "Be able to articulate the purpose, or reason, for the work, subject matter, focus, etc. Be able to demonstrate commitment in the work."

DALOIA DESIGN, P.O. Box 140268, Howard Beach NY 11414. (718)835-7641. Owner/Creative Director: Peter Daloia. Estab. 1983. Design, develop and market novelty and gift products. Photos used for paper products, stationery, novelty and gift items.
Needs: Uses freelancers for humorous, abstract, odd shots, backgrounds, collage, montage, patterns, scenics, nature, textures. Reviews stock photos. Model/property release required.
Making Contact & Terms: Query with samples. Provide résumé, business card, samples to be kept on file for possible future assignments. Works with freelancers on assignment only. Uses 8×10, 5×7, 4×6 color and b&w prints; 35mm slides. Keeps samples on file. Cannot return material. Reports only when interested. Pays "prevailing rates or royalties." Pays upon usage. Credit line sometimes given depending on use. Buys one-time rights and exclusive product rights.
Tips: "Show everything, even what you don't think is good."

DESIGN DESIGN, INC., P.O. Box 2266, Grand Rapids MI 49501. (616)774-2448. Fax: (616)774-4020. Creative Director: Tom Vituj. Estab. 1986. Specializes in greeting cards.
Needs: Licenses stock images from freelancers and assigns work. Specializes in humorous topics. Submit seasonal material 1 year in advance. Model/property release required.
Making Contact & Terms: Submit portfolio for review. Provide résumé, business card, self-promotion piece or tearsheets to be kept on file for possible future assignments. Do not send original work. Accepts images in digital format for Mac. Send via SyQuest or Zip disk. SASE. Pays royalties, negotiable. Pays upon sales. Credit line given.

DODO GRAPHICS INC., P.O. Box 585, Plattsburgh NY 12901. (518)561-7294. Fax: (518)561-6720. President: Frank How. Estab. 1979. Specializes in posters and framing prints.
Needs: Buys 50-100 images annually; 100% supplied by freelancers. Offers 25-50 assignments annually. Needs all subjects. Submit seasonal material 3 months in advance. Reviews stock photos. Model/property release preferred. Captions preferred.
Making Contact & Terms: Submit portfolio for review. Query with samples. Query with stock photo list. Works on assignment only. Uses color and b&w prints; 35mm, 4×5 transparencies. Keeps samples on file. SASE. Reports in 1 month. Payment negotiable. **Pays on acceptance.** Credit line given. Buys all rights; negotiable. Simultaneous submissions OK.

N DYNAMICS GRAPHICS, 6000 Forest Park Dr., Peoria IL 61614. (309)687-0236. Fax: (309)688-8828. E-mail: henvick@dgusa.com. Website: http://www.dgusa.com. Photo Editor: Jenna Henvick. Estab. 1964. Specializes in CD-ROMs, clip-art. Guidelines sheet free with SASE.

Needs: Buys 275 images annually; 50% are supplied by freelancers. Interested in holiday and seasonal, retail and model-released people photos. Submit seasonal material 6 months in advance. Not interested in copyrighted material (logos, etc.). Only want tasteful, conservative photos. Reviews stock photos of holiday, seasonal, model interaction. Model/property release required for all identifiable people and places.

Making Contact & Terms: Send query letter with samples. Art director will contact photographer for portfolio review if interested. Portfolio should include b&w and/or color, prints, slides, transparencies. Uses 8×10 color b&w prints; 35mm, 2¼×2¼ transparencies. Accepts images in digital format: must be at least 300 dpi for consideration. Does not keep samples on file; include SASE for return of material. Reports in 2 weeks on queries; 6-8 weeks on samples. Pays by the project, $100 minimum; maximum for color depends on quality and need; $60-100 for b&w. Pays on receipt of invoice. Credit line not given. Buys one-time rights.

Tips: "We use photos also as illustration reference, and in several aspects of our company besides clip-art, including advertising and marketing promos."

ELEGANT GREETING, 2330 Westwood Blvd., Suite 102, Los Angeles CA 90064. (310)446-4929. Fax: (310)446-4819. Owner: Sheldon Steier. Estab. 1991. Specializes in greeting cards, calendars, postcards, posters, framing prints, stationery, mugs and T-shirts.

Needs: Interested in all types of subject matter. Currently looking for humorous seasonal, girl friends, spiritual. Reviews stock photos of adults and children.

Making Contact & Terms: Submit portfolio for review. Works with local freelancers only. SASE Reports in 1-2 weeks. Payment negotiable. Credit line given.

Tips: "Basically, my company provides sales and marketing services for a wide variety of publishers of cards, and boxed stationery and gift items. If I see something I like, I submit it to a manufacturer."

FLASHCARDS, INC., 1211A NE Eighth Ave., Fort Lauderdale FL 33304. (954)467-1141. Photo Researcher: Micklos Huggins. Estab. 1980. Specializes in postcards, greeting cards, notecards and posters.

Needs: Buys 500 images/year. Humorous, human interest, animals in humorous situations, nostalgic looks, Christmas material, valentines, children in interesting and humorous situations. No traditional postcard material; no florals or scenic. "If the photo needs explaining, it's probably not for us." Submit seasonal material 8 months in advance. Reviews stock photos. Model release required.

Making Contact & Terms: Query with samples. Send photos by mail for consideration. Provide résumé, business card, brochure, flier or tearsheets to be kept on file for possible future assignments. Uses any size color or b&w prints, transparencies and color or b&w contact sheets. SASE. Reports in 5 weeks. Pays $100 for exclusive product rights. Pays on publication. Credit line given. Buys exclusive product rights. Simultaneous and previously published submissions OK.

FOTOFOLIO, INC., 536 Broadway, New York NY 10012. (212)226-0923. Fax: (212)226-0072. E-mail: fotofolio@aol.com. Website: http://www.fotofolio.com. Contact: Editorial Department. Estab. 1976. Specializes in greeting cards, postcards, posters, T-shirts and notecards. The Fotofolio line of over 5,000 images comprises the complete history of photography, and includes the work of virtually every major photographer, from past masters such as Walker Evans, Berenice Abbott, Brassai, Philippe Halsman and Paul Strand to contemporary artists including William Wegman, Richard Avedon, Andres Serrano, Cindy Sherman, Herb Ritts and Sandy Skoglund. Photo guidelines free with SASE.

Needs: Specializes in humorous, seasonal material. Submit seasonal material 9 months in advance. Reviews stock photos. Captions required; include name, date and title.

Make Contact & Terms: Send for guidelines. Uses up to 11×14 color and b&w prints; 35mm, 2¼×2¼, 4×5, 8×10 transparencies. Accepts images in digital format. Does not keep samples on file. SASE. Reports in 1 month. Pays royalties. Pays on usage. Credit line given. Buys exclusive product rights (only for that item—eg., postcard rights). Simultaneous submissions and/or previously published work OK.

N FRONT LINE ART PUBLISHING, 9808 Waples St., San Diego CA 92121. (800)321-2053 or (619)552-0944. Fax: (619)552-0534. Vice President Creative Director: Benita Sanserino. Specializes in posters and prints.

Needs: Buys 350 images annually; 100% are supplied by freelancers. Interested in "dramatic," sports, landscaping, animals, contemporary, b&w, hand tint and decorative. Reviews stock photos of sports and scenic. Model release is required. Photo captions are preferred.

Making Contact & Terms: Send query letter with samples, brochure, stock photo list, tearsheets. Art director will contact photographer for portfolio review if interested. Portfolio should include b&w and

color, prints, tearsheets, slides, transparencies or thumbnails. Uses color and b&w prints; 35mm, 2¼×2¼, 4×5, 8×10 transparencies. Accepts images in digital format. Include SASE for return of unsolicited material. Reports in 1 month on queries. Pays on publication. Credit line given. Rights negotiable.

GALLANT GREETINGS CORP., P.O. Box 308, Franklin Park IL 60131. (847)671-6500. Fax: (847)671-7500. Vice President-Sales & Marketing: Chris Allen. Estab. 1966. Specializes in greeting cards.
Needs: Produces material for Christmas, Easter, Mother's Day, Father's Day, graduation, Halloween, Thanksgiving, Valentine's Day, birthday, and most other card-giving occasions.
Making Contact & Terms: Contact Brandywine Art at phone: (415)435-6533. Does not keep samples on file. Cannot return material. Reports back only if interested.

GOES CALENDARS, 42 W. 61st St., Chicago IL 60621-3999. (773)684-6700. Fax: (773)684-2065. Contact: Dave Smith. Estab. 1879. Specializes in calendars, posters and stationery. Photo guidelines free with SASE.
Needs: Buys 3-10 images annually. Interested in photos of mountains, fall, streams and wildlife. Submit seasonal material any time. Does not want nudes. Reviews stock photos. Model/property release required. Captions preferred.
Making Contact & Terms: Submit portfolio for review. Uses 2¼×2¼, 4×5, 8×10 transparencies. Does not keep samples on file. SASE. Reports in 1 month. Payment negotiable. **Pays on acceptance.** Credit line sometimes given depending upon calendar it is used on. Buys the right to publish in the future; negotiable.
Tips: "Do not send work with washed-out color or not in focus—this is a waste of our time."

[N] RAYMOND L. GREENBERG ART PUBLISHING, P.O. Box 239, Circleville NY 10919-0239. (914)469-6699. (914)469-5955. Owner: Ray Greenberg. Estab. 1995. Publisher of posters and art prints. Guidelines sheet free with SASE.
Needs: Buys 100 images annually; all are supplied by freelancers. Interested in scenic, inspirational, juvenile, wildlife, ethnic, floral still life, romantic. Seasonal material should be submitted 7 months in advance. Reviews stock photos. Model release preferred. Photo captions preferred, include locations of scenics, types of animals, flowers, etc.
Making Contact & Terms: Send query letter with samples, brochure, stock photo list, tearsheets. Provide résumé, business card, self-promotion piece or tearsheets to be kept on file for possible future assignments. Art director will contact photographer for portfolio review if interested. Uses 35mm, 2¼×2¼, 4×5, 8×10 transparencies. Keeps samples on file. Reports in 3 weeks on queries; 6 weeks on samples. Pays $50-200 flat fee or advance against royalty. **Pays on acceptance.** Credit line sometimes given depending on photographer's needs. Buys all rights, negotiable.
Tips: "Be patient in awaiting answers on acceptance of submissions."

HALLMARK CARDS, INC., 2501 McGee, Drop #152, Kansas City MO 64108. Not accepting freelance submissions at this time. Unsolicited submissions will not be returned.

HIGH RANGE GRAPHICS, P.O. Box 3302, 365 N. Glenwood, Jackson WY 83001. (307)733-8723. Art Director: J.L. Stuessi. Estab. 1989. Specializes in screen printed T-shirts.
Needs: Buys 5-10 images annually; all supplied by freelancers. May offer one assignment annually. Interested in mountain biking, skiing (speed or Big Air), whitewater rafting. Submit seasonal material 6 months in advance. Reviews stock photos. Captions preferred, "just so we can identify the image in conversation."
Making Contact & Terms: Query with samples. Uses 8×10 maximum color prints; 35mm transparencies. Keeps samples on file. SASE. "We reply if interested." Pays $50-100/color photo; flat fee (plus one T-shirt). Pays on usage. Buys exclusive product rights for screen printed garments only. Simultaneous submissions and/or previously published work OK.
Tips: "We often graphically alter the image (i.e., posterize) and incorporate it as part of a design. Know the T-shirt market. Dynamite images on paper simply don't always work on garments. Action images need to be tack-sharp with good contrast and zero background competition."

IMAGE CONNECTION AMERICA, INC., 456 Penn St., Yeadon PA 19050. (610)626-7770. Fax: (610)626-2778. President: Michael Markowicz. Estab. 1988. Specializes in postcards and posters.
Needs: Contemporary. Model release required. Captions preferred.
Making Contact & Terms: Query with samples. Send unsolicited photos by mail for consideration. Uses 8×10 b&w prints and 35mm transparencies. SASE. Payment negotiable. Pays quarterly or monthly on sales. Credit line given. Buys exclusive product rights; negotiable.

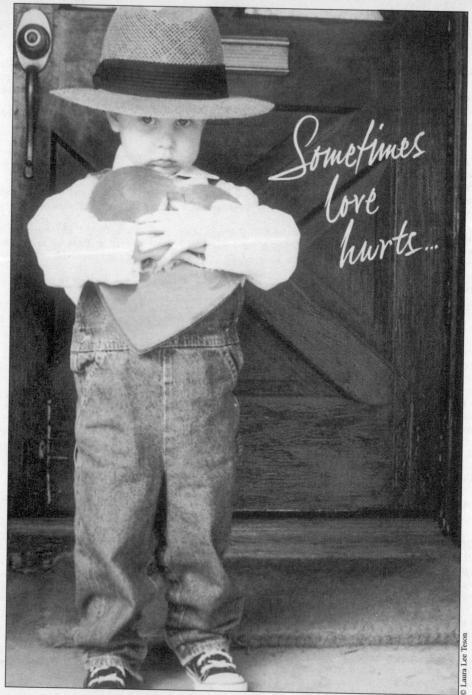

Sometimes love hurts...

© Laura Lee Teson

Despite Hallmark's warning in *Photographer's Market* that they do not accept unsolicited submissions, photographer Laura Lee Teson was so confident they would love her work that she sent it anyway. "I sent color copies of my black and white hand-painted photographs. I received some rejections but then sold photographs to Hallmark and Gibson Card Co." Hallmark contacted Teson after only a week and she sold them all the rights to this photo of her son for a year. "By having this piece published, it opened the door to showcase my talents and enhanced my credibility with future clients."

IMPACT, 4961 Windplay Dr., El Dorado Hills CA 95762. (916)939-9333. Fax: (916)939-9334. Estab. 1975. Specializes in calendars, bookmarks, magnets, postcard packets, postcards, posters and books for the tourist industry. Photo guidelines and fee schedule free with SASE.
 • This company sells to specific tourist destinations; their products are not sold nationally. They need material that will be sold for at least a 6-8 year period.
Needs: Buys stock and assigns work. Buys 3,000 photos/year. Offers 10-15 assignments/year. Wildlife, scenics, US travel destinations, national parks, theme parks and animals. Submit seasonal material 4-5 months in advance. Model/property release required. Captions preferred.
Making Contact & Terms: Query with samples. Query with stock photo list. Provide résumé, business card, self-promotion piece or tearsheets to be kept on file for possible future assignments. Uses 35mm, $2\frac{1}{4} \times 2\frac{1}{4}$, 4×5, 8×10 transparencies. Keeps samples on file. SASE. Reports in 1 month. Payment negotiable; request fee schedule; rates vary by size. Pays on usage. Credit line and printed samples of work given. Buys one-time and nonexclusive product rights; negotiable. Simultaneous submissions and previously published work OK.

INSPIRATIONART & SCRIPTURE, P.O. Box 5550, Cedar Rapids IA 52406. (319)365-4350. Fax: (319)366-2573. E-mail: lisa@inspirationart.com. Website: http://www.inspirationart.com. Contact: Lisa Edwards. Estab. 1996. Specializes in Christian posters (all contain scripture and are geared towards teens and young adults). Photo guidelines free with SASE.
Needs: Buys 5-6 images annually; all supplied by freelancers. "We've used sports, nature, etc. . . . All images must be able to work with scripture." Submit seasonal material 6 months in advance. Reviews stock photos. Model/property release required.
Making Contact & Terms: Query with samples. Request catalog for $3. Works with local freelancers on assignment only. Uses 35mm, $2\frac{1}{4} \times 2\frac{1}{4}$, 4×5, 8×10 transparencies. Prefers $2\frac{1}{4} \times 2\frac{1}{4}$ or 4×5 but can work with 35mm. ("We go up to 24×36.) Keeps samples on file. SASE. Reports in 3-4 months. Art acknowledgement is sent upon receipt. Pays $100-200/color photo. Pays on usage. Credit line given. Buys exclusive rights to use as a poster only.
Tips: "Photographers interested in having their work published by InspirationArt & Scripture should consider obtaining a catalog of the type of work we do prior to sending submissions. Also remember that we review art only three or four times per year and will take that long to return submissions."

INTERCONTINENTAL GREETINGS, 176 Madison Ave., New York NY 10016. (212)683-5830. Fax: (212)779-8564. Art Director: Robin Lipner. Estab. 1967. Specializes in greeting cards, calendars, post cards, posters, framing prints, stationery, gift wrap and playing cards. Photo guidelines free with SASE.
Needs: Buys 20-50 photos/year. Graphics, sports, occasions (i.e. baby, birthday, wedding), "soft-touch" romantic themes, graphic studio photography. No nature, landscape or cute children. Accepts seasonal material any time. Model release preferred.
Making Contact & Terms: Query with samples. Send unsolicited photos by mail for consideration. Submit portfolio for review. Provide résumé, business card, brochure, flier or tearsheets to be kept on file for possible future assignments. Works with freelancers only. Uses glossy color prints; 35mm, $2\frac{1}{4} \times 2\frac{1}{4}$, 4×5 and 8×10 transparencies. SASE. Reports in 3 weeks. Pays 20% royalties on sales. Pays on publication. No credit line given. Buys one-time rights and exclusive product rights. Simultaneous submissions and previously published work OK.
Tips: In photographer's portfolio samples, wants to see "a neat presentation, perhaps thematic in arrangement." The trend is toward "modern, graphic studio photography."

JII SALES PROMOTION ASSOCIATES, INC., 545 Walnut St., Coshocton OH 43812. (614)622-4422. Photo Editor: Walt Andrews. Estab. 1940. Specializes in advertising calendars and greetings. Photo guidelines free with SASE.
Needs: Buys 200 photos/year. Interested in traditional scenics, mood/inspirational scenics, human interest, special interest (contemporary homes in summer and winter, sailboats, hot air balloons), animals, plants. Reviews stock photos. Model release required. Captions with location information only required.
Making Contact & Terms: Query with stock photo list. Send unsolicited photos by mail for consideration in late September. Uses $2\frac{1}{4} \times 2\frac{1}{4}$, 4×5, 8×10 transparencies. SASE. Reports in 2 weeks. Payment negotia-

 SPECIAL COMMENTS within listings by the editor of *Photographer's Market* are set off by a bullet.

ble; pays by the job. **Pays on acceptance.** Buys all time advertising and calendar rights, some special 1 year rights.

Tips: "Our calendar selections are nearly all horizontal compositions. Greeting photos may be either horizontal or vertical."

JILLSON & ROBERTS GIFT WRAPPINGS, 5 Watson Ave., Irvine CA 92618. (714)859-8781. Fax: (714)859-0257. Art Director: Joshua J. Neufeld. Estab. 1974. Specializes in gift wrap, totes, printed tissues, accessories. Photo guidelines free with SASE.

Needs: Needs vary. Specializes in everyday and holiday products. Submit seasonal material 3-6 months in advance.

Making Contact & Terms: Submit portfolio for review. Query with samples. Provide résumé, business card, self-promotion piece or tearsheets to be kept on file for possible future assignments. Reports in 3 weeks. Pays average flat fee of $250; or royalties.

N **KEENE KARDS INC.**, #17-1950 Government St., Victoria, British Columbia V8T 4N8 Canada. (250)361-4449. Fax: (250)361-4479. Art Director: Paul Keene. Estab. 1987. Specializes in calendars, greeting cards, stationery, T-shirts.

Needs: Buys 200 images annually; 100 are supplied by freelancers. Interested in nature, humorous nature, humorous situations with children, risqué photos (humorous). Submit seasonal material 9 months in advance. Model/property release preferred. Photo caption preferred.

Making Contact & Terms: Send query letter with samples. Art director will contact photographer for portfolio review if interested. Portfolio should include "anything relevant, which will be discussed before appointment." Works with local freelancers only. Uses b&w prints and 4×5 transparencies. Accepts images in digital format. Keeps samples on file. Reports in 2 weeks on queries; 1 month on samples. Pays royalties only. Paid quarterly. Credit line given. Rights negotiated for greeting cards.

KOGLE CARDS, INC., 1498 S. Lipan St., Denver CO 80223. (303)698-9007. Fax: (303)698-9242. Send submissions Attn: Art Director. Estab. 1982. Specializes in greeting cards and postcards for all business occasions. Photo guidelines sheet free with SASE.

Needs: Buys about 250 photos/year. Interested in Thanksgiving, Christmas and other holidays, also humorous. Submit seasonal material 9 months in advance. Reviews stock photos. Model release required.

Making Contact & Terms: Query with samples and tearsheets. Provide résumé, business card, self-promotion piece or tearsheets to be kept on file for possible future assignments. "Do not send originals." Send slides or color photocopies with SASE. Art director will contact photographer for portfolio review if interested. Portfolio should include prints, slides, tearsheets. Works with freelancers on assignment only. Uses 35mm, 2¼×2¼, 4×5 transparencies. Sizes: Postcards, 4¼×6; Greeting Cards, 5×7. "When artwork is finished, be sure it is in proportion to the sizes listed. Allow ¼" bleed when bleed is used." Will work with color only. SASE. Reports in 1 month. Payment negotiable. **Pays on acceptance.** Credit line not given. Rights negotiable.

LESLIE LEVY FINE ART PUBLISHING, INC., 1015 W. Garfield, Seattle WA 98119. Fax: (602)945-8104. E-mail: /a/@drizzle.com. Website: http://www.leslielevy.com. Director: Leslie Levy. Estab. 1976. Publishes posters.

● Laura Levy works as a licensing agent.

Needs: Interested in landscape, gardenscape, animals, farm scenes, figurative, Southwest, children and much more. Reviews stock photos and slides. Model/property release required. Captions preferred; include location, date, subject matter or special information.

Making Contact & Terms: Submit photos or slides for review. Send SASE. Do not call. Uses 16×20, 22×28, 18×24, 24×30, 24×36 color and b&w prints; 4×5 transparencies. Reports in 4-6 weeks. Pays royalties quarterly based upon sales. Buys exclusive product rights. Simultaneous submissions and previously published work OK.

N **LIMITED EDITION PUBLISHING**, P.O. Box 5667, Sherman Oaks CA 91413. (310)546-6359. Owner: A. Costello. Estab. 1988. Specializes in calendars, posters, playing cards and keyrings.

Needs: Buys 200 images annually; all supplied by freelancers. Offers 6 freelance assignments annually. Interested in female shots, including body shots, swimsuits, lingerie, semi-nude and totally nude (mostly summer or tropical themes). Submit seasonal material throughout the year. Reviews stock photos. Model release required. Captions required, include name and age of model. Models must be over 18 years old.

Making Contact & Terms: Query with samples. Must send sample photos to be returned. Works with local freelancers on assignment only. Uses color prints; 4×5 transparencies and ½" videotape. Keeps samples on file. SASE. Reports in 1 month. Pays $20-50/hour; $500-1,000/day; $5-50/color photo. **Pays on**

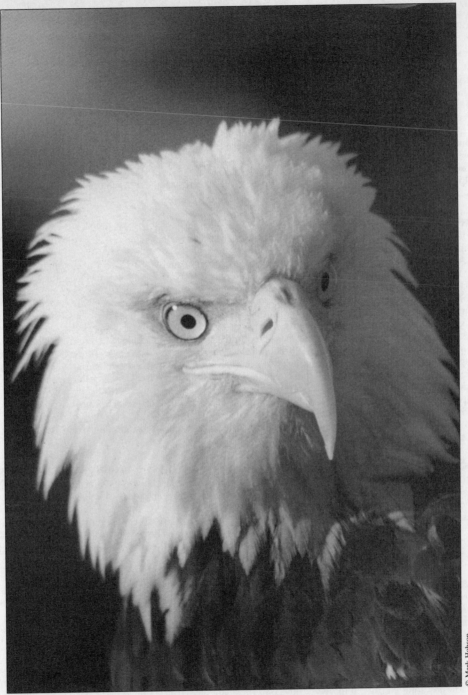

© Mark Hobson

Painter and photographer Mark Hobson first met Paul Keene, a greeting card publisher, at a trade show where he was displaying limited edition prints of his paintings. "Most of our contact has been over artwork and photography has recently been added to the line of cards published," says Hobson. The artist has an extensive stock file of wilderness and wildlife images from the Pacific Northwest where he lives in a floathouse that also serves as his painting studio. "This image and several others, also on cards, are very useful to send out with stock slide submissions. I often include a personal note to a client and the cards help the customer visualize what the slides can look like."

acceptance. Credit line sometimes given depending on medium. Buys exclusive product rights; negotiable. Previously published work OK.

LOVE GREETING CARDS, INC., 1717 Opa Locka Blvd., Opa Locka FL 33054. (305)685-LOVE. Fax: (305)685-8473. Vice President: Norman Drittel. Specializes in greeting cards, postcards and posters.
Needs: Buys 75-100 photos/year. Nature, flowers, boy/girl (contemporary looks). Submit seasonal material 6 months in advance. Reviews stock photos. Model release preferred.
Making Contact & Terms: Query with samples or stock photo list. Send unsolicited photos by mail for consideration. Provide résumé, business card, brochure, flier or tearsheets to be kept on file for possible future assignments. Uses 5×7 or 8×10 color prints; 35mm, 2¼×2¼ and 4×5 transparencies; color contact sheets, color negatives. SASE. Reports in 1 month. Pays minimum $100/color photo. Pays extra for electronic usage of photos. Pays on publication. Credit line given. Buys exclusive product rights. Previously published work OK.
Tips: "We are looking for outstanding photos for greeting cards and New Age posters." There is a "larger use of photos in posters for commercial sale."

BRUCE McGAW GRAPHICS, INC., 389 W. Nyack Rd., West Nyack NY 10994. (914)353-8600. Fax: (914)353-8907. Director of Purchasing/Acquisitons: Martin Lawlor. Estab. 1979. Specializes in posters, framing prints, wall decor.
Needs: 150-200 images in a variety of media are licensed annually; 10-15% in photography. Interested in b&w: still life, floral, figurative, landscape. Color: landscape, still life, floral. Does not want images that are too esoteric or too commercial. Model/property release required for figures, personalities, images including logos or copyrighted symbols. Captions required; include artist's name, title of image, year taken.
Making Contact & Terms: Submit portfolio for review. "Review is typically 1-2 weeks on portfolio dropoffs. Be certain to leave phone number for pick up." Provide résumé, business card, self-promotion piece or tearsheets to be kept on file for possible future assignments. Include SASE for return of materials. Do not send originals! Uses color and b&w prints; 35mm, 2¼×2¼, 4×5, 8×10 transparencies. SASE. Reports in 1 month. Pays royalties on sales. Pays quarterly following first sale and production expenses. Credit line given. Buys exclusive product rights for all wall decor. Simultaneous submissions and/or previously published work OK.
Tips: "Work must be accessible without being too commercial. Our posters/prints are sold to a mass audience worldwide who are buying art prints. Images that relate a story typically do well for us. The photographer should have some sort of unique style or look that separates him from the commercial market."

MODERN ART, 276 Fifth Ave., Suite 205, New York NY 10001. (212)779-0700. Fax: (212)779-1807. Art Coordinator: Mary Mizerany. Specializes in posters, wall decor. Photo guidelines free with SASE.
Needs: Interested in nature, seasonal landscapes, seascapes, European scenes, floral and still life. Reviews stock photos. Model/property release required.
Making Contact & Terms: Submit portfolio for review. Uses 16×20 and larger color and b&w prints; 35mm, 2¼×2¼, 4×5, 8×10 transparencies. Keeps samples on file "if the artist will let us." SASE. Reports in 3 weeks. Pays on usage. Credit line given. Buys one-time, all and exclusive product rights. Simultaneous submissions OK.

NEW YORK GRAPHIC SOCIETY PUBLISHING GROUP, P.O. Box 1469, Greenwich CT 06836-1469. (203)661-2400. Fax: (203)661-2480. Estab. 1925. Publish fine art reproductions, prints and posters.
Needs: Buys 150 images annually; 125 supplied by freelancers. "Looking for variety of images."
Making Contact & Terms: Query with samples. Uses 4×5 transparencies. Does not keep samples on file. SASE. Reports in 1 month. Payment negotiable. Pays on usage. Credit line given. Buys exclusive product rights.

NOVA MEDIA INC., 1724 N. State St., Big Rapids MI 49307-9073. Phone/fax: (616)796-7539. E-mail: trund@nov.com. Website: http://www.nov.com. President: Thomas J. Rundquist. Estab. 1981. Specializes in posters. Photo guidelines free with SASE.
Needs: Buys 100 images annually; most supplied by freelancers. Offers 20 assignments annually. Interested in art, factory photos. Submit seasonal material 2 months in advance. Reviews stock photos. Model release required. Photo captions preferred.
Making Contact & Terms: Query with samples. Works on assignment only. Uses color and b&w prints. Digital format for website, requires submissions on 3.5" disks (IBM compatible) or CD-ROM. SASE. Reports in 1 month. Payment negotiable. Pays extra for electronic usage of photos. Pays on usage. Credit

line given. Buys electronic rights; negotiable. Simultaneous submissions and/or previously published work OK.

PALM PRESS, INC., 1442A Walnut St., Berkeley CA 94709. (510)486-0502. Fax: (510)486-1158. E-mail: palmpress@aol.com. Photo Editor: Theresa McCormick. Estab. 1980. Specializes in greeting cards.
 • Palm Press has received Louie Awards from the Greeting Card Association.
Needs: Buys stock images from freelancers. Buys 200 photos/year. Humor, nostalgia, unusual and interesting b&w and color, Christmas and Valentine, wildlife. Does not want abstracts or portraits. Submit seasonal material 1 year in advance. Model/property release required. Captions required.
Making Contact & Terms: Query with résumé of credits. Query with samples. Uses b&w and color prints; 35mm transparencies. SASE. Reports in 2-3 weeks. Pays royalty on sales. Credit line given. Buys one-time and exclusive worldwide product rights; negotiable.
Tips: Sees trend in increased use of "occasion" photos.

PORTERFIELD'S FINE ART IN LIMITED EDITIONS, 12 Chestnut Pasture Rd., Concord NH 03301. (800)660-8345. Fax: (603)228-1888. E-mail: ljklass@aol.com. Website: http://www.porterfields.com. President: Lance J. Klass. Estab. 1994. Specializes primarily in limited-edition collectibles. Photo guidelines free with SASE.
Needs: Buys 12-15 images annually. Interested only in photos of children ages 1½-4, with 1 or 2 children in each photo. Submit seasonal material as soon as available. "We are seeking excellent color or black and white photographs of early childhood to be used as photo references and conceptual materials by one of America's leading portraitists, whose paintings will then be used as the basis for collectible products, principally collector plates and related material. We are seeking high-quality photographs, whether prints, slides or digital images, which show the wonder and joy, and occasionally even the sad moments, of real children in real-life settings. No posed images, no man-made toys, no looking 'at the camera,' but only photos which provide the viewer with a window into a special, perhaps magical moment of early childhood. Each image should be of one or two children engaged in some purposeful activity which is reminiscent of our own childhood or of the years when our own children or grandchildren were small, or which depicts a typical, lovely, charming or emotional activity or event in the life of a small child." Reviews stock photos. Model release required for children.
Making Contact & Terms: Query with samples. Uses color and b&w prints; transparencies; digital images: TIFF or JPEG. Keeps samples on file. SASE required. Reports in 1-2 weeks. "We pay $150 or more for single-use rights, but will negotiate. No foreign submissions accepted, other than Canadian. We'll work one on one with photographers." **Pays on acceptance.** Credit line not given. Buys single-use rights. "Porterfield's seeks the exclusive right to use a particular photo only to create derivative works, such as paintings, from which further derivative works such as collector plates may be made and sold. We have no desire to and never will reproduce a licensed photograph in its original form for any commercial use, thereby leaving the photographer free to continue to market the photo in its current form for direct reproduction in any medium other than derivative works." Simultaneous submissions and previously published work OK.

PORTFOLIO GRAPHICS, INC., 4060 S. 500 West, Salt Lake City UT 84123. (801)266-4844. Fax: (801)263-1076. Creative Director: Kent Barton. Estab. 1986. Specializes in greeting cards, posters and framing prints. Photo guidelines free with SASE.
Needs: Buys 100 images annually; nearly all supplied by freelancers. Interested in photos with a fine art/decorative look. Want "artistic, unique, fresh looks" for cards, "anything goes." For posters, "keep in mind that we need decorative art that can be framed and hung on the wall." Submit seasonal material on an ongoing basis. Reviews stock photos. Photo captions preferred.
Making Contact & Terms: Send slides, transparencies, tearsheets with SASE. Works with local freelancers only. Art director will contact photographer for portfolio review if interested. Uses prints, 4×5 transparencies. Does not keep samples on file. SASE. Reports in 2 weeks on queries, 1 month on samples. Pays 5-10% royalty on sales. Credit line given. Quarterly royalties paid per pieces sold. Buys exclusive product rights license per piece.

THE PRESS CHAPEAU, P.O. Box 4591, Baltimore MD 21212. Director: Elspeth Lightfoot. Estab. 1976. Specializes in fine art originals for corporate facilities, museums and private collectors. Photo guidelines free with SASE.
 • Press Chapeau maintains an image bank of 40,000 images.
Needs: Buys 400 images annually; 10% supplied by freelancers. Offers 10-20 commissions annually. Model/property release required. Captions required.
Making Contact & Terms: Query with samples, business card, self-promotion piece or tearsheets to be

kept on file for possible future assignments. "No artist's statements please." Uses 8×10, 24×30 matte b&w prints; 35mm, 2¼×2¼, 8×10 transparencies. Accepts images in digital format via disk or CD-ROM. Keeps samples on file. SASE. Reports in 1-2 weeks. Photographer determines rate. **Pays on acceptance.** Credit line given.

Tips: "Your work is more important than background, résumé or philosophy. We judge solely on the basis of the image before us."

PRODUCT CENTRE-S.W. INC., THE TEXAS POSTCARD CO., P.O. Box 860708, Plano TX 75086. (972)423-0411. Art Director: Susan Hudson. Estab. 1980. Specializes in postcards.

Needs: Buys approximately 100 freelance photos/year. Need photos of Texas, Oklahoma, Louisiana, Arkansas, Kansas, Missouri, New Mexico and Mississippi towns/scenics; regional (Southwest only) scenics, humorous, inspirational, nature (including animals), staged studio shots—model and/or products. No nudity. Submit seasonal material 1 year in advance. Model release required.

Making Contact & Terms: Send for current want list, then send insured samples with return postage/insurance. Include Social Security number and telephone number. Uses "C" print 8×10; 35mm, 2¼×2¼, 4×5 transparencies. SASE. No material returned without postage. Reports in usually 3-4 months, depending on season. Pays $50-100/photo. Pays on publication. Buys all rights.

Tips: "Submit slides only for viewing. Must be in plastic slide sleeves and each labeled with photographer's name and address. Include descriptive material detailing where and when photo was taken. Follow the guidelines—nine out of ten submissions rejected are rejected due to noncompliance with submission guidelines."

RECYCLED PAPER GREETINGS, INC., Art Dept., 3636 N. Broadway, Chicago IL 60613. (773)348-6410. Art Director: Melinda Gordon. Specializes in greeting cards and postcards.

Needs: Buys 30-50 photos/year. "Primarily humorous photos for postcards and greeting cards. Photos must have wit and a definite point of view. Unlikely subjects and offbeat themes have the best chance, but will consider all types." Model release required.

Making Contact & Terms: Send for artists' guidelines. Uses 4×5 b&w and color prints; b&w or color contact sheets. Please do not submit slides. SASE. Reports in 1 month. Pays $250/b&w or color photo. **Pays on acceptance.** Credit line given. Buys all rights; negotiable. Simultaneous submissions OK.

Tips: Prefers to see "up to ten samples of photographer's best work. Cards are printed 5×7 vertical format. Please include messages. The key word for submissions is wit."

Ⓝ RED FARM STUDIO, 1135 Roosevelt Ave., Pawtucket RI 02861. (401)728-9300. Fax: (401)728-0350. Receptionist: Crystal. Estab. 1947. Specializes in greeting cards, stationery.

Needs: Interested in photos of religious themes, flowers, wildlife, roses, nautical. Reviews stock photos.

Making Contact & Terms: Send query letter with samples and stock photo list. Art director will contact photographer for portfolio review if interested. Portfolio should include color, prints, slides, transparencies. Works with local freelancers only. Does not keep samples on file; include SASE for return of material. Pays on receipt of invoice. Credit line given. Rights negotiated for greeting cards and stationery.

REEDPRODUCTIONS, 52 Leveroni Ct., Suite 3, Novalo CA 94949. (415)883-1851. Fax: (415)883-1759. Art Director: Susie Reed. Estab. 1978. Specializes in postcards, key rings, address books, date books, magnets, pins, calendars and stationery.

Needs: Number of freelancers assigned varies. Needs classic celebrity portraits, Hollywood images and rock photographs. Model release preferred.

Making Contact & Terms: Query with samples or send unsolicited photos by mail for consideration. Include résumé, business card, brochure, flier or tearsheets to be kept on file for possible future assignments. Uses 35mm, 2¼×2¼, 4×5 and 8×10 transparencies; glossy b&w or color prints or contact sheets. Accepts images in Photoshop. SASE. Reports in 1 month. Pays one-time fee. Credit line negotiable. Buys one-time rights. Simultaneous submissions and previously published work OK.

Tips: "We're looking for classic celebrity portraits, b&w or color, shot in clean style."

REIMAN PUBLICATIONS, L.P., 5400 S. 60th St., Greendale WI 53129. (414)423-0100. Fax: (414)423-8463. Photo Coordinator: Trudi Bellin. Estab. 1965. Specializes in calendars and occasionally posters and cards. Photo guidelines free with SASE.

Needs: Buys more than 165 images annually; all supplied by freelancers. Interested in humorous cow, pig and chicken photos as well as scenic country images including barns and churches. Also need backyard gardens, wild birds, North American scenics by season, spring and winter shots from southern half of USA, as well as vintage shots both color and b&w. Unsolicited calendar work must arrive between September 1-15. Does not want smoking, drinking, nudity. Reviews stock photos. Model/property release required for

© Brenda Evans

"This was an idea I've had since a car show started coming to our town ten yeas ago," says photographer Brenda Evans of her Father's Day card, a hand-painted black & white image of an American muscle car. She submitted this image, along with others in her portfolio, by mail to Renaissance Greetings. They chose this shot for its playful mood and its appeal to a masculine audience. "I wanted to convey a message of a period in America that is gone," says Evans. "This is one of a series I did for a show called 'American Hot Flash.'"

children, private homes. Captions required; include season, location; birds and flowers must include common and/or scientific names.

Making Contact & Terms: Query with cover letter and résumé of credits. Query with stock photo list and ID each image. Uses b&w prints; 35mm, 2¼×2¼, 4×5, 8×10 transparencies. Tearsheets are kept on file but not dupes. Reports in 3 months for first review. Pays $50-300/color photo; $25-75/b&w photo. Pays on publication. Credit line given. Buys one-time rights. Simultaneous submissions and previously published work OK.

Tips: "Tack-sharp focus is a must if we are to consider photo for enlargement. Horizontal format is preferred. The subject of the calendar theme must be central to the photo composition. All projects look for technical quality. Focus has to be sharp—no soft focus and colors must be vivid so they 'pop off the page.'"

RENAISSANCE GREETING CARDS, INC., P.O. Box 845, Springvale ME 04083-0845. (207)324-4153. Fax: (207)324-9564. Photo Editor: Wendy Crowell. Estab. 1977. Photo guidelines free with SASE. Send submissions: ATTN: Product Development Assistant.
• Renaissance is doing more manipulation of images and adding of special effects.
Needs: Buys/assigns 50-100 photos/year. "We're interested in photographs that are artsy, quirky, nostalgic, dramatic, innovative and humorous. Very limited publication of nature/wildlife photos at this time. Special treatment such as hand-tinted b&w images are also of interest." No animals in clothing, risqué or religious. Limit slides/images to less than 50 per submission. Do not send originals on submission. Reviews stock photos. Model release preferred. Captions required; include location and name of subject.

THE SUBJECT INDEX, located at the back of this book, lists publications, book publishers, galleries, gift and paper product companies and stock agencies according to the subject areas they seek.

Making Contact & Terms: Uses b&w 35mm, 2¼×2¼, 4×5 transparencies; b&w, color contact sheets or color copies. SASE. Cannot return originals without postage supplied. Reports in 2 months. Rates negotiable. Pays $175-350 flat fee/color or b&w photo, or $150 advance against royalties. Credit line given. Buys all rights or exclusive product rights; negotiable.

Tips: "We strongly suggest starting with a review of our guidelines."

RIGHTS INTERNATIONAL GROUP, 463 First St., Suite 3C, Hoboken NJ 07030. (201)963-3123. Fax: (201)420-0679. President: Robert Hazaga. Estab. 1996. Rights International Group is a licensing agency specializing in representing photographers and artists to manufacturers for licensing purposes. Manufacturers include greeting cards, calendars, posters and gift wrap companies.

Needs: Interested in all subjects. Submit seasonal material 9 months in advance. Reviews stock photos. Model/property release required.

Making Contact & Terms: Submit portfolio for review. Uses prints, slides, transparencies. Keeps samples on file. SASE. Reports in 1-2 weeks. Payment negotiable. Pays on license deal. Credit line given. Buys exclusive product rights. Simultaneous submissions and/or previously published work OK.

N ▧ ROBINSON GREETING CARD CO., 2351 Des Carrières, Montreal, Quebec H2G 1X6 Canada. (514)279-6387. Fax: (514)279-9325. Art Director: Robert Lavoie. Specializes in greeting cards.

Needs: Reviews stock photos of flowers.

Making Contact & Terms: Send query letter with stock photo list. Art director will contact photographer for portfolio review if interested. Portfolio should include prints. Uses 4×5 transparencies. Accepts images in digital format. Does not keep samples on file; include SASE for return of material. Buys rights for Canada and US.

ROCKSHOTS, INC., 632 Broadway, New York NY 10012. Fax: (212)353-8756. Art Director: Bob Vesce. Estab. 1978. Specializes in greeting cards.

Needs: Buys 20-50 photos/year. Sexy (including male and female nudes and semi-nudes), outrageous, satirical, ironic, humorous photos. "One of our specialties is super-size female models, 500 to 650 lbs. Another is our male and female nude and semi-nude fantasy cards." Submit seasonal material at least 6 months in advance. Model release required.

Making Contact & Terms: Send SASE requesting photo guidelines. Provide flier and tearsheets to be kept on file for possible future assignments. Uses color prints; 35mm, 2¼×2¼ and 4×5 slides. "Do not send originals!" SASE. Reports in 8-10 weeks. Pays $125-300/color photo; other payment negotiable. **Pays on acceptance.** Rights negotiable. Simultaneous submissions and previously published work OK.

Tips: Prefers to see "greeting card themes, especially birthday, Christmas, Valentine's Day. Remember, male and female nudes and semi-nudes are fantasies. Models should definitely be better built than average folk. Also, have fun with nudity, take it out of the normal boundaries. It's much easier to write a gag line for an image that has a theme and/or props. We like to look at life with a very zany slant, not holding back because of society's imposed standards. We are always interested in adding freelance photography because it broadens the look of the line and showcases different points of view. We shoot extensively inhouse."

⊕ SANGHAUI ENTERPRISES, (formerly Greetwell), D-24, M.I.D.C., Satpur., Nasik 422 007 India. Phone: 253-350181. Fax: 253-351381. Chief Executive: Ms. V.H. Sanghavi. Estab. 1974. Specializes in greeting cards and calendars.

Needs: Buys approx. 50 photos/year. Landscapes, wildlife, nudes. No graphic illustrations. Submit seasonal material anytime throughout the year. Reviews stock photos. Model release preferred.

Making Contact & Terms: Query with samples. Uses any size color prints. SASE. Reports in 1 month. Pays $25/color photo. Pays on publication. Credit line given. Previously published work OK.

Tips: In photographer's samples, "quality of photo is important; would prefer nonreturnable copies. No originals please."

▨ SCAN VIDEO ENTERTAINMENT, P.O. Box 183, Willernie MN 55090-0183. (612)426-8492. Fax: (612)426-2022. President: Mats Ludwig. Estab. 1981. Distributors of Scandinavian video films, books, calendars, cards.

Needs: Buys 100 photos; 5-10 films/year. Wants any subject related to the Scandinavian countries. Examples of recent uses: travel videos, feature films and Scandinavian fairy tales, all VHS. Reviews stock photos. Model/property release required.

Audiovisual Needs: Uses videotape for marketing and distribution to retail and video stores. Subjects include everything Scandinavian: travel, history, feature, children's material, old fashion, art, nature etc.

Making Contact & Terms: Query with stock photo list. Uses color prints; 35mm transparencies; film and videotape. Does not keep samples. Cannot return material. Replies only if interested. Pays royalties

on sales. Pays upon usage. Credit line not given. Buys all rights; negotiable.

Tips: Wants professionally made and edited films with English subtitles or narrated in English. Seeks work which reflects an appreciation of Scandinavian life, traditions and history.

SCHURMAN DESIGN, (formerly Marcel Schurman Company), 101 N. Montgomery, San Francisco CA 94105. (800)685-2614 or (415)284-0133 ext. 4032 or 4018. Fax: (707)428-0425. Contact: Creative Department. Estab. 1950. Specializes in greeting cards, stationery, gift wrap. Guidelines free with SASE.

Needs: Buys several hundred images annually; all supplied by freelancers. Offers 50 assignments annually. Interested in humorous, seasonal, art/contemporary, some nature, still life. Submit seasonal material 1 year in advance. Does not want technical, medical, or industrial shots. Model/property release required. Captions preferred.

Making Contact & Terms: Submit portfolio for review. Query with samples. Provide résumé, business card, self-promotion piece or tearsheets to be kept on file for possible future assignments. Uses 8×10, 11×14 matte b&w prints; 35mm, $2\frac{1}{4} \times 2\frac{1}{4}$, 4×5 transparencies. Keeps samples on file. SASE. Reports in 6 weeks. Pays flat fee. **Pays on acceptance.** Credit line given. Buys 3-5 year worldwide exclusive rights to greeting cards/gift wraps. Simultaneous submissions OK.

Tips: "In terms of greeting cards, I advise any interested artists to familiarize themselves with the company's line by visiting a retailer. It is the fastest and most effective way to know what kind of work the company is willing to purchase or commission. Photography, in all forms, is very marketable now, specifically in different areas of technique, such as hand-colored, sepia/etc. toning, Polaroid transfer, b&w art photography."

N SPARROW & JACOBS, K&W Enterprises, 2870 Janitell Rd., Colorado Springs CO 80906. (719)579-9011. Fax: (719)579-9007. Art Director: Peter A. Schmidt. Estab. 1986. Specializes in bookmarks, calendars, greeting cards, stationery, post cards.

Needs: Buys 28 images annually; 18 are supplied by freelancers. The number of freelance images could grow depending on year. Interested in houses, doors, windows, flowers, animals, nature shots, seasonal, humorous animals. Submit seasonal material 1 year in advance. Not interested in babies, people (unless in a nature scene), foreign, eastern sites. Property release preferred.

Making Contact & Terms: Send query letter with samples, brochure, stock photo list, tearsheets. Provide résumé, business card, self-promotion piece or tearsheets to be kept on file for possible future assignments. Art director will contact photographer for portfolio review if interested. Portfolio should include color, tearsheets, slides, transparencies. Accepts images in digital format that are scanable for output to at least $4.25'' \times 6''$ at 300 dpi resolution. Keeps samples on file; include SASE for return of material. Reports back only if interested, send non-returnable samples. Pays by the project, $200-450 for color. Pays on receipt of invoice. Buys all rights; negotiable.

SYRACUSE CULTURAL WORKERS, Box 6367, Syracuse NY 13217. (315)474-1132. Fax: (315)475-1277. Research/Development Director: Dik Cool. Art Director: Karen Kerney. Specializes in posters, cards and calendars.

Needs: Buys 15-25 freelance photos/year. Images of social content, reflecting a consciousness of diversity, multiculturalism, community building, social justice, environment, liberation, etc. Model release preferred. Captions preferred.

Making Contact & Terms: Send unsolicited photos by mail for consideration. Uses any size b&w; 35mm, $2\frac{1}{4} \times 2\frac{1}{4}$, 4×5 or 8×10 color transparencies. SASE. Reports in 2-4 months. Pays $75-100/b&w or color photo plus free copies of item. Credit line given. Buys one-time rights.

Tips: "We are interested in photos that reflect a consciousness of peace and social justice, that portray the experience of people of color, disabled, elderly, gay/lesbian—must be progressive, feminist, non-sexist. Look at our catalog (available for $1)—understand our philosophy and politics. Send only what is appropriate and socially relevant. We are looking for positive, upbeat and visionary work."

TELDON CALENDARS, A Division of Teldon International Inc., 3500 Viking Way, Richmond, British Columbia, V6V 1N6 Canada. (604)272-0556. Fax: (604)272-9774. E-mail: move@rogers.wave.ca. Photo Editor: Monika Vent. Estab. 1968. Publishes high quality scenic and generic advertising calendars. Photos used for one time use in calendars. Photo guidelines free with SAE (9×11) and IRCs or stamps only for return postage.

Needs: Buys 1,000 images annually, 70% are supplied by freelancers. Looking for travel (world), wildlife (North America), classic automobiles, golf, scenic North America photos and much more. Reviews stock photos. Model/property release required for residential houses, people. Photo captions required that include complete detailed description of destination, i.e., Robson Square, Vancouver, British Columbia, Canada. "Month of picture taken also required as we are 'seasonal driven.' "

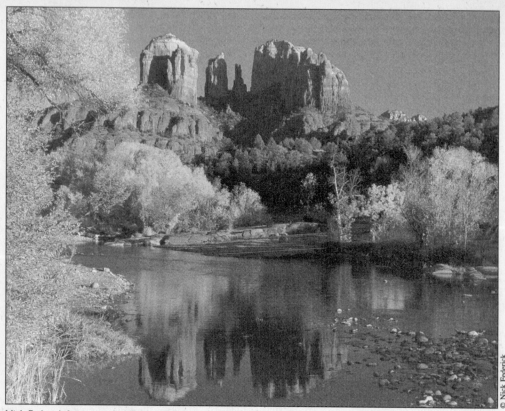

© Nick Federick

Nick Federick first contacted Teldon Calendars in 1994 after reading their listing in *Photographer's Market*. "I queried them with a stock photo list and a request for guidelines." The company filed several dupes of his slides for future calendars and in 1996 requested the originals of two images, including this one, for 1998 calendars. "The reflection of Cathedral Rocks in Oak Creek at Red Rock Crossing State Park near Sedona, Arizona, was used to illustrate the month of October in an Arizona calendar." Photo Editor Monika Vent chose Federick's image because "he captured the right mood, the colorful fall foliage and had a strong composition."

Making Contact & Terms: Query with stock photo list. No submissions accepted unless guidelines have been received and reviewed. Works with freelancers and stock agencies. Uses 35mm, 2¼×2¼, 4×5, 6×7, 8×10 horizontal only transparencies. "We are making duplicates of what we think is possible material and return the originals within a given time frame. Originals are recalled once final selection has been made." SASE. Reports in 1 month, depending on work load. Pays $100 for one-time use. Pays in September of publication year. Credit line and complementary calendar copies given. Simultaneous submissions and/or previously published works OK.

Tips: Horizontal transparencies only, dramatic and colorful nature/scenic/wildlife shots. City shots to be no older than 1 year. For scenic and nature pictures avoid "man made" objects, even though an old barn captured in the right moment can be quite beautiful. "Examine our catalogs and fliers carefully and you will see what we are looking for. Capture the beauty of nature and wildlife as long as it's still around— and that's the trend."

TIDE-MARK PRESS, Box 280311, East Hartford CT 06128-0311. (860)289-0363. Fax: (860)289-3654. Contact Sidelines Editor: Trish Reynolds. Estab. 1979. Specializes in calendars and coffee table books. Photo guidelines free with SASE.

Needs: Buys 500 images annually; 400 are supplied by freelancers. Needs complete calendar concepts which are unique, but also have identifiable markets; groups of photos which could work as an entire calendar; ideas and approach must be visually appealing and innovative but also have a definable audience. No general nature or varied subjects without a single theme. Interested in arts and architecture, birds, animals, gardens, hobby, inspiration, nature, nautical, regional, transport and travel. Submit seasonal ma-

terial 18 months in advance. Reviews stock photos. Model release preferred. Captions required.
Making Contact & Terms: "Contact us to offer specific topic suggestion which reflect specific strengths of your stock." Send query letter with stock photo list. Editor will contact photographer for portfolio review if interested. Uses 35mm, 2¼×2¼, 4×5 and 8×10 transparencies. SASE. Reports in 1 month. Pays $150-250/color photo; royalties on sales if entire calendar supplied. Pays on publication or per agreement. Credit line given. Buys one-time rights.
Tips: "We tend to be a niche publisher and we rely on niche photographers to supply our needs. Ask for a copy of our guidelines and a copy of our catalog so that you will be familiar with our product. Then send a query letter of specific concepts for a calendar."

N UNIQUE GREETINGS, INC., P.O. Box 5783, Manchester NH 03108. Estab. 1988. Specializes in calendars, decorations, gifts, greeting cards. Guidelines sheet free with SASE.
Needs: Buys 12 images annually; 10 are supplied by freelancers. Interested in humorous images. Submit seasonal material 6 months in advance. Reviews stock photos of foliage, animals and b&w images. Model release required. Photo captions are required.
Making Contact & Terms: Send query letter with samples and SASE. To show portfolio, photographer should follow-up with letter after initial query. Art director will contact photographer for portfolio review if interested. Portfolio should include b&w and/or color. Works with local freelancers only. Uses 4×6 prints. Include SASE for return of material. Reports back only if interested, send non-returnable samples. Pays by the project, $250-500 for color. Pays on publication. Credit line not given. Buys one-time rights.
Tips: "We also use photos for brochures."

VAGABOND CREATIONS, INC., 2560 Lance Dr., Dayton OH 45409. (937)298-1124. President: George F. Stanley, Jr. Specializes in greeting cards.
Needs: Buys 3 photos/year. Interested in general Christmas scenes . . . non-religious. Submit seasonal material 9 months in advance. Reviews stock photos. Uses 35mm transparencies. SASE. Reports in 1 week. Pays $100/color photo. **Pays on acceptance.** Buys all rights. Simultaneous submissions OK.

VINTAGE IMAGES, P.O. Box 4699, Silver Spring MD 20914. (301)879-6522. Fax: (301)879-6524. E-mail: vimages@erols.com. President: Brian Smolens. Estab. 1986. Specializes in greeting cards, usually produced in collaboration with foreign greeting card firms.
Needs: Buys or produces in joint ventures several hundred designs annually, 75% supplied by freelancers. Interested in primarily flowers/floral, cats, secondarily in babies or humorous concepts as well as any collection suitable to mass market card lines.
Making Contact & Terms: "We only work with 35mm transparencies. Do not request guidelines, as our needs are listed above. Please only contact us with large groups of tranparencies which we need to hold for a period of 12 months. Cash payment varies depending on what countries and what firms are involved, but averages $75. In some cases, if it is a royalty deal, total payment may go higher than this."
Tips: "In order to assemble a greeting card line, we need a large assortment on a given theme, of at least 100 different images."

WATERMARK, Suite 402, Lafayette Center, Kennebunk ME 04043. (207)985-6134. Fax: (207)985-7633. E-mail: watermrk@ime.net. Publisher: Alexander Bridge. Estab. 1982. Specializes in posters and stationery products.
Needs: Buys 6 images annually; 50% supplied by freelancers. Offers 2 assignments annually. Interested in rowing/crew and sailing. Submit seasonal material 6-12 months in advance. Does not want only rowing photos. Reviews stock photos of sports. Model release required. Photo captions preferred.
Making Contact & Terms: Query with samples. Works on assignment only. Uses 4×5 transparencies. Keeps samples on file. SASE. Reports in 3 weeks. Payment negotiable. Pays on usage. Credit line given. Buys all rights. Offers internships for photographers during summer. Contact President: Alexander Bridge.

N WEST GRAPHICS, 1117 California Dr., Burlingame CA 94010. (800)648-9378. Contact: Production Department. Specializes in humorous greeting cards. Photo guidelines free with SASE.
Needs: Buys 10-20 freelance photos/year. Humorous, animals, people in outrageous situations or anything

of an unusual nature; prefers color. Does not want to see scenics. Submit seasonal material 1 year in advance. Model release required. Captions preferred; include model's/photographer's name.

Making Contact & Terms: Query with samples. Send unsolicited photos by mail for consideration. Uses 8×10 b&w glossy prints; 35mm, 2¼×2¼ and 4×5 transparencies. Do not send originals. SASE. Reports in 6 weeks. Pays 5% royalty on sales 30 days after publication. Buys exclusive product rights; negotiable. Simultaneous submissions and previously published work OK.

Tips: "Our goal is to publish cards that challenge the limits of taste and keep people laughing. Using the latest in computer graphic technology we can creatively combine photographic images with settings and objects from a variety of resources. Computers and scanners have expanded the range of photographs we accept for publication."

WISCONSIN TRAILS, Box 5650, Madison WI 53705. (608)231-2444. Fax: (608)231-1557. E-mail: wistrail@mailbag.com. Photo Editor: Nancy Mead. Estab. 1960. Specializes in calendars (horizontal and vertical) portraying seasonal scenics, some books and activities from Wisconsin.

Needs: Buys 35 photos/issue. Needs photos of nature, landscapes, wildlife and Wisconsin activities. Makes selections in January for calendars, 6 months ahead for issues. Captions required.

Making Contact & Terms: Submit material by mail for consideration or submit portfolio. Uses 35mm, 2¼×2¼ and 4×5 transparencies. Accepts images in digital format for Mac (Photoshop). Send via compact disc, floppy disk, SyQuest, Zip disk, jazz disk (300 dpi output 1250 dpi). Reports in 1 month. Pays $50-100/b&w photo; $50-200/color photo. Buys one-time rights. Simultaneous submissions OK "if we are informed, and if there's not a competitive market among them." Previously published work OK.

Tips: "Be sure to inform us how you want materials returned and include proper postage. Calendar scenes must be horizontal to fit 8½×11 format, but we also want vertical formats for engagement calendars. See our magazine and books and be aware of our type of photography. Submit only Wisconsin scenes."

ZOLAN FINE ARTS, LTD., (formerly Zolan Fine Art Studio), Dept. PM, P.O. Box 656, Hershey PA 17033-2173. (717)534-2446. Fax: (717)534-1095. E-mail: donaldz798@aol.com. President/Art Director: Jennifer Zolan. Commercial and fine art business. Photos used for artist reference in oil paintings.

Needs: Buys 16-24 photos/year; assignments vary on need. Interested in candid, heart-warming, and endearing photos of children with high emotional appeal between the ages of 2-4 capturing the golden moments of early childhood. "Currently we are looking for the following subject matter: children in country scenes, children fishing, at the beach, children with pets, etc." Reviews stock photos. Model release preferred.

Making Contact & Terms: Write and send for photo guidelines by mail, fax or America Online. Uses any size color or b&w prints; 35mm, 2¼×2¼, 4×5, 8×10 transparencies. Accepts images in digital format for Mac (TIFF, GIF). Submit via online or floppy disk. Does not keep samples on file. SASE. Queries on guidelines 3-4 weeks; photo returns or acceptances up to 60 days. Pays $200-500/b&w or color photo; pays up to $1,000 to buy exclusive rights for artist reference. **Pays on acceptance**. Buys exclusive rights only for use as artist reference; negotiable.

Tips: "Photos should have high emotional appeal and tell a story. Children should be involved with activity or play. Photos should look candid and capture a child's natural mannerisms. Write for free photo guidelines before submitting your work. We are happy to work with amateur and professional photographers. We are always looking for human interest types of photographs on early childhood, ages two to four. Photos should evoke pleasant and happy memories of early childhood."

Stock Photo Agencies

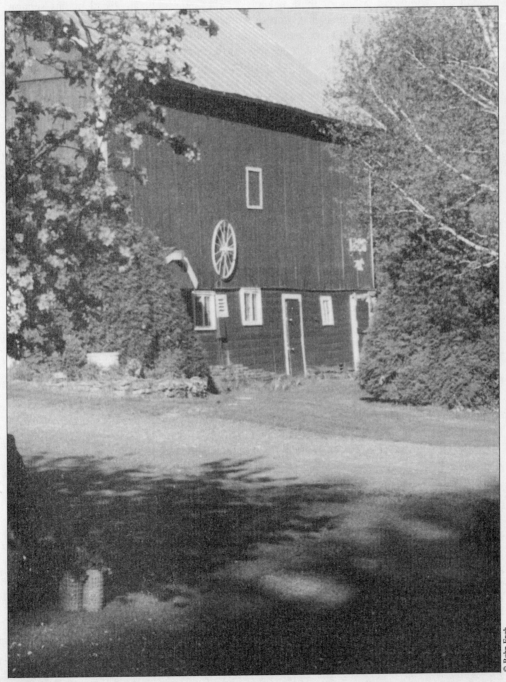

STOCK FACTS

If you are unfamiliar with how stock agencies work, the concept is easy to understand. Stock agencies house large files of images for contracted photographers and market the photos to potential buyers. In exchange for selling the images agencies typically extract a 50 percent commission from each sale. The photographer receives the other 50 percent.

In the past 15-20 years the stock industry has witnessed enormous growth, with agencies popping up worldwide. Many of these agencies, large and small, are listed in this section. However, as more and more agencies compete for sales there has been a trend toward partnerships among some small to mid-size agencies. In order to match the file content and financial strength of larger stock agencies, small agencies have begun to combine efforts when putting out catalogs and other promotional materials. In doing so they've pooled their financial resources to produce top-notch catalogs, both print and CD-ROM.

Other agencies have been acquired by larger agencies and essentially turned into subsidiaries. Often these subsidiaries are strategically located to cover different portions of the world. Typically, smaller agencies are bought if they have images that fill a need for the parent company. For example, a small agency might specialize in animal photographs and be purchased by a larger agency that needs those images but doesn't want to search for individual wildlife photographers.

The stock industry is extremely competitive and if you intend to sell stock through an agency you must know how they work. Below are seven ideas that can help you land a contract with an agency:

1. Build a solid base of quality images before contacting any agency. If you send an agency a package of 50-100 images they are going to want more if they're interested. You must have enough quality images in your files to withstand the initial review and get a contract.

2. Be prepared to supply new images on a regular basis. Most contracts stipulate that photographers must send additional submissions periodically—perhaps quarterly, monthly, or annually. Unless you are committed to shooting regularly, or unless you have amassed a gigantic collection of images, don't pursue a stock agency.

3. Make sure all of your work is properly cataloged and identified with a file number. Start this process early so that you're prepared when agencies ask for this information. They'll need to know what is contained in each photograph so that the images can be properly referenced in catalogs and on CD-ROMs.

4. Research those agencies that might be interested in your work. Often smaller agencies are more receptive to newcomers because they need to build their image files. When larger agencies seek new photographers, they usually want to see specific subjects in which photographers specialize. If you specialize in a certain subject area, be sure to check out our Subject Index of 46 categories, listing companies according to the types of images they need.

5. Conduct reference checks on any agencies you plan to approach to make sure they conduct business in a professional manner. Talk to current clients and other contracted photographers to see if they are happy with the agency. Remember you are interviewing them, too. Also, some stock agencies are run by photographers who market their own work through their own agencies. If you are interested in working with such an agency, be certain that

◀ "We are the meeting place for photographers who want to sell their stock photos, and for editors and art directors who want to buy them," says Rohn Engh, owner of PhotoSource International. "For more than 20 years we've been helping photographers and photobuyers from our worldwide connected electronic cottage on our farm in western Wisconsin." Engh explains the importance of the Internet as a marketing tool on page 313.

your work will be given fair marketing treatment.

6. Once you've selected a stock agency, write a brief cover letter explaining that you are searching for an agency and that you would like to send some images for review. It's usually OK to include some samples (20-40 slides), but do not send originals. Only send duplicates for review so that important work won't get lost or damaged. You also might be asked to submit a portfolio, so be prepared to do so. And always include a SASE.

7. Finally, don't expect sales to roll in the minute a contract is signed. It usually takes a few years before initial sales are made. Most agency sales come from catalogs and often it takes a while for new images to get printed in a catalog.

SIGNING AN AGREEMENT

When reviewing stock agency contracts there are several points to consider. First, it's common practice among many agencies to charge photographers fees, such as catalog insertion rates or image duping. Don't be alarmed and think the agency is trying to cheat you when you see these clauses. Besides, it might be possible to reduce or eliminate these fees through negotiation.

Another important item in most contracts deals with exclusive rights to market your images. Some agencies require exclusivity to sales of images that they are marketing for you. In other words, you can't market the same images they have on file. This prevents photographers from undercutting agencies on sales. Such clauses are fair to both sides as long as you can continue marketing images that are not in the agency's files.

An agency also may restrict your rights to sign with another stock house. Usually such clauses are merely designed to keep you from signing with a competitor. Be certain your contract allows you to work with other agencies. This may mean limiting the area of distribution for each agency. For example, one agency may get to sell your work in the United States, while the other gets Europe. Or it could mean that one agency sells only to commercial clients, while the other handles editorial work.

Finally, be certain you understand the term limitations of your contract. Some agreements renew automatically with each submission of images. Others renew automatically after a period of time unless photographers terminate their contracts in writing. This might be a problem if you and your agency are at odds for any reason. So, be certain you understand the contractual language before signing anything.

STOCK TRENDS REPORT

Stock is one of the only photography markets where trends are real and can be accurately tracked. This means it's easy to tell what's hot but it also means photographers may be tempted to "copy" popular work. This is dangerous for several reasons. Of course copyright infringement is always a danger if you deliberately model your work after someone else's. Beyond this, stock agencies aren't interested in images like ones they already sell and, if they're reputable, they won't want to copy their competition directly either.

Themes on the other hand are not copyrightable and can be illustrated in numerous ways. It is helpful to be aware of top-selling concepts and create new images to illustrate them. If you're already working with a stock agency, ask your contact what the most popular themes are—things like teamwork, happiness and technology. If you're still trying to find an agent, peruse business and trade publications, both big users of stock, and try to discover the reoccuring themes in them.

Jim Pickerell, author and owner of Stock Connection, publishes a helpful newsletter called *Selling Stock*. He sees these themes as timeless, high-demand stock concepts: caring, change, communication, elation, elderly, endurance, fast start, fresh, futuristic, good life, graceful, happiness, healthy, joy, love, new technology, power, risk, romance, security, simplicity, speed, strength, success, teamwork, time, wealth and working together. He also provides a free list of

200 concepts that are frequently used in advertising. (Send a SASE to Jim Pickerell, 110 Frederick Ave., Suite A, Rockville MD 20850.)

Other top concepts are reflected in our changing society. Many stock agencies are reporting an increased demand for images of minorities in unstereotypical settings. They are looking for images of diverse peoples in positions of power and at all stages of life. Old white men can no longer stand for typical business executives—this is just as true in real life as it is in stock. Finally, computer-generated, vintage and natural images are top sellers at the best stock agencies.

On a less optimistic note, the controversy over clip discs of royalty-free images has not subsided. At the PhotoPlus Expo in New York, an annual convention of imaging industry professionals, a panel discussion of royalty-free photography drew heated commentary from both sides of the debate. There is no question that RF is here to stay and that it is making inroads into the traditional stock market; the question is what effect this will have on the industry and on photographers. Many stock houses and their photographers have found success and profits in clip discs but the long-term effect of the loss of rights control won't be felt for several years.

The most optimistic stock agents claim that RF only takes away low-end sales and that higher-end buyers will still turn to traditional stock for personal service and for rights control. But as the quality of clip images grows the only way traditional stock agencies will be able to compete is to offer more creative, exciting images. This means photographers can no longer look at stock as a place to "dump" extra shots. They will need to shoot specifically for stock with an eye to the unique. This also means that competition among photographers, which is already fierce, will increase in the future.

WHERE TO LEARN MORE ABOUT THE STOCK MARKET

There are numerous resources available for photographers who want to learn about the stock industry. Here are a few of the best.

• **PhotoSource International (800)223-3860**. Owned by author/photographer Rohn Engh, this company produces several newsletters that can be extremely useful for stock photographers. A few of these include *PhotoStockNotes, PhotoMarket, PhotoLetter* and *PhotoBulletin*.

• *Taking Stock* **(301)251-0720**. This newsletter is published by one of the photo industry's leading insiders, Jim Pickerell. He gives plenty of behind-the-scenes information about agencies and is a huge advocate for stock photographers.

• **The Picture Agency Council of America (800)457-7222**. Anyone researching an American agency should check to see if the agency is a member of this organization. PACA members are required to practice certain standards of professionalism in order to maintain membership.

• **British Association of Picture Libraries and Agencies (081)883-2531**. This is PACA's counterpart in the United Kingdom and is a quick way to examine the track record of many foreign agencies.

INSIDER REPORT

Take stock in the Web to compete with market giants

You don't need to be affiliated with a major stock photography agency or a Web-savvy designer to sell your images digitally. Just as Internet service providers sell e-mail service, Internet access and server space for a monthly fee, third-party sources such as PhotoSource International (PSI) sell server space for photographers to display or describe their images for a flat monthly fee. With services like this, photographers can spend less time marketing photos and more time making images that will stand out from the volumes offered by huge stock photo companies.

PSI, located at Pine Lake Farm near Osceola, Wisconsin, provides photo marketing services to the international photo-buying and photo-supply industry. The company's website (www.photosource.com) offers services like bulletin boards, marketletters, directories and descriptions of photographers' images, and ancillary marketing products. These services facilitate better communication and quick transactions between photographers and photo buyers. Rohn Engh, who founded PSI in 1976 and serves as the company's director, is a veteran stock photographer who believes the Web is an invaluable marketing tool for photographers. "More and more photographers are emerging from the dark ages and finding that many photo buyers could learn about the excellent pictures photographers have stashed away in a shoe box, going no place but out of date," he says.

For these photographers, Engh has launched PhotoSourceFolio and PhotoSourceBank, two services offered on PSI's website. PhotoSourceFolio is a place for stock photographers to display six examples of their work on their own page within the PSI domain. PhotoSourceBank is a section of the site where, in 1,500 words, photographers can describe pictures in their portfolios. "It's been said that a picture is worth a thousand words, but on the Internet, it's a thousand times faster to call up a word than an image," says Engh. "Since photo buyers generally search for the source of pictures first and then attempt to locate the picture, we find this is a quick way for photo buyers to locate the hard-to-find picture they're researching." PhotoSourceBank and PhotoSourceFolio, which each cost $4.95 per month, cater to the marketing needs of individual photographers and very small stock agencies. But any photo buyer can access the information on the site for free.

To understand the picture-buying process—from the photo buyer logging onto the Net to her holding your image and you holding her money—consider the PhotoSourceBank. When a photo buyer wants to find an image using this service, she clicks on the PhotoSourceBank link and types a keyword for the subject she is interested in, such as "black horse," into the search box. The search produces a screen with a list of names and contact information for the photographers who have listed "black horse" in their 1,500-word descriptions. Next, the photo buyer contacts the photographers via telephone, e-mail or fax to discuss the pictures.

"At this point, three things can happen," says Engh. "If the photographer has a website,

INSIDER REPORT, *Engh*

the photo buyer can say, 'Would you put up three selections on your website? I'd like to review them.' Second, the photo buyer could request the photographer send a scanned image via e-mail or fax. The third option is for the photo buyer to use the traditional method of requesting that the photographer send three slides for review." Regardless of the method, PSI is not involved in the transaction beyond the initial search and does not take a commission fee for the sale. The company's website simply acts as a reference guide where photographers can display or describe their work and photo buyers can find it.

"Since there are dozens of newsgroups on the Internet, and hundreds of photographers' websites, communication between photographers, stock agencies and photo buyers is accelerating," says Engh. Perhaps the growing tendency for photo buyers to utilize this technology is due in part to human nature. Engh points out that consumers embrace one-stop shopping, and the same holds true for photo buyers. That's why they tend to turn first to stock photo agencies—who lump all their images together on a CD-ROM or a website—rather than to individual photographers.

But individual photographers now have the means to offer their pictures this way, too, for a minimal fee. "Theoretically, if stock photographers list descriptions of their photos on the Web, editorial photo buyers across the globe can locate in a matter of minutes highly specific pictures for their publishing projects." Engh advises that as a photographer your best strategy is to put your photos into a central repository, whether on the Web or a CD-ROM. There are several free and inexpensive Web services photographers can utilize. Advertising sales generate most of the profits for the sites; therefore, companies can sell their server space and services without charging exorbitant fees. Engh recommends using popular sites such as GeoCities (www.geocities.com), Angelfire (www.angelfire.com) and Tripod (www.tripod.com), which offer free space where photographers can post images.

Rohn and Jeri Engh in their "electronic cottage."

INSIDER REPORT, *continued*

This type of exposure can help you compete with large stock photo companies that sell vaults of "royalty-free" images on CD-ROM. Engh says many bargain hunters turn to what he calls "clip art photos" compiled by huge stock photo agencies. Their CD-ROMs offer "manufactured images such as hospital scenes where no one is sick, or playgrounds where all the children are clean and fresh looking." But photo buyers who need true-to-life photos can't afford to use clip art photos such as these in their work because it sends the wrong message. "It's true that if you are taking generic photos—the kind we see in commercial stock photo catalogs—it's nearly impossible to compete with these giants. Not because your pictures aren't good enough, but because their digital distribution process is so much more automated than yours. Photo buyers go not only for quality, but also for speed." This is where the importance of Web exposure becomes obvious.

If a photo buyer needs a photo of a subject you specialize in, such as rodeos or pediatrics, she won't go to a giant photo agency because they don't have a deep selection of those photos, says Engh. Instead, she'll turn to you. But first, she has to be able to find you. "When they're looking for specific pictures, photo buyers will go to a fresh specialized source, whether the photographer lives in New York City or in a mountain cabin in Utah. This is where the Web now makes it possible for individual photographers to be able to compete with the giants," explains Engh. "And because your pictures are highly specific and unique, you'll be able to demand a high fee for them." Another thing to keep in mind is that even if exposure to your work does not sell an image you've already shot, it could generate a new assignment. This individualized attention is something you can offer photo buyers that stock photo agencies usually cannot—they only offer catalogs.

Before you try to sell your next image, you may want to consider marketing it on a website such as PSI's, which averages 3,000 hits a day. "It's no longer a luxury for a photographer to be on the Web—it's a necessity, if not for sales, then for the benefits of promotion," says Engh. If you make your presence felt, as large stock photo agencies do, a photo buyer may pass over the CD-ROM catalog on her desk and log onto the website where your work is showcased or described. All it takes is a phone call and a nominal fee to position yourself to compete with the big boys of stock photography.

—*Sarah Morton*

AAA IMAGE MAKERS, 337 W. Pender St., Suite 301, Vancouver, British Columbia V6B 1T3 Canada. (604)688-3001. Owner: Reimut Lieder. Art Director: Larry Scherban. Estab. 1981. Stock photo agency. Has 250,000 photos. Clients include: advertising agencies, public relations firms, audiovisual firms, businesses, book/encyclopedia publishers, magazine and textbook publishers, postcard publishers, calendar companies and greeting card companies.

Needs: Model-released lifestyles, high-tech, medical, families, industry, computer-related subjects, active middle age and seniors, food, mixed ethnic groups, students, education, occupations, health and fitness, extreme and team sports, and office/business scenes. "We provide our photographers with a current needs list on a regular basis."

Specs: Uses 8×10 glossy or pearl b&w prints; 35mm, 2¼×2¼, 4×5 and 8×10 transparencies.

Payment & Terms: Pays 50% commission on color and b&w. Average price per image (to clients): $400-800/b&w and color. Enforces minimum prices. Offers volume discount to customers; terms specified in photographer's contract. Discount sales terms not negotiable. Works on contract basis only. Offers limited regional exclusivity, guaranteed subject exclusivity. Charges 50% duping fee, 50% catalog insertion fee. Statements issued quarterly. Payment made quarterly. Photographers allowed to review account records.

Rights negotiated by client needs. Does not inform photographer or allow him to negotiate when client requests all rights. Model releases required. "All work must be marked 'MR' or 'NMR' for model release or no model release. Photo captions required.

Making Contact: Interested in receiving work from established, especially commercial, photographers. Arrange personal interview to show portfolio or submit portfolio for review. Query with résumé of credits. Query with samples. Send SASE (IRCs) with letter of inquiry, résumé, business card, flier, tearsheets or samples. Expects minimum initial submission of 200 images. Reports in 2-3 weeks. Photo guideline sheet free with SASE (IRC). Market tips sheet distributed quarterly to all photographers on contract; free with SASE (IRCs).

Tips: "As we do not have submission minimums, be sure to edit your work ruthlessly. We expect quality work to be submitted on a regular basis. Research your subject completely and shoot shoot shoot!!"

ACE PHOTO AGENCY, Satellite House, 2 Salisbury Rd., Wimbledon, London SW19 4EZ United Kingdom. Phone: (181)944-9944. Fax: (181)944-9940. E-mail: info@acestock.com. Website: http://www.acestock.com. Chief Editor: John Panton. Stock photo agency. Has approximately 300,000 photos. Clients include: ad agencies, audiovisual firms, businesses, book/encyclopedia publishers, magazine publishers, postcard companies, calendar companies, greeting card companies, design companies and direct mail companies.

Needs: People, sport, corporate, industrial, travel (world), seas and skies, still life and humor.

Specs: Uses 35mm, $2\frac{1}{4} \times 2\frac{1}{4}$, 4×5 and 8×10 transparencies. Accepts images in digital format for Mac. Send via compact disc, SyQuest or Jazz.

Payment & Terms: Pays 50% commission on color photos, 30% overseas sales. General price range: $135-1,800. Works on contract basis only; offers limited regional exclusivity contracts. Contracts renew automatically for 2 years with each submission. Charges catalog insertion fee, $100 deducted from first sale. Statements issued quarterly. Payment made quarterly. Photographers permitted to review sales records with 1 month written notice. Offers one-time rights, first rights or mostly non-exclusive rights. Informs photographers when client requests to buy all rights, but agency negotiates for photographer. Model/property release required for people and buildings. Photo captions required; include place, date and function.

Making Contact: Arrange a personal interview to show portfolio. Query with samples. SASE (IRCs). Reports in 2 weeks. Photo guidelines free with SASE. Distributes tips sheet twice yearly to "Ace photographers under contract."

Tips: Prefers to see "total range of subjects in collection. Must be commercial work, not personal favorites. Must show command of color, composition and general rules of stock photography. All people must be mid-Atlantic to sell in UK. Must be sharp and also original. No dupes. Be professional and patient. We are now fully digital. Scanning and image manipulation is all done inhouse. We market CD-ROM stock to existing clients. Photographers are welcome to send CD, SyQuest, cartridge or diskette for speculative submissions. Please provide data for Mac only."

ADVENTURE PHOTO, 24 E. Main St., Ventura CA 93001. (805)643-7751. Fax: (805)643-4423. Estab. E-mail: apf@west.net. Estab. 1987. Stock agency. Member of Picture Agency Council of America (PACA). Has 250,000 images. Clients include: advertising agencies, public relations firms, businesses, publishers, calendar and greeting card companies.

Needs: Adventure Photo offers its clients 4 principal types of images: adventure sports (sailing, windsurfing, rock climbing, skiing, mountaineering, mountain biking, etc.), adventure travel worldwide, nature/landscapes and wildlife.

Specs: Uses 35mm, $2\frac{1}{4} \times 2\frac{1}{4}$ and 4×5 transparencies, b&w prints, footage.

Payment & Terms: Pays 50% commission. Works on contract basis only. Offers nonexclusive contract. Contracts renew automatically with each submission; time period not specified. Statements issued monthly. Payment made monthly. Photographers allowed to review sales figures. Offers one-time rights; occasionally negotiates exclusive and unlimited use rights. "We notify photographers and work to settle on acceptable

fee when client requests all rights." Model and property release required. Captions required, include description of subjects, locations and persons.

Making Contact: Write to photo editor for copy of submission guidelines. SASE. Reports in 1 month. Photo guidelines free with SASE.

Tips: Wants to see artist's portfolio/samples of "well-exposed, repro-quality transparencies of unique outdoor adventure sports, travel and wilderness photography. We love to see images that illustrate metaphors commonly used in advertising business (risk taking, teamwork, etc.)." To break-in, "We request inquiring artists send AP&F 40-60 images that best represent their work. After we sign an artist, we pass ideas along regularly about the type of imagery our clients are requesting. We direct our artists to always take note on the kinds of images our clients are using by looking at current media."

AGSTOCKUSA, 25315 Arriba Del Mundo Dr., Carmel CA 93923. (408)624-8600. Fax: (408)626-3260. E-mail: agstockusa@aol.com. Website: http://www.agstockusa.com. Owner: Ed Young. Estab. 1996. Stock photo agency. Has 100,000 photos. Clients include: advertising agencies, businesses, public relations firms, book/encyclopedia publishers, calendar companies, magazine publishers and greeting card companies.

Needs: Photos should cover all aspects of agriculture worldwide—agricultural scenes; fruits, vegetables and grains in various growth stages, studio work, aerials, harvesting, processing, irrigation, insects, weeds, farm life, agricultural equipment, livestock, plant damage and plant disease.

Specs: Uses 35mm, 2¼×2¼, 4×5, 6×7 and 6×17 transparencies.

Payment & Terms: Pays 50% on color photos. Enforces minimum price of $200. Offers volume discounts to customers; inquire about specific terms. Photographers can choose not to sell images on discount terms. Works on contract basis only. Offers nonexclusive contracts. Contracts renew automatically with additional submissions for two years. Charges 50% catalog insertion fee; 50% for production costs for direct mail and CD-ROM advertising. Statements issued monthly. Payment made monthly. Photographers allowed to review account records. Offers unlimited use and buyouts if photographer agrees to sale. Informs photographer when client requests all rights; final decision made by agency. Model/property release preferred. Captions required; include location of photo and all technical information (what, why, how, etc.).

Making Contact: Submit portfolio for review. Call first. Keeps samples on file. SASE. Expects minimum initial submission of 100 images. Reports in 3 weeks. Photo guidelines free with SASE. Market tip sheet distributed yearly to contributors under contract; free upon request.

Tips: "Build up a good file (quantity and quality) of photos before approaching any agency. A portfolio of images is currently displayed on our website. We plan to issue a CD-ROM disk by November, 1998."

ALASKA STOCK IMAGES, 2505 Fairbanks St., Anchorage AK 99503. (907)276-1343. Fax: (907)258-7848. Website: http://www.Alaskastock.com. Owner: Jeff Schultz. Stock photo agency. Member of the Picture Agency Council of America (PACA). Has 200,000 transparencies. Clients include: advertising agencies, businesses, newspapers, postcard publishers, book/encyclopedia publishers and calendar companies.

Needs: Outdoor adventure, wildlife, recreation—images which were or could have been shot in Alaska.

Specs: Uses 35mm, 2¼×2¼, 4×5, 6×17 panoramic transparencies.

Payment & Terms: Pays 50% commission on color photos; minimum use fee $125. Offers volume discounts to customers; inquire about specific terms. Photographers can choose not to sell images on discount terms. Works on contract basis only. Offers nonexclusive contract; exclusive contract for images in promotions. Contracts renew automatically with additional submissions; nonexclusive for 3 years. Charges variable catalog insertion fee. Statements issued monthly. Payment made monthly. Photographers allowed to review account records. Offers negotiable rights. Informs photographer and negotiates rights for photographer when client requests all rights. Model/property release preferred for any people and recognizable personal objects (boats, homes, etc.). Captions required; include who, what, when, where.

Making Contact: Query with samples. Samples not kept on file. SASE. Expects minimum initial submission of 20 images with periodic submission of 100-200 images 1-4 times/year. Reports in 3 weeks. Photo guidelines free on request. Market tips sheet distributed 2 times/year to those with contracts.

N ⊕ J. CATLING ALLEN PHOTO LIBRARY, St. Giles House, Little Torrington, Devon EX38 8PS England. Phone: (01805)622497. Estab. 1965. Picture library. Has 80,000 photos in files. Clients include: book publishers, magazine publishers, calendar companies, greeting card companies, postcard publishers.

Needs: Specializes in Bible lands including archaeological sites, religions of Christianity, Islam and Judaism; medieval abbeys, priories, cathedrals, churches; historic, rural and scenic Britain.

Payment/Terms: Offers volume discounts to customers.

AMERICAN STOCK PHOTOGRAPHY, Dept. PM, 6255 Sunset Blvd., Suite 716, Hollywood CA 90028. (213)469-3900. Fax: (213)469-3909. President: Christopher C. Johnson. General Manager: Jason Williams. Stock photo agency. Has 2 million photos. Clients include: advertising agencies, public relations firms, audiovisual firms, businesses, book/encyclopedia publishers, magazine publishers, newspapers, postcard companies, calendar companies, greeting card companies and TV and movie production companies.
• American Stock Photography is a subsidiary of Camerique, which is also listed in this section.
Needs: General stock, all categories. Special emphasis on California scenics and lifestyles.
Specs: Uses 35mm, 2¼×2¼, 4×5 transparencies; b&w contact sheets; b&w negatives.
Payment & Terms: Buys photos outright; pays $5-20. Pays 50% commission. General price range (to clients): $100-750. Works on contract basis only. Offers nonexclusive contracts. Contracts renew automatically with additional submissions. Charges 50% for catalog insertion, advertising, CD disks. Statements issued monthly. Payment made monthly. Photographers allowed to review account records. Offers one-time, electronic and multi-use rights. Informs photographer and allows them to negotiate when client requests all rights. Model/property release required for people, houses and animals. Captions required: include date, location, specific information on image.
Making Contact: Contact Camerique Inc., 1701 Skippack Pike., P.O. Box 175, Blue Bell, PA 19422. (610)272-4000. SASE. Reports in 1 week. Photo guidelines free with SASE. Tips sheet distributed quarterly to all active photographers with agency; free with SASE.

THE ANCIENT ART & ARCHITECTURE COLLECTION, 410-420 Rayners Lane, Suite 7, Pinner, Middlesex, London HA5 5DY England. Phone: (181)429-3131. Fax: (181)429-4646. E-mail: ancienta@dircon.co.uk. Contact: Michelle Jones. Picture library. Has 250,000 photos. Clients include: advertising agencies, book/encyclopedia publishers, magazine publishers and newspapers.
Needs: Ancient and medieval buildings, sculptures, objects, artifacts.
Specs: Uses 35mm, 2¼×2¼ or 4×5 transparencies.
Payment & Terms: Pays 50% commission. Works with photographers on contract basis only. Offers nonexclusive contracts. Contracts renew automatically with additional submissions. Statements issued quarterly. Payment made quarterly. Photographers allowed to review account records. Offers one-time rights. Fully detailed captions required.
Making Contact: Query with samples and list of stock photo subjects. SASE. Reports in 2 weeks.
Tips: "Material must be suitable for our specialist requirements. We cover historical and archeological periods from 25,000 BC to the 19th century AD, worldwide. All civilizations, cultures, religions, objects and artifacts as well as art are includable. Pictures with tourists, cars, TV aerials, and other modern intrusions not accepted."

ANDES PRESS AGENCY, 26 Padbury Ct., London E2 7EH England. Phone: (0171)613-5417 Fax: (0171)739-3159. E-mail: photos@andespress.demon.co.uk. Website: http://andespress.demon.co.uk. Contact: Val Baker. Picture library and news/feature syndicate. Has 300,000 photos. Clients include: magazine publishers, advertising agencies, businesses, book publishers, non-governmental charities and newspapers.
Needs: "We have a large section of travel photographs on social, political and economic aspects of Latin America, Africa, Asia, Europe and Britain, specializing in contemporary world religions."
Specs: Uses 8×10 glossy b&w prints; 35mm and 2¼×2¼; b&w contact sheets and negatives.
Payment & Terms: Pays 50% commission for b&w and color photos. General price range (to clients): £80-200/b&w photo; £80-300/color photo. Negotiates fees below stated minimums occasionally to local papers. Works on contract basis only. Offers nonexclusive contract. Contracts renew with additional submissions. Statements issued bimonthly. Payment made bimonthly. Photographers allowed to review account records in cases of discrepancies only. Offers one-time rights. "We never sell all rights; photographer has to negotiate if interested." Model/property release preferred. Captions required.
Making Contact: Query with samples. Send stock photo list. SASE. Reports in 3 weeks. Photo guidelines free with SASE.
Tips: "We want to see that the photographer has mastered one subject in depth. Also, we have a market for photo features as well as stock photos. When submitting work, send a small selection of no more than 100 color transparencies."

ANIMALS ANIMALS/EARTH SCENES, 17 Railroad Ave., Chatham NY 12037. (518)392-5500. Website: http://www.animalsanimals.com. Contact: Patricia McGlauflin. Member of Picture Agency Council of America (PACA). Has 1 million photos. Clients include: ad agencies, public relations firms, businesses, audiovisual firms, book publishers, magazine publishers, encyclopedia publishers, newspapers, postcard companies, calendar companies and greeting card companies.

Needs: "We specialize in nature photography with an emphasis on all animal life."

Specs: Uses 8×10 glossy or matte b&w prints; 35mm, 4×5 and 8×10 color transparencies.

Payment & Terms: Pays 50% commission. Works on contract basis only. Offers exclusive contracts. Charges catalog insertion fee of $70/image. Photographers allowed to review account records to verify sales figures "if requested and with proper notice and cause." Statements issued quarterly. Payment made quarterly. Offers one-time rights; other uses negotiable. Informs photographers and allows them to negotiate when clients request all rights. Model release required if used for advertising. Captions required, include Latin names, and "they must be correct!"

Making Contact: Send query for guidelines. SASE. Expects minimum initial submission of 200 images with quarterly submissions of at least 200 images.

Tips: "First, pre-edit your material. Second, know your subject."

(APL) ARGUS PHOTOLAND, LTD., Room 3901 Windsor House, 311 Gloucester Rd., Hong Kong. Phone: (852)2890-6970. Fax: (852)2881-6979. E-mail: argus@argusphoto.com.hk. Website: http://www.argusphoto.com.hk. Director: Joan Li. Estab. 1992. Stock photo agency. Has 160,000 photos; has 4 offices in mainland China which includes main cities Beijing, Shanghai, Guangzhou and Shenzhen. Clients include: advertising agencies, graphic houses, public relations firms, book/encyclopedia publishers, magazine publishers, postcard publishers, calendar companies, greeting card companies, mural printing companies and trading firms/manufacturers.

Needs: "We cover general subject matters with urgent needs of people images (baby, children, woman, couple, family and man, etc.) in all situations; business and finance; industry; science & technology; living facilities; flower arrangement/bonsai; waterfall/streamlet; securities; interior (including office/hotel lobby, shopping mall, museum, opera, library); cityscape and landscape; and highlight of Southeast Asian countries and sport images."

Specs: Any of 120mm and 4×5 transparencies.

Payment & Terms: Pays 50% commission. Offers volume discounts to customers. Works on contract basis only. Offers regional exclusivity. Contracts renew automatically with additional submissions. Statements issued quarterly. Payment made quarterly. Photographers allowed to review account records. Offers one-time rights, agency promotion rights. Informs photographer and allows them to negotiate when client requests all rights. Model/property releases a must. Photo captions required: include name of event(s), name of building(s), location and geographical area.

Making Contact: Submit portfolio for review. Expects minimum initial submission of 200 pieces with submission of at least 300 images quarterly. Reports in 2 weeks.

APPALIGHT, Griffith Run Rd., Clay Rt. Box 89-C, Spencer WV 25276. Phone/fax: (304)927-2978. Website: http://www.photosource.com. Director: Chuck Wyrostok. Estab. 1988. Stock photo agency. Has over 30,000 photos. Clients include advertising agencies, public relations firms, businesses, book/encyclopedia publishers, magazine publishers, calendar companies, greeting card companies and graphic designers.

• This agency also markets images through the Photo Source Bank (http://www.photosource.com.)

Needs: General subject matter with emphasis on child development and natural history, inspirational, landscapes, trees, cityscapes, travel in the eastern mountains and eastern shore. "Presently we're building comprehensive sections on animals, birds, flora and on positive solutions to environmental problems of all kinds."

Specs: Uses 8×10, glossy b&w prints; 35mm, 2¼×2¼, 4×5 transparencies.

Payment & Terms: Pays 50% commission. General price range: $150 and up. Works on contract basis only. Contracts renew automatically for 2-year period with additional submissions. Charges 100% duping rate. Statements issued quarterly. Payment made quarterly. Photographers allowed to review account records during regular business hours or by appointment. Offers one-time rights, electronic media rights. Model release required. Captions required.

Making Contact: Expects minimum initial submission of 300-500 images with periodic submissions of

**FOR EXPLANATIONS OF THESE SYMBOLS,
SEE THE INSIDE FRONT AND BACK COVERS OF THIS BOOK.**

200-300 several times/year. Reports in 1 month. Photo guidelines free with SASE. Market tips sheet distributed "periodically" to contracted photographers.

Tips: "We look for a solid blend of topnotch technical quality, style, content and impact. Images that portray metaphors applying to ideas, moods, business endeavors, risk-taking, teamwork and winning are especially desirable."

N **ARCHIVE PHOTOS**, 530 W. 25th St., New York NY 10001. (800)536-8442. Fax: (212)675-0379. Website: http://www.archivephotos.com. Vice President of Sales: Eric Rachlis. Estab. 1991. Stock photo agency. Member of the Picture Agency Council of America (PACA). Has 20 million photos; 14,000 hours of film. Has 8 branch offices. Clients include: advertising agencies, public relations firms, audiovisual firms, businesses, book/encyclopedia publishers, magazine publishers, newspapers, postcard publishers, calendar companies, greeting card companies, multimedia publishers.

Needs: All types of historical and new photos.

Specs: Uses 8 × 10 color and b&w prints; all sizes of transparencies, film and videotape.

Payment & Terms: Pays 60% commission on b&w and color photos; 50% commission on film and videotape. Average price per image (to clients): $125-5,000/b&w; $125-5,000/color; $20-100/sec of film. Enforces minimum prices. Offers volume discounts to customers; inquire about specific terms. Discount sales terms not negotiable. Works with or without contract. Offers nonexclusive contract. Contracts renew automatically with additional submissions. Statements issued monthly. Payment for photos made monthly within 15 days; payment for footage made quarterly within 30 days. Photographers allowed to review account records. Offers one-time rights, electronic media rights, agency promotion rights. Does not inform photographer or allow him to negotiate when client requests all rights. Captions required.

Making Contact: Query with résumé of credits and samples. Does not keep samples on file. SASE. Expects minimum initial submission of 100 images. Reports in 3 weeks.

ARMS COMMUNICATIONS, 1517 Maurice Dr., Woodbridge VA 22191. (703)690-3338. Fax: (703) 490-3298. President: Jonathan Arms. Estab. 1989. Stock photo agency. Has 80,000 photos. Clients include: advertising agencies, public relations firms, businesses and magazine publishers.

Needs: Interested in photos of military/aerospace—US/foreign ships, foreign weapon systems (land, air and sea), weaponry being fired.

Specs: Uses 35mm transparencies.

Payment & Terms: Pays 50% commission on b&w and color photos. Average price per image (to clients): $200. Enforces minimum price of $100. Offers volume discounts to customers; terms specified in photographer's contract. Discount terms not negotiable. Works on contract basis only. Offers nonexclusive contracts. Contracts renew automatically with additional submissions for 3 years. Payment made within 60 days of invoice payment. Photographers allowed to review account records. Offers one-time rights. Does not negotiate when client requests all rights. Model release preferred. Captions required.

Making Contact: Reports in 1-2 weeks.

ART RESOURCE, 65 Bleecker St., 9th Floor, New York NY 10012. (212)505-8700. Fax: (212)420-9286. E-mail: requests@artres.com. Website: http://www.artres.com. Permissions Director: Joanne Greenbaum. Estab. 1970. Stock photo agency specializing in fine arts. Member of the Picture Agency Council of America (PACA). Has access to 3 million photos. Clients include: advertising agencies, public relations firms, audiovisual firms, businesses, book/encyclopedia publishers, magazine publishers, newspapers, postcard publishers, calendar companies, greeting card companies and all other publishing and scholarly businesses.

Needs: Painting, sculpture, architecture *only*.

Specs: Uses 8 × 10 b&w prints; 35mm, 4 × 5, 8 × 10 transparencies.

Payment & Terms: Charges 50% commission. Average price per image (to client): $75-500/b&w photo; $185-10,000/color photo. Negotiates fees below standard minimum prices. Offers volume discounts to customers; terms specified in photographer's contract. Discount sales terms not negotiable. Offers exclusive only or nonexclusive rights. Contracts renew automatically with additional submissions. Statements issued quarterly. Payment made quarterly. Photographers allowed to review account records. Offers one-time rights, electronic media rights, agency promotion and other negotiated rights. Photo captions required.

Making Contact: Query with stock photo list. "Only fine art!"

Tips: "We only represent European fine art archives and museums in U.S and Europe, but occasionally represent a photographer with a specialty in certain art."

N **ARTWERKS STOCK PHOTOGRAPHY**, Artworks Design, 2915 Estrella Brillante NW, Albuquerque NM 87120. (505)836-1206. Fax: (505)836-1206. E-mail: photojournalistjerry@juno.com. Owner: Jerry Sinkover. Estab. 1984. News/feature syndicate. Has 100 million photos in files. Clients include:

advertising agencies, public relations firms, businesses, book publishers, magazine publishers, calendar companies, postcard publishers.

Needs: American Indians, ski action, ballooning, British Isles, Europe, Southwest scenery.

Specs: Uses 8×10, glossy, color and b&w prints; 35mm, $2\frac{1}{4} \times 2\frac{1}{4}$, 4×5 transparencies.

Payment/Terms: Charges 40% commission. Average price per image (to clients): $100-400 for b&w; $100-1,500 for color. Negotiates fees below stated minimums depending on number of photos being used. Offers volume discounts to customers. Terms not specified in photographers' contracts. Discount sales terms not negotiable. Works with or without a contract, negotiable. Offers nonexclusive contract. Charges 100% duping fee. Statements issued quarterly. Payments made quarterly. Offers one-time rights. Does not inform photographers or allow them to negotiate when a client requests all rights. Model release preferred; property release preferred. Photo captions preferred.

Making Contact: Send query letter with brochure, stock photo list, tearsheets. Provide résumé, business card. Portfolios may be dropped off every Monday. To show portfolio, photographer should follow-up with call. Agency will contact photographer for portfolio review if interested. Portfolio should include slides, tearsheets, transparencies. Works with freelancers on assignment only. Does not keep samples on file; include SASE for return of material. Expects minimum initial submission of 20 images. Reports in 2 weeks. Reports back only if interested, send non-returnable samples. Catalog free with SASE. Market tip sheet not available.

N ⊕ AUSTRAL-INTERNATIONAL PHOTOGRAPHIC LIBRARY P/L, 1 Chandos Level 5, St. Leonards NSW Australia 2065. Phone: (02)94398222. Fax: (02)99065258. E-mail: australphoto@compuserve.com. Contact: Nicki Robertson. Estab. 1944. Stock photo agency, picture library, news/feature syndicate. Has 2 million photos in files. Clients include: advertising agencies, public relations firms, audiovisual firms, businesses, book publishers, magazine publishers, newspapers, calendar companies, greeting card companies, postcard publishers.

Specs: Uses $2\frac{1}{4} \times 2\frac{1}{4}$ transparencies.

Payment/Terms: Pays 50% commission on b&w photos. Enforces strict minimum prices. Offers volume discounts to customers. Discount sales terms not negotiable. Works with photographers with or without a contract, negotiable. Offers nonexclusive contract. Contracts renew automatically with additional submissions. Statements issued monthly; payments made monthly. Photographers allowed to review account records in cases of discrepencies only. Offers one-time rights, electronic media rights, agency promotion rights. Does not inform photographers to negotiate when a clients requests all rights. Model/property release required. Photos captions required.

Making Contact: Send query letter with samples. Portfolios may be dropped off every Friday. Portfolio should include transparencies. Does not keep samples on file.

N ⊕ A-Z BOTANICAL COLLECTION LTD., 82-84 Clerkewwell Rd., London EC1M 5RJ United Kingdom. Phone: (0171)336 7942. Fax: (0171)336 7943. E-mail: a-z@image-data.com. Website: http://www.a-z.picture-library.com. Library Manager: Alastair McCombe. Estab. 1969. Stock photo agency and picture library. Has 160,000 photos. Clients include: ad agencies, public relations firms, businesses, book/encyclopedia publishers, magazine publishers, newspapers, calendar companies and greeting card companies.

Needs: Any plant in all situations; all "wild" plants; all garden cultivars.

Specs: Uses 35mm, $2\frac{1}{4} \times 2\frac{1}{4}$ transparencies.

Payment & Terms: Pays 50% commission on color photos. Average price per image (to clients): $75-150/color photo. Enforces minimum prices. Offers volume discounts to customers; inquire about specific terms. Discount sales terms not negotiable. Works with or without contract. Offers guaranteed subject exclusivity contract. Statements issued quarterly. Payment made quarterly. Photographers allowed to review account records. Offers one-time rights; negotiable. Informs photographers and allows them to negotiate when client requests all rights. Captions required; must have either Latin botanic name or the cultivar name.

Making Contact: Query with samples. SASE. Expects minimum initial submission of 20 images and 100 more as ready. Reports in 1 month. Photo guidelines free with SASE. Market tips sheet distributed bimonthly; free with SASE.

⊞ ROBERT J. BENNETT, INC., 310 Edgewood St., Bridgeville DE 19933. (302)337-3347, (302)270-0326. Fax: (302)337-3444. President: Robert Bennett. Estab. 1947. Stock photo agency.

Needs: General subject matter.

Specs: Uses 8×10 glossy b&w prints; 35mm, $2\frac{1}{4} \times 2\frac{1}{4}$ and 4×5 transparencies.

Payment & Terms: Pays 50% commission US; 40-60% foreign. Pays $5-50/hour; $40-400/day. Pays on publication. Works on contract basis only. Offers limited regional exclusivity. Charges filing fees and

duping fees. Statements issued monthly. Payment made monthly. Photographers allowed to review account records to verify sales figures. Buys one-time, electronic media and agency promotion rights. Informs photographer and allows them to negotiate when client requests all rights. Model/property release required. Captions required.

Making Contact: Query with résumé of credits. Query with stock photo list. Provide résumé, business card, brochure or tearsheets to be kept on file for possible future assignments. Works on assignment only. Keeps samples on file. Reports in 1 month.

N BRUCE BENNETT STUDIOS, 329 W. John St., Hicksville NY 11801. (516)681-2850. Fax: (516)681-2866. E-mail: bwinkler@bbshockey.com. Website: http://www.bbshockey.com and http://www.lo ngislandny.com. Studio Director: Brian Winkler. Estab. 1973. Stock photo agency. Has 4 million photos. Clients include: ad agencies, book/encyclopedia publishers, magazine publishers and newspapers.

Needs: Ice hockey and hockey-related, especially images shot before 1975.

Specs: Uses b&w photos and 35mm transparencies.

Payment & Terms: Buys photos outright; pays $3-30/color photo. Average price per image (to clients): $25-50/b&w photo; $50-150/color photo. Negotiates fees below stated minimum prices. Offers volume discounts to customers; terms specified in photographer's contract. Discount sales terms not negotiable. Works with or without contract. Offers nonexclusive contracts. Statements issued quarterly. Payment made quarterly. Offers one-time, electronic media or agency promotion rights. Does not inform photographer or allow him to negotiate when client requests all rights.

Making Contact: Query with samples. Works on assignment only. Samples not kept on file. SASE. Expects minimum initial submission of 10 images. Reports in 3 weeks.

Tips: "We have set up a subscribers-only Internet site service where clients can download photos they need."

BIOLOGICAL PHOTO SERVICE, P.O. Box 490, Moss Beach CA 94038. Phone/fax: (650)359-6219. E-mail: Bpsterra@aol.com. Website: http://www.agpix.com/biological.photo.shtml. Photo Agent: Carl W. May. Stock photo agency. Estab. 1980. Has 90,000 photos. Clients include: ad agencies, businesses, book/encyclopedia publishers and magazine publishers.

Needs: All subjects in the life sciences, including agriculture, natural history and medicine. Stock photographers must be scientists. Subject needs include: electron micrographs of all sorts; biotechnology; modern medical imaging; animal behavior; tropical biology; and biological conservation. All aspects of general and pathogenic microbiology. All aspects of normal human biology and the basic medical sciences, including anatomy, human embryology and human genetics. Computer-generated images of molecules (structural biology).

Specs: Uses 4×5 through 11×14 glossy, high-contrast b&w prints; 35mm, $2\frac{1}{4} \times 2\frac{1}{4}$, 4×5, 8×10 transparencies. "Dupes acceptable for rare and unusual subjects, but we prefer originals."

Payment & Terms: Pays 50% commission on b&w and color photos. General price range (for clients): $90-500, sometimes higher for advertising uses. Works with or without contract. Offers exclusive contracts. Statements issued quarterly. Payment made quarterly; "one month after end of quarter." Photographers allowed to review account records to verify sales figures "by appointment at any time." Offers one-time, electronic media, promotion rights; negotiable. Informs photographer and allows them veto authority when client requests all rights. "Photographer is consulted during negotiations for 'buyouts,' etc." Model or property release required for photos used in advertising and other commercial areas. Thorough photo captions required; include complete identification of subject and location.

Making Contact: Interested in receiving work from newer, lesser-known photographers if they have the proper background. Query with list of stock subjects and résumé of scientific and photographic background. SASE. Reports in 2 weeks. Photo guidelines free with query, résumé and SASE. Tips sheet distributed intermittently to stock photographers only.

Tips: "When samples are requested, we look for proper exposure, maximum depth of field, adequate visual information and composition, and adequate technical and general information in captions. Requests fresh light and electron micrographs of traditional textbook subjects; applied biology such as biotechnology, agriculture, industrial microbiology, and medical research; biological careers; field research. We avoid excessive overlap among our photographer/scientists. We are experiencing an ever-growing demand for

MARKET CONDITIONS are constantly changing! If you're still using this book and it's 2000 or later, buy the newest edition of *Photographer's Market* at your favorite bookstore or order directly from Writer's Digest Books.

photos covering environmental problems of all sorts—local to global, domestic and foreign. Tropical biology, marine biology, and forestry are hot subjects. Our three greatest problems with potential photographers are: 1) inadequate captions; 2) inadequate quantities of *fresh* and *diverse* photos; 3) poor sharpness/depth of field/grain/composition in photos."

D. DONNE BRYANT STOCK PHOTOGRAPHY (DDB STOCK), P.O. Box 80155, Baton Rouge LA 70898. (504)763-6235. Fax: (504)763-6894. E-mail: dougbryant@aol.com. Website: http://www.ddb.simplenet.com. President: Douglas D. Bryant. Stock photo agency. Estab. 1970. Member of American Society of Picture Professionals. Currently represents 110 professional photographers. Has 500,000 photos. Clients include: ad agencies, audiovisual firms, book/encyclopedia publishers, magazine publishers, CD-ROM publishers and a large number of foreign publishers.

Needs: Specializes in picture coverage of Latin America with emphasis on Mexico, Central America, South America, the Caribbean Basin and the Southern USA. Eighty percent of picture rentals are for editorial usage. Important subjects include agriculture, anthropology/archeology, art, commerce and industry, crafts, education, festivals and ritual, geography, history, indigenous people and culture, museums, parks, political figures, religion, scenics, sports and recreation, subsistence, tourism, transportation, travel and urban centers.

Specs: Accepts 35mm, $2\frac{1}{4} \times 2\frac{1}{4}$, 4×5 and 8×10 transparencies.

Payment & Terms: Pays 50% commission; 30% on foreign sales through foreign agents. Payment rates: $50-2,000 for b&w and $50-10,000 for color. Average price per image (to clients): $100-400 b&w and $170-3,400 for color. Offers volume discount to customers; terms specified in photographers contract but are not negotiable. Works with or without a signed contract, negotiable. Offers nonexclusive contracts. Three year initial contract minumum after which all slides can be demanded for return by photographer. Statements issued monthly. Payment made monthly. Does not allow photographers to review account records to verify sales figures. "We are a small agency and do not have staff to oversee audits." Offers one-time, electronic media, world and all language rights. Offers $1,500 per image for all rights. Model/property release preferred, especially for ad set-up shots. Captions required; include location and brief description. "We have a geographic focus and need specific location info on captions."

Making Contact: Interested in receiving work from professional photographers who regularly visit Latin America. Query with brochure, tearsheets and list of stock photo subjects. Expects minimum initial submission of 300 images with yearly submissions of at least 500 images. Reports in 3 weeks. Photo guidelines free with SASE and on Website. Tips sheet distributed every 3 months to agency photographers and on website.

Tips: "Speak Spanish and spend one to six months shooting in Latin America every year. Follow our needs list closely. Shoot Fuji transparency film and cover the broadest range of subjects and countries. We have an active duping service where we provide European and Asian agencies with images they market in film and on CD. The Internet provides a great delivery mechanism for marketing stock photos and we have digitized and put up hundreds on our site. Edit carefully. Eliminate any images with focus framing or exposure problems. Be an active professional before sending imges to DDB Stock. The market is far too competitive for average pictures and amateur photographers."

CALIFORNIA VIEWS/MR. PAT HATHAWAY HISTORICAL COLLECTION, 469 Pacific St., Monterey CA 93940-2702. (408)373-3811. Website: http://www.caviews.com. Photo Archivist: Mr. Pat Hathaway. Picture library; historical collection. Has 80,000 b&w images, 10,000 35mm color. Clients include: ad agencies, public relations firms, audiovisual firms, book/encyclopedia publishers, magazine publishers, museums, postcard companies, calendar companies, television companies, interior decorators, film companies.

Needs: Historical photos of California from 1860-1995.

Payment & Terms: Payment negotiable.

Making Contact: "We accept donations of photographic material in order to maintain our position as one of California's largest archives." Does not return unsolicited material. Reports in 3 months.

CAMERA PRESS LTD., 21 Queen Elizabeth Street, London SE1 2PD England. Phone: (0171)378-1300. Fax: (0171)278-5126. Modem: (0171)378 9064. ISDN: (Planet) (0171)378 6078 or (0171)378 9141. Operations Director: Roger Eldridge. Picture library, news/feature syndicate. Clients include: ad agencies, public relations firms, audiovisual firms, book/encyclopedia publishers, magazine publishers, newspapers, postcard companies, calendar companies, greeting card companies and TV stations. Clients principally press, but also advertising, publishers, etc.

● Camera Press has a fully operational electronic picture desk to receive/send digital images via modem/ISDN lines.

Needs: Celebrities, world personalities (e.g. politics, sports, entertainment, arts, etc.), features, news/

documentary, scientific, human interest, humor, women's features, stock.

Specs: Uses prints; 35mm, 2¼×2¼ and 4×5 transparencies; b&w contact sheets and negatives.

Payment & Terms: Pays 50% commission for color or b&w photos. "Top rates in every country." Contracts renewable every year. Statements issued every 2 months. Payment made every 2 months. Photographers allowed to review account records. Offers one-time rights. Informs photographers and permits them to negotiate when a client requests to buy all rights. Model release preferred. Captions required.

Making Contact: SASE.

Tips: "Camera Press celebrated 50 years in the pictures business in 1997. We represent some of the top names in the photographic world, but also welcome emerging talents and gifted newcomers. We seek lively, colorful features which tell a story and individual portraits of world personalities, both established and up-and-coming. We specialize in world-wide syndication of news stories, human interest, features, show business personalities 'at home' and general portraits of celebrities. Good accompanying text and/or interviews are an advantage; accurate captions are essential. Remember there is a big world-wide demand for premieres, openings and US celebrity-based events. Other needs include: scientific development and novelties; beauty, fashion, interiors, food and women's interests; humorous pictures featuring the weird, the wacky and the wonderful. Camera Press is also developing a top-quality stock image service (model release essential). In general, remember that subjects which seem old-hat and clichéd in America may have considerable appeal overseas. Try to look at the US with an outsider's eye."

CAMERIQUE INC. INTERNATIONAL, Main office: Dept. PM, 1701 Skippack Pike, P.O. Box 175, Blue Bell PA 19422. (610)272-4000. Fax: (610)272-7651. Representatives in Boston, Los Angeles, Chicago, New York City, Montreal, Sarasota, Florida and Tokyo. Photo Director: Christopher C. Johnson. Estab. 1973. Has 1 million photos. Clients include: advertising agencies, public relations firms, audiovisual firms, businesses, book/encyclopedia publishers, magazine publishers, newspapers, postcard companies, calendar companies, greeting card companies.

● Don't miss the listing in this section for American Stock Photography, which is a subsidiary of Camerique.

Needs: "Only professional freelancers need submit—does not use entries from amateur photographers." Needs general stock photos, all categories. Emphasizes people activities all seasons. Always need large format color scenics from all over the world. No fashion shots. All people shots, including celebrities, must have releases.

Specs: Uses 35mm, 2¼×2¼, 4×5 transparencies; b&w contact sheets; b&w negatives; "35mm accepted if of unusual interest or outstanding quality."

Payment & Terms: Sometimes buys photos outright; pays $10-25/photo. Also pays 50-60% commission on b&w/color after sub-agent commissions. General price range (for clients): $300-500. Works on contract basis only. Offers nonexclusive contracts. Contracts are valid "indefinitely until canceled in writing." Charges 50% of cost of catalog insertion fee; for advertising, CD and online services. Statements issued monthly. Payment made monthly; within 10 days of end of month. Photographers allowed to review account records. Offers one-time rights, electronic media and multi-rights. Informs photographer and allows them to negotiate when client requests all rights. Model/property release required for people, houses, pets. Captions required; include "date, place, technical detail and any descriptive information that would help to market photos."

Making Contact: Query with list of stock photo subjects. Send unsolicited photos by mail for consideration. "Send letter first, we'll send our questionnaire and spec sheet." SASE. Reports in 2 weeks. "You must include correct return postage for your material to be returned." Tips sheet distributed periodically to established contributors.

Tips: Prefers to see "well-selected, edited color on a variety of subjects. Well-composed, well-lighted shots, featuring contemporary styles and clothes. Be creative, selective, professional and loyal. Communicate openly and often."

CANADA IN STOCK INC., 109 Vanderhoof Ave., Suite 214, Toronto, Ontario M4G 2H7 Canada. (416)425-8215. Fax: (416)425-6966. E-mail: canstock@istar.ca. Director: Ottmar Bierwagen. Estab. 1994. Stock photo agency. Member of the Picture Agency Council of America (PACA). Has 125,000 photos. Clients include: ad agencies, public relations firms, businesses, book/encyclopedia publishers, magazine publishers, calendar companies, government and graphic designers.

● This agency will send clients e-mail images of low-res scans with attached watermark on demand. If image is purchased, film is then sent by courier.

Needs: Photos of people, industry, Europe, Asia, sports and wildlife. "Our needs are model-released people, lifestyles and medical."

Specs: Uses 35mm, 2¼×2¼, 4×5, 8×10 transparencies.

Payment & Terms: Pays 40-60% commission on color photos. Average price per image (to clients):

$400/color photo. Enforces minimum prices. Offers volume discounts to customers; inquire about specific terms. Photographers can choose not to sell images on discount terms. Works on contract basis only. Offers exclusive or limited regional exclusivity contracts. Contracts renew automatically with additional submissions. Charges 50% duping and catalog insertion fees. Statements issued quarterly. Payment made quarterly. Photographers allowed to review account records. Offers one-time rights and North American rights; exclusivity and/or buyouts negotiated. "We negotiate with client, but photographer is made aware of the process." Model release required; property release preferred. Captions required; include location, detail, model release, copyright symbol and name (no date).

Making Contact: Query with samples. Query with stock photo list. Works with local freelancers on assignment only. Samples kept on file. SASE. Expects minimum initial submission of 300-500 images with 300 more annually. Reports in 3 weeks. Photo guidelines free with SASE. Market tips sheet distributed monthly via fax to contracted photographers.

Tips: "Ask hard questions and expect hard answers. Examine a contract in detail. Accepting work is becoming more difficult with generalists; specialty niche photographers have a better chance."

[N] ⊕ CAPITAL PICTURES, 54 A Clerkenwell Rd., London W9 IDL England. Phone: (+44)171-253-1122. Fax: (+44)171-253-1414. Picture library. Has 400,000 photos in files. Clients include: advertising agencies, book publishers, magazine publishers, newspapers.

Needs: Specialize in high quality photographs of famous people (politics, royalty, music, fashion, film and television).

Specs: Uses 35mm, $2\frac{1}{4} \times 2\frac{1}{4}$ transparencies.

Payment/Terms: Pays 50% commission on b&w and color photos. "We have our own price guide but will negotiate competitive fees for large quantity usage, or supply agreements." Offers volume discounts to customers. Discount sales terms negotiable. Works with photographers with or without a contract, negotiable, whatever is most appropriate. No charges—only 50% commission on sales. Statements issued monthly; payment made monthly. Photographers allowed to review account records. Offers any rights they wish to purchase. Informs photographer and allows them to negotiate when client requests all rights "if we think it appropriate." Photo captions preferred; include date, place, event, name of subject(s).

Making Contact: Send query letter with samples. Agency will contact photographer for portfolio review if interested. Portfolio should include color transparencies. Keeps samples on file. Expects minimum initial submission of 24 images with monthly submissions of at least 24 images. Reports in 1 month on queries. Market tips sheet not available.

CATHOLIC NEWS SERVICE, 3211 Fourth St. NE, Washington DC 20017-1100. (202)541-3251. Fax: (202)541-3255. E-mail: cnspix@aol.com. Photos/Graphics Manager: Nancy Wiechec. Photos/Graphics Researcher: Bob Roller. Wire service transmitting news, features and photos to Catholic newspapers and stock to Catholic publications.

Needs: News or feature material related to the Catholic Church or Catholics; head shots of Catholic newsmakers; close-up shots of news events, religious activities. Also interested in photos aimed toward a general family audience and photos depicting modern lifestyles, e.g., family life, human interest, teens, poverty, active senior citizens, families in conflict, unusual ministries, seasonal and humor.

Specs: Uses 8×10 color glossy prints/slides. Accepts images in digital format for Mac or Windows (JPEG high quality, 8×10 inches, 170 ppi). Send via compact disc, online, floppy disk, Zip disk (8×10 inch @ 170 ppi).

Payment & Terms: Pays $50/photo; $75-200/job. Charges 50% on stock sales. Statements never issued. Payment made monthly. Offers one-time rights. Informs photographer and allows them to negotiate when client requests all rights. Model/property release preferred. Captions preferred; include who, what, when, where, why.

Making Contact: Send material by mail for consideration. SASE.

Tips: Submit 10-20 good quality prints covering a variety of subjects. Some prints should have relevance to a religious audience. "Knowledge of Catholic religion and issues is helpful. Read a Diocesan newspaper for ideas of the kind of photos used. Photos should be up-to-date and appeal to a general family audience. No flowers, no scenics, no animals. As we use more than 1,000 photos a year, chances for frequent sales are good. Send only your best photos."

⊕ CEPHAS PICTURE LIBRARY, Hurst House, 157 Walton Rd., E. Molesey, Surrey KTB 0DX United Kingdom. Phone: (0181)979-8647. Fax: (0181)224-8095. E-mail: mickrock@cephas.co.uk. Website: http://www.cephas.co.uk. Director: Mick Rock. Picture library. Has 120,000 photos. Clients include: ad agencies, public relations firms, businesses, book/encyclopedia publishers, magazine publishers, postcard companies and calendar companies.

Needs: "We are a general picture library covering all aspects of all countries. Wine industry, food and

drink are major specialties."

Specs: Prefers $2\frac{1}{4} \times 2\frac{1}{4}$ transparencies, 35mm accepted.

Payment & Terms: Pays 50% commission for color photos. General price range: £50-500 (English currency). Works on contract basis only. Offers global representation. Contracts renew automatically after 3 years. Photographers allowed to review account records. Statements issued quarterly with payments. Offers one-time rights. Informs photographers when a client requests to buy all rights. Model release preferred. Captions required.

Making Contact: Send best 40 photos by mail for consideration. SASE. Reports in 1 week. Photo guidelines for SASE.

Tips: Looks for "transparencies in white card mounts with informative captions and names on front of mounts. Only top-quality, eye-catching transparencies required."

CHARLTON PHOTOS, INC., 11518 N. Port Washington Rd., Mequon WI 53092. (414)241-8634. Fax: (414)241-4612. E-mail: charlton@mail.execpc.com. Website: http://www.charlton.com. Director of Research: Karen Kirsch. Estab. 1981. Stock photo agency. Has 475,000 photos; 200 hours film. Clients include: ad agencies, public relations firms, audiovisual firms, businesses, book/encyclopedia publishers, magazine publishers, newspapers and calendar companies.

Needs: "We handle photos of agriculture, people and pets."

Specs: Uses b&w prints and color photos; 35mm, $2\frac{1}{4} \times 2\frac{1}{4}$, 4×5 transparencies.

Payment & Terms: Pays 50% commission on color photos. Average price per image (to clients): $500-650/color photo. Offers volume discounts to customers; terms specified in photographer's contract. Works on contract basis only. Prefers exclusive contract, but negotiable based on subject matter submitted. Contracts renew automatically with additional submissons for 2 years minimum. Charges duping fee, 50% catalog insertion fee and materials fee. Statements issued monthly. Payment made monthly. Photographers allowed to review account records which relate to their work. Offers one-time rights. Informs photographer and allows them to negotiate when client requests all rights. Model/property release required for identifiable people and places. Captions required; include who, what, when, where.

Making Contact: Query by phone before sending any material. SASE. No minimum number of images expected in initial submission. Reports in 1-2 weeks. Photo guidelines free with SASE. Market tips sheet distributed quarterly to contract freelance photographers; free wtih SASE.

Tips: "Provide our agency with images we request by shooting a self-directed assignment each month. Visit our website."

CHINASTOCK, 2506 Country Village, Ann Arbor MI 48103-6500. (734)996-1440. Fax: (734)996-1481 or (800)315-4462. Director: Dennis Cox. Estab. 1993. Stock photo agency. Has 50,000 photos. Has branch office in Beijing and Shanghai, China. Clients include: advertising agencies, public relations firms, book/encyclopedia publishers, magazine publishers, newspapers, calendar companies.

Needs: Only handles photos of China (including Hong Kong and Taiwan) including tourism, business, historical, cultural relics, etc. Needs hard-to-locate photos of all but tourism and exceptional images of tourism subjects.

Specs: Uses 35mm, $2\frac{1}{4} \times 2\frac{1}{4}$ transparencies. Pays 50% commission on color photos. Occasionally negotiates fees below standard minimum prices. "Prices are based on usage and take into consideration budget of client." Offers volume discounts to customers. Photographers can choose not to sell images on discount terms. Works with or without a signed contract. "Will negotiate contract to fit photographer's and agency's mutual needs." Photographers are paid quarterly. Photographers allowed to review account records. Offers one-time rights and electronic media rights. Informs photographer and allows them to negotiate when client requests all rights. Model/property release preferred. Captions required; include where image was shot and what is taking place.

Making Contact: Query with stock photo list. "Let me know if you have unusual material." Keeps samples on file. SASE. Agency is willing to accept 1 great photo and has no minimum submission requirements. Reports in 1-2 weeks. Market tips sheet available upon request.

Tips: Agency "represents mostly veteran Chinese photographers and some special coverage by Americans. We're not interested in usual photos of major tourist sites. We have most of those covered. We need more photos of festivals, modern family life, joint ventures, and all aspects of Hong Kong and Taiwan."

BRUCE COLEMAN PHOTO LIBRARY, 117 E. 24th St., New York NY 10010. (212)979-6252. Fax: (212)979-5468. Photo Director: Norman Owen Tomalin. Estab. 1970. Stock photo agency. Has 1,250,000 photos. Clients include: advertising agencies, public relations firms, audiovisual firms, businesses, book/encyclopedia publishers, magazine publishers, newspapers, postcard publishers, calendar companies, greeting card companies, zoos (installations), TV.

Needs: Nature, travel, science, people, industry.

Specs: Uses 35mm, 2¼ × 2¼, 4 × 5 color transparencies.
Payment & Terms: Pays 50% commission on color film. Average price per image (to clients): color $175-975. Works on exclusive contract basis only. Contracts renew automatically for 5 years. Statements issued quarterly. Payment made quarterly. Does not allow photographer to review account records; any deductions are itemized. Offers one-time rights. Model/property release preferred for people, private property. Captions required; location, species, genus name, Latin name, points of interest.
Making Contact: Query with résumé of credits. SASE. Expects minimum initial submission of 200 images with annual submission of 2,000. Reports in 3 months on completed submission; 1 week acknowledgement. Photo guidelines free with SASE. Catalog available. Want lists distributed to all active photographers monthly.
Tips: "We look for strong dramatic angles, beautiful light, sharpness. No gimmicks (prism, color, starburst filters, etc.). We like photos that express moods/feelings and show us a unique eye/style. We like work to be properly captioned. Caption labels should be typed or computer generated and they should contain all vital information regarding the photograph." Sees a trend "toward a journalistic style of stock photos. We are asked for natural settings, dramatic use of light and/or angles. Photographs should not be contrived and should express strong feelings toward the subject. We advise photographers to shoot a lot of film, photograph what they really love and follow our want lists."

EDUARDO COMESANA-AGENCIA DE PRENSA, Casilla de Correo 178 (Suc.26), Buenos Aires 1426 Argentina. Phone: (541)771-9418, 773-5943. Fax: (541)777-3719. E-mail: comesana@cpsarg.com. Director: Eduardo Comesana. Stock photo agency, picture library and news/feature syndicate. Has 500,000 photos. Clients include: ad agencies, book/encyclopedia publishers, magazine publishers and newspapers.
Needs: Personalities, entertainment, politics, science and technology, expeditions, archeology, travel, industry, nature, human interest, education, medicine, foreign countries, agriculture, space, ecology, leisure and recreation, couples, families and landscapes. "We have a strong demand for science-related subjects like shown in *Discover, Smithsonian* and *National Geographic* magazines."
Specs: Uses 8 × 10 glossy b&w prints; 35mm, 2¼ × 2¼ and 4 × 5 transparencies.
Payment & Terms: Pays $80/b&w photo; $100-300/color photo; 60% commission. Works with or without contract; negotiable. Offers limited regional exclusivity. Contracts continue "indefinitely unless terminated by either party with not less than 90 days written notice." Statements issued quarterly. Payment made quarterly. Photographers allowed to review account records to verify sales figures. Offers one-time and electronic media rights. Informs photographer and allows them to negotiate when client requests all rights. Model/property release preferred. Photo captions required; include "who, what, where, when, why and how."
Making Contact: "Send introductory letter or fax stating what photographer wants to syndicate. Do not send unsolicited material without previous approval. We would like to know as much as possible about the prospective contributor. A complete list of subjects will be appreciated." Include IRCs or check for postage in US dollars. Reports in 1 month.
Tips: Represents Black Star in South America; Woodfin Camp & Associates, Outline Press Syndicate from New York City; and Shooting Star from Los Angeles. "We would like to review magazine-oriented stories with a well-written text and clear captions. In case of hot news material, please fax or phone before sending anything. Freelancer should send us an introductory letter stating the type of photography he intends to sell through us. In our reply we will request him to send at least 5 stories of 10 to 20 colors each, for review. We would like to have some clippings of his photography."

N **SYLVIA CORDAIY LIBRARY LTD.,** 72 E. Ham Rd., Littlehampton, West Sussex BN17 7BQ England. Phone: 01903715297. Fax: 01903715297. E-mail: 113023.2732@compuserve.com. Website: http://www.photosource.co.uk/photosource/sylvia_cordaiy.htm. Estab. 1990. Stock photo agency. Has 200,000 photos in files. Clients include: advertising agencies, public relations firms, audiovisual firms, businesses, book publishers, magazine publishers, newspapers, calendar companies, greeting card companies, postcard publishers.
Needs: Worldwide, travel, wildlife, environmental issues, architecture, the polar regions, ancient civilizations, natural history, flora and fauna, livestock, domestic pets, veterinary, equestrian and marine biology, specialist files include London and UK, transport railways, shipping, aircraft, aerial photography. Also handles the Paul Kaye archive of 20,000 b&w prints.
Specs: Uses 35mm, 2¼ × 2¼, 4 × 5, 8 × 10 transparencies.
Payment/Terms: Pays 50% commission on b&w and color photos. Pay "varies widely according to publisher and usage." Offers volume discounts to customers. Works with photographers with or without a contract, negotiable. Offers exclusive contract only, limited regional exclusivity, nonexclusive contract. Charges for return postage. Statements issued monthly. Payments made monthly. Statements only issued

with payments. Photographers allowed to review account records. Offers one-time rights, electronic media rights. Model release preferred. Photo captions required; include location and content of image.

Making Contact: Send query with samples, stock photo list. Provide résumé, business card, self-promotion piece or tearsheets to be kept on file for possible future assignments. Agency will contact photographer for portfolio review if interested. Portfolio should include transparencies. Keeps samples on file; include SASE for return of material. Expects minimum initial submission of 100 images. Reports in 2 weeks on queries; 2 weeks on samples. Photo guidelines sheet free with SASE.

Tips: "Send SASE, location of images list and brief résumé of previous experience."

N ⊕ SUE CUNNINGHAM PHOTOGRAPHIC, 56 Chatham Rd., Kingston Upon Thames, Surrey KT1 3AA England. Phone: (+44)181 541 3024. Fax: (+44)181 541 5388. E-mail: scphotographic@btinternet.com. Partner: Sue or Patrick Cunningham. Estab. 1989. Picture library. Member of BAPLA (British Association of Picture Libraries and Agencies). Has 120,000 photos in files. Clients include: advertising agencies, audiovisual firms, businesses, book publishers, magazine publishers, newspapers.

Needs: "Broad subject coverage on the areas listed. A submission should cover a range of subjects from one or more of these areas/subjects: local icons and typical views (must be excellent pictures); buildings; banks; political institutions; industry; tourism; people; landscapes; agriculture. Establishing shots which typify the location. Areas: Latin America, Spain, Portugal, Central and Eastern Europe. Other areas covered in depth will be considered if the submission represents a marketable body of work."

Specs: Uses 8×10 glossy b&w prints; 35mm, 2¼×2¼, 4×5 transparencies.

Payment/Terms: Pays 50% commission on b&w and color photos. Average price per image (to clients): $90-9,000 for b&w; $90-9,000 for color. Negotiates fees below stated minimums. "Clients using large numbers of images on a single project occasionally receive a discount which brings the individual cost per image below the minimum. Offers volume discounts to customers. Works with photographers on contract basis only. Offers nonexclusive contract. Statements issued quarterly; payment made quarterly. Offers one-time or electronic media rights. Informs photographer and allows them to negotiate when client requests all rights. "50% fee applicable to all sales arising out of a contact established by us." Photo captions required; include "location, date (can be approximate), any details directly related to subject (name of person, building etc., history, etc.)"

Making Contact: Send query letter with samples, brochure, stock photo list, tearsheets. Agency will contact photographer for portfolio review if interested. Expects minimum initial submission of 250 images with annual submission of at least 100 images. Reports in 2 weeks on queries; 1 month on samples.

Tips: "We are currently in the run-up to digital systems. They are essential to the future of the stock picture industry, and we will have a searchable website in the foreseeable future. Send only well-framed images which are technically good. Use only Fujichrome Velvia/Provia/Sensia, Kodachrome or new Ectachrome. Submit a good cross-section of work, bearing in mind the end users. Send non-returnable copies or enclose reply-paid addressed envelope."

▣ CUSTOM MEDICAL STOCK PHOTO, Dept. PM, The Evanston Medical Bldg., 3660 W. Irving Park Rd., Chicago IL 60618. (773)267-3100. Fax: (773)267-6071. E-mail: info@cmsp.com. Website: http://www.cmsp.com. Medical Archivists: Mike Fisher, Henry Schleichkorn. Member of Picture Agency Council of America (PACA), American Society of Picture Professionals (ASPP), Biological Photographic Association (BPA) and Association of Medical Illustrations (AMI). Clients include: ad agencies, magazines, journals, textbook publishers, design firms, audiovisual firms, hospitals and Web designers—all commercial and editorial markets that express interest in medical and scientific subject area.

Needs: Biomedical, scientific, healthcare environmentals and general biology for advertising illustrations, textbook and journal articles, annual reports, editorial use and patient education.

Specs: Uses 35mm, 2¼×2¼ and 4×5 transparencies; negatives for electron microscopy; 4×5 copy transparencies of medical illustrations or flat art. Digital files accepted with Preview in Mac or Windows. Send via CD-ROM, online, floppy disk, SyQuest, Zip disk or JAZZ drive.

Payment & Terms: Pays per shot or commission. Per-shot rate depends on usage. Commission: 40-50% on domestic leases; 30% on foreign leases. Works on contract basis only. Offers guaranteed subject exclusivity contract. Contracts of 5-7 years automatically renew yearly. Administrative costs charged based on commission structure. Statements issued bimonthly. Payment made bimonthly. Credit line given if applicable, client discretion. Offers one-time, electronic media and agency promotion rights; other rights negotiable. Informs photographer but does not permit him to negotiate when a client requests all rights.

Making Contact: Query with list of stock photo subjects or check contributor website. Call for address and submission packet. "PC captioning disk available for database inclusion; please request. Do not send uncaptioned unsolicited photos by mail." SASE. Reports on average 1 month. Monthly want list available on Internet. Model and property release copies required.

Tips: "Our past want lists are a valuable guide to the types of images requested by our clients. Past want

lists are available on the Web. Environmentals of researchers, hi-tech biomedicine, physicians, nurses and patients of all ages in situations from neonatal care to mature adults are requested frequently. Almost any image can qualify to be medical if it touches an area of life: breakfast, sports, etc. Trends also follow newsworthy events found on newswires. Photos should be good clean images that portray a single idea, whether it is biological, medical, scientific or conceptual. Photographers should possess the ability to recognize the newsworthiness of subjects. Put together a minimum of 20 images for submission. Call before shipping to receive computer disk, caption information and return information. Contributing to our agency can be very profitable if a solid commitment can exist."

N **DESIGN CONCEPTIONS**, 112 Fourth Ave., New York NY 10003. (212)254-1688. Fax: (212)533-0760. Owner: Elaine Abrams. Picture Agent: Joel Gordon. Estab. 1970. Stock photo agency. Has 500,000 photos. Clients include: book/encyclopedia publishers, magazine publishers, advertising agencies.
Needs: "Real people."
Specs: Uses 8 × 10 RC b&w prints; 35mm transparencies.
Payment & Terms: Charges 50% commission on b&w and color photos. Average price per image (to clients): $175/b&w; $200/color. Enforces minimum prices. Offers volume discounts to customers; terms specified in photographer's contract. Works with or without contract. Offers limited regional exclusivity, nonexclusive. Statements issued monthly. Payment made monthly. Photographers allowed to review account records. Offers one-time rights. Offers electronic media and agency promotion rights. Informs photographer when client requests all rights. Model/property release preferred. Captions preferred.
Making Contact: Arrange personal interview to show portfolio. Query with samples.
Tips: Looks for "real people doing real, not set up, things."

DEVANEY STOCK PHOTOS, 755 New York Ave., Suite 306, Huntington NY 11743. (516)673-4477. Fax: (516)673-4440. President: William Hagerty. Photo Editor: Pamela Alexander. Has over 500,000 photos. Clients include: ad agencies, book publishers, magazines, corporations and newspapers. Previous/current clients: Young & Rubicam, BBD&O, Hallmark Cards, *Parade* Magazine, Harcourt Brace & Co.
Needs: Accidents, animals, education, medical, artists, elderly, scenics, assembly lines (auto and other) entertainers, schools, astronomy, factory, science, automobiles, family groups, aviation, finance, babies, fires, shipping, movies, shopping, flowers, food, beaches, oceans, skylines, foreign, office, birds, sports, gardens, operations, still life, pets, business, graduation, health, police, teenagers, pollution, television, children, history, hobbies, travel, churches, holidays, cities, weddings, communications, houses, women, writing, zoos, computers, housework, recreation, religion, couples, crime, crowds, dams, industry, laboratories, law, lawns, lumbering, restaurants, retirement, romance, etc.—virtually all subjects.
Specs: Uses all sizes of transparencies.
Payment & Terms: Does not buy photos outright. Pays 50% commission on color. Works with photographers with a signed contract. Contracts automatically renew for a 3-year period. Offers nonexclusive contract. Statements issued upon sale. Payment made monthly. Offers one-time rights. Model release preferred. Captions required.
Making Contact: Query with list of stock photo subjects or send material by mail for consideration. SASE. Reports in 1 month. Free photo guidelines with SASE. Distributes monthly tips sheet free to any photographer. Model/property release preferred. Captions required. "Releases from individuals and homeowners are most always required if photos are used in advertisements."
Tips: "An original submission of 200 original transparencies in vinyl sheets is required. We will coach."

DIANA PHOTO PRESS, Box 6266, S-102 34 Stockholm Sweden. Phone: (46)8 314428. Fax: (46)8 314401. Manager: Diana Schwarcz. Estab. 1973. Clients include: magazine publishers and newspapers.
Needs: Personalities and portraits of well-known people.
Specs: Uses 18 × 24 b&w prints; 35mm transparencies. "No CD-ROM; no computerising; no electronics."
Payment & Terms: Pays 30% commission on b&w and color photos. Average price per image (to clients): $150/b&w and color image. Enforces minimum prices. Works on contract basis only. Statements issued monthly. Payment made in 2 months. Offers one-time rights. Informs photographer and allows them to negotiate when client requests all rights. Captions required.
Making Contact: Query with samples. Samples kept on file. SASE. Does not report.

THE SUBJECT INDEX, located at the back of this book, lists publications, book publishers, galleries, gift and paper product companies and stock agencies according to the subject areas they seek.

🌐 **MICHAEL DIGGIN PHOTOGRAPHY**, 5 Castle St., Tralee, County Kerry, Ireland. Phone/fax: 353-66-22201. Managing Director/Owner: Michael Diggin. Estab. 1984. Has 30,000 images. Clients include: ad agencies, public relations firms, audiovisual firms, book/encyclopedia publishers, magazine publishers, newspapers, calendar companies, greeting card companies and postcard publishers.

Needs: Landscapes and historical, nature and geological photos of Ireland, Switzerland, France, Spain, Russia, China, Indonesia, Malaysia, Borneo, South Africa, Maldives, Seychelles, Azores, Vietnam, Ecuador, Mexico, US (California), Canada, Nepal, Northern India, West Indies, Austria, England (London), Scotland, Egypt, Kenya, Tanzania, South Africa, Holland, Gibralter, Spain and Sri Lanka. Stock list available on request.

Specs: Uses 36×24, 4×5 glossy Cibachrome color prints; 35 mm, 4×5 transparencies; Fujichrome Velvia film.

Payment & Terms: Pays 50% commission. Average price per image (to clients): $25-200/color photo. Photographers can choose not to sell images on discount terms. Works on contract basis only. Offers exclusive contracts. Statements issued quarterly. Payment made monthly. Photographers allowed to review account records. Offers one-time rights. Does not inform photographer and allow him to negotiate if client requests all rights. Model/property release required for people who are dominant in picture and for private dwellings. Captions required; include location and time of year.

Making Contact: Arrange personal interview to show portfolio. Works on assignment only. Samples kept on file. SASE. Expects minimum initial submission of 250 images with regular submissions at least twice yearly. Reports in 3 weeks. Catalog available on CD-ROM.

Tips: "Edit material thoroughly. Composite and exposure must be 100% and images must be on transparency (Fuji Velvia) larger than 35mm."

[N] DIGITAL STOCK CORP., 750 Second St., Encinitas CA 92024. (760)634-6500 or (800)545-4514. Fax: (760)634-6510. Website: http://www.digitalstock.com. President: Charles Smith. Specializes in royalty-free stock on CD-ROM. Has 9,700 photos. Clients include ad agencies, businesses, magazine publishers and newspapers.

Needs: Lifestyle, business and industry, technology and sports shots.

Specs: Uses transparencies.

Payment & Terms: Pays 15% commission on gross price of discs. Offers volume discounts to customers; inquire about specific terms. Discount sales terms not negotiable. Works on contract basis only. Offers nonexclusive contract. Statements issued quarterly. Payment made quarterly. Photographers allowed to review account records. Offers print and multimedia rights; no product for resale. Does not inform photographer or allow him to negotiate when client requests all rights. Model release required. Captions required.

Making Contact: Submit portfolio for review. Samples kept on file. SASE. Expects minimum of at least 400-10,000 images. Reports in 1-5 weeks. Photo guidelines free with SASE. Market tips sheet distributed; free upon request.

Tips: "All our images are marketed via CD-ROM and royalty-free. We have the highest quality work in this arena."

[N] DIMENSIONS & DIRECTIONS LTD., 41 Old Rt. 6, RR #9, Brewster NY 10509. (914)279-7043. Fax: (914)279-0023. President: Helena Frost. Estab. 1972. Stock photo agency. Has 100,000 photos in files. Clients include: book publishers.

Payment/Terms: Offers volume discounts to customers. Photographers can choose not to sell images on discount terms. Works with photographers on contract basis only. Statesments issued annually. Photographers allowed to review account records. Offers one-time rights. Informs photographers and allows them to negotiate when a client requests all rights. Model release preferred. Photo captions preferred.

Making Contact: Send query letter with stock photo list. Agency will contact photographer for portfolio review if interested. Portfolio should include tearsheets. Works with freelancers on assignment only. Does not keep sampoles on file; include SASE for return of material.

🌐 📷 **DINODIA PICTURE AGENCY**, 13 Vithoba Lane, 2nd Fl., Vithalwadi, Kalbadevi, Mumbai 400 002 India. Phone: (91)22-2014026. Fax: (91)22-206017675. E-mail: jagarwal@giasbm01.vsnl.net.in. Website: http://www.pickphoto.com/dinodia. Owner: Jagdish Agarwal. Estab. 1987. Stock photo agency. Has 500,000 photos. Clients include: advertising agencies, public relations firms, audiovisual firms, businesses, book/encyclopedia publishers, magazine publishers, newspapers, postcard companies, calendar companies and greeting card companies.

Needs: "We specialize in photos on India—people and places, fairs and festivals, scenic and sports, animals and agriculture."

Specs: Uses 35mm, 2¼×2¼ and 4×5 transparencies.

Payment & Terms: Pays 50% commission on b&w and color photos. General price range (to clients): US $100-600. Negotiates fees below stated minimum prices. Offers volume discounts to customers; inquire about specific terms. Discount sales terms not negotiable. Works on contract basis only. Offers limited regional exclusivity. "Prefers exclusive for India." Contracts renew automatically with additional submissions for 5 years. Statement issued monthly. Payment made monthly. Photographers permitted to review sales figures. Informs photographer and allows them to negotiate when client requests all rights. Offers one-time rights. Model release preferred. Captions required.

Making Contact: Query with résumé of credits, samples and list of stock photo subjects. SASE. Reports in 1 month. Photo guidelines free with SASE. Market tips sheet distributed monthly to contracted photographers.

Tips: "We look for style, maybe in color, composition, mood, subject-matter, whatever, but the photos should have above-average appeal." Sees trend that "market is saturated with standard documentary-type photos. Buyers are looking more often for stock that appears to have been shot on assignment."

DRK PHOTO, 265 Verde Valley School Rd., Sedona AZ 86351. (520)284-9808. Fax: (520)284-9096. President: Daniel R. Krasemann. "We handle only the personal best of a select few photographers—not hundreds. This allows us to do a better job aggressively marketing the work of these photographers." Member of Picture Agency Council of America (PACA) and A.S.P.P. Clients include: ad agencies; PR and AV firms; businesses; book, magazine, textbook and encyclopedia publishers; newspapers; postcard, calendar and greeting card companies; branches of the government, and nearly every facet of the publishing industry, both domestic and foreign.

Needs: "Especially need marine and underwater coverage." Also interested in S.E.M.'s, African, European and Far East wildlife, and good rainforest coverage.

Specs: Uses 35mm, 2¼×2¼ and 4×5 transparencies.

Payment & Terms: Pays 50% commission on color photos. General price range (to clients): $100 "into thousands." Works on contract basis only. Offers nonexclusive contracts. Contracts renew automatically. Statements issued quarterly. Payment made quarterly. Offers one-time rights; "other rights negotiable between agency/photographer and client." Model release preferred. Captions required.

Making Contact: "With the exception of established professional photographers shooting enough volume to support an agency relationship, we are not soliciting open submissions at this time. Those professionals wishing to contact us in regards to representation should query with a brief letter of introduction and tearsheets."

EARTH IMAGES, P.O. Box 10352, Bainbridge Island WA 98110. (206)842-7793. Managing Director: Terry Domico. Estab. 1977. Picture library specializing in worldwide outdoor and nature photography. Member of the Picture Agency Council of America (PACA). Has 150,000 photos; 2,000 feet of film. Has 2 branch offices; contact above address for locations. Clients include: ad agencies, public relations firms, audiovisual firms, businesses, book/encyclopedia publishers, magazine publishers, newspapers, calendar companies, greeting card companies, postcard publishers and overseas news agencies.

Needs: Natural history and outdoor photography (from micro to macro and worldwide to space); plant and animal life histories, natural phenomena, conservation projects and natural science.

Specs: Uses 35mm, 4×5 transparencies.

Payment & Terms: Pays 50% commission. Enforces minimum prices. Offers volume discounts to customers. Works on contract basis only. Offers nonexclusive contract. Contracts renew automatically with additional submissions. Buys one-time and electronic media rights. Model release preferred. Captions required; include species, place, pertinent data.

Making Contact: "However, unpublished photographers need not apply." Query with resume of credits. "Do not call for first contact." Samples kept on file. SASE. Expects minimum initial submission of 100 images. "Captions must be on mount." Reports in 3-6 weeks. Photo guidelines free with SASE.

Tips: "Sending us 500 photos and sitting back for the money to roll in is poor strategy. Submissions must be continuing over years for agencies to be most effective. Specialties sell better than general photo work. Animal behavior sells better than portraits. Environmental (such as illustrating the effects of acid rain) sells better than pretty scenics. 'Nature' per se is not a specialty; macro and underwater photography are."

EARTHVIEWS, A Subsidiary of the Marine Mammal Fund, Fort Mason Center, E205, San Francisco CA 94123. (415)775-0124. Fax: (415)921-1302. Librarian: Stan Minasian. Estab. 1971. Non-profit stock photo agency. Has 8,000 photos. Clients include: advertising agencies, book/encyclopedia publishers, magazine publishers, newspapers, postcard publishers, calendar companies, exhibits and advocacy groups.

Needs: Wildlife (no captive animals) with emphasis on marine mammals.

Specs: Uses 35mm, 2¼ × 2¼, 4 × 5 transparencies; 16mm, 35mm film, Betacam SP, Hi-8, S-VHS videotape.

Payment & Terms: Pays 50% commission. Offers nonexclusive contract. Statements issued upon request. Payment made semiannually. Offers one-time rights. Informs photographer and allows them to negotiate when client requests all rights. Captions required; include species, location.

Making Contact & Terms: Query with samples. Does not keep samples on file. SASE. Expects minimum initial submission of 20 images. Reports in 1-2 weeks.

Tips: "We do not hold originals. EarthViews will produce repro-quality duplicates and return all originals to the photographer. Contact us for more information."

ECLIPSE AND SUNS, 316 Main St., Box 669, Haines AK 99827-0669. (907)766-2670. Call for fax number. President and CEO: Erich von Stauffenberg. Estab. 1973. Photography, video and film archive. Has 1.3 million photos, 8,000 hours film. Clients include: advertising agencies, public relations firms, audiovisual firms, businesses, book/encyclopedia publishers, magazine publishers, calendar companies, greeting card companies, postcard publishers, film/television production companies and studios.

Needs: Uses 35mm transparencies; 8mm Super 8, 16 mm, 35mm film; Hi8, ¾ SP, Beta SP videotape.

Payment & Terms: Buys photos/film outright. Pays $25-500/color photo; $25-500/b&w photo; $50-1,000/minute film; $50-1,000/minute videotape. Negotiates individual contracts. Works on contract basis only. Offers exclusive contract. Charges 2% filing fee and 5% duping fee. Statements issued when work is requested, sent, returned, paid for. Payment made immediately after client check clears. Photographers allowed to review account records. Offers negotiable rights, "determined by photographer in contract with us." Informs photographer and allows them to negotiate when client requests all rights. "We encourage our photographers to never sell all rights to images." Model/property release required for all recognizable persons, real and personal property, pets. Captions required; include who, what, where, why, when; camera model, lens F/stop, shutter speed, film ASA/ISO rating.

Making Contact: Query with résumé of credits. Query with stock photo list. Samples kept on file. SASE. Expects minimum initial submission of 25-50 images; 30-minute reel. Reports in 3 weeks; foreign submissions at rate of mail transit. Photo guidelines available for $5 US funds. Catalog available (on CD-ROM) for $29.95. Market tips sheet distributed quarterly; $5 US.

Tips: Uses Adobe Photo Shop, Kodak CD-ROMs, Nikon Scanner; multimedia authoring, Sanyo CD-ROM Recording Drives and Digital Workstation. "We only provide low res watermarked (with photographer's copyright) materials to clients for comps and pasteups. Images are sufficiently degraded that no duplication is possible; any enlargement is totally pixel expanded to render it useless. Video footage is similarly degraded to avert copying or unauthorized use. Film footage is mastered on SP Beta returned to photo and degraded to an uncopyable condition for demo reels. We are currently seeking photographers from China, Japan, Korea, Southeast Asia, Europe, Middle East, Central and South America and Australia. Photos must be bracketed by ½ stops over and under each image, must be razor sharp, proper saturation, density with highlight detail and shadow detail clearly visible. We will accept duplicates for portfolio review only. Selected images for deposit must be originals with brackets, ½ stop plus and minus. All images submitted for final acceptance and deposit must be copyrighted by photographer prior to our marketing works for sale or submissions."

ECOSCENE, The Oasts, Headley Lane, Passfield, Liphook, Hampshire AV30 7RX United Kingdom. Phone: (44)1428 751056. Fax: (44)1428 751057. E-mail: ecoscene.@photosource.co.uk. Website: http://www.photosource.co.uk/photosource/ecoscene.htm. Owner: Sally Morgan. Estab. 1988. Stock photo agency and picture library. Has 80,000 photos. Clients include: advertising agencies, book/encyclopedia publishers, magazine publishers, newspapers and multimedia.

Needs: Environment, energy, agricultural and tourism.

Specs: Uses 35mm, 2¼ × 2¼ transparencies.

Payment & Terms: Pays 55% commission on color photos. Average price per image (to clients): $100-300/color photo. Negotiates fees below stated minimum prices, depending on quantity reproduced by a single client. Offers volume discounts to customers. Discount sales terms not negotiable. Works on contract basis only. Offers nonexclusive contract. Statements issued quarterly. Payment made quarterly. Offers one-time and electronic media rights. Informs photographers and allows them to negotiate when clients request all rights. Model/property release preferred. Captions required; include common and Latin names of wildlife and as much detail as possible.

Making Contact: Query with résumé of credits. Samples kept on file. SASE. Expects initial submission of at least 100 images with annual submissions of at least 200 images. Reports in 3 weeks. Photo guidelines free with SASE. Catalog available. Market tips sheet distributed quarterly to anybody who requests and to all contributors.

ENP IMAGES, 1332 NW Kearney St., Portland OR 97209. (503)916-0234. Fax: (503)916-8849. E-mail: info@enpimages.com. Estab. 1991. Stock photo library. Has 450,000 images. Clients include: ad agencies, design firms, businesses, book/electronic publishers, magazine publishers, calendar companies, greeting card companies and postcard companies.
Needs: All nature-related; the environment, wildlife, underwater, micro, ecotourism, traditional culture. "In-depth collections given highest consideration."
Specs: Uses 35mm, 2¼×2¼, 4×5, 8×10 transparencies and b&w historical material.
Payment & Terms: Pays standard 50% commission on b&w and color photos. Works on contract basis only. Offers guaranteed subject exclusivity contracts. Contracts renew automatically with additional submissions after one year. Statements/payments issued monthly. Photographers allowed to review account records. Offers negotiable rights. Informs photographer and allows them to negotiate when client requests all rights. Captions and scientific identification required.
Making Contact: Write or e-mail for contact information sheet or see website at www.enpimages. com. Reports in up to 1 month. *Do not submit photography.* Interested in receiving work from newer, lesser-known photographers "who have large in-depth files of single subjects or geographic areas."

🌐 🎬 **ENVIRONMENTAL INVESTIGATION AGENCY**, 15 Bowling Green Lane, London ECIR OBD England. Phone: (71)490-7040. Fax: (71)490-0436. E-mail: eiauk@gr.apc.org. Communications Manager: Matthew Snead. Estab. 1986. Conservation organization with picture and film library. Has 5,000 photos, 13,000 hours film. Clients include: book/encyclopedia publishers, magazine publishers and newspapers.
Needs: Photos about conservation of animals and the environment; trade in endangered species and endangered wildlife; and habitat destruction.
Specs: Uses 5×7 color prints; 35mm transparencies; 16mm film; BetaSP and HI-8 videotape.
Payment & Terms: Average price per image (to clients): $100/b&w photo; $200/color photo; $800/videotape. Negotiates fees below standard minimum prices. Offers volume discounts to customers; terms specified in photographer's contract. Offers one-time rights; will "negotiate on occasions in perpetuity or 5-year contract." Does not inform photographer or allow him to negotiate when client requests all rights. Captions required; include "full credit and detail of investigation/campaign where possible."
Making Contact: Query with samples. Query with stock photo list. Works with local freelancers only. Samples kept on file. SASE. Expects minimum initial submission of 10 images with periodic submission of additional images. Reports in 1-2 weeks.

🎬 **ENVISION**, 50 Pine St., New York NY 10005. (212)344-4000. Director: Sue Pashko. Estab. 1987. Stock photo agency. Member of the Picture Agency Council of America (PACA). Has 150,000 photos. Clients include: advertising agencies, public relations firms, businesses, book/encyclopedia publishers, magazine publishers, newspapers, calendar and greeting card companies and graphic design firms.
Needs: Professional quality photos of food, commercial food processing, fine dining, American cities (especially the Midwest), crops, Third World lifestyles, marine mammals, European landmarks, tourists in Europe and Europe in winter looking lovely with snow, and anything on Africa and African-Americans.
Specs: Uses 35mm, 2¼×2¼, 4×5 or 8×10 transparencies. "We prefer large and medium formats."
Payment & Terms: Pays 50% commission on b&w and color photos. General price range (to clients): $200 and up. Works on contract basis only. Statements issued monthly. Payment made monthly. Offers one-time rights; "each sale individually negotiated—usually one-time rights." Model/property release required. Captions required.
Making Contact: Arrange personal interview to show portfolio. Query with résumé of credits "on company/professional stationery." Regular submissions are mandatory. SASE. Reports in 1 month.
Tips: "Clients expect the very best in professional quality material. Photos that are unique, taken with a very individual style. Demands for traditional subjects *but* with a different point of view; African- and Hispanic-American lifestyle photos are in great demand. We have a need for model-released, professional quality photos of people with food—eating, cooking, growing, processing, etc."

🎬 **EWING GALLOWAY**, 100 Merrick Rd., Rockville Centre NY 11570. (516)764-8620. Fax: (516)764-1196. Photo Editor: Janet McDermott. Estab. 1920. Stock photo agency. Member of Picture Agency Council of America (PACA), American Society of Media Photographers (ASMP). Has 3 million photos. Clients include: advertising agencies, public relations firms, audiovisual firms, businesses, book/encyclopedia publishers, magazine publishers, newspapers, postcard companies, calendar companies, greeting card companies and religious organizations.
Needs: General subject library. Does not carry personalities or news items. Lifestyle shots (model released) are most in demand.
Specs: Uses 8×10 glossy b&w prints; 35mm, 2¼×2¼ and 4×5 transparencies.

Payment & Terms: Pays 30% commission on b&w photos; 50% on color photos. General price range: $400-450. Charges catalog insertion fee of $400/photo. Statements issued monthly. Payment made monthly. Offers one-time rights; also unlimited rights for specific media. Model/property release required. Photo captions required; include location, specific industry, etc.

Making Contact: Query with samples. Send unsolicited photos by mail for consideration; must include return postage. SASE. Reports in 3 weeks. Photo guidelines with SASE (55¢). Market tips sheet distributed monthly; SASE (55¢).

Tips: Wants to see "high quality—sharpness, subjects released, shot only on best days—bright sky and clouds. Medical and educational material is currently in demand. We see a trend toward photography related to health and fitness, high-tech industry, and mixed race in business and leisure."

FAMOUS PICTURES & FEATURES, Studio 4, Limehouse Cut, 46 Morris Rd., London E14 6NQ United Kingdom. Phone: (+44)171 510 2500. Fax: (+44) 171 510 2510. E-mail: famous@compuser ve.com. Website: http://www.famous.uk.com. Contact: Lee Howard. Estab. 1985. Picture library, news/feature syndicate. Has 20,000 photos in file. Clients include: advertising agencies, book publishers, magazine publishers, newspapers, calendar companies, postcard publishers.

Needs: Studio and live party events of music, film, TV celebrities.

Specs: Uses 35mm, 4×5 transparencies. Accepts images in digital format.

Payment/Terms: Pays 50% commission on color photos. Offers volume discounts to customers. Photographers can choose not to sell images on discount terms. Works with photographers with or without a contract. Offers limited regional exclusivity. Statements issued quarterly; payments made bimonthly. Photographers allowed to review account records. Offers one-time rights. Photo captions required.

Making Contact: Send query letter with samples. Provide résumé, business card, self promotion piece or tearsheets to be kept on file for future assignments. Agency will contact photographers for portfolio review if interested. Portfolio should include transparencies. Keeps samples on file. Will return material with SASE.

Tips: "We are increasingly marketing images via computer networks. When submitting work, caption pictures correctly."

FIRST LIGHT ASSOCIATED PHOTOGRAPHERS, 333 Adelaide St. West, 6th Fl., Toronto, Ontario M5V 1R5 Canada. (416)597-8665. President: Pierre Guevremont. Estab. 1984. Stock and assignment agency. Has 450,000 photos. Clients include: advertising agencies, public relations firms, audiovisual firms, businesses, book/encyclopedia publishers, magazine publishers, newspapers, postcard companies, calendar companies and greeting card companies.

Needs: Natural history, international travel, commercial imagery in all categories. Special emphasis upon model-released people, high tech, industry and business. "Our broad files require variety of subjects."

Specs: Uses 35mm, 2¼×2¼ and 4×5 transparencies.

Payment & Terms: Pays 50% commmission. General price range: $150-5,000. Works on contract basis only. Offers limited regional exclusivity. Charges variable catalog insertion fees. Statements issued monthly. Payment made monthly. Offers one-time rights. Informs photographers and permits them to negotiate when client requests all rights. Model release preferred. Captions required.

Making Contact: Query with list of stock photo subjects. SASE. Reports in 1 month. Photo guidelines free with SASE. Tips sheet distributed every 6 weeks.

Tips: Wants to see "tight, quality edit and description of goals and shooting plans."

FIRTH PHOTOBANK, 15612 Hwy. 7, Suite 77, Minnetonka MN 55345. (612)931-0847. Fax: (612)938-9362. E-mail: firthphotobank@juno.com. Photo Researcher: Andrea Wilson. Owner: Bob Firth. Stock photo agency. Has 500,000 photos in files. Clients include: advertising agencies, businesses, book publishers, magazine publishers, calendar companies, greeting card companies, postcard publishers.

Specs: Uses 35mm, 2¼×2¼, 4×5 transparencies.

Payments & Terms: Pays 40-50% commission on b&w and color photos. Average price per image (to clients): $150 minimum. Enforces minimum prices. Offers volume discounts to customers. Works with photographers on nonexclusive contract. Contracts renew automatically with additional submissions for 1 year. Statement issued upon sale; payment made upon receipt of payment. Photographers allowed to review account records in cases of discrepancies only. Offers one-time rights. Inform photographers and allows them to negotiate when a client requests all rights. Model/property release preferred. Photo captions required.

Making Contact: Send query letter with brochure, stock photo list, tearsheets or call. To show portfolio, photographer should follow-up with call and/or letter after initial query. Works with local freelancers only. Samples kept on file; will return material with SASE. Reports back only if interested, send non-returnable samples.

FOTO EXPRESSION INTERNATIONAL (Toronto), Box 1268, Station "Q," Toronto, Ontario M4T 2P4 Canada. (416)299-4887. Fax: (416)299-6442. E-mail: operations@fotopressnews.com. Website: http://fotopressnews.com. Director: John Milan Kubik. Selective archive of photo, film and audiovisual materials. Clients include: ad agencies; public relations and audiovisual firms; TV stations and networks; film distributors; businesses; book, encyclopedia, trade and news magazine publishers; newspapers; postcard, calendar and greeting card companies.

Needs: City views, aerial, travel, wildlife, nature/natural phenomena and disasters, underwater, aerospace, weapons, warfare, industry, research, computers, educational, religions, art, antique, abstract, models, sports. Worldwide news and features, personalities and celebrities.

Specs: Uses 8×10 b&w prints; 35mm and larger transparencies; 16mm, 35mm film; VHS, Beta and commercial videotapes (AV). Motion picture, news film, film strip and homemade video. Accepts images in digital format for Windows. Send via compact disc, floppy disk or Zip disk.

Payment & Terms: Sometimes buys transparencies outright. Pays 40% for b&w; 50% for color and 16mm, 35mm films and AV (if not otherwise negotiated). Statements issued semi-annually. Payment made monthly. Offers one-time and electronic rights. Model release required for photos. Captions required.

Making Contact: Submit portfolio for review. The ideal portfolio for 8×10 b&w prints includes 10 prints; for transparencies include 60 selections in plastic slide pages. With portfolio you must send $4 US money order or $4.50 Canadian money order for postage—no personal checks, no postage stamps. Reports in 3 weeks. Photo guidelines free with SASE. Tips sheet distributed twice a year only "on approved portfolio."

Tips: "We require photos, slides, motion picture films, news film, homemade video and AV that can fulfill the demand of our clientele." Quality and content is essential. Photographers, cameramen, reporters, writers, correspondents and representatives are represented worldwide by FOTOPRESS, Independent News Service International, (416)299-4887, Fax: (416)299-6442.

FOTOCONCEPT INC., 18020 SW 66th St., Ft. Lauderdale FL 33331. (305)680-1771. Fax: (305)680-8996. Vice President: Aida Bertsch. Estab. 1985. Stock photo agency. Member of Picture Agency Council of America (PACA). Has 250,000 photos. Clients include: magazines, advertising agencies, newspapers and publishers.

Needs: General worldwide travel, medical and industrial.

Specs: Uses 35mm, 2¼×2¼, 4×5 transparencies.

Payment & Terms: Pays 50% commission for color photos. Works on contract basis only. Offers nonexclusive contract. Contracts renew automatically with each submission for 1 year. Statements issued quarterly. Payment made quarterly. Photographers allowed to review account records to verify sales figures. Offers one-time rights. Informs photographer and allows them to negotiate when client requests all rights. Model release required. Captions required.

Making Contact: Query with list of stock photo subjects. SASE. Reports in 1 month. Tips sheet distributed annually to all photographers.

Tips: Wants to see "clear, bright colors and graphic style." Points out that they are "looking for photographs with people of all ages with good composition, lighting and color in any material for stock use."

FOTO-PRESS TIMMERMANN, Speckweg 34A, D-91096 Moehrendorf, Germany. Phone: 499131/42801. Fax: 499131/450528. E-mail: timmermann.foto@t-online.de. Contact: Wolfgang Timmermann. Stock photo agency. Has 750,000 slides. Clients include: ad agencies, audiovisual firms, businesses, book/encyclopedia publishers, magazine publishers, newspapers and calendar companies.

Needs: All themes: landscapes, countries, travel, tourism, towns, people, business, nature.

Specs: Uses 2¼×2¼, 4×5 and 8×10 transparencies.

Payment & Terms: Pays 50% commission on color prints. Works on nonexclusive contract basis (limited regional exclusivity). First period: 3 years, contract automatically renewed for 1 year. Photographers allowed to review account records. Statements issued quarterly. Payment made quarterly. Offers one-time rights. Informs photographers and permits them to negotiate when a client requests to buy all rights. Model/property release preferred. Captions required; include state, country, city, subject, etc.

Making Contact: Query with list of stock photo subjects. Send unsolicited photos by mail for consideration. SASE. Reports in 1 month.

THE INTERNATIONAL MARKETS INDEX, located in the back of this book, lists markets located outside the U.S. by country.

FOTOS INTERNATIONAL, 10410 Palms Blvd., Suite 9, Los Angeles CA 90034-4812. (818)508-6400. Fax: (818)762-2181. E-mail: entertainment@earthlink.net or fotos@mail.org. Manager: Max B. Miller. Has 4 million photos. Clients include: ad agencies, public relations firms, businesses, book publishers, magazine publishers, encyclopedia publishers, newspapers, calendar companies, TV and posters.
Needs: "We are the world's largest entertainment photo agency. We specialize exclusively in motion picture, TV and popular music subjects. We want color only! The subjects can include scenes from productions, candid photos, rock, popular or classical concerts, etc., and must be accompanied by full caption information."
Specs: Uses 35mm color transparencies only.
Payment & Terms: Buys photos outright; no commission offered. Pays $5-200/photo. Works with or without contract. Offers nonexclusive contract and guaranteed subject exclusivity (within files). Offers one-time rights and first rights. Offers electronic media and agency promotion rights. Model release optional. Captions required.
Making Contact: "We prefer e-mails or faxes." Query with list of stock photo subjects. Reports "promptly which could be one hour or two months, depending on importance and whatever emergency project we're on."

FPG INTERNATIONAL LLC, 32 Union Square E., New York NY 10003. (212)777-4210. Fax: (212)475-8542. Director of Photography: Rana Faure. Affiliations Manager: Claudia Micare. A full service agency with emphasis on images for the advertising, corporate, design and travel markets. Member of Picture Agency Council of America (PACA).
Needs: High-tech industry, model-released human interest, foreign and domestic scenics in medium formats, still life, animals, architectural interiors/exteriors with property releases.
Specs: Minimum submission requirement per year—1,000 original color transparencies, exceptions for large format, 250 b&w full-frame 8×10 glossy prints.
Payment & Terms: Pays 50% commission upon licensing of reproduction rights. Works on contract basis only. Offers exclusive contract only. Contracts renew automatically upon contract date; 4-year contract. Charges catalog insertion fee; rate not specified. Statements issued monthly. Payment made monthly. Photographers allowed to review account records to verify sales figures. Licenses one-time rights. "We sell various rights as required by the client." When client requests all rights, "we will contact a photographer and obtain permission."
Making Contact: "Initial approach should be by mail. Tell us what kind of material you have, what your plans are for producing stock and what kind of commercial work you do. Enclose reprints of published work." Photo guidelines and tip sheets provided for affiliated photographers. Model/property releases required and must be indicated on photograph. Captions required.
Tips: "Submit regularly; we're interested in committed, high-caliber photographers only. Be selective and send only first-rate work. Our files are highly competitive."

FRANKLIN PHOTO AGENCY, 85 James Otis Ave., Centerville MA 02632. President: Nelson Groffman. Has 35,000 transparencies. Clients include: publishers, advertising and industrial.
Needs: Scenics, animals, horticultural subjects, dogs, cats, fish, horses, antique and classic cars, and insects.
Specs: Uses 35mm, 2¼×2¼ and 4×5 color transparencies. "More interest now in medium size format—2¼×2¼." Accepts images in digital format.
Payment & Terms: Pays 50% commission. General price range (to clients): $100-300; $60/b&w photo; $100/color photo. Works with or without contract, negotiable. Offers nonexclusive contract. Statements issued when pictures are sold. Payment made within a month after sales "when we receive payment." Offers one-time, electronic media, agency promotion rights and 1-year exclusive rights. Informs photographer and allows them to negotiate when client requests all rights. Model/property release required for people, houses; present release on acceptance of photo. Captions preferred.
Making Contact: Query first with résumé of credits. SASE. Reports in 1 month.
Tips: Wants to see "clear, creative pictures—dramatically recorded."

FRONTLINE PHOTO PRESS AGENCY, P.O. Box 162, Kent Town, South Australia 5071 Australia. 18 Wall St., Norwood, South Australia 5067 Australia. Phone: 61-8-8333-2691. Fax: 61-8-8364-0604. E-mail: info@frontline.net.au. Website: http://www.frontline.net.au. Photo Editor: Carlo Irlitti. Sales & Marketing: Marco Irlitti. Estab. 1988. Stock photo agency, picture library and photographic press agency. Has 350,000 photos. Clients include: advertising agencies, marketing/public relations firms, book/encyclopedia publishers, magazine publishers, newspapers, postcard publishers, calendar companies, poster companies, multimedia/audiovisual firms, graphic designers, corporations, private and government institutions.

• This agency markets images via online catalogs and low resolution watermarked CD-ROM catalogs. Digital picture transmission service available.

Needs: People (all walks of life, at work and at leisure), lifestyles, sports, cities and landscapes, travel, industrial and agricultural, natural history, enviromental, celebrities and important people, social documentary, concepts, science and medicine.

Specs: Uses 8×12 glossy color and b&w prints; 35mm color and b&w negatives; 35mm, $2\frac{1}{4} \times 2\frac{1}{4}$, 4×5, 8×10 transparencies; CD-ROMs in ISO 9660 Format, Kodak Photo/Pro Photo CD Masters (Base $\times 16$ and Base $\times 64$). Accepts images in digital format for Mac and Windows (JPEG, TIFF and most other types PhotoCD). Submit via compact disc, Online, floppy disk, Zip disk or on Internet: 72 dpi and up (thumbnails), 300 dpi and up (high-resolution).

Payment & Terms: Pays 60% commission on all stock images. Assignment rates negotiable. Average price per stock image: b&w $AUD125, color $AUD200 paid to the photographer; overall $AUD50-$AUD6,000. Prices vary considerably depending on use, market and rights requested. Enforces minimum prices. Discounts only on bulk sales. Prefers to work on contract basis but can work without if necessary. Offers exclusive, nonexclusive and tailored contracts to suit the individual photographer. Contracts are for a minimum of 3 years and are automatically renewed 6 months before the expiration date (if not advised in writing) or renewed automatically with additional submissions. No charges for filing or duping. No charge on in-house produced low and high resolution CD-ROM catalog insertions but charges a once only 50% Photo CD insertion rate on Photo CD Base $\times 64$ high resolution scans. Statements issued monthly (quarterly outside Australia). Payment made monthly and within 15 days (quarterly and within 15 days outside Australia). Photographers allowed to review account records as stipulated in contract. Offers one-time and first-time rights, but also promotional, serial, exclusive and electronic media rights. Photographers informed and allowed to negotiate when client requests all rights. Agency will counsel, but if photographer is unable to negotiate agency will revert to broker on his/her behalf. Model/property release required. Accepts accompanying mss or extended captions with images submitted; commission on copy negotiable.

Making Contact: Interested in receiving work from competent amateur and professional photographers only. Query with samples or list of stock subjects. Send unsolicited photos (negatives with proofs, transparencies, CD-ROMs ISO 9660), Zip disks and images by e-mail for consideration. Works with local and foreign freelancers on assignment. Samples kept on file with permission. SASE (include insurance and IRC). Expects minimum initial submission of 100-200 images with periodic submissions of 200-1,000 images/year. Reports in 1-3 weeks. Photo guidelines free with SAE and IRCs. Market tips sheet distributed to photographers on contract; free upon request.

Tips: "We look for creative photographers who are dedicated to their work, who can provide unique and technically sound images. We prefer our photographers to specialize in their subject coverage in fields they know best. All work submitted must be original, well-composed, well-lit (depending on the mood), sharp and meticulously edited with quality in mind. In the initial submission we prefer to see 100-200 of the photographer's best work. Send slides in plastic files and not in glass mounts or loose in boxes. All material must be captioned or attached to an information sheet; indicate if model/property released. Model and property releases are mostly requested for advertising and are essential for quick, hassle-free sales. Please package work appropriately; we do not accept responsibility for losses or damage. We would like all subjects covered equally but the ones most sought are: environmental issues, science and medicine, people (occupations, life-style and leisure), dramatic landscapes, general travel and conceptual images. We also need more pictures of sports (up-and-coming and established athletes who make the news worldwide), celebrities and entertainers, important people, social documentary (contemporary issues) including captioned photo-essays for our editorial clients. Feature articles on topical issues, celebrity gossip, sport, travel, lifestyle, fashion, beauty, women's interests, general interest etc., are welcomed and will help sell images in editorial markets, but inquire first before sending any copy. Write, call or fax for complete subject list. We also provide regular advice for our contributors and will direct freelancers to photograph specific, market-oriented subjects as well as help in coordinating their own private assignments to assure saleable subjects."

FUNDAMENTAL PHOTOGRAPHS, Dept. PM, 210 Forsyth St., New York NY 10002. (212)473-5770. Fax: (212)228-5059. E-mail: 70214.3663@compuserve.com. Website: http://www.fphoto.com. Partner: Kip Peticolas. Estab. 1979. Stock photo agency. Applied for membership into the Picture Agency Council of America (PACA). Has 100,000 photos. Clients include: advertising agencies, book/encyclopedia publishers.

Needs: Science-related topics.

Specs: Uses 35mm, $2\frac{1}{4} \times 2\frac{1}{4}$, 4×5 and 8×10 transparencies.

Payment & Terms: Pays on commission basis; b&w 40%, color 50%. General price range (to clients): $100-500/b&w photo; $150-1,200/color photo, depends on rights needed. Enforces minimum prices. Offers volume discount to customers which requires photographer's approval but does not allow him to negotiate

when client requests all rights. Works on contract basis only. Offers guaranteed subject exclusivity. Contracts renew automatically with additional submissions for 1 or 2 years. Charges 50% duping fees ($25/ 4×5 dupe). Statements issued quarterly. Payment made quarterly. Photographers allowed to review account records with written request submitted 2 months in advance. Offers one-time and electronic media rights. Informs photographer when client requests all rights; negotiation conducted by Fundamental (the agency). Model release required. Captions required; include date and location.

Making Contact: Arrange a personal interview to show portfolio. Submit portfolio for review. Query with résumé of credits, samples or list of stock photo subjects. Keeps samples on file. SASE. Expects minimum initial submission of 100 images. Reports in 1-2 weeks. Photo guidelines free with SASE. Tips sheet distributed.

Tips: "Our primary market is science textbooks. Photographers should research the type of illustration used and tailor submissions to show awareness of saleable material. We are looking for science subjects ranging from nature and rocks to industrials, medicine, chemistry and physics; macrophotography, stroboscopic; well-lit still life shots are desirable. The biggest trend that affects us is the increased need for images that relate to the sciences and ecology."

N ⊕ GARDEN & WILDLIFE MATTERS, Marlham, Henley Down, Battle, Essex TN33 9BN United Kingdom. Phone: 01424-830566. Fax: 01424-830224. E-mail: gardens@ftech.cr.uk. Website: http://web.f-tech.net/~gardens. Contact: John Feltwell. Estab. 1990. Stock photo agency. Member of B.A.P.L.A. Has 100,000 photos on files. Clients include: advertising agencies, public relations firms, businesses, book publishers, magazine publishers, newspapers, greeting card companies, postcard publishers.

Needs: Garden: plant profiles, gardening, houseplants, crops, rainforests, trees, herbs. Wildlife: whales, Africa wildlife, mammals, birds.

Specs: Uses color prints; 35mm, 4×5 transparencies. Accepts images in digital format.

Payment/Terms: Pays 50% for color. Enforces strict minimum prices. Offers volume discounts to customers. Works with photographers on contract basis only. Offers nonexclusive contract. Contracts renew automatically with additional submissions. Statements issued quarterly; payment made quarterly. Photographers allowed to review account records. Offers one-time rights. Does not inform photographers and allow them to negotiate when a client requests all rights. Model/property release required. Photo captions required.

Making Contact: Send query letter. Agency will contact photographer for portfolio review if interested. Portfolio should include slides or transparencies. Works with local freelancers only. Will return material with SASE. Expects minimum initial submission of 50 images. Reports in 2 weeks. Catalog available. Market tips sheet not available.

Tips: "We are marketing images via computer networks but not CD-ROMS yet."

⊕ ▧ GEOSLIDES & GEO AERIAL PHOTOGRAPHY, 4 Christian Fields, London SW16 3JZ England. Phone: (181)764-6292. Marketing Director: John Douglas. Picture library. Has approximately 100,000 photos. Clients include: ad agencies, public relations firms, audiovisual firms, businesses, book/ encyclopedia publishers, magazine publishers, newspapers, calendar companies and television.

Needs: Accent on travel/geography and aerial (oblique) shots.

Specs: Uses 35mm, 2¼×2¼, 4×5 transparencies.

Payment & Terms: Pays 50% commission. General price range (to clients) $75-750. Works with or without contract; negotiable. Offers nonexclusive contract. Statements issued monthly. Payment made upon receipt of client's fees. Offers one-time rights and first rights. Does not inform photographers or allow them to negotiate when clients request all rights. Model release required. Photo captions required; include description of location, subject matter and sometimes the date.

Making Contact: Query with résumé of credits and list of stock photo subjects. SASE. Photo guidelines for SASE (International Reply Coupon). No samples until called for.

Tips: Looks for "technical perfection, detailed captions, must suit lists (especially in areas). Increasingly competitive on an international scale. Quality is important. Need for large stocks with frequent renewals." To break in, "build up a comprehensive (i.e., in subject or geographical area) collection of photographs which are well documented."

GLOBE PHOTOS, INC., 275 Seventh Ave., New York NY 10001. (212)645-9292. Fax: (212)627-8932. E-mail: info@globephotos.com. General Manager (celebrity photos): Ray Whelan Sr. Stock Photography Editor: Bob Shamis. Estab. 1939. Stock photo agency. Member of the Picture Agency Council of America. Has 10 million photos. Clients include: ad agencies, public relations firms, audiovisual firms, businesses, book/encyclopedia publishers, magazine publishers, newspapers and calendar companies.

Needs: General stock photography, celebrity photos and coverage of the entertainment industry.

Specs: Uses 8×10 b&w prints; 35mm, 2¼×2¼, 4×5, 8×10 transparencies.

Payment & Terms: Pays 50% commission on b&w and color photos. Offers volume discounts to custom-

ers; inquire about specific terms. Discount sales terms not negotiable. Works on contract basis only. Offers nonexclusive and exclusive contracts. Contracts renew automatically with additional submissions for 3 years. Statements issued monthly, when there is sales activity in photographer's account. Payment made monthly. Photographers allowed to review account records once a year, after request in writing stating reasons. Offers one-time or electronic media rights and exclusivity upon negotiation. Model/property release required for recognizable people, commercial establishments and private homes.

Making Contact: Arrange personal interview to show portfolio. Query with résumé of credits. Query with stock photo list. "Résumé or stock list appreciated but not required." Samples kept on file. SASE. Expects minimum initial submission of 150-200 images (depends on medium). Reports in 3 weeks. Photo guidelines free with SASE. Market tips sheet distributed periodically to contributing photographers upon request.

Tips: "We transmit images digitally via modem and ISDN lines to affiliates and clients."

[N] JOEL GORDON PHOTOGRAPHY, 112 Fourth Ave., New York NY 10003. (212)254-1688. E-mail: joelgordon112@juno.com. Picture Agent: Joel Gordon. Stock photo agency. Clients include: ad agencies, designers and textbook/encyclopedia publishers.

Specs: Uses 8×10 b&w prints, 35mm transparencies, b&w contact sheets and b&w negatives.

Payment & Terms: Usually charges 50% commission on b&w and color photos. Offers volume discounts to customers; terms specified in contract. Photographers can choose not to sell images on discount terms. Works with or without a contract. Offers nonexclusive contract. Payment made after client's check clears. Photographers allowed to review account records to verify sales figures. Informs photographer and allows them to negotiate when client requests all rights. Offers one-time, electronic media and agency promotion rights. Model/property release preferred. Captions preferred.

GEORGE HALL/CHECK SIX, 426 Greenwood Beach, Tiburon CA 94920. (415)381-6363. Fax: (415)383-4935. E-mail: george@check-6.com. Website: http://www.check-6.com. Owner: George Hall. Estab. 1980. Stock photo agency. Member of the Picture Agency Council of America (PACA). Has 50,000 photos. Clients include advertising agencies, public relations firms, businesses, magazine publishers, calendar companies.

Needs: All modern aviation and military.

Specs: Uses 35mm, $2\frac{1}{4} \times 2\frac{1}{4}$, 4×5 transparencies.

Payment & Terms: Pays 50% commission on color photos. Average price per stock sale: $1,000. Has minimum price of $300 (some lower fees with large bulk sales, rare). Offers volume discounts to customers; terms specified in photographer's contract. Photographers can choose not to sell images on discount terms. Works on contract basis only. Offers nonexclusive contract. Payment made within 5 days of each sale. Photographers allowed to review account records. Offers one-time and electronic media rights. Does not inform photographer or allow him to negotiate when client requests all rights. Model release preferred. Captions preferred; include basic description.

Making Contact: Call or write. SASE. Reports in 3 days. Photo guidelines available.

GEORGE HALL/CODE RED, 426 Greenwood Beach, Tiburon CA 94920. (415)381-6363. Fax: (415)383-4935. E-mail: george@code-Red.com. Website: http://www.code-Red.com. Owner: George Hall. Stock photo agency. Member of the Picture Agency Council of America (PACA). Has 5,000 photos (just starting). Clients include: advertising agencies, public relations firms, businesses, book/encyclopedia publishers, magazine publishers, calendar companies.

Needs: Interested in firefighting, emergencies, disasters, hostile weather: hurricanes, quakes, floods, etc.

Specs: Uses color prints; 35mm, $2\frac{1}{4} \times 2\frac{1}{4}$, 4×5 transparencies.

Payment & Terms: Pays 50% commission. Average price (to clients) $1,000. Enforces minimum prices of $300. Offers volume discounts to customers; terms specified in photographer's contract. Photographers can choose not to sell images on discount terms. Works on contract basis only. Offers nonexclusive contract. Payment made within 5 days of each sale. Photographers allowed to review account records. Offers one-time rights. Does not inform photographer or allow him to negotiate when client requests all rights. Model release preferred. Captions required.

Making Contact: Call or write with details. SASE. Reports in 3 days. Photo guidelines available.

[globe] HOLT STUDIOS INTERNATIONAL, LTD., The Courtyard, 24 High St., Hungerford, Berkshire, RG17 0NF United Kingdom. Phone: (01488)683523. Fax: 44(01488)683511. E-mail: library@holt~studios.co.uk. Website: http://www.holt~studios.co.uk/library. Director: Nigel D. Cattlin. Picture library. Has 80,000 photos. Clients include: ad agencies, public relations firms, audiovisual firms, businesses, book/encyclopedia publishers, magazines, newspapers and commercial companies.

Needs: Photographs of world agriculture associated with crop production and crop protection including

healthy crops and relevant weeds, pests, diseases and deficiencies. Farming, people and machines through-out the year including good landscapes. Livestock and livestock management, horticulture, gardens, orna-mental plants and garden operations. Worldwide assignments undertaken.

Specs: Uses 35mm, 2¼×2¼ and 4×5 transparencies.

Payment & Terms: Occasionally buys photos outright. Pays 50% commission. General price range: $100-1,500. Offers photographers nonexclusive contract. Contracts renew automatically with additional submissions for 3 years. Photographers allowed to review account records. Statements issued quarterly. Payment made quarterly. Offers one-time rights. Model release preferred. Captions required; "identity of biological organisms is critically important."

Making Contact: Send unsolicited photos by mail for consideration. SAE (with sufficient return postage). Reports in 2 weeks. Photo guidelines free with SASE. Distributes tips sheets every 3 months to all associ-ates.

Tips: "Holt Studios looks for high quality, technically well-informed and fully labeled color transparencies of subjects of agricultural and horticultural interest." Currently sees "expanding interest, particularly in conservation and the environment, gardening and garden plants."

N ⊕ HORIZON INTERNATIONAL CI LTD., P.O. Box 144, 3 St. Anne's Walk, Alderney, Guern-sey GY9 3HF British Channel Islands (United Kingdom). Phone: (44)1481 822587. Fax: (44)1481 823880. E-mail: horizon.int@virgin.net. Website: http://www.horizoninternational.co.uk. Estab. 1978. Stock photo agency. Has branch offices. Licensed representative in Australia is Horizon International Pty. Ltd. Also represented in North America, South America, Europe and Asia (including China and Japan). Horizon sells stock image use rights via catalogs, international agents and website.

Needs: "Digital imagery, all commercial formats of photography, illustration, and film and video so long as it is suitable for advertising use."

Payment/Terms: Information sheet, terms and conditions available upon request.

Making Contact: Unsolicited submissions not accepted. Horizon purchases and commissions stock. "Ho-rizon considers solicited stock images only after information and standard terms and conditions of represen-tation have been received by interested party."

⟨⟩ ▦ HOT SHOTS STOCK SHOTS, INC., 341 Lesmill Rd., Toronto, Ontario M3B 2V1 Canada. (416)441-3281. Fax: (416)441-1468. Contact: Joanne Kolody. Member of Picture Agency Council of America (PACA). Clients include: advertising and design agencies, publishers, major printing houses and product manufacturers.

Needs: People and human interest/lifestyles, business and industry, wildlife, historic and symbolic Cana-dian.

Specs: Color transparency material any size.

Payment & Terms: Pays 50% commission, quarterly upon collection; 30% for foreign sales through sub-agents. Price ranges: $200-5,000. Works on contract basis only. Offers exclusive, limited regional exclusivity and nonexclusive contracts. Most contracts renew automatically for 3-year period with each submission. Statements issued quarterly. Payment made quarterly. Photographers allowed to review account to verify sales figures. Offers one-time, electronic media, and other rights to clients. Allows photographer to negotiate when client requests all rights. Requests agency promotion rights. Model/property release preferred. Photo captions required, include where, when, what, who, etc.

Making Contact: Must send a minimum of 300 images. Unsolicited submissions must have return post-age. Reports in 1 week. Photo guidelines free with business SASE.

Tips: "Submit colorful, creative, current, technically strong images with negative space in composition." Looks for people, lifestyles, variety, bold composition, style, flexibility and productivity. "People should be model released for top sales. Prefer medium format." Photographers should "shoot for business, not for artistic gratification; tightly edited, good technical points (exposure, sharpness, etc.), professionally mounted, captioned/labeled and good detail."

N ⊕ HULTON GETTY, Getty Images Ltd., Unique House, 21-31 Woodfield Rd., London W9ZBA United Kingdom. Phone: (+44)171 266 2662. Fax: (+44)171 266 2414. E-mail: info@getty~images.com. Website: http://www.getty~images.com. General Manager: Matthew Butson. Estab. 1938. Picture Library. Has 15 million photos in file. Has 20 branch offices worldwide. Clients include: advertising agencies, public relations firms, audiovisual firms, businesses, book publishers, magazine publishers, newspapers, calendar companies, greeting card companies, postcard publishers, electronic publishers, film, TV and video packaging etc.

Needs: All conceivable subjects under the sun! Photographs, lithographs, etchings, engravings, maps, woodcuts, postcards, drawings, cartoons and ephemera. Up to 1980s.

Specs: Uses 8×10 glossy b&w prints; 4×5 transparencies. Accepts images in digital format. Send via

CD-ROM, Syquest etc. Must be TIFs—JPEGs (if compressed) with accompanying caption information.
Payment/Terms: Pays 50% commission on b&w and color photos. Negotiates fees below stated minimums. "Depends on the nature of the request—we will negotiate on bulk deals/multiple usage on occasions." Offers volume discounts to customers. Works with photographers on contract basis only. Offers exclusive contract only, nonexclusive contract "rarely;" negotiable, depending on subject matter. We rarely sign photographers since HG is archival." Statements issued monthly; payment made monthly. Photographers allowed to review account records in cases of discrepancies only. Offers one-time, electronic media rights. "Other arrangements variable, depending on usage." Model release preferred for personalities; property release preferred. Photo captions required.
Making Contact: Send query letter with samples. To show portfolio, photographer should follow-up with letter after initial query. Agency will contact photographer for portfolio review if interested. Portfolio should include b&w prints, color transparencies. Include SASE for return of material. Expects minimum initial submission of 24 images. Reports in 2 weeks on queries.
Tips: Digital technologies are "enormously important now and into the future. We currently have over 150,000 images available for on-line browsing and digital delivery via CD-ROM. Ensure everything is captioned properly and provide two copies of everything."

HUTCHISON PICTURE LIBRARY, 118B Holland Park Ave., London W11 4UA England. Phone: (071)229-2743. Fax: (0171)792-0259. E-mail: Katepink@hutchinsonpic.demon.co.uk. Director: Michael Lee. Stock photo agency, picture library. Has around 500,000 photos. Clients include: ad agencies, public relations firms, audiovisual firms, businesses, book/encyclopedia publishers, magazine publishers, newspapers, postcard companies, calendar companies, television and film companies.
Needs: "We are a general, documentary library (no news or personalities, no modeled 'set-up' shots). We file mainly by country and aim to have coverage of every country in the world. Within each country we cover such subjects as industry, agriculture, people, customs, urban, landscapes, etc. We have special files on many subjects such as medical (traditional, alternative, hospital etc.), energy, environmental issues, human relations (relationships, childbirth, young children, etc. but all *real people*, not models). We are a color library,"
Specs: Principally 35mm transparencies.
Payment & Terms: Pays 50% commission for color photos. Statements issued semiannually. Payment made semiannually. Sends statement with check in June and January. Offers one-time rights. Model release preferred. Captions required.
Making Contact: Only very occasionally accepts a new collection. Arrange a personal interview to show portfolio. Send letter with brief description of collection and photographic intentions. Reports in about 2 weeks, depends on backlog of material to be reviewed. "We have letters outlining working practices and lists of particular needs (they change)." Distributes tips sheets to photographers who already have a relationship with the library.
Tips: Looks for "collections of reasonable size (rarely less than 1,000 transparencies) and variety; well captioned (or at least well indicated picture subjects, captions can be added to mounts later); sharp pictures (an out of focus tree branch or whatever the photographer thinks adds mood is not acceptable; clients must not be relied on to cut out difficult areas of any picture), good color, composition and informative pictures. Prettiness is rarely enough. Our clients want information, whether it is about what a landscape looks like or how people live, etc." We only very occasionally accept a new collection. The general rule of thumb is that we would consider a collection which had a subject we did not already have coverage of or a detailed and thorough specialist collection. Please do no send *any* photographs without prior agreement."

I.C.P. INTERNATIONAL COLOUR PRESS, Via Alberto Da Giussano 9, Milano 20145 Italy. Phone: (02)468689 or 48008493. Fax: (02)48195625. Marketing Assistant: Mrs. Annamaria James. Estab. 1970. Stock photo agency. Has 1.2 million transparencies. Clients include: advertising agencies, public relations firms, audiovisual firms, businesses, book/encyclopedia publishers, magazine publishers, postcard publishers, calendar companies and greeting card companies.
Specs: Uses 35mm, $2\frac{1}{4} \times 2\frac{1}{4}$, 4×5 and 8×10 transparencies only.
Payment & Terms: Pays 50% commission on color photos. Average price per image (to clients): $400/ color image. Offers volume discounts to customers; terms specified in photographer's contract. Discount sales terms not negotiable. Works on exclusive contract basis only. Contracts renew automatically with

CONTACT THE EDITOR, of *Photographer's Market* by e-mail at photomarket@fwpubs.com with your questions and comments.

additional submissions, for three years. Charges 100% duping, postage and packing fees. Statements issued monthly. Payment made monthly. Photographers permitted to review account records to verify sales figures or deductions. Offers one-time, first and sectorial exclusive rights. Model/property release required. Captions required.

Making Contact: Arrange personal interview to show portfolio. Query with samples and stock photo list. Works on assignment only. SASE. No fixed minimum for initial submission. Reports in 3 weeks.

[N:] [globe] THE ICCE (International Centre for Conservation Education Photo Library), 1 Sceftbeara House, Shebbear, Beaworthy, Devon EX21 5RU England. Phone/fax: (0044)(0)1409 281302. Manager: Jacolyn Wakeford. Estab. 1984. Specialist environmental photo library. Has 55,000 photos in files. Clients include: advertising agencies, businesses, newspapers, public relations firms, book publishers, calendar companies, audiovisual firms, magazine publishers, environmental organizations.

Needs: High quality photos of wildlife, conservation, environment worldwide, bears, polar bears, pandas, tigers, arctic, underwater, American wildlife and scenics.

Specs: Uses 35mm, 2¼×2¼ transparencies.

Payment/Terms: Pays 50% commission on color photos. Average price per image (to clients): £60 and up. Negotiates fees below stated minimums occasionally for low budget bona fide conservation organizations. Offers volume discounts to customers. Discount sales terms not negotiable. Works with photographers on contract basis only. Offers nonexclusive contract. Contracts renew automatically with additional submissions. Statements issued semiannually. Payments made semiannually. Photographers allowed to review account records. Offers one-time rights. Model/property release preferred. Photo caption required; include subject title, scientific names where appropriate, details of behavior, location, country and month/year as per our notes on captioning.

Making Contact: Send query letter and SASE. Agency will contact photographer for portfolio review if interested. Portfolio should include color slides, transparencies. Works with freelancers on assignment only. Will return material with SASE. Expects minimum initial submission of 100 images with ongoing submissions of appropriate images. Reports ASAP on queries. Photo guidelines sheet free. Lists of subjects/regions represented available free. Market tips sheet available.

Tips: "Send high quality, well edited, appropriate material captioned in accordance with our guidelines and presented with credits in individual photosleeves only after initial letter/phone call. All submissions must be accompanied by adequate return postage and recorded delivery."

THE IMAGE FINDERS, 2003 St. Clair Ave., Cleveland OH 44114. (216)781-7729. Fax: (216)443-1080. E-mail: 75217.106.compuserve. Owner: Jim Baron. Estab. 1988. Stock photo agency. Has 150,000 photos. Clients include: advertising agencies, public relations firms, audiovisual firms, businesses, book/encyclopedia publishers, magazine publishers, calendar companies, greeting card companies.

Needs: General stock agency. Needs more people images. Always interested in good Ohio images.

Specs: Uses 35mm, 2¼×2¼, 4×5 transparencies.

Payment & Terms: Pays 50% commission on b&w and color photos. Average price per image (to clients): $250-350/color. "This is a small agency and we will, on occasion, go below stated minimum prices." Offers volume discounts to customers; terms specified in photographer's contract. Works on contract basis only. Contracts renew automatically with additional submissions for 2 years. Statements issued monthly if requested. Payment made monthly. Photographers allowed to review account records. Offers one-time rights; negotiable depending on what the client needs and will pay for. Informs photographer and allows them to negotiate when client requests all rights. "This is rare for us. I would inform photographer of what client wants and work with photographer to strike best deal." Model release required. Property release preferred. Captions required; include location, city, state, country, type of plant or animal, etc.

Making Contact: Query with stock photo list. Call before you send anything. SASE. Expects minimum initial submission of 100 images with periodic submission of at least 100-500 images. Reports in 3 weeks. Photo guidelines free with SASE. Market tips sheet distributed 2-4 times/year to photographers under contract.

Tips: Photographers must be willing to build their file of images. "We need more people images, industry, lifestyles, medical, etc. Scenics and landscapes must be outstanding to be considered."

[image] THE IMAGE WORKS, P.O. Box 443, Woodstock NY 12498. (914)246-8800. Fax: (914)246-0383. E-mail: info@theimageworks.com. Website: http://www.theimageworks.com. Co-Director: Alan Carey. Estab. 1983. Stock photo agency. Member of Picture Agency Council of America (PACA). Has 670,000 photos. Clients include: ad agencies, book/encyclopedia publishers, magazine publishers, newspapers, postcard publishers and greeting card companies.

Needs: "We are always looking for excellent documentary photography. Our prime subjects are people

related subjects like family, education, health care, work place issues. In the past year we began building an extensive environmental issues file including nature, wildlife and pollution."

Specs: Uses 35mm and 2¼×2¼ transparencies. Accepts images in digital format for Mac and Windows.

Payment & Terms: Pays 50% commission on b&w and color photos. Works on contract basis only. Offers nonexclusive contract. Offers guaranteed subject exclusivity (within files). Charges $2/image duping fee. Charges catalog insertion fee of 50%. Statements issued monthly. Payment made monthly. Photographers allowed to review account records to verify sales figures by appointment. Offers one-time, agency promotion and electronic media rights. Informs photographers and allows them to negotiate when clients request all rights. Model release preferred. Captions required.

Making Contact: Query with list of stock photo subjects and tearsheets. SASE. Reports in 1 month. Expects minimum initial submission of 200 images. Tips sheet distributed monthly to contributing photographers.

Tips: "The Image Works was one of the first agencies to market images digitally. We continue to do so over our website and CD-ROMs. Most of our digital efforts have been for private delivery to clients and sub-agents around the world. We also accept digital images from our photographers. This technology will greatly transform the stock photo industry and we intend to make it an essential part of the way we operate on many levels, not just for marketing. When making a new submission to us be sure to include a variety of images that show your range as a photographer. We also want to see some depth in specialized subject areas. Thorough captions are a must. We will not look at uncaptioned images."

IMAGES PICTURES CORP., Dept. PM, 89 Fifth Ave., New York NY 10003. (212)675-3707. Fax: (212)243-2308. Managers: Peter Gould and Barbara Rosen. Has 100,000 photos. Clients include: public relations firms, book publishers, magazine publishers and newspapers.

Needs: Current events, celebrities, feature stories, pop music, pin-ups and travel.

Specs: Uses b&w prints, 35mm transparencies, b&w contact sheets and b&w negatives.

Payment & Terms: Pays 50% commission on b&w and color photos. General price range: $50-1,000. Offers one-time rights or first rights. Captions required.

Making Contact: Query with résumé of credits or with list of stock photo subjects. Also send tearsheets or photocopies of "already published material, original story ideas, gallery shows, etc." SASE. Reports in 2 weeks.

Tips: Prefers to see "material of wide appeal with commercial value to publication market; original material similar to what is being published by magazines sold on newsstands. We are interested in ideas from freelancers that can be marketed and assignments arranged with our clients and sub-agents." Wants to see "features that might be of interest to the European or Japanese press, and that have already been published in local media. Send copy of publication and advise rights available." To break in, "be persistent and offer fresh perspective."

INDEX STOCK PHOTOGRAPHY, 23 W. 18th, 3rd Floor, New York NY 10011. (212)929-4644. Fax: (212)633-1914. E-mail: editing@indexstock.com Website: http://www.indexstock.com. Senior Photo Editor: Lindsey Nicholson. Has 1 million tightly edited photos. Branch Office: Suite 500, 6500 Wilshire Blvd., Los Angeles CA 90048. (213)658-7707. Fax: (213)651-4975. Clients include: ad agencies; corporate design firms; graphic design and in-house agencies; direct mail production houses; magazine publishers; audiovisual firms; calendar, postcard and greeting card companies.

• Index Stock is a content provider for several on-line services such as PressLink, CompuServe, Infonautics and Photos To Go. The agency markets images for use in multimedia projects, software packages and other electronic uses, and has taken care to arrange contracts that protect photographer's rights. Agency photographers are given the option to participate or not in these electronic ventures.

Needs: Up-to-date, model-released, images of people, lifestyles, corporate and business situations. Also looking for industry, technology, science and medicine, sports, family, travel and location and nature images. "We are seeking stock photography with a fresh look. Be sure to keep up with current advertising themes."

Specs: Uses all sizes; 35mm, 2¼×2¼, 4×5 and 8×10 transparencies, including panoramas. Accepts images in digital format. "We prefer that you submit low-res digital images for review and editing via e-mail, although we will also accept Photo CD's, Zip discs or SyQuest 44 or 88 discs. *Scan size*: approximately 200×300@72dpi (comparable to a 128K Kodak Photo CD scan) and *saved as JPEG* (standard quality compression). If you are sending a large quantity of images for review you will probably want to create a self-extracting archive (.sea) of your scans for attachment to your e-mail. Although not required, you might want to consider submitting your images in an Extensis Portfolio catalog (a new cross-platform version of Fetch). *Captions:* Please submit a corresponding text file containing your scan reference number, caption information and release information. We recommend that you label each scan using your last name

and a sequential code i.e.; Smith001, Smith002. If your images have close variations or similars, add an 'a, b, c' to the number it relates to i.e.; Smith 003a, Smith 003b, Smith 003c."

Payment & Terms: Pays 25-50% commission on general file images; has various options for catalog comissions. All contracts automatically renew at 5 years. Statements issued quarterly. Payment made quarterly. Photographers allowed to review account records "as per our contract." General price range: $125-5,000. Sells one-time rights, electronic media rights, plus some limited buyouts (all rights) and exclusives. Model/property releases required. Captions required.

Making Contact: Query with list of stock photo subjects. Reports in 2 weeks with submission guidelines. All portfolios done on mail in or drop off basis. "We like to see 200 originals representing your best work or e-mail us."

Tips: "The stock photography industry has become increasingly more competitive. Keep up with current trends in advertising and print photography. Educate yourself to the demands and realities of the stock photography marketplace. Find out where your own particular style and expertise fit in, edit your work tightly. Index offers worldwide representation through its many overseas affiliates as well as an East Coast office."

N 🌐 **THE INTERIOR ARCHIVE LTD.**, 7 Chelsea Studios, 410 Fulham Rd., London SW6 1EB United Kingdom. Phone: (0171)370 0595. Fax: (0171)385 5403. E-mail: karen@interior-archive.netconect. com.uk. Estab. 1994. Picture library. Has 900,000 photos in files. Clients include: advertising agencies, public relations firms, businesses, book publishers, magazine publishers, newspapers.

Needs: Interior design, architecture, gardens.

Specs: Uses color 35mm and 2¼×2¼ transparencies.

Payment/Terms: Pays 50% commission on color photos. Average price per image (to clients): $150 minimum. Offers volume discounts to customers. Photographers can choose not to sell images on discount terms. Works with photographers with or without a contract. Offers guaranteed subject exclusivity. Contracts renew automatically with additional submissions annually. Statements issued quarterly; payments made quarterly. Photographers allowed to review account records. Offers one-time rights. Informs photographers and allows them to negotiate when a client requests all rights. Property release preferred from home owners/designers. Photo captions required; include location, name of designer to be credited, special information.

Making Contact: Send query letter. Portfolio should include color, tearsheets or transparencies. Will return material with SASE.

INTERNATIONAL COLOR STOCK, INC., Dept. PM, 3841 NE Second Ave., Suite 304, Miami FL 33137. (305)573-5200. Website: http://www.stockphoto.com. Contact: Dagmar Fabricius or Randy Taylor. Estab. 1987. Stock photo syndicate. Clients include: foreign agencies distributing to all markets.

Needs: "We serve as a conduit, passing top-grade, model-released production stock to foreign agencies." Currently promotes its images via the Internet and CD-ROM.

Specs: Uses 35mm, 2¼×2¼ transparencies.

Payment & Terms: Pays 70% commission. Works on contract basis only. Offers exclusive foreign contract only. Contracts renew automatically on annual basis. Charges duping fee of 100%/image. Also charges catalog insertion fee of 100%/image. Statements issued monthly. Payment made monthly. Photographers allowed to review account records to verify sales figures "upon reasonable notice, during normal business hours." Offers one-time rights. Requests agency promotion rights. Informs photographer and allows them to negotiate when client requests all rights, "if notified by subagents." Model/property release required. Captions preferred; include "who, what, where, when, why and how."

Making Contact: Query with résumé of credits. Reports "only when photographer is of interest." Photo guidelines sheet not available. Tips sheet not distributed.

Tips: Has strong preference for experienced photographers. "Our percentages are extremely low. Because of this, we deal only with top shooters seeking long-term success. If you are not published 20 times a month or have not worked on contract for two or more photo agencies or have less than 15 years experience, please do not call us."

INTERNATIONAL SPORTS, 1078 Route 33, P.O. Box 614, Farmingdale NJ 07727. (732)938-3533. Fax: (732)938-9290. Director: Robert J. Hack. Estab. 1993. Stock photo agency. Clients include: advertising agencies, public relations firms, book/encyclopedia publishers, magazine publishers and calendar companies.

Needs: Model released action, leisure and adventure sports, all professional and college sports.

Specs: Uses 35mm, 2¼×2¼, 4×5, 8×10 transparencies.

Payment & Terms: Pays 50% commission on color photos. Average price per image (to clients): $150-4,000/color photo. Works on contract basis only Offers exclusive and nonexclusive contracts. Statements

issued quarterly. Payment made quarterly. Photographers allowed to review account records. Offers one-time rights. Informs photographer and allows them to negotiate when client requests all rights. Model/property release preferred for all subjects except professional athletes.
Making Contact: Query with samples. SASE. Expects minimum initial submission of 500 images. Reports in 1-2 weeks. Photo guidelines free with SASE. Market tips sheets distributed quarterly to contracted photographers free upon request.

INTERPRESS OF LONDON AND NEW YORK, 400 Madison Ave., New York NY 10017. (212)832-2839. Editor: Jeffrey Blyth. Has 5,000 photos. Clients include: magazine publishers and newspapers.
Needs: Offbeat news and feature stories of interest to European editors. Captions required.
Specs: Uses 8×10 b&w prints and 35mm color transparencies.
Payment & Terms: Payment negotiable. Offers one-time rights.
Making Contact: Send material by mail for consideration. SASE. Reports in 1 week.

BRUCE IVERSON PHOTOMICROGRAPHY, 31 Boss Ave., Portsmouth NH 03801. Phone/fax: (603)433-8484. Owner: Bruce Iverson. Estab. 1981. Stock photo agency. Has 10,000 photos. Clients include: advertising agencies, book/encyclopedia publishers.
• This agency uses Kodak Photo CD for demos/portfolios.
Needs: Currently only interested in submission of scanning electron micrographs and transmission electron micrographs—all subjects.
Specs: Uses 8×10 glossy or matte color and b&w prints; 35mm, $2\frac{1}{4} \times 2\frac{1}{4}$, 4×5 transparencies; 6×17 panoramic.
Payment & Terms: Pays 50% commission on b&w and color photos. There is a minimum use fee of $175; maximum 10% discount. Terms specified in photographer's contract. Works on contract basis only. Offers nonexclusive contracts. Photographer paid within 1 month of agency's receipt of payment. Offers one-time rights. Captions required; include magnification and subject matter.
Making Contact: "Give us a call first. Our subject matter is very specialized." SASE. Reports in 1-2 weeks.
Tips: "We are a specialist agency for science photos and technical images taken through the microscope."

JAYAWARDENE TRAVEL PHOTO LIBRARY, 7A Napier Rd., Wembley, Middlesex HA0 4UA United Kingdom. Phone: (0181)902-3588. Fax: (0181)902-7114. Contact: Rohith or Marion Jayawardene. Estab. 1992. Stock photo agency and picture library. Has 100,000 photos. Clients include: ad agencies, businesses, book/encyclopedia publishers, magazine publishers, newspapers, greeting card companies, postcard publishers and tour operators/travel companies.
Needs: Travel and tourism-related images worldwide, particularly of the US, the Caribbean and South America; couples/families on vacation and local lifestyle. "Pictures, especially of city views, must not be out of date."
Specs: Uses 35mm, $2\frac{1}{4} \times 2\frac{1}{4}$, $6 \times 4 \frac{1}{2}$ cm, 6×7 cm transparencies.
Payment & Terms : Pays 50% commission. Average price per image (to clients): $125-1,000. Enforces minimum prices of $80-100, "but negotiable on quantity purchases." Offers volume discounts to customers; inquire about specific terms. Discount sales terms not negotiable. Works on contract basis only. Offers limited regional exclusivity contract. Statements issued semiannually. Payment made semiannually, within 30 days of payment received from client. Offers one-time and exclusive rights for fixed periods. Does not inform photographer or allow him to negotiate when client requests all rights. Model/property release preferred. Captions required; include country, city/location, subject description.
Making Contact: Query letter with stock photo list. Expects a minimum initial submission of 300 images with periodic submission of at least 150 images on quarterly basis. Reports in 3 weeks. Photo guidelines and market tips sent. Include SASE (International Reply Paid Coupons) with query letter and initial submission.

JAYDEE MEDIA, P.O. Box 149, Cochrane, Alberta T0L 0W0 Canada. Phone/fax: (403)932-9397. Owner: J. David Corry. Stock photo agency. Has 80,000 photos; limited BetacamSp video. Clients include: advertising agencies, public relations firms and businesses.
Needs: Agricultural—crop, livestock and food production.
Specs: Uses 35mm, $2\frac{1}{4} \times 2\frac{1}{4}$, panoramic, 4×5 transparencies; Betacam SP videotape.
Payment & Terms: Pays 50% commission. Average price per image (to clients): $100-200/b&w; $200-2,000/color; $50-200/second, videotape. Negotiates fees below stated minimum for educational purposes or noncommercial uses. Offers volume discounts to customers; terms specified in photographer's contract. Discount sales terms not negotiable. Works on contract basis only. Statements issued quarterly. Payment made quarterly. Offers one-time rights. Informs photographer and allows them to negotiate when client

requests all rights. Model/property release preferred for people, recognizable vehicles, equipment and buildings. Captions preferred.
Making Contact: Query with stock photo list. SASE. Expects minimum initial submission of 100-200 images with periodic submissions of 100-200 images. Reports in 1 month. Photo guidelines free with SASE (IRCs). Market tips sheet distributed annually; free with SASE.
Tips: Looks for talent with solid agricultural background and photographic expertise. Photos must be agriculturally and technically correct. Documentaries should "tell a true story with artistic composition and lighting."

JEROBOAM, 120-D 27th St., San Francisco CA 94110. (415)824-8085. Call first before faxing. E-mail: jeroboam@inreach.com. Contact: Ellen Bunning. Estab. 1972. Has 150,000 b&w photos, 150,000 color slides. Clients include: text and trade books, magazine and encyclopedia publishers and editorial.
Needs: "We want people interacting, relating photos, artistic/documentary/photojournalistic images, especially ethnic and handicapped. Images must have excellent print quality—contextually interesting and exciting, and artistically stimulating." Needs shots of school, family, career and other living situations. Child development, growth and therapy, medical situations. No nature or studio shots.
Specs: Uses 8×10 double weight glossy b&w prints with a ¾″ border. Also uses 35mm transparencies.
Payment & Terms: Works on consignment only; pays 50% commission. Works without a signed contract. Statements issued monthly. Payment made monthly. Photographers allowed to review account records to verify sales figures. Offers one-time and electronic media rights. Informs photographer and allows them to negotiate when client requests all rights. Model/property release preferred for people in contexts of special education, sexuality, etc. Captions preferred; include "age of subject, location, etc."
Making Contact: Call if in the Bay area; if not, query with samples and list of stock photo subjects; send material by mail for consideration or submit portfolio for review. "Let us know how long you've been shooting." SASE. Reports in 2 weeks.
Tips: "The Jeroboam photographers have shot professionally a minimum of five years, have experienced some success in marketing their talent and care about their craft excellence and their own creative vision. Jeroboam images are clear statements of single moments with graphic or emotional tension. We look for people interacting, well exposed and printed with a moment of interaction. New trends are toward more intimate, action shots; more ethnic images needed. Be honest in regards to subject matter (what he/she *likes* to shoot)."

KEYSTONE PRESS AGENCY, INC., 202 East 42nd St., New York NY 10017. (212)924-8123. E-mail: BAlpert@worldnet.att.net. Managing Editor: Brian F. Alpert. Types of clients: book publishers, magazines and major newspapers.
Needs: Uses photos for slide sets. Subjects include: photojournalism. Reviews stock photos/footage. Captions required.
Specs: Uses 8×10 glossy b&w and color prints; 35mm and 2¼×2¼ transparencies.
Making Contact & Terms: Cannot return material. Reports upon sale. Payment is 50% of sale per photo. Credit line given.

KEYSTONE PRESSEDIENST GMBH, Kleine Reichenstr. 1, 20457 Hamburg, 2 162 408 Germany. Phone: (040)33 66 9799. Fax: (040)32 40 36. E-mail: keystonede@aol.com. Website: http://www.keystone-press.de. President: Jan Leidicke. Stock photo agency, picture library and news/feature syndicate. Has 3.5 million color transparencies and b&w photos. Clients include: ad agencies, public relations firms, audiovisual firms, businesses, book/encyclopedia publishers, magazine publishers, newspapers, postcard companies, calendar companies, greeting card companies and TV stations.
Needs: All subjects excluding sports events.
Specs: Uses b&w prints; 35mm, 2¼×2¼, 4×5 and 8×10 transparencies. Accepts images in digital format for Windows (TIFF or JPEG). Send via CD, Zip disk or online.
Payment & Terms: Charges 40-50% commission on b&w and color photos. General price range: $30-1,000. Works on contract basis only. Contracts renew automatically for one year. Does not charge duping, filing or catalog insertion fees. Payment made one month after photo is sold. Offers one-time and agency promotion rights. "We ask the photographer if client requests exclusive rights." Model release preferred. Captions required; include who, what, where, when and why.
Making Contact: Send unsolicited photos by mail for consideration. Contact us before first submission! Deals with local freelancers by assignment only. SASE. Reports in 2 weeks. Distributes a monthly tip sheet.
Tips: Prefers to see "American way of life—people, cities, general features—human and animal, current events—political, show business, scenics from the USA—travel, tourism, personalities—politics, TV. An advantage of working with KEYSTONE is our wide circle of clients and very close connections to all

leading German photo users." Especially wants to see skylines of all US cities. Send only highest quality works.

 JOAN KRAMER AND ASSOCIATES, INC., 10490 Wilshire Blvd., Suite 1701, Los Angeles CA 90024. (310)446-1866. Fax: (310)446-1856. President: Joan Kramer. Member of Picture Agency Council of America (PACA). Has 1 million b&w and color photos dealing with travel, cities, personalities, animals, flowers, lifestyles, underwater, scenics, sports and couples. Clients include: ad agencies, magazines, recording companies, photo researchers, book publishers, greeting card companies, promotional companies and AV producers.

Needs: "We use any and all subjects! Stock slides must be of professional quality."

Specs: Uses 8×10 glossy b&w prints; any size transparencies.

Payment & Terms: Pays 50% commission. Offers all rights. Model release required.

Making Contact: Query or call to arrange an appointment. Do not send photos before calling. SASE.

LIGHT SOURCES STOCK, 23 Drydock Ave., Boston MA 02210. (617)261-0346. Fax: (617)261-0358. E-mail: lsources@tiac.net or lsources@aol.com. Senior Editor: David R. Urbina. Estab. 1989. Stock photo agency. Has 200,000 photos. Clients include: advertising agencies, textbook/editorial publishers, magazine publishers, calendar companies, greeting card companies, corporations.

Needs: Children, seniors, families, lifestyles, educational, medical, scenics (travel), conceptual/creative and New England settings.

Specs: Uses 35mm, 2¼×2¼, 4×5, 8×10 transparencies. Accepts images in digital format for Mac (any file type). Send via compact disc, online, floppy disk, SyQuest or Zip disk (72 dpi for viewing only; 40-75 mb for permanent submission).

Payment & Terms: Pays 50% commission. Average price per image (to clients): $100-2,000/ color photo. Enforces minimum prices. Offers volume discounts to customers; inquire about specific terms. Photographers can choose not to sell images on discount terms. Works on contract basis only. Offers nonexclusive contracts. Contracts renew automatically with additional submissions. Statements issued annually. "Payment is made when agency is paid by the client." Rights negotiated at time of purchase. Informs photographer and allows them to negotiate when client requests all rights. Model/property release preferred. Captions required.

Making Contact: Send SASE to receive guidelines. Expects minimum initial submission of 200 images with periodic submission of at least 100 images every six months. Fewer required for conceptual work or digital work. Reports in 1-2 weeks.

LIGHTWAVE, 170 Lowell St., Arlington MA 02174. Phone/fax: (781)646-1747. (800)628-6809 (outside 781 area code). E-mail: lightwav@tiac.net. Website: http://www.tiac.net/users/lightwav. Contact: Paul Light. Has 250,000 photos. Clients include: ad agencies and textbook publishers.

• Paul Light offers photo workshops over the Internet. Check out his website for details.

Needs: Candid photos of people in school, work and leisure activities.

Specs: Uses 35mm color transparencies.

Payment & Terms: Pays $210/photo; 50% commission. Works on contract basis only. Offers nonexclusive contract. Contracts renew automatically each year. Statements issued annually. Payment made "after each usage." Offers one-time rights. Informs photographer and allows them to negotiate when client requests all rights. Model/property release preferred. Captions preferred.

Making Contact: Send SASE or e-mail for guidelines.

Tips: "Photographers should enjoy photographing people in everyday activities. Work should be carefully edited before submission. Shoot constantly and watch what is being published. We are looking for photographers who can photograph daily life with compassion and originality."

LINEAIR FOTOARCHIEF, B.V., van der Helllaan 6, Arnhem 6824 HT Netherlands. (00.31)26.4456713. Fax: (00.31)26.3511123. E-mail: lineair@worldonline.nl. Manager: Ron Giling. Estab. 1990. Stock photo agency. Has 150,000 photos. Clients include advertising agencies, public relations firms, book/encyclopedia publishers, magazine publishers. Library specializes in images from Asia, Africa, Latin America and Eastern Europe.

● **SPECIAL COMMENTS** within listings by the editor of *Photographer's Market* are set off by a bullet.

• Due to international cooperation with nature photo agencies LINEAIR established a specialized nature section in May 1998.

Needs: Interested in everything that has to do with the development of countries in Asia, Africa and Latin America.

Specs: Uses 8×10 b&w prints; 35mm, 2¼×2¼ transparencies. Pays 50% commission on color and b&w prints. Average price per image (to clients): $75-125/b&w; $100-400/color. Enforces minimum prices. Offers volume discounts to customers; inquire about specific terms. Photographers can choose not to sell images on discount terms. Works with or without a signed contract; negotiable. Offers limited regional exclusivity. Charges 50% duping fees. Statements issued quarterly. Payment made quarterly. Photographers allowed to review account records. "They can review bills to clients involved." Offers one-time rights. Informs photographer and allows them to negotiate when client requests all rights. Captions required; include country, city or region, description of the image.

Making Contact: Submit portfolio for review. SASE. There is no minimum for initial submissions. Reports in 3 weeks. Brochure free with SASE (IRC). Market tips sheet available upon request.

Tips: "We like to see high-quality pictures in all aspects of photography. So we'd rather see 50 good ones, than 500 for us to select the 50 out of."

MACH 2 STOCK EXCHANGE LTD., #204-1409 Edmonton Tr NE, Calgary, Alberta T2E 3K8 Canada. (403)230-9363. Fax: (403)230-5855. E-mail: m2stock@net.500.com. Website: http://www.m2stock.com. Manager: Pamela Varga. Estab. 1986. Stock photo agency. Member of Picture Agency Council of America (PACA). Clients include: advertising agencies, public relations firms, audiovisual firms and corporations.

Needs: Corporate, high-tech, lifestyle, industry. In all cases, prefer people-oriented images.

Specs: Uses 35mm, 2¼×2¼, 4×5, 8×10 transparencies.

Payment & Terms: Pays 50% commission on color photos. Average sale: $300. Works on contract basis only. Offers limited regional exclusivity. Contracts renew automatically with additional submissions. Charges 50% duping and catalog insertion fees. Statements issued monthly. Payment made monthly. "All photographers' statements are itemized in detail. They may ask us anything concerning their account." Offers 1-time and 1-year exclusive rights; no electronic media rights for clip art type CD's. Informs photographer and allows them to negotiate when client requests all rights. "We generally do not sell buyout." Model/property release required. Captions required.

Making Contact: Query with samples and list of stock photo subjects. SASE. Reports in 1 month. Market tips sheet distributed 4 times/year to contracted photographers.

Tips: "Please call first. We will then send a basic information package. If terms are agreeable between the two parties then original images can be submitted pre-paid." Sees trend toward more photo requests for families, women in business, the environment and waste management, active vibrant seniors, high-tech and computer-generated or manipulated images, minorities (Asians mostly).

MAJOR LEAGUE BASEBALL PHOTOS, 350 Park Ave., New York NY 10022. (212)339-8290. Fax: (212)750-3345. E-mail: rpilling@mlbp.com. Manager: Rich Pilling. Estab. 1994. Stock photo agency. Has 500,000 photos. Clients include: ad agencies, public relations firms, businesses, book/encyclopedia publishers, magazine publishers, newspapers, calendar companies, greeting card companies, postcard publishers and MLB licensees.

Needs: Photos of any subject for major league baseball—action, feature, fans, stadiums, umpires, still life.

Specs: Uses 8×10 glossy color prints; 35mm, 2¼×2¼ transparencies; CD-ROM digital format.

Payment & Terms: Buys photos outright; payment varies according to assignment. Pays 60% commission on color photos. Enforces minimum prices. Offers volume discounts to customers; inquire about specific terms. Discount sales terms not negotiable. Works on contract basis only. Offers exclusive contract only. Statements issued monthly. Payment made monthly. Photographers allowed to review account records. Offers one-time rights. Informs photographer and allows them to negotiate when client requests all rights. Captions preferred.

Making Contact: Arrange personal interview to show portfolio. Works with local freelancers on assignment only. Samples kept on file. SASE. No minimum number of images expected with initial submission. Reports in 1-2 weeks. Photo guidlines available.

MASTERFILE, 175 Bloor St. E., South Tower, 2nd Floor, Toronto, Ontario M4W 3R8 Canada. (416)929-3000. Fax: (416)929-2104. E-mail: inquiries@masterfile.com. or portfolios@masterfile.com. Website: http://www.masterfile.com. Artist Liaison: Linda Crawford. Stock photo agency. Has 300,000 photos. Clients include: advertising agencies, public relations firms, audiovisual firms, book/encyclopedia

publishers, magazine publishers, newspapers, postcard publishers, calendar companies, greeting card companies, all media.

• This agency has "complete electronic imaging capabilities," including scanning, manipulation and color separations. Masterfile produces annual catalogues and CD-ROMs

Specs: Uses 35mm, $2\frac{1}{4} \times 2\frac{1}{4}$, 4×5, 8×10 transparencies. All formats plus digital.

Payment & Terms: Pays 40-50% royalties. Enforces minimum prices. Offers volume discounts to customers; terms specified in photographer's contract. Discount sales terms not negotiable. Works on contract basis only. Offers worldwide exclusive contracts only. Contracts renew automatically after 5 years for 1 year terms. Charges duping and catalog insertion fees. Statements issued monthly. Payments made monthly. Photographers allowed to review account records. Offers one-time and electronic media rights and allows artist to negotiate when client requests all rights. Model release required. Property release preferred. Captions required.

Making Contact: Ask for submission guidelines. SASE. Expects maximum initial submission of 200 images. Reports in 1-2 weeks on portfolios; same day on queries. Photo guidelines free. Market tips sheet distributed to contract photographers only.

MEDICAL IMAGES INC., 40 Sharon Rd., P.O. Box 141, Lakeville CT 06039. (860)435-8878. Fax: (860)435-8890. E-mail: medimag@aol.com. President: Anne Richardson. Estab. 1990. Stock photo agency. Has 50,000 photos. Clients include: advertising agencies, public relations firms, corporate accounts, book/encyclopedia publishers, magazine publishers and newspapers.

Needs: Medical and health-related material, including commercial-looking photography of generic doctor's office scenes, hospital scenarios and still life shots. Also, technical close-ups of surgical procedures, diseases, high-tech colorized diagnostic imaging, microphotography, nutrition, exercise and preventive medicine.

Specs: Uses 8×10 glossy b&w prints; 35mm, $2\frac{1}{4} \times 2\frac{1}{4}$, 4×5 and 8×10 transparencies.

Payment & Terms: Pays 50% commission on b&w and color photos. Average price per image (to clients): $175-3,500. Enforces minimum prices. Works with or without contract. Offers nonexclusive contract. Contracts renew automatically. Statements and checks issued bimonthly. "If client pays within same period, photographer gets check right away; otherwise, in next payment period." Photographer's accountant may review records with prior appointment. Offers one-time and electronic media rights. Model/property release preferred. Captions required; include medical procedures, diagnosis when applicable, whether model released or not, etc.

Making Contact: Query with list of stock photo subjects or telephone with list of subject matter. SASE. Reports in 2 weeks. Photo guidelines available. Market tips sheet distributed quarterly to contracted photographers.

Tips: Looks for "quality of photograph—focus, exposure, composition, interesting angles; scientific value; and subject matter being right for our markets." Sees trend toward "more emphasis on editorial or realistic looking medical situations. Anything too 'canned' is much less marketable."

MEDICHROME, 232 Madison Ave., New York NY 10016. (212)679-8480. Fax: (212)532-1934. E-mail: medichrome@aol.com. Website: http://www.workbook.com. Manager: Ivan Kaminoff. Has 1 million photos. Clients include: advertising agencies, design houses, publishing houses, magazines, newspapers, in-house design departments, and pharmaceutical companies.

Needs: Everything that is considered medical or health-care related, from the very specific to the very general. "Our needs include doctor/patient relationships, surgery and diagnostics processes such as CAT scans and MRIs, physical therapy, home health care, micrography, diseases and disorders, organ transplants, counseling services, use of computers by medical personnel and everything in between."

Specs: "We accept b&w prints but prefer color, 35mm, $2\frac{1}{4} \times 2\frac{1}{4}$, 4×5 and 8×10 transparencies."

Payment & Terms: Pays 50% commission on b&w and color photos. All brochures are based on size and print run. Ads are based on exposure and length of campaign. Offers one-time or first rights; all rights are rarely needed—very costly. Model release preferred. Captions required.

Making Contact: Query by "letter or phone call explaining how many photos you have and their subject matter." SASE. Reports in 2 weeks. Distributes tips sheet every 6 months to Medichrome photographers only.

Tips: Prefers to see "loose prints and slides in 20-up sheets. All printed samples welcome; no carousel, please. Lots of need for medical stock. Very specialized and unusual area of emphasis, very costly/difficult to shoot, therefore buyers are using more stock."

MEGAPRESS IMAGES, 5352 St. Laurent Blvd., Montreal, Quebec H2T 1S5 Canada. (514)279-9859. Fax: (514)279-1971. Estab. 1992. Stock photo agency. Half million photos. Has 2 branch offices.

Clients include: book/encyclopedia publishers, magazine publishers, postcard publishers, calendar companies, greeting card companies.

Needs: Photos of people (couples, children, beauty, teenagers, people at work, medical); animals including puppies in studio; industries; celebrities and general stock.

Specs: Uses 35mm, 2¼×2¼, 4×5 transparencies.

Payment & Terms: Pays 50% commission on color photos. General price range (to client): $75-500/image. Enforces minimum prices. Will not negotiate below $60. Works with or without a signed contract. Offers limited regional exclusivity. Statements issued semiannually. Payments made semiannually. Offers one-time rights. Model release required for people and controversial news. Captions required. Each slide must have the name of the photographer and the subject.

Making Contact: Submit portfolio for review by registered mail or courier only. Samples not kept on file. SASE. Expects minimum initial submission of 250 images with periodic submission of at least 1,000 pictures per year. Make first contact by fax.

Tips: "Pictures must be very sharp. Work must be consistent. We also like photographers who are specialized in particular subjects."

MIDWESTOCK, 1925 Central, Suite 200, Kansas City MO 64108. (816)474-0229. Fax: (816)474-2229. E-mail: photogs@midwestock.com. Website: http://www.midwestock.com. Director: Susan L. Anderson. Estab. 1991. Stock photo agency. Has 100,000 photos. Clients include: advertising agencies, public relations firms, businesses, book/encyclopedia publishers, magazine publishers, newspapers, postcard publishers, calendar companies, greeting card companies.

- Midwestock currently uses CD-ROM discs to showcase categories of work and to provide economical scans for certain projects at standard stock prices. They do not distribute photo clip discs but are developing an online portfolio of selective photographers.

Needs: "We need more quality people shots depicting ethnic diversity." Also general interest with distinct emphasis on "Heartland" themes.

Specs: "Clean, stylized business and lifestyle themes are biggest sellers in 35mm and medium formats. In scenics, our clientele prefers medium and large formats." Uses 35mm, 4×5, 6×6, 6×7, 8×10 transparencies. Accepts images in digital format for Mac and Windows. Send via compact disc.

Payment & Terms: Pays 50% commission. Average price per image (to clients): $300/color. Enforces minimum prices of $195, except in cases of reuse or volume purchase. Offers volume discounts to customers; inquire about specific terms. Works on contract basis only. "We negotiate with photographers on an individual basis." Prefers exclusivity. Contracts renew automatically after 2 years and annually thereafter, unless notified in writing. Charges 50% duping and catalog insertion fees and mounting fee. Statements issued monthly. Payment made monthly. Model release required. Offers one-time and electronic media rights; negotiable. Property release preferred. Captions required.

Making Contact: Query with stock photo list. Request submittal information first. Expects minimum initial submission of 1,000 in 35mm format (less if larger formats). Reports in 3 weeks. Photo guidelines free with SASE. Market tips sheet distributed quarterly to photographers on contract.

Tips: "We prefer photographers who can offer a large selection of medium and large formats and who are full-time professional photographers who already understand the value of upholding stock prices and trends in marketing and shooting stock."

MONKMEYER, 118 E. 28th St., New York NY 10016. (212)689-2242. Fax: (212)779-2549. Owner: Sheila Sheridan. Estab. 1930s. Has 500,000-800,000 photos. Clients include: book/encyclopedia publishers.

Needs: General human interest and educational images with a realistic appearance.

Specs: Uses 8×10 matte b&w prints; 35mm transparencies.

Payment & Terms: Pays 50% commission on b&w and color photos. Average price per image (to clients): $140/b&w, $185/color. "We hold to standard rates." Offers volume discounts to customers; terms specified in photographer's contract. Discount sales terms not negotiable. Offers nonexclusive contract. "We have very few contracts—negotiable." Statements issued monthly. Payment made monthly. Photographers allowed to review account records. Buys one-time rights. Informs photographer and allows them to negotiate when client requests all rights. Model/property release preferred. Captions preferred.

Making Contact: Arrange personal interview to show portfolio. Submit portfolio for review. Keeps samples on file. SASE. Expects minimum initial submission of 200 images. Reports in 1-2 weeks. Publishes tip sheet.

Tips: "Dealing with publishers, we need specific images that will make an impact on students."

MOTION PICTURE AND TV PHOTO ARCHIVE, 16735 Saticoy St., Van Nuys CA 91406. (818)997-8292. Fax: (818)997-3998. President: Ron Avery. Estab. 1988. Stock photo agency. Has 1 million photos. Clients include: advertising agencies, book/encyclopedia publishers, magazine publishers, news-

papers, postcard publishers, calendar companies, greeting card companies.
Needs: Color shots of current stars and old TV and movie stills.
Specs: Uses 8×10 b&w/color prints; 35mm, 2¼×2¼, 4×5 and 8×10 transparencies.
Payment & Terms: Buys photos/film outright. Pays 50% commission on b&w and color photos. Average price per image (to clients): $180-1,000/b&w image; $180-1,500/color image. Enforces minimum prices. Offers volume discounts to customers; terms specified in photographer's contract. Works on contract basis only. Offers exclusive contract. Contracts renew automatically with additional submissions. Statements issued monthly. Payment made monthly. Photographers allowed to review account records. Rights negotiable; "whatever fits the job."
Making Contact: Reports in 1-2 weeks.

MOUNTAIN STOCK PHOTO & FILM, P.O. Box 1910, Tahoe City CA 96145. (530)583-6646. Fax: (530)583-5935. Contact: Paul Vatistas or Meg de Vine. Estab. 1986. Stock photo agency. Member of Picture Agency Council of America (PACA). Has 60,000 photos; minimal films/videos. Clients include: ad agencies, public relations firms, audiovisual firms, businesses, book/encyclopedia publishers, magazine publishers, newspapers, calendar companies, greeting card companies.
Needs: "We specialize in and always need action sports, scenic and lifestyle images."
Specs: Uses 35mm, 2¼×2¼, 4×5, transparencies.
Payment & Terms: Pays 50% commission on color photos. Enforces minimum prices. "We have a $100 minimum fee." Offers volume discounts to customers; inquire about specific terms. Discount sales terms not negotiable. Works on contract basis only. Some contracts renew automatically. Charges 50% catalog insertion fee. Statements issued quarterly. Payment made quarterly. Photographers are allowed to review account records with due notice. Offers unlimited and limited exclusive rights. Informs photographer and allows them to negotiate when client requests all rights. Model/property release required. Captions required.
Making Contact: Query with résumé of credits. Query with samples. Query with stock photo list. Samples kept on file. SASE. Expects minimum initial submission of 500 images. Reports in 1 month. Photo guidelines free with SAE and 64¢ postage. Market tips sheet distributed quarterly to contracted photographers upon request.
Tips: "I see the need for images, whether action or just scenic, that evoke a feeling or emotion."

NATURAL SCIENCE PHOTOS, 33 Woodland Dr., Watford, Hertfordshire WD1 3BY England. Phone: 01923-245265. Fax: 01923-246067. Partners: Peter and Sondra Ward. Estab. 1969. Stock photo agency and picture library. Members of British Association of Picture Libraries and Agencies. Has 175,000 photos. Clients include: ad agencies, public relations firms, audiovisual firms, businesses, book/encyclopedia publishers, magazine publishers, newspapers, postcard companies, calendar companies, greeting card companies and television.
Needs: Natural science of all types, including wildlife (terrestrial and aquatic), habitats (including destruction and reclamation), botany (including horticulture, agriculture, pests, diseases, treatments and effects), ecology, pollution, geology, primitive peoples, astronomy, scenics (mostly without artifacts), climate and effects (e.g., hurricane damage), creatures of economic importance (e.g., disease carriers and domestic animals and fowl). "We need all areas of natural history, habitat and environment from South and Central America, also high quality marine organisms."
Specs: Uses 35mm, 2¼×2¼ original color transparencies.
Payment & Terms: Pays 33-50% commission. General price range: $55-1,400. "We have minimum fees for small numbers, but negotiate bulk deals sometimes involving up to 200 photos at a time." Works on contract basis only. Offers nonexclusive contract. Statements issued semiannually. Payment made semiannually. "We are a private company; as such our books are for tax authorities only." Offers one-time and electronic media rights; exclusive rights on calendars. Informs photographers and permits them to negotiate when a client requests all rights. Copyright not sold without written permission. Captions required include English and scientific names, location and photographer's name.
Making Contact: Arrange a personal interview to show a portfolio. Submit portfolio for review. Query with samples. Send unsolicited photos by mail for consideration. "We require a sample of at least 20 transparencies together with an indication of how many are on offer, also likely size and frequency of subsequent submissions." Samples kept on file. SASE. Reports in 1-4 weeks, according to pressure on time.
Tips: "We look for all kinds of living organisms, accurately identified and documented, also habitats, environment, weather and effects, primitive peoples, horticulture, agriculture, pests, diseases, etc. Animals, birds, etc., showing action or behavior particularly welcome. We are not looking for 'arty' presentation, just straightforward graphic images, only exceptions being 'moody' scenics. There has been a marked increase in demand for really good images with good color and fine grain with good lighting. Pictures that

would have sold a few years ago that were a little 'soft' or grainy are now rejected, particularly where advertising clients are concerned."

NATURAL SELECTION STOCK PHOTOGRAPHY INC., 183 St. Paul St., Rochester NY 14604. (716)232-1502. Fax: (716)232-6325. E-mail: nssp@netacc.net. Manager: Deborah A. Free. Estab. 1987. Stock photo agency. Member of the Picture Agency Council of America (PACA). Has over 750,000 photos. Clients include: advertising agencies, public relations firms, businesses, book/encyclopedia publishers, magazine publishers, newspapers, postcard publishers, calendar companies, greeting card companies.
Needs: Interested in photos of nature in all its diversity.
Specs: All formats.
Payment & Terms: Pays 50% commission on color photos. Works on contract basis only. Offers nonexclusive contracts. Contracts renew automatically with additional submissions for 3 years. Charges 50% duping fee. Payment made monthly on fees collected. Offers one-time rights. "Informs photographer when client requests all rights." Model/property release required. Captions required; include photographer's name, where image was taken and specific information as to what is in the picture.
Making Contact: Query with résumé of credits; include types of images on file, number of images, etc. SASE. Expects minimum initial submission of 200 images. Reports in 1 month. Market tips sheet distributed quarterly to all photographers under contract.
Tips: "All images must be completely captioned, properly sleeved, and of the utmost quality."

NAWROCKI STOCK PHOTO, P.O. Box 16565, Chicago IL 60616. (312)427-8625. Fax: (312)427-0178. Director: William S. Nawrocki. Stock photo agency, picture library. Member of Picture Agency Council of America (PACA). Has over 300,000 photos and 500,000 historical photos. Clients include: ad agencies, public relations firms, editorial, businesses, book/encyclopedia publishers, magazine publishers, newspapers, postcard companies, calendar companies and greeting card companies.
Needs: Model-released people, all age groups, all types of activities; families; couples; relationships; updated travel, domestic and international; food.
Specs: Uses 35mm, 2¼×2¼, 2¼×2¾, 4×5 and 8×10 transparencies. "We look for good composition, exposure and subject matter; good color." Also, finds large format work "in great demand." Medium format and professional photographers preferred.
Payment & Terms: Buys only historical photos outright. Pays variable percentage on commission according to use/press run. Commission depends on agent—foreign or domestic 50%/40%/35%. Works on contract basis only. Contracts renew automatically with additional submissions for 5 years. Offers limited regional exclusivity and nonexclusivity. Charges duping and catalog insertion fees. Statements issued quarterly. Payment made quarterly. Offers one-time media and some electronic rights; other rights negotiable. Requests agency promotion rights. Informs photographer when client requests all rights. Model release required. Captions required. Mounted images required.
Making Contact: Arrange a personal interview to show portfolio. Query with résumé of credits, samples and list of stock photo subjects. Submit portfolio for review. Provide return Federal Express. SASE. Reports ASAP. Allow 2 weeks for review. Photo guidelines free with SASE. Tips sheet distributed "to our photographers." Suggest that you call first—discuss your photography with the agency, your goals, etc. "NSP prefers to help photographers develop their skills. We tend to give direction and offer advice to our photographers. We don't take photographers on just for their images. NSP prefers to treat photographers as individuals and likes to work with them." Label and caption images. Has network with domestic and international agencies.
Tips: "A stock agency uses just about everything. We are using more people images, all types—family, couples, relationships, leisure, the over-40 group. Looking for large format—variety and quality. More images are being custom shot for stock with model releases. Model releases are very, very important—a key to a photographer's success and income. Model releases are the most requested for ads/brochures."

NETWORK ASPEN, 319 Studio N, Aspen Business Center, Aspen CO 81611. (970)925-5574. Fax: (970)925-5680. E-mail: images@networkaspen.com. Website: http://www.nteworkaspen.com. Founder/Owner: Jeffrey Aaronson. Studio Manager: Becky Green. Photojournalism and stock photography agency. Has 250,000 photos. Clients include: advertising agencies, public relations, businesses, book/encyclopedia publishers, magazine publishers, newspapers, calendar companies.
Needs: Reportage, world events, travel, cultures, business, the environment, sports, people, industry.
Specs: Uses 35mm transparencies.
Payment & Terms: Pays 50% commission on color photos. Works on contract basis only. Offers nonexclusive and guaranteed subject exclusivity contracts. Statements issued quarterly. Payments made quarterly. Photographers allowed to review account records. Offers one-time and electronic media rights. Model/property release preferred. Captions required.

Making Contact: Query with résumé of credits. Query with samples. Query with stock photo list. Keeps samples on file. SASE. Expects minimum initial submission of 250 duplicates. Reports in 3 weeks.
Tips: "Our agency focuses on world events, travel and international cultures, but we would also be interested in reviewing other subjects as long as the quality is excellent."

NEW ENGLAND STOCK PHOTO, 2389 Main St., Dept. PM, Glastenbury CT 06033. (860)659-3737. Fax: (860)659-3235. President: Rich James. Estab. 1985. A full service agency with emphasis toward serving advertising, corporate, editorial and design companies. Member of the Picture Agency Council of America (PACA). Stock photo agency.
 • New England Stock Photo participated in: Stock Workbook Print Catalogues (10, 11 & 12); Stock Workbook CD ROM's (5, 6, 7 and specialty disks); Blackbook CD ROM's (3 & 4); and is producing catalogue 4 and CD ROM.
Needs: "We are a general interest agency with a growing variety of clients and subjects. Always looking for great people shots—(especially multicultural, business, children, teenagers, couples, families, middle age and senior citizens) engaged in every day life situations (business, home, travel, recreation, outdoor activities and depicting ethnicity). Other needs include sports and recreation, architecture (cities and towns), transportation, nature (animals and wildlife) birds, waterfowl, technology, energy and communications. We get many requests for particular historical sites, annual events and need more coverage of towns/cities, main streets and tourist spots.
Specs: Uses 35mm, 2¼×2¼, 4×5 transparencies.
Payment & Terms: Pays 50% commission; 75% to photographer on assignments obtained by agency. Average price per image (to client): $100-5,000. Works with photographers on contract basis only. Offers nonexclusive contract. Charges catalog insertion fee. Statements issued monthly. Payments made monthly. Photographers allowed to review account records to verify sales figures. Offers one-time rights; postcard, calendar and greeting card rights. Informs photographer and allows them to negotiate when client requests all rights. Model/property release preferred (people and private property). Captions required; include who, what, where.
Making Contact: Interested in receiving work. Query with list of stock photo subjects or send unsolicited photos by mail for consideration with check or money order for $9.95. Reports as soon as possible. Distributes newsletter and tips sheet regularly. "We provide one of the most comprehensive photo guideline packages in the business. Please write for it, including $4.95 for shipping and handling."
Tips: "There is an increased use of stock. Submissions must be high quality, in sharpest focus, perfectly composed and with strongest composition. Whether you are a picture buyer or photographer, we will provide the personalized service you need to succeed."

NEWS FLASH INTERNATIONAL, INC., Division of Observer Newspapers, P.O. Box 407, Belmore NY 11710. (516)679-9888. Fax: (516)731-0338. Editor: Jackson B. Pokress. Has 25,000 photos. Clients include: ad agencies, public relations firms, businesses and newspapers.
Needs: "We handle news photos of all major league sports: football, baseball, basketball, boxing, wrestling, hockey. We are now handling women's sports in all phases, including women in boxing, basketball, softball, etc." Some college and junior college sports. Wants emphasis on individual players with dramatic impact. "We are now covering the Washington DC scene. There is currently an interest in political news photos."
Specs: Super 8 and 16mm documentary and educational film on sports, business and news; 8×10 glossy b&w prints or contact sheet; transparencies.
Payment & Terms: Pays 40-50% commission/photo and film. Pays $5 minimum/photo. Works with or without contract. Offers nonexclusive contracts. Informs photographer and allows them to negotiate when client requests all rights. Statements issued quarterly. Payment made monthly or quarterly. Photographers allowed to review account records. Offers one-time, agency promotion or first rights. Informs photographer and allows them to negotiate when client requests all rights. Model release required. Captions required.
Making Contact: Query with samples. Send material by mail for consideration or make a personal visit if in the area. SASE. Reports in 1 month. Free photo guidelines and tips sheet on request.
Tips: "Exert constant efforts to make good photos—what newspapers call grabbers. Make them different than other photos, look for new ideas. There is more use of color and large format chromes." Special emphasis on major league sports. "We cover Mets, Yankees, Jets, Giants, Islanders on daily basis. Rangers and Knicks on weekly basis. We handle bios and profiles on athletes in all sports. There is an interest in women athletes in all sports."

NONSTOCK INC. PHOTOGRAPHY & ILLUSTRATION ARCHIVES, 5 W. 19th St., 6th Floor, New York NY 10011. (212)633-2388. Fax: (212)741-3412. E-mail: service@nonstock.com. President: Jerry Tavin. Stock photography and illustration agency. Clients include: advertising agencies, public rela-

tions firms, audiovisual firms, businesses, book/encyclopedia publishers, magazine publishers, newspapers, postcard publishers, calendar companies, greeting card companies.
Needs: Interested in images that are commercially applicable.
Specs: Uses 35mm transparencies.
Payment & Terms: Pays 50% commission. All fees are negotiated, balancing the value of the image with the budget of the client. Offers volume discounts to customers; inquire about specific terms. Works on contract basis only. Statements issued quarterly. Payment made quarterly. Photographers allowed to review account records. Offers all rights, "but we negotiate." Model/property release required. Captions preferred; include industry standards.
Making Contact: Submit portfolio for review. Keeps samples on file. SASE. Expects minimum initial submission of 50 images. Reports in 1-2 weeks. Photo guidelines free with SASE. Catalog free with SASE.

🌐 **OKAPIA K.G.**, Michael Grzimek & Co., D-60 385 Frankfurt/Main, Roderbergweg 168 Germany. Phone: 01149/69/449041. Fax: 01149/69/498449; or Constanze Presse-haus, Kurfürstenstr. 72 -74 D-10787 Berlin Germany. Phone: 01149/30/26400180. Fax: 01149/30/26400182; or Bilder Pur Kaiserplatz 8 D-80803 München Germany. Phone: 01149/89/339070. Fax: 01149/89/366435. E-mail: OKAPIA@t-online. de. Website: http://www.okapia.com. President: Grzimek. Stock photo agency and picture library. Has 700,000 photos. Clients include: ad agencies, book/encyclopedia publishers, magazine publishers, newspapers, postcard companies, calendar companies, greeting card companies and school book publishers.
Needs: Natural history, medical science and technology, and general interest.
Specs: Uses 35mm, 2¼×2¼, 4×5 and 8×10 transparencies. Accepts digital images for Windows by online transmission.
Payment & Terms: Pays 50% commission on b&w and color photos. Works on contract basis only. Offers nonexclusive and guaranteed subject exclusivity (within files). Contracts renew automatically for 5 years with additional submissions. Charges catalog insertion fee. Statements issued quarterly, semi-annually or annually, depending on money photographers earn. Payment made quarterly, semi-annually or annually with statement. Photographers allowed to review account records in the case of disagreements. Offers one-time, electronic media rights (if requested). Does not permit photographer to negotiate when client requests all rights. Model release required. Captions required.
Making Contact: Send unsolicited material by mail for consideration. SASE. Expects minimum initial submission of 300 slides. Distributes tips sheets on request.
Tips: "We need every theme which can be photographed." For best results, "send pictures continuously." Work must be of "high standard quality."

▣ **OMNI-PHOTO COMMUNICATIONS**, 10 E. 23rd St., New York NY 10010. (212)995-0805. Fax: (212)995-0895. E-mail: rguerette@aol.com. President: Roberta Guerette. Estab. 1979. Stock photo agency. Has 100,000 photos. Clients include: advertising agencies, public relations firms, audiovisual firms, businesses, book/encyclopedia publishers, magazine publishers, postcard publishers, calendar companies, greeting card companies.
Needs: Travel, multicultural and people.
Specs: Uses 8×10 b&w prints; 35mm, 2¼×2¼, 4×5, 8×10 transparencies.
Payment & Terms: Pays 50% commission on b&w and color photos. Works on contract basis only. Offers limited regional exclusive contracts. Contracts renew automatically with additional submissions for 4 years. Charges catalog insertion fee. Statements issued with payment on a quarterly basis. Offers one-time rights. Informs photographer and allows them to negotiate when client requests all rights. Model/property release required. Captions required.
Making Contact: Query with résumé of credits. Query with samples. SASE. Expects minimum initial submission of 200-300 images. Photo guidelines free with SASE.
Tips: "Spontaneous-looking, yet professional quality photos of people interacting with each other. Carefully thought out backgrounds, props and composition, commanding use of color. Stock photographers must produce high quality work at an abundant rate. Self-assignment is very important, as is a willingness to obtain model releases, caption thoroughly and make submissions regularly."

🅝 🌐 **ORION PRESS**, 1-13 Kanda-Jimbocho, Chiyoda-ku, Tokyo Japan 101. Phone: (03)3295-1400. Fax: (03)3295-0227. E-mail: info@orionpress.co.jp. Website: http://www.orionpress.co.jp. Managing Di-

MARKET CONDITIONS are constantly changing! If you're still using this book and it's 2000 or later, buy the newest edition of *Photographer's Market* at your favorite bookstore or order directly from Writer's Digest Books.

rector: Junichi Nakamura. Estab. 1952. Stock photo agency. Has 700,000 photos. Has 3 branch offices. Clients include: advertising agencies, public relations firms, businesses, book/encyclopedia publishers, magazine publishers, newspapers, postcard publishers, calendar companies, greeting card companies.
Needs: All subjects, especially wish to have images of people.
Specs: Uses 35mm, 2¼×2¼, 6×6 cm., 4×5, 8×10 transparencies.
Payment & Terms: Pays 40-50% commission on b&w and color photos. Average price per image (to clients): $175-290/b&w photo; $290-500/color photo. Negotiates fees below standard minimum prices. Offers volume discounts to customers; inquire about specific terms. Photographers can choose not to sell images on discount terms. Works on contract basis only. Offers limited regional exclusivity; negotiable. Contracts renew automatically with additional submissions for 2 years. Statements issued monthy. Payment made monthly. Photographers allowed to review account records. Offers one-time rights. Informs photographer and allows them to negotiate when client requests all rights. Model/property release required. Captions required.
Making Contact: Query with samples. SASE. Expects minimum initial submission of 100 images with periodic submission of at least 100-200 images. Photo guidelines free on request.

OUTLINE, Dept. PM, 596 Broadway, 11th Floor, New York NY 10012. (212)226-8790. President: Jim Roehrig. Contact: Lisa Diamond or Mimi Brown. Personality/portrait stock photo agency. Has 250,000 photos. Clients include: advertising agencies, public relations firms, magazine publishers, newspapers and production/film companies.
Needs: Heavy emphasis on personalities, film, TV, political feature stories.
Payment & Terms: General price range: negotiable. Rights negotiable. Model release preferred. Captions required.
Making Contact: Query with résumé of credits. Works with local freelancers by assignment only. Cannot return material. Reports in 3 weeks.
Tips: Prefers a photographer who can create situations out of nothing. "The market seems to have a non-ending need for celebrities and the highest-quality material will always be in demand."

OXFORD SCIENTIFIC FILMS, Lower Road, Long Hanborough, Oxfordshire OX8 8LL England. Phone: +44 (993)881881. Fax: +44 (993)882808. E-mail: 101573.163@compuserve.com. Senior Account Manager/Photo Library: Suzanne Aitzetmuller. Senior Account Manager/Film Library: Sandra Berry. Stock Footage Library Manager: Jane Mulleneux. Film unit and stills and film libraries. Has 350,000 photos; over one million feet of stock footage on 16mm, and 40,000 feet on 35mm. Clients include: ad agencies, design companies, audiovisual firms, book/encyclopedia publishers, magazine and newspaper publishers, merchandising companies, multimedia publishers, film production companies.
Needs: Natural history: animals, plants, behavior, close-ups, life-histories, histology, embryology, electron microscopy, scenics, geology, weather, conservation, country practices, ecological techniques, pollution, special-effects, high speed, time-lapse, landscapes, environmental, travel, pets, domestic animals.
Specs: Uses 35mm and larger transparencies; 16 and 35mm film and videotapes.
Payment & Terms: Pays 40-50% commission on b&w and color photos. Enforces minimum prices. Offers volume discounts to regular customers; inquire about specific terms. Discount sale terms not negotiable. Works on contract basis only; prefers exclusivity, but negotiable by territory. Contracts renew automatically with additional submissions. "All contracts reviewed after two years initially, either party may then terminate contract, giving three months notice in writing." Statements issued quarterly. Payment made quarterly. Photographers permitted to review sales figures. Offers one-time rights and electronic media rights. Informs photographer and allows them to negotiate when client requests all rights. Photo captions required, Captions required; include common name, Latin name, behavior, location and country, magnification where appropriate.
Making Contact: Interested in receiving high quality, creative, inspiring work from both amateur and professional photographers. Enquire for stock photo list plus photographers pack. SASE. Reports in 1 month. Distributes want lists every 6 months to all photographers.
Tips: Prefers to see "good focus, composition, exposure, rare or unusual natural history subjects and behavioral and action shots."

OZARK STOCK, 1926 S. Glenstone #325, Springfield MO 65804. Phone/fax: (417)890-5600. E-mail: ozstock@dialus.com. Website: http://www.ozstock.com. Director: John S. Stewart. Estab. 1991. Stock photo agency. Has 45,000 photos. Clients include: advertising agencies, public relations firms, businesses, book/encyclopedia publishers, magazine publishers, newspapers, postcard publishers, calendar companies.
Needs: "People at work, at play, in the workplace, interacting with other people young and old and interacting with pets. Children-toddlers through teens interacting with others younger and older and racially mixed. Agriculture and farm and relaxed subjects. Health care and people doing 'healthy' things like

exercise and eating and shopping for healthy foods. Also, images of the Ozarks showing the scenic beauty of this fast growing area, travel destinations of the area and the people who live there."

Specs: Uses 35mm, color negative or transparencies, b&w film, or digital files (Mac).

Payment & Terms: Pays 50% commission on all usage fees. "Photographer retains all original negatives and chromes and is free to sell elsewhere. The photographer's name is attached to each image in our file. Each photographer is assigned an account number. The computer keeps track of the sales activity for that account number and checks are written monthly. Statements issued and photographers paid monthly.

Making Contact: "You may submit photos any way possible. This includes original color transparencies or black & white and color negatives with contact sheets. Ozark Stock does not keep your originals. We do a scan of the images we want on file and use low resolution watermarked versions to market your images. The original images are returned to you. Include SASE or postage or shipping account number for their return. Photographers may also submit photo CDs. Include postage for their return. Photos and CDs are returned within 2 weeks. If model or property releases are available, please indicate which photos apply. Copies of the release may be requested later."

Tips: "Include caption information. The more information, like where photo was taken, the better. Sales are sometimes lost because not enough specific information is known and there just is not time to call up the photographer."

PACIFIC STOCK, 758 Kapahulu Ave., Suite 250, Honolulu HI 96816. (808)735-5665. Fax: (808)735-7801. E-mail: pics@pacificstock.com. Website: http://pacificstock.com. Owner/President: Barbara Brundage. Estab. 1987. Stock photo agency. Member of Picture Agency Council of America (PACA). Has 150,000 photos. Clients include advertising agencies, public relations firms, audiovisual firms, businesses, book/encyclopedia publishers, magazine publishers, postcard companies, calendar companies and greeting card companies. Previous/current clients: American Airlines, *Life* magazine (cover), Eveready Battery (TV commercial).

Needs: "Pacific Stock is the *only* stock photo agency worldwide specializing exclusively in Pacific- and Asia-related photography. Locations include North American West Coast, Hawaii, Pacific Islands, Australia, New Zealand, Far East, etc. Subjects include: people, travel, culture, sports, marine science and industrial."

Specs: Uses 35mm, 2¼×2¼, 4×5 and 8×10 (all formats) transparencies.

Payment & Terms: Pays 50% commission on color photos. Works on contract basis only. Offers limited regional exclusivity. Charges catalog insertion rate of 50%/image. Statements issued monthly. Payment made monthly. Photographers allowed to review account records to verify sales figures. Offers one-time or first rights; additional rights with photographer's permission. Informs photographer and allows them to negotiate when client requests all rights. Model and property release required for all people and certain properties, i.e., homes and boats. Photo captions are required; include: "who, what, where."

Making Contact: Query with résumé of credits and list of stock photo subjects. SASE. Reports in 2 weeks. Photo guidelines free with SASE. Tips sheet distributed quarterly to represented photographers; free with SASE to interested photographers.

Tips: Looks for "highly edited shots preferably captioned in archival slide pages. Photographer must be able to supply minimum of 1,000 slides (must be model released) for initial entry and must make quarterly submissions of fresh material from Pacific and Asia area destinations and from areas outside Hawaii." Major trends to be aware of include: "increased requests for 'assignment style' photography so it will be resellable as stock. The two general areas (subjects) requested are: tourism usage and economic development. Looks for focus, composition and color. As the Asia/Pacific region expands, more people are choosing to travel to various Asia/Pacific destinations while greater development occurs, i.e., tourism, construction, banking, trade, etc. Be interested in working with our agency to supply what is on our want lists."

PAINET, 20 8th St. S., New Rockford ND 58356. (701)947-5932. Fax: (701)947-5933. E-mail: photogs@painetworks.com. Website: http://www.painetworks.com. Owner: Mark Goebel. Estab. 1985. Picture library. Has 80,000 photos. Clients include: advertising agencies and magazine publishers.

Needs: "Anything and everything."

Specs: Accepts images in digital format for Mac (JPEG only). Send via compact disc, floppy disk, Jaz disk or send as an attachment to an e-mail. Resolution requirement is 4×6 inches at 72dpi.

Payment & Terms: Pays 50% commission. Works with or without signed contract. Offers nonexclusive contract. Payment made immediately after sale is made. Offers one-time rights. Informs photographer and allows them to negotiate when client requests all rights.

Making Contact: "To recieve bi-weekly photo requests from our clients, send an e-mail message to addphotog@painetworks.com."

Tips: "Selected photographers can have their images placed on our Website in the gallery section. Painet markets color and b&w images electronically by internet or by contact with the photographer. Because

images and image descriptions are entered into a database from which searches are made, we encourage our photographers to include lengthy descriptions which improve their chances of finding their images during a database search. Photographers who provide us their e-mail address will receive a bi-weekly list of current photo requests from buyers. Photographers can then send matching images in JPEG format via e-mail and we forward them to the buyer. When the buyer selects an image, we contact the photographer to upload a larger file (usually in TIFF format) to our FTP site. Instructions are provided on how to do this. The buyer then downloads the image file from our FTP site. Credit card payment is made in advance by the buyer. Photographer is paid immediately after sale is made."

N **PANORAMIC IMAGES**, 70 E. Lake St., Suite 415, Chicago IL 60601. (312)236-8545. Fax: (312)704-4077. E-mail: panchicago@earthlink.net. Website: www.panoramicimages.com. Contact: Colleen McCarty and Tracy Richards. Estab. 1986. Stock photo agency. Member of PACA, ASPP and IAPP. Clients include advertising agencies, businesses, magazine publishers, newspapers, postcard companies, calendar companies, corporate design firms, graphic designers and corporate art consultants.
Needs: Works only with *panoramic formats* (2:1 aspect ratio or greater). Subject include: cityscapes/skylines, landscape/scenics, international travel, natures, sports, industry, architecture, tabletop, backgrounds and conceptual. "No 35mm."
Specs: Uses 2¼×5, 2¼×7 and 2¼×10 (6×12cm, 6×17cm and 6×24cm). "2¼ formats (chromes only) preferred; will accept 70mm pans, 5×7, 4×10 and 8×10 horizontals and verticals."
Payment & Terms: Pays 50% commission on color photos. Average price: $750. Statements issued quarterly; payments made quarterly. Offers one-time, electronic rights and limited exclusive usage. Model release preferred "and/or property release, if necessary." Captions required. Call for submission guidelines before submitting.
Making Contact: Arrange a personal interview to show portfolio. Query with list of stock photo subjects. Reports in 1 month; also sends "response postcard immediately to all photo submissions." Newsletter distributed 3-4 times yearly to photographers. Specific want lists created for contributing photographers. Our photographer's work is represented in catalogs with worldwide distribution.
Tips: Wants to see "well-exposed chromes. Panoramic views of well-known locations nationwide and worldwide. Also, generic beauty panoramics. PSI has grown in gross sales, staff and number of contributing photographers and continues strong growth with the release of a new catalog yearly."

N **PANOS PICTURES**, 1 Chapel Court, Borough High St., London SE1 1HH United Kingdom. Phone: (44)171-234-0010. Fax: (44)171-357-0094. E-mail: pics@panos.co.uk. Website: http://www.panos.co.uk. Contact: Adrian Evans. Estab. 1986. Picture library. Member of B.A.P.L.A. Has 250,000 photos in files. Clients include: book publishers, magazine publishers, newspapers.
Needs: "Documentary photography from developing world and Eastern Europe (i.e. everywhere except North America and Western Europe)."
Specs: Uses 8×10 b&w prints; 35mm transparencies.
Payment/Terms: Pays 50% commission for b&w; 50% for color photos. Average price per imate (to clients): $100 minimum for b&w, $100 minimum for color. Enforces strict minimum prices. Offers volume discounts to customers. Works with photographers with or without a contract. Offers nonexclusive contract. Contracts renew automatically with additional submissions. Statements issued quarterly. Photographers allowed to review account records in cases of discrepancies only. Offers one-time rights. Informs photographers and allows them to negotiate when a client requests all rights. Model release preferred. Photo captions required.
Making Contact: Send query letter with stock photo list, tearsheets. Expects minimum initial submission of 500 images.
Tips: "I will begin to market images via computer networks this year." When submitting work, photographers should have "good captions and edit their work tightly."

PHOTO AGORA, Hidden Meadow Farm, Keezletown VA 22832. Phone/fax: (540)269-8283. E-mail: photoagora@aol.com. Contact: Robert Maust. Estab. 1972. Stock photo agency. Has 50,000 photos. Clients include: businesses, book/encyclopedia and textbook publishers, magazine publishers and calendar companies.
Needs: Families, children, students, Virginia, Africa and other third world areas, work situations, etc.
Specs: Uses 8×10 matte and glossy b&w prints; 35mm, 2¼×2¼, 4×5 transparencies.
Payment & Terms: Pays 50% commission on b&w and color photos. Average price per image (to clients): $40-150/b&w photo; $125-300/color photo. Negotiates fees below standard minimum prices. Offers volume discounts to customers; inquire about specific terms. Photographers can choose not to sell images on discount terms. Works with or without a signed contract. Offers nonexclusive contract. Statements issued quarterly. Payment made quarterly. Photographer allowed to review account records. Offers

one-time rights. Informs photographer and allows them to negotiate when client requests all rights. Model/property release preferred. Captions required; include location, important dates, names etc.

Making Contact: Call, write or e-mail. No minimum number of images required in initial submission. Reports in 3 weeks. Photo guidelines free with SASE.

PHOTO ASSOCIATES NEWS SERVICE, P.O. Box 2163, Reston VA 20195. (703)648-9167. Fax: (703)648-0260. Bureau Manager: Peter Heimsath. Estab. 1970. News/feature syndicate. Has 25,000 photos. Clients include: public relations firms, book publishers, magazine publishers, newspapers, newsletters.

Needs: Needs feature and immediate news for worldwide distribution, also celebrities doing unusual things.

Specs: Uses 8×10 glossy or matte b&w or color prints; 35mm transparencies.

Payment & Terms: Pays $175-500/color photo; $125-250/b&w photo. Pays 50% commission on b&w and color photos. Average price per image (to clients): $150-750/b&w photo; $100-500/color photo. Negotiates fees at standard minimum prices depending on subject matter and need; reflects monies to be charged. Offers discounts to customers; terms specified in photographer's contract. Photographers can choose not to sell images on discount terms. Works on contract basis only. Offers nonexclusive contract. Statements issued monthly. Payment made "as we are paid. Photographers may review records to verify sales, but don't make a habit of it. Must be a written request." Offers one-time rights. Informs photographer and allows them to negotiate when client requests all rights. Photo Associates News Service will negotiate with client requests of all rights. Model/property release required. Captions required; include name of subject, when taken, where taken, competition and process instructions.

Making Contact: Query with résumé of credits, samples or stock photo list. Samples kept on file. SASE. Expects minimum initial submission of 20 images with periodic submission of at least 50 images every two months. Reports in 1 month. Photo guidelines free with SASE. Market tips sheet distributed to those who make serious inquiries with SASE.

Tips: "Put yourself on the opposite side of the camera, to grasp what the composition has to say. Are you satisfied with your material before you submit it? More and more companies seem to take the short route to achieve their visual goals. They don't want to spend real money to obtain a new approach to a possible old idea. Too many times, photographs lose their creativity because the process isn't thought out correctly."

PHOTO INDEX, 2 Prowse St., West Perth 6005 Western Australia. Phone: (08)948-10375. Fax: (08)948-16547. Manager: Lyn Woldendorp. Estab. 1979. Stock photo agency. Has 100,000 photos. Clients include: advertising agencies, public relations firms, audiovisual firms, businesses, book/encyclopedia publishers, magazine publishers, postcard publishers, calendar companies.

Needs: Generic stock photos, especially lifestyle, sport and business with people.

Specs: Uses 35mm, $2\frac{1}{4} \times 2\frac{1}{4}$, 4×5 transparencies.

Payment & Terms: Pays 50% commission on sales. Five-year contract renewed automatically. Statements issued quarterly. Payment made quarterly. Photographers permitted to review account records to verify sales figures or account for various deductions "within reason." Offers one-time rights. Informs photographer and allows them to negotiate when client requests all rights. Model/property release required. Captions required.

Making Contact: Query with samples. Expects minimum initial submission of 500 images with periodic submissions. Reports in 1-2 weeks. Photo guidelines free with SASE. Catalog available. Market tips sheet distributed quarterly to contributing photographers.

Tips: "A photographer working in the stock industry should treat it professionally. Observe what sells of his work in each agency, as one agency's market can be very different to another's. Take agencies' photo needs lists seriously. Treat it as a business."

THE PHOTO LIBRARY (Photographic Library of Australia, Ltd.), Level 1, No. 7 West St., North Sydney 2060 N.S.W. Australia. Phone: (02)9929-8511. Fax: (02)9923-2319. E-mail: lucette@photolibrary.com. Editor: Lucette Moore. General photo library. Has over 500,000 photos. Clients include: advertising agencies, book/magazine publishers, government departments and corporate clients.

Needs: Good-quality, strong images.

Specs: Uses 35mm, 120 roll film and 4×5 transparencies.

Payment & Terms: Pays 50% commission for photos. Works on contract basis only. Offers exclusive 5 year contract and regional exclusivity in Australia and New Zealand. After 5 years contract continues until photographer wants to withdraw images. Statements issued quarterly. Photographers allowed to verify sales figures once a year. Payment made quarterly, 10 days after end of quarter. Offers one-time and electronic media rights. Informs photographers when clients request all rights; handles all negotiations. Requires model release (held by photographer) and accurate photo captions.

Making Contact: Send submission of photos (including return postage) by mail for consideration to

Lucette Moore. Guidelines free with SASE.

Tips: Notes "35mm does not sell as well as the medium and large formats but will accept 35mm if other formats are included."

PHOTO RESEARCHERS, INC., 60 E. 56th St., New York NY 10022. (212)758-3420. Fax: (212)355-0731. E-mail: photorsch@aol.com. Stock photography agency representing over 1 million images specializing in science, wildlife, medicine, people and travel. Member of Picture Agency Council of American (PACA). Clients include: ad agencies, graphic designers, publishers of textbooks, encyclopedias, trade books, magazines, newspapers, calendars, greeting cards and annual reports in US and foreign markets.

Needs: All aspects of natural history, science, astronomy, medicine, people (especially contemporary shots of teens, couples and seniors). Particularly needs model-released people, European wildlife, up-to-date travel and scientific subjects.

Specs: Any size transparencies.

Payment & Terms: Rarely buys outright; works on 50% stock sales and 30% assignments. General price range (to clients): $150-7,500. Works on contract basis only. Offers limited regional exclusivity. Contracts renew automatically with additional submissions for 5 years initial term/1 year thereafter. Charges 50% foreign duping fee for subagents; 50% catalog insertion fee; placement cost when image sells (if no sales or sales less than 50% placement amount, 0-49%). Photographers allowed to review account records upon reasonable notice during normal business hours. Statements issued monthly, bimonthly or quarterly, depending on volume. Offers one-time, electronic media and one-year exclusive rights. Informs photographer and allows them to negotiate when a client requests to buy all rights, but does not allow direct negotiation with customer. Model/property release required for advertising; preferred for editorial. Captions required; include who, what, where, when. Indicate model release on photo.

Making Contact: Query with description of work, type of equipment used and subject matter available. Send to Bug Sutton, Creative Director. Submit portfolio for review when requested. SASE. Reports in 1 month maximum.

Tips: "When a photographer is accepted, we analyze his portfolio and have consultations to give the photographer direction and leads for making sales of reproduction rights. We seek the photographer who is highly imaginative or into a specialty and who is dedicated to technical accuracy. We are looking for serious photographers who have many hundreds of photographs to offer for a first submission and who are able to contribute often."

PHOTO RESOURCE HAWAII, 116 Hekili St., #204, Kailua HI 96734. (808)599-7773. Fax: (808)599-7754. E-mail: photohi@lava.net. Website: http://www.photoresourceHawaii.com. Owner: Tami Dawson. Estab. 1983. Stock photo agency. Has 75,000 photos. Clients include: ad agencies, audiovisual firms, businesses, book/encyclopedia publishers, magazine publishers, calendar companies, greeting card companies and postcard publishers.

Needs: Photos mainly of Hawaii and some of the South Pacific.

Specs: Uses 35mm, 2¼×2¼, 4×5 transparencies.

Payment & Terms: Pays 50% commission. Enforces minimum prices. Offers volume discounts to customers. Discount sales terms not negotiable. Works on contract basis only. Offers nonexclusive contract. Contracts renew automatically with additional submissions. Statements issued bimonthly. Payment made bimonthly. Photographers allowed to review account records. Offers one-time and other negotiated rights. Does not inform photographer or allow him to negotiate when client requests all rights. Model/property release preferred. Captions required.

Making Contact: Query with samples. Samples kept on file. SASE. Expects minimum initial submission of 100 images with periodic submissions at least 5 times a year. Reports in 3 weeks.

PHOTO 20-20, 435 Brannan St., Ste. 203, San Francisco CA 94107. (415)543-8983. Fax: (415)543-2199. Principal Editor: Ted Streshinsky. Estab. 1990. Stock photo agency. Has 500,000 photos. Clients include: advertising agencies, public relations firms, book/encyclopedia publishers, magazine publishers, newspapers, calendar companies, greeting card companies, design firms.

● This agency also markets images via the Picture Network International.

Needs: Model released people, international travel destinations.

Specs: Uses 35mm, 2¼×2¼, 4×5, 6×7, 8×10 transparencies.

Payment & Terms: Pays 50% commission on b&w and color photos; "25% to agency on assignment." Average price per image (to clients): $300/b&w; $300/color. Enforces minimum prices. Photographers can choose not to sell images on discount terms. Works on contract basis only. Offers nonexclusive contract. Contract renews automatically. "As payment for their work arrives checks are sent with statements." Photographers allowed to review account records. Offers one-time rights; negotiable. Requests photogra-

pher's permission to negotiate when client requests buy out. Model/property release preferred. Captions essential; include location and all pertinent information.

Making Contact: Query with stock photo list and non-returnable printed samples. Expects minimum initial submission of 300 images with periodic submission of at least 300 images every 3 months. Market tips sheet distributed every 2 months to contracted photographers.

Tips: "Our agency's philosophy is to try to avoid competition between photographers within the agency. Because of this we look for photographers who are specialists in certain subjects and have unique styles and approaches to their work. Photographers must be technically proficient, productive, and show interest and involvement in their work."

PHOTOBANK, INC., 17952 Skypark Circle, Suite B, Irvine CA 92614. (714)250-4480. Fax: (714)752-5495. E-mail: photobank@earthlink.net. Photo Editor: Kristi Bressert. Stock photo agency. Has 750,000 transparencies. Clients include: ad agencies, public relations firms, audiovisual firms, book/encyclopedia publishers, magazine publishers, postcard companies, calendar publishers, greeting card companies, corporations and multimedia users.

Needs: Emphasis on active couples, lifestyle, medical, family, multiethnic, multi-generational and business. High-tech shots are always needed. These subjects are highly marketable, but model releases are a must.

Specs: Uses all formats: 35mm, 2¼×2¼, 4×5, 6×7 and 8×10 transparencies; color only. Accepts images in digital format for Mac (PICT, JPEG). Send via compact disc, or Zip disk (high resolution only if used; low resolution OK for review).

Payment & Terms: Pays 50% commission. Average price per image (to clients): $275-500/color photo. Negotiates fees below minimum prices. Offers volume discounts to customers; terms specified in photographer's contract. Photographers can choose not to sell images on discount terms. Works on contract basis only. Offers exclusive, limited regional exclusive, nonexclusive and guaranteed subject exclusivity contracts. Contracts renew automatically with additional submissions. Statements issued quarterly. Payment made quarterly. Photographers permitted to review account records to verify sales figures or account for various deductions. Offers one-time rights, electronic media rights and agency promotion rights. Informs photographer and allows them to negotiate when client requests all rights. Model/property release required. Captions preferred.

Making Contact: Query with samples and list of stock photos. SASE. Reports in 2 weeks. Photo guidelines free with SASE.

Tips: "Clients are looking for assignment quality and are very discerning with their selections. Only your best should be considered for submission. Please tightly edit your work before submitting. Model-released people shots in all subjects sell well. Multiethnic and multigenerational images are 'key.' "

PHOTODAILY, Pine Lake Farm, Osceola WI 54020. (800)223-3860 ext. 24. Fax: (800)-PHOTO-FAX. E-mail: info@photosource.com. Website: http://www.photosource.com. Editor: Tracy Rutledge. Estab. 1976. Sales lead marketer. Members have 1,500,000 photos in files. Has one branch office. Clients include: advertising agencies, public relations firms, book publishers, magazine publishers, greeting card companies.

Needs: Editorial stock photography.

Specs: Uses 35mm transparencies. Accepts images in digital format.

Payment/Terms: Photographer receives 100% of sale. Average price per image (to client) $125 minimum for b&w, $125 minimum for color. Terms specified in photographer's contracts. Works with photographers with or without a contract. Offers nonexclusive contract. Charges no fees. Offers one-time rights. Informs photographer and allows them to negotiate when client requests all rights. Model release preferred; property release preferred. Not needed for editorial use.

Making Contact: Send query letter with stock photo list, tearsheets. Provide résumé, business card, self-promotion piece or tearsheets to be kept on file. Cannot return material. Reports back only if interested. Photo guidelines sheet free with SASE. Market tips sheet available daily to subscribers for $48 monthly (fax) $27.50 email or channel.

Tips: "We transmit via fax and email, plus use Internet Explorer Channel (push) technology."

PHOTOEDIT, 110 W. Ocean Blvd., Suite 430, Long Beach CA 90802-4623. (562)435-2722. Fax: (562)435-7161. E-mail: photoedit@earthlink.net. President: Leslye Borden. Estab. 1987. Stock photo agency. Member of Picture Agency Council of America (PACA). Has 500,000 photos. Clients include: ad agencies, public relations firms, businesses, book/encyclopedia publishers, magazine publishers.

Needs: People—seniors, teens, children, families, minorities, handicapped.

Specs: Uses 35mm transparencies.

Payment & Terms: Pays 50% commission on color photos. Average price per image (to clients): $200/

quarter page textbook only, other sales higher. Works on contract basis only. Offers nonexclusive contract. Charges catalog insertion fee of $400/image. Statements issued quarterly; monthly if earnings over $1,000/month. Payment made monthly or quarterly at time of statement. Photographers are allowed to review account records. Offers one-time rights; limited time use. Consults photographer when client requests all rights. Model release preferred for people.
Making Contact: Submit portfolio for review. Query with samples. Samples not kept on file. SASE. Expects minimum initial submission of 1,000 images with additional submission of 1,000 per year. Reports in 1 month. Photo guidelines free with SASE.
Tips: In samples looks for "drama, color, social relevance, inter-relationships, current (*not* dated material), tight editing. We want photographers who have easy access to models (not professional) and will shoot actively and on spec."

PHOTOGRAPHIC RESOURCES INC., 6633 Delmar, St. Louis MO 63130. (314)721-5838. Fax: (314)721-0301. Website: http://www.photographic~resources.com. President: Ellen Curlee. Estab. 1986. Stock photo agency. Member of the Picture Agency Council of America (PACA). Has 250,000 photos. Clients include: ad agencies, public relations firms, businesses, greeting card companies and postcard publishers.
Needs: Lifestyles, sports and medical.
Specs: Uses 8×10 glossy b&w prints; 35mm, 2¼×2¼, 4×5, 8×10 transparencies.
Payment & Terms: Pays 50% commission; 25% on assignment work. Works on contract basis only. Offers exclusive and guaranteed subject exclusivity contracts. Contracts renew automatically with additional submissions. Charges catalog insertion fee. Statements issued monthly. Payment made monthly. Offers one-time and electronic media rights; negotiable. Informs photographer when a client requests all rights. Model/property release required. Captions required.
Making Contact: Query with samples. Reports in 3 weeks. Catalog free with SASE. Market tips sheet distributed quarterly to photographers on contract.

 PHOTOPHILE, 2400 Kettner Blvd., Studio 250, San Diego CA 92101. (619)595-7989. Fax: (619)595-0016. E-mail: njmasten@aol.com. Website: http://www.vsii.com/portfolio/photophile. Owner: Nancy Likins-Masten. Clients include: ad agencies, public relations firms, audiovisual firms, businesses, publishers, postcard and calendar producers, and greeting card companies.
Needs: Lifestyle, vocations, sports, industry, entertainment, business, computer graphics, medical and travel.
Specs: Uses 35mm, 2¼×2¼, 4×5 and 6×7 original transparencies. Accepts images in digital format for Mac. Send via compact disc or Zip disk.
Payment & Terms: Pays 50% commission. Payment negotiable. Works on contract basis only. Offers limited regional exclusivity. Contracts renew automatically for 5 years. Statements issued quarterly. Payment made quarterly. Photographers are allowed to review account records. Offers one-time and electronic media rights; negotiable. Informs photographer and allows them to negotiate when client requests all rights. Model/property release required. Captions required, include location or description of obscure subjects; travel photos should be captioned with complete destination information.
Making Contact: Write with SASE for photographer's information. "Professionals only, please." Expects a minimum submission of 500 saleable images and a photographer must be continuously shooting to add new images to files.
Tips: "Specialize, and shoot for the broadest possible sales potential. Get releases!" Points out that the "greatest need is for model-released people subjects; sharp-focus and good composition are important." If photographer's work is saleable, "it will sell itself."

 PHOTOSEARCH, P.O. Box 92656, Milwaukee WI 53202. (414)271-5777. President: Nicholas Patrinos. Estab. 1970. Stock photo agency. Has 1 million photos. Has 2 branch offices. Clients include: ad agencies, public relations firms, audiovisual firms, businesses, book/encyclopedia publishers, magazine

publishers, newspapers, postcard publishers, calendar companies, greeting card companies, network TV/ nonprofit market (social services types).

Needs: Interested in all types of photos.

Specs: Uses 8×10 any finish b&w prints; 35mm, 2¼×2¼, 4×5, 8×10 transparencies.

Payment & Terms: Buys photos; pays $300-5,000/image. Pays 50% commission on b&w and color photos. Offers volume discounts to customers; terms specified in photographer's contract. Photographers can choose not to sell images on discount terms. Works only with contract. Offers limited regional exclusivity, nonexclusive, guaranteed subject exclusivity contracts. Contracts renew automatically with additional submissions. Statements issued upon sale. Payment made immediately upon sale receipt from clients. Offers one-time, electronic media and agency promotion rights. Does not inform photographer or allow him to negotiate when client requests all rights. "This is pre-arranged and understood with the photographers." Model/property release required. Captions preferred; include basic specifics (i.e., place, date, etc.).

Making Contact: Query with stock photo list. Keeps samples on file. SASE. Expects minimum initial submission of 250 images. Reports in 6 weeks or less. Photo guidelines free with SASE. Market tips sheet faxed directly to photographer, free with SASE with prearranged contract first. Send only a typed or printed list initially.

PHOTOTAKE, INC., 224 W. 29th St., 9th Floor, New York NY 10001. (212)736-2525. (800)542-3686. Fax: (212)736-1919. Director: Leila Levy. Stock photo agency; "fully computerized photo agency specializing in science and technology in stock and on assignment." Has 500,000 photos. Clients include: ad agencies, businesses, newspapers, public relations and AV firms, book/encyclopedia and magazine publishers, and postcard, calendar and greeting card companies.

Needs: General science and technology photographs, medical, high-tech, computer graphics, special effects for general purposes, health-oriented photographs, natural history, people and careers.

Specs: Uses 8×10 prints; 35mm, 2¼×2¼, 4×5 or 8×10 transparencies; contact sheets or negatives.

Payment & Terms: Pays 50% commission on b&w and color photos. Works on contract basis only. Offers guaranteed subject exclusivity. Contracts renew automatically with additional submissions. Charges 50¢ duping fee. Charges $75-125 catalog insertion fees. Statements issued quarterly. Payment made quarterly. Photographers allowed to review account records. Offers one-time or first rights (world rights in English language, etc.). Informs photographer when client requests all rights, but agency negotiates the sale. Model/property release required. Captions required.

Making Contact: Arrange a personal interview to show portfolio. Query with samples or with list of stock photo subjects. Submit portfolio for review. SASE. Reports in 1 month. Photo guidelines "given on the phone only." Tips sheet distributed monthly to "photographers that have contracted with us at least for a minimum of 500 photos."

Tips: Prefers to see "at least 100 color photos on general photojournalism or studio photography and at least 5 tearsheets—this, to evaluate photographer for assignment. If photographer has enough in medical, science, general technology photos, send these also for stock consideration." Using more "illustration type of photography. Topics we currently see as hot are: general health, computers, news on science. Photographers should always look for new ways to illustrate concepts generally."

PHOTRI INC. - MICROSTOCK, 3701 S. George Mason Dr., Suite C2 North, Falls Church VA 22041. (703)931-8600. Fax: (703)998-8407. E-mail: photri@mail.erols.com. Website: http://www.microsto ck.com. President: Jack Novak. Member of Picture Agency Council of America (PACA). Has 1 million b&w photos and color transparencies of all subjects. Clients include: book and encyclopedia publishers, ad agencies, record companies, calendar companies, and "various media for AV presentations."

Needs: Military, computer graphics, space, science, technology, energy, environment, romantic couples, people doing things, humor, picture stories, major sports events. Special needs include calendar and poster subjects. Needs ethnic mix in photos. Has sub-agents in 10 foreign countries interested in photos of USA in general.

Specs: Uses 8×10 glossy b&w prints; 35mm and larger transparencies. Accepts images in digital format for Mac or Windows. Send via CD, SyQuest, floppy or Zip disk.

Payment & Terms: Seldom buys outright; pays 35-50% commission. Pays: $45-65/b&w photo; $100-1,500/color photo; $50-100/ft. for film. Negotiates fees below standard minimums. Offers volume discounts to customers; terms specified in photographer's contract. Discount sale terms not negotiable. Works with or without contract. Offers nonexclusive contract. Charges $150 catalog insertion fee. Statements issued as sales occur. Payment made semi-annually. Photographers allowed to review records. Offers one-time, electronic media and agency promotion rights. Informs photographer and allows them to negotiate when client requests all rights. Model release required if available and if photo is to be used for advertising purposes. Property release required. Captions required.

Making Contact: Call to arrange an appointment or query with résumé of credits. SASE. Reports in 2-

4 weeks.
Tips: "Respond to current needs with good quality photos. Take, other than sciences, people and situations useful to illustrate processes and professions."

🌐 📷 **PICTOR INTERNATIONAL, LTD.**, Lymehouse Studios, 30-31 Lyme St., London NW1 0EE England. Phone: (171)482-0478. Fax: (171)267-5759. Creative Director: Adrian Peacock. Stock photo agency and picture library with 17 offices including London, Paris, Munich, Milan, Vienna, Atlanta, New York, Santa Monica and Washington DC. Clients include: advertising agencies, public relations firms, audiovisual firms, businesses, book/encyclopedia publishers, magazine publishers, postcard companies, calendar companies, greeting card companies, jigsaw companies and travel plus decorative poster companies.
Needs: "Pictor is a general stock agency. We accept *all* subjects." Needs primarily people shots (released): business, families, couples, children, etc. Criteria for acceptance: "photos which are technically and aesthetically excellent."
Specs: Uses 35mm, 6×6cm, 6×7cm and 4×5 transparencies.
Payment & Terms: Pays 50% commission for color photos. General price range: $100-$15,000. Statements issued monthly. Offers one-time, first and all rights. Requires model release and photo captions. Buys photos outright depending on subject.
Making Contact: Arrange a personal interview to show portfolio. Query with list of stock photo subjects. Send unsolicited photos by mail for consideration. Photo guidelines sheet available for SASE. Publishes annual catalog. Tips sheet for "photographers we represent only."
Tips: Looks for "photographs covering all subjects. Clients are getting more demanding and expect to receive only excellent material. Through our marketing techniques and PR, we advertise widely the economic advantages of using more stock photos. Through this technique we're attracting 'new' clients who require a whole different set of subjects."

📷 **THE PICTURE CUBE INC.**, Dept. PM, 67 Broad St., Boston MA 02109. (617)443-1113. Fax: (617)443-1114. E-mail: piccube@shore.net. Website: http://www.picturecube.com. President: Sheri Blaney. Member of Picture Agency Council of America (PACA). Has 300,000 photos. Clients include: ad agencies, public relations firms, businesses, audiovisual firms, textbook publishers, magazine publishers, encyclopedia publishers, newspapers, postcard companies, calendar companies, greeting card companies and TV. Guidelines available with SASE.
Needs: US and foreign coverage, contemporary images, agriculture, industry, energy, high technology, religion, family life, multicultural, animals, transportation, work, leisure, travel, ethnicity, communications, people of all ages, psychology and sociology subjects. "We need lifestyle, model-released images of families, couples, technology and work situations. We emphasize New England/Boston subjects for our ad/design and corporate clients. We also have a growing vintage collection."
Specs: Uses 8×10 prints; 35mm, 2¼×2¼, 4×5 and larger slides. "Our clients use both color and b&w photography."
Payment & Terms: Pays 50% commission. General price range (to clients): $150-400/b&w; $175-500/color photo. "We negotiate special rates for nonprofit organizations." Offers volume discounts to customers; inquire about specific terms. Discount sales terms not negotiable. Works on contract basis only. Offers limited regional exclusivity contract. Contracts renew automatically for 3 years. Charges 50% catalog insertion fee. Payment made bimonthly with statement. Photographers allowed to review account records to verify sales figures. Offers one-time rights. Model/property release preferred. Captions required; include event, location, description, if model-released.
Making Contact: Request guidelines before sending any materials. Arrange a personal interview to show portfolio. SASE. Reports in 1 month.
Tips: "Black & white photography is being used more and we will continue to stock it." Serious freelance photographers "must supply a good amount (at least 1,000 images per year, sales-oriented subject matter) of material, in order to produce steady sales. All photography submitted must be high quality, with needle-sharp focus, strong composition, correctly exposed. All of our advertising clients require model releases on all photos of people, and often on property (real estate)."

📷 **PICTURE LIBRARY ASSOCIATES**, 4800 Hernandez Dr., Guadalupe CA 93434. (805)343-1844. Fax: (805)343-6766. E-mail: pla@impulse.net. Website: http://www.impulse.net/~pla/. Director of Marketing: Robert A. Nelson. Director of Administration: Bess Nelson. Estab. 1991. Stock photo agency. Has 32,000 photos. Clients include: ad agencies, public relations firms, audiovisual firms, businesses, book/encyclopedia publishers, magazine publishers, newspapers, postcard publishers, calendar companies, greeting card companies, electronic publishing companies.
● Marketing is accomplished with digitized images via the Internet and catalog on disk. First edition

of the digital catalog planned for December 1998. Currently specific category listings available to clients as computer printouts.

Needs: All subjects. "People doing their thing in everyday activities." All ages and races. Write with SASE for want lists. Must be carefully pre-edited for good technical quality.

Specs: Uses 35mm transparencies (slides); videotape (contact agency for specifics).

Payment & Terms: Photographer specifies minimum amount to charge. Pays 60% commission. Original slides only are accepted. Photographer retains all slides after selected ones are digitized. Photographer pays shipping costs. This agency uses ASMP contract. Works on nonexclusive contract basis. Payment made within a few days of agency's receipt of payment. Model/property release required for recognizable persons and recognizable property.

Making Contact: Contact agency for guidelines before submission. Send SAE (6×9 or 9×12). No required minimum submission. Computer printout of subject categories to clients and photographers on request. Free with SASE. Established photographers asked to consider PLA as an additional agency. Agency files consist only of digitized images.

Tips: "Primarily look at technical quality for reproduction. Try to submit horizontal and verticals of each subject submitted. Increased need for ethnic people and subject matter. Need people doing things. Need senior citizen activity. Need health-related subject matter with people involved. Shoot for a theme when possible. Submit new stock regularly. Repeat: Don't submit recognizable people without model releases."

PICTURE PERFECT, (formerly Picture Perfect USA, Inc.), 254 W. 31st St., New York NY 10001. (212)279-1234. Fax: (212)279-1241. Contact: Denise Childs or Linda Waldman. Estab. 1991. Stock photo agency. Has 500,000 photos. Clients include: ad agencies, graphic design firms, public relations firms, audiovisual firms, businesses, book/encyclopedia publishers, magazine publishers, newspapers, postcard publishers, calendar companies, greeting card companies, corporations.

Needs: General—people, lifestyles, business, industry, travel, recreation, sports.

Specs: Uses 35mm, 4×5, 6×4½, 6×6, 6×7, 6×9 transparencies. Accepts images in digital format for Mac. Send via compact, floppy or Zip disk.

Payment & Terms: Pays 50% commission. Average price per image (to clients): varies by usage. Enforces minimum prices. Offers volume discounts to customers. Works on contract basis only. Offers nonexclusive contract. Contracts renew automatically with additional submissions; usually same as original contract. Catalog insertion rate varies according to project. Statements issued quarterly on paid up accounts. Payment made quarterly. Photographers allowed to review account records. Offers one-time rights. "We negotiate on photographer's behalf." Model/property release required. Captions required.

Making Contact: Interested in receiving work from established commercial photographers only. Submit portfolio for review. "Phone/write—first." SASE. Expects minimum initial submission of 1,000-2,000 images with submissions of 500-2,000 images 2 times/year. Photo guidelines free with SASE.

Tips: "All subjects, commercial applications, sharp, well composed, colorful—any format—color only. Business situations, lifestyles, model-released people shots in particular. We market photos nationally and are heavily involved in catalog distribution worldwide."

PICTURE PERSON PLUS, 59 E. Linden Ave, #B7, Englewood NJ 07631. (201)568-3919. President: Rhoda Sidney. Stock and photo research agency. Clients include: public relations, book publishers.

Needs: Images for text books and covers.

Specs: Average price per image (to clients): $175 minimum for b&w. $250-700 for color.

Making Contact: Works with freelancers on assignment only. Cannot return material.

PICTURESQUE STOCK PHOTOS, 1520 Brookside Drive #3, Raleigh NC 27604. (919)828-0023. Fax: (919)828-8635. E-mail: picturesque@picturesque.com. Website: http://www.picturesque.com. Manager: Syd Jeffrey. Estab. 1987. Stock photo agency. Has over 250,000 photos. Clients include: ad agencies, design firms, corporations, book/encyclopedia publishers and magazine publishers.

Needs: Model-released people, lifestyle, business, industry and general topics.

Specs: Uses 35mm, 2¼×2¼, 4×5 transparencies. Accepts images in digital format for Mac (TIFF). Send via compact disc or Zip disk.

Payment & Terms: Pays 50% commission. Works on contract basis only. Offers nonexclusive contract. Contracts renew automatically. Statements issued monthly. Payment made monthly. Photographers allowed to review account records. Offers one-time, electronic media and various rights depending on client needs. Contacts photographer for authorization of sale when client requests all rights. Model/property release required. Captions required.

Making Contact: Contact by telephone or Website for submission guidelines. SASE. Tips sheet distributed quarterly to member photographers.

🌐 🏞 **PLANET EARTH PICTURES**, The Innovation Centre, 225 Marsh Wall, London E14 9FX England. Phone: (171)293-2999. Fax: (171)293-2998. E-mail: planetearth@visualgroup.com. Website: http://www.planet-earth-pictures.com. Library Manager: Jennifer Jeffrey. Estab. 1970. Picture library. Has 500,000 photos. Clients include: ad agencies, public relations and audiovisual firms, businesses, book/encyclopedia and magazine publishers, and postcard and calendar companies.
Needs: Natural history and natural environment pictures.
Specs: Uses any size color transparencies.
Payment & Terms: Pays 50% commission on color photos. General price range: £50 (1 picture/1 AV showing), to over £1,000 for advertising use. Prices negotiable according to use. Works on contract basis only. Offers exclusive and nonexclusive contracts. Statements issued quarterly. Payment made quarterly. Photographers allowed to review account records. Offers one-time rights and electronic media rights. Model release preferred. Captions required.
Making Contact: Send query letter with samples. SASE. Reports in 1 week on queries; 1 month on samples. Photo guidelines sheet available free.
Tips: "We like photographers to receive our photographer's booklet and current color brochure that gives details about photos and captions. In reviewing a portfolio, we look for a range of photographs on any subject—important for the magazine market—and the quality. Trends change rapidly. There is a strong emphasis that photos taken in the wild are preferable to studio pictures. Advertising clients still like larger format photographs. Exciting and artistic photographs used even for wildlife photography, protection of environment."

POSITIVE IMAGES, 89 Main St., Andover MA 01810. (978)749-9901. Fax: (978)749-2747. E-mail: positiveimage@mdc.net. Manager: Pat Bruno. Stock photo agency. Member ASPP. Clients include ad agencies, public relations firms, book/encyclopedia publishers, magazine publishers, greeting card companies, sales/promotion firms, design firms.
● This agency has images on *The Stock Workbook* CD-ROM.
Needs: Garden/horticulture, fruits and vegetables, insects, plant damage, health, nutrition, nature, human nature—all suitable for advertising and editorial publication.
Payment & Terms: Pays 50% commission. Works on contract basis only. Offers limited regional exclusivity and guaranteed subject exclusivity (within files). Charges fee for CD insertion, 100% of which is refunded when photo sells. Statements issued annually. Payment issued monthly. Photographers allowed to review account records. Offers one-time and electronic media rights. "We never sell all rights."
Making Contact: Query letter. Call to schedule an appointment. Reports in 2 weeks.
Tips: "We take on only one or two new photographers per year. We respond to everyone who contacts us and have a yearly portfolio review. Positive Images accepts only fulltime working professionals who can contribute regular submissions."

N 🌐 **POWERSTOCK/ZEFA**, 9 Coborn Rd., London E3 2DA United Kingdom. Phone: (44)181-983-4222. Fax: (44)181-983-3846. E-mail: zefa@powerstock.com. Website: http://www.powerstock.com. Creative Director: Ian Allenden. Estab. 1988. Stock photo agency. Member of BAPLA. Has 250,000 photos in files. Clients include: advertising agencies, businesses, newspapers, postcard publishers, public relations firms, book publishers, calendar companies, audiovisual firms, magazine publishers, greeting card companies.
Payment/Terms: Pays 50% commission on b&w and color photos. Average price per image (to clients): £96-175 for b&w. Enforces strict minimum prices. Offers volume discounts to customers. Discount sales terms not negotiable. Works with photographers on contract basis only. Offers guaranteed subject exclusivity (within files). Contracts renew automatically with additional submissions for 5 years. Statements issued monthly and quarterly. Payments made monthly and quarterly. Photographers allowed to review account records in cases of discrepancies only. Offers one-time rights and electronic media rights. Inform photographers and allows them to negotiate when a client requests all rights. Model release required; property release preferred. Photo captions required.
Making Contact: Send query letter with samples. Portfolio should include b&w, color prints, slides. Expects minimum initial submission of 200 images with bimonthly submissions of at least 200 images. Reports in 1 week on queries; 1 month on samples. Photo guidelines sheet free with SASE. Market tips sheet available every 6 months for contracted suppliers upon request.
Tips: "We consider online databases too large and download times too slow for the majority of clients to use constructively. We would rather use our expertise in understanding our clients picture needs to research suitable images and use the speed of new technologies such as e-mail to deliver material to them. When submitting work be original, include work which, through your own research, will be right for stock and right for our needs as an agency rather than things that they personally 'like'."

RAINBOW, Dept. PM, P.O. Box 573, Housatonic MA 01236. (413)274-6211. Fax: (413)274-6689. E-mail: rainbow@bcn.net. Website: http://www.rainbowimages.com. Director: Coco McCoy. Library Manager: Kate Cook. Estab. 1976. Stock photo agency. Member of Picture Agency Council of America (PACA). Has 195,000 photos. Clients include: ad agencies, public relations firms, design agencies, audiovisual firms, book/encyclopedia publishers, magazine publishers and calendar companies. 20% of sales come from overseas.
 • Rainbow offers its own CD-ROM discs with 4,500 images on-line at http://www.publishersdepot. com and over 200 at http://www.rainbowimages.com.
Needs: Although Rainbow is a general coverage agency, it specializes in high technology images and is continually looking for computer graphics, pharmaceutical and DNA research, photomicrography, communications, lasers and space. "We are also looking for graphically strong and colorful images in physics, biology and earth science concepts; also active children, teenagers and elderly people. Worldwide travel locations are always in demand, showing people, culture and architecture. Our rain forest file is growing but is never big enough!"
Specs: Uses 35mm and larger transparencies. Accepts images in digital format for Mac. Send via floppy disk or Zip disk.
Payment & Terms: Pays 50% commission. Works with or without contract, negotiable. Offers limited regional exclusivity contract. Contracts renew automatically with each submission; no time limit. Statements issued quarterly. Payment made quarterly. Photographers allowed to review account records to verify sales figures. Offers one-time rights. Informs photographer and allows them to negotiate when client requests all rights. Model release is required for advertising, book covers or calendar sales. Photo captions required for scientific photos or geographic locations, etc.; include simple description if not evident from photo, Prefers both Latin and common names for plants and insects to make photos more valuable.
Making Contact: Interested in receiving work from published photographers. "Photographers may write or call us for more information. We may ask for an initial submission of 150-300 chromes." Arrange a personal interview to show portfolio or query with samples. SASE. Reports in 2 weeks. Guidelines sheet for SASE. Distributes a tips sheet twice a year.
Tips: "The best advice we can give is to encourage photographers to carefully edit their photos before sending. No carefully agency wants to look at grey rocks backlit on a cloudy day! With no caption!" Looks for luminous images with either a concept illustrated or a mood conveyed by beauty or light. "Clear captions help our researchers choose wisely and ultimately improve sales. As far as trends in subject matter go, health issues and strong, simple images conveying the American Spirit—families together, farming, scientific research, winning marathons, hikers reaching the top—are the winners. Females doing 'male' jobs, black scientists, Hispanic professionals, Oriental children with a blend of others at play, etc. are also in demand. The importance of model releases for editorial covers, selected magazine usage and always for advertising/corporate clients cannot be stressed enough!"

REFLEXION PHOTOTHEQUE, 1255 Square Phillips, Suite 307, Montreal, Quebec H3B 3G1 Canada. (514)876-1620. Fax: (514)876-3957. E-mail: reflexio@interlink.net. President: Michel Gagne. Estab. 1981. Stock photo agency. Has 100,000 photos. Clients include: ad agencies, public relations firms, audiovisual firms, businesses, book/encyclopedia publishers, magazine publishers, newspapers, postcard companies, calendar companies and greeting card companies.
 • Reflexion Phototheque sells mostly by catalog.
Needs: Model-released people of all ages in various activities. Also, beautiful homes, recreational sports, North American wildlife, industries, US cities, antique cars, hunting and fishing scenes, food, and dogs and cats in studio setting.
Specs: Uses 35mm, 2¼×2¼, 4×5, 8×10 transparencies. Accepts images in digital format for Mac.
Payment & Terms: Pays 50% commission on color photos. Average price per image: $150-500. Enforces minimum prices. Offers volume discounts to customers; inquire about specific terms. Discount sales terms not negotiable. Works on contract basis only. Offers limited regional exclusivity. Contracts renew automatically for 5 years. Charges 50% duping fee and 100% catalog insertion fee. Statements issued quarterly. Payment made quarterly. Offers one-time rights. Model/property release preferred. Photo captions required; include country, place, city, or activity.
Making Contact: Arrange a personal interview to show portfolio. Query with list of stock photo subjects. Submit portfolio for review. SASE. Reports in 1 month. Photo guidelines available.

THE INTERNATIONAL MARKETS INDEX, located in the back of this book, lists markets located outside the U.S. by country.

Tips: "Limit your selection to 200 images. Images must be sharp and well exposed. Send only if you have high quality material on the listed subjects."

RETNA LTD., 18 E. 17th St., 3rd Floor, New York NY 10003. (212)255-0622. Contact: Lori Reese. Estab. 1978. Member of the Picture Agency Council of America (PACA). Stock photo agency, assignment agency. Has 1 million photos. Clients include advertising agencies, public relations firms, book/encyclopedia publishers, magazine publishers, newspapers and record companies.
 • Retna wires images worldwide to sub agents and domestically to editorial clients.
Needs: Handles photos of musicians (pop, country, rock, jazz, contemporary, rap, R&B) and celebrities (movie, film, television and politicians). Covers New York, Milan and Paris fashion shows; has file on royals.
Specs: Original material required. All formats accepted.
Payment & Terms: Pays 50% commission on domestic sales. General price range (to clients): $200 and up. Works on contract basis only. Contracts renew automatically with additional submissions for 3 years. Statements issued monthly. Payment made monthly. Offers one-time rights; negotiable. When client requests all rights photographer will be consulted, but Retna will negotiate. Model/property release required. Captions required.
Making Contact: Works on contract basis only. Arrange a personal interview to show portfolio. Primarily concentrating on selling stock, but do assign on occasion. Does not publish "tips" sheets, but makes regular phone calls to photographers.
Tips: Wants to see a variety of celebrity studio or location shoots. Some music. Photography must be creative, innovative and of the highest aesthetic quality possible.

REX USA LTD, 351 W. 54th St., New York NY 10019. (212)586-4432. Fax: (212)541-5724. Manager: Charles Musse. Estab. 1935. Stock photo agency, news/feature syndicate. Affiliated with Rex Features in London. Member of Picture Agency Council of America (PACA). Has 1.5 million photos. Clients include: ad agencies, public relations firms, audiovisual firms, businesses, book/encyclopedia publishers, magazine publishers, newspapers, postcard companies, calendar companies, greeting card companies and TV, film and record companies.
Needs: Primarily editorial material: celebrities, personalities (studio portraits, candid, paparazzi), human interest, news features, movie stills, glamour, historical, geographic, general stock, sports and scientific.
Specs: Uses all sizes and finishes of b&w and color prints; 35mm, 2¼×2¼, 4×5, and 8×10 transparencies; b&w and color contact sheets; b&w and color negatives; VHS videotape.
Payment & Terms: Pays 50-65% commission; payment varies depending on quality of subject matter and exclusivity. "We obtain highest possible prices, starting at $100-100,000 for one-time sale." Pays 50% commission on b&w and color photos. Works with or without contract. Offers nonexclusive contracts. Statements issued monthly. Payment made monthly. Photographers allowed to review account records. Offers one-time rights, first rights and all rights. Informs photographer and allows them to negotiate when client requests all rights. Model release required. Captions required.
Making Contact: Arrange a personal interview to show portfolio. Query with samples. Query with list of stock photo subjects. If mailing photos, send no more than 40; include SASE. Reports in 1-2 weeks.

H. ARMSTRONG ROBERTS, Dept. PM, 4203 Locust St., Philadelphia PA 19104. (800)786-6300. Fax: (800)786-1920. President: Bob Roberts. Estab. 1920. Stock photo agency. Member of the Picture Agency Council of America (PACA). Has 2 million photos. Has 2 branch offices. Clients include: advertising agencies, public relations firms, audiovisual firms, businesses, book/encyclopedia publishers, magazine publishers, newspapers, postcard publishers, calendar companies and greeting card companies.
Needs: Uses images on all subjects in depth except personalities and news.
Specs: Uses b&w negatives only; 35mm, 2¼×2¼, 4×5 and 8×10 transparencies.
Payment & Terms: Buys only b&w negatives outright. Payment negotiable. Pays 35% commission on b&w photos; 45-50% on color photos. Works with or without a signed contract, negotiable. Offers various contracts including exclusive, limited regional exclusivity, and nonexclusive. Guarantees subject exclusivity within files. Charges duping fee 5%/image. Charges .5%/image for catalog insertion. Statements issued monthly. Payment made monthly. Payment sent with statement. Photographers allowed to review account records to verify sales figures "upon advance notice." Offers one-time rights. Informs photographer and allows them to negotiate when client requests all rights. Model release and captions required.
Making Contact: Query with résumé of credits. Does not keep samples on file. SASE. Expects minimum initial submission of 250 images with quarterly submissions of 250 images. Reports in 1 month. Photo guidelines free with SASE.

RO-MA STOCK, P.O. Box 50732, Pasadena CA 91115-0732. (626)799-7733. Fax: (626)799-6622. E-mail: RoMaStock@aol.com. Owner: Robert Marién. Estab. 1989. Stock photo agency. Member of Picture Agency Council of America (PACA). Has more than 150,000 photos. Clients include: ad agencies, multimedia firms, corporations, graphic design and film/video production companies. International affiliations in Malaysia, Germany, Spain, France, Italy, England, Poland, Brazil and Japan.

• RO-MA STOCK markets its images throughout its new "Eye Catching Images" CD-ROM catalog containing 6,300 images distributed worldwide and throughout its affiliated international agencies and its domestic agency, Index Stock Photography, Inc. located in New York City.

Needs: Looking for fictional images of Earth and outerspace, microscopic and electromicrographic images of insects, micro-organisms, cells, etc. General situations in sciences (botany, ecology, geology, astronomy, weather, natural history, medicine). Also extreme close-up shots of animal faces including baby animals. Very interested in people (young adults, elderly, children and babies) involved with nature and/or with animals and outdoor action sports involving every age range. People depicting their occupations as technicians, workers, scientists, doctors, executives, etc. Most well-known landmarks and skylines around the world are needed.

Specs: Primarily uses 35mm. "When submitting medium, large and digital formats, these images should have a matching 35mm slide for scanning purposes. This will speed up the process of including selected images in our marketing systems. All selected images are digitized and stored on Photo-CD." Accepts images in digital format for Mac (TIFF, no JPEG). Send via compact disc (photo CD formats up to 2048×3072, 18.9 MB or more), SyQuest, Online, Zip disk, floppy disk and JAZ disk.

Payment & Terms: Pays 50% commission on b&w and color; international sales, 40% of gross. General price range: $200 + . Offers volume discounts to customers; terms specified in photographer's contract. Guaranteed subject exclusivity (within files). Contract renews automatically with each submission (of 1,000 images) for 1 year. Charges 100% duping fees; 50% catalog insertion fee from commissions and $3.50/each image in the KPX and CD-ROM catalog to cover half of digitizing cost. Statements issued with payment. Offers one-time rights and first rights. Informs photographer when client requests all rights for approval. Model/property release required for recognizable people and private places "and such photos should be marked with 'M.R.' or 'N.M.R.' respectively." Captions required for animals/plants; include common name, scientific name, habitat, photographer's name; for others include subject, location, photographer's name.

Making Contact: Query with résumé of credits, tearsheets and list of specialties. No unsolicited original work. Responds with tips sheet, agency profile and questionnaire for photographer with SASE. Photo guidelines and tips distributed periodically to contracted photographers.

Tips: Wants photographers with ability to produce excellent competitive photographs for the stock photography market on specialized subjects and be willing to learn, listen and improve agency's file contents. Looking for well-composed subjects, high sharpness and color saturation. Emphasis in medical and laboratory situations; people involved with the environment, manufacturing and industrial. Also, photographers with collections of patterns in nature, art, architecture and macro/micro imagery are welcome.

RSPCA PHOTOLIBRARY, RSPCA Royal Society for the Protection of Animals, Causeway, Horsham, West Sussex RH12 1H9 England. (01403)223150. Fax: (01403)241048. E-mail: photolibrary@rspca.org.uk. Website: http://www.rspca.org.uk. Photolibrary Manager: Andrew Forsyth. Estab. 1992. Picture library. Has 35,000 photos in files. Clients include: advertising agencies, public relations firms, businesses, book publishers, magazine publishers, newspapers, marketing.

Needs: Transparencies of any format/color of environmental issues, wild animals, domestic animals, exotic animals, birds, scenics and plants, insects, marine and work of the RSPCA.

Specs: Uses 35mm, 2¼×2¼, 4×5, 8×10 transparencies.

Payment: Pays 50% commission for b&w. Use BAPLA price guidelines, though does negotiate special deals. Offers volume discounts to customers, terms specified in photographers' contracts. Works with photographers on contract basis only. Offers nonexclusive contract. "Must be unique images." Statements issued quarterly. Payments made quarterly. Photographers allowed to review account records. Offers one-time, electronic media and agency promotion rights. Informs photographers and allows them to negotiate when a client requests all rights. Model release required. Photo captions required; include Latin species name, country and origin.

Making Contact: Send query letter. Provide résumé, business card, self-promotion piece or tearsheets to be kept on file for possible future assignments. Works with local freelancers only. Works with freelancers on assignment only. Does not keep samples on file; include SASE for return of material. Expects minimum initial submission of 24 images with quarterly submissions of at least 24 images. Photo guidelines sheet and catalog free with SASE.

Tips: "CD-ROM images can be sent to us and then onto clients. All photos should be numbered and fully captioned and properly edited before submitting."

⊕ 🖼 **S & I WILLIAMS POWER PIX**, Castle Lodge, Wenvoe, Cardiff CF5 6AD Wales, United Kingdom. Phone: (1222) 595163. Fax: (01222)593905. President: Steven Williams. Picture library. Has 100,000 photos. Clients include: ad agencies, public relations firms, audiovisual firms, businesses, book/encyclopedia publishers, magazine publishers, postcard companies, calendar companies, greeting card companies and music business, i.e., records, cassettes and CDs.
Specs: Uses 35mm, 2¼×2¼, 4×5 and 8×10 transparencies.
Payment & Terms: Pays 50% commission on b&w and color photos. General price range: £50-£500 (English currency). Model release required. Captions required.
Making Contact: Arrange a personal interview to show portfolio. Query with résumé of credits, samples or stock photo list. SASE. Reports in 1-2 weeks. Photo guidelines available for SASE. Distributes a tips sheet every 3-6 months to photographers on books.
Tips: Prefers to see "a photographer who knows his subject and has done his market research by looking at pictures used in magazines, record covers, books, etc.—bright, colorful images and an eye for something just that little bit special."

SHARPSHOOTERS, INC., 4950 SW 72nd Ave., Suite 114, Miami FL 33155. (305)666-1266. Fax: (305)666-5485. Manager, Photographer Relations: Edie Tobias. Estab. 1984. Stock photo agency. Member of Picture Agency Council of America (PACA). Has 500,000 photos. Clients include: ad agencies.
Needs: Model-released people for advertising use. Well-designed, styled photographs that capture the essence of life: children; families; couples at home, at work and at play; also beautiful landscapes and wildlife geared toward advertising. Large format preferred for landscapes.
Specs: Uses transparencies only, all formats.
Payment & Terms: Pays 50% commission on color photos. General price range (to clients): $275-15,000. Works on contract basis only. Offers exclusive contract only. Statements issued monthly. Payments made monthly. Photographers allowed to review account records; "monthly statements are derived from computer records of all transactions and are highly detailed." Offers one-time and electronic media rights usually, "but if clients pay more they get more usage rights. We never offer all rights on photos." Model/property release required. Photo captions preferred.
Making Contact: Query along with nonreturnable printed promotion pieces. Cannot return unsolicited material. Reports in 1 week.
Tips: Wants to see "technical excellence, originality, creativity and design sense, excellent ability to cast and direct talent and commitment to shooting stock." Observes that "photographer should be in control of all elements of his/her production: casting, styling, props, location, etc., but be able to make a photograph that looks natural and spontaneous."

SILVER IMAGE PHOTO AGENCY, INC., 4104 NW 70th Terrace, Gainesville FL 32606. (352)373-5771. Fax: (352)374-4074. E-mail: silverimag@aol.com. Website: http://www.silver-image.com. President/Owner: Carla Hotvedt. Estab. 1988. Stock photo agency. Assignments in Florida/S. Georgia. Has 20,000 color/b&w photos. Clients include: public relations firms, book/encyclopedia publishers, magazine publishers and newspapers.
Needs: Florida-based travel/tourism, Florida cityscapes and people, nationally oriented topics such as drugs, environment, recycling, pollution, etc. Humorous people, animal photos and movie/TV celebrities.
Specs: Uses 35mm transparencies and prints.
Payment & Terms: Pays 50% commission on b&w/color photos. General price range (to clients): $150-600. Works on contract basis only. Offers nonexclusive contract. Statements issued monthly. Payment made monthly. Photographers allowed to review account records. Offers one-time rights. Informs photographer and allows them to be involved when client requests all rights. Model release preferred. Captions required: include name, year shot, city, state, etc.
Making Contact: Query with list of stock photo subjects. SASE; will return if query first. Reports on queries in 1 month; material up to 2 months. Photo guidelines free with SASE. Tips sheets distributed as needed. SASE. Do not submit material unless first requested. "E-mail query preferred."
Tips: "I will review a photographer's work if it rounds out our current inventory. Photographers should review our website to get a feel for our needs."

🖼 **SIPA PRESS/SIPA IMAGE**, 30 W. 21st St., 6th Floor, New York NY 10010. Prefers not to share information.

🅽 ⊕ **SKISHOOT-OFFSHOOT**, Hall Place, Upper Woodcott, Whitchurch, Hants RG28 7PY Britain. (44)1635 255527. Fax: (44)1635 255528. E-mail: skishoot@surfersparadise.net. Estab. 1986. Stock photo agency. Member of British Association of Picture Libraries and Agencies (BAPLA). Has 100,000 photos

Photographers aren't the only people in the industry who need self-promotion. Stock agencies must also send mailers to potential clients. Carla Hotvedt of the Silver Image stock agency saw "Territorial Dispute" by Phil Coale in a professional trade journal and asked him to send it to her. "The photographer and I have worked together for many years," she says. "We periodically send promotional postcards to our clients, and we look for an eye-catching image. This photograph was visually interesting and also depicted Florida nature, one of our specialties."

in files. Clients include: advertising agencies, book publishers, magazine publishers, newspapers, greeting card companies, postcard publishers.

Needs: Photos of skiing and other winter sports.

Specs: Uses 8×10 (approx.) glossy color prints; 35mm, $2\frac{1}{4} \times 2\frac{1}{4}$, 4×5, 8×10 transparencies.

Payment/Terms: Pays 50% commission for color photos. Average price per image (to clients): $100-5,000 for color. Enforces strict minimum prices. BAPLA recommended rates are used. Offers volume discounts to customers. Photographers can choose not to sell images on discount terms. Works with photographers with or without a contract, negotiable. Offers limited regional exclusivity. Contracts renew automatically with additional submissions within originally agreed time period. Charges 50% of cost of dollar transfer fees from £sterling. Statements issued quarterly. Payments made quarterly. Photographers allowed to review account records in cases of discrepancies only. Offers one-time rights. Does inform photographers when a client requests all rights. Model release preferred for ski and snowboarding action models. Photo captions required; include location details.

Making Contact: Send query letter with samples, stock photo list. Portfolio should include color. Works on assignment only. Include SASE for return of material. Expects minimum initial submission of 50 images. Reports in 1 month on queries.

Tips: "We are about to start digitalizing our work so that we can send images to clients by modem or isdn. Label each transparency clearly or provide clear list which relates to transparencies sent."

SKYSCAN PHOTOLIBRARY, Oak House, Toddington, Cheltenham, Glos. GL54 5BY United Kingdom. (+44)1242 621357. Fax: (+44)1242 621343. E-mail: info@skyscan.co.uk. Website: http://www.skyscan.co.uk. Library Manager: Brenda Marks. Estab. 1984. Picture library. Member of British Association of Picture Libraries and Agencies (BAPLA). Has 100,000. Clients include: advertising agencies, public relations firms, businesses, book publishers, magazine publishers, newspapers, calendar companies, postcard publishers.

Needs: Anything aerial! Air to ground; aviation; aerial sports. As well as holding images ourselves, we also wish to make contact with holders of other aerial collections worldwide to exchange information.

Specs: Uses color and b&w prints; 35mm, $2\frac{1}{4} \times 2\frac{1}{4}$, 4×5, 8×10 transparencies. Accepts images in digital format—CD-ROM; e-mailed images also handled.

Payment/Terms: Buys photos/film outright. Pays 50% commission for b&w; 50% commission for color. Average price per image (to clients): $100 minimum. Enforces strict minimum prices. Offers volume

discounts to customers. Photographers can choose not to sell images on discount terms. Works with photographers with or without a contract, negotiable. Offers guaranteed subject exclusivity (within files) negotiable to suit both parties. Statements issued quarterly; payments made quarterly. Photographers allowed to review account records in cases of discrepancies only. Offers one-time, electronic media and agency promotion rights. Informs photographers and allows them to negotiate when a client requests all rights. Will inform photographers and act with photographer's agreement. Model release preferred. Property release preferred for "air to ground of famous buildings (some now insist they have copyright to their building)." Photo captions required; include subject matter; date of photography; location; interesting features/notes.

Making Contact: Send query letter. Provide résumé, business card, self-promotion piece or tearsheets to be kept on file for possible future assignments. Agency will contact photographer for portfolio review if interested. Portfolio should include color slides and transparencies. Does not keep samples on file; include SASE for return of material. No minimum submissions. Reports back only if interested, send non-returnable samples. Photo guidelines sheet free with SASE. Catalog free with SASE. Market tips sheet free quarterly to contributors only.

Tips: "We see digital transfer of low resolution images for layout purposes as essential to stock libraries future and we are investing in suitable technology. Contact first by letter or email with résumé of material held and subjects covered."

🌐 **THE SLIDE FILE**, 79 Merrion Square, Dublin 2 Ireland. Phone: (0001)6766850. Fax: (0001)66224476. E-mail: admin@slidefile.ie. Website: http://www.slidefile.ie/stock. Picture Editor: Ms. Carrie Fonseca. Stock photo agency and picture library. Has 130,000 photos. Clients include: ad agencies, public relations firms, businesses, book/encyclopedia publishers, magazine publishers, newspapers and designers.

Needs: Overriding consideration is given to Irish or Irish-connected subjects. Has limited need for overseas locations, but is happy to accept material depicting other subjects, particularly people.

Specs: Uses 35mm, 2¼×2¼ and 4×5 transparencies.

Payment & Terms: Pays 50% commission on color photos. General price range: £60-1,000 English currency ($90-1,500). Works on contract basis only. Offers exclusive contracts and limited regional exclusivity. Contracts renew automatically with additional submissions. Statements issued quarterly. Payment made quarterly. Photographers allowed to review account records. Offers one-time rights and electronic media rights. Informs photographer when client requests all rights, but "we take care of negotiations." Model releases required. Captions required.

Making Contact: Query with list of stock photo subjects. Works with local freelancers only. Does not return unsolicited material. Expects minimum initial submission of 250 transparencies; 1,000 images annually. "A return shipping fee is required: important that all similars are submitted together. We keep our contributor numbers down and the quantity and quality of submissions high. Send for information first." Reports in 1 month.

Tips: "Our affiliation with international picture agencies provides us with a lot of general material of people, overseas travel, etc. However, our continued sales of Irish-oriented pictures need to be kept supplied. Pictures of Irish-Americans in Irish bars, folk singing, Irish dancing, would prove to be useful. They would be required to be beautifully lit, carefully composed and good-looking, model-released people."

📷 **SOVFOTO/EASTFOTO, INC.**, 48 W. 21 St., 11th Floor, New York NY 10010. (212)727-8170. Fax: (212)727-8228. Director: Victoria Edwards. Estab. 1935. Stock photo agency. Has 1 million photos. Clients include: audiovisual firms, book/encyclopedia publishers, magazine publishers, newspapers.

• This agency markets images via the Picture Network International.

Needs: Interested in photos of Eastern Europe, Russia, China, CIS republics.

Specs: Uses 8×10 glossy b&w and color prints; 35mm transparencies.

Payment & Terms: Pays 50% commission. Average price per image (to clients): $200-250/photo. Negotiates fees below standard minimum prices. Offers exclusive contracts, limited regional exclusivity and nonexclusivity. Statements issued quarterly. Payment made quarterly. Photographers permitted to review account records to verify sales figures or account for various deductions. Offers one-time, electronic media and nonexclusive rights. Model/property release preferred. Captions required.

Making Contact: Arrange personal interview to show portfolio. Query with samples. Query with stock photo list. Samples kept on file. SASE. Expects minimum initial submission of 50-100 images. Reports in 1-2 weeks.

Tips: Looks for "news and general interest photos (color) with human element."

SPORTSLIGHT PHOTO, 7 Holland Rd., Sharon CT 06069. (860)364-5901. Website: http://www.fotosh ow.com/fotoshow/sportslight/. Director: Roderick Beebe. Stock photo agency. Has 500,000 photos. Clients include: ad agencies, public relations firms, corporations, book publishers, magazine publishers, news-

papers, postcard companies, calendar companies, greeting card companies and design firms.

Needs: "We specialize in every sport in the world. We deal primarily in the recreational sports such as skiing, golf, tennis, running, canoeing, etc., but are expanding into pro sports, and have needs for all pro sports, action and candid close-ups of top athletes. We also handle adventure-travel photos, e.g., rafting in Chile, trekking in Nepal, dogsledding in the Arctic, etc."

Specs: Uses 35mm transparencies.

Payment & Terms: Pays 50% commission. General price range (to clients): $100-6,000. Contract negotiable. Offers limited regional exclusivity. Contract is of indefinite length until either party (agency or photographer) seeks termination. Charges fees for catalog and CD-ROM promotions. Statements issued quarterly. Payment made quarterly. Photographers allowed to review account records to verify sales figures "when discrepancy occurs." Offers one-time rights, rights depend on client, sometimes exclusive rights for a period of time. Informs photographer and consults with them when client requests all rights. Model release required for corporate and advertising usage. (Obtain releases whenever possible.) Strong need for model-released "pro-type" sports. Captions required; include who, what, when, where, why.

Making Contact: Interested in receiving work from newer and known photographers. Query with list of stock photo subjects, "send samples *after* our response." SASE must be included. Cannot return unsolicited material. Reports in 2-4 weeks. Photo guideline sheet free with SASE.

Tips: In reviewing work looks for "range of sports subjects that shows photographer's grasp of the action, drama, color and intensity of sports, as well as capability of capturing great shots under all conditions in all sports. Well edited, perfect exposure and sharpness, good composition and lighting in all photos. Seeking photographers with strong interests in particular sports. Shoot variety of action, singles and groups, youths, male/female—all combinations. Plus leisure, relaxing after tennis, lunch on the ski slope, golf's 19th hole, etc. Clients are looking for all sports these days. All ages, also. Sports fashions change rapidly, so that is a factor. Art direction of photo shoots is important. Avoid brand names and minor flaws in the look of clothing. Attention to detail is very important. Shoot with concepts/ideas such as teamwork, determination, success, lifestyle, leisure, cooperation in mind. Clients look not only for individual sports, but for photos to illustrate a mood or idea. There is a trend toward use of real-life action photos in advertising as opposed to the set-up slick ad look. More unusual shots are being used to express feelings, attitude, etc."

TOM STACK & ASSOCIATES, 103400 Overseas Hwy., Suite 238, Key Largo FL 33037. (305)453-4344. Fax: (305)453-3868. Contact: Therisa Stack. Member of the Picture Agency Council of America (PACA). Has 1.5 million photos. Clients include: ad agencies, public relations firms, businesses, audiovisual firms, book publishers, magazine publishers, encyclopedia publishers, postcard companies, calendar companies and greeting card companies.

Needs: Wildlife, endangered species, marine-life, landscapes, foreign geography, people and customs, children, sports, abstract/art and mood shots, plants and flowers, photomicrography, scientific research, current events and political figures, Native Americans, etc. Especially needs women in "men's" occupations; whales; solar heating; up-to-date transparencies of foreign countries and people; smaller mammals such as weasels, moles, shrews, fisher, marten, etc.; extremely rare endangered wildlife; wildlife behavior photos; current sports; lightning and tornadoes; hurricane damage. Sharp images, dramatic and unusual angles and approach to composition, creative and original photography with impact. Especially needs photos on life science, flora and fauna and photomicrography. No run-of-the-mill travel or vacation shots. Special needs include photos of energy-related topics—solar and wind generators, recycling, nuclear power and coal burning plants, waste disposal and landfills, oil and gas drilling, supertankers, electric cars, geothermal energy.

Specs: Uses 35mm transparencies. Accepts images in digital format for Mac (TIFF). Send via compact disc, SyQuest or Zip disk.

Payment & Terms: Pays 50-60% commission. General price range (to clients): $150-200/color; as high as $7,000. Works on contract basis only. Contracts renew automatically with additional submissions for 3 years. Charges duping and catalog insertion fees. Statements issued quarterly. Payment made quarterly. Offers one-time and electronic media rights. Informs photographer and allows them to negotiate when client requests all rights. Model release preferred. Captions preferred.

Making Contact: Query with list of stock photo subjects or send at least 800 transparencies for consideration. SASE or mailer for photos. Reports in 2 weeks. Photo guidelines with SASE.

THE SUBJECT INDEX, located at the back of this book, lists publications, book publishers, galleries, gift and paper product companies and stock agencies according to the subject areas they seek.

Tips: "Strive to be original, creative and take an unusual approach to the commonplace; do it in a different and fresh way." Have "more action and behavioral requests for wildlife. We are large enough to market worldwide and yet small enough to be personable. Don't get lost in the 'New York' crunch—try us. Shoot quantity. We try harder to keep our photographers happy. We attempt to turn new submissions around within two weeks. We take on only the best so we can continue to give more effective service."

THE STOCK BROKER, Dept. PM, 757 Santa Fe Dr., Denver CO 80204. (303)260-7540. Fax: (303)260-7543. E-mail: quality@tsbroker.com. Website: http://www.tsbroker.com. Contact: Dawn Fink or Garth Gibson. Estab. 1981. Stock photo agency. Member of Picture Agency Council of America (PACA). Has 300,000 photos. Clients include: advertising agencies, public relations firms, audiovisual firms, businesses, book/encyclopedia publishers, magazine publishers and calendar companies.
Needs: Recreational and adventure sports, travel, nature, business/industry, people and lifestyles.
Specs: Uses 8×10 glossy b&w prints; 35mm, 2¼×2¼, 4×5 or 8×10 transparencies.
Payment & Terms: Pays 50% commission on color and b&w photos. General price range: $200-4,000. Works on contract basis only. Offers guaranteed subject exclusivity (within files). Statements issued quarterly. Payment made monthly. Offers one-time rights. Informs photographer and allows them to negotiate when client requests all rights. Model release required.
Making Contact: Query with samples. SASE. Reports in 1 month. Photo guidelines free with SASE. Market tips sheet distributed to contract photographers.

STOCK CONNECTION, INC., 110 Frederick Ave., Suite A, Rockville MD 20850. (301)251-0720. Fax: (301)309-0941. E-mail: cheryl@chd.com. Website: http://www.pickphoto.com. President: Cheryl Pickerell. Stock photo agency. Member of PACA. Has 10,000 photos in files. Clients include advertising agencies, businesses, postcard publishers, public relations firms, book publishers, calendar companies, audiovisual firms, magazine publishers, greeting card companies.
Needs: "We handle many subject categories including people, lifestyles, sports, business, concepts, landscapes, scenics, wildlife. We will help photographers place their images into catalogs."
Specs: Uses color and b&w prints, 35mm, 2¼×2¼, 4×5, 8×10 transparencies. Accepts images in digital format (PICT files no larger than 4MB).
Payment & Terms: Pays 65% commission. Average price per image (to client): $250-650. Enforces strict minimum prices. "We will only go below our minimum of $250 for certain editorial uses. We will turn away sales if a client is not willing to pay reasonable rates." Offers volume discounts to customers. Works with photographers on contract basis only. Offers nonexclusive contract. Contracts renew automatically with additional submissions for life of catalog. Photographers may cancel contract with 60 days written notice. Charges $50/image for catalog insertion. Statements issued monthly. Photographers allowed to review account records. Offers one-time rights. Informs photographers when a client requests all rights. Model and property release preferred. Photo captions required, include locations, non-obvious elements.
Making Contact: Send query letter with samples, stock photo list, tearsheets. Reports back only if interested, send non-returnable samples. Provide resume, business card, self-promotion piece or tearsheets to be kept on file. Agency will contact photographer for portfolio review if interested. Expects minimum initial submission of 100 images. Catalog available for $10. Market tips sheet available for $3.
Tips: "We market very heavily through CD-ROM and Internet technology. Based on the results we have gotten over the past five years, we are convinced this is where the market is going. The cost to advertise images in this medium is so much less than in print catalogs. The return on investment is much greater for photographers."

STOCK IMAGERY, L.L.C., 1822 Blake St.. Suite A, Denver CO 80202. (303)293-0202. Fax: (303)293-3140. E-mail: ddennis@stockimagery.com or jpalting@stockimagery.com. Website: http://www.stockimagery.com. Contact: Joaquin Palting. Estab. 1981. Stock photo agency. Member of Picture Agency Council of America (PACA). "With representation in over 50 countries worldwide, our catalogs receive maximum exposure."
Needs: Alternative processes and stylistically creative imagery of the highest quality.
Specs: Transparencies and b&w prints only; no color prints, negatives or contact sheets.
Payment & Terms: Pays 50% commission on image sales. "We have competitive prices, but under special circumstances we contact photographer prior to negotiations." Works on an image exclusive contract basis only. Statements and payments issued monthly. Photographers allowed to review account records. Offers one-time and electronic media rights. Informs photographer and allows them to negotiate when client requests all rights. Model/property release required. Captions required.
Making Contact: "We are always willing to review new photographers' work. However, we prefer to see that the individual has a subject specialty or a stylistic signature that sets them apart in this highly competitive industry. Therefore, we ask that an initial submission be properly edited to demonstrate that

they have a high degree of vision, creativity and style that can be relied upon on a regular basis. Quite simply we are looking for technically superior, highly creative images."

THE STOCK MARKET, 360 Park Ave. S., New York NY 10010. (212)684-7878. Fax: (212)532-6750. Contact: Gerry Thies or Keith Goldstein. Estab. 1981. Stock photo agency. Member of Picture Agency Council of America (PACA). Has 2 million images. Clients include: ad agencies, public relations firms, corporate design firms, book/encyclopedia publishers, magazine publishers, newspapers, postcard companies, calendar companies and greeting card companies.

● This agency publishes two printed catalogs annually, and has released its fourth *Idea* specialty CD-Rom collection of images that are Mac/PC compatible. Their image searchable website is located at http://www.stockmarketphoto.com.

Needs: Topics include lifestyle, corporate, industry, nature, travel and digital concepts.

Specs: Uses color and b&w, all formats. Houses transparencies only.

Payment & Terms: Pays 50% gross sale on color photos. Works on exclusive contract basis only. Charges catalog insertion fee of 50%/image for US edition only. Statements issued monthly. Payment made monthly. Photographers allowed to review account records to verify sales figures. Offers one-time rights. When client requests to buy all rights, "we ask permission of photographer, then we negotiate." Model/property release required for all people, private homes, boats, cars, property. Captions are required; include "what and where."

Making Contact: Send SASE for portfolio guideline information..

Tips: "The Stock Market represents work by some of the world's best photographers. Producing work of the highest caliber, we are always interested in reviewing work by dedicated professional photographers who feel they can make a contribution to the world of stock."

STOCK OPTIONS®, Dept. PM, 4602 East Side Ave., Dallas TX 75226. (214)823-6262. Fax: (214)826-6263. Owner: Karen Hughes. Estab. 1985. Stock photo agency. Member of Picture Agency Council of America (PACA). Has 200,000 photos. Clients include: ad agencies, public relations firms, audiovisual firms, corporations, book/encyclopedia and magazine publishers, newspapers, postcard companies, calendar and greeting card companies.

● This agency hopes to market work on CD-ROM in the near future.

Needs: Emphasizes the southern US. Files include Gulf Coast scenics, wildlife, fishing, festivals, food, industry, business, people, etc. Also western folklore and the Southwest.

Specs: Uses 35mm, 2¼×2¼ and 4×5 transparencies.

Payment & Terms: Pays 50% commission on color photos. General price range (to clients): $300-3,000. Works on contract basis only. Offers nonexclusive contract. Contract automatically renews with each submission to 5 years from expiration date. When contract ends photographer must renew within 60 days. Charges catalog insertion fee of $300/image and marketing fee of $6/hour. Statements issued upon receipt of payment from client. Payment made immediately. Photographers allowed to review account records to verify sales figures. Offers one-time and electronic media rights. "We will inform photographers for their consent only when a client requests all rights, but we will handle all negotiations." Model/property release preferred for people, some properties, all models. Captions required; include subject and location.

Making Contact: Interested in receiving work from full-time commercial photographers. Arrange a personal interview to show portfolio. Query with list of stock photo subjects. Contact by "phone and submit 200 sample photos." Tips sheet distributed annually to all photographers.

Tips: Wants to see "clean, in focus, relevant and current materials." Current stock requests include: industry, environmental subjects, people in up-beat situations, minorities, food, cityscapes and rural scenics.

STOCK PILE, INC., Main office: Dept. PM, 2404 N. Charles St., Baltimore MD 21218. (410)889-4243. Branch: P.O. Box 30168, Grand Junction CO 81503. (303)243-4255. Vice President: D.B. Cooper. Picture library. Has 28,000 photos. Clients include: ad agencies, art studios, slide show producers, etc.

Needs: General agency looking for well-lit, properly composed images that will attract attention. Also, people, places and things that lend themselves to an advertising-oriented marketplace.

Specs: Transparencies, all formats. Some b&w 8×10 glossies.

Payment & Terms: Pays 50% commission on b&w and color photos. Works on contract basis only. Contracts renew automatically with additional submissions. Payment made monthly. Offers one-time rights. Informs photographer and permits them to negotiate when client requests all rights. Model release preferred. Captions required.

Making Contact: Inquire for guidelines, submit directly (minimum 200) or call for personal interview. All inquiries and submissions must be accompanied by SASE. *Send all submissions to Colorado address.* Periodic newsletter sent to all regular contributing photographers.

⊠ THE STOCK SHOP, 232 Madison Ave., New York NY 10016. (212)679-8480. Fax: (212)532-1934. E-mail: stockshop@aol.com. Website: http://www.workbook.com. President: Barbara Gottlieb. Estab. 1975. Member of Picture Agency Council of America (PACA). Has over 2 million photos. Clients include: advertising agencies, public relations firms, businesses, book/encyclopedia publishers, magazine publishers, postcard companies, calendar companies and greeting card companies.
Needs: Needs photos of travel, industry and medicine. Also model-released lifestyle including old age, couples, babies, men, women, families.
Specs: Uses 35mm, 2¼×2¼, 4×5 and 8×10 transparencies.
Payment & Terms: Pays 50% commission on color photos. General price range: $250 and up. Works on exclusive contract basis only. Contracts renew automatically with each submission for length of original contract. Charges catalog insertion fee of 7½%/image. Statements issued monthly. Payment made monthly. Offers one-time rights. Does inform photographer of client's request for all rights. Model release required. Captions required.
Making Contact: Arrange a personal interview to show portfolio. Submit portfolio for review. SASE. Tips sheet distributed as needed to contract photographers only.
Tips: Wants to see "a cross section of the style and subjects the photographer has in his/her library. 200-300 samples should tell the story. Photographers should have at least 1,000 in their library. Photographers should not photograph people *before* getting a model release. The day of the 'grab shot' is over."

⊠ ⊕ STOCK SHOT, 27 Hartington Place, Edinburgh EH1O 4LF United Kingdom. Phone: (0131)228-9368. Fax: (0131)228-9464. E-mail: info@stockshot.co.uk. Website: http://www.stockshot.co.uk. Office Manager: Jemma Wallace. Estab. 1988. Picture library. Has 50,000 photos in file. Clients include: advertising agencies, public relations firms, businesses, book publishers, magazine publishers, newspapers, calendar companies, tour operators.
Needs: Extreme adventure sports—skiing, mountaineering, snowboarding etc.
Specs: Uses 35mm transparencies.
Payment/Terms: Pays 50% commission for color photos. Average price per image (to clients): $100 minimum for color. Negotiates fees below stated minimums "depending on circumstances e.g. discount for quality usage." Offers volume discounts to customers. Photographers can choose not to sell images on discount terms. Works with photographers on contract basis only. Offers nonexclusive contract. Photographers allowed to review account records. Offers one-time rights. Model release required. Photo captions required.
Making Contact: Send query letter with stock photo list. Agency will contact photographer for portfolio review if interested. Portfolio should include slides. Will return material with SASE. Photo guidelines sheet free with SASE. Catalog free with SASE.
Tips: "Take on board the fact that we are an adventure sports library. Scenic shots just won't be accepted."

⊠ ⊕ STOCKFILE, 5 High St., Sunningdale, Berkshire SL5 0LX England. Phone: (+44)1344 872249. Fax: (+44)1344 872263. E-mail: sbehr@cix.co.uk. Library Manager: Jill Behr. Estab. 1989. Stock photo agency. Member of British Association of Picture Libraries and Agencies (BAPLA). Has 50,000 photos in files. Clients include: advertising agencies, public relations firms, businesses, book publishers, magazine publishers, newspapers and calendar companies.
Needs: Images of cycling, skiing, mountain biking and snowboarding; need shots in USA, Canada and worldwide ski resorts.
Specs: Uses 35mm transparencies.
Payment/Terms: Pays 50% commission for color photos. Average price per image (to clients): $40-1,000 for color. Offers volume discounts to customers. Discount sales terms not negotiable. Works with photographers with or without a contract, negotiable. Offers nonexclusive contract. Charges for marketing and administrative costs are "negotiable—no charges made without consultation." Statements issued semiannually; payments made semiannually. Photographers allowed to review account records in cases of discrepancies only. Offers one-time rights. Informs photographer and allows them to negotiate when client requests all rights. Model release preferred. Photo captions required; include location.
Making Contact: Send query letter with stock photo list. Expects minimum initial submission of 50 images with annual submissions of at least 50 images. Reports back only if interested, send non-returnable samples. Photo guidelines sheet free with SASE. Market tips sheet not available.
Tips: "Edit out unsharp or badly exposed pictures, and caption properly."

THE STOCKHOUSE, INC., 3301 W. Alabama, Houston TX 77098. (713)942-8400. Fax: (713)526-4634. E-mail: staff@stockhouse-houston.com. Website: http://www.stockhouse-houston.com. Director, Sales & Marketing: Celia Jumonville. Estab. 1980. Stock photo agency. Has 500,000 photos on file. Clients include: advertising agencies, public relations firms, audiovisual firms, businesses, book publishers,

magazine publishers, newpapers, calendar companies, greeting card companies, postcard publishers, anyone who needs photos.

Needs: Industry, lifestyles, travel, medical.

Specs: Uses color prints; 35mm, $2\frac{1}{4} \times 2\frac{1}{4}$, 4×5 transparencies.

Payment/Terms: Pays 50% commission for color prints. Average price per image (to clients): $250 minimum. "Prices are based on usage only. Minimum is $250 printed and negotiable for exclusive or layouts." Offers volume discounts to customers. Works with photographers on contract basis only. Offers limited regional exclusivity. Contracts are valid until canceled. Photographers allowed to review account records by appointment. Offers one-time rights. Inform photographers and allows them to negotiate when a client requests all rights. Model release preferred; property release preferred. Photo captions required; include location, specific type of industry shown.

Making Contact: Send query letter. Portfolios may be dropped off Monday-Friday. Agency will contact photographer for portfolio review if interested. Portfolio should include color slides, transparencies. Expects minimum initial submission of 200-300 images with quarterly submissions of at least 200 images. Photo guidelines sheet free with SASE. Market tips sheet available quarterly to photographers, free with SASE.

N ☒ **TONY STONE IMAGES, INC.**, 6100 Wilshire Blvd., #1250, Los Angeles CA 90048. (213)938-1700. (Offices in 25 locations worldwide). Director of Photography: Charlie Holland. Estab. in US 1988, worldwide 1968. Stock photo agency. Member of Picture Agency Council of America (PACA). Clients include: advertising agencies; public relations firms; audiovisual firms; businesses; book/encyclopedia publishers; magazine publishers; newspapers; calendar, greeting card and travel companies.

Needs: Very high quality, technically and creatively excellent stock imagery on all general subjects for worldwide and US distribution.

Specs: Wants to see great images in any format—print, transparencies or digital. "Large and medium format transparencies are always put into our custom mounts, so you do not have to mount them. We do, however, want them submitted (with acetate sleeves) in appropriately-sized viewing sheets." As for digital submissions "at the moment, only high resolution drum scans will yield image files of the quality and resolution to meet our standards."

Making Contact: "Please do not send unsolicited images. Call our Creative Department for free submission guidelines." Expects minimum initial submission of 50 images.

Tips: Wants to see "technical ability, creativity, commitment to high standards." Sees increased demand for high quality. "If you can't shoot better imagery than that already available, don't bother at all."

☒ **SUPERSTOCK INC.**, 7660 Centurion Pkwy, Jacksonville FL 32256. (904)565-0066. E-mail: superstk@superstock.images.com. Photographer Liaison: Dawn Hendel. Photographer Development: Renee Hawkins. Photo Editor: Vincent Hobbs. International stock photo agency represented in 38 countries. Extensive contemporary, vintage and fine art collections available for use by clients. Clients include: ad agencies, public relations firms, audiovisual firms, businesses, book/encyclopedia publishers, magazine publishers, newspapers, postcard companies, calendar companies, greeting card companies and major corporations.

Needs: "We are a general stock agency involved in all markets. Our files are comprised of all subject matter."

Specs: Uses small and large format transparencies and prints

Payment & Terms: "We work on a contract basis." Statements issued monthly. Photographers allowed to review account records to verify sales figures. Rights offered "vary, depending on client's request." Informs photographer when client requests all rights. Model release required. Captions required.

Making Contact: Query with samples. "When requested, we ask that you submit a portfolio of a maximum of 200 original transparencies, duplicate transparencies or prints as your sample. If we need to see additional images, we will contact you." Reports in approximately 3 weeks. Photo guidelines free if requested via mail, e-mail or phone. Newsletter distributed quarterly to contributing photographers.

Tips: "We are interested in seeing fresh, creative images that are on the cutting edge of photography. We are particularly interested in lifestyles, people, sports, still life, digital concepts, business and industry, as well as other images that show the range of your photography."

SWANSTOCK AGENCY INC., 100 N. Stone, Suite 1105, Tucson AZ 85701. (520)622-7133. Fax: (520)622-7180. Contact: Submissions. Estab. 1991. Stock photo agency. Has 100,000 photos. Clients include: ad agencies, public relations firms, book/encyclopedia publishers, magazine publishers, newspapers, design firms, record companies and inhouse agencies.

Needs: Swanstock's image files are artist-priority, not subject-driven. Needs range from photo-illustration to realistic family life in the '90s. (Must be able to provide releases upon submission.)

Specs: Uses 8×10 or smaller color and b&w prints; 35mm, $2\frac{1}{4} \times 2\frac{1}{4}$, 4×5, 8×10 transparencies. Send

dupes only.

Payment & Terms: Pays 50% commission on stock sale. Average price per image (to clients): $200-1,000. Negotiates fees below standard minimum prices if agreeable to photographer in exchange for volume overrun of piece for promotional needs. Works on contract basis only. Photographers provide all dupes for agency files. Statements issued upon sales only, within 2 months of payment by client. Photographers allowed to review account records by appointment only. "We sell primarily one-time rights, but clients frequently want one of the following arrangements: one year, domestic only; one year, international; one year with an option for an immediate second year at a predetermined price; one year, unlimited usage for a specific market only; one year, unlimited usages within ALL markets; all rights for the life of that specific edition only (books) and so forth." Informs photographer when client requests all rights. Releases and captions required.

Making Contact: Interested in receiving work from lesser-known photographers with accomplished work. Send SASE to receive submission details. Keeps samples on file. SASE. Reporting time may be longer than 1 month.

Tips: "We look for bodies of work that reflect the photographer's consistent vision and sense of craft—whether their subject be the landscape, still lifes, family, or more interpretive illustration. Alternative processes are encouraged (i.e., Polaroid transfer, hand-coloring, infrared films, photo montage, pinhole and Diana camera work, etc.). Long-term personal photojournalistic projects are of interest as well. We want to see the work that you feel strongest about, regardless of the quantity. Artists are not required to submit new work on any specific calendar, but rather are asked to send new bodies of work upon completion. We do not house traditional commercial stock photography, but rather work that was created by fine art photographers for personal reasons or for the gallery/museum arena. The majority of requests we receive require images to illustrate an emotion, a gesture, a season rather than a specific place geographically or a particular product. Our goal with each submission to clients is to send as many different photographers' interpretations of their need, in as many photographic processes as possible. We communicate with our clients in order to keep the usages within the original intent of the photographer (i.e., submitting proofs of desired placement of copy, wrapping an image around a book jacket, etc.) and frequently place the artist in communication with the client with regard to creative issues. Swanstock offers a nonexclusive contract and encourages photographers to place specific bodies of their work with the appropriate agency(s) for maximum return. We do NOT publish a catalog and ask that photographers supply us with appropriate promotional materials to send to clients. Under no circumstances should artists presume they will make a living on fine art stock in the way that commercial stock shooters do. However, we are confident that this 'niche' market will continue to improve, and encourage artists who previously felt there was no market for their personal work to contact us."

TAKE STOCK INC., 307, 319 Tenth Ave. SW, Calgary, Alberta T2R 0A5 Canada. (403)261-5815. Fax: (403)261-5723. Estab. 1987. Stock photo agency. Clients include: ad agencies, public relations firms, audiovisual firms, corporate, book/encyclopedia publishers, magazine publishers, newspapers, postcard companies, calendar companies and greeting card companies.

Needs: Model-released people, lifestyle images (all ages), Asian people, Canadian images, arts/recreation, industry/occupation, business, high-tech, beach scenics with and without model released people.

Specs: Uses 35mm, medium to large format transparencies.

Payment & Terms: Pays 50% commission on transparencies. General price range (to clients): $300-700. Works on contract basis only. Offers limited regional exclusivity. Contracts renew automatically with additional submissions for 3 year terms. Charges 100% duping and catalog insertion fees. Statements issued monthly. Payment made monthly. Photographers allowed to review account records to verify sales figures, "with written notice and at their expense." Offers one-time, exclusive and some multi-use rights; some buy-outs with photographer's permission. Model/property release required. Captions required.

Making Contact: Query with list of stock photo subjects. SASE. Reports in 3 weeks. Photo guidelines free with SASE. Tips sheet distributed every 2 months to photographers on file.

TANK INCORPORATED, Box 212, Shinjuku, Tokyo 160-91, Japan. Phone: 81-3-3239-1431. Fax: 81-3-3230-3668. Telex: 26347 PHTPRESS. E-mail: max-tank@mx2.nisiq.net. President: Masayoshi Seki. Has 500,000 slides. Clients include: advertising agencies, encyclopedia/book publishers, magazine publishers and newspapers.

Needs: "Women in various situations, families, special effect and abstract, nudes, scenic, sports, animal, celebrities, flowers, picture stories with texts, humorous photos, etc."

Specs: Uses 8×10 b&w prints; 35mm, $2\frac{1}{4} \times 2\frac{1}{4}$ and 4×5 slides; b&w contact sheets; videotape. Accepts images in digital format for Mac. Send via CD or online.

Payment & Terms: Pays 40% commission on b&w and color photos. "As for video, we negotiate at case by case basis." General price range: $70-1,000. Works on contract basis only. Offers limited regional

exclusivity within files. Contracts renew automatically with each submission for 3 years. Statements issued monthly. Payment made monthly; within 45 days. Photographers allowed to review account records to verify sales figures. Offers one-time rights. Informs photographer and allows them to negotiate when client requests all rights. Model and property release is required for glamour/nude sets. Photo captions required.
Making Contact: Query with samples, with list of stock photo subjects or send unsolicited material by mail for consideration. SASE. Reports in 1 month. Photo guidelines free with International Reply Coupons.
Tips: "We need some pictures or subjects which strike viewers. Pop or rock musicians are very much in demand. If you want to make quick sales, give us some story ideas with sample pictures which show quality, and we will respond to you very quickly. Also, give us brief bio. Color transparencies with sample stories to accompany—no color prints at all. Stock photography business requires patience. Try to find some other subjects than your competitors. Keep a fresh mind to see saleable subjects." Remarks that "photographers should have eyes of photo editor. Try to take photos which make editors use them easily. Also, give a little background of these photos."

TERRAPHOTOGRAPHICS, Box 490, Moss Beach CA 94038. Phone/fax: (650)359-6219. E-mail: Bpsterra@aol.com. Website: http://www.agpix.com/biologicalphoto.shtml. Photo Agent: Carl May. Estab. 1985. Stock photo agency. Has 30,000 photos on hand. Clients include: ad agencies, businesses, book/encyclopedia publishers and magazine publishers.
Needs: All subjects in the earth sciences: geological features seen from space, paleontology, volcanology, seismology, petrology, oceanography, climatology, mining, petroleum industry, meteorology, physical geography. Stock photographers must be scientists. "Currently, we need more on energy conservation, gems, economic minerals, volcanic eruptions, earthquakes, floods and severe weather."
Specs: Uses 8×10 glossy b&w prints; 35mm, $2\frac{1}{4} \times 2\frac{1}{4}$, 4×5 and 8×10 transparencies.
Payment & Terms: Pays 50% commission on all photos. General price range (to clients): $90-500. Works with or without a signed contract, negotiable. Offers exclusive contract only. Statements issued quarterly. Payment quarterly within 1 month of end of quarter. Photographers allowed to review account records to verify sales figures. Offers one-time rights and electronic media rights for specific projects only; other rights negotiable. Informs photographer and allows participation when client requests all rights. Model release required for any commercial use, but not purely editorial. Thorough photo captions required; include "all information necessary to identify subject matter and give geographical location."
Making Contact: Will consider work from newer, lesser-known scientist-photographers as well as established professionals. Query with list and résumé of scientific and photographic background. SASE. Reports in 2 weeks. Photo guidelines free with query, résumé and SASE. Tips sheet distributed intermittently only to stock photographers.
Tips: Prefers to see "proper exposure, maximum depth of field, interesting composition, good technical and general information in caption, scientists at work using modern equipment. We are a suitable agency only for those with both photographic skills and sufficient technical expertise to identify subject matter. We only respond to those who provide a rundown of their scientific and photographic background and at least a brief description of coverage. Captions must be neat and contain precise information on geographical locations. Don't waste your time submitting images on grainy film. Our photographers are able to distinguish between dramatic, compelling examples of phenomena and run-of-the-mill images in the earth and environmental sciences. We need more on all sorts of weather phenomena; the petroleum and mining industries from exploration through refinement; problems and management of toxic wastes; environmental problems associated with resource development; natural areas threatened by development; and oceanography."

🌐 **TROPIX PHOTOGRAPHIC LIBRARY**, 156 Meols Parade, Meols, Merseyside L47 6AN England. Phone/fax: 151-632-1698. Website: http://www.merseyworld.com/Tropix. Proprietor: Veronica Birley. Picture library specialist. Has 50,000 transparencies. Clients include: book/encyclopedia publishers, magazine publishers, newspapers, government departments, public relations firms, businesses, calendar/card companies and travel agents.
Needs: "All aspects of the developing world and the natural environment. Detailed and accurate captioning according to Tropix guidelines is essential. Tropix documents the developing world from its economy and environment to its society and culture: education, medicine, agriculture, industry, technology and other developing world topics. Particularly need to show positive, modern aspects. Plus the full range of environ-

CONTACT THE EDITOR, of *Photographer's Market* by e-mail at photomarket@fwpubs.com with your questions and comments.

mental topics worldwide; only very recent stock except for historical prints."

Specs: Uses 35mm and medium format transparencies; some large format.

Payment & Terms: Pays 50% commission. General price range (to clients): £70-250 (English currency). Offers guaranteed subject exclusivity. Charges cost of returning photographs by insured/registered post, if required. Statements made quarterly with payment. Photographers allowed to have qualified auditor review account records to verify sales figures in the event of a dispute but not as routine procedure. Offers one-time, electronic media and agency promotion rights. Other rights only by special written agreement. Informs photographer when a client requests all rights but agency handles negotiation. Model release preferred, for commercial use and for medical images. Full photo captions required; accurate, detailed data, to be supplied on disk. It is essential to follow guidelines available from agency.

Making Contact: Query with list of stock photo subjects and destinations, plus SASE (Stamped International Reply Paid Coupon to value of £3). "*No* unsolicited photographs, please." Reports in 1 month, sooner if material is topical. "On receipt of our leaflets, a very detailed reply should be made by letter. Transparencies are requested only after receipt of this letter, if the collection appears suitable. When submitting transparencies, always screen out those which are technically imperfect."

Tips: Looks for "special interest topics, accurate and informative captioning, sharp focus always, correct exposure, strong images and an understanding of and involvement with specific subject matters. Travel scenes, views and impressions, however artistic, are not required except as part of a much more informed, detailed collection. Not less than 150 saleable transparencies per country photographed should be available." Sees a trend toward electronic image grabbing and development of a pictorial data base.

N ULTRASTOCK, INC., 6460 N. 77th Way, Scottsdale AZ 85250. Phone/fax: (602)596-0099. E-mail: sherilyn1@prodigy.net. President: Sherilyn McLain. Estab. 1997. Stock photo agency. Has 20,000 photos in files. Clients include: advertising agencies, public relations firms, businesses, book publishers, magazine publishers, newspapers, calendar companies, greeting card companies, postcard publishers.

Needs: Animals, business, food, lifestyle, medical, people, sports, transportation, travel/scenic, and need ethnic people—all ages.

Specs: Uses color prints; 35mm, 2¼ × 2¼ transparencies.

Payment/Terms: Pays 50% commission on b&w and color photos. Average price per image (to clients): $125 minimum for b&w and color. Enforces strict minimum prices. Works with photographers on contract basis only. Offers nonexclusive contract, guaranteed subject exclusivity. Statements issued when paid—comes with check. "When we get paid, photographer gets paid." Photographers allowed to review account records "for their own account only." Model release required; property release is required; include recognizable people and places (privately owned). Photo captions required; include who, what, when, where and © with name.

Making Contact: Send query letter with sample, stock photo list, e-mail address. Agency will contact photographer for portfolio review if interested. Keeps samples on file. Will return material with SASE. Expects minimum initial submission of 50 images. Reports in 1 month. Photo guidelines free with SASE. Market tips sheet free monthly to photographers signed with us.

Tips: Marketing images via computer networks and CD-ROMs "is the way of the future. Until we can be sure there are 100% foolproof ways to protect images on-line, we will not take the chance on behalf of our photographers. As for CD-ROMs, they are time consuming to peruse, and no way to guarantee to clients who/where else images are going and how used. Not a fan of royalty-free. When submitting work, group submissions in categories/subjects, find out what our needs are before submitting, caption either on label or at least on paper so we don't have to guess!"

UNICORN STOCK PHOTOS L.L.C., 6501 Yankee Hill Rd., Lincoln NE 68516. (402)423-4747. Fax: (402)423-4742. E-mail: info@unicorn-photos.com. Website: http://www.unicorn-photos.com. President/Owner: Carol Prange. Has over 350,000 color slides. Clients include: ad agencies, corporate accounts, textbooks, magazines, calendars and religious publishers.

Needs: Ordinary people of all ages and races doing everyday things at home, school, work and play. Current skylines of all major cities, tourist attractions, historical, wildlife, seasonal/holiday, and religious subjects. "We particularly need images showing two or more races represented in one photo and family scenes with BOTH parents. There is a critical need for more minority shots including Hispanics, Asians and African-Americans. We also need ecology illustrations such as recycling, pollution and people cleaning up the earth."

Specs: Uses 35mm color slides.

Payment & Terms: Pays 50% commission. General price range (to clients): $50-400. Works on contract basis only. Offers nonexclusive contract. Contracts renew automatically with additional submissions for 4 years. Charges duping fee of $5. Statement issued quarterly. Payment made quarterly. Offers one-time rights, electronic media rights and agency promotion rights. Informs photographer and allows them to

negotiate when client requests all rights. Model release preferred; increases sales potential considerably. Photo captions required; include: location, ages of people, dates on skylines.

Making Contact: Write first for guidelines. "We are looking for professionals who understand this business and will provide a steady supply of top-quality images. At least 500 images are generally required to open a file. Contact us by letter including $10 for our 'Information for Photographers' package."

Tips: "We keep in close, personal contact with all our photographers. Our monthly newsletter is a very popular medium for doing this. Our biggest need is for minorities and interracial shots. Because UNICORN is in the Midwest, we have many requests for farming/gardening/agriculture/winter and general scenics of the Midwest."

UNIPHOTO PICTURE AGENCY, a Pictor Group company, 3307 M St. NW, Suite 300, Washington DC 20007. (202)333-0500. Fax: (202)338-5578. Art Director: Keith Simonsen. Estab. 1977. Stock photo agency. Has more than 750,000 photos. Has 22 other branch offices worldwide. US photographers contact Washington DC. European photographers please see Pictor International in this section. Clients include: advertising agencies, public relations firms, audiovisual firms, businesses, book/encyclopedia publishers, magazine publishers, postcard publishers, calendar companies, greeting card companies and travel agencies.

• In 1997, Uniphoto acquired the photo library of F-Stock, Inc. and has moved the F-Stock library and roster to the Uniphoto West Office.

Needs: Uniphoto is a general library and requires all stock subjects.

Specs: Uses 35mm, $2\frac{1}{4} \times 2\frac{1}{4}$, 4×5 transparencies.

Payment & Terms: Buys photos outright only occasionally. Payment "depends on the pictures." Takes 50% commission on licensing revenues received by Uniphoto. Average fee per image (to clients): $250-30,000. Enforces minimum prices. Works on contract basis only. Offers exclusive contract. "Under special circumstances, contract terms may be negotiated." Contracts renew automatically with additional submissions for 5 years. Charges various rates for catalog insertion fees. Statements issued monthly. Payment made monthly within $3\frac{1}{2}$ months. Offers one-time and all other commercial rights. When client requests all rights we negotiate with photographer's permission. Model/property release required. Captions required.

Making Contact: Query with résumé of credits and non-returnable samples. Keeps samples on file. SASE. Reports in 4 months on queries; up to 2 weeks on portfolio submissions. Portfolio submission guidelines free with SASE. Market tips sheet distributed to Uniphoto photographers only.

Tips: "Portfolios should demonstrate the photographer's creative and technical range. We seek professional photographers and accomplished fine artists with commercial potential as well as experienced stock photographers."

THE VIESTI COLLECTION, INC., P.O. Box 4449, Durango CO 81302. (970)382-2600. Fax: (970)382-2700. E-mail: photos@theviesticollection.com. President: Joe Viesti. Estab. 1987. Stock photo agency. Has 30 affiliated foreign sub-agents. Clients include: ad agencies, businesses, book/encyclopedia publishers, magazine publishers, calendar companies, greeting card companies, design firms.

• Viesti is involved with digital transmission of images via website. Viesti is "dead set against clip art sales."

Needs: "We are a full service agency."

Specs: Uses 35mm, $2\frac{1}{4} \times 2\frac{1}{4}$, 4×5, 6×7, 8×10 transparencies; both color and b&w transparencies; all film formats.

Payment & Terms: Charges 50% commission. "We negotiate fees above our competitors on a regular basis." Works on contract basis only. "Catalog photos are exclusive." Contract renews automatically upon expiration for 5 years. Charges duping fees "at cost. Many clients now require submission of dupes only." Statements issued quarterly. "Payment is made quarterly after payment is received. Rights vary. Informs photographer and allows them to negotiate when client requests all rights. Model/property release preferred. Captions required.

Making Contact: Query with samples. Send no originals. Send dupes or tearsheets only with bio info and size of available stock; include return postage if return desired. Samples kept on file. Expects minimum submissions of 500 edited images; 100 edited images per month is average. Submissions edited and returned usually within one week. Catalog available for fee, depending upon availability.

Tips: There is an "increasing need for large quantities of images for interactive, multimedia clients and traditional clients. No need to sell work for lower prices to compete with low ball competitors. Our clients regularly pay higher prices if they value the work."

VIREO (Visual Resources for Ornithology), The Academy of Natural Sciences, 1900 Benjamin Franklin Pkwy, Philadelphia PA 19103-1195. (215)299-1069. Fax: (215)299-1182. E-mail: vireo@acnatsci. org. Website: http://www.acnatsci.org/vireo. Director: Doug Wechsler. Estab. 1979. Picture library. "We specialize in birds only." Has 90,000 photos in files. Clients include: advertising agencies, businesses,

book publishers, magazine publishers, newspapers, calendar companies, CD-ROM publishers.

Needs: "High-quality photographs of birds from around the world with special emphasis on behavior. All photos must be related to birds or ornithology."

Specs: Uses 35mm, 2¼×2¼ transparencies.

Payment/Terms: Pays 50% for b&w and color photos. Negotiates fees below stated minimums; "we deal with many small nonprofits as well as commercial clients." Offers volume discounts to customers. Discount sales terms not negotiable. Works with photographers on contract basis only. Offers nonexclusive contract. Statements issued semiannually; payments made semiannually. Offers one-time rights. Model release preferred. Photo captions preferred; include date, location.

Making Contact: Send query letter. To show portfolio, photographer should follow-up with a call. Reports in 1 month on queries. Catalog not available.

Tips: "We are currently sending scanned images to clients over the Internet. We expect to expand electronic offerings dramatically in the future. Edit work carefully."

VISIONQUEST, P.O. Box 8005, Charlotte NC 28203. (704)525-4800; (800)801-6717. Fax: (704)525-7030. E-mail: atvisionquest@mindspring.com. Owner: Pamela Brackett. Estab. 1994. Has 200,000 photos. Clients include: advertising agencies, businesses, newspapers, postcard publishers, public relations firms, book/encyclopedia publishers, calendar companies, audiovisual firms, magazine publishers and greeting card companies.

Needs: Uses transparencies.

Payment & Terms: Pays 50% commission on b&w and color photos. Offers volume discounts to customers; terms specified in photographer's contract. Works on contract basis only. Offers limited regional exclusivity contracts. Contracts renew automatically with additional submissions after 5 years. Statements issued annually. Payment made semi-annually. Offers one-time rights. "If client pays more they can get more usage rights." This is not recommended, but we will negotiate with client if approved by photographer. Model release required. Property release preferred. Captions required.

Making Contact: Query with résumé of credits. Query with samples. Query with stock photo list. Keeps samples on file. SASE. Expects minimum intial submission of 200 images. Reports in 1-2 weeks. Photo guidelines free with SASE. Catalog available. Market tips sheet distributed weekly to photographers with agency; free by fax or e-mail. VisionQuest offers seminars and lectures to organizations and clients.

Tips: Looking for "professional photographers with excellence, creativity and personal style who are committed to shooting stock."

■ VISUAL CONTACT, 67 Mowat Ave., Suite 241, Toronto, Ontario M6K 3E3 Canada. (416)532-8131. Fax: (416)532-3792. E-mail: viscon@interlog.com. Website: http://www.interlog.com/~viscon. President: Thomas Freda. Library Administrator: Laura Chen. Estab. 1990. Stock photo agency. Has applied to become PACA member. Has 30,000 photos. Clients include: ad agencies, public relations firms, businesses, book/encyclopedia publishers, magazine publishers, calendar companies, greeting card companies.

Needs: Interested in photos of people/lifestyle, people/corporate, industry, nature, travel, science and technology, medical, food.

Specs: Uses transparencies.

Payment & Terms: Pays 50% commission on color photos. Offers volume discounts to customers; inquire about specific terms. Works with or without signed contract, negotiable. Offers exclusive only, limited regional, nonexclusive, or guaranteed subject exclusivity contracts. Contracts renew automatically with additional submissions for 1 year (after first 5 years). Charges 100% duping fee, 100% mounting, 100% CD/online service. Statements issued quarterly. Payment made quarterly. Photographers allowed to review account records in cases of discrepancies only. Offers one-time rights. Informs photographer and allows them to negotiate when client requests all rights. Model/property release required. Captions required; include location, specific names, i.e. plants, animals.

Making Contact: Arrange personal interview to show portfolio. Query with résumé of credits, samples and/or stock photo list. Keeps samples on file. SASE. Expects minimum initial submission of 100-200 images. Reports in 4-6 weeks. Photo guidelines free with SASE. Market tips sheet distributed free with SASE; also available, along with periodic newsletter, at website.

VISUALS UNLIMITED, Dept. PM, P.O. Box 10246, East Swanzey NH 03446-0146. (603)352-6436. Fax: (603)357-7931. President: Dr. John D. Cunningham. Stock photo agency and photo research service. Has 500,000 photos. Clients include: ad agencies, public relations firms, audiovisual firms, businesses, book/encyclopedia publishers, magazine publishers, CD-ROM producers, television and motion picture companies, postcard companies, calendar companies and greeting card companies.

Needs: All fields: biology, environmental, medical, natural history, geography, history, scenics, chemistry, geology, physics, industrial, astronomy and "general."

Specs: Uses 5×7 or larger b&w prints; 35mm, 2¼×2¼, 4×5 and 8×10 transparencies.

Payment & Terms: Pays 50% commission for b&w and color photos. Negotiates fees based on use, type of publication, user (e.g., nonprofit group vs. publisher). Average price per image (to clients): $30-90/b&w photo; $50-190/color photo. Offers volume discounts to customers; terms specified in contract. Photographers can choose not to sell images on discount terms. Works on contract basis only. Offers nonexclusive contract. Contracts renew automatically for an indefinite time unless return of photos is requested. Statements issued monthly. Payment made monthly. Photographers not allowed to review account records to verify sales figures; "All payments are exactly 50% of fees generated." Offers one-time rights. Informs photographer and allows them to negotiate when client requests all rights. Model release preferred. Captions required.

Making Contact: Query with samples or send unsolicited photos for consideration. Submit portfolio for review. SASE. Reports in 3 weeks. Photo guidelines free with SASE. Distributes a tips sheet several times/year as deadlines allow, to all people with files.

Tips: Looks for "focus, composition and contrast, of course. Instructional potential (e.g., behavior, anatomical detail, habitat, example of problem, living conditions, human interest). Increasing need for exact identification, behavior, and methodology in scientific photos; some return to b&w as color costs rise. Edit carefully for focus and distracting details; submit anything and everything from everywhere that is geographical, biological, geological, environmental, and people oriented."

WESTLIGHT, 2223 S. Carmelina Ave., Los Angeles CA 90064. (310)820-7077. Fax: (310)820-2687. Website: http://www.westlight.com. Owner: Craig Aurness. Estab. 1977. Stock photo agency. Member of Picture Agency Council of America (PACA). Has 3 million photos. Clients include: advertising agencies, public relations firms, audiovisual firms, corporations, book/encyclopedia publishers, magazine publishers, newspapers, postcard companies, calendar companies, greeting card companies and TV.

Needs: Needs photos of all top quality subjects.

Specs: Uses 35mm, 2¼×2¼, 4×5 transparencies.

Payment & Terms: Pays 50% commission. Works on contact basis only. Offers nonexclusive and limited regional exclusivity contracts. Statements issued quarterly. Payment made quarterly; within 45 days of end of quarter. Photographers allowed to review account records to verify sales figures. Offers one-time rights, electronic media and agency promotion rights. Model/property release required for recognizable people and private places. Captions required.

Making Contact: Send query letter. Provide résumé, business card, self promotion piece to be kept on file. Cannot return material. Reports in 1 month. Photo guidelines free with SASE. Tips sheet distributed monthly to contract photographers. Send tearsheets only, no unsolicited photos.

Tips: "Photographers must request application in writing only. All other approaches will not be answered. Send samples that do not have to be returned. Good photocopies are sufficient in the early stages of agency introduction."

THE WILDLIFE COLLECTION, Division of Cranberry Press Inc., 69 Cranberry St., Brooklyn NY 11201. (718)935-9600. Fax: (718)935-9031. E-mail: office@wildlifephoto.com. Website: http://www.wildlifephoto.com. Director: Sharon A. Cohen. Estab. 1987. Stock photo agency. Has 250,000 photos. Clients include: ad agencies, public relations firms, businesses, book/encyclopedia publishers, magazine publishers, newspapers, postcard companies, calendar companies, greeting card companies, zoos and aquariums.

- The Wildlife Collection has scanned thousands of images onto CD-ROM which they use for promotion.

Needs: "We handle anything to do with nature—animals, scenics, vegetation, underwater. We are in particular need of coverage from India, the Caribbean, Europe, Western Africa and the Middle East, as well as endangered animals, in particular chimpanzees, bonobos and California Condors. We also need pets and farm animals."

Specs: Uses 35mm, 2¼×2¼, 4×5, 6×4½ transparencies.

Payment & Terms: Pays 50% commission on color photos. General price range (to clients): $100-6,000. Works on contract basis only. Minimum US exclusivity but prefers world exclusivity. Contracts renew automatically for 1 year. There are no charges to be included in catalogs or other promotional materials. Statements issued quarterly. Payment made quarterly. Photographers allowed to review sales figures. Offers one-time rights. Informs photographers when client requests all rights, "but they can only negotiate through

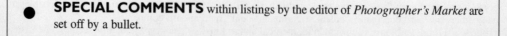
● **SPECIAL COMMENTS** within listings by the editor of *Photographer's Market* are set off by a bullet.

us—not directly." Model release "not necessary with nature subjects." Photo captions required; include common, scientific name and location where taken.

Making Contact: Interested in receiving work from newer, lesser-known photographers, as well as more established photographers. Query with samples. SASE. Expects minimum initial submission of 200 images. "We would like 2,000 images/year; this will vary." Reports in 2 weeks. Photo guidelines and free catalog with 6½×9½ SAE with 78¢ postage. Market tips sheet distributed quarterly to signed photographers only.

Tips: In samples wants to see "great lighting, extreme sharpness, *non-stressed* animals, large range of subjects, excellent captioning, general presentation. Care of work makes a large impression. The effect of humans on the environment is being requested more often as are unusual and endangered animals."

WILDLIGHT PHOTO AGENCY, 87 Gloucester St., The Rocks, NSW 2000 Australia. Phone: 61-2-9251-5852. Fax: 61-2-9251-5334. E-mail: wild@geko.com.au Website: http://www.wildlight.com.au Contact: Manager. Estab. 1985. Photo agency and picture library. Has 300,000 photos. Clients include: ad agencies, public relations firms, audiovisual firms, businesses, book/encyclopedia publishers, magazine publishers, newspapers, postcard publishers, calendar companies, greeting card companies.

Specs: Uses 35mm, 4×5, 6×12, 6×17 transparencies.

Payment & Terms: Pays 50% commission on color photos. Works on exclusive contract basis only. Statements issued quarterly. Payment made quarterly. Offers one-time rights. Model/property release required. Captions required.

Making Contact: Arrange personal interview to show portfolio. Expects minimum initial submission of 1,000 images with periodic submission of at least 250/month. Reports in 1-2 weeks. Photo guidelines available.

WORLD PICTURES, 85A Great Portland St., London W1N 5RA England. Phone: (0171)437 2121. Fax: (0171)439 1307. Director: Carlo Irek. Stock photo agency. Has 750,000 photos in files. Clients include advertising agencies, businesses, book publishers, magazine publishers, newspapers, calendar companies, postcard publishers, tour operators.

Specs: Uses 35mm, 2¼×2¼ transparencies.

Payment/Terms: Pays 50% commission. Discounts offered to valued clients making volume use of stock images. Discount sales terms not negotiable. Works with photographers with or without a contract, negotiable. Offers limited regional exclusivity. Contracts renew automatically with additional submissions. Statements issued quarterly. Payments made quarterly. Offers one-time rights. Model release required; property release preferred. Photo captions required.

Making Contact: Send query letter with samples. To show portfolio, photographer should follow-up with call. Portfolio should include transparencies. Reports in 2 weeks. Catalog not available.

Tips: "We are planning to market images via computer networks and CD-ROMs in the future."

WORLDWIDE IMAGES, P.O. Box 150547, San Rafael CA 94915. (415)459-0627. Owner: Norman Buller. Estab. 1988. Stock photo agency. Has 4,000 photos. Clients include: publishers, magazine publishers, postcard companies, calendar companies, greeting card companies and men's magazines, foreign and domestic.

Needs: Nude layouts for men's magazines, foreign and domestic; celebrities, rock stars, all professional sports teams, amateur X-rated videos and photos, glamour, swimsuit—"anything in this field!"

Specs: Uses slides and transparencies, VHS videos. "We need videos!"

Payment & Terms: Pays 50% commission on all sales. Works with or without a signed contract, negotiable. Offers nonexclusive contract. Statements issued upon request. Payment made immediately upon payment from client. Photographers allowed to review account records to verify sales figures. Offers one-time or first rights and all rights. Informs photographer and allows them to negotiate when client requests all rights but handles all negotiation. Model release required. Captions required.

Making Contact: Query with samples and list of stock photo subjects. Send unsolicited photos by mail for consideration. Reports immediately.

Tips: "Work must be good. Don't edit too tightly; let me see 90% of your material on hand and critique it from there. We're getting new clients around the world every week and have more clients than photos! We need new and varied photographers ASAP! We are the best agency for new photographers trying to break into this field. We work very hard for each and every photographer we have."

ZEPHYR IMAGES, 339 N. Highway 101, Solana Beach CA 92075-1130. (619)755-1200. Fax: (619)755-3723. Owner: Leo Gradinger and R. Robinson. Estab. 1982. Stock photo agency. Member of Picture Agency Council of America (PACA). Also commercial photo studio. Has 400,000 photos. Clients include: advertising agencies, public relations firms, audiovisual firms, businesses, book/encyclopedia pub-

lishers, magazine publishers, newspapers, postcard and calendar companies, developers, corporate, finance, education, design studios and TV stations.

Needs: "We handle everything from A to Z. We specialize in people (model-released) for advertising. New material is shot on a weekly basis. We also have lots of great material for the textbook and editorial markets."

Specs: Uses 35mm, 2¼×2¼, 4×5, 8×10, 6×7 transparencies. Accepts images in digital format for Windows (JPEG or TIFF). Send via compact, floppy or Zip disk.

Payment & Terms: Pays 50% commission for b&w and color photos. Average price per image: $868. Enforces minimum prices. Sub-agency agreement 50% domestic, 40% to photographer on foreign sales. Offers volume discounts to customers; inquire about specific terms. Discount sales terms not negotiable. Works on contract basis only. Offers limited regional exclusivity. Contracts renew automatically for three years, auto-renewal each year thereafter. Charges 25% catalog insertion fee. Statements issued monthly. Payment made monthly. Photographers allowed to review account records to verify sales figures. Offers one-time, electronic and agency promotion rights. Model/property release required. Captions required.

Making Contact: "We are always interested in reviewing the work of photographers who understand the demands and requirements needed to be successful in stock photography. Call first for our submission guideline package."

Tips: "We are looking for photographers who specialize in model released lifestyle imagery. Licensing fees will remain high for this type of photography and it is little influenced by the royalty-free market. We are known for the very best People, Business and Lifestyle photography since 1981. Catalog participation encouraged."

Advertising, Design & Related Markets

The line between what an advertising agency and a design firm do is blurred. The two industries, which used to work hand-in-hand, are now reaching hand-over-fist to fight for the same assignments. For photographers, this means the market for your highly creative, technically excellent work has expanded. If you've traditionally worked with only ad agencies, have no fear about branching out to design firms. You can approach each kind of company in the same way and they will be looking for the same kinds of work.

Trade magazines such as *HOW*, *Print*, *Communication Arts* and *Graphis* are good places to start when learning about design firms. These magazines not only provide information about how designers operate, but they also explain how creatives use photography. For ad agencies, try *Adweek* and *Advertising Age*. These magazines are more business oriented, but they will reveal facts about the top agencies and about specific successful campaigns. (See Helpful Resources for Photographers on page 576 for ordering information.)

When approaching ad agencies and design firms it is important to be aware of regional trends and sensibilities. Although technology has bridged the distance between photographers and agencies, a campaign that soars in New York may well flop in North Platte, Nebraska. Don't be afraid to send samples to agencies and firms outside your region, but know that you may have to do a little extra research to make your work appropriate for them.

To make this a little easier, we've organized this section alphabetically by region. The listings in each region will also be preceded by a report about top industries and top agencies. This information should help you begin your research when you decide to branch out. Don't forget telling information included in the listings as well. In some, you will notice figures for annual billing and total number of employees. If you are a beginning photographer trying to get your feet wet in the advertising and design arena, consider approaching houses with smaller annual billings and fewer employees. They may be more willing to work with newcomers. On the flip side, if you have a sizable list of ad and design credits, larger firms may be more receptive to your work and be able to pay what you're worth.

REGIONS

- **Northeast & Midatlantic**: Connecticut, Delaware, Maine, Maryland, Massachusetts, New Hampshire, New Jersey, New York, Pennsylvania, Rhode Island, Vermont, Washington DC.
- **Midsouth & Southeast**: Alabama, Arkansas, Florida, Georgia, Louisiana, Mississippi, North Carolina, South Carolina, Tennessee, Virginia, West Virginia.
- **Midwest & North Central**: Illinois, Indiana, Iowa, Kentucky, Michigan, Minnesota, Nebraska, North Dakota, Ohio, South Dakota, Wisconsin.
- **South Central & West**: Arizona, California, Colorado, Hawaii, Kansas, Missouri, Nevada, New Mexico, Oklahoma, Texas, Utah.
- **Northwest & Canada**: Alaska, Canada, Idaho, Montana, Oregon, Washington, Wyoming.
- **International**

REGIONAL REPORT: NORTHEAST & MIDATLANTIC

This region encompasses states from Maine to Maryland including the advertising mecca of New York City. The main industries in this region are varied from medical products to aircraft engines to publishing to clothing and textiles. Here you'll find heavy hitters like Saatchi & Saatchi and Ogilvy & Mather creating campaigns for Procter & Gamble and Pepsi.

Principle industries and manufactured goods

Connecticut—Industries: manufacturing, retail trade, government, services, finances, insurance, real estate. Manufactured Goods: aircraft engines and parts, submarines, helicopters, machinery and computer equipment, electronics and electrical equipment, medical instruments, pharmaceuticals.

Delaware—Industries: chemicals, agriculture, finance, poultry, shellfish, tourism, auto assembly, food processing, transportation equipment. Manufactured Goods: nylon, apparel, luggage, foods, autos, processed meats and vegetables, railroad and aircraft equipment.

Maine—Industries: manufacturing, agriculture, fishing, services, trade, government, finance, insurance, real estate, construction. Manufactured Goods: paper and wood products, transportation equipment.

Maryland—Industries: biotechnology and information technology, services, tourism. Manufactured Goods: electric and electronic equipment, food, chemicals, printed materials.

Massachusetts—Industries: services, trade, manufacturing. Manufactured Goods: electric and electronic equipment, instruments, industrial machinery and equipment, printing and publishing, fabricated metal products.

New Hampshire—Industries: tourism, manufacturing, agriculture, trade, mining. Manufactured Goods: machinery, electrical and electronic products, plastics, fabricated metal products.

New Jersey—Industries: services, trade, manufacturing, printing and publishing, food. Manufactured Goods: chemicals, electric and electronic equipment, non-electrical machinery, fabricated metals.

New York—Industries: manufacturing, finance, communications, tourism, transportation, services. Manufactured Goods: books and periodicals, clothing and apparel, pharmaceuticals, machinery, instruments, toys and sporting goods, electronic equipment, automotive and aircraft components.

Pennsylvania—Industries: steel, travel and tourism, biotechnology, apparel, advanced materials, agribusiness. Manufactured Goods: primary metals, foods, fabricated metal products, non-electrical and electrical machinery, printing and publishing, stone, clay and glass products.

Rhode Island—Industries: services, manufacturing. Manufactured Goods: costume jewelry, toys, machinery, textiles, electronics.

Vermont—Industries: manufacturing, tourism, agriculture, trade, finance, insurance, real estate, government. Manufactured Goods: machine tools, furniture, scales, books, computer components, specialty foods.

Washington DC—Industries: government, service, tourism.

Leading national advertisers

Philip Morris Cos., New York NY
Time Warner, New York NY
PepsiCo, Purchase, New York NY
Warner-Lambert, Morris Plains NJ
AT&T, New York NY
Johnson & Johnson, New Brunswick NJ
Viacom, New York NY
Bristol-Myers Squibb, New York,NY

IBM Corp., Armonk, New York NY
Bell Atlantic Corp., New York NY
MCI, Washington DC
Eastman Kodak Corp., Rochester NY
RJR Nabisco, New York NY
Gillette Co., Boston MA
H.J. Heinz Co., Pittsburgh PA
General Electric Co., Fairfield CT

Campbell Soup Co., Camden NJ
Schering-Plough Corp., Madison NJ
Pfizer Inc., New York NY
Hasbro Inc., Pawtucket RI
Hershey Foods Corp., Hershey PA
HFS Inc., Parsippany NJ
Reebok International, Stoughton MA
UPS, Greenwich CT

Notable ad agencies in the region

Arnold Communications, 101 Arch St., Boston MA 02110. (617)587-8900. Major accounts: Boston Gas, Foot-Joy, Massachusetts State Lottery, Mobil Oil Corp., NYNEX, Ocean Spray.

Earle Palmer Brown, 1650 Market St., 1 Liberty Plaza, Philadelphia PA 19103. (215)851-9600. Major accounts: Bristol-Myers Squibb, Cigna, Dollar Rent-a-Car, Dupont, *Philadelphia Inquirer.*

Gillespie, 3450 Princeton Pike, Lawrenceville NJ 08648. (609)895-0200. Major accounts: Capital One, Chemical Bank, Intelnet, National Discount Brokers, *Star Ledger, The Wall Street Journal.*

Grey Advertising, 777 Third Ave., New York NY 10017. (212)546-2000. Major accounts: ConAgra Inc., Darden Restaurants, Hasbro Inc., Mars Inc., Pharmacia & Upjohn, Procter & Gamble.

Leonard/Monahan, 127 Dorrance St., Providence RI 02903. (401)277-9020. Major accounts: CTI Cryogenics, Hewlett-Packard Medical Products, Polaroid Corp., Software 2000, Women & Infants Hospital.

McCann-Erickson, 750 Third Ave., New York NY 10017. (212)697-6000. Major accounts: AT&T Business Services, Johnson & Johnson Consumer Products, Nabisco Foods Group, Ortho Pharmaceutical Corp.

North Castle Partners, 300 First Stamford Place, 5th Floor, Stamford CT 06902. (203)358-2100. Major accounts: Champion Paper, Keep America Beautiful, People's Bank, Slim Jim Meat Snacks, UNO Restaurants.

Ogilvy & Mather, 309 W. 49th St., New York NY 10019. (212)237-4000. Major accounts: American Express, Ford Motor Co., Hershey Foods Corp., IBM Corp., PepsiCo, Sears, World Wildlife Fund.

Saatchi & Saatchi, 375 Hudson St., New York NY 10014. (212)463-2000. Major accounts: Cocoa Puffs (General Mills), Ivory Liquid Soap (Procter & Gamble), Mylanta (Johnson & Johnson), Olive Garden (Darden Restaurants).

Young & Rubicam, 285 Madison Ave., New York NY 10017. (212) 210-3000. Major accounts: AT&T, American Express, Colgate-Palmolive, Paramount Pictures, Philip Morris, Sears.

A.T. ASSOCIATES, 63 Old Rutherford Ave., Charlestown MA 02129. (617)242-8595. Fax: (617)242-0697. Contact: Dan Kovacevic. Estab. 1980. Member of IDSA. Design firm. Approximate annual billing: $200,000. Number of employees: 3. Specializes in publication design, display design, packaging, signage and product. Types of clients: industrial, financial and retail. Examples of recent projects: real estate brochures (city scapes); and sales brochure (bikes/bikers).
Needs: Works with 1 freelancer/month. Uses photos for catalogs, packaging and signage. Reviews stock photos as needed. Model/property release preferred. Captions preferred.
Specs: Uses 35mm, 4×5 transparencies; and film (specs vary).
Making Contact & Terms: Provide résumé, business card, brochure, flier or tearsheets to be kept on file for possible future assignments. Works with local freelancers only. Keeps samples on file. Cannot return material. Reports only if interested. Payment negotiable. **Pays on receipt of invoice.** Credit line sometimes given. Buys all rights; negotiable.

ADVERTEL, INC., P.O. Box 18053, Pittsburgh PA 15236-0053. (412)469-0307, ext. 107. Fax: (800)470-4290 or (412)469-8244. President: Paul Beran. Estab. 1994. Member of MMTA (Multimedia Telecommunications Association). Specialized production house. Approximate annual billing: $500,000-1 million. Types of clients: all, including airlines, utility companies, manufacturers, distributors and retailers.
Needs: Uses photos for direct mail, P-O-P displays, catalogs, signage and audiovisual. Subjects include: communications, telecommunications and business. Reviews stock photos. Model release preferred. Property release required.
Audiovisual Needs: Uses slides and printing and computer files.
Specs: Uses 4×5 matte color and b&w prints; 4×5 transparencies; VHS videotape; PCX, TIFF digital format.
Making Contact & Terms: Interested in receiving work from newer, lesser-known photographers. Query with stock photo list or with samples. Provide résumé, business card, brochure, flier or tearsheets to be

kept on file for possible future assignment. Works with local freelancers only. Keeps samples on file. Cannot return material. Reporting time varies; "I travel a lot." Payment negotiable. **Pays on receipt of invoice,** net 30 days. Rights negotiable.
Tips: Looks for ability to mix media—video, print, color, b&w.

ELIE ALIMAN DESIGN, INC., 134 Spring St., New York, NY 10012. (212)925-9621. Fax: (212)941-9138. Creative Director: Elie Aliman. Estab. 1981. Design firm. Specializes in annual reports, publication design, display design, packaging, direct mail. Types of clients: industrial, financial, publishers, nonprofit.
Needs: Works with 4 freelancers/month. Uses photos for annual reports, consumer and trade magazines, direct mail, posters. Model release required. Property release preferred. Photo captions preferred.
Specs: Uses 35mm, 2¼×2¼, 4×5, 8×10 color transparencies.
Making Contact & Terms: Query with résumé of credits. Provide résumé, business card, brochure, flier or tearsheets to be kept on file for possible future assignments. Keeps samples on file. Cannot return material. Payment negotiable. **Pays on receipt of invoice.** Credit line sometimes given. Buys first rights, one-time rights and all rights; negotiable.
Tips: Looking for "creative, new ways of visualization and conceptualization."

 AMERICA HOUSE COMMUNICATIONS, 28 Jacome Way, Newport RI 02840. (401)849-9600. Fax: (401)846-1379. E-mail: jribera@amaltd.com. Design Director: Jeanie Ribera. Estab. 1992. Design, advertising, marketing and PR firm. Specializes in annual reports, publication design, display design, packaging, direct mail, signage and advertising. Types of clients: industrial, financial, retail, publishers and health care. Examples of recent projects: University of Connecticut School of Medicine brochures.
Needs: Works with 1 freelancer/month. Uses photos for annual reports, direct mail, P-O-P displays, catalogs and destination guides. Reviews stock photos of New England scenics, people and medical/health care. Model/property release preferred. Captions preferred.
Specs: Uses 8×10 prints; 35mm, 2¼×2¼, 4×5 transparencies.
Making Contact & Terms: Submit portfolio for review. Provide résumé, business card, brochure, flier or tearsheets to be kept on file for possible future assignments. Keeps samples on file. Cannot return material. Reporting time varies depending on project. Pays $800-1,100/day. Pays on receipt of invoice, net 30 days. Credit line given depending on usage. Buys one-time rights unless client photo shoot.
Tips: Looks for composition and impact.

AMMIRATI PURIS LINTAS, 1 Dag Hammarskjold Plaza, New York NY 10017. (212)605-8000. Art Buyers: Jean Wolff, Julie Rosenoff, Betsy Thompson, Stephanie Perrott, Jacquie Jones, Karen Rossiter. Member of AAAA. Ad agency. Approximate annual billing: $500 million. Number of employees: 750. Types of clients: financial, food, consumer goods. Examples of recent projects: Four Seasons Hotels, Compaq Computers, RCA, Burger King, Epson, Johnson & Johnson.
Needs: Works with 50 freelancers/month. Uses photos for billboards, trade magazines, direct mail, P-O-P displays, catalogs, posters, newspapers. Reviews stock photos. Model/property release required for all subjects.
Specs: Accepts images in digital format for Mac. Send via online, floppy disk, SyQuest or Zip disk.
Making Contact & Terms: Interested in receiving work from newer, lesser-known photographers. Contact through rep. Arrange personal interview to show portfolio. Submit portfolio for review. Provide résumé, business card, brochure, flier or tearsheets to be kept on file for possible future assignments. Works on assignment only. Keeps samples on file. SASE. Reports in 1-2 weeks. Payment negotiable. Pays extra for electronic usage of images. **Pays on receipt of invoice.** Credit line not given. Buys all rights.

AM/PM ADVERTISING, INC., 196 Clinton Ave., Newark NJ 07108. (201)824-8600. Fax: (201)824-6631. President: Robert A. Saks. Estab. 1962. Member of Art Directors Club, Illustrators Club, National Association of Advertising Agencies and Type Directors Club. Ad agency. Approximate annual billing: $250 million. Number of employees: 1,100. Types of clients: food, pharmaceuticals, health and

**FOR EXPLANATIONS OF THESE SYMBOLS,
SEE THE INSIDE FRONT AND BACK COVERS OF THIS BOOK.**

beauty aids and entertainment industry. Examples of recent projects: AT&T (TV commercials); Nabisco (print ads for Oreo cookies); and Revlon (prints ads for lipstick colors).

Needs: Works with 6 freelance photographers/month. Uses photos for consumer and trade magazines, direct mail, P-O-P displays, catalogs, posters, newspapers and audiovisual. Subjects include: fashion, still life and commercials. Reviews stock photos of food and beauty products. Model release required. Captions preferred.

Audiovisual Needs: "We use multimedia slide shows and multimedia video shows."

Specs: Uses 8×10 color and/or b&w prints; 35mm, 2¼×2¼, 4×5, 8×10 transparencies; 8×10 film; broadcast videotape.

Making Contact & Terms: Arrange personal interview to show portfolio. Send unsolicited photos by mail for consideration. Provide résumé, business card, brochure, flier or tearsheets to be kept on file for possible future assignments. Works on assignment only. Keeps samples on file. Reports in 1-2 weeks. Pays $50-250/hour; $500-2,000/day; $2,000-5,000/job; $50-500/color or b&w photo. **Pays on receipt of invoice.** Credit line sometimes given, depending upon client and use. Buys one-time, exclusive product, electronic and all rights; negotiable.

Tips: In portfolio or samples, wants to see originality. Sees trend toward more use of special lighting.

A-1 FILM AND VIDEO WORLD WIDE DUPLICATION, 4650 Dewey Ave., Rochester NY 14612. (716)663-1400. Fax: (716)663-0246. President: Michael Gross Ordway. Estab. 1976. AV firm. Approximate annual billing: $1 million. Number of employees: 7. Types of clients: industrial and retail.

Needs: Works with 4 freelance photographers, 1 filmmaker and 4 videographers/month. Uses photos for trade magazines, direct mail, catalogs and audiovisual uses. Reviews stock photos or video. Model release required.

Audiovisual Needs: Uses slides, film and video.

Specs: Uses color prints; 35mm transparencies; 16mm film and all types of videotape.

Making Contact & Terms: Fax or write only. Works with local freelancers only. Pays $12/hour; $96/day. **Pays on receipt of invoice.** Credit line not given. Buys all rights.

BOB BARRY ASSOCIATES, 4109 Goshen Rd., Newtown Square PA 19073. Phone: (610)353-7333. Fax: (610)356-5759. Contact: Bob Barry. Estab. 1964. Design firm. Approximate annual billing: $300,000. Number of employees: 5. Specializes in annual reports, publication design, displays, packaging, exhibitions, museums, interiors and audiovisual productions. Types of clients: industrial, financial, commercial and government. Examples of recent projects: corporate profile brochure, Zerodec 1 Corporation (text illustration); marketing program, Focht's Inc. (ads, brochures and direct mail); and Mavic Inc. exhibit (large color transparencies in display installations).

Needs: Works with 2-3 freelancers per month. Uses photos for annual reports, consumer and trade magazines, direct mail, P-O-P displays, catalogs, posters, packaging and signage. Subjects include: products, on-site installations, people working. Reviews stock images of related subjects. Model release preferred for individual subjects.

Specs: Uses matte b&w and color prints, "very small to cyclorama (mural) size;" 35mm, 2¼×2¼, 4×5, 8×10 transparencies.

Making Contact & Terms: Provide résumé, business card, brochure, flier or tearsheets to be kept on file for possible future assignments. Works on assignment only. Keeps samples on file. SASE. Reports as needed; can be "days to months." Pays $50-150/hour; $600-1,200/day; other payment negotiable. Pays on variable basis, according to project. Credit lines sometimes given, depending upon "end use and client guidelines." Buys all rights; negotiable.

Tips: Wants to see "creative use of subjects, color and lighting. Also, simplicity and clarity. Style should not be too arty." Points out that the objective of a photo should be readily identifiable. Sees trend toward more use of photos within the firm and in the design field in general. To break in, photographers should "understand the objective" they're trying to achieve. "Be creative within personal boundaries. Be my eyes and ears and help me to see things I've missed. Be available and prompt."

MICHAEL D. BECKERMAN & ASSOCIATES, 35 Mill St., Bernardsville NJ 07924. (908)766-9238. Ad agency. Contact: Jay Zukus. Types of clients: real estate, banks, retail, miscellaneous.

Needs: Works with 2 photographers/month. Uses photos for advertisements, posters and brochures.

Specs: Uses b&w prints and 2¼×2¼ transparencies.

Making Contact & Terms: Arrange a personal interview to show portfolio. Provide résumé, business

card, brochure, flier or tearsheets to be kept on file for possible future assignments. Works with freelance photographers on assignment only. Does not return unsolicited material. Reports as needed. Payment negotiable; maximum $1,500/day. **Pays on receipt of invoice.** Buys all rights. Model release required.
Tips: Looks for "the ability to think conceptually and solve a problem in a strong, fresh way."

N. BERENSON, ISHAM & PARTNERS, 31 Milk St., Boston MA 02109. (617)423-1120. Fax: (617)423-4597. Associate Creative Director: Anne Liddell. Senior Art Director: Morgan Curran. Estab. 1971. Member of Art Directors Club—Boston, New England Direct Marketing Association, Director Marketing Association-National. Direct marketing firm. Types of clients: financial and communications. Examples of recent projects: relationship marketing for Club Med (direct mail), Gilette-Waterman Pens, Fidelity Investments, investment advisor ads.
Needs: Works with 1-2 freelancers/month. Uses photos for direct mail. Subjects include: tabletop/still life shots, some people, electronic imaging. Model/property release required. Captions preferred.
Specs: Uses 8×10 b&w prints; 35mm transparencies.
Making Contact & Terms: Query with samples. Provide résumé, business card, brochure, flier or tearsheets to be kept on file for possible future assignment. Works on assignment only. Keeps samples on file. SASE. Reports in 1-2 weeks. Payment negotiable. Pays on receipt of invoice. Credit line not given. "We will negotiate either limited use or complete buyout of images depending on job."

BODZIOCH DESIGN, 30 Robbins Farm Rd., Dunstable MA 01827. (978)649-2949. Fax: (978)649-2969. Art Director: Leon Bodzioch. Estab. 1986. Design firm. Specializes in annual reports, publication design and direct mail. Types of clients: industrial. Examples of recent projects: direct mail, Analog Devices (electronic circuit photography); product brochure/fact sheet, Genrad Inc. (product photography); and direct mail, Nebs, Inc. (background textures).
Needs: Uses 4 freelancers/month. Uses photos for annual reports and direct mail. Subjects include: high tech issues. Reviews stock photos. Model/property release preferred. Captions required; identify whether straight or computer-manipulated photography.
Specs: Uses 35mm, 2¼×2¼, 4×5 transparencies and Photoshop files.
Making Contact & Terms: Query with stock photo list. Query with samples. Send unsolicited photos by mail for consideration. Keeps samples on file. SASE. Reports when need arises. Pays based on project quote or range of $1,200-2,200/day. Pays net 30 days. Credit line sometimes given depending upon agreement. Buys one-time and all rights; negotiable.
Tips: Looks for "strong artistic composition and unique photographic point-of-view without being trend driven imagery. Photographer's ability to provide digital images on disk is also a benefit."

☒ ANITA HELEN BROOKS ASSOCIATES, 155 E. 55th St., New York NY 10022. (212)755-4498. Contact: Anita Helen Brooks. PR firm. Types of clients: beauty, entertainment, fashion, food, publishing, travel, society, art, politics, exhibits and charity events.
Needs: Photos used in PR releases, AV presentations and consumer and trade magazines. Buys "several hundred" photos/year. Most interested in fashion shots, society, entertainment and literary celebrity/personality shots. Model release preferred.
Specs: Uses 8×10 glossy b&w or color prints; contact sheet OK.
Making Contact & Terms: Provide résumé and brochure to be kept on file for possible future assignments. Query with résumé of credits. No unsolicited material; cannot return unsolicited material. Works on assignment only. Pays $50 minimum/job; negotiates payment based on client's budget. Credit line given.

CAMBRIDGE PREPRESS, 215 First St., Cambridge MA 02142. (617)354-1991. Fax: (617)494-6575. E-mail: cindyd@cindydavis.com. Creative Director: Cynthia Davis. Estab. 1968. Design firm. Approximate annual billing: $3.5 million. Number of employees: 50. Specializes in publication design and packaging. Types of clients: financial and publishers. Examples of past projects: "Fidelity Focus," Fidelity Investments (editorial); Goldhirsh Group (editorial); and "Dragon Dictate" Dragon Systems (packaging).
Needs: Works with 5-10 freelancers/month. Uses photos for consumer magazines, trade magazines, catalogs and packaging. Subjects include: people. Reviews stock photos. Model release preferred.
Specs: Uses 35mm, 2¼×2¼ transparencies; film appropriate for project.
Making Contact & Terms: Query with samples. Works on assignment only. Keeps samples on file. Do not submit originals. Payment negotiable. Pays 30 days net. Credit line given. Rights purchased depend on project; negotiable.

CHARITABLE CHOICES, 1804 "S" St. NW, Washington DC 20009. (202)483-2906. Fax: (202)328-0627. E-mail: info@charitablechoices.org. Managing Partner: Robert Minnich. Estab. 1984. PR firm. Ap-

proximate annual billing: $300,000. Number of employees: 10. Types of clients: industrial, financial, charities, nonprofit groups and government.
Needs: Uses photos for catalogs and newspapers. Subjects include environment, international, children, civil and human rights and social services. Reviews stock photos.
Specs: Uses b&w and color prints.
Making Contact & Terms: Submit portfolio for review. Query with stock photo list. Send unsolicited photos by mail for consideration. Works with local freelancers only. SASE. Reports in 3 months. Pays $75-125/b&w photo. **Pays on acceptance.** Buys one-time rights.

THE CONCEPTS CORPORATION, 120 Kedron Ave., Holmes PA 19043. (610)461-1600. Fax: (610)461-1650. E-mail: Concepts.Corp@Erols.com. President: James Higgins. Estab. 1962. Company specializes in graphic arts/visual communications. Approximate annual billing: $360,000. Number of employees: 5. Types of clients: industrial, financial, retail and food. Examples of recent projects: GE Power Management (internet file creation); Adult Communities Total Services (marketing material); Chilton Publishing (slide presentations).
Needs: Number of photographers used on a monthly basis varies. Uses photos for trade magazines and catalogs. Subjects include: industrial equipment. Reviews stock photos in all subject matter.
Audiovisual Needs: Uses slides for presentations. Subjects include: corporate/industrial.
Specs: Uses color and b&w prints; 35mm, 2¼×2¼, 4×5 transparencies. Accepts images in digital format for Windows (TIFF). Send via compact disc, online, floppy disk, SyQuest or Zip disk.
Making Contact & Terms: Provide résumé, business card, brochure, flier or tearsheets to be kept on file for possible future assignments. Keeps samples on file. Cannot return material. Reporting time varies. Payment negotiable. Pays net 30 days. Credit line sometimes given depending upon circumstances. Buys one-time and all rights; negotiable.

SANDY CONNOR ART DIRECTION, 90 Ship St., Providence RI 02903. (401)831-5796. Fax: (401)831-5797. Owner: Sandy Connor. Estab. 1992. Member of Providence Chamber of Commerce. Design firm, advertising/design. Number of employees: 1. Specializes in annual reports, publication design, direct mail. Types of clients: industrial, financial, nonprofit. Examples of recent projects: Washington Trust Company (annual report); Arconium (brochures); and Handy & Hamon (corporate brochures).
Needs: Works with 1 freelancer/month. Uses photos for annual reports, trade magazines, direct mail, P-O-P displays, catalogs. Subjects include: industrial, location and product. Reviews stock photos. Model release required.
Specs: Uses b&w prints; 35mm, 2¼×2¼, 4×5, 8×10 transparencies.
Making Contact & Terms: Submit portfolio for review. Query with samples. Send unsolicited photos by mail for consideration. Provide résumé, business card, brochure, flier or tearsheets to be kept on file for possible future assignments. Works on assignment only. Keeps samples on file. Reports as need for work arises. Pays $50-200/hour; $1,000-2,000/day. Pays on acceptance; 30 days from receipt of invoice. Buys first, one-time and all rights; negotiable.

COX ADVERTISING, 379 W. Broadway, New York NY 10012. (212)334-9141. Fax: (212)334-9179. Ad agency. Associate Creative Director: Marc Rubin. Types of clients: industrial, retail, fashion and travel.
Needs: Works with 2 freelance photographers or videographers/month. Uses photographers for billboards, consumer magazines, trade magazines, direct mail, P-O-P displays, catalogs, posters, newspapers, signage and audiovisual. Reviews stock photos or video.
Audiovisual Needs: Uses photos for slide shows; also uses videotape.
Specs: Uses 16×20 b&w prints; 35mm, 2¼×2¼, 4×5 and 8×10 transparencies.
Making Contact & Terms: Arrange personal interview to show portfolio. Works on assignment only. Cannot return material. Reports in 1-2 weeks. Pays minimum of $1,500/job; higher amounts negotiable according to needs of client. Pays within 30-60 days of receipt of invoice. Buys all rights when possible. Model release required. Credit line sometimes given.

CREATIVE ASSOCIATES, 44 Park Ave., Madison NJ 07940. (973)377-4440. Producer: Harrison Feather. Estab. 1975. AV firm. Types of clients: industrial, cosmetic and pharmaceutical.
Needs: Works with 1-2 photographers, filmmakers and/or videographers/month. Uses photos for trade magazines and audiovisual uses. Subjects include product and general environment. Reviews stock photos or videotape. Model release required. Property release preferred. Captions preferred.
Audiovisual Needs: Uses photos/video for slides and videotape.
Specs: Uses 35mm, 4×5 and 8×10 transparencies; videotape.
Making Contact & Terms: Provide résumé, business card, brochure, flier or tearsheets to be kept on

file for possible future assignments. Works on assignment only. Reports as needed. Pays $500-1,000/day; $1,500-3,000/job. Pays on publication. Credit line sometimes given, depending on assignment. Rights negotiable; "depends on budget."

D.C.A./DENTSU CORPORATION OF AMERICA, 666 Fifth Ave., New York NY 10103. (212)261-2668. Fax: (212)261-2360. Art Buyer: Hedy Sikora. Estab. 1971. Ad agency. Types of clients: Canon, U.S.A.; Shiseido (skin care products); JAL Japanese Air Lines; Modern Woman fashion; Sanyo, Lorus (watches); and Butler (oral hygiene products).
Needs: Works with 5-10 freelance photographers, 1-2 filmmakers. Uses photos for billboards, consumer magazines, trade magazines, direct mail, P-O-P displays, catalogs, posters, newspapers, signage for annual reports, sales and marketing kits. Reviews stock photos. All subjects with a slant on business and sports. Model/property release required. Captions preferred; include location, date and original client.
Audiovisual Needs: Uses slides and videotape for presentations.
Specs: Uses 8×10 to 16×20 color and b&w prints; 35mm, 4×5, 8×10 transparencies. Accepts images in digital format for Mac. Send via compact disc, floppy disk, SyQuest or Zip disk.
Making Contact & Terms: Query with samples. Provide résumé, business card, brochure, flier or tearsheets to be kept on file for possible future assignments. Works with local freelancers on assignment only. Keeps samples on file. Reporting time depends on the quality of work; calls will be returned as they apply to ongoing projects. Payment negotiable. Pays 45 days from assignment completion. Credit line sometimes given depending on placement of work. Buys one-time and all rights.
Tips: "Your capabilities must be on par with top industry talent. We're always looking for new techniques and new talent."

DCP COMMUNICATIONS GROUP, LTD., 301 Wall St., Princeton NJ 08540-1515. (609)921-3700. Fax: (609)921-3283. Editor: David McKenna. Estab. 1979. Specializes in multimedia production, video production.
Needs: Buys 20 photos/year; offers 10 assignments/year. Uses freelancers for lifestyle, editorial, public relation shots. Examples of recent uses: video montages for manufacturers. Model/property release required. Captions required.
Audiovisual Needs: Uses videotape for multimedia purposes (corporate marketing). Subjects include: lifestyles.
Specs: Uses 8×10 glossy color and b&w prints; 35mm, $2\frac{1}{4} \times 2\frac{1}{4}$, 4×5 transparencies; Betacam SP videotape.
Making Contact & Terms: Query with résumé of credits. Query with samples. Query with stock photo list. Provide résumé, business card, self-promotion piece or tearsheets to be kept on file for possible future assignments. Keeps samples on file. SASE. Reports in 1 month. Pays $100-150/hour; $500-1,500/day. **Pays on acceptance.** Credit line given. Buys first, one-time and all rights; negotiable.

DESIGN CONCEPTS-CARLA SCHROEDER BURCHETT, 104 Main St., Box 5A, Unadilla NY 13849-9701. (607)369-4709. Owner: Carla Schroeder. Estab. 1972. Number of employees: 2. Specializes in direct mail. Types of clients: industrial, manufacturers. Examples of projects: "Used Footlets" (marketing firm).
Needs: Uses photos for catalogs. Subjects include: wild nature to still life and houses. Model release preferred. Captions required.
Specs: Uses prints; 35mm transparencies.
Making Contact & Terms: Send nonreturnable samples by mail for consideration. SASE for reply. Payment negotiable. **Pays on acceptance.** Credit line given. Buys first rights; negotiable.

DESIGNATION, 53 Spring St., 5th Floor, New York NY 10012. (212)226-6024. Fax: (212)219-0331. President/Creative Director: Mike Quon. Design firm. Specializes in packaging, direct mail, signage, illustration. Types of clients: industrial, financial, retail, publishers, nonprofit.
● Mike Quon says he is using more stock photography and less assignment work.
Needs: Works with 1-3 freelancers/year. Uses photos for direct mail, P-O-P displays, packaging, signage. Model/property release preferred. Captions required; include company name.
Specs: Uses color, b&w prints; $2\frac{1}{4} \times 2\frac{1}{4}$, 4×5 transparencies.
Making Contact & Terms: Submit portfolio for review by mail only. Send unsolicited photos by mail for consideration. Works on assignment only. Keeps samples on file. Cannot return material. Reports only when interested. Pays $1,000-3,000/day. Pays net 30 days. Credit line given when possible. Buys first rights, one-time rights; negotiable.

DIRECT SOURCE ADVERTISING, (formerly Gerew Graphic Design), 4403 Wickford Rd., Baltimore MD 21210-2809. (410)366-5429. Fax: (410)366-6123. Owner: Cynthia Serfas. Estab. 1988. Design firm. Approximate annual billing: $150,000. Number of employees: 3. Specializes in publication design and direct mail. Types of clients: financial, publishers and insurance.
Needs: Uses photos for direct mail. Subjects include: families, health, real estate, senior market and credit card usage. Model/property release required.
Specs: Uses 8×10 glossy b&w prints; 35mm, 2¼×2¼, 4×5 transparencies, high-res digital files (Mac format).
Making Contact & Terms: Arrange personal interview to show portfolio. Send unsolicited photos by mail for consideration. Provide résumé, business card, brochure, flier or tearsheets to be kept on file for possible future assignments. Works on assignment only. Keeps samples on file. SASE. Responds if an appropriate assignment is available. Pays $300-900/shot depending on usage. Pays 30 days from receipt of invoice. Credit line not given. Buys one-time rights.
Tips: "I like everyday-type people in the shots with a good cross-market representation."

DONAHUE ADVERTISING & PUBLIC RELATIONS, INC., 227 Lawrence St., Hartford CT 06106. (860)728-0000. Fax: (860)247-9247. Ad agency and PR firm. Creative Director: Jim Donahue. Estab. 1980. Types of clients: industrial, high-tech, food/beverage, corporate and finance.
● Jim Donahue says there has been a dramatic increase in their need for food and beverage photography.
Needs: Works with 5-6 photographers/month. Uses photos for trade magazines, catalogs and posters. Subjects include: products.
Specs: Uses 8×10 matte and glossy color or b&w prints; 4×5 transparencies. Accepts images in digital format for Mac (EPS). Send via CD, floppy disk or SyQuest cartridge (300 dpi or better).
Making Contact & Terms: Contact through rep. Arrange personal interview to show portfolio. Send samples by mail for consideration. Provide résumé, business card, brochure, flier or tearsheets to be kept on file for possible future assignments. Keeps samples on file. Cannot return material. Reports in 1-2 weeks. Pays $1,200-1,500/day. **Pays on receipt of invoice with purchase order**. Buys all rights. Model/property release required. Credit line not given.

▣ DOWNEY COMMUNICATIONS, INC., 4800 Montgomery Lane, Suite 710, Bethesda MD 20814. (301)718-7600. Fax: (301)718-7604. E-mail: grocer@downey-data.com. Art Director: Craig Borucki. Estab. 1969. Member of Art Directors Club of Washington DC, Society of Publication Designers. Specializes in publication design. Types of clients: retail. Examples of recent projects: "Consumer Electronics," *Military Exchange Magazine* (people shot with electronic background); "Personality Profile," *Military Grocer Magazine* (person in setting); "Comstore Profile," *Military Grocer Magazine* (variety of shots throughout the store).
Needs: Works with 1-2 freelancers/month. Uses photos for trade magazines. Subjects include: people and interiors. Model release preferred. Captions required; include name, title, occupation of subject.
Specs: Uses 35mm, 2¼×2¼ transparencies.
Making Contact & Terms: Send unsolicited photos by mail for consideration. Keeps samples on file. SASE. Pays $400-500/day. Pays on publication. Credit line given. Buys one-time rights.
Tips: Looks for composition, style and uniqueness of traditional people shots.

▨ RICHARD L. DOYLE ASSOC., INC., RLDA COMMUNICATIONS, 15 Maiden Lane, New York NY 10038. (212)349-2828. Fax: (212)619-5350. Ad agency. Client Services: R.L. Stewart, Jr. Estab. 1979. Types of clients: primarily insurance/financial services and publishers. Client list free with SASE.
Needs: Works with 3-4 freelance photographers/month. Uses photographers for consumer and trade magazines, direct mail, newspapers, audiovisual, sales promotion and annual reports. Subjects include people—portrait and candid. Model release required. Captions required.
Audiovisual Needs: Typically uses prepared slides—in presentation formats, video promotions and video editorials.
Specs: Uses b&w and color prints; 35mm and 2¼×2¼ transparencies.
Making Contact & Terms: Query with résumé of credits and samples. Prefers résumé, business card, brochure, flier or tearsheets to be kept on file for possible future assignments. SASE. Reports in 2 weeks. Payment negotiable. **Pays on acceptance** or receipt of invoice. Buys all rights.
Tips: Prefers to see photos of people; "good coverage/creativity in presentation. Be perfectly honest as to capabilities; be reasonable in cost and let us know you'll work *with us* to satisfy the client."

emdash inc., 588 Broadway, Suite 610, New York NY 10012. (212)343-1451. Fax: (212)274-0545. Creative Director: Andrea Meyer. Estab. 1992. Approximate annual billing: $100,000. Number of employ-

ees: 4. Specializes in annual reports, publication design, display design and direct mail. Types of clients: financial, publishers and nonprofit.

Needs: Works with 1 freelancer/month. Uses photos for annual reports, direct mail, catalogs, posters, and packaging. Subjects include: portraits, architecture and product shots. Reviews stock photos. Model/property release required. Captions preferred.

Specs: Uses prints, transparencies and digital format.

Making Contact & Terms: Query with samples. Provide résumé, business card, brochure, flier or tearsheets to be kept on file for possible future assignments. Keeps samples on file. SASE. Reports in 1 month. Payment negotiable.

EPSTEIN & WALKER ASSOCIATES, #5A, 65 W. 55 St., New York NY 10019. Phone/fax: (212)246-0565. President/Creative Director: Lee Epstein. Member of Art Directors Club of New York. Ad agency. Approximate annual billing: $1.5 million. Number of employees: 3. Types of clients: retail, publication, consumer.

Needs: Works with 1-2 freelance photographers/year. Uses photos for consumer and trade magazines, direct mail and newspapers. Subjects include still life, people, etc.; "depends on concept of ads." Model release required.

Specs: Any size or format b&w prints; also 35mm, 2¼×2¼ transparencies.

Making Contact & Terms: Arrange personal interview to show portfolio. Provide résumé, business card, brochure, flier or tearsheets to be kept on file for possible future assignments. Works with local freelancers on assignment only. Cannot return material. Reports "as needed." Pays minimum of $250/b&w photo or negotiates day rate for multiple images. Pays 30-60 days after receipt of invoice. Credit line not given. Usually buys rights for "1 year usage across the board."

Tips: Trend within agency is "to solve problems with illustration, and more recently with type/copy only, more because of budget restraints regarding models and location expenses." Is receptive to working with new talent. To break in, show "intelligent conceptual photography with exciting ideas and great composition."

FINE ART PRODUCTIONS, RICHIE SURACI PICTURES, MULTI MEDIA, INTERACTIVE, 67 Maple St., Newburgh NY 12550-4034. Phone/fax: (914)561-5866. E-mail: rs7.fap@mhv.net. Websites: http://www.woodstock69.com; http://www.audionet.com/books; http://www.audiohighway.com; http://www.indyjones.simplenet.com/kunda.htm; http://www.mhv.net/~rs7.fap/netWORKEROTICA.html. Director: Richie Suraci. Estab. 1989. Ad agency, PR firm and AV firm. Types of clients: industrial, financial, fashion, retail, food—all industries. Examples of previous projects: "Great Hudson River Revival," Clearwater, Inc. (folk concert, brochure); feature articles, Hudson Valley News (newspaper); "Wheel and Rock to Woodstock," MS Society (brochure); and Network Erotica (Website).

Needs: Uses photos for billboards, consumer and trade magazines, direct mail, P-O-P displays, catalogs, posters, Web Pages, brochures, newspapers, signage and audiovisual. Especially needs erotic art, adult erotica, science fiction, fantasy, sunrises, waterfalls, beautiful nude women and men, futuristic concepts. Reviews stock photos. Model/property release required. Captions required; include basic information.

Audiovisual Needs: Uses slides, film (all formats) and videotape.

Specs: Uses color and b&w prints, any size or finish; 35mm, 2¼×2¼, 4×5, 8×10 transparencies; film, all formats; ½", ¾" or 1" Beta videotape. Accepts images in digital format for Mac (2HD). Send via online or floppy disk (highest resolution).

Making Contact & Terms: Submit portfolio for review. Query with résumé of credits, list of stock photo subjects or samples. Provide résumé, business card, brochure, flier or tearsheets to be kept on file for possible future assignments. SASE. Reports in 1 month or longer. "All payment negotiable relative to subject matter." Pays on acceptance, publication or on receipt of invoice; "varies relative to project." Credit line sometimes given, "depending on project or if negotiated." Buys first, one-time and all rights; negotiable.

Tips: "We are also requesting any fantasy, avant-garde, sensuous or classy photos, video clips, PR data, short stories, adult erotic scripts, résumé, fan club information, PR schedules, etc. for use on our Website. Nothing will be posted unless accompanied by a release form. We will post this free of charge on the Website and give you free advertising for the use of your submissions We will make a separate agreement for usage for any materials besides ones used on the Website and/or any photos or filming sessions we create together in the future. If you would like to make public appearances in our network and area, send a return reply and include PR information for our files."

FORDESIGN GROUP LTD., 87 Dayton Rd., Redding CT 06896. (203)938-0008. Fax: (203)938-0805. E-mail: fordsign@webquill.com. Website: http://www.Fordesign.com. Creative Director: Steven Ford. Estab. 1990. Member of AIGA, P.D.C. Design firm. Specializes in packaging. Types of clients: industrial,

retail. Examples of recent projects: Talk Xpress for AT&T Wireless (location, people); Packaging for SONY (product); and KAME Chinese Food for Liberty Richter (food).

Needs: Works with 2 freelancers/month. Uses photos for packaging. Subjects include: food. Reviews stock photos. Model release required. Location preferred.

Specs: Uses 4×5 transparencies. Accepts images in digital format for Mac (EPS, Photoshop, TIFF). Send via compact disc, online, floppy disk, SyQuest or Zip disk.

Making Contact & Terms: Submit portfolio for review. Query with samples. Send unsolicited photos by mail for consideration. Keeps samples on file. SASE. Reports in 1-2 weeks. Pays "typical" day rate. **Pays on receipt of invoice.** Credit line given. Rights negotiable.

DAVID FOX, PHOTOGRAPHER, 59 Fountain St., Framingham MA 01701. (508)820-1130. Fax: (508)820-0558. E-mail: davidfox@virtmall.com. Website: http://www.virtmall.com/davidfoxphotographer. President: David Fox. Estab. 1983. Member of Professional Photographers of America, Professional Photographers of Massachusetts. Video production/post production photography company. Approximate annual billing: $150,000. Number of employees: 2. Types of clients: consumer, industrial and corporate. Examples of recent projects: Wayside Community Projects (brochures, newsletter); Harlem Rockers National Basketball Team photos.

Needs: Works with 2-4 freelance photographers/videographers/year. Subjects include: executive portraiture, fine art, stock, children, families. Reviews area footage. Model/property release required. Captions preferred.

Audiovisual Needs: Uses videotape; photos, all media related materials. "We are primarily producers of photographic and video images."

Specs: Uses 35mm and 2¼×2¼ transparencies, slides and ½", SVHS, Hi 8mm and 8mm formats of videotape. Accepts images in digital format for Mac and Windows (PICT, TIFF, Photoshop EPS). Send 4×5 electronic digital photos via floppy disk, e-mail.

Making Contact & Terms: Arrange personal interview to show portfolio. Provide résumé, business card, brochure, flier or tearsheets to be kept on file for possible future assignments. Portfolio and references required. Works on assignment only. Looking for wedding photographers and freelancers. Works closely with freelancers. Buys all rights; negotiable.

Tips: Looks for style, abilities, quality and commitment similar to ours. "We have expanded our commercial photography. We tend to have more need in springtime and fall, than other times of the year. We're very diversified in our services—projects come along and we use people on an as-need basis. We are scanning and delivering images on disk to our clients. Manipulation of images enables us to create new images for stock use."

FUESSLER GROUP INC., 288 Shawmut Ave., Boston MA 02118. (617)451-9383. Fax: (617)451-5950. E-mail: fuessler@fuessler.com. President: Rolf Fuessler. Estab. 1984. Member of Society for Marketing Professional Services, Public Relations Society of America. Marketing communications firm. Types of clients: industrial, professional services. Has done work for Ogden Yorkshire, Earth Tech Inc., Stan Webster, Montgomery Watson.

Needs: Works with 2 freelancers/month; rarely works with videographers. Uses photos for trade magazines, collateral advertising and direct mail pieces. Subjects include: industrial and environmental. Reviews stock photos. Model/property release required, especially with hazardous waste photos. Captions preferred.

Specs: Uses 35mm transparencies.

Making Contact & Terms: Query with résumé of credits. Query with samples. Works with local freelancers on assignment only. Keeps samples on file. SASE. Reports in 3 weeks. Payment negotiable. Pays on receipt of invoice. Credit line given. Buys first rights, one-time rights, all rights and has purchased unlimited usage rights for one client; negotiable.

⚄ ⚄ GARVAN COMMUNICATIONS, INC., 501 S. Broadway, Hicksville NY 11801-5043. (516)827-4000. Fax: (516)827-4001. E-mail: info@garvan.com. Website: http://www.garvan.com. Creative Director: Rick Chiorando. Estab. 1974. Member of A.A.A.A., A.M.A. Ad agency. Approximate annual billing: $9.5 million. Number of employees: 32. Firm specializes in magazine ads, packaging, direct mail, collateral, marketing. Types of clients: industrial, financial. Examples of recent clients: Zeus direct mail (promote website), Arrow Electronic; EAB.com website; "Time of Your Life" (product promo), H.I. Savings Bank.

Needs: Works with 1-2 freelancers/month, 1 videographer/month. Uses photos for brochures, catalogs, consumer magazines, direct mail, newspapers, P-O-P displays, posters, signage, trade magazines. Subjects include: people, situations, products, landmarks of the world. Reviews stock photos. Model release required. Photo caption preferred.

Audiovisual Needs: Uses slides or video for interactive multimedia shows for laptop presentations.

Subjects include: people in situations, food, sports, exotic places.

Specs: Uses 8×10 prints; 35mm, 2¼×2¼ transparencies; Beta videotape. Accepts images in digital format.

Making Contact & Terms: Send query letter with samples, brochure, stock photo list, tearsheets. Provide résumé, business card, self-promotion piece or tearsheets to be kept on file for possible future assignments. Art director will contact photographer for portfolio review if interested. Portfolio should include b&w, color, prints, tearsheets, slides, thumbnails. Keeps samples on file; cannot return material. Reports back only if interested, send nonreturnable samples. Payment depends on assignment; payment for electronic usage negotiable. Pays 30 days following receipt of invoice. Credit line sometimes given depending upon situation and negotiation. Buys all rights, electronic rights; negotiable.

Tips: "Just show quality and think outside the box. Submit work only in relation to assignment. Ask good questions, be efficient, deliver on-time and budget when possible."

GRAPHIC COMMUNICATIONS, 3 Juniper Lane, Dover MA 02030-2146. (508)785-1301. Fax: (508)785-2072. Owner: Richard Bertucci. Estab. 1970. Member of Art Directors Club, Graphic Artists Guild. Ad agency. Approximate annual billing: $1 million. Number of employees: 5. Types of clients: industrial, consumer, finance. Examples of recent projects: campaigns for Avant Incorporated; Bird Incorporated; and Ernst Asset Management.

Needs: Works with 3 freelancers/month. Uses photos for consumer magazines, trade magazines, catalogs, direct response and annual reports. Subjects include: products, models. Reviews stock photos. Model/property release required. Captions preferred.

Specs: Uses 8×10 glossy color and b&w prints; 2¼×2¼, 4×5 transparencies.

Making Contact & Terms: Interested in receiving work from newer, lesser-known photographers. Query with stock photo list. Provide résumé, business card, brochure, flier or tearsheets to be kept on file for possible future assignments. Works with local freelancers on assignment only. Keeps samples on file. Cannot return material. Reports as needed. Payment negotiable. Pays on receipt of invoice. Credit line not given. Buys all rights.

HAMMOND DESIGN ASSOCIATES, 79 Amherst St., Milford NH 03055. (603)673-5253. Fax: (603)673-4297. President: Duane Hammond. Estab. 1969. Design firm. Specializes in annual reports, publication design, display design, packaging, direct mail, signage. Types of clients: industrial, financial, publishers and nonprofit. Examples of projects: Resonetics Capabilities brochure, Micro Lasering (product photos, cover and inside); golf courses yardage guides; Granite Bank (advertising literature); and Cornerstone Software (collateral material).

Needs: Works with 1 freelancer/month. Uses photos for annual reports, trade magazines, direct mail, catalogs and posters. Subject matter varies. Reviews stock photos. Model release required. Property release preferred. Captions preferred.

Specs: Uses 8×10 and 4×5 matte or glossy, color and b&w prints; 35mm, 2¼×2¼, 4×5 transparencies.

Making Contact & Terms: Send unsolicited photos by mail for consideration. Provide résumé, business card, brochure, flier or tearsheets to be kept on file for possible future assignments. Works with freelancers on assignment only. Cannot return unsolicited material. Pays $25-100/hour; $450-1,000/day; $25-2,000/job; $50-100/color photo; $25-75/b&w photo. Pays on receipt of invoice net 30 days. Credit line sometimes given. Buys one-time, exclusive product and all rights; negotiable.

Tips: Wants to see creative and atmosphere shots, "turning the mundane into something exciting."

HARRINGTON ASSOCIATES INC., 57 Fairmont Ave., Kingston NY 12401-5221. (914)331-7136. Fax: (914)331-7168. E-mail: gharring@aol.com. President: Gerard Harrington. Estab. 1988. Member of Hudson Valley Area Marketing Association, Hudson Valley Direct Marketing Association. PR firm. Types of clients: industrial, high technology, retail, fashion, finance, transportation, architectural, artistic and publishing. Examples of recent clients include: Ulster Performing Arts Center (PR, brochures, advertising); Salomon Smith Barney, Inc. (community relations, investment product/service brochures); MICR Data Systems, Inc. (corporate ID campaign, product/service brochure, advertising campaign, Website enhancement).

● This company has received the Gold Eclat Award, Hudson Valley Area Marketing Association, for best PR effort.

Needs: Number of photographers used on a monthly basis varies. Uses photos for consumer and trade magazines, P-O-P displays, catalogs and newspapers. Subjects include: general publicity including head shots and candids. Also still lifes. Model release required.

Specs: Uses b&w prints, any size and format. Also uses 4×5 color transparencies; and Betacam SP videotape.

Making Contact & Terms: Interested in receiving work from newer, lesser-known photographers. Pro-

vide résumé, business card, brochure, flier or tearsheets to be kept on file for possible future assignments. Works with freelancers on assignment only. Cannot return material. Reports only when interested. Payment negotiable. Pays on receipt of invoice. Credit line given whenever possible, depending on use. Buys all rights; negotiable.

N HOLLEY THOMAS INC., 462 Sagamore Ave., E. Williston NY 11592-2431. (516)746-5656. Fax: (516)741-0718. E-mail: holleythomasinc@worldnet.att.net. Creative Director: Frank Randi. Estab. 1957. Member of AAAA and BPA. Ad agency. Approximate annual billing: $1.4 million. Number of employees: 6. Firm specializes in magazine ads, packaging, collateral. Types of clients: industrial, financial. Examples of recent clients: "Mortgages" for JSB (bank signage and collateral materials); "Loans" for JSB (bank signage and collateral materials); "Direct Mail" for Rival (mailing piece).
Needs: Uses photos for billboards, brochures, catalogs, direct mail. Subjects include: landscapes, crowds, personnel, still life. Reviews stock photos. Model release required. Photo caption preferred.
Specs: Uses color prints; 2¼×2¼ and 4×5 transparencies.
Making Contact & Terms: Send query letter with samples or brochure. To show portfolio, photographer should follow-up with call. Portfolio should include color tearsheets. Works with freelancers on assignment only. Does not keep samples on file. Reports back only if interested, send nonreturnable samples. **Pays on receipt of invoice.** Buys first rights; negotiable.
Tips: "When submitting work freelancers should answer specific questions directly and briefly. Listen clearly to requirement—then offer solutions and advice as to how the project should proceed."

ICONS, 76 Elm St., Suite 313, Boston MA 02130. Phone: (617)522-0165. Fax: (617)524-5378. Contact: Glenn Johnson. Estab. 1984. Design firm. Approximate annual billing: $250,000. Number of employees: 2. Specializes in annual reports, publication design, packaging, direct mail and signage. Types of clients: high-tech. Examples of clients: SQA Inc., Leaf Systems, Picturetel.
Needs: Works with 2 freelancers/month. Uses photos for annual reports, trade magazines, packaging, direct mail and posters. Subjects include: portraits, photo montage and products. Reviews unusual abstract, non-conventional stock photos. Model/property release preferred for product photography. Captions preferred; include film and exposure information and technique details.
Specs: Uses 4×5 transparencies.
Making Contact & Terms: Query with samples. Works with local freelancers only. Keeps samples on file. SASE. Reports in 3 weeks. Pays $1,200-1,800/day; $750-5,000/job. **Pays on receipt of invoice.** Credit line given. Buys first rights.

IMAGE ZONE, INC., 101 Fifth Ave., New York NY 10003. (212)924-8804. Fax: (212)924-5585. Managing Director: Doug Ehrlich. Estab. 1986. AV firm. Approximate annual billing: $4 million. Number of employees: 12. Types of clients: industrial, financial, fashion, pharmaceutical. Examples of recent projects: Incentive meeting for Monsanto (a/v show); awards presentation for Lebar Friedman (holiday celebration); managers presentation for Pfizer (video tribute); Roche, Ortho (launch meeting).
Needs: Works with 1 freelance photographer, 2 filmmakers and 3 videographers/month. Uses photos for audiovisual projects. Subjects vary. Reviews stock photos. Model/property release preferred. Captions preferred.
Audiovisual Needs: Uses slides, film and videotape. Subjects include: "original material."
Specs: Uses 35mm transparencies; ¾" or ½" videotape. Accepts images in digital format for Mac (various formats).
Making Contact & Terms: Query with résumé of credits. Provide résumé, business card, brochure, flier or tearsheets to be kept on file for possible future assignments. Works with local freelancers on assignment only. Keeps samples on file. Cannot return material. Reports when needed. Pays $500-1,500/job; also depends on size, scope and budget of project. Pays within 30 days of receipt of invoice. Credit line not given. Buys one-time rights; negotiable.

INSIGHT ASSOCIATES, 14 Rita Lane, Oak Ridge NJ 07438. (973)697-0880. Fax: (973)697-6904. President: Raymond Valente. Types of clients: major industrial companies, public utilities. Examples of projects: "Savety on the Job" for Ecolab, Inc.; "Handling Gases" for Matheson Gas; and "Training Drivers" for Suburban Propane (all inserts to videos).
Needs: Works with 4 freelancers/month. Uses freelancers for slide sets, multimedia productions, videotapes and print material—catalogs. Subjects include: industrial productions. Examples of clients: Matheson (safety); Witco Corp. (corporate image); Volvo (sales training); P.S.E.&G.; Ecolab Inc. Interested in stock photos/footage. Model release preferred.
Specs: Uses 35mm, 2¼×2¼ and 4×5 transparencies.
Making Contact & Terms: Arrange a personal interview to show portfolio. SASE. Reports in 1 week.

Pays $450-750/day. **Pays on acceptance.** Credit line given. Buys all rights.
Tips: "Freelance photographers should have knowledge of business needs and video formats. Also, versatility with video or location work. In reviewing a freelancer's portfolio or samples we look for content appropriate to our clients' objectives. Still photographers interested in making the transition into film and video photography should learn the importance of understanding a script."

JANUARY PRODUCTIONS, P.O. Box 66, 210 Sixth Ave., Hawthorne NJ 07507. (973)423-4666. Fax: (973)423-5569. Art Director: Karen Sigler. Estab. 1973. AV firm. Number of employees: 12. Types of clients: schools, teachers and public libraries. Audience consists of primary, elementary and intermediate-grade school students. Produces children's books, videos and CD-ROM. Subjects are concerned with elementary education—science, social studies, math and conceptual development.
Audiovisual Needs: Uses 35mm color transparencies and b&w photographs of products for company catalogs.
Making Contact & Terms: Call or send résumé and samples of work "for us to keep on file." SASE. Payment negotiable. Payment amounts "depend on job." Buys all rights.
Tips: Wants to see "clarity, effective use of space, design, etc. We need clear photographs of our products for catalog use. The more pictures we have in the catalogs, the better they look and that helps to sell the product."

JEF FILMS INC, 143 Hickory Hill Circle, Osterville MA 02655-1322. (508)428-7198. Fax: (508)428-7198. President: Jeffrey H. Aikman. Estab. 1973. AV firm. Member of American Film Marketing Association, National Association of Television Programmers and Executives. Types of clients: retail. Examples of projects: "Yesterday Today & Tomorrow," JEF Films (video box); "M," Aikman Archive (video box).
Needs: Works with 5 freelance photographers, 5-6 filmmakers and 5-6 videographers/month. Uses photos for billboards, consumer magazines, trade magazines, direct mail, P-O-P displays, catalogs, posters, newspapers and audiovisual. Subjects include glamour photography. Reviews stock photos of all types. Model release preferred. Property release required. Captions preferred.
Audiovisual Needs: Uses slides, films and/or video for videocassette distribution at retail level.
Specs: Uses 35mm transparencies.
Making Contact & Terms: Submit portfolio for review. Works on assignment only. Keeps samples on file. Cannot return material. Reports in 1 month. Pays $25-300/job. Pays on publication. Credit line is not given. Buys all rights.

KEENAN-NAGLE ADVERTISING, 1301 S. 12th St., Allentown PA 18103-3814. (610)797-7100. Fax: (610)797-8212. Ad agency. Contact: Art Director. Types of clients: industrial, retail, finance, health care and high-tech.
Needs: Works with 7-8 freelance photographers/month. Uses photos for billboards, consumer magazines, trade magazines, direct mail, posters, signage and newspapers. Model release required.
Specs: Uses b&w and color prints; 35mm, 2¼×2¼, 4×5 and 8×10 transparencies.
Making Contact & Terms: Query with samples. Provide résumé, business card, brochure, flier or tearsheets to be kept on file for possible future assignments. Does not return unsolicited material. Payment negotiable. Pays on receipt of invoice. Credit line sometimes given.

KJD TELEPRODUCTIONS, INC., 30 Whyte Dr., Voorhees NJ 08043. (609)751-3500. Fax: (609)751-7729. E-mail: mactoday@ios.com. President: Larry Scott. Estab. 1989. Member of National Association of Television Programming Executives. AV firm. Approximate annual billing: $600,000. Number of employees: 6. Types of clients: industrial, fashion, retail, professional, service and food. Examples of projects: Marco Island Florida Convention, ICI Americas (new magazine show); "More Than Just a Game" (TV sports talk show); and PA Horticulture Society, Gardeners Studio (TV promo).
Needs: Works with 2 photographers, filmmakers and/or videographers/month. Uses photos for trade magazines and audiovisual. Model/property release required.
Audiovisual Needs: Primarily videotape; also slides and film.
Specs: Uses ½", ¾", Betacam/SP 1" videotape, DVC Pro Video format. Accepts images in digital format for Mac (any medium). Send via compact disc, online, floppy disk, SyQuest or Zip disk.
Making Contact & Terms: Send unsolicited photos by mail for consideration. Works on assignment only. Keeps samples on file. Reports in 1 month. Pays $50-300/day. **Pays on acceptance.** Credit lines sometimes given. Buys one-time, exclusive product, all and electronic rights; negotiable.
Tips: "We are seeing more use of freelancers, less staff. Be visible!"

KOLLINS COMMUNICATIONS, INC., 425 Meadowlands Pkwy., Secaucus NJ 07094. (201)617-5555. Fax: (201)319-8760. Manager: R.J. Martin. Estab. 1992. Types of clients: Fortune 1000 pharmaceuti-

cals, consumer electronics. Examples of projects: Sony (brochures); CBS Inc. (print ads); TBS Labs (slides).
Needs: Works with 1-2 freelance photographers/month. Uses photos for product shots, multimedia productions and videotapes. Subjects are various. Model release required.
Specs: Uses 35mm, 2¼×2¼, 4×5, 8×10 transparencies; Hi 8, ½" Betacam, SP, S-VHS. Accepts images in digital format for Mac. Submit via icompact disc, floppy disk, SyQuest or Zip disk.
Making Contact & Terms: Submit portfolio by mail. Provide résumé, business card, self-promotion piece or tearsheets to be kept on file for possible future assignments. Works on assignment only. Cannot return material. Reports in 2 weeks. Payment negotiable. Pays per day or per job. Pays by purchase order 30 days after work completed. Credit line given "when applicable." Buys all rights.
Tips: "Be specific about your best work (what areas), be flexible to budget on project—represent our company when on business."

LIEBER BREWSTER CORPORATE DESIGN, 19 W. 34th St., Suite 618, New York NY 10001. (212)279-9029. Contact: Anna Lieber. Estab. 1988. Design firm. Specializes in corporate communications and marketing promotion. Types of clients: health care, financial, publishers and nonprofit.
Needs: Works with freelancers on a per project basis. Uses photos for direct mail, catalogs, brochures, annual report and ads. Subjects include: food and wine, flowers, people, location, still life and corporate.
Specs: Uses 8×10 b&w prints; 35mm, 2¼×2¼, 4×5, 8×10 transparencies.
Making Contact & Terms: Provide résumé, business card, brochure, flier or tearsheets to be kept on file for possible future assignments. Works with freelancers on assignment only. Keeps samples on file. SASE. Reports only on solicited work. Pays $75-150/hour; $250-700/day; $500-2,000/job. **Pays on acceptance or receipt of invoice.** Credit line given. Rights negotiable.
Tips: Wants to see an "extremely professional presentation, well-defined style and versatility. Send professional mailers with actual work for clients, as well as creative personal work."

LIPPSERVICE, 305 W. 52nd St., New York NY 10019. Phone/fax: (212)956-0572. President: Ros Lipps. Estab. 1985. Celebrity consulting firm. Types of clients: industrial, financial, fashion, retail, food; "any company which requires use of celebrities." Examples of past projects: Projects for United Way of Tri-State, CARE, AIDS benefits, Child Find of America, League of American Theatres & Producers, *Celebrate Broadway*, United Jewish Appeal (UJA).
Needs: Works with freelance photographers and/or videographers. Uses photos for billboards, trade magazines, P-O-P displays, posters, audiovisual. Subjects include: celebrities only. Model/property release required.
Audiovisual Needs: Uses videotape.
Making Contact & Terms: Provide résumé, business card, brochure, flier or tearsheets to be kept on file for possible future assignments. Works on assignment only. Keeps samples on file. Cannot return material. Reports in 3 weeks. Payment negotiable. Credit line given. Rights purchased depend on job; negotiable.
Tips: Looks for "experience in photographing celebrities. *Contact us by mail only.*"

NEAL MARSHAD PRODUCTIONS, 145 Avenue of the Ameircas, New York NY 10013. (212)292-8910. E-mail: neal@marshad.com. Website: http://www.marshad.com. Owner: Neal Marshad. Estab. 1983. Video, motion picture and multimedia production house. Number of employees: 30.
Needs: Buys 20-50 photos/year; offers 5-10 assignments/year. Freelancers used for food, travel, production stills for publicity purposes. Examples of recent uses: "Conspiracy of Silence" (TV documentary/website using 35mm film); BBC Website (35mm); Estee Lauder (CD-Rom). Model release required. Property release preferred. Captions preferred.
Audiovisual Needs: Uses slides, film, video, Photo CD for multimedia CD-ROM. Subjects include: travel and food.
Specs: Uses 35mm, 2¼×2¼, 4×5 prints; 16mm film; Beta SP, 1" videotape. Accepts images in digital format for Mac or Windows. Send via compact, Zip or floppy disk or online.
Making Contact & Terms: Provide résumé, business card, self-promotion piece or tearsheets to be kept on file for possible future assignments. "No calls!" Works with local freelancers on assignment only. Keeps samples on file. SASE. Pays $50-100/hour; $150-300/day; $300-500/job; $10-100/color photo. Pays on usage. Credit line depends on client. Buys all rights; negotiable.
Tips: "Show high quality work, be on time, expect to be hired again if you're good." Expects "explosive growth in photography in the next two to five years as in the past five years."

MASEL ENTERPRISES, 2701 Bartram Rd., Bristol PA 19007. (215)785-1600. Fax: (215)785-1680. Marketing Manager: Richard Goldberg. Estab. 1906. Catalog producer. Photos used in posters, magazines, press releases, catalogs and trade shows.

• This company scans all photos and stores them. Photos are manipulated on PhotoShop, electronic photography welcome.

Needs: Buys over 250 photos/year; offers 15-20 assignments/year. Examples of recent uses: Internet Dictionary of Orthodontic Terms (website); "Gold Denture Teeth" (postcard); assorted product work for mail order catalogs. Reviews stock photos. Needs children and adults with braces on their teeth. Model release required.

Making Contact & Terms: Provide résumé, business card, self promotion piece or tearsheets to be kept on file for possible future assignments. Works with local freelancers on assignment only. Uses 4×5 glossy b&w prints; 35mm, 2¼×2¼, 4×5 transparencies. Accepts images in digital format for Mac. Send via CD, online, floppy disk, SyQuest or Zip disk. "Call for specs." Keeps samples on file. SASE. Reports in 2 weeks if interested. Pays $100/color or b&w photo; $250-500/cover shot; $800 maximum/day. Volume work is negotiated. **Pays on acceptance.** Credit line depends on terms and negotiation. Buys all rights.

Tips: "We're an interesting company with great layouts. We are always looking for new ideas. We invite input from our photographers and expect them to get involved."

MCANDREW ADVERTISING CO., 1 Mountain View Knolls, Suite M, Route 82, Fishkill NY 12524. Phone/fax: (914)897-2405. Contact: Robert McAndrew. Estab. 1961. Ad agency, PR firm. Approximate annual billing: $250,000. Number of employees: 2. Types of clients: industrial and technical. Examples of recent projects: trade advertising and printed material illustrations. Trade show photography.

Needs: Works with 1 freelance photographer/month. Uses photos for trade magazines, direct mail, brochures, catalogs, newspapers, audiovisual. Subjects include: technical products. Reviews stock photos of science subjects. Model release required for recognizable people. Property release required.

Audiovisual Needs: Uses slides and videotape.

Specs: Uses 8×10 glossy b&w or color prints; 35mm, 4×5 transparencies.

Making Contact & Terms: Interested in working with local photographers. Query with résumé of credits. Provide résumé, business card, brochure, flier, tearsheets or non-returnable samples to be kept on file for possible future assignments. Reports when appropriate. Pays $65/b&w photo; $150/color photo; $700/day. "Prices dropping because business is bad." Pays 30 days after receipt of invoice. Credit line sometimes given. Buys all rights; negotiable.

Tips: Photographers should "let us know how close they are, and what their prices are. We look for photographers who have experience in industrial photography." In samples, wants to see "sharp, well-lighted" work.

MEDIA LOGIC, INC., 1520 Central Ave., Albany NY 12205. (518)456-3015. Fax: (518)456-4279. E-mail: jhoe@mlinc.com. Production Manager: Jennifer Hoehn. Estab. 1984. Ad agency. Number of employees: 34. Types of clients: industrial, financial, fashion and retail.

Needs: Works with 2 freelancers/month. Uses photos for billboards, consumer magazines, trade magazines, direct mail, P-O-P displays, catalogs, posters, newspapers and signage. Subject matter varies. Reviews stock photos. Model release required. Property release preferred.

Specs: Uses transparencies.

Making Contact & Terms: Send unsolicited photos by mail for consideration. Provide résumé, business card, brochure, flier or tearsheets to be kept on file for possible future assignments. Keeps samples on file. SASE. Reports in 1-2 weeks. Pays $800/day. **Pays on receipt of invoice.** Credit line not given. Buys all rights; negotiable.

MIRACLE OF ALOE, 521 Riverside Ave., Westport CT 06880. (203)454-1919. Fax: (203)226-7333. Vice President: Jess F. Clarke, Jr. Estab. 1980. Manufacturers of aloe products for mail order buyers of healthcare products. Photos used in newsletters, catalogs, direct mail, consumer magazines, TV spots and infomercials.

• This company also has a contract with *Ripleys Believe It or Not!* They are working on a 2 minute direct response commercial to air January 1999. Needs both slides and video of unusual gardens, vegetables and flowers. Needs photographers to visit summer and fall 1998 county fairs and giant vegetable competitions.

Needs: Works with 2 freelancers per month. Uses testimonial photos and aloe vera plants. Model release preferred.

Making Contact & Terms: Provide résumé, business card, self-promotion piece or tearsheets to be kept on file for possible future assignments. Works on assignment only. Uses 4×5 b&w or color prints and 35mm transparencies. SASE. Reports in 1 month. Pays $30-45/photo. **Pays on receipt of invoice.** Credit line given. Buys one-time rights.

Tips: In freelancer's samples, looks for "older folks, head shots and nice white-haired ladies. Also show aloe vera plants in fields or pots; shoot scenes of southern Texas aloe farms. We need video photographers

to do testimonials of aloe users all around the country for pending 30-minute infomercial."

MIRANDA DESIGNS INC., 745 President St., Brooklyn NY 11215. (718)857-9839. Owner: Mike Miranda. Estab. 1970. Design firm and publisher. Specializes in publication design, direct mail and product development. Types of clients: industrial, financial, retail and nonprofit.
Needs: Works with 1 freelancer/month. Uses photos for annual reports, consumer magazines, direct mail and catalogs. Subjects include: product and reportage. Model/property release required.
Specs: Uses 8×10, matte, b&w prints; 35mm transparencies.
Making Contact & Terms: Interested in receiving work from newer, lesser-known photographers. Provide résumé, business card, brochure, flier or tearsheets to be kept on file for possible future assignments. Works on assignment only. Keeps samples on file. Cannot return material. Reports in 1-2 weeks. Payment negotiable. Credit line sometimes given depending upon client. Rights bought depend on client's needs.

MITCHELL STUDIOS DESIGN CONSULTANTS, 1111 Fordham Lane, Woodmere NY 11598. (516)374-5620. Fax: (516)374-6915. E-mail: msdesign@aol.com. Principal: Steven E. Mitchell. Estab. 1922. Design firm. Number of employees: 8. Types of clients: corporations with consumer products. Examples of projects: Lipton Cup-A-Soup, Thomas J. Lipton, Inc.; Colgate Toothpaste, Colgate Palmolive Co.; and Chef Boy-Ar-Dee, American Home Foods—all three involved package design.
Needs: Works with variable number of freelancers/month. Uses photographs for direct mail, P-O-P displays, catalogs, posters, signage and package design. Subjects include: still life/product. Reviews stock photos of still life/people. Model release required. Property release preferred. Captions preferred.
Specs: Uses all sizes and finishes of color and b&w prints; 35mm, 2¼×2¼, 4×5, 8×10 transparencies. Accepts images in digital format for Mac (EPS). Send via floppy disk or SyQuest (300 dpi).
Making Contact & Terms: Interested in receiving work from newer, lesser-known photographers. Submit portfolio for review. Provide résumé, business card, brochure, flier or tearsheets to be kept on file for possible future assignments. Cannot return material. Reports as needed. Pays $35-75/hour; $350-1,500/day; $500 and up/job. **Pays on receipt of invoice.** Credit line sometimes given depending on client approval. Buys all rights.
Tips: In portfolio, looks for "ability to complete assignment." Sees a trend toward "tighter budgets." To break in with this firm, keep in touch regularly.

MIZEREK ADVERTISING INC., 318 Lexington Ave., New York NY 10016. (212)689-4885. E-mail: mizerek@aol.com. President: Leonard Mizerek. Estab. 1974. Types of clients: fashion, jewelry and industrial.
Needs: Works with 2 freelance photographers/month. Uses photographs for trade magazines. Subjects include: still life and jewelry. Reviews stock photos of creative images showing fashion/style. Model release required. Property release preferred.
Specs: Uses 8×10 glossy b&w prints; 4×5 and 8×10 transparencies. Accepts images in digital format for Mac. Send via Zip disk or online.
Making Contact & Terms: Submit portfolio for review. Provide résumé, business card, brochure, flier or tearsheets to be kept on file for possible future assignments. SASE. Reports in 2 weeks. Pays $500-1,500/job; $1,500-2,500/day; $600/color photo; $400/b&w photo. **Pays on acceptance.** Credit line sometimes given.
Tips: Looks for "clear product visualization. Must show detail and have good color balance." Sees trend toward "more use of photography and expanded creativity." Likes a "thinking" photographer.

STEWART MONDERER DESIGN, INC., 10 Thacher St., Suite 112, Boston MA 02113, (617)720-5555. Fax: (617)720-5558. E-mail: monderer@shore.net. President: Stewart Monderer. Estab. 1981. Member of AIGA. Design firm. Number of employees: 4. Specializes in annual reports, publication design and packaging. Types of clients: industrial, financial and nonprofit. Examples of recent projects: Aspen Technology Annual Report (metaphorical imagery); Techgnosis, SequeLink Brochure for Techgnosis (metaphorical imagery); and Ariad Annual Report for Ariad Pharmaceuticals (closeup b&w faces).
Needs: Works with 2 freelancers/month. Uses photos for annual reports, catalogs, posters and brochures. Subjects include: conceptual, site specific, product shots, people on location. Model release preferred. Property release sometimes required.
Specs: Uses 8½×11 b&w prints; 35mm, 2¼×2¼, 4×5 transparencies. Accepts images in digital format.
Making Contact & Terms: Send unsolicited photos by mail for consideration. Keeps samples on file. SASE. Follow up from photographers recommended. Payment negotiable. **Pays on receipt of invoice.** Credit line sometimes given depending upon client. Rights always negotiated depending on use.

N. ☒ MONTGOMERY & PARTNERS, INC., 2345 Bernville Rd., Reading PA 19605-9604. (610)372-5106. Fax: (610)376-7636. E-mail: beverly1@epix.net. Website: http://www.montyads.com. President: Beverly Montgomery. Estab. 1986. Member of AAAA (American Association of Advertising Agencies). Ad agency. Approximate annual billing: $2 million. Number of employees: 15. Firm specializes in magazine ads, collateral, Internet. Types of clients: industrial, financial, retail, nonprofit.
Needs: Works with 4 freelancers/month. Uses photos for brochures, catalogs, consumer magazines, newspapers, P-O-P displays, trade magazines. Reviews stock photos. Model release required; property release required.
Audiovisual Needs: Uses slides and/or powerpoint presentations.
Specs: Uses 35mm transparencies. Accepts images in digital format.
Making Contact & Terms: Provide résumé, business card, self-promotion piece or tearsheets to be kept on file for possible future assignments. Art director will contact photographer for portfolio review if interested. Portfolio should include b&w, color, tearsheets, slides, transparencies. Works with freelancers on assignment only. Keeps samples on file. **Pays on receipt of invoice.** Credit line sometimes given depending upon usage. Buys one-time rights and negotiated rights based on length of time of usage.

☒ RUTH MORRISON ASSOCIATES, 246 Brattle St., Cambridge MA 02138. (617)354-4536. Fax: (617)354-6943. Account Executive: Rebecca Fields. Estab. 1972. PR firm. Types of clients: food, home furnishings, travel and general business.
Needs: Works with 1-2 freelance photographers/month. Uses photos for newspapers, consumer and trade magazines, posters and brochures.
Specs: Specifications vary according to clients' needs. Typically uses b&w prints and transparencies.
Making Contact & Terms: Send résumé, business card, brochure, flier or tearsheets to be kept on file for possible future assignments. Works with freelancers on assignment only. Reports "as needed." Pays $200-1,000 depending upon client's budget. Credit line sometimes given, depending on use. Rights negotiable.

☒ MUDERICK MEDIA, 101 Earlington Rd., Havertown PA 19083. (610)449-6970. Owner: Michael Muderick. Estab. 1984. Types of clients: industrial and financial.
Needs: Works with 4 photographers and/or videographers/month. Uses photos for audiovisual.
Audiovisual Needs: Uses slides and videotape.
Specs: Uses Betacam ¾" videotape, VHS for demo.
Making Contact & Terms: Provide résumé, business card, brochure, flier or tearsheets to be kept on file for possible future assignments. Works with local freelancers only. Keeps samples on file. Does not report on unsolicited material. "Payment negotiable depending on budget." Pays on acceptance or receipt of invoice. Buys all rights; negotiable. Model/property release required. Credit line not given.

NASSAR DESIGN, 560 Harrison Ave., Boston MA 02146. (617)482-1464. Fax: (617)426-3604. President: Nélida Nassar. Estab. 1980. Member of American Institute of Graphic Arts, Art Guild, Boston Spanish Association. Design firm. Approximate annual billing: $1.5 million. Number of employees: 3. Specializes in publication design, signage. Types of clients: publishers, nonprofit and colleges. Examples of recent projects: The Chinese Porcelain Company (photography of all objects); Metropolitan Museum of Art (photography of all sculptures); and Harvard University (photography of the campus and the architecture).
Needs: Works with 1-2 freelancers/month. Uses photos for catalogs, posters, signage. Subjects include art objects, architectural sites and products. Reviews stock photos. Model release required; property release preferred. Captions required.
Specs: Uses 8×10 glossy color and b&w prints; 4×5 transparencies.
Making Contact & Terms: Submit portfolio for review. Query with samples. Keeps samples on file. SASE. Reports in 1-2 weeks. Pays $1,200-1,500/day; $45/color or b&w photo; $150-175/hour; $3,000-6,000/job. **Pays on receipt of invoice.** Credit line given. Buys all rights.
Tips: "We always look for the mood created in a photograph that will make it interesting and unique."

NATIONAL BLACK CHILD DEVELOPMENT INSTITUTE, 1023 15th St. NW, Suite 600, Washington DC 20005. (202)387-1281. Fax: (202)234-1738. Deputy Director: Vicki D. Pinkston. Estab. 1970. Photos used in brochures, newsletters, annual reports and annual calendar.
Needs: Candid action photos of black children and youth. Reviews stock photos. Model release required.
Specs: Uses 5×7 or 8×10 color and glossy b&w prints and color slides or b&w contact sheets.
Making Contact & Terms: Query with samples. Send unsolicited photos by mail for consideration. SASE. Reports in 1 month. Pays $70/cover photo and $20/inside photo. Credit line given. Buys one-time rights.
Tips: "Candid action photographs of one black child or youth or a small group of children or youths.

Color photos selected are used in annual calendar and are placed beside an appropriate poem selected by organization. Therefore, photograph should communicate a message in an indirect way. Black & white photographs are used in quarterly newsletter and reports. Obtain sample of publications published by organization to see the type of photographs selected."

NATIONAL TEACHING AIDS, INC., 1845 Highland Ave., New Hyde Park NY 11040. (516)326-2555. Fax: (516)326-2560. President: A. Becker. Estab. 1960. AV firm. Types of clients: schools. Produces filmstrips and CD-ROMs.
Needs: Buys 20-100 photos/year. Subjects include: science; needs photomicrographs and space photography.
Specs: Uses 35mm transparencies.
Making Contact & Terms: Cannot return material. Pays $50 minimum. Buys one-time rights; negotiable.

THE NEIMAN GROUP, 415 Market St., Suite 201, Harrisburg PA 17101. (717)232-5554. Fax: (717)232-7998. E-mail: neimangrp@aol.com. Website: http://www.neimangrp.com. Contact: Art Director. Estab. 1980. Ad agency, PR firm. Firm specializes in annual reports, magazine ads, packaging, direct mail, signage, collateral. Types of clients: financial, retail, nonprofit, agricultural, food, medical, industrial.
Needs: Uses photos for brochures, consumer magazines, direct mail, newspapers, trade magazines. Reviews stock photos. Model release required.
Making Contact & Terms: Send query letter with samples, tearsheets. Art director will contact photographer for portfolio review if interested. Works with local freelancers on assignment only. Keeps samples on file. Pays by the project. **Pays on receipt of invoice.** Buys one-time rights, all rights.

LOUIS NELSON ASSOCIATES INC., 80 University Place, New York NY 10003. (212)620-9191. Fax: (212)620-9194. Design firm. Estab. 1980. Types of clients: corporate, retail, not-for-profit and government agencies.
Needs: Works with 3-4 freelance photographers/year. Uses photographs for consumer and trade magazines, catalogs and posters. Reviews stock photos only with a specific project in mind.
Audiovisual Needs: Occasionally needs visuals for interactive displays as part of exhibits.
Making Contact & Terms: Submit portfolio for review. Provide résumé, business card, brochure, flier or tearsheets to be kept on file for possible future assignments. Works on assignment only. Cannot return material. Does not report; call for response. Payment negotiable. **Pays on receipt of invoice.** Credit line sometimes given depending upon client needs.
Tips: In portfolio, wants to see "the usual . . . skill, sense of aesthetics that doesn't take over and ability to work with art director's concept." One trend is that "interactive videos are always being requested."

NICHOLSON NY, LLC, (formerly Tom Nicholson Associates Inc.), 295 Lafayette St., 8th Floor, New York NY 10012. (212)274-0470. Fax: (212)274-0380. President: Tom Nicholson. Estab. 1987. Full-service Interactive Media Developer. Types of clients: Fortune 500 and publishers. Examples of recent projects: Sony Professional Serivces, IBM Brand Banners, Reader Digest Web presence, Pequot Indian Museum interactive kiosk installation.
Needs: Works with 0-3 freelancers/month. Work with 0-3 freelancers per month. Hires Photoshop experts freelance and full-time to prepare production art.
Specs: Uses various formats.
Making Contact & Terms: Provide résumé, business card, brochure, flier or tearsheets to be kept on file for possible future assignments. Cannot return material. Payment negotiable. Pays on publication. Credit line given. Buys one-time, exclusive product and all rights; negotiable.
Tips: "The industry is moving toward electronic usage. Need realistic pricing to address this market."

NOSTRADAMUS ADVERTISING, #1128A, 250 W. 57th, New York NY 10107. (212)581-1362. Fax: (212)581-1369. President: Barry Sher. Estab. 1974. Ad agency. Types of clients: politicians, nonprofit organizations and small businesses.
Needs: Uses freelancers occasionally. Uses photos for consumer and trade magazines, direct mail, catalogs and posters. Subjects include: people and products. Model release required.
Specs: Uses 8×10 glossy b&w and color prints; transparencies, slides.
Making Contact & Terms: Provide résumé, business card, brochure. Works with local freelancers only. Cannot return material. Pays $50-100/hour. Pays 30 days from invoice. Credit line sometimes given. Buys all rights (work-for-hire).

NOVUS VISUAL COMMUNICATIONS, INC., 18 W. 27th St., New York NY 10001-6904. (212)689-2424. Fax: (212)696-9676. E-mail: novuscom@aol.com. Owner/President: Robert Antonik. Estab. 1988.

Creative marketing and communications firm. Specializes in advertising, annual reports, publication design, display design, multi-media, packaging, direct mail, signage and website and Internet and DVD development. Types of clients: industrial, financial, retail, health care, telecommunications, entertainment and nonprofit.

Needs: Works with 1 freelancer/month. Uses photos for annual reports, billboards, consumer and trade magazines, direct mail, P-O-P displays, catalogs, posters, packaging and signage. Reviews stock photos. Model/property release required. Captions preferred.

Specs: Uses color and b&w prints; 35mm, $2\frac{1}{4} \times 2\frac{1}{4}$, 4×5, 8×10 transparencies. Accepts images in digital format for Mac (Tiff). Send via Zip disk.

Making Contact & Terms: Arrange personal interview to show portfolio. Works on assignment only. Keeps samples on file. Material cannot be returned. Reports in 1-2 weeks. Payment negotiable. Pays upon client's payment. Credit line given. Rights negotiable.

Tips: "The marriage of photos with illustrations or opposite usage continues to be trendy, but more illustrators and photographers are adding stock usage as part of their business, alone or with stock shops."

■ PARAGON ADVERTISING, 43 Court St., Suite 1111, Buffalo NY 14202. (716)854-7161. Fax: (716)854-7163. Senior Art Director: Leo Abbott. Estab. 1988. Ad agency. Types of clients: industrial, retail, food and medical.

Needs: Works with 0-5 photographers, 0-1 filmmakers and 0-1 videographers/month. Uses photos for billboards, consumer and trade magazines, P-O-P displays, catalogs, posters, newspapers, signage and audiovisual. Subjects include: location. Reviews stock photos. Model release required. Property release preferred.

Audiovisual Needs: Uses film and videotape for on-air.

Specs: Uses 8×10 prints; $2\frac{1}{4} \times 2\frac{1}{4}$ or 4×5 transparencies; 16mm film; and ¾", 1" Betacam videotape.

Making Contact and Terms: Submit portfolio for review. Query with stock photo list. Send unsolicited photos by mail for consideration. Works on assignment only. Keeps samples on file. SASE. Reports in 1-2 weeks. Pays $500-2,000 day; $100-5,000 job. Pays on receipt of invoice. Credit line sometimes given. Buys all rights; negotiable.

■ PERCEPTIVE MARKETERS AGENCY, LTD., 1100 E. Hector St., Suite 301, Conshohocken PA 19428. (610)825-8710. Fax: (610)825-9186. E-mail: perceptmkt@aol.com. Contact: Jason Solovitz. Estab. 1972. Member of Advertising Agency Network International, Philadelphia Ad Club, Philadelphia Direct Marketing Association. Ad agency. Number of employees: 8. Types of clients: health care, business, industrial, financial, fashion, retail and food. Examples of recent projects: 900 Services Quarterly Newsletter, AT&T; Technology Campaign, Johnson Matthey; Transit Program, Young Windows; Model 51 Launch, OPEX Corporation.

Needs: Works with 3 freelance photographers, 1 filmmaker and 1 videographer/month. Uses photos for consumer magazines, trade magazines, direct mail, P-O-P displays, catalogs, posters, newspapers, signage and audiovisual. Reviews stock photos. Model release required; property release preferred. Captions preferred.

Audiovisual Needs: Uses slides and film or video.

Specs Uses 8×12 and 11×14 glossy color and b&w prints; $2\frac{1}{4} \times 2\frac{1}{4}$, 4×5 transparencies. Accepts images in digital format for Mac.Send via CD, SyQuest, floppy or Zip disk or Online.

Making Contact & Terms: Query with stock photo list. Provide résumé, business card, brochure, flier or tearsheets to be kept on file for possible future assignments. Works on assignment only. Keeps samples on file. Pays minimum $75/hour; $800/day. **Pays on receipt of invoice**. Credit line not given. Buys all rights; negotiable.

THE PHILIPSON AGENCY, 241 Perkins St., Suite B201, Boston MA 02130. (617)566-3334. Owner/Creative Director: Joe Philipson. Estab. 1977. Ad Agency. Number of employees: 4. Types of clients: financial, consumer product manufacturers, food service, computer products.

Needs: Works with 1 photographer/month. Uses photos for trade magazine ads, direct mail, P-O-P displays, catalogs, packaging, brochures and posters. Subjects include: product shots. Reviews stock photos. Model/property release preferred.

Audiovisual Needs: Uses slides for sales presentations.

CONTACT THE EDITOR, of *Photographer's Market* by e-mail at photomarket@fwpubs.com with your questions and comments.

Specs: Uses all sizes and finishes color and b&w prints; 35mm, 2¼×2¼, 4×5, 8×10 transparencies; film; and digital format. Accepts Mac compatible Tiff, EPS and JPEG files on CD, floppy, Zip, SyQuest or online.
Making Contact & Terms: Query with samples. Provide résumé, business card, brochure, flier or tear-sheets to be kept on file for possible future assignments. Works on assignment only. Keeps samples on file. Cannot return material. Calls photographer when work needed. Payment negotiable. **Pays on receipt of invoice.** Credit line sometimes given depending on client. Buys all rights.

POSEY SCHOOL OF DANCE, INC., Box 254, Northport NY 11768. (516)757-2700. E-mail: 74534.1 660@compuserve.com. President: Elsa Posey. Estab. 1953. Sponsors a school of dance and a regional dance company. Photos used in brochures, news releases and newspapers.
Needs: Buys 10-12 photos/year; offers 4 assignments/year. Special subject needs include children dancing, ballet, modern dance, jazz/tap (theater dance) and classes including women and men. Reviews stock photos. Model release required.
Specs: Uses 8×10 glossy b&w prints. Accepts images compatible with Windows on CD.
Making Contact & Terms: "Call us." Works on assignment only. Accepts images in digital format for Windows. SASE. Reports in 1 week. Pays $25-200/b&w or color photo. Credit line given if requested. Buys one-time rights; negotiable.
Tips: "We are small, but interested in quality (professional) work. Capture the joy of dance in a photo of children or adults. We prefer informal action photos, not 'posed pictures.' We need photos of REAL dancers doing dance."

PRO/CREATIVES, 25 W. Burda Place, New City NY 10956-7116. President: David Rapp. Ad agency. Uses all media except billboards and foreign. Types of clients: package goods, fashion, men's entertainment and leisure magazines, sports and entertainment.
Specs: Send any size b&w prints. For color, send 35mm transparencies or any size prints.
Making Contact & Terms: Submit material by mail for consideration. Reports as needed. SASE. Payment negotiable based on client's budget.

[N] SUSAN M. RAFAJ MARKETING ASSOCIATES, 135 E. 55th St., New York NY 10022. (212)759-1991. Fax: (212)755-4841. Website: http://www.rafaj.com. Executive Vice President: John Collier. Estab. 1978. Member of American Association of Advertising Agencies. Ad agency and design firm. Firm specializes in display design, magazine ads, packaging, collateral. Types of clients: industrial.
Needs: Uses photos for P-O-P displays. Subjects include: beauty and lifestyle. Reviews stock photos. Model release required.
Audiovisual Needs: Uses slides and/or videotape.
Making Contact & Terms: Send query letter with stock photo list. Art director will contact photographer for portfolio review if interested. Keeps samples on file; include SASE for return of material. Reports back only if interested, send non-returnable samples. Pays on receipt of invoice. Credit line not given. Rights negotiable.

ROSEN-COREN AGENCY, 2381 Philmont Ave., Suite 117, Huntingdon PA 19006. (215)938-1017. Fax: (215)938-7634. Office Administrator: Ellen R. Coren. PR firm. Types of clients: industrial, retail, fashion, finance, entertainment, health care.
Needs: Works with 4 freelance photographers/month. Uses photos for PR shots.
Specs: Uses b&w prints.
Making Contact & Terms: "Follow up with phone call." Works with local freelancers only. Reports when in need of service. Pays $75-85/hour for b&w and color photos. Pays when "assignment completed and invoice sent—45 days."

PETER ROTHHOLZ ASSOCIATES, INC., 355 Lexington Ave., 17th Floor, New York NY 10017. (212)687-6565. Contact: Peter Rothholz. PR firm. Types of clients: pharmaceuticals (health and beauty), government, travel.
Needs: Works with 2 freelance photographers/year, each with approximately 8 assignments. Uses photos for brochures, newsletters, PR releases, AV presentations and sales literature. Model release required.
Specs: Uses 8×10 glossy b&w prints; contact sheet OK.
Making Contact & Terms: Provide letter of inquiry to be kept on file for possible future assignments. Query with résumé of credits or list of stock photo subjects. Local freelancers preferred. SASE. Reports in 2 weeks. Payment negotiable based on client's budget. Credit line given on request. Buys one-time rights.
Tips: "We use mostly standard publicity shots and have some 'regulars' we deal with. If one of those is

unavailable we might begin with someone new—and he/she will then become a regular."

RPD GROUP, Richard Puder Design, (formerly Richard Puder Design) 2 W. Blackwell St., P.O. Box 1520, Dover NJ 07801. (973)361-1310. Fax: (973)361-1663. E-mail: strongtype@aol.com. Website: http://www.strongtype.com. Owner: Richard Puder. Estab. 1985. Member of Type Directors Club. Design firm. Approximate annual billing: $300,000. Number of employees: 3. Specializes in annual reports, publication design, packaging and direct mail. Types of clients: publishers, corporate and communication companies.
Needs: Works with 1 freelancer/month. Uses photos for annual reports, trade magazines, direct mail, posters and packaging. Subjects include: corporate situations and executive portraits. Reviews stock photos. Model/property release preferred.
Specs: Uses 8×10 glossy color and b&w prints; $2\frac{1}{4} \times 2\frac{1}{4}$, 4×5, 8×10 transparencies. Accepts images in digital format for Mac in TIF, JPEG and PDF files. Send via CD, SyQuest (44mg), Online, Zip disk or floppy disk.
Making Contact & Terms: Provide résumé, business card, brochure, flier or tearsheets to be kept on file for possible future assignments. Works on assignment only. Keeps samples on file. Cannot return material. "We reply on an as needed basis." Pays $500-1,200/day. Pays in 30 days upon receipt of invoice. Credit line sometimes given depending upon client needs and space availability. Buys one-time rights; negotiable.

RSVP MARKETING, INC., 450 Plain St., Marshfield MA 02050. (617)837-2804. Fax: (617)837-5389. E-mail: rsvpmktg@aol.com. President: Edward G. Hicks. Estab. 1981. Member of NEDMA, DMA, AMA. Ad agency and AV firm. Types of clients: industrial, financial, fashion, retail and construction. Examples of recent projects: "Landfill Reclamation," RETECH (trade shows); "Traffic," Taylor (print media); and "Fund Raising," CHF (newsletter).
Needs: Works with 1-2 freelance photographers and 1-2 videographers/month. Uses photos for trade magazines, direct mail, catalogs, newspapers and audiovisual. Subjects include: environment and people. Model release required.
Audiovisual Needs: Uses slides and videotape for advertising and trade shows.
Specs: Uses 5×7 color and b&w prints; 35mm, $2\frac{1}{4} \times 2\frac{1}{4}$, 4×5, 8×10 transparencies.
Making Contact & Terms: Query with stock photo list or samples. Works with freelancers on assignment only. Keeps samples on file. Reports in 1 month. Payment negotiable. Pays net 30 days. Buys all rights.

ARNOLD SAKS ASSOCIATES, 350 E. 81st St., New York NY 10028. (212)861-4300. Fax: (212)535-2590. Photo Librarian: Patricia Chan. Estab. 1968. Member of AIGA. Graphic design firm. Number of employees: 15. Types of clients: industrial, financial, legal, pharmaceutical and utilities. Clients include: 3M, Siemens, Alcoa, Goldman Sachs and MCI.
 • This firm conducts many stock photo searches using computer networks. They also scan images onto CD-ROM.
Needs: Works with approximately 15 photographers during busy season. Uses photos for annual reports and corporate brochures. Subjects include corporate situations and portraits. Reviews stock photos; subjects vary according to the nature of the annual report. Model release required. Captions preferred.
Specs: Uses b&w prints; 35mm, $2\frac{1}{4} \times 2\frac{1}{4}$, 4×5, 8×10 transparencies.
Making Contact & Terms: "Appointments are set up during the spring for summer review on a first-come only basis. We have a limit of approximately 30 portfolios each season." Call to arrange an appointment. Works on assignment only. Reports as needed. Payment negotiable, "based on project budgets. Generally we pay $1,250-2,250/day." Pays on receipt of invoice and payment by client; advances provided. Credit line sometimes given depending upon client specifications. Buys one-time and all rights; negotiable.
Tips: "Ideally a photographer should show a corporate book indicating his success with difficult working conditions and establishing an attractive and vital final product. Our company is well known in the design community for doing classic graphic design. We look for solid, conservative, straightforward corporate photography that will enhance these ideals."

JACK SCHECTERSON ASSOCIATES, 5316 251 Place, Little Neck NY 11362. (718)225-3536. Fax: (718)423-3478. Principal: Jack Schecterson. Estab. 1962. Design firm. Specializes in product, packaging and graphic design. Types of clients: industrial, consumer product manufacturers.
Needs: "Depends on work in-house." Uses photos for P-O-P displays and packaging. Reviews stock photos. Model/property release required. Captions preferred.
Specs: Variety of size color/b&w prints; 35mm, $2\frac{1}{4} \times 2\frac{1}{4}$, 4×5 and 8×10 transparencies.
Making Contact & Terms: Works with local freelancers on assignment only. Cannot return material. Reports in 3 weeks. Payment negotiable, "depends upon job." Credit line sometimes given. Buys all rights.
Tips: Wants to see creative and unique images.

SELBERT PERKINS DESIGN, 2067 Massachusetts Ave., Cambridge MA 02140. (617)497-6605. Fax: (617)661-5772. Second location: 1916 Main St., Santa Monica CA 90405. (310)664-9100. Fax: (310)452-7180. Estab. 1982. Member of AIGA, SEGD. Design firm. Number of employees: 50. Specializes in strategic corporate identity design, environmental communications design, product and packaging design, landscape architecture and urban design, multimedia design. Types of clients: architecture, institutional, entertainment, consumer products, sports, high tech and financial. Examples of current clients: State Street Research, Hasbro, University of Southern California, Care Group.
Needs: Number of photos bought each month varies. Uses photos for annual reports, billboards, consumer and trade magazines, direct mail, P-O-P displays, catalogs, posters, packaging and signage. Reviews stock photos.
Making Contact & Terms: Submit portfolio for review. Provide résumé, business card, brochure, flier or tearsheets to be kept on file for possible future assignments. "We have a drop off policy." Keeps samples on file. SASE. Payment negotiable. Credit line given.

MARC SMITH COMPANY, INC., 10 Luna Lane, Severna Park MD 21146. (410)647-2606. Art Director: Ed Smith. Estab. 1963. Ad agency. Types of clients: industrial. Client list on request with SASE.
Needs: Uses photos for trade magazines, direct mail, catalogs, slide programs and trade show booths. Subjects include: products, sales literature (still life), commercial buildings (interiors and exteriors). Model release required for building owners, designers, incidental persons. Captions required.
Specs: Vary: b&w and color prints and transparencies.
Making Contact & Terms: Provide résumé, business card, brochure, flier or tearsheets to be kept on file for possible future assignments. Works with freelance photographers on assignment only. Cannot return material. Reports in 1 month. Payment negotiable by the job. Pays when client pays agency, usually 30-60 days. Buys all rights.
Tips: Wants to see "proximity, suitability, cooperation and reasonable rates."

SORIN PRODUCTIONS, INC., 919 Hwy. 33, Suite 46, Freehold NJ 07728. (732)462-1785. Fax: (732)462-8411. E-mail: mail@sorinvideo.com. Website: http://www.sorinvideo.com.President: David Sorin. Type of client: corporate.
Needs: Works with 2 freelance photographers/month. Uses photographers for slide sets, multimedia productions, films and videotapes. Subjects include people and products.
Specs: Uses b&w and color prints; 35mm and 2¼×2¼ transparencies. Accepts images in digital format for Mac. Send via Zip disk or Online (72 dpi).
Making Contact & Terms: Query with stock photo list. Provide résumé, business card, self-promotion piece or tearsheets to be kept on file for possible future assignments. Works with freelancers by assignment only; interested in stock photos/footage. Does not return unsolicited material. Reports in 2 weeks. Payment negotiable. Pays per piece or per job. **Pays on acceptance.** Buys all rights. Captions and model releases preferred. Credit line given by project.

SPECIAL OLYMPICS INTERNATIONAL, 1325 G St. NW, Suite 500, Washington DC 20005. (202)628-3630. Fax: (202)824-0200. Visual Communications Manager: Jill Dixon. Estab. 1968. Provides sports training/competition to people with mental retardation. Photos used in brochures, newsletters, posters, annual reports, media and audiovisual.
Needs: Buys 500 photos/year; offers 3-5 assignments/year. Sports action and special events. Examples of recent uses: awards banquet (prints used in newsletters and momentos); sports training clinic (slides used for training presentation); sports exhibition (prints used for newsletter and momentos). Model/property release preferred for athletes and celebrities.
Audiovisual Needs: Uses slides and videotape.
Specs: Uses 3×5, 5×7 and 8×10 glossy color or b&w prints; 35mm transparencies; VHS, U-matic, Betacam, 1″ videotape.
Making Contact & Terms: Provide résumé, business card, self-promotion piece or tearsheets to be kept on file for possible future assignments. Keeps samples on file. SASE. Reports in 1 month. Pays $50-100/hour; $300-500/job. Processing additional. "Many volunteer time and processing because we're a not-for-profit organization." **Pays on acceptance.** Credit line depends on the material it is used on (no credit on brochure; credit in magazines). Buys one-time and all rights; negotiable.
Tips: Specific guidelines can be given upon request. Looking for "good action and close-up shots. Send example of work related to our organization's needs (i.e. sports photography, etc.). The best way to judge a photographer is to see the photographer's work."

SPENCER PRODUCTIONS, INC., 736 West End Ave., New York NY 10025. General Manager: Bruce Spencer. Estab. 1961. PR firm. Types of clients: business, industry. Produces motion pictures and videotape.

Needs: Works with 1-2 freelance videographers/month on assignment only. Buys 2-6 films/year. Satirical approach to business and industry problems. Length: "Films vary—from a 1-minute commercial to a 90-minute feature." Freelance photos used on special projects. Model/property release required. Captions required.

Making Contact & Terms: Provide résumé and letter of inquiry to be kept on file for possible future assignments. Query with samples and résumé of credits. "Be brief and pertinent!" SASE. Reports in 3 weeks. Pays $50-150/color and b&w photos (purchase of prints only; does not include photo session); $15/hour; $500-5,000/job. Payment negotiable based on client's budget. Pays a royalty of 5-10%. **Pays on acceptance.** Buys one-time rights and all rights; negotiable.

Tips: "Almost all of our talent was unknown in the field when hired by us. For a sample of our satirical philosophy, see paperback edition of *Don't Get Mad . . . Get Even* (W.W. Norton), by Alan Abel which we promoted, or *How to Thrive on Rejection* (Dembner Books, Inc.), or rent the home video *Is There Sex After Death?*, an R-rated comedy featuring Buck Henry."

STEWART DIGITAL VIDEO, 525 Mildred Ave., Primos PA 19018. (610)626-6500. Fax: (610)626-2638. Studio and video facility. Director of Sales: Mark von Zeck. Estab. 1970. Types of clients: corporate, commercial, industrial, retail.

Audiovisual Needs: Uses 15-25 freelancers/month for film and videotape productions.

Specs: Reviews film or video of industrial and commercial subjects. Film and videotape (specs vary).

Making Contact & Terms: Provide résumé, business card, brochure to be kept on file for possible future assignments. Works with freelancers on assignment basis only. Reports as needed. Pays $250-800/day; also pays "per job as market allows and per client specs." Photo captions preferred.

Tips: "The industry is really exploding with all types of new applications for film/video production." In freelancer's demos, looks for "a broad background with particular attention paid to strong lighting and technical ability." To break in with this firm, "be patient. We work with a lot of freelancers and have to establish a rapport with any new ones that we might be interested in before we will hire them." Also, "get involved on smaller productions as a 'grip' or assistant, learn the basics and meet the players."

TALCO PRODUCTIONS, 279 E. 44th St., New York NY 10017. (212)697-4015. Fax: (212)697-4827. E-mail: alaw@enet.com. President: Alan Lawrence. Vice President: Marty Holberton. Estab. 1968. Public relations agency and TV, film, radio and audiovisual production firm. Number of employees: 5. Types of clients: industrial, legal, political and nonprofit organizations. Produces motion pictures, videotape and radio programs.

Needs: Works with 1-2 freelancers/month. Model/property release required.

Audiovisual Needs: Uses 16mm and 35mm film, Beta videotape. Filmmaker might be assigned "second unit or pick-up shots."

Making Contact & Terms: Query with résumé of credits. Provide résumé, flier or brochure to be kept on file for possible future assignments. Prefers to see general work or "sample applicable to a specific project we are working on." Works on assignment only. SASE. Reports in 3 weeks. Payment negotiable according to client's budget and where the work will appear. **Pays on receipt of invoice.** Buys all rights.

Tips: Filmmaker "must be experienced—union member is preferred. We do not frequently use freelancers except outside the New York City area when it is less expensive than sending a crew. Query with résumé of credits only—don't send samples. We will ask for specifics when an assignment calls for particular experience or talent."

MARTIN THOMAS, INC., Advertising & Public Relations, 334 County Road, Barrington RI 02806. (401)245-8500. Fax: (401)245-1242. E-mail: mpottle@martinthomas.com. President: Martin K. Pottle. Estab. 1987. Ad agency, PR firm. Approximate annual billing: $6 million. Number of employees: 6. Types of clients: industrial and business-to-business. Examples of ad campaigns: "Bausch & Lomb" for GLS Corporation (magazine cover); "Soft Bottles" for McKechnie (booth graphics); and "Perfectly Clear" for ICI Acrylics (brochure).

Needs: Works with 3-5 freelance photographers/month. Uses photos for trade magazines. Subjects include: location shots of equipment in plants and some studio. Model release required.

Audiovisual Needs: Uses videotape for 5-7 minute capabilities or instructional videos.

Specs: Uses 8×10 color and b&w prints; 35mm and 4×5 transparencies. Accepts images in digital format for Windows (call first). Send via compact disc, on line or floppy disk.

Making Contact & Terms: Send stock photo list. Provide résumé, business card, brochure, flier or tearsheets to be kept on file for possible future assignments. Send materials on pricing, experience. "No

unsolicited portfolios will be accepted or reviewed." Works with local freelancers on assignment only. Cannot return material. Pays $1,000-1,500/day; $300-900/b&w photo; $400-1,000/color photo. Pays 30 days following receipt of invoice. Buys exclusive product rights; negotiable.

Tips: To break in, demonstrate you "can be aggressive, innovative, realistic and can work within our clients' parameters and budgets. Be responsive, be flexible."

TOBOL GROUP, INC., 14 Vanderventer Ave., Port Washington NY 11050. (516)767-8182. Fax: (516)767-8185. E-mail: mt@tobolgroup.com. Website: http://www.tobolgroup.com. Ad agency/design studio. President: Mitch Tobol. Estab. 1981. Types of clients: high-tech, industrial, business-to-business and consumer. Examples of ad campaigns: Weight Watchers (in-store promotion); Eutectic & Castolin; Mainco (trade ad); and Light Alarms.

Needs: Works with up to 4 photographers/videographers/month. Uses photos for billboards, consumer and trade magazines, direct mail, P-O-P displays, catalogs, posters, newspapers and audiovisual. Subjects are varied; mostly still-life photography. Reviews business-to-business and commercial video footage. Model release required.

Audiovisual Needs: Uses videotape.

Specs: Uses 4×5, 8×10, 11×14 b&w prints; 35mm, 2¼×2¼ and 4×5 transparencies; and ½″ videotape. Accepts images in digital format for Mac. Send via Zip, floppy, CD, SyQuest, optical or Online.

Making Contact & Terms: Send unsolicited photos by mail for consideration. Query with samples. Provide résumé, business card, brochure, flier or tearsheets to be kept on file for possible future assignments: follow-up with phone call. Works on assignment only. SASE. Reports in 3 weeks. Pays $100-10,000/job. Pays net 30 days. Credit line sometimes given, depending on client and price. Rights purchased depend on client.

Tips: In freelancer's samples or demos, wants to see "the best—any style or subject as long as it is done well. Trend is photos or videos to be multi-functional. Show me your *best* and what you enjoy shooting. Get experience with existing company to make the transition from still photography to audiovisual."

TR PRODUCTIONS, 1031 Commonwealth Ave., Boston MA 02215. (617)783-0200. Executive Vice President: Ross P. Benjamin. Types of clients: industrial, commercial and educational.

Needs: Works with 1-2 freelance photographers/month. Uses photographers for slide sets and multimedia productions. Subjects include: people shots, manufacturing/sales and facilities.

Specs: Uses 35mm transparencies.

Making Contact & Terms: Provide résumé, business card, self-promotion piece or tearsheets to be kept on file for possible future assignments. Works with local freelancers on assignment only; interested in stock photos/footage. Cannot return unsolicited material. Reports "when needed." Pays $600-1,500/day. Pays "14 days after acceptance." Buys all AV rights.

VISUAL HORIZONS, 180 Metro Park, Rochester NY 14623. (716)424-5300 or (800)424-1011. Fax: (716)424-5313 or (800)424-5411. E-mail: info@visualhorizons.com. Website: http://www.visualhorizons.com. President: Stanley Feingold. AV firm. Types of clients: industrial.

Audiovisual Needs: Works with 1 freelance photographer/month. Uses photos for AV presentations. Also works with freelance filmmakers to produce training films. Model release required. Captions required.

Specs: Uses 35mm transparencies and videotape.

Making Contact & Terms: Provide résumé, business card, brochure, flier or tearsheets to be kept on file for possible future assignments. Works on assignment only. Reports as needed. Payment negotiable. Pays on publication. Buys all rights.

WOLFF/SMG, 96 College Ave., Rochester NY 14607. (716)461-8300. Fax: (716)461-0835. E-mail: wolff@eznet.net. Creative Services Manager: Adele Simmons. Promotional communications agency. Types of clients: industrial, fashion, consumer, packaged goods.

Needs: Works with 3-4 freelance photographers/month. Uses photos for database, consumer magazines, direct mail, P-O-P displays, brochures, catalogs, posters, newspapers, AV presentations. Also works with freelance filmmakers to produce TV commercials.

Making Contact & Terms: Provide résumé, business card, brochure, flier or tearsheets to be kept on file for possible future assignments. Does not return unsolicited material. Terms vary by project.

WORLDWIDE TELEVISION NEWS (WTN), 1705 DeSales St. NW, Suite 300, Washington DC 20036. (202)222-7889. Fax: (202)222-7891. Bureau Manager, Washington: Paul C. Sisco. Estab. 1952. AV firm. "We basically supply news on tape for TV networks and stations. At this time, most of our business is with foreign nets and stations."

Needs: Buys "dozens of news stories per year, especially sports." Works with 6 freelance photographers/

month on assignment only. Generally hard news material, sometimes of documentary nature and sports.
Audiovisual Needs: Produces motion pictures and videotape.
Making Contact & Terms: Send name, phone number, equipment available and rates with material by mail for consideration. Provide business card to be kept on file for possible future assignments. Fast news material generally sent counter-to-air shipment; slower material by air freight. SASE. Reports in 2 weeks. Pays $100 minimum/job. **Pays on receipt of material**; nothing on speculation. Video rates about $500/half day, $900/full day. Negotiates payment based on amount of creativity required from photographer. Buys all video rights. Dupe sheets for film required.

SPENCER ZAHN & ASSOCIATES, 2015 Sansom St., Philadelphia PA 19103. (215)564-5979. Fax: (215)564-6285. President: Spencer Zahn. Estab. 1970. Member of GPCC. Marketing, advertising and design firm. Approximate annual billing: $5 million. Number of employees: 10. Specializes in direct mail and print ads. Types of clients: financial and retail. Examples of projects: Whiter Shade of Pale for Procol Harum (portrait); Stored Value Cards for First Union National Bank (portraits and action sports); and direct mail piece for National City Card Services (sky/sunset).
Needs: Works with 1-3 freelancers/month. Uses photos for billboards, consumer magazines, trade magazines, direct mail, P-O-P displays, posters and signage. Subjects include: people, still life. Reviews stock photos. Model/property release required.
Specs: Uses b&w and color prints; 4 × 5 transparencies. Accepts digital images on Zip, CD, etc.
Making Contact & Terms: Submit portfolio for review. Query with résumé of credits. Query with stock photo list. Query with samples. Provide résumé, business card, brochure, flier or tearsheets to be kept on file for possible future assignments. Keeps samples on file. SASE. Reports in 1 month. **Pays on publication.** Credit line sometimes given. Buys one time and/or all rights; negotiable.

▨ ZELMAN STUDIOS, LTD., 623 Cortelyou Rd., Brooklyn NY 11218. (718)941-5500. General Manager: Jerry Krone. Estab. 1966. AV firm. Types of clients: industrial, retail, fashion, public relations, fundraising, education, publishing, business and government.
Needs: Works on assignment only. Uses photographers for corporate, industrial and candid applications. Releasing work formats include print, transparency, slide sets, filmstrips, motion pictures and videotape. Subjects include: people, machines and aerial. Model release required. Property release preferred. Captions preferred.
Specs: Produces 16mm and 35mm documentary, educational and industrial video films and slide/sound shows. Uses 8 × 10 color prints; 35mm transparencies.
Making Contact & Terms: Query with samples. Send material by mail for consideration. Submit portfolio for review. Provide résumé, samples and calling card to be kept on file for possible future assignments. Pays $50-100/color photo; $250-800/job. **Pays on acceptance.** Buys all rights.

▧ ZMIEJKO & COMPANIES, INC., P.O. Box 126, Freeland PA 18224-0126. (717)636-2304. Fax: (717)636-9878. President: Thomas B.J. Zmiejko. Estab. 1971. Member of ASMP, PPANM, PPA, IPSW, Albuquerque Guild of Professional Photographers. Design firm. Number of employees: 5. Specializes in annual reports, publication design, display design, packaging, direct mail, signage, murals and billboards. Types of clients: industrial, financial, retail, publishers and nonprofit. Examples of recent projects: Pizza Hut House Organ; prep school newsletter; and Public Service New Mexico (murals).
Needs: Model/property release required. Captions required.
Specs: Uses 8 × 10 flat color and b&w prints; 35mm, 2¼ × 2¼, 4 × 5, 8 × 10 transparencies; Betacam videotape.
Making Contact & Terms: Arrange personal interview to show portfolio. Query with stock photo list. Provide résumé, business card, brochure, flier or tearsheets to be kept on file for possible future assignments. Works with freelancers on assignment only. Keeps samples on file. SASE. Reports in 3 weeks. Payment negotiable. Pays on publication. Credit line given. Buys one-time rights.

REGIONAL REPORT: MIDSOUTH & SOUTHEAST

This region stretches southeast from Tennessee to Florida encompassing the warmest states in the union. Atlanta is the advertising center of a region whose major industries include food processing, tobacco, wood and paper products and chemical production. Major advertisers like Coca-Cola, Wal-Mart and America Online are based here.

Principle industries and manufactured goods

Alabama—Industries: pulp and paper, chemicals, electronics, apparel, textiles, primary metals, lumber and wood products, food processing, fabricated metals, automotive tires, oil and gas exploration. Manufactured Goods: electronics, cast iron and plastic pipe, fabricated steel products, ships, paper products, chemicals, steel, mobile homes, fabrics, poultry processing, soft drinks, furniture, tires.

Arkansas—Industries: manufacturing, agriculture, tourism, forestry. Manufactured Goods: food products, chemicals, lumber, paper, plastics, electric motors, furniture, auto components, airplane parts, apparel, machinery, steel.

Florida—Industries: tourism, agriculture, manufacturing, construction, services, international trade. Manufactured Goods: electric and electronic equipment, transportation equipment, food, printing and publishing, chemicals, instruments.

Georgia—Industries: services, manufacturing, retail trade. Manufactured Goods: textiles, apparel, food, pulp and paper products.

Louisiana—Industries: wholesale and retail trade, tourism, manufacturing, construction, transportation, communication, public utilities, finance, insurance, real estate, mining. Manufactured Goods: chemical products, foods, transportation equipment, electronic equipment, petroleum products, lumber, wood and paper.

Mississippi—Industries: services, manufacturing, government, wholesale and retail trade. Manufactured Goods: apparel, food, furniture, lumber and wood products, electrical machinery, transportation equipment.

North Carolina—Industries: manufacturing, agriculture, tourism. Manufactured Goods: food products, textiles, industrial machinery and equipment, electrical and electronic equipment, furniture, tobacco products, apparel.

South Carolina— Industries: tourism, agriculture, manufacturing. Manufactured Goods: textiles, chemicals and allied products, machinery and fabricated metal products, apparel and related products.

Tennessee—Industries: manufacturing, trade, services, tourism, finance, insurance, real estate. Manufactured Goods: chemicals, food, transportation, equipment, industrial machinery and equipment, fabricated metal products, rubber/plastic products, paper and allied products, printing and publishing.

Virginia—Industries: services, trade, government, manufacturing, tourism, agriculture. Manufactured Goods: textiles, transportation equipment, electric and electronic equipment, food processing, chemicals, printing, lumber and wood products, apparel.

West Virginia—Industries: manufacturing, services, mining, tourism. Manufactured Goods: machinery, plastic and hardwood products, fabricated metals, chemicals, aluminum, automotive parts, steel.

Leading national advertisers

Coca-Cola, Atlanta GA
Mars Inc., McLean VA
Circuit City Stores, Richmond VA
Wal-Mart Stores, Bentonville AR
BellSouth Corp., Atlanta GA
Darden Restaurants, Orlando FL
Home Depot, Atlanta GA

U.S. Dairy Farmers, Arlington VA
Dillard Department Stores,
 Little Rock AR
Triarc Cos., Miami Beach FL
America Online, Vienna VA
Delta Airlines, Atlanta GA
Flagstar Cos., Spartanburg SC

Office Depot, Delray Beach FL
Investor AB, Norcross VA
State of Florida, Tallahassee FL
Michelin Group, Greenville SC
Federal Express Corp., Memphis TN

Notable ad agencies in the region

BBDO South, 3414 Peachtree Rd. NE, Suite 1600, Atlanta GA 30326. (404)231-1700. Major accounts: ADT Security Systems, American Cancer Society, Dodge Dealers Associations, U.S. Department of Housing and Urban Development.

The Buntin Group, 1001 Hawkins St., Nashville TN 37203. (615)244-5720. Major accounts:

American Camper, Georgia Work Boots, The Kroger Co., Red Lobster, Shoney's, Universal Tire, Zebco.

GodwinGroup, 188 E. Capitol, Jackson MS 39205. (601)354-5711. Major accounts: Blue Cross/Blue Shield, Chevron Refinery, Georgia-Pacific Corp., The Office Supply Co., Panasonic Office Automation.

Long Haymes Carr, 140 Charlois Blvd., Winston-Salem NC 27103. (910)765-3630. Major accounts: BellSouth Personal Communications, Hanes Her Way, Nabisco Foods, R.J. Reynolds Tobacco, Thomasville Furniture.

Martin Advertising, 2801 University Blvd., Suite 200, Birmingham AL 35233. (205)930-9200. Major account: Pontiac Dealer Assn.

The Martin Agency, 1 Shockoe Plaza, Richmond VA 23219. (804)698-8000. Major accounts: Banc One Corp., Coca-Cola Co., Men's Health Magazine, NASA, Saab, Vanity Fair Lingerie, Wrangler Corp.

McKinney & Silver, 333 Corporate Plaza, Raleigh NC 27601. (919)828-0691. Major accounts: Audi Cars, Barnett Banks, Carolina Power & Light, Hunter Fans, Royal Caribbean Cruise Line, Sunkist Juices.

WestWayne, Inc., 1100 Peachtree St. NE, Suite 1800, Atlanta GA 30309. (404)347-8700. Major accounts: Beautyrest Mattresses, BellSouth Corp., Citrus World, NAPA Automotive Parts, R.J. Reynolds Tobacco Co., Royal Caribbean International.

Yesawich, Pepperdine & Brown, 1900 Summit Tower Blvd, Suite 600, Orlando FL 32810. (407)875-1111. Major accounts: Amtrak, The Breakers Resort, Hilton International, Universal Studios Florida, Western Pacific Airlines.

Zimmerman & Partners Advertising, 2200 W. Commercial Blvd., Suite 300, Fort Lauderdale FL 33309. (954)731-2900. Major accounts: Budget Car Sales, Clarke Ford, Mitsubishi Dealers Assn., Plaza Auto Mall.

AD CONSULTANT GROUP INC., 3111 University Dr., #408, Coral Springs FL 33065. (954)340-0883. President: B. Weisblum. Estab. 1994. Ad agency. Approximate annual billing: $3 million. Number of employees: 3. Types of clients: fashion, retail and food.
Needs: Works with 1 freelancer and 1 videographer/month. Uses photos for consumer magazines, trade magazines, direct mail, catalogs and newspapers. Reviews stock photos. Model/property release required.
Audiovisual Needs: Uses videotape.
Making Contact & Terms: Query with stock photo list. Send unsolicited photos by mail for consideration. Provide résumé, business card, brochure, flier or tearsheets to be kept on file for possible future assignments.
Works with freelancers on assignment only. Cannot return material. Reports in 3 weeks. Payment negotiable. **Pays on acceptance.** Credit line sometimes given. Buys all rights; negotiable.

AMERICAN AUDIO VIDEO, 2862 Hartland Rd., Falls Church VA 22043. (703)573-6910. Fax: (703)573-3539. President: John Eltzroth. Estab. 1972. Member of ICIA and MPI. AV/Presentation Technology firm. Types of clients: industrial, information systems and financial.
Needs: Works with 1 freelance photographer and 2 videographers/month. Uses photos for catalogs and audiovisual uses. Subjects include: "inhouse photos for our catalogs and video shoots for clients." Reviews stock photos.
Audiovisual Needs: Uses slides and videotape.
Specs: Uses 35mm transparencies; ¾" Beta videotape.
Making Contact & Terms: Arrange personal interview to show portfolio. Send unsolicited photos by mail for consideration. Provide résumé, business card, brochure, flier or tearsheets to be kept on file for possible future assignments. SASE. Reports in 1 month. Payment negotiable. **Pays on acceptance and receipt of invoice.** Credit line not given. Buys all rights; negotiable.

● **SPECIAL COMMENTS** within listings by the editor of *Photographer's Market* are set off by a bullet.

BLACKWOOD, MARTIN, AND ASSOCIATES, 3 E. Colt Square Dr., P.O. Box 1968, Fayetteville AR 72703. (501)442-9803. Ad agency. Creative Director: Gary Weidner. Types of clients: food, financial, medical, insurance, some retail. Client list provided on request.
Needs: Works with 3 freelance photographers/month. Uses photos for direct mail, catalogs, consumer magazines, P-O-P displays, trade magazines and brochures. Subject matter includes "food shots—fried foods, industrial."
Specs: Uses 8 × 10 high contrast b&w prints; 35mm, 4 × 5 and 8 × 10 transparencies.
Making Contact & Terms: Arrange a personal interview to show portfolio; query with samples; provide résumé, business card, brochure, flier or tearsheets to be kept on file for possible future assignments. Works with freelance photographers on assignment basis only. Does not return unsolicited material. Reports in 1 month. Payment negotiable. Payment depends on budget—"whatever the market will bear." Buys all rights. Model release preferred.
Tips: Prefers to see "good, professional work, b&w and color" in a portfolio of samples. "Be willing to travel (we have been doing location shots) and willing to work within our budget. We are using less b&w photography because of newspaper reproduction in our area. We're using a lot of color for printing."

BOB BOEBERITZ DESIGN, 247 Charlotte St., Asheville NC 28801. (704)258-0316. Owner: Bob Boeberitz. Estab. 1984. Member of American Advertising Federation, Asheville Area Chamber of Commerce, Laurens County Chamber of Commerce, Asheville Freelance Network, National Academy of Recording Arts & Sciences. Graphic design studio. Number of employees: 1. Types of clients: management consultants, retail, recording artists, mail-order firms, industrial, restaurants, hotels and book publishers.
 • Awards include the 1995 Arts Alliance/Asheville Chamber Business Support of the Arts Award; Citation of Excellence in Sales Promotion/Packaging; 1995 3rd District AAF ADDY Competition; 1 Addy and 3 Citations of Excellence in the 1995 Greenville Addy Awards.
Needs: Works with 1 freelance photographer every 2 or 3 months. Uses photos for consumer and trade magazines, direct mail, brochures, catalogs and posters. Subjects include: studio product shots, some location, some stock photos. Model/property release required.
Specs: Uses 8 × 10 b&w glossy prints; 35mm or 4 × 5 transparencies. Accepts images in digital format for Windows (TIF, BMP, JPG). Send via CD, Zip disk or Online (300 dpi).
Making Contact & Terms: Provide résumé, business card, brochure, flier or tearsheets to be kept on file for possible future assignments. Cannot return unsolicited material. Reports "when there is a need." Pays $50-200/b&w photo; $100-500/color photo; $50-100/hour; $350-1,000/day. Pays on per-job basis. Buys all rights; negotiable.
Tips: "I usually look for a specific specialty. No photographer is good at everything. I also consider studio space and equipment. Show me something different, unusual, something that sets you apart from any average local photographer. If I'm going out of town for something it has to be for something I can't get done locally."

BROWER, LOWE & HALL ADVERTISING, INC., 215 W. Stone Ave., P.O. Box 3357, Greenville SC 29602. (864)242-5350. Fax: (864)233-0893. President: Ed Brower. Estab. 1945. Ad agency. Uses photos for billboards, consumer and trade magazines, direct mail, newspapers, P-O-P displays, radio and TV. Types of clients: consumer and business-to-business.
Needs: Commissions 6 freelancers/year; buys 50 photos/year. Model release required.
Specs: Uses 8 × 10 b&w and color semigloss prints; also videotape.
Making Contact & Terms: Arrange personal interview to show portfolio or query with list of stock photo subjects; will review unsolicited material. SASE. Reports in 2 weeks. Payment negotiable. Buys all rights; negotiable.

CAMBRIDGE CAREER PRODUCTS, 90 MacCorkle Ave., SW, South Charleston WV 25303. (800)468-4227. Fax: (304)744-9351. President: E.T. Gardner, Ph.D. Managing Editor: Amy Pauley. Estab. 1981.
Needs: Works with 2 still photographers and 3 videographers/month. Uses photos for multimedia productions, videotapes and catalog still photography. "We buy b&w prints and color transparencies for use in our 11 catalogs." Reviews stock photos/footage on sports, hi-tech, young people, parenting, general interest topics and other. Model release required.
Specs: Uses 5 × 7 or 8 × 10 b&w prints; 35mm, 2¼ × 2¼, 4 × 5, and 8 × 10 transparencies and videotape.
Making Contact & Terms: Video producers arrange a personal interview to show portfolio. Still photographers submit portfolio by mail. SASE. Reports in 2 weeks. Pays $20-80/b&w photo, $250-850/color photo and $8,000-45,000 per video production. Credit line given. "Color transparencies used for catalog covers and video production, but not for b&w catalog shots." Buys one-time and all rights (work-for-hire); negotiable.

Tips: "Still photographers should call our customer service department and get a copy of *all* our educational catalogs. Review the covers and inside shots, then arrange a meeting to show work. Video production firms should visit our headquarters with examples of work. For still color photographs we look for high-quality, colorful, eye-catching transparencies. Black & white photographs should be on sports, home economics (cooking, sewing, child rearing, parenting, food, etc.), and guidance (dating, sex, drugs, alcohol, careers, etc.). We have stopped producing educational filmstrips and now produce only full-motion video. Always need good b&w or color still photography for catalogs."

CEDAR CREST STUDIO, P.O. Box 28, Mountain Home AR 72653. (800)488-5777. Fax: (870)488-5255. E-mail: cedarcrest@oznet.com. Website: http://www.oznet.com/cedarcrest. Owner: Bob Ketchum. Estab. 1972. AV firm. Number of employees: 4. Types of clients: corporate, industrial, financial, broadcast, fashion, retail, food. Examples of recent projects: "T-Lite, T-Slumber," Williams Pharmaceuticals (national TV spots); "Christmas," Peoples Bank and Trust (regional TV spots); CBM demo, Baxter Healthcare Corp. (corporate sales).
• Cedar Crest is using computers for photo manipulation.
Needs: Works with 4 freelancers/month. Uses photos for covers on CDs and cassettes.
Audiovisual Needs: Uses slides, film and videotape.
Specs: Uses DV format video, as well as ½", 8mm, Hi 8mm and ¾" video formats.
Making Contact & Terms: Works with local freelancers only. Does not keep samples on file. Cannot return material. Pays $75 maximum/hour; $200 minimum/day. Pays on publication. Credit line sometimes given. Buys one-time rights; negotiable.

STEVEN COHEN MOTION PICTURE PRODUCTION, 1182 Coral Club Dr., Coral Springs FL 33071. (954)346-7370. Contact: Steven Cohen. Examples of productions: TV commercials, documentaries, 2nd unit feature films and 2nd unit TV series.
Needs: Model release required.
Specs: Uses 16mm, 35mm film; ½" VHS, Beta videotape, S/VHS videotape.
Making Contact & Terms: Query with résumé. Provide business card, self-promotion piece or tearsheets to be kept on file for possible future assignments. Works on assignment only. Cannot return material. Reports in 1 week. Payment negotiable. **Pays on acceptance** or publication. Credit line given. Buys all rights (work-for-hire).

CORPORATE RESOURCE ASSOCIATES, INC., 3082 Dauphin Square Connector, Mobile AL 36607. (334)473-4942. Fax: (334)473-1220. E-mail: cramobal@aol.com. President: David Wagner. Estab. 1985. Member of AMA, AdFed. Ad agency, PR firm, AV firm. Approximate annual billing: $1.5 million. Types of clients: industrial, financial, fashion, retail, food. Examples of recent projects: "Ask for ICI," International Converters, Inc. (all media); "ZEBA," Bay City Pasta Co.
Needs: Works with 5 photographers and 2 videographers/month. Uses photos for consumer magazines, trade magazines, P-O-P displays, catalogs, posters, signage and audiovisual. Subjects include: industrial, food and catalog product. Model release required. Property release preferred.
Audiovisual Needs: Uses slides and video.
Specs: Uses 8×10 glossy color and b&w prints; 35mm, 2¼×2¼, 4×5 transparencies; 100 ISO film; digital format (Mac).
Making Contact & Terms: Submit portfolio for review. Query with resume of credits. Provide resume, business card, brochure, flier or tearsheets to be kept on file for possible future assignments. Works on assignment only. Keeps samples on file. SASE. Reports in 3 weeks. Pays $20-50/b&w; $30-70/color; $65-125/hour; $800-1,200/day. **Pays on receipt of invoice**. Credit line not given. Buys electronic and all rights.

DEADY ADVERTISING, 17 E. Cary St., Richmond VA 23219. (804)643-4011. Fax: (804)643-4043. Website: http://www.deady.com. President: Jim Deady. Member of Richmond Ad Club, Chesterfield Business Council, Richmond Public Relations Association, Marketing Communications Agency Network. Approximate annual billing: $2 million. Number of employees 5. Types of clients: industrial, financial and food. Examples of past projects: "Reynolds Food Service," Reynolds Metals (brochures, trade journal ads); "Holiday 1996," The Peanut Roaster (Christmas catalog); and "OK Foundry" (presentation folder with direct sales and information requests).
Needs: Works with 3-5 freelancers/month. Uses photos for billboards, consumer magazines, trade magazines, direct mail, catalogs, posters, newspapers and exhibit signage. Subjects include: equipment, products and people. Reviews stock photos. Model/property release preferred.
Audiovisual Needs: Uses video for custom corporate videos.
Specs: Uses color and b&w prints; 35mm, 4×5 transparencies.
Making Contact & Terms: Arrange personal interview to show portfolio. Query with stock photo list.

Works on assignment only. Keeps samples on file. Cannot return material. Reports in 1-2 weeks. Payment negotiable. **Pays on receipt of invoice.** Credit line sometimes given. Buys all rights.

FRASER ADVERTISING, 1201 George C. Wilson Dr. #B, Augusta GA 30909. (706)855-0343. Fax: (706)855-0256. President: Jerry Fraser. Estab. 1980. Ad agency. Approximate annual billing: $1 million. Number of employees: 5. Types of clients: automotive, business-to-business, industrial, manufacturing, medical, residential. Examples of recent projects: Pollock Company (company presentation); STV Corp. (national ads).
Needs: Works with "possibly one freelance photographer every two or three months." Uses photos for consumer and trade magazines, catalogs, posters and AV presentations. Subject matter: "product and location shots." Also works with freelance filmmakers to produce TV commercials on videotape. Model release required. Property release preferred.
Specs: Uses glossy b&w and color prints; 35mm, 2¼×2¼ and 4×5 transparencies; videotape and film. "Specifications vary according to the job." Accepts images in digital format, Mac compatible EPS or DICT files on CD, Online or floppy disk.
Making Contact & Terms: Provide résumé, business card, brochure, flier or tearsheets to be kept on file for possible future assignments. Works with freelance photographers on assignment only. Cannot return unsolicited material. Reports in 1 month. Payment negotiable according to job. Pays on publication. Buys exclusive/product, electronic, one-time and all rights; negotiable.
Tips: Prefers to see "samples of finished work—the actual ad, for example, not the photography alone. Send us materials to keep on file and quote favorably when rate is requested."

FUSION INTERNATIONAL, 420-B Wharfside Way, Jacksonville FL 32207. E-mail: mocando@aol.c om. Design firm. Creative Director: Michael O'Connell. Estab. 1991. Specializes in annual reports, publication design, display design, direct mail and corporate communications/music industry. Types of clients: industrial, financial, sports retail, publishers, nonprofit and environmental/music. Examples of recent projects: First Union National Bank of Florida (photos used in ads and fliers); Advanced Sports Marketing (professional sports); *First Coast Parent* (parenting publication); and video album packaging.
Needs: Works with 0-4 freelance photographers/month. Uses photographs for trade magazines, direct mail, catalogs, posters. Subjects include: editorial for publications. Reviews stock photos of entertainment and medical. Model/property release required. Captions preferred.
Specs: Uses 8×10 color and b&w prints; 35mm, 2¼×2¼ transparencies. Accepts images in digital format for Mac. Send via compact disc, online, SyQuest or jaz disk (3000 dpi or better).
Making Contact & Terms: Provide résumé, business card, brochure, flier or tearsheets to be kept on file for possible future assignments. Works with freelancers on assignment only. Keeps samples on file. SASE. Reports in 2-4 weeks. Payment negotiable. Pays on publication. Credit line sometimes given depending on project/client specification. Rights negotiable.
Tips: "I am looking for two kinds of styles. I need financial and traditional for use with financial institutions and avant-garde styles used in sports and music."

GOLD & ASSOCIATES, INC., 6000-C Sawgrass Village Circle, Ponte Verde Beach FL 32082. (904)285-5669. Fax: (904)285-1579. Creative Director: Keith Gold. Estab. 1988. Marketing/design/advertising firm. Approximate annual billing: $21 million in capitalized billings. Number of employees: 19. Specializes in music, publishing, tourism and entertainment industries. Examples of recent projects: Time-Warner (videos, video packaging and music packaging); Harcourt General (book and collateral designs); and Ripley's Entertainment (advertising).
Needs: Works with 1-4 freelance photographers and 1-2 filmmakers/month. Uses photos for video, television spots, films and CD packaging. Subjects vary. Reviews stock photos and reels. Tries to buy out images.
Specs: Uses transparencies, film and disks.
Making Contact & Terms: Contact through rep. Provide flier or tearsheets to be kept on file for possible future assignments. Works with freelancers from across the US. Cannot return material. Only reports to "photographers being used." Payment negotiable. **Pays on receipt of invoice.** Credit line given only for original work where the photograph is the primary design element; never for spot or stock photos. Buys all rights.

GRANT/GARRETT COMMUNICATIONS, P.O. Box 53, Atlanta GA 30301. Phone/fax: (404)755-2513. President/Owner: Ruby Grant Garrett. Estab. 1979. Ad agency. Types of clients: technical. Examples of ad campaigns: Simons (help wanted); CIS Telecom (equipment); Anderson Communication (business-to-business).
Needs: Uses photos for trade magazines, direct mail and newspapers. Interested in reviewing stock photos/ video footage of people at work. Model/property release required. Photo captions preferred.

Audiovisual Needs: Uses stock video footage.
Specs: Uses 4×5 b&w prints; VHS videotape.
Making Contact & Terms: Query with résumé of credits. Query with list of stock photo subjects. Provide résumé, business card, brochure, flier or tearsheets to be kept on file for possible future assignments. Works with freelancers on an assignment basis only. SASE. Reports in 1 week. Payment negotiable per job. **Pays on receipt of invoice.** Credit line sometimes given, depending on client. Buys one-time and other rights; negotiable.
Tips: Wants to see b&w work in portfolio.

HACKMEISTER ADVERTISING & PUBLIC RELATIONS COMPANY., 2631 E. Oakland, Suite 204, Ft. Lauderdale FL 33306. (954)568-2511. President: Dick Hackmeister. Estab. 1979. Ad agency and PR firm. Serves industrial, electronics manufacturers who sell to other businesses.
Needs: Works with 1 freelance photographer/month. Uses photos for trade magazines, direct mail, catalogs. Subjects include: electronic products. Model release and captions required.
Specs: Uses 8×10 glossy b&w and color prints and 4×5 transparencies.
Making Contact & Terms: "Call on telephone first." Does not return unsolicited material. Pays by the day and $200-2,000/job. Buys all rights.
Tips: Looks for "good lighting on highly technical electronic products—creativity."

HODGES ASSOCIATES, INC., P.O. Box 53805, 912 Hay St., Fayetteville NC 28305. (910)483-8489. Fax: (910)483-7197. Art Director: Jeri Allison. Estab. 1974. Ad agency. Types of clients: industrial, financial, retail, food. Examples of projects: House of Raeford Farms (numerous food packaging/publication ads); The Esab Group, welding equipment (publication ads/collateral material).
Needs: Works with 1-2 freelancers/month. Uses photos for consumer magazines, trade magazines, direct mail, P-O-P displays, catalogs, posters, newspapers, signage, audiovisual uses. Subjects include: food, welding equipment, welding usage, financial, health care, industrial fabric usage, agribusiness products, medical tubing. Reviews stock photos. Model/property release required.
Audiovisual Needs: Uses slides and video. Subjects include: slide shows, charts, videos for every need.
Specs: Uses 4×5, 11×14, 48×96 color and b&w prints; 35mm, 2¼×2¼, 4×5, 8×10 transparencies.
Making Contact & Terms: Submit portfolio for review. Keeps samples on file. SASE. Reports in 1-2 weeks. Pays $100/hour; $800/day. **Pays on receipt of invoice.** Credit line given depending upon usage PSAs, etc. but not for industrial or consumer ads/collateral. Buys all rights; negotiable.
Tips: Looking for "all subjects and styles." Also, the "ability to shoot on location in adverse conditions (small cramped spaces). For food photography a kitchen is a must, as well as access to food stylist. Usually shoot both color and b&w on assignment. For people shots . . . photographer who works well with talent/models." Seeing "less concern about getting the 'exact' look, as photo can be 'retouched' so easily in Photoshop or on system at printer. Electronic retouching has enabled art director to 'paint' the image he wants. But by no means does this mean he will accept mediocre photographs."

HOWARD, MERRELL & PARTNERS ADVERTISING, INC., 8521 Six Forks Rd., Raleigh NC 27615. (919)848-2400. Fax: (919)845-9845. Art Buyer/Broadcast Business Supervisor: Jennifer McFarland. Estab. 1976. Member of Affiliated Advertising Agencies International, American Association of Advertising Agencies, American Advertising Federation. Ad agency. Approximate annual billing: $86 million. Number of employees: 83.
Needs: Works with 10-20 freelancers/month. Uses photos for consumer and trade magazines, direct mail, catalogs and newspapers. Reviews stock photos. Model/property release required.
Specs: Uses 8×10 glossy b&w prints; 35mm, 2¼×2¼, 4×5, 8×10 transparencies.
Making Contact & Terms: Provide résumé, business card, brochure, flier or tearsheets to be kept on file for possible future assignments. Works on assignment only. Keeps samples on file. SASE. Reports in 3 weeks. Payment individually negotiated. **Pays on receipt of invoice.** Buys one-time and all rights (1-year or 2-year unlimited use); negotiable.

HUEY, COOK & PARTNERS, 2017 Morris Ave., 2nd Floor, Birmingham AL 35203. (205)714-7070. Fax: (205)714-9884. Art Directors: Mike Macon/Shane Paris. Estab. 1972. Ad agency. Types of clients: retail and sporting goods.
Needs: Works with 6-10 freelance photographers/month. Uses photos for consumer magazines, trade magazines, P-O-P displays, catalogs, posters and audiovisuals. Subjects include: fishing industry, water sports. Model release preferred. Captions preferred.
Audiovisual Needs: Uses AV for product introductions, seminars and various presentations.
Specs: Uses 5×7 b&w prints; 35mm, 2¼×2¼, 4×5 and 8×10 transparencies.
Making Contact & Terms: Submit portfolio for review. Provide business card, brochure, flier or tear-

sheets to be kept on file for possible future assignments. Works on assignment basis only. Pays $50-400/ b&w photo; $85-3,000/color photo; $500-1,600/day; $150-20,000/job. Payment is made on acceptance plus 90 days. Buys all rights.

Tips: Prefers to see "table top products with new, exciting lighting, location, mood images of various forms of fishing and boating."

PETER JAMES DESIGN STUDIO, 7495 NW Fourth St., Plantation FL 33317-2204. (954)587-2842. Fax: (954)587-2866. President/Creative Director: Jim Spangler. Estab. 1980. Design firm. Specializes in advertising design, packaging, direct mail. Types of clients: industrial, corporate. Example of recent project: VSI International (packaging/print).

Needs: Works with 1-2 freelancers/month. Uses photos for consumer and trade magazines, direct mail, P-O-P displays, catalogs, posters and packaging. Subjects include: lifestyle shots and products. Reviews stock photos. Model release required. Captions preferred.

Specs: Uses 8×10, glossy, color prints; 35mm, 2¼×2¼, 4×5 transparencies.

Making Contact & Terms: Arrange personal interview to show portfolio. Query with résumé of credits. Query with samples. Provide résumé, business card, brochure, flier or tearsheets to be kept on file for possible future assignments. Works with freelancers on assignment only. Keeps samples on file. SASE. Reports as needed. Pays $150 minimum/hour; $1,200 minimum/day. Pays net 30 days. Credit line sometimes given depending upon usage.

Tips: Wants to see "specific style, knowledge of the craft, innovation."

KIRKPATRICK WILLIAMS ASSOCIATES, 8201 Cantrell Rd., Little Rock AR 72227. (501)225-8833. Fax: (501)225-3433. E-mail: kwa@aristotle.net. Creative Director: Kirby Williams. Estab. 1977. Member of AAAA, AAF, PRSA. Ad agency. Approximate annual billing: $6.2 million. Number of employees: 17. Types of clients: industrial, financial, retail, food, tourism. Examples of past projects: "Christmas," City of Eureka Springs (regional TV); "Cardiac Care," Northwest Health (local TV); Little Rock Public Schools (national services brochure).

Needs: Works with 2-5 photographers, 1-2 filmmakers and 1-2 videographers/month. Uses photos for billboards, consumer magazines, trade magazines, direct mail, P-O-P displays, catalogs, posters, newspapers and audiovisual. Subjects include: people. Reviews stock photos. Model/property release required.

Audiovisual Needs: Uses slides, film and video for people and products.

Specs: Uses 8×10 glossy color prints; 2¼×2¼ transparencies; 16mm film; digital format (compact disc).

Making Contact & Terms: Query with samples. Works on assignment only. Keeps samples on file. SASE. Pays $500-1,500/day. Buys all rights; negotiable.

J.H. LEWIS ADVERTISING, INC., 1668 Government St., Mobile AL 36604. (334)470-9658. President; Mobile Office: Emil Graf; Birmingham Office: Larry Norris. Creative Director; Birmingham Office: Spencer Till. Senior Art Directors; Mobile Office: Ben Jordan and Helen Savage. Ad agency. Uses photos for billboards, consumer and trade magazines, direct mail, foreign media, newspapers, P-O-P displays, radio and TV. Serves industrial, entertainment, financial, agricultural, medical and consumer clients. Commissions 25 photographers/year.

Specs: Uses b&w contact sheets and 8×10 b&w glossy prints; uses 8×10 color prints and 4×5 transparencies; produces 16mm documentaries.

Making Contact & Terms: Payment negotiable. Pays per job, or royalties on 16mm film sales. Buys all rights. Model release preferred. Arrange a personal interview to show portfolio; submit portfolio for review; or send material, "preferably slides we can keep on file," by mail for consideration. SASE. Reports in 1 week.

LORENC DESIGN, 724 Longleaf Dr., Atlanta GA 30342. (404)266-2711. Fax: (404)233-5619. Manager: Paula Whitaker. Estab. 1978. Member of SEGD, AIGA, AIA. Design firm. Approximate annual billing: $750,000. Number of employees: 7. Specializes in display design and signage. Types of clients: industrial, financial and retail. Examples of recent projects: "Holiday Inn Worldwide Headquarters," Holiday Inn (exhibit); and "Georgia Pacific Sales Center," Georgia-Pacific (exhibit).

Needs: Works with 1 freelancer/month. Uses photos for P-O-P displays, posters, signage and exhibits. Subjects include: architectural photography, scenery and people. Reviews stock photos.

Specs: Uses 8×10 glossy color and b&w prints; 35mm, 4×5 transparencies.

Making Contact & Terms: Contact through rep. Submit portfolio for review. Keeps samples on file. SASE. Reports in 1-2 weeks. **Pays on receipt of invoice.** Credit line given. Buys all rights; negotiable.

THE MEDIA MARKET, INC., 285 College St., P.O. Box 2692, Batesville AR 72503-2692. (870)793-6902. Fax: (870)793-7603. Art Director: Barth Boyd. Estab. 1980. Ad agency. Approximate

annual billing: $500,000. Number of employees: 4. Types of clients: industrial, financial, retail, health care and tourism. Examples of recent projects: "See the Ozark Gateway," Ozark Gateway Tourist Council (television promotion); "Appreciation," Union Planters Bank (newspaper); and "People-Hometown Choice," Citizens Bank of Batesville (varied media).

Needs: Works with 1-3 freelance photographers, 1-3 filmmakers and 1-3 videographers/month. Uses photos for billboards, consumer magazines, trade magazines, direct mail, P-O-P displays, catalogs, posters, newspapers, signage and audiovisual. Subjects include: tourism and financial. Reviews stock photos. Model/property release required. Captions preferred.

Audiovisual Needs: Uses slides, film and videotape for business-to-business and business-to-consumer.

Specs: Uses all sizes glossy color and b&w prints; 35mm, 2¼×2¼, 4×5 transparencies; ¾″ film; VHS videotape.

Making Contact & Terms: Provide résumé, business card, brochure, flier or tearsheets to be kept on file for possible future assignments. Works on assignment only. Keeps samples on file. SASE. Reports in 1-2 weeks. Pays $25-50/hour; $200-400/day; $50-400/job; $25-200/color or b&w photo. Pays on publication. Credit line sometimes given depending upon terms. Buys all rights; negotiable.

MYRIAD PRODUCTIONS, P.O. Box 888886, Atlanta GA 30356. (770)698-8600. President: Ed Harris. Estab. 1965. Primarily involved with sports productions and events. Works with freelance photographers on assignment only basis.

Needs: Uses photos for portraits, live-action and studio shots, special effects, advertising, illustrations, brochures, TV and film graphics, theatrical and production stills. Model/property release required. Captions preferred; include name(s), location, date, description.

Specs: Uses 8×10 b&w glossy prints, 8×10 color prints; and 2¼×2¼ transparancies.

Making Contact & Terms: Provide brochure, résumé and samples to be kept on file for possible future assignments. Send material by mail for consideration. Cannot return material. Reporting time "depends on urgency of job or production." Payment negotiable. Credit line sometimes given. Buys all rights.

Tips: "We look for an imaginative photographer; one who captures all the subtle nuances, as the photographer is as much a part of the creative process as the artist or scene being shot. Working with us depends almost entirely on the photographer's skill and creative sensitivity with the subject. All materials submitted will be placed on file and not returned, pending future assignments. Photographers should not send us their only prints, transparencies, etc., for this reason."

PIKE AND CASSELS, INC., 300 S. Liberty St., Suite 100, Winston-Salem NC 27101. (910)723-9219. Fax: (919)723-9249. Creative Director: Tim Love. Estab. 1985. Design and advertising firm. Specializes in publication design, display design, packaging, graphic standards and fashion. Types of clients: industrial, financial, retail and nonprofit.

Needs: Works with 1 freelancer/month. Uses photos for consumer and trade magazines, direct mail, P-O-P displays, catalogs, posters and packaging. Subjects include: tabletop-food and product. Model release preferred. Property release required. Captions preferred; include technique.

Specs: Uses color 35mm, 2¼×2¼, 4×5 transparencies.

Making Contact & Terms: Provide résumé, business card, brochure, flier or tearsheets to be kept on file for possible future assignments. Works with freelancers on assignment only. Keeps samples on file. SASE. Reports in 1 month. Payment negotiable. **Pays on receipt of invoice.** Credit line not given. Buys all rights; negotiable.

Tips: Wants to see "flexibility in subjects and technique, fashion photography, processing control and organization of shoots."

STEVE POSTAL PRODUCTIONS, P.O. Box 428, 108 Carraway St., Bostwick FL 32007. (904)325-9356. Website: http://www.caisa.com/worstfilms. Director: Steve Postal. Estab. 1957. Member of SMPTE. AV firm. Approximate annual billing: $1 million plus. Number of employees: 10-48. Types of clients: distributors. Examples of recent projects: "The Importance of Going Amtrak," Washington DC

**FOR EXPLANATIONS OF THESE SYMBOLS,
SEE THE INSIDE FRONT AND BACK COVERS OF THIS BOOK.**

AMTRAK (overseas info film); and many feature films on video for release (distributed to many countries).
Needs: Works with 2-3 freelance photographers, 2-3 filmmakers and 3-4 videographers/month. Uses photos for billboards, consumer magazines, trade magazines, direct mail and audiovisual. Subjects include: feature film publicity. Reviews stock photos of travel, food, glamour modeling and industrial processes. Model/property release preferred for glamour modeling. Captions required; include name, address, telephone number, date taken and equipment used.
Audiovisual Needs: Uses slides and/or film or video.
Specs: Uses 4×5, 8×10 glossy color and/or b&w prints; 35mm, 2¼×2¼ transparencies; 16mm film; VHS (NTSC signal) videotape.
Making Contact & Terms: Query with samples. Provide résumé, business card, brochure, flier or tearsheets to be kept on file for possible future assignments. Works with freelancers on assignment only. Keeps samples on file. Photographers should call in 3 weeks for report. Pays per job or feature film; negotiable. **Pays on acceptance.** Credit line given. Buys all rights.
Tips: Looks for "sharpness of image, trueness of color, dramatic lighting or very nice full lighting."

PRODUCTION INK, 2826 NE 19 Dr., Gainesville FL 32609-3391. (352)377-8973. Fax: (352)373-1175. President: Terry Van Nortwick. Ad agency, PR, marketing and graphic design firm. Types of clients: hospital, industrial, computer.
Needs: Works with 1 freelance photographer/month. Uses photos for ads, billboards, trade magazines, catalogs and newspapers. Reviews stock photos. Model release required.
Specs: Uses b&w prints and 35mm, 2¼×2¼ and 4×5 transparencies.
Making Contact & Terms: Arrange personal interview to show portfolio. Submit portfolio for review. Provide résumé, business card, brochure, flier or tearsheets to be kept on file for possible future assignments. Keeps samples on file. Payment negotiable. **Pays on receipt of invoice.** Credit line sometimes given; negotiable. Buys all rights only.

N SIDES AND ASSOCIATES, 404 Eraste Landry Rd., Lafayette LA 70506. (318)233-6473. Fax: (318)233-6485. E-mail: sides@1stnet.com. Account Executive Assistant: Shana Y. Guilbeau. Estab. 1976. Member of AAAA, PRSA, Chamber of Commerce, Better Business Bureau. Ad agency. Number of employees: 13. Firm specializes in publication design, display design, signage, video and radio production. Types of clients: industrial, financial, retail, nonprofit. Examples of recent clients: name change for Iberia Bank (revised all brochures and new newspaper); identity, for Louisiana Lottery Corp. (new newspaper); celebrity campaign for Louisiana Dairy Industry Promotion Board (posters).
Needs: Works with 2 freelance photographers, 2 filmmakers, 2 videographers/month. Uses photos for billboards, brochures, newspapers, P-O-P displays, posters, signage. Subjects include: setup shots of people. Reviews stock photos of everything. Model release required; property release required.
Audiovisual Needs: Uses slides and/or film or video for broadcast, TV, newspaper.
Specs: Uses 35mm, 2¼×2¼, 4×5; 35 film.
Making Contact & Terms: Provide résumé, business card, self-promotion piece or tearsheets to be kept on file for possible future assignments. Works with local freelancers only. Keeps samples on file. Reports back only if interested, send non-returnable samples. Payment determined by client and usage. Pays "when paid by our client." Rights negotiable.
Tips: "Freelance photographers should keep size standard—8½×11. We need fast workers with quick turnaround."

N ▨ SMITH ADVERTISING & ASSOCIATES, P.O. Drawer 2187, Fayetteville NC 28302. (910)323-0920. Fax: (910)323-3328. Contact: Creative Director. Estab. 1974. Ad agency, PR firm. Types of clients: industrial, medical, financial, retail, tourism, resort, real estate.
Needs: Works with 0-10 photographers, 0-3 filmmakers, 0-3 videographers/month. Uses photos for billboards, consumer and trade magazines, direct mail, P-O-P displays, catalogs, posters, newspapers, signage, audiovisual. Subjects include: area, specific city, specific landmark. Model release preferred for identifiable people in photos for national publications. Property release preferred. Photo captions preferred.
Audiovisual Needs: Uses slides, film, videotape for slide shows, TVC. Subjects include: archive, early years.
Specs: Uses 5×7 glossy color and b&w prints; 35mm, 2¼×2¼, 4×5 transparencies; 16 and 35mm film; Beta SP tape.
Making Contact & Terms: Provide résumé, business card, brochure, flier or tearsheets to be kept on file for possible future assignments. Samples are kept on file "for limited time." SASE. Reports in 1-2 weeks. Payment negotiable according to client's budget. Pays on publication. Credit lines sometimes given depending on subject and job. Buys all rights; negotiable.

⚏ SOUTH CAROLINA FILM OFFICE, P.O. Box 7367, Columbia SC 29202. (803)737-0490. Contact: Lou Armstrong. Types of clients: motion picture and television producers.
Needs: Works with 8 freelance photographers/month. Uses photos to recruit feature films/TV productions. Subjects include location photos for feature films, TV projects, national commercials, print ads and catalogs.
Specs: Uses 3×5 color prints; 35mm film.
Making Contact & Terms: Submit portfolio by mail. Provide résumé, business card, self-promotion piece or tearsheets to be kept on file for possible future assignments. Works with local freelancers on assignment only. Does not return unsolicited material. Payment negotiable. Pays per yearly contract, upon completion of assignment. Buys all rights.
Tips: "Experience working in the film/video industry is essential. Ability needed to identify and photograph suitable structures or settings to work as a movie location."

⚏ TOWNSEND, BARNEY & PATRICK, 5909 Airport Blvd., Mobile AL 36608. (334)343-0640. Ad agency. Vice President/Creative Services: George Yurcisin. Types of clients: industrial, financial, medical, retail, fashion, fast food, tourism, packaging, supermarkets and food services.
Needs: Works with 1-3 freelance photographers/month. Uses photos for consumer magazines, trade magazines, direct mail, brochures, P-O-P displays, audiovisuals, posters and newspapers. Model release required.
Audiovisual Needs: Works with freelance filmmakers to produce audiovisuals.
Specs: Uses 8×10 and 11×17 glossy b&w prints; 35mm, 2¼×2¼, 4×5 and 8×10 transparencies; 16mm, 35mm film and videotape.
Making Contact & Terms: Arrange a personal interview to show portfolio. Query with samples and list of stock photo subjects. Provide résumé, business card, brochure, flier or tearsheets to be kept on file for possible future assignments. Does not return unsolicited material. Reports as needed. Payment "varies according to budget." Pays net 30. Buys all rights.

⚏ WILLIAMS/CRAWFORD & ASSOCIATES, INC., P.O. Box 789, Ft. Smith AR 72901. (501)782-5230. Fax: (501)782-6970. Creative Director: Branden Sharp. Estab. 1983. Types of clients: financial, health care, manufacturing, tourism. Examples of ad campaigns: Touche-Ross, 401K and employee benefits (videos); Cummins Diesel Engines (print campaigns); and Freightliner Trucks (sales promotion and training videos).
Needs: Works with 2-3 freelance photographers, filmmakers or videographers/month. Uses photos for consumer magazines, trade magazines, direct mail, P-O-P displays, catalogs, posters, newspapers and audiovisual uses. Subjects include: people, products and architecture. Reviews stock photos, film or video of health care and financial.
Audiovisual Needs: Uses photos/film/video for 30-second video and film TV spots; 5-10-minute video sales, training and educational.
Specs: Uses 5×7, 8×10 b&w prints; 35mm, 2¼×2¼ and 4×5 transparencies.
Making Contact & Terms: Query with samples, provide résumé, business card, brochure, flier or tearsheets to be kept on file for possible future assignments. Works with freelancers on assignment basis only. Cannot return material. Reports in 1-2 weeks. Pays $500-1,200/day. Pays on receipt of invoice and client approval. Buys all rights (work-for-hire). Model release required; captions preferred. Credit line given sometimes, depending on client's attitude (payment arrangement with photographer).
Tips: In freelancer's samples, wants to see "quality and unique approaches to common problems." There is "a demand for fresh graphics and design solutions." Freelancers should "expect to be pushed to their creative limits, to work hard and be able to input ideas into the process, not just be directed."

YEAR ONE INC., 4820 Hammermill Rd., Tucker GA 30084. (770)493-6568. Fax: (770)723-3498. Graphics Manager: Phil Brewer. Estab. 1981. Mail order catalog company for automotive restoration parts. Photos used in catalogs.
Needs: Buys 75 photos/year. Subjects include historic photos of car-related themes (1955-1975) or photos with muscle-car theme. "We are mainly looking for historic photos from Muscle Car Era 60s and 70s. The photos can be b&w or color. The photos will represent the era by showing normal daily occurances that highlight or accent the American muscle car. These photos can be of racing themes, gas stations, drive-ins, traffic scenes, street scenes, car dealerships, factory assembly lines, or other related photos."
Specs: Uses 5×7, 8×10 b&w or color prints; 35mm, 2¼×2¼, 4×5, 8×10 transparencies.
Making Contact & Terms: Query with samples. Query with stock photo list. Provide résumé, business card, self-promotion piece or tearsheets to be kept on file for possible future assignments. Keeps samples on file. SASE. Reports in 1 month. **Pays on acceptance**; net 30 days of invoice. Buys first, one-time, electronic and all rights. Rights negotiable.

REGIONAL REPORT: MIDWEST & NORTH CENTRAL

This region cuts a square from the middle of America, North Dakota to Ohio. The industries here lean heavily toward agriculture and automobiles. Plastic and rubber products are also important. Chicago, the big advertising city in this region, is home to Leo Burnett, Foote Cone & Belding and J. Walter Thompson, among other important agencies.

Principle industries and manufactured goods

Illinois—Industries: services, manufacturing, travel, wholesale and retail trade, finance, insurance, real estate, construction, health care, agriculture. Manufactured Goods: machinery, electric and electronic equipment, primary and fabricated metals, chemical products, printing and publishing, food.

Indiana—Industries: manufacturing, services, agriculture, government, wholesale and retail trade, transportation and public utilities. Manufactured Goods: primary metals, transportation equipment, motor vehicles and equipment, industrial machinery and equipment, electronic and electric equipment.

Iowa—Industries: agriculture, communications, construction, finance, insurance, trade, services, manufacturing. Manufactured Goods: processed food products, tires, farm machinery, electronic products, appliances, household furniture, chemicals, fertilizers, auto accessories.

Kentucky—Industries: manufacturing, services, finance, insurance and real estate, retail trade. Manufactured Goods: industrial machinery, transportation equipment, apparel, printing and publishing, food products, rubber and plastic products.

Michigan—Industries: manufacturing, services, tourism, agriculture, forestry/lumber. Manufactured Goods: automobiles, transportation equipment, machinery, fabricated metals, food products, plastics, office furniture.

Minnesota—Industries: agribusiness, forest products, mining, manufacturing, tourism. Manufactured Goods: food, chemical and paper products, industrial machinery, electric and electronic equipment, computers, printing and publishing, scientific and medical instruments, fabricated metal products, forest products.

Nebraska—Industries: agriculture, manufacturing. Manufactured Goods: processed foods, industrial machinery, printed materials, electric and electronic equipment, primary and fabricated metal products, transportation equipment.

North Dakota—Industries: agriculture, mining, tourism, manufacturing, telecommunications, energy, food processing. Manufactured Goods: farm equipment, processed foods, fabricated metal, high-tech electronics.

Ohio—Industries: manufacturing, trade, services. Manufactured Goods: transportation equipment, machinery, primary and fabricated metal products.

South Dakota—Industries: agriculture, services, manufacturing. Manufactured Goods: food and related products, machinery, electric and electronic equipment.

Wisconsin—Industries: services, manufacturing, trade, government, agriculture, tourism. Manufactured Goods: food products, motor vehicles and equipment, paper products, medical instruments and supplies, printing, plastics.

Leading national advertisers

Procter & Gamble Co., Cincinnati OH
General Motors Corp., Detroit MI
Chrysler Corp., Highland Park MI
Sears, Roebuck & Co., Chicago IL
Ford Motor Co., Dearborn MI
McDonald's Corp., Oakbrook IL
Kellogg Co., Battle Creek MI
Federated Department Stores, Cincinnati OH

Dayton Hudson, Minneapolis MN
General Mills, Minneapolis MN
Kmart Corp., Troy MI
Sara Lee Corp., Chicago IL
Quaker Oats Co., Chicago IL
S.C. Johnson & Son, Racine WI
Wendy's International, Dublin OH
Pharmacia & Upjohn, Kalamazoo MI
Goodyear Tire & Rubber Co., Akron OH

William Wrigley, Jr. Co., Chicago IL
Best Buy Co., Minneapolis MN
ConAgra, Omaha NE
Abbott Laboratories, Abbott Park IL
Montgomery Ward, Chicago IL
Maytag Co., Newton IA
Motorola, Schaumburg IL
Dominos Pizza, Ann Arbor MI

Notable ad agencies in the region

Bader Rutter & Associates, 13555 Bishops Court, Brookfield WI 53005. (414)784-7200. Major accounts: Beloit Corp., Caterpiller Inc., Ford-New Holland Agriculture, S.C. Johnson Commercial Floor Care, Western Publishing, Inc.

Bozell, 1000 Towne Center, Suite 1500, Southfield MI 48075. (248)354-5400. Major accounts: Airtouch Cellular, Chrysler Corp., Detroit Red Wings, Hush Puppies, The Rockettes, Second City.

Leo Burnett, 35 W. Wacker Dr., Chicago IL 60601. (312)220-5959. Major accounts: Amaco Oil Company, Keebler Company, Kellogg Co., Nintendo of America, Philip Morris, Procter & Gamble, Walt Disney Co.

Creswell, Munsell, Fultz & Zirbel, 4211 Signal Ridge Rd. NE, Cedar Rapids IA 52402. (319)395-6500. Major accounts: Blue Cross/Blue Shield of Iowa, DowElanco, Iowa Department of Economic Development, Pella Corp., Seaboard Farms.

Fallon McElligott, 901 Marquette Ave., Suite 3200, Minneapolis MN 55402. (612)321-2345. Major accounts: Ameritech Long Distance, BMW Cars & Motorcycles, Coke Japan, Conde Nast Publications, Jim Beam, Miller Beer, United Airlines.

HMS Partners, 1 Columbus, 10 W. Broad St., Columbus OH 43215. (614)221-7667. Major accounts: American Automobile Association, Nationwide Insurance, Procter & Gamble (oral healthcare), Target Stores.

Keller-Crescent, 1100 E. Louisiana St., Evansville IN 47711. (812)464-2461. Major accounts: Atlas Van Lines, Eureka Vacuum Cleaners, Fruit of the Loom, Hardee's Systems, Kano Laboratories.

Kragie/Newell, 2633 Fleur Dr., Des Moines IA 50321. (515)288-7910. Major accounts: Chevrolet, Firestone Agriculture, McDonald's, NAPA, Vermeer.

Laughlin/Constable, 207 E. Michigan St., Milwaukee WI 53202. (414)272-2400. Major accounts: Buell Motorcycles, Kohler Plumbing Fixtures, Miller Brewery Tours, Mootown Snackers, Regal Ware Cookware.

Wyse Advertising, 25 Prospect West, Cleveland OH 44115. (216)696-2424. Major accounts: American Greetings, BF Goodrich, GE Light Bulbs, KeyBank, Norwalk Furniture, Sherwin-Williams, United Way Services.

AD ENTERPRISE ADVERTISING AGENCY, 6617 Maplewood Dr., Suite 203, Cleveland OH 44124. (216)449-1333. Art Director: Jim McPherson. Estab. 1953. Ad agency and PR firm. Types of clients: industrial, financial, retail and food.
Needs: Works with 1 freelance photographer, 1 filmmaker and 1 videographer/month. Uses photos for consumer and trade magazines, direct mail, P-O-P displays, catalogs and newspapers. Subjects vary to suit job. Reviews stock photos. Model release required with identifiable faces. Captions preferred.
Audiovisual Needs: Uses slides, film and videotape.
Specs: Uses 4×5, 8×10 glossy color and b&w prints; 35mm, 2¼×2¼ and 4×5 transparencies.
Making Contact & Terms: Provide résumé, business card, brochure, flier or tearsheets to be kept on file for possible future assignments. Works with freelancers on assignment only. Keeps samples on file. SASE. Reports in 1-2 weeks. Pays $50-100/hour; $400-1,000/day. Pays after billing client. Credit line sometimes given, depending on agreement. Buys one-time rights and all rights; negotiable.
Tips: Wants to see industrial, pictorial and consumer photos.

AGA COMMUNICATIONS, (formerly Greinke, Eiers and Associates), 2557C N. Terrace Ave., Milwaukee WI 53211-3822. (414)962-9810. E-mail: agacom@juno.com. CEO: Arthur Greinke. Estab. 1984. Member of Public Relations Society of America, International Association of Business Communicators, Society of Professional Journalists. Number of employees: 9. Ad agency, PR firm and marketing firm. Types of clients: entertainment, special events, music business, adult entertainment, professional sports, olympic sports.
Needs: Works with 6-12 freelance photographers, 2 filmmakers, 4-8 videographers/year. Uses photos for billboards, direct mail, P-O-P displays, posters, newspapers, signage, audiovisual. Most photos come from

special events. Reviews stock photos of anything related to entertainment/music industry, model photography. Model/property release preferred. Captions preferred; include who, what, where, why, how.
Audiovisual Needs: Uses slides, film, videotape. Subjects include: special events and model work.
Specs: Uses 5×7 or 8×10 color and b&w prints; 2¼×2¼, 4×5 transparencies; 16mm and 35mm film; ½″ and ¾″ videotape. Accepts images in digital format for Mac or Windows. Send via CD or floppy disk.
Making Contact & Terms: Query with résumé of credits. Query with stock photo list or samples. Provide résumé, business card, brochure, flier or tearsheets to be kept on file for possible future assignments. Cannot return material. "We respond when we need a photographer or a job becomes available for their special skills." Payment negotiable. **Pays on acceptance.** Credit line sometimes given depending on client. Buys all rights; negotiable.
Tips: "Search for a specific style or look, and make good use of light and shade."

ART ETC., 316 W. 4th St., Cincinnati OH 45202. (513)621-6225. Fax: (513)621-6316. Art Director: Doug Carpenter. Estab. 1971. Art Studio. Specializes in industrial, financial, food and OTC drugs.
Needs: Works with 1-2 freelance photographers/6 months. Uses photos for consumer and trade magazines, direct mail, P-O-P displays, catalogs and posters. Subjects include: musical instruments, OTC drugs, pet food, people and skin products. Reviews stock photos. Model/property release required.
Specs: Uses 4×5, 8×10 color and b&w prints; 35mm, 2¼×2¼, 4×5, 8×10 transparencies.
Making Contact & Terms: Contact through rep. Arrange personal interview to show portfolio. Query with list of stock photo subjects. Provide résumé, business card, brochure, flier or tearsheets to be kept on file for possible future assignments. Works with local freelancers on assignment only. Keeps samples on file. SASE. Reports in 1-2 weeks. Pays $40-250/hour; $600-2,000/day; $150-3,500/job; $150/color photo; $50/b&w photo. Pays in 30 days. Buys all rights; negotiable. Credit line sometimes given depending upon marketing target.
Tips: Wants to see food, people and product shots.

BARON ADVERTISING, INC., 1422 Euclid Ave., Suite 645, Cleveland OH 44115-1901. (216)621-6800. President: Selma Baron. Incorporated 1973. Ad agency. Types of clients: food, industrial, electronics, telecommunications, building products, architectural. In particular, serves various manufacturers of tabletop and food service equipment.
Needs: Uses 20-25 freelance photographers/month. Uses photos for direct mail, catalogs, newspapers, consumer magazines, P-O-P displays, posters, trade magazines, brochures and signage. Subject matter varies. Model/property release required.
Audiovisual Needs: Works with freelance filmmakers for AV presentations.
Making Contact & Terms: Arrange a personal interview to show portfolio. Query with list of stock photo subjects. Provide résumé, business card, brochure, flier or tearsheets to be kept on file for possible future assignments. Works with freelancers on assignment only. Cannot return material. Payment negotiable. Payment "depends on the photographer." Pays on completion. Buys all rights.
Tips: Prefers to see "food and equipment" photos in the photographer's samples. "Samples not to be returned."

BRAGAW PUBLIC RELATIONS SERVICES, 800 E. Northwest Hwy., Suite 1040, Palatine IL 60067. (847)934-5580. Fax: (847)934-5596. Contact: Richard S. Bragaw. Estab. 1981. Member of Public Relations Society of America, Publicity Club of Chicago. PR firm. Number of employees: 3. Types of clients: professional service firms, high-tech entrepreneurs.
Needs: Works with 1 freelance photographer/month. Uses photos for trade magazines, direct mail, brochures, newspapers, newsletters/news releases. Subjects include: "products and people." Model release preferred. Captions preferred.
Specs: Uses 3×5, 5×7 and 8×10 glossy prints.
Making Contact & Terms: Provide résumé, business card, brochure, flier or tearsheets to be kept on file for possible future assignments. Works with freelance photographers on assignment basis only. SASE. Pays $25-100/b&w photo; $50-200/color photo; $35-100/hour; $200-500/day; $100-1,000/job. **Pays on receipt of invoice.** Credit line "possible." Buys all rights; negotiable.
Tips: "Execute an assignment well, at reasonable costs, with speedy delivery."

MARKET CONDITIONS are constantly changing! If you're still using this book and it's 2000 or later, buy the newest edition of *Photographer's Market* at your favorite bookstore or order directly from Writer's Digest Books.

■ **BRIGHT LIGHT PRODUCTIONS**, 602 Main St., Suite 810, Cincinnati OH 45202. (513)721-2574. Fax: (513)721-3329. President: Linda Spalazzi. Film and videotape firm. Types of clients: national, regional and local companies in the governmental, educational, industrial and commercial categories. Examples of productions: Health Power (image piece); Procter & Gamble (quarterly video); and Martiny & Co. (corporate image piece). Produces 16mm and 35mm films and videotape, including Betacam.
Needs: Model/property release required. Captions preferred.
Audiovisual Needs: 16mm and 35mm documentary, industrial, educational and commercial films.
Making Contact & Terms: Provide résumé, flier and brochure to be kept on file for possible future assignments. Call to arrange appointment or query with résumé of credits. Works on assignment only. Pays $100 minimum/day for grip; payment negotiable based on photographer's previous experience/reputation and day rate (10 hours). Pays within 30 days of completion of job. Buys all rights.
Tips: Sample assignments include camera assistant, gaffer or grip. Wants to see sample reels or samples of still work. Looking for sensitivity to subject matter and lighting. "Show a willingness to work hard. Every client wants us to work smarter and provide quality at a good value."

BVK/MCDONALD, INC, 250 W. Coventry Court, Milwaukee WI 53217. (414)228-1990. Ad agency. Art Directors: Lisa Kunzelmann, Brian Marconnet, Brent Goral, Mike Lyons, Leigh Matz. Estab. 1984. Types of clients: travel, health care, financial, industrial and fashion clients such as Funjet Vacations, Flyjet Vacations, Covenant HealthCare, Waukesha Memorial Hospital, United Vacations, Budgetel, Tenet Health Systems, Airadigm Communications.
Needs: Uses 5 freelance photographers/month. Uses photos for billboards, consumer magazines, trade magazines, direct mail, catalogs, posters and newspapers. Subjects include travel and health care. Interested in reviewing stock photos of travel scenes in Carribean, California, Nevada, Mexico and Florida. Model release required.
Specs: Uses 35mm, 2¼×2¼, 4×5, 8×10 transparencies.
Making Contact & Terms: Arrange a personal interview to show portfolio or query with résumé of credits or list of stock photo subjects. Provide résumé, business card, brochure, flier or tearsheets to be kept on file for possible future assignments. Cannot return material. Payment negotiable. Buys all rights.
Tips: Looks for "primarily cover shots for travel brochures; ads selling Florida, the Caribbean, Mexico, California and Nevada destinations."

■ **CC&L, INC.**, (formerly Chicago Computer & Light, Inc.), 5001 N. Lowell Ave., Chicago IL 60630-2610. (773)283-2749. Fax: (773)283-9972. President: Larry Feit. Estab. 1987. Design firm. Approximate annual billing: $200,000. Number of employees: 4. Specializes in display design, signage and manufacturing. Types of clients: industrial and nonprofit. Examples of recent projects: "Bushman Penny Machine," Field Museum of Natural History (display); "Public Education at School," Schiller Park City (fire safety).
Needs: Works with 1 freelancer/month. Uses photos for billboards, consumer magazines, trade magazines, direct mail, P-O-P displays, posters, packaging and signage. Subjects include products, end products, consumer products. Model release required; property release preferred. Photo captions preferred.
Specs: Uses 4×5 glossy color and b&w prints; 35mm, 4×5 transparencies.
Making Contact & Terms: Send unsolicited photos by mail for consideration. Provide résumé, business card, brochure, flier or tearsheets to be kept on file for possible future assignments. Keeps samples on file. SASE. Reports in 1 month. Pays $20-85/hour; $100-500/job. **Pays on receipt of invoice**, 30 days net. Credit line not given. Buys all rights; negotiable.

COMMUNICATIONS ELECTRONICS JOURNAL, P.O. Box 1045-PM, Ann Arbor MI 48106. (734)996-8888. Fax: (734)663-8888. CEO: Ken Ascher. Estab. 1969. Ad agency. Approximate annual billing: $7 million. Number of employees: 38. Types of clients: industrial, financial, retail. Examples of recent projects: Super Disk (computer ad); Eaton Medical (medical ad); Ocean Tech Group (scuba diving ad); and Weather Bureau (weather poster ad).
Needs: Works with 45 freelance photographers, 4 filmmakers and 5 videographers/month. Uses photos for consumer magazines, trade magazines, direct mail, P-O-P displays, catalogs, posters and newspapers. Subjects include: merchandise. Reviews stock photos of electronics, hi-tech, scuba diving, disasters, weather. Model/property release required. Captions required; include location.
Audiovisual Needs: Uses videotape for commercials.
Specs: Uses various size glossy color prints; 35mm, 2¼×2¼, 4×5 transparencies.
Making Contact & Terms: Query with résumé of credits. Provide résumé, business card, brochure, flier or tearsheets to be kept on file for possible future assignments. Cannot return material. Reports in 1 month. Pays $100-2,000/job; $15-1,000/color photo. Pays on publication. Credit line sometimes given depending on client. Buys one-time rights.

CREATIVE HOUSE ADVERTISING, INC., 30777 Northwestern Hwy., Suite 301, Farmington Hills MI 48334. (248)737-7077. Executive Vice President/Creative Director: Robert G. Washburn. Senior Art Director: Amy Hepner. Art Director: Kristen Brooks. Ad agency. Types of clients: retail, industry, finance and commercial products.

Needs: Works with 4-5 freelance photographers/year on assignment only. Also produces TV commercials and demo film. Uses photos for brochures, catalogs, annual reports, billboards, consumer and trade magazines, direct mail, newspapers, P-O-P displays, radio and TV. Model release required.

Audiovisual Needs: Uses 35mm and 16mm film.

Specs: Uses b&w and color prints; transparencies; digital.

Making Contact & Terms: Arrange personal interview to show portfolio. Query with résumé of credits, samples or list of stock photo subjects. Submit portfolio for review. "Include your specialty and show your range of versatility." Provide résumé, business card, brochure, flier and anything to indicate the type and quality of photos to be kept on file for future assignments. Local freelancers preferred. SASE. Reports in 2 weeks. Pays $100-200/hour or $800-1,600/day; negotiates payment based on client's budget and photographer's previous experience/reputation. Pays in 1-3 months, depending on the job. Does not pay royalties. Buys all rights.

JOHN CROWE ADVERTISING AGENCY, 2319½ N. 15th St., Springfield IL 62702-1226. (217)528-1076. President: Bryan J. Crowe. Ad agency. Serves clients in industry, commerce, aviation, banking, state and federal government, retail stores, publishing and institutes.

Needs: Works with 1 freelance photographer/month on assignment only. Uses photos for billboards, consumer and trade magazines, direct mail, newspapers and TV. Model release required.

Specs: Uses 8×10 glossy color and b&w prints; also uses color 8×10 glossy prints; and 2¼×2¼ transparencies.

Making Contact & Terms: Send material by mail for consideration. Provide letter of inquiry, flier, brochure and tearsheet to be kept on file for future assignments. SASE. Reports in 2 weeks. Pays $50 minimum/job or $18 minimum/hour. Payment negotiable based on client's budget. Buys all rights.

DEFRANCESCO/GOODFRIEND, 444 N. Michigan Ave., Suite 1000, Chicago IL 60611. (312)644-4409. Fax: (312)644-7651. E-mail: office@dgpr.com. Partner: John DeFrancesco. Estab. 1985. PR firm. Approximate annual billing: $1 million. Number of employees: 11. Types of clients: industrial, consumer products. Examples of recent projects: publicity campaigns for Promotional Products Association International and S-B Power Tool Company, and a newsletter for Teraco Inc.

Needs: Works with 1-2 freelancers/month. Uses photos for consumer magazines, trade magazines, direct mail, newspapers, audiovisual. Subjects include: people, equipment. Model/property release required. Captions preferred.

Audiovisual Needs: Uses slides and video for publicity, presentation and training.

Specs: Uses 5×7, 8×10, glossy color and b&w prints; 35mm transparencies; ½″ VHS videotape.

Making Contact & Terms: Query with résumé of credits. Provide résumé, business card, brochure, flier or tearsheets to be kept on file for possible future assignments. Works with freelancers on assignment only. Keeps samples on file. SASE. Reports in 1-2 weeks. Pays $25-200/hour; $500-2,500/day; $250-1,500/job; payment negotiable. Pays in 30 days. Credit line sometimes given.

Tips: "Because most photography is used in publicity, the photo must tell the story. We're not interested in high-style, high-fashion techniques."

DESIGN & MORE, 1222 Cavell, Highland Park IL 60035. (847)831-4437. Fax: (847)831-4462. Principal Creative Director: Burt Bentkover. Estab. 1989. Design and marketing firm. Approximate annual billing: $350,000. Number of employees: 2. Specializes in food advertising, annual reports, packaging, signage, publication design, brochures and promotions. Types of clients: foodservice and business-to-business.

Needs: Works with 1 freelancer/month. Uses photos for annual reports, consumer and trade magazines and sales brochures. Subjects include abstracts and food. Reviews stock photos of concepts and food. Property release required.

Specs: Uses 35mm and 2¼×2¼ transparencies.

Making Contact & Terms: Provide résumé, business card, brochure, flier or tearsheets to be kept on file for possible future assignments. Never send originals. Keeps samples on file. Cannot return material. Reports in 1-2 weeks. Pays $500-1,000/day. Pays in 45 days. Cannot offer photo credit. Buys negotiable rights.

EGD & ASSOCIATES, INC., 4300 Lincoln Ave., Suite K, Rolling Meadows IL 60008. (847)991-1270. Fax: (847)991-1519. Vice President: Kathleen Williams. Estab. 1970. Ad agency. Types of

clients: industrial, retail, finance, food. Examples of ad campaigns: national ads for Toshiba and Sellstrom; packaging for Barna.

Needs: Works with 7-8 freelance photographers and videographers/month. Uses photos for billboards, consumer and trade magazines, direct mail, P-O-P displays, catalogs and audiovisual. Subjects include: industrial products and facilities. Reviews stock photos/video footage of "creative firsts." Model release required. Captions preferred.

Audiovisual Needs: Uses photos/video for slide shows and videotape.

Specs: Uses 5×7 b&w/color prints; 35mm, 2¼×2¼, 4×5, 8×10 transparencies; videotape.

Making Contact & Terms: Arrange personal interview to show portfolio. Provide résumé, business card, brochure, flier or tearsheets to be kept on file for possible future assignments. Works on assignment basis only. Cannot return material. Reports in 3 weeks. Pays according to "client's budget" within 30 days of invoice. Credit line sometimes given; credit line offered in lieu of payment. Buys all rights.

Tips: Sees trend toward "larger budget for exclusive rights and creative firsts. Contact us every six months."

FLINT COMMUNICATIONS, 101 10th St. N., Fargo ND 58102. (701)237-4850. Fax: (701)234-9680. Art Director: Gerri Lien. Estab. 1946. Ad agency. Approximate annual billing: $9 million. Number of employees: 30. Types of clients: industrial, financial, agriculture and health care.

Needs: Works with 2-3 freelance photographers, 1-2 filmmakers and 1-2 videographers/month. Uses photos for direct mail, P-O-P displays, posters and audiovisual. Subjects include: agriculture, health care and business. Reviews stock photos. Model release preferred.

Audiovisual Needs: Uses slides and film.

Specs: Uses 35mm, 2¼×2¼, 4×5 transparencies; CD-ROM digital format.

Making Contact & Terms: Submit portfolio for review. Query with stock photo list. Provide résumé, business card, brochure, flier or tearsheets to be kept on file for possible future assignments. Keeps samples on file. Reports in 1-2 weeks. Pays $50-100/hour; $400-800/day; $100-1,000/job. **Pays on receipt of invoice.** Buys one-time rights.

FRANZ DESIGN GROUP, 115 5th Ave. S., Suite 401, LaCrosse WI 54601. (608)791-1020. Fax: (608)791-1021. Design firm. Creative Director: Alan Franz. Estab. 1990. Specializes in publication design, display design and packaging. Types of clients: industrial, retail. Examples of past projects: "In Line in Life" video, Rollerblade, Inc. (cover photo for video); Schmidt Loon Search, G. Heileman Brewing Co. (point of purchase display); and Burros Promotional Products (catalog).

Needs: Works with 2 freelance photographers/month. Uses photos for trade magazines, P-O-P displays, catalogs and packaging. Subjects include: models, products and food. Reviews stock photos of studio-food and location-models. Model/property release preferred; usually needs model shots. Captions preferred.

Specs: Uses 2¼×2¼, 4×5 transparencies.

Making Contact & Terms: Provide tearsheets to be kept on file for possible future assignments. Works with freelancers on assignment only. Keeps samples on file. SASE. Reports in 1-2 weeks. Pays $100-3,500/job. **Pays on receipt of invoice.** Credit lines sometimes given depending on the project; "yes, if we can make the decision." Buys all rights; negotiable.

Tips: Interested in "general quality of portfolio and specifically the design and styling of each photo. We like to work with photographers who can suggest solutions to lighting and styling problems—no 'yes' men/women!"

H. GREENE & COMPANY, 230 W. Huron, Chicago IL 60610. (312)642-0088. Fax: (312)642-0028. President: Howard Greene. Estab. 1985. Member of AIGA. Design firm. Approximate annual billing: $5 million. Number of employees: 11. Specializes in annual reports, publication design, direct mail, signage and technology. Types of clients: industrial, financial and nonprofit. Examples of recent clients: Rand McNally, Motorola, Nalco and Comdisco.

Needs: Works with 1 freelancer/month. Uses photos for direct mail, catalogs and posters. Subjects include: people and locations. Reviews stock photos. Model/property release required.

Specs: Uses 35mm, 2¼×2¼, 4×5 transparencies.

Making Contact & Terms: Send unsolicited photos by mail for consideration. Provide résumé, business card, brochure, flier or tearsheets to be kept on file for possible future assignments. Works on assignment only. Keeps samples on file. Cannot return material. Payment negotiable. **Pays on receipt of invoice.** Credit line given. Buys one-time and electronic rights; negotiable.

HEART GRAPHIC DESIGN, 501 George St., Midland MI 48640. (517)832-9710. Owner: Clark Most. Estab. 1982. Ad agency. Approximate annual billing: $250,000. Number of employees: 3. Types of clients: industrial.

Needs: Works with 1 freelancer/month. Uses photos for consumer magazines, catalogs and posters. Subjects include: product shots. Reviews stock photos. Model/property release preferred. Captions preferred.
Specs: Uses 8×10, 11×14 color and b&w prints; 2¼×2¼, 4×5 and 8×10 transparencies.
Making Contact & Terms: Send unsolicited photos by mail for consideration. Provide résumé, business card, brochure, flier or tearsheets to be kept on file for possible future assignments. Works with local freelancers only. Keeps samples on file. SASE. Reports in 1-2 weeks. Pays $200-2,500/job. **Pays on receipt of invoice.** Credit line not given. Rights negotiated depending on job.
Tips: "Display an innovative eye, ability to creatively compose shots and have interesting techniques."

HIRSCH O'CONNOR DESIGN GROUP, INC., (formerly David Hirsch Design Group, Inc.); 205 W. Wacker Drive, Chicago IL 60606. (312)329-1500. Art Director: Peter Dugan. Estab. 1976. Design firm. Specializes in annual reports, publication design, direct mail and signage. Types of clients: industrial, financial and nonprofit. Examples of past projects: employee annual report, Keebler Company; healthy children, Blue Cross/Blue Shield; and annual report, Baker Fentress Management Company.
Needs: Works with a various number of freelancers/month. Uses photos for annual reports and catalogs. Subject matter varies. Model release required; property release preferred. Captions preferred.
Specs: Uses 8×10 color/b&w prints; 35mm, 2¼×2¼ and 4×5 transparencies.
Making Contact & Terms: Send unsolicited photos by mail for consideration. Provide résumé, business card, brochure, flier or tearsheets to be kept on file for possible future assignments. Keeps samples on file. Sometimes returns material. "Reports as soon as we know something." **Pays on receipt of invoice.** Credit line not given. Buys all rights; negotiable.

HUTCHINSON ASSOCIATES, INC., 1147 W. Ohio St., Suite 305, Chicago IL 60622-5874. (312)455-9191. Fax: (312)455-9190. E-mail: hutch@hutchinson.com. Website: http://www.hutchinson.com. Design firm. Contact: Jerry Hutchinson. Estab. 1988. Member of American Center for Design, American Institute of Graphic Arts. Number of employees: 3. Specializes in annual reports, marketing brochures, etc. Types of clients: industrial, finance, real estate and medical. Examples of recent projects: annual reports and capabilities brochures, multimedia and web page design.
Needs: Works with 1 freelance photographer/month. Uses photographs for annual reports, brochures, consumer and trade magazines, direct mail, catalogs and posters. Reviews stock photos. Subjects include: still life, real estate.
Specs: Uses 35mm, 2¼×2¼, 4×5, color and b&w prints; 35mm, 4×5 transparencies.
Making Contact & Terms: Query with samples. Keeps samples on file. SASE. Reports "when the right project comes." Payment rates depend on the client. Pays within 30 days. Buys one-time, exclusive product and all rights; negotiable. Credit line sometimes given.
Tips: In samples "quality and composition count."

IDEA BANK MARKETING, (formerly Portwood Martin Jones Advertising), 701 W. Second St., P.O. Box 2117, Hastings NE 68902. (402)463-0588. Fax: (402)463-2187. E-mail: pmjadv@tcgcs.com. Vice President/Creative Director: Sherma Jones. Estab. 1982. Member of Lincoln Ad Federation. Ad agency. Approximate annual billing: $850,000. Number of employees: 7. Types of clients: industrial, financial, tourism and retail.
Needs: Works with 1-2 freelance photographers and 1 videographer/month. Uses photos for direct mail, catalogs, posters and newspapers. Subjects include people and product. Reviews stock photos. Model release required. Property release preferred.
Audiovisual Needs: Uses slides and videotape for presentations.
Specs: Uses 5×7 glossy color and b&w prints.
Making Contact & Terms: Provide résumé, business card, brochure, flier or tearsheets to be kept on file for possible future assignments. Works with freelancers on assignment only. Keeps samples on file. SASE. Reports in 1-2 weeks. Pays $75-125/hour; $650-1,000/day. **Pays on acceptance** with receipt of invoice. Credit line sometimes given depending on client and project. Buys all rights; negotiable.

INTERNATIONAL RESEARCH & EDUCATION (IRE), 21098 IRE Control Center, Eagan MN 55121-0098. (612)888-9635. Fax: (612)888-9124. IP Director: George Franklin, Jr. IRE conducts in-depth research probes, surveys, and studies to improve the decision support process. Company conducts market research, taste testing, brand image/usage studies, premium testing, and design and development of product/service marketing campaigns. Photos used in brochures, newsletters, posters, audiovisual presentations, annual reports, catalogs, press releases, and as support material for specific project/survey/reports.
Needs: Buys 75-110 photos/year; offers 50-60 assignments/year. "Subjects and topics cover a vast spectrum of possibilities and needs." Model release required.
Audiovisual Needs: Uses freelance filmmakers to produce promotional pieces for 16mm or videotape.

Specs: Uses prints (15% b&w, 85% color), transparencies and negatives.

Making Contact & Terms: Provide résumé, business card, brochure, flier or tearsheets to be kept on file for possible future assignments. "Materials sent are put on optic disk for options to pursue by project managers responsible for a program or job." Works on assignment only. Cannot return material. Reports when a job is available. Payment negotiable; pays on a bid, per job basis. Credit line given. Buys all rights.

Tips: "We look for creativity, innovation and ability to relate to the given job and carry out the mission accordingly."

 JONES, ANASTASI, BIRCHFIELD ADVERTISING INC., 6065 Frantz Rd., Suite 204, Dublin OH 43017. (614)764-1274. Creative Director/VP: Joe Anastasi. Ad agency. Types of clients: telecommunications, hospitals, insurance, food and restaurants and financial.

Needs: Works on assignment basis only. Uses photographers for billboards, consumer and trade magazines, brochures, posters, newspapers and AV presentations.

Making Contact & Terms: Arrange interview to show portfolio. Payment negotiable. per hour, per day, and per project according to client's budget.

KAUFMAN RYAN STRAL INC., 650 North Dearborn, Suite 700, Chicago IL 60610. (312)467-9494. Fax: (312)467-0298. E-mail: krs@chi.il.us. Website: http://www.bworld.com. President: Robert Ryan. Estab. 1993. Member of BMA, BPA, AICE. Ad agency. Approximate annual billing: $4.5 million. Number of employees: 5. Types of clients: industrial and trade shows.

Needs: Works with 1 photographer and 1 videographer/month. Uses photos for trade magazines, direct mail, catalogs, posters, newspapers, signage and audiovisual. Model/property release preferred.

Audiovisual Needs: Uses slides and videotape.

Making Contact & Terms: Query with résumé of credits. Provide résumé, business card, brochure, flier or tearsheets to be kept on file for possible future assignments. Keeps samples on file. SASE. Reports in 3 weeks. Pays $900-1,500/day. Pays on receipt of invoice. Credit line sometimes given depending upon project. Buys all rights.

KELLER CRESCENT COMPANY, 1100 E. Louisiana, Evansville IN 47701. (812)426-7551 or (812)464-2461. Manager Still Photography: Cal Barrett. Ad agency, PR and AV firm. Serves industrial, consumer, finance, food, auto parts and dairy products clients. Types of clients: Old National Bank, Fruit of the Loom and Eureka Vacuums.

Needs: Works with 2-3 freelance photographers/month on assignment only basis. Uses photos for billboards, consumer and trade magazines, direct mail, newspapers, P-O-P displays, radio and TV. Model release required.

Specs: Uses 8×10 b&w prints; 35mm, 4×5 and 8×10 transparencies.

Making Contact & Terms: Query with résumé of credits, list of stock photo subjects. Send material by mail for consideration. Provide business card, tearsheets and brochure to be kept on file for possible future assignments. Prefers to see printed samples, transparencies and prints. Cannot return material. Pays $200-2,500/job; negotiates payment based on client's budget, amount of creativity required from photographer and photographer's previous experience/reputation. Buys all rights.

LERNER ET AL, INC., 733 Lakeview Plaza Blvd., Suite D, Worthington OH 43085. (614)864-8554. Fax: (614)755-5402. President: Frank Lerner. Estab. 1987. Ad agency and design firm with inhouse photography. Approximate annual billing: $1.5 million. Number of employees: 10. Types of clients: industrial, financial and manufacturers.

Needs: Works with 1-2 freelancers/month. Uses photos for consumer magazines, trade magazines, direct mail, P-O-P displays, catalogs, posters, annual reports and packaging. Subjects include: commercial products. Reviews stock photos of all subjects—medical, industrial, science, lifestyles. Model release required. Property release preferred. Captions preferred.

Spec: Uses all sizes color and b&w prints; 35mm, 2¼×2¼, 4×5 transparencies.

**FOR EXPLANATIONS OF THESE SYMBOLS,
SEE THE INSIDE FRONT AND BACK COVERS OF THIS BOOK.**

Making Contact & Terms: Arrange personal interview to show portfolio. Submit portfolio for review. Send unsolicited photos by mail for consideration. Query with samples. Provide résumé, business card, brochure, flier or tearsheets to be kept on file for possible future assignments. Keeps samples on file. SASE. Reports depending on the job. Pays $150-350/day (in-studio). Pays net 30 days. Credit line not given. Buys all rights.
Tips: Looks for skill with lifestyles (people), studio ability, layout/design ability, propping/setup speed and excellent lighting techniques.

N **◩** **LIGGETT STASHOWER ADVERTISING, INC.**, 1228 Euclid Ave., Cleveland OH 44115. (216)348-8500. Fax: (216)736-8113. Contact: Kelly McNamara. Estab. 1932. Ad agency. Types of clients: full service agency. Examples of recent projects: Sears Optical, Babcock and Wilcox, and Evenflo.
Needs: Works with 10 freelance photographers, filmmakers and/or videographers/month. Uses photos for billboards, consumer and trade magazines, direct mail, P-O-P displays, catalogs, posters, newspapers, signage and audiovisual. Interested in reviewing stock photos/film or video footage. Model/property release required.
Audiovisual Needs: Uses photos/film/commercials.
Specs: Uses b&w/color prints (size and finish varies); 35mm, 2¼×2¼, 4×5, 8×10, 16mm film; ¼-¾" videotape.
Making Contact & Terms: Send unsolicited photos by mail for consideration. Query with samples. Provide résumé, business card, brochure, flier or tearsheets to be kept on file for possible future assignments. SASE. Reports in 1-2 weeks. Pays $100/b&w photo; $50-200/hour; $800-2,500/day. **Pays within 45 days of acceptance.** Credit line sometimes given, depending on usage. Buys one-time, exclusive product, all rights; negotiable.

LOHRE & ASSOCIATES INC., 2330 Victory Pkwy., Suite 701, Cincinnati OH 45206. (513)961-1174. Ad agency. President: Charles R. Lohre. Types of clients: industrial.
Needs: Works with 1 photographer/month. Uses photographers for trade magazines, direct mail, catalogs and prints. Subjects include: machine-industrial themes and various eye-catchers.
Specs: Uses 8×10 glossy b&w and color prints; 4×5 transparencies.
Making Contact & Terms: Query with résumé of credits. Provide résumé, business card, brochure, flier or tearsheets to be kept on file for possible future assignments. Works with local freelancers only. SASE. Reports in 1 week. Pays $60/b&w photo; $250/color photo; $60/hour; $275/day. Pays on publication. Buys all rights.
Tips: Prefers to see eye-catching and thought-provoking images/non-human. Need someone to take 35mm photos on short notice in Cincinnati plants.

MAUCK & ASSOCIATES, 516 Third St., Suite 200, Des Moines IA 50309. (515)243-6010. Fax: (515)243-6011. President: Kent Mauck. Estab. 1986. Design firm. Specializes in annual reports and publication design. Types of clients: industrial, financial, retail, publishers and nonprofit. Examples of recent projects: Iowa Health System annual report; Iowa State University publications; Wellmark Blue Cross Publications.
Needs: Works with 3 freelancers/month. Uses photos for annual reports, billboards, consumer and trade magazines and posters. Subject matter varies. Reviews stock photos. Model release required.
Specs: Uses 35mm, 2¼×2¼, 4×5 transparencies.
Making Contact & Terms: Arrange personal interview to show portfolio. Query with stock photo list or samples. Provide résumé, business card, brochure, flier or tearsheets to be kept on file for possible future assignments. Keeps samples on file. SASE. Reports only when interested. Pays $700-1,000/day. **Pays on receipt of invoice.** Credit line given. Rights negotiable.

◩ **ART MERIMS COMMUNICATIONS**, 600 Superior Ave., Suite 1300, Cleveland OH 44114. (216)522-1909. Fax: (216)479-6801. E-mail: amerims@hqcom.com. President: Art Merims. Estab. 1981. Member of Public Relations Society of America. Ad agency and PR firm. Approximate annual billing: $700,000. Number of employees: 4. Types of clients: industrial, financial, fashion, retail and food.
Needs: Works with 1 freelancer/month. Uses photo for consumer magazines, trade magazines and newspapers. Model/property release preferred. Captions preferred.
Audiovisual Needs: Uses videotape for advertising.
Specs: Uses prints.
Making Contact & Terms: Query with résumé of credits. Works with local freelancers on assignment only. Cannot return material. Payment negotiable. **Pays on receipt of invoice.** Credit line sometimes given. Rights negotiable.

⚡ MESSAGE MAKERS, 1217 Turner St., Lansing MI 48906. (517)482-3333. Fax: (517)482-9933. Executive Director: Terry Terry. Estab. 1977. Member of LRCC, NSPI, AIVF, ITVA. AV firm. Number of employees: 4. Types of clients: broadcast, industrial and retail.
Needs: Works with 2 freelance photographers, 1 filmmaker and 2 videographers/month. Uses photos for direct mail, posters and newspapers. Subjects include: people or products. Model release preferred. Property release required. Captions preferred.
Audiovisual Needs: Uses slides, film, video and CD.
Specs: Uses 4×5 color and b&w prints; 35mm, 2¼×2¼ transparencies; Beta SP videotape.
Making Contact & Terms: Provide résumé, business card, brochure, flier or tearsheets to be kept on file for possible future assignments. Keeps samples on file. Cannot return material. Reports only if interested. Payment negotiable. **Pays on receipt of invoice.** Credit line sometimes given depending upon client. Buys all rights; negotiable.

Ⓝ MG DESIGN ASSOCIATES CORP., 824 W. Superior St., Chicago IL 60622. (312)243-3661. Fax: (312)243-5268. E-mail: solution@mgdesign.com. Contact: Graphics Designer. Estab. 1959. Member of IEA, EDPA, HCEA. Design firm. Number of employees: 30. Specializes in display design and signage. Types of clients: corporate.
Needs: Subjects include: corporate images and industrial. Model release required. Captions preferred.
Specs: Uses 35mm, 4×5, 8×10 transparencies.
Making Contact & Terms: Query with résumé of credits. Works on assignment only. Does not keep samples on file. Reports in 1 month. Payment negotiable. **Pays on receipt of invoice.** Credit line not given.

MID AMERICA DESIGNS, INC., P.O. Box 1368, Effingham IL 62401. (217)347-5591. Fax: (217)347-2952. Catalog Production Manager: Cheryl Habing. Estab. 1975. Provides mail order catalog for Corvette parts & accessories.
Needs: Buys 300 freelance photos/year; offers 2 freelance assignments/year. Apparel and automotive parts. Reviews stock photos. Model release required. Property release preferred.
Specs: Uses 2¼×2¼, 4×5 and 8×10 transparencies.
Making Contact & Terms: Provide résumé, business card, brochure, flier or tearsheets to be kept on file for possible future assignments. Works on assignment. Reports in 2 weeks. Buys all rights; negotiable.

⚡ MSR ADVERTISING, INC., P.O. Box 10214, Chicago IL 60610-0214. (312)573-0001. Fax: (312)573-1907. E-mail: marc@msradv.com. Website: http://www.msradv.com. President: Marc S. Rosenbaum. Vice President: Barry Waterman. Creative Director: Indiana Wilkins. Estab. 1983. Ad agency. Number of employees: 7. Types of clients: industrial, fashion, financial, retail, food, aerospace, hospital, legal and medical. Examples of recent projects: "Back to Basics," MPC Products; "Throw Mother Nature a Curve," New Dimensions Center for Cosmetic Surgery; and "Innovative Strategies Practical Solutions," Becker & Pouakoff (full identity).
Needs: Works with 4-6 freelance photographers and 1-2 videographers/month. Uses photos for billboards, consumer and trade magazines, direct mail, P-O-P displays, catalogs, posters and signage. Subject matter varies. Reviews stock photos. Model/property release required.
Audiovisual Needs: Uses slides and videotape for business-to-business seminars, consumer focus groups, etc. Subject matter varies.
Specs: Uses 35mm, 2¼×2¼, 4×5 and 8×10 transparencies. Accepts images in digital format for Mac. Send via CD, SyQuest or Zip disk (low and high resolution).
Making Contact & Terms: Submit portfolio for review. Query with samples. Provide résumé, business card, brochure, flier or tearsheets to be kept on file for possible future assignments. Works on assignment only. Keeps samples on file. SASE. Reports in 1-2 weeks. Pays $750-1,500/day. Payment terms stated on invoice. Credit line sometimes given. Buys all rights; negotiable.

⚡ OLSON AND GIBBONS, INC., 1501 Euclid Ave., Suite 518, Cleveland OH 44115-2108. (216)623-1881. Fax: (216)623-1884. E-mail: olsgib@aol.com. Executive Vice-President/Creative Director: Barry Olson. Estab. 1991. Ad agency, PR/marketing firm. Types of clients: industrial, financial, medical, automotive, retail and food. Examples of recent projects: PHS Primary Health System (ads, outdoor, collateral); Lake View Cemetery (direct mail); Ansell Edmont (ads, literature, direct mail); STERIS (corporate ads); OM Group (financial ads).
Needs: Works with 10 freelancers/month. Uses photos for billboards, trade magazines, consumer newspapers and magazines, direct mail and P-O-P displays. Model/property release required.
Audiovisual Needs: Uses film and videotape.
Specs: Uses color and/or b&w prints; 35mm, 2¼×2¼, 4×5, 8×10 transparencies; 16mm, 35mm film.
Making Contact & Terms: Arrange personal interview to show portfolio. Provide résumé, business

card, brochure, flier or tearsheets to be kept on file for possible future assignments. Works with local freelancers on assignment only. Keeps samples on file. SASE. Reports in 1-2 weeks. Payment negotiable. **Pays on receipt of invoice,** payment by client. Credit line not given. Buys one-time or all rights; negotiable.

OMNI PRODUCTIONS, 12955 Old Meridian St., P.O. Box 302, Carmel IN 46032-0302. (317)844-6664. Fax: (317)573-8189. President: Winston Long. AV firm. Types of clients: industrial, corporate, educational, government and medical.
Needs: Works with 6-12 freelance photographers/month. Uses photographers for AV presentations. Subject matter varies. Also works with freelance filmmakers to produce training films and commercials.
Specs: Uses b&w and color prints; 35mm transparencies; 16mm and 35mm film and videotape.
Making Contact & Terms: Provide résumé, business card, brochure, flier or tearsheets to be kept on file for possible future assignments. Works with freelance photographers on assignment basis only. Cannot return unsolicited material. Payment negotiable. **Pays on acceptance.** Buys all rights "on most work; will purchase one-time use on some projects." Model release required. Credit line given "sometimes, as specified in production agreement with client."

PHOENIX ADVERTISING CO., W. Delta Park, Hwy. 18 W., Clear Lake IA 50428. (515)357-9999. Fax: (515)357-5364. Contact: James Clark. Ad agency. Estab. 1986. Types of clients: industrial, financial and consumer. Examples of projects: "Western Tough," Bridon (print/outdoor/collateral); "Blockbuster," Video News Network (direct mail, print); and "Blue Jeans," Clear Lake Bank & Trust (TV/print/newspaper).
Needs: Works with 2-3 photographers or videographers/month. Uses photos for billboards, consumer and trade magazines, direct mail, P-O-P displays, catalogs, posters, newspapers, signage, audiovisual uses. Subjects include: people/products. Reviews stock photos and/or video.
Audiovisual Needs: Uses slides and videotape.
Specs: Uses 8 × 10 color and b&w prints; 35mm, 2¼ × 2¼, 4 × 5, 8 × 10 transparencies; ½" or ¾" videotape.
Making Contact & Terms: Contact through rep or submit portfolio for review. Provide résumé, business card, brochure, flier or tearsheets to be kept on file for possible future assignments. Works on assignment only. Keeps samples on file. SASE. Reports in 3 weeks. Pays $1,000-10,000/day. **Pays on receipt of invoice.** Buys first rights, one-time rights, all rights and others; negotiable. Model/property release required. Credit line sometimes given; no conditions specified.

PHOTO COMMUNICATION SERVICES, INC., 6055 Robert Dr., Traverse City MI 49684-8645. (616)943-5050. E-mail: lesnmore@aol.com. President: M'Lynn Hartwell. Estab. 1970. Commercial/Illustrative and AV firm. Types of clients: commercial/industrial, fashion, food, general, human interest.
Needs: Works with variable number of freelance photographers/month. Uses photos for catalogs, P-O-P displays, AV presentations, trade magazines and brochures. Photos used for a "large variety of subjects." Sometimes works with freelance filmmakers. Model release required.
Audiovisual Needs: Primarily industrial multi-image and video.
Specs: Uses 8 × 10 (or larger) gloss and semigloss b&w and color prints; 35mm, 2¼ × 2¼, 4 × 5 and 8 × 10 transparencies; 16mm film; VHS/SVHS; Hi8 and ¾" videotape.
Making Contact & Terms: Query with résumé of credits, samples or list of stock photo subjects. Works with freelance photographers on assignment basis only. SASE. Reports in 1 month. Payment determined by private negotiation. **Pays 30 days from acceptance.** Credit line given "whenever possible." Rights negotiated.
Tips: Looks for professionalism in portfolio or demos. "Be professional and to the point. If I see something I can use I will make an appointment to discuss the project in detail. We also have a library of stock photography."

QUALLY & COMPANY, INC., Suite 3, 2238 Central St., Evanston IL 60201-1457. (847)864-6316. Creative Director: Robert Qually. Ad agency and graphic design firm. Types of clients: finance, package goods and business-to-business.
Needs: Works with 4-5 freelance photographers/month. Uses photos for billboards, consumer and trade magazines, direct mail, P-O-P displays, posters and newspapers. "Subject matter varies, but is always a 'quality image' regardless of what it portrays." Model release required.
Specs: Uses b&w and color prints; 35mm, 2¼ × 2¼, 4 × 5 and 8 × 10 transparencies.
Making Contact & Terms: Query with samples or submit portfolio for review. Provide résumé, business card, brochure, flier or tearsheets to be kept on file for possible future assignments. Works with local freelance photographers on assignment only. Cannot return material. Reports in 2 weeks. Payment negotia-

ble. **Pays on acceptance** or net 45 days. Credit line sometimes given, depending on client's cooperation. Rights purchased depend on circumstances.

PATRICK REDMOND DESIGN, P.O. Box 75430-PM, St. Paul MN 55175-0430. (612)646-4254. Designer/Owner/President: Patrick Michael Redmond, M.A. Estab. 1966. Design firm. Specializes in publication design, book covers, books, packaging, direct mail, posters, logos, trademarks, annual reports. Number of employees: 1. Types of clients: publishers, financial, retail, advertising, marketing, education, nonprofit, arts. Examples of recent projects: Mid-List Press (book cover design); Norwest Corporation (graphic design).
• Patrick Redmond Design listed in the *Marquis® Who's Who in the Midwest 1996-1997* 25th Anniversary Edition. Books designed by Redmond won awards from Midwest Independent Publishers Association, Midwest Book Achievement Awards, Publishers Marketing Association Benjamin Franklin Awards.
Needs: Uses photos for books and book covers, direct mail, P-O-P displays, catalogs, posters, packaging, annual reports. Subject varies with client—may be editorial, product, how-to, etc. May need custom b&w photos of authors (for books/covers designed by PRD). "Poetry book covers provide unique opportunities for unusual images (but typically have miniscule budgets)." Reviews stock photos; subject matter varies with need—like to be aware of resources. Model/property release required; varies with assignment/project. Captions required; include correct spelling and identification of all factual matters, re: images; i.e., names, locations, etc.—to be used optionally—if needed.
Specs: Uses 5×7, 8×10 glossy prints; 35mm, 2¼×2¼, 4×5 transparencies. Accepts images in digital format for Mac; type varies with need, production requirements, budgets. Send via CD, online, floppy disk, SyQuest, zip disk or as requested. "Do not send digital formats unless requested."
Making Contact & Terms: Contact through rep. Arrange personal interview to show portfolio. Query with résumé of credits. Query with stock photo list. Provide résumé, business card, brochure, flier, or tearsheets to be kept on file for possible future assignments. "Patrick Redmond Design will not reply unless specific photographer may be needed for respective project." Works with local freelancers on assignment only. Keeps samples on file. Cannot return material. Payment negotiable. "Client typically pays photographer directly even though PRD may be involved in photo/photographer selection and photo direction." Payment depends on client. Credit line sometimes given depending upon publication style/individual projects. Rights purchased vary with project; negotiable. "Clients typically involved with negotiation of rights directly with photographer."
Tips: Needs are "open—vary with project . . . location work; studio; table-top; product; portraits; travel; etc." Seeing "use of existing stock images when image/price are right for project and use of b&w photos in low-to-mid budget/price books. Provide URLs (website addresses) and e-mail addresses. Freelance photographers need web presence in today's market—in addition to exposure via direct mail, catalogs, brochures, etc."

RIPON COLLEGE, P.O. Box 248, Ripon WI 54971. (920)748-8364. Contact: Director of College Relations. Estab. 1851. Photos used in brochures, newsletters, posters, newspapers, audiovisual presentations, annual reports, magazines and press releases.
Needs: Offers 3-5 assignments/year. Formal and informal portraits of Ripon alumni, on-location shots, architecture. Model/property release preferred. Captions preferred.
Making Contact & Terms: Provide résumé, business card, brochure, flier or tearsheets to be kept on file for possible future assignments. Works on assignment only. SASE. Reports in 1 month. Pays $10-25/b&w photo; $10-50/color photo; $30-40/hour; $300-500/day; $300-500/job; negotiable. Buys one-time and all rights; negotiable.

SANDRA SANOSKI COMPANY, INC., 166 E. Superior St., Chicago IL 60611. (312)664-7795. President: Sandra Sanoski. Estab. 1974. Marketing communications and design firm specializing in display and publication design, packaging and web/internet design. Types of clients: retail and consumer goods.
Needs: Works with 3-4 freelancers/month. Uses photos for catalogs and packaging. Subject matter varies. Reviews stock photos. Model/property release required.
Specs: Uses 35mm, 2¼×2¼, 4×5, 8×10 transparencies. Accepts digital images.

MARKET CONDITIONS are constantly changing! If you're still using this book and it's 2000 or later, buy the newest edition of *Photographer's Market* at your favorite bookstore or order directly from Writer's Digest Books.

Making Contact & Terms: Query with list of stock photo images. Arrange personal interview to show portfolio. Works on assignment only. Keeps samples on file. SASE. Payment negotiable. Pays net 30 days. Credit line not given. Buys all rights.

SMILEY/HANCHULAK, INC., 47 N. Cleveland-Massillon Rd., Akron OH 44333. (330)666-0868. Fax: (330)666-5762. Ad agency. Contact: Susan Breen Clients: all types.
Needs: Works with 1-2 photographers/month. Uses freelance photos for consumer and trade magazines, direct mail, P-O-P displays, catalogs, posters and sales promotion. Model release required. Captions preferred.
Specs: Uses 11×14 b&w and color prints, finish depends on job; 35mm or $2\frac{1}{4} \times 2\frac{1}{4}$ (location) or 4×5 or 8×10 (usually studio) transparencies, depends on job.
Making Contact & Terms: Arrange a personal interview to show portfolio. Query with résumé of credits, list of stock photo subjects or samples. Send unsolicited photos by mail for consideration or submit portfolio for review. Provide résumé, business card, brochure, flier or tearsheets to be kept on file for possible future assignments. If a personal interview cannot be arranged, a letter would be acceptable. Works with freelance photographers on assignment basis only. SASE. Report depends on work schedule. Payment negotiable. Pays per day or per job. Buys all rights unless requested otherwise.
Tips: Prefers to see studio product photos. "Jobs vary—we need to see all types with the exception of fashion. We would like to get more contemporary, but photo should still do the job."

J. GREG SMITH, 1004 Farnam, Suite 102, Burlington on the Mall, Omaha NE 68102. (402)444-1600. Art Director: Mike Briardy. Ad agency. Types of clients: finance, banking institutions, national and state associations, agriculture, insurance, retail, travel.
Needs: Works with 10 freelance photographers/year on assignment only basis. Uses photographers for consumer and trade magazines, brochures, catalogs and AV presentations. Special subject needs include outer space, science and forest scenes, also high tech.
Making Contact & Terms: Arrange interview to show portfolio. Looks for "people shots (with expression), scenics (well known, bright colors)." Pays $500/color photo; $60/hour; $800/day; varies/job. Buys all rights, one-time rights or others, depending on use.
Tips: Considers "composition, color, interest, subject and special effects when reviewing a portfolio or samples."

SWANSON RUSSELL ASSOCIATES, 9140 W. Dodge Rd., Suite 402, Omaha NE 68114. (402)393-4940. Fax: (402)393-6926. E-mail: paul_b@oma.sramarketing.com. Senior Art Director: Paul Berger. Estab. 1963. Member of NAMA, PRSA, DMA, Ad Club, AIGA, 4-As. Ad agency. Approximate annual billing: $30 million. Number of employees: 80. Examples of past projects: "Nuflor Product Launch"; "Orbax Product Launch," Schering-Plough Animal Health (print, direct mail); and "Branding Campaign," Alegant Health System (print and TV).
Needs: Works with 2 photographers/month; 3-4 filmmakers/year and 1 videographer/year. Uses photos for billboards, trade magazines, direct mail, P-O-P displays, newspapers and audiovisual. Subjects include human health, animal health, pharmaceuticals and agriculture (cattle, hogs, crops, rural life). Model/property release preferred. Captions preferred.
Audiovisual Needs: Uses slides, film and video for training videos, etc.
Making Contact & Terms: Submit portfolio for review. Query with samples. Provide résumé, business card, brochure, flier or tearsheets to be kept on file for possible future assignments. Work with local freelancers on assignment only. Keeps samples on file. SASE. Reports in 1-2 weeks. Pays $100-150/hour; $800-1,500/day; $400-1,000/color photo. **Pays on receipt of invoice**. Credit line sometimes given. Buys first, one-time, electronic and all rights; negotiable.
Tips: "We have begun to use photographers who also have the skills and tools to digitally manipulate their images."

TAKE 1 PRODUCTIONS, 5325 W. 74th St., Minneapolis MN 55439. (612)831-7757. Fax: (612)831-2193. E-mail: take1@take1productions.com. Producer: Bob Hewitt. Estab. 1985. Member of ITVA, IICS. AV firm. Approximate annual billing: $1 million. Number of employees: 10. Types of clients: industrial. Examples of recent projects: USWest; Kraft (industrial); Paramount (broadcast).
Needs: Works with 2 photographers and 4 videographers/month. Uses photos for direct mail and audiovisual. Subjects include: industrial. Reviews stock photos. Model/property release required. Captions preferred.
Audiovisual Needs: Uses slides and/or video.
Specs: Uses 35mm transparencies; Betacam videotape.
Making Contact & Terms: Provide résumé, business card, brochure, flier or tearsheets to be kept on

file for possible future assignments. Works with freelancers on assignment only. Keeps samples on file. Cannot return material. Reports in 1 month. Payment negotiable. **Pays on receipt of invoice**, net 30 days. Credit line not given. Buys all rights.

🎦 **UNION INSTITUTE**, 440 E. McMillan St., Cincinnati OH 45206. (513)861-6400. Fax: (513)861-0779. Publications Manager: Carolyn Krause. Provides alternative higher education, baccalaureate and doctoral programs. Photos used in brochures, newsletters, magazines, posters, audiovisual presentations, annual reports, catalogs and news releases.
Specs: Uses 5×7 glossy b&w and color prints; b&w and color contact sheets.
Needs: Uses photos of the Union Institute community involved in their activities. Also, photos that portray themes. Model release required.
Making Contact & Terms: Arrange a personal interview to show portfolio. SASE. Reports in 3 weeks. Payment negotiable. Credit line given.
Tips: Prefers "good closeups and action shots of alums/faculty, etc. Our alumni magazines reach an international audience concerned with major issues. Illustrating stories with quality photos involving our people is our constant challenge. We welcome your involvement."

VARON & ASSOCIATES, INC., 31333 Southfield Rd., Beverly Hills MI 48025. (248)645-9730. Fax: (248)642-1303. President: Shaaron Varon. Estab. 1963. Ad agency. Approximate annual billing: $1 million. Number of employees: 6. Types of clients: industrial and retail.
Needs: Uses photos for trade magazines, catalogs and audiovisual. Subjects include: industrial. Reviews stock photos. Model/property release required. Captions preferred.
Audiovisual Needs: Uses slides and videotape for sales and training. Subjects include: industrial.
Specs: Uses 8×10 color prints; 4×5 transparencies. Accepts images in digital format for Mac and Windows.
Making Contact & Terms: Arrange personal interview to show portfolio. Works with freelancers on assignment only. Keeps samples on file. Cannot return material. Reports in 1-2 weeks. Pays $1,000/day. **Pays on acceptance**. Credit line sometimes given. Buys all rights.

🎦 **VIDEO I-D, INC.**, 105 Muller Rd., Washington IL 61571. (309)444-4323. Fax: (309)444-4333. E-mail: videoid@videoid.com. Website: http://www.videoid.com. President: Sam B. Wagner. Number of employees: 6. Types of clients: health, education, industry, service, cable and broadcast.
Needs: Works with 5 freelance photographers/month to shoot slide sets, multimedia productions, films and videotapes. Subjects "vary from commercial to industrial—always high quality." "Somewhat" interested in stock photos/footage. Model release required.
Specs: Uses 35mm transparencies; 16mm film; U-matic ¾" and 1" videotape, Beta SP. Accepts images in digital format for Windows ("inquire for file types"). Send via CD, Online, floppy or on Zip disk.
Making Contact & Terms: Provide résumé, business card, self-promotion piece or tearsheets to be kept on file for possible future assignments, "also send video sample reel." Works with freelancers on assignment only. SASE. Reports in 3 weeks. Pays $10-65/hour; $160-650/day. Usually pays by the job; negotiable. **Pays on acceptance.** Credit line sometimes given. Buys all rights; negotiable.
Tips: Sample reel—indicate goal for specific pieces. "Show good lighting and visualization skills. Show me you can communicate what I need to see—and willingness to put out effort to get top quality."

🎦 **WILLIAM K. WALTHERS, INC.**, 5601 W. Florist Ave., Milwaukee WI 53218. (414)527-0770. Fax: (414)527-4423. Publications Manager: Kim Benson. Estab. 1932. Importer/wholesaler of hobby products. Photos used in catalogs, text illustration and promotional materials.
Needs: Buys 50-100 photos/year; offers 20 assignments/year. Interested in any photos relating to historic or model railroading. Reviews stock photos. Model/property release required. Captions preferred; include brief overview of action, location, any unusual spellings, names of photographer and model builder.
Specs: Uses 4×5, 8½×11 color and b&w prints; 35mm, 2¼×2¼ transparencies.
Making Contact & Terms: Send unsolicited photos by mail for consideration. Keeps samples on file. SASE. Reports in 1-2 weeks. Payment negotiated based on usage. Pays on publication or **receipt of invoice**. Credit line given. Buys all rights.
Tips: "Knowledge of railroading is essential since customers consider themselves experts on the subject. With model railroad shots, it should be difficult to see that the subject is a miniature."

WATT, ROOP & CO., 1100 Superior Ave., Cleveland OH 44114. (216)566-7019. Vice President of Design Operations: Thomas Federico. Estab. 1981. Member of AIGA, PRSA, Press Club of Cleveland, Cleveland Ad Club. PR firm. Approximate annual billing: $3 million. Number of employees: 30. Types

of clients: industrial, manufacturing and health care. Examples of recent projects: Olympic Steel (annual report); OMGroup (annual report); NCR (case studies).

Needs: Works with 2 freelance photographers/month. Uses photos for magazines and corporate/capabilities brochures, annual reports, catalogs and posters. Subjects include: corporate. Reviews stock photos. Model/property release required. Captions preferred.

Specs: Uses 35mm, $2\frac{1}{4} \times 2\frac{1}{4}$, 4×5 transparencies.

Making Contact & Terms: Provide résumé, business card, brochure, flier or tearsheets to be kept on file for possible future assignments. Works with local freelancers on assignment only. Reports "as needed." Pays $50-1,500/b&w photo; $100-2,500/color photo; $50-200/hour; $150-2,000/day. **Pays on receipt of invoice.** Credit line sometimes given. Buys all rights (work-for-hire); one-time rights; negotiable.

Tips: Wants to see "variety, an eye for the unusual. Be professional."

REGIONAL REPORT: SOUTH CENTRAL & WEST

This region, stretching from California to Texas, includes several major advertising cities—Dallas, Houston, Los Angeles, San Francisco. The industries here lean heavily toward tourism and computer hardware manufacturing, but also include mining and food products. Major advertisers in this region include Walt Disney, Anheuser Busch, Levi Strauss and Apple Computer.

Principle industries and manufactured goods

Arizona—Industries: manufacturing, construction, tourism, mining, agriculture. Manufactured Goods: electronics, printing and publishing, foods, primary and fabricated metals, aircraft and missiles, apparel.

California—Industries: agriculture, tourism, apparel, electronics, telecommunications, entertainment. Manufactured Goods: electronic and electrical equipment, computers, industrial machinery, transportation equipment and instruments, food.

Colorado—Industries: manufacturing, construction, government, tourism, agriculture, aerospace, electronics equipment. Manufactured Goods: computer equipment and instruments, food, machinery, aerospace products.

Hawaii—Industries: tourism, defense, sugar, pineapples. Manufactured Goods: processed sugar, canned pineapples, clothing, foods, printing and publishing.

Kansas—Industries: manufacturing, finance, insurance, real estate, services. Manufactured Goods: transportation equipment, machinery and computer equipment, food, printing and publishing.

Missouri—Industries: agriculture, manufacturing, aerospace, tourism. Manufactured Goods: transportation equipment, food and related products, electrical and electronic equipment, chemicals.

Nevada—Industries: gaming, tourism, mining, manufacturing, government, retailing, warehousing, trucking. Manufactured Goods: food products, plastics, chemicals, aerospace products, lawn and garden irrigation equipment, seismic and machinery monitoring devices.

New Mexico—Industries: government, services, trade. Manufactured Goods: foods, machinery, apparel, lumber, printing, transportation equipment, electronics, semiconductors.

Oklahoma—Industries: manufacturing, mineral and energy exploration and production, agriculture, services. Manufactured Goods: non-electrical machinery, transportation equipment, food products, fabricated metal products.

Texas—Industries: manufacturing, trade, oil and gas extraction, services. Manufactured Goods: industrial machinery and equipment, food, electrical and electronic products, chemicals and allied products, apparel.

Utah—Industries: services, trade, manufacturing, government, transportation, utilities. Manufactured Goods: medical instruments, electronic components, food products, fabricated metals, transportation equipment, steel and copper.

Leading national advertisers

Walt Disney Co., Burbank CA Levi Strauss, San Francisco CA Apple Computer, Cupertino CA

J.C. Penney Co., Dallas TX
Anheuser-Busch Cos., St. Louis MO
Sprint Corp., Shawnee Mission KS
Intel Corp., Santa Clara CA
May Department Stores, St. Louis MO
Mattell, Hathorne CA
Ralston Purina, St. Louis MO
Visa, San Francisco CA

Tandy Corp., Fort Worth TX
Clorox Co., Oakland CA
Adolph Coors, Co., Golden CO
Kimberly-Clark Corp., Irving TX
SBC Communications, San Antonio TX
Hallmark Cards, Kansas City MO
Compaq, Houston TX
Southwest Airlines, Dallas TX

Monsanto Co., St. Louis MO
Hewlett-Packard, Palo Alto CA
Boston Chicken, Golden CO
CKE Restaurants, Anaheim CA
American Stores Co., Salt Lake City UT
Cellular One, Dallas TX

Notable ad agencies in the region

Ackerman McQueen, 1601 NW Highway 100, Bank IV Tower, Oklahoma City OK 73118. (405)843-7777. Major accounts: Bank of Oklahoma, Dallas Cowboys, Homeland Food Stores, National Rifle Association of America, Pizza Hut, Thrifty Car Rental.

Cranford Johnson Robinson Woods, Capitol Center, 303 W. Capitol Ave., Little Rock AR 72201. (501)376-6251. Major accounts: Arkansas Children's Hospital, Arkansas Power & Light, First Commercial Corp., Straight Arrow.

Foote, Cone & Belding, 733 Front St., San Francisco CA 94111. (415)820-8000. Major accounts: Amazon.com, Coors, Dockers, Excite, Hewlett Packard, Janus Funds, Levi Strauss & Co., Powerbar, Sega, WebTV.

Heathcott Associates, 17500 Chenal Parkway, Little Rock AR 72211. (501)399-9900. Major accounts: Chevrolet Regional Co-ops, KFC Regional Co-ops, Mexico Chiquito Restaurants, Unpainted Furniture Stores.

Rick Johnson & Co., 1120 Pennsylvania NE, Albuquerque NM 87110. (505)266-1100. Major Accounts: Angel Fire Resort, Los Alamos National Bank, McDonald's, New Mexico Tourism Department, University of New Mexico.

The Richards Group, 8750 N. Central Expressway, #1200, Dallas TX 75231. (214)891-5700. Major accounts: AlphaGraphics, Brueggers Bagels, Cole-Haan, Corona Beer, Greyhound Bus Lines, Motel 6, Papa John's, 7-Eleven.

Saatchi & Saatchi Pacific, 3501 Sepulveda Blvd., Torrance CA 90505. (310)214-6000. Major accounts: Capitol Records, Geocities, Guess?, MGM/UA, Toyota Dealer Associations, The Wellness Community, YMCA.

TBWA Chiat/Day, 340 Main St., Venice CA 90291. (310)314-5000. Major accounts: ABC Television, Air Touch Communications, American Tourister, Energizer Batteries, Infiniti Cars, PlayStation, Taco Bell, The Weather Channel.

Temerlin McClain, 201 E. Carpenter Freeway, Irving TX 75062. (972)556-1100. Major Accounts: American Airlines, GTE Corp., Halliburton Co., Just My Size Pantyhose, Long John Silver's, Subaru Cars.

J. Walter Thompson West, 4 Embarcadero Center, San Francisco CA 94111. (415)955-2000. Major accounts: Baby Ruth, California Tourism, Nestle New Products, Sprint Corp., Sunsweet Prune Juice, Toll House Morsels.

THE AD AGENCY, P.O. Box 470572, San Francisco CA 94147. President: Michael Carden. Estab. 1970. Member of NCAAA, San Francisco Ad Club. Ad agency. Number of employees: 14. Types of clients: industrial, financial, retail and food.
Needs: Number of photographers, filmmakers and videographers used on a monthly basis varies. Uses photos for billboards, consumer magazines, trade magazines, direct mail, catalogs, posters and newspapers. Subject matter varies. Reviews stock photos. Model/property release preferred. Captions preferred.
Audiovisual Needs: Uses film and videotape for commercials.
Making Contact & Terms: Submit portfolio for review. Query with samples. Keeps samples on file. SASE. Reports in 1 month. Payment negotiable. Rights negotiable.

ADVANCE ADVERTISING AGENCY, 606 E. Belmont, #202, Fresno CA 93701. (209)445-0383. Manager: Martin Nissen. Ad and PR agency and graphic design firm. Types of clients: industrial, commercial, retail, financial. Examples of projects: Spyder Autoworks (direct mail, trade magazines); Windshield

Repair Service (radio, TV, newspaper); Mr. G's Carpets (radio, TV, newspaper); Fresno Dixieland Society (programs and newsletters).
Needs: Model release required.
Specs: Uses color and b&w prints.
Making Contact & Terms: Send unsolicited photos by mail for consideration. Provide business card, brochure, flier to be kept on file for possible future assignments. Keeps samples on file. Reports in 1-2 weeks. Payment negotiated per job. Pays 30 days from invoice. Credit line given. Buys all rights.
Tips: In samples, looks for "not very abstract or overly sophisticated or 'trendy.' Stay with basic, high quality material." Advises that photographers "consider *local* market target audience."

THE ADVERTISING CONSORTIUM, 10536 Culver Blvd., Suite D., Culver City, CA 90232. (310)287-2222. Fax: (310)287-2227. President: Kim Miyade. Ad agency. Approximate annual billing: $1 million. Number of employees: 2. Types of clients: industrial, fashion and retail.
Needs: Number of photographers used on a monthly basis varies. Uses photos for billboards, consumer magazines, trade magazines, direct mail, posters, newspapers and signage. Subjects include: product shots and model and stock photographs. Reviews stock photos. Model release required. Property release preferred.
Audiovisual Needs: Uses slides and film.
Specs: Uses color and b&w prints.
Making Contact & Terms: Send unsolicited photos by mail for consideration. Provide résumé, business card, brochure, flier or tearsheets to be kept on file for possible future assignments. Works with local freelancers only. Keeps samples on file. Notification dependent upon opportunity. Payment negotiable. **Pays half on invoice, half upfront.** Credit line sometimes given. Buys all rights.

AMERTRON-AMERICAN ELECTRONIC SUPPLY, 1200 N. Vine St., Hollywood CA 90038-1600. (213)462-1200. Fax: (213)871-0127. General Manager: Fred Rosenthal. Estab. 1953. AV and electronics distributing firm; also sales, service and rentals. Approximate annual billing: $5 million. Number of employees: 35. Types of clients: industrial, financial, fashion and retail. "We participate in shows and conventions throughout the country."
Needs: Most photos used for advertising purposes.
Audiovisual Needs: Uses slides, film and videotape.
Making Contact & Terms: Query with samples. Provide résumé, business card, brochure, flier or tearsheets to be kept on file for possible future assignments. Cannot return material. Reports in 6 months. Payment negotiable.

ANGEL FILMS NATIONAL ADVERTISING, 967 Highway 40, New Franklin MO 65274-9778. Phone/fax: (314)698-3900. E-mail: angelfilm@aol.com. Vice President Marketing & Advertising: Linda G. Grotzinger. Estab. 1980. Ad agency, AV firm. Approximate annual billing: $11.5 million. Number of employees: 35. Types of clients: fashion, retail, film, TV and records. Examples of recent projects: Teddies Album, Angel One Records (album cover/posters); MESN Swimwear, MESN (print-TV); The Christmas Teddie Mouse, Angel Films (print-TV ads/posters/record cover).
Needs: Works with 4 freelance photographers, 1 filmmaker and 1 videographer/month. Uses photos for billboards, consumer and trade magazines, direct mail, catalogs, posters, newspapers and audiovisual. Subjects include: attractive women in swimwear and lingerie. Glamour type shots of both Asian and non-Asian women needed. Reviews stock photos of attractive women and athletic men with attractive women. Model release required.
Audiovisual Needs: Uses slides and video for fill material in commercial spots.
Specs: Uses all sizes color and b&w prints; 35mm transparencies; 16mm film; ½" videotape. Accepts images in digital format for Windows (JPG, TIFF). Send via CD, online or floppy disk (300 dpi or better).
Making Contact & Terms: Provide résumé, business card, brochure, flier or tearsheets to be kept on file for possible future assignments. Works on assignment only. Keeps samples on file. SASE. Reports in 1 month. Payment negotiable based upon budget of project. Pays within 30 days of receipt of invoice. Credit line sometimes given depending upon the project. Buys all rights.
Tips: "Our company does business both here and in Asia. We do about six record covers a year and accompanying posters using mostly glamour photography."

CONTACT THE EDITOR, of *Photographer's Market* by e-mail at photomarket@fwpubs.com with your questions and comments.

THE ATKINS AGENCY, Suite 1100, 1777 N.E. Loop 410, San Antonio TX 78217. Associate Creative Director: Becky Benavides. Estab. 1963. Ad agency. Types of clients: telecommunications, tourism, healthcare. Examples of recent projects: San Antonio Convention & Visitors Bureau; *Express-News* (daily newspaper in San Antonio); Mother Frances Regional Hospital; Mexico tourism.
Needs: Works with 2-3 freelance photographers, 1 filmmaker and 2-3 videographers/month. Uses photos for billboards, consumer magazines, trade magazines, direct mail, P-O-P displays, catalogs, posters, newspapers, audiovisual uses. Subject matter is too varied to define. Reviews stock photos related to tourism, healthcare. Model/property release required.
Audiovisual Needs: Uses slides and/or film or video.
Making Contact & Terms: Query with stock photo list. Send unsolicited photos by mail for consideration. Query with samples. Provide résumé, business card, brochure, flier or tearsheets to be kept on file for possible future assignments. Works with local freelancers on assignment only. Keeps samples on file. Cannot return material. Payment negotiable. Credit line sometimes given depending upon "prior arrangement we make with our clients." Rights negotiable.
Tips: "We are always looking for fresh, original looks/ways to see things. This is particularly true with our tourism accounts. We all appreciate innovative photography techniques."

BELL & ROBERTS, INC., 1275 N. Manassero St., Anaheim Hills CA 92807. (714)777-8600. Fax: (714)777-9571. President/Creative Director: Thomas Bell. Estab. 1980. Ad agency. Number of employees: 6. Types of clients: retail, food, sporting companies. Examples of recent projects: annual campaigns for Van-K Engineering, Total Food Management and Cornell Computers.
Needs: Works with 1 freelancer and 1 videographer/month. Uses photos for consumer magazines, trade magazines, direct mail, P-O-P displays, catalogs and newspapers. Subjects include various product shots. Reviews stock images. Model release required. Property release preferred.
Audiovisual Needs: Uses ½″ videotape for internal reviewing.
Specs: Uses 8×10 or larger b&w prints; 2¼×2¼, 4×5 transparencies. Accepts images in digital format for Windows. Send via compact disc or Online.
Making Contact & Terms: Provide résumé, business card, brochure, flier or tearsheets to be kept on file for possible future assignments. Do not submit photos. Works with freelancers on assignment only. Keeps samples on file. Cannot return material. Payment negotiable. Pays on receipt of invoice. Credit line not given. Rights purchased depend on usage.

BERSON, DEAN, STEVENS, 210 High Meadow St., Wood Ranch CA 93065. (805)582-0898. Owner: Lori Berson. Estab. 1981. Design firm. Specializes in annual reports, display design, packaging and direct mail. Types of clients: industrial, financial and retail.
Needs: Works with 1 freelancer/month. Uses photos for billboards, trade magazines, direct mail, P-O-P displays, catalogs, posters, packaging and signage. Subjects include: product shots and food. Reviews stock photos. Model/property release required.
Specs: Uses 8×10 b&w prints; 35mm, 2¼×2¼, 4×5, 8×10 transparencies. Accepts images in digital format for Mac (Photoshop).
Making Contact & Terms: Provide résumé, business card, brochure, flier or tearsheets to be kept on file for possible future assignments. Works on assignment only. Keeps samples on file. SASE. Reports in 1-2 weeks. Payment negotiable. Pays within 30 days after receipt of invoice. Credit line not given. Rights negotiable.

BOB BOND & OTHERS, The Bond Group, 5025 Araphaho Rd., #300, Dallas TX 75248. (972)991-0077. Fax: (972)991-8982. E-mail: abby@bbando.com. Website: http://www.bbando.com. Traffic Coordinator: Abby Warren. Estab. 1975. Ad agency. Approximate annual billing: 8 million. Number of employees: 13. Firm specializes in annual reports, publication design, display design, magazine ads, direct mail, collateral. Types of clients: industrial, financial, nonprofit. Examples of recent clients: "Flagship Brochure" for Source Services (business setting); ad for Sterling Commerce (police line up); presentation for Virtual Impact (hospital).
Needs: Works with 2 freelancers/month. Uses photos for billboards, brochures, catalogs, consumer magazines, direct mail, newspapers, P-O-P diaplays, posters, signage, trade magazines. Model/property release required.
Audiovisual Needs: Uses slides.
Making Contact & Terms: Provide résumé, business card, self-promotion piece or tearsheets to be kept on file for possible future assignments. Art director will contact photographer for portfolio review if interested. Portfolio should include b&w prints, slides, thumbnails, tearsheets. Keeps samples on file; cannot return material. Reports back only if interested, send non-returnable samples. **Pays on receipt of invoice.** Credit line sometimes given. Buys all rights; negotiable.

BRAINWORKS DESIGN GROUP, 2 Harris Court, Suite A-7, Monterey CA 93940. (408)657-0650. Fax: (408)657-0750. E-mail: brainwks@mbay.net. Website: http://www.brainwks.com. President: Al Kahn. Estab. 1986. Design firm. Approximate annual billing: $1 million. Number of employees: 6. Specializes in publication design and direct mail. Types of clients: education.
Needs: Works with 2 freelancers/month. Uses photographs for direct mail, catalogs and posters. Wants conceptual images. Model release required.
Specs: Uses 35mm, 4×5 transparencies.
Making Contact & Terms: Arrange personal interview to show portfolio. Send unsolicited photos by mail for consideration. Works with freelancers on assignment only. Keeps samples on file. Cannot return material. Reports in 1 month. Pays $200-400/b&w photo; $400-600/color photo; $100-150/hour; $750-1,200/day; $2,500-4,000/job. **Pays on receipt of invoice**. Credit line sometimes given, depending on client. Buys first rights, one-time rights and all rights; negotiable.

BRAMSON + ASSOCIATES, 7400 Beverly Blvd., Los Angeles CA 90036. (213)938-3595. Fax: (213)938-0852. Principal: Gene Bramson. Estab. 1970. Ad agency. Approximate annual billing: $2 million. Number of employees: 8. Types of clients: industrial, financial, food, retail, health care. Examples of recent projects: Hypo Tears ad, 10 Lab Corporation (people shots); brochure, Chiron Vision (background shots).
Needs: Works with 2-5 freelance photographers and 1 videographer/month. Uses photos for trade magazines, direct mail, catalogs, posters, newspapers, signage. Subject matter varies. Reviews stock photos. Model/property release required. Captions preferred.
Audiovisual Needs: Uses slides and/or videotape for industrial, product.
Specs: Uses 11×15 color and b&w prints; 35mm, 2¼×2¼, 4×5, 8×10 transparencies. Accepts submissions in digital format for Mac. Send via SyQuest cartridge with high resolution.
Making Contact & Terms: Submit portfolio for review. Send unsolicited photos by mail for consideration. Provide résumé, business card, brochure, flier or tearsheet to be kept on file for possible future assignments. Works with local freelancers on assignment only. Keeps samples on file. SASE. Reports in 3 weeks. Payment negotiable. **Pays on receipt of invoice**. Payment varies depending on budget for each project. Credit line not given. Buys one-time and all rights.
Tips: "Innovative—crisp—dynamic—unique style—different—otherwise we'll stick with our photographers. If it's not great work, don't bother."

BROWNING, One Browning Place, Morgan UT 84050. (801)876-2711. Fax: (801)876-3331. Art Directors: Jodi VanOrman and John Gibby. Estab. 1878. Photos used in posters, magazines, catalogs. Uses photos to promote sporting good products.
Needs: Works with 2 freelancers/month. Outdoor, wildlife, hunting, shooting sports and archery. Reviews stock photos. Model/property release required. Captions preferred; include location, types of props used, especially brand names (such as Winchester and Browning).
Specs: Uses 35mm, 2¼×2¼, 4×5, 8×10 transparencies.
Making Contact & Terms: Interested in receiving work from outdoor and wildlife photographers. Query with samples. Provide résumé, business card, self-promotion piece or tearsheets to be kept on file for possible future assignments. Works on assignment only. Keeps samples on file. Reports in 1 month. Payment within 30 days of invoice. Buys one-time rights, all rights; negotiable.
Tips: "We look for dramatic lighting, exceptional settings and believable interactions."

CAREW DESIGN, 49 Sunset Way, San Rafael CA 94901. (415)454-1989. Fax: (415)457-7916. President: Jim Carew. Estab. 1977. Design firm. Specializes in publication design, packaging, direct mail and signage. Types of clients: sporting goods manufacturers, "hi-tec" companies.
Needs: Works with 2 freelancers/month. Uses photos for consumer and trade magazines, catalogs and packaging. Reviews stock photos. Model/property release required. Captions preferred.
Specs: Uses 8×10, 11×17 semigloss color and/or b&w prints; 2¼×2¼, 4×5 transparencies.
Making Contact & Terms: Provide résumé, business card, brochure, flier or tearsheets to be kept on file for possible future assignments. Works with local freelancers only. Keeps samples on file. SASE. Responds in 3 weeks. Payment negotiable. Credit line sometimes given depending on use. Buys first rights; negotiable.

CLIFF AND ASSOCIATES, 715 Fremont Ave., South Pasadena CA 91030. (818)799-5906. Fax: (818)799-9809. Owner: Greg Cliff. Estab. 1984. Design firm. Specializes in annual reports, display design, direct mail, signage. Types of clients: industrial, financial, corporate. Examples of recent projects: international brochure for ARCO.
Needs: Works with 1-2 freelancers/month. Uses photos for annual reports, direct mail, P-O-P displays,

catalogs. Subjects include: people and food. Reviews stock photos. Model/property release preferred. Captions preferred.

Specs: Uses all glossy color prints.

Making Contact & Terms: Provide résumé, business card, brochure, flier or tearsheets to be kept on file for future assignments. Works with local freelancers on assignment only. Keeps samples on file. SASE. Reports in 1-2 weeks. Pays $600-3,500/day. **Pays on receipt of invoice.** Credit line sometimes given. Rights negotiable.

DAVIDSON & ASSOCIATES, 3940 Mohigan Way, Las Vegas NV 89119-5147. (702)871-7172. President: George Davidson. Full-service ad agency. Types of clients: beauty, construction, finance, entertainment, retailing, publishing, travel.

Needs: Photos used in brochures, newsletters, annual reports, PR releases, AV presentations, sales literature, consumer and trade magazines.

Making Contact & Terms: Arrange a personal interview to show portfolio. Query with samples or submit portfolio for review. Provide résumé, brochure and tearsheets to be kept on file for possible future assignments. Offers 150-200 assignments/year. Pays $15-50/b&w photo; $25-100/color photo; $15-50/hour; $100-400/day; $25-1,000 by the project. Pays on production. Buys all rights. Model release required.

DYKEMAN ASSOCIATES INC., 4115 Rawlins, Dallas TX 75219. (214)528-2991. Fax: (214)528-0241. E-mail: adykeman@airmail.net. Website: http://www.dykemanassoc.com. Contact: Alice Dykeman. Estab. 1974. Member of Public Relations Society of America. PR and AV firm. Types of clients: industrial, financial, sports, varied.

Needs: Works with 4-5 photographers and/or videographers. Uses photos for publicity, billboards, consumer and trade magazines, direct mail, P-O-P displays, catalogs, posters, newspapers, signage, and audiovisual uses. "We handle model and/or property releases."

Audiovisual Needs: "We produce and direct video. Just need crew with good equipment and people and ability to do their part."

Specs: Uses 8½×11 and glossy b&w transparencies or color prints; ¾" or Beta videotape. Accepts images in digital format for Windows. Send via floppy disk, SyQuest or on Zip disk.

Making Contact & Terms: Arrange personal interview to show portfolio. Provide résumé, business card, brochure, flier or tearsheets to be kept on file for possible future assignments. Works on assignment only. Cannot return material. Pays $800-1,200/day; $250-400/1-2 days. "Currently we work only with photographers who are willing to be part of our trade dollar network. Call if you don't understand this term." Pays 30 days after receipt of invoice. Credit line sometimes given, "maybe for lifestyle publications—especially if photographer helps place." Buys exclusive product rights.

Tips: Reviews portfolios with current needs in mind. "If PSA, we would want to see examples. If for news story, we would need to see photojournalism capabilities. Show portfolio, state pricing, remember that either we or our clients will keep negatives or slide originals."

EDUCATIONAL VIDEO NETWORK, 1401 19th St., Huntsville TX 77340. (409)291-2860. E-mail: pop123@mail.lcc.net. Chief Executive Officer: George H. Russell. Estab. 1953. AV firm. Number of employees: 70. Types of clients: "We produce for ourselves in the education market." Examples of recent projects: catalogs to illustrate EVD video titles.

Needs: Works with 2-3 videographers/month.

Audiovisual Needs: Uses videotape for all projects; slides.

Specs: Uses ½" videotape. Accepts images in digital format for Mac (PICF, TIFF). Send via online, Zip disk or Jaz disk (300 dpi or better).

Making Contact & Terms: Query with program proposal. SASE. Reports in 3 weeks. Payment negotiable. Pays in royalties or flat fee based on length, amount of post-production work and marketability; royalties paid quarterly. Credit line given. Buys all rights; negotiable.

Tips: In freelancer's demos, looks for "literate, visually accurate, curriculum-oriented video programs that could serve as a class lesson in junior high, high school or college classroom. The switch from slides and filmstrips to video is complete. The schools need good educational material."

EVANS & PARTNERS, INC., 55 E. G St., Encinitas CA 92024-3615. (619)944-9400. Fax: (619)944-9422. President/Creative Director: David R. Evans. Estab. 1989. Ad agency. Approximate annual billing: $1.2 million. Number of employees: 7. Types of clients: industrial, financial, medical. Examples of recent projects: "Total Water Management," U.S. Filter Corporation (8-minute Lap-top presentation and an electronic library with 8 modules); Baxter Healthcare Corporation (annual report, corporate literature); 1997 catalog; "Expander," Ortho Organizer (direct mail/advertising).

• This agency is utilizing photo manipulation technologies, which gives photographers the latitude to create.

Needs: Works with 2-3 freelance photographers, 1-2 videographers/month. Uses photos for billboards, trade magazines, direct mail, P-O-P displays, catalogs, posters, newspapers, signage and audiovisual uses. Subjects include: medical, medical high tech, real estate. Reviews stock photos. Model release required for people. Property release preferred. Captions preferred; include name of photographer.

Audiovisual Needs: Uses slides, powerpoint software and video for presentations, educational.

Specs: Uses 35mm, $2\frac{1}{4} \times 2\frac{1}{4}$, 4×5 transparencies; $\frac{1}{2}''$ VHS-SVHS videotape. Accepts images in digital format for Mac or Windows. Send via CD or Zip disk or Online.

Making Contact & Terms: Query with stock photo list and samples. Provide résumé, business card, brochure, flier or tearsheets to be kept on file for possible future assignments. Works with local freelancers on assignment only. Keeps samples on file. SASE. Will notify if interested. Pays $700-2,000/day; $175 and up/job. Pays upon receipt of payment from client. Credit line given depending upon nature of assignment, sophistication of client. Buys first, one-time, all, exclusive product, electronic rights; negotiable.

Tips: Looking for "ability to see structure, line tensions, composition innovation; finesse in capturing people's energy; ability to create visuals equal to the level of sophistication of the business or product."

EVANSGROUP, 110 Social Hall Ave., Salt Lake City UT 84111. (801)364-7452. Ad agency. Art Director: Michael Cullis. Types of clients: industrial, finance.

Needs: Works with 2-3 photographers/month. Uses photos for billboards, consumer and trade magazines, direct mail, P-O-P displays, posters and newspapers. Subject matter includes scenic and people. Model release required; captions preferred.

Specs: Uses color prints and 35mm, $2\frac{1}{4} \times 2\frac{1}{4}$ and 4×5 transparencies.

Making Contact & Terms: Query with list of stock photo subjects. Submit portfolio for review. Provide résumé, business card, brochure, flier or tearsheets to be kept on file for possible future assignments. Works with freelance photographers on assignment only. SASE. Reports in 1-2 weeks. Payment negotiable. **Pays on receipt of invoice.** Credit live given when possible. Buys one-time rights.

N □ FARNAM COMPANIES, INC., Dept. PM, 301 W. Osborn, Phoenix AZ 85013-3928. Fax: (602)207-2147. Creative Director: Trish Spencer. Types of clients: animal health products, primarily for horses and dogs, some cattle, cats and birds.

• This company has an in-house ad agency called Charles Duff Advertising.

Needs: Works with 2 freelance photographers/month. Uses photos for direct mail, catalogs, consumer magazines, P-O-P displays, posters, AV presentations, trade magazines and brochures. Subject matter includes horses, dogs, cats, birds, farm scenes, ranch scenes, cowboys, cattle and horse shows. Occasionally works with freelance filmmakers to produce educational horse health films and demonstrations of product use.

Specs: Uses 8×10 glossy b&w and color prints; 35mm, $2\frac{1}{4} \times 2\frac{1}{4}$ and 4×5 transparencies; 16mm and 35mm film and videotape. Accepts images in digital format for Mac (JPEG, EPS, TIFF). Send via CD or Zip disk, SyQuest or online.

Making Contact & Terms: Arrange a personal interview to show portfolio. Query with samples. Provide résumé, business card, brochure, flier or tearsheets to be kept on file for possible future assignments. Works with freelance photographers on assignment basis only. SASE. Pays $25-100/b&w photo; $50-350/color photo. Pays on publication. Buys one-time rights. Model release required. Credit line given whenever possible.

Tips: "Send me a number of good, reasonably priced for one-time use photos of dogs, horses or farm scenes. Better yet, send me good quality dupes I can keep on file for *rush* use. When the dupes are in the file and I see them regularly, the ones I like stick in my mind and I find myself planning ways to use them. We are looking for original, dramatic work. We especially like to see horses, dogs, cats and cattle captured in artistic scenes or poses. All shots should show off quality animals with good conformation. We rarely use shots if people are shown and prefer animals in natural settings or in barns/stalls."

□ FOCUS ADVERTISING, INC., 292 Placitas NW, Albuquerque NM 89107. (505)345-8480. Fax: (505)341-2608. President: Al Costanzo. Member of Nikon Professional Services, New Mexico Professional Photographer's Association. Ad agency. Approximate annual billing: $350,000. Number of employees: 3-5. Types of clients: industry, electronics, software, government, law. Produces overhead transparencies, slide sets, motion pictures, sound-slide sets, videotape, print ads, trade show displays and brochures. Examples of recent projects: "S.O.P." for Xynatech, Inc.; and "Night Sights" for Innovative Weaponry (brochures/ads/trade show displays).

Needs: Works with 1-2 freelance photographers/month on assignment only basis. Buys 70 photos and 5-

8 films/year: health, business, environment and products. No animals or flowers. Length requirements: 80 slides or 15-20 minutes, or 60 frames, 20 minutes.

Specs: Produces ½″ and ¾″ video for broadcasts; also b&w photos or color prints and 35mm transparencies, "and a lot of 2¼ transparencies and some 4×5 transparencies." Accepts images in digital format for Windows. Send via Jazz or CD-ROM.

Making Contact & Terms: Arrange personal interview or query with résumé. Provide résumé, flier and brochure to be kept on file for possible future assignments. Prefers to see a variety of subject matter and styles in portfolio. Does not return unsolicited material. Pays minimum $75/b&w or color photo; $40-75/hour; $350-750/day; $100-1,000/job. Negotiates payment based on client's budget and photographer's previous experience/reputation. Pays on job completion. Buys all rights. Model release required.

FRIEDENTAG PHOTOGRAPHICS, 356 Grape St., Denver CO 80220. (303)333-7096. Manager: Harvey Friedentag. Estab. 1957. AV firm. Serves clients in business, industry, government, trade and union organizations. Produces slide sets, motion pictures and videotape.

Needs: Works with 5-10 freelancers/month on assignment only. Buys 1,000 photos and 25 films/year. Reviews stock photos of business, training, public relations and industrial plants showing people and equipment or products in use. Model release required.

Audiovisual Needs: Uses freelance photos in color slide sets and motion pictures. No posed looks. Also produces mostly 16mm Ektachrome and some 16mm b&w; ¾″ and VHS videotape. Length requirement: 3-30 minutes. Interested in stock footage on business, industry, education and unusual information. "No scenics please!"

Specs: Uses 8×10 glossy b&w and color prints; 35mm, 2¼×2¼ or 4×5 color transparencies.

Making Contact & Terms: Send material by mail for consideration. Provide flier, business card and brochure and nonreturnable samples to show clients. SASE. Reports in 3 weeks. Pays $400/day for still; $600/day for motion picture plus expenses; $50/b&w photo; $100/color photo. **Pays on acceptance.** Buys rights as required by clients.

Tips: "More imagination needed—be different, and above all, technical quality is a must. There are more opportunities now than ever, especially for new people. We are looking to strengthen our file of talent across the nation."

GEILE/REXFORD CREATIVE ASSOCIATES, 135 N. Meramec, St. Louis MO 63105. (314)727-5850. Fax: (314)727-5819. Creative Director: David Geile. Estab. 1989. Member of American Marketing Association, BPAA. Ad agency. Approximate annual billing: $4 million. Number of employees: 15. Types of clients: industrial and financial. Recent clients include: Texas Boot Company; First Bank; and Monsanto.

Needs: Works with 2-3 freelance photographers/month, 3 filmmakers and 5 videographers/year. Uses photos for billboards, consumer and trade magazines, direct mail, P-O-P displays, catalogs, posters and newspapers. Subjects include: product shots. Model/property release preferred.

Audiovisual Needs: Computer generated and projected graphics for sales meetings.

Specs: Uses color and b&w prints; 35mm, 2¼×2¼, 4×5 transparencies; 16mm film; 1″ videotape.

Making Contact & Terms: Provide résumé, business card, brochure, flier or tearsheets to be kept on file for possible future assignments. Keeps samples on file. Cannot return material. Reports when approval is given from client. Pays $800-1,200/day; $300-500/b&w photo; also accepts bids for jobs. Pays net 30-45 days. Buys one-time and all rights.

GORDON GELFOND ASSOCIATES, INC., Suite 350, 11500 Olympic Blvd., Los Angeles CA 90064. (213)478-3600. Fax: (213)477-4825. Ad agency. Art Director: Barry Brenner. Types of clients: retail, financial, hospitals and consumer eletronics.

Needs: Works with 1-2 photographers/month. Uses freelance photographers for billboards, consumer magazines, trade magazines, direct mail and newspapers. Subject matter varies.

Specs: Uses b&w and color prints; 35mm, 2¼×2¼ and 4×5 transparencies.

Making Contact & Terms: Reps only to show portfolio, otherwise drop off portfolio on Thursdays only. Provide résumé, business card, brochure, flier or tearsheets to be kept on file for possible future assignments. Works with local freelance photographers on assignment basis only. Reports ASAP. Payment negotiable/job. "Works within a budget." Payment is made 30 days after receipt of invoice. Buys all rights. Model release required. Credit line sometimes given.

GK&A ADVERTISING, INC., 8200 Brookriver Dr., Suite 510, Dallas TX 75247. (214)634-9486. Fax: (214)634-9490 or (214)638-4984. Production Manager: Tracy Rotter. Estab. 1982. Member of AAAA. Ad agency, PR firm. Approximate annual billing: $3 million. Number of employees: 4. Types of clients: financial, service, retail.

● This agency is using computer manipulation and stock photos on CD.

Needs: Works with 1 freelance photographer, 2 filmmakers and 2 videographers/month. Uses photos for billboards, direct mail, P-O-P displays, posters, newspapers, audiovisual uses. Reviews stock photos. Model/property release required. Captions preferred.

Audiovisual Needs: Uses slides, film and video.

Specs: Uses 35mm transparencies; ½" VHS videotape.

Making Contact & Terms: Submit portfolio for review. Works on assignment only. Keeps samples on file. Cannot return material. Reports in 3 weeks. Payment negotiable. Pays net 30 days. Credit line not given. Buys one-time rights.

GRAFICA, 7053 Owensmouth Ave., Canoga Park CA 91303. (818)712-0071. Fax: (818)348-7582. E-mail: graficaeps@aol.com. Owner: Larry Girardi. Estab. 1974. Member of Apple Developer Group, Adobe Authorized Imaging Center, Quark Service Alliance, Corel Approved Service Bureau. Design Studio and Service Bureau. Approximate annual billing: $150,000. Number of employees: 3-5. Specializes in annual reports, publication design, display design and video graphics-titling. Types of clients: industrial, financial, retail, publishers and entertainment. Examples of past projects: Reed's "Wet" Table Tent for Reed's Original Beverage Corporation (photo behind product); and recruitment brochure for CA State University, Northridge (campus/student photos).

Needs: Works with 1-2 freelancers/month. Uses photos for annual reports, billboards, consumer magazines, trade magazines, P-O-P displays, catalogs, posters and packaging. Reviews stock photos. Model release required. Property release preferred.

Specs: Uses 35mm, 2¼×2¼, 4×5 transparencies.

Making Contact & Terms: Query with samples. Provide résumé, business card, brochure, flier or tearsheets to be kept on file for possible future assignments. Keeps samples on file. SASE. Reports in 1-2 weeks. Payment negotiable. Credit line sometimes given. Buys first, one-time, electronic and all rights; negotiable.

GRAPHIC DESIGN CONCEPTS, 4123 Wade St., Suite 2, Los Angeles CA 90066. (310)306-8143. President: C. Weinstein. Estab. 1980. Design firm. Specializes in annual reports, publication design, display design, packaging, direct mail and signage. Types of clients: industrial, financial, retail, publishers and nonprofit. Examples of recent projects: "Cosmo Package," Amboy, Inc. (product/package photo); "Aircraft Instruments," General Instruments, Inc. (product/package photo); and "Retirement Residence," Dove, Inc. (pictorial brochure).

Needs: Works with 10 freelancers/month. Uses photos for annual reports, billboards, consumer and trade magazines, direct mail, P-O-P displays, catalogs, posters, packaging and signage. Subjects include: pictorial, scenic, product and travel. Reviews stock photos of pictorial, product, scenic and travel. Model/property release required for people, places, art. Captions required; include who, what, when, where.

Specs: Uses 8×10 glossy, color and b&w prints; 35mm, 2¼×2¼, 4×5, 8×10 transparencies.

Making Contact & Terms: Provide résumé, business card, brochure, flier or tearsheets to be kept on file for possible future assignments. Works with freelancers on assignment only. Keeps samples on file. SASE. Reports as needed. Pays $15 minimum/hour; $100 minimum/day; $100 minimum/job; $50 minimum/color photo; $25 minimum/b&w photo. **Pays on receipt of invoice.** Credit line sometimes given depending upon usage. Buys rights according to usage.

Tips: In samples, looks for "composition, lighting and styling." Sees trend toward "photos being digitized and manipulated by computer."

 HALLOWES PRODUCTIONS & ADVERTISING, 11260 Regent St., Los Angeles CA 90066-3414. (310)390-4767. Fax: (310)397-2977. Creative Director/Producer-Director: Jim Hallowes. Estab. 1984. Produces TV commercials, corporate films and print advertising.

Needs: Buys 8-10 photos annually. Uses photos for magazines, posters, newspapers and brochures. Reviews stock photos; subjects vary.

Audiovisual Needs: Uses film and video for TV commercials and corporate films.

Specs: Uses 35mm, 4×5 transparencies; 35mm/16mm film; Beta SP videotape.

Making Contact & Terms: Query with résumé of credits. Do not fax unless requested. Keeps samples on file. SASE. Reports if interested. Payment negotiable. Pays on usage. Credit line sometimes given, depending upon usage, usually not. Buys first and all rights; rights vary depending on client.

● **SPECIAL COMMENTS** within listings by the editor of *Photographer's Market* are set off by a bullet.

⛰ HARRIS & LOVE, INC., 630 E. South Temple, Salt Lake City UT 84102. (801)532-7333. Fax: (801)532-6029. Senior Art Director: Preston Wood. Art Director: Kathy Kunz. Estab. 1938. Member of AAAA. Approximate annual billing: $8 million. Number of employees: 35. Types of clients: finance, tourism, industrial, retail, fashion, health care, winter sports. Examples of past projects: Utah travel summer campaign (national magazines); "HMO Blue," Blue Cross & Blue Shield (regional newspaper).
Needs: Works with 4 freelance photographers, filmmakers or videographers/month. Uses photos for billboards, consumer magazines, trade magazines, newspapers and audiovisual. Needs mostly images of Utah (travel and winter sports) and people. Interested in reviewing stock photos/film or video footage on people, science, health care and industrial.
Audiovisual Needs: Contact Creative Director, Bob Wassom, by phone or mail.
Specs: Uses 35mm, 2¼×2¼, 4×5 transparencies.
Making Contact & Terms: Send unsolicited photos by mail for consideration. Submit portfolio for review. Provide résumé, business card, brochure, flier or tearsheets to be kept on file for possible future assignments. Works with freelancers on assignment basis only. Pays $150-1,000/b&w photo; $200-2,000/ color photo; $600-1,200/day. Rights negotiable depending on project. Model and property releases required. Credit line given sometimes, depending on client, outlet or usage.
Tips: In freelancer's portfolio or demos, wants to see "craftsmanship, mood of photography and creativity." Sees trend toward "more abstract" images in advertising. "Most of our photography is a total buy out (work-for-hire). Photographer can only reuse images in his promotional material."

⛰ HAYES ORLIE CUNDALL INC., 46 Varda Landing, Sausalito CA 94965. (415)332-7414. Fax: (415)332-5924. Executive Director: Ted Davis. Estab. 1991. Ad agency. Uses all media except foreign. Types of clients: industrial, retail, fashion, finance, computer and hi-tech, travel, healthcare, insurance and real estate.
Needs: Works with 1 freelance photographer/month on assignment only. Model release required. Captions preferred.
Making Contact & Terms: Provide résumé, business card and brochure to be kept on file for future assignments. "Don't send anything unless it's a brochure of your work or company. We keep a file of talent—we then contact photographers as jobs come up." Payment negotiable. Pays on a per-photo basis; negotiates payment based on client's budget, amount of creativity required and where work will appear. "We abide by local photographer's rates."
Tips: "Most books are alike. I look for creative and technical excellence, then how close to our offices; cheap versus costly; personal rapport; references from friends in agencies who've used him/her. Call first. Send samples and résumé if I'm not able to meet with you personally due to work pressure. Keep in touch with new samples." Produces occasional audiovisual for industrial and computer clients; also produces a couple of videos a year.

⛰ HEPWORTH ADVERTISING CO., 3403 McKinney Ave., Dallas TX 75204. (214)220-2415. Fax: (214)220-2416. President: S.W. Hepworth. Estab. 1952. Ad agency. Uses all media except P-O-P displays. Types of clients: industrial, consumer and financial. Examples of recent projects: Houston General Insurance, Holman Boiler, Hillcrest State Bank.
Needs: Uses photos for trade magazines, direct mail, P-O-P displays, newspapers and audiovisual. Model/ property release required. Captions required.
Specs: Uses 8×10 glossy color prints, 35mm transparencies.
Making Contact & Terms: Submit portfolio by mail. Works on assignment only. Reports in 1-2 weeks. Pays $350 minimum/job; negotiates payment based on client's budget and photographer's previous experience/reputation. **Pays on acceptance.** Credit line sometimes given. Buys all rights.
Tips: "For best relations with the supplier, we prefer to seek out a photographer in the area of the job location." Sees trend toward machinery shots. "Contact us by letter or phone."

THE HITCHINS COMPANY, 22756 Hartland St., Canoga Park CA 91307. Phone/fax: (818)715-0510. E-mail: ohitchins@soca.com. President: W.E. Hitchins. Estab. 1985. Ad agency. Approximate annual billing: $300,000. Number of employees: 2. Types of clients: industrial, retail (food) and auctioneers. Examples of recent projects: Electronic Expediters (brochure showing products).
Needs: Uses photos for trade and consumer magazines, direct mail and newspapers. Model release required.
Specs: Uses b&w and color prints. "Copy should be flexible for scanning." Accepts images in digital format for Mac (TIFF or EPS). Send via CD, floppy disk, Zip, SyQuest or Online.
Making Contact & Terms: Provide résumé, business card, brochure, flier or tearsheets to be kept on file for possible future assignments. Works on assignment only. Cannot return material. Payment negotiable depending on job. **Pays on receipt of invoice** (30 days). Rights purchased negotiable; "varies as to project."

Tips: Wants to see shots of people and products in samples.

HUMPHREY ASSOCIATES, 233 S. Detroit, Suite 201, Tulsa OK 74120. (918)584-4774. Fax: (918)584-4733. E-mail: humpass@earthlink.net. Art Director: Jeff VanAusdall. Estab. 1986. Ad agency. Approximate annual billing: $2 million. Types of clients: industrial, financial, retail. Examples of recent projects: Ramsey Winch (consumer ad campaign); Flare/Duct Burner campaign, Callidus Technologies (direct mail and trade magazines).
Needs: Works with 3-6 freelance photographers, 1 filmmaker and 1 videographer/month. Uses photos for billboards, consumer magazines, trade magazines, direct mail, P-O-P displays, catalogs, posters, newspapers, signage. Subjects include vehicles in rugged setting with Ramsey Winch. Reviews stock photos. Model release required.
Audiovisual Needs: Uses slides and video.
Specs: Uses 8×10 color and b&w prints; 35mm, $2\frac{1}{4} \times 2\frac{1}{4}$, 4×5 transparencies; digital format (any Mac format).
Making Contact & Terms: Query with stock photo list or samples. Provide résumé, business card, brochure, flier or tearsheets to be kept on file for possible future assignments. Works with local freelancers on assignment only. Keeps samples on file. SASE. Reports depending upon projects. Payment negotiable. Credit line sometimes given. Buys first, one-time, electronic and all rights; negotiable.

IMAGE INTEGRATION, 2418 Stuart St., Berkeley CA 94705. (510)841-8524. Fax: (510)704-1868. E-mail: vince@bmre.berkeley.edu. Owner: Vince Casalaina. Estab. 1971. Specializes in material for TV productions and Internet sites. Approximate annual billing: $100,000. Examples of projects: "Ultimate Subscription" for *Sailing World* (30 second spot); "Road to America's Cup" for ESPN (stock footage); and "Sail with the Best" for US Sailing (promotional video).
Needs: Works with 1 freelance photographer and 1 videographer/month. Reviews stock photos of sailing. Property release preferred. Captions required; include regatta name, regatta location, date.
Audiovisual Needs: Uses videotape. Subjects include: sailing.
Specs: Uses 4×5 or larger matte color or b&w prints; 35mm transparencies; 16mm film and Betacam videotape. Accepts mages in digital format for Mac. Send via Zip or Jazz disk.
Making Contact & Terms: Send unsolicited photos by mail for consideration. Works on assignment only. Keeps samples on file. SASE. Reports in 1-2 weeks. Payment depends on distribution. Pays on publication. Credit line sometimes given, depending upon whether any credits included. Buys nonexclusive rights; negotiable.

IMPACT MEDIA GROUP, Mad Avenues, Inc., 300 Deharo St., South Train Car, San Francisco CA 94103. (415)865-3700. Fax: (415)865-3704. E-mail: impactmg@aol.com. Website: http://www.impactmg.com. Partner: Garner Moss. Estab. 1993. Member of American Advertising Association, Art Directors of America, Robot Warrior Association-IRWA. Digital design firm. Approximate annual billing: $250,000-1 million. Number of employees: 10. Specializes in annual reports, publication design, display design, packaging, direct mail, signage, website design/corporate identities and logos. Types of clients: industrial, financial, retail, publishers, nonprofit, political, high-tech, virtual reality and Internet/intranet. Examples of recent projects: Hitachi CD-ROM (package and CD design); Christmas 96 site for Life Magazine; and LA Kings.com for Los Angeles Kings Hockey Team (sports photography, fully integrated website).
Needs: Works with 2-3 freelancers/month. Uses photos for annual reports, billboards, consumer magazines, direct mail, P-O-P displays, packaging, signage, website and political mail. Subjects include: still life and portraits. Reviews stock photos. Model/property release preferred. Captions preferred.
Specs: Uses 5×7, 8×10 prints; 35mm transparencies; videotape. Accepts images in digital format for Mac (TIFF, PICT, EPS). Send via Zip disk, CD, SyQuest, floppy disk or Online (72-300 dpi).
Making Contact & Terms: Arrange personal interview to show portfolio. Send unsolicited photos by mail for consideration. Provide résumé, business card, brochure, flier or tearsheets to be kept on file for possible future assignments. Send disk with samples on it. Keeps samples on file. SASE. Reports in 3 weeks. Pays $20-150/hour; $100-1,000/day. **Pays on receipt of invoice.** Credit line sometimes given depending upon publication or website. Rights negotiable.

JB West, P.O. Box 66895, Los Angeles CA 90066. (800)393-9278. Creative Director: John Belletti. Estab. 1979. Ad agency. Approximate annual billing: $500,000. Number of employees: 7. Types of clients: industrial, financial and food. Examples of recent projects: "Train of Values" for Coca-Cola (promotion); and "Game of Credit" for N.Y. Credit (book project).
Needs: Works with 1 or 2 freelancers/month. Uses photos for consumer magazines, trade magazines, direct mail, P-O-P displays, catalogs, posters. Subjects include: food and people. Reviews stock photos of business and finance.

Audiovisual Needs: Uses slides for slide shows.
Specs: Uses 35mm, 2¼×2¼, 4×5 transparencies.
Making Contact & Terms: Arrange personal interview to show portfolio. Works with freelancers on assignment only. Keeps samples on file. Cannot return material. Reports in 1-2 weeks. Payment negotiable. **Pays on receipt of invoice** after 30 days. Credit line sometimes given depending upon project. Buys all rights; negotiable.

PAUL S. KARR PRODUCTIONS, 2925 W. Indian School Rd., Phoenix AZ 85017. (602)266-4198. Contact: Kelly Karr. Film and tape firm. Types of clients: industrial, business and education. Works with freelancers on assignment only.
Needs: Uses filmmakers for motion pictures. "You must be an experienced filmmaker with your own location equipment, and understand editing and negative cutting to be considered for any assignment." Primarily produces industrial films for training, marketing, public relations and government contracts. Does high-speed photo instrumentation. Also produces business promotional tapes, recruiting tapes and instructional and entertainment tapes for VCR and cable. "We are also interested in funded co-production ventures with other video and film producers."
Specs: Uses 16mm films and videotapes. Provides production services, including sound transfers, scoring and mixing and video production, post production, and film-to-tape services.
Making Contact & Terms: Query with résumé of credits and advise if sample reel is available. Payment negotiable. Pays/job; negotiates payment based on client's budget and photographer's ability to handle the work. Pays on production. Buys all rights. Model release required.
Tips: Branch office in Utah: Karr Productions, 1045 N. 300 East, Orem UT 84057. (801)226-8209. Contact: Mike Karr.

PAUL S. KARR PRODUCTIONS, UTAH DIVISION, 1024 N. 250 East, Orem UT 84057. (801)226-8209. Vice President & Manager: Michael Karr. Types of clients: education, business, industry, TV-spot and theatrical spot advertising. Provides inhouse production services of sound recording, looping, printing and processing, high-speed photo instrumentation as well as production capabilities in 35mm and 16mm.
Needs: Same as Arizona office but additionally interested in motivational human interest material—film stories that would lead people to a better way of life, build better character, improve situations, strengthen families.
Making Contact & Terms: Query with résumé of credits and advise if sample reel is available. Payment negotiable. Pays per job, negotiates payment based on client's budget and ability to handle the work. Pays on production. Buys all rights. Model release required.

KOCHAN & COMPANY, 800 Geyer Ave., St Louis MO 63104. (314)621-4455. Fax: (314)621-1777. Creative Director/Vice President: Tracy Tucker. Estab. 1987. Member of AAAA. Ad agency. Number of employees: 9. Firm specializes in display design, magazine ads, packaging, direct mail, signage. Types of clients: industrial, retail, nonprofit. Example of recent projects: Alton Bell Casino (billboards/duratrans); Pasta House Co. (menu inserts); Jake's Steaks (postcard).
Needs: Uses photos for billboards, brochures, catalogs, direct mail, newspapers, posters, signage. Reviews stock photos. Model release required; property release required. Photo caption required.
Making Contact & Terms: Send query letter with samples, brochure, stock photo list, tearsheets. To show portfolio, photographer should follow-up with call and/or letter after initial query. Portfolio should include b&w, color, prints, tearsheets, slides, transparencies. Works with freelancers on assignment only. Keeps samples on file. Reports back only if interested, send non-returnable samples. **Pays on receipt of invoice**. Credit line given. Buys all rights.

KUPPER PARKER COMMUNICATIONS INC., 8301 Maryland Ave., St. Louis MO 63105. (314)727-4000. Fax: (314)727-3034. Advertising, public relations and direct mail firm. Executive Creative Director: Peter Charlton. Creative Directors: Lew Cohn and Steve Slais. Estab. 1992. Types of clients: retail, fashion, automobile dealers, consumer, broadcast stations, health care marketing, sports and entertainment, business-to-business sales and direct marketing.
Needs: Works with 12-16 freelance photographers/month. Uses photos for billboards, consumer and trade magazines, direct mail, P-O-P displays, catalogs, posters, signage and newspapers. Model release required; captions preferred.
Making Contact & Terms: Query with résumé of credits or with list of stock photo subjects. Provide résumé, business card, brochure, flier or tearsheets to be kept on file for possible future assignments. Works on assignment only. Does not return unsolicited material. Reports in 2 weeks. Pays $50-2,500/b&w photo; $250-5,000/color photo; $50-300/hour; $400-2,500/day. Buys one-time rights, exclusive product rights, all

rights, and limited-time or limited-run usage rights. Pays upon receipt of client payment.

LINEAR CYCLE PRODUCTIONS, Box 2608, Sepulveda CA 91393-2608. Production Manager: R. Borowy. Estab. 1980. Member of Internation United Photographer Publishers, Inc. Ad agency, PR firm. Approximate annual billing: $5 million. Number of employees: 10. Types of clients: industrial, commercial, advertising. Examples of recent projects: "The Sam Twee," Bob's Bob-O-Bob (ad); "Milk the Milk," Dolan's (ad); "Faster . . . not better," Groxnic, O'Fopp & Pippernatz (ad).
Needs: Works with 7-10 freelance photographers, 8-12 filmmakers, 8-12 videographers/month. Uses photos for billboards, consumer magazines, direct mail, P-O-P displays, posters, newspapers, audiovisual uses. Subjects include: candid photographs. Reviews stock photos, archival. Model/property release required. Captions required; include description of subject matter.
Audiovisual Needs: Uses slides and/or film or video for television/motion pictures. Subjects include: archival-humor material.
Specs: Uses 8×10 color and b&w prints; 35mm, 8×10 transparencies; 16mm-35mm film; ½″, ¾″, 1″ videotape.
Making Contact & Terms: Submit portfolio for review. Query with résumé of credits. Query with stock photo list. Provide résumé, business card, brochure, flier or tearsheets to be kept on file for possible future assignments. Works with local freelancers on assignment only. Keeps samples on file. Reports in 1 month. Pays $100-500/b&w photo; $150-750/color photo; $100-1,000/job. Prices paid depend on position. Pays on publication. Credit line given. Buys one-time rights; negotiable.
Tips: "Send a good portfolio with color pix shot in color (not b&w of color). No sloppy pictures or portfolios! The better the portfolio is set up, the better the chances that we would consider it . . . let alone look at it!" Seeing a trend toward "more archival/vintage, and a lot of humor pieces!"

MARKEN COMMUNICATIONS, 3375 Scott Blvd., Suite 108, Santa Clara CA 95054-3111. (408)986-0100. Fax: (408)986-0162. E-mail: marken@cerfnet.com. President: Andy Marken. Production Manager: Leslie Posada. Estab. 1977. Ad agency and PR firm. Approximate annual billing: $4.5 million. Number of employees: 8. Types of clients: furnishings, electronics and computers. Examples of recent ad campaigns include: Burke Industries (resilient flooring, carpet); Boole and Babbage (mainframe software); Maxar (PCs).
Needs: Works with 3-4 freelance photographers/month. Uses photos for trade magazines, direct mail, publicity and catalogs. Subjects include: product/applications. Model release required.
Audiovisual Needs: Slide presentations and sales/demo videos.
Specs: Uses color and b&w prints; 35mm, 2¼×2¼ and 4×5 transparencies.
Making Contact & Terms: Arrange a personal interview to show portfolio. Query with samples. Submit portfolio for review. Works with freelancers on assignment basis only. SASE. Reports in 1 month. Pays $50-1,000/b&w photo; $100-1,800/color photo; $50-100/hour; $500-1,000/day; $200-2,500/job. Pays 30 days after receipt of invoice. Credit line sometimes given. Buys one-time rights.

MARKETAIDE, INC., Dept. PM, 1300 E. Iron, P.O. Box 500, Salina KS 67402-0500. (800)204-2433. (913)825-7161. Fax: (913)825-4697. Copy Chief: Ted Hale. Marketing Manager: Kathleen Atkinson. Ad agency. Uses all media. Serves industrial, retail, financial, nonprofit organizations, political, agribusiness and manufacturing clients.
Needs: Needs industrial photography (studio and on site), agricultural photography, and photos of banks, people and places.
Making Contact & Terms: Call to arrange an appointment. Provide résumé and tearsheets to be kept on file for possible future assignments. Reports in 3 weeks. SASE. Buys all rights. "We generally work on a day rate ranging from $200-1,000/day." Pays within 30 days of invoice.
Tips: Photographers should have "a good range of equipment and lighting, good light equipment portability, high quality darkroom work for b&w, a wide range of subjects in portfolio with examples of processing capabilities." Prefers to see "set-up shots, lighting, people, heavy equipment, interiors, industrial and manufacturing" in a portfolio. Prefers to see "8×10 minimum size on prints, or 35mm transparencies, preferably unretouched" as samples.

MEDIA CONSULTANTS INC., P.O. Box 130, Sikeston MO 63801-0130. (573)472-1116. Fax: (573)472-3299. E-mail: media@ldd.net. President: Rich Wrather. Estab. 1980. Ad agency. Number of employees: 10. Types of clients: industrial, financial, fashion, retail and food.
Needs: Works with 2-4 photographers and 1-2 videographers/month. Uses photos for billboards, consumer magazines, trade magazines, direct mail, P-O-P displays, catalogs, posters, newspapers, signage and audiovisual. Subject matter varies. Reviews stock photos. Model/property release required. Photo captions preferred.

Audiovisual Needs: Uses film and videotape for audiovisual presentations and commercials. Subject includes stock.

Specs: Uses color and b&w prints; 35mm, 2¼×2¼ transparencies; ¾"-½" film.

Making Contact & Terms: Send unsolicited photos by mail for consideration. Query with samples. Provide résumé, business card, brochure, flier or tearsheets to be kept on file for possible future assignments. Works on assignment only. Keeps samples on file. Cannot return material. Reports in 3 weeks. Payment negotiable. Pays on publication. Credit line not given. Buys first and all rights; negotiable.

NEW & UNIQUE VIDEOS, 2336 Sumac Dr., San Diego CA 92105. (619)282-6126. Fax: (619)283-8264. E-mail: videos@concentric.net. Website: http://www.concentric.net/~videos. Director of Acquisitions: Candace Love. Estab. 1981. AV firm. Number of employees: 4. Types of clients: industrial, financial, fashion, retail and special interest video distribution. Examples of recent projects: "Full-Cycle: A World Odyssey" (special-interest video); "Ultimate Mountain Biking," Raleigh Cycle Co. of America (special interest video); "John Howard's Lessons in Cycling," John Howard (special interest video); and "Battle at Durango: First-Ever World Mountain Bike Championships," *Mountain & City Biking Magazine* (special interest video).

Needs: Works with 8-10 photographers and/or videographers/year. Subjects include "new and unique" special interest, such as cycling and sports. Reviews stock footage: cycling, sports, comedy, romance, "new and unique." Model/property release preferred.

Audiovisual Needs: Uses VHS videotape, Hi-8 and Betacam SP. Accepts images in digital format for Mac. Submit via compact disc, online, floppy disk or SyQuest.

Making Contact & Terms: Query with list of video subjects. Works on assignment only. Keeps samples on file. SASE. Reports in 3 weeks. Payment negotiable. **Pays on acceptance.** Credit line given. Buys exclusive and nonexclusive rights.

Tips: In samples looks for "originality, good humor and timelessness. We are seeing an international hunger for action footage, good wholesome adventure, comedy, educational, how-to and special interest. The entrepreneurial, creative and original video artiste—with the right attitude—can always feel free to call us."

ON-Q PRODUCTIONS INC., 618 E. Gutierrez St., Santa Barbara CA 93103. (805)963-1331. President: Vincent Quaranta. Estab. 1984. Producers of multi-projector slide presentations and computer graphics. Types of clients: industrial, fashion and finance.

Needs: Buys 100 freelance photos/year; offers 50 assignments/year. Uses photos for brochures, posters, audiovisual presentations, annual reports, catalogs and magazines. Subjects include: scenic, people and general stock. Model release required. Captions required.

Specs: Uses 35mm, 2¼×2¼ and 4×5 transparencies.

Making Contact & Terms: Provide stock list, business card, brochure, flier or tearsheets to be kept on file for possible future assignments. Pays $100 minimum/job. Buys rights according to client's needs.

Tips: Looks for stock slides for AV uses.

PALM SPRINGS DESERT RESORT CONVENTION AND VISITORS BUREAU, 69-930 Highway 111, Rancho Mirage CA 92270. (619)770-9000. Fax: (619)770-9001. Vice President of Communications: Laurie Armstrong. "We are the tourism promotion bureau for Palm Springs and the entire Coachella Valley." Photos used in brochures, posters, newspapers, audiovisual presentations, magazines and PR releases.

Needs: Buys 20 freelance photos/year; gives 5 assignments/year. "Photos of tourism interest . . . specifically in Coachella Valley." Model release required. Captions required.

Specs: Uses 8×10 b&w prints; 35mm slides; b&w contact sheet and negatives OK.

Making Contact & Terms: Query with résumé of credits or stock photo list. Provide résumé, business card, brochure, flier, and tearsheets to be kept on file for possible future assignments. Prefers to work with local freelancers or photographers who know the area.

Tips: "We will discuss only photographs of the Coachella Valley, California. No generic materials will be considered."

POINT BLANK, (formerly Austin/Kerr Marketing), 307 Orchard City Dr., Campbell CA 95008-2948. Fax: (408)295-1313. Ad agency. Art Director: Nate Digre. Serves travel, high technology and consumer technology clients. Examples of recent projects: Back Country Active Vacations (catalog and direct mail website); "Ours Is Legal" campaign, Logic Associates (apread/page ads).

Needs: Works with 3 photographers/month. Uses work for billboards, consumer magazines, trade magazines, direct mail, P-O-P displays, newspapers. Subject matter of photography purchased includes: conceptual shots of people and table top (tight shots of electronics products).

Specs: Uses 8×10 matte b&w and color prints; 35mm, 2¼×2¼, 4×5 or 8×10 transparencies. Accepts images in ditigal format for Mac. Send via compact disc, online, floppy disk, SyQuest or Zip disk.
Making Contact & Terms: Arrange a personal interview to show portfolio. Send unsolicited photos by mail for consideration. Provide résumé, business card, brochure, flier or tearsheets to be kept on file for possible future assignments. Works on assignment basis only. Does not return unsolicited material. Reports in 3 weeks. Pays $100-5,000/b&w photo; $100-8,000/color photo; maximum $5,000/day; $200-2,000 for electronic usage (Web banners, etc.), depending on budget. **Pays on receipt of invoice.** Buys one-time, exclusive product, electronic and all rights (work-for-hire); negotiable. Model release required, captions preferred.
Tips: Prefers to see "originality, creativity, uniqueness, technical expertise" in work submitted. There is more use of "photo composites, dramatic lighting, and more attention to detail" in photography.

PURDOM PUBLIC RELATIONS, 2330 Marinship Way, Sausalito CA 94965. (415)339-2890. Fax: (415)339-2989. E-mail: purdom@purdompr.com. President: Paul Purdom. Estab. 1965. Member of IPREX, Public Relations Society of America. PR firm. Approximate annual billing: $1.75 million. Number of employees: 17. Types of clients: computer manufacturers, software, industrial, general high-technology products. Examples of recent PR campaigns: Sun Microsystems, Autodesk, Vanian Assoc., Acuron Corporation (all application articles in trade publications).
Needs: Works with 4-6 freelance photographers/month. Uses photos for trade magazines, direct mail and newspapers. Subjects include: high technology and scientific topics. Model release preferred.
Specs: Uses 35mm and 2¼×2¼ transparencies.
Making Contact & Terms: Query with résumé of credits, list of stock photo subjects. Provide résumé, business card, brochure, flier or tearsheets to be kept on file for possible future assignments. Works on assignment only. Cannot return material. Reports as needed. Pays $50-150/hour, $400-1,500/day. Pays on receipt of invoice. Buys all rights; negotiable.

TED ROGGEN ADVERTISING AND PUBLIC RELATIONS, 5858 Westheimer, Suite 630, Houston TX 77057. (713)789-0999. Fax: (713)465-0625. Contact: Ted Roggen. Estab. 1945. Ad agency and PR firm. Types of clients: construction, entertainment, food, finance, publishing and travel.
Needs: Buys 25-50 photos/year; offers 50-75 assignments/year. Uses photos for billboards, direct mail, radio, TV, P-O-P displays, brochures, annual reports, PR releases, sales literature and trade magazines. Model release required. Captions required.
Specs: Uses 5×7 glossy or matte b&w prints; 4×5 transparencies; 5×7 color prints. Contact sheet OK.
Making Contact & Terms: Provide résumé to be kept on file for possible future assignments. Pays $75-250/b&w photo; $125-300/color photo; $150/hour. **Pays on acceptance.** Rights negotiable.

SAN FRANCISCO CONSERVATORY OF MUSIC, 1201 Ortega St., San Francisco CA 94122. (415)564-8086. Publications Coordinator: Cindy Dove. Estab. 1917. Provides publications about Conservatory programs, concerts and musicians. Photos used in brochures, posters, newspapers, annual reports, catalogs, magazines and newsletters.
Needs: Offers 10-15 assignments/year. Subjects include performances, head shots, rehearsals, classrooms, candid student life, some environmental, instruments, operas, orchestras, ensembles, special events. Does not use stock photos.
Specs: Uses 5×7 b&w prints and color slides.
Making Contact & Terms: "Contact us only if you are experienced in photographing performing musicians." Knowledge of classical music helpful. Works with local freelancers only. Payment varies by photographer; "credit line" to $25/b&w photo; $100-300/job. Credit line given "most of the time." Buys one-time rights and all rights; negotiable.

 SANDERS, WINGO, GALVIN & MORTON ADVERTISING, 4050 Rio Bravo, Suite 230, El Paso TX 79902. (915)533-9583. E-mail: swgm@swgm.com. Creative Director: Kerry Jackson. Member

**FOR EXPLANATIONS OF THESE SYMBOLS,
SEE THE INSIDE FRONT AND BACK COVERS OF THIS BOOK.**

of American Association of Advertising Agencies. Ad agency. Approximate annual billing: $14 million. Number of employees: 30. Uses photos for billboards, consumer and trade magazines, direct mail, foreign media, newspapers, P-O-P displays, radio and TV. Types of clients: finance, retail and apparel industries. Examples of recent projects: "Marketbook," Farah USA, Inc. (ads, posters, outdoor); "Write Your Own Ticket," Sears (ads, posters). Free client list.

Needs: Works with 5 photographers/year. Model release required.

Specs: Uses b&w photos and color transparencies. Works with freelance filmmakers in production of slide presentations and TV commercials. Accepts images in digital format for Mac (all file types). Send via compact disc, online, floppy disk, SyQuest or Zip disk.

Making Contact & Terms: Query with samples, list of stock photo subjects. Send material by mail for consideration. Submit portfolio for review. SASE. Reports in 1 week. Pays $65-500/hour, $600-3,500/day, negotiates pay on photos. Buys all rights.

N SANGRE DE CRISTO CHORALE, P.O. Box 4462, Santa Fe NM 87502. (505)662-9717. Fax: (505)665-4433. Business Manager: Hastings Smith. Estab. 1978. Producers of chorale concerts. Photos used in brochures, posters, newspapers, press releases, programs and advertising.

Needs: Buys one set of photos every two years; offers 1 freelance assignment every two years. Photographers used to take group shots of performers. Examples of recent uses: newspaper feature (5×7, b&w); concert posters (5×7, b&w); and group pictures in a program book (5×7, b&w).

Specs: Uses 8×10, 5×7 glossy b&w prints.

Making Contact & Terms: Provide résumé, business card, self-promotion piece or tearsheets to be kept on file for possible future assignments. Works with local freelancers only. Keeps samples on file. SASE. Reports in 1 month, or sooner. Payment negotiable. **Pays on acceptance**. Credit line given. Buys all rights; negotiable.

Tips: "We are a small group—35 singers with a $35,000/year budget. We need promotional material updated about every two years. We prefer photo sessions during rehearsal, to which we can come dressed. We find that the ability to provide usable action photos of the group makes promotional pieces more acceptable."

STEVEN SESSIONS, INC., 5177 Richmond Ave, Suite 500, Houston TX 77056. Phone: (713)850-8450. Fax: (713)850-9324. President: Steven Sessions. Estab. 1982. Design firm. Specializes in annual reports, packaging and publication design. Types of clients: industrial, financial, women's fashion, cosmetics, retail, publishers and nonprofit.

Needs: Always works with freelancers. Uses photos for annual reports, consumer and trade magazines, P-O-P displays, catalogs and packaging. Subject matter varies according to need. Reviews stock photos. Model/property release preferred.

Specs: Uses b&w and color prints; no preference for format or finish. Prefers 35mm, 2¼×2¼, 4×5, 8×10 transparencies.

Making Contact & Terms: Submit portfolio for review. Send unsolicited photos by mail for consideration. Provide résumé, business card, brochure, flier or tearsheets to be kept on file for possible future assignments. Keeps samples on file. SASE. Reports in 1-2 weeks. Pays $1,800-5,000/day. **Pays on receipt of invoice**. Credit line given. Sometimes buys all rights; negotiable.

SIGNATURE DESIGN, 2101 Locust St., St. Louis MO 63103. (314)621-6333. Fax: (314)621-0179. Contact: Therese McKee. Estab. 1988. Design firm. Specializes in print graphics and exhibit design and signage. Types of clients: corporations, museums, botanical gardens and government agencies. Examples of projects: Center for Biospheric Education and Research exhibits, Huntsville Botanical Garden; walking map of St. Louis, AIA, St. Louis Chapter; Flood of '93 exhibit, U.S. Army Corps of Engineers; brochure, U.S. Postal Service; Center for Home Gardening exhibits, Missouri Botanical Garden; Hawaii exhibits, S.S. Independence; Delta Queen Steamboat Development Co.

Needs: Works with 1 freelancer/month. Uses photos for posters, copy shots, brochures and exhibits. Reviews stock photos.

Specs: Uses prints and 35mm, 2¼×2¼ and 4×5 transparencies.

Making Contact & Terms: Arrange personal interview to show portfolio. Send unsolicited photos by mail for consideration. Provide résumé, business card, brochure, flier or tearsheets to be kept on file for possible future assignments. Keeps samples on file. Reports in 1-2 weeks. Payment negotiable. Pays 30 days from receipt of invoice. Credit line sometimes given. Buys all rights; negotiable.

SOTER ASSOCIATES INC., 209 N. 400 West, Provo UT 84601. (801)375-6200. Fax: (801)375-6280. Ad agency. President: N. Gregory Soter. Types of clients: industrial, financial, hardware/software and other. Examples of projects: boating publications ad campaign for major boat manufacturer; consumer

brochures for residential/commercial mortgage loan company; private school brochure; software ads for magazine use; various direct mail campaigns.

Needs: Uses photos for consumer and trade magazines, direct mail and newspapers. Subjects include product, editorial or stock. Reviews stock photos/videotape. Model/property release required.

Audiovisual Needs: Uses photos for slides and videotape.

Specs: Uses 8×10 b&w prints; 2¼×2¼, 4×5 transparencies; videotape.

Making Contact & Terms: Arrange personal interview to show portfolio. Query with samples. Provide résumé, business card, brochure, flier or tearsheets to be kept on file for possible future assignments. Works on assignment only. Keeps samples on file. SASE. Reports in 1-2 weeks. Payment negotiable. **Pays on receipt of invoice.** Credit line not given. Buys all rights; negotiable.

N̲ SOUNDLIGHT, 3356 Kehala Dr., Kihei, Maui HI 96753-9368. (808)879-5517. Fax: (808)891-1144. Contact: Keth Luke. Estab. 1972. Types of clients: corporations, industrial, businesses, training institutions, astrological and spiritual workshops, books, calendars, fashion, magazines.

Needs: Works with 1 freelance photographer/3 months. Subjects include: people in activities, scenic landscapes, animals, travel sites and activities, dance and models (glamour and nude). Reviews stock photos, slides, computer images. Model release preferred for models and advertising people. Captions preferred; include "who, what, where."

Audiovisual Needs: Uses freelance photographers for slide sets, multimedia productions and videotapes.

Specs: Uses 4×6 to 8×10 glossy color prints, 35mm color slides.

Making Contact & Terms: Query with résumé. Send stock photo list. Provide prints, slides, business card, contact sheets, self-promotion piece or tearsheets to be kept on file for possible future assignments. Works on assignment; sometimes buys stock model photos. May not return unsolicited material. Reports in 3 weeks. Pays $5-100/b&w and color photo; $10-100/hour; $50-750/day; $2,000 maximum/job; sometimes also pays in "trades." Pays on publication. Credit line sometimes given. Buys one-time rights, all rights and various negotiable rights; depends on use.

Tips: In portfolios or demos, looks for "unique lighting, style, emotional involvement, beautiful, artistic, sensual viewpoint." Sees trend toward "manipulated computer images."

STUDIO WILKS, 2148-A Federal Ave., Los Angeles CA 90025. Fax: (310)478-0013. E-mail: teri@-graphic.com. Owners: Teri and Richard Wilks. Estab. 1991. Member of American Institute of Graphic Arts. Design firm. Number of employees: 3. Specializes in annual reports, publication design, packaging, signage. Types of clients: corporate, retail.

Needs: Works with 1-2 freelancers/month. Uses photos for annual reports, trade magazines, catalogs, packaging, signage. Reviews stock photos.

Specs: Uses 8×10 prints.

Making Contact & Terms: Provide résumé, business card, brochure, flier or tearsheets to be kept on file for possible future assignments. Works with local freelancers only. Keeps samples on file. SASE. Reports in 3 weeks. Pays $300-750/day. **Pays on receipt of invoice.** Credit line given. Buys one-time, exclusive and all rights; negotiable.

Tips: Looking for "interesting, conceptual, experimental."

▨ RON TANSKY ADVERTISING CO., Suite 111, 14852 Ventura Blvd., Sherman Oaks CA 91403. (818)990-9370. Fax: (818)990-0456. Consulting Art Director: Norm Galston. Estab. 1976. Ad agency and PR firm. Serves all types of clients.

Needs: Uses photos for billboards, consumer and trade magazines, direct mail, P-O-P displays, brochures, catalogs, signage, newspapers and AV presentations. Subjects include: "mostly product—but some without product as well." Special subject needs include: industrial electronics, nutrition products and over-the-counter drugs. Model release required.

Audiovisual Needs: Works with freelance filmmakers to produce TV commercials.

Specs: Uses b&w or color prints; 2¼×2¼, 4×5 transparencies; 16mm film and videotape. Accepts images in digital format for Mac "if that is the only way it can be delivered." Send via online, floppy disk or on SyQuest.

Making Contact & Terms: Query with résumé of credits. Provide résumé, business card, brochure, flier or tearsheets to be kept on file for possible future assignments. SASE. Payment "depends on subject and client's budget." Pays $50-250/b&w photo; $100-1,500/color photo; $500-1,500/day; $100-1,500/complete job. Pays in 30 days. Buys all rights.

Tips: Prefers to see "product photos, originality of position and lighting" in a portfolio. "We look for creativity and general competence, i.e., focus and lighting as well as ability to work with models." Photographers should provide "rate structure and ideas of how they would handle product shots." Also, "don't use fax unless we make request."

TBWA CHIAT-DAY, 320 Hampton Dr., Venice CA 90291. (310)314-5000. Fax: (310)396-1273. Contact: Art Buyer. Types of clients: industrial, financial, fashion, retail, food. Examples of recent projects: Nissan, Sony, Jack-in-the-Box and Eveready Battery Company.
Needs: Works with 10-50 freelancers/month. Uses photos for billboards, consumer and trade magazines, direct mail, P-O-P displays, catalogs, posters, newspapers, signage and audiovisual uses. Subjects used depend on the company. Model/property release required.
Specs: Uses 8×10 and 11×14 matte b&w prints; 35mm, 2¼×2¼, 4×5, 8×10 transparencies (prefers 4×5 and 8×10).
Making Contact & Terms: Contact through rep. Arrange personal interview to show portfolio. Submit portfolio for review. Query with samples. Leave promo sheet. Provide résumé, business card, brochure, flier or tearsheets to be kept on file for possible future assignments. Reporting time depends; can call for feedback. Payment negotiable. Pays on receipt of invoice. Rights purchased vary; negotiable.

TRIBOTTI DESIGNS, 22907 Bluebird Dr., Calabasas CA 91302. (818)591-7720. Fax: (818)591-7910. E-mail: bob4149@aol.com. Contact: Bob Tribotti. Estab. 1970. Design firm. Approximate annual billing: $200,000. Number of employees: 2. Specializes in annual reports, publication design, display design, packaging, direct mail and signage. Types of clients: educational, industrial, financial, retail, government, publishers and nonprofit. Examples of projects: school catalog, SouthWestern University School of Law; magazine design, *Knitking*; signage, city of Calabasas.
Needs: Uses photos for annual reports, consumer and trade magazines, direct mail, catalogs and posters. Subjects vary. Reviews stock photos. Model/property release required. Captions preferred.
Specs: Uses 8×10, glossy, color and b&w prints; 35mm, 2¼×2¼, 4×5, 8×10 transparencies.
Making Contact & Terms: Contact through rep. Query with résumé of credits. Provide résumé, business card, brochure, flier or tearsheets to be kept on file for possible future assignments. Works with local freelancers only. Keeps samples on file. Cannot return material. Reports in 3 weeks. Pays $500-1,000/day; $75-1,000/job; $50 minimum/b&w photo; $50 minimum/color photo; $50 minimum/hour. **Pays on receipt of invoice.** Credit line sometimes given. Buys one-time, electronic and all rights; negotiable.

☒ UNELL & BALLOU, INC., (formerly Unell Communications), 6740 Antioch, Suite 155, Merriam KS 66204. (913)722-1090. Fax: (913)722-1767. Art Director: Cindy Himmelberg. Creative Director: Russell McCorkle. Estab. 1984. Member of Kansas City Ad Club, Missouri-Kansas NAMA, Council of Growing Companies. Ad agency and marketing communications firm. Number of employees: 15. Types of clients: industrial, financial, retail and agriculture. Recent clients include: Golden Harvest Seeds, Inc.; Interconnect Devices, Inc.; and Copaken, White & Blitt.
Needs: Works with 5 freelance photographers and 1 videographer/month. Uses photos for trade magazines, direct mail, catalogs, posters and signage. Subjects include: agriculture (on location); studio (technology). Reviews stock photos. Model release required. Property release preferred. Photo captions preferred.
Audiovisual Needs: Uses slides and videotape.
Specs: Uses color prints; 35mm, 2¼×2¼, 4×5 transparencies.
Making Contact & Terms: Query with résumé of credits or samples. Provide résumé, business card, brochure, flier or tearsheets to be kept on file for possible future assignments. Keeps samples on file. SASE. Reports in 1 month. Payment negotiable. **Pays on receipt of invoice.** Credit line given. Rights negotiable.

☒ VISUAL AID MARKETING/ASSOCIATION, (Box 4502, Inglewood CA 90309-4502. (310)399-0696. Manager: Lee Clapp. Estab. 1965. Ad agency. Number of employees: 3. Types of clients: industrial, fashion, retail, food, travel hospitality. Examples of projects: "Robot Show, Tokyo" (magazine story) and "American Hawaii Cruise" (articles).
Needs: Works with 1-2 freelance photographers, 1-2 filmmakers and 1-2 videographers/month. Uses photos for billboards, consumer magazines, trade magazines, direct mail, P-O-P displays, catalogs, posters, newspapers, signage. Model/property release required for models and copyrighted printed matter. Captions required; include how, what, where, when, identity.
Audiovisual Needs: Uses slides for travel presentations.
Specs: Uses 8×10, glossy color and b&w prints; 35mm, 2¼×2¼, 4×5, 8×10 transparencies; Ektachrome film; Beta/Cam videotape.
Making Contact & Terms: Query with résumé of credits or stock photo list. Provide résumé, business card, brochure, flier or tearsheets. Works with local freelancers on assignment only. Reports in 1-2 weeks. Payment negotiable upon submission. **Pays on acceptance,** publication or **receipt of invoice.** Credit line given depending upon client's wishes. Buys first and one-time rights; negotiable.

WATKINS ADVERTISING DESIGN, 621 W. 58th Terrace, Kansas City MO 64113-1157. (816)333-6600. Fax: (816)333-6610. E-mail: unicom.net@aol.com. Creative Director: Phil Watkins III. Estab. 1991. Member of Kansas City Advertising Club. Design firm. Number of employees: 1. Specializes in publication design, packaging, direct mail, collateral. Types of clients: industrial, retail, nonprofit, business-to-business. Examples of past projects: "Italian Feast," Mr Goodcents (posters, in-store promotion). California Health Vitamins, products brochure (shots of product line); Sprint, 1995 international invitation (invitation/golf . . . shots); Met Life, agricultural investments brochure (direct mail/people shots).
Needs: Works with 1 freelancer/month. Uses photos for trade magazines, direct mail, P-O-P displays, catalogs, packaging, newspaper, newsletter. Subjects include: location photographs, people. Reviews stock photos. Model release preferred for locations, people shots for retail.
Specs: Uses 8×10 matte b&w prints; 35mm, 2¼×2¼ transparencies.
Making Contact & Terms: Arrange personal interview to show portfolio. Works with freelancers on assignment only. Keeps samples on file. SASE. Reports in 1-2 weeks. Pays $1,000-1,500/day. Pays on publication. Credit line sometimes given. Buys one-time or all rights "if usage to span one or more years."

DANA WHITE PRODUCTIONS, INC., 2623 29th St., Santa Monica CA 90405. (310)450-9101. Full-service audiovisual, multi-image, photography and design, video/film production studio. President: Dana White. Estab. 1977. Types of clients: corporate, government and educational. Examples of productions: Southern California Gas Company/South Coast AQMD (Clean Air Environmental Film Trailers in 300 LA-based motion picture theaters); Glencoe/Macmillan/McGraw-Hill (textbook photography and illustrations, slide shows); Pepperdine University (awards banquets presentations, fundraising, biographical tribute programs); US Forest Service (slide shows and training programs); Venice Family Clinic (newsletter photography); Johnson & Higgins (brochure photography).
Needs: Works with 2-3 freelance photographers/month. Uses photos for catalogs, audiovisual and books. Subjects include: people, products, still life and architecture. Interested in reviewing 35mm stock photos by appointment. Signed model release required for people and companies.
Audiovisual Needs: Uses all AV formats including also slides for multi-image presentations using 1-9 projectors.
Specs: Uses color and b&w prints; 35mm, 2¼×2¼ transparencies.
Making Contact & Terms: Arrange a personal interview to show portfolio and samples. Works with freelancers on assignment only. Will assign certain work on spec. Do not submit unsolicited material. Cannot return material. **Pays when images are shot to White's satisfaction**—never delays until acceptance by client. Pays according to job: $25-100/hour, up to $500/day; $20-50/shot; or fixed fee based upon job complexity and priority of exposure. Hires according to work-for-hire and will share photo credit when possible.
Tips: In freelancer's portfolio or demo, Mr. White wants to see "quality of composition, lighting, saturation, degree of difficulty and importance of assignment. The trend seems to be toward more video, less AV. Clients are paying less and expecting more. To break in, freelancers should "diversify, negotiate, be flexible, go the distance to get and keep the job. Don't get stuck in thinking things can be done just one way. Support your co-workers."

EVANS WYATT ADVERTISING & PUBLIC RELATIONS, 346 Mediterranean Dr., Corpus Christi TX 78418. (512)939-7200. Owner: E. Wyatt. Estab. 1975. Ad agency, PR firm. Types of clients: industrial, technical, distribution and retail. Examples of recent projects: H&S Construction Co. (calendars); L.E.P.C. Industrial (calendars and business advertising); The Home Group (newspaper advertising).
Needs: Works with 3-5 freelance photographers and/or videographers/month. Uses photos for consumer and trade magazines, direct mail, catalogs, posters and newspapers. Subjects include: people and industrial. Reviews stock photos/video footage of any subject matter. Model release required. Captions preferred.
Audiovisual Needs: Uses slide shows and videos.
Specs: Uses 5×7 glossy b&w and color prints; 35mm, 2¼×2¼ transparencies; ½" videotape (for demo or review), VHS format.
Making Contact & Terms: Query with résumé of credits, list of stock photo subjects and samples. Submit portfolio for review. Provide résumé, business card, brochure, flier or tearsheets to be kept on file for possible future assignments. Works on assignment only. Reports in 1 month. Pays $500-1,000/day; $100-700/job; negotiated in advance of assignment. Pays on receipt of invoice. Credit line sometimes given, depending on client's wishes. Buys all rights.
Tips: "Resolution and contrast are expected." Especially interested in industrial photography. Wants to see "sharpness, clarity and reproduction possibilities." Also, creative imagery (mood, aspect, view and lighting). Advises freelancers to "do professional work with an eye to marketability. Pure art is used only rarely."

N: ZIERHUT DESIGN STUDIOS, 2014 Platinum, Garland TX 75042. Phone: (972)276-1722. Fax: (972)272-5570. President: Jerry Nichols. Estab. 1956. Design firm. Specializes in displays, packaging and product design. Types of clients: industrial.
Needs: Uses photos for direct mail, catalogs and packaging. Subjects usually are "prototype models." Model/property release required.
Specs: Uses 8×10 color prints, matte finish; 35mm transparencies.
Making Contact & Terms: Provide résumé, business card, brochure, flier or tearsheets to be kept on file for possible future assignments. Works with local freelancers only. Keeps samples on file. Cannot return material. Reports in 1-2 weeks. Payment negotiable on bid basis. **Pays on receipt of invoice**. Credit line sometimes given depending upon client. Buys all rights.
Tips: Wants to see product photos showing "color, depth and detail."

REGIONAL REPORT: NORTHWEST & CANADA

Although this region includes only a few U.S. states and the entire country of Canada, its main industries are the same—fishing, mining, forest products and oil and petroleum products. Computer software manufacturing is also big here, but concentrated in Washington. The major advertising cities in this region include Seattle and Toronto.

Principle industries and manufactured goods

Alaska—Industries: petroleum, tourism, fishing, mining, forestry, transportation, aerospace. Manufactured Goods: fish products, lumber and pulp, furs.

Canada—Industries: mining, wood and food products, transportation equipment, chemicals, oil and gas.

Idaho—Industries: agriculture, manufacturing, tourism, lumber, mining, electronics. Manufactured Goods: processed foods, lumber and wood products, machinery, electronic components, computer equipment.

Montana—Industries: agriculture, timber, mining, tourism, oil and gas. Manufactured Goods: food products, wood and paper products, primary metals, printing and publishing, petroleum and coal products.

Oregon—Industries: aerospace, forestry, agriculture, biotechnology, environmental technology, fisheries, film and video. Manufactured Goods: lumber and wood products, computer equipment, foods, machinery, fabricated metals, paper, primary metals.

Washington—Industries: forestry, aerospace, manufacturing, agriculture. Manufactured Goods: aircraft, pulp and paper, lumber and plywood, aluminum, processed fruits and vegetables, machinery, electronics, computer software.

Wyoming—Industries: mineral extraction, oil, natural gas, tourism and recreation, agriculture. Manufactured Goods: refined petroleum, wood, stone, clay products, foods, electronic devices, sporting apparel, aircraft.

Leading national advertisers

Seagram Co., Montreal, Quebec CAN
Nike Inc., Beaverton OR
Microsoft Corp., Redmond WA
Nintendo Co., Redmond WA
Allied Domecq, Windsor, Ontario CAN

Notable ad agencies in the region

CF2GS, 1008 Western Ave., Suite 201, Seattle WA 98104. (206)223-6464. Major accounts: California State Automobile Association, Eddie Bauer, Los Angeles Cellular Communications, Royal Caribbean International.

Cole & Weber, 308 Occidental Ave. S., Seattle WA 98104. (206)447-9595. Major accounts: The Boeing Co., e-Fusion, Kentucky Fried Chicken, Pacific One Bank, SAFECO, Seattle International Film Festival.

Elgin DDB, 1008 Western Ave., Suite 601, Seattle WA 98104. (206)442-9900. Major accounts: AAA, Holland America Line Westours, Nordstrom, Seagate Software, Washington Energy Services, Wigwam.

Grey Canada, 1881 Yonge St., Toronto, Ontario M4S 3C4 Canada. (416)486-0700. Major accounts: Effem Foods, Pfizer Canada, Procter & Gamble, Smithkline Beecham, Sprint Canada, Warner Bros.

MacLaren McCann Canada Inc., 10 Bay St., Toronto, Ontario M5J 2S3 Canada. (416)594-6000. Major accounts: Bacardi-Martini Canada, Black & Decker Canada, Coca-Cola Canada, General Motors of Canada, Molson Breweries.

McCann-Erickson, 1011 Western Ave., Suite 600, Seattle WA 98104. (206)971-4200. Major accounts: Alaska Division of Tourism, Bon Marche, Darigold, Seattle Reign, Washington Apple Commission, Washington State Lottery.

Palmer Jarvis Communications, 777 Hornby St., Box 1600, Vancouver, British Columbia V6Z 2T3 Canada. (604)687-7911. Major accounts: Greyhound Lines of Canada, Manitoba Lotteries, Mohawk Oil, Northwest Telephones, Richmond Savings.

Vickers & Benson Advertising, 1920 Yonge St., Toronto, Ontario M4S 3E4 Canada. (416)487-9393. Major accounts: British Airways, Canadian Tourism Commission, Ford Motor Company of Canada, McDonald's Restaurants of Canada.

Wieden & Kennedy, 320 SW Washington, Portland OR 97204. (503)228-4381. Major accounts: American Indian College Fund, Coca-Cola Projects, ESPN International, Microsoft Computer Software, Miller Genuine Draft, Nike, SportsCenter.

Wolf Group, 35 Prince Arthur Ave., Toronto, Ontario M5R 1B2 Canada. (416)967-9000. Major accounts: Arrow Shirts, Bauch & Lomb, Genesis Research Foundation, Mr. Coffee, Rubbermaid, Starbucks Coffee.

ADFILIATION ADVERTISING, 323 W. 13th, Eugene OR 97401. E-mail: vip@adfiliation.com. Website: http://www.adfiliation.com. Creative Director: Gary Schubert. Estab. 1976. Ad agency. Types of clients: industrial, food, computer, medical.
Needs: Works with 2 freelance photographers, filmmakers and/or videographers/month. Uses photos for billboards, consumer and trade magazines, P-O-P displays, catalogs and posters. Interested in reviewing stock photos/film or video footage. Model/property release required. Captions preferred.
Audiovisual Needs: Uses slides, film and videotape. Accepts images in digital format for Mac. Send via Zip disk, Online, SyQuest or optical (300 dpi).
Specs: Uses color and b&w prints and 35mm transparencies.
Making Contact & Terms: Submit portfolio for review. Query with résumé of credits or stock photo list. Provide résumé, business card, brochure, flier or tearsheets to be kept on file for possible future assignments. Works on assignment only. Keeps samples on file. SASE. Reports in 1-2 weeks. Payment negotiable based on job and location. **Pays on receipt of invoice.** Credit line sometimes given, depending on project and client. Rights purchased depends on usage; negotiable.

BRIDGER PRODUCTIONS, INC., P.O. Box 8131, Jackson Hole WY 83002. (307)733-7871. Fax: (307)734-1947. President: Mike Emmer. Estab. 1990. Operates as a freelancer for ESPN, Prime Network. AV firm. Number of employees: 3. Types of clients: industrial, financial, fashion, retail, food and sports. Examples of recent projects: national TV ads for Michelin, ESPN and Dark Light Pictures.
Needs: Works with 1-2 freelance photographers, 1-2 filmmakers and 1-2 videographers/month. Uses photos for billboards, trade magazines, P-O-P displays, catalogs, posters, video covers and publicity. Subjects include: sports. Model/property release required for sports. Captions required; "include name of our films/programs we are releasing."
Audiovisual Needs: Uses slides, film, videotape and digital mediums for promotion of national broadcasts. Subjects include: sports.
Specs: Uses 8×10 glossy color prints; 16 or 35mm film; Beta or Digital (IFF-24) videotape.
Making Contact & Terms: Query with résumé of credits. Query with stock photo list. Works with local freelancers on assignment only. SASE. Reporting time "depends on our schedule and how busy we are." Pays for assignments. **Pays on acceptance.** Credit line given. Buys one-time and electronic rights; negotiable.

■🖿 **THE CABER PRODUCTION COMPANY**, (formerly Caber Communications), 266 Rutherford Rd. S., #22, Brampton, Ontario L6W 3N3 Canada. (905)454-5141. Fax: (905)454-5936. E-mail: caber@trigger.net. Producers: Chuck Scott and Christine Rath. Estab. 1988. Film and video producer with a focus in the television market. Recent projects include the second season of "A Day In The Country" for Life Network, and the new series "Home Additions", airing on HGTV. Upcoming projects include series, one-off dramas and documentaries. Caber still maintains their corporate client base.
Needs: Works with 2-3 freelance photographers and 3-5 videographers/month. Uses photos for posters, newsletters, brochures. Model/property release required.
Audiovisual Needs: Uses film or video. "We mainly shoot our own material for our projects."
Specs: 35mm, 2¼×2¼, 4×5 transparencies; videotape (Betacam SP quality or better).
Making Contact & Terms: Contact through rep. Query with résumé of credits. Provide résumé, business card, brochure, flier or tearsheets to be kept on file for possible future assignments. Works with local freelancers on assignment only. Keeps samples on file. SASE. Reports in 1-2 weeks. Pays $250/3-hour day. **Pays on receipt of invoice.** Rights negotiable.

■🖿 **CHISHOLM ARCHIVES INC.**, (formerly Chisholm Stock Footage), 99 Atlantic Ave., #50, Toronto, Ontario M6K 3J8 Canada. (416)588-5200. Fax: (416)588-5324. E-mail: chisholm@istar.ca. President: Mary Di Tursi. Estab. 1956. Stock, film and video library. Member of International Television Association, The Federation of Commercial Audio Visual Libraries, Canadian Film and Television Producers Association, Toronto Women in Film and Television, International Quorum of Film Producers, Association of Moving Image Archivists, International Federation of Television Archives. Types of clients: finance, industrial, government, TV networks and educational TV/multimedia, motion picture production.
Needs: Supplies stock film and video footage.
Making Contact & Terms: Works with freelancers on an assignment basis only. Rights negotiable.

CIPRA AD AGENCY, 314 E. Curling Dr., Boise ID 83702. (208)344-7770. Fax: (208)344-7794. President: Ed Gellert. Estab. 1979. Ad agency. Types of clients: agriculture (regional basis), transmission repair, health information.
Needs: Works with 1 freelance photographer/month. Uses photos for trade magazines. Subjects include: electronic, agriculture and garden. Reviews general stock photos. Model release required.
Specs: Uses 4×5, 8×10, 11×14 glossy or matte, color and b&w prints; 35mm, 4×5 transparencies.
Making Contact & Terms: Provide résumé, business card, brochure, flier or tearsheets to be kept on file for possible future assignments. Usually works with local freelancers only. Keeps samples on file. Cannot return material. Reports as needed. Pays $75/hour. Pays on publication. Buys all rights.

🖿 **CREATIVE COMPANY**, 3276 Commercial St. SE, Salem OR 97302. (503)363-4433. Fax: (503)363-6817. E-mail: brains@creativeco.com. President: Jennifer L. Morrow. Creative Director: Steven Johnsen. Estab. 1978. Member of American Institute of Graphic Artists, Portland Ad Federation. Marketing communications firm. Approximate annual billing: $1 million. Number of employees: 13. Types of clients: food products, manufacturing, business-to-business. Examples of recent projects: Church Extension Plan sales inquiry materials (brochures, postcards, mailers); Norpac Foods (Just Add brand packaging); Tec Lab's Oak'n Ivy Brand; and Tec Labs (collateral direct mail).
Needs: Works with 1-2 freelancers/month. Uses photos for direct mail, P-O-P displays, catalogs, posters, audiovisual and sales promotion packages. Model release preferred.
Specs: Uses 5×7 and larger glossy color or b&w prints; 2¼×2¼, 4×5 transparencies. Accepts images in digital format for Mac. Send via CD, online, floppy disk, SyQuest or Zip disk.
Making Contact & Terms: Arrange personal interview to show portfolio. Provide résumé, business card, brochure, flier or tearsheets to be kept on file for possible future assignments. Works with local freelancers only. SASE. Reports "when needed." Pays $75-300/b&w photo; $200-1,000/color photo; $20-75/hour; $700-2,000/day; $200-15,000/job. Credit line not given. Buys one-time, one-year and all rights; negotiable.
Tips: In freelancer's portfolio, looks for "product shots, lighting, creative approach, understanding of sales message and reproduction." Sees trend toward "more special effect photography, manipulation of photos in computers." To break in with this firm, "do good work, be responsive and understand what color separations and printing will do to photos."

THE INTERNATIONAL MARKETS INDEX, located in the back of this book, lists markets located outside the U.S. by country.

AL DOYLE ADVERTISING DIRECTION, 4926 McDonald Ave. NE, Bainbridge Island WA 98110. (206)718-2121. Fax: (206)842-1618. E-mail: aldoyle@aol.com. Creative Director: Al Doyle. Estab. 1981. Ad agency. Number of employees: 1-10. Types of clients: industrial, financial, retail, food. Examples of recent projects; Sky Island Ranch Planned Community (billboard, collateral print); Daniel's Ranch Planned Community (collateral, print); Shoreside Townhomes (collateral, print).
Needs: Works with 3-5 freelance photographers, varying numbers of filmmakers and videographers/month. Uses photos for billboards trade magazines and signage. Subjects include: lifestyle, people and families, active recreation and home life. Reviews stock photos. Model release required.
Audiovisual Needs: Uses slides and video for video presentations and brochures.
Specs: Uses color prints; 35mm, 2¼ × 2¼ transparencies; digital format.
Making Contact & Terms: Works with freelancers on assignment only. Does not keep samples on file. SASE. Reports in 1-2 weeks. Payment negotiable. Rights negotiable.
Tips: "We use over 50% digital images from stock sources."

DUCK SOUP GRAPHICS, INC., 257 Grandmeadow Crescent, Edmonton, Alberta T6L 1W9 Canada. (403)462-4760. Fax: (403)463-0924. Creative Director: William Doucette. Estab. 1980. Design firm. Specializes in annual reports, publication design, corporate literature/identity, packaging and direct mail. Types of clients: industrial, government, institutional, financial and retail.
Needs: Works with 2-4 freelancers/month. Uses photos for annual reports, billboards, consumer and trade magazines, direct mail, posters and packaging. Subject matter varies. Reviews stock photos. Model release preferred.
Specs: Uses color and b&w prints; 35mm, 4 × 5, 8 × 10 transparencies.
Making Contact & Terms: Interested in receiving work from newer, lesser-known photographers as well as established photographers. Interested in seeing new, digital work. Provide résumé, business card, brochure, flier or tearsheets to be kept on file for possible future assignments. Works on assignment only. Keeps samples on file. SAE and IRC. Reports in 1-2 weeks. Pays $100-150/hour; $800-1,000/day; $500-10,000/job. **Pays on receipt of invoice**. Credit line sometimes given depending on number of photos in publication. Buys first rights; negotiable.

GIBSON ADVERTISING & DESIGN, P.O. Box 21697, Billings MT 59104. (406)248-3555. Fax: (406)248-9998. E-mail: gibco@imt.net. President: Bill Gibson. Estab. 1984. Ad agency. Number of employees 3. Types of clients: industrial, financial, retail, food, medical.
Needs: Works with 1-3 freelance photographers and 1-2 videographers/month. Uses photos for direct mail, P-O-P displays, catalogs, posters, newspapers, signage and audiovisual. Subjects vary with job. Reviews stock photos. "We would like to see more Western photos." Model release required. Property release preferred.
Audiovisual Needs: Uses slides and videotape.
Specs: Uses color and b&w prints; 35mm, 2¼ × 2¼, 4 × 5, 8 × 10 transparencies; 16mm, VHS, Betacam videotape; and digital format.
Making Contact & Terms: Query with résumé of credits or samples. Provide résumé, business card, brochure, flier or tearsheets to be kept on file for possible future assignments. Works with local freelancers on assignment only. Keeps samples on file. Cannot return material. Reports in 1-2 weeks. Pays $75-150/job; $150-250/color photo; $75-150/b&w photo; $100-150/hour for video. **Pays on receipt of invoice**, net 30 days. Credit line sometimes given. Buys one-time and electronic rights. Right negotiable.

MATTHEWS ASSOC. INC., 603 Stewart St., Suite 1018, Seattle WA 98101. (206)340-0680. Fax: (206)626-0988. E-mail: matthewsassociates@msn.com. Ad agency. President: Dean Matthews. Types of clients: industrial.
Needs: Works with 0-3 freelance photographers/month. Uses photographers for trade magazines, direct mail, P-O-P displays, catalogs and public relations. Frequently uses architectural photography; other subjects include building products.
Specs: Uses 8 × 10 b&w and color prints; 35mm, 2¼ × 2¼ and 4 × 5 transparencies. Accepts images in digital format for Windows. Send via CD.
Making Contact & Terms: Arrange a personal interview to show portfolio if local. If not, provide résumé, business card, brochure, flier or tearsheets to be kept on file for possible future assignments. SASE. Works with freelance photographers on assignment only. Payment negotiable. Pays per hour, day or job. **Pays on receipt of invoice.** Buys all rights. Model release preferred.
Tips: Samples preferred depends on client or job needs. "Be good at industrial photography."

THE NERLAND AGENCY, 808 E St., Anchorage AK 99501. (907)274-9553. Ad agency. Contact: Curt Potter. Types of clients: retail, hotel, restaurant, fitness, health care. Client list free with SASE.

Needs: Works with 3 freelance photographers/month. Uses photos for consumer and trade magazines, newspaper ads, direct mail and brochures and collateral pieces. Subjects include people and still lifes.
Specs: Uses 11 × 14 matte b&w prints; 35mm, 2¼ × 2¼ and 4 × 5 transparencies.
Making Contact & Terms: Query with samples. Provide résumé, business card, brochure, flier or tearsheets to be kept on file for possible future assignments. Does not return unsolicited material. Pays $500-800/day or minimum $100/job (depends on job). **Pays on receipt of invoice.** Buys all rights or one-time rights. Model release and captions preferred.
Tips: Prefers to see "high technical quality (sharpness, lighting, etc). All photos should capture a mood—good people, expression on camera. Simplicity of subject matter. Keep sending updated samples of work you are doing (monthly). We are demanding higher technical quality and looking for more 'feeling' photos than still life of product."

SUN.ERGOS, A Company of Theatre and Dance, 2203, 700 Ninth St., SW, Calgary, Alberta T2P 2B5 Canada. (403)264-4621. Fax: (403)269-1896. E-mail: sunergos@nucleus.com. Website: http://www.sunergos.com. Artistic and Managing Director: Robert Greenwood. Estab. 1977. Company established in theater and dance, performing arts, international touring. Photos used in brochures, newsletters, posters, newspapers, annual reports, magazines, press releases, audiovisual uses and catalogs.
Needs: Buys 10-30 photos/year; offers 3-5 assignments/year. Performances. Examples of recent uses: "Birds of Stones" (8 × 10 b&w slides); "A Christmas Gift" (8 × 10 b&w slides); "Pearl Rain/Deep Thunder" (8 × 10 b&w slides). Reviews theater and dance stock photos. Property release required for performance photos for media use. Captions required; include subject, date, city, performance title.
Audiovisual Needs: Uses slides, film and videotape for media usage, showcases and international conferences. Subjects include performance pieces/showcase materials.
Specs: Uses 8 × 10, 8½ × 11 color and b&w prints; 35mm, 2¼ × 2¼ transparencies; 16mm film; NTSC/PAL/SECAM videotape.
Making Contact & Terms: Arrange a personal interview to show portfolio. Query with résumé of credits. Provide résumé, business card, self-promotion piece or tearsheets to be kept on file for possible future assignments. Works on assignment only. Keeps samples on file. SASE. Reporting time depends on project. Pays $100-150/day; $150-300/job; $2.50-10/color photo; $2.50-10/b&w photo. Pays on usage. Credit line given. Buys all rights.
Tips: "You must have experience shooting dance and *live* theater performances."

WARNE MARKETING & COMMUNICATIONS, 111 Avenue Rd., Suite 810, Toronto, Ontario M5R 3J8 Canada. (416)927-0881. Fax: (416)927-1676. President: Keith Warne. Estab. 1979. Ad agency. Types of clients: business-to-business.
Needs: Works with 5 photographers/month. Uses photos for trade magazines, direct mail, P-O-P displays, catalogs and posters. Subjects include: in-plant photography, studio set-ups and product shots. Special subject needs include in-plant shots for background use. Model release required.
Audiovisual Needs: Uses both videotape and slides for product promotion.
Specs: Uses 8 × 10 glossy b&w prints; 4 × 5 transparencies and color prints.
Making Contact & Terms: Send letter citing related experience plus 2 or 3 samples. Works on assignment only. Cannot return material. Reports in 2 weeks. Pays $1,000-1,500/day. Pays within 30 days. Buys all rights.
Tips: In portfolio/samples, prefers to see industrial subjects and creative styles. "We look for lighting knowledge, composition and imagination." Send letter and three samples, and wait for trial assignment.

International

EH6 DESIGN CONSULTANTS, The Silvermills Groups, 19 Silvermills Court, Henderson Place Lane, Edinburgh, Scotland EH3 5DG UK. Phone: (0044)131 558 3383. Fax: (0044)131 556 1154. E-mail: e.ross@silvermills.co.uk. Design Assistant: Elaine Ross. Estab. 1992. Design firm. Number of employees: 10. Firm specializes in annual reports, packaging, identities. Types of clients: financial.
Needs: Half of projects use freelance photographers. Uses photos for brochures.
Specs: Uses color prints; 4 × 5 transparencies.
Making Contact & Terms: Provide résumé, business card, self-promotion piece or tearsheets to be kept on file for possible future assignments. Art director will contact photographer for portfolio review if interested. Portfolio should include b&w color. Works with local freelancers only. Keeps samples on file. Reports back only if interested, send non-returnable samples. Payment negotiable. Pays on publication.
Tips: "Prefer to use local freelancers, as it is often easier to get hold of them for quick turnarounds, and briefing. When submitting work, you should enclose samples to keep on our files."

Galleries

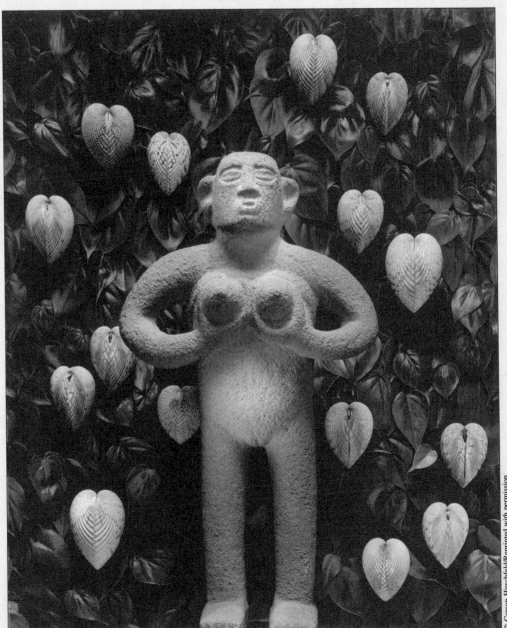

A MARKET FOR FINE PHOTOGRAPHY

The popularity of photography as a collectible art form has improved the market for fine art photographs over the last decade. Viewers now recognize the investment value of prints by Ansel Adams, Irving Penn and Henri Cartier-Bresson, and therefore frequently turn to galleries for stirring photographs to place in their private collections.

The gallery/fine art market is one that can make money for many photographers. However, unlike commercial and editorial markets, galleries seldom generate quick income for artists. Galleries should be considered venues for important, thought-provoking imagery, rather than markets through which you can make a substantial living.

More than any other market, this area is filled with photographers who are interested in delivering a message. Whole shows often focus on one overriding theme by a single artist. Group shows also are popular for galleries that see promise in the style of several up-and-coming photographers.

It might be easiest to think of the gallery market as you would book publishing. The two are similar in that dozens of pictures are needed to thoroughly tell a story or explore a specific topic. Publishers and gallery directors are interested in the overall interpretation of the final message. And they want artists who can excite viewers, make them think about important subjects and be willing to pay for photographs that pique their emotions.

As with picture buyers and art directors, gallery directors love to see strong, well-organized portfolios. Limit your portfolio to 20 top-notch images. When putting together your portfolio focus on one overriding theme. A director wants to be certain you have enough quality work to carry an entire show. After the portfolio review, if the director likes your style, then you might discuss future projects or past work that you've done.

Directors who see promise in your work, but don't think you're ready for a solo exhibition, may place your material in a group exhibition. In group shows, numerous artists display work at the same time. You might even see different mediums, such as photography, illustration or abstract sculptures, on display. The emphasis of a group show is to explore an overriding theme from various perspectives. Such shows can be juried, which means participants have been accepted by a review committee, or non-juried.

HOW GALLERIES OPERATE

In exchange for brokering images a gallery often receives a commission of 40-50 percent. They usually exhibit work for a month, sometimes longer, and hold openings to kick off new shows. And they frequently provide pre-exhibition publicity. Something to be aware of is that some smaller galleries require exhibiting photographers to help with opening night reception expenses. Galleries also may require photographers to appear during the show or opening. Be certain that such policies are put in writing before you allow them to show your work.

Gallery directors who foresee a bright future for you might want exclusive rights to represent

◄ In addition to photographing for commercial assignments, Corson Hirschfeld works on two lifelong fine art projects he calls *Objects of Myth and Mystery* and *Places of Power*. This piece from Hirschfeld's *Objects* collection, which also appears in a book of his work, features a Costa Rican fertility figure from A.D. 1000-1500. The Costa Rican people's figurative sculpture of that time centered on themes of warriors and fertile females. The heart-shaped shells surrounding the figure echo the shapes of the leaves in the background. Hirschfeld shares how he uses commercial assignments to fund his personal projects on page 463.

your work. This type of arrangement forces buyers to get your images directly from the gallery that represents you. Such contracts are quite common, usually limiting the exclusive rights to specified distances. For example, a gallery in Tulsa, Oklahoma, may have exclusive rights to distribute your work within a 200-mile radius of the gallery. This would allow you to sign similar contracts with galleries outside the 200-mile range.

FIND THE RIGHT FIT

As you search for the perfect gallery, it's important to understand the different types of spaces and how they operate. The route you choose depends on your needs, the type of work you do, your long term goals, and the audience you're trying to reach. (The following descriptions were provided by the editor of *Artist's & Graphic Designer's Market*.)

- **Retail or commercial galleries.** The goal of the retail gallery is to sell and promote artists while turning a profit. Retail galleries take a commission of 40 to 50 percent of all sales.
- **Co-op galleries.** Co-ops exist to sell and promote artists' work, but they are run by artists. Members exhibit their own work in exchange for a fee, which covers the gallery's overhead. Some co-ops also take a commission of 20-30 percent to cover expenses. Members share the responsibilities of gallery-sitting, sales, housekeeping and maintenance.
- **Rental galleries.** The gallery makes its profit primarily through renting space to artists and consequently may not take a commission on sales (or will take only a very small commission). Some rental spaces provide publicity for artists, while others do not. Showing in this type of gallery is risky. Rental galleries are sometimes thought of as "vanity galleries" and, consequently they do not have the credibility other galleries enjoy.
- **Nonprofit galleries.** Nonprofit spaces will provide you with an opportunity to sell work and gain publicity, but will not market your work agressively, because their goals are not necessarily sales-oriented. Nonprofits normally take a commission of 20-30 percent.
- **Museums.** Don't approach museums unless you have already exhibited in galleries. The work in museums is by established artists and is usually donated by collectors or purchased through art dealers.
- **Art consultancies.** Generally, art consultants act as liasions between fine artists and buyers. Most take a commission on sales (as would a gallery). Some maintain small gallery spaces and show work to clients by appointment.

If you've never exhibited your work in a traditional gallery space before, you may want to start with a less traditional kind of show. Alternative spaces are becoming a more and more viable way to help the public see your work. Try bookstores (even large chains), restaurants, coffee shops, upscale home furnishings stores and boutiques. The art will help give their business a more pleasant, interesting environment at no cost to them and you may generate a few fans or even a few sales.

Think carefully about what you take pictures of and what kinds of businesses might benefit from displaying them. If you shoot flowers and other plant life perhaps you could approach a nursery about hanging your work in their sales office. If you shoot landscapes of exotic locations maybe a travel agent would like to take you on. Think creatively and don't be afraid to approach a business person with a proposal. Just make the sure the final agreement is spelled out in writing so there will be no misunderstandings, especially about who gets what money from sales.

Whether you're a newcomer to the gallery scene or a seasoned professional, read the listings carefully to determine which galleries will suit you best. Some provide guidelines or promotional information about recent exhibits for a self-addressed, stamped envelope. Galleries are also included in our Subject Index. Check this index to help you narrow your search for galleries interested in your type of work. Whenever possible, visit those galleries that interest you to get a real feel for their particular needs, philosophy and exhibition capabilities. Do not, however, try to show a portfolio without first making an appointment.

PRICING TIPS

Deciding how much to charge for your fine art photography can be a challenge. The work is highly personal and creative, made up of much more than the material and labor you put into it. The easiest way to get an idea about what you should charge is to see what other photographers of your experience level are charging. When you start to work with a gallery, there are other pricing considerations to keep in mind. The following tips were written by Constance Smith, a fine art marketing expert. Knowing how pricing works in the fine art world will let gallery owners know you're a professional who's done his homework.

1. **When you have an exhibit, always have at least one piece priced high above the others,** perhaps twice the price of the next highest piece. Perhaps you don't want to sell this piece, as it's your favorite—though this is the piece that often sells first!

2. **The price you charge from your studio and the price your dealer sells for must be the same.** You usually get to keep the commission when you sell a piece from your studio. Some collectors mistakenly expect your studio price to be 50% less, but it never should be.

3. **Develop a long-term strategy connected with the pricing of your artwork.** As you sell more, your prices will, of course, rise. Soon your pricing will establish itself, rising slowly—no more than about 10% per year. As your prices increase, have smaller works or prints available in the lower price range. Keep your work affordable to all your previous clients.

4. **Studio inventory should always be at least 10 pieces.** If you only have four pieces in stock, it might be because you're selling at too low a price.

5. **Always note the retail price on your price list.** No net pricing. Net pricing is selling your work at a wholesale/net price, allowing your dealer to charge whatever he wishes at resale. This creates havoc in your pricing. Don't do it.

6. **Your prices should not vary from state to state**—perhaps by a slight amount, but nothing noticeable.

7. **Don't undersell your work.** You must feel comfortable with the prices you decide on; otherwise you will feel resentful.

8. **Never prepare a proposal or model or a piece of work for anyone unless you are being paid for it.** This is customary for architects and interior designers, and, as an artist, you need to make it customary, too. Clients respect the artist more if this is done.

9. **Make sure your clients are aware** that the price on the tag does not include sales tax, packing, shipping and possibly framing.

10. **Know your prices.** When you have studied the market and how the various factors of pricing a product, you will have more confidence when someone questions a price.

These tips are excerpted from Art Marketing 101: A Handbook for the Fine Artist © *1998 by Constance Smith. Published by ArtNetwork and available through North Light Book Club. Reprinted by permission of ArtNetwork.*

INSIDER REPORT

Using commercial assignments to fund fine art projects

Corson Hirschfeld

Corson Hirschfeld has made a career out of balancing commercial photography assignments with his personal fine art photos. During almost 30 years in the visual arts, Hirschfeld has photographed for corporations, agencies and design firms through his own studio as well as amassing an extensive list of freelance editorial assignments for magazines, from *Smithsonian* and *Sports Illustrated* to *Reader's Digest* and *Redbook*.

Between these jobs, which give him the means to visit places all over the world, Hirschfeld is on location throughout the U.S., Canada, Mexico, Puerto Rico, Bolivia, Peru, England, France, China, Easter Island, Fiji, Hawaii, Samoa, Tonga or Africa, collecting photographic records of sacred locations and ancient objects, like a shutterbug Indiana Jones. The results are his two life-long projects, *Places of Power* and *Objects of Myth and Mystery*. These aren't collections of textbook-like shots of the world's wonders; they are works of art—full of symbolism and feeling, void of modern civilization, timeless records of places and things most of us will never see in person.

"If I travel commercially to an interesting area and my expenses are taken care of, I'll take a couple days and do some of my own work," he says. And even if the trip is to a place without archeological interest, Hirschfeld can still take advantage of the location. He often shoots museum pieces for his *Objects of Myth and Mystery* collection.

To create his fine art photos, which have been shown in galleries and museums across the United States including the Smithsonian and in several abroad, Hirschfeld shoots with a 35mm camera in black and white. Then he painstakingly hand-colors the matte surface of his silver gelatin prints with acrylic, watercolor, dyes and wax pencil. "The hand-colored prints I do are super time-consuming. [Selling] fine art is kind of tough because you need an inventory, which I try to avoid," he says.

To combat this problem, Hirschfeld took advantage of a commercial contact. The Hennegan Company, a printer that does "incredible work for automobile companies, the movie industry and others," commissioned him to create a book of black and white photos from his *Objects of Myth and Mystery* collection, which they printed on lush, weighty paper. Hennegan gives the book to current and potential clients as gifts to show the capabilities of the company. Hirschfeld uses the book in the same way—it serves as a portfolio for the photographer. "I can show museums or galleries my work without having to cart around the originals, which is a real problem—they're big prints." And instead of keeping pieces on hand, he can do prints on commission for interested buyers.

Commercial assignments also offer means of learning. "I've always loved editorial

INSIDER REPORT, *Hirschfeld*

This photo, from photographer Corson Hirschfeld's lifelong project *Objects of Myth and Mystery*, is of one of the few figures (if not the only) from prehistoric North America of a mother nursing an infant. Hirschfeld photographed the piece in a St. Louis museum. He incorporated a kind of Christian iconography with the Indian art. "It's a madonna and child. The flower is a cross or a star symbol, but it's the same flower in different stages, and it opens up, like going from an infant to an adult. It's an endless, repeating cycle. The circle, which is a sort of halo to the figure, is the same—a circle of life. The object is probably a gaming stone."

INSIDER REPORT, *continued*

work. Before I'd photograph, I might read the manuscript and I might not, but I'd spend time with the people and ask questions. You come away with a lot of knowledge." One of his current commercial projects is photographing steel mills for a local company. "It's a pretty horrific environment, but also really fascinating—the power of the melted steel, the noise. They put scrap metal into huge caldrons, then drop electrodes in and shoot in incredible amounts of electricity. It's really very disturbing. It's like the metal is alive— it shakes and shivers and screams."

Hirschfeld's empathy for the inanimate is certainly evident in his gallery pieces. He is well-read and knowledgeable about ancient sites and objects, and truly fascinated by them. "It's hard to imagine anyone not being influenced by places like the pyramids or Machu Picchu because they are so striking," he says. "But you have to have a certain awareness and interest, and a certain sense of history, to enjoy what they're about. When you do, it's such a learning experience. Photography is your way of recording and interpreting."

Hirschfeld encourages photographers to not only take advantage of learning opportunities, but to create them. "When I started photography, I bought tons of magazine and how-to books and read them. I tell people to go through books and magazines and find photos they like and ask themselves questions like: What camera did they use? What lens? Why is it black and white? Why is it color? What about the composition? What about the subject? Why is it out of focus? You can teach yourself a lot this way."

He also recommends new photographers attend conferences or workshops to learn about their business. "There's a time in your career when conferences are most beneficial. When you're really psyched up and gaining some confidence, and you need a rush to be elevated into the next step, conferences are really effective," he says. "You see that other people have the same problems you do, and you see people who've been successful, and they're always very candid about what they did to get where they are."

When attending conferences, though, it's important to be pragmatic—don't expect to find all the answers. "People will ask, 'What kind of camera do you use? What kind of film do you use?' like all of a sudden they've got the inside information and now their photographs are going to be much better. There are no real shortcuts or secrets."

Workshops, too, are invaluable learning experiences, offering photographers the chance to spend several weeks working closely with a well-respected professional. A bonus is that they're often held in photographically interesting places—Hawaii, Paris, Italy, the Southwest—which photographers can take advantage of. Hirschfeld is about to attend an art conference in Senegal, and made plans to visit the west African countryside and Mali to meet the people and photograph their artwork. "The indigenous people of the region have resisted Islam and managed to live pretty much as they always have. They create some pretty great art." He's also hoping to visit Timbuktu to photograph the unusual art of the Dogon people.

Genuine interest, and even awe, in his subjects is part of what makes Hirschfeld's photos so successful. "These things are amazing to me. When you experience mysterious things like interaction with the sun and the moon at ancient shrines, they start to come alive. You realize that 100 years ago or 1,000 years ago or 5,000 years ago, those people were seeing the same things you are today. It makes you feel in touch with history and with the universe. My challenge as a photographer is to recreate that sense of mystery in my photos."

—*Alice P. Buening*

© Bohnchang Koo

"In Korea, we say, lines of a palm show how our life will go on," says Bohnchang Koo. "I want to express a feeling of an old man who tries hard to hold on to many things and works life long for his duty, looking down on his own empty palms when he is about to return to dust." Koo's mural-size image "Hands of Time" was part of an exhibit of Asian photography at the A.O.I Gallery in New York. Gallery Director Frank Aoi says the image's strength lies in its size and power of expression. "The image goes beyond mere pictorial representation to an abstract emotion, which does not please the eye, but pierces through our minds and becomes something ephemeral."

A.O.I. GALLERY, One Columbus Plaza, Apt. N-29E, New York NY 10019. (212)863-3360. Director: Frank Aoi. Estab. 1992. Examples of recent exhibits: "ASIA: Contemporary Photography from China, Korea and Japan"; Felix Beato: The Rare Vintage Photographs of India, Korea, Japan and Burma." Presents 2-3 shows/year. Shows last 1 month. General price range of work: $500-15,000.
Exhibits: Must be involved with fine art photography. No students' work. Interested in contemporary/ avant-garde photography or videos. Very coherent content and professional presentation.
Making Contact & Terms: Charges 50% commission or buys photos outright. Call for size limits. Cannot return material.
Tips: "Be extremely polite and professional."

A.R.C. GALLERY, 1040 W. Huron, 2nd Floor, Chicago IL 60622. (312)733-2787. President: Pamela Staker Matson. Estab. 1973. Examples of exhibitions: "Presence of Mind," by Jane Stevens (infrared photographs, b&w); "Take Away the Pictures . . .," by Barbara Thomas (C-prints); "Watershed Investigations . . .," by Mark Abrahamson (cibachrome prints). Presents 5-8 shows/year. Shows last 1 month. General price range of work: $100-1,200.
Exhibits: Must send slides, résumé and statement to gallery for review. All styles considered. Contemporary fine art photography, documentary and journalism.
Making Contact & Term: Charges no commission. Reviews transparencies. Interested in seeing slides for review. No size limits or other restrictions. Send material by mail for consideration. SASE. Reports in 1 month.
Tips: Photographers "should have a consistent body of work. Show emerging and experimental work."

ANSEL ADAMS CENTER FOR PHOTOGRAPHY, 250 Fourth St., San Francisco CA 94103. (415)495-7000. Fax: (415)495-8517. Attention: Portfolio Review. The Center was established in 1989. The Friends of Photography, the parent organization which runs the center, was founded in 1967. Examples

of recent exhibitions: "Picasso and Villers: The Diurnes Portfolio" by Pablo Picasso and Andre Villers; "The Wilderness Idea: Ansel Adams and the Sierra Club" and "Summer of Love: Evolution and Revolution," photography which examines 1960s subculture in the Bay area.

Exhibits: "Photographers are welcome to submit exhibition proposals through our portfolio review system. Generally this entails sending 15-26 slides, a brief artist's statement, a brief résumé (optional), and a SASE for return of submission. Call for future info." Interested in all styles and subjects of photography.

Making Contact & Terms: Payment negotiable. Reviews transparencies. Interested in unframed, mounted or unmounted, matted or unmatted work. Submit portfolio for review. Send material by mail for consideration. Call for details on portfolio review. SASE. Reports back on portfolio reviews in 1-2 weeks; submitted work in 1 month.

Tips: "We are a museum, not a gallery. We don't represent artists, and usually *exhibit* only established artists (locally or nationally). We are, however, very open to seeing/reviewing new work, and welcome exhibition proposals so long as artists follow the guidelines (available if a SASE is sent)."

ADIRONDACK LAKES CENTER FOR THE ARTS, Rt. 28, P.O. Box 205, Blue Mt. Lake NY 12812. (518)352-7715. Fax: (518)352-7333. E-mail: alca@netheaven.con. Program Coordinator: Daisy Kelley. Estab. 1967 Examples of recent exhibits: "Loving the Landscape-Adirondacks and Western Mountain States," by Janet Friauf; "Rt. 30," by Mark Kurtz (hand-colored panoramic photographs); "Abstract Florals," by Walter Carstens. Presents 6-8 exhibits/year. Shows last 1 month. General price range of work: $100-250.

Exhibits: Send résumé, artist's statement, slides or photos. Interested in contemporary Adirondack and nature photography.

Making Contact & Terms: Charges 30% commission. "Pricing is determined by photographer. Payment made to photographer at end of exhibit." Reviews transparencies. Interested in framed and matted work. Send material by mail for consideration. SASE. Material reviewed annually in February.

Tips: "Our gallery is open during all events taking place at the Arts Center, including concerts, films, workshops and theater productions. Guests for these events are often customers seeking images from our gallery for their own collections or their places of business. Customers are often vacationers who have come to enjoy the natural beauty of the Adirondacks. For this reason, landscape and nature photographs sell well here."

N **ADONIS ART**, 1b Coleherne Rd., London SW10 9BS United Kingdom. Phone: (0044)71 460 3888. E-mail: adonis@dircon.co.uk. Proprietor: Stewart Hardman. Gallery of male figurative art. Estab. 1995. Example of recent exhibit: "Photos of My Friends," by Geri Pozzar (tie-in with book). Average display time 1 month. Gallery open Monday through Saturday from 10:30 to 6:30; Sunday from 12 to 5, all year. Located in one of London's central gay areas. On two floors—a gallery presenting monthly exhibitions and a mixed gallery—sculpture, paintings, drawings. Overall price range $100-10,000. Most work sold at $200-2,000.

Exhibits: High quality male figurative photography only.

Making Contact & Terms: Artwork is bought outright. Gallery provides insurance, promotion, contract. Accepted work should be framed, mounted, matted. Requires exclusive representation locally. "No restrictions on type of artist but subject matter must be male." Call or write to show portfolio. Replies in 2 weeks. Finds artists through word of mouth, submissions, art exhibits, referrals by other artists.

Tips: "Best to contact me by letter including a brief résumé and a few photos of work. Photography's role in the fine art world is becoming more acceptable in the U.K."

AKRON ART MUSEUM, 70 E. Market St., Akron OH 44308. (330)376-9185. Website: http://www.akro nartmuseum.org. Chief Curator: Barbara Tannenbaum. Example of recent exhibitions: "A History of Women Photographers"; "Hiroshi Sugimoto." Presents 4 exhibits/year. Shows last 2 months.

● This gallery annually awards the Knight Purchase Award to a living artist working with photographic media.

Exhibits: To exhibit, photographers must possess "a notable record of exhibitions, inclusion in publications, and/or a role in the historical development of photography. We also feature local photographers (northeast Ohio)." Interested in innovative works by contemporary photographers; any subject matter.

Making Contact & Terms: Payment negotiable. Buys photography outright. Will review transparencies.

 SPECIAL COMMENTS within listings by the editor of *Photographer's Market* are set off by a bullet.

Send material by mail for consideration. SASE. Reports in 1-2 months, "depending on our workload."
Tips: "Prepare a professional-looking packet of materials including high-quality slides, and always send a SASE. Never send original prints."

N: ALBER GALLERIES, 3300 Darby Rd., #5111, Haverford PA 19041. (610)896-9297. Director: Howard Alber. Estab. 1977. Has shown work by Michael Hogan, Harry Auspitz (deceased), Barry Slavin, Joan E. Rosenstein, Ken Roberts (computer-restoration), and Joan Z. Rough. "Cooperative show space only. We do not have our own gallery space." General price range of work: $75-1,000.
 • This is a private gallery with a very limited operation.
Exhibits: Professional presentation, well priced for sales, consistent quality and willingness to deliver promptly. Interested in Philadelphia subjects, land conservation, wetlands, artful treatments of creative presentation.
Making Contact & Terms: Charges 40% commission. Reviews transparencies; only as requested by us. Not interested in new presentations. Slides only on first presentation.
Tips: "Give us copies of all reproduced photos, calendars, etc., only if we can retain them permanently."

THE ALBUQUERQUE MUSEUM, 2000 Mountain Rd. NW, Albuquerque NM 87104. (505)243-7255. Fax: (505)764-6546. Curator of Art: Ellen Landis. Estab. 1967. Examples of previous exhibitions: "Gus Foster," by Gus Foster (panoramic photographs); "Santiago," by Joan Myers (b&w 16×20); and "Frida Kahlo," by Lola Alvaraz Bravo (b&w various sizes). Presents 3-6 shows/year. Shows last 2-3 months.
Exhibits: Interested in all subjects.
Making Contact & Terms: Buys photos outright. Reviews transparencies. Interested in framed or unframed work, mounted or unmounted work, matted or unmatted work. Arrange a personal interview to show portfolio. Submit portfolio for review. Send material by mail for consideration. "Sometimes we return material; sometimes we keep works on file." Reports in 1 month.

AMERICAN SOCIETY OF ARTISTS, INC., Box 1326, Palatine IL 60078. (847)991-4748 or (312)751-2500. Membership Chairman: Helen Del Valle.
Exhibits: Members and nonmembers may exhibit. "Our members range from internationally known artists to unknown artists—quality of work is the important factor. We have about 25 shows throughout the year which accept photographic art."
Making Contact & Terms: Payment negotiable. Interested in framed, mounted or matted work only. Send SASE for membership information and application (state media). Reports in 2 weeks. Accepted members may participate in lecture and demonstration service. Member publication: *ASA Artisan*.

ARIZONA STATE UNIVERSITY ART MUSEUM, Nelson Fine Arts Center, Tempe AZ 85287-2911. (602)965-2787. Fax: (602)965-5254. E-mail: artmuse@asuvm.inre.asu.edu. Website: http://www.asuam.fa. asu.edu. Curator: Heather Lineberry. Estab. 1950. Examples of recent exhibits: "Big Sister/Little Sister," by Annie Lopez (photography and installation); "The Curtain Falls: Russian American Stories," by Tamarra Kaida (photography and installation); "Art on the Edge of Fashion," photographs by Elaine Reichek, Nich Vaughn and Beverly Semmes. Shows last 6-8 weeks. The ASU Art Museum has two facilities and approximately eight galleries of 2,500 square feet each; mounts over 20 exhibitions per year.
Exhibits: Work must be approved by curatorial staff as meeting museum criteria.
Making Contact & Terms: Sometimes buys photography outright for collection. Reviews transparencies. Interested in framed, mounted, matted work. Query with samples. Send material by mail for consideration. SASE. Reports "depending on when we can review work."

ART CENTER AT FULLER LODGE, 2132 Central Ave., Los Alamos NM 87544. (505)662-9331. Director: Gloria Gilmore-House. Non-profit visual arts organization. Estab. 1977. Examples of recent exhibits: "Through the Looking Glass 1998," an annual regional show devoted exclusively to photography, initiated in 1993; "Contemporary Art 1998," a regional juried exhibition (all media); and "Traditional Fine Arts 1998," a regionaljuried competition (all media). Regional competitions open to residents of AZ, CO, NM, OK, TX and UT. Cash and sponsored awards presented after viewing actual works. Shows juried from 35mm slides. Presents 9-10 art shows/year, 3 of which are juried, one exclusively for photography. Shows last 5-6 weeks. Interested in all styles and genres. General price range of work: $50-500.
Exhibits: For more information and prospectus send SASE.
Making Contact & Terms: Charges 30% commission. Interested in framed or unframed, mounted or unmounted work. Query with résumé of credits. SASE. Reports in 3 weeks.
Tips: "Be aware that we never do one-person shows—artists will be used as they fit into scheduled shows. Work should show impeccable craftsmanship. We rely on a vairety of expert jurors, so preferences vary

show to show, but all subjects, styles are considered. Work must have been completed in last two years for consideration."

ART CENTER OF BATTLE CREEK, 265 E. Emmett St., Battle Creek MI 49017. (616)962-9511. Fax: (616)969-3838. Curator: Carol Snapp. Estab. 1962. Examples of recent exhibits: "Midwest Focus '96 Regional Juried Photo Competition," 75 works accepted from 450 entries; "Mental States," intimate portraits by Kalamazoo artist, Mary Whalen; and "Kidsfocus," photographs resulting from an 8-week photography workshop with area school children. All subjects, formats and processes represented. Occasionally presents one-person exhibits. Shows last 6 weeks. General price range of work: $100-500. Art Center is composed of three gallery spaces.
Exhibits: Interested in "experimentation; technical/compositional skill; originality and personal statement—avoid clichés."
Making Contact & Terms: Primarily interested in Michigan and Midwestern artists. Charges 40% commission. "We also accept gifts of photography by Michigan artists into the collection." Will review transparencies if artist wants a solo exhibit. Interested in seeing framed or unframed, mounted or unmounted, matted work only. Send material by mail for consideration. SASE. Reports after exhibits committee has met (1-2 months).
Tips: Sees trend toward "experimentation with older formats and processes, use of handtinting and an increase in social commentary. All photographers are invited to apply for exhibitions. The Center has a history of showing the work of emerging artists. Send examples of your best and most recent work. Be honest in your work and in presentation." Traditional landscapes are most popular with buying public.

ART SOURCE L.A., INC., 11901 Santa Monica Blvd., Suite 555, Los Angeles CA 90025. (310)479-6649. Fax: (310)479-3400. E-mail: ellman@aol.com. Website: http://www.artsourcela.com. President: Francine Ellman. In Maryland: 182 Kendrick Place, Suite 32, North Potomac MD 20878. (301)208-9201. Fax: (301)208-8855. E-mail: bkogodART@aol.com. Director: Bonnie Kogod. Estab. 1980. Exhibitions vary. General price range of work: $300-15,000. Represents photographers Linda Adelstein, Sara Einstein, Robert Glenn Ketchum, Jill Enfield.
Exhibits: "We do projects worldwide, putting together fine art for public spaces, hotels, restaurants, corporations, government, private collections." Interested in all types of quality work. "We use a lot of photography."
Making Contact & Terms: Interested in receiving work from emerging and established photographers. Charges 50% commission. Reviews transparencies. Interested in unframed work, mounted or matted OK. Submit portfolio for review. Include for consideration visuals, résumé, SASE. Reports in 1-2 months.
Tips: "We review actuals, video, CD ROM, photo disk transparencies, photographs, laser color and/or black and white, as well as pieces created through digital imagery or other high-tech means. Show a consistent body of work, well-marked and presented so it may be viewed to see its merits."

ARTEMISIA GALLERY, 700 N. Carpenter, Chicago IL 60622. (312)226-7323. Fax: (312)227-7756. E-mail: artemisi@enteract.com. Website: http://www.enteract.com/~artemisi. Contact: Search Committee. Not-for-profit, cooperative, women artist-run alternative art gallery established in 1973. Interested in innovative, leading edge work and very receptive to newer, lesser-known, fine-art photographers demonstrating quality work and concept. Examples of photo exhibitions: "Forest Dance" by Judy O'Conner (b&w mother's illness); "Decadence" by Angela Strassheim (color portraits); and "New Work" by Susan Sensemann (self-portraits/color). Huge gallery with 5 separate spaces. Presents 60 shows a year; each lasts 1 month. Approximately 15 exhibits are photography. General price range of work: $200-800.
Exhibits: Concurrently showcases major women artists, sponsors lectures, international exchange exhibitions.
Making Contact & Terms: Sells works; does not charge commission. Charges $650 average gallery rental fee. No size limits or restrictions on photography. Jurying requirements: send 10 slides of a consistent body of work, résumé and SASE and a slide sheet. Returns in 4-6 weeks.
Tips: Opportunities for photographers in galleries are "fair to good." Photo exhibitions are treated as fine art. Buying public is most interested in work that is "innovative, finely composed, or concerned with contemporary issues. We encourage artists of color and/or members of minority groups, along with those interested in feminist issues, to apply. Please submit professional quality slides, marked 'top,' of a consistent body of work."

ARTISTS' COOPERATIVE GALLERY, 405 S. 11th St., Omaha NE 68102. (402)342-9617. President: Robert Schipper. Estab. 1974. Examples of exhibitions: works by Ulla Gallagher (sabattier, hand coloring), Pam King (polaroid transfers), Dale Shenefelt (Dianatypes and Silver prints), Nancy Gould-Ratliff (Rolaroid image and emulsion prints). Alessandra Petersen (C-prints, large format prints, and Margie Schimenti

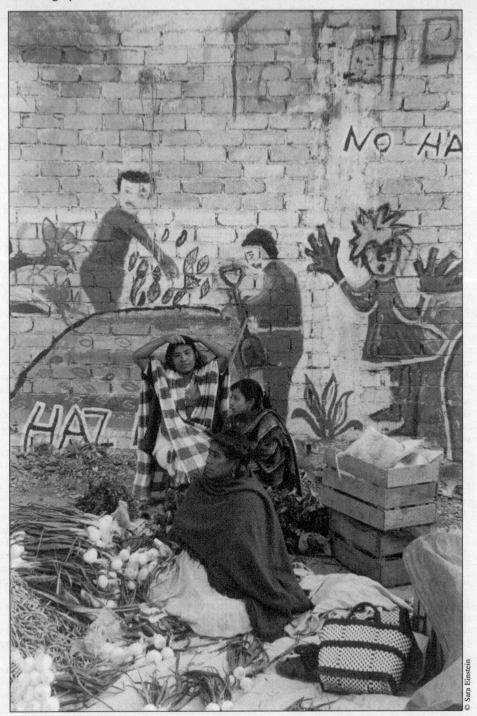

© Sara Einstein

Photographer Sara Einstein was referred to Art Source L.A. by a friend. The gallery now represents her work, including this image, "Oaxaca Market." Gallery President Francine Ellman says there is great interest in this kind of Latin image in the Los Angeles market. "The position of the figures in front of the mural is clever and eye catching, making the viewer take a good look to differentiate between the two. We are always looking for quality, uniqueness, fresh ideas and good presentations." All these are qualities "Oaxaca Market" exhibits.

(Cibachrome prints). Presents 14 shows/year. Shows last one month. Gallery sponsors 1 all-member exhibit and outreach exhibits, individual artists sponsor their own small group exhibits throughout the year. General price range of work: $100-300.

Exhibits: Fine art photography only. Artist must be willing to work 13 days per year at the gallery or pay another member to do so. "We are a member-owned and -operated cooperative. Artist must also serve on one committee." Interested in all types, styles and subject matter.

Making Contact & Terms: Charges no commission. Reviews transparencies. Interested in framed work only. Query with résumé of credits. SASE. Reports in 2 months.

Tips: "Write for membership application. Membership committee screens applicants August 1-15 each year. Reports back by September 1. New membership year begins October 1. Members must pay annual fee of $300. Will consider well-known artists of regional or national importance for one of our community outreach exhibits. Membership is not required for outreach program and gallery will host one-month exhibit with opening reception."

ARTSPACE, INC., 201 East Davie St., Raleigh NC 27601. (919)821-2787. Fax: (919)821-0383. E-mail: artspace10@aol.com. Website: www.citysearch.com/rdu/artspace. Executive Director: Megg Rader. Estab. 1986. Shows last 5-7 weeks. Price range of work varies.

Exhibits: Works are reviewed by the Artspace Gallery Committee for invitational exhibitions; Artspace sponsors juried shows periodically that are open to all artists and photographers. Send slides, résumé and SASE." Interested in all types, styles and subjects.

Making Contact & Terms: Charges 30% commission. Reviews transparencies. Send material by mail for consideration to Gallery Committee. SASE. Reports in 60 days.

ARTWORKS GALLERY, 233 Pearl St., Hartford CT 06103. (860)247-3522. Fax: (860)548-0779. Executive Director: Judith Green. Estab. 1976. Examples of recent exhibits: Maria Reid Morsted, Roger Crossgrove and John Bryan. Shows last 1 month. General price range of work: $100-5,000.

Exhibits: "We have juried shows; members must be voted in after interview." Interested in contemporary work.

Making Contact & Terms: Charges 30-40% commission. Reviews transparencies. Send for membership application. SASE. Reports in 1 month.

Tips: "Have a close relationship with the gallery director. Be involved; go to events. Work!"

ASCHERMAN GALLERY/CLEVELAND PHOTOGRAPHIC WORKSHOP, 23500 Mercantile Rd., Suite D, Beachwood OH 44122. (216)464-4944. Fax: (216)464-3188. E-mail: herbasch@apk.net. Director: Herbert Ascherman, Jr. Estab. 1977. Sponsored by Cleveland Photographic Workshop. Presents 5 shows/year. Shows last about 10 weeks. Openings are held for some shows. Photographers are expected to contribute toward expenses of publicity. Price range: $100-1,000. "Photos in the $100-300 range sell best."

Exhibits: "All forms of photographic art and production. "Membership is not necessary. A prospective photographer must show a portfolio of 40-60 slides or prints for consideration. We prefer to see distinctive work—a signature in the print, work that could only be done by one person, not repetitive or replicative of others."

Making Contact & Terms: Charges 25-40% commission, depending on the artist. Sometimes buys photography outright. Will review transparencies. Matted work only for show.

Tips: "Photographers should show a sincere interest in photography as fine art. Be as professional in your presentation as possible; identify slides with name, title, etc.; matte, mount, box prints. We are a Midwest gallery and we are always looking for innovative work that best represents the artist (all subject matter). We enjoy a variety of images and subject matters. Know our gallery; call first; find out something about us, about our background or interests. Never come in cold."

ASIAN AMERICAN ARTS CENTRE, 26 Bowery, 3rd Floor, New York NY 10013. (212)233-2154. Fax: (212)766-1287. Director: Robert Lee. Estab. 1974. Examples of recent exhibitions: work by Dinh Le, Monica Chau, John Shelby Schmidt and Wing Young Huie. Shows last 6 weeks.

Exhibits: Be Asian or significantly influenced by Asian culture and should be entered into the Archive—an historical record of the presence of Asia in the US. Interested in "creative art pieces."

Making Contact & Terms: Requests 20% "donation" on works sold. Sometimes buys photos outright. To be considered send dupes of slides, bio and letter to be entered into the Archive. These will be kept for users of archive to review.

BARLETT FINE ARTS GALLERY, 77 W. Angela St., Pleasanton CA 94566. (510)846-4322. Owner: Dorothea Barlett. Estab. 1982. Example of exhibits: "Photography 1994," by Al Weber. Shows last 1 month. General price range of work: $125-500.
Exhibits: Interested in landscape, dramatic images.
Making Contact & Terms: Reviews transparencies. Interested in matted work only. Requires exclusive representation locally. Works are limited to 8 × 10 (smallest). Query with samples. Send material by mail for consideration. SASE.
Tips: "Submit work that has high artistic quality."

BARRON ARTS CENTER, 582 Rahway Ave., Woodbridge NJ 07095. (908)634-0413. Director: Stephen J. Kager. Estab. 1975. Examples of recent exhibitions: New Jersey Print Making Council. General price range of work: $150-400.
Making Contact & Terms: Photography sold in gallery. Charges 20% commission. Reviews transparencies but prefers portfolio. Submit portfolio for review. SASE. Reports "depending upon date of review, but in general within a month of receiving materials."
Tips: "Make a professional presentation of work with all pieces matted or treated in a like manner. In terms of the market, we tend to hear that there are not enough galleries existing that will exhibit photography."

BATON ROUGE GALLERY, INC., 1442 City Park Ave., Baton Rouge LA 70808. (504)383-1470. Fax: (504)336-0943. E-mail: BRGallry@aol.com. Director: Kitty Pheney. Estab. 1966. Examples of recent exhibitions: "Stories of the Truth," by Jennifer Simmons (portraits of everyday life); and "Animal Dance," by Lori Waselchuk (photographic essay on Cajun Mardi Gras). Presents approximately 3 exhibits/year. Shows last 4 weeks. General price range of work: $200-600.
 ● This gallery is the oldest artist co-op in the US.
Exhibits: Professional artists with established exhibition history—must submit 20 slides and résumé to programming committee for approval. Open to all types, styles and subject matter.
Making Contact & Terms: Charges 33.3% commission. Reviews transparencies and artwork on CD-ROM. Interested in "professional presentation." Send material by mail for consideration. SASE. Reports in 2-3 months. Accepts submissions in March and September.

BENHAM STUDIO GALLERY, 1216 First Ave., Seattle WA 98101. (206)622-2480. Fax: (206)622-6383. E-mail: benham@halcyon.com. Website: http://www.halcyon.com/benham. Owner: Marita Holdaway. Estab. 1987. Examples of recent exhibitions: works by Michael Gesinger-toned images from Oaxaca; Phil Borges-selectively toned portraits from Africa & Indonesia; juried exhibition with juror Jock Sturges. Presents 12 shows/year. Shows last 1 month. General price range of work: $175-2,000.
Making Contact & Terms: Call in December for review appointment in March. Charges 40% commission. Accepts images in digital format for Mac. "No online images please, Zip or floppy."

BONNI BENRUBI GALLERY, 52 E. 76th St., New York NY 10021. (212)517-3766. Fax: (212)288-7815. Director: Karen Marks. Estab. 1987. Examples of recent exhibits: "Early Work: 1930's," by Andreas Feninger (vintage prints); "Quiet Grace," by Tom Baril (contemporary); and "Paris/NY," by Louis Steltner (modern). This gallery represents numerous photographers, including Merry Alpern, Dick Arentz, Andreas Feininger, Rena Bass Forman, Jean Kallina, Joel Meyerowitz, Tom Baril and Abelardo Morell. Presents 7-8 shows/year. Shows last 6 weeks. General price range of work: $500-50,000.
Exhibits: Portfolio review is the first Thursday of every month. Out-of-towners can send slides with SASE and work will be returned. Interested in 19th and 20th century photography, mainly contemporary.
Making Contact & Terms: Charges commission. Buys photos outright. Reviews transparencies. Accepted work should be matted. Requires exclusive representation locally. No manipulated work. Submit portfolio for review. SASE. Reports in 1-2 weeks.

**FOR EXPLANATIONS OF THESE SYMBOLS,
SEE THE INSIDE FRONT AND BACK COVERS OF THIS BOOK.**

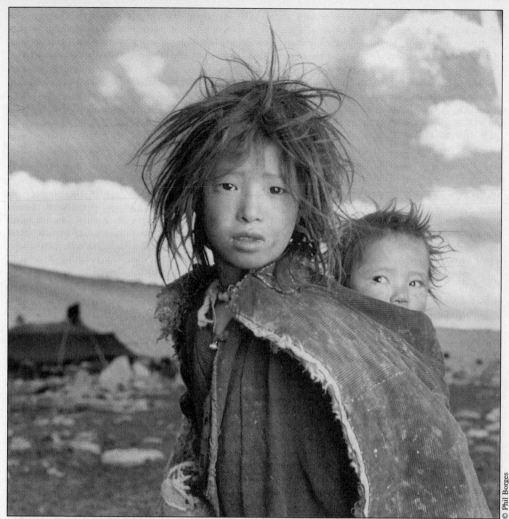

© Phil Borges

"Phil is the kind of photographer every gallery would like to work with," says Marita Holdaway, Benham Studio Gallery owner, of photographer Phil Borges. "He has vision, unique approach and great integrity, both in the way he works with his subjects and in his professional dealings with the gallery. "Jigme & Sonam" is indicative of the sensitive portraits Borges is known for. "His images convey a dignity in people in their environment, a beauty in photographs my buyers find very appealing." Borges's work can also be found in an upcoming calendar devoted to the preservation of Tibetan culture, "Tibetan Portrait: Faces of Compassion," published by Ronnie Sellers Productions.

BERKSHIRE ARTISANS GALLERY, Lichtenstein Center for the Arts, 28 Renne Ave., Pittsfield MA 01201. (413)499-9348. Fax: (413)442-8043. E-mail: berkart@taconic.com. Artistic Director: Daniel M. O'Connell. Estab. 1975. Examples of recent exhibits: b&w photographs by Kevin Burninski; color Cibachromes by David Ricci; and b&w photos by Chris Farrell. Presents 10 shows/year. General price range of work: $50-1,500.

• This gallery was written about in a *Watercolors* magazine article by Daniel Grant, on galleries that do open-jury selections. They were also included in *Art in America*, guide to galleries and *Who's Who in American Art*.

Exhibits: Professionalism in portfolio presentation, professionalism in printing photographs, professionalism.

Making Contact & Terms: Charges $25 fee plus 20% commission on sales. Will review transparencies of photographic work. Interested in seeing framed, mounted, matted work only. "Photographer should send SASE with 20 slides or prints and résumé by mail only to gallery." SASE.

Tips: To break in, "Send portfolio, slides and SASE. We accept all art photography. Work must be professionally presented. Send in by July 1, each year. Expect exhibition 4-6 years from submission date. We have a professional juror look at slide entries once a year (usually July-September). Expect that work to be tied up for 6-8 months in jury." Sees trend toward "b&w and Cibachrome architectural photography."

MONA BERMAN FINE ARTS, 78 Lyon St., New Haven CT 06511. (203)562-4720. Fax: (203)787-6855 E-mail: mbfineart@snet.com. Director: Mona Berman. Estab. 1979. Examples of previous exhibits: "From the Occident to the Orient: Part 2," featuring photographs of Angkor Wat by Tom Hricko. Presents 0-1 exhibits/year. Shows last 1 month. General price range of work: $300 and up.
- "We are primarily art consultants serving corporations, architects and designers. We also have private clients. We hold very few exhibits; we mainly show work to our clients for consideration and sell a lot of photographs."

Exhibits: "Photographers must have been represented by us for over two years. Interested in all except figurative, although we do use some portrait work."
Making Contact & Terms: Charges 50% commission. "Payment to artist 30 days after receipt of payment from client." Reviews 35mm transparencies only. Interested in seeing unframed, unmounted, unmatted work only. Accepts images in digital format for Windows. Send via online or Zip disk. Inquire about file format first. Submit portfolio for review (35mm slides only). Query with résumé of credits. Send material by mail for consideration (35mm slides with RETAIL prices and SASE). Reports in 1 month.
Tips: "Looking for new perspectives, new images, new ideas, excellent print quality, ability to print in large sizes, consistency of vision."

JESSE BESSER MUSEUM, 491 Johnson St., Alpena MI 49707. (517)356-2202. Chief of Resources: Robert Haltiner. Estab. 1965. Examples of exhibits: "Ophthalmic Images," extreme color close-ups of the eye and its problems, by Csaba L. Martonyi; "One-Percent—To The Right," by Scott J. Simpson (color photography); "Fall-En Leaves: Primal Maps Home," by David Ochsner (Ilfochrome photography). Presents 1-2 shows/year. Shows last 6-8 weeks. Price range: $25-500.
Exhibits: Interested in a variety of photos suitable for showing in general museum.
Making Contact & Terms: Charges 20% sales commission. "However, being a museum, emphasis is not placed on sales, per se." Reviews transparencies. Submit samples to Chief of Resources, Robert Haltiner. Framed work only. SASE for return of slides. Reports in 2 weeks. "All work for exhibit must be framed and ready for hanging. Send *good* slides of work with résumé and perhaps artist's statement. Trend is toward manipulative work to achieve the desired effect."
Tips: Most recently, northern Michigan scenes sell best.

N 🌐 BLACKHEATH GALLERY, 34a Tranquil Vale, London SE 3 0AX United Kingdom. Phone: 0181 8521802. Fax: 01580 291321. Contact: Mrs. B. Simpson. Private retail gallery. Estab. 1975. Approached by 100 artists a year; represents or exhibits 74 artists. One photography exhibit/year. Average display time 6 weeks. Gallery open Monday through Saturday from 10 to 6. Closed Thursday. Gallery located in "center of thriving London village advacent to Greenwich. On two floors—can hang up to 150 pictures depending on size (up to 6'×6'). Interior is modern and white walled." Overall price range $150-8,000. Most work sold at $700.
Making Contact & Terms: Artwork is accepted on consignment and there is a 50% commission. There is a rental fee for space only if artist requires the whole gallery space. Gallery provides insurance, promotion, contract. Accepted work should be framed, mounted. Requires exclusive representation locally. Mail portfolio for review. Send artist's statement, photographs, résumé. Replies in 2 weeks. Finds artists by word of mouth, submissions, referrals by other artists, classified ads, magazine ads.
Tips: "Send good, clear photos or slides with additional information about each item, size, title, media, etc. and date executed—and a good résumé or biography. Photography's role in the fine art world is gaining slowly in England. Still a misunderstood and under-rated medium. Education on the subject is sorely needed!"

BOOK BEAT GALLERY, 26010 Greenfield, Oak Park MI 48237. (248)968-1190. Fax: (248)968-3102. E-mail: bookbeat@aol.com. Director: Cary Loren. Estab. 1982. Examples of recent exhibitions: "Male Nudes," by Bruce of Los Angeles; "Stills from Andy Warhol," by Billy Name (films); "Mr. Lotus Smiles," by Jeffrey Silverthorne (still life). Presents 6-8 shows/year. Shows last 1-2 months. General price range of work: $200-5,000.
Making Contact & Terms: Charges 50% commission. Buys photos outright. Reviews transparencies. Interested in framed or unframed, mounted or unmounted, matted or unmatted work. Arrange a personal interview to show portfolio. Query with samples. Submit résumé, artist's statement, slide sheets and SASE for return of slides. Reports in 1-2 months.

Tips: "We have just published our first catalog and are marketing some of our photographers internationally. Photographers should display a solid portfolio with work that is figurative, documentary, surrealistic, off-beat, mythological or theatrical."

BROMFIELD ART GALLERY, 560 Harrison Ave., Boston MA 02118. (617)451-3605. Gallery President: Adam Sherman. Presents 12 shows/year. Shows last 1 month. General price range of work: $200-2,000.
Exhibits: Usually shows New England artists. Interested in "programs of diversity and excellence."
Making Contact & Terms: Rents gallery to artists ($650-750). Charges 50% commission. Reviews transparencies. Interested in framed or unframed, mounted or unmounted, matted or unmatted work. Submit portfolio for review. Send material by mail for consideration. Reports in 1 month.
Tips: "We are looking to expand our presentation of photographers." There is a "small percentage of galleries handling photographers."

N: **THE CAMERA OBSCURA GALLERY**, 1309 Bannock St., Denver CO 80204. (303)623-4059. E-mail: hgould@iws.net. Website: http://www.thor.he.net/~methney. Owner/Director: Hal Gould. Estab. 1980. Approached by 350 artists a year; represents or exhibits 20 artists. Examples of recent exhibitions: "Still in the Dark" by Jerry Uelsmann; "Two Generations" by Paul Caponigro and John Paul Caponigro; and "Retrospective" by Willy Ronnis (France). Sponsors 8 photography exhibits/year. Open Tuesday through Saturday from 10 to 6; Sunday from 1 to 5, all year. Overall price range $350-20,000. Most work sold at $500.
Making Contact & Terms: Artwork is accepted on consignment. Write to arrange a personal interview to show portfolio of photographs. Send bio, brochure, résumé, reviews. Replies in 1 month. Finds artists by word of mouth, submissions, portfolio reviews, art exhibits, art fairs, referrals by other artists, reputation.
Tips: "To make a professional gallery submission, provide a good representation of your finished work that is of exhibition quality. Slowly but certainly we are experiencing a more sophisticated audience. The last few years have shown a tremendous increase in media reporting on photography-related events and personalities, exhibitions, artist profiles and market news."

CAPITOL COMPLEX EXHIBITIONS, Florida Division of Cultural Affairs, Department of State, The Capitol, Tallahassee FL 32399-0250. (904)487-2980. Fax: (904)922-5259. Arts Consultant: Katie Dempsey. Examples of recent exhibits: Rick Wagner (b&w); Lee Dunkel (b&w); and Barbara Edwards (color). Shows last 3 months.
Exhibits: "The Capitol Complex Exhibitions Program is designed to showcase Florida artists and art organizations. Exhibition spaces include the Capitol Gallery (22nd floor), the Cabinet Meeting Room, the Old Capitol Gallery, the Secretary of State's Reception Room and the Florida Supreme Court. Exhibitions are selected based on quality, diversity of medium, and regional representation."
Making Contact & Terms: Does not charge commission. Interested in framed work only. Request an application. SASE. Reports in 3 weeks. Only interested in Florida artists or arts organizations.

SANDY CARSON GALLERY, 1734 Wazee, Denver CO 80202. (303)297-8585. Fax: (303)297-8933. E-mail: scarson@ecentral.com. Director: Greg Adams-Woodford. Estab. 1975. Examples of recent exhibits: "We the People," by Rimma & Valeriy Gerlovin (color); "Recent Exposures," by Peter de Lory and others (b&w and color); photography by Thomas Harris, Carolyn Krieg, David Teplica, Rimma & Valeriy Gerlovin, Gary Isaacs (June 1996); Teresa Camozzi (photo college). Shows last 6 weeks.
Exhibits: Professional, committed, body of work and continually producing new work. Interests vary.
Making Contact & Terms: Charges 50% commission. Reviews transparencies. Interested in framed or unframed, matted or unmatted work. Requires exclusive representation locally. Send material by mail for consideration. SASE. Reports in 1 month.
Tips: "We like an original point of view. Properly developed prints. Seeing more photography being included in gallery shows."

KATHARINE T. CARTER & ASSOCIATES, P.O. Box 2449, St. Leo FL 33574. (352)523-1948. Fax: (352)523-1949. New York: 24 Fifth Ave., Suite 703, New York NY 10011. Phone/fax: (212)533-9530.

MARKET CONDITIONS are constantly changing! If you're still using this book and it's 2000 or later, buy the newest edition of *Photographer's Market* at your favorite bookstore or order directly from Writer's Digest Books.

Website: http://www.ktcasso.com/ktcassoc.@icanect.net. Executive Director: Katharine T. Carter. Estab. 1985. Examples of recent museum exhibitions: Joan Rough (Cibachrome); Sally Crooks (Polaroid); Danny Conant (Polaroid Transfer); Marian Bingham (Mixed-media). Schedules one-person and group museum exhibitions and secures gallery placements for artist/clients. The company is a marketing and public relations firm for professional artists working in all media.

Exhibits: One-person and thematic group exhibitions are scheduled in mid-size museums and art centers as well as alternative, corporate and better college and university galleries.

Making Contact & Terms: Services are fee based. Reviews transparencies. Send résumé and slides. SASE to Marty Menane, Director of Artist Services.

Tips: "Katharine T. Carter & Associates is committed to the development of the careers of their artist/clients. Gallery space is primarily used to exhibit the work of artist/clients with whom long standing relationships have been built over several years and for whom museum exhibitions have been scheduled."

N CENTER FOR PHOTOGRAPHIC ART, P.O. Box 1100, Suite 1, San Carlos & Ninth Ave., Carmel CA 93921. (408)625-5181. Fax: (408)625-5199. Estab. 1988. Examples of recent exhibits: "Immediate Family," by Sally Mann (b&w large format); Michael Kenna (b&w medium format); "Oil on Silver," by Holly Roberts (b&w, overpainted oils on large-scale prints). Presents 7-8 shows/year. Shows last 5-7 weeks.

Exhibits: Interested in fine art photography.

Making Contact & Terms: Reviews transparencies. Interested in slides. Send slides, résumé and artists statement with cover letter. SASE. Reports in 1 month.

Tips: "Submit for exhibition consideration: slides or transparencies accompanied by a concise bio and artist statement. We are a nonprofit."

CENTER FOR PHOTOGRAPHY AT WOODSTOCK, 59 Tinker St., Woodstock NY 12498. (914)679-9957. Fax: (914)679-6337. E-mail: cpwphoto@aol.com. Exhibitions Director: Kathleen Kenyon. Estab. 1977. Examples of previous exhibits: "Home is Where the Heart Is"; "Mirror-Mirror"; and "High Anxiety" (all were group shows). Presents 5 thematic and 5 solo shows/year. Shows last 6 weeks. Sponsors openings.

Exhibits: Interested in all creative photography.

Making Contact & Terms: Charges 25% sales commission. Send 20 slides plus cover letter, résumé and artist's statement by mail for consideration. SASE. Reports in 4 months.

Tips: "We are closed Mondays and Tuesdays. Interested in innovative, contemporary work. Emerging and minority photographers encouraged."

THE CENTRAL BANK GALLERY, Box 1360, Lexington KY 40590. In U.S. only (800)637-6884. In Kentucky (800)432-0721. Fax: (606)253-6244. Curator: John G. Irvin. Estab. 1987. Examples of recent exhibits: "Images of the World" by Allen and Nancy Grimes; "Alaska Today" by David Massey; and "Stealing Home" by Doug Flynn. Presents 2-3 photography shows/year. Shows last 3 weeks. "We pay for everything, invitations, receptions and hanging. We give the photographer 100 percent of the proceeds." General price range of work: $75-1,500.

Exhibits: No nudes and only Kentucky photographers. Interested in all types of photos.

Making Contact & Terms: Charges no commission. Query with telephone call. Reports back probably same day.

Tips: "We enjoy encouraging artists."

CENTRAL CALIFORNIA ART LEAGUE GALLERY, 1402 "I" St., Modesto CA 95354. (209)529-3369. Fax: (209)529-9002. E-mail: ccal@a.com. Gallery Director: Mary Gallagher. Estab. 1951.

Exhibits: "League members judge artwork every other Wednesday of the month. Interested in landmarks, landscapes and personalities of Central California.

Making Contact & Terms: Charges 30% commission. Interested in framed or unframed, mounted, matted or unmatted work. Cannot return material.

CHAPMAN ART CENTER GALLERY, Cazenovia College, Cazenovia NY 13035. (315)655-9446. Fax: (315)655-2190. E-mail: jaistars@cazcollege.edu. Director: John Aistars. Estab. 1978. Examples of recent exhibits: "Bridge of Transparent Hours," by Leslie Yudelson (b&w surrealistic photos); Jeri Robinson (Cibachrome prints); "Masterworks of 20th Century Photography" (collection of Donald Baxter). Presents 1-2 shows/year. Shows last 3-4 weeks. "The Cazenovia College Public Relations Office will publicize the exhibition to the news media and the Cazenovia College community, but if the artist wishes to schedule an opening or have printed invitations, it will have to be done by the artist at his/her own expense. College food service will provide a reception for a fee." General price range of work: $150-300.

Exhibits: Submit work by March 1. Interested in "a diverse range of stylistic approaches."

Tom Hricko has been exhibiting his work at Mona Berman Gallery and Mona Berman Fine Arts for 19 years. His most recent exhibition there was entitled "From the Occident to the Orient." This image is part of a body of work created in Angkor Wat, Cambodia. His work "captures the spirit of these old ruins as they once must have been hundreds of years ago and at the same time captures the effect of the years of their neglect and the intense power of the jungle enveloping this temple area," says Mona Berman. "Indeed, it has captured Mr. Hricko's soul—he is now living in Cambodia."

Making Contact & Terms: Charges no commission. Reviews transparencies. Interested in framed or unframed, mounted or unmounted, matted or unmatted work. Send material by mail for consideration. SASE. Reports approximately 3 weeks after Exhibitions Committee meeting.

Tips: "The criteria in the selection process is to schedule a variety of exhibitions every year to represent different media and different stylistic approaches; other than that our primary concern is quality."

CLEVELAND STATE UNIVERSITY ART GALLERY, 2307 Chester Ave., Cleveland OH 44114. (216)687-2103. Fax: (216)687-2275. E-mail: r.thurmer@popmail.csuohio.edu. Director: Robert Thurmer. Estab. 1973. Examples of recent exhibits: "Re-Photo Construct," with Lorna Simpson; "El Salvador," by Steve Cagan; "In Search of the Media Monster," with Jenny Holzer; and "Body of Evidence: The Figure in Contemporary Photography," by Dieter Appelt, Cindy Sherman, Joel Peter Witkin and others, curated by Robert Thurmer (1995). Presents 0-1 show/year. Shows last 1 month. General price range of work: $100-1,000.

Exhibits: Photographs must be of superior quality. Interested in all subjects and styles. Looks for professionalism, creativity, uniqueness.

Making Contact & Terms: Charges 25% commission. Reviews transparencies. Interested in framed or unframed, mounted or unmounted, matted or unmatted work. Send material by mail for consideration. SASE. Reports within 3 months.

Tips: "Write us! Do not submit oversized materials. This gallery is interested in new, challenging work—we are not interested in sales (sales are a service to artists and public)."

COASTAL CENTER FOR THE ARTS, INC., 2012 Demere Rd., St. Simons Island GA 31522. Phone/fax: (912)634-0404. Director: Mittie B. Hendrix. Estab. 1946. Examples of recent exhibits: "Eye on Nature," by Joan Hartzeel (nature studies); "Photo National/97" and "Photoworks." Presents 2 shows/year. Shows last 3 weeks. Art center includes six galleries and four classrooms for a total of 12,000 sq. ft. General price range of work: $25-625.

Exhibits: Unframed work must be shrink-wrapped for bin; framed work must be ready for hanging. Looking for "photo art rather than 'vacation' photos."

Making Contact & Terms: Charges 30% commission to members; 40% to nonmembers. Reviews transparencies. Interested in framed or unframed work. "We have six galleries and can show photos of all sizes." Send slides and résumé of credits. SASE. Reports in 3-4 weeks.

Tips: "In past years national jurors selected computer art to be hung in our annual Artists' National, considered the year's premiere exhibit for the region. If framed, use a simple frame. Know what the gallery mission is—more fine art (as we are) or walk-in tourists (as others in the area). Use a good printer. Do not substitute other work for work selected by the gallery."

⒩ STEPHEN COHEN GALLERY, 7358 Beverly Blvd., Los Angeles CA 90036. (213)937-5525. Fax: (213)937-5523. E-mail: stephen@stephencohengallery.com. Website: http://www.stephencohengallery.com. Photography and photo-based art gallery. Estab. 1992. Approximately 10 shows per year; represents 40 artists. Exhibited artists include Lynn Geesaman, Bill Witt, Luis Gonzales Palma, Lauren Greenfield, John Dugdale. Examples of recent exhibit: "Fast Forward," by Laren Greenfield (documentary color photos); Lynn Geesaman (b&w landscape photos); "Dreaming of A White Christmas" (b&w and color photography and video group show). Average display time 1 month. Gallery open Tuesday through Saturday from 11 to 5; all year. "We are a large, spacious, clean gallery and are flexible in terms of types of shows we can mount." Overall price range $400-20,000. Most work sold at $2,000.

Exhibits: All styles of photography and photo-based art.

Making Contact & Terms: Artwork is accepted on consignment and there is a 50% commission. Gallery provides insurance, promotion, contract. Requires exclusive representation locally. Mail portfolio for review. Send query letter with artist's statement, bio, brochure, business card, photographs, résumé, reviews, SASE. Replies only if interested within 3 months. Finds artists through word of mouth, published work.

Tips: "Photography is still the best bargain in 20th century art. There are more people collecting photography now, increasingly sophisticated and knowledgeable people aware of the beauty and variety of the medium."

COLLECTOR'S CHOICE GALLERY, 20352 Laguna Canyon Rd., Laguna Beach CA 92651-1164. Phone/fax: (714)494-8215. E-mail: canyonco@aol.com. Director: Beverly Inskeep. Estab. 1979. Examples of recent exhibits: "Deceptions," by Jennifer Griffiths (photo magic); "Portraits," by Glenn Aaron and D. Richardson (faces around world). General price range of work: $15-2,000.

Exhibits: Interested in vintage styles, surrealism and computer-enhanced works.

Making Contact & Terms: Charges 40% commission. Buys photos outright. Interested in unframed, unmounted and unmatted work only. Accepts images in digital format for Windows. Send via compact

"I've been a student of the past as a way to live in the present for a long time. I'm using the past to express myself now in the 20th century," says John Dugdale of his haunting cyanotype images. Stephen Cohen, owner of the Los Angeles gallery of the same name, discovered Dugdale's work in New York at the Wessel & O'Connor Gallery and was struck by its beauty. "We represent photographers and artists who use photography as a basis for their work," he says. This image, titled "Annunciation," is a "beautiful representation of the style and genre of John Dugdale's work."

disc or Online (150 dpi). Works are limited to unmounted, $13' \times 16'$ largest. No minimum restrictions. Send material by mail for consideration. SASE. Reports in 3 weeks.

Tips: "When we review a freelancer's portfolio we look for a large body of work . . . sustainable inventory skills and a unique eye on the subject."

CONCEPT ART GALLERY, 1031 S. Braddock, Pittsburgh PA 15218. (412)242-9200. Fax: (412)242-7443. Director: Sam Berkovitz. Estab. 1972. Examples of exhibits: "Home Earth Sky," by Seth Dickerman and selected photos from Orlando E. Romig.

Exhibits: Desires "interesting, mature work," work that stretches the bounds of what is perceived as typical photography.

Making Contact & Terms: Very interested in receiving work from newer, lesser-known photographers. Payment negotiable. Reviews transparencies. Interested in unmounted work only. Requires exclusive representation within metropolitan area. Send material by mail for consideration. SASE.

Tips: "Mail portfolio with SASE for best results. Will arrange appointment with artist if interested."

THE COPLEY SOCIETY OF BOSTON, 158 Newbury St., Boston MA 02116. (617)536-5049. Fax: (617)267-9396. Gallery Manager: Karen Pfefferle. Estab. 1879. A nonprofit institution. Examples of exhibits: portraiture by Al Fisher (b&w, platinum prints); landscape/exotic works by Eugene Epstein (b&w, limited edition prints); and landscapes by Jack Wilkerson (b&w). Presents 15-20 shows/year. Shows last 3-4 weeks. General price range of work: $100-10,000.

Exhibits: Must apply and be accepted as an artist member. Once accepted, artists are eligible to compete in juried competitions. Guaranteed showing in annual Small Works Show. There is a possibility of group or individual show, on an invitational basis, if merit exists. Interested in all styles. Workshops offered.

Making Contact & Terms: Charges 40% commission. Reviews slides only with application. Request membership application. Quarterly review deadlines.

Tips: Wants to see "professional, concise and informative completion of application. The weight of the judgment for admission is based on quality of slides. Only the strongest work is accepted. We are in the process of strengthening our membership, especially as regards photographers. We look for quality work in any genre, medium or discipline."

CREATIONS INTERNATIONAL FINE ARTS GALLERY, P.O. Box 492, New Smyrna Beach FL 32170-0492. Phone/fax: (904)673-8778. E-mail: 2bhy42a@peedigo. Website: http://ourworld.compuserve. com/homepages/creations-International-Gallery. Owner: Benton Ledbetter. Director: Vickie Haer. Estab. 1984. Recent exhibit: by Michael Starry, Benton Ledbetter and Gaetan Charbonneau. Presents 12 shows/year. Shows last 1 month. General price range of work: $50 and up.

Exhibits: "There are no limits in the world of art, but we do keep it clean here due to the large numbers of children and families that visit Creations International each year."

Making Contact & Terms: Charges 25% commission. Reviews transparencies. Interested in framed or unframed, mounted or unmounted, matted or unmatted work. Accepts images in digital format. Send via compact disc, Online, floppy disk or Zip disk. Submit bio indicating past shows, awards, collectors, education, and any other information that will help present the artist and the work. SASE. Reports in 1 month.

Tips: "We currently have 30 Web pages and are up to date with the new computer trends. We represent work by slide registry and disk registry and train other businesses to use computers for their market needs. Be faithful to your work as an artist and keep working at it no matter what."

DALLAS VISUAL ART CENTER, 2917 Swiss Ave., Dallas TX 75204. (214)821-2522. Fax: (214)821-9103. Executive Director: Katherine Wagner. Estab. 1981. Examples of recent exhibits: "World View" (group show of noted Dallas photographers); Mosaics series by Pablo Esparza (b&w/airbrushed). Presents variable number of photo shows (2-3)/year. Shows last 3-6 weeks.

Exhibits: Photographer must be from Texas. Interested in all types.

Making Contact & Terms: Charges no commission (nonprofit organization). Reviews slides. Send material by mail for consideration. SASE. Reports Oct. 15 annually.

Tips: "We have funding from Exxon Corporation to underwrite exhibits for artists who have incorporated their ethnic heritage in their work; they should make a note that they are applying for the Mosaics series. (We have a Collector series for which we underwrite expenses. All submissions are reviewed by committee.) Other gallery space is available for artists upon slide review. We have a resource newsletter that is published bimonthly and contains artist opportunities (galleries, call for entries, commissions) available to members (membership starts at $35)."

DE HAVILLAND FINE ART, 39 Newbury St., Boston MA 02116. (617)859-3880. Fax: (617)859-3973. Website: http://www.ArtExplorer.com. Gallery Director: Jennifer Gilbert. Estab. 1989. Presents 10 shows/ year. Shows last 2 weeks. General price range of work: $200-5,000.
Exhibits: Interested in mixed media, photo manipulation, Polaroid transfers, etc. Shows only New England artists.
Making Contact & Terms: Charges 50% commission. Reviews transparencies. Interested in framed, mounted or matted work. "We prefer work that is matted and framed. Shape and size is of no particular consideration." Submit portfolio for review. SASE. Reports in 1 month.
Tips: "The public is becoming more interested in photography. It must be unique, consistant and outstanding. Representation is very competitive. Located in the first block of Boston's exclusive Newbury Street, our gallery has been featured in dozens of publications as well as on NBC News for it's innovative support of emerging artists through video tapes."

CATHERINE EDELMAN GALLERY, Lower Level, 300 W. Superior, Chicago IL 60610. (312)266-2350. Fax: (312)266-1967. Director: Catherine Edelman. Estab. 1987. Examples of recent exhibitions: work of Joel-Peter Witkin; Michael Kenna; Lynn Geesman. Presents 9 exhibits/year. Shows last 4-5 weeks. General price range of work: $600-5,000.
Exhibits: "We exhibit works ranging from traditional landscapes to painted photo works done by artists who use photography as the medium through which to explore an idea. The work must be engaging and honest."
Making Contact & Terms: Charges 50% commission. Reviews transparencies. Accepted work should be matted. Requires exclusive representation within metropolitan area. Send material by mail for consideration. SASE. Reports in 2 weeks.
Tips: Looks for "consistency, dedication and honesty. Try to not be overly eager and realize that the process of arranging an exhibition takes a long time. The relationship between gallery and photographer is a partnership."

PAUL EDELSTEIN GALLERY, 519 N. Highland, Memphis TN 38122-4521. (901)454-7105. E-mail: pedelst414@aol.com. Director/Owner: Paul R. Edelstein. Estab. 1985. Examples of exhibits: vintage b&w and color prints by William Eggleston; "Mind Visions," by Vincent de Gerlando (figurative); "Eudora Welty Portfolio," by Eudora Welty (figurative); and "Still Lives," by Lucia Burch Dogrell. Shows are presented continually throughout the year. General price range of work: $400-5,000.
Exhibits: Interested in 20th century photography "that intrigues the viewer"—figurative still life, landscape, abstract—by upcoming and established photographers.
Making Contact & Terms: Charges 30-40% commission. Buys photos outright. Reviews transparencies. Interested in framed or unframed, mounted or unmounted, matted or unmatted work. There are no size limitations. Submit portfolio for review. Query with samples. Cannot return material. Reports in 3 months.
Tips: "Looking for figurative and abstract figurative work."

⊞ 🌐 EGEE ART CONSULTANCY, 9 Chelsea Manor Studios Flood St., London SW 3 5SR United Kingdom. Phone: (44+)171 3516818. Fax: (44+)171376. E-mail: egee.art@btinternet.com. Website: http://www.egeeart.co.uk. Director: Dale Egee. Art Consultant: Kate Brown. Art consultancy. Estab. 1978. Approached by 50 artists a year; represents or exhibits 30-40 artists. Examples of recent exhibits: "Art of the Alhambra" (mixed show); "Contemporary Art of the Arab World" (mixed). "We are consultants therefore not many exhibitions." Average display time 1 month. Open Monday through Friday from 8:30 to 5:30; weekends by appointment, all year. "Located in a Victorian artists studio just off the King's Road in Chelsea. Egee Art Consultancy is based in a light and airy gallery space." Overall price range $100-80,000. Most work sold at $1,500.
Exhibits: "Middle East subjects, particularly architecture/dhows/souks."
Making Contact & Terms: Artwork is accepted on consignment. Retail price set by gallery. "Normally we reframe." Exclusive representation locally preferred. Accepts only artists whose work influenced by Middle East. Call/write to arrange personal interview to show portfolio. Mail for review. Send query letter with bio, photographs, résumé. Replies in 1 week. Finds artists by word of mouth, submissions, portfolio reviews, art exhibits, art fairs, referrals by other artists, trade directories, internet.
Tips: It is "worthwhile typing c.v./résumé, cover letter making it clear they want us to represent them,

THE INTERNATIONAL MARKETS INDEX, located in the back of this book, lists markets located outside the U.S. by country.

not just any gallery; and show good clear photos/transparencies; any reviews/articles. More people seem to be open to the idea of photography as an art form in its own right. (Can only be a good thing!)"

ELEVEN EAST ASHLAND (Independent Art Space), 11 E. Ashland, Phoenix AZ 85004. (602)257-8543. Director: David Cook. Estab. 1986. Examples of recent exhibits: works by Meredith McCloud (b&w photo); Mark Dolce (b&w photo); Elizabeth Dondis (b&w photo); and one juried show in fall of each year "Exclusively Photography." (Call for information—$25 fee, 3 slides, SASE, deadline 10/15/98). Presents 13 shows/year. Shows last 3 weeks. General price range of work: $100-500.
Exhibits: Contemporary only (portrait, landscape, genre, mixed media in b&w, color, non-silver, etc.); photographers must represent themselves, complete exhibition proposal form and be responsible for own announcements. Interested in "all subjects in the contemporary vein—manipulated, straight and non-silver processes."
Making Contact & Terms: Charges 25% commission. Reviews transparencies. Interested in framed or unframed, mounted or unmounted, matted or unmatted work. Shows are limited to material able to fit through the front door and in the $4' \times 8'$ space. Query with résumé of credits. Query with samples. SASE. Reports in 2 weeks.
Tips: "Sincerely look for a venue for your art, and follow through. Search for traditional and non-traditional spaces."

FAVA (Firelands Association for the Visual Arts), New Union Center for the Arts, 39 S. Main St., Oberlin OH 44074. (440)774-7158. Fax: (440)775-1107. Gallery Director: Susan Jones. Nonprofit gallery. Estab. 1979. Sponsors 1 photography exhibit/year. Shows last 1 month. General price range of work: $75-3,000.
Exhibits: Open to all media, including photography. Presents 1 regional juried photo show/year ("Six-State Photography"). Open to residents of Ohio, Kentucky, West Virginia, Pennsylvania, Indiana, Michigan. Deadline for applications: February. Send annual application for 5 invitational shows by October 15 of each year; include 15-20 slides, résumé, slide list.
Making Contact & Terms: Charges 30% commission. Interested in framed or matted work. Send SASE for "Exhibition Opportunity" flier or Six-State Photo Show entry form.
Tips: "As a nonprofit gallery, we do not represent artists except during the show."

FIELD ART STUDIO, 24242 Woodward Ave., Pleasant Ridge MI 48069-1144. (248)399-1320. Fax: (248)399-7018. Owner: Jerome S. Feig. Estab. 1950. Presents 6-8 shows/year. Shows last 1 month.
Making Contact & Terms: Charges 40% commission. Reviews transparencies. Interested in framed or unframed work. Requires exclusive representation locally. Works are limited to maximum 30×40. Query with samples. SASE. Reports in 1-2 weeks.

FOCAL POINT GALLERY, 321 City Island Ave., New York NY 10464. (718)885-1403. Photographer/Director: Ron Terner. Estab. 1974. Examples of recent exhibits: Charles Brackman (warm toned prints); Mark Woods (personal portfolio b&w); and Laine Whitcomb (nudes, gum prints and Kodalith combined). General price range of work: $175-700.
Exhibits: Open to all subjects, styles and capabilities. "I'm looking for the artist to show me a way of seeing I haven't seen before." Nudes and landscapes sell best.
Making Contact & Terms: Charges 30% sales commission. Artist should call for information about exhibition policies.
Tips: Sees trend toward more use of alternative processes. "The gallery is geared toward exposure—letting the public know what contemporary artists are doing—and is not concerned with whether it will sell. If the photographer is only interested in selling, this is not the gallery for him/her, but if the artist is concerned with people seeing the work and gaining feedback, this is the place. Most of the work shown at Focal Point Gallery is of lesser-known artists. Don't be discouraged if not accepted the first time. But continue to come back with new work when ready."

FRAGA FRAMING & ART GALLERY, 4532 Magazine St., New Orleans LA 70115. (504)899-7002. Fax: (504)834-5045. E-mail: gfraga1534@aol.com. President: Grace Fraga. Estab. 1992. Examples of recent exhibits: photography by Michael White (distorted color images); Dorien Romer (11×14 color documentary images); "Nice Shots," by Steven Snyder, Michael White and Dorien Romer (documentary); and Steven Snyder (11×14 b&w nudes and documentary). Presents 1-3 shows/year. Shows last 1-2 months. Gallery is located on "shopping" Magazine Street, a historic and commercial 6 mile street in the heart of New Orleans. General price range of work: $200-600.
Exhibits: Must be established for a minimum of 3 years. Interested in any kind of subject matter and style, especially unique, innovative styles.

Making Contact & Terms: Charges 50% commission. Reviews transparencies. Interested in framed or unframed work. Submit portfolio for review; call for appointment or mail with SASE. Requires exclusive representation locally. Works are limited to maximum 16×20 image. SASE. Reports in 2-3 months.

FREEPORT ARTS CENTER, (formerly Freeport Art Museum & Cultural Center), 121 N. Harlem Ave., Freeport IL 61032. Phone/fax: (815)235-9755. Director: Becky Connors. Estab. 1976. Examples of recent exhibitions: "On The Land: Three Centuries of American Farm Life," by Stan Sherer; "Au Naturel," group show (wildlife photos and carvings). Presents 1 or 2 shows/year. Shows last 2 months.
Exhibits: All artists are eligible for solo or group shows.
Making Contact & Terms: Charges 20% commission. Reviews transparencies or photographs. Interested in framed work only. Send material by mail for consideration. SASE. Reports in 3 months.

GALERIA MESA, P.O. Box 1466, 155 N. Center, Mesa AZ 85211-1466. (602)644-2056. Fax: (602)644-2901. Website: http://www.artresources.com. Contact: Curator. Estab. 1980. Examples of recent exhibit: "Un-Portrait," by Donald Scavarda (autobiographical); "Image Conscious," by 35 artists (nationally juried); "Out and About Landscape," by Tom Strich, Chris Burkett, Laurie Lundquist (internationally juried); and "Reality Check," by several artists (nationally juried). Presents 7-9 national juried exhibits/year. Shows last 4-6 weeks. General price range of work: $300-800.
Exhibits: Interested in contemporary photography as part of its national juried exhibitions in any and all media.
Making Contact & Terms: Charges 25% commission. Interested in seeing slides of all styles and aesthetics. Slides are reviewed by changing professional jurors. Must fit through a standard size door and be ready for hanging. Enter national juried shows; awards total $1,500. SASE. Reports in 1 month.
Tips: "We do invitational or national juried exhibits only. Submit professional quality slides."

N **GALERIE DART LE JARDIN DE L'OEIL**, 413 Racine E., Room 106, Chicoutimi, Quebec G7H 1S8 Canada. (418)545-0898. Fax: (418)543-2733. Co-owner: Richard Giroux. Retail gallery. Estab. 1991. Approached by 10 artists a year; represents or exhibits 4 artists. Average display time 3 weeks. Gallery open Monday through Sunday from 9 to 5; weekends from 1 to 5, all year. Gallery is 880 sq. ft.— 1 bigger room 15×40 feet; 4 smaller rooms 8×10. Overall price range $200-2,000. Most work sold at $600.
Exhibits: Portraits, landscapes, urban life.
Making Contact & Terms: Artwork is accepted on consignment and there is a 40% commission. Gallery provides insurance, promotioni, contact. Accepted work should be framed. Requires exclusive representation locally. Call to arrange personal interview to show portfolio of photographs or send bio, résumé, SASE. Replies in 2 weeks. Finds artists through word of mouth, portfolio reviews, referrals by other artists.
Tips: To make their gallery submissions professional artists must show "an up-to-date and impeccable résumé, good photographs and empathic communication."

GALLERY 825/LA ART ASSOCIATION, 825 N. La Cienega Blvd., Los Angeles CA 90069. (310)652-8272. Fax: (310)652-9251. Director: Amy Perez. Assistant Director: Rachel Pinto. Estab. 1924. Examples of recent exhibits: "Nature (re)Contained," by Bob Sanov (b&w nature); "Objects/Images/Ideas," by Nick Capito (sepia toned b&w urban landscape); and Gary Rosenblum (color poloroid abstracts). Presents 6-11 shows/year. Shows last 3-5 weeks. Sponsors openings; provides wine/cheese. General price range of work: $150-7,500.
Exhibits: Must "go through membership screening conducted twice a year; contact the gallery for dates. Shows are group shows." Interested in Southern Californian artists—all media.
Making Contact & Terms: Charges 33% commission. Reviews transparencies on screening dates. Interested in framed or unframed, mounted or unmounted, matted or unmatted work. Works are limited to 100 lbs. Submit 3 pieces during screening date. Reports immediately following screening. Call for screening dates and prospectus shows.

N **GALLERY ET. AL.**, 29205 Greening Blvd., Farmington Hills MI 48334-2945. (248)932-0090. Fax: (248)932-8763. E-mail: JSAPub@aol.com. Director: Joe Ajlouny. Retail gallery and exhibition space.
Exhibits: "Interested in b&w nudes or partial nudes only. Variations on this theme are acceptable, even in color."
Making Contact & Terms: Send query letter with photographs, contact sheets. Replies in 1 month.

N **GALLERY OF MODERN ART**, 9 Barmouth Rd., London SW18 2DT United Kingdom. Phone/fax: 0181 875 1481. Contact: Mrs. Ba'hons Newberry. Art consultancy and gallery. Estab. 1993. Approached by 30 artists a year; represents or exhibits 40 artists. Average display time 2 months. Gallery

open Monday through Thursday from 10 to 4; weekends by appointment, all year. Overall price range £300-8,000. Most work sold at £400-500.

Exhibits: We have shown some series of photographs with landscape connotations.

Making Contact & Terms: Artwork is accepted on consignment and there is a 33% commission. Gallery provides insurance, promotion, contract. Accepted work should be framed, mounted. Write to arrange to show portfolio of photographs. Send artist's statement, photographs, résumé. Replies in 1 month.

Tips: Finds artists by portfolio reviews, contacts and liason with other galleries. "Always looking for good art photographers."

GALMAN LEPOW ASSOCIATES, INC., Unit #12, 1879 Old Cuthbert Rd., Cherry Hill NJ 08034. (609)354-0771. Fax: (609)428-7559. Principals: Elaine Galman and Judith Lepow. Estab. 1979.

Making Contact & Terms: Reviews transparencies. Interested in seeing matted or unmatted work. No size limit. Query with résumé of credits. Visual imagery of work is helpful. SASE. Reports in 3 weeks.

Tips: "We are corporate art consultants and use photography for our clients."

FAY GOLD GALLERY, 247 Buckhead Ave., Atlanta GA 30305. (404)233-3843. Fax: (404)365-8633. Owner/Director: Fay Gold. Estab. 1981.

Exhibits: Contemporary fine art photography by established artists. Holds monthly photography exhibitions. In addition, the gallery maintains a major inventory of vintage and recent prints for beginning and advanced collectors, museums and institutions.

Making Contact & Terms: Send slides, résumé and artist's statement with SASE for weekly review. Terms discussed on an individual basis.

Tips: "Please do not send original material for review."

GOMEZ GALLERY, 836 Leadenhall St., Baltimore MD 21230. (410)752-2080. Fax: (410)752-2082. E-mail: walter@gomez.com. Website: http://www.gomez.com. Director: Walter Gomez. Contact: Director. Estab. 1988. Photographers represented include: Connie Imboden, Robert Flynt, Jose Villarrubia, Mary Wagner, Frank Yamrus, Dan Burkholder, Stephen John Phillips, Linda Ingraham and Holly roberts. Presents 10 photo shows/year. Shows last 1 month. General price range of work: $300-5,000.

Exhibits: Interested in work exploring human relationships or having psychological dimensions. Provocative work accepted. "Innovative figurative photography, male and female, is a particular direction."

Making Contact & Terms: Charges 50% commission. "Initially will only review transparencies and résumé; may later request to see actual work." Requires exclusive representation within metropolitan area or Mid-Atlantic region." No "walk-ins" please. SASE. Reports 1-2 months.

Tips: "Personal work is most interesting to the gallery."

WELLINGTON B. GRAY GALLERY, East Carolina University, Greenville NC 27858. (919)328-6336. Fax: (919)328-6441. Director: Gilbert Leebrick. Estab. 1978. Examples of exhibits: "A Question of Gender," by Angela Borodimos (color C-prints) and "Photographs from America," by Marsha Burns (gelatin silver prints). Presents 1 show/year. Shows last 1-2 months. General price range of work: $200-1,000.

Exhibits: For exhibit review, submit 20 slides, résumé, catalogs, etc., by November 15th annually. Exhibits are booked the next academic year. Work accepted must be framed or ready to hang. Interested in fine art photography.

Making Contact & Terms: Charges 20% commission. Reviews transparencies. Interested in framed work for exhibitions; send slides for exhibit committee's review. Send material by mail for consideration. SASE. Reports 1 month after slide deadline (November 15th).

HALLWALLS CONTEMPORARY ARTS CENTER, 2495 Main St., Suite 425, Buffalo NY 14214. (716)835-7362. Fax: (716)835-7364. E-mail: hallwall@pce.net.com. Visual Arts Director: Sara Kellner. Estab. 1974. Examples of recent exhibits: "Feed," by Heidi Kumao (zoetrope, mixed media); "Amendments," including Ricardo Zulueta (b&w performance stills); and "Altered Egos," including Janieta Eyre (Polaroid portraits). Presents 10 shows/year. Shows last 6 weeks.

Exhibits: Hallwalls is a nonprofit multimedia organization. "While we do not focus on the presentation of photography alone, we present innovative work by contemporary photographers in the context of contemporary art as a whole." Interested in work which expands the boundaries of traditional photography. No limitations on type, style or subject matter.

Making Contact & Terms: Photography sold in gallery. Reviews transparencies. Send material by mail for consideration. Do not send work. Work may be kept on file for additional review for 6 months.

Tips: "We're looking for photographers with innovative work; work that challenges the boundaries of the medium."

LEE HANSLEY GALLERY, 16 W. Martin St., #201, Raleigh NC 27601. (919)828-7557. Website: http://www.citysearch.com/rdu/hansleygallery. Gallery Director: Lee Hansley. Estab. 1993. Examples of recent exhibitions: "Nudes in Nature," by Ruth Pinnell (b&w photos); "Portrait of America," by Marsha Burns (large framed silver prints); "Landscapes," by Nona Short (b&w prints); Karl Koga (color prints); "The City" by Diana Bloomfield (platinum/paladium prints). Presents 3 shows/year. Shows last 4-6 weeks. General price range of work: $200-800.
Exhibits: Interested in new images using camera as a tool of manipulation; also minimalist works. Looks for top-quality work and a unique vision.
Making Contact & Terms: Charges 50% commission. Payment within one month of sale. Reviews transparencies. Interested in framed or unframed work. No mural-size works. Send material by mail for consideration. SASE. Reports in 2 months.
Tips: Looks for "originality and creativity—someone who sees with the camera and uses the parameters of the format to extract slices of life, architecture and nature."

HAYDON GALLERY, 335 N. Eighth St., Suite A, Lincoln NE 68508. (402)475-5421. Fax: (402)472-9185. E-mail: ap63142@navix.net. Director: Anne Pagel. Estab. 1987 (part of Sheldon Art & Gift Shop for 20 years prior). Example of recent exhibits: "The Digital Show" (12 photographers using computers). Presents 1 or 2 (of 9 solo exhibitions) plus group exhibitions/year. Shows last 1 month. Hors d'oeuvres provided by host couple, cost of beverages split between gallery and artist. (Exhibitions booked through 2002.) Artist presents gallery talk 1 week after the opening. General price range of work: $350-1,500.
Exhibits: Must do fine-quality, professional level art. "Interested in any photography medium or content, so long as the work is of high quality."
Making Contact & Terms: Charges 45% commission. Reviews transparencies. Interested in seeing framed or unframed, mounted or unmounted, matted or unmatted work. "Photos in inventory must be framed or boxed." Requires exclusive representation locally. Arrange a personal interview to show portfolio. Submit portfolio for review. SASE. Reports in 1 month.
Tips: "Submit a professional portfolio, including résumé, statement of purpose and a representative sampling from a cohesive body of work." Opportunities for photographers through galleries is becoming more competitive. "The public is still very conservative in its response to photography. My observation has been that although people express a preference for b&w photography, they purchase color."

THOMAS HEALY GALLERY, 530 W. 22nd St., New York NY 10011. (212)243-3753. Fax: (212)243-3668. Gallery Assistant: Kelly Calanni. Estab. 1995. Example of recent exhibitions: John Schabel Esco Männikkö (representational). Presents 1-2 shows/year. Shows last 1 month. General price range of work: $1,000-3,000.
Exhibits: "The photographers hopefully will have shown at some other galleries and have work that fits the conceptual ideology of our gallery. We are open to many different types and styles, however, the work must be provocative and strong technically."
Making Contact & Terms: Commission depends on individual situation. Reviews transparencies if requested. Interested in framed or unframed work. Requires exclusive representation locally. Arrange a personal interview to show portfolio. SASE.
Tips: "Get a contact person in the gallery, develop a relationship with that person and then invite him/her to your studio."

HEMPHILL FINE ARTS, 1027 33rd St. NW, Washington DC 20007. (202)342-5610. Fax: (202)342-2107. E-mail: hemphillfa@aol.com. Owner: George Hemphill. Estab. 1993. Examples of recent exhibitions: William Christenberry (color and b&w photos of rural Alabama); Robert Frank (street photography/gelatin silver); Colby Caldwell (hand-manipulated gelatin silver); and "Timeless Style: Ageless Photographs of Fashion from Bellocq to Newton." Shows last 5 weeks. General price range of work: $400-200,000.
Exhibits: "Must present a quality product and make art that is innovative, fresh and interesting. Personality is a big factor as well." Interested in wide-ranging art of all periods.
Making Contact & Terms: Receives variable commission. Buys photos outright. Reviews transparencies. Requires exclusive representation locally. Arrange a personal interview to show portfolio. Send material by mail for consideration. SASE. Reporting time varies.

HUGHES FINE ARTS CENTER, Dept. of Visual Arts, Box 7099, Grand Forks ND 58202-7099. (701)777-2906. Fax: (701)777-3395. Website: http://www.und.edu/dept/fac/visual-home.html. Director: Brian Paulsen. Estab. 1979. Examples of exhibits: works by James Falkofske and Alexis Schaefer. Presents 11-14 shows/year. Shows last 2-3 weeks. Gallery has 99 feet of wall space. "We pay shipping costs."
Exhibits: Interested in any subject; mixed media photos, unique technique, unusual subjects.
Making Contact & Terms: Does not charge commission; sales are between artist-buyer. Reviews trans-

parencies. "Works should be framed and matted." No size limits or restrictions. Send 10-20 transparencies with résumé. SASE. Reports in 2 weeks.

Tips: "Send slides of work . . . we will dupe originals and return ASAP and contact you later." Needs "fewer photos imitating other art movements. Photographers should show their own inherent qualities. No Ansel Adams. No airport lobby landscapes. Have a personal vision or statement."

HUNTSVILLE MUSEUM OF ART, 300 Church St. South, Huntsville AL 35801. (205)535-4350. Fax: (205)532-1743. Chief Curator: Peter J. Baldaia. Estab. 1970. Examples of recent exhibits: "Still Time," by Sally Mann (b&w/color); "Salvation on Sand Mountain," by Melissa Springer/Jim Neel (b&w documentary); and "Encounters," by John Reese (b&w Alabama subjects). Presents 1-2 shows/year. Shows last 6-8 weeks.

Exhibits: Must have professional track record and résumé, slides, critical reviews in package (for curatorial review). Regional connection preferred. No specific stylistic or thematic criteria.

Making Contact & Terms: Buys photos outright. Reviews transparencies. Interested in framed or unframed, mounted or unmounted, matted or unmatted work. Send material by mail for consideration. SASE. Reports in 1-3 months.

ICEBOX QUALITY FRAMING & GALLERY, 2401 Central Ave. NE, Minneapolis MN 55418. (612)788-1790. Contact: Howard Christopherson. Exhibition, promotion and sales gallery. Estab. 1988. Examples of recent exhibits: "The Nude, Form & Spirit" by Doug Beasley; "South of the Border" by 13 Minnesota photographers (photographs of South and Central America); and "Greetings From New York City" by Flo Fox. Represents photographers and fine artists in all media. Specializes in "thought-provoking artwork and photography, predominantly Minnesota artists." Markets include: corporate collections; interior decorators; museums; private collections.

Exhibits: Fine art and fine art photographs of "artists with serious, thought-provoking work who find it hard to fit in with the more commercial art gallery scene. A for-profit alternative gallery, Icebox sponsors installations and exhibits in the gallery's intimate black-walled space."

Making Contact & Terms: Sliding sales commission. Send letter of interest telling why you would like to exhibit at Icebox. Include slides and other appropriate materials for review. "At first, send materials that can be kept at the gallery and updated as needed."

Tips: "We are also experienced with the out-of-town artist's needs."

INDIANAPOLIS ART CENTER, 820 E. 67th St., Indianapolis IN 46220. (317)255-2464. Fax: (317)254-0486. E-mail: inartctr@inetdirect.net. Exhibitions Curator: Julia Moore. Estab. 1934. Examples of exhibitions: "Rough Basement" by Deborah Brackenburg, Aimee Bott and Mark Sawrie (photo-based installations); "Memories" by Mary Pencheff and Keith Holms (infrared photography; photo installation); and (Untitled) by Richard Jurus, Amanda Warner Fruits and Kellie Murphy Klein (unusual processes). Presents 1-2 photography shows/year out of 13-20 shows in a season. Shows last 4-6 weeks. General price range of work: $100-1,000.

Exhibits: Preferably live within 250 miles of Indianapolis. Interested in very contemporary work, preferably unusual processes.

Making Contact & Terms: Charges 35% commission. One-person show: $300 honorarium; two-person show: $200 honorarium; three-person show $100 honorarium; plus $0.28/mile travel stipend. Reviews transparencies. Interested in framed (or other finished-presentation formatted) work only for final exhibition. Send material by mail for consideration. Send minimum 20 slides with résumé, reviews, artist's statement by December 31. No wildlife or landscape photography. Interesting color work is appreciated. SASE.

Tips: "We like photography with a very contemporary look that incorporates unusual processes and/or photography with mixed media."

INTERNATIONAL CENTER OF PHOTOGRAPHY, 1130 Fifth Ave., New York NY 10128. (212)860-1777. Fax: (212)360-6490. Contact: Department of Exhibitions. Estab. 1974.

Making Contact & Terms: Portfolio reviews are held the first Monday of each month. Submit portfolio to the receptionist by noon and pick up the following afternoon. Include cover letter, résumé of exhibitions and publications, artist's statement and, if necessary, a project description. "Once reviewed by the Exhibitions Department Curatorial Committee, the portfolio can be picked up on the following day any time after noon. We would prefer that you submit only one portfolio and that it not exceed 20×24 inches. The exterior of the portfolio must be labeled clearly with your name, address, and telephone number." Work also may be submitted by mail. "We do not recommend sending prints through the mail due to the possibility of loss or damage. We suggest sending 20-40 slides, along with the supporting materials listed above. All slides should be labeled or accompanied by a slide list. Please allow 6-8 weeks for response. Video work

should be submitted in ½-¾ inch format. Return postage must be included to ensure return of materials."

[N] [icon] **INTRALUX GALLERY**, 227 Carrall St., Vancouver, British Columbia V6B 2J2 Canada. (604)602-0570. Fax: (604)602-7060. E-mail: cami@intergate.bc.ca. Website: http://artsource.shinnova.ca. Director: Arvind Thadhani. Alternative space, art consultancy, rental gallery. Estab. 1997. Approached by 120 artists a year; represents or exhibits 2-4 artists/month. Example of recent exhibit: "Wallflowers Rebirth," by Barbara Worth (photograms). Average display time 1-2 months. Open Tuesday through Sunday from 11 to 6; weekends from 12 to 5 all year. "Location: Gastown/Tourist District of Vancouver; 600 square feet, wood floors, fireplace, white wall space and 16 ft. ceilings." Overall price range $500-5,000. Most work sold at $600.
Exhibits: All types of photography with unique style and concepts.
Making Contact & Terms: Artwork is accepted on consignment and there is a 50% commission. Retail price set by the gallery and the artist. Gallery provides insurance, promotion and contract. Accepted work should be framed, mounted. Requires exclusive representation locally. Accepts only artists living in Vancouver or British Columbia. Call to show portfolio of photographs, slides, transparencies. Send query letter with artist's statement, bio, photographs, résumé. Replies in 2 weeks to 1 month. Artist should "keep in touch as well." Finds artists by word of mouth, submissions, portfolio reviews, art exhibits, referrals by other artists.
Tips: "No amateurism. Be professional. Photography has made huge strides to prove that it is a technically skilled art form and requires as much of a creative eye and talent as other forms, if not more in order to be unique. Photos can be quite painterly if processed well."

ISLIP ART MUSEUM, 50 Irish Lane, Islip NY 11730. (516)224-5402. Director: M.L. Cohalan. Estab. 1973. Has exhibited work by Robert Flynt, Skeet McAuley and James Fraschetti. Shows last 6-8 weeks. General price range of work: $200-3,000.
Exhibits: Interested in contemporary or avant-garde works.
Making Contact & Terms: Charges 30% commission. Reviews transparencies. Send slides and résumé; no original work. Reports in 1 month.
Tips: "Our museum exhibits theme shows. We seldom exhibit work of individual artists. Themes reflect ideas and issues facing current avant-garde art world. We are a museum. Our prime function is to exhibit, not promote or sell work."

JADITE GALLERIES, 413 W. 50th St., New York NY 10019. (212)315-2740. Fax: (212)315-2793. Director: Roland Sainz. Estab. 1985. Examples of recent exhibits: "Old World/New World," by Juliet Stelsman (b&w photographs); "Political Collages," by Brent James (mixed media photographs); and "ErOs," by Luis Mayo (mixed media photographs). Presents 1-2 shows/year. Shows last 1 month. General price range of work: $200-1,000.
Exhibits: Interested in b&w, color and mixed media.
Making Contact & Terms: Charges 40% commission. Reviews transparencies. Interested in unframed work only. Arrange a personal interview to show portfolio. Submit portfolio for review. SASE. Reports in 2-5 weeks.

KEARON-HEMPENSTALL GALLERY, 536 Bergen Ave., Jersey City NJ 07304. (201)333-8855. Fax: (201)333-8488. E-mail: khgallery@usa.net Director: Suzann McKiernan. Estab. 1980. Example of recent exhibits: "Guitars" by Emanuel Pontoriero (16×20 Cibachrome/guitars and the female form). Presents 1 show/year. Shows last 1 month. General price range of work: $150-400.
Exhibits: Interested in color and b&w prints.
Making Contact & Terms: Charges 50% commission. Reviews transparencies. Interested in mounted, matted work only. Requires exclusive representation locally. Send material by mail for consideration. Include resume, exhibition listing, artist's statement and price of sold work. SASE. Reports in 1 month.
Tips: "Be professional: have a full portfolio; be energetic and willing to assist with sales of your work."

KENT STATE UNIVERSITY SCHOOL OF ART GALLERY, Dept. PM, KSU, 201 Art Building, Kent OH 44242. (330)672-7853. Fax: (330)672-9570 Director: Fred T. Smith. Examples of recent exhibits:

THE SUBJECT INDEX, located at the back of this book, lists publications, book publishers, galleries, gift and paper product companies and stock agencies according to the subject areas they seek.

"Settings by Eight: New Work by Northern Ohio Women Photographers," Mary Adler, Linda Bourassa, Linda Butler, Judith McMillian, Rene Psiakas, Penny Rakoff, Mary Jo Toles, Garie Waltzer. Presents 1 show/year. Exhibits last 3 weeks.
Exhibits: Interested in all types, styles and subject matter of photography. Photographer must present quality work.
Making Contact & Terms: Photography can be sold in gallery. Charges 20% commission. Buys photography outright. Will review transparencies. Write a proposal and send with slides. Send material by mail for consideration. SASE. Reports usually in 4 months, but it depends on time submitted.

ROBERT KLEIN GALLERY, 38 Newbury St., Boston MA 02116. (617)267-7997. Fax: (617)267-5567. President: Robert L. Klein. Estab. 1978. Examples of recent exhibits: work by William Wegman, Tom Baril and Atget. Presents 10 exhibits/year. Shows last 5 weeks. General price range of work: $600-200,000.
Exhibits: Must be established a minimum of 5 years; preferably published. Interested in fashion, documentary, nudes, portraiture, and work that has been fabricated to be photographs.
Making Contact & Terms: Charges 50% commission. Buys photos outright. Reviews transparencies. Interested in unframed, unmatted, unmounted work only. Requires exclusive representation locally. Send material by mail for consideration. SASE. Reports in 2 months.

PAUL KOPEIKIN GALLERY, 138 N. La Brea Ave., Los Angeles CA 90036. (213)937-0765. Fax: (213)937-5974. Associate Director: Pilar Graves. Estab. 1990. Examples of recent exhibitions: Lee Friedlander (b&w 35mm); Karen Halverson (color landscapes). Presents 7-9 shows/year. Shows last 4-6 weeks. General price range of work: $400-4,000.
Exhibits: Must be highly professional. Quality and unique point of view also important. No restriction on type, style or subject.
Making Contact & Terms: Charges 50% commission. Reviews transparencies. Requires exclusive representation locally. Submit slides and support material. SASE. Reports in 1-2 weeks.
Tips: "Don't waste people's time by showing work before you're ready to do so."

N ⊕ **KUFA GALLERY**, 26 Westbourne Grove, London W 2 5RH United Kingdom. Phone: (0171)229-1928. Fax: (0171)243-8513. E-mail: kufa@dikon.co.uk. Manager: Walid Atiyeh. Nonprofit gallery. Estab. 1986. Approached by 50 artists a year; represents or exhibits 12 artists. Sponsors 12 photography exhibits/year. Average display time 2-4 weeks. Open 10 through 6 from Monday to Saturday.
Exhibits: Photographic work on the Middle East, mainly architecture and historical places.
Making Contact & Terms: Retail price set by the artist. Accepted work should be framed, mounted, matted. Requires exclusive representation locally. Call/write to arrange a personal interview to show portfolio of photographs, slides, transparencies, other. Send query letter. Finds artists through submissions.
Tips: "Send work or call but must have good slides or photographs."

KUNTSWERK GALERIE, 1800 W. Cornelia, Chicago IL 60657. (773)935-1854. Fax: (773)478-2395. Website: http://www.fota.com. Co-director: Thomas Frerk. Estab. 1995. Examples of recent exhibits: "Legume du Jour," by Scott Mayer (b&w city photography); "Manhood," by Gina Dawden (layered b&w male figurative); and "Art Crawl," by Terry Gaskins (Chicago personalities). Presents 4-8 shows/year. Shows last 2-6 weeks. General price range of work: $50-500.
Exhibits: Photographer "must be interested in showing work in a more avant garde setting." Interested in female/male figurative; landscapes (b&w preferably); experimental (i.e., layered images, polaroid transfers, photography painting, etc.).
Making Contact & Terms: Charges maximum 25% commission; varies by artist. Reviews transparencies. Interested in framed or unframed, matted or unmatted work. Send material by mail for consideration. SASE. Reports in 1 month.
Tips: "We encourage emerging artists. Go out and beat the bushes. Beginners should be wary of overpricing their work. To avoid this, don't bother framing or use simple framing to keep costs down. Also, find outlets to get your work published, i.e., bands who need album covers and free newspapers in search of artistic photos. We can arrange for an artist to put their portfolio on our website."

LA MAMA LA GALLERIA, 6 E. First Street, New York NY 10003. (212)505-2476. Director/Curator: Merry Geng. Estab. 1982. La Galleria is located in the downtown East Village section of Manhattan. Close to various transportation. Street level access. Also doubles as a poetry/play reading center during weekends. Examples of exhibits: "Jocks in Frocks," by Charles Justina; "Styles & Aesthetics," group show. Presents 2 shows/year. Shows last 3 weeks. General price range of work: $200-2,000.
Exhibits: Interested in all types of work. Looking for "focused creativity."
Making Contact & Terms: Charges 20% commission. Prices set by agreement between director/curator

and photographer. Reviews transparencies. Interested in framed or mounted work. Arrange a personal interview to show portfolio. Send material by mail for consideration. SASE. Reports in 1 month.
Tips: "Be patient; we are continuously booked 18 months-2 years ahead. I look for something that catches my interest by way of beauty, creativity. Also looking for unusual combinations of photography/art work."

J. LAWRENCE GALLERY, 1435 Highland Ave., Melbourne FL 32935. (407)259-1492. Fax: (407)259-1494. Owner: Joseph L. Conneen, Jr. Estab. 1984. Examples of exhibits: works by Lloyd Behrendt (hand-tinted b&w), Chuck Harris (Cibachrome), and Clyde & Nikki Butcher (b&w and hand-tinted b&w). Most shows are group exhibits. Shows last 6 weeks. General price range of work: $200-1,000.
Exhibits: Must be original works done by the photographer. Interested in Cibachrome; hand-tinted b&w and b&w.
Making Contact & Terms: Charges 40% commission. Reviews transparencies. Interested in framed or unframed, mounted or unmounted, matted or unmatted work. Requires exclusive representation locally. Arrange a personal interview to show portfolio. Submit portfolio for review. Query with résumé of credits. Query with samples. Send material by mail for consideration. SASE. Reports in 1-2 weeks.
Tips: "The market for fine art photography is growing stronger."

LE PETIT MUSÉE, 137 Front St., P.O. Box 556, Housatonic MA 01236. (416)274-1200. Director: Sherry Steiner. Estab. 1992. General price range of work: $50-500.
Making Contact & Terms: Charges 50% commission. Reviews transparencies. Interested in framed or unframed, mounted or unmounted, matted or unmatted work. Works are limited to no larger than 12×16 framed. Send material by mail for consideration. SASE. Reports in 1-2 weeks.

ELIZABETH LEACH GALLERY, 207 SW Pine, Portland OR 97204. (503)224-0521. Fax: (503)224-0844. Gallery Director: Steven Tremble. Examples of recent exhibits: Terry Toedtemeier (landscape/gelatin silver prints); Christopher Rauschenberg (landscape/gelatin silver print collage); and Richard Misrach (Extacolor photographs). Presents 1-2 shows/year. Shows last 1 month. "The gallery has extended hours every first Thursday of the month for our openings." General price range of work: $300-5,000.
Exhibits: Photographers must meet museum conservation standards. Interested in "high quality and fine craftmanship."
Making Contact & Terms: Charges 50% commission. Reviews transparencies. Interested in framed or unframed, matted work. Requires exclusive representation locally. Submit slides with résumé, artist statement, articles and SASE. Reports every 4 months.

N **L'ESPACE F:**, 299 Avenue Saint-Jérôme, Matane, Québec G4W 4A1 Canada. (418)562-8661. E-mail: espacef@cit.qc.ca. Coordinator: Diane Lajoie. Nonprofit artist center. Estab. 1987. Approached by 25 artists a year. Examples of recent exhibits: "Conversations in times avec la nature," by Réal Filion; "Voyage à Domicile," by Bertrand Carrière; "Sept Villes," by Pierre Guimond. Sponsors 9 photography exhibits/year. Average display time 1 month.
Exhibits: "We present any work in photography or video that shows skill and art."
Making Contact & Terms: Gallery provides promotion, contract. Accepted work should be framed, mounted. Requires exclusive representation locally. Mail portfolio for review. Send query letter with artist's statement, bio, brochure, photographs, résumé, reviews. Replies in 2 weeks. Finds artists through submissions, portfolio reviews, art exhibits.

LEWIS LEHR INC., Box 1008, Gracie Station, New York NY 10028. (212)288-6765. Director: Lewis Lehr. Estab. 1984. Private dealer. Buys vintage photos. Examples of recent exhibits: "American West" and "Farm Security Administration," both by various photographers; "Camera Work," by Stieglitz. General price range of work: $500 plus.
Making Contact & Terms: Charges 50% commission. Buys photography outright. Do not submit transparencies. Requires exclusive representation within metropolitan area. Query with résumé of credits. SASE. Member AIPAD.
Tips: Vintage American sells best. Sees trend toward "more color and larger" print sizes. To break in, "knock on doors." Do not send work or slides.

THE LIGHT FACTORY, P.O. Box 32815, Charlotte NC 28232. (704)333-9755. Fax: (704)333-5910. E-mail: tlf@webserve.net. Website: http://www.lightfactory.org. Executive Director: Bruce Lineker. Nonprofit. Estab. 1972. Presents 8-10 shows/year. Shows last 2 months. General price range of work: $500-15,000.
Exhibits: Photographer must have a professional exhibition record. Interested in light-generated media (photography, video, film, the Internet).

Making Contact & Terms: Artwork sold in the gallery. "Artists price their work." Charges 33% commission. No permanent collection. Reviews transparencies. Query with résumé of credits and slides. Artist's statement requested. SASE. Reports in 2 months.

LIZARDI/HARP GALLERY, P.O. Box 91895, Pasadena CA 91109. (626)791-8123. Fax: (626)791-8887. E-mail: lizardiharp@earthlink.net. Director: Grady Harp. Estab. 1981. Examples of exhibits: "E.F. Kitchen," by E.F. Kitchen (nudes, still lifes); "Ghosting," by Erik Olson (male nudes); and "Vatican Series," by Christopher James ("inside" view of nuns). Presents 3-4 shows/year. Shows last 4-6 weeks. General price range of work: $500-4,000.
Exhibits: Must have more than one portfolio of subject, unique slant and professional manner. Interested in figurative, nudes, "maybe" manipulated work, documentary and mood landscapes, both b&w and color.
Making Contact & Terms: Charges 50% commission. Reviews transparencies. Interested in unframed, unmounted and matted or unmatted work. Submit portfolio for review. Query with résumé of credits. Query with samples. Send material by mail for consideration. SASE. Reports in 1 month.

M.C. GALLERY, 400 First Ave. N., Minneapolis MN 55401. (612)339-1480. Fax: (612)339-1480. Director: M.C. Anderson. Estab. 1984. Examples of recent exhibits: works by Gloria Dephilips Brush, Ann Hofkin and Catherine Kemp. Shows last 6 weeks. General price range of work: $300-1,200.
Exhibits: Interested in avant-garde work.
Making Contact & Terms: Charges 50% commission. Reviews transparencies. Interested in framed or unframed work. Requires exclusive representation within metropolitan area. Submit portfolio for review. Query with résumé of credits. Send material by mail for consideration. Material will be returned, but 2-3 times/year. Reports in 1-2 weeks if strongly interested, or it could be several months.

MAINE COAST ARTISTS, 162 Russell Ave., Rockport ME 04856. (207)236-2875. Fax: (207)236-2490. E-mail: mca@midcoast.com. Website: http://www.midcoast.com/~mca. Artistic Director: John Chandler. Estab. 1952. Examples of recent exhibits: "Rockport Harbor and Village 1890-1930," private and area historical societies (photographic history); "Maine Debuts" (juried show since 1979) by Dick McDonnel, Paul D'Amato and others; "When Pixels Replace Paints," by John Paul Caponigro and others (digitally remastered photos). Number of shows varies. Shows last 1 month. General price range of work: $200-2,000.
• This gallery has received a National Endowment for the Arts grant.
Exhibits: Photographer must live and work part of the year in Maine; work should be recent and not previously exhibited in the area.
Making Contact & Terms: Charges 40% commission. Reviews transparencies. Accepts images in digital format for Mac. Send via compact disc or Online. Query with résumé of credits. Query with samples. Send material by mail for consideration. SASE. Reports in 2 months.
Tips: "A photographer can request receipt of application for our annual juried exhibition (June 13-July 19), as well as apply for solo or group exhibitions. MCA is exhibiting more and more photography."

MARLBORO GALLERY, Prince George's Community College, 301 Largo Road, Largo MD 20772-2199. (301)322-0967. Gallery Curator: John Krumrein. Estab. 1976. Examples of recent exhibitions: "Blues Face/Blues Places," John Belushi's blues collection photos (various photographers); "Blues Face/Blues Places," the David Spitzer collection of blues; and "Greek Influence," photos of Greece by various photographers. Shows last 3-4 weeks. General price range of work: $50-5,000.
Exhibits: Not interested in commercial work. "We are looking for fine art photos, we need between 10 to 20 to make assessment, and reviews are done every six months. We prefer submissions during February-April."
Making Contact & Terms: Reviews transparencies. Interested in framed work only. Query with samples. Send material by mail for consideration. SASE. Reports in 3-4 weeks.
Tips: "Send examples of what you wish to display and explanations if photos do not meet normal standards (i.e., in focus, experimental subject matter)."

MARSH ART GALLERY, University of Richmond, Richmond VA 23173. (804)289-8276. Fax: (804)287-6006. E-mail: rwaller@richmond.edu. Website: http://www.richmond.edu/. Director: Richard Waller. Estab. 1968. Example of recent exhibition: "Personal Visions: 101 Photographs by 101 Photographers." Presents 8-10 shows/year. Shows last 1 month.
Exhibits: Interested in all subjects.
Making Contact & Terms: Charges 10% commission. Reviews transparencies. Interested in framed or unframed, mounted or unmounted, matted or unmatted work. Work must be framed for exhibition. Query with résumé of credits. Query with samples. Send material by mail for consideration. Reports in 1 month.

© Willis Lee

"Willis Lee first came to our attention through his photogravures at Hand Graphics, where he prints some of his beautiful limited editions. Following that, he made a presentation of one of his quality portfolios and as a result we began exhibiting his photographs on a regular basis five years ago," says Ernesto Mayans, owner of the Mayans Gallery in Santa Fe. This image, as part of the "Grama Grass Series," was released in a limited edition of 50. "Grama Grass I & II" are photogravures printed as chine collé on handmade Japanese rice paper then mounted on a heavier paper. "This is as close to perfection as a photographer gets when printing his or her own work," Mayans says.

Tips: If possible, submit material which can be left on file and fits standard letter file. "We are a nonprofit university gallery interested in presenting contemporary art."

MORTON J. MAY FOUNDATION GALLERY—MARYVILLE UNIVERSITY, 13550 Conway Rd., St. Louis MO 63141. (314)529-9415. Fax: (314)529-9965. Gallery Director and Art Professor: Nancy N. Rice. Examples of recent exhibits: "Recent Work," by Stacey C. Morse (b&w landscapes). Presents 1-3 shows/year. Shows last 1 month. General price range of work: $25-500.
Exhibits: Must transcend student work, must have a consistent aesthetic point of view or consistent theme, and must be technically excellent.
Making Contact & Terms: Photographer is responsible for all shipping costs to and from gallery. Gallery takes no commission; photographer responsible for collecting fees. Interested in framed or unframed, mounted or unmounted, matted or unmatted work (when exhibited, work must be framed or suitably presented.) Send material by mail for consideration. SASE. Reports in 3-4 months.

THE MAYANS GALLERY LTD., 601 Canyon Rd., Santa Fe NM 87501. (505)983-8068. Fax: (505)982-1999. E-mail: arte2@aol.com. Website: http://www.arnet.com./mayans/html. Director: Ernesto Mayans. Associate: Ava M. Hu. Estab. 1977. Examples of exhibits: "Cholos/East L.A.," by Graciela Iturbide (b&w); "Ranchos de Taos Portfolio," by Doug Keats (Fresson), "A Diary of Light," by André Kertész (b&w), "Floralia" by Willis Lee (photo gravures prints); Manuel Alvarez Bravo (b&w); and Diane Kaye (b&w). Publishes books, catalogs and portfolios. General price range of work: $200-5,000.
Making Contact & Terms: Charges 50% commission. Consigns; also buys photos outright. Interested in framed or unframed, mounted or unmounted work. Requires exclusive representation within area. Size limited to 11×20 maximum. Arrange a personal interview to show portfolio. Send inquiry by mail for consideration. SASE. Reports in 1-2 weeks.
Tips: "Please call before submitting."

PETER MILLER GALLERY, 740 N. Franklin, Chicago IL 60610. (312)951-0252. Fax: (312)951-2628. E-mail: pmgallery@aol.com. Directors: Peter Miller and Natalie R. Domchenko. Estab. 1979. Gallery is 2,000 sq. ft. with 12 foot ceilings.
Exhibits: "We are interested in adding photography to the work currently exhibited here."
Making Contact & Terms: Charges 50% commission. Reviews transparencies. Interested in framed or unframed, mounted or unmounted, matted or unmatted work. Requires exclusive representation locally. Send 20 slides of the most recent work with SASE. Reports in 1-2 weeks.
Tips: "We look for work we haven't seen before, i.e. new images and new approaches to the medium."

MONTEREY MUSEUM OF ART, (formerly Monterey Peninsula Museum of Art), 559 Pacific St., Monterey CA 93940. (408)372-5477. Fax: (408)372-5680. Director: Richard W. Gadd. Estab. 1969. Examples of recent exhibits: "The Edge of Shadow," photographs from the Page Collection; "Peninsula People: Portraits," by John McCleary. Presents 4-6 shows/year. Shows last approximately 6-12 weeks.
Exhibits: Interested in all subjects.
Making Contact & Terms: Reviews transparencies. Work must be framed to be displayed; review can be by slides, transparencies. Send material by mail for consideration. SASE. Reports in 1 month.
Tips: "Send 20 slides and résumé at any time to the attention of the museum director."

MORGAN GALLERY, 412 Delaware, Suite A, Kansas City MO 64105. (816)842-8755. Fax: (816)842-3376. Director: Dennis Morgan. Estab. 1969. Examples of recent exhibitions: photos by Holly Roberts; Dick Arentz (platinum); Linda Conner (b&w) and William Christenberry. Presents 1-2 shows/year. Shows last 4-6 weeks. General price range of work: $250-5,000.
Making Contact & Terms: Reviews transparencies. Submit portfolio for review. Send material by mail for consideration. SASE. Reports in 3 months.

N THE MUSEUM OF CONTEMPORARY PHOTOGRAPHY, COLUMBIA COLLEGE CHICAGO, 600 S. Michigan Ave., Chicago IL 60605-1996. (312)663-5554. Fax: (312)360-1656. Director: Denise Miller. Assistant Director: Nancy Fewkes. Estab. 1984. Examples of exhibits: "Open Spain/Espana Abierta" (contemporary documentary Spanish photography/group show); "The Duane Michals Show," by Duane Michals (b&w narrative sequences, surreal, directorial); "Irving Penn: Master Images," by Irving Penn (b&w fashion, still life, portraiture). Presents 5 main shows and 8-10 smaller shows/year. Shows last 8 weeks. General price range of work: $300-2,000.
Exhibits: Interested in fine art, documentary, photojournalism, commercial, technical/scientific. "All high quality work considered."
Making Contact & Terms: Charges 30% commission. Buys photos outright. Reviews transparencies. Accepts images in digital format for Mac and Windows. Send via compact disc, floppy disk or SyQuest. Interested in reviewing unframed work only, matted or unmatted. Submit portfolio for review. SASE. Reports in 2 weeks. No critical review offered.
Tips: "Interested in fine art, documentary, photojournalism, commercial, technical/scientific. Professional standards apply; only very high quality work considered."

MUSEUM OF PHOTOGRAPHIC ARTS, 1649 El Prado, Balboa Park, San Diego CA 92101. (619)238-7559. Fax: (619)238-8777. E-mail: info@mopa.org. Website: http://www.mopa.org. Director: Arthur Ollman. Curator: Diana Gaston. Estab. 1983. Examples of recent exhibits featuring contemporary photographers from the U.S. and abroad include: "Current Fictions," by 8 emerging artists; "Republic: History of San Diego," by Richard Bolton (video-based installation); and "Points of Entry: A Nation of Strangers." Presents 6-8 exhibitions annually from 19th century to contemporary. Each exhibition lasts approximately 2 months. Exhibition schedules planned 2-3 years in advance. Holds a private Members' Opening Reception for each exhibition.
Exhibits: "The criteria is simply that the photography be the finest and most interesting in the world, relative to other fine art activity. MoPA is a museum and therefore does not sell works in exhibitions. There are no fees involved."
Making Contact & Terms: "For space, time and curatorial reasons, there are few opportunities to present the work of newer, lesser-known photographers." Send an artist's statement and a résumé of credits with a portfolio (unframed photographs) or slides. Portfolios may be submitted for review with advance notification and picked up in 2-3 days. Files are kept on contemporary artists for future reference. Send return address and postage. Reports in 2 months.
Tips: "Exhibitions presented by the museum represent the full range of artistic and journalistic photographic works." There are no specific requirements. "The executive director and curator make all decisions on works that will be included in exhibitions. There is an enormous stylistic diversity in the photographic arts. The museum does not place an emphasis on one style or technique over another."

N ⊕ NORTHCOTE GALLERY, 110 Northcote Rd., London SW11 6QP United Kingdom. Phone: (0171)924-6761. Fax: (0171)926-6741. Director: Ali Pettit. Art consultancy, wholesale gallery. Estab. 1992. Approached by 100 artists a year; represents or exhibits 30 artists. Sponsors 2 photography exhibits/year. Average display time 3-4 weeks. Open Tuesday through Saturday from 11 to 7; weekends from 11 to 6, all year. "Located in southwest London. Popular High Street area. One large exhibition space, 1 smaller space; average of 35 works exhibited per time."
Exhibits: Accepts most genres, specifically hand painted/tinted.
Making Contact & Terms: Artwork is accepted on consignment and there is a 45% commission. Retail

price set by the gallery. Accepted work should be framed. Send query letter with, artist's statement, bio, brochure, photographs, résumé, reviews, SASE. Replies in 4-6 weeks. Finds artists by word of mouth, submissions, portfolio reviews, referrals by other artists.

NORTHLIGHT GALLERY, School of Art, Arizona State University, Tempe AZ 85287-1505. (602)965-6517. Contact: Advisory Committee. Estab. 1972. Examples of recent exhibits: "Family Matters," by Sally Mann, Vince Leo, Melissa Shook, Phillip Lorca DiCorcia; Richard Bolton; Jay Wolke, Paul DaMato, Beaumont Newhall. Presents 6 shows/year. Shows last 1 month.
Exhibits: Review by Northlight advisory committee for academic year scheduling. Interested in "any and all" photography.
Making Contact & Terms: Reviews transparencies. SASE. Reports in 1 month.

NORTHWEST ART CENTER, 500 University Ave. W., Minot ND 58707. (701)858-3264. Fax: (701)839-6933. Director: Linda Olson. Estab. 1976. Presents 24 shows/year. Shows last 1 month. Northwest Art Center consists of 2 galleries: Hartnet Hall Gallery and the Library Gallery. General price range of work: $50-300. Examples of recent exhibitions: "Abandon in Place," by Zoe Spooner (b&w photos).
Making Contact & Terms: Charges 30% commission. Reviews transparencies. Interested in framed work only, mounted or unmounted, matted or unmatted. Send material by mail for consideration. SASE. Reports in 1 month.

THE NOYES MUSEUM OF ART, Lily Lake Rd., Oceanville NJ 08231. (609)652-8848. Fax: (609)652-6166. Curator: Stacy Smith. Estab. 1983. Examples of recent exhibitions: "American Amusements," by David Ricci (silver dye-bleach); photographs by Dwight Hiscano (Cibachrome); "Dust-shaped Hearts: Photographic Portraits," by Don Camp (casein and earth pigment monoprints). Presents 2-3 shows/year. Shows last 6-12 weeks. General price range of work: $150-1,000.
Exhibits: Works must be ready for hanging, framed preferable. Interested in all styles.
Making Contact & Terms: Charges 10% commission. Infrequently buys photos for permanent collection. Reviews transparencies. Any format OK for initial review. Send material by mail for consideration, include résumé and slide samples. Reports in 1 month.
Tips: "Send challenging, cohesive body of work. May include photography and mixed media."

O.K. HARRIS WORKS OF ART, 383 W. Broadway, New York NY 10012. (212)431-3600. Fax: (212)925-4797. Director: Ivan C. Karp. Estab. 1969. Examples of exhibits: "No Easy Walk," by Helen Stummer (scenes from Newark, New Jersey, rural Maine and Guatemala); "Castaways," by Kevin P. Hughes (squatters and passersby on the Williamsburg (Brooklyn) waterfront); and "Snowbirds," by Greg Ceo (retirement couples in their Florida homes). Presents 3-8 shows/year. Shows last 4 weeks. General price range of work: $350-1,200.
● This gallery is closed the month of August .
Exhibits: "The images should be startling or profoundly evocative. No rock, dunes, weeds or nudes reclining on any of the above or seascapes." Interested in urban and industrial subjects and cogent photojournalism.
Making Contact & Terms: Charges 40% commission. Interested in matted or unmatted work. Appear in person, no appointment: Tuesday-Friday 10-6. SASE. Reports back immediately.
Tips: "Do not provide a descriptive text."

OLIN FINE ARTS GALLERY, Washington & Jefferson College, Washington PA 15301. (412)222-4400. Fax: (412)223-5271. Website: http://www.washjeff.edu. Contact: Pat Maloney. Estab. 1982. Examples of previous exhibits: one-person show by William Wellman; "The Eighties," by Mark Perrott. Presents 1 show/year. Shows last 3 weeks. General price range of work: $50-1,500.
Exhibits: Interested in large format, experimental, traditional photos.
Making Contact & Terms: Charges 20% commission. Reviews transparencies. Interested in framed work only. Shows are limited to works that are no bigger than 6 feet and not for publication. Send material by mail for consideration. SASE. Reports in 1 month.

OLIVER ART CENTER-CALIFORNIA COLLEGE OF ARTS & CRAFTS, 5212 Broadway, Oakland CA 94618. (510)594-3650. Fax: (510)428-1346. Director-Exhibitions/Public Programming: Lawrence

CONTACT THE EDITOR, of *Photographer's Market* by e-mail at photomarket@fwpubs.com with your questions and comments.

Rinder. Estab. 1989. Examples of recent exhibitions: "Landscape: A Concept," by Andy Goldsworthy, Vito Acconci, Catherine Wagner, Judy Fiskin and others; "Cultural Identities and Immigration-Changing Images of America in the 90's," by Larry Sultan, Young Kim, Su-Chen Hung and others; and "Judy Dater: A Survey." Presents 1-2 exhibits/year. Shows last 6-8 weeks.

Exhibits: Must be professional photographer with at least a 5-year exhibition record. Interested in contemporary photography in all formats and genres.

Making Contact & Terms: "All subjects and styles are accepted for our slide registry." Payment negotiable. Reviews transparencies. Query with résumé of credits. SASE. Reports in 1 month.

Tips: "Know the types of exhibitions we have presented and the audience which we serve."

N ⊕ THE 198 GALLERY, 194-198, Railton Rd., London SE24 0JT United Kingdom. Phone: (0171)978-8309. Fax: (0171)652-1418. E-mail: 198gallery@globalnet.co.uk. Website: http://www.globaln et.co.uk/~198gallery. Director: Zoë Linsley-Thomas. Nonprofit gallery, craft shop, artists studios. Estab. 1989. Approached by 40-50 artists a year; represents or exhibits 10 artists. Examples of recent exhibits: "Deep," by Clement Cooper (photographic portraits). Sponsors 1 photography exhibit/year. Average display time 4-5 weeks. Open Tuesday through Saturday from 1-7, all year; Tuesday through Friday from 9-1 for education/schools. "Located at Herne Hill near Brixton with two small galleries, exclusive craft shop, education workshop and exhibition space."

Exhibits: Cultural issue based art.

Making Contact & Terms: Artwork is accepted on consignment and there is a 33% commission. Retail price set by the artist. Accepted work should be framed. Accepts only artists of African, Asian, Caribbean descent living and working in Britain. Write to arrange a personal interview to show portfolio of photographs, transparencies. Send query letter with artist's statement, bio, photographs, reviews. Replies in 2 months. Finds artists through submissions, degree shows.

ORGANIZATION OF INDEPENDENT ARTISTS, 19 Hudson St., #402, New York NY 10013. (212)219-9213. Fax: (212)219-9216. Website: http://www.arts-online.com/oia.htm. Program Director: Nadini Richardson. Estab. 1976. Presents several shows a year. Shows last 4-6 weeks.

• OIA is a non-profit organization that helps sponsor group exhibitions at the OIA office and in public spaces throughout New York City.

Making Contact & Terms: Membership $35 per year. Submit slides with proposal. Send material by mail for consideration according to guidelines only. Write for information on membership. SASE. "We review twice a year (April and October)."

Tips: "It is not required to be a member to submit a proposal, but interested photographers may want to become OIA members to be included in OIA's active slide file that is used regularly by curators and artists. You must be a member to have your slides in the registry to be considered for exhibits at the OIA gallery, Gallery 402."

ORLANDO GALLERY, Dept. PM, 14553 Ventura Blvd., Sherman Oaks CA 91403. Phone/fax: (818)789-6012. Website: http://artsceneal.com.gotoorlando. Directors: Robert Gino, Don Grant. Estab. 1958. Examples of recent exhibits: landscapes by Steve Wallace; personal images by Fred Kurestski; figures by Pat Whiteside Phillips; and collage photos/landscapes by Lynn Bassler. Shows last 1 month. Price range of work: $600-3,000.

Exhibits: Interested in photography demonstrating "inventiveness" on any subject.

Making Contact & Terms: Charges 50% commission. Query with résumé of credits. Send material by mail for consideration. SASE. Accepts images in digital format. Framed work only. Reports in 1 month. Requires exclusive representation in area.

Tips: Make a good presentation. "Make sure that personality is reflected in images. We're not interested in what sells the best—just good photos."

PACEWILDENSTEINMACGILL, 32 E. 57th St., 9th Floor, New York NY 10022. (212)759-7999. Contact: Laura Santaniello. Estab. 1983. Presents 18 shows/year. Shows last 6-8 weeks. General price range of work: $1,000-300,000.

• PaceWildensteinMacGill has a second location in Los Angeles: 9540 Wilshire Blvd., Beverly Hills CA 90212. (310)205-5522. Contact: Chelsea Hadley.

Exhibits: "We like to show original work that changes the direction of the medium."

Making Contact & Terms: Photography sold in gallery. Commission varies. On occasion, buys photos outright.

Tips: "Review our exhibitions and ask, 'Does my work make a similar contribution to photography?' If so, seek third party to recommend your work."

N ⊕ PEACOCK COLLECTION, The Smithy, Old Warden, Biggleswade, Bedfordshire SG18 9HQ United Kingdom. Phone: (01767)627132. Fax: (01767)627027. E-mail: peacockcol@aol.com. Contact: Elaine Baker. Retail gallery. Estab. 1997. Example of recent exhibit: "From Camera to Screen," by Martin Timbers (digital photography). Sponsors 1 photography exhibit/year. Average display time 2 weeks. Open Monday through Friday from 9 to 5:30; weekends from 1 to 4:30, all year. "Located in the beautiful 18th century award winning village of Old Warden. The gallery has 2 rooms both spot lit. Room 1 is 30×20'; Room 2 is 15×10'."

Exhibits: Landscapes, wildlife, surreal, still life.

Making Contact & Terms: Artwork is accepted on consignment and there is a 30% commission. Retail price set by the gallery. Accepted work should be framed, mounted. Required exclusive representation locally. Write with details and photographic samples. Send query letter with bio, photographs. Replies in 2 weeks. Finds artists by word of mouth, submissions, art exhibits, referrals by other artists.

Tips: Send "good, clear photographs of your work with contact details and indication of best times to phone."

PHOENIX GALLERY, 568 Broadway, Suite 607, New York NY 10012. (212)226-8711. Fax: (212)343-7303. Website: http://www.gallery-guide.com/gallery/phoenix. Director: Linda Handler. Estab. 1958. Presents 10-12 shows/year. Shows last 1 month. General price range of work: $100-10,000.

Exhibits: "The gallery is an artist-co-operative and an artist has to be a member in order to exhibit in the gallery." Interested in all media.

Making Contact & Terms: Charges 25% commission. Reviews transparencies and slides. Interested in framed work only. Ask for membership application. SASE. Reports in 1 month.

Tips: "The Gallery has a small works project room where nonmembers can exhibit their work. If an artist is interested he/she may send a proposal with art to the gallery. The space is free. The artist also shares in the cost of the reception with the other artists showing at that time."

THE PHOTO LOUNGE, Truckee Meadows Community College, 7000 Dandini Blvd, Reno NV 89512. (702)673-7084. Fax: (702)673-7221. Director: Professor Erik Lauritzen. Estab. 1993. Examples of recent exhibits: "Ruins of the Anasazi," Val Brinkerhoff (giclée prints); "Recent Handcolored Images," by Saszon Renkes. Presents 7 shows/year. Shows last 1 month. General price range of work: $150-1,500.

Making Contact & Terms: Charges 20% commission. Reviews transparencies (no originals). Interested in matted work only, of standard sizes. Works are limited to 30×40 maximum. Send 15 slides of recent work, résumé, artist's statement and SASE for return of slides. Annual deadline April 1.

Tips: Slides submitted should be sharp, in focus, color correct and show entire image. "Ours is a nonprofit educational space. Students and community rarely purchase work, but appreciate images shown. In Reno, exposure to art is valuable particularly due to a rapid interest in art in the last few years."

N PHOTOCOLLECT, 22 E. 72nd St., New York NY 10021. (212)327-2211. Fax: (212)327-0143. E-mail: photocol@interport.net. Website: http://www.photocollect.com. President: Alan Klotz. Rental gallery. Estab. 1977. Approached by 20 artists a year; represents or exhibits 8 artists. Examples of recent exhibit: Lewis Hine/Dorothea Lange (vintage photographs); Edouard-Denis Baldus (vintage photographs); Jed Fielding (contemporary photographs). Sponsors 5-6 photography exhibits/year. Average display time 5-6 weeks. Overall price range $250-100,000. Most work sold at $3,500. Gallery open Wednesday through Saturday from 11 to 6, all year. Gallery is 1,000 sq. ft.

Exhibits: Social documentary, modernism, architecture, landscapes and 20s and 30s experimental.

Making Contact & Terms: Artwork is accepted on consignment and there is a 50% commission. Gallery provides insurance, promotion, contract. Accepted work should be matted or framed if an unusual size or has special requirements. Requires exclusive representation locally. Shows artists who have already had a strong show history. To show portfolio send slides with return SASE. Send bio, résumé, reviews, SASE and 20 of your best works in slide form. Replies only if interested within 3 weeks. Finds artists through portfolio reviews, art exhibits, art fairs.

Tips: "Gallery submissions should be the finest work presented in the final, finished form."

PHOTOGRAPHIC IMAGE GALLERY, 240 SW First St., Portland OR 97204. (503)224-3543. Fax: (503)224-3607. E-mail: photogal@teleport.com. Director: Guy Swanson. Estab. 1984. Examples of recent exhibits: "The Enduring Spirit," by Phil Borges; Cibachrome landscapes by Christopher Burkett; and Fotofest artists. Presents 12 shows/year. Shows last 1 month. General price range of work: $300-1,500.

Exhibits: Interested in primarily mid-career to contemporary Master-Traditional Landscape in color and b&w.

Making Contact & Terms: Charges 50% commission. Reviews transparencies. Requires exclusive representation within metropolitan area. Query with résumé of credits. SASE. Reports in 1 month.

Tips: Current opportunities through this gallery are fair. Sees trend toward "more specializing in imagery rather than trying to cover all areas."

PHOTOGRAPHIC RESOURCE CENTER, 602 Commonwealth Ave., Boston MA 02215. (617)353-0700. Fax: (617)353-1662. E-mail: prc@bu.edu. Website: http://web.bn.edu/PRC. Director of Exhibitions: Sara Rosenfeld Dassel. "The PRC is a nonprofit gallery." Examples of previous exhibitions: "Facing Death: Portaits from Cambodia's Killing Fields"; "Extended Play: Between Rock & An Art Space"; and The Leopold Godowsky, Jr. Color Photography Awards (focusing on Asian artists for 1998). Presents 5-6 group thematic exhibitions in the David and Sandra Bakalar Gallery and 5-6 one- and two-person shows in the Natalie G. Klebenov Gallery/year. Shows last 6-8 weeks. Gallery brings in nationally recognized artists to lecture to large audiences and host workshops on photography.
Exhibits: Interested in contemporary and historical photography and mixed-media work incorporating photography. "The photographer must meet our high quality requirements."
Making Contact & Terms: Will review transparencies. Interested in matted or unmatted work. Query with samples or send material by mail for consideration. SASE. Reports in 2-3 months "depending upon frequency of programming committee meetings. We are continuing to consider new work, but because the PRC's exhibitions are currently scheduled into 1999, we are not offering exhibition dates."

PHOTO-SPACE AT ROCKLAND CENTER FOR THE ARTS, 27 S. Greenbush Rd., West Nyack NY 10994. (914)358-0877. Fax: (914)358-0971. Executive Director: Julianne Ramos. Estab. 1947. Examples of recent exhibits: "Panoramic Photography," by Sally Spivak; "Tomorrow," new works by young photographers; and "Digital Photography." Presents 4-5 shows/year. Shows last 2 months. General price range of work: $250-2,500.
Exhibits: Geographic Limits: Rockland, Westchester and Orange counties in New York and Bergen County in New Jersey. Interested in all types of photos.
Making Contact & Terms: Charges 33% commission. Reviews transparencies. Interested in matted or unmatted work. Shows are limited to 32 × 40. Query with samples. Send material by mail for consideration. SASE. Reports in 3 months.

PRAKAPAS GALLERY, 1 Northgate 6B, Bronxville NY 10078. (914)961-5091. Fax: (914)961-5192. Director: Eugene J. Prakapas.
Making Contact & Terms: Commission "depends on the particular situation." General price range of work: $500-100,000.
Tips: "We are concentrating primarily on vintage work, especially from between the World Wars, but some as late as the 70s. We are not currently doing exhibitions."

PYRAMID ARTS CENTER, INC., 302 N. Goodman St., Rochester NY 14607. (716)461-2222. Fax: (716)461-2223. E-mail: pyramid1@frontiernet.net. Executive Director: Elizabeth McDade. Estab. 1977. Examples of recent exhibitions: "Upstate Invitational," by Vincent Borrelli (20 × 24 color prints); work by Margaret Wagner (16 × 20 toned b&w prints); and "Brazil: The Thinking Photography," by Luis Monforte (digitalized computer prints). Presents 2-3 shows/year. Shows last 4-6 weeks. General price range $100-500.
Making Contact & Terms: Charges 25% commission. Reviews transparencies. Send slides, letter of inquiry, resume and statement. Reports in 2-3 months.

QUEENS COLLEGE ART CENTER, Benjamin S. Rosenthal Library, Queens College, Flushing NY 11367-1597. (718)997-3770. Fax: (718)997-3753. E-mail: sbsqc@cunyvm.cuny.edu. Website: http://www.qc.edu/Library/Acpage.html. Director: Suzanna Simor. Curator: Alexandra de Luise. Estab. 1952. Examples of recent exhibits: "Gypsies Portrayed: Photographs," by Ramón Zabalza; "Photographs," by Francesc Català-Roca. Shows last approximately 1 month. Sponsors openings. Photographer is responsible for providing/arranging, refreshments and cleanup. General price range of work: $100-500.
Exhibits: Open to all types, styles, subject matter; decisive factor is quality.
Making Contact & Terms: Charges 40% commission. Interested in framed or unframed, mounted or unmounted, matted or unmatted work. Query with résumé of credits and samples. Send material by mail for consideration. SASE. Reports in 3-4 weeks.

MARCIA RAFELMAN FINE ARTS, 10 Clarendon Ave., Toronto, Ontario M4V 1H9 Canada. (416)920-4468 Fax: (416)968-6715. President: Marcia Rafelman. Semi-private gallery. Estab. 1984. Examples of recent exhibits: "insideout," group show (photography); "Curator's Choice," group show (photographs, paintings and graphics). Average display time 1 month. Gallery is centrally located in Toronto, 2,000 sq. ft. on 2 floors. Overall price range $500-30,000. Most work sold at $1,500.

Exhibits: Photo journalism, landscape, photo documentary, b&w.
Making Contact & Terms: Artwork is accepted on consignment and there is a 50% commission. Gallery provides insurance, promotion, contract. Requires exclusive representation locally. Mail portfolio for review, include bio, photographs, reviews. Replies only if interested within 1-2 weeks. Finds artists through word of mouth, submissions, art fairs, referrals by other artists.
Tips: "We only accept work that is archival."

ANNE REED GALLERY, P.O. Box 597, 620 Sun Valley Rd., Ketchum ID 83340. (208)726-3036. Fax: (208)726-9630. Director: Jennifer Gately. Estab. 1980. Example of recent exhibits: "Echoes of Perceived Stillness," by Tom Barze. Presents 1-2 photography shows/year. Shows last 1 month. General price range of work: $400-4,000.
Exhibits: Work must be of exceptional quality. Interested in platinum, palladium prints, landscapes, still lifes and regional material (West).
Making Contact & Terms: Charges 50% commission. Reviews transparencies. Interested in framed or unframed, mounted or unmounted, matted or unmatted work. Requires exclusive representation locally. Submit portfolio for review. Query with résumé of credits. Query with samples. Send material by mail for consideration. "It helps to have previous exhibition experience." SASE. Reports in 1-3 weeks.
Tips: "We're interested only in fine art photography. Work should be sensitive, social issues are difficult to sell. We want work of substance, quality in execution and uniqueness. Exhibitions are planned one year in advance. Photography is still a difficult medium to sell, however there is always a market for exceptional work!"

ROBINSON GALLERIES, 2800 Kipling, Houston TX 77098. (713)521-2215. Fax: (713)526-0763. E-mail: robin@wt.net. Website: http://web.wt.net/~robin. Director: Thomas V. Robinson. Estab. 1969. Examples of recent exhibits: works by Pablo Corral (Cibachrome); Ron English (b&w and hand-colored silver gelatin prints); Blair Pittman (audiovisual with 35mm slides in addition to Cibachrome and b&w framed photographs); and Fotofest '98 exhibition of b&w 35mm and Holga prints of Terry Vine. Presents 1 show every other year. (Photographs included in all media exhibitions 1 or 2 times per year.) Shows last 4-6 weeks. Sponsors openings; provides invitations, reception and traditional promotion. General price range $100-1,000.
 ● Robinson Galleries, through Art Travel Studies, has developed various travel programs whereby individual photographers provide their leadership and expertise to travel groups of other photographers, artists, museum personnel, collectors, ecologists and travelers in general. Ecuador and Mexico are the featured countries, however, the services are not limited to any one destination. Artists/photographers are requested to submit biographies and proposals for projects that would be of interest to them, and possibly to others that would pay the expenses and an honorarium to the photographer leader.
Exhibits: Archivally framed and ready for presentation. Limited editions only. Work must be professional. Not interested in pure abstractions.
Making Contact & Terms: Charges 50% commission. Reviews transparencies. Interested in framed or unframed, matted or unmatted work. Requires exclusive representation within metropolitan or state area. Arrange a personal interview to show portfolio. Submit portfolio for review. Query with résumé of credits. SASE. Reports in 1-2 weeks.
Tips: "Robinson Galleries is a fine arts gallery first, the medium is secondary."

THE ROLAND GALLERY, 601 Sun Valley Rd., P.O. Box 221, Ketchum ID 83340. (208)726-2333. Fax: (208)726-6266. Contact: Roger Roland. Estab. 1990. Example of exhibitions: works by Al Wertheimer (1956 original Elvis Presley prints). Presents 5 shows/year. Shows last 1 month. General price range of work: $100-1,000.
Making Contact & Terms: Charges 50% commission. Reviews transparencies. Interested in matted or unmatted work. Submit portfolio for review. SASE. Reports in 1 month.

THE ROSSI GALLERY, 2821 McKinney Ave., Dallas TX 75204. (214)871-0777. Fax: (214)871-1343. Owner: Hank Rossi. Estab. 1987. Examples of recent exhibits: "Visions of the West," by Skeeter Hagler (b&w); photography by Natalie Caudill (mixed media photographs); "Spirit," by David Chasey (b&w). Presents 2 shows/year. Shows last 1 month. General price range of work: $400-1,500.
Exhibits: Pays shipping both ways. Interested in b&w film noir. Challenging work and conceptual are preferred.
Making Contact & Terms: Charges 40% commission. Reviews transparencies. Interested in mounted, matted, or unmatted work only. Query with samples. SASE. Reports in 1 month.
Tips: "Be responsible and prompt. Figurative work is very strong."

THE ROTUNDA GALLERY, 33 Clinton St., Brooklyn NY 11201. (718)875-4047. Fax: (718)488-0609. Director: Janet Riker. Examples of previous exhibits: "All That Jazz," by Cheung Ching Ming (jazz musicians); "Undiscovered New York," by Stanley Greenberg (hidden New York scenes); "To Have and to Hold," by Lauren Piperno (ballroom dancing). Presents 1 show/year. Shows last 5 weeks.
Exhibits: Must live in, work in or have studio in Brooklyn. Interested in contemporary works.
Making Contact & Terms: Charges 20% commission. Reviews transparencies. Interested in framed or unframed, mounted or unmounted, matted or unmatted work. Shows are limited by walls that are 22 feet high. Send material by mail for consideration. Join artists slide registry, call for form. SASE.

SANGRE DE CRISTO ARTS CENTER, 210 N. Santa Fe Ave., Pueblo CO 81003. (719)543-0130. Fax: (719)543-0134. Curator of Visual Arts: Jennifer Cook. Estab. 1972. Examples of exhibits: Yousef Karsh (b&w, large format); Laura Gilpin (photos of the Southwest); James Balog ("Survivors" series and "Material World," international photographic project). Presents 3 shows/year. Shows last 3 months. General price range of work: $200-800.
Exhibits: Work must be artistically and technically superior; all displayed works must be framed. It is preferred that emerging and mid-career artists be regional.
Making Contact & Terms: Charges 30% commission. Reviews transparencies. Interested in framed or unframed, matted or unmatted work. Arrange a personal interview to show portfolio. Submit portfolio for review. Query with résumé of credits. Query with samples. Send material by mail for consideration. Reports in 2 months.

 SAW GALLERY INC., 67 Nicholas St., Ottawa, Ontario K1N 7B9 Canada. (613)236-6181. Fax: (613)238-4617. E-mail: saw@magi.com. Visual Arts Coordinator: Sue-Ellen Gerritsen. Alternative space. Estab. 1973. Approached by hundreds of artists a year; represents or exhibits 8-30 artists. Example of recent exhibit: "Chaos Theories," by Anitra Hamilton and Adrienne Trent (sculpture and photography). Average display time 4-5 weeks. Open Tuesday through Saturday from 11 to 5, all year. "We are a not-for-profit gallery. Sales are conducted with artist directly."
Exhibits: Contemporary and avant garde.
Making Contact & Terms: All sales arranged between interested buyer and artist directly. Retail price set by the artist. Only accepts art attuned to contemporary issues. Send artist's statement, bio, slides (10), résumé, reviews, SASE. Replies in 4-6 months. Proposals are reviewed in June and December. Finds artists through word of mouth, submissions, referrals by other artists, calls for porposals, advertising in Canadian art magazines.
Tips: "Have another artist offer an opinion of the proposal and build on the suggestions before submitting."

SECOND STREET GALLERY, 201 Second St. NW, Charlottsville VA 22902. (804)977-7284. Fax: (804)979-9793. E-mail: fsg@cstone.net. Director: Sarah Sargent. Estab. 1973. Examples of recent exhibitions: works by Bill Emory, Nick Havholm, Jeanette Montgomery Baron and Elijah Gowin. Presents 1-2 shows/year. Shows last 1 month. General price range of work: $250-2,000.
Making Contact & Terms: Charges 25% commission. Reviews transparencies in fall. Submit 10 slides for review. SASE. Reports in 6-8 weeks.
Tips: Looks for work that is "cutting edge, innovative, original."

SELECT ART, 10315 Gooding Dr., Dallas TX 75229. (214)353-0011. Fax: (214)350-0027. Owner: Paul Adelson. Estab. 1986. General price range of work: $250-600.
 • This market deals fine art photography to corporations and sells to collectors.
Exhibits: Interested in architectural pieces and landscapes.
Making Contact & Terms: Charges 50% commission. Retail price range: $100-1,000. Reviews transparencies. Interested in unframed and matted work only. Send material by mail for consideration. SASE. Reports in 1 month.
Tips: Make sure the work you submit is fine art photography, not documentary/photojournalistic or com-

**FOR EXPLANATIONS OF THESE SYMBOLS,
SEE THE INSIDE FRONT AND BACK COVERS OF THIS BOOK.**

mercial photography. No nudes.

SOUTH SHORE ART CENTER, INC., 119 Ripley Rd., Cohasset MA 02025. (781)383-2787. Fax: (781)383-2964. Website: http://www.ssac.org. Executive Director: Dillon Bustin. Estab. 1954. Example of recent exhibits: "Color/Black & White," (all media, no theme), 100 selected from 350 entries. Presents at least 25 shows/year—juried and invitational. Shows last 4-5 weeks. General price range of work: $100-500.
Exhibits: Interested in "all types of fine arts photography."
Making Contact & Terms: Charges 40% commission. Charges $10/piece for juried shows; $100-150/person for invitational group shows. Reviews transparencies. Interested in exhibiting framed work only. Limitations: work "must be framed in wood or metal—no bare glass edges." Send résumé and slide sheet, request call for entries.

N ⊕ THE SPECIAL PHOTOGRAPHERS CO., 21 Kensington Park Rd., London W11 2EU United Kingdom. Phone: (0171)221 3489. Fax: (0171)792 9112. E-mail: info@specialphoto.co.uk. Website: http://www.specialphoto.co.uk. Contact: Addie Elliott. Gallery. Estab. 1986. Approached by 175 artists a year; represents or exhibits 130 artists. Examples of recent exhibits: "Inside Life," by Greg Gorman (b&w photos, celebrity portraits); "Formula One, The Golden Era 1950-69," by Michael Tee (b&w photos of racing images); "For Paul," by Barry Ryan (manipulated b&w photos). Presents 8 photography shows/year. Average display time 6 weeks. Gallery open Monday through Thursday from 10 to 6; Friday 10-5:30; Saturday 11-5, all year. Overall price range $150-6,000. Most work sold at $500.
Exhibits: Figurative work, florals, landscapes, portraits—any printing process that includes a photographic technique.
Making Contact & Terms: Artwork is accepted on consignment and there is a 50% commission. Gallery provides insurance, promotion, contract. Call to arrange personal interview to show portfolio or send query letter with artist's statement, bio, business card, résumé, reviews, SASE, slides. Replies in 3 months. Finds artists through word of mouth, art exhibits, referrals by artists, college shows.
Tips: "Make sure that any attached information is susinct and clear. An easy-to-handle sized folio is always more appealing. Considerably, the art world is, it appears, more and more accepting of photography as a fine art medium. This can be seen by the fact that many fine art galleries are now dealing with photography and including the medium in their exhibition programmes."

THE STATE MUSEUM OF PENNSYLVANIA, P.O. Box 1026, Third & North Streets, Harrisburg PA 17108-1026. (717)787-4980. Fax: (717)783-4558. Senior Curator, Art Collections: N. Lee Stevens. Museum established in 1905; Current Fine Arts Gallery opened in 1993. Examples of exhibitis: "Art of the State: PA '94," by Bruce Fry (manipulated, sepia-toned, b&w photo), and works by Norinne Betjemann (gelatin silver print with paint), and David Lebe (painted photogram). Number of exhibits varies. Shows last 2 months. General price range of work: $50-3,000.
Exhibits: Photography must be created by native or resident of Pennsylvania, or contain subject matter relevant to Pennsylvania. Art photography is a new area of endeavor for The State Museum, both collecting and exhibiting. Interested in works produced with experimental techniques.
Making Contact & Terms: Work is sold in gallery, but not actively. Reviews transparencies. Interested in framed work. Send material by mail for consideration. SASE. Reports in 1 month.

N STUDIO FOTOGRAFICA, 1008½ Broad St., Augusta GA 30901. (706)823-0332. E-mail: jpolito888@aol.com. Director/Owner: Tom Barrett. Cooperative gallery. Estab. 1995. Approached by 18 artists a year; represents or exhibits 8 artists. Examples of recent exhibits: "Fragments," by Tom Barrett (large format b&w photography); "France Profound: It's the Life!," by Jeri Polito (35mm photography); "My World," by Don Ferguson (infrared photography). Sponsors 8 photography exhibits/year. Average display time 1 month. Open Wednesday through Saturday from 11 to 5, all year. Studio Fotografica is a member of Broad Street Artists' Row. There are 12 galleries which are members of Broad Street Artists' Row, located in historic downtown Augusta. Space available for artists to hang about 30 pieces of work. Overall price range $150-500. Most work sold at $500.
Exhibits: Considers all types of photography.
Making Contact & Terms: Artwork is accepted on consignment and there is a 30% commission. Gallery provides promotion. Accepted work should be framed, mounted, matted. Requires exclusive representation locally. Write to arrange a personal interview to show portfolio of photographs, slides, transparencies or mail portfolio for review. Send query letter with artist's statement, bio, photographs, résumé, SASE. Replies in 2 months. Finds artists through word of mouth, submissions, portfolio reviews, referrals by other artists.
Tips: "Our primary interest is in black and white photography but we will consider color as well. We don't want to see pictures. We want to see images. Our mission is to provide exhibit space and educational

© Emma Parker

"It is important for me to continue producing personal work alongside commercial commissions to keep ideas fresh," says British photographer Emma Parker. "The Discovery of New Worlds" is part of a series of images contrasting traditional India with modern India. Parker is represented by The Special Photographers Company in London. "We first saw Emma's work while she was still studying at the Royal College of Art, London," says Gallery Manager Addie Elliot. "As a photography gallery we work with a wide variety of photographers working in every area of photography. Emma's work is extremely individual."

programs dedicated to the photographic arts. We are committed to promoting photography as a fine art. Artists should submit a professional portfolio which best demonstrates their technical and creative photographic abilities. Our collectors want a lasting product therefore we prefer photographs which are printed on fiber based paper and are dry-mounted, matted and framed. Photography is no longer the step-child of fine art. Collectors are now viewing photography as a medium equal to all other art media."

UCR/CALIFORNIA MUSEUM OF PHOTOGRAPHY, University of California, Riverside CA 92521. (909)787-4787. Fax: (909)787-4797. Website: http://www.cmp.ucr.edu. Director: Jonathan Green. Examples of recent exhibitions: "Signs of Gods and Goddesses: Four Decades of Lucien Clergue's Photography"; "Ocean View: The Depiction of Southern California Coastal Lifestyle"; "Indochina Document" by Sheila Pinkel; "The Impossible Synthesis: William Amos Haines' Residential Panoramas of Early Southern California." Presents 12-18 shows/year. Shows last 6-8 weeks.
Exhibits: The photographer must have the "highest quality work."
Making Contact & Terms: Curatorial committee reviews transparencies and/or matted or unmatted work. Query with résumé of credits. Accepts images in digital format for Mac. Send via compact disc, or Zip disk. SASE. Reports in 90 days.
Tips: "This museum attempts to balance exhibitions among historical, technology, contemporary, etc. We do not sell photos but provide photographers with exposure. The museum is always interested in newer, lesser-known photographers who are producing interesting work. We're especially interested in work relevant to underserved communities. We can show only a small percent of what we see in a year. The UCR/CMP has moved into a renovated 23,000 sq. ft. building. It is the largest exhibition space devoted to photography in the West."

UNIVERSITY ART GALLERY, NEW MEXICO STATE UNIVERSITY, Dept. 3572, P.O. Box 30001, Las Cruces NM 88003. (505)646-2545. Fax: (505)646-8036. Director: Charles M. Lovell. Estab. 1973. Examples of recent exhibitions: "Breath Taken," by Bill Ravanesz (documentary of asbestos workers); "Celia Munoz," by Celia Munoz (conceptual); and "Nino Fidencio, A Heart Thrown Open," by Dore Gardner (documentary photographs of followers of a Mexican faith healer). Presents 1 show/year. Shows last 2 months. General price range of work: $100-1,000.
Making Contact & Terms: Buys photos outright. Interested in framed or unframed work. Arrange a personal interview to show portfolio. Submit portfolio for review. Query with samples. Send material by mail for consideration by end of October. SASE. Reports in 2 months.
Tips: Looks for "quality fine art photography. The gallery does mostly curated, thematic exhibitions. Very few one-person exhibitions."

VIRIDIAN ARTISTS, INC., 24 W. 57 St., New York NY 10019. (212)245-2882. Director: Joan Krawczyk. Estab. 1968. Examples of recent exhibits: works by Susan Hockaday and Robert Smith. Presents 1-2 shows/year. Shows last 3 weeks. General price range of work: $300-3,000.
Exhibits: Interested in eclectic work. Member of Cooperative Gallery.
Making Contact & Terms: Charges 30% commission. Will review transparencies only if submitted as membership application. Interested in framed or unframed, mounted, and matted or unmatted work. Request membership application details. Send materials by mail for consideration. SASE. Reports in 3 weeks.
Tips: Opportunities for photographers in galleries are "improving." Sees trend toward "a broad range of styles" being shown in galleries. "Photography is getting a large audience that is seemingly appreciative of technical and aesthetic abilities of the individual artists."

N WACH GALLERY, 31860 Walker Rd., Avon Lake OH 44012. (440)933-2780. Fax: (440)933-2781. Owner: Peter M. Wach. Private dealer. Estab. 1979. Approached by 10 artists/year; represents or exhibits 100 artists. Examples of recent exhibits: Brett Weston retrospective; Ansel Adams; Carl Hyatt, nude studies in platinum. Open all year by appointment. Overall price range: $1,000-50,000.
Exhibits: Considers all styles and genres of photography, including conceptualism, post modernism, expressionism. "Must be archival process."
Making Contact & Terms: Artwork is accepted on consignment and there is a 40-50% commission. Gallery provides insurance. Accepted work should be mounted. Call or write to show portfolio of slides and transparencies. Replies in 1 week to queries. Finds artists by word of mouth, submissions, art exhibits and art fairs.
Tips: "Do not explain images. Let the image speak for itself. Before the artist frames and mats the work, consult with the gallery about the various techniques and styles. Framing must be archival with UV filtering plastic. I personally like images unmounted. The photography market is affected by the economy. Usually a ten year cycle determines the prices. When a recession occurs, lower priced images (contemporaries) sell over the higher priced masters."

THE WAILOA CENTER GALLERY, P.O. Box 936, Hilo HI 96720. (808)933-0416. Fax: (808)933-0417. Director: Mrs. Pudding Lassiter. Estab. 1967. Examples of recent exhibits: Cliff Panis (photography); Dennis Jones (photographic journal); and Diane McMillen (photographic flora studies). Presents 3 shows/year. Shows last 30 days.
Exhibits: Pictures must be submitted to Director for approval.
Making Contact & Terms: Gallery receives 10% "donation" on works sold. Reviews transparencies. Interested in framed work only. "Pictures must also be fully fitted for hanging. Expenses involved in shipping, insurance, etc. are the responsibility of the exhibitor." Submit portfolio for review. Query with resume of credits. Query with samples. SASE. Reports in 3 weeks.
Tips: "The Wailoa Center Gallery is operated by the State of Hawaii, Department of Land and Natural Resources. We are unique in that there are no costs to the artist to exhibit here as far as rental or commissions are concerned. We welcome artists from anywhere in the world who would like to show their works in Hawaii. The gallery is also a visitor information center with thousands of people from all over the world visiting."

SANDE WEBSTER GALLERY, 2018 Locust St., Philadelphia PA 19103. (215)732-8850. Fax: (215)732-7850. E-mail: swgart@erols.com. Contact: Michael Murphy or Megan Walborn. Examples of exhibits: "Dust Shaped Hearts," by Don Camp (photo sensitized portraits); works by Norrine Betjemann (hand-tinted); Kevin Reilly (documentary landscape and automotive images). Also carries works by emerging talents Ron Tarver, Elena Bouvier, Ray Holman, Leonard Morris and Steve Leibowitz. Presents 10 shows/year. Shows last 1 month. General price range of work: $200-5,000.
● The gallery will review the work of emerging artists, but due to a crowded exhibition schedule, may defer in handling their work.
Exhibits: Interested in contemporary, fine art photography in limited editions. "We encourage the use of non-traditional materials in the pursuit of expression, but favor quality as the criterion for inclusion in exhibits."
Making Contact & Terms: Charges 50% commission. Reviews transparencies. Interested in framed or unframed work. Send material by mail for consideration. Include résumé, price list and any additional support material. SASE. Reports in 1 month.

[N] [■] WHISTLER INUIT GALLERY, 4599 Chateau Blvd., Whistler, British Columbia V0N 1B4 Canada. (604)938-3366. Fax: (604)938-5404. Website: http://www.Inuit.com. Director: Bill Quinney. Retail gallery. Estab. 1991. Approached by 40 artists a year; represents or exhibits 30 artists. Gallery open Monday through Sunday from 10 to 10; weekends from 10 to 10 all year. Overall price range $100-10,000. Most work sold at $1,000.
Making Contact & Terms: Artwork is accepted on consignment and there is a 50% commission. Artwork is bought outright for 60% of retail price; net 30 days. Gallery provides insurance, promotion, contract. Accepted work should be framed. Requires exclusive representation locally. Must be "one of a kind." Call to show portfolio. Mail portfolio for review. Send query letter with artist's statement, bio, brochure, photographs, résumé, reviews, SASE. Replies in 1 week-1 month. Finds artists through word of mouth, submissions, portfolio reviews, newspaper ads.
Tips: "For a professional gallery submission you must have slides, full supporting bio, list of exhibitions and works should be well or tastefully framed or presented."

[N] [⊕] WILL'S ART WAREHOUSE, Unit 3, Heathmans Rd., London SW6 4TJ United Kingdom. Phone: (0066)171 371 8787. Fax: (0066)171 371 0066. E-mail: will@willsart.decor.co.uk. Website: http://www.willsart.decor.co.uk. Contact: Will Rosy. Commercial gallery and art consultancy. Estab. 1996. Approached by 400 artists a year; represents or exhibits 100 artists. Average display time 1 month. Open Monday through Friday from 10:30 to 8; weekends for 10:30 to 6. "Located on a side street; 3,600 sq. ft. for up to 150 works."
Making Contact & Terms: Artwork is accepted on consignment and there is a 50% commission. Retail price set by the artist. Accepted work should be framed. "No conceptual work." Mail portfolio for review. Send artist's statement, bio, photographs, SASE. Replies in 1 month. Finds artists through word of mouth, submissions, portfolio reviews, art exhibits, art fairs, referrals by other artists.

WYCKOFF GALLERY, 648 Wyckoff Ave., Wyckoff NJ 07481. (201)891-7436. Director: Sherry Cosloy. Estab. 1978. Example of exhibits: works by Jorge Hernandez (landscapes). Presents 1 exhibit/year. Shows last 1 month. General price range of work: $200-2,000.
Exhibits: Prior exhibition schedule, mid-career level. Interested in all styles except depressing subject matter (e.g. AIDS, homelessness).
Making Contact & Terms: Reviews transparencies. Interested in framed or unframed, mounted or

unmounted, matted or unmatted work. Requires exclusive presentation locally. Query with résumé of credits. Query with samples. SASE. Reports in 1-2 weeks.

Tips: "I am predominantly a fine arts (paintings and sculptures) gallery so photography is not the prime focus. People like photography that is hand-colored and/or artistic in composition and clarity."

YESHIVA UNIVERSITY MUSEUM, 2520 Amsterdam Ave., New York NY 10033. (212)960-5390. Fax: (212)960-5406. Website: http://www.yu.edu/museum. Director: Sylvia A. Herskowitz. Estab. 1973. The museum has several gallery spaces: a well area in the Museum Hall, accessible by steps; a rear gallery also accessible by steps; a 4th floor gallery accessible by elevator from lobby of building; other gallery areas as well, varying in size. Examples of recent exhibits: "Silenced Sacred Spaces-Selected Photographs of Syrian Synagogues," by Robert Lyons; "If You Will It, It Is Not a Dream," by Theodor Herzl; "In Search of the Arks: Synagogue Photographs," by Joel Berkowitz. Presents 3-4 shows/year. Shows last 4-8 months. General price range of work: $100 and up.

Exhibits: Seeks work focusing on Jewish themes and interest.

Making Contact & Terms: Photography sold in museum shop. Payment negotiable; commission negotiable. Interested in framed work. Send material by mail for consideration. Reports following meeting of exhibits committee.

Tips: "We exhibit contemporary art and photography based on a Jewish theme. We look for excellent quality; individuality; and especially look for unknown artists who have not widely exhibited either in the New York area or at all. Send a slide portfolio of ten slides, an exhibition proposal, a résumé, and other pertinent information with a SASE. We conduct portfolio reviews three times a year."

OZTEN ZEKI GALLERY, 174 Walton St., London SW3 2JL United Kingdom. Phone: (0171)225-1624 or (0171)225-2899. Contact: Ozten Zeki. Fine art gallery. Estab. 1989. Sponsors 1 or 2 photography exhibits/year. Changes exhibition every 2-3 weeks. Open Monday through Saturday from 11 to 6.

Making Contact & Terms: Artwork is accepted on consignment and there is a 50% commission. Retail price set by the gallery. Accepted work should be framed. Requires exclusive representation locally. Write to arrange a personal interview to show portfolio of photographs. Send artist's statement, brochure, photographs, résumé. Replies only if interested withing 2 months. Finds artists through word of mouth, submissions, portfolio reviews, art exhibits, art fairs, referrals by other artists.

THE INTERNATIONAL MARKETS INDEX, located in the back of this book, lists markets located outside the U.S. by country.

Record Labels

FROM COVERS TO PROMOTION

The worldwide record industry brings in nearly $40 billion a year. There's certainly a place for photographers in that number. Photography helps sell recorded music by showcasing bands and performers on CD covers, promotional posters, T-shirts and more. And even if you don't live in Los Angeles or New York, you can still make opportunities to shoot your favorite bands when they tour in your area.

Like art directors in any other market, record label photo buyers will want to see samples of your past work before they give you an assignment. Of course the samples they really want to see are of CD covers and music promotional material. It's important to show photo buyers that you can work in a small format, $4\frac{3}{4} \times 4\frac{3}{4}$ for CDs, and still have a big impact. So how can you get started if you don't have those samples? One way is to contact local bands who are releasing their own CDs, tapes and records. They will be happy to use the services of a professional photographer, perhaps at a discounted rate, and you will get your samples.

From your shots for local acts, you can work your way up to independent labels and onto the bigger markets. When you start working with small labels, be sure to query prospective clients and request copies of their various forms and contracts for photographers. Seeing the content of such material can tell you a great deal about how well organized and professional a company is. Also talk to people in the music industry to get a better understanding of companies you might work with.

If there is a particular label you'd especially like to work for, you can do a little research and plot a course to publication. Most labels are owned by large parent companies and if you identify a small label owned by the company that also owns the label you want to work for, there's your path. For example if you'd really like to shoot a cover for the band Radiohead on Capitol Records you might want to start with the smaller alternative label Matador.

But there's no reason not to shoot for the top if the opportunity comes your way. I recently met a photography student who's already sold her work to a major record label. A friend got her a media pass to a Korn concert for her birthday and she used the pass to get great live shots of the band. Instead of just putting the photos in an album for herself, she e-mailed the art director at the band's label and asked if she could send more sample shots. The art director agreed to take a look and then licensed the rights to use some of her work in promotional materials for the band. You never know, so you might as well try.

For more information about the recording industry and individual labels check out *Songwriter's Market* (Writer's Digest Books) or *The Yellow Pages of Rock* (The Album Network).

◄ The final image of Rob, for the CD liner of "North American Drum & Steel," was the result of a collaboration between photographer David Steckert and a team of graphic designers, Joel Rodgers, Meg Pullis and Kristian Roebling. "We wanted to keep a sort of 'live performance' vibe to it," says Steckert of the image. "We just let Rob be Rob and we came out with some great shots." Mia Mind Music, responsible for the promotion of this album, often utilizes images that interweave graphic textures and design in their promotion efforts. "Our artists seek photographers who are a little left of center and like to collaborate with graphic designers," says Promotions Director Ashley Wilkes.

A&M RECORDS, 1416 N. Labrea Ave., Hollywood CA 90028. Website: http://www.amrecords.com. Did not respond to our request for information.

 AFTERSCHOOL PUBLISHING COMPANY, P.O. Box 14157, Detroit MI 48214. (313)894-8855. President: Herman Kelly. Estab. 1977. Handles all forms of music. Freelancers used for portraits, in-concert shots, studio shots and special effects for publicity, brochures, posters and print advertising. Examples of recent uses: "Tell You What You're Going To Do," "Take A Journey," and "Love Letter-Dance to the Drummer" (all CD covers).
Needs: Buys 5-10 images annually. Offers 5-10 assignments annually. Interested in animation, love. Reviews stock photos. Model/property release preferred. Captions preferred.
Audiovisual Needs: Uses videotape, prints, papers for reproductions. Subjects include: love, fun, comedy, life, food, sports, cars, cultures.
Specs: Uses prints, all sizes and finishes, and videotape, all sizes. Accepts images in digital format for Windows (all file types).
Making Contact & Terms: Submit portfolio for review. Keeps samples on file. SASE. Reports in 1 month. Payment negotiable. Credit line given. Buys one-time, exclusive product and all rights; negotiable.

ALERT MUSIC, INC., 41 Britain St., Suite 305, Toronto, Ontario M5A 1R7 Canada. (416)364-4200. Fax: (416)364-8632. E-mail: alert@inforamp.net. Promotion Coordinator: Rose Slanic. Handles rock, pop and alternative. Freelancers used for cover/liner shots, inside shots and publicity.
Needs: Reviews stock photos. Model/property release preferred. Captions required.
Audiovisual Needs: Uses slides and videotape.
Specs: Uses color and b&w prints.
Making Contact & Terms: Query with résumé of credits. Works with local freelancers on assignment only. Keeps samples on file. SASE. Credit line given. Rights negotiable.

AMERICAN MUSIC NETWORKING INC., SCARAMOUCHÉ RECORDINGS, (formerly Scaramouché Recordings), P.O. Box 7018, Warner Robins GA 31095-7018. (912)953-2800. CEO: Robert R. Kovach. Estab. 1986. Produces country, folk, gospel, jazz, pop, progressive, R&B, rock, soul. Recent releases: "One Man's Junk," by Wayne Little; "Pots & Pans," by Theresa Justus. Uses portraits, in-concert shots, studio shots, special effects for cover/liner shots, inside shots, publicity, brochures, posters, print advertising.
Needs: Buys 12 images annually; 12 supplied by freelancers. Model release preferred; property release preferred. Photo caption preferred.
Specs: Uses all image formats.
Making Contact & Terms: Send query letter with samples. Provide résumé, business card, self-promotion pieces or tearsheets to be kept on file for possible future assignments. Art director will contact photographer for portfolio review if interested. Works with local freelancers on assignment only. Sometimes keeps samples on file; include SASE for return of material. Reports in 4 months on queries. Pays by the project, $25-145 for b&w; $50-200 for color. Pays on usage. Credit line not given. Rights negotiated.
Tips: "We want freelancers who are reasonable to work with. When submitting work, be patient."

ARIANA RECORDS, Myko Music, 1336 S. Avenida Polar, #C-208, Tucson AZ 85710. (520)790-7324. President: James M. Gasper. Estab. 1980. Handles all types of records. Freelancers used for portraits, studio shots, special effects, cover/liner shots, inside shots, publicity, posters and print advertising.
Needs: Buys 10-15 images annually; most supplied by freelancers. Offers 20-30 assignments annually. Reviews stock photos. Model/property release required for models, actors and musicians.
Audiovisual Needs: Uses film and videotape for music videos, animation films (shorts), documentary projects and commercials. Subjects include faces, forms, light and dark.
Specs: "Please transfer film to ½″ VHS videotape."
Making Contact & Terms: Query with samples. Provide résumé, business card, self-promotion pieces

or tearsheets to be kept on file for possible future assignments.. Works on assignment only. Keeps samples on file. SASE. Reports in 1 month. Pays upon completion of project. Buys one-time rights.

ARISTA RECORDS , 6 W. 57th St., New York NY 10019. Website: http://www.aristarec.com. Did not respond to our request for information.

ATLANTIC RECORDS, 75 Rockefeller Plaza, New York NY 10019. Website: http://www.atlantic-records.com. Did not respond to our request for information.

B-ATLAS & JODY RECORDS INC., 1353 E. 59th St., Brooklyn NY 11234. (718)968-8362. Vice President A&R Department: Vincent Vallis. Public Relations: Ron Alexander. Handles rock, rap, pop, country. Freelancers used for portraits, in-concert shots and studio shots for cover/liner shots.
Needs: Buys 10 images annually; 10 supplied by freelancers.
Making Contact & Terms: Query with samples. SASE. Reports in 1-2 weeks. Payment negotiable; payment on assignment. Credit line given. Buys first rights; negotiable.
Tips: "Keep trying."

ROBERT BATOR & ASSOCIATES, 31 State St., Suite 44D, Monson MA 01057. Art Director: Joan Bator. Estab. 1969. Handles rock and country. Photographers used for in-concert shots and studio shots for album covers, inside album shots, publicity and posters.
Needs: Buys 5,000 photos/year. Offers 400 assignments/year. Model release preferred. Captions preferred.
Specs: Uses 4×5 and 8×10 glossy ("mostly color") prints. "No slides."
Making Contact & Terms: Send unsolicited photos by mail for consideration. Provide résumé, business card, brochure, flier or tearsheets to be kept on file for possible future assignments. "You can submit female suggestive photos for sex appeal, or male, but in good taste." Works with freelancers on assignment only. SASE. Reports in 1 week. Pays $100-150/b&w photo; $150-250/color photo; $150-189/hour; $400-500/day; $375-495/job. Credit line given. Buys one-time rights; other rights negotiable.
Tips: Looks "for good clear photos of models. Show some imagination. Would like some sexually-oriented prints—because advertising is geared for it. Also fashion shots—men's and women's apparel, especially swimsuits and casual clothing."

N 📷 BELL RECORD INTERNATIONAL, Associate Pickwick/Mecca/International Rec., P.O. Box 725, Daytona Beach FL 32114. (904)252-4849. Produces alternative, classical, country, folk, gospel, jazz, pop, progressive, R&B, rap, rock and soul. Recent releases: "Heaven So High You Can't Get Over It," by Charles Vickers; and "Have You Heard of That Holy City," by Charles Vickers.
Audiovisual Needs: Uses slides, film and videotape.
Specs: Uses 35mm, $2\frac{1}{4} \times 2\frac{1}{4}$, 4×5 or 8×10 color transparencies.
Making Contact & Terms: Contact through rep. Send query letter. Provide résumé, business card, self-promotion pieces or tearsheets to be kept on file for possible future assignments. Art director will contact photographer for portfolio review if interested. Portfolio should include b&w and color slides, transparencies or thumbnails. Keeps samples on file; include SASE for return of material. Pays upon usage or receipt of invoice. Credit line sometimes given. Buys one-time, first and electronic rights.

📷 BLACK DIAMOND RECORDS, INC., P.O. Box 8073, Pittsburg CA 94565. (510)980-0893. Fax: (510)432-4342. Associate Director of Marketing: Sherece Burnley. Estab. 1987. Handles rhythm & blues, rap, hip-hop, jazz hip-hop, rock dance, blues rock, jazz. Freelancers used for portraits and studio shots for cover/liner shots, publicity, brochures, posters, print advertising.
Needs: Buys 50 images annually; 10% supplied by freelancers. Offers 2-3 assignments annually. Interested in clean, creative shots. Reviews stock photos. Model release required. Property release preferred. Captions preferred.
Audiovisual Needs: Uses videotape for reviewing artist's work. Wants to see style, creativity, uniqueness, avant garde work.
Specs: Uses 8×11 b&w prints; 35mm transparencies.
Making Contact & Terms: Submit portfolio for review. Provide résumé, business card, self-promotion pieces or tearsheets to be kept on file for possible assignments. Works on assignment only. Keeps samples on file. SASE. Reports in 3 months to 1 year. Payment negotiable. Pays upon usage. Credit line given. Buys all rights; negotiable.
Tips: "Be flexible. Look for the right project. Create a memory."

BLASTER-BOXX HITS/MARICAO RECORDS/HARD HAT RECORDS/BROADWAY SHOW MUSIC, 519 N. Halifax Ave., Daytona Beach FL 32118. Phone/fax: (904)252-0381. CEO: Bobby Lee

Cude. Estab. 1978. Handles country, MOR, pop, disco and gospel. Photographers used for portraits, in-concert shots, studio shots and special effects for album covers, inside album shots, publicity, brochures, posters, event/convention coverage and product advertising. Examples of recent uses: "Broadway, USA!," CD Show Series album, Volumes 1, 2, 3 (cover art); "Times-Square Fantasy Theatre," CD audio shows (cover art).
Needs: Offers 12 assignments/year. Model/property release required. Captions preferred.
Specs: Uses b&w and color photos.
Making Contact & Terms: Submit portfolio for review. Provide résumé, business card, self-promotion pieces, tearsheets or samples to be kept on file for possible future assignments. Works on assignment only. SASE. Reports in 2 weeks. Pays "standard fees." Credit line sometimes given. Buys all rights.
Tips: "Submit sample photo with SASE along with introductory letter stating fees, etc. Read *Mix Music* magazine."

BOUQUET-ORCHID ENTERPRISES, P.O. Box 1335, Norcross GA 30091. (770)814-2420. President: Bill Bohannon. Photographers used for live action and studio shots for publicity fliers and brochures.
Making Contact & Terms: Provide brochure and résumé to be kept on file for possible future assignments. Works on assignment only. SASE. Reports in 1 month. Pays $200 minimum/job.
Tips: "We are using more freelance photography in our organization. We are looking for material for future reference and future needs."

N **BRIGHT GREEN RECORDS**, P.O. BOX 24, Bradley IL 60915. E-mail: bgrecords@aol.com. Website: http://www.members.aol.com/bgrecords/bgr.html. Contact: Mykel Boyd. Estab. 1989. Produces alternative, classical, folk, jazz, pop, rap, rock, experimental. Recent releases: "Super God," by Angry Red Planet; "The Sin Eaters," by E.A. Zann. Uses portraits, in-concert shots, studio shots, special effects for cover/liner shots, inside shots, publicity, brochures, posters, print advertising, event/convention coverage.
Needs: Buys 10 images annually; 10 supplied by freelancers. Interested in unique nudes, landscapes and abstracts. Interested in reviewing stock photos.
Audiovisual Needs: Uses slides and/or film or video.
Specs: Uses color and/or b&w prints; 2¼×2¼, 4×5, 8×10 transparencies. Accepts images in digital format on Zip disk.
Making Contact & Terms: Send query letter with samples, brochure, stock photo list, tearsheets. Provide résumé, business card, self-promotion pieces or tearsheets to be kept on file for possible future assignments. Art director will contact photographer for portfolio review if interested. Portfolio should include b&w and/or color, prints, tearsheets, slides, transparencies or thumbnails. Works with freelancers on assignment only. Keeps samples on file; include SASE for return of material. Reports in 3 months on queries. Pays extra for electronic usage of photos. Pays on usage. Buys one-rights; negotiable.
Tips: "We are photo collectors as well as a record company. Show us something that will make us get our check book out. Be patient when submitting work."

N **BSW RECORDS**, P.O. Box 2297, Universal City TX 78148. (210)599-0022. Fax: (210)653-3989. E-mail: bswr18@txdirect.net. President: Frank Willson. Estab. 1987. Produces country, jazz, pop and rock. Recent releases: "Only the Dead Are Free," by Larry Buthen; and "Downtown Austin," by Marion Randell. Uses portraits, in-concert shots and studio shots for cover/liner shots, posters, publicity and brochures.
Needs: Interested in reviewing stock photos. Model release preferred. Photo caption preferred.
Audiovisual Needs: Uses videotape.
Specs: Uses 35mm or 4×5 transparencies.
Making Contact & Terms: Send query letter with samples and brochures. Art director will contact photographer for portfolio review if interested. Portfolio should include b&w and color prints or thumbnails. Keeps samples on file; include SASE for return of material. Reports in 3 weeks. **Pays on acceptance**. Buys one-time rights; negotiable.

CANYON RECORDS PRODUCTIONS, 4143 N. 16th St., Suite 6, Phoenix AZ 85016. (602)266-7835. Fax: (602)279-9233. E-mail: canyon@canyonrecords.com. Website: http://www.canyonrecords.com. Executive Producer: Robert Doyle. Estab. 1951. Produces and distributes Native American music on CDs and cassettes. Freelancers used for portraits, studio shots, shots of pow-wows and traditional Native American dances, cover/liner shots, inside shots, publicity, brochures, posters and print advertising. Examples of recent products: "Kokopelli's Cafe," and "Naked in Eureka" (covers, interiors).
Needs: Buys 10-15 images annually; all supplied by freelancers. Offers 4 assignments annually. Reviews stock photos. Model/property release required.
Specs: Uses any size glossy color and b&w prints; 4×5 transparencies.

Making Contact & Terms: Submit portfolio for review. Query with samples. Query with stock photo list. Keeps samples on file. SASE. Reports depending on current scheduling. Payment negotiable. Pays on usage. Credit line given. Buys one-time rights to reproduce on covers only; negotiable.

CAPITOL RECORDS, 1750 N. Vine St., Hollywood CA 90028. Website: http://www.hollywoodandvine. com. Did not respond to our request for information.

CAREFREE RECORDS GROUP, Box 2463, Carefree AZ 85377. (602)230-4177. Vice President: Doya Fairbains. Estab. 1991. Handles rock, jazz, classical, country, New Age, Spanish/Mexican and heavy metal. Freelancers used for portraits, in-concert shots, studio shots and special effects for cover/liner shots, publicity, brochures, posters, event/convention coverage, print advertising, CD covers, cassette covers. Recent releases: "Pablo" by Pablo; "The Visitor" by Rick Kaufman.
Needs: Buys 45-105 images annually. Offers 2-8 assignments/month. Interested in all types of material. Reviews stock photos. Model/property release required. Captions required.
Audiovisual Needs: Uses slides, film, videotape. Subjects include: outdoor scenes—horses, lakes, trees, female models.
Specs: Uses all sizes of glossy color or b&w prints; 8×10 transparencies; all sizes of film; all types of videotape.
Making Contact & Terms: Submit portfolio for review. Works on assignment only. Keeps samples on file. SASE. Reports in 1 month. Payment negotiable. Pays upon usage. Credit line given. Buys all rights; negotiable.
Tips: "Keep your eyes and mind open to all types of photographs."

CHERRY STREET RECORDS, INC., P.O. Box 52681, Tulsa OK 74152-0681. Fax: (918)742-8087. E-mail: cherryst@msn.com. Website: http://www.cherrystreetrecords.com. President: R.J. Young. Estab. 1989. Produces country, jazz, rock, blues. Recent releases: "Rhythm Gypsy," by Steve Hardin; "Find You Tonight," by Brad Absler; "Land of the Living," by Richard Elkerton; "Moments of Love," by George W. Carroll. Uses in-concert shots for cover/liner shots, publicity, brochures, posters, print advertising.
Needs: Buys 2 images annually. Interested in CD cover art and photos. "Open to tasteful photos. No medical, blood or sick photos." Model release required; property/location release required. "All photographs must be completely clean. All releases should be signed and sent with purchased photos." Photo captions preferred.
Audiovisual Needs: Uses slides and/or film or videotape for videos and Internet presentations. "Live performance—we purchase all rights. Photographer must sell the negatives and all reprint and copyrights etc."
Specs: Uses 3¾×4 color and/or b&w prints; 4×, 8×10 transparencies.
Making Contact & Terms: Send query letter with samples. Provide résumé, business card, self-promotion pieces or tearsheets to be kept on file for possible future assignments. "No calls." To show portfolio, photographer should follow-up with letter after initial query. Art director will contact photographer for portfolio review if interested. Works with freelancers on assignment only in Tulsa, OK; Nashville, TN; New York; San Francisco; and Sarasota, FL. Does not keep samples on file; include SASE for return of material. Reports in 6-8 weeks on queries; 3-16 weeks on samples. Pays on usage, **receipt of invoice**. Buys all rights.
Tips: "Do not photograph our artist unless Cherry Street has been contacted and approval given. We own likeness and name by contract. When submitting work keep it short and simple."

COMMA RECORDS & TAPES, P.O. Box 2148, 63243 New Isenburg 63243 Germany. Phone/fax: (+6102) 52696. Head Marketing Department: Theo Weinberger. Estab. 1969. Produces classical, country, folk, gospel, pop, progressive, R&B, rap, rock, soul. Uses portraits, in-concert shots, studio shots for cover/liner shots, inside shots, publicity, brochures, posters, print advertising.
Audiovisual Needs: Uses slides.
Specs: Uses any size color prints; 2¼×2¼, 4×5 transparencies.
Making Contact & Terms: Provide résumé, business card, self-promotion pieces or tearsheets to be kept on file for possible future assignments. Art director will contact photographer for portfolio review if interested. Portfolio should include color, prints, tearsheets, slides, transparencies or thumbnails. Works with freelancers on assignment only. Keeps samples on file; include SASE for return of material. Reports back only if interested, send non-returnable samples. Payment is negotiated. **Pays on receipt of invoice**. Credit line not given. Buys first rights, all rights.

N CONTINENTAL AND DIRECT RESPONSE RECORDS, Cash Productions, 744 Joppa Farm Rd., Joppa MD 21085. (410)679-2262. Fax: (410)679-2692. Director: Ernest W. Cash. Estab. 1978. Produces country, gospel. Uses studio shots, special effects for publicity, brochures.
Audiovisual Needs: Uses video.
Specs: Uses 4×5 color and/or b&w prints; VHS videotape.
Making Contact & Terms: Send query letter with samples, brochure. Provide résumé, business card, self-promotion pieces or tearsheets to be kept on file for possible future assignments. To show portfolio, photographer should follow-up with call and/or letter after intial query. Portfolio should include b&w and/or color, prints, tearsheets, slides, transparencies or thumbnails. Works on assignment only. Keeps samples on file; include SASE for return of material. Reports in 2 weeks on queries. Payment negotiable. **Pays on receipt of invoice**. Credit line not given. Buys all rights.

N CREEK RECORDS, P.O. Box 1946, Cave Creek AZ 85327. (602)488-8132. Vice President: Jeff Lober. Produces alternative, classical, country, folk, jazz, pop, R&B, rock, soul. Recent releases: "Chrissy Williams," by Chrissy Williams; "Pablo," by Pablo. Uses portraits, in-concert shots, studio shots, special effects for cover/liner shots, inside shots, publicity, brochures, posters, print advertising.
Needs: Interested in CD covers. Interested in reviewing stock photos. Model release required; property release required. Photo caption preferred.
Audiovisual Needs: Uses slides and/or film or video.
Specs: Uses color and/or b&w prints; 35mm, 8×10 transparencies.
Making Contact & Terms: Send query letter with samples, stock photo list. To show portfolio, photographer should follow-up with call. Portfolio should include b&w and/or color, prints or slides. Works on assignment only. Keeps samples on file. Reports in 2 months on queries. Pays by the project, $900-1,500 for b&w, $900-2,000 for color. **Pays on acceptance**. Credit line given. Buys one-time rights; negotiable.
Tips: "Use your own thoughts. Call editor for follow up."

N DEMI MONDE RECORDS AND PUBLICATIONS, D.M.F. Ltd., Foel Studio, Llanfair Caereinion, Powes SL21 ODS Wales. Phone/fax: (44)1938-810758. E-mail: demi.monde@dial.pipex.com. Website: http://www.demi.monde.co.uk. Managing Director: Dave Anderson. Estab. 1984. Produces alternative, pop, progressive, R&B, rock. Uses portraits, in-concert shots, studio shots, special effects for cover/liner shots, inside shots, publicity, brochures, posters.
Needs: Buys 25 images annually; 10 supplied by freelancers. Interested in reviewing stock photos.
Audiovisual Needs: Uses slides and/or film or video.
Making Contact & Terms: Send query letter with samples, brochure, stock photo list. Works with local freelancers on assignment only. Keeps samples on file; include SASE for return of material. Reports in 6 weeks on queries. Reports back only if interested, send non-returnable samples. Pays on usage. Credit line given. Buys all rights.

N HOTTRAX RECORDS, 1957 Kilburn Dr., Atlanta GA 30324-4852. (770)662-6661. E-mail: hotwax@hottrax.com. Website: http://www.hottrax.com. Vice President Public Relations/Publicity: Teri Blackman. Estab. 1975. Produces alternative, country, jazz, pop, rap, rock, blues rock. Recent releases: "Live From The Eye," by Roger Hurricane Wilson; "Night Shadows Vol.2, The Little Phil Era," by Night Shadows. Uses portraits, in-concert shots, studio shots, candid for cover/liner shots, inside shots, publicity, brochures, posters, print advertising, event/convention coverage, website.
Needs: Buys 15-24 images annually; 1-6 supplied by freelancers. Interested in scenery for backgrounds with artists superimposed digitally upon them; models; and shots of artists being produced. Model release required; property release required.
Audiovisual Needs: Uses slides and/or film or photo CD disks. Subjects include: 75% models, 20% scenery, 5% candid and studio shots of artists.
Specs: Uses color and/or b&w prints; 35mm transparencies. Accepts images in digital format (Kodak photo CD-ROM).
Making Contact & Terms: Send query letter with samples. Art director will contact photographer for portfolio review if interested. Portfolio should include b&w and/or color, prints. Works on assignment only. Keeps samples on file; cannot return material. Reports back only if interested, send non-returnable

MARKET CONDITIONS are constantly changing! If you're still using this book and it's 2000 or later, buy the newest edition of *Photographer's Market* at your favorite bookstore or order directly from Writer's Digest Books.

samples. Pays by the project, $100-600 for b&w, $100-600 for color. **Pays on acceptance and receipt of invoice**. Credit line sometimes given depending upon knowledge of photographers ability to shoot useful product.

Tips: "Hottrax receives several unsolicited submissions each week from both photographers and illustrators. We review all submissions and file material by potential usage needs. For example, shots of bar room scenes for Blues product, models on motorcycles and hotrods for Rock product, etc. Photo compatibility with project is essential. Send only three to five samples of work, all the same size. Because of file limitations, we cannot file all samples submitted if there are too many. Also label each photo with your permanent address. If you move please update. One photographic trend is that art directors are sometimes altering photographs for particular needs. For example, a color photo may wind-up as a duo-tone, or a composite photo may be digitally produced to superimpose artists on a background scene."

HOWDY RECORDS, 1810 S. Pea Ridge Rd., Jempee TX 76502. (254)939-8000. Owner: Andy Anderson. Estab. 1965. Produces country, gospel, Tex-Mex. Recent releases: "Heaven's Gate," by Jim Bradley. Uses portraits, in-concert shots, studio shots for cover/liner shots, publicity, brochures, posters.
Needs: Interested in concert shots and publicity shots. Model release required. Photo caption preferred; include type of music.
Audiovisual Needs: Uses slides and/or film or video. Subjects include: outdoor shots and publicity.
Specs: Uses 8×10 color prints.
Making Contact & Terms: Send query letter with stock photo list, tearsheets. Art director will contact photographer for portfolio review if interested. Portfolio should include color, tearsheets. Works on assignment only. Keeps samples on file; cannot return material. Reports in 1 month on queries. Reports back only if interested, send non-returnable samples. **Pays on acceptance and usage**. Credit line given. Buys all rights.
Tips: "Show honest and good work. Call first before submitting work.".

ISLAND RECORDS, 825 Eighth Ave., New York NY 10019. Los Angeles office: 8920 Sunset Blvd., 2nd Floor, Los Angeles CA 90069. Did not respond to our request for information.

KAT RECORDS, P.O. Box 460692, Escondido CA 92046-0692. Fax: (760)942-8228. E-mail: kat@antisocial.com. Website: http://www.junkdealer.com. Art Director: Mollie Ehn. Produces alternative, pop, rock. Recent releases: "Movie Songs E.P.," by Less Than Jake; "Half Fiction," by Discount. Uses portraits, in-concert shots, special effects for cover/liner shots, inside shots, publicity, print advertising, event/convention coverage, web pages.
Needs: Buys 20 images annually; 7 supplied by freelancers. Interested in concert and 50s photos. Wants original and exciting photos. Interested in reviewing stock photos. Model release preferred; property release preferred.
Audiovisual Needs: Uses film or video for music video. Subjects include: action shots of bands for video production.
Specs: Uses 35mm, 4×5 transparencies; VHS videotape. Accepts images in digital format. E-mail samples OK. Query first.
Making Contact & Terms: Provide résumé, business card, self-promotion pieces or tearsheets to be kept on file for possible future assignments. Art director will contact photographer for portfolio review if interested. Portfolio should include b&w and/or color, prints, tearsheets or thumbnails. Keeps samples on file. Reports back only if interested, send non-returnable samples. Payment varies by project. **Pays on acceptance**. Credit line sometimes given depending upon use and photographers preference. Negotiates rights based on use.
Tips: "Must be very avant-garde. Look at the new magazines, new albums and new websites—look ahead."

KIMBO EDUCATIONAL, 10 N. Third Ave., P.O. Box 477, Long Branch NJ 07740. (732)229-4949. Production Manager: Amy Laufer. Handles educational—early childhood movement-oriented records, tapes and videocassettes. General entertainment songs for young children. Physical fitness programs for all ages. Photographers used for album and catalog covers, brochures and product advertising.
Needs: Offers 5 assignments/year.
Specs: Uses transparencies.
Making Contact & Terms: Provide résumé, business card, self-promotion pieces or tearsheets to be kept on file for possible future assignments. Cannot return material. "We keep samples on file and contact photographer if in need of their services." Payment for each job is different—small advertising job, $75 minimum; album covers, $200-400." Buys all rights; negotiable.
Tips: "We are looking for top quality work but our budgets do not allow us to pay New York City prices

(need reasonable quotes). We prefer local photographers—communication is easier. We are leaning a little more toward photography, especially in our catalog. In the educational marketplace, it's becoming more prevalent to actually show our products being used by children and dynamite kids' faces, in general.''

N: ⊠ L.A. RECORDS, P.O. Box 1096, Hudson, Quebec J0P 1H0 Canada. (514)864-3236. Fax: (514)458-2819. E-mail: larecord@total.net. Website: http://www.radiofreedom.com. Manager: Tina Sexton. Estab. 1991. Produces alternative, rock. Recent releases: "Tempted," by Freeload; "Paradigm," by Golden Mean. Uses portraits, in-concert shots, special effects for cover/liner shots, inside shots, publicity, posters, print advertising.
Needs: Interested in images with visual impact.
Making Contact & Terms: Send query letter with samples. Provide résumé, business card, self-promotion pieces or tearsheets to be kept on file for possible future assignments. Art director will contact photographer for portfolio review if interested. Works with local freelancers only. Keeps samples on file; cannot return material. Reports in 6 months. Reports back only if interested, send non-returnable samples. Payment negotiable. Pays on usage. Credit line given. Rights negotiated.
Tips: "Go to the edge, then step beyond it. Know the artist's concept and image."

PATTY LEE RECORDS, 6034 Graciosa Dr., Hollywood CA 90068. Phone/fax: (213)469-5431. 1920 Audubon St., New Orleans LA 70118. (504)866-4480. Assistant to the President: Susan Neidhart. Estab. 1985. Handles New Orleans rock & roll, cowboy poetry, bebop and eclectic. Freelancers used for cover/liner shots, posters. Example of recent uses: *Alligator Ball* (CD cover).
Needs: "We look for unique artwork that works best for the genre of music we are promoting."
Specs: Varies from project to project.
Making Contact & Terms: "Send postcard query only; don't send actual art." Works with freelancers on assignment only. Keeps samples on file. Payment based on project. Credit line given. Buys one-time rights.

N: LMNOP, P.O. Box 8989, Atlanta GA 31106-8989. (404)320-1178. E-mail: LMNOP@babysue.com. Website: http://www.babysue.com. President: Don Seven. Estab. 1982. Produces country, folk, pop, rock. Recent releases: "Shoelaces," by The Mommy; "Happy Now," by babysue; "La La For You," by LMNOP. Uses portraits, in-concert shots, studio shots for cover/liner shots, brochures, posters, print advertising.
Needs: Buys 25 images annually; 15% supplied by freelancers. Interested in reviewing stock photos. Model release required; property release required. Photo caption required.
Specs: Uses any format.
Making Contact & Terms: Send query letter with sample. Provide résumé, business card, self-promotion pieces or tearsheets to be kept on file for possible future assignments. Art director will contact photographer for portfolio review if interested. Portfolio should include b&w and/or color, prints. Works on assignment only. Reports back only if interested, send non-returnable samples. Pays extra for electronic usage of photos. **Pays on acceptance**. Credit line not given. Buys one-time rights; negotiable.
Tips: "We like high contrast, far out stuff."

N: LUCIFER RECORDS, INC., P.O. Box 263, Brigantine NJ 08203. (609)266-2623. President: Ron Luciano. Photographers used for portraits, live action shots and studio shots for album covers, record sleeves, publicity fliers, brochures and posters.
Needs: Freelancers supply 50% of photos.
Making Contact & Terms: Provide self-promotion pieces, résumé and samples. Submit portfolio for review. SASE. Reports in 2-6 weeks. NPI; payment negotiable. Buys all rights.

MCA RECORDS, 1755 Broadway, 8th Floor, New York NY 10019. Did not respond to our request for information.

⊠ MIA MIND MUSIC, 259 W. 30th St., 12th Floor, New York NY 10001. (212)564-4611. Fax: (212)564-4448. E-mail: Mimimus@aol.com. Website: http://thewebslinger.com/miamind.htm. Promotions Director: Ashley Wilkes. Estab. 1982. Freelancers used for cover/liner shots, posters, direct mail, newspapers and videos. Recent releases: "Eternity" by Kissing Judas; "Skirts & Art" by The Ashley Wilkes Band; and "Allahrama" by North American Drum and Steel.
Needs: Offers 3 assignments annually. Interested in photos of recording artists. Reviews stock photos appropriate for album/CD covers. Model/property release preferred. Captions preferred.
Audiovisual Needs: Uses slides and video to present an artist to record labels to obtain a record deal.
Specs: Uses 8×10 matte color and b&w prints. Accepts images in digital format for Windows in TIFF, JPEG (PC format) and Corel Draw file formats. Send via Zip disk or floppy disk at 300 dpi.

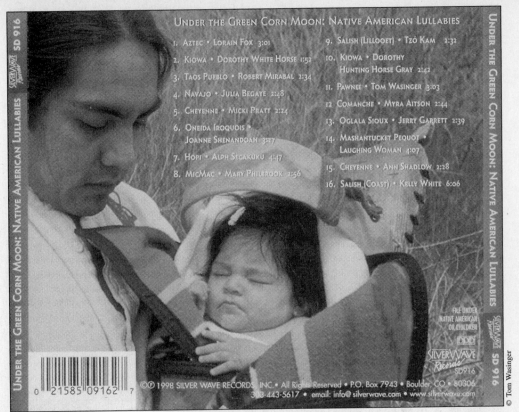

Although Tom Wasinger is not a professional photographer, he agreed to supply the images for an album of Native American lullabies. "I am a music producer and have worked with Silver Wave Records for nine years," Wasinger says. "It was agreed between myself and the people at the record company, that as I collected material for the record, I would photograph those who were participating." Despite his amateur status, Wasinger succeeded in capturing the intimacy between father and child in this back cover image. "It was pleasing for me to be involved in not only the music but the visual presentation as well."

Making Contact & Terms: Please call first. Submit 2 samples for review. Provide résumé, business card, self-promotion pieces or tearsheets to be kept on file for possible future assignments. "Follow up 2 weeks later for appointment to review portfolio. Portfolio reviews are only scheduled if a project is under development." Works with freelancers on assignment only. Keeps samples on file. SASE. Reports in 1-2 weeks. Pays max. $3,000/job; max. $5,000/color photo; max. $2,500/b&w photo. "In general, we are the liason between the photographer and the artists we work with. It is usually decided between the two, what the fee is." **Pays on acceptance.** Credit line given.

Tips: Looking for conceptual, interesting, edgy borderline-controversial photography. Seeing a trend toward conceptual, art photography. "Be willing to work on spec, meet deadlines and be as creative and flexible as possible."

MIRAMAR PRODUCTIONS, 200 Second Ave. W., Seattle WA 98119. (206)284-4700. Fax: (206)286-4433. E-mail: miramarpd@halcyon.com. Website: http://www.uspan.com/miramar. Contact: Mike Boydstun. Estab. 1985. Handles rock and New Age. Freelancers used for portraits, in-concert shots and studio shots for cover/liner, inside shots, publicity, brochure, posters and print advertising. Example of recent uses: *Imaginit* (children's animated music video, photo of performer on back).

Needs: Buys 10-20 images annually; 10-20 supplied by freelancers. Offers 10-20 assignments annually. Reviews stock photos. Model/property release required. Captions preferred.

Audiovisual Needs: Uses slides, film and videotape.

Specs: Uses 35mm, 2¼×2¼, 4×5 transparencies; 35mm, 16mm film; no less than Betacam videotape. Accepts images in digital format for Mac (Photoshop, PICT, TIFF). Send via floppy disk or Zip disk.

Making Contact & Terms: Query with samples. Works on assignment only. Keeps samples on file. SASE. Pays $100-2,500/job; negotiable. **Pays on acceptance.** Credit line given. Buys all rights; negotiable.

N **MOTION CITY RECORDS**, 1847 Centinella Ave., Santa Monica CA 90404. (310)264-4870. Fax: (310)264-4871. E-mail: kc@motioncity.com. Website: http://www.motioncity.com. A&R Director: Kevin Caetans. Estab. 1994. Produces alternative, pop, rock. Recent releases: "Cyberspace Cowboy," by Velvet; "Utah!", by Ufo Bro. Uses in-concert shots, studio shots, special effects for cover/liner shots, inside shots, posters.
Needs: Buys 20 images annually; 5 supplied by freelancers. Interested in reviewing stock photos. Model release preferred; property release preferred. Photo caption preferred; include where and when.
Audiovisual Needs: Uses videotape.
Specs: Uses glossy color and/or b&w prints; 35mm transparencies.
Making Contact & Terms: Provide résumé, business card, self-promotion pieces or tearsheets to be kept on file for possible future assignments. Art director will contact photographer for portfolio review if interested. Portfolio should include b&w and/or color, prints. Works with local freelancers only. Keeps samples on file; cannot return material. Reports back only if interested, send non-returnable samples. Payment negotiable. Pays on usage. Buys one-time rights.

N **MUSIC QUEST® ENTERTAINMENT & TELEVISION**, P.O. Box 822, Newark NJ 07102. (973)374-4421. Fax: (973)374-5888. E-mail: music@mqtv.com. Website: http://www.mqtv.com. Senior Vice President: La Sasha Sampson. Estab. 1994. Produces alternative, classical, country, folk, gospel, jazz, pop, progressive, R&B, rap, rock, soul, comedy, hip-hop, dance, spoken word, children's, fitness. Recent releases: "Very Special Christmas" by Melba Moore; "Can 'U' Feel It," by Survival Crew. Uses portraits, in-concert shots, studio shots, special effects for cover/liner shorts, inside shots, publicity, brochures, posters, print advertising, event/convention coverage.
Needs: Buys 20 images annually; 20 supplied by freelancers. Interested in everything interesting from rap, urban, pop, soul, soft jazz, sexy, lovers, youth, children, nature. Interested in reviewing stock photos. Model release required; property release required. Photo caption preferred.
Specs: Uses any format.
Making Contact & Terms: Send query letter with samples, brochure, stock photo list or tearsheets. Provide résumé, business card, self-promotion pieces or tearsheets to be kept on file for possible future assignments. Art director will contact photographer for portfolio review if interested. Keeps samples on file. Reports in 3 weeks. Reports back only if interested, send non-returnable samples. Payment negotiable. Pays on usage. Buys all rights, electronic rights; negotiable.
Tips: "I like creative color and black and white. May need a series of African-American lovers and children, midnight love scenes, children and teens dancing and moons. Be organized and send as many ideas as possible, because we have various projects in production."

N **NIGHTMARE RECORDS**, 7751 Greenwood Dr., St. Paul MN 55112. (612)784-9654. E-mail: nightdiscs@aol.com. Website: http://www.nightmare-records.com. Owner: Lance King. Estab. 1990. Produces progressive, rock. Recent releases: "Conditioned Response," Pavlov's Dogs; "From Cradle to Grave," by Malicious. Uses in-concert shots, studio shots, special effects for cover/liner shots, inside shots, publicity, posters, print advertising.
Needs: Interested in album cover art concepts. Model release preferred; property release preferred.
Audiovisual Needs: Uses videotape, CD-ROM. Subjects include: a broad spectrum of concepts.
Specs: Accepts images in digital format (CD-ROM, Zip or SyQuest in Mac format).
Making Contact & Terms: Send query letter with samples. Provide résumé, business card, self-promotion pieces or tearsheets to be kept on file for possible future assignments. Reports back only if interested, send non-returnable samples.

NUCLEUS RECORDS, 885 Broadway, #282, Bayonne NJ 07002-3032. President: Robert Bowden. Estab. 1979. Handles rock, country. Photographers used for portraits, studio shots for publicity, posters and product advertising.
Needs: Send still photos of people for consideration. Model release preferred. Property release required. Captions preferred.
Making Contact & Terms: Works on assignment only. SASE. Reports in 3 weeks. Pays $100-150/b&w photo; $200-250/color photo; $200-250/job. Credit line given. Buys one-time and all rights.

N **ORINDA REWARDS**, LB Enterprises, P.O. Box 838, Orinda CA 94563. (510)441-1300. Fax: (510)793-1187. Produces classical, jazz, pop, rock. Uses studio shots for cover/liner shots.
Needs: Model release required. Photo caption required.

Specs: Uses color prints.
Making Contact & Terms: Send query letter with samples. Art director will contact photographer for portfolio review if interested. Portfolio should include b&w and/or color, tearsheets. Keeps samples on file. Reports in 3 months on queries. Reports back only if interested, send non-returnable samples. Pays on usage and receipt of invoice. Credit line given. Buys all rights.

N ☀ PPL RECORDS, PPL-ZMI Entertainment, P.O. Box 8442, Universal City CA 91618. (818)506-8533. Fax: (818)506-8534. E-mail: pplzmi@aol.com. Website: http://www.pplzmi.com. Vice President: Ted Steele. Estab. 1979. Produces country, pop, R&B, rap, rock, soul. Recent releases: "Rodeo Time," by Jay Sattiewhite; "Flow," by Lejenz. Uses work for cover/liner shots, posters.
Needs: Buys 50 images annually; 25 supplied by freelancers. Interested in reviewing stock photos. Model release required. Photo caption required.
Audiovisual Needs: Uses film or videotape.
Specs: Uses 35mm, 4×5 transparencies.
Making Contact & Terms: Send query letter with samples, brochure, stock photo list. Provide résumé, business card, self-promotion pieces or tearsheets to be kept on file for possible future assignments. Art director will contact photographer for portfolio review if interested. Works with local freelancers only. Keeps samples on file. Reports in 2 weeks on queries. **Pays on acceptance.** Buys one-time rights.
Tips: "Be professional."

PRO/CREATIVES, 25 W. Burda Place, New City NY 10956-7116. President: David Rapp. Handles pop and classical. Photographers used for record album photos, men's magazines, sports, advertising illustrations, posters and brochures.
Making Contact & Terms: Query with examples, résumé of credits and business card. SASE. Reports in 1 month. Payment negotiable. Buys all rights.

RCA RECORDS, 1540 Broadway, 36th Floor, New York NY 10036. Website: http://www.bmgmusic.com. Did not respond to our request for information.

N ⊕ ☀ R·T·F·M, Value for Money Productions, White House Farm, Shropshire TF9 4HA United Kingdom. Phone: (01630)647374. Fax: (01630)647612. Hound Dog A&R: Tanya Lee. Estab. 1971. Produces alternative, classical, country, folk, Latin jazz, pop, R&B, rap, rock, soul, IWC classical. Recent releases: "I Wana Be Shot," by Nightmare; "Borstal," by Emmitt Till. Uses portraits, in-concert shots, studio shots, special effects for publicity, posters, print advertising, recording scenes.
Needs: Buys 20 images annually; 10 supplied by freelancers. Interested in all types of photos. Model release required for recording artists. Photo caption preferred.
Audiovisual Needs: Uses videotape.
Specs: Any size color prints; P·A·L videotape.
Making Contact & Terms: Send query letter with samples, brochure, stock photo list, tearsheets. Art director will contact photographer for portfolio review if interested. Portfolio should include color. Works on assignment only. Does not keep samples on file; include SASE for return of material. Reports in 6 weeks on queries. Payment negotiable. Pays on usage. Credit line given. Buys all rights.
Tips: "Be original. Make sure all submitted material has name and address for easy identification."

⊕ R.T.L. MUSIC/SWOOP RECORDS, White House Farm, Shropshire TF9 4HA England. Phone: (01630)647374. Fax: (01630)647612. Owner: Ron Lee. Estab. 1970. Uses portraits, in-concert shots, studio shots and special effects for album covers, inside album shots, publicity, brochures, posters, event/convention coverage and product advertising. Examples of recent uses: "Greatest Hits," by Swoops; "Slam," by Suburban Studs; and "Phobias," by Orphan (all CD covers).
Needs: Wants to see all types of photos. Model/property release required. Photo captions required.
Specs: Uses 8×10 glossy or matte, b&w or color prints.
Making Contact & Terms: Reports in 3 weeks. Payment always negotiated. Credit line given. Buys exclusive product and all rights; negotiable.
Tips: Depending on the photographer's originality, "prospects can be very good."

CONTACT THE EDITOR, of *Photographer's Market* by e-mail at photomarket@fwpubs.com with your questions and comments.

N ⟨image⟩ **REVOLUTION**, Warner Bros., 8900 Wilshire Blvd., Suite 200, Beverly Hills CA 90211. (310)289-5575. Fax: (310)289-7336. E-mail: mstuyvesan@wbr.com. Website: http://www.revolution-onlin e.com. Produces alternative, folk, pop, rock. Recent releases: "Alone," by Greg Garine; "Troubles," by Kenny Wayne Shepherd. Uses portraits, in-concert shots, studio shots, special effects for cover/liner shots, inside shots, publicity, posters, print advertising.
Needs: Model release required; property release required.
Audiovisual Needs: Uses slides, film and videotape.
Making Contact & Terms: Send query letter with samples, brochure, stock photo list, tearsheets. Provide résumé, business card, self-promotion pieces or tearsheets to be kept on file for possible future assignments. Art director will contact photographer for portfolio review if interested. Portfolio should include b&w and/ or color, prints or tearsheets. Works on assignment only. Keeps samples on file. Buys all rights.

N **ROCK DOG RECORDS/SATURN STUDIOS**, P.O. Box 3687, Hollywood CA 90078. (213)661-0259. E-mail: patt@ix.netcom.com. Production Coordinator: Gerry North. Estab. 1987. Produces alternative, instrumental music. Recent releases: "The Technology of Art," by Brain Storm; "Abduction," by Empath. Uses special effects for cover/liner shots, inside shots.
Needs: Buys 6 images annually; 6 supplied by freelancers. Interested in unusual, artistic, special effects and moody graphics. Interested in reviewing stock photos, unique material only.
Specs: Uses 35mm, 2¼×2¼ transparencies. Accepts images in digital format in IBM compatible TIFF files, must be compatible with Windows '95.
Making Contact & Terms: Send query letter with samples. Keeps samples on file; include SASE for return of material. Payment negotiable. Buys one-time rights; negotiable.
Tips: "Looking for something that sets a mood. All of our artists create instrumental music only, no lyrics. Send as many images as possible on a single page, or send a computer disk with samples."

ROCKWELL RECORDS, 227 Concord St., Haverhill MA 01830. (508)373-5677. President: Bill Macek. Produces top 40 and rock 'n' roll records. Photographers used for live action shots, studio shots and special effects for album covers, inside album shots, publicity, brochures and posters. Photos used for jacket design and artist shots.
Needs: Buys 1-2 images annually. Offers 1-2 assignments/annually. Freelancers supply 100% of photos. Interested in seeing all types of photos. "No restrictions. I may see something in a portfolio I really like and hadn't thought about using."
Making Contact & Terms: Arrange a personal interview. Submit b&w and color sample photos by mail for consideration. Submit portfolio for review. Provide résumé, business card or self-promotion pieces to be kept on file for possible future assignments. Local photographers preferred, but will review work of photographers from anywhere. SASE. Payment negotiable.

N ⟨image⟩ **ROYALTY RECORDS**, 176 Madison Ave., 4th Floor, New York NY 10016. (212)779-0101. Fax: (212)779-3255. Website: http://www.testicle.com. Vice President/A&R: Dave R. Estab. 1994. Produces alternative, rock. Recent releases: "Iggy Pop Tribute," by various artists; R.E.O. Speedealer. Uses in-concert shots, studio shots for cover/liner shots, inside shots, publicity, posters, print advertising, event/ convention coverage.
Needs: Buys 20 images annually; 4 supplied by freelancers. Interested in reviewing stock photos of live music/performance shots and group shots for publicity. Model release required; property release preferred for band photos. Photo caption preferred; include band name, record label/logo.
Audiovisual Needs: Uses slides and/or videotape for magazines and publicity. Subjects include: music video.
Specs: Uses glossy or matte color and/or b&w prints; 35mm transparencies; ½″, ¾″ videotape.
Making Contact & Terms: Send query letter with samples, brochure, stock photo list, tearsheets. Provide résumé, business card, self-promotion pieces or tearsheets to be kept on file for possible future assignments. Art director will contact photographer for portfolio review if interested. Portfolio should include b&w and/ or prints tearsheets. Works on assignment only. Keeps samples on file; include SASE for return of material. Reports back only if interested, send non-returnable samples. Pays by the project, $200 minimum for b&w, $200 minimum for color. **Pays on acceptance, receipt of invoice.** Buys all rights; negotiable.
Tips: "Send prints and negatives (or slides)."

N **SILVER WAVE RECORDS**, 2475 Broadway, Boulder CO 80304. (303)443-5617. Fax: (303)443-0877. E-mail: valerie@silverwave.com. Website: http://www.silverwave.com. Art Director: Valerie Sanford. Estab. 1985. Produces alternative, Native American, world. Recent releases: "The Offering," by Mary Youngblood; "Matriarch," by Shenandoah; "Under the Green Corn Moon—Native Lullabies," by

various artists. Uses portraits, in-concert shots, studio shots for cover/liner shots, inside shots, publicity, posters, print advertising.

Needs: Buys 10-25 images annually; 4-6 supplied by freelancers. Interested in 4-color slides or prints. Possibly interested in reviewing stock photos of native American images.

Specs: Uses 35mm, 4×5 transparencies.

Making Contact & Terms: Send query letter with samples. Provide résumé, business card, self-promotion pieces or tearsheets to be kept on file for possible future assignments. Portfolio should include b&w and/or color, prints, tearsheets or slides. Works on assignment only. Keeps samples on file. Reports back only if interested, send non-returnable samples. Payment ranges anywhere from $100-1,500 for photos. Pays on receipt of invoice. Credit line not given. Buys one-time rights with reprints of pieces and supplementary materials; negotiable.

Tips: "I like drama/unusual photos. Do not send cliché native photos. We need native images and I like colorful work although subtle tones are fine. Keep it simple—submit a small to medium amount of your typical style."

JERRY SIMS RECORDS, P.O. Box 648, Woodacre CA 94973. (415)789-8322. Owner: Jerome Sims. Estab. 1984. Produces alternative, R&B, Celtic. Recent releases: "Slippy-Do-Ride," by Disfunctional Family; "Winter Dreams," by Coral. Uses portraits, studio shots, special effects for cover/liner shots, publicity, brochures.

Needs: Buys 15 images annually; 6-7 supplied by freelancers. Interested in nature shots of oceans, landscapes etc. Model release required.

Specs: "Smallest sample is best initially."

Making Contact & Terms: Send query letter with postcard-size samples. Art director will contact photographer for portfolio review if interested. Works on assignment only. Keeps samples on file. Reports back only if interested, send non-returnable samples. Pays on usage with agreement. Rights negotiated.

Tips: "Don't be fancy, I like simplicity."

SIRR RODD RECORD & PUBLISHING CO., P.O. Box 18825, Philadelphia PA 19138. President/A&R: Rodney Jerome Keitt. Handles R&B, jazz, top 40, rap, pop, gospel and soul. Uses photographers for portraits, in-concert shots, studio shots and special effects for album covers, inside album shots, publicity, posters, event/convention and product advertising.

Needs: Buys 10 (minimum) photos/year.

Specs: Uses 8×10 glossy b&w or color prints.

Making Contact & Terms: Submit portfolio for review. Provide résumé, business card, self-promotion pieces or tearsheets to be kept on file for possible future assignments. SASE. Reports in 1 month. Pays $40-200/b&w photo; $60-250/color photo; $75-450/job. Credit line given. Buys all rights, negotiable.

Tips: "We look for the total versatility of the photographer. Of course, you can show us the more common group photos, but we like to see new concepts in group photography. Remember that you are freelancing. You do not have the name, studio, or reputation of 'Big Time' photographers, so we both are working for the same thing—exposure! If your pieces are good and the quality is equally good, your chances of working with record companies are excellent. Show your originality, ability to present the unusual, and what 'effects' you have to offer."

SONY MUSIC GROUP, 550 Madison Ave., 18th Floor, New York NY 10022. Did not respond to our request for information.

TREND RECORDS, Trend Rec. and Distribution Co., P.O. Box 201, Smyrna GA 30081. (770)432-2494. E-mail: tom@trendr.com. President: Tom Hodges. Estab. 1965. Produces country, folk, gospel, jazz, R&B, rap, soul. Recent releases: "Thank The Cowboy," by Rusty Lane; "A Big Smokin Gun," by Hilda Gonzalez. Uses portraits, studio shots for cover/liner shots, inside shots, brochures.

Needs: Buys 12 images annually; 6 supplied by freelancers. Interested in "CD and cassette album potentials." Interested in reviewing stock photos. Property release preferred. Photo caption preferred.

Specs: Uses 8½×11 glossy color and/or b&w prints. Accepts images in digital format.

Making Contact & Terms: Send query letter with samples, brochure, stock photo list, tearsheets. Art director will contact photographer for portfolio review if interested. Portfolio should include b&w and/or color prints. Works with local freelancers only. Keeps samples on file; include SASE for return of material. Reports in 3 weeks. **Pays on acceptance.** Credit line given. Buys one-time rights; negotiable.

Tips: "Be very versatile and neat."

28 RECORDS, 19700 NW 86th Court, Miami FL 33015-6917. (305)829-8142. E-mail: rec28@aol.com. President: Eric Diaz. Estab. 1994. Produces alternative, pop, progressive, rock, punk, metal. Recent

releases: "Near Life Experience," by Eric Knight; "Julian Day," by Helltown's Infamous Vandal. Uses portraits, in-concert, studio shots, special effects for cover/liner shots, inside shots, publicity, posters, print advertising.

Needs: Buys 7 images annually; all supplied by freelancers. Interested in "cutting edge inventive stuff, cross processing and high grain." Model release preferred; property release preferred. Photo caption preferred; include all necessary information.

Specs: Uses 35mm, 2¼×2¼, 4×5, 8×10 transparencies.

Making Contact & Terms: Send query letter with samples. Art director will contact photographer for portfolio review if interested. Portfolio should include b&w and/or color, tearsheets. Works with local freelancers only. Keeps samples on file. Reports back only if interested, send non-returnable samples. Buys all rights; negotiable.

Tips: "We are looking for people who are setting trends in photography and not following them. Looking for photos that are going to the next level. Freelancers should follow-up with future work. What we don't like today could be something new that we are looking for tomorrow."

VICTORY RECORDS, P.O. Box 146546, Chicago IL 60614. (312)666-8661. Fax: (312)666-8665. E-mail: victory@victoryrecords.com. Website: http://www.victoryrecords.com. Art Director: Sean Bonner. Estab. 1989. Produces hardcore, punk rock, rockabilly, ska. Examples of recent releases: "Satisfaction is the Death of Desire," by Hatebreed; "Omega Sessions," by Bad Brains. Uses portraits, in-concert shots for cover/liner shots, inside shots, publicity, brochures, posters, print advertising.

Needs: Interested in photos of our bands.

Specs: Uses 8×10 color prints; 35mm transparencies. Accepts images in digital format (Macintosh only).

Making Contact & Terms: Send query letter with samples, tearsheets. Portfolio should include b&w and/or color, prints, or tearsheets. Does not keep samples on file; include SASE for return of material. Payment varies. Pays on usage. Buys all rights; negotiable.

Tips: "Our music is very specific. We need photographers with a background in this already. You should be familiar with our bands."

VIRGIN RECORDS, 338 N. Foothill Rd., Beverly Hills CA 90210. Website: http://www.virginrecords.com. Did not respond to our request for information.

WARNER BROS. RECORDS, 3300 Warner Blvd., Burbank CA 91505. Website: http://www.wbr.com. Did not respond to our request for information.

WHITEHOUSE RECORDS, WATERDOG RECORDS AND ABSOLUTE RECORDS, P.O. Box 18439, Chicago IL 60618. (773)421-7499. E-mail: wthouse@housedog.com. Website: http://www.housedog.com. Label Manager: Rob Gillis. Estab. 1991. Produces alternative, folk, pop, progressive, rock. Recent releases: "Too Much Light Makes the Baby Go Blind," by The Neo-Futurists; "The Two Meter Sessions," by The Bad Examples. Uses portraits, studio shots for cover/liner shots, inside shots, publicity, posters.

Needs: Buys 8 images annually; 8 supplied by freelancers. Interested in portrait/publicity shots only. Photo caption preferred.

Making Contact & Terms: Send query letter with samples, brochure. Art director will contact photographer for portfolio review if interested. Works with local freelancers only. Does not keep samples on file. Reports back only if interested, send non-returnable samples. Pays by the project. **Pays on receipt of invoice.** Credit line given. Buys all rights.

Resources

Art/Photo Representatives

As your photographic business grows you may find yourself inundated with office work, such as creating self promotions, billing clients, attending portfolio reviews and filing images. All of this takes time away from shooting, and most photographers would rather practice their craft. However, there are ways to remove the marketing burden that's been placed upon you. One of the best ways is to hire a photo rep.

When you sign with a photo rep you basically hire someone to tote your portfolio around town to art directors, make cold calls in search of new clients, and develop promotional ideas to market your talents. The main goal is to find assignment work for you with corporations, advertising firms, or design studios. And, unlike stock agencies or galleries, a photo rep is interested in marketing your talents rather than your images.

For their time most reps charge 20-30 percent commission. They handle several photographers at one time, usually making certain that each shooter specializes in a different area. For example, a rep may have contracts to promote three different photographers, one that handles product shots, another that shoots interiors and a third who photographs food.

HOW TO DECIDE IF YOU NEED A REP

You need a rep if you:

- are too busy with work to make the personal contacts necessary to find new clients and keep the ones you have.
- have enough "bread-and-butter" work in a stable client base that allows you to spend money on the additional promotional material reps require.
- have a strong style or specialty that a rep can target clients for.
- have enough knowledge about how to sell yourself but want someone else to do it.
- consider yourself first as a business than as a photographer. Reps work best with people who appreciate the "profit-making" nature of their work. Anyone can say they want to be successful, but that means you must have the business education to be in charge of setting your goals and direction. A rep is there to realize your goals, not set them for you.
- are willing to spend the time to assist the rep in selling your work. You won't spend less time on marketing. You just won't do the same things. For example, instead of showing the portfolio, you will be creating new portfolio pieces for the rep to show.
- are looking for ways to promote your business and need a rep's time and expertise.
- practice good business management methods and have a professional attitude toward promotion. Established and efficient project management procedures and policies are important criteria of professionalism required by reps.
- have a head start on a portfolio of the kind of work you want to do. With commission sales, no portfolio means "down" time a rep can't afford.
- have the marketing plan and budget for your promotion pieces and plans to support the direction you give the rep.

(These tips are excerpted from Marketing & Promoting Your Work *©1995 by Maria Piscopo. Published by North Light Books. Reprinted by permission of North Light Books.)*

As you search for a rep there are numerous points to consider. First, how established is the rep you plan to approach? Established reps have an edge over newcomers in that they know the territory. They've built up contacts in ad agencies, magazines and elsewhere. This is essential since most art directors and picture editors do not stay in their positions for long periods of time. Therefore, established reps will have an easier time helping you penetrate new markets.

If you decide to go with a new rep, consider paying an advance against commission in order to help the rep financially during an equitable trial period. Usually it takes a year to see returns on portfolio reviews and other marketing efforts, and a rep who is relying on income from sales might go hungry if he doesn't have a base income from which to live.

And whatever you agree upon, always have a written agreement. Handshake deals won't cut it. You must know the tasks that each of you is required to complete and having your roles discussed in a contract will guarantee there are no misunderstandings. For example, spell out in your contract what happens with clients that you had before hiring the rep. Most photographers refuse to pay commissions for these "house" accounts, unless the rep handles them completely and continues to bring in new clients.

Also, it's likely that some costs, such as promotional fees, will be shared. For example, freelancers often pay 75 percent of any advertising fees (such as sourcebook ads and direct mail pieces).

If you want to know more about a specific rep, or how reps operate, contact the Society of Photographer and Artist Representatives, 60 E. 42nd St., Suite 1166, New York NY 10165, (212)779-7464. SPAR sponsors educational programs and maintains a code of ethics to which all members must adhere.

ANNE ALBRECHT AND ASSOCIATES, 405 N. Wabash, Suite 4410, Chicago IL 60611. (312)595-0300. Fax: (312)595-0378. Contact: Anne Albrecht. Commercial photography and illustration representative. Estab. 1991. President of C.A.R. (Chicago Artists Representatives). Represents 3 photographers and 7 illustrators. Markets include advertising agencies, corporations/clients direct, design firms, editorial/magazines, publishing/books and sales/promotion firms.
Handles: Illustration, photography.
Terms: Rep receives 25% commission. Advertises in *American Showcase*, *Creative Black Book* and *The Workbook*.
How to Contact: For first contact, send tearsheets. Reports only if interested. After initial contact drop off or mail materials for review. Portfolios should include photographs, tearsheets and/or photocopies.

N ARTIST DEVELOPMENT GROUP, 21 Emmett St., Suite 2, Providence RI 02903-4503. (401)521-5774. Fax: (401)521-5776. Contact: Rita Campbell. Represents photography, fine art, graphic design, as well as performing talent. Estab. 1982. Member of Rhode Island Women's Advertising Club. Markets include: advertising agencies; corporations/clients direct.
Handles: Illustration, photography.
Terms: Rep receives 20-25% commission. Advertising costs are split: 50% paid by talent; 50% paid by representative. For promotional purposes, talent must provide direct mail promotional piece; samples in book for sales meetings.
How to Contact: For first contact, send résumé, bio, direct mail flier/brochure. Reports in 3 weeks. After initial contact, drop off or mail in appropriate materials for review. Portfolios should include tearsheets, photographs.
Tips: Obtains new talent through "referrals as well as inquiries from talent exposed to agency promo."

ROBERT BACALL REPRESENTATIVE, 350 Seventh Ave., 20th Floor, Suite 2004, New York NY 10011-5013. (212)695-1729. Fax: (212)695-1739. E-mail: rob@bacall.com. Website: http://www.bacall.com. Contact: Robert Bacall. Commercial photography representative. Estab. 1988. Represents 6 photographers. Specializes in food, still life, fashion, beauty, kids, corporate, environmental, portrait, lifestyle, location, landscape. Markets include: advertising agencies; corporations/clients direct; design firms; editorial/magazines; publishing/books; sales/promotion firms.
Terms: Rep receives 30% commission. Exclusive area representation required. For promotional purposes,

talent must provide portfolios, cases, tearsheets, prints, etc. Advertises in *Creative Black Book, NY Gold, Workbook, Single Image.*

How to Contact: For first contact, send query letter, direct mail flier/brochure. Reports only if interested. After initial contact, drop off or mail materials for review.

Tips: "I usually get solicited and keep seeing new work until something interests me and I feel I can sell it to someone else. Seek representation when you feel your portfolio is unique and can bring in new business."

CECI BARTELS ASSOCIATES, 3286 Ivanhoe, St. Louis MO 63139. (314)781-7377. Fax: (314)781-8017. Contact: Ceci Bartels. Commercial illustration, photography and graphic design representative. Estab. 1980. Member of SPAR, Graphic Artists Guild, ASMP. Represents 30 illustrators, 4 photographers and 1 designer. "My staff functions in sales, marketing and bookkeeping. There are 7 of us. We concentrate on advertising agencies and sales promotion." Markets include advertising agencies; corporations/client direct; design firms; publishing/books; sales/promotion firms.

Handles: Illustration, photography, and new media. "Photographers who can project human positive emotions with strength interest us. We also want NYC talent and photographers to do liquids, splashes and pours."

Terms: Rep receives 30% commission. Advertising costs are 100% paid by talent. "We need direct mail support and advertising to work on the national level. We welcome 6 portfolios/artist. Artist is advised not to produce multiple portfolios or promotional materials until brought on." Advertises in *American Showcase, The Workbook.*

How to Contact: For first contact, send query letter, direct mail flier/brochure, tearsheets, slides, SASE, portfolio with SASE or promotional materials. Reports if SASE enclosed. Rep will contact photographer for portfolio review if interested. Portfolio should include "the best work the artist has, displayed to its best advantage." Obtains new talent through recommendations from others, solicitations and artists submitting work."

Tips: "We like to look at new work but can't always market the styles sent. Your work may be outstanding but we need to be able to market it within our niche. Usually we need to see it to make that determination."

BEATE WORKS, 2400 S. Shenandoah St., Los Angeles CA 90034-2026. (310)558-1100. Fax: (310)842-8889. E-mail: BeateWorks@aol.com. Contact: Beate Chelette. Commercial photography and graphic design representative. Estab. 1992. Represents 5 photographers and 2 designers. Staff includes Larry Bartholomew (fashion and lifestyle); Rick Strauss (beauty and fashion); Tracy Kahn (health, beauty, fitness); Rudy Schwab (fashion); and Grey Crawford (architecture, interior). A full service agency that covers preproduction to final product. Markets include advertising agencies, corporations/clients direct, design firms, publishing/books and editorial/magazines.

Handles: Photography. Only interested in established photographers. "Must have a client base."

Terms: Rep receives 25% commission. Charges all messenger fees; FedEx is charged back. Exclusive area representation required. Advertising costs are split: 75% paid by talent; 25% paid by representative. For promotional purposes, talent must provide at least 3 portfolios and plenty of promo cards.

How to Contact: For first contact, send photos. Reports in a week if interested. Rep will contact for portfolio review if interested. Portfolios should include b&w and color tearsheets and prints.

Tips: Typically obtains new talent through recommendations and referrals. "Do your research on a rep before you approach him."

N BENJAMIN PHOTOGRAPHERS NY, 149 Fifth Ave., New York NY 10011. (212)253-8688. Fax: (212)253-8689. E-mail: benjamin@portfolioview.com. Website: http://www.portfolioview.com. Contact: Benjamin. Commercial photography representative. Estab. 1992. Represents 3 photographers. Staff includes Skip Caplan (still-life), Dennis Gottlieb (food/still-life) and Zan (still-life). Agency specializes in advertising. Markets include: advertising agencies; corporations/clients direct; design firms; editorial/magazines; paper products/greeting cards; publishing/books; sales/promotion firms.

Will Handle: Photography.

Terms: Exclusive area representation required. Advertises in *Creative Black Book* and *The Workbook.*

How to Contact: Send tearsheets. If no reply, photographer should call. Rep will contact photographer for portfolio review if interested. Portfolio should include color tearsheets, transparencies.

BERENDSEN & ASSOCIATES, INC., 2233 Kemper Lane, Cincinnati OH 45206. (513)861-1400. Fax: (513)861-6420. Contact: Bob Berendsen. Commercial illustration, photography, graphic design representative. Estab. 1986. Represents 24 illustrators, 2 photographers, 25 Mac designers/illustrators in the MacWindows Group Division. Specializes in "high-visibility consumer accounts." Markets include: adver-

© Chris Amaral

This series of four images was a personal project created by photographer Chris Amaral. His agent, Ceci Bartels, used the series as a promotional piece for his work. Amaral discovered the model working in an antique shop and asked her to pose for him. "This promotional piece has worked very well for me, and has caught the attention of many art directors and designers, which led to future work in advertising. I feel this piece represents my work and the style I usually create."

tising agencies; corporations/clients direct; design firms; editorial/magazines; paper products/greeting cards; publishing/books; sales/promotion firms.

Handles: Illustration, photography. "We are always looking for illustrators who can draw people, product and action well. Also, we look for styles that are unique."

Terms: Rep receives 25% commission. Charges "mostly for postage but figures not available." No geographic restrictions. Advertising costs are split: 75% paid by talent; 25% paid by representative. For promotional purposes, "artist must co-op in our direct mail promotions, and sourcebooks are recommended. Portfolios are updated regularly." Advertises in *RSVP*, *Creative Illustration Book*, *The Ohio Source Book* and *American Showcase*.

How to Contact: For first contact, send query letter, résumé, non-returnable tearsheets, slides, photographs and photocopies. After initial contact, drop off or mail in appropriate materials for review. Portfolios should include tearsheets, slides, photographs, photostats, photocopies and SASE if materials need to be returned.

Tips: Obtains new talent "through recommendations from other professionals. Contact Bob Berendsen, president of Berendsen and Associates, Inc. for first meeting."

BERNSTEIN & ANDRIULLI INC., 60 E. 42nd St., New York NY 10165. (212)682-1490. Fax: (212)286-1890. Contact: Howard Bernstein. Photography representative. Estab. 1975. Member of SPAR. Represents 12 photographers. Markets include: advertising agencies; corporations/clients direct; design firms; editorial/magazines.

Handles: Photography.

Terms: Rep receives a commission. Exclusive career representation is required. No geographic restrictions. Advertises in *Creative Black Book*, *The Workbook*, *CA Magazine*, *Archive Magazine* and *Klik*.

How to Contact: For first contact, send query letter, direct mail flier/brochure, tearsheets, slides, photographs, photocopies. Reports in 1 week. After initial contact, drop off or mail in appropriate materials for review. Portfolio should include tearsheets and personal photos.

[N] BRAUN ART, 2925 Griffith St., San Francisco CA 94124. (415)467-9676. Fax: (415)467-5252. Contact: Star Jilek. Commercial photography, fine art and illustration buyer; illustration and photography broker; graphic design referral. Estab. 1980. Staff includes Kathy Braun and Star Jilek. Markets include: advertising agencies; corporations/clients direct; design firms; editorial/magazines; publishing/books; sales/promotion firms; packaging.

Will Handle: Illustration, photography, fine art, design.

Terms: Advertises in *American Showcase*, *The Workbook*.

How to Contact: For first contact, send tearsheets. Photographer should "send 8½×11 samples we can keep on file." Buyer will contact photographer for portfolio review if interested.

[N] MARIANNE CAMPBELL ASSOCIATES, (formerly Marianne Campbell), Pier 9 Embarcadero, San Francisco CA 94111. (415)433-0353. Fax: (415)433-0351. Contact: Marianne Campbell or Quinci Payne. Commercial photography representative. Estab. 1989. Member of APA, SPAR, Western Art Directors Club. Represents 5 photographers. Markets include: advertising agencies; corporations/clients direct; design firms; editorial/magazines.

Handles: Photography.

Terms: Negotiated individually with each photographer.

How to Contact: For first contact, send printed samples of work. Reports in 2 weeks, only if interested. After initial contact, call for appointment to show portfolio of tearsheets, slides, photographs.

Tips: Obtains new talent through recommendations from art directors and designers and outstanding promotional materials.

CORPORATE ART PLANNING, 27 Union Square West, Suite 407, New York NY 10003. (212)242-8995. Fax: (212)242-9198. Contact: Maureen McGovern. Fine art consultant and corporate curator. Estab. 1983. Specializes in corporate art programs. Markets include corporations/clients direct, architects, corporate collections, museums and developers.

Handles: Photography, fine art only.

Terms: Rep receives 15% commission. Advertising costs are split: 30% paid by talent; 70% paid by the representative. Advertises in *Art in America*, *Creative Black Book*, *American Showcase* and *The Workbook*.

How to Contact: For first contact, send query letter, résumé, bio, direct mail flier/brochure, tearsheets, SASE, e-mail address and color photocopies. Reports in 10 days. Rep will contact photographer for portfolio review only if interested. Portfolios should include tearsheets, thumbnails, slides, photographs and photocopies.

Tips: Obtains new talent through gallery recommendations.

N ⬛ **CREATIVE MANAGEMENT PARTNERS,** 1180 Avenue of the Americas, New York NY 10036. (212)655-6500. Fax: (212)271-7073. Commercial photography representative. Estab. 1979. Represents photographers. Staff includes Frank Parvis and Debra Shin. Agency specializes in advertising and editorial photography and film. Markets include: advertising agencies; corporations/clients direct; design firms; editorial/magazines; paper products/greeting cards.
Will Handle: Photography and film. "Just looking for great work—aggressive images."
Terms: Rep receives 25% commission. Exclusive area representation required. Advertising costs are split: 75% paid by talent; 25% paid by representative. Advertises in *The Workbook* and other sourcebooks.
How to Contact: Send photos. Replies only if interested within 1 week. If no reply, photographers should "move on and continue to stay in touch through promo materials." Portfolios may be dropped off every Wednesday. To show portfolio, photographer should follow-up with call. Rep will contact photographer for portfolio review if interested. Portfolio should include b&w and color prints.
Tips: Obtains new talent through word of mouth or seeing editorial work in magazines. "Know who you're going after—what their past is and what they specialize in!"

BROOKE DAVIS & COMPANY, (formerly Brooke & Company), 4323 Bluffview Blvd., Dallas TX 75209. (214)352-9192. Fax: (214)350-2101. Contact: Brooke Davis. Commercial illustration and photography representative. Estab. 1988. Member of Graphic Artists Guild. Represents 6 illustrators, 4 photographers. "Owner has 18 years experience in sales and marketing in the advertising and design fields." Markets include: advertising agencies, corporations/clients direct; design firms, editorial/magazines; sales/promotion firms.
Will Handle: Illustration and photography.
Terms: Rep receives 25% commission. Advertising costs are split: 75% paid by talent; 25% paid by representative. For promotional purposes, talent must provide a "solid portfolio and arresting and informational 'leave behinds.'" Advertises in *Creative Black Book* and *The Workbook*.
How to Contact: For first contact, send bio, direct mail flier/brochure, "sample we can keep on file if possible" and SASE. Reports in 3 weeks. If no reply, photographer should follow-up. Portfolio should include b&w and color tearsheets, transparencies and whatever photographer feels is the best representation of work as well as reproduced samples."
Tips: Obtains new talent through referral or by an interest in a specific style. "Only show your best work. Develop an individual style. Show the type of work that you enjoy doing and want to do more often. We must have a sample to leave with potential clients. Keep current, advertise and constantly test and update portfolio."

LINDA DE MORETA REPRESENTS, 1839 Ninth St., Alameda CA 94501. (510)769-1421. Fax: (510)521-1674. E-mail: ldmreps@aol.com. Contact: Linda de Moreta. Commercial photography and illustration representative; also portfolio and career consultant. Estab. 1988. Member of San Francisco Creative Alliance, Western Art Directors Club and Graphic Artists' Guild. Represents 4 photographers, 1 photodigital imager, 8 illustrators. Markets include: advertising agencies; design firms; corporations/client direct; editorial/magazines; paper products/greeting cards; publishing/books; sales/promotion firms.
Handles: Photography, digital imaging, illustration, calligraphy.
Terms: Rep receives 25% commission. Exclusive representation requirements vary. Advertising costs are handled by individual agreement. Materials for promotional purposes vary with each artist. Advertises in *The Workbook, American Showcase, The Black Book.*
How to Contact: For first contact, send direct mail flier/brochure, tearsheets, slides, photocopies, photostats and SASE. "Please do *not* send original art. SASE for any items you wish returned." Responds to any inquiry in which there is an interest. Portfolios are individually developed for each artist and may include prints, transparencies, tearsheets.
Tips: Obtains new talent primarily through client and artist referrals, some solicitation. "I look for a personal vision and style of photography or illustration and exceptional creativity, combined with professionalism, maturity and a willingness to work hard."

N **FRANCOISE DUBOIS/DENNIS REPRESENTS,** 305 Newbury Lane, Newbury Park CA 91320. (805)376-9738. Fax: (805)376-9729. E-mail: fdubois@primenet.com. Owner: Francoise Dubois. Commercial photography representative and creative and marketing consultant. Represents 5 photographers. Staff includes Andrew Bernstein (sports and sports celebrities), Ron Derhacopian (still-life/fashion), Eric Sander (people with a twist), Stephen Lee (fashion/entertainment) and Michael Baciu (photo impressionism). Agency specializes in commercial photography for advertising and editorial and creative and marketing consulting for freelance photographers. Markets include: advertising agencies; corporations/clients direct; design firms; editorial/magazines; paper products/greeting cards; publishing/books; sales/promotion firms.

Will Handle: Photography.

Terms: Rep receives 25% commission. Charges FedEx charges (if not paid by advertising agency or other potential client). Exclusive area representation required. Advertising costs are 100% paid by talent. For promotional purposes, talent must provide "3 portfolios, advertising in national sourcebook, 3 or 4 direct mail pieces a year. All must carry my name and number." Advertises in *American Showcase*, *Creative Black Book*, *The Workbook*, *The Alternative Pick* and *Klik*.

How to Contact: Send tearsheets, bio and interesting direct mail promos. Replies only if interested within 6-8 weeks. Rep will contact photographer for portfolio review if interested. Portfolio should include "whatever format as long as it is consistent."

Tips: Obtains new talent through consulting services. "Do not look for a rep if your target market is too small a niche. Do not look for a rep if you're not somewhat established. Hire a consultant to help you design a consistent and unique portfolio, a marketing strategy and to make sure your strengths are made evident and you remain focused."

RHONI EPSTEIN/Photographer's Representative, 11977 Kiowa Ave., Los Angeles CA 90049-6119. (310)207-5937. E-mail: gr8rep@earthlink.net. Contact: Rhoni Epstein. Photography representative. Estab. 1983. Member of APA. Represents 8 photographers. Specializes in advertising/entertainment photography.

Handles: Photography.

Terms: Rep receives 25-30% commission. Exclusive representation required in specific geographic area. Advertising costs are paid by talent. For promotional purposes, talent must have a strong direct mail campaign and/or double-page spread in national advertising book and a portfolio to meet requirements of agent. Advertises in *The Workbook*, *Klik*, *Alternative Pick*.

How to Contact: For first contact, send direct mail samples. Reports in 1 week, only if interested. After initial contact, call for appointment or drop off or mail in appropriate materials for review. Portfolio should demonstrate own personal style.

Tips: Obtains new talent through recommendations. "Research the rep and her agency the way you would research an agency before soliciting work! Remain enthusiastic. There is always a market for creative and talented people."

N FLOWER CHILDREN LTD., P.O. Box 46043, West Hollywood CA 90069. (213)871-6917. Fax: (213)656-6208. Vice President: Sue Schneider. Commercial photography representative. Estab. 1986. Represents 7 photographers. Agency specializes in music, celebrity, sci-fi photography.

Handles: Photography. Also interested in stock photos of musicians from the 50s, 60s, 70s.

Terms: Rep receives 40% commission.

How to Contact: For first contact, send query letter. Reports in 1 month. Rep will contact photographer for portfolio review of b&w and color prints and tearsheets if interested.

FORTUNI, 2508 E. Belleview Place, Milwaukee WI 53211. (414)964-8088. Fax: (414)332-9629. Contact: Marian Deegan. Commercial photography and illustration representative. Estab. 1990. Member of ASMP. Represents 2 photographers and 6 illustrators. Fortuni handles artists with unique, distinctive styles appropriate for commercial markets. Markets include advertising agencies, corporations, design firms, editorial/magazines, publishing/books.

Handles: Illustration and photography. "I am interested in artists with a thorough professional approach to their work."

Terms: Rep receives 30% commission. Exclusive area representation required. Advertising costs are split: 70% paid by the talent; 30% paid by the representative. For promotional purposes, talent must provide 4 duplicate transparency portfolios, leave behinds and 4-6 promo pieces per year. "All artist materials must be formatted to my promotional specifications." Advertises in *Workbook*, *Single Image* and *Chicago Source Book*.

How To Contact: For first contact, send query letter, direct mail flier/brochure, tearsheets, photocopies, photostats and SASE. Reports in 2 weeks only if interested. After initial contact, call to schedule an appointment. Portfolios should include photocopies and transparencies.

Tips: "I obtain new artists through referrals. Organize your work in a way that clearly reflects your style, and the type of projects you most want to handle; and then be professional and thorough in your initial contact and follow-through."

JEAN GARDNER & ASSOCIATES, 444 N. Larchmont Blvd., Suite 207, Los Angeles CA 90004. (213)464-2492. Fax: (213)465-7013. Contact: Jean Gardner. Commercial photography representative. Estab. 1985. Member of APA. Represents 6 photographers. Specializes in photography. Markets include: advertising agencies; design firms.

Handles: Photography.
Terms: Rep receives 25% commission. Exclusive representation is required. No geographic restrictions. Advertising costs are paid by the talent. For promotional purposes, talent must provide promos, *Workbook* advertising, a quality portfolio. Advertises in *The Workbook*.
How to Contact: For first contact, send direct mail flier/brochure.
Tips: Obtains new talent through recommendations from others.

GIANNINI & TALENT, 1932 Mcfall St., McLean VA 22101-5544. (703)534-8316. Fax: (703)534-8351. E-mail: gt@giannini~t.com. Website: http://www.giannini~t.com. Contact: Judi Giannini. Stock photography and commercial photography representative. Estab. 1987. Member of ADCMW. Represents 6 photographers. Specializes in talent that works in fine art and commercial arenas, or "who have singular personal styles that stand out in the market place." Markets include: advertising agencies; corporations/client direct; design firms; editorial/magazines; publishing/books; art consultants. Clients include private collections.
Handles: Photography, select DC images, panoramic images, digital and video animation.
Terms: Rep receives 25% commission. Charges for out-of-town travel, messenger and FedEx services, newsletter. Exclusive East Coast and Southern representation is required. Advertising costs are split: 75% paid by the talent; 25% paid by the representative. For promotional purposes, talent must provide leave-behinds and "at least have a direct mail campaign planned, as well as advertising in local and national sourcebooks. Portfolio must be professional." Advertises in *American Showcase*, *Creative Black Book*, *The Workbook* and *Creative Sourcebook*.
How to Contact: For first contact, talent should send query letter, direct mail flier/brochure. Reports in 1 week, only if interested. Call for appointment to show portfolio of slides, photographs.
Tips: Obtains new talent through recommendations from others. "Learn to be your own best rep while you are getting established. Then consider forming a co-op with other artists of non-competitive styles who can pay someone for six months to help them get started. Candidates for good reps have an art and sales background."

BARBARA GORDON ASSOCIATES LTD., 165 E. 32nd St., New York NY 10016. (212)686-3514. Fax: (212)532-4302. Contact: Barbara Gordon. Commercial illustration and photography representative. Estab. 1969. Member of SPAR, Society of Illustrators, Graphic Artists Guild. Represents 9 illustrators, 1 photographer. "I represent only a small select group of people and therefore give a great deal of personal time and attention to the people I represent."
Terms: Rep receives 25% commission. No geographic restrictions in continental US.
How to Contact: For first contact, send direct mail flier/brochure. Reports in 2 weeks. After initial contact, drop off or mail in appropriate materials for review. Portfolio should include tearsheets, slides, photographs; "if the talent wants materials or promotion piece returned, include SASE."
Tips: Obtains new talent through recommendations from others, solicitation, at conferences, etc. "I have obtained talent from all of the above. I do not care if an artist or photographer has been published or is experienced. I am essentially interested in people with a good, commercial style. Don't send résumés and don't call to give me a verbal description of your work. Send promotion pieces. *Never* send original art. If you want something back, include a SASE. Always label your slides in case they get separated from your cover letter. And always include a phone number where you can be reached."

CAROL GUENZI AGENTS, INC., 865 Delaware, Denver CO 80204-4533. (303)820-2599. Fax: (303)820-2598. E-mail: cggiant@aol.com. Website: http://www.artagent.com. Contact: Carol Guenzi. Commercial illustration, film and animation representative. Estab. 1984. Member of Denver Advertising Federation, Art Directors Club of Denver, SPAR and ASMP. Represents 25 illustrators, 5 photographers, 3 computer designers. Specializes in a "wide selection of talent in all areas of visual communications." Markets include: advertising agencies; corporations/clients direct; design firms; editorial/magazine, paper products/greeting cards, sales/promotions firms.
Handles: Illustration, photography. Looking for "unique style application" and digital imaging.
Terms: Rep receives 25-30% commission. Exclusive area representation is required. Advertising costs are split: 70-75% paid by talent; 25-30% paid by the representation. For promotional purposes, talent must provide "promotional material after six months, some restrictions on portfolios." Advertises in *American*

CONTACT THE EDITOR, of *Photographer's Market* by e-mail at photomarket@fwpubs.com with your questions and comments.

SELECT DC

ASSIGNMENT & STOCK PHOTOGRAPHY OF WASHINGTON, DC, & VICINITY

REPRESENTED BY

GIANNINI & TALENT

☎ 703.534.8316 FAX 703.534.8351 ✳ www.giannini-t.com

PHOTOS BY: MARK SEGAL (TOP, BOTTOM), GREG PEASE (MIDDLE)

Judy Giannini, owner of Giannini & Talent, created this promotional piece to showcase the work of two photographers she represents. The promo, featuring shots by Mark Segal and Greg Pease, "gets calls from all over the country," Giannini says. "It is also a great leave-behind piece for art directors." Segal's work is unique because of his use of varied formats, including panoramics. Giannini says Pease's strength lies in the "something extra" he brings to his images. "He is a very versatile shooter. He always comes through, even under difficult circumstances."

Showcase, Creative Black Book, The Workbook, Creative Options, Rocky Mountain Sourcebook.
How to Contact: For first contact, send direct mail flier/brochure, tearsheets, slides, photocopies. Reports in 2-3 weeks, only if interested. After initial contact, call or write for appointment to drop off or mail in appropriate materials for review, depending on artist's location. Portfolio should include tearsheets, slides, photographs.
Tips: Obtains new talent through solicitation, art directors' referrals, an active pursuit by individual. "Show your strongest style and have at least 12 samples of that style, before introducing all your capabilities. Be prepared to add additional work to your portfolio to help round out your style. We do a large percentage of computer manipulation and accessing on network. All our portfolios are on disk or CD-ROM."

PAT HACKETT/ARTIST REPRESENTATIVE, 1809 Seventh Ave., Suite 1710, Seattle, WA 98101-1320. (206)447-1600. Fax: (206)447-0739. E-mail: pathackett@aol.com. Website: http://www.pathackett.c om. Contact: Pat Hackett. Commercial illustration and photography representative. Estab. 1979. Member of Graphic Artists Guild. Represents 30 illustrators, 3 photographers. Markets include: advertising agencies; corporations/client direct; design firms; editorial/magazines.
Handles: Illustration and photography.
Terms: Rep receives 25-33% commission. Exclusive area representation is required. No geographic restrictions, but sells mostly in Washington, Oregon, Idaho, Montana, Alaska and Hawaii. Advertising costs are split: 75% paid by talent; 25% paid by representative. For promotional purposes, talent must provide "standardized portfolio, i.e., all pieces within the book are the same format. Reprints are nice, but not absolutely required." Advertises in *American Showcase, The Workbook, New Media Showcase.*
How to Contact: For first contact, send direct mail flier/brochure. Reports in 1 week, only if interested. After initial contact, drop off or mail in appropriate materials: tearsheets, slides, photographs, photostats, photocopies.
Tips: Obtains new talent through "recommendations and calls/letters from artists moving to the area. We represent talent based both nationally and locally."

BARB HAUSER, ANOTHER GIRL REP, P.O.Box 421443, San Francisco CA 94142-1443. (415)647-5660. Fax: (415)546-4180. Estab. 1980. Represents 11 illustrators but no photographers currently. Markets include: primarily advertising agencies and design firms; corporations/clients direct.
Handles: Illustration and photography.
Terms: Rep receives 25-30% commission. Exclusive representation in the San Francisco area is required. No geographic restrictions.
How to Contact: For first contact, send direct mail flier/brochure, tearsheets, slides, photographs, photocopies and SASE. Reports in 3-4 weeks. After initial contact call for appointment to show portfolio of tearsheets, slides, photographs, photostats, photocopies.

INDUSTRY ARTS, P.O. Box 1737, Beverly Hills CA 90213-1737. (310)302-0088. Fax: (310)305-7364. E-mail: tocker@gte.net. Website: http://www.industryarts.com. Agent/Broker: Marc Tocker. Commercial photography, illustration, digital art and graphic design representative. Photography and digital art broker. Estab. 1997. Member of California Lawyers for the Arts. Represents 1 photographer, 1 illustrator, 1 designer. Agency specializes in "cutting edge design based upon a philosophy that challenges dominant cultural paradigms." Markets include advertising agencies, corporations/clients direct, design firms.
Will Handle: Illustration, photography, digital art and graphic design. "We are looking for design mindful people who create cutting edge work."
Terms: Rep receives 15-25% commission. Exclusive area representation required. Advertising costs are paid by talent. Portfolio must be adopted to digital format for internet website presentation. Advertises in The Workbook.
How to Contact: Send query letter, bio, brochure, tearsheets, photos, SASE. Replies in 2 weeks. To show portfolio, photographer, should follow-up with call. Portfolio should include b&w and/or color prints, tearsheets or transparencies.
Tips: New talent obtained by recommendations, solicitations. "Distinguish yourself in the new hyper-competitive international art market through innovative structure, meaning and humor."

INFINITY FEATURES, 313 Heathcote Rd., Scarsdale NY 10583-7154. (914)472-9459. Fax: (914)472-7496. E-mail: infinityf@aol.com. President: Leslie Wigon. Illustration and photography broker, photo editor. Estab. 1982. Member of ASPP. Agency specializes in "finding overseas buyers for images already produced for domestic (editorial and commercial) clients. We market both photo features and stock and are most successful with spectacular images of unique people, places and things." Markets include advertising agencies, editorial/magazines, sales/promotion firms, corporations/clients direct, paper products/greeting cards, publishing/books.

Will Handle: Photography and photo/text packages. "We only work with well established, professional photographers whose work is published on a regular basis."
Terms: Commission varies from nothing to 50%. "We take nothing when dealing with certain magazines."
How to Contact: Send tearsheets, list of magazine credits and detailed descriptions of available images. Replies only if interested within 2 weeks.
Tips: "A lot of the photos and photo stories we circulate to overseas clients are found in domestic magazines and newspapers. Then after we sell material—the photographer keeps us informed of new material available and we phone from time to time. We also find new and interesting photos to market via the many photo catalogs available."

N INTERPRESS WORLDWIDE, P.O. Box 8374, Universal City CA 91618-8374. (213)876-7675. Contact: Ellen Bow. Representative for commercial and fashion photography, illustration, fine art, graphic design, models, actors/musicians, make-up artists and hairstylists; also illustration and photography broker. Estab. 1989. Represents 10 photographers, 6 make-up artists, 4 hairstylists, 20 models, 15 musicians, 4 actors, 2 illustrators, 2 designers and 5 fine artists. Specializes in subsidiaries worldwide: Vienna, Austria; Milan, Italy; London, England; and Madrid, Spain. Markets include: advertising agencies; corporations/clients direct; editorial/magazines; publishing/books; movie industry; art publishers; galleries; private collections; and music industry.
Handles: Illustration, photography, fine art, design, graphic art.
Terms: Rep receives 30% commission. Charges initial rep fee and postage. Exclusive representation negotiable. Advertising costs are split: 80% paid by the talent; 20% paid by representative. For promotional purposes, talent must provide 2 show portfolios, 6 traveling portfolios. Advertises in *Creative Black Book*, *The Workbook*, *Production-Creation*, *The Red Book*.
How to Contact: For first contact, send query letter, résumé, bio, direct mail flier/brochure, tearsheets, photos, photostats, e-folio, VHS, audio portfolio, CD, tape. Reports in 45-60 days. After initial contact, call or write for appointment or drop off or mail materials for review. Portfolios should include thumbnails, roughs, original art, tearsheets, slides, photographs, photostats, e-folio (Mac disk), CD-ROM (Mac).
Tips: Obtains new talent through recommendations from others and the extraordinary work, personality and talent of the artist. "Try as hard as you can and don't take our 'no' as a 'no' to your talent."

ELLEN KNABLE & ASSOCIATES, INC., 1233 S. LaCienega Blvd., Los Angeles CA 90035. (310)855-8855. Fax: (310)657-0265. E-mail: pearl2eka@aol.com. Contact: Ellen Knable. Commercial illustration, photography and production representative. Estab. 1978. Member of SPAR, Graphic Artists Guild. Represents 6 illustrators, 5 photographers. Markets include: advertising agencies; corporations/clients direct; design firms.
Terms: Rep receives 25-30% commission. Exclusive West Coast/Southern California representation is required. Advertising costs split varies. Advertises in *The Workbook*.
How to Contact: For first contact, send query letter, direct mail flier/brochure and tearsheets. Reports within 2 weeks. Call for appointment to show portfolio.
Tips: Obtains new talent from recommendations and samples received in mail. "Have patience and persistence!"

KORMAN & COMPANY, 135 W. 24th St. PH.A, New York NY 10011. (212)727-1442. Fax: (212)727-1443. Second office: 325 S. Berkeley, Pasadena CA 91107. (626)583-1442. Fax: (626)795-0627. Contact: Alison Korman or Patricia Muzikar. Commercial photography representative. Estab. 1984. Markets include: advertising agencies; corporations/clients direct; editorial/magazines; publishing/books.
Handles: Photography.
Terms: Rep receives 25-30% commission. "Talent pays for messengers, mailings, promotion." Exclusive area representation is required. Advertising costs are paid by talent "for first two years, unless very established and sharing house." For promotional purposes, talent must provide portfolio, directory ads, mailing pieces. Advertises in *Creative Black Book*, *The Workbook*, *Gold Book*.
How to Contact: For first contact, send direct mail flier/brochure. Reports in 1 month if interested. After initial contact, write for appointment or drop off or mail in portfolio of tearsheets, photographs.
Tips: Obtains new talent through "recommendations, seeing somebody's work out in the market and liking it. Be prepared to discuss your short term and long term goals and how you think a rep can help you achieve them."

ELAINE KORN ASSOCIATES, LTD., 2E, 372 Fifth Ave., New York NY 10018. (212)760-0057. Fax: (212)465-8093. Commercial photography representative. Estab. 1983. Member of SPAR. Represents 6 photographers. Specializes in advertising photography, still life, fashion, kids/babies. Markets include:

advertising agencies; editorial/magazines; sales/promotion firms; corporations/clients direct; paper products/greeting cards; design firms; publishing/books.
Handles: Photography.
How to Contact: For first contact, send promotional pieces, brochure, résumé, photostats, tearsheets and query letter. After initial contact, call or write for appointment to show portfolio.
Tips: Obtains new talent from recommendations from others. While looking for a rep, "don't give up and don't be a pain."

JOAN KRAMER AND ASSOCIATES, INC., 10490 Wilshire Blvd., #1701, Los Angeles CA 90024. (310)446-1866. Fax: (310)446-1856. Contact: Joan Kramer. Commercial photography representative and stock photo agency. Estab. 1971. Member of SPAR, ASMP, PACA. Represents 45 photographers. Specializes in model-released lifestyle. Markets include: advertising agencies; design firms; publishing/books; sales/promotion firms; producers of TV commercials.
Handles: Photography.
Terms: Rep receives 50% commission. Advertising costs split: 50% paid by talent; 50% paid by representative. Advertises in *Creative Black Book*, *The Workbook*.
How to Contact: Call to schedule an appointment or send a query letter. Portfolio should include slides. Reports only if interested.
Tips: Obtains new talent through recommendations from others.

N CAROYL LABARGE REPRESENTING, 161 E. 89th St., #4B, New York NY 10128. Fax: (212)831-6050. Contact by fax: Caroyl LaBarge. Commercial photography representative. Estab. 1991. Represents 5 photographers. Agency specializes in still life. Markets include: advertising agencies; corporations/clients direct; design firms; editorial/magazines; publishing/books; sales/promotion firms.
Will Handle: Photography.
Terms: Rep receives 25% commission. Charges 25% of messengers, couriers and all expenses. Exclusive area representation required. Advertising costs are split: 75% paid by talent; 25% paid by representative. For promotional purposes, talent must provide promo pieces.
How to Contact: Send query letter, tearsheets and fax materials. Replies only if interested within 1 week. Rep will contact photographer for portfolio review if interested. Portfolio should include b&w and color prints, slides and tearsheets.
Tips: Obtains new talent through references and magazines.

N LEHMAN-DABNEY INC., 1431 35th Ave. S., Seattle WA 98144. (206)325-8595. E-mail: dabsa@awol.com. President: Nathan Dabney. Commercial photography and illustration representative. Estab. 1989. Represents 1 photographer and 15 illustrators. Staff includes Connie Lehmen (vice president). Agency specializes in marketing commercial art to nationally and regionally based design firms and ad agencies. Markets include: advertising agencies; corporations/clients direct; design firms; editorial/magazines; publishing/books; sales/promotion firms.
Will Handle: Illustration and photography.
Terms: Rep receives 25% commission. Exclusive area representation required. Advertising costs are split: 25% paid by representative; 75% paid by talent. For promotional purposes, talent must provide portfolio and samples. Advertises in *American Showcase* and *The Alternative Pick*.
How to Contact: Send query letter, tearsheets and sourcebook samples. Replies only if interested within 2 weeks. Rep will contact photographer for portfolio review if interested. Portfolio should include b&w and color prints, slides, tearsheets and transparencies.
Tips: Obtains new talent through reviews of samples and portfolios. "Show your best work, no more than 10 pieces, with exceptional presentation."

LEVIN•DORR, 1123 Broadway, Suite 1005, New York NY 10010. (212)627-9871. Fax: (212)243-4036. E-mail: therepboys@aol.com. President: Bruce Levin. Commercial photography representative. Estab. 1983. Member of SPAR and ASMP. Represents 10 photographers. Agency specializes in advertising, editorial and catalogue; heavy emphasis on fashion, lifestyle and computer graphics.
Handles: Photography. Looking for photographers who are "young and college-educated."
Terms: Rep receives 25% commission. Exclusive area representation is required. Advertising costs are split: 75% paid by talent; 25% paid by representative. Advertises in *The Workbook* and other sourcebooks.
How to Contact: For first contact, send brochure, photos; call. Portfolios may be dropped off every Monday and Friday.
Tips: Obtains new talent through recommendations, research, word-of-mouth, solicitation. "Don't get discouraged."

LORRAINE & ASSOCIATES, 2311 Farrington, Dallas TX 75207. (214)688-1540. Fax: (214)688-1608. E-mail: lorainel@airmail.net. Contact: Lorraine Haugen. Commercial photography, illustration and digital imaging representative. Estab. 1992. Member of DSVC. Represents 3 photographers, 2 illustrators, 1 fine artist, 1 digital retoucher. "We have over eight years experience marketing and selling digital retouching and point-of-purchase advertising in a photographic lab." Markets include: advertising agencies; corporations/clients direct; design firms; interior decorators; high-end interior showrooms and retail.
Handles: Illustration, photography, digital illustrators and co-animators. Looking for unique established photographers and illustrators, CD digital animators and interactive CD-ROM animators.
Terms: Rep receives 25-30% commission, plus monthly retainer fee per talent. Advertising costs are split: 90% paid by talent; 10% paid by representative. For promotional purposes, talent must provide 2 show portfolios, 1 traveling portfolio, leave-behinds and at least 5 new promo pieces per year. Must advertise in national publications and participate in pro bono projects. Advertises in *American Showcase*, *Black Book*.
How to Contact: For first contact, send bio, direct mail flier/brochure, tearsheets. Reports in 2-3 weeks if interested. After initial contact, call to schedule an appointment. Portfolios should include photographs.
Tips: Obtains new talent through referrals and personal working relationships. "Talents' portfolios are also reviewed by talent represented for approval and complement of styles to the group represented. Photographer should be willing to participate in group projects and be very professional in following instructions, organization and presentation."

MCCONNELL & MCNAMARA, 182 Broad St., Wethersfield CT 06109. (860)563-6154. Fax: (860)563-6159. E-mail: jack_mcconnell@msn.com. Contact: Paula McNamara. Commercial illustration, photography and fine art representative. Estab. 1975. Member of SPAR, ASMP, ASPP. Represents 1 illustrator, 1 photographer and 1 fine artist. Staff includes Paula McNamara (photography, illustration and fine art). Specializes in advertising and annual report photography. Markets include: advertising agencies; corporations/client direct; design firms; editorial/magazines; paper products/greeting cards; publishing/books; sales/promotion firms; stock photography/travel; corporate collections; galleries.
Handles: Photography. "Looking for photographers specializing in stock photography of New England and 'concept' photography."
Terms: Rep receives 25-30% commission. Exclusive area representation is required. Advertising costs are split: 75% paid by talent; 25% paid by representative. For promotional purposes, talent must provide "professional portfolio and tearsheets already available and ready for improving; direct mail piece needed within 3 months after collaborating."
How to Contact: For first contact, send query letter, bio, résumé, direct mail flier/brochure, tearsheets, SASE. Reports in 1 month if interested. "Unfortunately we don't have staff to evaluate and investigate new talent or offer counsel." After initial contact, write for appointment to show portfolio of tearsheets, slides, photographs.
Tips: Obtains new talent through "recommendations by other professionals, sourcebooks and industry magazines. We prefer to follow our own leads rather than receive unsolicited promotions and inquiries. It's best to have repped yourself for several years to know your strengths and be realistic about your marketplace. The same is true of having experience with direct mail pieces, developing client lists, and having a system of follow up. We want our talent to have experience with all this so they can properly value our contribution to their growth and success—otherwise that 25% becomes a burden and point of resentment."

COLLEEN MCKAY PHOTOGRAPHY, 229 E. Fifth St., #2, New York NY 10003. (212)598-0469. Fax: (212)598-4059. Contact: Colleen McKay. Commercial editorial and fine art photography representative. Estab. 1985. Member of SPAR. Represents 4 photographers. "Our photographers cover a wide range of work from location, still life, fine art, fashion and beauty." Markets include: advertising agencies; design firms; editorial/magazines; retail.
Handles: Commercial and fine art photography.
Terms: Rep receives 25% commission. Exclusive area representation is required. Advertising costs are split: 75% paid by talent; 25% paid by representative. "Promotional pieces are very necessary. They must be current. The portfolio should be established." Advertises in *Creative Black Book*, *Select*, *New York Gold*.
How to Contact: For first contact, send query letter, résumé, bio, direct mail flier/brochure, tearsheets, slides, photographs. Reports in 2-3 weeks. "I like to respond to everyone but if we're really swamped I may only get a chance to respond to those we're most interested in." Portfolio should include tearsheets, slides, photographs, transparencies (usually for still life).
Tips: Obtains talent through recommendations of other people and solicitations. "I recommend that you look in current resource books and call the representatives who are handling the kind of work that you

admire or is similar to your own. Ask these reps for an initial consultation and additional references. Do not be intimidated to approach anyone. Even if they do not take you on, a meeting with a good rep can prove to be very fruitful! Never give up! A clear, positive attitude is very important."

MASLOV AGENT INTERNATIONAL, 608 York St., San Francisco CA 94110. (415)641-4376. Contact: Norman Maslov. Commercial photography and illustration representative. Estab. 1986. Member of APA. Represents 5 photographers, 13 illustrators. Markets include: advertising agencies; corporations/clients direct; design firms; editorial/magazines; paper products/greeting cards; publishing/books; private collections.
Handles: Photography. Looking for "original work not derivative of other artists. Artist must have developed style."
Terms: Rep receives 25% commission. Exclusive US national representation required. Advertising costs split varies. For promotional purposes, talent must provide 3-4 direct mail pieces a year. Advertises in *Single-Image, Archive, Workbook, Alternative Pick*.
How to Contact: For first contact, send query letter, direct mail flier/brochure, tearsheets. DO NOT send original work. Reports in 2-3 weeks only if interested. After initial contact, call to schedule an appointment or drop off or mail materials for review. Portfolio should include photographs.
Tips: Obtains new talent through suggestions from art buyers and recommendations from designers, art directors and other agents. "Enter your best work into competitions such as *Communication Arts* and *Graphis* photo annuals. Create a distinctive promotion mailer if your concepts and executions are strong."

MEO REPRESENTS, 60 Spring St., Suite 314, New York NY 10012. Contact: Frank Meo. Commercial photography representative. Estab. 1983. Member of SPAR. Represents 4 photographers. Markets include: advertising agencies; corporations/client direct; design firms.
Handles: Photography.
Terms: Rep receives 25% commission. Exclusive representation required. Advertising costs are split: 25% paid by talent; 75% paid by representative. Advertises in *Creative Black Book*.
How to Contact: For first contact, send query letter, photographs, direct mail flier/brochure. Reports in 5 days. After initial contact, drop off or mail in appropriate materials for review. Portfolio should include tearsheets, photographs.
Tips: Obtains new talent through recommendations and solicitations.

SUSAN MILLER REPRESENTS, 1641 Third Ave., Suite 29A, New York NY 10128. (212)427-9604. Fax: (212)427-7777. E-mail given upon request. Contact: Susan Miller. Commercial photography representative. Estab. 1983. Member of SPAR. Represents 8 photographers. "Firm deals only in advertising photography."
Handles: Photography.
Terms: Rep receives 25-30% commission in US; 33% in Europe. Advertising costs are paid by talent. "Talent must be able to self-promote in a directory page and other mailers if possible." Advertises in *Creative Black Book, The Workbook* and by direct mail.
How to Contact: For first contact, send query letter with direct mail flier/brochure, photocopies and SASE. "No e-mail or faxes, please." Reports in 3 weeks. After initial contact, call for appointment to show portfolio photographs.
Tips: "New talent comes to us through a variety of means; recommendation from art buyers and art directors, award shows, editorial portfolios, articles and direct solicitation. Photographers sending portfolio must pay courier both ways. Talent should please check directory ads to see if we have conflicting talent before contacting us. Most people calling us do not take the time to do any research, which is not wise."

MONTAGANO & ASSOCIATES, 11 E. Hubbard, 7th Floor, Chicago IL 60611. (312)527-3283. Fax: (312)527-2108. E-mail: dmontag@aol.com. Contact: David Montagano. Commercial illustration, photography and television production representative and broker. Estab. 1983. Member of Chicago Artist Representatives. Represents 8 illustrators, 2 photographers. Markets include: advertising agencies; corporations/clients direct; design firms; editorial/magazines; paper products/greeting cards.
Handles: Illustration, photography, design. Looking for tabletop food photography.
Terms: Rep receives 30% commission. No geographic restrictions. Advertising costs are split: 70% paid by talent; 30% paid by representative. Advertises in *American Showcase, The Workbook, Creative Illustration Book*.
How to Contact: For first contact, send direct mail flier/brochure, tearsheets, photographs, disk samples. Reports in 5 days. After initial contact, call to schedule an appointment. Portfolio should include tearsheets, photographs. "No slides."
Tips: Obtains new talent through recommendations from others.

MUNRO GOODMAN ARTISTS REPRESENTATIVES, 4 E. Ohio St., Studio B, Chicago IL 60611. (312)321-1336. Fax: (312)321-1350. Contact: Steve Munro. Commercial photography and illustration representative. Estab. 1987. Member of SPAR, CAR (Chicago Artist Representatives). Represents 2 photographers, 22 illustrators. Markets include: advertising agencies; corporations/clients direct; design firms; publishing/books.
Handles: Illustration, photography.
Terms: Rep receives 25-30% commission. Exclusive area representation required. Advertising costs are split: 75% paid by talent; 25% paid by representative. For promotional purposes, talent must provide 2 portfolios, leave-behinds, several promos. Advertises in *American Showcase*, *Creative Black Book*, *The Workbook*, other sourcebooks.
How to Contact: For first contact, send query letter, bio, tearsheets and SASE. Reports in 2 weeks only if interested. After initial contact, write to schedule an appointment.
Tips: Obtains new talent through recommendations, periodicals. "Do a little homework and target appropriate rep."

THE NEIS GROUP, 11440 Oak Dr., Shelbyville MI 49344. (616)672-5756. Fax: (616)672-5757. Contact: Judy Neis. Commercial illustration and photography representative. Estab. 1982. Represents 30 illustrators, 7 photographers. Markets include: advertising agencies; design firms; editorial/magazines; publishing/books.
Handles: Illustration, photography.
Terms: Rep receives 25% commission. Advertising costs are split: 75% paid by talent; 25% paid by representative. Advertises in *The American Showcase*.
How to Contact: For first contact, send direct mail flier/brochure, tearsheets, photographs. Reports in 5 days. After initial contact, drop off or mail in appropriate materials for review. Portfolio should include non-returnable tearsheets, photographs.
Tips: "I am mostly sought out by the talent. If I pursue, I call and request a portfolio review."

N 100 ARTISTS, 4170 S. Arbor Circle, Marietta GA 30066. (404)924-4793. Fax: (404)924-7174. Contact: Brenda Bender. Commercial photography, illustration and graphic design representative; also illustration or photography broker. Estab. 1990. Member of Society of Illustrators, Graphic Artists Guild. Represents 8 photographers, 40 illustrators, 8 designers. Specializes in first-rate, top-quality work. Markets include: advertising agencies; corporations/clients direct; design firms; editorial/magazines; publishing/books; sales/promotion firms.
Handles: Illustration, photography. "We will consider new talent but you must be ready to invest in portfolio, tearsheets, national advertisement and promos."
Terms: Rep receives 25-30% commission. $30-50 added to all out-of-town projects to lower expenses, i.e. fax, long-distance, etc. Exclusive area representation negotiable. Advertising costs are split: 75% paid by talent; 25% paid by representative. For promotional purposes, talent must provide portfolio, 2 traveling portfolios, leave-behinds, and at least 4 new promo pieces per year. Advertises in *American Showcase*, *The Workbook*.
How to Contact: For first contact, send query letter, direct mail flier/brochure, tearsheets and SASE. Reports in 3 weeks if interested. After initial contact, call to schedule an appointment or drop off or mail materials for review. Portfolio should include tearsheets, slides, photographs.
Tips: Obtains new talent through recommendations from others and solicitations. "Be very business like and organized, check out work rep already has, and follow up."

N JACKIE PAGE, 219 E. 69th St., New York NY 10021. (212)772-0346. Commercial photography representative. Estab. 1987. Member of SPAR and Ad Club. Represents 10 photographers. Markets include: advertising agencies.
Handles: Photography.
Terms: "Details given at a personal interview." Advertises in *The Workbook*.
How to Contact: For first contact, send direct mail flier/brochure. After initial contact, call for appointment to show portfolio of tearsheets, slides, photographs.
Tips: Obtains new talent through recommendations from others and mailings.

MARIA PISCOPO, 3603 S. Aspen Village Way #E, Santa Ana CA 92704-7570. (714)556-8133. Fax: (714)556-8133. E-mail: mpiscopo@aol.com. Website: http://e~folio.com/piscopo. Contact: Maria Piscopo. Commercial photography representative. Estab. 1978. Member of SPAR, Women in Photography, Society of Illustrative Photographers. Markets include: advertising agencies; design firms; corporations.
Handles: Photography. Looking for "unique, unusual styles; handles only established photographers."
Terms: Rep receives 25-30% commission. Exclusive area representation is required. No geographic re-

strictions. Advertising costs are split: 50% paid by talent; 50% paid by representative. For promotional purposes, talent must provide 1 show portfolio, 3 traveling portfolios, leave-behinds and at least 6 new promo pieces per year. Plans advertising and direct mail campaigns.

How to Contact: For first contact, send query letter, bio, direct mail flier/brochure and SASE. Reports in 2 weeks, if interested.

Tips: Obtains new talent through personal referral and photo magazine articles. "Be very business-like, organized, professional and follow the above instructions!"

ALYSSA PIZER, 13121 Garden Land Rd., Los Angeles CA 90049. (310)440-3930. Fax: (310)440-3830. Contact: Alyssa Pizer. Commercial photography representative. Estab. 1990. Member of APCA. Represents 5 photographers. Specializes in entertainment (movie posters, TV Gallery, record/album); fashion (catalog, image campaign, department store). Markets include: advertising agencies, corporations/clients direct, design firms, editorial/magazines, record companies; movie studios, TV networks, publicists.

Handles: Photography. Established photographers only.

Terms: Rep receives 25% commission. Photographer pays for Federal Express and messenger charges. Talent pays 100% of advertising costs. For promotional purposes, talent must provide 1 show portfolio, 4-7 traveling portfolios, leave-behinds and quarterly promotional pieces.

How to Contact: For first contact, send query letter or direct mail flier/brochure or call. Reports in a couple of days. After initial contact, call to schedule an appointment or drop off or mail materials for review.

Tips: Obtains new talent through recommendations from clients.

REDMOND REPRESENTS, 4 Cormer Court, Apt. #304, Timonium MD 21093. (410)560-0833. E-mail: sony@erols.com. Contact: Sharon Redmond. Commercial illustration and photography representative. Estab. 1987. Markets include: advertising agencies; corporations/client direct; design firms.

Handles: Illustration, photography.

Terms: Rep receives 30% commission. Exclusive area representation is required. No geographic restrictions. Advertising costs and expenses are split: 50% paid by talent; 50% paid by representative. For promotional purposes, talent must provide a small portfolio (easy to Federal Express) and at least 6 direct mail pieces (with fax number). Advertises in *American Showcase*, *Creative Black Book*.

How to Contact: For first contact, send mailouts. Reports in 2 weeks if interested.

Tips: Obtains new talent through recommendations from others, advertisting in *Black Book*, etc. "Even if I'm not taking in new talent, I do want samples sent of new work. I never know when an ad agency will require a different style of illustration/photography, and it's always nice to refer to my files."

KERRY REILLY: REPS, 1826 Asheville Place, Charlotte NC 28203. Phone/fax: (704)372-6007. Contact: Kerry Reilly. Commercial illustration and photography representative. Estab. 1990. Represents 16 illustrators, 3 photographers. Markets include: advertising agencies; corporations/clients direct; design firms; editorial/magazines.

Handles: Illustration, photography.

Terms: Rep receives 25% commission. Exclusive area representation is desired. No geographic restrictions. Advertising costs are split: 75% paid by talent; 25% paid by representative. For promotional purposes, talent must provide at least 2 pages printed leave-behind samples. Preferred format is 9×12 pages, portfolio work on 4×5 transparencies. Advertises in *American Showcase*, *Workbook*.

How to Contact: For first contact, send direct mail flier/brochure or samples of work. Reports in 2 weeks. After initial contact, call for appointment to show portfolio or drop off or mail tearsheets, slides, 4×5 transparencies.

Tips: Obtains new talent through recommendations from others. "It's essential to have printed samples—a lot of printed samples."

JULIAN RICHARDS, 262 Mott St., New York NY 10012. (212)219-1269. Fax: (212)925-7803. Contact: Juliette Consigny. Commercial photography representative. Estab. 1992. Represents 5 photographers. Specializes in portraits, travel. Markets include: advertising agencies; design firms; editorial/magazines; publishing/books.

Terms: Rep receives 20% commission. Exclusive area representation required. Advertising costs are split: 80% paid by talent; 20% paid by representative.

How to Contact: For first contact, send direct mail flier/brochure.

Tips: Obtains new talent by working closely with potential representees over a period of months. "Be reasonable in your approach—let your work do the selling."

THE ROLAND GROUP INC., 4948 St. Elmo Ave., #201, Bethesda MD 20814. (301)718-7955. Fax: (301)718-7958. E-mail: rolandgrp@aol.com. Contact: Rochel Roland. Commercial photography and illustration representatives as well as illustration and photography brokers. Estab. 1988. Member of SPAR, ASMP, Art Directors Club and Ad Club. Markets include advertising agencies; corporations/clients direct; design firms and sales/promotion firms.
Handles: Illustration, photography.
Terms: Agent receives 35% commission. For promotional purposes, talent must provide transparencies, slides, tearsheets or a digital portfolio. Advertises in *Print Magazine*, *American Showcase*, *The Workbook* and *Creative Sourcebook*.
How to Contact: For first contact, send résumé, tearsheets or photocopies and any other nonreturnable samples. Reports only if interested. After initial contact, drop off portfolio materials for review. Portfolios should include tearsheets, slides, photographs, photocopies.
Tips: "The Roland Group provides the National Photography Network Service in which over 200 photographers are assigned to specific geographic territories around the world to handle projects for all types of clients."

LINDA RUDERMAN, 1245 Park Ave., New York NY 10128. Contact: Linda Ruderman. Commercial photography representative. Estab. 1988. Member of SPAR. Represents 2 photographers. Specializes in children and still life photography. Markets include: advertising agencies; corporations/clients direct; design firms; sales/promotion firms, editorial/magazines.
Handles: Photography.
Terms: To be discussed. Advertises in *Creative Black Book* and *The Workbook*.
How to Contact: For first contact send bio, direct mail flier. Reports back only if interested.
Tips: Obtains new talent through recommendations, *Creative Black Book* portfolio review and by calling photographers who advertise in *The Creative Black Book* and *The Workbook*.

DARIO SACRAMONE, 302 W. 12th St., New York NY 10014. (212)929-0487. Fax: (212)242-4429. Commercial photography representative. Estab. 1972. Represents 2 photographers, Marty Umans and John Wilkes. Markets include: advertising agencies; design firms; corporations; editorial.
Handles: Photography.
Terms: Rep receives 25% commission. Exclusive area representation is required. For promotional purposes, talent must provide direct mail piece, minimum of 3 professionally-put-together portfolios.
How to Contact: For first contact, send bio, direct mail flier/brochure. After initial contact, drop off or mail in appropriate materials for review.

FREDA SCOTT, INC., 1015-B Battery St., San Francisco CA 94111. (415)398-9121. Fax: (415)398-6136. Contact: Freda Scott. Commercial illustration and photography representative. Estab. 1980. Member of SPAR. Represents 10 illustrators, 10 photographers. Markets include: advertising agencies; corporations/clients direct; design firms; editorial/magazines; paper products/greeting cards; publishing/books; sales/promotion firms.
Handles: Illustration, photography.
Terms: Rep receives 25% commission. No geographic restrictions. Advertising costs are split: 75% paid by talent; 25% paid by representative. For promotional purposes, talent must provide "promotion piece and ad in a directory. I also need at least three portfolios." Advertises in *American Showcase*, *Creative Black Book*, *The Workbook*.
How to Contact: For first contact, send direct mail flier/brochure, tearsheets and SASE. If you send transparencies, reports in 1 week, if interested. "You need to make follow up calls." After initial contact, call for appointment to show portfolio of tearsheets, photographs (4×5 or 8×10).
Tips: Obtains new talent sometimes through recommendations, sometimes solicitation. "If you are seriously interested in getting repped, keep sending promos—once every six months or so. Do it yourself a year or two until you know what you need a rep to do."

SHARPE + ASSOCIATES INC., 7536 Ogelsby Ave., Los Angeles, CA 90045. (310)641-8556. Fax: (310)641-8534. E-mail: sharpela@eastlink.net. Contact: John Sharpe (LA), Colleen Hedleston (NY: (212)595-1125). Commercial illustration and photography representative. Estab. 1987. Member of APA. Represents 5 illustrators, 5 photographers. Not currently seeking new talent but "always willing to look at work." Staff includes: John Sharpe, Irene Sharpe, Colleen Hedleston and Eva Burnett (general commercial—advertising and design), "all have ad agency marketing backgrounds. We tend to show more nonmainstream work." Markets include: advertising agencies; corporations/clients direct; design firms; editorial/magazines; music/publishing; sales/promotion firms.
Handles: Illustration, photography.

Terms: Agent recieves 25% commission. Exclusive area representation is required, Advertising costs are paid by talent. For promotional purposes, "promotion and advertising materials are the talent's responsibility. The portfolios are 100% the talent's responsiblity and we like to have at least three complete books per market." Advertises in major sourcebooks and through direct mail.

How to Contact: For first contact, call, then follow up with printed samples. Reports in 2 weeks. After initial contact, call for appointment to show portfolio.

Tips: Obtains new talent mostly through referrals, occasional solicitations. "Once they have a professional portfolio together and at least one representative promotional piece, photographers should target reps along with potential buyers of their work as if the two groups are one and the same. They need to market themselves to reps as if the reps are potential clients."

N **SOODAK REPRESENTS**, 11135 Korman Dr., Potomac MD 20854. (301)983-2343. Fax: (301)983-3040. Contact: Arlene Soodak. Commercial photography representative. Estab. 1985. Member of ASMP, AIGA. Represents 4 photographers. Specializes in international capabilities—photography, food, location, still life. Markets include: advertising agencies; design firms, corporations.

Handles: Photography. Looking for "established or award winners such as Kodak's European Photographer of the Year, former *National Geographic* photographer, etc."

Terms: Rep receives 25% commission. Exclusive area representation is required. Payment of advertising costs "depends on length of time artist is with me." For promotional purposes, talent must provide "intact portfolio of excellent quality work and promo package and direct mail campaign which I will market." Advertises in *The Workbook* and featured on cover of *CA Magazine*, January 1996.

How to Contact: For first contact, send direct mail flier/brochure, tearsheets, photocopies. Reports in 10 days. After initial contact, drop off or mail in portfolio for review.

Tips: Obtains new talent through recommendations from others and direct contact with photographers.

SULLIVAN & ASSOCIATES, 3805 Maple Court, Marietta GA 30066. (770)971-6782. Fax: (770)977-3882. E-mail: sullivan@atlcom.net. Contact: Tom Sullivan. Commercial illustration, photography and graphic design representative. Estab. 1988. Member of Creative Club of Atlanta, Atlanta Ad Club. Represents 14 illustrators, 7 photographers and 7 designers, including computer graphic skills in illustration/design/production and photography. Staff includes Tom Sullivan (sales, talent evaluation, management), Debbie Sullivan (accounting, administration). Specializes in "providing whatever creative or production resource the client needs." Markets include: advertising agencies; corporations/client direct; design firms; editorial/magazines; publishing/books; sales/promotion firms.

Handles: Illustration, photography. "Open to what is marketable; computer graphics skills."

Terms: Rep receives 25% commission. Exclusive area representation in Southeastern US is required. Advertising costs paid by talent. For promotional purposes, talent must provide "direct mail piece, portfolio in form of 8½×11 (8×10 prints) pages in 22-ring presentation book." Advertises in *American Showcase*, *The Workbook*.

How to Contact: For first contact, send bio, direct mail flier/brochure; "follow up with phone call." Reports in 2 weeks if interested. After initial contact, call for appointment to show portfolio of tearsheets, photographs, photostats, photocopies, "anything appropriate in nothing larger than 8½×11 print format."

Tips: Obtains new talent through referrals and direct contact from creative person. "Have direct mail piece or be ready to produce it immediately upon reaching an agreement with a rep. Be prepared to immediately put together a portfolio based on what the rep needs for that specific market area."

TM ENTERPRISES, (formerly T & M Enterprises), 270 N. Canon Dr., Suite 2020, Beverly Hills CA 90210. (310)274-2664. Fax: (310)274-4678. E-mail: tmarques@idt.net. Contact: Tony Marques. Commercial photography representative and photography broker. Estab. 1985. Member of Beverly Hills Chamber of Commerce. Represents 50 photographers. Specializes in photography of women only: high fashion, swimsuit, lingerie, glamour and fine (good taste) *Playboy*-style pictures. Markets include: advertising agencies; corporations/clients direct; editorial/magazines; paper products/greeting cards; publishing/books; sales/promotion firms; medical magazines.

Handles: Photography.

Terms: Rep receives 50% commission. Advertising costs are paid by representative. "We promote the standard material the photographer has available, unless our clients request something else." Advertises

● **SPECIAL COMMENTS** within listings by the editor of *Photographer's Market* are set off by a bullet.

in Europe, South and Central America and magazines not known in the US.

How to Contact: For first contact, send everything available. Reports in 2 days. After initial contact, drop off or mail in appropriate materials for review. Portfolio should include slides, photographs, transparencies, printed work.

Tips: Obtains new talent through worldwide famous fashion shows in Paris, Rome, London and Tokyo; participating in well-known international beauty contests; recommendations from others. "Send your material clean. Send your material organized (neat). Do not borrow other photographers' work in order to get representation. Protect—always—yourself by copyrighting your material. Get releases from everybody who is in the picture (or who owns something in the picture)."

TY REPS, 920¼ N. Formosa Ave., Los Angeles CA 90046. (213)850-7957. Fax: (213)850-0245. Contact: Ty Methfessel. Commercial photography and illustration representative. Specializes in automotive photography, portfolio reviews and marketing advice. Markets include advertising agencies; corporations/clients direct; design firms.

Handles: Illustration and photography.

Terms: Rep receives 25-30% commission. Exclusive area representation required. Advertising costs paid by talent. For promotional purposes, talent must provide a minimum of 3 portfolios, 4 new promos per year and a double-page ad in a national directory. Advertises in *American Showcase, Creative Black Book* and *The Workbook.*

How to Contact: For first contact, send query letter, direct mail flier/brochure and tearsheets. Reports in 2 weeks only if interested.

ELYSE WEISSBERG, 225 Broadway, Suite 700, New York NY 10007. (212)227-7272. Fax: (212)385-0349. E-mail: elyserep@aol.com. Website: http://www.elyserep.com. Contact: Elyse Weissberg. Commercial photography representative, photography creative consultant. Estab. 1982. Member of SPAR. Markets include: advertising agencies; corporations/clients direct; design firms; editorial/magazines; publishing/books; sales/promotion firms.

Handles: Commercial photography. "I'm not looking for talent at this time."

Terms: "Each talent contract is negotiated separately." No geographic restrictions. No specific promotional requirements. "My only requirement is ambition." Advertises in *KLIK, Creative Black Book, The Workbook.*

How to Contact: Send mailers.

Tips: Elyse Weissberg is available on a consultation basis. She reviews photography portfolios and gives direction in marketing and promotion.

 DAVID WILEY REPRESENTS, 282 Second St., 2nd Floor, San Francisco CA 94105. (415)442-1822. Fax: (415)442-1823. E-mail: david@dwrepresents.com. Website: http://www.dwrepresents.com. Contact: David Wiley. Commercial illustration and photography representative. Estab. 1984. Member of AIP (Artists in Print), Society of Illustrators and Graphic Artists Guild. Represents 8 illustrators, 1 photographer. Specializes in "Going beyond expectations!"

Terms: Rep receives 25% commission. No geographical restriction. Artist is responsible for 100% of portfolio costs. Promotional materials and expenses including portfolio courier costs are split: 75% paid by artist, 25% paid by agent. Each year the artists are promoted in *American Showcase, Black Book* and *Workbook* through direct mail (bimonthly mailings, quarterly postcard mailings).

How to Contact: For first contact, send query letter, tearsheets ("very important"), slides, photographs and SASE . Will call back if requested within 48 hours. After initial contact, call for appointment or drop off appropriate materials. "To find out what's appropriate, just ask! Portfolio should include personal and commissioned work, tearsheets—color and b&w if possible."

Tips: "Generate new clients through creative directories, direct mail and a rep relationship. To create new images that will hopefully sell, consult an artist rep or someone qualified to suggest ideas keeping in alignment with your goals. I suggest working with a style that will allow quick turnaround, 1-2 weeks,

preferably within 10 days (this includes pencils and making changes). Present portfolios with examples of roughs and finished commissioned work. Show color and b&w imagery, concepts to finish process, i.e., paper napkin sketches through finish. Ask questions and then sit back and listen! and take notes. Three key words I work with: 'ask, listen and act.' Learn how to work with these and new discoveries will unfold! Remember to give yourself permission to make mistakes—it's just another way of doing something."

WINSTON WEST, LTD., 204 S. Beverly Dr., Suite 108, Beverly Hills CA 90212. (310)275-2858. Fax: (310)275-0917. Contact: Bonnie Winston. Commercial photography representative (fashion/entertainment). Estab. 1986. Represents 8 photographers. Specializes in "editorial fashion and commercial advertising (with an edge)." Markets include: advertising agencies; client direct; editorial/magazines.
Handles: Photography.
Terms: Rep receives 25% commission. Charges 100% for courier services. Exclusive area representation is required. No geographic restrictions. Advertising costs are paid by talent 100%. Advertises by direct mail and industry publications.
How to Contact: For first contact, send direct mail flier/brochure, photographs, photocopies, photostats. Reports in days, only if interested. After initial contact, call for appointment to show portfolio of tearsheets.
Tips: Obtains new talent through "recommendations from the modeling agencies. If you are a new fashion photographer or a photographer who has relocated recently, develop relationships with the modeling agencies in town. They are invaluable sources for client leads and know all the reps."

JIM ZACCARO & ASSOC., 315 E. 68th St., New York NY 10021. (212)744-4000. E-mail: jimzacc@earthlink.net. Website: http://www.home.earthlink.net/~jimzacc. Contact: Jim Zaccaro. Commercial photography, illustration and fine art representative; illustration/photography broker; and television director. Estab. 1962. Member of SPAR, DGA. Represents 4 photographers.
Terms: Rep receives 25% commission.
How to Contact: For first contact, send query letter, direct mail flier/brochure. Reports in 10 days. After initial contact, call for appointment to show portfolio.

Contests

Whether you're a seasoned veteran or a newcomer still cutting your teeth, you should consider entering contests to see how your work matches up against that of other photographers. The contests in this section range in scope from tiny juried county fairs to massive international competitions. When possible we've included entry fees and other pertinent information in our limited space. Contact sponsors for entry forms and more details.

Once you receive rules and entry forms, pay particular attention to the sections describing rights. Some sponsors retain all rights to winning entries or even *submitted* images. Be wary of these. While you can benefit from the publicity and awards connected with winning prestigious competitions, you shouldn't unknowingly forfeit copyright. Granting limited rights for publicity is reasonable, but never assign rights of any kind without adequate financial compensation or a written agreement. If such terms are not stated in contest rules, ask sponsors for clarification.

If you're satisfied with the contest's copyright rules, check with contest officials to see what types of images won in previous years. By scrutinizing former winners you might notice a trend in judging that could help when choosing your entries. If you can't view the images, ask what styles and subject matter have been popular.

N ANACORTES ARTS & CRAFTS FESTIVAL, 819 Commercial, Suite E, Anacortes WA 98221. (360)293-6211. Director: Joan Tezak. Two-day festival, first weekend in August. An invitational, juried fine art show with over 250 booths. Over $1,500 in prizes awarded for fine arts.

ANNUAL INTERNATIONAL UNDERWATER PHOTOGRAPHIC COMPETITION, P.O. Box 2401, Culver City CA 90231. (562)437-6468. Cost: $7.50 per image, maximum 4 images per category. Offers annual competition in 9 categories (8 underwater, 1 water related). Thousands of dollars worth of prizes. Deadline mid-October.

AQUINO INTERNATIONAL, P.O. Box 125, Rochester VT 05767. (802)767-9341. Website: http://www.aaquino.com. Publisher: Andres Aquino. Ongoing photo contest in many subjects. Offers publishing opportunities, cash prizes and outlet for potential stock sales. Send SAE with 2 first-class stamps for details.

ART OF CARING PHOTOGRAPHY CONTEST, Caring Institute, 513 "C" St. NE, Washington DC 20002-5809. (202)547-4273. Director: Marian Brown. Image must relate to the subject of caring. Photos must be 8×10, color or b&w and must be submitted with a completed entry blank which may be obtained from Caring Institute.

N ASSIGNMENT EARTH, Photo Contest/SFPW P.O. Box 9916, Santa Fe NM 87504-5916. Website: http://www.sf.workshop.com. Cost: $30 for 4 images in b&w or color, $5 additional up to $10. Assignment Earth honors single images of b&w and color photographs. Prizes include workshops, photo equipment and web publication. January deadline annually. For prospectus send a self-addressed business size envelope or access the web.

N THE CAMERA BUG® PHOTO CONTEST, World Headquarters, 2106 Hoffnagle St., Philadelphia PA 19152. (215)742-5515. E-mail: LFried6932@aol.com. Director: Leonard Freidman. Annual contest open to all "Student" Photographers. Provide (SASE) Self Addressed Stamped Envelope for details.

CASEY MEDALS FOR MERITORIOUS JOURNALISM, Casey Journalism Center for Children & Families, 8701-B Adelphi Rd., Adelphi MD 20783-1716. (301)445-4971. Director: Cathy Trost. Honors distinguished coverage of disadvantaged and at-risk children and their families. Photojournalism category: Series of photos from daily or non-daily newspaper or general interest magazine. Deadline: early August. Contact for official entry form.

N COMMUNICATION ARTS ANNUAL PHOTOGRAPHY COMPETITION, 410 Sherman Ave., P.O. Box 10300, Palo Alto CA 94303-0807. (800)258-9111. E-mail: shows@commarts.com. Website: http://www.commarts.com. Entries must be accompanied by a completed entry forms. "Entries may originate from any country. Explanation of the function in English is very important to the judges. The work will be chosen on the basis of its creative excellence by a nationally representative jury of designers, art directors and photographers. Winning work will be published in the Communication Arts Photography Annual; the photographer, client and art director will each receive a Communication Arts' *Award of Excellence* certificate." Categories include advertising (ads, CD jackets, packaging), books (cover or jacket), editorial (magazine or newspaper), work produced for sale (such as posters or greeting cards), institutional (annual reports, catalogs), self-promotion and unpublished. Deadline: March 16, 1999.

N CREALDE SCHOOL OF ART, 600 St. Andrews Blvd., Winter Park FL 32792. (407)671-1886. Fax: (407)671-0311. Director of Photography: Rick Lang. The school's gallery has 8-10 exhibitions/year representing artists from regional/national stature in all media. Anyone who would like to show here may send 20 slides, résumé, statement and return postage. We do have a juried photo show for Southeast photographers in the spring. Send SASE for a prospectus.

THE CREATIVITY AWARDS SHOW, 456 Glenbrook Rd., Glenbrook CT 06906. (203)353-1441. Fax: (203)353-1371. Show Director: Dan Barron. Sponsor: *Art Direction* magazine. Annual show for photos and films appearing in advertising and mass communication media, annual reports, brochures, etc.

N DANCE ON CAMERA FESTIVAL, Sponsored by Dance Films Association, Inc., 3rd Floor, 31 West 21st St., New York NY 10010. (212)727-0764. Executive Director: Louise Spain. Annual festival competition for 16mm films with optical soundtrack and ¾-inch videotapes in NTSC format, on all aspects of dance. Entrants must be members in good standing of Dance Films Association.

N ROY W. DEAN FILM GRANT, 1215 N. Highland, Hollywood CA 90038. (213)769-0900. Website: http://www.sftweb.com. Grant Manager: Gloria Mungaray. Cost: $26 to enter. Any proposal film or tape documentary that makes a contribution to society can apply. Grant is over $40,000 in goods and services.

50th EXHIBITION OF PHOTOGRAPHY, Del Mar Fair Entry Office, P.O. Box 2663, Del Mar CA 92014. (619)792-4207. Sponsor: Del Mar Fair (22nd District Agricultural Association). Annual event for still photos/prints. Pre-registration deadline: April 30, 1999. Send #10 SASE for brochure, available early March.

FINE ARTS WORK CENTER IN PROVINCETOWN, 24 Pearl St., Provincetown MA 02657. (508)487-9960. Contact: Visual Coordinator. Seven-month residency program for artists and writers. Housing, monthly stipend and materials allowance provided from October 1 through May 1. Send SASE for application. Deadline February 1.

N FIRELANDS ASSOCIATION FOR THE VISUAL ARTS, 39 S. Main St., Oberlin OH 44074. (440)774-7158. Gallery Director: Susan Jones. Cost: $15/photographer; $12 for FAVA members. Annual juried photography contest for residents of Ohio, Kentucky, Indiana, Michigan, Pennsylvania and West Virginia. Both traditional and experimental techniques welcome. Photographers may submit up to three works completed in the last three years. Call for entry form. Annual entry deadline: mid February (date varies).

GALLERY MAGAZINE GIRL NEXT DOOR CONTEST, 401 Park Ave. S., New York NY 10016-8802. Contest Editor: Judy Linden. Sponsors monthly event for still photos of nudes. Offers monthly and annual grand prizes: $250 entry photo; $2,500 monthly winner; $25,000 yearly winner. "Must be amateurs!" Photographers: entry photo receives 1-year free subscription; monthly winner, $500; yearly winner, $2,500. Write for details or buy magazine.

THE INTERNATIONAL MARKETS INDEX, located in the back of this book, lists markets located outside the U.S. by country.

GOLDEN ISLES ARTS FESTIVAL, P.O. Box 20673, Saint Simons Island GA 31522. (912)638-8770. Contact: Registration Chairman. Sponsor: Glynn Art Association. Annual 2-day festival for still photos/prints; all fine art and craft. Deadline: August 30.

GOLDEN LIGHT & ERNST HAAS AWARDS, Maine Photographic Workshops, P.O. Box 200, 2 Central St., Rockport ME 04856. (207)236-8581. Fax: (207)236-2558. Website: http://www.MEWorkshops .com. An annual competition for the world's photographers. Awards include: The $10,000 Ernst Haas Award for personal photography, Photographer Support Awards of $1,000 each, the Print Competition in 6 categories. Entry fee: $30 for a portfolio, $5/print for the Print Competition. Also, Photography Student of The Year, Photography Educator of The Year and the Photographic Book of The Year Awards. Entry deadline: September 1. Awards made in New York City at VISCOM Trade Show. Request competition rules via phone, fax or Internet.

GREATER MIDWEST INTERNATIONAL XV, CMSU Art Center Gallery, Clark St., Warrensburg MO 64093-5246. (816)543-4498. Gallery Director: Morgan Dean Gallatin. Sponsor: CMSU Art Center Gallery/Missouri Arts Council. Sponsors annual competition for 2-D and 3-D all media. Send SASE for current prospectus after June 1, 1999. Entry deadline October 15, 1999.

IDAHO WILDLIFE, P.O. Box 25, Boise ID 83707-0025. (208)334-3746. Fax: (208)334-2148. E-mail: dronayne@idfg.state.id.us. Editor: Diane Ronayne. Annual contest; pays cash prizes of $20-150. Rules in fishing and hunting issues of *Idaho Wildlife* magazine. Deadline September 1. Winners published. Freelance accepted in response to want list. Pays b&w or color inside $40; cover $80. Fax request for submission guidelines.

IMAGES CENTER FOR PHOTOGRAPHY, 1310 Pendleton St., Suite 608, Cincinnati OH 45210. (513)241-8124. Cost: Up to 5 slides may be submitted along with a non-refundable $20 entry fee. Up to 5 additional slides may be submitted for $7 per slide. Annual juried exhibition. All work that utilizes any photographic process, from traditional silver printing techniques to the latest in technologically-generated imagery, are eligible. Artists must be members of IMAGES. Individual annual membership fees are $10 for students and $25 for individual members.

INTERNATIONAL WILDLIFE AND LANDSCAPE PHOTO COMPETITION, 210 N. Higgins Ave., Suite 101, Missoula MT 59802. (800)394-7677. Contact: Susanna Gaunt. Professional and amateur catagories, color and b&w prints. Pays $1,200 in cash prizes plus additional prizes. Entry deadline: early March. Co-sponsored by the 22nd Annual International Wildlife Film Festival and Rocky Mountain School of Photography.

⊕ **KRASZNA-KRAUSZ PHOTOGRAPHY BOOK AWARDS**, 122 Fawnbrake Ave., London SE24 OBZ, England. Phone: (171)738-6701. Awards Administrator: Andrea Livingstone. Awards made to encourage and recognize outstanding achievements in the writing and publishing of books on the art, history, practice and technology of photography and the moving image. Entries from publishers only by July 1st. Announcements of winners in early February 1999.

LARSON GALLERY JURIED PHOTOGRAPHY EXHIBITION, Yakima Valley Community College, P.O. Box 22520, Yakima WA 98907. (509)574-4875. Director: Carol Hassen. Cost: $6/entry (limit 4 entries). National juried competition with approximately $3,000 in prize money. Held annually in April. Write for prospectus in January.

▨ **THE "MOBIUS"™ ADVERTISING AWARDS**, 841 N. Addison Ave., Elmhurst IL 60126-1291. (630)834-7773. Fax: (630)834-5565. E-mail: mobiusinfo@mobiusawards.com. Website: http://www.mobiu sawards.com. Chairman: J.W. Anderson. Executive Director: Patricia Meyer. Sponsor: The United States Festivals Association. Annual international awards competition for TV and radio commericals, print advertising and package design. Annual October 1st entry deadline. Awards in early February each year in Chicago (February 11, 1999.)

NAVAL AND MARITIME PHOTO CONTEST, U.S. Naval Institute, 118 Maryland Ave., Annapolis MD 21402. (410)268-6110. Contact: Photo Editor. Sponsors annual competition for still photos/prints and transparencies. Three prize winners and 15 honorable mentions selected, with cash prizes ranging from $100-500. December 31 deadline, but early entries are appreciated.

NEW YORK STATE FAIR PHOTOGRAPHY COMPETITION AND SHOW, 581 State Fair Blvd., Syracuse NY 13209. (315)487-7711, ext. 241 or 239. Program Manager: Mary Lou Sobon. Fee: $5/entrant for 1 or 2 works. Open to amateurs and professionals in both b&w and color. Two prints may be entered per person. Prints only, no transparencies. Youth competition also featured. Entry deadline July 23, 1999. Open to New York State residents only.

NEW YORK STATE YOUTH MEDIA ARTS SHOWS, Media Arts Teachers Association, 1401 Taylor Rd., Jamesville NY 13078. (315)469-8574. Co-sponsored by the New York State Media Arts Teachers Association and the State Education Department. Annual regional shows and exhibitions for still photos, film, videotape and computer arts. *Open to all New York state, public and non-public elementary and secondary students.*

NIKON SMALL WORLD COMPETITION, 1300 Walt Whitman Rd., Melville New York 11747. (516)547-8500. Advertising Manager: B. Loechner. International contest for photography through the microscope, 35mm—limit 3 entries. First prize $4,000. Deadline is the last working day of June each year-June 30, 1999.

1999 NATIONAL JURIED SHOW, Phoenix Gallery, 568 Broadway, New York NY 10012. Send SASE for prospectus. Open to all media. Award: solo/group show. Deadline: April, 1999.

NORTH AMERICAN OUTDOOR FILM/VIDEO AWARDS, 2155 E. College Ave., State College PA 16801. (814)234-1011. Sponsor: Outdoor Writers Association of America. $125 entry fee. Annual competition for films/videos on conservation and outdoor recreation subjects. Two categories: Recreation/Promotion and Conservation/Natural History. Receiving deadline: December 30, 1998, for 1998 publication date.

NORTHERN COUNTIES INTERNATIONAL COLOUR SLIDE EXHIBITION, 9 Cardigan Grove, Tynemouth, Tyne & Wear NE30 3HN England. Phone: (0191)252-2870. Honorary Exhibition Chairman: Mrs. J.H. Black, ARPS, APAGB. Judges 35mm slides—4 entries per person. Three sections: general, nature and photo travel. PSA and FIAP recognition and medals.

OUTDOOR GRANDEUR PHOTOGRAPHY CONTEST, Black River Publishing, P.O. Box 10091, Dept. 0PM, Marina del Rey CA 90295. (310)410-4202. E-mail: contest@brpub.com. Website: http://www.brpub.com. Contact: Francis J. Nickels III. Annual outdoor scenic competition with 12 cash prizes including $1,000 to the first place winner. Winning images are also published in the *Outdoor Grandeur* calendar. "Acceptable themes include images of outdoor scenery, such as waterfalls, snow covered mountains, scenic beaches and forests of changing leaves. Images reflecting all seasons of the year are needed. There is no limit to the number of 35mm slides submitted. Entries will be judged on their photographic quality, appeal and content. Entrants providing a SASE will have their slides returned. Winning images will be used on a nonexclusive basis." Deadline: June 30th. Cost: $5 entry fee, regardless of the number of slides submitted. Winning images from prior year's contests can be viewed on website.

GORDON PARKS PHOTOGRAPHY COMPETITION, Fort Scott Community College, 2108 S. Horton, Fort Scott KS 66701. (316)223-2700. E-mail: johnbl@fsccax.ftscott.cc.ks.us. Website: http://www.ftscott.cc.ks.us. Director of Community Relations: John W. Beal. Cost: $15 for 2 photos; $20 for 3 photos; $25 for 4 photos. Prizes of $1,000, $500, $250 for photographs reflecting important themes in the life and works of Gordon Parks. Winners and honorable mentions will be featured in annual nationwide traveling exhibition. Entry deadline September 30; write for entry form.

PHOTO COMPETITION U.S.A., 1229 Chestnut St., #1629, Philadelphia PA 19107. (215)569-1904. Publisher: Allan K. Marshall. "We sponsor five contests in different categories for our *Quarterly Magazine for Amateur Photographers*. In each issue of this 100-page glossy, all-color magazine we publish about 80 prize winning photos in color or black & white." Chance of Publication: 1 in 20. Entry fee range: $18-36. Total prize money awarded for every issue: $4,000. Highest Prize: $1,000 for a single-photo. Write for more information.

PHOTO METRO MAGAZINE ANNUAL CONTEST, 17 Tehama St., San Francisco CA 94105. (415)243-9917. Photography contest with cash prizes, publication and exhibition. Send SASE for information after June. Call for entries goes out in July. Contest deadline is around September.

PHOTO REVIEW ANNUAL COMPETITION, 301 Hill Ave., Langhorne PA 19047. (215)757-8921. Editor: Stephen Perloff. Cost: $20 for up to 3 prints or slides, $5 each for up to 2 more. National annual photo competition; all winners reproduced in summer issue of *Photo Review* magazine. "Several entrants selected for exhibition at Owen Patrick Gallery in Philadelphia's lively Manayunk district." Awards $1,000 cash prizes plus $500 museum purchase prize. Deadline: May 15-31.

N **PHOTOGRAPHERS' COUNCIL INTERNATIONAL**, P.O. Box 2632, Station R, Kelowna, British Columbia V1X 6A7 Canada. (250)861-0176. Registrar of Certification: Robert K. Manning, M.A.P., M.C.A. Cost: $3 (US) PCI members/photo; $4/photo non-members. Continual photo awards—due 15th of each month. Write for complete application information. Also award honorable mentions and Master of Arts Award (unlimited monthly awards).

PHOTOGRAPHIC ALLIANCE USA, 1864 61st St., Brooklyn NY 11204-2352. President: Henry Mass. FPSA, HonESFIAP. Sole US representative of the International Federation of Photographic Art. Furnishes members with entry forms and information regarding worldwide international salons (over 100 each year) as well as other information regarding upcoming photographic events. Recommends members for distinctions and honors in FIAP (Federation de la Art Photographique) as well as approves US international salons for patronage in FIAP.

PHOTOGRAPHY 18, Perkins Center for the Arts, 395 Kings Hwy., Moorestown NJ 08057. (609)235-6488. E-mail: create@perkinscenter.com. Director: Alan Willoughby. Regional juried photography exhibition. Past jurors include Merry Foresta, Curator of Photography at the National Museum of American Art (Smithsonian Institution); Willis Hartshorn, curator at the International Center for Photography (NYC) and photographer, Emmet Gowin. Juror for *Photography 18* will be Vik Muniz, a Brazilian photographer that has shows scheduled for the Museum of Modern Art and the International Center of Photography. Call for prospectus.

PHOTOGRAPHY NOW, % the Center for Photography at Woodstock, 59 Tinker St., Woodstock NY 12498. (914)679-9957. Fax: (914)679-6337. E-mail: cpwphoto@aol.com. Website: http://www.users.aol.com/cpwphoto. Sponsors annual competition. Call or write for entries. SASE. Juried annually by renowned photographers, critics, museums. 2 contests annually, deadlines vary.

N **PHOTOSPIVA 99**, Spiva Center for the Arts, 222 W. Third St., Joplin MO 64801. (417)623-0183. Director: Darlene Brown. National photography competition. Send SASE for prospectus.

PHOTOWORK 99, Barrett House Galleries, 55 Noxon St., Poughkeepsie NY 12601. (914)471-2550. Director: Ursula Morgan. National photography exhibition judged by New York City curator. Deadline for submissions: December 1998. Send SASE in September for prospectus.

N **PICTURES OF THE YEAR**, 105 Lee Hills Hall, Columbia MO 65211. (573)882-4442. Coordinator: Catherine Mohesky. Photography competition for professional magazine, newspaper and freelance photographers and editors.

POSITIVE NEGATIVE #14, P.O. Box 70708, East Tennessee State University, Johnson City TN 37614-0708. (423)439-7078. Gallery Director: Ann Ropp. Juried national show open to all media. Call or write for prospectus. Deadline for application: October 1998.

N **THE PROJECT COMPETITION**, Photo Contest/SFPW P.O. Box 9916, Santa Fe NM 87504-5916. Website: http://www.sfworkshop.com. Cost: $30 for 10-15 slides or prints. The Project Competition supports photographers with long-term projects. Cash awards, workshops and photographic equipment, web publication and more. January deadline annually. Send self-addressed business size envelope for prospectus.

PULITZER PRIZES, 709 Journalism, Columbia University, New York NY 10027. (212)854-3841 or 3842. Costs: $50/entry. Annual competition for still photos/prints published in American newspapers. February 1 deadline for work published in the previous year.

CONSTANCE SALTONSTALL FOUNDATION FOR THE ARTS, 120 Brindley St., Ithaca NY 14850. (607)277-4933. Offers summer residencies and grants to writers, painters and photographers who live in New York state. Send SASE for application information.

SAN FRANCISCO SPCA PHOTO CONTEST, SF/SPCA, 2500 16th St., San Francisco CA 94103. (415)554-3000. Coordinator: Judy Jenkins. Entry fee $5 per image, no limit. Photos of pet(s) with or without people. Color slides, color or b&w prints, no larger than 8 × 12 (matte limit 11 × 14). Make check payable to SF/SPCA. Three best images win prizes. Deadline for entry: December 15 each year; include return postage and phone number.

SISTER KENNY INSTITUTE INTERNATIONAL ART SHOW BY DISABLED ARTISTS, 800 E. 28th St., Minneapolis MN 55407-3799. (612)863-4630. Art Show Coordinator: Linda Frederickson. Show is held once a year in April and May for disabled artists. Deadline for entries: March 20. Award monies of over $5,000 offered.

SOHO PHOTO GALLERY COMPETITION, 15 White St., New York NY 10013. (212)799-4100. Contact: Wayne Parsons. Jurors: nationally known, varies yearly. Awards: one-month solo show; group show. Cost: $25 entry fee for a maximum of 6 slides. "Eligibility extends to any U.S.-resident photographer 18 years of age or older and to all photo-based images. Members of Soho Photo are not eligible; prior first-place winners at Soho Photo are not eligible for a first-place award, though they are eligible for the group show. There is no limitation as to subject matter; however, submitted work should show stylistic and thematic unity. Maximum dimension of any piece (including frame) is 48 inches." SASE for prospectus and deadline for 1999. For general information on the Gallery, contact Mary Ann Lynch, (212)929-2511.

TEXAS FINE ARTS ASSOCIATION'S NEW AMERICAN TALENT, 3809 B West 35th St., Austin TX 78703. (512)453-5312. A national all-media competition selected by a nationally prominent museum curator. Provides catalog and tour. Entry deadline: March. Send SASE for prospectus.

N **THREE RIVERS ARTS FESTIVAL**, 707 Penn Ave., Pittsburgh PA 15222. (412)281-8723. Fax: (412)281-8722. Website: http://www.artswire.org/traf. Annual competition for still photos/prints and videotape. Early February deadline.

U.S. INTERNATIONAL FILM AND VIDEO FESTIVAL, 841 N. Addison Ave., Elmhurst IL 60126-1291. (630)834-7773. Fax: (630)834-5565. E-mail: filmfestinfo@filmfestawards.com. Website: http://www.filmfestawards.com. Chairman: J.W. Anderson. Executive Director: Patricia Meyer. Sponsor: The United States Festivals Association. Annual international awards competition for business, television, industrial and informational film and video. Founded 1968. Annual March 1st entry deadline. Awards in early June each year in Chicago. (June 9-10, 1999).

UNLIMITED EDITIONS INTERNATIONAL JURIED PHOTOGRAPHY COMPETITIONS, % Competition Chairman, P.O. Box 1509, Candler NC 28715-1509. (704)665-7005. President/Owner: Gregory Hugh Leng. Sponsors juried photography contests offering cash and prizes. Also offers opportunity to sell work to Unlimited Editions.

VAL-TECH PUBLISHING INC., P.O. Box 25376, St. Paul MN 55125. (612)730-4280. Website: http://www.sowashco.com/writersjournal. Contact: Valerie Hockert. Cost: $3/entry. Deadlines: June 15 and November 30. Photos can be scenic, with or without people. Send SASE for guidelines.

VISIONS OF U.S. HOME VIDEO COMPETITION, P.O. Box 200, Los Angeles CA 90078. (213)856-7707. Contact: Carla Sanders. No fee is required. Annual competition for home videos shot on 8mm video, Beta or VHS. Competition is open to anyone with a home format camera in the US.

WELCOME TO MY WORLD, P.O. Box 20673, Saint Simons Island GA 31522. (912)638-8770. Contact: Registration Chairman. Sponsored by the Glynn Art Association. Call or write for application. Cash awards. Deadline June.

N **WESTMORELAND ART NATIONALS**, P.O. Box 355A, RR. #2, Latrobe PA 15650. (412)834-7474. Website: http://www.westol.com/wanf. Executive Director: Olga Gera. Produces two exhibitions with separate juries and awards. Write for details. SASE. Deadline: March 25, 1999.

YOUR BEST SHOT, % *Popular Photography*, P.O. Box 1247, Teaneck NJ 07666. Monthly photo contest, 2-page spread featuring 5 pictures: first ($300), second ($200), third ($100) and 2 honorable mention ($50 each).

Workshops

Photography is headed in a new direction, one filled with computer manipulation, compact discs and online images. Technological advances are no longer the wave of the future—they're here.

Even if you haven't invested a lot of time and money into electronic cameras, computers or software, you should understand what you're up against if you plan to succeed as a professional photographer. Outdoor and nature photography are still popular with instructors, but technological advances are examined closely in a number of the workshops listed in this section.

As you peruse these pages take a good look at the quality of workshops and the level of photographers the sponsors want to attract. It is important to know if a workshop is for beginners, advanced amateurs or professionals, and information from a workshop organizer can help you make that determination.

These workshop listings contain only the basic information needed to make contact with sponsors and a brief description of the styles or media covered in the programs. We also include information on workshop costs. Write for complete information.

The workshop experience can be whatever the photographer wishes—a holiday from the normal working routine, or an exciting introduction to new skills and perspectives on the craft. Whatever you desire, you'll probably find a workshop that fulfills your expectations on these pages.

N EDDIE ADAMS WORKSHOP, P.O. Box 4182, Grand Central Station NY 10163-4182. (212)880-1613. E-mail: eaworkshop@aol.com. Website: http://www.s2f.com/eaworkshop. Managing Director: Shauna Lyon. Annual tuition-free photojournalism workshop. Accepts 100 students and professionals with two years or less experience based on portfolio. Deadline mid-May for October workshop.

N ADVENTURE TRAVEL, 201 E. Ninth St., #305, Anchorage AK 99509. (907)279-5367. Director of Photography: David Wallace. Cost: varies by location. Tours are custom tailored to worldwide locations including Brazil, Australia, Burma, China, Japan, Korea, Thailand, Madagascar, Eastern Europe, India.

N ⊕ AEGEAN CENTER FOR THE FINE ARTS, Paros, Kyklades 84400 Greece. Phone: (30)28423287. E-mail: studyart@aegeancenter.org. Website: http://www.aegeancenter.org. Director: John Pack. Cost: $6,000/13 weeks; $2,500/3 weeks, includes lodging, studio, lab fees. Workshop stressing artistic technique and personal vision for beginner, intermediate and advanced photographers.

AERIAL AND CREATIVE PHOTOGRAPHY WORKSHOPS, P.O. Box 470455, San Francisco CA 94147. (415)563-3599. Fax: (415)771-5077. Director: Herb Lingl. Offers Polaroid sponsored seminars covering creative uses of Polaroid films and aerial photography workshops in unique locations from helicopters, light planes and balloons.

ALASKA ADVENTURES, P.O. Box 111309, Anchorage AK 99511. (907)345-4597. Contact: Chuck Miknich. Offers photo opportunities of Alaska wildlife and scenery on remote fishing/float trips and remote fish camp. Trips are conducted throughout the remotest parts of the state. "All trips offer a variety of wildlife viewing opportunities besides great fishing. You don't have to be a fisherman to enjoy these trips. The varying locations and timings of our trips offer a wide range of photo opportunities, so any particular interests should be directed to our attention."

N ALASKA PHOTO TOURS, Box 141, Talkeetna AK 99676. (800)799-3051. E-mail: photoak@alask a.net. Website: http://www.alaska.net/~photoak. Guide: Steve Gilroy. Cost: $2,000-4,000; includes lodging, transportation and most meals. Workshop for beginner to advanced photographers covering landscape, macro and wildlife work. Custom trips last from 6 to 12 days, featuring private marine life boat excursions, bear viewing camps and other exclusive services.

N ALASKA'S SEAWOLF ADVENTURES, P.O. Box 97, Gustavus AK 99826. (907)697-2416. Contact: Trip Coordinator. Cost: $1,500/5 days. "Photograph glaciers, whales, bears, wolves, incredible scenics etc., while using the Seawolf, a 65 foot yacht, as your basecamp in the Glacier Bay area."

N ALCHEMY WORKSHOPS, P.O. Box 633, Rancho de Taos NM 87557. (505)751-0542. E-mail: wizard@laplaza.org. Website: http://www.quetzl.com/alchemy/index.html. Contact: John Rudiak. Cost: $1,000-1,500. Individual instruction in platinum printing for intermediate to advanced photographers. Workshop includes instruction in creating enlarged negatives.

N ALDERMAN'S SLICKROCK ADVENTURES, 19 W. Center St., Kanab UT 84741. (435)644-5981. E-mail: fotomd@xpressweb.com. Website: http://www.onpages.com/fotomd. Contact: Terry Alderman. Cost: $75/day. Small workshop, 4 students at a time, covering landscape photography of ghost towns, arches, petroglyphs and narrow canyons in the back country of Utah and Arizona.

N ALLAMAN'S MONTANA PHOTOGRAPHIC ADVENTURES, Box 77, Virginia City MT 59755-0077. (406)843-5550. Contact: Ken Allaman. Cost: $595/week. Five-day workshop and photo opportunities for beginning to advanced photographers covering landscape and wildlife photography in Montana.

AMBIENT LIGHT WORKSHOPS, 5585 Commons Lane, Alpharetta GA 30202-6776. Contact: John Mariana. $45-125/day. In-the-field and darkroom. One-day and one-week travel workshops of canyons, Yosemite and the Southwest, 35mm, medium format and 4×5.

THE AMERICAN SAFARI, by Wilderness Institute, P.O. Box 485, Lisle IL 60532. (630)960-5314. Executive Director: Joe Speno. Cost: varies. Nature study and photography workshops from 1-14 days devoted to natural areas of the Midwest. Beginners are welcomed and encouraged to participate. "Groups study and observe everything from black bears to wildflowers."

AMERICAN SOUTHWEST PHOTOGRAPHY WORKSHOPS, 11C Founders, El Paso TX 79906. (915)757-2800. Director: Geo. B. Drennan. Offers intense field and darkroom workshops for the serious b&w photographer. Technical darkroom workshops limited to 5 days, 2 participants only.

AMPRO PHOTO WORKSHOPS, 636 E. Broadway, Vancouver BC V5T 1X6 Canada. (604)876-5501. Fax: (604)876-5502. Website: http://www.ampro-photo.com. Course tuition ranges from under $100 for part-time to $6,900 for full-time. Approved trade school. Offers part-time and full-time career courses in commercial photography and photofinishing. "Eighty-seven different courses in camera, darkroom and studio lighting—from basic to advanced levels. Special seminars with top professional photographers. Career courses in photofinishing, photojournalism, electronic imaging and commercial photography." New winter, spring, summer and fall week-long field photography shoots.

N ANDERSON RANCH ARTS CENTER, P.O. Box 5598, Snowmass Village CO 81615. (970)923-3181. Fax: (970)923-3871. Weekend to 3-week workshops run June to September in photography, digital imaging and creative studies. "Instructors are top artists from around the world. Classes are small and the facilities have the highest quality equipment." Program highlights include portrait and landscape photography; technical themes include photojournalism and advanced techniques. Offers field expeditions to the American Southwest and other locations around the globe.

N ⊕ APER TOUR PHOTOGRAPHY WORKSHOP, Calle Tonala #27, San Cristobal, Chiapas Mexico. Phone: (52)967-85727 or (800)303-4983. E-mail: apertour@sancristobal.podernet.com.mx. Website: http://www.mexonline.com/aper1.htm. Contact: Cisco Craig Dietz. Cost: $1,000, includes lodging, transportation at school and most meals. Nine-day photography tour of Chiapas, Mexico. Emphasizes people, landscape work, finding a new outlook and darkroom technique.

ARROWMONT SCHOOL OF ARTS AND CRAFTS, P.O. Box 567, Gatlinburg TN 37738. (423)436-5860. Tuition is $275 per week. Room and board packages start at $185. Offers 1- and 2-week spring and summer workshops in various techniques.

THE INTERNATIONAL MARKETS INDEX, located in the back of this book, lists markets located outside the U.S. by country.

N ART NEW ENGLAND SUMMER WORKSHOPS, 425 Washington St., Brighton MA 02135. (617)232-1604. Cost: $845, including lodging and meals. Week-long workshop for intermediate to advanced students covering fine art photography. Classes include alternative photography, hand coloring and cliché verre.

N ARTIST'S AND PHOTOGRAPHER'S CRUISE, Schooner Roseway, P.O. Box 696, Camden ME 04843. (800)ROSEWAY. E-mail: photo@roseway.com. Website: http://www.roseway.com. Cost: $999. Six-day art and photo workshop on historic Maine Windjammer, all levels of proficiency welcomed.

ASSIGNMENT PHOTOGRAPHER WORKSHOP, 17171 Bolsa Chica #99, Huntington Beach CA 92649. (714)846-6471. Instructor: Stan Zimmerman. "The workshop provides the instruction necessary to taking professional quality photographs, marketing these skills, and earning money in the process."

NOELLA BALLENGER & ASSOCIATES PHOTO WORKSHOPS, P.O. Box 457, La Canada CA 91012. (818)954-0933. Fax: (818)954-0910. E-mail: noella1b@aol.com. Website: http://www.apogeephoto .com. Contact: Noella Ballenger. Travel and nature workshop/tours, west coast locations. Individual instruction in small groups emphasizes visual awareness, composition and problem solving in the field. All formats and levels of expertise welcome. Call or write for information.

N FRANK BALTHIS PHOTOGRAPHY WORKSHOPS, P.O. Box 255, Davenport CA 95017. (408)426-8205. Photographer/Owner: Frank S. Balthis. Cost depends on the length of program and travel costs. "Workshops emphasize natural history, wildlife and travel photography. World-wide locations range from Baja, California to Alaska. Frank Balthis runs a stock photo business and is the publisher of the Nature's Design line of cards and other publications. Workshops often provide opportunities to photograph marine mammals."

N BIRDS AS ART/INSTRUCTIONAL PHOTO-TOURS, 1455 Whitewood Dr., Deltona FL 32725. (407)860-2013. E-mail: birdsasart@worldnet.att.net. Instructor: Arthur Morris. Cost varies by length of tour. Approximately $125/day. The tours, which visit the top bird photography hot spots in North America, feature evening in-classroom lectures, in-the-field instruction, 6 or more hours of photography, and post-workshop written critique service.

BIXEMINARS, 919 Clinton Ave. SW, Canton OH 44706-5196. (330)455-0135. Founder/Instructor: R.C. Bixler. Offers 3-day, weekend seminars for beginners through advanced amateurs. Usually held third weekend of February, June and October. Covers composition, lighting, location work and macro.

N BODYSCAPES, P.O. Box 4069, Boulder CO 80306. (800)208-2266. E-mail: jamie@sensuousline.c om. Website: lavondyss.com/bodyscapes/. Contact: Jamie Cotton. Cost: $1,200-4,000 depending on tour package. "Specialty photography tours and workshops on working with the artistic nude figure in the landscape."

HOWARD BOND WORKSHOPS, 1095 Harold Circle, Ann Arbor MI 48103. (313)665-6597. Owner: Howard Bond. Offers 1-day workshop: View Camera Techniques; and 2-day workshops: Zone System for All Formats, Refinements in B&W Printing and Unsharp Masking for Better Prints.

NANCY BROWN HANDS-ON WORKSHOPS, 6 W. 20 St., New York NY 10011. (212)924-9105. Fax: (212)633-0911. Contact: Nancy Brown. Cost: $1,500 for week, breakfast and lunch included. Offers two 1-week workshops in New York City studio; workshops held 1 week each month in August and September. Also offers one-on-one intensive workshops of shooting for one full day with Nancy Brown and professional models, hair and makeup artist and assistant.

N CALIFORNIA PHOTOGRAPHIC WORKSHOPS, 2500 N. Texas St., Fairfield CA 94533. (888)422-6606. E-mail: calif_school@juno.com. Director: James Inks. Five-day seminar covering many aspects of professional commercial and portrait photography.

JOHN C. CAMPBELL FOLK SCHOOL, One Folk School Rd., Brasstown NC 28902. (704)837-2775 or (800)365-5724. Cost: $142-258 tuition; room and board available for additional fee. The Folk School offers weekend and week-long courses in photography year-round (b&w, color, wildlife and plants, image transfer, darkroom set-up, abstract landscapes). Please call for free catalog.

N ⬛ **CANADIAN ROCKIES NATURE PHOTOGRAPHY WORKSHOP**, 61-200 Glacier Dr., Canmore, Alberta T1W 1K6 Canada. (403)678-8719. E-mail: marriott@telusplanet.net. Website: http://www.canadianrockies.net/JemPhotogrpahy. Owner: John Marriott. Cost: $960 CDN, includes lodging, breakfast and lunch and ground transportation. Four-day landscape and wildlife workshop led by a professional nature photographer.

CAPE COD NATURE PHOTOGRAPHY FIELD SCHOOL, P.O. Box 236, S. Wellfleet MA 02663. (508)349-2615. Program Coordinator: Melissa Lowe. Cost: $400 per week. Week long field course on Cape Cod focusing on nature photography in a coastal setting. Whale watch, saltmarsh cruise, sunrise, sunset, stars, wildflowers, shore birds featured. Taught by John Green. Sponsored by Massachusetts Audubon Society.

N **CAPE COD PHOTO WORKSHOPS**, 135 Oak Leaf Rd., P.O. Box 1619, N. Eastham MA 02651. (508)255-6808. E-mail: ccpw@capecod.net. Director: Linda E. McCausland. Cost: 1 day/$95, weekend/ $195, week-long/$295-325. 20-25 weekend or weeklong photography workshops for beginner to advanced students. Workshops run June-September.

N **CAROLINA PHOTOGRAPHIC ART SCHOOL**, P.O. Box 33637, Raleigh NC 27636. (919)832-1678. E-mail: 73734.3127@compuserve.com. Director: Toby Hardister. Five-day workshop for advanced students of professional commercial photography.

VERONICA CASS ACADEMY OF PHOTOGRAPHIC ARTS, 7506 New Jersey Ave., Hudson FL 34667. (813)863-2738. E-mail: veronicacassinc@worldnet.att.net. Website: http://www.quikpage.com/V/veronicacass. Office Manager: Reatha Jones. Price per week: $410. Offers 8 one-week workshops in photo retouching techniques.

CENTER FOR PHOTOGRAPHY, 59 Tinker St., Woodstock NY 12498. (914)679-9957. Fax: (914)679-9957. E-mail: cpwphoto@aol.com. Website: http://www.users.aol.com/photo. Contact: Director. Offers monthly exhibitions, a summer and fall workshop series, annual call for entry shows, library, darkroom, fellowships, memberships, and photography magazine, classes, lectures. Has interns in workshops and arts administration. Free workshop catalog available in March.

N **CHASE THE LIGHT PHOTOGRAPHY ADVENTURES**, P.O. Box 3021, Durango CO 81302. (888)238-7468. E-mail: photokit@frontier.net. Owner: Kit Frost. Cost: $625, includes meals and camping. Photography camping trips for young adults. Week-long workshop covers landscapes, travel and wildlife photography.

N **CHAUTAUQUA INSTITUTION**, P.O. Box 28, Chautauqua NY 14722. (800)836-ARTS. Cost: $180/week access fee plus about $70 in course fees. Beginner to intermediate summer workshop covering architecture, landscape and portrait photography.

CLOSE-UP EXPEDITIONS, 858 56th St., Oakland CA 94608. (510)654-1548 or (800)457-9553. Guide and Outfitter: Donald Lyon. Sponsored by the Photographic Society of America. Worldwide, year-round travel and nature photography expeditions, 7-25 days. "Professional photography guides put you in the right place at the right time to create unique marketable images."

COASTAL CENTER FOR THE ARTS, 2012 Demere Rd., St. Simons Island GA 31522. Director: Mittie B. Hendrix. Write for details.

N **COMMUNITY DARKROOM**, 713 Monroe Ave., Rochester NY 14607. (716)271-5920. Director: Sharon Turner. Costs $30-150, depending on type and length of class. "We offer over 20 different photography classes for all ages on a quarterly basis. Classes include basic and intermediate camera and darkroom techniques; studio lighting; matting and framing; hand-coloring; alternative processes; night, sports and wedding photography and much much more! Call for a free brochure."

N **CONROE PHOTOGRAPHY CENTER**, 201 Enterprise Row #3, Conroe TX 77301. (409)756-5933. Owners: Karl and Lorane Hoke. Cost: $300 for 3-week workshop. Teaches basics of camera functions, darkroom techniques, color printing, studio photography, flash fill, filters and open areas of students' interests.

CORY NATURE PHOTOGRAPHY WORKSHOPS, P.O. Box 42, Signal Mountain TN 37377. (423)886-1004 or (800)495-6190. E-mail: TomPatCory@aol.com. Contact: Tom or Pat Cory. Small workshops/field trips with some formal instruction, but mostly one-on-one instruction tailored to each individual's needs. "We spend the majority of our time in the field. Cost and length vary by workshop. Many of our workshop fees include single occupancy lodging and some also include home-cooked meals and snacks. We offer special prices for two people sharing the same room and, in some cases, special non-participant prices. Workshops include spring and fall workshops in Smoky Mountain National Park and Chattanooga, Tennessee. Other workshops vary from year to year but include locations such as the High Sierra of California, Olympic National Park, Arches National Park, Acadia National Park, the Upper Peninsula of Michigan, Mt. Rainier National Park, Bryce Canyon/Zion National Park, Death Valley National Park and Glacier National Park." Write, call or e-mail for a brochure or more information.

N COUPVILLE ARTS CENTER, P.O. Box 171, Coupville WA 98239. (360)678-3396. E-mail: cac@whidbey.net. Website: http://www.coupevillearts.org. Director: Judy Lynn. Cost: $100-400. 2- to 7-day workshops for beginning to advanced students covering fine art, portrait and landscape photography.

N CREALDE SCHOOL OF ART, 600 St. Andrews Blvd., Winter Park FL 32792. (407)671-1886. Website: http://www.crealde.org. Executive Director: Peter Schreyer. Cost: Membership fee begins at $35/individual. Offers classes covering b&w and color photography; dark room techniques; and landscape, portrait, travel, wildlife and abstract photography.

CREATIVE ARTS WORKSHOP, 80 Audubon St., New Haven CT 06511. (203)562-4927. Photography Department Head: Harold Shapiro. Offers advanced workshops and exciting courses for beginning and serious photographers.

N CREATIVE PHOTOGRAPHY WORKSHOPS, W. Dean, Chichester, W. Sussex PO18 OQ2 United Kingdom. Phone: (+44)1243 811301. Fax: (+44)1243 811343. E-mail: westdean@pavilion.co.uk. Website: http://www.pavilion.co.uk/westdean. Press & Public Relations Co-ordinator: Heather Way. Cost: £373 to 458. "West Dean College runs week long summer courses in photography including master class garden and plant photography; full creative control of your SLR camera, black and white photography; creative printing techniques; hand coloring for black and white photographs; and getting the best from your camera."

N CYPRESS HILLS PHOTOGRAPHIC WORKSHOP, 73 Read Ave., Regina, Saskatchewan S4T 6R1 Canada. (306)543-8546. E-mail: winverar@sk.sympatico.ca. Contact: Wayne Inverarity. Cost: $500 (Canadian), includes lodging, meals and ground transportation on site and film and processing for critique sessions. Five-day, annual workshop held in August. Covers professional commercial photography including portrait and landscape work.

DAUPHIN ISLAND ART CENTER, 1406 Cadillac Ave., P.O. Box 699, Dauphin Island AL 36528. (800)861-5701. Director: Nick Colquitt. Offers workshops, seminars and safaris to amateur and professional photographers. "The Center serves as a wholesaler of its student's work. Items sold include greeting cards, framed prints and wall decor." Free photography course catalog upon request.

N DAWSON COLLEGE CENTRE FOR IMAGING ARTS AND TECHNOLOGIES, 4001 de Maisonneuve Blvd. W., Suite 2G.2, Montreal, Quebec H3Z 3G4 Canada. (514)933-0047. Fax: (514)937-3832. Director: Donald Walker. Cost: Ranges from $160-400. Workshop subjects include imaging arts and technologies, animation, photography, computer imaging, desktop publishing, multimedia and video.

N DJERASSI RESIDENT ARTISTS PROGRAM, 2325 Bear Gulch Rd., Woodside CA 94062-4405. (650)747-1250. Program Assistant: Judy Freeland. Cost: $25 application fee. 4-week or 6-week residencies April-November, in country setting, open to international artists in dance, music, visual arts, literature, media arts/new genres. Application deadline is February 15, each year, for the following year.

N DORLAND MOUNTAIN ARTS COLONY, P.O. Box 6, Temecula CA 92593. (909)676-5039. E-mail: dorland@ezz.net. Website: http://www.ezz.net/dorland. Contact: Admissions Committee. Cost: $50 non-refundable scheduling fee; $300/month. Tranquil environment providing uninterrupted time to artists for serious concentrated work in their respective field. Residents housed in individual rustic cottages with private baths and kitchens, but no electricity. Encourages multi-cultural and multi-discipline applications. Deadlines are March 1 and September 1.

DRAMATIC LIGHT NATURE PHOTOGRAPHY WORKSHOPS, 2292 Shiprock Rd., Grand Junction CO 81503. (800)20-PHOTO (74686). Workshop Leader: Joseph K. Lange. Cost: $1,095-1995 for 6-8 day workshops—includes motel, transportation, continental breakfast and instruction in the field and classroom. Maximum workshop size,10 participants. Specializing in the American West. Trips for the 98-99 season include: Anasazi Ruins and Rock Art, Oct. 24-30, 1998; Zion and S.W. Utah in Autumn, Oct. 31-Nov. 6, 1998; Arches in Winter, UT, Jan. 9-15, 1999; Death Valley and Joshua Tree, CA, Feb. 13-19, 1999; Arizona Desert in Springtime, Mar. 20-26, 1999; Bryce, Zion and Slot Canyons, UT and AZ, Apr. 17-23, 1999; Monument Valley and Canyon De Chelly, AZ, Apr. 24-30, 1999; Arches in Springtime, UT, May 15-21, 1999; Yellowstone in Springtime, WY, June 12-18, 1999; Glacier National Park, MT, July 10-16, 1999; Canadian Rockies, July 17-25, 1999; Olympic Peninsula, WA , Aug. 14-20, 1999; Oregon Coast, Aug. 21-27, 1999; Yellowstone in Autumn, WY, Sept. 18-24, 1999; and Grand Tetons in Autumn, WY, Sept. 25-Oct., 1999.

EAST COAST SCHOOL PHOTOGRAPHIC WORKSHOPS, 705 Randolph St., #E, Thomsville NC 27360. (910)476-4938. E-mail: clatruell@aol.com. Website: http://www.ppofnc.com. Director: Rex C. Truell. Annual seminar for advanced photographers covering commercial and fine art work, including digital imaging.

ROHN ENGH'S "HOW TO PRODUCE MARKETABLE PHOTOS/HOW TO SELL YOUR MARKETABLE PHOTOS", Pine Lake Farm, 1910 35th Rd., Osceola WI 54020. (800)624-0266, ext. 21. E-mail: psi2@photosource.com. Website: http://www.photosource.com. Cost: $595 early registration; $695 after May 15th. "A three-day 'hands-on' workshop in July 1999 on how to take marketable photos and how to sell and resell your photos. Workshop geared to anyone with a collection of 500 or more photos, who wants to see their work published." Taught by Richard Nowitz, a *National Geographic* World photographer and Rohn Engh, a veteran editorial stock photographer. Workshop is held in the Tetons in Jackson, WY.

JOE ENGLANDER PHOTOGRAPHY WORKSHOPS & TOURS, P.O. Box 1261, Manchaca TX 78652. (512)295-3348. Contact: Joe Englander. Cost: $275-5,000. "Photographic instruction in beautiful locations throughout the world, all formats, color and b&w, darkroom instruction." Locations covered include Europe, Asia as well as USA.

EXPOSURES PHOTO WORKSHOPS, 2076 Constitution Blvd., Sarasota FL 34231. (941)927-2003. E-mail: photolearn@aol.com. Website: http://www.wimall.com/fotoworkshop. Director: John Hynal. Cost: $30-100. "One- to four-day workshop covering professional commercial photography (advertising, boudoir, landscape, wedding, wildlife, etc.)."

F/8 AND BEING THERE, Bob Grytten and Associates, P.O. Box 3195, Holiday FL 34690. (813)934-1222; (800)990-1988. E-mail: f8news@aol.com. Director: Bob Grytten. Offers weekend tours and workshops in 35mm nature photography, emphasizing Florida flora and fauna. Also offers programs on marketing.

FINDING & KEEPING CLIENTS, 3603 Aspen Village Way Apt. E, Santa Ana CA 92704-7570. Phone/fax: (714)556-8133. Website: http://e-folio.com/piscopo. Instructor: Maria Piscopo. "How to find new photo assignment clients and get paid what you're worth! Call for schedule and leave address or fax number or send query to 'seminars', mpiscopo@aol.com."

FIRST LIGHT PHOTOGRAPHIC WORKSHOPS AND SAFARIS, P.O. Box 246, Sayville NY 11782. (516)563-0500. E-mail: photours@aol.com. President: Bill Rudock. Photo workshops and photo safaris for all skill levels. Workshops are held on Long Island, all national parks, Africa and Australia.

FOR EXPLANATIONS OF THESE SYMBOLS, SEE THE INSIDE FRONT AND BACK COVERS OF THIS BOOK.

N **FIRST LIGHT PHOTOGRAPHY TOURS**, P.O. Box 11066, Englewood CO 80151. (303)762-8191. E-mail: zshort@aol.com. Owner: Andy Long. Cost: $500-1,500. Offers 4- to 7-day small group trips focusing on wildlife and nature at locations throughout North America.

N **FLORENCE PHOTOGRAPHY WORKSHOP**, Washington University, St. Louis MO 63130. (314)935-6597. E-mail: sjstremb@art.wustl.edu. Professor: Stan Strembicki. "Four week intensive photographic study of urban and rural landscape, June 1999. Black and white darkroom, field trips, housing available."

N **FLORIDA SCHOOL OF PROFESSIONAL PHOTOGRAPHY**, 2312 Farewell Dr., Tampa FL 33603. (800)330-0532. Director: Robin Phillips. Annual seminar held in May. Covers professional commercial photography topics for advanced photographers. Includes traditional and digital imaging.

N **FOCUS ADVENTURES**, P.O. Box 771640, Steamboat Springs CO 80477. Phone/fax: (970)879-2244. Owner: Karen Schulman. Workshops in the Art of Seeing, Self-discovery through Photography and Hand Coloring Photographs. Field trips to working ranches and wilderness areas. Offers special women's photo weeks, a Cozumel photo workshop and retreat, and a scuba-dive underwater photo workshop. Customized private and small group lessons available year round. Workshops in Steamboat Springs are summer and fall.

N 🌐 **FOCUS 10**, P.O. Box 88, Mt. Kuring-gai, Sydney NSW 2080 Australia. Phone: (612)9457-9924. E-mail: focus10@zip.com.au. Director: Andrew Thomason. Cost: $160 Australian. Small classes cover travel photography including camera and film choice, lighting and composition.

FORT SCOTT COMMUNITY COLLEGE PHOTO WORKSHOPS, 2108 S. Horton, Fort Scott KS 66701. (316)223-2700. E-mail: johnbl@fsccax.ftscott.cc.ks.us. Website: http://www.ftscott.cc.ks.us. Photography Instructor: John W. Beal. Cost: $80-180. Weekend workshops in hand-coated processes, infrared photography, Zone System, color printing, b&w fine printing and nature photography.

N **FRENCH FOTO TOURS**, 1009 Bayridge Ave., #202, Annapolis MD 21403. (800)897-0055. E-mail: rodbell@romarin.univ.aix.fr. Website: http://www.frenchfototours.com. U.S. Director: Stan Rodbell. Cost: $1,800, includes lodging and ground transportation. One-week workshop of 3-6 photographers. Covers landscape, travel, wildlife and artistic photography.

FRIENDS OF ARIZONA HIGHWAYS PHOTO WORKSHOPS, P.O. Box 6106, Phoenix AZ 85005-6106. (602)271-5904. Offers photo adventures to Arizona's spectacular locations with top professional photographers whose work routinely appears in *Arizona Highways*.

FRIENDS OF PHOTOGRAPHY, 250 Fourth St., San Francisco CA 94103. (415)495-7000. Director of Education: Julia Brashares. "One-day seminars are conducted by a faculty of well-known photographers and provide artistic stimulation and technical skills in a relaxed, focused environment."

N **GALAPAGOS TRAVEL**, P.O. Box 1220, San Juan Bautista CA 95045. (800)969-9014. E-mail: galapagostravel@compuserve.com. Website: http://www.galapagostravel.com/galapagos. Cost: $3,050/two weeks, includes lodging and most meals. Landscape and wildlife photography tour of the islands with an emphasis on natural history.

N **GEORGIA SCHOOL OF PROFESSIONAL PHOTOGRAPHY**, P.O. Box 933, Lilburn GA 30048. (800)805-5510. E-mail: gppaed@mindspring.com. Website: http://www.surfsouth.com/~9ppa. Director: Louis Tonsmeire, Jr. 6-day workshop for advanced photographers. Covers professional commercial photography topics including traditional and digital imaging.

N **GERLACH NATURE PHOTOGRAPHY WORKSHOPS & TOURS**, P.O. Box 259, Chatham MI 49816. (906)439-5991. Fax: (906)439-5144. Office Manager: Bill Jasko. Cost: $450 tuition; tours vary. Professional nature photographers John and Barbara Gerlach conduct intensive seminars and field workshops in the beautiful Upper Penninsula of Michigan. They also lead wildlife photo expeditions to exotic locations. Write for their informative color catalog.

GETTING & HAVING A SUCCESSFUL EXHIBITION, 163 Amsterdam Ave., # 201, New York NY 10023. (212)838-8640. Speaker: Bob Persky. Cost: 1997/1998 tuition, $125 for 1-day seminar; course manual alone $28.95 postpaid.

THE GLACIER INSTITUTE PHOTOGRAPHY WORKSHOPS, P.O. Box 7457. Kalispell MT 59904. (406)755-1211. General Manager: Kris Bruninga. Cost: $130-175. Workshops sponsored in the following areas: nature photography, advanced photography, wildlife photography and photographic ethics. "All courses take place in beautiful Glacier National Park."

GLAMOUR WORKSHOPS, P.O. Box 485, Lisle IL 60532. (630)960-5314. Contact: Workshop Registrar. Cost: from $95. These are intensive glamour photo workshops and shoots in various cities and locations. Beginners are welcomed. Length varies from half day to full weekends.

N **GLENGARRY PHOTOGRAPHIC WORKSHOP**, 812 Pitt, Unit #29, Cornwall, Ontario K6J 5R3 Canada. (613)935-9456. E-mail: photobiz@cnwl.igs.net. Website: http://www.generation.net/~gjones/shadows/shadows.htm. Contact: Aubrey Johnson. Cost: $60. Weekend workshops for beginner to advanced photographers. Topics include landscape, macro, fine art, portraiture and wildlife.

GLOBAL PRESERVATION PROJECTS, P.O. Box 30866, Santa Barbara CA 93130. (805)682-3398. Fax: (805)563-1234. Director: Thomas I. Morse. Offers workshops promoting the preservation of environmental and historic treasures. Produces international photographic exhibitions and publications.

GOLDEN GATE SCHOOL OF PROFESSIONAL PHOTOGRAPHY, 1251 Fifth Ave., Redwood City CA 94063-4019. (650)548-0889. Contact: Julie Olson. Offers short courses in photography in the San Francisco Bay Area.

N **GREAT LAKES INSTITUTE OF PHOTOGRAPHY**, 19276 Eureka Rd., Southgate MI 48195. (313)283-8433. E-mail: ppofmich@aol.com. Website: http://www.glip.org. Director: Ron Nichols. Offers annual six-day seminar covering professional commercial photography. Open to advanced photographers.

HALLMARK INSTITUTE OF PHOTOGRAPHY, P.O. Box 308, Turners Falls MA 01376. (413)863-2478. E-mail: hallmark@tiac.net Website: http://www.hallmark-institute.com. President: George J. Rosa III. Director of Admissions: Tammy Murphy. Tuition: $13,950. Offers an intensive 10-month resident program teaching the technical, artistic and business aspects of professional photography for the career-minded individual.

N **JOHN HART PORTRAIT SEMINARS**, 344 W. 72nd St., New York NY 10023. (212)873-6585. One-on-one advanced portraiture seminars covering lighting and other techniques. John Hart is a New York University faculty member and author of *50 Portrait Lighting Techniques.*

N **HAWAII PHOTO SEMINARS**, Changing Image Workshops, P.O. Box 99, Kualapu, Molokai HI 96757. (808)567-6430. Contact: Rik Cooke. Cost: $1,550, includes lodging, meals and ground transportation. 7-day landscape photography workshop for beginners to advanced. Workshops taught by 2 *National Geographic* photographers and a multimedia producer.

N ⊕ **DAVID HEMMINGS SEMINARS**, 9 Booker Ave., Bradwell Common, Milton Keynes MK 13 8AY England. Phone: (44)1908-240460. Cost: £200-275, includes lodging and meals. "Two- to three-day seminars for beginner and intermediate photographers designed to help them improve their work by learning the skills and techniques of commercial photography."

N **HIDDEN WORLDS-BALI BEYOND THE GUIDEBOOKS**, P.O. Box 171, Dutch Flat CA 95714. (510)845-5754. E-mail: hiddenworlds@foothill.net. Website: http://www.foothill.net/hiddenworlds. Director: Dr. John Cool. Cost: $2,295 (excluding air fare). "Two-week workshop/tours in Bali. We take you to the hidden heart of Bali, providing unsurpassed shooting opportunity. Special attention to macro, wildlife and scenic photography."

N ⊕ **ELLIS HOLT STUDIOS LTD.**, Thornfield House, Delamer Rd., Basement Studio, Altrincham, Cheshire WA14 2NG England. (161)928-8689. Director: Clifford Stokes. Cost: £70/day. "One- to two-day workshop for photographers of all levels covering digital and darkroom techniques."

HORIZONS: THE NEW ENGLAND CRAFT PROGRAM, 108 N. Main St.-L, Sunderland MA 01375. (413)665-0300. Fax: (413)665-4141. E-mail: horizons@horizons-art.org. Website: http://www.horizons-art.org. Director: Jane Sinauer. Cross Cultural Art and Travel Programs: week-long workshops in Italy, the American Southwest, France, Ireland and Mexico. Horizons intensives in Massachusetts: long

weekend workshops (spring, summer, fall) and 2 3-Week Summer Sessions for High School Students in b&w (July, August).

N HORSES! HORSES! THE "ART" OF EQUINE PHOTOGRAPHY, 1984 Rt. 109, Acton ME 04001. (207)636-1304. E-mail: ladyhawkimages@worldnet.att.net. Contact: Dusty L. Perin. Cost: $35 half day; $95 full day; $195 weekend. "Learn to capture the beauty and fire of horses on film. The live shoot segments feature free running purebred Arabian horses. The full day and weekend courses are limited to 14 participants. The half day course is classroom only. Familiarity around horses is helpful."

N IDYLLWILD ARTS SUMMER PROGRAM, P.O. Box 38, Idyllwild CA 92549. (909)659-2171, ext. 365. E-mail: iasumcat@aol.com. Summer Registrar: Diane Dennis. Cost: $720/week, includes room, board and supplies. Two-week workshop for young photographers covering artistic and darkroom techniques.

N ILLINOIS WORKSHOPS, 229 E. State St., Box 318, Jacksonville IL 62650. (217)245-5418. Director: Steve Humphrey. Annual 5-day seminar covering professional commercial photography topics. Open to advanced photographers.

N IMAGES INTERNATIONAL ADVENTURE TOURS, 37381 S. Desert Star Dr., Tucson AZ 85739. (520)825-9355. E-mail: imagesint@aol.com. Contact: Erwin "Bud" Nielsen. Cost: $600-3,600, depending on location. Landscape/wildlife photography tours. Programs offered year-round.

IN FOCUS WITH MICHELE BURGESS, 20741 Catamaran Lane, Huntington Beach CA 92646. (714)536-6104. Fax: (714)536-6578. President: Michele Burgess. Tour prices range from $4,000 to $6,000 from US. Offers overseas tours to photogenic areas with expert photography consultation, at a leisurely pace and in small groups (maximum group size 20).

N INTERNATIONAL CENTER OF PHOTOGRAPHY, 1130 Fifth Ave., New York NY 10128. (212)860-1776. Education Associate: Donna Ruskin. "The cost of our weekend workshops range from $255 to $325 plus registration and lab fees. Our five- and ten-week courses range from $220 to $380 plus registration and lab fees." ICP offers photography courses, lectures and workshops for all levels of experience—from intensive beginner classes to rigorous professional workshops.

N ⊕ INTERNATIONAL SUMMER ACADEMY OF FINE ARTS/PHOTOGRAPHY, P.O. Box 18, Salzburg 5010 Austria. Phone: (43)662-8421-13. E-mail: soak.salzburg@magnet.at. Website: http://www.land-sbg.gv.at/sommerakademie. Manager: Barbara Wally. Fine art workshops for intermediate to advanced photographers. Cover traditional and digital images. Emphasizes personal critiques and group discussions.

IRISH PHOTOGRAPHIC & CULTURAL EXCURSIONS, Voyagers, P.O. Box 915, Ithaca NY 14851. (607)273-4321. Offers 2-week trips in County Mayo in the west of Ireland from May-October.

N KANSAS PROFESSIONAL PHOTOGRAPHERS SCHOOL, 4105 SW 29th St., Topeka KS 66614. (785)271-5355. E-mail: kppsphoto@aol.com. Website: http://www.kpps.com. Director: Mark Weber. Week-long workshop covering wedding and portrait photography for intermediate to advanced photographers.

N ART KETCHUM HANDS-ON WORKSHOPS, 2818 W. Barry Ave., Chicago IL 60618. (773)478-9217. E-mail: ketch22@ix.netcom.com. Website: http://www.artketchum.com. Owner: Art Ketchum. Cost: 1-day workshops in Chicago studio $85; 2-day workshops in various cities across US, $289. Hands-on photo workshops with live models. Emphasizes learning the latest lighting techniques and building a great portfolio.

N GEORGE LEPP WORKSHOP, P.O. Box 6240, Los Osos CA 93412. (805)528-7385. Website: leppphoto.com. Coordinator: Arlie Lepp. "Always stressing knowing one's equipment; maximizing gear and seeing differently. Small groups."

THE LIGHT FACTORY, P.O. Box 32815, Charlotte NC 28232. (704)333-9755. Executive Director: Bruce Lineker. Since 1972. The Light Factory is an art museum presenting the latest in light-generated media (photography, video, film, the Internet). Year-round education programs, community outreach and special events complement its changing exhibitions.

N LIGHT WORK ARTIST-IN-RESIDENCE PROGRAM, 316 Waverly Ave., Syracuse NY 13244. (315)443-1300. E-mail: mlhodgen@syr.edu. Website: http://sumweb.syr.edu/com_dark/lw.html. Administraive Assistant: Mary Lee Hodgens. Artist-in-Residence Program for Photographers. Artists are awarded a $1,200 stipend, an apartment for one month and 24-hour a day access to darkrooms. Their work is then published in Contact Sheet.

C.C. LOCKWOOD WILDLIFE PHOTOGRAPHY WORKSHOP, 821 Rodney Dr., Baton Rouge LA 70808. (504)769-4766. E-mail: cactusclyd@aol.com. Photographer: C.C. Lockwood. Cost: Atchafalaya Swamp, $95; Yellowstone, $1,500; Grand Canyon, $1,695. Each October and April C.C. conducts a 2-day Atchafalaya Basin Swamp Wildlife Workshop. It includes lecture, canoe trip into swamp, critique session. Every other year C.C. does a 7-day winter wildlife workshop in Yellowstone National Park. C.C. leads an 8-day Grand Canyon raft trip photo workshop, May 8 and July 31.

N LONG ISLAND PHOTO WORKSHOP, 216 Lakeville Rd., Great Neck NY 11020. (516)487-1313. Registrar: Ronald J. Krowne. Annual 5-day seminar covering professional wedding and portrait photography. Open to advanced photographers.

HELEN LONGEST-SLAUGHTER AND MARTY SACCONNE, P.O. Box 2019, Quincy MA 02269-2019. (617)847-0091. Fax: (617)847-0952. E-mail: mjsquincy@pipeline.com. Photo workshops offered in North Carolina Outer Banks, Costa Rica, Florida and New England. 1-day seminars in various cities in the US covering how-to and marketing.

JOE & MARY ANN McDONALD WILDLIFE PHOTOGRAPHY WORKSHOPS AND TOURS, 73 Loht Rd., McClure PA 17841-9340. (717)543-6423. Owner: Joe McDonald. Offers small groups, quality instruction with emphasis on wildlife. Workshops and tours range from $400-2,000.

THE MacDOWELL COLONY, 100 High St., Peterborough NH 03458. (603)924-3886. Website: http://www.macdowellcolony.org. Founded in 1907 to provide creative artists with uninterrupted time and seclusion to work and enjoy the experience of living in a community of gifted artists. Residencies of up to 2 months for writers, composers, film/video makers, visual artists, architects and interdisciplinary artists. Artists in residence receive room, board and exclusive use of a studio. Average length of residency is 6 weeks. Ability to pay for residency is not a factor. Application deadlines: January 15: summer (May-August); April 15: fall/winter (September-December); September 15: winter/spring (January-April). Please write or call for application and guidelines.

McNUTT FARM II/OUTDOOR WORKSHOP, 6120 Cutler Lake Rd., Blue Rock OH 43720. (614)674-4555. Director: Patty L. McNutt. 1994 Fees: $160/day/person, lodging included. Minimum of 2 days. Outdoor shooting of livestock, pets, wildlife and scenes in all types of weather.

N MACRO TOURS PHOTO WORKSHOPS, P.O. Box 460041, San Francisco CA 94146. (800)369-7430. Director: Bert Banks. Fees range from $55-2,995 for 1- to 10-day workshops. Offers workshops on digital darkroom, color slide printing, stock photography and beginner classes. Offers weekend and week-long tours to various USA destinations. Brochure available; call or write.

N MAINE ISLAND WORKSHOPS, 49 Oak Hill Rd., Southborough MA 01772, located on magical magnificent Monhyan Island. (508)460-4889. Contact: Budd Titlow. Cost: $645, includes meals, tuition, ferry and lodging. Write for details.

THE MAINE PHOTOGRAPHIC WORKSHOPS, 2 Central St., Box 200, Rockport ME 04856. (207)236-8581. Fax: (207)236-2558. Website: http://www.meworkshops.com. More than 100 one, two and four week summer workshops for photographers, digital artists and designers. Courses are for working pros, serious amateurs, artists and students. Master Classes with renowned faculty including Mary Ellen Mark, Arnold Newman, Joyce Tenneson, Sam Abell and other photographers from around the world. Workshops in all areas of photography. Destination workshops in Tuscany, Italy; Provence, France; Oaxaxa,

MARKET CONDITIONS are constantly changing! If you're still using this book and it's 2000 or later, buy the newest edition of *Photographer's Market* at your favorite bookstore or order directly from Writer's Digest Books.

Mexico, Skopelos, Greece and Martha's Vineyard. Tuition begins at $695 for a one-week workshop. Lab fees begin at $120. Room and meals $425-695/week. Also offers Professional Certificate Programs, Associate of Arts and Master of Arts Degree programs. Request current catalog by phone, fax or Internet.

MANSCAPES NUDE FIGURE PHOTOGRAPHY WORKSHOPS, 5666 La Jolla Blvd., Suite 111, La Jolla CA 92037. (800)684-2872. Website: http://manscapes.com. Director: Bob Stickel. Cost: $100-185/day. Ten Management offers a range of studio and location (mountain, beach, desert, etc.) workshops on the subject of photographing the male nude figure.

MENDOCINO COAST PHOTOGRAPHY SEMINARS, P.O. Box 1614, Mendocino CA 95460. (707)961-0883. Program Director: Deirdre Lamb. Offers a variety of workshops.

MEXICO PHOTOGRAPHY WORKSHOPS, Otter Creek Photography, Hendricks WV 26271. (304)478-3586. Instructor: John Warner. Cost: $1,300. Intensive week-long, hands-on workshops held throughout the year in the most visually rich regions of Mexico. Photograph snow-capped volcanos, thundering waterfalls, pre-Columbian ruins, botanical gardens, fascinating people, markets and colonial churches in jungle, mountain, desert and alpine environments.

N MID-AMERICA INSTITUTE OF PROFESSIONAL PHOTOGRAPHY, 220 E. Second St., Ottumwa IA 52501. (515)683-7824. Website: http://www.netins.net/showcase/maipp. Director: Walt Stutzman. Annual 5-day seminar covering professional commercial photography. Open to advanced photographers.

N MID-ATLANTIC REGIONAL SCHOOL OF PHOTOGRAPHY, 1114 Crown Point Rd., Box 70, Westville NJ 08093. (888)267-MARS. Website: cmpsolv.com/ppanj/mars.html. Director: Milt Techner. Cost: $795, includes lodging and some meals. Annual 5-day workshop covering many aspects of commercial photography from digital to portrait to wedding. Open to photographers of all levels.

MIDWEST PHOTOGRAPHIC WORKSHOPS, 28830 W. Eight Mile Rd., Farmington Hills MI 48336. (248)471-7299. E-mail: mpw@mpw.com. Website: http://www.mpw.com. Co-Director: Alan Lowy. Cost varies as to workshop. "One-day weekend and week-long photo workshops, small group sizes and hands-on shooting seminars by professional photographers-instructors."

MISSISSIPPI VALLEY WRITERS CONFERENCE, 3403 45th St., Moline IL 61265. Director: David R. Collins. Registration $25, plus individual workshop expenses. Open to the basic beginner or polished professional, the MVWC provides a week-long series of workshops in June, including 5 daily sessions in photography.

N MISSOURI PHOTOJOURNALISM WORKSHOP, 109 Lee Hills Hall, Columbia MO 65211. (573)882-5737. Coordinator: Jennifer Woods. Workshop for photojournalists. Participants learn the fundamentals of documentary photo research, shooting, editing and layout.

MONO LAKE PHOTOGRAPHY WORKSHOPS, P.O. Box 29, Lee Vining CA 93541. (760)647-6595. Website: http://www.monolake.org. Contact: Education Director. Cost: $100-250. "The Mono Lake Committee offers a variety of photography workshops in the surreal and majestic Mono Basin." Workshop leaders include local photographers Moose Peterson and Richard Knepp. 2- to 3-day workshops take place from June to October. Call or write for free brochure.

N MT. CARROLL CENTER FOR APPLIED PHOTOGRAPHIC ARTS, 202 N. Main, Mt. Carroll IL 61053. (815)946-2370. E-mail: mccapa@aol.com. Website: http://members.aol.com/mccapa. Director of Admissions: Laurel Bergren. Cost: $265-625, includes room and 2 meals/deal.

N MOUNTAIN WORKSHOP, Western Kentucky University, Garrett Center 215, Bowling Green KY 42101. (502)745-6292. E-mail: mike.morse@wku.edu. Photojournalism Program Coordinator: Mike Morse. Cost: $395 plus expenses. Annual week-long documentary photojournalism workshop for intermediate to advanced shooters.

N NANTUCKETT ISLAND SCHOOL OF DESIGN AND THE ARTS, P.O. Box 1848, Nantucket MA 02554. (508)228-9248. Executive Director: Kathy Kelm. Artist in Residency Coordinator: Jennifer Page. Cost: Workshop and residency fees vary. Workshops and classes for all levels, and residencies for all interested in the creative process. Includes classroom instruction, site trips and critiques. Artist residen-

cies offered September-June. Basic b&w darkrooms at Seaview Farm Studios and housekeeping cottages in historic Nantucket town. Offers 1-week summer institutes.

N̈ NATURAL HABITAT ADVENTURES, 2945 Center Green Court, Boulder CO 80301. (800)543-8917. E-mail: nathab@worldnet.att.net. Website: http://www.nathab.com. Cost: $2,500-12,000, includes lodging, meals and ground transportation. Guided photo tours for wildlife photographers. Tours last from 5 to 27 days. Destinations include Mexico, Portugal, Australia, Costa Rica, South Africa and others.

NATURE PHOTOGRAPHY EXPEDITIONS, 418 Knottingham Dr., Twin Falls ID 83301. (800)574-2839. Contact: Douglas C. Bobb. Cost: $1,200/person, includes room, meals and transportation during the tour; requires a $300 deposit. Offers week-long trips in Yellowstone and the Tetons from June to October.

NATURE PHOTOGRAPHY WORKSHOPS, GREAT SMOKY MOUNTAIN INSTITUTE, TREMONT, 108 Enchanted Lane, Franklin NC 28734. (423)448-6709. Instructor: Bill Lea, David Duhl and others. Offers programs which emphasize the use of natural light in creating quality scenic, wildflower and wildlife images.

N̈ NATURE'S IMAGES OF LIFE, P.O. Box 2019, Quincy MA 02269. (617)847-0091. E-mail: mjsquincy@pipeline.com. Directors: Helen Longest-Slaughter and Marty Saccone. Cost: $265-2,100. Travel, landscape and wildlife photography workshops for all skill levels. 2- to 8-day trips along the east coast of America, Alaska or Costa Rica.

N̈ NATURE'S LIGHT PHOTOGRAPHY, 7805 Lake Ave., Cincinnati OH 45236. (513)793-2346. E-mail: natureslight@fuse.net. Director: William Manning. Cost: Workshops $375; Tours vary $1,000-3,000. Offers small group tours and workshops. Fifteen programs worldwide, with emphasis on landscapes and wildlife.

NEVER SINK PHOTO WORKSHOP, P.O. Box 641, Woodbourne NY 12788. (212)929-0008; (914)434-0575. E-mail: Jawitzphoto@worldnet.net. Owner: Louis Jawitz. Offers weekend workshops in scenic, travel, location and stock photography from late July through early September in Catskill Mountains.

N̈ NEW ENGLAND INSTITUTE OF PROFESSIONAL PHOTOGRAPHY, 659 Sandy Lane, Warwick RI 02886. (401)738-3778. Registrar: Serafino Genuario. Annual 6-day seminar for professional photographers. Topics include marketing, portrait, wedding and digital photography.

NEW ENGLAND SCHOOL OF PHOTOGRAPHY, 537 Commonwealth Ave., Boston MA 02215. (617)437-1868. Academic Director: Martha Hassell. Instruction in professional and creative photography.

N̈ NEW MEDIA PHOTO EDITING WORKSHOP, Western Kentucky University, Garrett Center 215, Bowling Green KY 42101. (502)745-6292. E-mail: mike.morse@wku.edu. Director: Mike Morse. Cost: $500. Week-long photojournalism workshop. Participants will edit and produce a photo book using only digital technologies.

NEW VISIONS SEMINAR, 10 E. 13th St., Atlantic IA 50022. Director: Jane Murray. Offers workshops in developing personal vision for beginning and intermediate photographers.

N̈ NIKON SCHOOL OF PHOTOGRAPHY, 1300 Walt Whitman Rd., Melville NY 11747. (516)547-8666. Cost: $99. Weekend seminars for amateur to advanced amateur photographers covering SLR photo techniques. Traveling seminar visits 21 major cities in the US.

N̈ NORTH AMERICAN NATURE PHOTOGRAPHY ASSOCIATION-ANNUAL SUMMIT, 10200 W. 44th, #304, Wheat Ridge CO 80033. (303)422-8527. E-mail: nanpa@resourcenter.com. Summit includes workshops, portfolio reviews and special programs for young photographers. Emphasizes wildlife and landscape photography.

NORTHEAST PHOTO ADVENTURE SERIES WORKSHOPS, 55 Bobwhite Dr., Glemont NY 12077. (518)432-9913. E-mail: images@peterfinger.com. Website: http://www.peterfinger.com/photo-workshops.html. President: Peter Finger. Price ranges from $95 for a weekend to $695 for a week-long workshop. Offers over 20 weekend and week-long photo workshops, held in various locations. 1998 workshops include: the coast of Maine, Acadia National Park, Great Smokey Mountains, Southern Vermont,

White Mountains of New Hampshire, South Florida and the Islands of Georgia. "Small group instruction from dawn till dusk." Write for additional information.

N NORTHERN EXPOSURES, 11221 Ninth Place W., Suite 4, Everett WA 98204. (425)347-7650. Director: Linda Moore. Cost: $275-500 for 3-5 day workshops (U.S. and W. Canada); $150-250/day for tours in Canada. Offers 3- to 5- day intermediate to advanced nature photography workshops in several locations in Pacific Northwest and Western Canada; spectacular settings including coast, alpine, badlands, desert and rain forest. Also, 1- to 2-week Canadian Wildlife Photo Adventures and nature photo tours to extraordinary remote wildlands of British Columbia, Alberta, Saskatchewan, Yukon and Northwest Territories.

N NORTHLIGHT PHOTO EXPEDITIONS & WORKSHOPS, 96 Gordon Rd., Middletown NY 10941. (914)361-1017. Director: Brent McCullough. Cost: $625 (approx.). 6- to 8-day workshops in the field. Emphasizes outdoor photography. Locations include the Florida Everglades, Yellowstone National Park and Olympic National Park.

N NYU TISCH SCHOOL OF THE ARTS, Dept. of Photography, 721 Broadway, 8th Floor, New York NY 10003. (212)998-1930. E-mail: photo.tsoa@nyu.edu. Website: http://www.nyu.edu/summer. Contact: Department of Photography. Summer classes offered for credit and noncredit covering photography topics including digital imaging, basic photography and darkroom techniques. Courses offered for all skill levels. Also summer photography program in Maui.

N OKLAHOMA FALL ARTS INSTITUTES, P.O. Box 18154, Oklahoma City OK 73154. (405)842-0890. Fax: (405)848-4538. Website: http://www.okartinst.org. 4-day weekend workshops in photography with nationally recognized photographers. Cost: $450 includes room and board in newly rebuilt Quartz Mountain Arts and Conference Center, southwest Oklahoma.

N OLIVE-HARVEY COLLEGE, 10001 S. Woodlawn Ave., Chicago IL 60628. (773)291-6292. Cost: $35. 6-week Saturday workshop for beginners. Covers basic darkroom techniques.

OSPREY PHOTO WORKSHOPS & TOURS, 2719 Berwick Ave., Baltimore MD 21234-7616. (410)426-5071. Workshop Operator: Irene Hinke-Sacilotto. Cost: varies with program. Programs for '98/99 include: WV Mountains; Chincoteague, VA; Africa (Kenya & Tanzania); Utah's Canyon Country; Mexico & South Texas; Puffin Adventure, Maine; and Northwest Territory. Classes are small with personal attention and practical tips.

N OUTBACK RANCH OUTFITTERS, P.O Box 384, Joseph OR 97846. (503)426-4037. Owner: Ken Wick. Offers photography trips by horseback or river raft into Oregon wilderness areas.

N PACIFIC NORTHWEST SCHOOL OF PROFESSIONAL PHOTOGRAPHY, 6203 97th Ave. Ct. West, Tacoma WA 98467. (206)565-1711. Director: Russell Rodgers. Offers 2-5 day seminars for advanced photographers covering professional topics including digital imaging.

N PALM BEACH PHOTOGRAPHIC WORKSHOPS, 55 NE 2nd Ave. Delray Beach FL 33444 (561)276-1932. Executive Director: Fatima Nejame. Palm Beach Photographic Workshops is an innovative learning facility offering 1- to 5-day seminars in photography and digital imaging all year round. Costs range from $75-1,300 depending on the class.

N ⊕ PAN HORAMA, Puskurinkatu 2, FIN-33730 Tampere Finland. Fax: 011-358-3-364-5382. Chairman: Rainer K. Lampinen. Annual Pan Horama (panorama photography) workshops. International Panarama Photo Exhibition held annually in August in Tampere, Finland.

N PECOS RIVER WORKSHOP, Santa Fe Workshop, Box 9916, Santa Fe NM 87504. (505)983-1400. E-mail: sfworkshop@aol.com. Contact: Bruce Dale. Cost: $685. 7-day documentary and travel photography workshop. "Small class size provides ample feedback and opportunity for one-on-one critiques." Open to intermediate level photographers.

N PENLAND SCHOOL OF CRAFTS, P.O. Box 37, Penland NC 28765. (704)765-2359. E-mail: office@penland.org. Website: http://www.penland.org. Publications Manager: Robin Dreyer. Cost: $275-340/week plus room and board. Offers 1- and 2-week summer sessions plus 4- and 8-week spring and fall sessions. Concentration is on artistic technique and darkroom work for photographers of all skill levels.

N PETERS VALLEY CRAFT CENTER, 19 Kuhn Rd., Layton NJ 07851. (973)948-5200. Fax: (973)948-0011. Offers workshops May, June, July, August and September; 3-6 days long. Offers instruction by talented photographers as well as gifted teachers in a wide range of photographic disciplines as well as classes in blacksmithing/metals, ceramics, fibers, fine metals and woodworking. Located in northwest New Jersey in the Delaware Water Gap National Recreation Area, 1½ hours west of New York City. Write, call or fax for catalog.

PHOTO ADVENTURE TOURS, 2035 Park St., Atlantic Beach NY 11509-1236. (516)371-0067. Fax: (516)371-1352. Manager: Richard Libbey. Offers photographic tours to Iceland, India, Nepal, China, Scandinavia and domestic locations such as New Mexico, Navajo Indian regions, Hawaiian Islands, Albuquerque Balloon Festival and New York.

N PHOTO DIARY, 625 Commerce St., #500, Tacoma WA 98402. (253)428-8258. E-mail: sbourne@f64 .com. Website: http://www.photodiary.com. President: Scott Bourne. Cost: $2,100 includes lodging, meals and other fees. Small week-long workshops emphasizing digital, fine art, travel and landscape photography techniques through field trips, seminars and evaluations. Open to photographers of all skill levels. One-day seminars also available.

PHOTO EXPLORER TOURS, 2506 Country Village, Ann Arbor MI 48103-6500. (800)315-4462 and (734)996-1440. Director: Dennis Cox. Specialist since 1981 in annual photo tours to China's most scenic areas and major cities with guidance to special photo opportunities by top Chinese photographers. Program now includes tours to various other countries: including Turkey, India, South Africa, and Myanmar (Burma) with emphasis on travel photography and photojournalism.

PHOTO FOCUS/COUPEVILLE ARTS CENTER, P.O. Box 171 MP, Coupeville WA 98239. (360)678-3396. Director: Judy Lynn. Cost: $235-330. Locations: Whidbey Island, and various locations throughout the Pacific Northwest. Held April through October. "Workshops in b&w, photojournalism, stock photography, portraiture, human figure, nature photography and more with internationally acclaimed faculty. PhotoFocus 1998 includes workshops on Whidbey Island and on location in the Puget Sound area in nature, portraiture, photojournalism, photo design and photo history."

PHOTOCENTRAL, 1099 E St., Hayward CA 94541. (510)881-6721. Fax: (510)881-6763. E-mail: photc entrl@aol.com. Coordinators: Geir and Kate Jordahl. Cost: $50-300/workshop. PhotoCentral offers workshops and classes for all levels of photographers with an emphasis on small group learning, development of vision and a balance of the technical and artistic approaches to photography. Special workshops include panoramic photography, infrared photography and handcoloring. Workshops run 1-4 days and are offered year round.

N PHOTOGRAPHIC ARTS CENTER, 24-20 Jackson Ave., Long Island City NY 11101-4332. (718)482-9816. President: Gilbert Pizano. Cost varies. Offer workshops on basics to advanced, b&w and color; Mac computers, Photoshop and Digital photography. Rents studios and labs and offer advice to photographers. English and Spanish lessons.

N PHOTOGRAPHIC CENTER SCHOOL, 900 12th Ave., Seattle WA 98121. (206)720-7222. E-mail: photocen@aol.com. Website: http://www.speakeasy.org/photocen. Director of Education: Jenifer Schramm. Ten-week accredited classes; weekend and introductory workshops for photographers of all skill levels. Topics include business, darkroom technique, fashion, fine art, large format, photojournalism, etc.

N PHOTOGRAPHS II, P.O. Box 4376, Carmel CA 93921. (408)624-6870. E-mail: rfremier@earth.mp c.cc.ca.us. Website: http://www.redshift.com/~estarr/photos2. Contact: Roger Fremier and Henry Gilpin. Cost: $150-900/3-5 day workshops; $1,390/9-day workshop in Mexico. Small workshops for photographers of all skill levels. Emphasizes creativity in photography. Offers 6-8 programs/year.

PHOTOGRAPHY AT THE SUMMIT: JACKSON HOLE, Denver Place Plaza Tower, 1099 18th St., Suite 1840, Denver CO 80202. (303)295-7770 or (800)745-3211. Administrator: Rich Clarkson. A week-

CONTACT THE EDITOR, of *Photographer's Market* by e-mail at photomarket@fwpubs.com with your questions and comments.

long workshop and weekend conferences with top journalistic, fine art and illustrative photographers and editors.

PHOTOGRAPHY INSTITUTES, % Pocono Environmental Education Center, RR2, Box 1010, Dingmans Ferry PA 18328. (717)828-2319. Attention: Tom Shimalla. Offers weekend and week-long institutes throughout the year focusing on subjects in the natural world.

N THE PHOTOGRAPHY SCHOOLHOUSE, 2330 E. McDowell Rd., Phoenix AZ 85006-2440. (602)267-7038. E-mail: wrk@photographyschool.com. Website: http://www.photographyschool.com. Owner: George "Nick" Nichols. Cost: $125-1,000. Teaches basic photo and darkroom workshops and advanced classes in lighting, wedding and advanced photography.

N PHOTONATURALIST, P.O. Box 621454, Littleton CO 80162. (303)933-0732. E-mail: magicscene @aol.com. Website: http://www.photonaturalist.com. Program Director: Charles Campbell. Cost: $333-444. Workshop covering chroma-zone exposure system and nature photography for all skill levels. Program lasts 3-4 days. Call for catalog.

N PHOTOWORKS, 7300 MacArthur Blvd., Glen Echo MD 20812. (301)229-7930. Director: Karen Keating. Photoworks is an artist residency in b&w photography located at Glen Echo Park, managed by The National Park Service. Offers courses and an open darkroom to the public year round.

PT. REYES FIELD SEMINARS, Pt. Reyes National Seashore, Pt. Reyes CA 94956. (415)663-1200. Director: Margaret Pearson Pinkam. Fees range from $50-350. Offers 1-5 day photography seminars taught by recognized professionals. Classes taught in the field at Pt. Reyes National Seashore.

N POLAROID TRANSFER WORKSHOPS, P.O. Box 723, Graton CA 95444. (707)829-5649. Fax: (707)824-8174. E-mail: kcarrphoto@aol.com. Website: http://www.mcn.org/a/kcarr. Contact: Kathleen Thormod Carr. Cost: $50-75/day plus $30 for materials. Carr, author of *Polaroid Transfer: A Complete Visual Guide to Creating Image & Emulsion Transfers*, offers her expertise on the subject for photographers of all skill levels. Programs last 1-5 days.

PORT TOWNSEND PHOTOGRAPHY IMMERSION WORKSHOP, 1005 Lawrence, Port Townsend WA 98368. (604)469-1651. Instructor: Ron Long. Cost: $470. Six-day workshops include lectures, critiques, overnight processing, individual instruction, field trips and lots of shooting. All levels welcome.

N DAVID WILLIAM POWELL WORKSHOPS ON LOCATION, 9 E. 19th St., 6th Floor, New York NY 10003. (212)529-7446. E-mail: dwpny@tuna.net. Website: http://www.tuna.net/dwpny. Owner: David William Powell. Cost: $795 (approx.), includes lodging and model fees. 4- to 8-day workshop covering fine art figure studies on location across the globe.

N ⊕ PRACTICAL WEDDING AND PORTRAIT PHOTOGRAPHY COURSE, R.H. Davenport Photography, Tresillian House, St. Mary's Rd., Netley Abbey, Southampton, Hampshire S031 5AU England. Phone: (44)170 345 2175. Contact: Raymond Davenport. Cost: £355, includes room and two meals a day. Small 3-day workshops for intermediate level photographers covering all aspects of portrait and wedding photography including lighting, special effects and business concerns.

PROFESSIONAL PHOTOGRAPHER'S SOCIETY OF NEW YORK PHOTO WORKSHOPS, 121 Genesee St., Avon NY 14414. (716)226-8351. Director: Lois Miller. Cost is $475. Offers week-long, specialized, hands-on workshops for professional photographers in August.

PUBLISHING YOUR PHOTOS AS CARDS, POSTERS, & CALENDARS, #201, 163 Amsterdam Ave., New York NY 10023. (212)362-6637. Lecturer: Harold Davis. 1998/1999 cost: $150 including course manual. Course manual alone $23.95, postpaid. A one-day workshop.

BRANSON REYNOLDS' PHOTOGRAPHIC WORKSHOPS, P.O. Box 3471, Durango CO 81302. (970)247-5274. Fax: (970)247-1441. E-mail: branson@simwell.com. Website: http://www.simwell.com/reynolds and http://www.desertdolphin.com/reynolds. Owner: Branson Reynolds. Cost: $755-1,350. Offers a variety of workshops including, Southwestern landscapes, Native Americans, and "Figure-in-the-Landscape." Workshops are based out of Durango, Colorado, and are taught by nationally published photographer Branson Reynolds.

Ⓝ JEFFREY RICH PHOTOGRAPHY TOURS, P.O. Box 66, Millville CA 96062. (530)547-3480. Fax: (530)547-5542. Owner: Jeff Rich. Wildlife photography workshops cover image making and marketing.

ROCHESTER INSTITUTE OF TECHNOLOGY ADOBE PHOTOSHOP IMAGE RESTORATION AND RETOUCHING, 66 Lomb Memorial Dr., Rochester NY 14623. (800)724-2536. Cost: $895. This learn-by-doing workshop demystifies the process for digitally restoring and retouching images in Photoshop. This intensive 3-day hands-on workshop is designed for imaging professionasl who have a solid working knowledge of Photoshop and want to improve their digital imaging skills for image restoration and retouching.

ROCHESTER INSTITUTE OF TECHNOLOGY DIGITAL PHOTOGRAPHY, 66 Lomb Memorial Dr., Rochester NY 14623. (800)724-2536. Cost: $1,095. A 3-day, hands-on exploration of this new technology. Through lectures, practice, evaluation and discussion, learn how to use digital photography. Create and produce images in the "electronic darkroom."

ROCKY MOUNTAIN SCHOOL OF PHOTOGRAPHY, 210 N. Higgins, Suite 101, Missoula MT 59802. (406)543-0171 or (800)394-7677. Co-director: Jeanne Chaput de Saintonge. Cost: $200-4,000. "RMSP offers professional career training in an 11-week 'Summer Intensive' program held each year in Missoula, Montana. Program courses include: basic and advanced color and b&w, studio and natural lighting, portraiture, marketing, stock, landscape, portfolio and others. Offers 10-day advanced training programs in nature, commercial and documentary photography. We also offer over 25 workshops year-round with Galen Rowell, Bruce Barnbaum, John Shaw, Alison Shaw, Dewitt Jones, David Middleton and others. Locations all across U.S. and abroad."

ROCKY MOUNTAIN SEMINARS, Rocky Mountain National Park, Estes Park CO 80517. (970)586-0108. Seminar Coordinator: Nancy Wilson. Cost: $45-175, day-long to 6-day seminars. Workshops covering photographic techniques of wildlife and scenics in Rocky Mountain National Park. Professional instructors include David Halpern, Perry Conway, Wendy Shattil, Bob Rozinski, Willard Clay, Ruth Hoyt, Joe Berke and James Frank.

Ⓝ SALT LAKE ART CENTER PHOTO WORKSHOPS, 20 S. West Temple, Salt Lake City UT 84101. (801)328-4201. E-mail: photoart@photoarts.org. Website: http://www.photoarts.org. Contact: Rodger Newbold. Cost: $65-300. Small workshops for photographers of all skill levels. Covers landscape, wildlife and alternative photography, as well as large format and darkroom techniques.

Ⓝ SANTA FE PHOTOGRAPHIC & DIGITAL WORKSHOPS, P.O. Box 9916, Santa Fe NM 87504-5916. (505)983-1400. E-mail: sfworkshop@aol.com. Website: http://www.sfworkshop.com. Registrar: Roberta Koska. Cost: $645-1,095 for tuition; lab fees, housing and meals added. Over 80 week-long workshops encompassing all levels of photography and 40 two- to five-day digital workshops annually. Led by top professional photographers, the workshops are located on a campus not far from the center of Santa Fe. Call for free brochure.

PETER SCHREYER PHOTOGRAPHIC TOURS, (Associated with Crealdé School of Art), P.O. Box 533, Winter Park FL 32790. (407)671-1886. Tour Director: Peter Schreyer. Specialty photographic tours to the American West, Europe and the backroads of Florida. Travel in small groups of 10-15 participants.

THE SEATTLE WORKSHOP, P.O. Box 481, Ivy VA 22945. (206)322-6886 or (804)296-5661 ext. 774. Contact: Glenn Showalter. Cost: $200-500, depending on curriculum and length of program. Course projects include downtown Seattle markets and piers, cruises to the San Juan Islands, aerial photography, field visits to winerys, the Washington seacoast and various areas in the Cascade Mountains. All camera formats, primarily 35mm. "Emphasis is on the art of seeing, composition, visual communication and camera work for the productive scientist and businessman as well as the artist. Glenn Showalter has degrees in photography and education and has worked at Gannett Rochester Newspapers, UPI, AP and DuPont Corporation." Send for information. "Would like to see a 3×5 postcard with a photograph you have produced."

"SELL & RESELL YOUR PHOTOS" SEMINAR, by Rohn Engh, Pine Lake Farm, Osceola WI 54020. (715)248-3800. Fax: (715)248-7394. E-mail: info@photosource.com. Website: http://www.photosource.com. Seminar Coordinator: Sue Bailey. Offers half-day workshops in major cities. 1997 cities included: Philadelphia, Washington DC, Detroit, Minneapolis, San Francisco, Atlanta, Charlotte, Orlando, St. Louis,

Las Vegas, Honolulu and Houston. Workshops cover principles based on methods outlined in author's best-selling book of the same name. Marketing critique of attendee's slides follows seminar. Phone for free 1998 schedule.

BARNEY SELLERS OZARK PHOTOGRAPHY WORKSHOP FIELDTRIP, 40 Kyle St., Batesville AR 72501. (870)793-4552. Conductor: Barney Sellers. Retired photojournalist after 36 years with *The Commercial Appeal*, Memphis. Cost for 2-day trip: $100. Participants furnish own food, lodging, transportation and carpool. Limited to 12 people. No slides shown. Fast moving to improve alertness to light and outdoor subjects. Sellers also shoots.

N SELLING YOUR PHOTOGRAPHY, 3603 Aspen Village Way E, Santa Ana CA 92704. (714)556-8133. E-mail: mpiscopo@aol.com. Website: http://www.e-folio.com/piscopo. Contact: Maria Piscopo. Cost: $25-100. One-day workshops cover techniques for marketing photography for photographers of all skill levels.

JOHN SEXTON PHOTOGRAPHY WORKSHOPS, 291 Los Agrinemsors, Carmel Valley CA 93924. (408)659-3130. Website: http://www.apogeephoto.com/johnsexton.html. Director: John Sexton. Cost: $150 deposit; workshops range from $650-750. Offers a selection of intensive workshops with master photographers in scenic locations throughout the US and abroad. All workshops offer a combination of instruction in the aesthetic and technical considerations involved in making expressive prints.

N BOB SHELL PHOTO WORKSHOPS, P.O. Box 808, Radford VA 24141. (540)639-4393. E-mail: bob@bobshell.com. Website: http://www.bobshell.com. Owner: Bob Shell. Cost: $350-400. "Glamour and nude photography workshops in exciting locations with top models. Taught by Bob Shell, one of the world's top glamour/nude photographers and editor of *Shutterbug* magazine. Full details on website."

N SHENANDOAH PHOTOGRAPHIC WORKSHOPS, P.O. Box 54, Sperryville VA 22740. (703)937-5555. Directors: Frederick Figall and John Neubauer. Three days to 1-week photo workshops in the Virginia Blue Ridge foothills, held in summer and fall. Weekend workshop held year round in Washington DC area.

BOB SISSON'S "THE ART OF CLOSE UP AND NATURE PHOTOGRAPHY," P.O. Box 1649, Englewood FL 34295. (941)475-0757. Contact: Bob Sisson (Former Chief Natural Sciences Division, *National Geographic Magazine*.) Cost: $200/day. Special one-on-one course; "you will be encouraged to take a closer look at nature through the lens, to learn the techniques of using nature's light correctly and to think before exposing film."

N SNOWDONIA CENTRE OF PHOTOGRAPHY, Glanraton House, Talysarn, Gwynedd LL54 6AB Wales. Phone: (44)1286 881545. Contact: Brian Allen. Cost: £69/day, includes darkroom use. 1- to 5-day workshops for photographers of all skill levels emphasizing fine print making.

N SOUTH CAROLINA SCHOOL OF PROFESSIONAL PHOTOGRAPHY, 150 Portman Dr., Townville SC 29689. (864)646-8361. Director: Charles Jordan. Annual 5-day seminar for advanced photographers covering many aspects of professional commercial photography.

SOUTHAMPTON MASTER PHOTOGRAPHY WORKSHOP, % Long Island University-Southampton College, Southampton NY 11968-9822. (516)287-8349. E-mail: info@southampton.liunet.edu. Contact: Carla Caglioti, Summer Director. Offers a diverse series of 1-week and weekend photo workshops during July and August.

N SOUTHWEST SCHOOL OF ART AND CRAFT, 300 Augusta, San Antonio TX 78205. (210)224-1848. Cost: $50-210/5-14 weeks, lab fee additional. Offer 30 workshops a year for photographers of all skill levels. Covers b&w, color and advanced darkroom techniques for architecture, portrait, figure, landscape and photojournalism. School is nonprofit and non-degree granting.

SPECIAL EFFECTS BACKGROUNDS, P.O. Box 1745, San Marcos TX 78667. (800)647-3777 or (512)353-3111. Fax: (512)353-0611. E-mail: jwilson@epsphoto.com. Director of Photography: Jim Wilson. Offers 3-day programs in background projection techniques. Open to all levels of photographic education; participants are limited to 12/workshop. Workshops are scheduled every month except December.

⊠ SPORTS PHOTOGRAPHY WORKSHOP: COLORADO SPRINGS, Denver Place Plaza Tower, 1099 18th St., Suite 1840, Denver CO 80202. (303)295-7770 or (800)745-3211. Administrator: Jennifer Logan. A week-long workshop in sports photography taught by *Sports Illustrated* photographers and editors on the grounds of the U.S. Olympic Committee headquarters and training Center.

STONE CELLAR DARKROOM WORKSHOPS, 51 Hickory Flat Rd., Buckhannon WV 26201. (304)472-1669. Photographer/Printmaker: Jim Stansbury. Master color printing and color field work. Small classes with Jim Stansbury. Work at entry level or experienced level. Individual instruction available.

⊠ SUMMER WEEKEND OF PHOTOGRAPHY, P.O. Box 1333, Holland MI 49422-1333. (616)925-8238. E-mail: swmccc.novagate.com. Website: http://www.swmccc.org. Registrar: Randy Kleinhelcsel. Program Coordinator: Sylvia Schlender. Cost: $300 for room and board and tuition—a small optional fee for field trips. Classes for novice and intermediate. Workshops designed to be hands-on. Subjects include nature, portraiture, blacklight, travel, digital, etc.

⊠ SUMMIT PHOTOGRAPHIC WORKSHOPS, P.O. Box 889, Groveland CA 95321. (209)962-4321. E-mail: shtgstar@sonnet.com. Website: http://www.summitphotographic.com. Owner: Barbara Brundege. Cost: $59-700. Photo tours available.

SUPERIOR/GUNFLINT PHOTOGRAPHY WORKSHOPS, P.O. Box 19286, Minneapolis MN 55419. Director: Layne Kennedy. Prices range from $585-895. Write for details on session dates. Fee includes all meals/lodging and workshop. Offers wilderness adventure photo workshops twice yearly. Winter session includes driving your own dogsled team in northeastern Minnesota. Summer session includes kayak trips into border waters of Canada-Minnesota and Apostle Islands in Lake Superior. All trips professionally guided. Workshop stresses how to shoot effective and marketable magazine photos.

SYNERGISTIC VISIONS WORKSHOPS, P.O. Box 2585, Grand Junction CO 81502. Phone/fax: (970)245-6700. E-mail: synvis@gj.net. Website: http://www.apogeephoto.com/synvis.html. Director: Steve Traudt, NANPA. Costs vary. Offers a variety of classes, workshops and photo trips including Galapagos, Costa Rica, Slot Canyons, Colorado Wildflowers and more. All skill levels welcome. Author of *Heliotrope-The Book* and creator of *Hyperfocal Card*, "Traudt's trademark is enthusiasm and his classes promise a true synergy of art, craft and self." Call or write for brochures.

TAOS INSTITUTE OF ARTS, 5280NDCBU, Taos NM 87571-6155. (505)758-2793. Director: Judith Krull. Cost: $350. "In the magnificent light of northern New Mexico improve your skills with some of the best photographers in the country."

⊠ TEXAS SCHOOL OF PROFESSIONAL PHOTOGRAPHY, 1501 W. Fifth, Plainview TX 79072. (806)296-2276. E-mail: ddickson@lonestarbbs.com. Director: Don Dickson. Cost: $360-420. Seventeen different classes offered including Portrait, Wedding, Marketing, Background Painting and Video.

TOUCH OF SUCCESS PHOTO SEMINARS, P.O. Box 194, Lowell FL 32663. (352)867-0463. Director: Bill Thomas. Costs vary from $250-895 (US) to $5,000 for safaris. Offers workshops on nature scenics, plants, wildlife, stalking, building rapport and communication, composition, subject selection, lighting, marketing and business management. Workshops held at various locations in US. Photo safaris led into upper Amazon, Andes, Arctic, Alaska, Africa and Australia. Also, sailboat whale safaris in Washington's San Juan Islands and Canada's Inland Passage. Writer's workshops for photographers who wish to learn to write.

⊠ TRAVEL IMAGES, 305 E. Park St., Suite 400, McCall ID 83638. (800)325-8320. E-mail: jaybee@cyberhighway.net. Owner: John Baker. Small workshops in the field. Locations include Alaska, Canada, India, Thailand, Japan, Germany and others.

⊠ TRIANGLE INSTITUTE OF PROFESSIONAL PHOTOGRAPHY, 441 State St., Baden PA 15005. (724)869-5455. E-mail: tpa@timesnet.net. Website: http://www.trianglephotographers.org. Director: Sam Pelaia. "Founded in 1967, The Triangle Institute of Professional Photography is held the third

week of January in the Pittsburgh, PA area. Affiliated with Professional Photographers of America, Triangle is admired for its innovative and progressive ideas in photographic education as well as providing a quality learning environment for the beginner or the advanced photographer."

UNIVERSITY OF WISCONSIN SCHOOL OF THE ARTS AT RHINELANDER, 726 Lowell Hall, 610 Langdon St., Madison WI 53703. (608)263-3494. Fax: (608)265-2475. E-mail: kathy.berigan@cc mail.adp.wisc.edu. Website: http://www.dcs.wisc.edu/art/soa.htm. Coordinator: Kathy Berigan. One-week multi-disciplinary arts program held during July in northern Wisconsin.

N UTAH CANYONS WORKSHOPS, P.O. Box 296, Springdale UT 84767. (435)772-0117. Director: Michael Plyler. Cost: $375 Great Basin; $375 Burr Trail; $550 Zion Canyon. "Utah Canyons Workshops starts its fourth year by adding the new Great Basin National Park/Ely, Nevada workshop. Because enrollment in all workshops is limited to 12 participants, our 6:1 student to teacher ratio ensures a quality workshop experience."

JOSEPH VAN OS PHOTO SAFARIS, INC., P.O. Box 655, Vashon Island WA 98070. (206)463-5383. Fax: (206)463-5484. E-mail: info@photosafaris.com. Website: http://www.photosafaris.com. Director: Joseph Van Os. Offers over 50 different photo tours and workshops worldwide.

N VENICE CARNIVAL PHOTO TOUR, Great Travels, 5506 Connecticut Ave. NW, Suite 28, Washington DC 20015. (202)237-5220. E-mail: gtravels@erols.com. President: Patricia Absher. Cost: $2,595, includes lodging and some meals. Small 6-day photo tour of Venice during Carnival (Feb. 11-17, 1999). Offers hands-on instruction in people and architecture photography. Open to photographers at all skill levels. Small groups.

VENTURE WEST, P.O. Box 7543, Missoula MT 59807. (406)825-6200. Owner: Cathy Ream. Offers various photographic opportunities, including wilderness pack and raft trips, ranches, housekeeping cabins, fishing and hunting.

N VILLA MONTALVO ARTIST RESIDENCY PROGRAM, P.O. Box 158, Saratoga CA 95071-0158. (408)961-5818. E-mail: kfunk@villamontalvo.org. Website: http://www.villamontalvo.org. Artist Residency Program Director: Kathryn Funk. Free 1-3 month residencies—$20 application processing fee. "Villa Montalvo, a nonprofit arts center located on a 175 acre historic estate, offers free one- to three-month residencies to writers, musicians and artists. Artists must provide their own food, supplies and living expenses." Application deadlines are March 1 and September 1.

N VISION, Vail Valley Arts Council, P.O. Box 1153, Vail CO 81658. (970)827-5299. E-mail: vailarts@vail.net. Website: http://www.vailarts.com. 2- to 4-day workshops covering all aspects of outdoor and travel photography for all levels of experience. Special winter workshop covers composition, metering and camera-set up in snowy conditions.

MARK WARNER NATURE PHOTO WORKSHOPS, P.O. Box 398, Hollis Center ME 04042. (207)727-4375. Offers 1-4 day workshops on nature and wildlife photography by nationally published photographer and writer at various northeast locations.

N AL WEBER WORKSHOPS, 145 Boyd Way, Carmel CA 93923. (408)624-5535. Contact: Al Weber. Cost: $100/day. Workshops for advanced photographers emphasizing fine art, landscape and craft photography. Offered workshops since 1963.

N ⊕ WEST CRETE PHOTO WORKSHOPS, Galatas, Chania 73100 Crete Greece. Phone/fax: (011)30-821-32201. E-mail: steve.outram@eudoramail.com. Website: http://www.SteveOutram.com. Workshop Photographer: Steve Outram. Cost: $1,660 per person, including lodging. 7-day workshops in May and October in Chania Town, the most picturesque harbour in Greece. "Capture on film, the landscape, the people, the light and the graphic image." Workshops are a maximum of 10 people.

THE INTERNATIONAL MARKETS INDEX, located in the back of this book, lists markets located outside the U.S. by country.

N WILD EYES PHOTO ADVENTURES, 894 Lake Dr., Columbia Falls MT 59912. (406)387-5391. E-mail: wildeyes@bigsky.net. Website: http://kalispell.bigsky.net/wildeyes. Owner: Robin Allen. Cost $1,025. Three-day group photo tours limited to 6. Tuition includes meals, lodging and 2 photo sessions per day.

WILD HORIZONS, INC., P.O. Box 5118-PM, Tucson AZ 85703. (520)743-4551. Fax: (520)743-4552. President: Thomas A. Wiewandt. Average all-inclusive costs: domestic travel $1,400/week; foreign travel $2,000/week. Offers workshops in field techniques in nature/travel photography at vacation destinations in the American West selected for their outstanding natural beauty and wealth of photographic opportunities. Customized learning vacations for small groups are also offered abroad.

WILDERNESS ALASKA, Box 113063, Anchorage AK 99511. (907)345-3567. Fax: (907)345-3967. E-mail: macgill@alaska.net. Website: http://www.gorp.com/wildak. Contact: MacGill Adams. Offers custom photography trips featuring natural history and wildlife to small groups.

WILDERNESS PHOTOGRAPHY EXPEDITIONS, 402 S. Fifth, Livingston MT 59047. (406)222-2302. President: Tom Murphy. Offers programs in wildlife and landscape photography in Yellowstone Park and special destinations.

N WILDLIFE PHOTOGRAPHY SEMINAR, Leonard Rue Enterprises, 138 Millbrook Rd., Blairstown NJ 07825. (908)362-6616. Program Support: Barbara. This is an indepth day-long seminar covering all major aspects of wildlife photography. Based on a slide presentation format with question and answer periods. Topics covered include animal, bird, closeup, reptile and landscape photography as well as exposure and equipment.

N WINONA INTERNATIONAL SCHOOL OF PROFESSIONAL PHOTOGRAPHY, 57 Forsyth St. NW, #1500, Atlanta GA 30303. (404)522-3030, etx. 266. E-mail: winona@america.net. Website: http://www.ppa-world.org. Administrative Assistant: Claudette Kimble. Cost: $520-900/non-members, $320-750/PPA members. Sponsors over 300 1- to 5-day seminars for professional commercial photographers. Locations include Nashville, Denver, Washington DC, Oklahoma City and Phoenix.

N WINSLOW PHOTO TOURS, INC., P.O. Box 334, Durango CO 81302-0334. (970)259-4143. Fax: (970)259-7748. President: Robert Winslow. Cost: varies from workshop to workshop and photo tour to photo tour. "We conduct wildlife model workshops in totally natural settings. We also run various domestic and international photo tours concentrating mostly on intense wildlife photography."

WOMEN'S PHOTOGRAPHY WORKSHOP, P.O. Box 3998, Hayward CA 94540. (510)278-7705. E-mail: kpjordahl@aol.com. Coordinator: Kate Jordahl. Cost: $160/intensive 3-day workshop. Workshops dedicated to seeing more through photography and inspiring women toward growth in their image making and lives through community and interchange. Specializing in women's concerns in photography.

WOMEN'S STUDIO WORKSHOP, SUMMER ARTS INSTITUTE, P.O. Box 489, Rosendale NY 12472. (914)658-9133. E-mail: wsu@ulster.net. Website: http://www.wsworkshop.org. Program Director: Amy Ciullo. Cost: 2-day workshop, $215/$200 for members; 5-day workshop, $430/$410 for members. WSW offers weekend and week-long classes in our comprehensive fully-equipped studios throughout the summer. Photographers may also spend 2-4 weeks here November-May as part of our fellowship program. SASE for specific information.

WOODSTOCK PHOTOGRAPHY WORKSHOPS, 59 Tinker St., Woodstock NY 12498. (914)679-9957. Fax: (914)679-6337. Offers annual lectures and workshops in creative photography from June through October. Faculty includes numerous top professionals in fine art and commercial photography. Interviews workshop interns each March. Topics include still life, landscape, portraiture, lighting, alternative processes. Offers 1-, 2- and 3-day events. Tuition range $55-350.

N THE HELENE WURLITZER FOUNDATION, P.O. Box 545, Taos NM 87571. (505)758-2413. Fax: (505)758-2559. Executive Director: Kenneth G. Peterson. Rent free and utility-free housing. Residents are responsible for their own meals and transportation. No families. Offers residencies to creative, *not* interpretive, artists in all media, for varying periods of time, usually 3 months, from April 1 through September 30, annually, and on a limited basis from October 1 through March 31. No deadlines on applications. However, all residences are assigned into 2001. Send SASE or fax request for application.

YELLOWSTONE INSTITUTE, P.O. Box 117, Yellowstone National Park WY 82190. (307)344-2294. Registrar: Diane Kline. Offers workshops in nature and wildlife photography during the summer, fall and winter. Custom courses can be arranged.

N **YOSEMITE FIELD SEMINARS**, P.O. Box 230, El Portal CA 95318. (209)379-2646. Seminar Coordinator: Penny Otwell. Costs: $80-250. Offers small (8-15 people) workshops in outdoor field photography and natural history throughout the year. Write or call for free brochure. "We're a nonprofit organization."

N **AIVARS ZAKIS PHOTOGRAPHER**, Rt. 1, Box 236, Mason WI 54856. (715)765-4427. Photographer/Owner: Aivars Zakis. Cost: $200. Basic photographic knowledge is required for a 3-day intense course in nature close-up photography with 35mm, medium or large format cameras. Some of the subjects covered include lenses, exposure determination, lighting including flash, films, accessories (some made by photographer) and problem solving.

N **ZEGRAHM EXPEDITIONS**, 1414 Dexter Ave. N., #327, Seattle WA 98109. (206)285-4000. E-mail: zoe@zeco.com. President: Werner Zehnder. 10-day to 1-month photo expeditions for photographers of all skill levels. Locations include Antarctica, Indonesia, South America, Africa and Australia.

Schools

BY TRICIA WADDELL

Whether you are a long-time professional or a newcomer, having a solid education in photography is very important to your success. There are many schools that specialize in photography and offer everything from night school classes to week-long seminars to full-time college-level programs. A good photography program can offer you the opportunity to update your technical skills, focus on self-expression and creativity, and explore different specialties within photography. The following list of photography schools provides a range of programs that focus on photojournalism, professional, fine art and documentary photography and range in length from one-year programs all the way to four-year programs and beyond.

ASSOCIATE DEGREE AND CERTIFICATE PROGRAMS

The following programs primarily emphasize commercial photography and take two years of full-time study or less to complete. Whether you are interested in doing advertising photography, working in a photography lab or opening your own wedding photography studio, these schools provide a solid foundation in the technical, creative and business aspects of photography.

Antonelli College, 124 E. Seventh St., Cincinnati OH 45202. (513)241-4338. E-mail: mdms@mindspring.com. Website: http://www.antonellic.com. Antonelli's seven-quarter photography program offers classes in all aspects of commercial photography. Heavy emphasis is placed on computers and image software as it relates to photography.

The Creative Circus, 1935 Cliff Valley Way, Atlanta GA 30329. (404)633-1990 or (800)728-1590. E-mail: circus@mindspring.com. Website: http://www.creativecircus.com. Established in 1995, this two-year program focuses on commercial advertising photography taught by working professionals. Photography students work closely with students in the design, art direction and copywriting programs.

Fashion Institute of Technology, 227 W. 27th St., New York NY 10001. (212)760-7675. Website: http://www.fitnyc.suny.edu. FIT's Associate Degree program in photography prepares students for positions as studio assistants, corporate or advertising photographers, or entry level entrepreneurs in fashion, illustration and still life photography. Students will gain experience working with models and stylists and learn how to source props and locations. With its strong industry connections, FIT offers many internship opportunities and a strong placement program.

Hallmark Institute of Photography, The Airport, Turner Falls MA 01376. (413)863-2478. E-mail: hallmark@tiac.net. Website: http://www.hallmark-institute.com. The Hallmark Institute offers a ten-month Certificate in Professional Photography. This full-time resident program covers the technical, creative and business aspects of photography and includes courses in commercial photography, visual arts, portraiture, retouching, marketing, finance and management.

Ohio Institute of Photography and Technology, 2029 Edgefield Rd., Dayton OH 45439. (513)294-6155. E-mail: Admissions_OIPT@hotmail.com. Website: http://www.oipt.com. OIPT offers programs in General Applied Photography; Portraiture; Commercial Photography; Biomedical Photography; Desktop Media and Design; and Professional Imaging Technologies, which combines computer desktop technology with the photographic, video and graphic arts fields.

Portfolio Center, 125 Bennett St., Atlanta GA 30309. (800)255-3169 or (404)351-5055. E-mail: portfolioc@aol.com. Website: http://www.portfoliocenter.com. The Portfolio Center offers a two-year diploma in advertising and editorial photography, with a focus on creating a professional portfolio. By third quarter, all photography students are given their own private studio space. Photography students collaborate with students in the art direction, copywriting and graphic design programs. Faculty includes over 60 professional photographers, artists, writers and designers.

Rockport College, 2 Central St., P.O. Box 200, Rockport ME 04856. (207)236-2558. E-mail: mpw@midcoast.com. Website: http://www.MEworkshops.com. Offered in association with the prestigious Maine Photographic Workshops, Rockport offers associate degree programs in photography, digital arts, film and video. With less than 200 students and a conservatory atmosphere, the associate program is for students interested in working for newspapers and magazines, as advertising, portrait and corporate photographers or freelance artists. In the summer, the guest workshop faculty includes some of the world's most creative minds in the visual arts. Rockport also offers graduate level programs and a summer residency program.

Washington School of Photography, 4850 Rugby Ave., Bethesda MD 20814. (301)654-1998. E-mail: wsp@tidalwave.net. Website: http://www.tidalwave.net/~wsp. The Washington School offers a state-certified diploma program in professional photography plus workshops and lectures covering various aspects of photography for both professionals and non-professionals.

Western Academy of Photography, 755A Queens Ave., Victoria, British Columbia V8T 1M2 Canada. (250)383-1522. Western Academy offers ten-month diploma programs in professional photography and journalism/photojournalism. Divided into two parts, Fundamentals of Photography and Applied Photography, Fundamentals covers basic photo and computer imaging skills, while Applied Photography covers portrait, wedding, architectural, fashion, stock, advertising, sports, wildlife, landscape and photojournalism.

BACHELOR DEGREE AND ADVANCED PROGRAMS

The following programs represent some of the best photography schools in the country. The list mixes fine art photography, professional photography, documentary photography and photojournalism. These schools offer intensive course work, prestigious working faculty, alumni and visiting artists, and a creatively stimulating and competitive environment. While this brief list mainly concentrates on schools located in the image-conscious centers of the east and west coasts, there are many four-year college and graduate-level programs across the country that can provide you with an excellent education in photography. For more information about university degrees in photography, check your local library for the most recent edition of *Peterson's Guide to Four-Year Colleges*.

Art Center College of Design, 1700 Lida St., Pasadena CA 91103. (818)584-5035. Website: http://www.artcenter.edu. The exclusive ACCD offers an intensive and structured four-year program focusing on advertising, fashion and editorial photography. However, photography students can also opt for a fine art minor, or take electives from many of the other specialized design programs such as graphic and packaging design, film or advertising design.

Brooks Institute of Photography, 801 Alston Rd., Santa Barbara CA 93108. (805)966-3888. E-mail: admissions@brooks.edu. Website: http://www.brooks.edu. With its decidedly commercial bent, Brooks offers diploma, BA and MS degree programs taught by working professionals. Students can choose between seven photography majors including Color Technology, Commercial Photography, Digital Imaging, Illustration/Advertising, Industrial/Scientific, Professional Portraiture and Motion Picture/Video.

California Institute of the Arts, 24700 McBean Pkwy., Valencia CA 91350. (800)545-2787 (outside CA), (800)292-2787 (within CA). E-mail: admiss@muse.calarts.edu. Website: http:// www.calarts.edu. Known as Cal Arts, its BFA and MFA programs are openly anti-technical, emphasizing theory, criticism and experimentation instead. The school fosters an interdisciplinary and multicultural approach to art due to the close proximity of the Schools of Art, Dance, Film/Video, Music and Theater. With a focus on fine art photography, Cal Arts boasts a prestigious faculty and alumni roster and hosts many world-renowned guest artists and speakers.

International Center of Photography, 1130 Fifth Ave., New York NY 10128. (212)860-1776. Website: http://www.icp.org. ICP is both a museum and school, offering three full-time programs. There is a one-year certificate program in General Studies focusing on fine art photography and a one-year certificate program in Documentary Photography and Photojournalism. Both programs are geared for intermediate and advanced students and are competitive. ICP also ofers a masters program in conjunction with NYU. Faculty members are first-rate working photographers, such as Mary Ellen Mark, Mark Seliger and Barbara Degenevieve.

Rochester Institute of Technology, School of Photographic Arts & Sciences, 60 Lomb Memorial Dr., Rochester NY 14623-5604. (716)475-6631. E-mail: admissions@rit.edu. Website: http:// www.rit.edu. RIT is known as a world center for photography and offers the most comprehensive photography program in the country. Specialties include BFA programs in Fine Art Photography, Advertising Photography and Photojournalism; BS degrees in Biomedical Photographic Communications, Imaging and Photographic Technology and Imaging Systems Management; and masters-level programs.

San Francisco Art Institute, 800 Chestnut St., San Francisco CA 94133. (415)749-4500 and (800)345-7324. Website: http://www.sfai.edu. Founded by Ansel Adams, this fine art photography program is designed for the self-directed student. With a program focus on self-evaluation and personal expression, students can design their own curriculum and are encouraged to combine photography with other media. SFAI offers a BFA, MFA and a one-year post-baccalaureate program focused on studio work to prepare students for graduate study.

School of Visual Arts, Photography Dept., 209 E. 23rd St., New York NY 10010. (212)592-2100. Website: http://www.schoolofvisualarts.edu. SVA offers a diverse program with concentrations in commercial, fine art or documentary photography. As the largest art college in the country, SVA has a student body of around 2,500, and also operates a small branch campus in Savannah, Georgia, for approximately 100 students. In the fourth year, students are required to complete a year-long thesis project under the supervision of a faculty member who is a working professional. Students can pursue BFA or MFA degrees in photography.

University of Missouri School of Journalism, P.O. Box 838, Columbia MO 65205. (314)882-6194. Website: http://www.missouri.edu/~jschool/index.html. Ranked as the #1 journalism school in the country, the Missouri School of Journalism offers an intensive photojournalism degree program. Students have access to many visiting photographers and editors, opportunities for internships and field experience, and can participate in the publishing of a daily city paper and a weekly magazine.

Professional Organizations

The organizations in the following list can be valuable to photographers who are seeking to broaden their knowledge and contacts within the photo industry. Typically, such organizations have regional or local chapters and offer regular activities and/or publications for their members. To learn more about a particular organization and what it can offer you, call or write for more information.

ADVERTISING PHOTOGRAPHERS OF NEW YORK (APNY), 27 W. 20th St., Room 601, New York NY 10011. (212)807-0399.

AMERICAN SOCIETY OF MEDIA PHOTOGRAPHERS (ASMP), 14 Washington Rd., Suite 502, Princeton Junction NJ 08550-1033. (609)799-8300.

AMERICAN SOCIETY OF PICTURE PROFESSIONALS (ASPP), ASPP Membership, 2025 Pennsylvania Ave. NW, Suite 226, Washington DC 20006. (202)955-5578. Executive Director: Cathy Sachs.

THE ASSOCIATION OF PHOTOGRAPHERS UK, 9-10 Domingo St., London EC1Y 0TA England. Phone: 44 171 608 1441. Fax: 44 171 253 3007. E-mail: aop@dircom.co.uk.

BRITISH ASSOCIATION OF PICTURE LIBRARIES AND AGENCIES, 18 Vine Hill, London EC1R 5DX England. Phone: 44 171 713-1780. Fax: 44 171 712-1211.

BRITISH INSTITUTE OF PROFESSIONAL PHOTOGRAPHY (BIPP), Fox Talbot House, Amwell End, Ware, Herts, England. Phone: 44 192 464011. Fax: 44 192 487056.

CANADIAN ASSOCIATION OF JOURNALISTS, PHOTOJOURNALISM CAUCUS, 2 Mullock St., St. Johns, Newfoundland A1C 2R5 Canada. (709)576-2297. Contact: Greg Locke.

CANADIAN ASSOCIATION OF PHOTOGRAPHERS & ILLUSTRATORS IN COMMUNICATIONS, 100 Broadview Ave., Suite 322, Toronto, Ontario M4M 2E8 Canada. (416)462-3700. Fax: (416)462-3678. http://www.capic.org.

THE CENTER FOR PHOTOGRAPHY AT WOODSTOCK (CPW), 59 Tinker St., Woodstock NY 12498. (914)679-9957. Fax: (914)679-6337. Executive Director: Colleen Kenyon.

EVIDENCE PHOTOGRAPHERS INTERNATIONAL COUNCIL (EPIC), 600 Main St., Honesdale PA 18431. (717)253-5450. President: Bob Jennings.

THE FRIENDS OF PHOTOGRAPHY, 250 Fourth St., San Francisco CA 94103. (415)495-7000.

INTERNATIONAL ASSOCIATION OF PANORAMIC PHOTOGRAPHERS, 3042 Cardinal Dr., Del Ray Beach FL 33444. (407)276-0886.

INTERNATIONAL CENTER OF PHOTOGRAPHY (ICP), 1130 Fifth Ave., New York NY 10128. (212)860-1781.

INTERNATIONAL SOCIETY OF FINE ART PHOTOGRAPHERS, P.O. Box 440735, Miami FL 33144.

THE LIGHT FACTORY (TLF) PHOTOGRAPHIC ARTS CENTER, 809 W. Hill St., Charlotte NC 28208. Mailing Address: P.O. Box 32815, Charlotte NC 28232. (704)333-9755.

NATIONAL PRESS PHOTOGRAPHERS ASSOCIATION (NPPA), 3200 Croasdaile Dr., Suite 306, Durham NC 27705. (800)289-6772. NPPA Executive Director: Charles Cooper.

NORTH AMERICAN NATURE PHOTOGRAPHY ASSOCIATION (NANPA), 10200 W. 44th Ave., Suite 304, Wheat Ridge CO 80033-2840. (303)422-8527. President: Jane S. Kinne. Executive Director: Jerry Bowman.

PHOTOGRAPHIC SOCIETY OF AMERICA (PSA), 3000 United Founders Blvd., Suite 103, Oklahoma City OK 73112. (405)843-1437.

PICTURE AGENCY COUNCIL OF AMERICA (PACA), P.O. Box 308, Northfield MN 55057-0308. (800)457-7222.

THE PROFESSIONAL PHOTOGRAPHERS MINORITY NETWORK (PPMN), 352 Cotton Ave., Macon GA 31201. (912)741-5151. Fax: (912)741-5152. E-mail: hholmesjr@aol.com.

PROFESSIONAL PHOTOGRAPHERS OF AMERICA (PPA), 229 Peachtree St. NE, Suite 2200, Atlanta GA 30303. (404)522-8600.

PROFESSIONAL PHOTOGRAPHERS OF CANADA (PPOC), P.O. Box 337, Gatineau, Quebec J8P GJ3 Canada. Website: http://www.ppoc.ca.

SOCIETY FOR PHOTOGRAPHIC EDUCATION, P.O. Box 222116, Dallas TX 75222. E-mail: socphoto@aol.com. Website: http://www.arts.ucsb.edu/SPE.

SOCIETY OF PHOTOGRAPHER AND ARTIST REPRESENTATIVES, INC. (SPAR), 60 E. 42nd St., Suite 1166, New York NY 10165. (212)779-7464.

VOLUNTEER LAWYERS FOR THE ARTS, 1 E. 53rd St., 6th Floor, New York NY 10022. (212)319-2787.

WEDDING & PORTRAIT PHOTOGRAPHERS INTERNATIONAL (WPPI), P.O. Box 2003, 1312 Lincoln Blvd., Santa Monica CA 90406. (310)451-0090.

WHITE HOUSE NEWS PHOTOGRAPHERS' ASSOCIATION, INC. (WHNPA), P.O. Box 7119, Ben Franklin Station, Washington DC 20044-7119. (202)785-5230.

WORLD COUNCIL OF PROFESSIONAL PHOTOGRAPHERS, 654 Street Rd., Bensalem PA 19020.

Websites for Photographers

New photography websites are popping up on the Internet everyday, as photographers, galleries, magazines, retailers and organizations realize the graphic power and reach of the World Wide Web. We have listed some of the most useful sites for accessing information about the business and craft of photography, along with a section of links pages that list hundreds of photography sites we don't have the space to include here. Don't forget to check the websites given in many of our listings, too. No matter what your specific interest in photography, there's a website out there for you. If you run across other quality sites that we haven't listed, let us know! (E-mail us at photomarket@fwpubs.com.)

GENERAL

ACE - All Camera Equipment http://www.acecam.com
A photo site extravaganza, this web guide contains more than 500 links for camera stores, mail order and specialty houses, used equipment dealers and more than 90 online photo magazines from around the world.

Focal Point http://www.fpointinc.com
This website directory can help you find almost anything photographic, including products, services, technical help and photo-related jobs through a classifieds section. Also check out "Photo-Site Roulette" which whisks you away to a new, randomly selected photo site with just a click of the wheel.

Black Book http://www.blackbook.com
The Alternative Pick http://www.AltPick.com
These creative directories of commercial photographers, illustrators and artists are typically only distributed to creative directors, designers and photo editors, but now you can access them on the Internet. The online versions show some of the best examples of self-promotional materials by photographers and include links to many portfolio websites. Also, if you are shopping for an art/photo representative, this is the place to find out who reps who.

photo.net Nature Photography pages http://www.photo.net/photo/nature
Devoted exclusively to nature photography, this website has information on photo equipment needs in the great outdoors and advice on how to photograph different subjects from butterflies to the sun, moon and stars. Also includes reviews of the best travel destinations for capturing mother nature on film.

Sports Servers Hot Off the Photo Wires http://www4.nando.net/SportServer/Hot_Pix.html
If you love sports photography, this is the site to see. This website delivers a collection of breaking photos from the world of sports, updated daily.

Art DEADLINES List http://www.xensei.com/adl/
This information-packed website provides a list of juried competitions, calls for entries, jobs, internships, scholarships, residencies, grants and other opportunities for artists, art educators and

art students of all ages. This list is updated monthly and is also available in an e-mail version.

PHOTOJOURNALISM

National Press Photographers Association Online http://sunsite.unc.edu/nppa
This informative site by the NPPA features a calendar of photojournalism conferences, workshops and contests in addition to membership info and benefits.

The Digital Journalist http://digitaljournalist.org
Billed as "a multimedia magazine for photojournalism in the digital age," this website features articles, interviews and photo essays by some of the best photojournalists in the world.

Newsies http://www.newsies.com
If you are interested in news photography (TV and print), look no further. This website provides a wealth of information on all aspects and current issues within the news industry, along with links to many news photographers' individual websites. Includes valuable information for freelancers.

MAGAZINES

Photo District News http://www.pdn-pix.com/index.html
If you are already familiar with the oversize newsstand edition of *PDN*, this website will not disappoint. *PDN*'s website is beautifully designed, easy to navigate and packed full of industry news and trends, portfolios of the world's best photographers, technical features and equipment reviews, and valuable information for digital photographers. The site also includes an interactive bulletin board for Q & A, a download page of Internet tools, classifieds and an archive of articles dating back to 1985.

PEI Magazine http://www.peimag.com
PEI (Photo Electronic Imaging) has a website version designed specifically for professionals in the digital imaging field. The site includes informative articles, discussion forums and downloadable tutorials on how to maximize the stunning effects achieved through electronic imaging.

Time Life Photo Sight http://pathfinder.com/photo/sighthome.html
The Time Life Photo Gallery contains five decades of 20th century history in unforgettable images from *Time* and *Life* magazines. Check out the Photo Essay section to witness photojournalism at its best. This site also contains links to all of the magazines in the Time Inc. empire including **Sports Illustrated, Fortune, People** and *Entertainment Weekly*.

Communication Arts Magazine http://www.commarts.com/index.html
This online resource for creative professionals covers all aspects of visual communications from around the world. Geared to graphic designers, photographers, art directors, copywriters, illustrators and multimedia designers, the site also contains a Career section that advertises job prospects from around the country and a Community Forum for members of the creative community to discuss design issues.

Adweek, Mediaweek and Brandweek http://www.adweek.com
These industry bibles are a must for anyone working in advertising photography. This website offers the hottest trends and latest news in the marketing and advertising world. Get a behind the scenes look at the advertising and design firms that are getting noticed and find out how companies are spending their advertising dollars. Be sure to look at the Creative section to see current examples of some of the best advertising photography around.

STOCK PHOTOGRAPHY

Stockphoto http://www.stockphoto.joelday.com/stockphoto/index.html

This comprehensive stock photography site offers resources for photographers and photo buyers. Its pages include links to over 100 online catalogs that license images for the Internet; an A-Z listing of major worldwide stock agencies, with addresses and hot links; and a market leads service that sends photographers daily, weekly or monthly stock requests. The site also provides a link to a moderated discussion forum and a page of answers to frequently asked questions about the stock photography industry.

Global Photographers Search http://www.photographers.com/default.asp
This extensive website offers free listings to photo professionals as well as a subscription service—the company will post your sample images or design and maintain your home page. The site can be searched for free by anyone looking for a photographer, assistant, model, supplies or stock photos. Buyers looking for specific images can also post stock requests.

PhotoSource International http://www.photosource.com
PhotoSource International provides an electronic "meeting place" for photographers and photo buyers. For a monthly fee, photographers can display sample images and stocklists for photo buyers to search. PSI facilitates the initial stock search but takes no commission on sales. The site also provides helpful resources to stock photographers including marketing tips, newsletters, books, etc.

Most major stock agencies have their own websites. You should always gather as much information about an agency as possible before sending your work—the following sites are fast and easy information-gathering tools:

Black Star http://www.blackstar.com
Comstock http://www.comstock.com
Corbis http://www.corbisimages.com
FPG Stock http://www.fpg.com
Image Bank http://www.imagebank.com
Liaison International http://www.liaisonintl.com
PhotoBank http://www.photobank.com
Sharpshooters http://www.sharpshooters.com
Tony Stone Images http://www.getty-images.com
Westlight http://www.stockworkbook.com

FINE ART PHOTOGRAPHY
Photography in New York International http://www.photography-guide.com/index.html
This valuable web guide contains listings of New York City, national and international exhibitions, private dealers, auctions and events, plus a directory of photographic services. It also includes a list of the major fine art photographers past and present and tells who represents and shows their work. Check out the photography links page for a comprehensive list of resources for fine art photography.

GEN ART http://www.genart.com
GEN ART is a nonprofit organization supporting emerging talent (you must be 35 or younger) in the visual arts, film and fashion. With offices located in New York, Los Angeles and San Francisco, their website provides information on their many programs and includes portfolio submission guidelines for their group exhibitions.

Art Support http://www.gonesouth.com/artsupport/
This website is devoted to fine art photographers and self-promotion. Art Support offers artist

portfolio guidelines, sample business forms (such as model releases), and a wealth of information about how to get your work considered for exhibition.

Creative Nude Photography Network http://www.ethoseros.com/cnpn.html
For those specializing in fine art nude photography, this online guide features established and emerging photographers, galleries of varied works, workshops and fine art books. You can also join the network and have your portfolio and/or website added to the site.

TECHNICAL
Darkroom Online http://www.sound.net/~lanoue/
Aimed at both professionals and beginners, this site covers all levels of both color and black & white photography. You can find darkroom tips, techniques, how-to's, and questions and answers for both film and paper processing. Also featured is a section on how to build a darkroom and extensive information about all types of film and papers.

Hyperzine http://www.hyperzine.com
Check out this jam-packed site that gives you the latest news on photography, digital imaging, video and consumer electronics. Filled with equipment reviews, pro features, buying tips, hands-on tests, reviews of photo-related books, videos and software, creative and technical advice and information on the latest high-tech products, this site also provides a constantly updated list of competitions, a classifieds page and a list of camera clubs across the country. It even has a "Hyper Glossary" page that defines all the photo, video and digital terms you can think of.

Photo.net http://photo.net/photo/
This site is great for anyone relatively new to photography who wants information about equipment and techniques in easy to understand language. You'll find articles on how to buy a camera that fits your needs, whether you want 35mm, large format or are thinking about investing in digital. It also includes basic information everyone needs about framing, storage, camera cleaning, choosing the right film and more.

The Pixel Foundry http://the-tech.mit.edu/KPT
This site includes Kai's Power Tips and Tricks for working with Photoshop (a must-have resource for Photoshop users) as well as Tom's Tips for Web Designers and Swanson's Technical Support for advanced Photoshop techniques. Get the most out of Photoshop by doing research here.

Handmade Photographic Images http://www2.ari.net/glsmyth
Want to learn some alternative photographic techniques? This website will teach you how to explore creative shooting with infrared and ultraviolet photography, pinhole photography and many alternative printing techniques such as dye transfer, kallitypes, platinum, cyanotype, albumen, Polaroid image transfers and more.

Image Perfected http://home.earthlink.net/~/waldon
This site tells you how to digitally retouch, repaint, and composite photos to create photo-digital fine art. It also features a gallery of digital photography and illustration.

LINKS
There are hundreds of photography sites on the Internet, and it would be impossible to list them all, so here are some great links pages that will connect you to an endless source of photographic inspiration and resources.

Bengt's Photo Page http://www.algonet.se/~bengtha/photo
This is an extensive links page organized under headings including Photo Exhibitions, Documents, Digital Imaging, Mailing List Archives, News Groups, User Groups, Magazines and others.

Charles Daney's Photography Pages http://www.mbay.net/~cgd/photo/pholinks.htm
Site of over 600 links organized by categories including General, Digital, Commercial, Individual Photographers, Online Galleries, etc. This site offers something for everyone.

Focus on Photography http://www.goldcanyon.com/photography/index.html
This is the perfect place for beginning photographers to learn more about their craft. The site's links include information about basic camera functions, composition, lighting, famous photographers and other photo resources.

The Photo Page http://www.generation.net/~gjones
Mega list of over 950 photo-related links. Categories include Camera Clubs, Equipment Manufacturers, Photographers' Associations, Photojournalism, Photo News Groups, Education and others.

PhotoLinks http://www.atchison.net/PhotoLinks
Deceptively simple-looking links page. This site is extremely well-organized and easy to navigate. Categories include Amateur Photography, Professional Photography, Fine Art Photography and Equipment.

All-Photography.com http://www.all-photography.com/index_1.html
With hundreds of links, this site can connect you to webpages of famous and emerging photographers, photo equipment and technical advice, multi-artist galleries, darkroom and digital imaging information and much more.

Helpful Resources for Photographers

Photographer's Market recommends the following additional reading material to stay informed about market trends as well as to find additional names and addresses of photo buyers. Most are available either in a library or bookstore or from the publisher. To insure accuracy of information, use the most recent copies and editions of these resources.

PERIODICALS

ADVERTISING AGE, 220 E. 42nd St., New York NY 10017. (212)210-0100. Weekly magazine covering marketing, media and advertising.

ADWEEK, 1515 Broadway, New York NY 10036. (212)536-6504. Weekly magazine covering advertising agencies.

AMERICAN PHOTO, 1633 Broadway, 43rd Floor, New York NY 10019. (212)767-6086. Monthly magazine emphasizing the craft and philosophy of photography.

ART CALENDAR, P.O. Box 199, Upper Fairmont MD 21867-0199. (410)651-9150. Monthly magazine listing galleries reviewing portfolios, juried shows, percent-for-art programs, scholarships and art colonies, among other art-related topics.

ASMP BULLETIN, 14 Washington Rd., Suite 502, Princeton Junction NJ 08550-1033. (609)799-8300. Monthly newsletter of the American Society of Media Photographers. Subscription comes with membership in ASMP.

COMMUNICATION ARTS, 410 Sherman Ave., Box 10300, Palo Alto CA 94303. Website: http://www.commarts.com. Magazine covering design, illustration and photography. Published 8 times a year.

EDITOR & PUBLISHER, The Editor & Publisher Co., Inc., 11 W. 19th St., New York NY 10011. (212)675-4380. Website: http://www.mediainfo.com. Weekly magazine covering latest developments in journalism and newspaper production. Publishes an annual directory issue listing syndicates and another directory listing newspapers.

F8 and BEING THERE, P.O. Box 8792, St. Petersburg FL 33738. (813)397-3013. A bimonthly newsletter for nature photographers who enjoy travel.

FOLIO, 911 Hope St., P.O. Box 4949, Bldg. 6, Stamford CT 06907-0949. (203)358-9900. Monthly magazine featuring trends in magazine circulation, production and editorial.

GRAPHIS, 141 Lexington Ave., New York NY 10016-8193. (212)532-9387. Fax: (212)213-3229. Website: http://www.pathfinder.com. Magazine for the visual arts.

GREETINGS TODAY, The Greeting Card Association, 810 E. 10th St., Lawrence KS 66044. (800)627-0932. Monthly trade magazine covering the greeting card and stationery industry.

GUILFOYLE REPORT, AG Editions, 41 Union Square W., #523, New York NY 10003. (212)929-0959. Website: http://www.agpix.com. Market tips newsletter published 10 times/year for nature and stock photographers.

HOW, F&W Publications, 1507 Dana Ave., Cincinnati OH 45207. (800)289-0963. Website: http://www.howdesign.com. Bimonthly magazine for the design industry.

MARKETING MAGAZINE, 777 Bay St., 5th Floor, Toronto, Ontario M5W 1A7 Canada. (416)596-5000. Canadian weekly dedicated to marketing, advertising and the media.

NEWS PHOTOGRAPHER, 1446 Conneaut Ave., Bowling Green OH 43402. (419)352-8175. Monthly news tabloid published by the National Press Photographers Association.

OUTDOOR PHOTOGRAPHER, 12121 Wilshire Blvd., Suite 1220, Los Angeles CA 90025. (310)820-1500. Monthly magazine emphasizing equipment and techniques for shooting in outdoor conditions.

PETERSEN'S PHOTOGRAPHIC MAGAZINE, 6420 Wilshire Blvd., Los Angeles CA 90048-5515. (213)782-2200. Monthly magazine for beginning and semi-professional photographers in all phases of still photography.

PHOTO DISTRICT NEWS, 1515 Broadway, New York NY 10036. Website: http//www.pdn-pix.com. Monthly trade magazine for the photography industry.

PHOTOSOURCE INTERNATIONAL, Pine Lake Farm, 1910 35th Rd., Osceola WI 54020. (715)248-3800. This company publishes several helpful newsletters, including *PhotoLetter*, *PhotoMarket*, *Photo-Bulletin* and *PhotoStockNotes*.

POPULAR PHOTOGRAPHY, 1633 Broadway, New York NY 10019. (212)767-6000. Monthly magazine specializing in technical information for photography.

PRINT, RC Publications Inc., 104 Fifth Ave., 19th Floor, New York NY 10011. (212)463-0600. Fax: (212)989-9891. Bimonthly magazine focusing on creative trends and technological advances in illustration, design, photography and printing.

PROFESSIONAL PHOTOGRAPHER, Professional Photographers of America (PPA), 57 Forsyth St. NW, Suite 1600, Atlanta GA 30303. (404)522-8600. Website: http://www.ppa-world.org. Monthly magazine emphasizing technique and equipment for working photographers.

PUBLISHERS WEEKLY, Bowker Magazine Group, Cahners Publishing Co., 249 W. 17th St., New York NY 10011. (212)645-0067. Weekly magazine covering industry trends and news in book publishing, book reviews and interviews.

THE RANGEFINDER, 1312 Lincoln Blvd., Santa Monica CA 90401. (310)451-8506. Monthly magazine on photography technique, products and business practices.

SHUTTERBUG, Patch Communications, 5211 S. Washington Ave., Titusville FL 32780. (407)268-5010. Monthly magazine of photography news and equipment reviews.

STUDIO PHOTOGRAPHY AND DESIGN, Cygnus Publishing, 445 Broad Hollow Rd., Melville NY 11747. (516)845-2700. This magazine was formed when The Commercial Image merged with another publication.

TAKING STOCK, published by Jim Pickerell, Pickerell Services, 110 Frederick Ave., Suite A, Rockville MD 20850. (301)251-0720. Website: http://www.pickphoto.com. Newsletter for stock photographers; includes coverage of trends in business practices such as pricing and contract terms.

BOOKS & DIRECTORIES

ADWEEK AGENCY DIRECTORY, Adweek Publications, 1515 Broadway, New York NY 10036. (212)536-5336. Annual directory of advertising agencies in the U.S.

ADWEEK CLIENT (BRAND) DIRECTORY, Adweek Publications, 1515 Broadway, New York NY 10036. (212)536-5336. Directory listing top 2,000 brands, ranked by media spending.

ASMP COPYRIGHT GUIDE FOR PHOTOGRAPHERS, 14 Washington Rd., Suite 502, Princeton Junction NJ 08550. (609)799-8300.

ASMP PROFESSIONAL BUSINESS PRACTICES IN PHOTOGRAPHY, 5th Edition, published by Allworth Press, distributed by Writer's Digest Books, 1507 Dana Ave., Cincinnati OH 45207. (800)289-

0963. Handbook covering all aspects of running a photography business including copyright, contracts and billing.

BACON'S DIRECTORY, 332 S. Michigan, Suite 900, Chicago IL 60604. (312)922-2400. Directory of magazines.

THE BEST SEASONAL PROMOTIONS, by Poppy Evans, North Light Books, 1507 Dana Ave., Cincinnati OH 45207. (800)289-0963. Idea book of self-promotions focusing on seasonal opportunities.

BEST SMALL BUDGET SELF-PROMOTIONS, by Carol Buchanan, North Light Books, 1507 Dana Ave., Cincinnati OH 45207. (800)289-0963. Idea book of self-promotions focusing on money-saving ideas.

BLUE BOOK, AG Editions, 41 Union Square W., #523, New York NY 10003. (212)929-0959. Website: http://www.agpix.com. Biannual directory of geographic, travel and destination stock photographers for use by photo editors and researchers.

BUSINESS AND LEGAL FORMS FOR PHOTOGRAPHERS, by Tad Crawford, Allworth Press, 10 E. 23rd St., New York NY 10010. (212)777-8395. Book of negotiation tactics and 24 forms for photographers.

THE BUSINESS OF COMMERCIAL PHOTOGRAPHY, by Ira Wexler, Amphoto Books, 1515 Broadway, New York NY 10036. Comprehensive career guide including interviews with 30 leading commercial photographers.

THE BUSINESS OF STUDIO PHOTOGRAPHY, by Edward R. Lilley, Allworth Press, 10 E. 23rd St., New York NY 10010. (212)777-8395. A complete guide to starting and running a successful photography studio.

CHILDREN'S WRITERS & ILLUSTRATOR'S MARKET, Writer's Digest Books, 1507 Dana Ave., Cincinnati OH 45207. (800)289-0963. Annual directory including photo needs of book publishers, magazines and multimedia producers in the children's publishing industry.

CREATIVE BLACK BOOK, 10 Astor Place, 6th Floor, New York NY 10003. (800)841-1246. Sourcebook used by photo buyers to find photographers.

THE DESIGN FIRM DIRECTORY, Wefler & Associates, P.O. Box 1167, Evanston IL 60204. (847)475-1866. The graphic design edition of this directory lists more than 1,600 firms.

DIRECT STOCK, 10 E. 21st St., 14th Floor, New York NY 10010. (212)979-6560. Sourcebook used by photo buyers to find photographers.

DIRECTORY OF MAJOR MAILERS, Target Marketing, 401 N. Broad St., Philadelphia PA 19108. (215)238-5300. Guide to direct marketers.

ENCYCLOPEDIA OF ASSOCIATIONS, Gale Research Inc., 645 Griswold St., 835 Penobscot Bldg., Detroit MI 48226-4094. (313)961-2242. Annual directory listing active organizations.

FRESH IDEAS IN PROMOTION (1&2), by Lynn Haller, North Light Books, 1507 Dana Ave., Cincinnati OH 45207. (800)289-0963. Idea book of self-promotions.

GALE'S DIRECTORY OF DATABASES, Gale Research Inc., 645 Griswold St., 835 Penobscot Bldg., Detroit MI 48226. (800)877-4253.

GREEN BOOK, AG Editions, 41 Union Square W., #523, New York NY 10003. (212)929-0959. Website: http://www.agpix.com. Biannual directory of nature and general stock photographers for use by photo editors and researchers.

A GUIDE TO TRAVEL WRITING & PHOTOGRAPHY, by Ann and Carl Purcell, published by Writer's Digest Books, 1507 Dana Ave., Cincinnati OH 45207. (800)289-0963. Two experienced travel writers/photographers share their experience about how to be successful in this field.

HOW TO SELL YOUR PHOTOGRAPHS & ILLUSTRATIONS, by Elliot & Barbara Gordon, published by Writer's Digest Books, 1507 Dana Ave., Cincinnati OH 45207. (800)289-0963.

HOW TO SHOOT STOCK PHOTOS THAT SELL, by Michal Heron, published by Allworth Press, distributed by Writer's Digest Books, 1507 Dana Ave., Cincinnati OH 45207. (513)531-2222.

HOW YOU CAN MAKE $25,000 A YEAR WITH YOUR CAMERA, by Larry Cribb, published by Writer's Digest Books, 1507 Dana Ave., Cincinnati OH 45207. (800)289-0963. Newly revised edition of the popular book on finding photo opportunities in your own hometown.

KLIK, American Showcase, 915 Broadway, 14th Floor, New York NY 10010. (212)673-6600. Sourcebook used by photo buyers to find photographers.

LA 411, 7083 Hollywood Blvd., Suite 501, Los Angeles CA 90028. (213)460-6304. Music industry guide, including record labels.

LEGAL GUIDE FOR THE VISUAL ARTIST, by Tad Crawford, Allworth Press, 10 E. 23rd St., New York NY 10010. (212)777-8395. The author, an attorney, offers legal advice for artists and includes forms dealing with copyright, sales, taxes, etc.

LIGHTING SECRETS FOR THE PROFESSIONAL PHOTOGRAPHER, by Alan Brown, Tim Grondin and Joe Braun, published by Writer's Digest Books, 1507 Dana Ave., Cincinnati OH 45207. (800)289-0963. Step-by-step lighting instructions for 31 different shoots.

LITERARY MARKET PLACE, R.R. Bowker Company, 121 Chanlon Rd., New Providence NJ 07974. (908)464-6800. Directory that lists book publishers and other book industry contacts.

MANUFACTURERS REGISTER, Database Publishing, P.O. Box 70024, Anaheim CA 92825. (714)778-6400. This group of directories is published by state and provides a comprehensive listing of manufacturing companies that photographers can contact for assignments.

MARKETING & PROMOTING YOUR WORK, by Maria Piscopo, North Light Books, 1507 Dana Ave., Cincinnati OH 45207. (800)289-0963. Marketing guide for visual artists.

NEGOTIATING STOCK PHOTO PRICES, by Jim Pickerell, 110 Fredereck Ave., Suite A, Rockville MD 20850. (800)868-6376. Website: http://www.pickphoto.com. Hardbound book which offers pricing guidelines for selling photos through stock photo agencies.

NEWSLETTERS IN PRINT, Gale Research Inc., 645 Griswold St., 835 Penobscot Building, Detroit MI 48226-4094. (313)961-6083. Annual directory listing newsletters.

O'DWYER DIRECTORY OF PUBLIC RELATIONS FIRMS, J.R. O'Dwyer Company, Inc., 271 Madison Ave., New York NY 10016. (212)679-2471. Annual directory listing public relations firms, indexed by specialties.

PHOTOGRAPHER'S GUIDE TO MARKETING & SELF-PROMOTION, by Maria Piscopo, Allworth Press, 10 E. 23rd St., New York NY 10010. (212)777-8395. Marketing guide specifically for photographers.

THE PHOTOGRAPHER'S INTERNET HANDBOOK, by Joe Farace, Allworth Press, 10 E. 23rd St., New York NY 10010. (212)777-8395. Covers the many ways photographers can use the Internet as a marketing and informational resource.

THE PHOTOGRAPHER'S MARKET GUIDE TO PHOTO SUBMISSION & PORTFOLIO FORMATS, by Michael Willins, Writer's Digest Books, 1507 Dana Ave., Cincinnati OH 45207. (800)289-0963. A detailed, visual guide to making submissions and selling yourself as a photographer.

PHOTOGRAPHER'S RESOURCE, The Watson-Guptill Guide to Workshops, Conferences, Artists' Colonies and Academic Programs, by Stuart Cohen, Watson-Guptill, 1515 Broadway, New York NY 10036.

PRICING PHOTOGRAPHY: THE COMPLETE GUIDE TO ASSIGNMENT & STOCK PRICES, 2nd Edition, by Michal Heron and David MacTavish, published by Allworth Press, 10 E. 23rd St., New York NY 10010. (212)777-8395.

PROFESSIONAL PHOTOGRAPHER'S GUIDE TO SHOOTING & SELLING NATURE & WILDLIFE PHOTOS, by Jim Zuckerman, Writer's Digest Books, 1507 Dana Ave., Cincinnati OH 45207. (800)289-0963. A well-known nature photographer explains how to take great nature shots and how to reach the right markets for them.

SELL & RESELL YOUR PHOTOS, by Rohn Engh, Writer's Digest Books, 1507 Dana Ave., Cincinnati OH 45207. (800)289-0963. Newly revised edition of the classic volume on marketing your own stock images.

SONGWRITER'S MARKET, Writer's Digest Books, 1507 Dana Ave., Cincinnati OH 45207. (800)289-0963. Annual directory listing record labels.

STANDARD DIRECTORY OF ADVERTISERS, Reed Reference Publishing Co., 121 Chanlon Rd., New Providence NJ 07974. (908)464-6800. Annual directory listing advertising agencies.

STANDARD RATE AND DATA SERVICE (SRDS), 1700 Higgins Rd., Des Plains IL 60018. (847)375-5000. Website: http://www.srds.com. Monthly directory listing magazines, plus their advertising rates.

STOCK PHOTOGRAPHY: THE COMPLETE GUIDE, by Ann and Carl Purcell, published by Writer's Digest Books, 1507 Dana Ave., Cincinnati OH 45207. (800)289-0963. Everything a stock photographer needs to know from what to shoot to organizing an inventory of photos.

THE STOCK WORKBOOK, Scott & Daughters Publishing, Inc., 940 N. Highland Ave., Suite A, Los Angeles CA 90038. (213)856-0008. Annual directory of stock photo agencies.

WRITER'S MARKET, Writer's Digest Books, 1507 Dana Ave., Cincinnati OH 45207. (800)289-0963. Annual directory listing markets for freelance writers. Lists names, addresses, contact people and marketing information for book publishers, magazines, greeting card companies and syndicates. Many listings also list photo needs and payment rates.

THE YELLOW PAGES OF ROCK, The Album Network, 120 N. Victory Blvd., Burbank CA 91502. (818)944-4000. Music industry guide.

Glossary

Absolute-released images. Any images for which signed model or property releases are on file and immediately available. For working with stock photo agencies that deal with advertising agencies, corporations and other commercial clients, such images are absolutely necessary to sell usage of images. Also see Model release, Property release.

Acceptance (payment on). The buyer pays for certain rights to publish a picture at the time he accepts it, prior to its publication.

Agency promotion rights. In stock photography, these are the rights that the agency requests in order to reproduce a photographer's images in any promotional materials such as catalogs, brochures and advertising.

Agent. A person who calls upon potential buyers to present and sell existing work or obtain assignments for his client. A commission is usually charged. Such a person may also be called a *photographer's rep*.

All reproduction rights. See All rights.

All rights. A form of rights often confused with work for hire. Identical to a buyout, this typically applies when the client buys all rights or claim to ownership of copyright, usually for a lump sum payment. This entitles the client to unlimited, exclusive usage and usually with no further compensation to the creator. Unlike work for hire, the transfer of copyright is not permanent. A time limit can be negotiated, or the copyright ownership can run to the maximum of 35 years.

Alternative Processes. Printing processes that do not depend on the sensitivity of silver to form an image. These processes include cyanotype and platinum printing.

Archival. The storage and display of photographic negatives and prints in materials that are harmless to them and prevent fading and deterioration. Archival products include storage boxes, slide pages, mats and other mounting agents.

ASMP member pricing survey. These statistics are the result of a national survey of the American Society of Media Photographers (ASMP) compiled to give an overview of various specialties comprising the photography market. Though erroneously referred to as "ASMP rates," this survey is not intended to suggest rates or to establish minimum or maximum fees.

Assign (designated recipient). A third-party person or business to which a client assigns or designates ownership of copyrights that the client purchased originally from a creator, such as a photographer. This term commonly appears on model and property releases.

Assignment. A definite OK to take photos for a specific client with mutual understanding as to the provisions and terms involved.

Assignment of copyright, rights. The photographer transfers claim to ownership of copyright over to another party in a written contract signed by both parties. Terms are almost always exclusive, but can be negotiated for a limited time period or as a permanent transfer.

Audiovisual. Materials such as filmstrips, motion pictures and overhead transparencies which use audio backup for visual material.

Automatic renewal clause. In contracts with stock photo agencies, this clause works on the concept that every time the photographer delivers an image, the contract is automatically renewed for a specified number of years. The drawback is that a photographer can be bound by the contract terms beyond the contract's termination and be blocked from marketing the same images to other clients for an extended period of time.

AV. See Audiovisual.

Betacam. A videotape mastering format typically used for documentary/location work. Because of its compact equipment design allowing mobility and its extremely high quality for its size, it has become an accepted standard among TV stations for news coverage.

Bimonthly. Occurring once every two months.

Biweekly. Occurring once every two weeks.

Bleed. In a mounted photograph it refers to an image that extends to the boundaries of the board.

Blurb. Written material appearing on a magazine's cover describing its contents.

Body copy. Text used in a printed ad.

Bounce light. Light that is directed away from the subject toward a reflective surface.

Bracket. To make a number of different exposures of the same subject in the same lighting conditions.

Buyout. A form of work for hire where the client buys all rights or claim to ownership of copyright, usually for a lump sum payment. Also see All rights, Work for hire.

Capabilities brochure. In advertising and design firms, this type of brochure—similar to an annual report—is a frequent request from many corporate clients. This brochure outlines for prospective clients the nature of a company's business and the range of products or services it provides.

Caption. The words printed with a photo (usually directly beneath it) describing the scene or action. Synonymous with *cutline*.

Catalog work. The design of sales catalogs is a type of print work that many art/design studios and advertising agencies do for retail clients on a regular basis. Because the emphasis in catalogs is upon selling merchandise, photography is used heavily in catalog design. There is a great demand for such work, so many designers, art directors and photographers consider this to be "bread and butter" work, or a reliable source of income.

CCD. Charged Coupled Device. A type of light detection device, made up of pixels, that generates an electrical signal in direct relation to how much light struck the sensor.

CD-ROM. Compact disc read-only memory; non-erasable electronic medium used for digitized image and document storage and retrieval on computers.

Chrome. A color transparency, usually called a slide.

Cibachrome. A photo printing process that produces fade-resistant color prints directly from color slides.

Clip art. Collections of copyright-free, ready-made illustrations available in b&w and color, both line and tone, in book form or in digital form.

Clips. See Tearsheets.

CMYK. Cyan, magenta, yellow and black—refers to four-color process printing.

Collateral materials. In advertising and design work, these are any materials or methods used to communicate a client's marketing identity or promote its product or service. For instance, in corporate identity designing, everything from the company's trademark to labels and packaging to print ads and marketing brochures is often designed at the same time. In this sense, collateral design—which uses photography at least as much as straight advertising does—is not separate from advertising but support-ive to an overall marketing concept.

Color Correction. The process of adjusting an image to compensate for digital input and output charac-teristics.

Commission. The fee (usually a percentage of the total price received for a picture) charged by a photo agency, agent or gallery for finding a buyer and attending to the details of billing, collecting, etc.

Composition. The visual arrangement of all elements in a photograph.

Compression. The process of reducing the size of a digital file, usually through software. This speeds processing, transmission times and reduces storage requirements.

Contact Sheet. A sheet of negative-size images made by placing the negative in direct contact with the printing paper during exposure. Contact sheets are used to view an entire roll of film on one piece of paper.

Copyright. The exclusive legal right to reproduce, publish and sell the matter and form of a literary or artistic work.

C-print. Any enlargement printed from a negative. (Any enlargement from a transparency is called an R-print.)

Credit line. The byline of a photographer or organization that appears below or beside published photos.

Crop. To omit parts of an image when making a print or copy negative in order to focus attention on one area of the image.

Cutline. See Caption.

Day rate. A minimum fee which many photographers charge for a day's work, whether a full day is spent on a shoot or not. Some photographers offer a half-day rate for projects involving up to a half-day of work. This rate typically includes mark-up but not additional expenses, which are usually billed to the customer.

Demo(s). A sample reel of film or sample videocassette which includes excerpts of a filmmaker's or videographer's production work for clients.

Density. The blackness of an image area on a negative or print. On a negative, the denser the black, the less light that can pass through.

Digital Camera. A filmless camera system that converts an analog image into a digital signal or file.

Disclaimer. A denial of legal claim used in ads and on products.

DPI. Dots per inch. The unit of measure used to describe the resolution of image files, scanners and output devices. How many pixels a device can produce in one inch.

Dry mounting. A method of mounting prints on cardboard or similar materials by means of heat, pressure, and tissue impregnated with shellac.

Emulsion. The light sensitive layer of film or paper.

Enlargement. An image that is larger than its negative, made by projecting the image of the negative onto sensitized paper.

Exclusive property rights. A type of exclusive rights in which the client owns the physical image, such as a print, slide, film reel or videotape. A good example is when a portrait is shot for a person to keep, while the photographer retains the copyright.

Exclusive rights. A type of rights in which the client purchases exclusive usage of the image for a negotiated time period, such as one, three or five years. May also be permanent. Also see All rights, Work for hire.

Fee-plus basis. An arrangement whereby a photographer is given a certain fee for an assignment—plus reimbursement for travel costs, model fees, props and other related expenses incurred in filling the assignment.

File Format. The particular way digital information is recorded. Common formats are TIFF and JPEG.

First rights. The photographer gives the purchaser the right to reproduce the work for the first time. The photographer agrees not to permit any publication of the work for a specified amount of time.

Format. The size or shape of a negative or print.

Four-color printing, four-color process. A printing process in which four primary printing inks are run in four separate passes on the press to create the visual effect of a full-color photo, as in magazines, posters and various other print media. Four separate negatives of the color photo—shot through filters—are placed identically (stripped) and exposed onto printing plates, and the images are printed from the plates in four ink colors.

GIF Graphics Interchange Format. A graphics file format common to the Internet.

Glossy. Printing paper with a great deal of surface sheen. The opposite of matte.

Hard Copy. Any kind of printed output, as opposed to display on a monitor.

Image Resolution. An indication of the amount of detail an image holds. Usually expressed as the dimension of the image in pixels and the color depth each pixel has. Example: 640×480, 24 bit image has higher resolution than a 640×480, 16 bit image.

In perpetuity. A term used in business contracts which means that once a photographer has sold his copyrights to a client, the client has claim to ownership of the image or images forever. Also see All rights, Work for hire.

Internegative. An intermediate image used to convert a color transparency to a b&w print.

IRC. Abbreviation for International Reply Coupon. IRCs are used instead of stamps when submitting material to buyers located outside a photographer's home country.

JPEG Joint Photographic Experts Group. One of the more common compression methods that reduces file size without a great loss of detail.

Leasing. A term used in reference to the repeated selling of one-time rights to a photo; also known as *renting*.

Logo. The distinctive nameplate of a publication which appears on its cover.

Matte. Printing paper with a dull, nonreflective surface. The opposite of glossy.

Model release. Written permission to use a person's photo in publications or for commercial use.

Ms, mss. Manuscript and manuscripts, respectively. These abbreviations are used in *Photographer's Market* listings.

Multi-image. A type of slide show which uses more than one projector to create greater visual impact with the subject. In more sophisticated multi-image shows, the projectors can be programmed to run by computer for split-second timing and animated effects.

Multimedia. A generic term used by advertising, public relations and audiovisual firms to describe productions using more than one medium together—such as slides and full-motion, color video—to create a variety of visual effects. Usually such productions are used in sales meetings and similar kinds of public events.

News release. See Press release.

No right of reversion. A term in business contracts which specifies once a photographer sells his copyrights to an image or images, he has surrendered his claim to ownership. This may be unenforceable, though, in light of the 1989 Supreme Court decision on copyright law. Also see All rights, Work for hire.

Offset. A printing process using flat plates. The plate is treated to accept ink in image areas and to reject it in nonimage areas. The inking is transferred to a rubber roller and then to the paper.

One-time rights. The photographer sells the right to use a photo one time only in any medium. The rights transfer back to the photographer on his request after the photo's use.

On spec. Abbreviation for "on speculation." Also see Speculation.

Page rate. An arrangement in which a photographer is paid at a standard rate per page. A page consists of both illustrations and text.

Panoramic format. A camera format which creates the impression of peripheral vision for the viewer. It was first developed for use in motion pictures and later adapted to still formats. In still work, this format requires a very specialized camera and lens system.

Photo CD. A trademarked Eastman Kodak designed storage system for photographic images using a CD.

PICT. The saving format for bit-mapped and object-oriented images.

Picture Library. See Stock photo agency.

Pixels. The individual light sensitive elements that make up a CCD array. Pixels respond in a linear fashion. Doubling the light intensity doubles the electrical output of the pixel.

Point-of-purchase, point-of-sale. A generic term used in the advertising industry to describe in-store marketing displays which promote a product. Typically, these colorful and highly-illustrated displays are placed near check out lanes or counters, and offer tear-off discount coupons or trial samples of the product.

P-O-P, P-O-S. See Point-of-purchase.

Portfolio. A group of photographs assembled to demonstrate a photographer's talent and abilities, often presented to buyers.

PPI Pixels per inch. Often used interchangeably with DPI, PPI refers to the number of pixels per inch in an image.

Press release. A form of publicity announcement which public relations agencies and corporate communications staff people send out to newspapers and TV stations to generate news coverage. Usually this is sent in typewritten form with accompanying photos or videotape materials. Also see Video news release.

Property release. Written permission to use a photo of private property or public or government facilities in publications or for commercial use.

Publication (payment on). The buyer does not pay for rights to publish a photo until it is actually published, as opposed to payment on acceptance.

Query. A letter of inquiry to an editor or potential buyer soliciting his interest in a possible photo assignment or photos that the photographer may already have.

Release. See Model release, Property release.

Rep. Trade jargon for sales representative. Also see Agent.

Resolution. The particular pixel density of an image, or the number of dots per inch a device is capable of recognizing or reproducing.

Résumé. A short written account of one's career, qualifications and accomplishments.

Royalty. A percentage payment made to a photographer/filmmaker for each copy of his work sold.

R-print. Any enlargement made from a transparency. (Any enlargement from a negative is called a C-print.)

SAE. Self-addressed envelope.

SASE. Self-addressed stamped envelope. (Most buyers require a SASE if a photographer wishes unused photos returned to him, especially unsolicited materials.)

Self-assignment. Any photography project which a photographer shoots to show his abilities to prospective clients. This can be used by beginning photographers who want to build a portfolio or by photographers wanting to make a transition into a new market.

Self-promotion piece. A printed piece photographers use for advertising and promoting their businesses. These pieces usually use one or more examples of the photographer's best work, and are professionally designed and printed to make the best impression.

Semigloss. A paper surface with a texture between glossy and matte, but closer to glossy.

Semimonthly. Occurring twice a month.

Serial rights. The photographer sells the right to use a photo in a periodical. Rights usually transfer back to the photographer on his request after the photo's use.

Simultaneous submissions. Submission of the same photo or group of photos to more than one potential buyer at the same time.

Speculation. The photographer takes photos on his own with no assurance that the buyer will either purchase them or reimburse his expenses in any way, as opposed to taking photos on assignment.

Stock photo agency. A business that maintains a large collection of photos which it makes available to a variety of clients such as advertising agencies, calendar firms, and periodicals. Agencies usually retain 40-60 percent of the sales price they collect, and remit the balance to the photographers whose photo rights they've sold.

Stock photography. Primarily the selling of reprint rights to existing photographs rather than shooting on assignment for a client. Some stock photos are sold outright, but most are rented for a limited time period. Individuals can market and sell stock images to individual clients from their personal inventory, or stock photo agencies can market photographers' work for them. Many stock agencies hire photographers to shoot new work on assignment, which then becomes the inventory of the stock agency.

Stringer. A freelancer who works part-time for a newspaper, handling spot news and assignments in his area.

Stripping. A process in printing production where negatives are put together to make a composite image or prepared for making the final printing plates, especially in four-color printing work. Also see Four-color printing.

Subsidiary agent. In stock photography, this is a stock photo agency which handles marketing of stock images for a primary stock agency in certain US or foreign markets. These are usually affiliated with the primary agency by a contractual agreement rather than by direct ownership, as in the case of an agency which has its own branch offices.

SVHS. Abbreviation for Super VHS. Videotape that is a step above regular VHS tape. The number of lines of resolution in a SVHS picture is greater, thereby producing a sharper picture.

Table-top. Still-life photography; also the use of miniature props or models constructed to simulate reality.

Tabloid. A newspaper about half the page size of an ordinary newspaper, which contains many photos and news in condensed form.

Tearsheet. An actual sample of a published work from a publication.

TIFF Tagged Image File Format. A common bitmap image format developed by Aldus. TIFFs can be b&w or color.

Trade journal. A publication devoted strictly to the interests of readers involved in a specific trade or profession, such as dancers, beekeepers, pilots or manicurists, and generally available only by subscription.

Transparency. A color film with positive image, also referred to as a slide.

Tungsten light. Artificial illumination as opposed to daylight.

Unlimited use. A type of rights in which the client has total control over both how and how many times an image will be used. Also see All rights, Exclusive rights, Work for hire.

Video news release. A videocassette recording containing a brief news segment specially prepared for broadcast on TV new programs. Usually, public relations firms hire AV firms or filmmaker/videographers to shoot and produce these recordings for the publicity purposes of their clients.

Videotape. Magnetic recording tape similar to that used for recording sound, but which also records moving images, especially for broadcast on television.

Work for hire, Work made for hire. Any work that is assigned by an employer and the employer becomes the owner of the copyright. Copyright law clearly defines the types of photography which come under the work-for-hire definition. An employer can claim ownership to the copyright only in cases in which the photographer is a fulltime staff person for the employer or in special cases in which the photographer negotiates and assigns ownership of the copyright in writing to the employer for a limited time period. Stock images cannot be purchased under work-for-hire terms.

World rights. A type of rights in which the client buys usage of an image in the international marketplace. Also see All rights.

Worldwide exclusive rights. A form of world rights in which the client buys exclusive usage of an image in the international marketplace. Also see All rights.

Zone System. A system of exposure which allows the photographer to previsualize the print, based on a gray scale containing nine zones. Many workshops offer classes in the Zone System.

International Index

This index lists photo markets located outside the United States. Eighteen countries are included here, however, most of the markets are located in Canada and the United Kingdom. To work with markets located outside your home country, you will have to be especially professional and patient.

INTERNATIONAL INDEX

Wales

Subject Index

This index can help you find buyers who are searching for the kinds of images you are producing. Consisting of markets from the Publications, Book Publishers, Gifts & Paper Products, Stock Photo Agencies and Galleries sections, this index is broken down into 38 different subjects. If, for example, you shoot outdoor scenes and want to find out which markets purchase this material, turn to the categories Landscapes/Scenics and Outdoors/Environmental.

Celebrities

Erotica/Nudity

Families

Fashion/Glamour

Foreign/Ethnic

Gardening/Horticulture

Humor

Landscapes/Scenics

Medicine

Memorabilia/Hobbies

Outdoors/Environmental

People

Political

Portraits

Product Shots/Still Lifes

Regional

Religious

Science

Technology/Computers

Travel

General Index

This index lists every market appearing in the book; use it to find specific companies you wish to approach. The index also lists companies that appeared in the 1998 edition of *Photographer's Market*, but do not appear this year. Instead of page numbers, beside these markets you'll find two-letter codes in parentheses that explain why they were exlcuded. The codes are: **(ED)**—Editorial Decision, **(NS)**—Not Accepting Submissions, **(NR)**—No or Late Response to Listing Request, **(OB)**—Out of Business, **(RP)**—Business Restructured or Sold, **(RR)**—Removed by Market's Request, **(UC)**—Unable to Contact.

GENERAL INDEX

More Great Books
to Help You Sell What You Shoot!